Ever Yours

Qu'est devenu le souvenir de mauve n'en ayant plus entendu parler j'ai été porté à croire que Tersteeg t'aurait dit quelque chose de desagreable pour faire savoir qu'on le refuserait ou autre misère. Naturellement je ne m'en ferais pas de mauvais sang dans ce cas

Je travaille dans ce moment à une étude comme ceci des bateaux vu d'en haut d'un quai les deux bateaux sont d'un

rose violacé l'eau est très verte. pas de ciel un drapeau incolore au mat un ouvrier avec une brouette décharge du sable. J'en ai aussi un dessin. As tu reçu les trois autres dessins du jardin On finira par ne plus les prendre à la poste parceque le format est trop grand. Je crois que je n'aurai pas un bien beau modèle de femme. elle avait promis puis elle a à ce qui paraît gagné des sous en

Vincent van Gogh

Ever Yours **The Essential Letters**

Edited by Leo Jansen, Hans Luijten, and Nienke Bakker

Yale University Press, New Haven and London

This publication is part of the Van Gogh Letters Project executed under the auspices of the Van Gogh Museum, Amsterdam, and Huygens ING (a division of the Royal Netherlands Academy of Arts and Sciences), The Hague, and is an abridged edition of the complete six-volume publication, *Vincent van Gogh—The Letters: The Complete Illustrated and Annotated Edition*, edited by Leo Jansen, Hans Luijten, and Nienke Bakker (Brussels: Mercatorfonds; London and New York: Thames and Hudson, 2009).
www.vangoghletters.org

www.vangoghmuseum.com

www.huygens.knaw.nl

Published in 2014 by Yale University Press, New Haven and London

Yale
yalebooks.com/art

The publisher gratefully acknowledges the support of the Dutch Foundation for Literature.

Nederlands
letterenfonds
dutch foundation
for literature

Translation of introduction texts: Diane Webb

Translation of the Van Gogh letters:
Translation editor: Michael Hoyle
Translations from the Dutch by Lynne Richards, John Rudge and Diane Webb
Translations from the French by Sue Dyson and Imogen Forster

Designed and set in Bembo and Scala Sans by Chris Crochetière, BW&A Books, Inc.
Printed in China through Oceanic Graphic International, Inc.

Library of Congress Control Number: 2014939683
ISBN 978-0-300-20947-1
A catalogue record for this book is available from the British Library.

The paper in this book meets the requirements of ANSI/NISO Z39.48-1992 (Permanence of Paper).

10 9 8 7 6 5 4 3 2 1

Jacket illustrations: *(front)* detail of letter 400, 1883; *(back)* detail of letter 609, 1888
Frontispiece: detail of letter 660, 1888

All of the letters in this volume belong to the Vincent van Gogh Foundation and are in the Van Gogh Museum, with the exception of the following letters and pages from letters: Fonds Van der Linden, Musées Royaux des Beaux-Arts de Belgique, Brussels: 821; Institut National d'Histoire de l'Art, Paris: 695; Musée Reáttu, Arles: 739; private collections: 325, 569, 665, 691 (part), 740, 756, 853; Thannhauser Collection, Guggenheim Museum, New York: 849; Thaw Collection, The Morgan Library & Museum, New York: 587, 599, 622, 628, 632, 651, 655, 698, 706, 822; and present whereabouts unknown: 716, 776 (part)

Contents

1 Setbacks and Perseverance: An Artist's Life
Leo Jansen, Hans Luijten, and Nienke Bakker

37 Letters with a History

41 Note to the Reader

43 The Hague, 29 September 1872–17 March 1873

46 London, 13 June 1873–8 May 1875

54 Paris, 6 July 1875–28 March 1876

62 Ramsgate, Welwyn, and Isleworth, 17 April–25 November 1876

82 Dordrecht, 7 February–23 March 1877

89 Amsterdam, 30 May 1877–3 April 1878

113 Borinage and Brussels, c. 13 November 1878–2 April 1881

142 Etten, 5 August–c. 23 December 1881

171 The Hague, 29 December 1881–10 September 1883

340 Drenthe, c. 14 September–1 December 1883

365 Nuenen, c. 7 December 1883–c. 14 November 1885

452 Antwerp, 28 November 1885–c. 11 February 1886

472 Paris, c. 28 February 1886–late October 1887

479 Arles, 21 February 1888–3 May 1889

665 Saint-Rémy-de-Provence, 9 May 1889–13 May 1890

736 Auvers-sur-Oise, 20 May–23 July 1890

755 Sketch Illustrations

759 Index of Names

777 Biographies of the Editors

Setbacks and Perseverance An Artist's Life

Leo Jansen, Hans Luijten, and Nienke Bakker

Sorrowful, yet alway rejoicing.
—2 Corinthians 6:10

The letters and artworks of Vincent van Gogh (1853–1890) strike at the very heart of desires and emotions we all share. Intensely inquisitive, Van Gogh absorbed the world around him, but the only way he could relate to that world was to create a counterworld in words and images. He wanted to make art that would comfort people: 'a consolatory art for distressed hearts' (letter 739), by means of compelling colours and peerless lines. His letters are a masterly account of how he set out to achieve this and what drove him to persevere in this endeavour.

Van Gogh was enthusiastic to the point of fanaticism; he set excruciatingly high hurdles for himself, and struggled long and hard to overcome them. His personal life became completely subordinate to art, as time and again he gave his utmost to further his cause, thinking it only natural that he should do so. That this attitude had its dangers had already dawned on him five years before his death: 'The fact that I have a definite belief as regards art also means that I know what I want to get in my own work, and that I'll try to get it even if I go under in the attempt' (531).

Vincent van Gogh was a jack-of-all-trades and master of none until 1880, when he decided to pursue an artistic career and gradually came to grips with his destiny. With hindsight it can be said that he developed as an artist with amazing speed: it took him only ten years to draw and paint the extensive oeuvre that would make him world-famous. Recognition was a long time in coming, however. Only after his self-inflicted death in 1890 did his work finally begin to receive the attention it deserved and his reputation as a pioneering artist become firmly established—a development in which his letters played a vital role.

Vincent van Gogh: A Complex Character

Van Gogh cut a striking figure. Jo van Gogh-Bonger, who became acquainted with Vincent in 1890, described him in her introduction to the 1914 letters edition as 'a robust, broad-shouldered man with a healthy complexion, a cheerful expression and something very determined in his appearance'. Small in stature, he had green eyes, a red beard and freckles; his hair was ginger-coloured like that of his brother Theo, his junior by four years. He had a facial tic, and his hands seemed to be in constant motion. He was rather unsociable, which made him difficult to live with. People were often afraid of him, because of his wild and unkempt appearance and his intense manner of speaking. The way he looked and acted alienated people, which did not make life easy for him.

Van Gogh was almost always convinced that he was right, and this made him quite tiresome. He was a passionate, driven man, whose tendency to act like an egocentric bully made many people dislike him. They saw him as 'a madman—a murderer—a vagabond' (408). Van Gogh refused to let this upset him: '[B]elieve me that I sometimes laugh heartily at how people suspect me (who am really just a friend of nature, of study, of work—and of people chiefly) of various acts of malice and absurdities which I never dream of' (252). He did not avoid confrontations, nor did he spare himself. Theo described him in a letter of March 1887 to their sister Willemien as 'his own enemy'.

Van Gogh was strongly inclined towards introspection: he never hesitated to explore and record his mood swings, or to redefine his moral position. He did this mainly because he had few people to talk to. Examining his own state of mind, he saw a 'highly strung' individual. At the age of twenty-nine, he sketched a merciless picture of himself:

> Don't imagine that I think myself perfect—or that I believe it isn't my fault that many people find me a disagreeable character. I'm often terribly and cantankerously melancholic, irritable—yearning for sympathy as if with a kind of hunger and thirst—I become indifferent, sharp, and sometimes even pour oil on the flames if I don't get sympathy. I don't enjoy company, and dealing with people, talking to them, is often painful and difficult for me. But do you know where a great deal if not all of this comes from? Simply from nervousness—I who am terribly sensitive, both physically and morally, only really acquired it in the years when I was deeply miserable. (244)

These last words refer to the years immediately before he embarked on his artistic career.

However impulsive Van Gogh was, he generally set to work only after much deliberation: 'For the great doesn't happen through impulse alone, and is a succession of little things that are brought together' (274). Time and again, it was willpower and hard work that enabled Van Gogh to raise his low spirits. He repressed his feelings of guilt towards Theo, his dearest friend and confidant, and the only one who could cope with his difficult character. Vincent was well aware that his brother was investing a great deal in him, and the knowledge that he would never be able to repay Theo occasionally made him despair.

The Bond with Theo

Vincent's late decision—in 1880, at the age of twenty-seven—to become an artist was largely due to Theo's encouragement. The fact that it was Theo who persuaded him to

pursue an artistic career greatly influenced their relationship in the following years. Theo considered it his duty to lend Vincent both moral and financial support. Throughout the ten years of Vincent's life as an artist, Theo remained an obliging benefactor, whose support was invaluable in furthering his brother's artistic endeavours. At first Vincent viewed Theo's financial support as a loan that he would one day be able to repay—an advance on what he would be earning as soon as buyers could be found for his work. When this failed to happen, however, the brothers agreed that Theo could deal freely with Vincent's drawings and paintings. Theo thought that brotherliness was much more important than cashing in on his investment, although as time went on he also became convinced of the special quality and value of Vincent's work.

It may seem as though it was mainly one-way traffic between the brothers, as though the calm, generous Theo was always ready to help his stubborn, impulsive brother and got little in return. But Theo, for his part, depended heavily on Vincent, describing him to Jo as his 'adviser and brother to both of us, in every sense of the word' (1 January 1889). Vincent and Theo's mutual dependence continued to grow over the years, but not without many conflicts. At times Vincent was mean and nasty to Theo, and he always tried to get his way. This put a lot of strain on their relationship, so much so that at one point Theo was convinced that it would be better for them to part ways. Yet their fraternal friendship proved able to withstand such fierce clashes. Theo dragged Vincent through life's difficulties and acted as a buffer between him and the 'hostile world' (406). The kindhearted Theo, who felt responsible for Vincent his whole life and always remained loyal to him, protected his brother and saved him from many pitfalls.

A Loving and Protective Family

The close ties between the brothers date from their earliest years, when they were growing up together as the sons of a village parson in rural Brabant. Their parents, Theodorus van Gogh (1822–1885; fig. 1) and Anna van Gogh-Carbentus (1819–1907; fig. 2), raised their children with Christian values that formed the basis of a virtuous and hardworking life. As was usual among middle-class families in the nineteenth century, they all did their utmost to prevent any member of the family from drifting away from the fold, as it were. Together they strove to lead a respectable life, in strict observance of the proprieties and in the firm conviction that those who become well-regarded members of society will encounter much good in their lives. The modest livings occupied by the Reverend Theodorus van Gogh comprised the villages of Zundert, Helvoirt, Etten and Nuenen, all situated in the province of Noord-Brabant in the south of the Netherlands. As a preacher who attached great importance to morally acceptable behaviour, he could count on a good deal of sympathy from his parishioners.

Vincent (1853–1890; figs. 3, 4), the oldest of six children, was not the firstborn: exactly one year before his birth, his mother had been delivered of a stillborn child, likewise named Vincent. Vincent was followed by Anna (1855–1930), Theo (1857–1891), Elisabeth ('Lies', 1859–1936), Willemien ('Wil', 1862–1941) and Cor (1867–1900). Their mother, a kindhearted woman, shared the care of the family with her husband and a nursemaid.

The love between the parents and their children and the respect they showed one another is evident from the family correspondence, of which hundreds of letters have survived. Fond memories of his early years were deeply rooted in Vincent, and they surfaced during the attacks of mental illness (considered in those days to be a form of

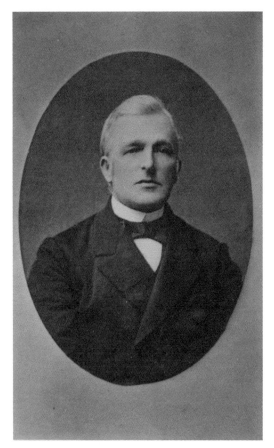

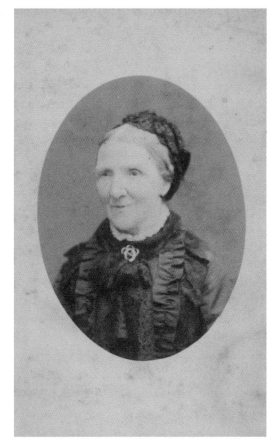

1. Theodorus van Gogh

2. Anna van Gogh-Carbentus

epilepsy, accompanied by hallucinations) that disrupted the last year and a half of his life. At the end of 1888, after his first serious breakdown, he reported that during his illness he had seen 'each room in the house at Zundert, each path, each plant in the garden, the views round about'—every detail, in fact, of the surroundings of his parental home (741).

The Van Goghs wanted to give all their children an education that would allow them to develop their talents to the full, but this was no easy task, financially speaking. Their main worry turned out to be finding a suitable position for Vincent. In the nineteenth century, association with the upper class was often a means of advancement for members of the middle class, and parents who were determined to help their children succeed stimulated and even engineered their climb up the social ladder. This is apparent from the advice the Van Goghs gave their children about moving in society, which books to read, and the courtesy calls they should make. By present-day standards the children were extremely obedient, but this can be explained by the prevailing standards of conduct, which were dictated by middle-class Christian morals. When things went wrong, however, and a person was unwilling or unable to comply with these high standards, it could easily lead, as it did in Van Gogh's case, to a gnawing sense of guilt and a permanent feeling of failure in one's duties towards those who had one's best interests at heart.

The need for solidarity was characteristic of the Van Gogh family. Leading a pious

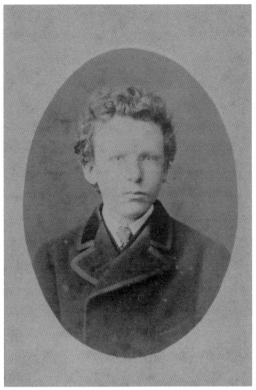

3. Vincent van Gogh at the age of thirteen 4. Vincent van Gogh at the age of nineteen

life and lending one another support were in the general interest, and that was also true of other group activities that kept the family together, such as attending church, singing hymns and reading and reciting morally acceptable poetry and novels, all of which strengthened both heart and mind.

For a long time harmony prevailed in the Van Gogh family, but in 1876 there was a flare-up of the tension between Vincent and his father, and the discord continued until the latter's death in 1885. Their lifestyles became increasingly incompatible, and Vincent's social maladjustment was a constant source of irritation to his father. Vincent, in turn, was annoyed at his father's interference and narrow-mindedness; holding his ground, he showed complete disregard for the conventions his parents considered so important. His workman's clothes, his unpredictable behaviour and his association with people from the lower classes were thorns in his parents' sides. For Vincent, things became clear to him late in 1883: 'In character I'm quite different from the various members of the family, and I'm actually *not* a "Van Gogh"' (411).

Working in the Art Trade, 1869–1876

Vincent attended the village school in Zundert and received lessons at home from a governess. He then spent several years at a boarding school for boys in Zevenbergen and

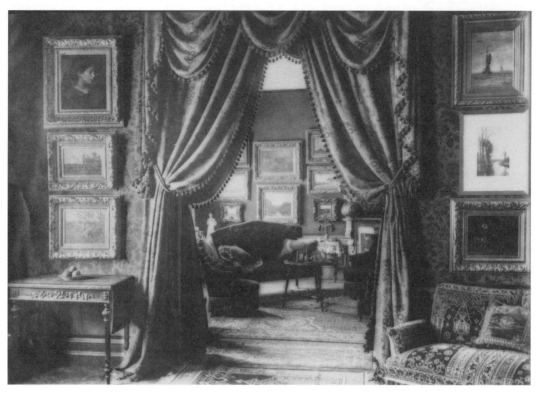

5. Goupil & Cie Gallery, The Hague, c. 1900

went from there to a secondary school in Tilburg, the Hogere Burgerschool Willem II. After living at home for another year, at the end of July 1869 he finally found—at the age of sixteen—a position as the youngest employee of the international art dealer Goupil & Cie in The Hague (fig. 5).

It was one of his father's brothers, also called Vincent (Uncle Cent), who introduced Vincent to the art world. For years Uncle Cent had been a partner in the firm of Goupil & Cie, and he now put in a good word for his nephew. Vincent was thus given a chance to become intimately acquainted with the art trade. The firm flourished, its success due in part to the publication and sale of reproductions of numerous artworks. Van Gogh's work for an art dealer—spending his days surrounded by paintings, prints and photographs—and his visits to museums laid the basis for his impressive knowledge of art. His boss, Hermanus Tersteeg, showed him the ropes and taught him a great deal about art and literature. Vincent lived at this time with the Roos family on Lange Beestenmarkt, from which address he wrote the earliest of his surviving letters to Theo on 29 September 1872.

Goupil & Cie had a number of branches, and in May 1873 Van Gogh began working for them in London. The correspondence from these years reveals that he was seeking a place outside the protected world in which he had grown up. In his spare time he walked as much as he could and worked in the garden. Sometimes he was very homesick. On holidays such as Christmas and Easter, the family tended to gather at the Helvoirt parsonage, where the Van Goghs were now living. By this time Theo was also working for Goupil, beginning at the Brussels branch and moving to the Hague branch

at the end of 1873 (fig. 6). In London Vincent changed
his address often: in August he moved to Brixton, and
a year later to Kennington. His appreciation of the
city grew, as did his interest in art and literature. His
letters contain more than one quotation from books
that had moved him; Theo, in turn, sent his brother
poetry. Their tastes and preferences were perfectly in
keeping with the fashions of the day: romantic poetry
(Heinrich Heine, Alphonse de Lamartine) and Victo-
rian novels (George Eliot). Literature was a comfort to
the boys and helped them expand their horizons.

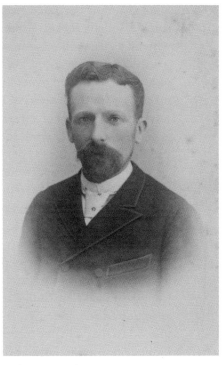

6. Theo van Gogh, 1889

Religious Obsession

After a temporary transfer to the main branch in Paris
in rue Chaptal, Vincent returned in early 1875 to Lon-
don, where he began working for the gallery of Hol-
loway & Sons in Bedford Street, which had been taken
over by Goupil & Cie. In mid-May he was back at the
Paris branch. He gave detailed accounts of his visits to
the Salon, the Louvre and the Musée du Luxembourg,
and he described the prints he had hung in his small
room in Montmartre, where he became friendly with
his housemate, Harry Gladwell. Night after night he read the Bible out loud to this En-
glishman: 'We intend to read it all the way through' (55). Van Gogh became more and
more obsessed with Bible study and went to church frequently. The letters written at this
time are full of references to Holy Scripture, rhyming psalms, Evangelical hymns and
devotional literature. This religious obsession, which lasted for several years, caused him
to neglect his work and was one of the reasons for his eventual dismissal from Goupil's.

In October 1875 the Van Gogh family moved to the village of Etten, where the Rev-
erend Van Gogh had taken a living. Vincent spent Christmas and New Year's with them
there. When he returned to Paris, he heard that Goupil had decided to terminate his
contract as of 1 April, partly because he had stayed away too long during the busy time
at the end of the year, though another cause of consternation was his attitude to his
job. His father was deeply disappointed, and wrote about it in what were, by his stan-
dards, very bitter letters to Theo, since the consequences for the family were especially
painful: 'How much he has spurned! What bitter sorrow for Uncle Cent. What a bitter
experience. We are glad that we live in relative isolation here and would really like to
shut ourselves in. It is an unspeakable sorrow'. Vincent seemed less upset by this loss of
face, although he definitely felt guilty. Working in the art trade for six years had indeed
taught him a lot, but it had not made him happy or opened up any prospects for a career.
His future was now completely up in the air.

The Search for a Calling, 1876–1880

Van Gogh now spent four years attempting—in England, the Netherlands and Belgium—
to shape his future. After his dismissal from Goupil & Cie, he travelled in April 1876 to

Ramsgate, near London, to work as an assistant teacher at the boarding school for boys run by William Stokes. After a trial period of one month, he was allowed to stay, but without a salary. Shortly afterwards the school—along with Van Gogh—moved to Isleworth. There he enjoyed long walks and took pleasure in the boys' company, but he soon realized that he would prefer pastoral work, something 'between minister and missionary, in the suburbs of London among working folk' (84). Not only that, but he was urgently in need of a steady income.

In July he went to work at another boarding school in Isleworth, which was run by the Methodist minister Thomas Slade-Jones. In this period Vincent's letters to Theo became longer and longer, owing to serious digressions and an abundance of biblical quotations. His increasing interest in religion was accompanied by more moralistic reading, his favourites being George Eliot's *Scenes of Clerical Life* and *Felix Holt*, John Bunyan's *Pilgrim's Progress* and Thomas a Kempis's *De imitatione Christi*. To his immense satisfaction he was given his first opportunity to deliver a sermon at the Wesleyan Methodist Church in Richmond in October. The sermon, which he copied out for Theo and enclosed in a letter, compared life to a pilgrimage (96). Shortly after this he became a lay preacher at the Congregational Church in Turnham Green, and also taught at their Sunday school, but as an unpaid volunteer. While he was home for Christmas—as always, a time for reflection, when they all came together in a veritable conclave—the family discussed Vincent's limited prospects in England, and it was decided that he would stay in the Netherlands.

Uncle Vincent arranged a job for him as a clerk-cum-factotum for Blussé & Van Braam, a bookseller in Dordrecht. In this period his religious fanaticism started to get out of hand. His letters were now full of devotional texts and musings about his desire to become a preacher; numerous biblical prints decorated the walls of his room; and he attended one church service after another, exploring a wide variety of denominations. A line from Paul's second epistle to the Corinthians—'sorrowful, yet alway rejoicing'—became a motto that he wore like 'a good cloak in the storm of life' (109).

Yet Another Failure

Van Gogh's struggle with the world was bound up with his own internal struggle about his place in that world. He dreamed of a vocation in the church, spreading the Word as a preacher, like his father. He viewed striving to achieve that goal as a means of freeing himself from the 'torrent of reproaches' that he had 'heard and felt' (106). Influenced by his Calvinist upbringing, he spoke more than once of the conscience as man's infallible, God-given moral compass. But however conscientiously he tried to live his life, somehow he could not find the right path. His work at the bookshop was merely a temporary solution; the family continued to search for a suitable situation for him. Uncle Cent, who had been so supportive up to now, stopped trying to help when it became apparent that his nephew was serious about becoming a preacher.

Vincent—who had no high school diploma—approached other uncles in Amsterdam for suggestions and help in preparing himself to study theology. His family was by no means convinced that this was his true calling, and they worried about his unstable mental state. Even so, Vincent, in good spirits, moved in May 1877 to Amsterdam, where he went to live with one of his father's brothers, Uncle Jan van Gogh, director of the naval dockyard. A maternal uncle, the minister Johannes Stricker, took it upon himself to supervise Vincent's studies.

Preparing for the university entrance exam proved extremely difficult for Vincent. As he so often did, he compensated for his lack of ability by taking long walks and writing about them in letters full of long, evocative passages. No matter how hard he tried to persevere in his studies, he became more and more downcast and disheartened. He wrote to Theo that his head was numb and burning and his thoughts confused. Once again he realized that he had failed in the task he had set himself. Years later he would look back on his year in Amsterdam as 'the worst time' he had ever been through (154). Dejected and defeated, he returned to his parents' house in Etten, hoping that he might still become a Sunday-school teacher.

Evangelist in the Borinage

In July 1878 Vincent went to Brussels in the company of his father and the Reverend Slade-Jones to discuss his admission to a Flemish training college for evangelists. He was given a three-month trial period and sent to work in Laken, where he lived with a board member's family. He was not accepted for the training course, however, and left in early December 1878 for the Borinage, the mining region of Belgium, to look for evangelization work. In mid-January 1879 he was given a six-month appointment as a lay preacher in Wasmes, a village near Mons. His tasks included giving Bible readings, teaching children and visiting the sick. Van Gogh was confronted with real poverty and squalor, but he devoted himself wholeheartedly to caring for the sick and injured. He identified so much with the poor that he gave away all his possessions and lived in a small hut, where he slept on the ground.

This exaggerated display of humility was one reason for the evangelization committee's dissatisfaction with him, and they also judged him to be lacking in both the gift of speech and the organizational skills necessary to hold gatherings at which the congregation could be taught the Gospel. His appointment was terminated, and in August he left for the nearby village of Cuesmes, where he went to live with an evangelist. Impressed by this 'singular, remarkable and picturesque region of the country' (150), he concentrated more and more on drawing. For years he had drawn for his own pleasure, and had occasionally included sketches in his letters. Now, however, drawing—alongside writing—became an increasingly important way of capturing his impressions in images: 'Often sit up drawing until late at night to have some keepsakes and to strengthen thoughts that automatically spring to mind upon seeing the things' (153).

Theo went to visit him, and they discussed Vincent's future. Feelings must have run high during this talk, because immediately after Theo's departure, Vincent defended himself in a letter that reveals the fears and differences of opinion that were seriously undermining his relations with Theo and the rest of the family (154). The rift between the brothers ultimately led them to stop corresponding for nearly a year. Vincent broke the silence with a cri de coeur in which he expressed himself with exceptional force. He felt like a caged bird, a good-for-nothing, but he wanted to make himself useful and find his vocation in life, and he accepted the help Theo was offering him (155).

Vincent had become estranged from his parents too. As early as 1875 they had discussed Vincent's 'otherness' and worried about his religious fanaticism. When he was rejected for the training course in evangelization, they urged him to take a different path and try a practical occupation. In their eyes he remained 'obstinate and pigheaded', however, and refused to take their advice. During his time in the Borinage, Vincent dreaded

returning home, but he nevertheless paid two short visits to his parents. They found his behaviour, which bordered on the autistic (as it would be called nowadays), so alarming that his father talked openly about having him committed to the psychiatric hospital in Geel in Belgium, but this idea met with fierce resistance from Vincent.

Now that their eldest son had been found wanting, it was Theo's responsibility to uphold the family honour. In November 1879 he had been given a permanent position with Goupil & Cie in Paris, so he was now able to contribute to his brother's upkeep. Vincent received his first allowance from Theo in March 1880. He had been doing more drawing, and Theo began urging him to make art his profession. Vincent decided to give it a try; this choice proved definitive.

Struggle and Passion for Work: Van Gogh's Beginnings as an Artist, 1880–1883

Now that he had resolved to pursue an artistic career, Van Gogh threw himself passionately into a self-devised programme of study. Hoping to earn a living as an illustrator, he turned his full attention to drawing. He knew that he had to start from scratch, learning as much as possible about materials, perspective, proportion and anatomy. He read handbooks and worked from morning to night, making copies after prints and from the examples in the drawing course Theo had sent him. His small room in Cuesmes was far from ideal as a studio, however. This lack of space, as well as a growing need to be near museums and artists, prompted him to move to Brussels in October 1880. Acting on the advice of the painter Willem Roelofs—whom Theo had advised him to visit—Van Gogh enrolled at the art academy for the course Drawing from the Antique. After a month he had had enough: no doubt he had been forced to endure much criticism of his under-

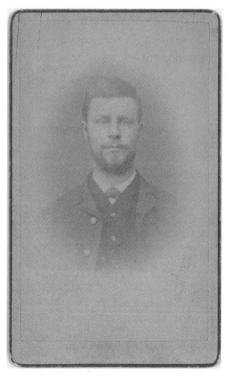

7. Anthon van Rappard, c. 1880

developed technique and limited knowledge of anatomy and perspective. As a result of that experience, he was filled with loathing for academic instruction—a subject that would crop up often in his letters—and believed even more strongly that an artist's means of expression was more important than technique. In the meantime he had become acquainted with Anthon van Rappard, a Dutch artist who suggested that Vincent come and draw in his spacious studio in Brussels (fig. 7). The two men became friends, and when Van Gogh returned to the Netherlands, they struck up a lively correspondence.

At the end of April 1881 Vincent again moved in with his parents in Etten, where he stayed until Christmas. He worked and slept in a room in the annex built on to his parents' house. In these months he practised drawing landscapes and figures at work, modelled upon the people from the village who posed for him. During a short stay in The Hague, he visited museums and exhibitions—not for the first time, but now as an artist—and received welcome advice from Anton Mauve, a successful painter of the Hague School who

was married to Van Gogh's cousin, Jet Carbentus. Van Gogh was in his element; quoting a phrase used by Mauve, he observed with satisfaction that 'the factory is in full swing' (172).

Escalating Tension

In the summer of 1881 Kee Vos-Stricker—Uncle Stricker's daughter, who had recently been widowed—came to stay at the parsonage in Etten (fig. 8). Van Gogh fell passionately in love with her. She told him in no uncertain terms that she could never return his feelings, but he persisted and, blinded by desire, caused his family a great deal of embarrassment. Vincent's father warned him that such 'indelicate and untimely' behaviour jeopardized their family ties (185). But Vincent was so insensitive to the opinions and feelings of his parents that they finally asked him to move out. He then decided to work for a while with Mauve in The Hague; it was in Mauve's studio, in fact, that he made his first oil studies and learned the rudiments of watercolour. When Van Gogh returned to Etten after three weeks, he was full of new plans and intended to look for a large studio in the vicinity, but after only a couple of days he had another serious clash with his father. Swearing that he wanted nothing more to do with religion, he left that same day for The Hague.

A New Step

In The Hague, Vincent soon found lodgings in Schenkweg, at the edge of the city. He was still suffering from the negative reactions to his love for Kee, and abhorred his family's shortsightedness. Even though Theo blamed Vincent, saying that his stubbornness was making things unnecessarily difficult for their parents, he continued to support him. In February 1881 Theo was appointed manager of Goupil's branch on the boulevard Montmartre in Paris (later taken over by Boussod, Valadon & Cie), and from then on he assumed responsibility for Vincent's expenses. Theo, who made a good living throughout Vincent's artistic career, gave some fifteen percent of his income to his brother. The reason for Vincent's frequent financial straits was his tendency to spend money much too easily, a habit that was inseparable from his unrelenting passion for work: he was always running out of drawing and painting materials; he needed models, who had to be paid for posing; and he was determined to install himself in adequate living and working quarters every time he moved house. Naturally this was also true of his accommodation in Schenkweg, where he immediately set up a studio.

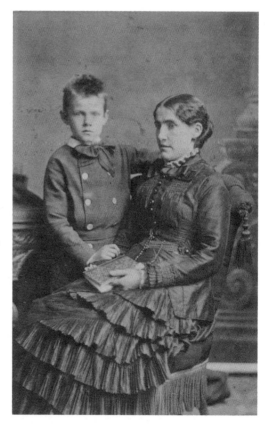

His early days in The Hague, then the cultural capital of the Netherlands, started off well: he received advice and support from Tersteeg, his

8. Kee Vos-Stricker and her son Jan, c. 1881

former boss at Goupil's, and Mauve introduced him at the painters' society Pulchri, the ideal place to draw from a model and meet other artists. He became acquainted with the young artists George Breitner and Théophile de Bock. Vincent was also delighted to receive from his uncle Cor van Gogh his first paid commission, which was followed by a second, both for views of The Hague.

At the end of January 1882 Vincent met Sien Hoornik, a pregnant prostitute who became his regular model. Sien's mother and daughter also posed for him frequently, at first for a fee, and later, when he and Sien became lovers, for free. Together with Breitner, he went to sketch in soup kitchens and railway station waiting rooms. His favourite subjects were workers and impoverished people: 'I feel that my work lies in the heart of the people, that I must keep close to the ground, that I must delve deeply into life and must get ahead by coping with great cares and difficulties' (226). Van Gogh hoped that his art would reach ordinary folk; he wanted to make figures 'from the people for the people' (294). Because he was still toying with the idea of becoming an illustrator, he began to collect illustrated magazines. The prints in these magazines—wood engravings made by professional engravers after drawings by well-known artists—moved him with their realism, immediacy and unpolished technique. He collected hundreds of them, which he cut out, ordered by subject, and put into folders. Vincent was particularly fond of prints with 'soul' and 'character'. He exchanged prints with Van Rappard, and their letters contained long discussions about artistic and technical questions.

It was also Van Rappard who sent Vincent Alfred Sensier's book on the French painter Jean-François Millet. This highly romanticized biography of the Barbizon painter who led a simple life among peasants had a decisive influence on Van Gogh's approach to art. He declared 'Père Millet' to be his mentor, and many of the artist's utterances became his mottos.

Family Life

After a couple of weeks in a hospital, where he was treated for venereal disease, Van Gogh moved in July 1882 to a better and more spacious studio farther down the street. Two weeks later he was joined by Sien, her five-year-old daughter, Maria, and her newborn son, Willem. For as long as they were living together, Van Gogh defended time and again his decision to live with Sien, appealing to Jules Michelet's moral and didactic treatises on women, love and marriage. Naturally their cohabitation met with strong disapproval from the conservative Van Gogh family.

Vincent, however, had complete disregard for the standards of behaviour befitting his station. In this period he dressed like a member of the working class, to the dismay of Theo and the rest of the family. His influential uncle Cent viewed a couple living together outside of marriage as a gross breach of social decorum and a disgrace from which the entire family suffered. Nor could he accept the fact that Sien and her children were also profiting from Theo's generosity.

Despite their disapproval, Vincent's parents did not cut him off completely: in the autumn of 1883 they sent him not only a pair of trousers and a winter jacket, but also a woman's coat—a sign that they did not reject Sien entirely, despite their serious reservations. In the meantime Van Gogh was living happily in his modest household. His letters reveal his version of reality: a man is duty-bound to help a fallen woman, and it stands to

reason that this will cost money. His idea of respectability was obviously very different from that of most people of his background.

Experimenting with Technique and Colour

During his period in The Hague, Van Gogh made great progress in drawing, working with numerous materials—everything from pencil, charcoal and chalk to lithographic ink—and trying out new techniques. In his letters he describes, for example, how he fixed his drawings by pouring milk over them (a method he had read about in a handbook). In the summer of 1882 he began to work in colour, documenting the landscape in the vicinity of his studio in a group of impressive watercolour drawings and making oil studies in the woods and on the beach. His subdued palette was in keeping with that preferred by painters of the Hague School and the School of Barbizon—established artists whose work sold well in galleries and was much in evidence at exhibitions. He also devoted himself briefly to making lithographs after drawings of workers and the poor, as part of a plan—which he never carried out—for a series of prints intended for the lower classes.

Vincent sent Theo drawings of folk types, town views and landscapes. Their correspondence in these years is full of exuberant and lyrical descriptions of colour:

> To keep it light and yet keep the glow, the depth of that rich colour, for there's no carpet imaginable as splendid as that deep brown-red in the glow of an autumnal evening sun, although tempered by the wood.
>
> Out of the ground shoot young beech trees that catch the light on one side— are brilliantly green there—and the shaded side of those trunks a warm, strong black-green. Beyond these trunks, beyond the brown-red ground, is a sky, a very delicate blue-grey, warm—almost not blue—sparkling. And set against this is another hazy edge of greenness and a network of slender trunks and yellowish leaves. A few figures gathering wood move about like dark masses of mysterious shadows. (260)

Friction of Ideas

Van Gogh, a relentless experimenter, longed to exchange technical knowledge and artistic ideas with his peers. He had an expressive term for this: 'friction of ideas' (396). His contact with the painters Herman van der Weele and Anthon van Rappard was one way to satisfy this longing. He wrote impassioned letters to Van Rappard about his work, and they carried on discussions that cut right to the heart of things. The two men kept each other informed of their activities by making sketches and enclosing drawings in their letters, and they did not shrink from frank criticism of one another. This was exactly what Van Gogh needed, especially since his relations with Mauve had cooled because of his entanglement with Sien Hoornik. His candid friendship with Van Rappard had a very stimulating effect.

Often Van Gogh worked like a fanatic, bent on using his energy to the full. It stands to reason that he would describe himself as a drudge, workhorse or draught ox, and repeatedly tried to stretch his working day by starting early in the morning (which in his case meant very early indeed) and going on till late at night. 'You know that nature can't

be conquered or made submissive without a terrible fight, without more than the ordinary level of patience' (403), he explained. He constantly exercised his 'draughtsman's fist' (220) by sketching scavengers on a rubbish dump, for instance, or workers in a sand quarry or farm labourers lifting potatoes in a field, to get a feel for human proportions and the perspective of the landscape.

'In the Heart of the People': Peasant Painter in Drenthe and Nuenen, 1883–1885

In September 1883 Vincent broke off his relationship with Sien, no longer trusting her intentions. He blamed her family for their dubious role in this conflict; he was certain that under their influence she would return to her life of prostitution. Taking along a minimum of artists' materials, he set off for rural Drenthe. The choice of this northern province must have been prompted by what Mauve, Van Rappard and Breitner had told him about its unspoiled nature.

Van Gogh stayed for a while in Hoogeveen before travelling in early October via passenger barge to Nieuw-Amsterdam/Veenoord, where he found lodgings in the boardinghouse run by Hendrik Scholte. From this base he explored the surrounding area for suitable subjects, which resulted in a series of evocative landscapes with dilapidated huts, women working in the peat bogs, a man burning weeds at dusk and workers by a peat barge. He made a trip to Zweeloo with Scholte and described this excursion to Theo in lyrical terms (402). Vincent had an ulterior motive in praising the landscape so highly to Theo: his brother's relations with his superiors were so strained that Vincent was trying to persuade him to become a painter and leave the art trade and city life behind. The prospect of breathtakingly beautiful nature was intended to make his proposal even more tempting. Theo, understandably, did not take his brother's suggestion seriously.

However impressed he was by the landscape, Vincent found the solitude depressing in these cold and rainy months. It was difficult to work outdoors, there were no models to be had, and he was running out of painting materials. The evenings were long, and this is reflected in the length of his letters. Theo's mention of his uncertain financial situation prompted Vincent to leave Drenthe and seek refuge again with his parents, who had meanwhile moved to Nuenen, near Eindhoven.

Return to His Parental Home

On 5 December 1883 Van Gogh first set foot in the austere but respectably furnished parsonage where his parents had been living for over a year. He was to remain in the village for two years. His homecoming and welcome were, to his mind, anything but cordial.

> I feel what Pa and Ma *instinctively* think about me (I don't say *reasonably*).
>
> There's a similar reluctance about taking me into the house as there would be about having a large, shaggy dog in the house. He'll come into the room with wet paws—and then, he's so shaggy. He'll get in everyone's way. *And he barks so loudly.* (413)

The room where the washing was pressed, behind the house, was fixed up as his studio (fig. 9). Its location and furnishings were far from ideal, however.

Van Gogh's new mission was to paint peasants and labourers at work. His first subjects were weavers: between December 1883 and July 1884 he made a series of drawings and

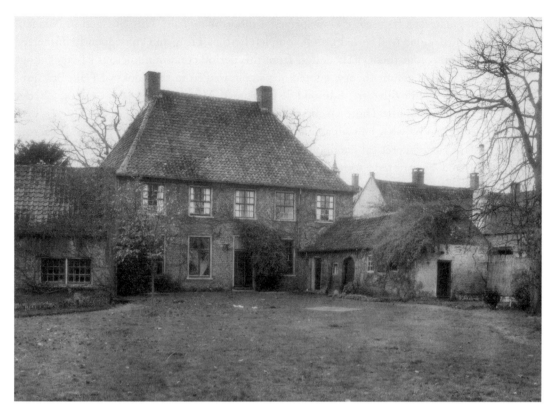

9. The parsonage in Nuenen. The studio was located at the lower right

paintings of weavers at their looms. In the months when it was difficult to work out of doors, he painted whole series of still lifes.

In early 1884 Vincent decided that, in exchange for the money Theo sent, his brother should do as he saw fit with his artworks, ideally finding buyers for them. Vincent was still in frequent contact with Van Rappard: they painted together and discussed technical problems, and Van Rappard came to respect his friend's talent for drawing. The fact that Van Gogh frequently gave lessons to amateur painters in the area testifies to his growing self-confidence.

From May 1884 he rented from the sacristan a reasonably large studio: two rooms en suite, which gave him enough room to work comfortably. In the summer he again caused consternation by starting up a relationship with his neighbour Margot Begemann, who was mentally unstable. Both of their families did everything they could to put an end to their affair, the low point of which was Margot's attempted suicide. Vincent briefly considered marrying her, but eventually abandoned the idea, to the relief of the parents. It was at times such as these that he felt how deep and irreconcilable the differences were between himself and those around him.

Colour Theory

In the first years of his career as an artist, Van Gogh had primarily occupied himself with questions of composition, such as the proportions and grouping of figures and the rendering of perspective. His main activity was drawing, and his chief considerations were of a technical nature: the handling of line, for example, and the effect produced

by the materials he used. Colour played a subordinate role. This changed in Nuenen, when he decided to devote himself completely to painting and consequently immersed himself in colour theory. The letters from this period contain numerous passages about art, artists and colour theory, quoted or paraphrased from the books of Félix Bracquemond, Théophile Silvestre, Edmond de Goncourt, Alfred Sensier, Jean Gigoux, Charles Blanc and Théophile Thoré (William Bürger), all of which he studied closely. His eyes were opened by what he read about the palette of the French painter Eugène Delacroix in Blanc's art-theoretical handbooks, and by the artists' anecdotes Silvestre and Gigoux recounted. He painted a series of still lifes in which he applied his newfound knowledge of the effect of colours and the result of mixing them. At first, however, these new ideas did not lead to a brighter palette. He stuck to his subdued colours, partly because he had no firsthand experience to help him put his book learning into practice.

Art above Nature

Van Gogh had a feeling of solidarity with labourers and stood in awe of the enthusiasm he perceived them as having for their work; indeed, he considered the portrayal of a peasant figure in action as 'the very heart of modern art' (515). It was not his aim, however, to make true-to-life depictions of landscapes and figures; instead, he sought to record them as *he* saw them. In imitation of the philosopher Francis Bacon and the novelist Emile Zola, he defined a work of art as 'a corner of nature seen through a temperament' (361). It was precisely this expression of a personal vision that conveyed reality more strongly and made works of art 'truer than the literal truth' (515). The objective was an intense magnification of the artist's perception, thus allowing him to touch the essence of reality.

After his period of religious fanaticism, Van Gogh's former belief in the principles of the church made way for a religious concept of nature, a 'faith in and consciousness of something higher, in short of *the something on High*' (333), which was expressed in nature and the cycle of the seasons. In his drawings and paintings he initially sought to capture the 'sentiment' and the atmosphere of the landscape. However, after he had declared himself to be a peasant painter like Millet, his principal subjects became the common people who worked the land and communed with nature—an ideal to which he steadfastly adhered. The ultimate challenge for an artist was to rise above the quotidian and arrive at '*the type* distilled from many *individuals*. That is the highest art, and *in that* art is sometimes above nature—as, for instance, in Millet's sower, in which there is more soul than in an ordinary sower in the field' (298). In Van Gogh's work the sower would grow into the ultimate symbol of the never-ending cycle of nature and 'the something on High'.

Test of Workmanship

Van Gogh had a growing conviction that the drawings and paintings he made deserved to be seen as works of art, and that he—'the little painter' (*schildermenneke*), as the people in Nuenen referred to him—was gaining control of the brush. 'The blank canvas IS AFRAID of the truly passionate painter who dares', he wrote self-confidently (464). He had left their parents' house and moved into his studio after an argument with his sister Anna, who, since the sudden death of their father, felt that Vincent should no longer be a burden to their mother. He had little contact with the family in this period, apart from his correspondence with Theo.

Vincent saw many of his works as experiments. He painted dozens of peasants' heads to get a feel for them, so that he could incorporate them into a real figure painting. This resulted in April/May 1885 in *The potato eaters*, which in his eyes was the first fully fledged painting he had ever made.

The frankly negative reactions to this great test of his workmanship made Van Gogh realize that in many respects he was in a rut. His work was apparently unsellable, his objectionable behaviour made models unwilling to pose for him, and he missed the necessary contact with the art world. Theo tried to make Vincent understand that his approach was not in step with the 'modern art' in Paris. There Impressionism had more or less become mainstream, whereas Van Gogh was still looking back, seeking to become a Barbizon painter *après la lettre*, as it were.

Van Gogh's visit to the Rijksmuseum in Amsterdam in October 1885 was a wake-up call. Up to then he had believed that technique was less important than the message conveyed by an artwork and the sentiment it expressed; the Old Masters, whom he now studied for the first time from the perspective of a painter, taught him how much could be achieved with a resolute brushstroke and an expressive palette. The *manner* in which an artwork was made could certainly make a difference. Deep down, his ambition remained the same—to convey his vision of reality—but he needed to change his palette and find a manner of painting that would enable him to define that vision more forcefully.

Feeling the need for new stimuli and further study, Van Gogh set out in November 1885 for Antwerp, where he enrolled at the art academy. He also hoped that the city would offer him a larger choice of subject matter and opportunities to sell his work.

The Beginning of Van Gogh's Modern Artistry: Antwerp and Paris, 1886–1888

Van Gogh made the short trip to Antwerp on 24 November 1885. The bustling, historic harbour city appealed to him immediately. His hunger for art and new ideas, stirred by what he had seen at the Rijksmuseum, drove him to visit every place in the city where the work of old and contemporary artists could be seen: the museums, the churches with their religious paintings by great masters, the viewing days at auction houses, and even an art lottery. He commented, more frequently than before, on the use of colour and technique in the paintings he saw. He looked at Rubens differently now, judging not so much his subject matter and convincing rendering of emotions as his effective use of colour. Van Gogh was now looking at things through the eyes of a painter. The small number of painted portraits that survive from this period—executed in looser brushwork and brighter colours than his Nuenen work—show how eager he was to put his new insights into practice.

He had hoped to make contact with some art dealers, but realized that the few paintings that had been shipped with his things were unlikely to sell. His chances of success were minimal, he now understood, unless he started producing town views and portraits. It was not easy to find affordable models, however. Occasionally he tried to persuade a prostitute or other folk type to pose for him, but they almost always refused. As he himself said, the high cost of painters' materials and the expense of hiring models were 'ruining' him (547).

Lessons at the Academy

The small room Van Gogh rented at 194 Lange Beeldekensstraat provided him with scant space for drawing and painting. In January 1886 he showed some of his recent work to the teachers at the art academy and was admitted for a course of study. There he could paint from live models and, in the evening, draw from plaster casts of antique statues. At drawing clubs for art students, which met late in the evening, he could also draw from the nude. His acquaintance with other students allowed him to sharpen his mind somewhat, but did not give him much satisfaction. In his eyes, most of them had been completely misled by their teachers, who wrongly focused on technique and disapproved of personal expression. At the same time, he was disappointed at the lack of fellowship and verve in the world of artists and art dealers. He actually found the dull artistic climate quite depressing. It strengthened his conviction that solidarity and collaboration were necessary to bring about a 'renaissance'.

In the meantime his health had deteriorated to an alarming degree. He generally tried to cut costs by spending less on food and personal hygiene, but in Antwerp this caused him to feel 'literally exhausted and overworked' (558). Acting on a doctor's advice, he finally got some rest. He had to be treated for venereal disease and needed a lot of dental work, all of which cost a great deal of money. It is touching to see that Theo, who often opposed Vincent's uncontrolled spending on materials and models, immediately sent extra money if his brother's health was at stake. Theo understood such things, because his health was even more fragile than Vincent's.

At the end of January Van Gogh finished his courses at the academy and took stock of the situation: he was glad he had come to Antwerp, for not only had it freed him from the social control of the village but he had also been able to study a lot of art and draw and paint from models. Most importantly, however, 'my ideas have changed and been refreshed, and that was actually the goal I had in mind in coming here' (562). No progress had been made, though, with regard to the 'friction of ideas' that he had sought among his peers and the hoped-for sale of his work.

An idea that had been brewing for some time became a serious plan in February: he pressed Theo to let him come to Paris—not in June or July, when Theo's lease was due to expire and he would be free to look for a more spacious apartment for the two of them, but immediately. Vincent wanted to spend a year honing his skills as a draughtsman. To this end, he had his eye on Cormon's studio, which was known to be less rigid than more traditional studios, and he wanted to paint copies in the Louvre and the École des Beaux-Arts. Theo tried to persuade him to return to Nuenen until the summer, but Vincent, leaving behind not just his possessions but also his debts, suddenly set out in late February for the capital of France, considered by artists to be the capital of the world.

Paris: Modern Art, Modern Life

Compared with rural Brabant, Antwerp was a large and bustling city, and Paris infinitely more so: busy and chaotic, worldly and picturesque. It had been ten years since Van Gogh's last visit to the metropolis. Hausmann's urban expansion, with its wide boulevards and stately apartment buildings, had boosted the city's allure, whereas the hill of Montmartre—where Theo lived and Vincent, too, now took up residence—had preserved its small-scale, rural character.

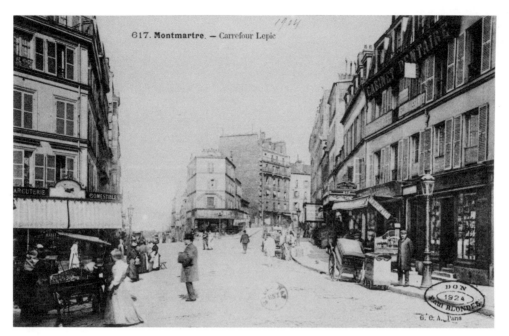

10. Rue Lepic, Paris

Everything that was progressive in art, literature, theatre and music came together in Paris, and the arts were strongly influenced by the most recent scientific discoveries in the fields of physics, medical science, psychiatry, biology, astronomy and spirituality, to name but a few. It was here that Van Gogh first heard the music of Wagner and saw experimental plays at the cafés and cabarets of Montmartre. Modern novels by such writers as Guy de Maupassant, Joris-Karl Huysmans and Lev Tolstoy sharpened his view of a society that was changing rapidly in the face of industrialization.

In Paris, Van Gogh went in search of new stimuli for his art. At first he sought to join the ranks of traditional artists, rather than strike out on a path of radical renewal. For him the world's artistic capital meant a select group of highly admired predecessors, whom he could study in museums and galleries as part of his efforts to master his craft. Shortly after his arrival he enrolled in the studio of Cormon (whose real name was Fernand Piestre), an undogmatic Salon artist who gave private lessons in a classroom on the boulevard de Clichy. The master stopped by several times a week to give instruction, but otherwise the pupils were left to their own devices. Cormon allowed his pupils to draw and paint from models as much as they liked, but the techniques that he taught proved to be rooted in the academic tradition. In retrospect Van Gogh had the following to say about his three months with Cormon: '[I] did not find that as useful as I had expected it to be' (569).

A Troublesome Housemate

Beforehand, when Van Gogh's coming to Paris was still just a possibility, Vincent and Theo had warned each other that living together might prove to be difficult. They were right. The apartment in rue Laval, where Theo unexpectedly had to make room for Vincent, was exchanged in June for a more spacious apartment in rue Lepic in Montmartre (fig. 10). Vincent, who had finished his studies with Cormon, was given a small room to

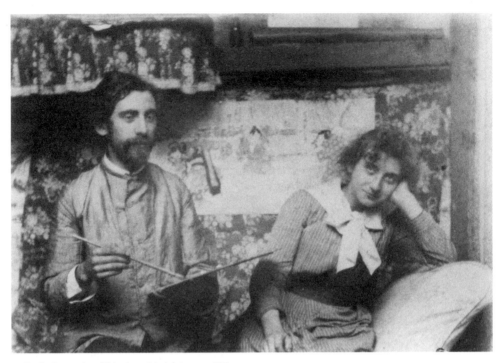

11. Emile Bernard and his sister Madeleine, c. 1888

use as a studio, but his chaotic lifestyle and way of working left their mark throughout the house. Theo had a responsible, prestigious job that brought with it certain social obligations; Vincent's sloppiness and nonconformist behaviour caused him a great deal of embarrassment.

The fact that the brothers were living together meant fewer letters, so their correspondence is not such a rich source of information on Vincent's activities and his relations with Theo in this period. Our knowledge of their time together in Paris comes from eyewitness accounts and from references and descriptions in Vincent's later letters. Artists with whom Vincent came into contact in this period reported that he was easily upset, aired his opinions whether they were called for or not, and always seemed to be looking for an argument. Feelings often ran high between the brothers, and Theo sometimes suggested in desperation that it would be better for them to live apart. But despite the difficulties, their fraternal bonds always prevailed.

Loose Brushwork, Bright Colours

During his first summer in Paris, Van Gogh painted many flower still lifes to increase his understanding of colour theory and to practise modelling with paint. His chief inspiration was the now-forgotten painter Adolphe Monticelli. His brushwork became looser and his colours brighter under the influence of Impressionism, which was ubiquitous in Paris. In the following period, Van Gogh's contact with the younger generation—and thus with new ideas—gradually intensified. He became friendly with the intelligent and ambitious Emile Bernard, who was just eighteen years old (figs. 11, 12), and Henri de Toulouse-Lautrec, who was at the beginning of his brief but highly successful career. Van Gogh also became acquainted with Paul Gauguin, who held great promise for the

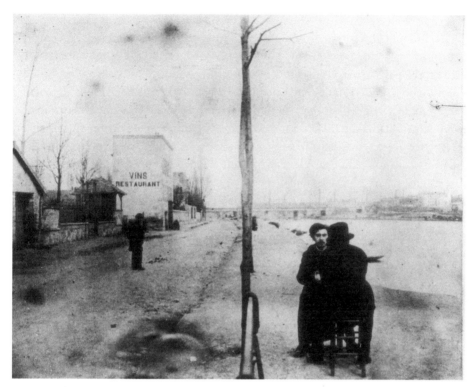

12. Van Gogh (seen from the back) and Bernard, Asnières, c. 1887

future, and he got to know the pointillists Paul Signac and Georges Seurat, who were experimenting with dots of unmixed paint that were meant to blend in the eyes of the viewer. Moreover, he became besotted with the clarity and elegance of Japanese prints.

Van Gogh's affiliation with these new trends is evidenced by the fact that early in 1887 he organized an exhibition of Japanese prints at the café run by Agostina Segatori, his new lover, and another show later that year of works by himself and several of his friends, this time at a restaurant. The Japanese prints kept him busy. He copied them in paint and adopted their pictorial devices: emphatic contours, flat areas of single colours, and perspectival effects. He experimented with techniques employed by his friends, such as Lautrec's use of diluted paint, and the stippling that was the signature style of Seurat and Signac. He did not imitate slavishly; instead, he tried out these methods and adopted what suited him, with a view to fulfilling his own, ever greater ambitions.

The Modern Van Gogh

Whereas several years earlier Van Gogh had declared that the truly modern should be sought in the art produced thirty or forty years earlier—i.e., that Millet was more modern than Manet—in Paris he came to the conclusion that being a 'modern artist' meant total immersion in the artistic, social and intellectual life of one's time.

Not only was Van Gogh convinced that portraiture was the perfect way to document contemporary attitudes, but he also considered it an eminently marketable genre. Of course there was still the problem of paying people to pose for him, and even though Paris was teeming with models—professional and otherwise—he made only about a

dozen portraits and figure paintings in these years. He did, however, try out his newly acquired techniques and palette in some thirty self-portraits and numerous landscapes.

It is astonishing to see how quickly Van Gogh, coming from the north with his gaze still fixed on the past, managed to reinvent himself in Paris in little over a year, becoming an artist who had shed all dogma. The modern Van Gogh was born in Paris, a fact he was well aware of when he left the city two years later. During that time there had also been a fundamental change in Theo and Vincent's relationship: not as regards financial dependence, for Theo remained Vincent's generous patron, but in terms of viewing each other more as equals. Previously Vincent had felt the need to justify his artistic choices and convictions, whereas now he and Theo were involved in a joint undertaking. Theo, too, had embraced the cause of the avant-garde, and according to Vincent, Theo contributed to it as an art dealer as much as he himself did as an artist. In February 1888, when Vincent fled the stressful and unhealthy life of the city to seek new, 'Japanese' colours and a more salubrious climate in Provence, he found strength in a fraternal bond that made him think of such revered examples as the Goncourts, the Bretons and the Marises. Vincent and Theo felt like 'companions in fate in many respects' and 'brothers for more than one reason' (790, 794).

His Best Days: Van Gogh in Arles, 1888–1889

Whenever Van Gogh moved, his first letters give a vivid impression of his new surroundings, and Arles was no exception. He thought the landscape and the inhabitants exceedingly picturesque, but life was not going to be as inexpensive as he had hoped. At the beginning of each new artistic adventure, he invariably underestimated the expense involved. He took up residence in a hotel in rue de la Cavalerie, not far from the railway station in the north of the city, which did not seem to him 'any bigger than Breda or Mons' (577), a far cry from the hectic metropolis of Paris.

Though his life had now changed fundamentally, his thoughts were, for a number of reasons, still anchored largely in Paris. For one thing, he continued to take an interest in the friends and acquaintances he had left behind; in his first months in Arles, he repeatedly asked Theo for news about this or that person, and he started to correspond with Emile Bernard, who remained in Paris until his departure for Brittany in mid-April. At the same time, Van Gogh was continually hatching plans to exhibit the work of modern artists (whom he referred to collectively as 'Impressionists') outside Paris. He had high hopes of Theo's initiative to send Impressionist paintings to Boussod's branch in The Hague, which was still run by Tersteeg, their former boss and mentor. In these years, modern painting in the Netherlands was nearly synonymous with the Hague School, and the Impressionism of Paris was scarcely known there. The Van Gogh brothers corresponded about what strategy they should employ to win over Tersteeg, with the result that in late March 1888 Theo sent him a number of works, including one by Vincent. Only one Monticelli was sold; the others were returned. Evidently the Netherlands was not yet ready for the art that Vincent and Theo so ardently championed.

Exhibitions and Sales

Vincent also devoted a lot of energy to another plan with a similar aim: an artists' society that would provide financial support to its members. Both established and younger

artists would put their work at the disposal of the society, and the proceeds would be divided among them. In this way successful Impressionists (such as Monet) would support younger fellow artists. Nothing ever came of this plan, but Van Gogh continued to search for possibilities for artists to collaborate more. He frequently denounced the lack of solidarity and the rivalries that constantly flared up between the highly opinionated artistic factions in Paris.

By the same token, Van Gogh had plans to collaborate with Theo in exhibiting and selling in nearby Marseille his own work and that of his friends. Just as he was fantasizing about possibilities to make a name for himself in Marseille, he had a modest success in Paris: three of his works were included in the exhibition mounted by the Société des Artistes Indépendants. Apart from the exhibitions he had organized himself and several works given on consignment to small art dealers, this was the first public acknowledgement of his place among the artists of the avant-garde. For someone who longed so fervently for recognition, it is striking how laconically he commented on his participation and the choice of works in the period leading up to the exhibition. In later years, when more appreciation was forthcoming, Van Gogh's reaction was the same: any praise or sign of recognition caused him to retreat into the background, as though he was afraid of falling into a trap and losing his independence. Fame, in the words of the writer Alphonse Daudet as reported by Van Gogh, 'is something like when smoking, sticking your cigar in your mouth by the lighted end' (673).

Painting and Drawing Campaigns

In the meantime Van Gogh was working as much as possible. Although he remained modest about his own talent compared with that of other artists, he had left Paris with increased confidence in his abilities and the feeling that he was 'on firmer ground' (602). Nature in Arles and the surrounding countryside was glorious, and the light and colours enthralled him. In the spring, when the snow had melted and the fruit trees were decked out in the most colourful blossoms, he made one painting after another, a veritable onslaught in true Van Gogh fashion. To mount such a campaign, he needed large quantities of paint and canvas, which he asked Theo to send. He also explored the landscape throughout the area, with its canals and drawbridges, farmhouses in the fields, and views across the plateau of La Crau.

When he needed to cut costs, he made drawings in ink and reed pen. He cut his reed pens himself from reeds he found during his walks along the canals. These pen-and-ink drawings, which display a very personal style, represent the prelude to a long series of masterly works that Van Gogh was to make in the south of France. He admired the Japanese draughtsmen who could capture a figure or landscape with a few simple strokes of the pen or brush. Van Gogh himself, however, achieved an equally admirable and seemingly effortless style of drawing that was unlike anything else being done at the time.

After returning from a three-day trip to the coast, he embarked on a new campaign, in which he again took up a subject that he had neglected since leaving Brabant: rural life, in this case the wheat harvest in the fields around Arles. In shimmering yellows he painted fields, sheaves of wheat and haystacks under an intensely blue Mediterranean sky. He later made drawings after many of these paintings, which he sent to Theo and friends such as Emile Bernard and John Peter Russell.

Friends in the South

He also resumed portrait painting. Even though he was a loner, Van Gogh tried to make contact with the people of Arles. His eccentric behaviour prevented him from building up a large circle of friends, but he struck up a friendship with the postman Joseph Roulin, whose portrait he painted on numerous occasions. Several months later he also persuaded Roulin's wife to pose for him; their children could not avoid having their portraits painted either. The postman, a socialist—unusual in those days—had outspoken political opinions to which Van Gogh gladly listened. Delighted with such down-to-earth, common folk, he also portrayed the gardener Patience Escalier, whose weathered face showed plain signs of the hard life of a peasant. Using large areas of the strongest possible colours, Van Gogh bestowed these works with an intensity never before seen in his portraits.

A different kind of contact was the friendship he enjoyed with several artists who were staying in the vicinity of Arles, such as Dodge MacKnight, whom he knew from Paris, the Danish artist Christian Mourier-Petersen and the Belgian Eugène Boch. Van Gogh attached great value to edifying discussions with fellow artists, but he did not think very highly of MacKnight. He liked Mourier-Petersen, but found him artistically immature. His fondness for Boch, however—a sensitive intellectual from an artistic milieu—led him to paint a portrait in which he exaggerated the colours and introduced a personal symbolism: 'To express the thought of a forehead through the radiance of a light tone on a dark background. To express hope through some star. The ardour of a living being through the rays of a setting sun. That's certainly not *trompe-l'oeil* realism, but isn't it something that really exists?' (673). Although Van Gogh always took reality as his starting point, he did not strive to create a literal image of it, 'because the reflection of reality in the mirror, if it was possible to fix it with colour and everything—would in no way be a painting, any more than a photograph' (620). A painting must, above all, express his *experience* of reality.

Poor Health and Bouts of Melancholy

A subject that continually arises in Van Gogh's letters is the fragile health of both brothers. Even though Vincent seemed hopeful and energetic during his first months in Arles, he nevertheless wrote in July: 'After the crisis I went through when I came here, I can no longer make plans or anything else; I'm definitely better now, but *hope, the desire to achieve*, is broken and I work *from necessity*, so as not to suffer so much mentally, to distract myself' (645). The 'crisis' probably refers to the physical ailments he had when he left Paris; in his first months in Provence he wrote mainly about stomach complaints, which gradually subsided. Like Theo, he believed in the alternative treatments that were all the rage in those days, for which the brothers had consulted Dr David Gruby in Paris. Theo had persistent physical complaints, such as a chronic cough and fatigue. In retrospect, it is clear that he was already suffering from the syphilis that would eventually kill him. Vincent's ailments, on the other hand, were the result of too much work and too little rest, an unhealthy diet, and too much alcohol. Gruby advised a strict regimen: nutritious food, eating and sleeping at regular times, and limited contact with 'women' (i.e., prostitutes).

There was also a psychological side to these ailments, however. Sometimes Vincent was overcome by dejection and melancholy; Theo, too, was familiar with such moods.

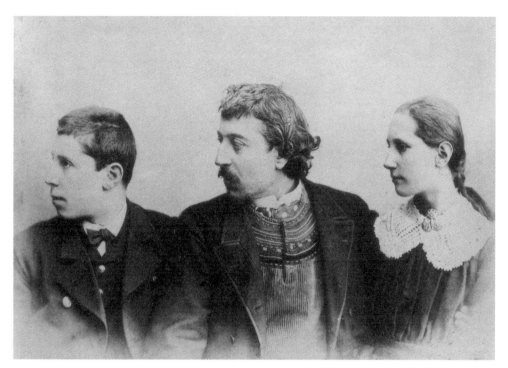

13. Paul Gauguin with his son Emil and his daughter Aline, 1891

Vincent describes their paradoxical effect: 'Now you talk about the emptiness you some-times feel; that's just the same thing that I have, too. . . . The more I become dissipated, ill, a broken pitcher, the more I too become a creative artist in that great revival of art of which we're speaking' (650). He seems to be saying that any striving for progress in art—the greatest good—is self-destructive. It is a curious mixture of optimism and fatalism, but he is wholeheartedly willing to make this sacrifice for the sake of art.

Waiting for Gauguin

Van Gogh was not the only artist who fought this battle; his friend Gauguin (fig. 13), who was working in Brittany at the time, was in bad shape too, both physically and mentally, and also deeply in debt, which prevented him from travelling. The brothers had great faith in Gauguin's talent, and looked for ways to support him. Theo tried to find buyers for his work, and even acquired one of Gauguin's paintings for himself.

Vincent thought that Gauguin's distressing situation pointed the way to a better future. He had meanwhile rented a small house on place Lamartine in Arles (fig. 14). At first he used his 'yellow house' only as a studio, but he began to see it as a means of realizing his dream of working together with Gauguin in Arles. In this Studio of the South they would be able to strike out on what he saw as the inevitable path to the future of paint-ing: collaboration and solidarity. Theo was willing to give financial support to this ad-venture in exchange for a certain number of Gauguin's works (he already had Vincent's at his disposal). By this time Vincent had worked out his plan in detail, but it was months before Gauguin was ready to take the step—not so much because he believed in Vincent's scheme but because it was his only opportunity to get away from Brittany.

Van Gogh's letters in the months preceding Gauguin's arrival in Arles make it clear

14. The Yellow House (at right), where Van Gogh lived in Arles

that these two men were not very compatible, yet Van Gogh began his preparations in a spirit of hope. He furnished his house as their living quarters—which put considerable strain on Theo's budget—and decided to decorate it with paintings, turning it into a true artists' house where Gauguin would feel at home and at the same time notice the progress Van Gogh had made as a painter. In fact, in these very months—the summer and autumn of 1888—Vincent created an impressive series of works, a number of which are now icons of modern art: sunflowers in a vase, a café at night, numerous portraits, park views and his bedroom. He was at the height of his powers, and he knew it. This demanded the utmost of him, both physically and mentally, so much so that shortly before Gauguin's arrival at the end of October 1888, he was forced to take a couple of days of urgently needed rest.

Gauguin in Arles: Battle of the Titans

The young artists who had gathered round Paul Gauguin in Pont-Aven in Brittany saw him as *the* man of the future. In the early years of Impressionism he had become friendly with several key players, such as Edgar Degas and Camille Pissarro, and had abandoned his wife and children to make a name for himself in Paris. Gauguin, who was anything but insecure, did his best to cultivate a virile image. In fact, he could justifiably be seen as the exact opposite of Van Gogh, yet they did have several things in common: a late calling to art, the ambition to make an important contribution to the renewal of art, and a constant lack of money. The imbalance in their relationship lay in the fact that Van Gogh revered Gauguin, whereas Gauguin's attitude towards Van Gogh was sooner one of affable condescension. Moreover, during the two months they were together, Gauguin succeeded in selling several of his works—a poignant reminder of his superiority.

At first Van Gogh was happy to have the company of 'a really great artist and a really excellent friend' (719). They painted outdoors, on the edge of Arles near an old Roman graveyard (Les Alyscamps), as well as in the brothels of Arles, where Gauguin, according to Van Gogh, enjoyed great success, and in the previously mentioned 'night café'. During a spell of bad weather, they worked together in the small studio in the Yellow House, where Van Gogh, who always based his works on reality, obeyed Gauguin's mantra to work from memory and the

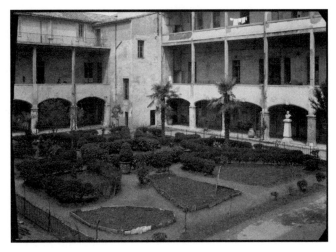

15. The hospital in Arles

imagination. It was a side road that led to a number of works that stand apart in Van Gogh's oeuvre, such as *Reminiscence of the garden at Etten*, *Woman reading a novel* and *The sower*.

They also discussed art and literature, of course, and the fundamental differences in their artistic notions became increasingly clear: 'The discussion is *excessively electric*. We sometimes emerge from it with tired minds, like an electric battery after it's run down' (726).

The low point came on the evening of 23 December, exactly two months after Gauguin's arrival. In the Yellow House, Van Gogh cut off part of his ear, which he brought to a prostitute in the nearby red-light district. He was taken to a hospital the next morning (fig. 15). Theo, who learned of the incident from a telegram sent by Gauguin, set off that same evening for Arles to be with Vincent. One day later—on Christmas Day—Theo returned to Paris in the company of Gauguin. The dream of a shared studio, which had briefly come true, had now been shattered.

Silent Suffering: Seeking New Balance, Arles 1889–1890

The crisis in late December 1888 heralded a long period of mental turmoil for Van Gogh. His collapse marked the first of a series of attacks of mental illness: at intervals of one to several weeks, he repeatedly spent a few days in complete confusion, plagued by unbearable fears and hallucinations, not knowing what he was doing. During most of his hospital stay he was under strict surveillance, if only because the people near the Yellow House no longer wanted him near them, and had even submitted a petition to that effect to the mayor. Van Gogh felt betrayed by his neighbours, but, powerless to act, he was forced to resign himself to the situation: 'If I didn't restrain my indignation I would immediately be judged to be a dangerous madman', he admitted (750). Gauguin, too, had betrayed him, not only by departing so hastily from Arles, but also by refusing—on the day after the incident, when he was still in town—to visit Van Gogh in the hospital, even though his friend had expressly requested it.

Van Gogh's strategy for survival in this lonely situation was, inevitably, to accept his sad fate and put it in perspective. He frequently quoted Pangloss, the pseudo-philosopher

from Voltaire's *Candide*, saying that everything always turned out for the best in this best of all possible worlds. At times he joked wryly about his condition: having already contracted his insanity, at least he could not catch it again. He explained away things he could have blamed on others, and tried to cling to more positive thoughts.

Vincent expressed deep respect for the medical profession and was filled with feelings of both gratitude and guilt towards Theo, who had invested so much money in him and now could only fear that the 'undertaking' would never pay off; 'but above all it seemed sad to me that all that had been given to me by you with so much brotherly affection, and that for so many years, it was however you alone who supported me, and then to be obliged to come back to tell you all this sad story' (760). No matter how hard Theo tried in his letters to assuage his brother's guilty feelings, they pressed down on Vincent like a lead weight. Moreover, he was convinced that everything would change for the worse in April 1889, when Theo was to marry Jo Bonger, for Theo would then have less money available, certainly if he gave up his job at Boussod, Valadon & Cie—a possibility the brothers had discussed.

Waning Self-Confidence

Van Gogh had always placed great demands on himself in order to give his utmost to his art, but now that both his mind and his body had let him down, he no longer had any faith in the future. Up to now he had fervently believed that his work represented one small link in the chain of progression towards a new art, and this had provided him with the comfort he so urgently needed. But now he feared that he would never produce

16. The asylum Saint-Paul de Mausole in Saint-Rémy

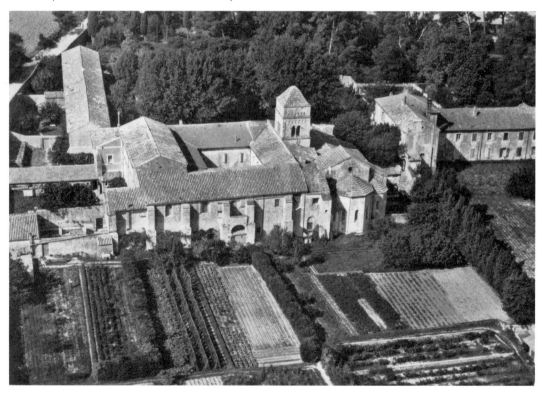

anything of importance and would remain, at best, a second-rate painter. He resigned himself to defeat.

The deterioration of his health had indeed caused a decline in Van Gogh's artistic production in these months. He made repetitions of canvases he thought important, such as *La berceuse*, *Portrait of the postman Roulin* and *Sunflowers in a vase*. Direct references to his unfortunate situation are two self-portraits with bandaged ear, a portrait of Dr Félix Rey, and two paintings of the hospital in Arles: one of a ward and the other of the garden in the inner courtyard. Most of these works are undiminished in strength and betray no sign of suffering—but given the great effort it cost him to make them, it is no wonder that he was less productive in this period.

His neighbours kept their distance, which only increased his isolation, but he also encountered support. Roulin helped with practical matters, and occasionally informed Theo of Vincent's condition. He had good talks with Dr Rey. Paul Signac visited him and sent a couple of letters, and the Reverend Frédéric Salles acted as a go-between, taking care of anything to do with the authorities. It was this clergyman who arranged Van Gogh's admission to the psychiatric clinic of Saint-Paul de Mausole in nearby Saint-Rémy (fig. 16). Van Gogh realized that he was not capable of living on his own. At the beginning of May he sent Theo more than thirty paintings and one drawing, and on 8 May he let the ever-helpful Salles accompany him to the asylum.

Therapeutic Isolation: Saint-Rémy, May 1889–May 1890

The village of Saint-Rémy-de-Provence is twenty-five kilometres northeast of Arles. The asylum where Van Gogh would spend a year of his life lay to the south of the village, with a view of the small mountain chain called the Alpilles. Saint-Paul de Mausole was originally a twelfth-century convent, and the nursing staff still included a number of nuns. Van Gogh was given a small room with a barred window and an extra room in which to work (fig. 17). The treatment consisted of a two-hour bath twice a week, and moderation in eating, smoking and drinking. He had little contact with his fellow sufferers, most of whom seemed to be in considerably worse shape.

The very first letters Van Gogh wrote from the asylum make it clear that he felt safer there, and that this had a calming effect on him. He now found himself in an environment where he was no longer a danger to himself or anyone else. The severe cases all around him helped him put his own condition in perspective, and he began 'to consider madness as being an illness like any other' (772). The real cause of his illness has been the subject of much speculation; we will probably never know how he would be diagnosed today, since the necessary details are lacking. Dr Théophile Peyron, the attending physician, described Van Gogh's attacks (in now-outdated terms) as 'epileptic in nature'. At any rate, Vincent's illness meant that after being perfectly all right for weeks or months on end, he would suddenly suffer an 'attack' that lasted days or even weeks.

17. The view from Van Gogh's room in Saint-Paul de Mausole

Between May 1889 and May 1890, Van Gogh had four such attacks, which left him in a state of complete mental derangement. He had no idea what he was doing and had self-destructive tendencies (such as eating dirt and paint), but the worst thing, as he said later, were the religious delusions. After these episodes he was downcast and lacked the will to live, and it took a long time for him to find his balance.

According to Van Gogh, work was the best remedy. As on previous occasions, he now attempted in Saint-Rémy to pull himself together, exhorting himself, not without irony and self-reproach, to set to work again. At the same time he deliberately tried not to reflect too deeply on religious and metaphysical matters, which tempted him into territory where his thoughts might again become confused. But a fear that had manifested itself in Arles now gripped him even more firmly: the conviction that he would never recover—'a broken pitcher is a broken pitcher' (839)—and thus never again reach the heights attained during his best days in Arles.

Stylization and Truth

In spite of his shaky mental health and his limited field of action, Van Gogh made a number of astonishingly strong works during his first months in Saint-Rémy. Abandoning extremes of colour, he was now preoccupied with the phenomenon of 'style': 'when the thing depicted and the manner of depicting it are in accord, the thing has style and quality' (779). A picture dating from this period, *Starry night*, was one of his most thoroughgoing experiments in this respect. Theo cautiously criticized the painting, and later Van Gogh admitted that he had gone too far in his striving for stylization. He realized that an overly systematic approach to line and brushstroke jarred with the demand he placed on all art, namely that the artist had to empathize with his subject, to feel it through and through, in order to endow the artwork with a deeply personal quality.

In the autumn of 1889 a remarkable epistolary discussion developed between Van Gogh, Gauguin and Bernard. The main issue was religious art. Van Gogh's friends had arrived at a synthetic notion of the image, which combined elements in ways and proportions that were not always 'realistic'. They created, for example, modern biblical scenes, based in part on the religious painting of previous centuries. Van Gogh had nothing good to say about it. He found it impersonal and unsound. 'Because I adore the true, the possible' (822): reality was the starting point; the art of today should not rely on an outdated idiom, but invent a new one. Heated discussions of this kind put Van Gogh in great danger of losing himself.

Need for Family

Meanwhile a lot had changed in Theo's life. Soon after he married Jo, in April 1889, she became pregnant (fig. 18). For Vincent this news was both joyful and worrying, because Theo now bore an even greater burden, and might begin to think of Vincent as a millstone around his neck. It was precisely at this time that Vincent tried to strengthen the ties with his family in the Netherlands. Since leaving Paris, he had been corresponding with his sister Willemien (fig. 19), but now he occasionally wrote to his mother as well. This shows a need for contact with like-minded people he trusted, a need that also emerges from recurrent recollections of his youth in rural Brabant and other nostalgic remarks about the early days. In Saint-Rémy he made several works from memory that he called 'souvenirs du Nord' and 'souvenirs de Brabant', and he thought about making

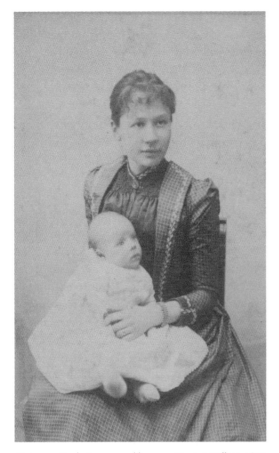

18. Jo van Gogh-Bonger and her son Vincent Willem, 1890 19. Willemien van Gogh, c. 1887

new versions of his Nuenen paintings *The old church tower*, *The cottage* and *The potato eaters*. He fell back on old values and certainties, and thus reread William Shakespeare and Charles Dickens.

In January 1890, while working on *Almond blossom*, intended as a present for his future nephew, Van Gogh had another attack of his illness (the third in Saint-Rémy). Afterwards, as he began to recover, he received in the mail the birth announcement of Vincent Willem van Gogh, who had been born on 31 January 1890. He was not particularly pleased that the baby was named after him, and suggested—too late—that the boy should be named Theo anyway, after his father and grandfather.

Recognition

January 1890 saw another extraordinary event, but of a completely different kind. The *Mercure de France*, the leading French magazine for modern art and literature, published an article by Albert Aurier in his series called Les Isolés (The isolated ones), in which the art critic heaped praise on Van Gogh. In exalted language he expressed his admiration for the swirling lines, explosive colours, strange forms and unusual symbolism in Van Gogh's work, which he had seen in Brussels at an exhibition mounted by Les Vingt, a society of avant-garde artists.

It seemed that recognition had come at last, yet Van Gogh experienced it as the

previously mentioned cigar—stuck in his mouth by the lighted end—and felt ill at ease with all the attention he was receiving. He wrote to Aurier, expressing admiration for his prose and his apt description of what he had *intended* to achieve, but suggesting that it would have been better if the critic had 'done justice to Gauguin' before praising him (853). Van Gogh's letter nevertheless shows how pleased he was that Aurier understood his work so well.

In the following months a large part of his work consisted of 'translations' into colour of black-and-white prints sent by Theo after paintings by Millet, Delacroix and Rembrandt. He had begun work on these the previous autumn, since it was difficult to leave the clinic's grounds, and there were scarcely any models available. Then, too, he felt the need to make these copies, because, as he wrote, 'It's a study I need, for I want to *learn*' (805).

Gradually Van Gogh began to entertain hopes of leaving the asylum and spending some time in the north of France. There were two options: finding another clinic where he would be allowed to work, or going to live near someone who would keep an eye on him. Theo found a doctor willing to do this: Paul Gachet, who lived in Auvers-sur-Oise, a village about thirty kilometres north of Paris. Even though Van Gogh suffered another attack in April, he recovered with remarkable speed and did not want to wait longer than necessary to arrange his departure from Saint-Rémy. Dr Peyron and Theo thought it risky, but Vincent was dying of boredom and sorrow: 'As for me, my patience is at an end, at an end, my dear brother, I can't go on, I must move, even if as a stopgap' (868).

And so it happened. Van Gogh viewed his stay in the south as a fiasco, but he left in the conviction that he had, in the end, managed to create a series of works that, taken altogether, truly reflected the character of Provence: the colour, the nature, the landscape, the people. Greatly relieved, he took the train to Paris on 16 May 1890.

Deceptive Peace and Quiet: Auvers-sur-Oise, May–July 1890

Vincent stayed briefly in Paris with Theo and his young family, and met several of his acquaintances, but it soon became too much for him. On 20 May he arrived by train in Auvers, a rural village on the banks of the river Oise, to the north of which extended hills with woods and fields. In this respect Van Gogh found everything his heart desired. He moved into the least expensive inn, run by Mr and Mrs Ravoux, where he rented a room and a place to store his personal belongings (fig. 20). He put himself under the supervision of Dr Gachet, who had obtained a PhD with a dissertation on the symptoms of melancholy. According to Vincent, however, the doctor was just as nervous and sick as Theo and he were. He soon considered Gachet a friend. For his part, Gachet—who in the course of his life had become acquainted with various Impressionists and other artists— soon came to admire Van Gogh's work. As far as his medical supervision was concerned, Gachet confined himself to reassuring Van Gogh by telling him that he would do best not to take too much notice of his illness, and that he should work a lot and eat well. Van Gogh visited the doctor regularly, ate copious meals—which he abhorred—and made paintings in and around the house.

Looking Cautiously to the Future

Obviously it did Vincent good to be near Theo and his family. In this tremendously productive period, Van Gogh averaged a picture a day, painting portraits, still lifes and

20. Auberge Ravoux, Auvers-sur-Oise

landscapes in a rather robust style that could almost be called rustic. Artist friends and more distant acquaintances—including Gauguin, Meijer de Haan and Joseph Isaäcson, as well as Anna Boch (the sister of Eugène), who bought Van Gogh's painting *The red vine-yard* at the exhibition of Les Vingt in Brussels—all expressed their growing appreciation for his work, which received positive reviews in several magazines.

Although Van Gogh dared not hope that his spells of insanity were a thing of the past, he began to look cautiously to the future. He wanted to make etchings (on Gachet's press) after works he had painted in Provence, and perhaps even pay a visit to Gauguin.

Nonetheless, there were worries. The living conditions and health of Theo and his family were a particular source of concern for Vincent. He urgently advised them to pay regular visits to the countryside, preferably even moving there. It was Theo's fervent desire as an art dealer to have more room to manoeuvre, to be able to do more for modern artists, but his employers at Boussod, Valadon & Cie were not inclined to give him that freedom. The question was whether Theo should go into business for himself, which would mean a very uncertain future, financially speaking. It was precisely this financial insecurity that troubled Vincent, and he was again plagued by his old feelings of guilt at being such a drain on Theo's resources.

On Sunday, 6 July, a conversation took place in Theo and Jo's apartment at which Andries Bonger and Vincent were also present. Bonger—Jo's brother, and a friend of Theo—had declared his unwillingness to enter into a business partnership, thus dashing Theo's hopes of setting up as an independent dealer. The discussion must have been very heated.

Loneliness and Gloom

Van Gogh, anxious and downcast, returned to Auvers and set to work immediately, in an attempt to give vent to his feelings:

> [O]nce back here I set to work again—the brush however almost falling from my hands and—knowing clearly what I wanted I've painted another three large canvases since then. They're immense stretches of wheatfields under turbulent skies,

21. The graves of Vincent and Theo van Gogh in Auvers-sur-Oise

and I made a point of trying to express sadness, extreme loneliness. . . . I hope to bring them to you in Paris as soon as possible, since I'd almost believe that these canvases will tell you what I can't say in words, what I consider healthy and fortifying about the countryside. (898)

Nature as a refuge, art as consolation. The letters exchanged by the brothers in these weeks of July reveal that Theo and Jo were less concerned about their future than Vincent was, and that they did their best to reassure him. In spite of this, Vincent was afraid: 'I feared—not completely—but a little nonetheless—that I was a danger to you, living at your expense' (898).

On Sunday, 27 July 1890, Van Gogh went to paint in the fields outside Auvers. At some point he decided to put an end to his life. The immediate cause and precise circumstances are unknown, but it is clear that he had little faith in the future, despite his passion for work. He shot himself in the chest with a pistol (it is not known how he got hold of it) and lost consciousness. When he came round, he managed somehow to return to the inn where he was living. Help was summoned, but nothing could be done to prevent his death in the early morning of 29 July.

Theo was at Vincent's deathbed, a broken man. He arranged for his brother's body to be put in a coffin, surrounded by his paintings and sunflowers. A dozen friends and acquaintances from Paris attended the funeral the following day at the small cemetery in the field outside Auvers.

After Vincent's death, Theo had a mission: to cultivate understanding and appreciation for his brother's work. His poor health got the better of him, however. In October 1890 Theo became mentally deranged as a result of advanced untreated syphilis. He was hospitalized and later transferred to a clinic in Utrecht, where he died in January 1891, only six months after Vincent. Jo van Gogh-Bonger subsequently devoted herself to promoting her brother-in-law's reputation, and in 1914 she published Vincent's letters to Theo. That same year she had her husband's remains reburied in Auvers, in a grave next to his brother's (fig. 21).

Letters with a History

The surviving correspondence of Vincent van Gogh, which begins in 1872 and ends in 1890, comprises 903 letters. They offer a detailed view of his life, his vision of existence, the genesis of his works and the evolution of his artistic ideas. Even in his lifetime, Van Gogh had begun to gain a reputation among a small group of artists and progressive art critics. The growth in popularity of Van Gogh's paintings shortly after his death coincided with a growing interest in his correspondence. Those who laid eyes on his extraordinary letters understood that not only did they testify to a remarkable talent for writing and a keen eye, but they also shed a great deal of light on his artistic notions and intentions.

Short quotations from the letters, some of which were written in Dutch and others in French, were published as early as 1892 in the catalogue of the Van Gogh exhibition at the Kunstzaal Panorama in Amsterdam, organized by the artist Richard Roland Holst. In August 1893 longer fragments appeared in the avant-garde magazine *Van Nu en Straks*. Meanwhile Van Gogh's friend Emile Bernard had begun in April 1893 to publish passages from the letters written in French in the *Mercure de France*, the leading French magazine for art and literature—a project that continued, with interruptions, until August 1897. This series was hugely important in generating interest not only in Van Gogh as an artist but also in his letters as biographical source material par excellence.

The above-mentioned letter fragments were translated into German and published in 1904–5 by Bruno Cassirer in Berlin in the magazine *Kunst und Künstler*, after which they appeared in book form in a volume that was reprinted many times. In the Netherlands, Van Gogh's letters to Anthon van Rappard were published in 1905, and those to Emile Bernard appeared in a luxury edition in 1911 in France.

The public at large finally discovered that Van Gogh was an exceptional letter writer with the appearance in 1914 of *Brieven aan zijn broeder* (Letters to his brother), a three-volume publication in Dutch edited by Theo's widow, Jo van Gogh-Bonger. Published almost simultaneously in German, it was subsequently translated, in whole or in part,

into many other languages. Aside from several family letters, Jo included only the letters from Vincent to Theo (and to herself, after her marriage to Theo in 1889).

In the intervening period Jo had made a vital contribution to the recognition of Van Gogh's work, for as the keeper of a considerable part of his oeuvre, she had devoted herself from the very beginning to exhibiting and selling his drawings and paintings. (All of the Van Goghs in the family collection had passed by descent to Jo and Theo's son, Vincent Willem van Gogh, but because he was still underage, Jo, his legal guardian, administered these holdings.) Jo saw the letters primarily as a means of becoming acquainted with Van Gogh the man, and her introduction to the publication was therefore biographical in nature.

Jo van Gogh-Bonger's edition laid the foundation for the study of Van Gogh's life and work. In all honesty it must be said, however, that she published the letters at her own discretion, omitting—in the early letters in particular—passages that were repetitive or potentially embarrassing to family members who were still living. In a number of cases she put the letters in the wrong order, and occasionally she inserted loose pages incorrectly.

In 1952–54 an improved and considerably enlarged four-volume edition was published: *Verzamelde brieven* (Collected letters), edited by Vincent Willem, who had meanwhile become the keeper of the family collection. Since the appearance of the publication edited by his mother, some previously unknown letters had been published in magazines and separate editions, such as Van Gogh's letters to his sister Willemien, Theo's letters to Vincent and the letters from and to Paul Gauguin. *Verzamelde brieven* was thus a compilation of all the correspondence known at the time. It is this edition that would become, for more than half a century, the basis of numerous publications worldwide; it also formed the foundation of the rapidly developing field of Van Gogh research in the last quarter of the twentieth century.

In the meantime Van Gogh's renown had attained great heights, and a broad public had become interested not just in his work but also in his life and letters. Irving Stone's novel *Lust for Life* (1934) gave great impetus to this development, and Vincente Minelli's film version (1956) defined the picture of Van Gogh's life and suffering for decades. Exhibitions in Europe, the United States and Japan drew large crowds of admirers. As part of Van Gogh's ever-growing fame, his letters were recognized as literary texts in their own right. The man who achieved renown as a pioneering painter and draughtsman has also come to be seen in recent decades as a gifted writer. Indeed, in many people's eyes his *document humain*, which was never intended for publication, is a highlight of world literature.

Yet another edition, considerably expanded but published only in Dutch, appeared in 1990. This was followed in 2009 by the scholarly edition *Vincent van Gogh—The Letters: The Complete Illustrated and Annotated Edition*. This was the result of a research project lasting fifteen years, carried out by a team of editors and Van Gogh specialists at the Van Gogh Museum, in collaboration with Huygens ING (at that time called the Constantijn Huygens Institute for Text Editions and Intellectual History) of the Royal Netherlands Academy of Arts and Sciences. It was the first annotated edition, and appeared both on the Internet (www.vangoghletters.org) and in printed form (in Dutch, French and English editions). Not only were all the letters retranscribed from the original manuscripts, but they were also fully annotated (although the notes were abridged for the printed edition) and illustrated with virtually every artwork mentioned, whether by Van Gogh or other artists. Accuracy and completeness were top priorities.

The present anthology is based on the complete edition of 2009; the same editors are responsible for the selection and the introduction. Since the wide dissemination of Van Gogh's correspondence, his fame rests in equal measure on his paintings, his life story and his letters. No article, book, catalogue, exhibition or film in which Van Gogh figures—let alone stars—can afford to ignore his letters. This explains the importance of publishing them, again and again, according to the latest insights, for the wide range of readers intent on delving into the unique realm of thought of an artist who is still a guiding light of modern art.

Note to the Reader

This anthology contains 265 of Vincent van Gogh's letters, nearly a third of all the surviving letters penned by the artist. This extensive selection has been drawn from the source documents, published in their entirety with illustrations and annotations in the online scientific edition at www.vangoghletters.org (first published in 2009 and regularly updated). The web edition is the end result of the Van Gogh Letters Project (1994–2009), a collaboration between the Van Gogh Museum in Amsterdam and the Huygens ING (a division of the Royal Netherlands Academy of Arts and Sciences) in The Hague. This project also resulted in the printed publication of Van Gogh's complete letters in 2009, published in Dutch, English and French with abridged annotations.

Readers requiring additional information about specific people, the places where Van Gogh stayed, the family history, quotes he uses, references to his own work and works by others, the grounds for dating the letters and so forth are directed to the online edition mentioned above. The web edition also features the complete transcripts of all of Van Gogh's letters in the original language.

The letters in this anthology are presented as Van Gogh wrote them, staying true to the original composition and style. The letters are presented in chronological order. The letter numbers (given within parentheses in the introduction) refer to the web edition. (D), (F) and (E) refer to the original language of the letter: Dutch, French or English.

Van Gogh's distinctive manner of accentuating text by underlining words (sometimes several times), making them larger or loading his pen with extra ink has been rendered in this anthology through the use of italics, small capitals and regular capitals.

In his Dutch-language letters, Van Gogh often used French words and expressions, and he made extensive use of French and English prose passages, fragments from the Bible, and poetry. The original source texts are, alongside background information, available in the web edition.

Pages of letters selected for this anthology that feature sketches are reproduced as whole pages.

The Hague, 29 September 1872–17 March 1873

1 | The Hague, Sunday, 29 September 1872 | *To Theo van Gogh* (D)

[The Hague, 29 September 187]2.

My dear Theo,

Thanks for your letter, I was glad to hear that you got back safely. I missed you the first few days, and it was strange for me not to find you when I came home in the afternoon.

We spent some pleasant days together, and actually did go for some walks and see a thing or two whenever we had the chance.

What terrible weather, you must feel *anxious* on your walks to Oisterwijk. Yesterday there were trotting races on the occasion of the exhibition, but the illumination and fireworks were postponed because of the bad weather, so it's just as well you didn't stay to see them. Regards from the Haanebeeks and the Rooses. Ever,

Your loving
Vincent

3 | The Hague, mid-January 1873 | *To Theo van Gogh* (D)

The Hague, January 1873

My dear Theo,

I heard from home that you arrived safe and sound in Brussels, and that your first impression was good.

I understand completely how strange it will be in the beginning, but be of good heart, you'll surely succeed. You must write to me soon about how things are going and how your boarding-house suits you.

I hope that the latter will be all right. Pa wrote that you're good friends with Schmidt. Bravo, I think he's a fine fellow, and one who'll be sure to show you the ropes.

How pleasant those days at Christmas were, I think of them so often; they'll also long be remembered by you, as they were also your last days at home. You must write to me in particular about what kind of paintings you see and what you find beautiful.

I'm busy now at the beginning of the year. My new year began well, I was given a monthly rise of 10 guilders, so I now earn 50 guilders a month, and on top of that I received a 50-guilder bonus. Isn't that wonderful? I now hope to be entirely self-supporting.

I'm really very happy that you're also part of this firm. It's such a fine firm, the longer one is part of it the more enthusiastic one becomes.

The beginning is perhaps more difficult than in other jobs, but keep your chin up and you'll get along.

Do ask Schmidt what the 'Album Corot. lithographies par *Emile Vernier*' costs. We've been asked about it in the shop, and I know it's in stock in Brussels.

The next time I write I'll send you my portrait; I had it taken last Sunday.

Have you been to the Palais Ducal yet? Do go when you get the chance.

How is Uncle Hein? I feel so sorry for him, and hope so much that he'll get better. Give him and Aunt my warm regards.

Did Uncle Cent stop off at Brussels?

Well, old chap, keep well, all your acquaintances here send their regards and hope things will go well for you. Bid good-day to Schmidt and Eduard for me, and let me hear from you soon.

Adieu

Your loving brother
Vincent.

You know that my address is Lange Beestenmarkt 32 or Maison Goupil & Cie, Plaats.

5 | The Hague, Monday, 17 March 1873 | *To Theo van Gogh* (D)

The Hague, 17 March 1873

My dear Theo,

It's time you heard from me again, and I'm also longing to hear how you are and how Uncle Hein is doing, so I hope you'll write to me when you can find the time.

You'll have heard that I'm going to London, and probably very soon. I do hope we'll be able to see each other before then.

I'll go to Helvoirt at Easter if I possibly can, but it will depend on the *nouveautés* that Iterson takes along on his trip. I won't be able to leave until he gets back.

Life in L. will be very different for me, for I'll probably have to live alone in lodgings, and will therefore have to deal with many things that I needn't trouble myself with now.

I'm looking forward to seeing L. very much, as you can imagine, and yet I'm sorry to have to leave this place. I'm only just noticing how attached I am to The Hague, now that it's been decided I must go away. Still, it can't be helped, and I intend not to take things too hard. I think it's wonderful for my English, which I understand well, though I don't speak it nearly as well as I'd like.

I heard from Anna that you had your portrait taken. If you can spare another, I commend myself.

How is Uncle Hein? Certainly no better, and how is Aunt doing? Can Uncle keep himself occupied, and is he in a lot of pain? Give them my warm regards, I think of them so often.

How is business with you? It must be busy, as it is here. You probably know your way around by now.

How is your boarding-house? Is it still to your liking? That's important. Above all, you must write more about the kind of things you see. Sunday a fortnight ago I was in Amsterdam to see an exhibition of the paintings going to Vienna from here. It was very interesting, and I'm curious as to the impression the Dutch will make in Vienna.

I'm very curious about the English painters, we see so little of them, because almost everything stays in England.

Goupil has no gallery in London; they only supply the trade.

Uncle Cent is coming here at the end of the month, I'm longing to hear more from him.

The Haanebeeks and Aunt Fie ask after you constantly, and send you their regards.

What wonderful weather we've been having, I'm taking advantage of it as much as I can. Last Sunday I went rowing with Willem. How much I'd have liked to stay here this summer, but we must take things as they come. And now, adieu, I wish you well, and write to me. Bid good-day to Uncle and Aunt, Schmidt and Eduard from me. As to Easter, I'm just hoping. Ever,

Your loving brother
Vincent

Mr and Mrs Roos and Willem also send you their regards.

I just received your letter, for which I thank you. I'm very pleased with the portrait, it turned out well. If I hear anything more about my trip to Helvoirt I'll write to you immediately. It would be nice if we could arrive on the same day. Adieu.

Theo, I must again recommend that you start smoking a pipe. It does you a lot of good when you're out of spirits, as I quite often am nowadays.

9 | London, Friday, 13 June 1873 | *To Theo van Gogh* (D)

London, 13 June 1873.

My dear Theo,

You're probably longing to hear from me, so I don't want to keep you waiting for a letter any longer.

I heard from home that you're now staying with Mr Schmidt, and that Pa has been to see you. I sincerely hope that this will be more to your liking than your previous boarding-house, and don't doubt that it will be. Write to me soon, I'm longing to hear from you, and tell me how you're spending your days at present, &c. Write to me especially about the paintings you've seen recently, and also whether anything new has been published in the way of etchings or lithographs. You must keep me well informed about this, because here I don't see much in that genre, as the firm here is just a stockroom.

I'm very well, considering the circumstances.

I've come by a boarding-house that suits me very well for the present. There are also three Germans in the house who really love music and play piano and sing themselves, which makes the evenings very pleasant indeed. I'm not as busy here as I was in The Hague, as I only have to be in the office from 9 in the morning until 6 in the evening, and on Saturdays I'm finished by 4 o'clock. I live in one of the suburbs of London, where it's comparatively quiet. It's a bit like Tilburg or some such place.

I spent some very pleasant days in Paris and, as you can imagine, very much enjoyed all the beautiful things I saw at the exhibition and in the Louvre and the Luxembourg. The Paris branch is splendid, and much larger than I'd imagined. Especially the Place de l'Opéra.

Life here is very expensive. I pay 18 shillings a week for my lodgings, not including the washing, and then I still have to eat in town.

Last Sunday I went on an outing with Mr Obach, my superior, to Box Hill, which is a high hill (some 6 hours from L.), partly of chalk and covered with box trees, and on one side a wood of tall oak trees. The countryside here is magnificent, completely different from Holland or Belgium. Everywhere one sees splendid parks with tall trees and shrubs, where one is allowed to walk. During the Whitsun holiday I also took a nice trip with those Germans, but those gentlemen spend a great deal of money and I shan't go out with them any more.

I was glad to hear from Pa that Uncle H. is reasonably well. Would you give my warm regards to him and Aunt and give them news of me? Bid good-day to Mr Schmidt and Eduard from me, and write to me soon. Adieu, I wish you well.

Vincent.

My address is:
Care of Messrs Goupil & Co.
17 Southampton Street
Strand
London.

11 | London, Sunday, 20 July 1873 | *To Theo van Gogh* (D)

London, 20 July 1873

My dear Theo,

Thanks for your letter, which gave me a great deal of pleasure. I'm glad you're well and that living at Mr Schmidt's is still to your liking. Mr Obach was pleased to make your acquaintance. I hope that in future we'll do a lot of business with you. That painting by Linder is very beautiful.

As to the photogravure, I know more or less how they're made, though I haven't seen it, and it isn't clear enough to me to explain it.

English art didn't appeal to me much at first, one has to get used to it. There are some good painters here, though, including Millais, who made 'The Huguenot', Ophelia, &c., engravings of which you probably know, they're very beautiful. Then Boughton, of whom you know the 'Puritans going to church' in our Galerie photographique. I've seen very beautiful things by him. Moreover, among the old painters, Constable, a landscape painter who lived around 30 years ago, whose work is splendid, something like Diaz and Daubigny. And Reynolds and Gainsborough, who mostly painted very, very beautiful portraits of women, and then Turner, after whom you'll probably have seen engravings.

Several good French painters live here, including Tissot, after whom there are various photos in our Galerie photographique, Otto Weber and Heilbuth. The latter is currently making dazzlingly beautiful paintings in the style of the one by Linder.

Be sure, when you get the chance, to write and tell me whether there are photographs after Wauters, besides Hugo van der Goes and Mary of Burgundy, and whether you also know photographs of paintings by Lagye and De Braekeleer. It's not the elder De Braekeleer I mean but, I believe, a son of his, who had 3 splendid paintings at the last exhibition in Brussels, titled 'Antwerp', 'The school' and 'The atlas'.

Things are going well for me here. I go walking a lot. Here where I live it's a quiet, convivial, nice-looking neighbourhood, in this I've really been fortunate. And yet I sometimes think back with nostalgia to the wonderful Sundays in Scheveningen and so on, but never mind that.

You'll surely have heard that Anna is at home and not well. It's a bad start to her holiday, but let's hope she's better by now.

Thanks for what you wrote to me about paintings. Be sure to write and tell me if you ever see anything by Lagye, De Braekeleer, Wauters, Maris, Tissot, George Saal, Jundt, Ziem, Mauve, who are painters I like very much, and by whom you'll probably see something now and then.

Herewith a copy of that poem about that painter 'who entered The Swan, the inn where he boarded', which you no doubt remember. It's Brabant to a T, and I'm so fond of it. Lies copied it out for me on my last evening at home. How much I'd like to have you here, what pleasant days we spent together in The Hague. I still think so often of our walk on Rijswijkseweg, where we drank milk at the mill after the rain. If those paintings we have from you are to be sent back, I'll send you a portrait of that mill by Weissenbruch. Perhaps you remember, 'the merry tune' is his nickname, 'I say, superrrb'. That Rijswijkseweg holds memories for me which are perhaps the most delightful I have. Perhaps we'll speak of it again sometime when we meet.

And now, old chap, I wish you well, think of me from time to time and write to me soon. It's so refreshing when I receive a letter.

Vincent

My regards to Mr Schmidt and Eduard. How are Uncle Hein and Aunt? Write to me about them, do you go there often? Give them my warm regards.

The evening hour.

Slowly the toll of the angelus-bell resounded o'er the fields,
As they blissfully bathed in the gold of the evening sun.
O solemn, moving moment! When every mother in the village suddenly
Stops the whirring of the wheel to bless herself with the sign of the cross;

While in the field the farmer reins in his steaming horses,
And, behind the plough, bares his head to murmur an Ave.
O solemn, moving moment! When the bell that proclaims far and wide
The end of the day's work makes those powerful, dripping heads
Bow down for Him who causes the sweat in the furrow to thrive.

For the artist, too, on the slope of yon shady hill,
Absorbed in his painting from the earliest morning,
The angelus now gave the sign to retreat. Slowly he wiped
His brush and palette, which he stowed with his canvas in the valise,
Folded his camp-stool and dreamily descended the path
That leads, gently winding, through the flowery dale to the village.

Yet how oft, before reaching the foot of the hill, did he
Stand admiringly still, to imprint on his mind once again
The refreshing scene down below, unfolding before his eyes.

Just before him lay the village, with a hill to north and to south,
Between whose crests the sun, inflamed and sinking in the west,
Let flow the whole wealth of its colours and up-conjured glory.
The bell, in the grey tower entwined with black-green ivy,
Was now silent. Hanging motionless on high were the brown
Sails of the windmill; the leaves stood still and above the huts
Blue clouds of peat-smoke ascended so straight from the chimneys
That they, too, seemed to hang motionless in the shimmering air.

'Twas as though this village, this field, those hills, as though everything,
Before wrapping itself in a cloak of evening dew to sleep
Beneath the sun's parting kiss, silently and gratefully
Recalled once more the peace and plenty it had again savoured.

Soon, though, this silence was gently disturbed by the sweet sounds
Of the evening. In the distance, from a hollow in the hill echoed
Lingeringly the sound of the cow-horn, calling the cattle.
And at this sign from their herdsman there soon appeared in the furrowed
Sandy mountain road the whole of a colourful herd of cows.
Cracking and smacking, the lad's lash drove them forward,
While they, as if by turns, their necks outstretched, with friendly lowing
Greeted from afar the cow-shed where the milkmaid
Waited for them each evening to ease their taut udders.
Thus on the paths running out from the village like spokes
From an axle, there slowly came movement and life.
Here, 'twas a farmer, dragging homeward a harrow or plough
On a sledge, whistling a tune and riding beside on his bay;
There, a blushing lass, on her head a lock of sweet clover
Laced with daisies and poppies, called from afar to the others,
Kindly and gaily at once, her clear-toned 'good evening'.
Further . . . But on the same track where the painter's path
Led, he suddenly heard peals of joyous laughter.
Rocking from side to side, a wagon, nearly toppling
Under its load of fresh-harvested buckwheat, came rumbling closer,
Both horse and burden adorned with fluttering ribbons and greenery.
Children, all with wreaths of flowers on their little flaxen heads,
Were seated on top, happily waving branches of alder,
Or scattering flowers and leaves, which rained down on all sides,
While round the wagon a troop of country lads and lasses
Skipped and sang enough to startle the whole drowsy plain.

Quietly smiling, the Painter, from behind the thicket,
Watched as the revellers slowly wound their way down the rutted road.
'Aye', he thus mumbled, 'Aye, the Lord must think it
A happy sound, the jubilance with which these hearts
So simply pour forth their thanks as they gather the last
Fruits, which He yearly lets grow fully ripe from their toil.
Yea, for the purest prayer of simplicity and innocence is joy!'

And thus contemplating the calm, deep delight upon which the soul
Feasts in the fields; or with his artist's mind reconstructing
In silent rapture the glorious scene of a moment ago,
He found he had sauntered, unnoticing, into the village.

Already the purple and yellow had faded to grey in the west,
And in the east there had risen close by the little church the full

Copper-coloured disc of the moon, in mist enshrouded,
When he entered The Swan, the inn where he boarded.

Jan van Beers
(*The boarder*)

17 | London, beginning of January 1874 | *To Theo van Gogh* (D)

London, January 1874

My dear Theo,

Thanks for writing.

I sincerely wish you a very happy New Year. I know that things are going well for you in the office, because I heard as much from Mr Tersteeg. I saw from your letter that you have art in your blood, and that's a good thing, old chap. I'm glad you like Millet, Jacque, Schreyer, Lambinet, Frans Hals &c., because — as Mauve says — 'that's it'. Yes, that painting by Millet 'The evening angelus', 'that's it'. That's rich, that's poetry. How I'd like to talk to you about art again, but now we can only write to each other about it often; *find things beautiful* as much as you can, most people *find too little beautiful*.

I'm writing below a few names of painters whom I like very much indeed. Scheffer, Delaroche, Hébert, Hamon.

Leys, Tissot, Lagye, Boughton, Millais, Thijs Maris, Degroux, De Braekeleer Jr.

Millet, Jules Breton, Feyen-Perrin, Eugène Feyen, Brion, Jundt, George Saal. Israëls, Anker, Knaus, Vautier, Jourdan, Jalabert, Antigna, Compte-Calix, Rochussen, Meissonier, Zamacois, Madrazo, Ziem, Boudin, Gérôme, Fromentin, De Tournemine, Pasini.

Decamps, Bonington, Diaz, T. Rousseau, Troyon, Dupré, Paul Huet, Corot, Schreyer, Jacque, Otto Weber, Daubigny, Wahlberg, Bernier, Emile Breton, Chenu, César de Cock, Mlle Collart. Bodmer, Koekkoek, Schelfhout, Weissenbruch, and last but not least Maris and Mauve.

But I could go on like this for I don't know how long, and then come all the old ones, and I'm sure I've left out some of the best new ones.

Always continue walking a lot and loving nature, for that's the real way to learn to understand art better and better. Painters understand nature and love it, and *teach us to see*.

And then, there are painters who make nothing but good things, who *cannot* make anything bad, just as there are ordinary people who cannot do anything that isn't good.

Things are going well for me here, I have a wonderful home and it's a great pleasure for me to observe London and the English way of life and the English themselves, and I also have nature and art and poetry, and if that isn't enough, what is? Yet I haven't forgotten Holland, and especially The Hague and Brabant.

We're busy in the office, we're occupied with the inventory, which is however drawn up in 5 days, so we have it a little easier than you do in The Hague.

I hope you had a nice Christmas, just as I did.

Well, old chap, I wish you well and write to me soon; in this letter I've written just what popped into my pen, I hope you'll be able to understand it. Adieu, regards to everyone in the office and anyone else who asks after me, particularly everyone at Aunt Fie's and the Haanebeeks'.

Vincent

Herewith a few words for Mr Roos.

18 | London, Monday, 9 February 1874 | *To Caroline van Stockum-Haanebeek* (D)

London, 9 February 1874

My dear Caroline,

I feel the need to write a few words to you.

What happy days those were 'when we were together'. You must know that I haven't forgotten you, but writing doesn't come to me as easily as I'd like.

I have a rich life here, 'having nothing, yet possessing all things'. Sometimes I start to believe that I'm gradually beginning to turn into a true cosmopolitan, meaning not a Dutchman, Englishman or Frenchman, but simply a *man*. With the world as my mother country, meaning that tiny spot in the world where we're set down. But we aren't there yet, but I follow after, if that I may apprehend.

And as our ideal that which Mauve calls 'that's it'.

Old girl, adieu.

Yours truly,
Vincent

A handshake for you and Willem, like old times, so that it hurts your fingers.

22 | London, Thursday, 30 April 1874 | *To Theo van Gogh* (D)

London, 30 April 1874

My dear Theo,

Many happy returns of the day. Do right and don't look back, and things will turn out well.

I was glad to get your last letter. I sent you a photo a couple of days ago:

Young girl with a sword, Jacquet

because I thought you'd like to have it.

Van Gorkom's painting isn't very dirty. (Between you and me, I didn't see it, but anyway tell him I wrote that it wasn't very dirty.)

How are Mauve and Jet Carbentus? Write to me with news of them.

It's good that you visit the Haanebeeks.

If I come to Holland, I'll also come to The Hague for a day or two if possible, because The Hague is like a second home to me. (I'll come and stay with you.)

I'd have liked to go on that walk to De Vink. I walk here as much as I can, but I'm very busy. It's absolutely beautiful here (even though it's in the city). There are lilacs and hawthorns and laburnums &c. blossoming in all the gardens, and the chestnut trees are magnificent.

If one truly loves nature one finds beauty everywhere. Yet I sometimes yearn so much for Holland, and especially Helvoirt.

I'm doing a lot of gardening and have sown sweet peas, poppies and reseda, now we just have to wait and see what comes of it.

I enjoy the walk from home to the office and in the evening from the office back home. It takes about three-quarters of an hour.

It's wonderful to be finished so early here; we close at 6 o'clock and yet we work none the less because of it.

Give my regards to everyone I know at the Tersteegs', Haanebeeks' and Carbentuses', and especially the Rooses', also everyone at Uncle Pompe's, because they're going to Kampen, and Mr Bakhuyzen &c.

I wish you the best.

Vincent

The apple trees &c. have blossomed beautifully here; it seems to me that everything is earlier here than in Holland.

As soon as I know something more definite about my going home, I'll write to you directly. I fear, however, that it will be around 4 weeks or so before it can happen. Write soon.

33 | London, Saturday, 8 May 1875 | *To Theo van Gogh* (D)

London, 8 May 1875

My dear Theo,

Thanks for your last letter. How is the patient? I'd already heard from Pa that she was ill, but I didn't know that it was as bad as you said.

Write to me about this soon, if you will. Yes, old boy, 'what shall we say?'

C.M. and Mr Tersteeg were here and left again last Saturday. In my opinion they went a little too often to the Crystal Palace and other places that didn't concern them. It seems to me they could also have come and seen where I lived.

You ask about Anna, but we'll discuss that another time.

I hope and believe that I'm not what many think me to be at present, we'll see, we have to give it time; people will probably say the same about you in a couple of years; at least if you continue to be what you are: my brother in two senses of the word.

Regards, and my regards to the patient. With a handshake,

Vincent

To act on the world one must die to oneself. The people that makes itself the missionary of a religious thought has no other country henceforth than that thought.

Man is not placed on the earth merely to be happy; nor is he placed here merely to be honest, he is here to accomplish great things through society, to arrive at nobleness, and to outgrow the vulgarity in which the existence of almost all individuals drags on.

Renan

37 | Paris, Tuesday, 6 July 1875 | *To Theo van Gogh* (D)

Paris, 6 July 1875

My dear Theo,

Thanks for writing, yes, old boy, I thought so. You must write and tell me sometime how your English is, have you done anything about it? If not, it's not such a great disaster.

I've rented a small room in Montmartre which you'd like; it's small, but overlooks a little garden full of ivy and Virginia creeper.

I want to tell you which prints I have on the wall.

Ruisdael	The bush
ditto	Bleaching fields
Rembrandt	Reading the Bible (a large, old Dutch room, (in the evening, a candle on the table) in which a young mother sits beside her child's cradle reading the Bible; an old woman listens, it's something that recalls: Verily I say unto you, 'for where 2 or 3 are gathered together in my name, there am I in the midst of them', it's an old copper engraving, as large as 'The bush', superb).
P. de Champaigne	Portrait of a lady
Corot	Evening
ditto	ditto
Bodmer	Fontainebleau
Bonington	A road
Troyon	Morning
Jules Dupré	Evening (resting place)
Maris	Washerwoman
ditto	A baptism
Millet	The four times of the day (woodcuts, 4 prints)
Van der Maaten	Funeral in the cornfield
Daubigny	Dawn (cock crowing)
Charlet	Hospitality. Farmhouse surrounded by fir trees, winter scene with snow. A peasant and a soldier before a door.
Ed. Frère	Seamstresses
ditto	A cooper

Well, old boy, keep well, you know it, longsuffering and meek, as much as possible. Let us remain good friends.

Adieu

Vincent

Paris, 15 July 1875

My dear Theo,

Uncle Vincent was here again, we were together quite a lot and talked about one thing and another. I asked him whether he thought there would be an opportunity to get you here, into the Paris branch. At first he wouldn't hear of it, and said it was much better that you stay in The Hague; but I kept insisting, and you can be sure that he'll bear it in mind.

When he comes to The Hague he'll probably talk to you; stay calm and let him have his say; it won't do you any harm, and later on you'll probably need him now and again. You shouldn't talk about me if it's not the right moment.

He's terribly clever, when I was here last winter one of the things he said to me was 'perhaps I know nothing of supernatural things, but of natural things I know everything'. I'm not sure whether those were his exact words, but that was the gist of it.

I also want to tell you that one of his favourite paintings is 'Lost illusions' by Gleyre.

Sainte-Beuve said, 'There is in most men a poet who died young, whom the man survived' and Musset, 'know that in us there is often a sleeping poet, ever young and alive'. I believe that the former is true of Uncle Vincent. So you know who it is you're dealing with, and so be warned.

Don't hesitate to ask him openly to have you sent here or to London.

I thank you for your letter of this morning, and for the verse by Rückert. Do you have his poems? I'd like to know more of them. When there's an opportunity I'll send you a French Bible and L'imitation de Jesus Christ. This was probably the favourite book of that woman whom P. de Champaigne painted; in the Louvre there's a portrait, also by P. de C., of her daughter, a nun; she has L'imitation lying on a chair next to her.

Pa once wrote to me: 'you know that the same lips that uttered "be harmless as doves" also immediately added "and wise as serpents"'. You should bear that in mind as well, and believe me to be ever

Your loving brother
Vincent

Do you have the photos of the Meissoniers in the gallery? Look at them often; he painted *men*. You may well know The smoker at the window and The young man having lunch.

My dear Theo,

You hadn't expected to get this letter back again, had you.

No, old boy, this isn't the path to follow.

The death of Weehuizen is certainly sad, but sad in a different way than you say.

Keep your eyes open and try to become strong and resolute. Was that book by Michelet really meant for him?

Actually, I'd like to suggest something to you, Theo, which will perhaps amaze you:

Read no more Michelet or any other book (except the Bible) until we've seen each other again at Christmas, and do what I told you, go often in the evenings to the Van Stockums, Borchers &c. I believe you won't regret it, you'll feel much freer as soon as you've started this regimen. Be careful with the words I underlined in your letter.

There is quiet melancholy, certainly, thank God, but I don't know if we're allowed to feel it yet, you see I say *we*, I no more than you.

Pa wrote to me recently 'Melancholy does not hurt, but makes us see things with a holier eye'. *That* is true 'quiet melancholy', fine gold, but we aren't that far yet, not by a long way. Let us hope and pray that we may come so far and believe me ever

Your loving brother
Vincent

I'm already a little bit further than you and already see, alas, that the expression 'childhood and youth are vanity' are *almost* completely true. So remain steadfast, old chap; I heartily shake your hand.

49 | Paris, Friday, 17 September 1875 | *To Theo van Gogh* (D)

Paris, 17 Sept. 1875.

My dear Theo,

Feeling, even a fine feeling, for the beauties of nature isn't the same as religious feeling, although I believe that the two are closely connected. The same is true of a feeling for art. Don't give in to that *too* much either.

Hold fast especially to your love for the firm and for your work and to respect for Mr Tersteeg. Later on you'll see, better than now, that he deserves it. You don't have to take it to extremes, though.

Nearly everyone has a feeling for nature, some more than others, but there are few who feel that God is a spirit, and they that worship Him must worship him in spirit and in truth. Pa is one of the few, Ma too, and also Uncle Vincent, I believe.

You know that it is written 'The world passeth away and all its glory', and that on the other hand there are also the words 'that part which shall not be taken away', about 'a well of living water springing up into everlasting life'. Let us also pray that we may become rich in God. But don't think too deeply about these things, which will become clearer to you of themselves with time, and just do what I've advised you to do. Let us ask for our part in life that we may become the poor in the kingdom of God, God's servants. We haven't achieved this yet, however, for often there are beams in our eye of which we ourselves are unaware; let us ask that our eye may become single, for then we shall be completely single.

My regards to the Rooses and if anyone should ask after me, and believe me ever,

Your loving brother
Vincent

Paris, 11 October 1875

My dear Theo,

Thanks for your letter of this morning. This time I'd like to write to you as I seldom do; I'd actually like to tell you in detail about my life here.

As you know, I live in Montmartre. Also living here is a young Englishman, an employee of the firm, 18 years old, the son of an art dealer in London, who will probably enter his father's firm later on. He had never been away from home and was tremendously boorish, especially the first few weeks he was here; he ate, for example, mornings, afternoons and evenings 4–6 sous worth of bread (bread, *nota bene*, is cheap here) and supplemented that with pounds of apples and pears &c. In spite of all that he's as lean as a pole, with two strong rows of teeth, large red lips, sparkling eyes, a couple of large, usually red, jug-ears, a shorn head (black hair) &c. &c.

I assure you, an altogether different creature from that lady by Philippe de Champaigne. This young person was ridiculed a lot in the beginning, even by me. But I nonetheless warmed to him gradually and now, I assure you, I'm very glad of his company in the evenings. He has a completely naïve and unspoiled heart, and works very hard in the firm. Every evening we go home together, eat something or other in my room, and the rest of the evening I read aloud, usually from the Bible. We intend to read it all the way through. In the morning, he's already there to wake me up, usually between 5 and 6 o'clock; we then have breakfast in my room and go to the gallery around 8 o'clock. Recently he's begun to eat with more moderation, and he's started to collect prints, with my help.

Yesterday we went to the Luxembourg together and I showed him the paintings I like best there. And truthfully, unto babes is revealed much that is hidden from the wise.

J. Breton, Alone, The blessing of the corn, Calling the gleaners
Brion, Noah, The pilgrims of St Odile.
Bernier, Fields in winter
Cabat. The pond and Autumnal evening
Emile Breton, Winter evening. Bodmer, Fontainebleau
Duverger, The labourer and his children
Millet, The church at Gréville
Daubigny, Spring and Autumn
Français, The end of winter and The cemetery
Gleyre, Lost illusions and Hébert, Christ in the Garden of Olives and Malaria, also
Rosa Bonheur, Ploughing &c.

Also a painting by ? (I can't remember his name), a monastery where monks receive a stranger and suddenly notice that it is Jesus. Written on the wall of the monastery is L'homme s'agite et Dieu le mène. Qui vous reçoit, me recoit et qui Me reçoit, reçoit celui qui m'a envoyé.

At the gallery I simply do whatever the hand finds to do, that is our work our whole life long, old boy, may I do it with all my might.

Have you done what I advised you to do, have you got rid of the books by Michelet, Renan &c? I believe it will give you peace. You certainly won't forget that page from Michelet about that portrait of a lady by P. de Champaigne, and don't forget Renan either, but still, get rid of them. 'If you have found honey, see to it that you don't eat too much of it, lest it disagree with you' it says in Proverbs, or something to that effect. Do you know Erckmann-Chatrian, Le conscrit, Waterloo, and especially L'ami Fritz and also Madame Thérèse? Read them some time if you can get hold of them. A change of fare whets the appetite (provided we take especial care to eat *simply*; not for nothing is it written 'Give us this day our daily *bread*'), and the bow cannot always stay bent. You won't take it amiss if I tell you to do one thing and another. I know you have your wits about you as well. Do not think *everything* good, and learn to distinguish for yourself between relative good and *evil*; and let that feeling show you the right way with guidance from above because, old boy, it's so necessary 'that God dispose us'. Do write again soon with some particulars, give my regards to my acquaintances, especially Mr Tersteeg and his family, and I wish you the very best. Adieu, believe me ever,

Your loving brother
Vincent

61 | Paris, Friday, 10 December 1875 | *To Theo van Gogh* (D)

Paris, 10 Dec. 1875

My dear Theo,

Herewith what I promised. You'll like the book by Jules Breton. There's one poem of his that I found especially moving: 'Illusions'. Blessed are those whose hearts are thus attuned.

All things work together for good to them that love God is a beautiful saying. It will be so for you, too; and the aftertaste of these difficult days will be good.

But write and tell me soon how things are and when the doctor says you'll be better, if you haven't done so already, that is.

In a fortnight I hope to be in Etten, you can imagine how much I'm looking forward to it.

Have I already told you that I've taken up pipe-smoking &c. again? I've rediscovered in my pipe an old, trusty friend, and I imagine we'll never part again.

I heard from Uncle Vincent that you smoke too.

Tell everyone at the Rooses' especially that I bid them good-day; you and I have had a lot of good times in their house, and have met with much loyalty.

We have 'Sunday morning' by Emile Breton here at present. You know it, don't you? It's a village street with farmhouses and sheds, and at the end the church surrounded by poplars. Everything covered with snow and little black figures going to church. It tells us that winter is cold but that there are warm human hearts.

I wish you the very best, old boy, and believe me ever

Your loving brother
Vincent

The packages of chocolate marked X are for you, the other two are for Mrs Roos.
Smoke the cigarettes with your housemates. Adieu.

65 | Paris, Monday, 10 January 1876 | *To Theo van Gogh* (D)

Paris, 10 January 1875.

My dear Theo,

I haven't written to you since we saw each other; in the meantime something has hap-
pened that didn't come as a total surprise to me.
 When I saw Mr Boussod again I asked if His Hon. indeed thought it a good thing
for me to go on working in the firm this year, since His Hon. had never had any very
serious complaints against me.
 The latter was indeed the case, though, and His Hon. took the words out of my
mouth, so to speak, saying that I would leave on 1 April, thanking the gentlemen for
anything I might have learned in their firm.
 When an apple is ripe, all it takes is a gentle breeze to make it fall from the tree, it's
also like that here. I've certainly done things that were in some way very wrong, and
so have little to say.
 And now, old boy, so far I'm really rather in the dark about what I should do, but we
must try and keep hope and courage alive.
 Be so good as to let Mr Tersteeg read this letter, His Hon. may know it, but I believe
it's better that you speak to no one else of it for the time being, and behave as if noth-
ing is going on.
 Do write again soon, and believe me ever,

Your loving brother
Vincent.

66 | Paris, on or about Monday, 17 January 1876 | *To Theo van Gogh* (D)

Paris, January 1876

My dear Theo,

In the first crate going to The Hague you'll find various packages; be so good as to take
care of them.
 First of all, one for you containing 'Felix Holt', when you've read it please send it to
Etten, and when they've finished it there please send it back here, *when you get the chance*,
because it doesn't belong to me. It's a book that touched me deeply, and it will no
doubt have the same effect on you.
 There's also a package for Mr Tersteeg and one for Mrs Tersteeg, and also one for

Mauve and his wife. I wrote and told Mauve that he should ask you for that book about Michel; please show it to him sometime when it suits you.

There's also a package for Pa; do your best to ensure that it arrives in Etten on Pa's birthday. Perhaps you could add Felix Holt to it and read it after it's been in Etten, that might be the best thing.

In the small roll addressed to you you'll find 3 etchings after Jules Dupré, one for you, one for Uncle Jan van Gogh, with my regards, and one for Pa. Also for Pa a lithograph after Bodmer and an etching by Jacque, and then there's a lithograph after Cabat for you. Cabat is a lot like Ruisdael, there are two magnificent paintings by him in the Luxembourg, one a pond with trees around it in the autumn at sunset, and the other the evening of a grey autumn day, a road by the waterside and a couple of large oak trees.

That etching after Jules Dupré is beautiful, it's one from an album of 6 with Dupré's portrait. He has such a simple and noble face, it reminds me a bit of Mauve's, though he's older, and perhaps in reality he looks different from Mauve.

It's good that you're taking English lessons, you won't regret it.

I'd like to send you a Longfellow and 'Andersen's fairy tales', I'll see if I can find them. If I do send them, read especially Longfellow's Evangeline, Miles Standish, The baron of St Castine and King Robert of Sicily &c.

And now I'll bid you good-day again and shake your hand in thought. Regards to everyone at the Rooses' and if anyone else should ask after me, and believe me ever

Your loving brother
Vincent.

Give my regards again to my friend Borchers.

73 | Paris, Tuesday, 28 March 1876 | *To Theo van Gogh* (D)

Paris, 28 March 1876

My dear Theo,

A few more words, probably the last I'll write to you from Paris.

I'll probably leave here on Friday evening to be home on Saturday morning at the same time as at Christmas.

Yesterday I saw around 6 paintings by Michel, how I wish you'd been there, sunken roads through sandy soil leading to a mill, or a man going home over the heath or sandy ground with a grey sky above, so simple and so fine. It seems to me that the pilgrims on their way to Emmaus saw nature as Michel does, I always think of them whenever I see one of his paintings.

At the same time I saw a painting by Jules Dupré, and a very large one at that.

As far as the eye could see, black marshy terrain, in the middle distance a river and in the foreground a pond (near it 3 horses). Reflected in both, the bank of white and grey clouds behind which the sun has set; on the horizon some greyish red and purple, the upper sky a gentle blue.

I saw these paintings at Durand-Ruel's. There they have no fewer than 25 etchings after Millet, and the same number after Michel, and masses after Dupré and Corot and all other artists, to be had for 1 franc apiece. That's tempting indeed. I couldn't resist buying a couple after Millet: I bought the last 3 of The evening angelus, and my brother will of course receive one when the opportunity arises.

I hear that Mr Iterson is coming to live at the Rooses', he's the youngest, I believe. Write again soon. Regards to everyone at the Rooses' and to Mr and Mrs Tersteeg and to anyone who might ask after me, and in thought a handshake, and ever

Your loving brother
Vincent.

Adieu!

76 | Ramsgate, Monday, 17 April 1876 | *To Theodorus van Gogh
and Anna van Gogh-Carbentus* (D)

Ramsgate, 17 April 1876.

Dear Father and Mother,

By now you've no doubt received the telegram, but will be wanting to know more particulars. I wrote down a few things in the train and am sending you that, so you can see how my trip went.

Friday
We want to stay together today. Which would be better, the joy of seeing each other again or the sadness of parting?

We've often parted from each other already, though this time there was more sorrow than before, on both sides, but courage as well, from the firmer faith in, and greater need for, blessing. And wasn't it as though nature sympathized with us? It was so grey and rather dismal a couple of hours ago.

Now I look out over rolling pastures, and everything is so quiet and the sun is setting behind the grey clouds and throws a golden glow across the land. How much we long for each other, those first hours after parting, which you're spending in church and I in the station and the train, and how much we think of the others, of Theo, and of Anna and the other sisters and of little brother.

We just passed Zevenbergen, and I thought of the day you took me there and I stood on Mr Provily's steps and watched your carriage driving away down the wet street. And then the evening when my Father came to visit me for the first time. And that first homecoming at Christmas.

Saturday and Sunday.
How much I thought of Anna on the boat; everything there reminded me of our journey together.

The weather was clear, and on the Maas especially it was beautiful, also the view from the sea of the dunes, gleaming white in the sun. The last thing one saw of Holland was a small grey tower.

I stayed on deck until sunset, but then it grew cold and dismal.

The next morning in the train from Harwich to London it was beautiful to see in the morning twilight the black fields and green pastures with sheep and lambs, and here and there a hedge of thorn-bushes and a few large oak trees with dark branches and grey, moss-covered trunks. The blue twilit sky, still with a few stars, and a bank of grey clouds above the horizon. Even before the sun rose I heard a lark.

When we arrived at the last station before London the sun rose. The bank of grey clouds had disappeared and there was the sun, so simple and as big as possible, a real Easter sun.

The grass was sparkling with dew and night frost.

And yet I prefer that grey hour when we parted.

Saturday afternoon I stayed on deck until the sun was down. The water was quite dark blue as far as one could see, with rather high waves with white crests. The coast had already disappeared from view. The sky was light blue, burnished and without a cloud.

And the sun went down and cast a streak of dazzling light on the water.

It was a truly grand and majestic sight, and yet simpler, quieter things move one so much more deeply, for now I couldn't help shuddering, and thought of the night in the stuffy saloon with smoking and singing passengers.

A train was leaving for Ramsgate 2 hours after my arrival in London. That's another train ride of around 4½ hours. It's a beautiful ride; we passed, among other things, a hilly region. The hills have a sparse covering of grass at the bottom and oak woods on the top. It's very similar to our dunes. Between those hills lay a village with a grey church covered with ivy like most of the houses. The orchards were in blossom, and the sky was light blue with grey and white clouds.

We also came past Canterbury, a town which still has a lot of medieval buildings, in particular a splendid church with old elm trees around it. Often, already, I've seen something of this town in paintings.

You can imagine how I sat looking out of the window, watching well ahead of time for Ramsgate.

I arrived at Mr Stokes's around 1 o'clock. He was away from home but will be coming back this evening. During his absence his place was taken by his son (23 years old, I think), a schoolmaster in London.

I saw Mrs Stokes in the afternoon at table. There are 24 boys between the ages of 10 and 14. (It was a fine sight, seeing those 24 boys eating.)

So the school isn't large. The window looks out onto the sea.

After eating we went for a walk by the sea, it's beautiful there. The houses on the sea are mostly built of yellow brick in a simple Gothic style, and have gardens full of cedars and other dark evergreen shrubs.

There's a harbour full of ships, closed in by stone jetties on which one can walk. And further out one sees the sea in its natural state, and that's beautiful.

Yesterday everything was grey.

In the evening we went to church with the boys. On the wall of the church was written 'Lo, I am with you alway, even unto the end of the world'.

The boys go to bed at 8 o'clock and get up at 6.

There's another assistant teacher, 17 years old. He, 4 boys and I sleep in another house close by, where I have a small room, which wants some prints on the wall.

And now enough for today, what a good time we had together, thank you, thank you for everything. Many regards to Lies, Albertine and little brother, and in thought a handshake from

Your loving
Vincent.

Thanks for your letters which just arrived; more soon, when I've been here a few days and have seen Mr Stokes.

Ramsgate, 28 April 1876

My dear Theo,

Many happy returns; my hearty congratulations on this day, may our love for one another only increase as we get older.

I'm so happy that we have so much in common, not only memories of the past but also that you're working for the same firm I worked for until now, and therefore know so many people and places that I know too, and that you love nature and art so much.

You'll have received that letter containing Anna's advertisement in good order. There's also an advertisement in the Daily News; now we can only hope that something will come of it.

Mr Stokes told me that he intends to move after the holidays — with the whole school, naturally — to a village on the Thames, around 3 hours from London. He would then furnish the school somewhat differently and perhaps expand it.

Now let me tell you about a walk we took yesterday. It was to an inlet of the sea, and the road to it led through the fields of young wheat and along hedgerows of hawthorn etc. When we got there we had on our left a high, steep wall of sand and stone, as high as a two-storey house, on top of which stood old, gnarled hawthorn bushes. Their black or grey, lichen-covered stems and branches had all been bent to the same side by the wind, also a few elder bushes.

The ground we walked on was completely covered with large grey stones, chalk and shells.

To the right the sea, as calm as a pond, reflecting the delicate grey sky where the sun was setting. It was ebb tide and the water was very low.

Thanks for your letter of yesterday, I think it very nice that Willem Valkis will be joining the branch. Give him my particular regards. I'd like to walk with you both sometime through the Bosjes to Scheveningen.

Have a pleasant day today, and give my regards to everyone who asks after me, and believe me

Your loving brother
Vincent.

I wish you well today, old boy, and begin a happy and blessed year. These are important years for us both, years on which much already depends. May everything turn out well.

I'll be glad when Anna has found something, but situations like the ones she is looking for are rather scarce. A sickly lady here who needed someone to look after her received 300 replies to her advertisement.

I shake your hand heartily in thought. Adieu!

Ramsgate, 31 May 1876

My dear Theo,

Bully for you, being in Etten on 21 May, happily there were 4 of the 6 at home. Pa wrote to me in detail about everything that happened that day. Thanks, too, for your last letter.

Have I already written to you about the storm I saw recently? The sea was yellowish, especially close to the beach; a streak of light on the horizon and, above this, tremendously huge dark grey clouds from which one saw the rain coming down in slanting streaks. The wind blew the dust from the small white path on the rocks into the sea and tossed the blossoming hawthorn bushes and wallflowers that grow on the rocks.

On the right, fields of young green wheat, and, in the distance, the town with its towers, mills, slate roofs and houses built in Gothic style, and, below, the harbour between the 2 jetties running out into the sea, looking like the cities Albrecht Dürer used to etch. I also saw the sea last Sunday night, everything was dark grey, but day was beginning to break on the horizon. It was still very early, and yet a lark was already singing. And the nightingales in the gardens on the sea-front. In the distance the light of the lighthouse, the guard-ship &c.

That same night I looked out of the window of my room onto the roofs of the houses one sees from there and the tops of the elms, dark against the night sky. Above those roofs, one single star, but a nice, big friendly one. And I thought of us all, and I thought of the years of my life that had already passed, and of our home, and the words and feeling came to me, 'Keep me from being a son that causeth shame, give me Your blessing, not because I deserve it, but for my Mother's sake. Thou art Love, beareth all things. Without your constant blessing we can do nothing.'

Herewith a little drawing of the view from the school window where the boys stand and watch their parents going back to the station after a visit. Many a boy will never forget the view from that window. You should have seen it this week when we had rainy days, especially in the twilight when the street-lamps are being lit and their light is reflected in the wet street.

Mr Stokes was sometimes moody during those days, and when the boys were too boisterous for him it sometimes happened that they didn't get their bread and tea in the evening. You should have seen them then, standing at the window looking out, it was really rather sad. They have so little apart from their food and drink to look forward to and to get them through the day. I'd also like you to see them going down the dark stairs and small corridor to table. On that, however, the friendly sun shines.

Another extraordinary place is the room with the rotten floor where there are 6 basins at which they wash themselves, with only a feeble light falling onto the washstand through a window with broken panes. It's quite a melancholy sight, to be sure. How I'd like to spend or to have spent a winter with them, to know what it's like.

The youngsters are making an oil stain on your little drawing, forgive them.

Herewith a few words for Uncle Jan.

And now good-night, if anyone should ask after me bid them good-day. Do you still

visit Borchers once in a while? Give him my regards if you see him, and also Willem Valkis and everyone at the Rooses'. A handshake in thought from

Your loving
Vincent

[*Sketch* 83A]

83A. *View of Royal Road, Ramsgate*

84 | Welwyn, Saturday, 17 June 1876 | *To Theo van Gogh* (D)

Welwyn, 17 June 1876

My dear Theo,

Last Monday I left Ramsgate for London. That's a long walk indeed, and when I left it was awfully hot and it remained so until the evening, when I arrived at Canterbury. That same evening I walked a bit further until I came to a couple of large beeches and elms next to a small pond, where I rested for a while. In the morning at half past 3 the birds began to sing upon seeing the morning twilight, and I continued on my way. It was good to walk then. In the afternoon I arrived at Chatham, where, in the distance, past partly flooded, low-lying meadows, with elms here and there, one sees the Thames full of ships. It's always grey weather there, I think. There I met a cart that brought me a couple of miles further, but then the driver went into an inn and I thought he might stay there a long time, so I walked on and arrived towards evening in the well-known suburbs of London and walked on towards the city down the long, long 'Roads'. I stayed in London for two days and often ran from one end of the city to the other in order to see various people, including a minister to whom I'd written. Herewith a translation of the letter, I'm sending it to you because you should know that the feeling I have as I start out is 'Father, I am not worthy!' and 'Father be merciful to me!' Should I find anything it will probably be a situation somewhere between

minister and missionary, in the suburbs of London among working folk. Don't speak about this to anyone, Theo. My salary at Mr Stokes's will be very small. Probably only board and lodging and some free time in which to teach, or if there's no free time, at most 20 pounds a year.

But to continue: I spent one night at Mr Reid's and the next at Mr Gladwell's, where they were very, very kind. Mr Gladwell kissed me good-night and that did me good, may it be granted me sometime in the future to show some more friendship to his son every now and then. I wanted to leave for Welwyn that evening, but they literally held me back by force because of the pouring rain. However, when it had let up somewhat, around 4 in the morning, I set out for Welwyn. First a long walk from one end of the city to the other, something like 10 miles (each taking 20 minutes). In the afternoon at 5, I was with our sister and was very glad to see her. She looks well and you would be as pleased with her room as I am, with 'Good Friday', 'Christ in the Garden of Olives', 'Mater Dolorosa' &c. with ivy around them instead of frames. Old boy, when you read my letter to that minister you'll perhaps say: he's not so bad after all, though in fact he is. Think of him as he is, however, every once in a while. A handshake in thought from

Your loving brother
Vincent

Rev. Sir.

A clergyman's son, who, because he must work to earn a living, has no money and no time to study at King's College, and who, besides that, is already a couple of years older than is usual for someone starting there, and has not even begun on the preparatory studies of Latin and Greek, would, in spite of everything, dearly like to find a situation connected with the church, even though the position of a clergyman who has had college training is beyond his reach.

My father is a clergyman in a village in Holland. When I was 11 years old I started going to school and stayed there until I was 16. At that time I had to choose a profession and didn't know what to choose. Through the offices of one of my uncles, an associate in the firm of Goupil & Co., art dealers and publishers of engravings, I was given a position in his branch at The Hague. I worked for the firm for 3 years. From there I went to London to learn English, and after 2 years from there to Paris. Forced by various circumstances to quit the firm, however, I left Messrs G.&Co. and have since taught for 2 months at Mr Stokes's school at Ramsgate. As my goal is a situation connected with the church, however, I must look further.

Although I have not been trained for the church, perhaps my past life of travelling, living in various countries, associating with a variety of people, rich and poor, religious and not religious, working at a variety of jobs, days of manual labour in between days of office work &c., perhaps also my speaking various languages, will compensate in part for my lack of formal training. But what I should prefer to give as my reason for commending myself to you is my innate love of the church and that which concerns the church, which has at times lain dormant, though it awakened repeatedly, and — if I may say so, despite feelings of great inadequacy and shortcoming — the Love of God and of humankind. And also, when I think of my past life and of my father's house in that Dutch village, a feeling of 'Father, I have sinned against heaven, and in thy sight,

and am no more worthy to be called thy son, make me as one of thy hired servants. Be merciful to me.' When I was living in London I often attended your church and I have not forgotten you. Now I am asking you for a recommendation in my search for a situation, and to keep a fatherly eye on me should I find such a situation. I have been left very much to myself; I believe that your fatherly eye could do me good, now that

The early dew of morning
has passed away at noon.

Thanking you in advance for whatever you may be willing to do for me . . .

88 | Isleworth, Friday, 18 August 1876 | *To Theo van Gogh* (D)

Isleworth, 18 Aug. 1876

My dear Theo,

Yesterday I went to see Gladwell, who's home for a few days. Something very sad happened to his family: his sister, a girl full of life, with dark eyes and hair, 17 years old, fell from her horse while riding on Blackheath. She was unconscious when they picked her up, and died 5 hours later without regaining consciousness.

I went there as soon as I heard what had happened and that Gladwell was at home. I left here yesterday morning at 11 o'clock, and had a long walk to Lewisham, the road went from one end of London to the other. At 5 o'clock I was at Gladwell's. I'd gone to their gallery first, but it was closed.

They had all just come back from the funeral, it was a real house of mourning and it did me good to be there. I had feelings of embarrassment and shame at seeing that deep, estimable grief, for these people are estimable.

Blessed are they that mourn, blessed are they that are 'sorrowful, yet alway rejoicing', blessed are the pure in heart, for God comforts the simple. Blessed are they that find Love on their path, who are bound intimately with one another by God, for to them all things work together for good. I talked with Harry for a long time, until the evening, about all kinds of things, about the kingdom of God and about his Bible, and we walked up and down on the station, talking, and those moments before parting we'll probably never forget.

We know each other so well, his work was my work, the people he knows there I know too, his life was my life, and it was given to me to see so deeply into their family affairs, I think, because I believe that I love them, not so much because I know the particulars of those affairs, but because I feel the tone and feeling of their being and life.

So we walked back and forth on that station, in that everyday world, but with a feeling that was not everyday.

They don't last long, such moments, and we soon had to take leave of each other. It was a beautiful sight, looking out from the train over London, that lay there in the dark, St Paul's and other churches in the distance. I stayed in the train until Richmond and walked along the Thames to Isleworth, that was a lovely walk, on the left the parks

with their tall poplars, oaks and elms, on the right the river, reflecting the tall trees. It was a beautiful, almost solemn, evening; I got home at quarter past 10.

Thanks for your last letter. You hadn't yet written that Mrs Vintcent had died; how often I brought her home in the evenings. Do you still visit Borchers sometimes? How I'd like to have walked with you to Hoeven! I often teach the boys biblical history, and last Sunday I read the Bible with them. Mornings and evenings we all read the Bible and sing and pray, and that is good. We did that at Ramsgate, too, and when those 21 sons of the London markets and streets prayed 'Our Father, who art in Heaven, give us this day our daily bread', I've sometimes thought of the cry of the young ravens that the Lord hears, and it did me good to pray with them and to bow my head, probably even lower than they did, at the words *Do not lead us into temptation but deliver us from evil.*

I'm still full of yesterday; it must be good to be the brother of the man I saw so sorrowful yesterday, I mean that it must 'be blessed to mourn' with manly sorrow, how I'd have liked to comfort the Father, but I was embarrassed, though I could talk to the son. There was something hallowed in that house yesterday.

Have you ever read 'A life for a life', I think in Dutch it's called 'Uit het leven voor het leven', by the woman who wrote John Halifax? You'd find it very beautiful. How's your English coming along?

It was a delight to take a long walk again, very little walking is done here at school. When I think of my life of struggle in Paris last year and now here, where sometimes I can't leave the house for a whole day, or at least no further than the garden, then I sometimes think, when will I return to that world? If I do return to it, though, it will probably be some other kind of work than I did last year. But I think that I prefer doing biblical history with the boys to walking; one feels more or less safe doing the former.

And now, regards to everyone at the Rooses', and if anyone else should ask after me. How are the Van den Berghs, and the Van Stockums on Buitenhof? Do you ever hear anything from them? A handshake in thought and best wishes from

Your most loving brother
Vincent

And herewith a letter for Mauve. You may read it, I believe it's good not to forget one's old acquaintances, that's why I'm writing again to some of them, also those in Paris, to Soek and others.

If you can persuade anyone to read Scenes from clerical life by Eliot, and Felix Holt, you'll be doing a good deed. The former is a wonderful book. Recommend the former to Caroline and to the Mauves and, *if possible*, to Mr Tersteeg as well.

Could you write by return of post saying whether a *Dutch* pound of butter costs 80 cents and — if it's a different pound — what part of a kilo is it then?

Also give my regards to Mr and Mrs Tersteeg and Betsy.

I'm writing to you between school hours and rather in haste, as you can see.

Isleworth

My dear Theo,

It's again high time that you heard something from me. Thank God you're recovering, I long so much for Christmas — perhaps that time will come before we know it, even though it seems a long way off.

Theo, your brother spoke for the first time in God's house last Sunday, in the place where it is written 'I will give peace in this place'. I'm copying out what it was herewith. May it be the first of many.

It was a clear autumn day and a lovely walk from here to Richmond along the Thames, which reflected the large chestnut trees with their load of yellow leaves and the clear blue sky, and between the tree-tops the part of Richmond that lies on the hill, the houses with their red roofs and windows without curtains and green gardens, and the grey tower above it all, and below, the large grey bridge with tall poplars on either side, with people crossing it who looked like small black figures. When I stood in the pulpit I felt like someone emerging from a dark, underground vault into the friendly daylight, and it's a wonderful thought that from now on, wherever I go, I'll be preaching the gospel — to do that *well* one must have the gospel in his heart, may He bring this about. God says, Let there be light: and there is light. He speaks, and *it* is done. He commands, and it stands, and it stands fast. Faithful is He that calleth us, who also will do *it*. You know enough of the world, Theo, to see how a *poor* preacher stands rather alone as far as the world is concerned — but He can awaken in us, more and more, awareness and firmness of faith. 'And yet I am not alone, because the Father is with me'.

I know in Whom my faith is founded,
Though day and night change constantly,
I know the rock on which I'm grounded,
My Saviour waits, unfailingly.
When once life's evening overcomes me,
Worn down by ills and strife always,
For every day Thou hast allowed me,
I'll bring Thee higher, purer praise.

Praise, Christian, there on your left hand,
And on your right, is God—
When I have no more strength to stand,
When anguished, there is God—
When loving hand of faithful friend
Helps not, there is God—
In death and agony at life's end,
Yes, everywhere is God.

How I long for Christmas and to see all of you, old boy, it seems to me that I've grown years older in these few months.

The panting hart, the hunt escapèd,
Cries no harder for the pleasure
Of fresh flowing streams of water
Than my soul doth long for God.
Yea, my soul thirsts for the Lord,
God of life, oh when shall I
Approach Thy sight, and drawing nigh,
Give Thee praise in Thine own house.

Why art thou cast down, my soul,
Disquieted in me, oh why?
Foster again the faith of old,
Rejoice in praising Him most high.
Oft hath he taken your distress
And turned it into happiness.
Hope in Him, eyes heavenward raised,
For to my God I still give praise.

My boy, if illness and difficulties come to meet us, let us thank Him for bringing us into these hours — and let us not forget meekness, for it is written: On this man will I look, even on him who is poor and sorrowful and who trembleth at My word. Yesterday evening I went to Richmond again, and took a walk there on a large common surrounded by trees, and houses around it, above which the tower rose. Dew lay on the grass and it was growing dark; on one side the sky was still full of the glow of the sun that had just set there, on the other side the moon was rising. An old lady (dressed in black) with lovely grey hair was walking beneath the trees. In the middle of the common, some boys had lit a big fire, which one saw flickering in the distance; I thought of this: when once life's evening overcomes me, worn down by ills and strife always, for every day Thou hast allowed me, I'll bring Thee higher, purer praise. Adieu, a handshake in thought from

Your most loving brother,
Vincent

Regards to Mr and Mrs Tersteeg, Haanebeeks, Van Stockums and everyone at the Rooses' and Van Iterson and if you should see someone or other whom I know.

Your brother was indeed moved when he stood at the foot of the pulpit and bowed his head and prayed 'Abba, Father, let Thy name be our beginning'.

On Thursday week I hope to speak at Mr Jones's church: And the Lord added daily to the church such as should be saved, on John and Theagenes.

Psalm 119:19 I am a stranger in the earth, hide not Thy commandments from me.

It is an old faith and it is a good faith that our life is a pilgrims progress — that we are strangers in the earth, but that though this be so, yet we are not alone for our Father is with us. We are pilgrims, our life is a long walk, a journey from earth to heaven.

The beginning of this life is this. There is one who remembereth no more Her sorrow and Her anguish for joy that a man is born into the world. She is our Mother.

The end of our pilgrimage is the entering in Our Fathers house where are many mansions, where He has gone before us to prepare a place for us. The end of this life is what we call death—it is an hour in which words are spoken, things are seen and felt that are kept in the secret chambers of the hearts of those who stand by, it is so that all of us have such things in our hearts or forebodings of such things. There is sorrow in the hour when a man is born into the world, but also joy—deep and unspeakable—thankfulness so great that it reacheth the highest Heavens. Yes the Angels of God, they smile, they hope and they rejoice when a man is born in the world. There is sorrow in the hour of death—but there too is joy unspeakable when it is the hour of death of one who has fought a good fight. There is One who has said, I am the resurrection and the life, if any man believeth in Me, though he were dead, yet shall he live. There was an Apostle who heard a voice from heaven, saying: Blessed are they that die in the Lord for they rest from their labour and their works follow them. There is joy when a man is born in the world but there is greater joy when a Spirit has passed through great tribu-lation, when an Angel is born in Heaven. Sorrow is better than joy—and even in mirth the heart is sad—and it is better to go to the house of mourning than to the house of feasts, for by the sadness of the countenance the heart is made better. Our nature is sorrowful but for those who have learnt and are learning to look at Jesus Christ there is always reason to rejoice. It is a good word, that of St Paul: As being sorrowful yet always rejoicing. For those who believe in Jesus Christ there is no death and no sorrow that is not mixed with hope—no despair—there is only a constantly being born again, a constantly going from darkness into light. They do not mourn as those who have no hope—Christian Faith makes life to evergreen life.

We are pilgrims in the earth and strangers—we come from afar and we are going far. The journey of our life goes from the loving breast of our Mother on earth to the arms of our Father in heaven. Everything on earth changes—we have no abiding city here—it is the experience of everybody: That it is Gods will that we should part with what we dearest have on earth—we ourselves, we change in many respects, we are not what we once were, we shall not remain what we are now. From infancy we grow up to boys and girls—young men and young women—and if God spares us and helps us—to husbands and wives, Fathers and Mothers in our turn, and then, slowly but surely the face that once had the 'early dew of morning' gets its wrinkles, the eyes that once beamed with youth and gladness speak of a sincere deep and earnest sadness—though they may keep the fire of Faith, Hope and Charity—though they may beam with Gods spirit. The hair turns grey or we loose it—ah—indeed we only pass through the earth, we only pass through life—we are strangers and pilgrims in the earth. The world passes and all its glory. Let our later days be nearer to Thee and therefore better than these.

Yet we may not live on just anyhow—no, we have a strife to strive and a fight to fight. What is it we must do: We must love God with all our strength, with all our might, with all our heart, with all our soul, we must love our neighbour as ourselves. These two commandments we must keep and if we follow after these, if we are de-voted to this, we are not alone for our Father in Heaven is with us, helps us and guides us, gives us strength day by day, hour by hour. and so we can do all things through Christ who gives us might. We are strangers in the earth, hide not Thy commandments

from us. Open Thou our eyes, that we may behold wondrous things out of Thy law. Teach us to do Thy will and influence our hearts that the love of Christ may constrain us and that we may be brought to do what we must do to be saved.

On the road from earth to Heaven
Do Thou guide us with Thine eye.

We are weak but Thou art mighty
Hold us with Thy powerful hand.

Our life, we might compare it to a journey, we go from the place where we were born to a far off haven. Our earlier life might be compared to sailing on a river, but very soon the waves become higher, the wind more violent, we are at sea almost before we are aware of it — and the prayer from the heart ariseth to God: Protect me o God, for my bark is so small and Thy sea is so great. The heart of man is very much like the sea, it has its storms, it has its tides and in its depths it has its pearls too. The heart that seeks for God and for a Godly life has more storms than any other. Let us see how the Psalmist describes a storm at sea, He must have felt the storm in his heart to describe it so. We read in the 107th Psalm, They that go down to the sea in ships, that do business in great waters, these see the works of the Lord and His wonders in the deep. For He commandeth and raiseth up a stormy wind which lifteth up the waves thereof. They mount up to Heaven, they go down again to the depth, their soul melteth in them because of their trouble. Then they cry unto the Lord in their trouble and He bringeth them out of their distresses, He bringeth them unto their desired haven.

Do we not feel this sometimes on the sea of our lives. Does not everyone of you feel with me the storms of life or their forebodings or their recollections?

And now let us read a description of another storm at sea in the New Testament, as we find it in the VIth Chapter of the Gospel according to St John in the 17th to the 21st verse. And the disciples entered into a ship and went over the sea toward Capernaum. And the sea arose by reason of a great wind that blew. So when they had rowed about five and twenty or thirty furlongs, they see Jesus walking on the sea and drawing nigh unto the ship and they were afraid. Then they willingly received Him into the ship and immediately the ship was at the land whither they went. You who have experienced the great storms of life, you over whom all the waves and all the billows of the Lord have gone — have you not heard, when your heart failed for fear, the beloved well known voice — with something in its tone that reminded you of the voices that charmed your childhood — the voice of Him whose name is Saviour and Prince of peace, saying as it were to you personally — mind to you personally 'It is I, be not afraid'. Fear not. Let not your heart be troubled. And we whose lives have been calm up to now, calm in comparison of what others have felt — let us not fear the storms of life, amidst the high waves of the sea and under the grey clouds of the sky we shall see Him approaching for Whom we have so often longed and watched, Him we need so — and we shall hear His voice, It is I, be not afraid. And if after an hour or season of anguish or distress or great difficulty or pain or sorrow we hear Him ask us 'Dost Thou love me' then let us say, Lord Thou knowest all things, Thou knowest that I love Thee. And let us keep that heart full of the love of Christ and may from thence issue a life which the love of Christ constraineth. Lord Thou knowest all things, Thou knowest

that I love Thee, when we look back on our past we feel sometimes as if we did love Thee, for whatsoever we have loved, we loved in Thy name. Have we not often felt as a widow and an orphan — in joy and prosperity as well, and more even than under grief — because of the thought of Thee.

Truly our soul waiteth for Thee more than they that watch for the morning — our eyes are up unto Thee, o Thou who dwellest in Heavens. In our days too there can be such a thing as seeking the Lord.

What is it we ask of God — is it a great thing? Yes it is a great thing, peace for the ground of our heart, rest for our soul — give us that one thing and then we want not much more, then we can do without many things, then can we suffer great things for Thy names sake. We want to know that we are Thine and that Thou art ours, we want to be thine — to be Christians. We want a Father, a Fathers love and a Fathers approval. May the experience of life make our eye single and fix it on Thee. May we grow better as we go on in life.

We have spoken of the storms on the journey of life, but now let us speak of the calms and joys of Christian life. And yet, my dear friends, let us rather cling to the seasons of difficulty and work and sorrow, even for the calms are treacherous often.

The heart has its storms, has its seasons of drooping but also its calms and even its times of exaltation. There is a time of sighing and of praying but there is also a time of answer to prayer. Weeping may endure for a night but joy cometh in the morning.

The heart that is fainting
May grow full to o'erflowing
And they that behold it
Shall wonder and know not
That God at its fountains
Far off has been raining.

My peace I leave with you — we saw how there is peace even in the storm. Thanks be to God who has given us to be born and to live in a Christian country. Has any of us forgotten the golden hours of our early days at home, and since we left that home — for many of us have had to leave that home and to earn their living and to make their way in the world. Has He not brought us thus far, have we lacked anything. We believe Lord, help Thou our unbelief. I still feel the rapture, the thrill of joy I felt when for the first time I cast a deep look in the lives of my Parents, when I felt by instinct how much they were Christians. And I still feel that feeling of eternal youth and enthusiasm wherewith I went to God, saying 'I will be a Christian too'.

Are we what we dreamt we should be? No — but still — the sorrows of life, the multitude of things of daily life and of daily duties, so much more numerous than we expected — the tossing to and fro in the world, they have covered it over — but it is not dead, it sleepeth. The old eternal faith and love of Christ, it may sleep in us but it is not dead and God can revive it in us. But though to be born again to eternal life, to the life of Faith, Hope and Charity — and to an evergreen life — to the life of a Christian and of a Christian workman be a gift of God, a work of God — and of God alone — yet let us put the hand to the plough on the field of our heart, let us cast out our net once more — let us try once more — God knows the intention of the spirit, God

knows us better than we know ourselves for He made us and not we ourselves. He knows of what things we have need, He knows what is good for us. May He give His blessing on the seed of His word that has been sown in our hearts.

God helping us, we shall get through life. With every temptation He will give a way to escape.

Father we pray Thee not that Thou shouldest take us out of the world, but we pray Thee to keep us from evil. Give us neither poverty nor riches, feed us with bread convenient for us. And let Thy songs be our delight in the houses of our pilgrimage. God of our Fathers be our God: may their people be our people, their Faith our faith. We are strangers in the earth, hide not Thy commandments from us but may the love of Christ constrain us. Entreat us not to leave Thee or to refrain from following after Thee. Thy people shall be our people, Thou shalt be our God.

Our life is a pilgrims progress. *I once saw a very beautiful picture*, it was a landscape at evening. In the distance on the right hand side a row of hills appearing blue in the evening mist. Above those hills the splendour of the sunset, the grey clouds with their linings of silver and gold and purple. The landscape is a plain or heath covered with grass and heather, here and there the white stem of a birch tree and its yellow leaves, for it was in Autumn. Through the landscape a road leads to a high mountain far far away, on the top of that mountain a city whereon the setting sun casts a glory. On the road walks a pilgrim, staff in hand. He has been walking for a good long while already and he is very tired. And now he meets a woman, a figure in black that makes one think of St Pauls word 'As being sorrowful yet always rejoicing'. That Angel of God has been placed there to encourage the pilgrims and to answer their questions:

And the pilgrim asks her:	Does the road go uphill then all the way?
and the answer is	"Yes to the very end"—
and he asks again:	And will the journey take all day long?
and the answer is:	"From morn till night my friend".

And the pilgrim goes on sorrowful yet always rejoicing — sorrowful because it is so far off and the road so long. Hopeful as he looks up to the eternal city far away, resplendent in the evening glow, and he thinks of two old sayings he has heard long ago — the one is:

'There must much strife be striven
There must much suffering be suffered
There must much prayer be prayed
And then the end will be peace.'

and the other:

The water comes up to the lips
But higher comes it not.

And he says, I shall be more and more tired but also nearer and nearer to Thee. Has not man a strife on earth? But there is a consolation from God in this life. An angel of God, comforting men — that is the Angel of Charity. Let us not forget Her. And when every-one of us goes back to daily things and daily duties, let us not forget — that things are

not what they seem, that God by the things of daily life teacheth us higher things, that our life is a pilgrims progress and that we are strangers in the earth—but that we have a God and Father who preserveth strangers, and that we are all bretheren.

Amen.

And now the grace of our Lord Jesus Christ, and the love of God, our Father, and the fellowship of the Holy Ghost, be with us for evermore.

Amen.

(Reading Scripture Psalm XCI)

Tossed with rough winds and faint with fear,
Above the tempest soft and clear
What still small accents greet mine ear
''t Is I, be not afraid.'

't Is I, who washed thy spirit white;
't Is I, who gave thy blind eyes sight,
't Is I, thy Lord, thy life, thy light,
't Is I, be not afraid.

These raging winds, this surging sea
Have spent their deadly force on me
They bear no breath of wrath to Thee
't Is I, be not afraid.

This bitter cup, I drank it first
To thee it is no draught accurst
The hand that gives it thee is pierced
''t Is I, be not afraid'.

When on the other side thy feet,
Shall rest, mid thousand welcomes sweet;
One well known voice thy heart shall greet—
't Is I, be not afraid.

Mine eyes are watching by thy bed
Mine arms are underneath thy head
My blessing is around Thee shed
''t Is I, be not afraid'.

Again, a handshake in thought—yesterday evening I was at Turnham Green in place of Mr Jones, who wasn't well. I walked over there with the oldest boy, 17 years old, but he's as big as I am and has a beard. He'll go into business later, his father has a large factory; he has a good, honest, feeling heart and a great need of religion, it is his hope and desire to do good among the workers later on in life, I recommended 'Felix Holt' by Eliot to him. It was lovely in the park with the old elm trees in the moonlight and the dew on the grass. It was so good for me to speak in the little church, it is a little wooden church. Goodbye, Theo. Goodbye, old boy, I hope I've written it so that you'll be able to read it. Remain steadfast and do get well soon.

Isleworth, 25 Nov. 1876

My dear Theo,

Thanks for your last letter, which I received at the same time as one from Etten. So you're back at the gallery. Do whatever your hand finds to do, with all your might, and your work and prayers cannot fail to be blessed. How I'd have liked to go along on that walk to Het Heike and to Sprundel in the first snow. But before I go further, I'll copy out a couple of poems that you'll no doubt like.

The journey of life

Two lovers by a mossgrown spring
They leaned soft cheeks together
Mingled the dark and sunny hair,
And heard the wooing thrushes sing
o Budding time
o Loves best prime.

Two wedded from the portal steps
The bells made happy carolings
The air was soft as fanning wings
While petals on the pathway slept
O pure eyed bride
o tender pride.

Two faces o'er a cradle bent
Two hands above the head were locked
These pressed each other while they rocked
Those watched a life which love had sent
O solemn hour
o hidden power.

Two parents by the evening fire
The red light fell about their knees
On heads that rose by slow degrees
Like buds upon the lily spire
O patient life
O tender strife.

The two still sat together there
The red light shone about their knees
But all the heads by slow degrees
Had gone and left that lonely pair
O Voyage fast
O Banished past.

The red light shone upon the floor
And made the space between them wide

They drew their chairs up side by side
Their pale cheeks joined, and said '*once more*'
O, memories!
O past that is!

The three little chairs.

They sat alone by the bright woodfire
The grey-haired dame and the aged sire
Dreaming of days gone by;
The tear drop fell on the wrinkled cheek
They both had thoughts that they could not speak,
And each heart uttered a sigh.

For their sad and tearful eyes descried
Three little chairs placed side by side
Against the sitting room wall;
Old fashioned enough as there they stood
Their seats of flag, and their frames of wood,
With their backs so straight and tall.

Then the sire shook His silvery head,
And with trembling voice he gently said,
'Mother, those empty chairs,
They bring us such sad, sad thoughts tonight,
We'll put them for ever out of sight
In the small dark room upstairs'.

But she answered: Father, no, not yet;
For I look at them, and I forget
That the children went away,
The boys come back, and our Mary, too,
With her apron on of checkered blue
And sit here every day.

Johnny still whittles a ships tall masts,
And Willie his leaden bullets casts
While Mary her patchwork sows;
At evening time three childish prayers
Go up to God from those little chairs,
So softly that no one knows.

Johnny comes back from the billowy deep,
Willie wakes from the battle field sleep,
To say good night to me:
Mary's a wife and mother no more,
But a tired child whose play-time is o'er,
And comes to rest on my knee.

So let them stand there — though empty now,
And every time when alone we bow
At the Fathers throne to pray,
We'll ask to meet the children above
In our Saviours home of rest and love,
Where no child goeth away.

In his letter Pa wrote, among other things: 'in the afternoon I had to go to Hoeven, Ma had ordered the cab but it couldn't come, because they hadn't yet been able to have the horses' shoes frosted — I therefore decided to go on foot and good Uncle Jan didn't want me to go alone, so he came along. It was a hard journey, but Uncle Jan rightly said: the devil is never so black that you can't look him in the face. And indeed, we arrived there and returned safe and sound, even though there was a gale blowing, coupled with freezing rain, so that the roads were slippery as ice, and I cannot describe how wonderful it was to sit so cosily in a nice warm room in the evening, resting after work — that dear Theo was still with us then'.

Shall we, too, go once again to some church *in this way*? As sorrowful yet alway rejoicing, with everlasting joy in our hearts because we are the poor in the kingdom of God, because we have found in Christ a friend in our lives that sticketh closer than a brother, who brought us to the end of the journey as to the door of the Father's house. May God grant it — what God hath done is done aright.

Last Sunday evening I went to a village on the Thames, Petersham. In the morning I had been at the Sunday school at Turnham Green, and went after sunset from there to Richmond and then on to Petersham. It grew dark early and I wasn't sure of the way, it was a surprisingly muddy road over a kind of embankment or rise on the hill covered with gnarled elm trees and shrubs. At last I saw below the rise a light in a small house, and scrambled and waded over to it, and there I was told the way. But, old boy, there was a beautiful little wooden church with a kindly light at the end of that dark road, I read Acts V:14–16. Acts XII:5–17, Peter in prison, and Acts XX:7–37, Paul preaching in Macedonia, and then I told the story of John and Theagenes yet again. There was a harmonium in the church, played by a young woman from a boarding school that was attending en masse.

In the morning it was so beautiful on the way to Turnham Green, the chestnut trees and clear blue sky and the morning sun were reflected in the water of the Thames, the grass was gloriously green and everywhere all around the sound of church bells. The day before I'd gone on a long journey to London, I left here at 4 in the morning, arrived at Hyde Park at half past six, the mist was lying on the grass and leaves were falling from the trees, in the distance one saw the shimmering lights of street-lamps that hadn't yet been put out, and the towers of Westminster Abbey and the Houses of Parliament, and the sun rose red in the morning mist — from there on to White-chapel, that poor district of London, then to Chancery Lane and Westminster, then to Clapham to visit Mrs Loyer again, her birthday was the day before. She is indeed a widow in whose heart the psalms of David and the chapters of Isaiah are not dead but sleeping. Her name is written in the book of life. I also went to Mr Obach's to see his wife and children again. Then from there to Lewisham, where I arrived at the Glad-wells at half past three. It was exactly 3 months ago that I was there that Saturday their

daughter was buried, I stayed with them around 3 hours and thoughts of many kinds occurred to all of us, too many to express. There I also wrote to Harry in Paris. I hope you'll see him sometime.

It may well be that you too will go to Paris sometime. That night I was back here at half past ten, I went part of the way with the underground railway. Fortunately I'd received some money for Mr Jones. Am working on Ps. 42:1, My soul thirsteth for God, for the living God. At Petersham I told the congregation that they would be hearing poor English, but that when I spoke I thought of the man in the parable who said 'have patience with me, and I will pay thee all', God help me.

At Mr Obach's I saw the painting, or rather the sketch, by Boughton: the pilgrim's progress. If you can ever get Bunyan's Pilgrim's progress, it's very worthwhile reading. For my part I love it with heart and soul.

It's night-time now, I'm still doing a bit of work for the Gladwells at Lewisham, copying out one thing and another etc.; one must strike while the iron is hot and soften the human heart when it is burning within us. Tomorrow off to London again for Mr Jones. Beneath that poem The journey of life and The three little chairs one should write: that in the dispensation of the fullness of times he might gather together in one all things in Christ, both which are in heaven, and which are on earth. So be it. A handshake in thought, give my regards to Mr and Mrs Tersteeg and to everyone at the Rooses' and the Haanebeeks' and the Van Stockums' and the Mauves', adieu and believe me

Your most loving brother
Vincent

[*Sketch* 99A]

het kan licht gebeuren dat Gij ook nog eens te
Parijs komt. 's avonds half 11 was ik weer hier
terug, ik ging gedeeltelijk met de underground
railway terug. — Gelukkig had ik wat geld binnen
gekregen voor Mr Jones. Ben bezig aan Ps. 42:1
Mijne ziel dorst naar God, naar den levenden God
Te Petersham zei ik tot de gemeente dat zij slecht
Engelsch van mij hooren, maar dat als ik sprak
ik dacht aan den man in de gelijkenis die
zei „heb geduld met my en ik zal u alles
betalen" God helpe mij. — ofleever schets —
Bij Mr. Obach zag ik het schilderij van
Boughton: the pilgrims progress. — Als Gij ooit
eens kunt krijgen Bunyan's Pilgrims pro-
gress het is zeer de moeite waard om dat
te lezen. Ik voor mij houd er ziels veel van.
Het is in den nacht ik zit nog wat te werken
voor de Gladwells te Lewisham, een en ander te
schrijven enz, men moet het ijzer smeden als
het heet is en het hart des menschen als het is
brandende in ons. — 's Morgens weer naar Londen
voor Mr Jones. Onder dat vers van The journey of life
en the three little chairs zou men nog moeten
schrijven: Om in de bedeeling van de volheid der
tijden wederom alles tot één te vergaderen, in
Christus, beide dat in den Hemel is en dat op aarde
is. — Zoo zij het. — een handdruk in gedachten
groet de Van der Loos. Terstege van my en allen bij Roos
en Haanebeek en v Stockum en Mauve, à Dieu en
geloof my
uw zoo liefh. broer
Vincent

Petersham Turnham Green

99A. *Small churches at Petersham and Turnham Green*

102 | Dordrecht, Wednesday, 7 and Thursday, 8 February 1877 | *To Theo van Gogh* (D)

My dear Theo,

Adam Bede costs 2.60 guilders, so herewith you get back 1.40 guilders. Now I only hope that it will give them some pleasure at home, but no doubt it will.

Thanks for your letter, which made me so happy. When next we meet we'll look each other straight in the eye. I sometimes think how wonderful it is that we have the same ground beneath our feet and that we speak the same language.

Last week we were flooded here. Coming from the shop between 12 and 1 at night, I took another turn around the Grote Kerk. The wind was blowing hard in the elm trees surrounding it, and the moon shone through the rain-clouds and reflected in the canals that were already filled to the brim. At 3 o'clock in the morning we were all rushing around at Rijken's, the grocer in whose house I'm lodging, bringing things upstairs from the shop, because the water was an ell high in the house. There was quite a bit of commotion, and in all the downstairs rooms people were busy bringing upstairs what they could, and a small boat came down the street. In the morning, when it was beginning to grow light, one saw a group of men at the end of the street, wading one after another to their warehouses. There's a lot of damage, the water has also got into the place where Mr Braat keeps his paper &c., not because of the flood but because of the great pressure coming from under the ground.

Mr Braat says it will cost him a banknote of the largest kind. It took us a day and a half to carry everything to an upstairs flat. Working with your hands like that for a day is a welcome change, though it was a pity it was for that reason. You should have seen the sun go down that evening, the streets shone of gold, the way Cuyp used to paint them.

Longing to have my trunk, which is on the way, one reason being to have some prints hanging in my room again. I now have Christus Consolator, which you gave me, and two English woodcuts, namely the Supper at Emmaus: 'But they constrained Him, saying, Abide with us: for it is toward evening, and the day is far spent', and another: 'They that sat in darkness and the shadow of death have seen a great light'; 'Weeping may endure for a night, but joy cometh in the morning'. There can come a time in life when one is tired of everything, as it were, and has the feeling as if everything that one does is wrong, and there's certainly some truth in that — is this a feeling that one ought to avoid and repress, or it is rather 'the godly sorrow' that one must not fear but carefully consider whether it can perhaps compel us to do good — is it perhaps 'the godly sorrow that worketh a choice not to be repented of'? And at such times, in which one feels tired of oneself, one may think with heedfulness, hope and love of the words 'Come unto Me, all ye that labour and are heavy laden, and I will give you rest. Take my yoke upon you, and learn of Me; for I am meek and lowly in heart: and ye shall find rest unto your soul. For My yoke is easy, and my burden is light'. 'If any man will come after Me, let him deny himself, and take up his cross daily, and follow

Me.' At such times one may well reflect upon: 'Except a man be born again, he cannot see the kingdom of God'. If we let ourselves be taught by the experience of life and led by godly sorrow, then new vitality may spring from the tired heart. If we are once good and tired, then we shall believe more firmly in God, and shall find in Christ, through His word, a Friend and Comforter. And then there may be times when we feel 'thou removest my iniquities from me as far as the east is from the west', when we feel something of 'the zeal for Thine house hath eaten me up' and 'our God is a consuming fire'—when we shall again know what it is to be fervent in spirit. Hope will not always fade away.

Let us not forget 'the things which we have heard from the beginning'.

In the beginning was the Word, and the Word was with God, and the Word was God. God so loved the world, that He gave his only begotten Son, that whosoever believeth in Him should not perish, but have everlasting life. Nothing shall separate us from the Love of Christ, neither things present, nor things to come.

Rejoice on earth, praise God on high,
Let thankful tears stream from your eye
For Him from whom all blessings flow.
This joyful day then celebrate,
The greatest the world has seen to date,
On its horizon all aglow.

Still welcoming us, that blessed night,
In which the stars with beauteous light
And heavenly hosts with one glad voice
In Jesus' coming do rejoice.

I know in Whom my faith is founded,
Though day and night change constantly,
I know the rock on which I'm grounded,
My Saviour waits, unfailingly.
When once life's evening overcomes me,
Worn down by ills and strife always,
For every day Thou hast allowed me,
I'll bring Thee higher, purer praise.

The panting hart, the hunt escapèd,
Cries no harder for the pleasure
Of fresh flowing streams of water
Than my soul doth long for God.
Yea, my soul thirsts for the Lord,
God of life, oh when shall I
Approach Thy sight, and drawing nigh,
Give Thee praise in Thine own house.

Why art thou cast down, my soul,
Disquieted in me, oh why?
Foster again the faith of old,

Rejoice in praising Him most high.
Oft hath he taken your distress
And turned it into happiness.
Hope in Him, eyes heavenward raised,
For to my God I still give praise.

Hope will not always fade forever.

Last Sunday morning I was in the French church here, which is very serious and dig-nified and has something very appealing. The text was Hold that fast which thou hast, that no man take thy crown. The end of the sermon was 'If I forget thee, O Jerusalem, let my right hand forget her cunning'.

After church I took a lovely walk alone on a dyke running past the mills, there was a brilliant sky above the meadows that was reflected in the ditches. There are curi-ous things in other countries, such as the French coast which I saw at Dieppe — the chalk cliffs with green grass on top — the sea and sky — the harbour with old boats like Daubigny paints them, with brown nets and sails, the small houses including a couple of restaurants with little white curtains and green pine branches in the window — the carts with white horses with big blue halters decorated with red tassels — the drivers with their blue smocks, the fishermen with their beards and oiled clothing and the French women with pale faces, dark, often somewhat deep-set eyes, black dress and white cap, and such as the streets of London in the rain with the street-lamps, and a night spent there on the steps of an old, small grey church, as happened to me this summer after that journey from Ramsgate — there are certainly curious things in other countries, too — but last Sunday when I was walking alone on that dyke, I thought how good that Dutch soil was, and I felt something akin to 'today it is in mine heart to make a covenant with my God' — because memories of times past came back to me, including how often we walked with Pa to Rijsbergen and so on in the last days of February and heard the lark above the black fields with young green wheat, the shim-mering blue sky with white clouds above — and then the paved road with the beech trees — O Jerusalem Jerusalem! or rather O Zundert O Zundert! Who knows but that we may go walking at the seaside together this summer? We really must remain good friends, Theo, and simply believe in God and trust with that faith of old in Him who is able to do above all that we ask or think — who can say to what heights grace can ascend?

Hearty congratulations for today, it's already half past 1 and therefore already 8 Feb-ruary. May God spare our Father for us for a long time yet 'and may He join us inti-mately to one another and let our love of Him make that bond ever stronger'.

Pa wrote that he had already seen starlings, do you remember how they used to sit on the church at Zundert? I haven't seen any here yet — though there are a lot of crows on the Grote Kerk in the mornings. Now it's almost spring again and the larks will return again. 'He reneweth the face of the earth' and it is written, Behold, I make all things new, and just as He renews the face of the earth, so can He renew and strengthen the human soul and heart and mind — the nature of every true son some-what resembles that of the son in the parable who 'was dead, and is alive again'. Let us not forget the words 'sorrowful, yet alway rejoicing', 'unknown, and yet well known',

and write the word woe-spiritedness as two words, *woe* and *spiritedness*, and believe in God who in His own good time can make the loneliness disappear which we sometimes feel so much even in the bustle, of whom Joseph said 'He hath made me forget my Father's house and all my sorrow' — and yet Joseph did not forget his father — you know that of course, but you also know what he meant by those words. Do keep well, give my regards to everyone at the Rooses', and especially to Mr Tersteeg and his wife, and accept in thought a handshake, and believe me

Your most loving brother,
Vincent

Tell Mr Tersteeg that he shouldn't be upset about the drawing examples being away for so long, it's for the high school, 30 have already been chosen — but they still want to select some for the secondary school, which is why they have to keep them for another week or so. You'll get them back as soon as possible.

Old boy, send me that page from Michelet again, the one you sent me earlier is in my reading-desk in my trunk and I need it again — do write again soon.

106 | Dordrecht, Thursday, 8 March 1877 | *To Theo van Gogh* (D)

God is faithful, who will not suffer you to be tempted above that ye are able; but will with the temptation also make a way to escape.

Let none of these things move thee.

My dear Theo,

Thanks for your letter, be of good heart, and He shall strengthen thine heart. Today I received a long letter from home in which Pa asked me if it would suit us both to go to Amsterdam next Sunday to visit Uncle Cor. If it's all right with you, then I'll come to you in The Hague on Saturday evening on the train that arrives a few minutes after 11, and in the morning we'll take the first train to Amsterdam and stay till evening.

We ought to do it, Pa seems very keen on the idea, then we'll be together again next Sunday. It is possible, isn't it, for me to stay with you that night? Otherwise I'll go to the Toelast. Write a postcard now if you agree, let us stick close together.

Herewith a few words for Uncle Cor, add something to it if you like. It's already late, this afternoon I took a walk, because I felt such a need to, first around the Grote Kerk, then the Nieuwe Kerk, and then up onto the dyke where all those mills are that one sees in the distance if one walks along the railway tracks. There is so much in that singular landscape and vicinity that speaks and seems to say 'be of good courage, fear not'.

There are days in one's life when all members suffer because one member suffers, and where there is true 'godly sorrow,' God is not far, He who will hold us. If we believe that, let us, in those days, fervently desire and ask for things we should like to see happen, that we might also be heard. Would you also ask for me that a way be found for me to devote my life, more so than is now the case, to the service of Him and the

gospel? I continue to insist and I believe that I'll be heard, I say this in all humility and bowing myself down, as it were. It is such an import and such a difficult matter, and yet I desire it. One might say it isn't humanly possible, but if I think about it more seriously and delve beneath the surface of what is humanly impossible, then truly my soul waiteth upon God, for it is possible for Him who speaks, and it is done, who commands, and it stands, and it stands fast. O Theo, Theo, old boy, if only it might happen to me and that deluge of downcastness about everything which I undertook and failed at, that torrent of reproaches I've heard and felt, if it might be taken away from me and if I might be given the opportunity and the strength and the love required to develop and to persevere and to stand firm in that for which my Father and I would offer the Lord such heartfelt thanks. A handshake in thought and regards to everyone at the Rooses', ask *it* for me in this thy day, and believe me

Your most loving brother
Vincent

109 | Dordrecht, Friday, 23 March 1877 | *To Theo van Gogh* (D)

Dordrecht, 23 March 1877

My dear Theo,

Want to make sure you receive a letter on your trip. What a good day we spent together in Amsterdam, I stood there watching the train you left in as long as it was still in sight. We're such old friends, aren't we? How long we've walked together, starting in the black fields with the young green wheat at Zundert, where we heard the lark at this time of year with Pa.

In the morning I went with Uncle Cor to see Uncle Stricker, where we had a long talk about you-know-what. In the evening at half past six Uncle Cor brought me to the station, it was a beautiful evening and in everything there was so much that seemed to speak, the weather was still and there was a bit of mist in the streets, as is usually the case in London. Uncle had toothache that morning, but fortunately it didn't last, we went to the flower market too, it's good to love flowers and pine branches and ivy and hedges of hawthorn, we have seen them from the very beginning. Wrote home about how we had spent our time in Amsterdam and what we talked about. Arriving here I found a letter from home at Rijken's. Pa was unable to preach last Sunday and the Rev. Kam stood in for him — I know that his heart is burning within him that something might happen so that I could give myself over not only almost but altogether to following Him, Pa always hoped I would do so, oh! may it come to pass, and may there be a blessing on it.

The print that you gave me of 'Heaven and earth shall pass away, but My words shall not pass away' and the portrait of the Rev. Heldring are already hanging in my room, oh, I'm so glad to have them, they give me hope. Am writing to you offhand about my plans; my idea becomes clear and firm by doing so. For the time being I'm thinking of the words 'it is my portion to keep Thy word', have such a desire to familiarize myself with the treasure of biblical scripture, to know all those old stories thoroughly

and lovingly, especially to learn what we know about Christ. In our family, which is indeed a Christian family in the full sense of the word, there has always been a minister of the gospel as far back as one can see, from generation to generation. Why should that voice not be heard in this and in following generations? Why should a member of that family not now feel himself called to that office and think, with some reason, that he can and must declare himself and seek the means to achieve that goal? It is my prayer and deepest desire that the spirit of my Father and Grandfather may rest upon me, and that it may be given me to be a Christian and a Christian labourer, that my life may resemble that of them whom I name — the more, the better — for behold, that old wine is good and I desire not the new. Their God shall be my God, and their people my people, that this may be my portion: to know Christ in His full worth and to be constrained by His love. What that Love is, is so beautifully said in the words 'as sorrowful, yet alway rejoicing', and in 1 Cor. XIII, it beareth all things, believeth all things, hopeth all things, endureth all things, it never faileth. It is in my heart today, those words of the pilgrims going to Emmaus when evening was come and the sun had gone down, 'But they constrained Him, saying, Abide with us'.

You like it too, that 'sorrowful, yet alway rejoicing', keep it in mind, because they are good words and a good cloak in the storm of life, keep it in mind at this time, now that you've experienced so much lately. And be careful, because even though it's no small thing that you've experienced, yet, if I see rightly, there is something greater in store, and you too will remember the words of the Lord: I have loved thee with an everlasting Love, I will comfort you as one whom his mother comforteth. I shall send you another Comforter, even the Spirit of truth, I will make a new covenant with you, be separate, and touch not the unclean thing, I will be your God, and you shall be My people, I will be a Father unto you, and you shall be My sons and daughters. *Hate* sin and the places where it resides, and come not nigh, it attracts so easily with a false appearance of being something great, and does what the devil did to Christ when he showed Him all the kingdoms of the earth and their glory and said, 'All these things will I give Thee, if Thou wilt kneel down and worship me'. There is something better than the glory of worldly things: it is the feeling we get when our heart burns within us upon hearing His word, it is faith in God, the Love of Christ, faith in immortality, in a life after this life. Hold fast to what you have. Theo, old boy, brother whom I love, I have such a great longing for that thing which you know of, but how shall I ever get it? How I wish that I, like Pa, had already done a lot of the difficult work of a Christian labourer and minister of the gospel and sower of the word. You see, Pa can count his services and Bible readings and visits to the sick and the poor and his written sermons by the thousands, and still he doesn't look back but goes on doing good. Lift up your eyes for me and pray that it may be given to me, just as I now do for you, may He give you the desires of thine heart, He who knows us better than we know ourselves and who is able to do above all that we ask or think, for His ways are higher than our ways and His thoughts are higher than our thoughts, as high as the Heaven is above the earth. And may you continue to think of Christ as a Comforter and God as a refuge.

I wish you well on your trip; write soon, and accept a handshake in thought, adieu, and believe me ever

Your loving brother
Vincent

May Pa get better soon, try to be in Etten at Easter, things will be all fine once more when we're together again.

With many things in the past, also with what you've experienced, it could be that 'thou shalt find it after many days'.

117 | Amsterdam, Wednesday, 30 May 1877 | *To Theo van Gogh* (D)

Amsterdam, 30 May 1877

My dear Theo,

Thanks for your letter of today, I have to do a few things and so am writing in haste. Gave your letter to Uncle Jan, accept his warm regards and he thanks you for writing.

There were some words in your letter that touched me, 'I should really like to get away from everything, I'm the cause of everything and only make others sad, I alone have caused all this misery to myself and others'. Those were words that touched me — because that same feeling, exactly the same, nothing more and nothing less, is also on my conscience.

When I think of the past — when I think of the future, of nearly insurmountable difficulties, of much and difficult work which I have no passion for, which I — the evil part of me, that is — would prefer to avoid, when I think of the eyes of so many that are fixed upon me — who, if I do not succeed, will know the reason why — who will not utter any ordinary reproaches but who, because they have been tried and are well versed in what is good and proper and fine gold, as it were, will say it by the expression on their faces: we helped you and have been a light unto you — we did for you what we could. Did you sincerely desire it? What are our wages and the fruits of our labours? You see, when I think of all that and of so much else, all manner of things — too many to mention, of all the troubles and worries which do not become less as one progresses through life, of suffering, of disappointment, of the danger of failing to a scandalous extent, then that desire is no stranger to me either — I would really like to get away from everything!

And yet — I go on — but with caution and in the hope that I'll succeed in warding off all these things, so that I can somehow answer all the reproaches that threaten, trusting that in spite of everything that seems to be against me I shall attain that thing that I desire, and, God willing, shall find grace in the eyes of some whom I love, and in the eyes of those who shall come after me.

It is written, lift up the feeble hands, and the knees which hang down, and when the disciples had toiled all night and had taken nothing, it was said unto them, Launch out into the deep, and let down your nets again.

My head is sometimes numb and is often burning hot, and my thoughts are confused — how shall I ever get all that difficult and detailed study into it? — I don't know — after those turbulent years, becoming accustomed to plain, well-ordered work and persevering in it isn't always easy. And yet I go on, if we're tired, isn't it because we've already gone a long way, and if it's true that man's life on earth is a struggle, isn't feeling tired and having a burning head a sign that we have struggled? When one labours at difficult work and strives for good results, one fights the good fight, the reward of which, surely, is already this: that one is preserved from much that is evil. And God beholds the labour and the sorrow, and can help in spite of everything.

Faith in God is for me a certainty — not some notion, not an idle belief, it is so, it is true — there is a God that lives — and He is with our parents, *and his eye is also upon us*, and I am certain that He intends us for something, and that we do not belong entirely to ourselves, as it were — and that God is none other than Christ of Whom we read in our Bible, whose word and story are also deep in your heart. If only I had worked at it sooner with all my might, yes, it would be better for me now — but even now He will be a mighty help, and it is in His power to make our life bearable, to keep us from evil, to let all things work together for good, to make the end of us peace. There is evil in the world and in ourselves, terrible things, and one doesn't have to have gone far in life to dread much and to feel the need for unfaltering hope in a life after this one, and to know that without faith in a God one cannot live — cannot endure. But with that faith one can long endure. And now, there are words in our Bible that are emphatically repeated in various places, on various occasions, under various circumstances, *Fear not*, our Father took that to heart and he says 'I never despair', let us repeat it after him. Isn't it your experience, too, that whenever you wanted to do something bad, you were held back — that whenever there was something upsetting you and you saw no way out, you came through it all unharmed? A book by Bunyan tells of a traveller who sees a lion lying at the side of the road he must traverse — and yet he continues on his way — there is nothing else he may or can do — and when he arrives at the place he notices that the lion is chained up and is only there to test the travellers' courage. Thus it is in life more than once. There is much in store for us, but others have lived, and so whosoever loves his parents must follow them on life's path. If you value the love and esteem of young people, declare your beliefs openly whenever suitable, and admit that you love Christ and the Bible, doesn't a son love his Father better for this reason than for any other? Women and children and the simple often feel and know these things so deeply, and there is hidden in so many a heart a great and vigorous faith. We, too, are in need of this when we think of much that is in store for us, He spoke from all His experience of life, and we know how much must have been going on in the heart whose plenitude made His mouth utter the words 'in the Heavenly Kingdom they do not marry, and are not given in marriage', and who said, he who hate not, even his own life also, he cannot be My disciple. Yes, those words of the Lord, surely they are the words issuing from the mouth of God whereby man shall live — and not by bread alone and the more one seeks in those words, the more one shall find therein. When I was standing next to Aertsen's body, the calm and seriousness and solemn stillness of death contrasted so greatly with us who were living, that everyone felt what his daughter said in her simplicity: he is delivered from the burden of life which we must still bear. And yet we are so attached to that old life because there is cheerfulness to counter despondency, and our heart and our soul are gladdened, just as the lark who cannot help singing in the morning, even if our soul is sometimes cast down within us and is disquieted in us. And the memory of everything we have loved remains and returns in the evening of our life. *It* is not dead, but sleepeth and it is good to collect a great store of it. Accept a handshake in thought, and I wish you the very best, and write again soon to

Your most loving brother
Vincent

Amsterdam, 12 June 1877

My dear Theo,

I received your letter of 7 June and was glad to see that you were in Etten and had a good Sunday there, it's nice that Pa and little brother brought you as far as Dordrecht.

And then you wrote about how you spoke at home of your plans for the future, when I read it, my heart spilled over for you, as it were, it seems very good to me. Launch out into the deep. What I hope now is only this — that you go to London before you see Paris. But we have to wait and see what happens. I've loved so much about those two cities, I think back on them with a feeling of nostalgia, and I'd almost like to go with you, if I'm ever far enough along to be permitted to fill a position in that great Dutch Church, then those memories will one day provide subjects for sermons, go onward in belief and with the faith of old, you and I; who knows whether we'll shake each other's hand again as I remember Pa and Uncle Jan doing at that little church in Zundert, once when Uncle came back from travelling and much had happened in both their lives, and they now felt firm ground beneath their feet, as it were.

Be sure and write as soon as you hear any more about this, I hope that we'll have a quiet moment together sometime before you leave. Even though there seems to be no opportunity at present, such a thing may soon come about. But I repeat, brother, my heart spills over for you, I think the plan is very good — my past comes completely alive again now that I'm thinking of your future. 'Behold, I make all things new' will perhaps soon be your experience.

Be blessed these days. Take a good look at the things around you — don't forget them — walk through the land again, as it says: in the length of it and in the breadth of it.

I have a lot to do every day, so the time goes quickly and the days are almost too short, even though I stretch them out a bit, I have such a great desire to progress and also to know the Bible well and thoroughly, and also to know many things, such as what I wrote to you about Cromwell. 'No day without a line', daily writing, reading, working and practising, with meekness and perseverance, will surely lead to *something*.

This week I went to the cemetery here, outside the Muiderpoort, there's a small wood in front of it where it's beautiful, especially in the evening when the sun shines through the leaves, there are also a lot of beautiful graves and all kinds of evergreens, and roses and forget-me-nots bloom there. Also took another walk to the Zuiderzee, which is 40 minutes from here, over a dyke from which one sees meadows everywhere and farms which always remind me of etchings by Rembrandt. It's a beautiful city, this, today I again saw a corner for Thijs Maris or Allebé, namely houses behind the Oosterkerk, on a small inner courtyard, I had to see the sexton to ask about Uncle's place in the church and I was in his house, also living there is a shoemaker &c., but one finds *it* everywhere, the world is full of it, may our own heart be filled with *it* and become so more and more. When I saw that sexton I couldn't help thinking of a wood engraving, by Rethel I think, you must know it too, 'Death as a friend'. I always found that scene very moving, in London in those days one saw it in front of nearly all the print-shop windows. It has a pendant, Cholera in Paris, and that dance of death is also by Rethel.

Heard the Rev. Laurillard on Sunday morning in the early sermon on 'Jesus went through the cornfields'. He made a deep impression on me — he also spoke in that sermon about the parable of the sower and about the man who cast seed into the ground, and he should sleep, and rise day and night, and the seed should spring and increase and grow up, he knoweth not how, he also spoke about the funeral in the cornfield by Van der Maaten. The sun shone through the windows — there weren't that many people in the church, mostly labourers and women. Afterwards I heard Uncle Stricker in the Oosterkerk on 'praise, not of men but of God', also occasioned by the death of H.M.

On Monday Aunt Mina and Margreet Meyboom left for Etten, and I saw them at the station of the Oosterspoor. While I was waiting for them there, I read the following in Lamennais:

At the head of a small inlet beneath a cliff hollowed out at its foot by the waves, among rocks from which hung long strands of sea-green weed, two men, one young, the other old but still sturdy, leaning against a fishing-boat, waited for the tide that was slowly coming in, barely ruffled by a dying breeze. Swelling as they neared the shore, the waves slid lazily over the sand with a faint and gentle murmur. A little later, the boat could be seen moving away from the shore towards the open sea, its prow raised, leaving behind it a ribbon of white foam. The old man, beside the tiller, watched the sails as they filled, then drooped like weary wings. His gaze then seemed to look for a sign on the horizon and in the dense, motionless clouds. Then, as he sank back into his thoughts, one read on his tanned brow an entire life of toil and unremitting struggle from which he had never flinched. The ebb tide created small valleys in the calm sea, where the hen petrel played, balancing gracefully on the glistening, lead-hued waves. From high in the air the seagull dived into them like an arrow, and on the black tip of a rock the ungainly cormorant stood motionless. The slightest movement, a faint breath of air, a streak of light, altered the aspect of these changing scenes. The young man, withdrawn into himself, saw them as one sees in dreams. His soul drifted and floated to the sound of the wake, like the light, monotonous sound with which the nurse sends the child to sleep. Suddenly, coming out of his reverie, his eyes light up, the air echoes to the sound of his resonant voice: To the ploughman the fields, to the huntsman the woods, to the fisherman the sea and its waves, and its reefs and its storms. The sky above his head, the depths beneath his feet, he is free, he has no master but himself. See her obey his hand, see her leap across the moving plains, the frail vessel into which the wind breathes life. He contends with the waves and subdues them, he contends with the wind and tames it. Who is as strong, who is as great as he? Where are the boundaries of his domains? Has anyone ever found them? Wherever the Ocean pours itself forth, God has said to him: Go, this is thine. His nets gather a living harvest in the depths of the waters. He has flocks beyond number which grow fat for him in pastures covered by the seas. Flowers — purple, blue, yellow, crimson, open in their bosom, and to charm his eye, the clouds present him with vast shores, beautiful azure lakes, wide rivers, mountains and valleys and fantastic cities, now plunged in shadow, now lit by all the glory of the setting sun. Oh, how sweet it is to me, the fisherman's life! How its harsh battles and its manly joys delight me. And yet, my mother, when at night the squall suddenly shakes our cabin, what fear grips your heart! See you rise, all trembling, to invoke the holy Virgin who protects poor sailors! Kneeling before her

image, your tears flow for your son, driven in the darkness by the whirlwind towards the reefs, where the moans of the dead are heard, mingling with the voice of the storm. Protect us, O Lord, for our barks are so small and Thy sea is so great.

A terrible storm blew up here this morning at quarter to 5, a little while later the first stream of workers came through the gate of the dockyard in the pouring rain. Got up and went into the yard and took a couple of notebooks to the cupola and sat there reading and looking round the whole yard and dock, the poplars and elders and other shrubs were bent by the strong wind, and the rain pelted on the wood-piles and the decks of the ships, sloops and a little steamboat went back and forth in the distance, near the village on the other side of the IJ, one saw brown sails passing quickly and the houses and trees on Buitenkant and churches in more vivid colours. Again and again one heard thunder and saw lightning, the sky looked like a painting by Ruisdael, and the gulls were flying low over the water.

It was a magnificent sight, and really refreshing after the oppressive heat of yesterday. It has refreshed me, because I was awfully tired when I went upstairs yesterday evening.

Paid a visit yesterday to the Rev. Meijjes and his wife, because Pa had told me to do this, and I had tea with them. When I arrived, His Reverence was taking his afternoon nap and I was requested to go for a half-hour walk, which I did, fortunately I had that little book by Lamennais in my pocket and I read under the trees lining the canals, where the evening sun was reflected in the dark water. Then I went back, and they made me think of 'Winter' by Thorvaldsen. One nevertheless sees it much more beautifully in Pa and Ma, but as I said, it was like that here, too.

The days fly past, I'm four years older than you and I feel that they probably go by faster for me than for you, but I fight against it by stretching them out a bit in the mornings and evenings.

Will you write again soon? It's a pity that Mager isn't coming after all. The weather has cleared up again, and the sky is blue and the sun is shining brightly and the birds are singing, there are rather a lot of them at the yard, and all kinds, in the evenings I always walk up and down there with the dog, often thinking of that poem 'Under the stars'.

When all sounds cease, God's voice is heard, under the stars.

The roses growing against the house are also blooming, and in the garden the elderberry and jasmine. Recently went to the Trippenhuis again to see whether those rooms, which were closed when we were there together, had been put back in order, but it will probably take another fortnight before one can go in again. There were a lot of foreigners at the time, French and English, hearing them speak revives a lot of memories in me. Yet I don't regret being back here. '*Life hath quicksands, life hath snares*' are true words.

How is Mrs Tersteeg? If you run into Mauve or go to see him, give him my regards, also to everyone at the Haanebeeks' and Rooses'.

Now I must get to work, don't have any lessons today, but on the other hand 2 hours tomorrow morning, so have really a lot to do. I've worked my way through the history of the Old Testament up to Samuel, this evening I'll start with Kings, when that work

is finished, it will be a valuable thing to have. As I sit here writing I cannot help making a little drawing now and then, like the one I sent you recently, and like the one I made this morning of Elijah in the desert with stormy skies and a couple of thornbushes in the foreground, it's nothing special, but sometimes I see it all so clearly in my mind's eye, and I believe that at such moments I should be able to talk about it passionately, may it later be granted me to do so.

I wish you the very best, if you ever go to the Scheveningen Bosjes or to the beach, give them my regards. When you next come here I'll be able to show you some beautiful spots here as well. Every day on my way to Mendes I have to pass through the Jewish quarter.

Should like you to hear the Rev. Laurillard too, one day.

And now, adieu, a handshake in thought from

Your loving brother,
Vincent

123 | Amsterdam, Friday, 27 July 1877 | *To Theo van Gogh* (D)

Amsterdam, 27 July 1877

My dear Theo,

Thanks for your last letter, I heard from home that you've already been to Mauve's, that was undoubtedly a good day, I'll certainly hear about it sometime, when the opportunity arises. Herewith a contribution for your collection, namely three lithographs after Bosboom and two by J. Weissenbruch, found them this morning at a Jewish bookseller's. Is that one after Bosboom the church in Scheveningen? The other is the Grote Kerk in Breda, the third after his painting that was at the large exhibition in Paris. Those two after Weissenbruch moved me — perhaps you already have them, but then again possibly not. Do go on collecting such prints, and books too.

I'm now collecting Latin and Greek themes and all kinds of writings on history and so on. Am working on one on the Reformation that's getting rather long.

Recently spoke to a young man who had just done his entrance examination for the Leiden college with a good result — it isn't easy, he told me what they asked him, but I do keep up my courage, and with God's help I'll pass them, and the following examinations as well. Mendes has given me every reason to believe that at the end of three months we'll be as far as he imagined we would be if everything went well. Still, Greek lessons in the heart of Amsterdam, in the heart of the Jewish quarter on a very warm and oppressive summer afternoon, with the feeling hanging over me that many difficult examinations will have to be taken, set by very learned and cunning professors, are rather more oppressive than a walk on the beach or in the Brabant wheatfields, which will certainly be beautiful now, on a day like that. But we must 'strive on' through everything, as Uncle Jan says.

A couple of days ago a couple of children fell into the water near the Kattenburg bridge. Uncle saw it and commandeered the sloop of the Makasser that is in dock here. A little boy was pulled out; I went along with two ship's doctors whom Uncle had sent

over, and the men carrying the boy into a chemist's shop made every effort to resuscitate the child, but to no avail. In the meantime it was recognized by the father, who's a stoker at the dockyard, and the little body was taken home in a woollen blanket. The search went on for an hour and a half, as it was thought that a girl had fallen in as well, though happily that seems not to be the case. In the evening I went back to see the people, it was then already dark in the house, the little body lay so still on a bed in a side room, he was such a sweet little boy. There was great sorrow, that child was the light of that house, as it were, and that light had now been put out. Even though coarse people express their grief in a coarse way and without dignity, as the mother did, among others, still, one feels a great deal in such a house of mourning, and the impression stayed with me the whole evening when I took a walk.

Last Sunday morning I made a nice excursion, namely first to the early sermon, the Rev. Posthumus Meijjes in the Noorderkerk, then to Bickerseiland, where I walked on the dyke along the IJ until it was time for church again, and then to the Eilandskerk where Uncle Stricker preached. Thus the time passes, and quickly too, already we're almost at the end of the week again.

How are you, old chap? So very often, daily, do I think of you.

God help us, struggling, to stay on top, it is good that you associate with good artists; I, too, still cling to the memory of many of them. Overcome evil with good, it is written, and one can seek to do it — and to this end God can help and make our days bearable with much good in the meantime, and preserve us from too much self-reproach.

When Uncle Jan commandeered the sloop and the doctors to go and help on the afternoon that accident happened, I saw him in his element.

Now I must get to work, though I still have to fill this page. Anna is in Leiden, as you surely know, and will come here one of these days with our future brother-in-law, am looking forward to seeing them very much, Pa wrote so cheerfully about last Sunday when they were in Etten and everything was good in his eyes, and they see rightly, so let us view what has happened to our sister as a blessing on our house, in which we all share; if one member be glad, let all the members be glad with her.

Next week, or perhaps even tomorrow, Uncle and Aunt Pompe are coming to stay here, and also Fanny and Bet 's Graeuwen, it's been a long time since I've seen any of them.

Am quite often up rather early in the morning, and when the sun rises over the yard and the workers come a while later it's a wonderful sight from the window, and I should wish to have you here. Will I later be working on such a morning on a sermon on 'He maketh His sun to rise on the evil and on the good', or on 'Awake thou that sleepest, and arise from the dead, and Christ shall give thee light', or on 'It is a good thing to praise the Lord in the morning' and 'It is a pleasant thing for the eyes to behold the sun' — I hope so.

All the same, it seems that the sun never shines so beautifully as it does in a parsonage or in a church. It's wonderful to work on 'the writings' early in the morning.

If you have the time and a stamp and paper, then write again soon. Uncle Jan sends you his regards, that evening you described there in the dunes must have been pleasant. In Uncle Cor's shop I recently saw The Gospels by Bida, how beautiful it is, how wonderful it must be to be a Christian labourer like that, but it's impossible to put into

words how beautiful it is, *that's it* again, there is much in that work that reminds one of Rembrandt. And now a handshake in thought, and I sincerely wish you the best, and believe me ever

Your most loving brother
Vincent

126 | Amsterdam, Sunday, 5 August 1877 | *To Theo van Gogh* (D)

Amsterdam, 5 Aug. 1877

My dear Theo,

Thanks for your letter of yesterday, it was a good one, the kind that is of some use, and it was a real comfort to me. Anna left again yesterday for Hengelo, they had a lot to do here, of course, so I wasn't with them so very much, she also came to my little study in the evening just as it was growing dark and people were leaving the dockyard to go home. It seems to me that that face and those eyes of Van Houten speak of heart and character, and he has entirely the appearance of a man of affairs, has — it appeared to me — something decisive and abrupt which often stems from a firm will and understanding acquired through experience, may she have made a good choice and may time turn that into the love that never faileth but brings our dear sister through life, covering and forbearing everything and making whole hope and faith.

I found a couple of stamps enclosed in your letter, for which I sincerely thank you, you also said you would send a postal order so that I could come to The Hague and see the exhibition of drawings. The postal order indeed arrived today, Sunday morning, I thank you for it and for your kind offer, but I'm sending the money back and am not coming, however much I'd like to see all the beautiful and interesting things you wrote about. Have already refused to go to Baarn, first of all because I'd rather spend my Sunday here going to church several times, and writing and studying some more, secondly because I'd have to ask for travelling money from Uncle Stricker, who has some money of Pa's to be put at my disposal if necessary, and I hope to go on doing that as little as possible. If I go to The Hague, then I have to go to Baarn as well, and not just once — in any case, it's better I don't. Moreover, old boy, I know you really need it yourself. Many thanks all the same. I'm not sorry not always to have money in my pocket. I have a great craving for so many things, and if I had money perhaps I'd quickly spend it on books and other things that I can well do without, and which would pull me away from the studies necessary at the moment, even now it isn't always easy to fight against distractions, and if I had money things would only get worse. And here in this world one remains poor and needy anyway, I've seen that already; one can, however, become rich in *one* thing and that is the goal of life, one can become rich toward God, and that is a part which shall not be taken away. And there may come a time when we can spend our money more wisely than on the best books and so on, and when one would regret having spent a lot on oneself in one's youth, namely when we'll perhaps have our own household and others to care and think for. There was a time when our parents, too, were uncomforted and tossed with tempest.

In the midst of life we are in death, those are words that apply to each of us personally, that is a truth we see reconfirmed in what you told me about Caroline van Stockum, and earlier we also saw it in another member of that family. It affected me, and I sincerely hope with all my heart that she'll recover. Oh, how much sadness and sorrow and suffering there is in the world, both in the open and in secret. 'Seek, and ye shall find' is also one of those truths. How much has changed in that family if one compares it with how it was a few years ago. It was many years ago when we were together. And that was the time of The landlady's daughter, and Longfellow says 'there are thoughts that make the strong heart weak', but it is written above all 'Let him who has put his hand to the plough not look back' and 'Shew thyself a man'.

I looked for it in the illustration after the painting by Ruisdael, Haarlem and Overveen, that painter knew it too.

Should she quickly recover sufficiently for her to be taken back to The Hague and you then see her, give her my regards, and if you can find the words to cheer her up or give her courage and remind her what important reasons she has for being and, as it were, the right to live, especially for her children's sake, tell her and you will be doing a good deed. Faith in God is renewed in a mother; what she feels for her children is holy and comes from Above and from God, and He says in holy writ to every mother '*Raise this child for Me and I will give thee thy reward*'. A strong word spoken from the heart at the right time can give comfort and do good.

Was up rather early this morning and left around 6 o'clock for the early service, afterwards I walked down all sorts of old streets and would have liked to have you with me. You know the painting (at least the lithograph and woodcut made after it) by Daubigny, The Marie bridge, I thought of that. I like to walk in those old, narrow, rather sombre streets with chemists' shops, lithographers and other printers, shops with sea-charts and warehouses for ships' victuals and so on, which one finds near the Oudezijdskapel and the Teertuinen and the end of Warmoesstraat, everything is evocative there. Then went to bid good-day to Vos and Kee, and then to the Eilandskerk where the Rev. Ten Kate — the poet of De schepping and the writer of many beautiful books, such as, for example, 'Bij brood en beker' — gave the sermon on Rom. I:15–17: So, as much as in me is, I am ready to preach the gospel to you. For I am not ashamed of the gospel of Christ: for it is the power of God unto salvation to every one that believeth. For therein is the righteousness of God revealed from faith to faith: as it is written, The just shall live by faith. The church was very full, and when one looked at those faces one saw something of *the faith*, for it was on many a countenance, on those of men and on those of women, written in their features in various ways, something to read. His voice sometimes uttered sounds and expressions like Pa's, and he spoke very well and from an overfull heart and, although the sermon wasn't short, church was out almost before one knew it, because his words were so enthralling that one forgot the time.

Made a summary last week, for a change, of the journeys of Paul, and drew a small map to accompany it, that is good to have. Uncle Stricker recently gave me a book on the geography of Palestine (German, by Raumer), of which he had two copies.

This is a nice excerpt from Télémaque. Mentor says, *The earth is never ungrateful, she always nourishes with her fruits those who cultivate her with care and with love, she denies her goods only to those who fear giving her their hard labour.* The more children the ploughmen have,

the richer they are if the Lord does not impoverish them, because their children, from their most tender youth, begin to help them. The youngest take the sheep to the pastures, the others who are older already lead the large flocks, the eldest plough with their father. Meanwhile, the mother of the whole family prepares a simple meal for her husband and her beloved children, who will return weary from the day's work; she takes care of milking her cows and her ewes, and we see streams of milk flowing; she makes a big fire, around which all the innocent, peaceful family takes pleasure in singing, the whole evening long, while waiting for sweet sleep. She prepares cheeses, sweet chestnuts and fruits preserved with the same freshness as if they had just been picked. The shepherd returns with his flute, and sings to the assembled family the songs he has learned in neighbouring hamlets. The ploughman returns with his plough, and his weary oxen walk, necks bowed, with slow and tardy tread, despite the goad that pricks them. All toil's evils end with the day. Sleep soothes black care with its spell, and holds all nature in a sweet enchantment; each one falls asleep without foreseeing the morrow's troubles.

It's especially nice if one imagines it illustrated by the etchings of Jacque.

Your postcard just arrived, fortunately, thanks for the quick reply, I sincerely hope that you had a good Sunday. Fan and Bet 's Graeuwen and Bertha van Gogh are still here and are flowers in the house, Bertha, in particular, is a nice girl. Give my regards to your housemates, and accept in thought a handshake from

Your most loving brother,
Vincent

Couldn't get a money order so have to send it back to you in stamps.

129 | Amsterdam, Tuesday, 4 September 1877 | *To Theo van Gogh* (D)

Amsterdam, 4 Sept. 1877.

My dear Theo,

Herewith a note for Anna and for Lies, do write something on it and send it when Ma's birthday is approaching. (I must tell you that the reason I'm sending it to you is that I'm afraid I won't have any more stamps by then, except to write home. If you don't write until later, just let this wait.)

Uncle Jan went to Helvoirt last Saturday, he intends to stay away until 10 September, so it's quiet in the house these days and yet the days fly by, as I have lessons daily and have to study for them, and would even so much like the days to be a little longer in order to get more done, because it's not always easy work, and even if one has been at it for some time, it gives but little satisfaction, enfin, what is difficult is good, I feel convinced of that even if one sees no results.

Am also busy copying out the whole of L'imitation de Jésus Christ from a French edition I've borrowed from Uncle Cor, that book is sublime, and he who wrote it must have been a man after God's heart; had such an irresistible yearning for that book a few days ago, perhaps because I look at that lithograph after Ruipérez so often, and asked

Uncle Cor if I could borrow it. Now I sit here in the evenings writing it out, it's a lot of work but a good part of it is done, and I know no better way of getting some of it into my head. I also bought Bossuet, Oraisons funèbres again (I got it for 40 cents), I feel compelled to seize hold of the task forcefully, I occasionally think of those words 'the days are evil', and one must arm oneself and try as much as possible to have something good in oneself in order to be able to withstand and be prepared. It is, as you well know, no small undertaking, and we don't know the outcome, and so in any case I want to try and fight a good fight.

It's a curious book, that one by Thomas a Kempis, there are words so deep and serious that one cannot read them without emotion and almost fear, at least if one reads them with a sincere desire for light and truth, that language is indeed the eloquence that wins hearts because it comes from the heart. You have it, surely. Pa wrote to me about an unfortunate incident that occurred at Uncle Vincent's. You no doubt know about it already, namely that the wife of the Rev. Richard fell down the stairs one evening and is in a very distressing condition. And so one hears daily now one thing then another, everywhere and on all sides, which is why I have at least the impression that 'the days are evil'. Because even if it doesn't happen to us, one feels nonetheless that perhaps it isn't far from us either, and that we are in the same ordeal, as it were. The fashion of this world passeth away — *yet would I have thee without carefulness.*

'Yet would I have thee without carefulness', doesn't that say, as far as you're concerned, feel all these things, 'feel thy sorrows', and keep them in thine heart with the others, but go your way, 'return on thy way', remain the same as you were in the beginning, when you sought good and thought to have found something of it — for God, too, is the same as He was in the beginning, and with Him is no variableness, neither shadow of turning — thou, too, have a right spirit within you and have faith in God, for those who trust in Him will not be ashamed. We see that in our father, who feels all the suffering, all the misery and also all the sin around him, who also shares in it and helps as much as he possibly can, and yet goes his own steady way, doing good and not looking back. Yes, it is certainly true, he has the spirit Jesus had, that spirit of which He said: Father, into Thy hands I commend My spirit. And so many have the same — although not in such great measure — that it isn't a hopeless task for us to strive for it also.

'Be zealous in amending your whole life' is written in Thomas a Kempis, and that is what one must do and not give up, not even if one is frightened by the wrong that is in us and that rightly causes us to say, I alone have caused all this misery to myself and others — he who feels that, for him it is time, that is '*the very man*'. For such people it is written 'Ye must be born again'. For such people the word of the Lord shall be a lamp and He himself through those words a Friend and Comforter, and godly sorrow shall worketh that which it shall worketh if one does not fear it.

There is something that I feel compelled to tell you, you from whom I have no secrets. In the life of Uncle Jan, of Uncle Cor, of Uncle Vincent, there is much, much good and purity, and yet something is missing. Wouldn't you think that when the two first-mentioned are sitting here, as often happens, talking in the evening in that beautiful, sober room familiar to you, that it's a sight that does the heart good, especially if one looks at them with love as I do? And yet — the Supper at Emmaus by Rembrandt is even more beautiful, and it could have been *that* and now it's almost that

but not altogether. Pa has what they lack — it is good to be a Christian, almost and also altogether, for that is life eternal — and now I'll go even further and say what is missing in them, missing in their homes and in their families, and then you will say or at least think of the man who beheld a mote in his brother's eye but did not consider the beam in his own eye — and then I shall answer, there is possibly something of that, but these at least are true words, 'it is good to be a Christian, almost and also altogether'.

A few days ago I spent an evening in the study of the Rev. Jeremie Meijjes, not the old minister but that very man who had moved me so much in church.

It was a pleasant evening, he asked a thing or two about London, about which I could tell quite a lot, and he told me about his work and the blessings he had apparently experienced. Hanging in the room was a very good charcoal drawing of a religious service which he was accustomed to keep with him at home on winter evenings, very good, Israëls would have liked it, the congregation was made up of workers and their wives, there are similar subjects in Doré's book about London. Went himself to London for a fortnight. Has a large family, 6 or 7 children, his wife has something indescribable — something of Ma — or of the wife of the Rev. Jones, for example. In a word, it's a Christian family there in all its strength and bloom, there is sometimes an expression of very great happiness on the tired face of that man, and when one is in that house one feels something of 'put off thy shoes from off thy feet, for the place whereon thou standest is holy ground'.

Also spent an evening at the Strickers' and heard Uncle preach last Sunday on I Cor. III:14, If any man's work abide which he hath built thereupon, he shall receive a reward. It often seems as though I already feel something of blessing and of change in my life. How I'd like to show you all kinds of things here. I think of Degroux so often in the Jewish quarter and also in other places; there are interiors there with woodcutters, carpenters, grocers' shops, chemist's shops, smithies and so on and so forth that would have delighted him. For example, this morning I saw a large, dark wine cellar and warehouse standing open, a spectre momentarily appeared to me — you know what — men were running back and forth with lights in the dark vault — now that is something one can see daily, but there are moments when ordinary daily things make an extraordinary impression and seem to have a deep meaning in another setting. Degroux managed to show that so well in his paintings, and especially in his lithographs.

Your letter just arrived as I write this. Thank you. Pa already wrote that he had visited you, but what really surprised me was that Gladwell is in The Hague. Give him my warm regards, and oh, how I'd like him to come here sometime, just wrote him a postcard to ask him to do his best to come to Amsterdam as well, you try and persuade him too. You know yourself how interesting it is for foreigners to see the city, also the dockyard and the area around here, and how I'd like to show him around as much as is in my power. And I'm longing to see his brown eyes, which could sparkle so when we saw the paintings of Michel and others or talked of 'many things'. Yes, it wouldn't be bad if he were to come, and even stayed as long as possible, and I believe that we'd certainly feel that there was something genuinely sincere in our earlier friendship and that it was no small thing, with the passing of time one does not always feel it strongly, but it is not dead but it sleepeth, and to make it awake and alive again it is good to see each other again.

Herewith a word for him, it seems to me that he mustn't leave Holland without

having seen the Trippenhuis and Van der Hoop, do your best to make him do it, at least if it can happen in this way and he doesn't do it against his will. Have to stay up this evening as long as I can keep my eyes open and so end this; if I have time, I'll finish this page.

If your acquaintance with Gladwell is strong and leaves something good behind, I would think it wonderful, it has been a long time since I last saw him.

Adieu, accept a handshake in thought and hearty congratulations on Ma's birthday, but perhaps I'll write again on the day itself. Now I've simply talked on and on in this letter and I don't know if it's good and am simply sending it the way it is. I wish you well, shake Gladwell's hand for me, and believe me ever

Your most loving brother,
Vincent

Longfellow wrote a book about life in Jesus, in which there is this and other things.

Come unto Me,
All ye that labour and are heavy laden
And I will give you rest — Come unto Me
For I am meek, and I am lowly in heart
And ye shall all find rest unto your souls.

Seest thou this woman? When thine house I entered,
Thou gavest Me no water for My feet,
But she hath washed them with her tears,
and wiped them,
With her own hair! Thou gavest Me no kiss,
This woman hath not ceased since I came in
To kiss My feet! My head with oil didst thou
Anoint not, but this woman hath anointed
My feet with ointment. Hence I say to thee
Her sins which have been many are forgiven
For she hath loved much.

Believe Me woman
The hour is coming, when ye neither shall
Upon this mountain, nor at Jerusalem
Worship the Father, for the hour is coming
And is now come, when the true worshippers
Shall worship the Father in Spirit and in truth.
The Father seeketh such to worship Him.
God is a Spirit, and they that worship Him,
Must worship Him in Spirit and in truth.

The publican,
Standing afar off would not lift so much,
Even as his eyes to Heaven, but smote his breast.
Saying: God be merciful to me, a sinner.
I tell you that this man went to his house

More justified than the other. Everyone
That doth exalt himself shall be abased.
And he that humbleth himself shall be exalted.

Suffer little children
To come unto Me, and forbid them not
Of Such is the Kingdom of Heaven, and their Angels
Look always on My Fathers face.

What, could ye not watch with Me one hour?
o Watch and pray that ye may enter not
Into temptation, For the Spirit indeed
Is willing, but the flesh is weak.

Father all things are possible to Thee!
If this cup may not pass away from me
Except I drink of it. Thy will be done.

133 | Amsterdam, Tuesday, 30 October 1877 | *To Theo van Gogh* (D)

Amsterdam, 30 October 1877

My dear Theo,

Thanks for your last letter, which I was glad to get. Yes, old boy, that etching after Jules Goupil is beautiful and forms, with all that's associated with it, a fine and good whole that is a thing to keep in one's heart. I rather envy your having read Carlyle, 'French Revolution', it's not unknown to me but didn't read all of it, I found parts of it in another book, namely by Taine.

Am busy making an extract from Motley, including capture of Den Briel and siege of Haarlem, Alkmaar and Leiden, have drawn a map to go with it, so as to complete it. Have also finished an extract from Bunyan's Pilgrim's progress. Am working all the time, day in, day out, so some things do get done.

I keep my work together, everything aimed at getting through the exams, I consult Mendes on everything, and model my studies on what he has done, for that is how I'd like to do it too. That history of the 80 Years' War is really wonderful, anyone would do well to make such a good fight of his life. Truly life is a fight, and one must defend oneself and resist and make plans and calculations with a cheerful and alert mind in order to make it through and get ahead. It becomes no easier the further one gets in life, and it has been rightly said:

Does the road go uphill then all the way?
'Yes to the very end'
And will the journey take all day long?
'From morn till night, my friend.'

But by fighting the difficulties in which one finds oneself, an inner strength develops from within our heart, which improves in life's fight (one matures in the storm), if we

always endeavour to keep that heart out of which are the issues of life, good and simple and rich toward God, to restore that and make it thus more and more, and to bear in mind the words that we must have a good conscience before God and before people.

As we regard others so are we regarded by many eyes. It is from the conscience — God's finest gift, and the proof that His eye is upon us, all-seeing and all-knowing, and also the assurance that He be not far from every one of us, but as our shade upon our right hand, and that He keeps us from the evil — that our light comes in the darkness of life and of the world. And if we feel an eye watching us, as it were, then it is good to gaze upward sometimes as though seeing Him who is invisible.

I know that life of Frederick the Great illustrated by Menzel, that's a good acquisition, do go on with that collection; I also know that woodcut after Jacque, The sheep-fold, do bring those things home with you at Christmas.

Have bought from the Jew that lithograph after L. Steffens of which you once showed me the painting, an old and a young priest conversing in a garden, it's a good lithograph. The scene reminds me of a painting by Jacquand, photographed in the *cartes de visite*, it's called 'The new vicar', I believe, it has the same sentiment, and also of The novice by G. Doré.

Old boy, Latin and Greek and studying are difficult, but all the same I feel very happy with it and am doing the things I have longed for. I'm no longer allowed to sit up late in the evenings, Uncle has very strictly forbidden it — yet the words written below the etching by Rembrandt stick in my mind, In medio noctis vim suam lux exerit (In the middle of the night the light diffuses its strength) and I make sure that a small gaslight goes on burning the whole night, and lie looking at it often *in medio noctis*, thinking about my plan for work the following day and considering how to go about that studying as well as possible. Hope in the winter to light the fire early in the morning (and while obeying Uncle yet letting the light shine in the night and darkness once in a while). The winter mornings have something special about them, Frère painted that in that workman, 'A cooper' (the etching is hanging in your room, I believe), among other things.

Fill my soul with a holy bitterness that shall be agreeable to Thee, and I shall humbly spend all the years of my life in Thy service, in the bitterness of my soul, yea, even in Thy Service, O Man of sorrows and acquainted with grief. That is certainly a good prayer, and I thought of it when I told you in simplicity that it was good to steep oneself in coffee in everyday life.

A person has needs, and requires strength and fortification to be able to work. And one must make do with what one has and fight with such weapons as are within one's reach, and use the means at one's disposal to make the most of it and gain from it.

(You can see from my handwriting that it had grown dark, but now the lamp is on.) Ate hotchpot at Uncle Stricker's one afternoon, and it occurred to me on that occasion to make that extract from Motley, I'll show it to you at Christmas. Because here in town I've seen and walked over so awfully many doorsteps and church floors and flights of steps up to houses, it occurred to me to make those maps of rocky Scotland, and while colouring them in (green and red) I thought of those pickles that Uncle is so fond of and I've grown fond of too. A person's soul is a singularly strange thing, and it is good, I think, to have one like a map of England made with love and to have in it as much as possible of that love which is holy and beareth all things and believeth all

things and hopeth all things and endureth all things and never faileth. That Love is the Light of the world, the true life that is the light of men. The knowledge of languages is certainly a good thing to have, and I follow after in the hope that I might also grasp something of it.

When one eats a crust of black rye bread it's certainly good to think of the words 'Tunc justi fulgebunt ut sol in regnum Patris sui' (Then shall the righteous shine forth as the Sun in the Kingdom of their Father), or also when one very often has muddy boots or wet, dirty clothes. May we all at sometime enter into that kingdom which is not of this world, where they do not marry and are not given in marriage, where the sun shall be no more thy light by day, neither for brightness shall the moon give light unto thee, but the Lord shall be an Everlasting Light, and God our glory, where the sun shall no more go down, neither shall the moon withdraw itself, for the Lord shall be thine Everlasting Light, and the days of mourning shall be ended and God shall wipe away all tears from the eyes. And so we can be leavened with the leaven of 'sorrowful, yet alway rejoicing', being what we are through God's grace, having in the secret recesses of the heart the words 'I never despair' because we have faith in God. And then 'Set your face as a flint' are really good words in many circumstances, and also 'be like an iron pillar or like an old oak tree'. It's also good to love thorns, such as the thorn-hedges around the little English church or the roses in the cemetery, they're so beautiful these days, yes, if one could make oneself a crown of the thorns of life, not for the people but with which one is seen by God, then one would do well.

I imagine you know the woodcuts by Swain, he's a clever man, his studio is in such a nice part of London, not far from that part of the Strand where the offices of the illustrated magazines are (Ill. Lond. News, The Graphic, Seeley &c.), not far from Booksellers' Row either, full of all kinds of bookstalls and shops where one sees all kinds of things, from the etchings of Rembrandt to the Household edition of Dickens and Chandos classics, everything there has a green cast (especially in foggy weather in the autumn, or during the dark days before Christmas), and it's a place that immediately reminds one of Ephesus, as it is described with such singular simplicity in Acts. (Similarly, the bookshops in Paris are also so interesting, in the Faubourg St Germain, for instance.)

Old boy, how inexpressibly happy I'll be if I manage to pass my exams, if I conquer the difficulties it will be done in singleness of heart, but also with prayer to God, for I so often pray fervently to Him for the wisdom I'm in need of, and that He may one day grant that I write and deliver many sermons, the more like our Father's the better, and to complete a Work in my life to which end all things work together for good.

I was at Uncle Cor's on Monday evening, and also saw Aunt and the whole family, all send you their warm regards. Stayed rather a long time because I hadn't seen Aunt for a long time and one offends so easily without meaning to by giving the *impression* of not appreciating and of neglecting people. Looked through that book at Uncle's, the engraved oeuvre of C. Daubigny. Went from there to Uncle Stricker's, Uncle was out but a son of the Rev. Meyboom was visiting (brother of Margreet), an officer in the Navy, and his girlfriend and a young man, Middelbeek, who has been in London for a while and is going back there.

At 10 o'clock Uncle came home soaking wet, for it was raining quite a lot that

evening, and I had a long talk with him and Aunt, because Mendes had paid them a visit a couple of days ago (one shouldn't utter the word genius lightly, even if one believes that there is more of it in the world than many people think, but Mendes certainly is a very remarkable person, and I'm happy and grateful for my contact with him) and hadn't given them a bad report, fortunately, but Uncle asked me if it wasn't difficult, and I admitted that it was very difficult and that I was doing my best to bear up and to be alert in all kinds of ways. He gave me encouragement, however. But now there's still that terrible algebra and geometry, anyway, we'll see — after Christmas I have to have lessons in those as well, there's nothing for it.

I also cling to the church and to the bookshops, if I can think of an errand to do there I do it. Today, for instance, I was at Schalekamp's and at C.L. Brinkman's in Hartestraat (that shop of Schalekamp's is an interesting sight) and bought a couple of maps from the Teachers' Society, of which there are around 100 at a stuiver apiece, including the Netherlands in every possible historical period. (So often, in the past as well, a visit to a bookshop has cheered me up and reminded me that there are good things in the world.)

Sunday morning I went to the early service and afterwards to the French church, where I heard an outstanding sermon from the Rev. Gagnebin: the house at Bethany. 'One thing is needful and Mary hath chosen that good part'. That Rev. Gagnebin has a pleasant appearance and a worthy head, and his face has something of the Peace of God which passeth all understanding. He does have something, I think, either of that priest in The last victims of the terror or of that humble and faithful manservant one sees in 'The women of the boarding-house'.

That painting by Israëls you describe must be beautiful, I can picture it from your clear description. Saw a small painting of his at C.M.'s, also one by Mauve, very beautiful, shepherd with flock of sheep in the dunes.

A good cheerful letter from home too, fortunately things seem to be going better in Princenhage. I'm longing not a little for Christmas, do bring one thing and another with you, as much as possible, it's good for all of us. Don't be in a hurry to send the tobacco; *still have some*, it's a good and necessary aid to study.

Wrote a long letter to Harry Gladwell that went off today, also sent your regards. If you have the time and the opportunity, think of Michelet, you know what, and J. Breton, but you know what it's for and that there's no hurry, and if necessary Christmas is soon enough. Now, I must get to work and the sheet of paper is nearly full, I wish you well, write if possible, I gave Uncle the receipt enclosed in your letter. Uncle sends you his regards, also Uncle and Aunt Stricker. Bid your housemates good-day from me, and should the opportunity arise also Mauve and his wife and the Tersteegs and Van Stockums (how is she?) and Haanebeeks, and Borchers if you run into him. *Blessings on everything you do*, I wish you strength and vigour in these autumn days, and let it be Christmas again with us together again before we know it, as it were, adieu, a handshake in thought, and believe me ever

Your most loving brother
Vincent.

Saw 2 photos of Gabriel Max, the raising of Jairus' daughter and a nun in a convent garden, the first one, in particular, was beautiful.

Do you know an engraving after Landseer? It's called The highlander, I believe, a high-lander in a snowstorm on top of a mountain holding an eagle he's shot.

137 | Amsterdam, Sunday, 9 December 1877 | *To Theo van Gogh* (D)

Amsterdam, 9 Dec. 1877

My dear Theo,

I feel the need to write to you without waiting too long, the reason being first of all that I must thank you for three things. First of all, for your excellent four-page letter, with which you gave me the greatest pleasure, because it does one good to feel that a brother of his also walks and lives on earth, when one has a lot of things to think about and a lot to do, one sometimes gets the feeling, where am I? what am I doing? where am I going? — and one starts to grow dizzy — but then such a familiar voice, or rather familiar handwriting, makes one feel firm ground beneath one's feet again, as it were.

Then I must thank you for an issue of the Galerie Contemporaine about E. Frère. It's very interesting and I'm happy to have something by him. And I also thank you for the 10 postage stamps, it really is too much and you shouldn't have done so much. A hearty handshake for everything.

Now I have a few things to tell you about St Nicholas; I received a good letter from Etten with a money order for a pair of gloves enclosed.

I already had some, however, so I bought something else with the money, namely another map by Stieler, namely Scotland alone. At present I can get them singly at Seyffardt's, but there probably won't always be that opportunity. I've drawn that map and so have it double, and because I did want to give Harry Gladwell a Christmas pres-ent I hope to send it to you for him, to enclose when a crate goes to Paris. ONE MUST BUILD ONE'S HOUSE UPON A ROCK, Scotland, Normandy and Brittany are really rather rocky, just take a look at that large map of Scotland when you get it. If I compare the work of studying to the building of a house, and these months to its foundation, then rocks accordingly lie at its base.

But all of this by the by, now more about the evening in question. From Uncle Cor I received Bossuet, Oraisons funèbres, in a very good and handy edition, very complete, it includes, among other things, the fine sermon about Paul on the text 'for when I am weak, then am I strong'. It's a noble book, you'll see it at Christmas, I was so happy with it that until today I've been carrying it around in my pocket, though it's time I stopped that because something might happen to it. From Mendes I received the works of Claudius, also a good, solid book; I had sent him Thomae Kempensis de imitatione Christi and written in the front, There is neither Jew nor Greek in Him, neither bond nor free, neither male nor female: but Christ is all, and in all. From Uncle Stricker a box of cigars, you know what I did with them, they're always so friendly at the Rooses' and I'd already been wondering if I had anything to send when that box of cigars arrived as a godsend. And in the evening I found a letter from Uncle Jan lying on my table. Was then briefly at Vos and Kee's, where Uncle and Aunt Stricker were as well,

but couldn't stay because I had a lesson from 8–10 with Teixeira. Uncle Jan spent the evening at Uncle Cor's.

Was at Uncle Stricker's service this morning, i.e. in the Eilandskerk, Uncle Cor was there too. The text was 'by Thy light shall we see light'.

It's always a nice walk to that Eilandskerk. This afternoon I took another walk around the little English church with those maps of those rocky countries, because I had a feeling that they were connected with that little church.

'The Church of God stands on a rock', those words were in this morning's hymn, and that's how Ruisdael painted it too, and Millet in the painting in the Luxembourg.

It's a good plan of yours to write those names etc. on the map of Brittany. Bring it along at Christmas, you know that I did that on the one I drew, then we can compare them. Be sure and do it, for that is good.

You talk about my coming to The Hague again on my way to Etten, I should really like to, would it be possible to stay a night at the Rooses'? If so, then you do *not* have to write, then I'll count on it being possible if necessary. I should like to see your room again and the tree with ivy, I hope that will be possible and that I can leave here early enough.

I can't tell you how much I long for Christmas. And may Pa be satisfied with what I've done.

It was such wonderful weather today, and so beautiful among those thorn-hedges by the little church when night began to fall.

Had a talk with Mendes this week, or rather last week, about 'He who hate not, even his own life also, he cannot be my disciple'. He declared that expression too strong, but I maintained that it was the simple truth, and doesn't Thomas a Kempis say it when he talks about knowing oneself and despising oneself?

If we look at others who have done more and are better than we are, then soon enough we come to hate our own life because it's not as good as that of others. Just look at a man like Thomas a Kempis, constrained by the love of Christ to write that little book, sincere and simple and true as few others were, either before or since. Or in another sphere, just take a look at the work of a Millet or that of a Stieler or The large oaks by Jules Dupré. They did it: 'let your light shine before men, that they may see your good works, and glorify your Father which is in heaven', and Pa is such a man too; and however much we can do, you see, the best thing is to keep our sights on such people and to seek whether we too may perhaps find something. And to believe that it's true what Pa said, that if someone asks 'Lord, I should so much like to be earnest', that it will be heard and granted by God.

Have a good Sunday today, how I'd like to be with you, Uncle Jan has gone to Haarlem so I'm alone this evening, but still have to do as much as I possibly can. You have really given me such pleasure with that magazine on E. Frère. I once saw him myself at Goupil's, he has something very unpretentious about him. 'At last, he triumphed' it says in his biography, may it be so with us one day — that can happen and it is good to say: I never despair.

A person doesn't get *it* all at once, and most of those who have become something very good have gone through a long, difficult period of preparation that was the rock upon which their house was founded.

Man is depraved by nature, at best a thief—but—with God's guidance and blessing he can become something of higher worth, as there came for Paul a day on which he could say with frankness and trust to Herod, I would to God, that not only thou, but also all that hear me this day, were such as I am, except these bonds.

Thanks for what you write about the lithographs. Something else—you also sent 2 pairs of Christus Consolator and pendant, I was very glad to get them.

It could do no harm if you also had that map of Scotland, then you would have three things from that atlas, and the proverb says: all good things come in threes. So count on getting that one too, and by no means buy it yourself, had first wanted to send you this one that is now going to Gladwell, but I consider it my duty to let him hear from me now and again. I hope he'll be able to go to Lewisham at Christmas. You know that painting by Cuyp in the museum here, an old Dutch family, when he saw that he stood looking at it for a long time and then spoke of 'the house built on the rock' and of his home in Lewisham. I, too, have memories of his father's house and will not easily forget it. Much and strong and great love lives there under that roof, and its fire is in him still, it is not dead, but sleepeth.

Now I have to hurry, for I have to get to work. So in all likelihood I'll be coming to The Hague next week for a day, Thursday say, possibly later, I have to see how it fits in best with my work. From The Hague I hope to go to Dordrecht, and if it turns out that you can leave Saturday evening, we'll meet each other at the station in Dordrecht.

In that case I would even spend two nights at the Rooses', if I'm going to The Hague anyway, it can't hurt to stay a bit longer and call on some people.

A pity, in a way, that Mauve is going to move, I hope that we'll go there again together, like that evening last spring, it was really pleasant then.

Now make sure they don't go to any trouble at the Rooses'. If I can't stay there you'll know it without asking them and can write to me, and I'll take it into account; if I can, tell them only the day before.

I wish you the very best and blessings in your work. You'll be busy, but actually one should be grateful for pressure and effort and all suchlike things more than for anything else, for it is only by long training in that that one develops. I sincerely hope that you'll be able to leave Saturday, because at home they'd surely like us to be in Etten the Sunday before Christmas. So goodbye for now, if I hear nothing more from you I'll come on Thursday or Friday, 20 or 21 December.

I finally decided to hang up that page again from Barguc's Cours dc dessin, Anne of Brittany, yes, man is depraved by nature and at best a thief, but in the battle of life he can become a being of higher worth; a being of higher worth, those words sprang to mind when I had been looking for a long time at the expression on the face of that beautiful woman Anne of Brittany, the expression which explains why she also recalls the words 'one of Sorrows and acquainted with grief; sorrowful yet always rejoicing'.

Adieu, give my regards to your housemates, and believe me

Your most loving brother
Vincent

Amsterdam, 3 April 1878

I've been thinking about what we discussed, and I couldn't help thinking of the words 'we are today what we were yesterday'. This isn't to say that one must stand still and ought not try to develop oneself, on the contrary, there are compelling reasons to do and think so.

But in order to remain faithful to those words one may not retreat and, once one has started to see things with a clear and trusting eye, one ought not to abandon or deviate from that.

They who said 'we are today what we were yesterday', those were *honnêtes hommes*, which is apparent from the constitution they drew up, which will remain for all time and of which it has rightly been said that it was written with a ray from on high and a finger of fire. It is good to be an 'honnête homme' and truly to endeavour to become one both almost and altogether, and one does well if one believes that being an 'homme intérieur et spirituel' is part of it.

If one only knew for certain that one belonged among them, one would always go one's way, calmly and collectedly, never doubting that things would turn out well. There was once a man who went into a church one day and asked, can it be that my zeal has deceived me, that I have turned down the wrong path and have gone about things the wrong way, oh, if only I could rid myself of this uncertainty and have the firm conviction that I will eventually overcome and succeed. And then a voice answered him, And if you knew that for certain, what would you do? Act now as though you knew it for certain and thou shalt not be ashamed. Then the man went on his way, not faithless but believing, and returned to his work, no longer doubting or wavering.

As far as being an *homme intérieur et spirituel* is concerned, couldn't one develop that in oneself through knowledge of history in general and of certain people of all eras in particular, from biblical times to the Revolution and from The odyssey to the books of Dickens and Michelet? And couldn't one learn something from the work of the likes of Rembrandt or from Weeds by Breton, or The four times of the day by Millet, or Saying grace by Degroux, or Brion, or The conscript by Degroux (or else by Conscience), or his Apothecary, or The large oaks by Dupré, or even the mills and sand flats by Michel?

It's by persevering in those ideas and things that one at last becomes thoroughly leavened with a good leaven, that of sorrowful yet alway rejoicing, and which will become apparent when the time of fruitfulness is come in our lives, the fruitfulness of good works.

The ray from on high doesn't always shine on us, and is sometimes behind the clouds, and without that light a person cannot live and is worth nothing and can do nothing good, and anyone who maintains that one can live without faith in that higher light and doesn't worry about attaining it will end up being disappointed.

We've talked quite a lot about what we feel to be our duty and how we should arrive at something good, and we rightly came to the conclusion that first of all our goal must be to find a certain position and a profession to which we can devote ourselves entirely.

And I think that we also agreed on this point, namely that one must pay special attention to the end, and that a victory achieved after lifelong work and effort is better than one achieved more quickly.

He who lives uprightly and experiences true difficulty and disappointment and is nonetheless undefeated by it is worth more than someone who prospers and knows nothing but relative good fortune. For who are they, those in whom one most clearly notices something higher? — it is those to whom the words 'workers, your life is sad, workers, you suffer in life, workers, you are blessed' are applicable, it is those who show the signs of 'bearing a whole life of strife and work without giving way'. It is good to try and become thus.

So we go on our way 'undefessi favente Deo'.

As far as I'm concerned, I must become a good minister, who has something to say that is good and can be useful in the world, and perhaps it's good after all that I have a relatively long time of preparation and become secure in a firm conviction before I'm called upon to speak about it to others. It is wise, before one begins that work, to gather together a wealth of things that could benefit others.

Do let us go on quietly, examining all things and holding fast to that which is good, and trying always to learn more that is useful, and gaining more experience.

Woe-spiritedness is quite a good thing to have, if only one writes it as two words, *woe* is in all people, everyone has reason enough for it, but one must also have *spirit*, the more the better, and it is good to be someone who never despairs.

If we but try to live uprightly, then we shall be all right, even though we shall inevitably experience true sorrow and genuine disappointments, and also probably make real mistakes and do wrong things, but it's certainly true that it is better to be fervent in spirit, even if one accordingly makes more mistakes, than narrow-minded and overly cautious. It is good to love as much as one can, for therein lies true strength, and he who loves much does much and is capable of much, and that which is done with love is well done. If one is moved by some book or other, for instance, just to mention something, 'The swallow, the lark, the nightingale', The longing for autumn, 'From here I see a lady', 'Never this unique little village' by Michelet, it's because it's written from the heart in simplicity and with poverty of spirit.

If one were to say but few words, though ones with meaning, one would do better than to say many that were only empty sounds, and just as easy to utter as they were of little use.

Love is the best and most noble thing in the human heart, especially when it has been tried and tested in life like gold in the fire, happy is he and strong in himself who has loved much and, even if he has wavered and doubted, has kept that divine fire and has returned to that which was in the beginning and shall never die. If only one continues to love faithfully that which is verily worthy of love, and does not squander his love on truly trivial and insignificant and faint-hearted things, then one will gradually become more enlightened and stronger. The sooner one seeks to become competent in a certain position and in a certain profession, and adopts a fairly independent way of thinking and acting, and the more one observes fixed rules, the stronger one's character becomes, and yet that doesn't mean that one has to become narrow-minded.

It is wise to do that, for life is but short and time passes quickly. If one is competent

in *one* thing and understands *one* thing well, one gains at the same time insight into and knowledge of many other things into the bargain.

It's sometimes good to go about much in the world and to be among people, and at times one is actually obliged and called upon to do so, or it can be one way of 'throwing oneself into one's work unreservedly and with all one's might', but he who actually goes quietly about his work, alone, preferring to have but very few friends, goes the most safely among people and in the world. One should never trust it when one is without difficulties or some worry or obstacle, and one shouldn't make things too easy for oneself. Even in the most cultured circles and the best surroundings and circumstances, one should retain something of the original nature of a Robinson Crusoe or a savage, for otherwise one hath not root in himself, and never let the fire in his soul go out but keep it going, there will always be a time when it will come in useful. And whosoever continues to hold fast to poverty for himself, and embraces it, possesses a great treasure and will always hear the voice of his conscience speaking clearly. Whosoever hears and follows the voice in his innermost being, which is God's best gift, ultimately finds therein a friend and is never alone.

Happy is he who has faith in God, for he shall overcome all of life's difficulties in the end, though it be not without pain and sorrow. One cannot do better than to hold fast to the thought of God and endeavour to learn more of Him, amidst everything, in all circumstances, in all places and at all times; one can do this with the Bible as with all other things. It is good to go on believing that everything is miraculous, more so than one can comprehend, for that is the truth, it is good to remain sensitive and lowly and meek in heart, even though one sometimes has to hide that feeling, because that is often necessary, it is good to be very knowledgeable about the things that are hidden from the wise and prudent of the world but that are revealed as though by nature to the poor and simple, to women and babes. For what can one learn that is better than that which God has put by nature into every human soul, that which in the depths of every soul lives and loves, hopes and believes, unless one should wilfully destroy it? There, in that, is the need for nothing less than the boundless and miraculous, and a man does well if he is satisfied with nothing less and doesn't feel at home until he has acquired it.

That is the avowal that all great men have expressed in their works, all who have thought a little more deeply and have sought and worked a little harder and have loved more than others, who have launched out into the deep of the sea of life. Launching out into the deep is what we too must do if we want to catch anything, and if it sometimes happens that we have to work the whole night and catch nothing, then it is good not to give up after all but to let down the nets again at dawn.

So let us simply go on quietly, each his own way, always following the light 'sursum corda', and as such who know that we are what others are and that others are what we are, and that it is good to have love one to another namely of the best kind, that believeth all things and hopeth all things, endureth all things and never faileth.

And not troubling ourselves too much if we have shortcomings, for he who has none has a shortcoming nonetheless, namely that he has none, and he who thinks he is perfectly wise would do well to start over from the beginning and become a fool.

We are today what we were yesterday, namely '*honnêtes hommes*', but ones who must be

tried with the fire of life to be innerly strengthened and confirmed in that which they are by nature through the grace of God.

May it be so with us, old boy, and I wish you well on your way, and God be with you in all things, and make you succeed at *that*, that is what is wished you with a hearty handshake at your departure by

Your most loving brother
Vincent

It's only a very small light, the one in the room of the Sunday school in Barndesteeg, let me keep it burning; in any event, if I don't do it, I don't think that Adler is the kind of man who would let it go out.

148 | Laken, on or about Wednesday, 13 and Friday, 15 or Saturday, 16 November 1878 |
To Theo van Gogh (D)

Laeken, Nov. 1878

My dear Theo,

On the evening of the day we spent together, which for me passed as if in a twinkling,
I want to write to you after all. It was a great joy for me to see and talk to you again,
and it's fortunate that such a day that passes in a twinkling and a joy of such short
duration nevertheless remains in our memory, and that the remembrance of it is of a
lasting nature. After we'd taken leave of each other I walked back, not the shortest way
but along Trekweg. There are workshops of all kinds there that look pleasant, espe-
cially lit up in the evening, which also speak in their own way to us who are, after all,
labourers and workers, each in the sphere and in the work whereunto we have been
called, if only we care to listen, for they say, work while it is day, before the night
cometh, when no man can work, and they remind us that the Father worketh hitherto,
and that we too must work.

It was the very moment when the street-sweepers were coming home with their
carts with old white horses, there was a long line of those carts standing by the so-
called sludge works at the beginning of Trekweg. Some of those old white horses
resemble a certain old aquatint that you perhaps know, an engraving with no very
great artistic value but which nevertheless struck me and made an impression on me. I
mean the last of the series of prints titled 'The life of a horse'. That print depicts an old
white horse, emaciated and spent and worn out to death by a long life of heavy labour
and much and difficult work. The poor animal stands in an indescribably lonely and
forsaken place, a plain with lank, withered grass and here and there a twisted tree, bent
and cracked by the storm wind. On the ground lies a skull and in the distance, in the
background, the bleached skeleton of a horse lying next to a hut, where the man who
slaughters horses lives.

A stormy sky hangs over the whole, it's a foul and bleak day, sombre and dark
weather. It's a sorrowful and profoundly melancholy scene that must move everyone
who knows and feels that we, too, must one day go through that which we call dying,
and that at the end of human life there are tears or grey hair. What lies beyond is a
great mystery that God alone comprehends, who has however revealed this irrefutably
in His word, that there is a resurrection of the dead.

The poor horse — the old faithful servant, stands patient and submissive, but cou-
rageous nonetheless and as resolute, as it were, as the old guard who said 'the guard
dies but does not surrender' — waits for its final hour. I couldn't help thinking of that
print this evening when I saw those dust-cart horses. And now, as far as the drivers
themselves are concerned, with their dirty, dingy clothes, they seemed to be sunk
or rooted in poverty almost more deeply than that long row or rather group of poor
people drawn by master Degroux in his paupers' pew. Write and tell me if you know

that print. I'd like to speak to the dustmen, if they would only come and sit in the paupers' pew and consider it worthwhile to come and hear about the gospel and the lot of the poor and God, too, their Keeper and their Shade upon their right hand. You see, it always strikes me and it is remarkable, when we see the image of unutterable and indescribable forsakenness — of loneliness — of poverty and misery, the end of things or their extremity — the thought of God comes to mind. At least this is the case with me, and doesn't Pa also say: There is no place I would rather speak than a cemetery, for there we are all on equal ground — there we not only stand on equal ground but there we also *feel* that we are standing on equal ground, and elsewhere we don't always feel that.

I'm glad that we saw the museum together, especially the works by Degroux and Leys and so many other remarkable paintings, such as that landscape by Coosemans, among others. I'm very happy about the two prints you gave me, but you should have let me give you that small etching, The three mills. Now you've paid it all yourself, not just half of it as I had so wished — you must keep it in your scrapbook, however, because it's remarkable, even though it isn't very well executed. In my ignorance I'd think it attributable to Peasant Bruegel rather than to Velvet Brueghel. I hereby enclose that scratch, 'The Au charbonnage café'. I should really rather like to start making rough sketches of some of the many things one meets along the way, but considering I wouldn't actually do it very well and it would most likely keep me from my real work, it's better I don't begin. As soon as I got home I began working on a sermon on 'the barren fig tree', Luke XIII:6–9.

I sincerely hope that you'll have had good days at home, that you also will have stayed over Sunday and found things well at Princenhage.

When you arrive home in The Hague write a quick note if you can find the time, and be sure to give my warm regards to the Rooses.

That little drawing, 'The Au charbonnage café' is really nothing special, but the reason I couldn't help making it is because one sees so many coalmen, and they really are a remarkable people. This little house is not far from Trekweg, it's actually a simple inn right next to the big workplace where the workers come in their free time to eat their bread and drink a glass of beer.

Back during my time in England I applied for a position as an evangelist among the coal-miners, but they brushed my request aside and said I had to be at least 25 years old. You surely know that one of the root or fundamental truths, not only of the gospel but of the entire Bible, is 'the light that dawns in the darkness'. *From darkness to Light.* Well then, who will most certainly need it, who will have an ear to hear it? Experience has taught us that those who work in darkness, in the heart of the earth like the mine-workers in the black coal-mines, among others, are very moved by the message of the gospel and also believe it. In the south of Belgium, in Hainaut, from around the area of Mons to the French borders and even extending far beyond them, there is a region called the Borinage, where there is one of those populations of labourers who work in the many coal-mines. I found this and other things about them in a geography book: The Borins (people who live in the Borinage, an area west of Mons) do nothing but mine coal. They're an impressive sight, these coal-mines, opened up 300 metres underground, down which a working population worthy of our respect and sympathy descends every day. The coal-miner is a type peculiar to the Borinage; daylight

hardly exists for him, and he scarcely enjoys the sun's rays except on Sunday. He works with great difficulty by the light of a lamp whose illumination is pale and feeble, in a narrow gallery, his body bent double, and sometimes forced to crawl; his work is to pull from the earth's entrails this mineral substance whose great usefulness we know, he thus works in the midst of a thousand constantly recurring dangers, but the Belgian foreman has a cheerful character, he's used to this way of life, and when he goes down the pit, his hat topped with a little lamp whose job is to guide him in the darkness, he entrusts himself to his God Who sees his labours and Who protects him, his wife and his children. His clothing consists of a hat of boiled leather, a jacket and a pair of canvas trousers. So the Borinage lies to the south of Lessines, where one finds the stone-quarries.

I should like to go there as an evangelist. The three-month trial period set by Messrs De Jonge and the Rev. Pieterszen is nearly over. Paul spent three years in Arabia before he became active as a preacher and began his great missionary journeys and his actual work among the heathens. If I could spend three years or so in a similar region, working in peace and always learning and observing, then I wouldn't return from there without having something to say that is indeed worth hearing; I say this in all humility yet with frankness. If God wills it and spares my life, I'd be ready by about the age of 30 and could begin, with my special training and experience, having more mastery of my affairs and more maturity for the work than I do now. I'm writing this to you again, even though we've already talked about it. There are already a number of small Protestant congregations in the Borinage, and certainly schools as well, may God point me to a place where I can be active as an evangelist in the way we spoke about, by preaching the gospel to the poor, thus to those who have need of it and for whom it is suited to perfection, and devoting my time during the week to teaching.

You've no doubt been to Saint-Gilles. I once took a walk from there to the 'old boundary mark'. Where the road to Mont Saint Jean begins there's another hill, the Alsemberg. Here, on the right, is the cemetery of Saint-Gilles, full of cedars and ivy, from which one can look out over the city. Further on one comes to Forest. The region is very picturesque there, standing on the high slopes are old houses like the huts in the dunes that Bosboom painted. One sees people doing all kinds of farm work, sowing wheat, lifting potatoes, washing turnips, and everything, right down to wood-gathering, is picturesque and looks very much like Montmartre.

There are old houses with ivy or Virginia creeper and charming inns, among the houses I noticed was that of a mustard-maker, one Verkissen. His place would be perfect for a painting by Thijs Maris, for example. There are places here and there where stones are found and therefore small quarries to which sunken roads with the deep ruts of cart tracks lead, where one sees small white horses with red tassels and drivers with blue smocks, and the shepherd is not lacking, nor old women in black with white caps reminiscent of those by Degroux. There are also places here — as there are everywhere, for that matter, thank God — where one feels at home more than elsewhere, where one gets a remarkable, familiar feeling like homesickness, which has something bitterly melancholy about it but which nevertheless strengthens and awakens the spirit in us and gives us new strength and appetite for work and stimulates us, we know not how or why. That day I walked on, past Forest, and took a side road to an old church overgrown with ivy. I saw many lime trees, even more entwined with one another and

even more Gothic, so to speak, than those we saw in the park, and at the side of the sunken road leading to the cemetery twisted bushes and the roots of trees, as gnarled as those Dürer etched in 'Knight, Death and the Devil'. Have you ever seen a painting, or rather a photo of it, by Carlo Dolci, The Garden of Olives? There's something Rembrandtesque about it, saw it recently. You no doubt know the large, rough etching of the same subject after Rembrandt, being the pendant of the other, Reading the Bible, with those two women and the cradle. It came to mind after you told me that you had seen the painting by *père* Corot of the same subject; I saw it at the exhibition of his work shortly after he died, and it moved me deeply.

How much there is in art that is beautiful, if only one can remember what one has seen, one is never empty or truly lonely, and never alone.

Adieu Theo, I shake your hand right heartily in thought, I wish you well, may you thrive in your work and encounter many good things on your path in life, such as stay in the memory and make us rich though we seemingly have nothing. If you see Borchers sometime, be so good as to tell him that I thank him very much for his letter of some time ago. If you go to Mauve's, give him my regards, and believe me

Your loving brother
Vincent

I kept this letter for a couple of days. 15 Nov. has passed, so the three months are up. Spoke with the Rev. De Jonge and with Master Bokma, they say there is no opportunity to be at the school under the same conditions they offer to native Flemings — I can attend the lessons, for free if necessary — but this is the only privilege — in order to stay, therefore, I would need to have more financial means at my disposal than I do now, which is none. So I'll probably soon try the Borinage plan. Once out of the city I shan't easily return to a big city. It wouldn't be easy to live without believing in Him and without having the faith of old in Him, and without that one would lose heart.

[*Sketch* 148A]

148A. *Café Au charbonnage*

Wasmes, April 1879

My dear Theo,

It's time that you hear something from me again. I heard from home that you were in Etten for a couple of days and that you were travelling for the firm. I sincerely hope that your trip went well.

These days you'll no doubt be in the dunes and in Scheveningen now and then. Here it's also attractive in the country in the spring; here and there are places where one could imagine oneself in the dunes, because of the hills.

I went on a very interesting excursion not long ago; the fact is, I spent 6 hours in a mine.

In one of the oldest and most dangerous mines in the area no less, called Marcasse. This mine has a bad name because many die in it, whether going down or coming up, or by suffocation or gas exploding, or because of water in the ground, or because of old passageways caving in and so on. It's a sombre place, and at first sight everything around it has something dismal and deathly about it. The workers there are usually people, emaciated and pale owing to fever, who look exhausted and haggard, weather-beaten and prematurely old, the women generally sallow and withered. All around the mine are poor miners' dwellings with a couple of dead trees, completely black from the smoke, and thorn-hedges, dung-heaps and rubbish dumps, mountains of unusable coal &c. Maris would make a beautiful painting of it.

Later I'll try and make a sketch of it to give you an idea of it.

Had a good guide, a man who has already worked there for 33 years, a friendly and patient man who explained everything clearly and tried to make it understandable.

We went down together, 700 metres deep this time, and went into the most hidden corners of that underworld.

The *maintenages* or *gradins* (cells where the miners work) that are farthest removed from the exit are called 'des caches' (hidden places, places where one searches). This mine has 5 levels, 3 of which, the uppermost ones, are exhausted and abandoned, one no longer works in them because there's no more coal. If anyone were to try and make a painting of the *maintenages*, that would be something new and something unheard-of or rather never-before-seen. Imagine a series of cells in a rather narrow and low passageway, supported by rough timber-work. In each of the cells is a worker in a coarse linen suit, dingy and soiled as a chimney-sweep, chipping away at the coal by the dim light of a small lamp. In some of the cells the worker stands upright, in others ('seams worked lying down') he lies flat on the ground.

[*Sketch* 151A]

The arrangement is more or less like the cells in a beehive, or like a dark, sombre passageway in an underground prison, or like a series of small looms, or actually they look like a row of ovens such as one sees among the peasants, or like the separate tombs

in a vault. The passageways themselves are like the large chimneys of the Brabant farmsteads.

In some, water leaks in everywhere and the light of the miner's lamp creates a peculiar effect and reflects as in a cave full of stalactites. Some of the miners work in the *maintenages*, others load the loosened coal into small wagons that are transported along rails resembling a tramway. It's mostly children who do this, both boys and girls. There's also a stable there, 700 metres below ground, with around 7 old horses that transport larger amounts, bringing them to the so-called *accrochage*, that being the place where they're hauled up. Other workers are busy restoring the antiquated passageways to prevent them from caving in, or are making new passageways in the coal seam. Just as sailors on land are homesick for the sea, despite all the dangers and difficulties that threaten them, so the mine-worker would rather be below ground than above.

The villages here have something forsaken and still and extinct about them, because life goes on underground instead of above. One could be here for years, but unless one has been down in the mines one has no clear picture of what goes on here.

The people here are very uneducated and ignorant, and most of them can't read, yet they're shrewd and nimble in their difficult work, courageous, of rather small build but square-shouldered, with sombre, deep-set eyes. They're skilled at many things and work amazingly hard. Very nervous dispositions, I mean not weak but sensitive. Have a festering and deep-rooted hatred and an innate distrust of anyone who tries to boss them around. With charcoal-burners one must have a charcoal-burner's nature and character, and no pretensions, pridefulness or imperiousness, otherwise one can't get on with them and could never win their trust.

Did I tell you at the time about the miner who was badly burned by a gas explosion? Thank God he has now recovered and goes out and about and is beginning to take long walks as practice, his hands are still weak and it will be some time before he's able to use them for his work, yet he has been saved. But since then there have been quite a few cases of typhus and virulent fever, including what is known as 'foolish fever', which causes one to have bad dreams such as nightmares and delirium. So there are again many sickly and bedridden people, lying emaciated on their beds, weak and miserable.

In one house everyone is sick with fever, and they have little or no help, which means that there the sick are taking care of the sick. 'Here it is the sick who nurse the sick,' said the woman, just as it is the poor who befriend the poor.

Have you seen anything beautiful recently? I'm eagerly longing for a letter from you.

Has Israëls been working a lot lately, and Maris and Mauve?

A couple of nights ago a foal was born in the stable here, a nice small creature that was quick to stand firmly on its feet. The workers keep a lot of goats here, and there are young ones in the houses everywhere, just like the rabbits commonly to be found in the workers' houses.

Must go out and visit the sick, so have to finish now, let me hear from you soon, to give a sign of life, should you have the time.

Give my regards to your housemates, and to Mauve when you get the chance, I wish you the very best, and believe me ever, with a handshake in thought,

Your loving brother
Vincent

Going down in a mine is an unpleasant business, in a kind of basket or cage like a bucket in a well, but then a well 500–700 metres deep, so that down there, looking upward, the daylight appears to be about as big as a star in the sky. One has a feeling similar to one's first time on a ship at sea, but worse, though fortunately it doesn't last long. The workers get used to it, but even so, they never shake off an unconquerable feeling of horror and dread that stays with them, not without reason or unjustifiably. Once down there, however, it isn't so bad, and the effort is richly rewarded by what one sees.

Address
Vincent van Gogh
c/o Jean-Baptiste Denis
rue du Petit-Wasmes
Wasmes (Borinage, Hainaut)

154 | Cuesmes, between about Monday, 11 and Thursday, 14 August 1879 |
　　　To Theo van Gogh (D)

My dear Theo,

It's mainly to tell you that I'm grateful for your visit that I'm writing to you. It was quite a long time ago that we saw each other or wrote to each other as we used to. All the same, it's better that we feel something for each other rather than behave like corpses towards one another, the more so because as long as one has no real right to be called a corpse by being legally dead, it smacks of hypocrisy or at least childishness to pose as such. Childish in the manner of a young man of 14 years who thinks that his dignity and social standing actually oblige him to wear a top hat. The hours we spent together in this way have at least assured us that we're both still in the land of the living. When I saw you again and took a walk with you, I had the same feeling I used to have more than I do now, as though life were something good and precious that one should cherish, and I felt more cheerful and alive than I had been for a long time, because in spite of myself life has gradually become or has seemed much less precious to me, much more unimportant and indifferent. When one lives with others and is bound by a feeling of affection one is aware that one has a reason for being, that one might not be entirely worthless and superfluous but perhaps good for one thing or another, considering that we need one another and are making the same journey as travelling companions. Proper self-respect, however, is also very dependent on relations with others.

　　A prisoner who's kept in isolation, who's prevented from working &c., would in the long run, especially if this were to last too long, suffer the consequences just as surely as one who went hungry for too long. Like everyone else, I have need of relationships of friendship or affection or trusting companionship, and am not like a street pump or lamp-post, whether of stone or iron, so that I can't do without them without

perceiving an emptiness and feeling their lack, like any other generally civilized and highly respectable man — and I tell you these things to let you know what a salutary effect your visit had on me.

And just as I wished that we not drift apart, this is also the case with regard to those at home. Even so, at the moment I really dread going there and am strongly inclined to stay here. It could, however, be my fault, and you could be right in thinking that I don't see things straight, which is why it may be that, despite my great reluctance and notwithstanding that it's a hard journey, I'm going to Etten for at least a few days.

As I think back on your visit with thankfulness, our talks naturally come to mind. I've heard such talks before, many, in fact, and often. Plans for improvement and change and raising the spirits — and yet, don't let it anger you, I'm a little afraid of them — also because I sometimes acted upon them and ended up rather disappointed. How much has been well thought out that is, however, impracticable.

The time spent at Amsterdam is still so fresh in my memory. You were there yourself, and so you know how the pros and cons were weighed, considered and deliberated upon, reasoned with wisdom, how it was well meant — and yet how pitiful the result, how daft the whole business, how grossly stupid. I still shudder at the thought. It was the worst time I've ever gone through. How desirable and appealing the rather difficult and troubled days here in this poor country, in these primitive surroundings, seem to me compared with then. Something similar, I fear, will be the result of following wise counsel given with the best of intentions.

For such experiences are pretty drastic for me. The damage, the sorrow, the heart's regretfulness is too great for both of us not to have learned the hard way. If we don't learn from this, what shall we then learn from? A striving such as reaching the goal set before me, as it was put then, truly that is an ambition that won't easily take hold of me again, the desire to achieve it has cooled considerably, and I now look at things from a different perspective, even though it may sound and look attractive, and even though it's unacceptable to think about it as experience taught me to think about it. Unacceptable, yes, just as, for example, Francq the Evangelist finds it unacceptable that I declared the sermons given by the Rev. Jean Andry to be only slightly more evangelical than the sermons of a priest. I would rather die a natural death than be prepared for it by the academy, and have occasionally had a lesson from a grass-mower that seemed to me more useful than one in Greek.

Improvement in my life — should I not desire it or should I not be in need of improvement? I really want to improve. But it's precisely because I yearn for it that I'm afraid of remedies that are worse than the disease. Can you blame a sick person if he looks the doctor straight in the eye and prefers not to be treated wrongly or by a quack?

Does someone who has consumption or typhus do wrong by maintaining that a stronger remedy than barley water might be useful or even necessary, or, finding that barley water in itself can do no harm, nevertheless doubts its efficacy and potency in his particular case?

The doctor who prescribed barley water mustn't say, this patient is a stubborn person who is set upon his own ruin because he doesn't want to take medicine — no, because the man is not unwilling, but the so-called medicine was unsuitable, because it was indeed 'it' but still not yet 'it' at all.

Do you blame someone if he fails to be moved by a painting which is recorded in

the catalogue as a Memling but which has nothing to do with Memling other than that it's a similar subject from the Gothic period but without artistic value?

And if you should now assume from what I've said that I intended to say you were a quack because of your advice then you will have completely misunderstood me, since I have no such idea or opinion of you.

If, on the other hand, you think that I thought I would do well to take your advice literally and become a lithographer of invoice headings and visiting cards, or a bookkeeper or a carpenter's apprentice — likewise that of my very dear sister Anna to devote myself to the baker's trade or many other things of that kind (quite remarkably diverse and mutually exclusive) — which it was suggested I pursue, you would also be mistaken.

But, you say, I'm not giving you this advice for you to follow to the letter, but because I thought you had a taste for idling and because I was of the opinion that you should put an end to it.

Might I be allowed to point out to you that such idling is really a rather strange sort of idling. It's rather difficult for me to defend myself on this score, but I would be sorry if you couldn't eventually see this in a different light. I also don't know if I would do well to counter such accusations by following the advice to become a baker, for example. That would really be a sufficient answer (supposing it were possible for us to assume the guise of a baker or hair-cutter or librarian with lightning speed) and yet actually a foolish response, rather like the way the man acted who, when accused of heartlessness because he was sitting on a donkey, immediately dismounted and continued on his way with the donkey on his shoulders.

And, joking apart, I honestly think it would be better if the relationship between us were more trusting on both sides. If I must seriously feel that I'm annoying or burdensome to you or those at home, useful for neither one thing nor another, and were to go on being forced to feel like an intruder or a fifth wheel in your presence, so that it would be better I weren't there, and if I should have to continue trying to keep further and further out of other people's way — if I think that indeed it would be so and cannot be otherwise, then I'm overcome by a feeling of sorrow and I must struggle against despair.

It's difficult for me to bear these thoughts and more difficult still to bear the thought that so much discord, misery and sorrow, in our midst and in our family, has been caused by me.

If it were indeed so, then I'd truly wish that it be granted me not to have to go on living too long. Yet whenever this depresses me beyond measure, all too deeply, after a long time the thought also occurs to me: it's perhaps only a bad, terrible dream, and later we'll perhaps learn to understand and comprehend it better. But is it not, after all, reality, and won't it one day become better rather than worse? To many it would no doubt appear foolish and superstitious to believe in any improvement for the better. Sometimes in winter it's so bitterly cold that one says, it's simply too cold, what do I care whether summer comes, the bad outweighs the good. But whether we like it or not, an end finally comes to the hard frost, and one fine morning the wind has turned and we have a thaw. Comparing the natural state of the weather with our state of mind and our circumstances, subject to variableness and change, I still have some hope that it can improve.

If you write, soon perhaps, you will make me happy. Just in case, address your letter care of J.Bte Denis, rue du Petit-Wasmes à Wasmes (Hainaut).

Walked to Wasmes after your departure that evening. Have since drawn a portrait.

Adieu, accept in thought a handshake, and believe me

Yours truly,
Vincent

155 | Cuesmes, between about Tuesday, 22 and Thursday, 24 June 1880 |
 To Theo van Gogh (F)

My dear Theo,

It's with some reluctance that I write to you, not having done so for so long, and that for many a reason. Up to a certain point you've become a stranger to me, and I too am one to you, perhaps more than you think; perhaps it would be better for us not to go on this way.

It's possible that I wouldn't even have written to you now if it weren't that I'm under the obligation, the necessity, of writing to you. If, I say, you yourself hadn't imposed that necessity. I learned at Etten that you had sent fifty francs for me; well, I accepted them. Certainly reluctantly, certainly with a rather melancholy feeling, but I'm in some sort of impasse or mess; what else can one do?

And so it's to thank you for it that I'm writing to you.

As you may perhaps know, I'm back in the Borinage; my father spoke to me of staying in the vicinity of Etten instead; I said no, and I believe I acted thus for the best. Without wishing to, I've more or less become some sort of impossible and suspect character in the family, in any event, somebody who isn't trusted, so how, then, could I be useful to anybody in any way?

That's why, first of all, so I'm inclined to believe, it is beneficial and the best and most reasonable position to take, for me to go away and to remain at a proper distance, as if I didn't exist. What moulting is to birds, the time when they change their feathers, that's adversity or misfortune, hard times, for us human beings. One may remain in this period of moulting, one may also come out of it renewed, but it's not to be done in public, however; it's scarcely entertaining, it's not cheerful, so it's a matter of making oneself scarce. Well, so be it. Now, although it may be a thing of rather demoralizing difficulty to regain the trust of an entire family perhaps not entirely devoid of preju-dices and other similarly honourable and fashionable qualities, nevertheless, I'm not utterly without hope that little by little, slowly and surely, a good understanding may be re-established with this person and that.

In the first place, then, I'd like to see this good understanding, to say no more, re-established between my father and me, and I would also be very keen that it be re-established between the two of us. Good understanding is infinitely better than misunderstanding.

I must now bore you with certain abstract things; however, I'd like you to listen to them patiently.

I, for one, am a man of passions, capable of and liable to do rather foolish things for which I sometimes feel rather sorry. I do often find myself speaking or acting somewhat too quickly when it would be better to wait more patiently. I think that other people may also sometimes do similar foolish things. Now that being so, what's to be done, must one consider oneself a dangerous man, incapable of anything at all? I don't think so. But it's a matter of trying by every means to turn even these passions to good account. For example, to name one passion among others, I have a more or less irresistible passion for books, and I have a need continually to educate myself, to study, if you like, precisely as I need to eat my bread. You'll be able to understand that yourself. When I was in different surroundings, in surroundings of paintings and works of art, you well know that I then took a violent passion for those surroundings that went as far as enthusiasm. And I don't repent it, and now, far from the country again, I often feel homesick for the country of paintings.

You may perhaps clearly remember that I knew very well (and it may well be that I still know) what Rembrandt was or what Millet was, or Jules Dupré or Delacroix or Millais or M. Maris.

Good—now I no longer have those surroundings—however, that something that's called soul, they claim that it never dies and that it lives for ever and seeks for ever and for ever and for evermore.

So instead of succumbing to homesickness, I said to myself, one's country or native land is everywhere. So instead of giving way to despair, I took the way of active melancholy as long as I had strength for activity, or in other words, I preferred the melancholy that hopes and aspires and searches to the one that despairs, mournful and stagnant. So I studied the books I had to hand rather seriously, such as the Bible and Michelet's La révolution Française, and then last winter, Shakespeare and a little V. Hugo and Dickens and Beecher Stowe, and then recently Aeschylus, and then several other less classic authors, several good minor masters. You well know that one who is ranked among the minor (?) masters is called Fabritius or Bida.

Now the man who is absorbed in all that is sometimes shocking, to others, and without wishing to, offends to a greater or lesser degree against certain forms and customs and social conventions. It's a pity, though, when people take that in bad part. For example, you well know that I've frequently neglected my appearance, I admit it, and I admit that it's shocking. But look, money troubles and poverty have something to do with it, and then a profound discouragement also has something to do with it, and then it's sometimes a good means of ensuring for oneself the solitude needed to be able to go somewhat more deeply into this or that field of study with which one is preoccupied. One very necessary field of study is medicine; there's hardly a man who doesn't try to know a little bit about it, who doesn't try to understand at least what it's about, and here I still don't know anything at all about it. But all of that absorbs you, but all of that preoccupies you, but all of that makes you dream, ponder, think.

And now for as much as 5 years, perhaps, I don't know exactly, I've been more or less without a position, wandering hither and thither. Now you say, from such and such a time you've been going downhill, you've faded away, you've done nothing. Is that entirely true?

It's true that sometimes I've earned my crust of bread, sometimes some friend has given me it as a favour; I've lived as best I could, better or worse, as things went; it's

true that I've lost several people's trust, it's true that my financial affairs are in a sorry state, it's true that the future's not a little dark, it's true that I could have done better, it's true that just in terms of earning my living I've lost time, it's true that my studies themselves are in a rather sorry and disheartening state, and that I lack more, infinitely more than I have. But is that called going downhill, and is that called doing nothing?

Perhaps you'll say, but why didn't you continue as people would have wished you to continue, along the university road?

To that I'd say only this, it costs too much and then, that future was no better than the present one, on the road that I'm on. But on the road that I'm on I must continue; if I do nothing, if I don't study, if I don't keep on trying, then I'm lost, then woe betide me. That's how I see this, to keep on, keep on, that's what's needed.

But what's your ultimate goal, you'll say. That goal will become clearer, will take shape slowly and surely, as the croquis becomes a sketch and the sketch a painting, as one works more seriously, as one digs deeper into the originally vague idea, the first fugitive, passing thought, unless it becomes firm.

You must know that it's the same with evangelists as with artists. There's an old, often detestable, tyrannical academic school, the abomination of desolation, in fact — men having, so to speak, a suit of armour, a steel breastplate of prejudices and conventions. Those men, when they're in charge of things, have positions at their disposal, and by a system of circumlocution seek to support their protégés, and to exclude the natural man from among them.

Their God is like the God of Shakespeare's drunkard, Falstaff, 'the inside of a church'; in truth, certain evangelical (???) gentlemen find themselves, by a strange conjunction (perhaps they themselves, if they were capable of human feeling, would be somewhat surprised) find themselves holding the very same point of view as the drunkard in spiritual matters. But there's little fear that their blindness will ever turn into clear-sightedness on the subject.

This state of affairs has its bad side for someone who doesn't agree with all that, and who protests against it with all his heart and with all his soul and with all the indignation of which he is capable.

Myself, I respect academicians who are not like those academicians, but the respectable ones are more thinly scattered than one would believe at first glance. Now one of the reasons why I'm now without a position, why I've been without a position for years, it's quite simply because I have different ideas from these gentlemen who give positions to individuals who think like them.

It's not a simple matter of appearance, as people have hypocritically held it against me, it's something more serious than that, I assure you.

Why am I telling you all this? — not to grumble, not to apologize for things in which I may be more or less wrong, but quite simply to tell you this: on your last visit, last summer, when we walked together near the disused mine they call La Sorcière, you reminded me that there was a time when we also walked together near the old canal and mill of Rijswijk, and then, you said, we were in agreement on many things, but, you added — you've really changed since then, you're not the same any more. Well, that's not quite how it is; what has changed is that my life was less difficult then and my future less dark, but as far as my inner self, as far as my way of seeing and thinking

are concerned, they haven't changed. But if in fact there were a change, it's that now I think and I believe and I love more seriously what then, too, I already thought, I believed and I loved.

So it would be a misunderstanding if you were to persist in believing that, for example, I would be less warm now towards Rembrandt or Millet or Delacroix, or whomever or whatever, because it's the opposite. But you see, there are several things that are to be believed and to be loved; there's something of Rembrandt in Shakespeare and something of Correggio or Sarto in Michelet, and something of Delacroix in V. Hugo, and in Beecher Stowe there's something of Ary Scheffer. And in Bunyan there's something of M. Maris or of Millet, a reality more real than reality, so to speak, but you have to know how to read him; then there are extraordinary things in him, and he knows how to say inexpressible things; and then there's something of Rembrandt in the Gospels or of the Gospels in Rembrandt, as you wish, it comes to more or less the same, provided that one understands it rightly, without trying to twist it in the wrong direction, and if one bears in mind the equivalents of the comparisons, which make no claim to diminish the merits of the original figures.

If now you can forgive a man for going more deeply into paintings, admit also that the love of books is as holy as that of Rembrandt, and I even think that the two complement each other.

I really love the portrait of a man by Fabritius, which one day, also while taking a walk together, we looked at for a long time in the Haarlem museum. Good, but I love Dickens's 'Richard Cartone' in his Paris et Londres en 1793 just as much, and I could show you other strangely vivid figures in yet other books, with more or less striking resemblance. And I think that Kent, a man in Shakespeare's King Lear, is just as noble and distinguished a character as any figure of Th. de Keyser, although Kent and King Lear are supposed to have lived a long time earlier. To put it no higher, my God, how beautiful that is. Shakespeare — who is as mysterious as he? — his language and his way of doing things are surely the equal of any brush trembling with fever and emotion. But one has to learn to read, as one has to learn to see and learn to live.

So you mustn't think that I'm rejecting this or that; in my unbelief I'm a believer, in a way, and though having changed I am the same, and my torment is none other than this, what could I be good for, couldn't I serve and be useful in some way, how could I come to know more thoroughly, and go more deeply into this subject or that? Do you see, it continually torments me, and then you feel a prisoner in penury, excluded from participating in this work or that, and such and such necessary things are beyond your reach. Because of that, you're not without melancholy, and you feel emptiness where there could be friendship and high and serious affections, and you feel a terrible discouragement gnawing at your psychic energy itself, and fate seems able to put a barrier against the instincts for affection, or a tide of revulsion that overcomes you. And then you say, How long, O Lord! Well, then, what can I say; does what goes on inside show on the outside? Someone has a great fire in his soul and nobody ever comes to warm themselves at it, and passers-by see nothing but a little smoke at the top of the chimney and then go on their way. So now what are we to do, keep this fire alive inside, have salt in ourselves, wait patiently, but with how much impatience, await the hour, I say, when whoever wants to, will come and sit down there, will stay there, for all I know? May whoever believes in God await the hour, which will come sooner or later.

Now for the moment all my affairs are going badly, so it would seem, and that has been so for a not so inconsiderable period of time, and it may stay that way for a future of longer or shorter duration, but it may be that after everything has seemed to go wrong, it may then all go better. I'm not counting on it, perhaps it won't happen, but supposing there were to come some change for the better, I would count that as so much gained; I'd be pleased about it, I'd say, well then, there you are, there was something, after all.

But you'll say, though, you're an execrable creature since you have impossible ideas on religion and childish scruples of conscience. If I have any that are impossible or childish, may I be freed from them; I'd like nothing better. But here's where I am on this subject, more or less. You'll find in Souvestre's Le philosophe sous les toits how a man of the people, a simple workman, very wretched, if you will, imagined his mother country, 'Perhaps you have never thought about what your mother country is, he continued, putting a hand on my shoulder; it's everything that surrounds you, everything that raised and nourished you, everything you have loved. This countryside that you see, these houses, these trees, these young girls, laughing as they pass by over there, that's your mother country! The laws that protect you, the bread that is the reward of your labour, the words that you exchange, the joy and sadness that come to you from the men and the things among which you live, that's your mother country! The little room where you once used to see your mother, the memories she left you, the earth in which she rests, that's your mother country! You see it, you breathe it everywhere! Just think, your rights and your duties, your attachments and your needs, your memories and your gratitude, put all that together under a single name, and that name will be your mother country.'

Now likewise, everything in men and in their works that is truly good, and beautiful with an inner moral, spiritual and sublime beauty, I think that that comes from God, and that everything that is bad and wicked in the works of men and in men, that's not from God, and God doesn't find it good, either. But without intending it, I'm always inclined to believe that the best way of knowing God is to love a great deal. Love that friend, that person, that thing, whatever you like, you'll be on the right path to knowing more thoroughly, afterwards; that's what I say to myself. But you must love with a high, serious intimate sympathy, with a will, with intelligence, and you must always seek to know more thoroughly, better, and more. That leads to God, that leads to unshakeable faith.

Someone, to give an example, will love Rembrandt, but seriously, that man will know there is a God, he'll believe firmly in Him.

Someone will make a deep study of the history of the French Revolution — he will not be an unbeliever, he will see that in great things, too, there is a sovereign power that manifests itself.

Someone will have attended, for a time only, the free course at the great university of poverty, and will have paid attention to the things he sees with his eyes and hears with his ears, and will have thought about it; he too, will come to believe, and will perhaps learn more about it than he could say.

Try to understand the last word of what the great artists, the serious masters, say in

their masterpieces; there will be God in it. Someone has written or said it in a book, someone in a painting.

And quite simply read the Bible, and the Gospels, because that will give you something to think about, and a great deal to think about and everything to think about, well then, think about this great deal, think about this everything, it raises your thinking above the ordinary level, despite yourself. Since we know how to read, let's read, then!

Now, afterwards, we may well at times be a little absent-minded, a little dreamy; there are those who become a little too absent-minded, a little too dreamy; that happens to me, perhaps, but it's my own fault. And after all, who knows, wasn't there some cause; it was for this or that reason that I was absorbed, preoccupied, anxious, but you get over that. The dreamer sometimes falls into a pit, but they say that afterwards he comes up out of it again.

And the absent-minded man, at times he too has his presence of mind, as if in compensation. He's sometimes a character who has his *raison d'être* for one reason or another which one doesn't always see right away, or which one forgets through being absent-minded, mostly unintentionally. One who has been rolling along for ages as if tossed on a stormy sea arrives at his destination at last; one who has seemed good for nothing and incapable of filling any position, any role, finds one in the end, and, active and capable of action, shows himself entirely different from what he had seemed at first sight.

I'm writing you somewhat at random whatever comes into my pen; I would be very happy if you could somehow see in me something other than some sort of idler.

Because there are idlers and idlers, who form a contrast.

There's the one who's an idler through laziness and weakness of character, through the baseness of his nature; you may, if you think fit, take me for such a one. Then there's the other idler, the idler truly despite himself, who is gnawed inwardly by a great desire for action, who does nothing because he finds it impossible to do anything since he's imprisoned in something, so to speak, because he doesn't have what he would need to be productive, because the inevitability of circumstances is reducing him to this point. Such a person doesn't always know himself what he could do, but he feels by instinct, I'm good for something, even so! I feel I have a *raison d'être*! I know that I could be a quite different man! For what then could I be of use, for what could I serve! There's something within me, so what is it! That's an entirely different idler; you may, if you think fit, take me for such a one.

In the springtime a bird in a cage knows very well that there's something he'd be good for; he feels very clearly that there's something to be done but he can't do it; what it is he can't clearly remember, and he has vague ideas and says to himself, 'the others are building their nests and making their little ones and raising the brood', and he bangs his head against the bars of his cage. And then the cage stays there and the bird is mad with suffering. 'Look, there's an idler', says another passing bird — that fellow's a sort of man of leisure. And yet the prisoner lives and doesn't die; nothing of what's going on within shows outside, he's in good health, he's rather cheerful in the sunshine. But then comes the season of migration. A bout of melancholy — but, say the children who look after him, he's got everything that he needs in his cage, after all — but he

looks at the sky outside, heavy with storm clouds, and within himself feels a rebellion against fate. I'm in a cage, I'm in a cage, and so I lack for nothing, you fools! Me, I have everything I need! Ah, for pity's sake, freedom, to be a bird like other birds!

An idle man like that resembles an idle bird like that.

And it's often impossible for men to do anything, prisoners in I don't know what kind of horrible, horrible, very horrible cage. There is also, I know, release, belated release. A reputation ruined rightly or wrongly, poverty, inevitability of circumstances, misfortune; that creates prisoners.

You may not always be able to say what it is that confines, that immures, that seems to bury, and yet you feel I know not what bars, I know not what gates — walls.

Is all that imaginary, a fantasy? I don't think so; and then you ask yourself, Dear God, is this for long, is this for ever, is this for eternity?

You know, what makes the prison disappear is every deep, serious attachment. To be friends, to be brothers, to love; that opens the prison through sovereign power, through a most powerful spell. But he who doesn't have that remains in death. But where sympathy springs up again, life springs up again.

And the prison is sometimes called Prejudice, misunderstanding, fatal ignorance of this or that, mistrust, false shame.

But to speak of something else, if I've come down in the world, you, on the other hand, have gone up. And while I may have lost friendships, you have won them. That's what I'm happy about, I say it in truth, and that will always make me glad. If you were not very serious and not very profound, I might fear that it won't last, but since I think you are very serious and very profound, I'm inclined to believe that it will last.

But if it became possible for you to see in me something other than an idler of the bad kind, I would be very pleased about that.

And if I could ever do something for you, be useful to you in some way, know that I am at your service. Since I've accepted what you gave me, you could equally ask me for something if I could be of service to you in some way or another; it would make me happy and I would consider it a sign of trust. We're quite distant from one another, and in certain respects we may have different ways of seeing, but nevertheless, sometime or some day one of us might be able to be of use to the other. For today, I shake your hand, thanking you again for the kindness you've shown me.

Now if you'd like to write to me one of these days, my address is care of C. Decrucq, rue du Pavillon 8, Cuesmes, near Mons, and know that by writing you'll do me good.

Yours truly,
Vincent

158 | Cuesmes, Friday, 24 September 1880 | *To Theo van Gogh* (F)

Cuesmes, 24 Sept. 1880

Dear Theo,

Your letter did me good; I thank you for writing to me like that.

Actually, the roll containing a new collection of etchings and various sheets has

just arrived. First and foremost, the masterly etching, *The bush*, by Daubigny/Ruisdael. That's it! I plan to do two drawings, either in sepia or something else, one of them after this etching—the other after T. Rousseau's The oven in Les Landes. This latter sepia is already done—it's true—but if you compare it with Daubigny's etching, you'll understand that it becomes weak, even though the sepia drawing considered on its own may very well have a certain tone and sentiment. I have to go back to it and work on it again.

I'm still working on Bargue's Cours de dessin, and plan to finish it before undertaking anything else, since day by day it exercises and strengthens both my hand and my mind, and I wouldn't be able to feel sufficiently indebted to Mr Tersteeg for having so generously lent them to me. These models are excellent. In the meantime I'm busy reading a book on anatomy and another on perspective, which Mr Tersteeg also sent me. This study is thorny, and sometimes these books are as irritating as could be, but nevertheless I believe that I'm doing the right thing by studying them.

You can see, then, that I'm working like mad, but for the moment it isn't giving very heartening results. But I have hopes that these thorns will bear white flowers in their time, and that this apparently sterile struggle is nothing other than a labour of giving birth. First pain, then joy afterwards.

You tell me about Lessore. I believe I can recall some very elegant watercolour landscapes which could be by him, in a pale tone, with brushwork that's apparently easy and light but at the same time accurate and refined, with an effect (let it be said with no bad intention, on the contrary, with a good one) that's a little decorative. So I could be said to know something about his work, and you'd be telling me about somebody who isn't altogether unfamiliar to me. I like the portrait of *Victor Hugo*. It's very conscientiously done, with the clear intention of bearing witness to the truth without searching for effect. By virtue of that, though, it does have an effect.

I studied some of Hugo's works a little this past winter. Namely Le dernier jour d'un condamné and a very beautiful book on Shakespeare. I took up the study of this writer a long time ago now. It's as beautiful as Rembrandt. Shakespeare is to Charles Dickens or to V. Hugo what Ruisdael is to Daubigny, and Rembrandt to Millet.

What you say in your letter on the subject of Barbizon is very true and I'll tell you one or two things that will prove to you that that's my own way of seeing as well. I haven't seen Barbizon, but although I haven't seen it, last winter I saw Courrières. I made a trip on foot mainly in the Pas de Calais, not the Channel but the department. Or province. I made that trip hoping perhaps to find work there (any sort, if possible; I would have accepted anything), but actually without any real plan, I couldn't precisely say why. But I'd said to myself, You must see Courrières. I had only 10 francs in my pocket, and having started out by taking the train I'd soon exhausted those resources, and having stayed on the road for a week, I trudged rather painfully. Nevertheless, I saw Courrières and the outside of Mr Jules Breton's studio. The outside of this studio disappointed me a little, seeing that it's a brand-new studio and newly built in brick, of a Methodist regularity, of an aspect as inhospitable and chilly and ascetic as C.M.'s Jovinda, which, between ourselves, I don't much like either for this same reason. If I'd been able to see the inside I would have thought no more about the outside, I'm inclined to believe, and I'm sure of it even, but there you are, I wasn't able to get a look at the inside.

Because I didn't dare to introduce myself, so as to go in. I looked elsewhere in Courrières for some trace of Jules Breton or of some other artist; all I found was his picture at a photographer's shop and then, in the old church, in a dark corner, a copy of Titian's Entombment, which in the darkness seemed to me to be very beautiful and of a masterly tone. Was it by him? I don't know, being unable to make out any signature.

But of a living artist, not a trace, there was only a café, the so-called Café des Beaux-Arts, also in inhospitable and chilly and mortifying new brick, which café was decorated with some sort of frescoes or mural paintings depicting episodes from the life of the illustrious knight, Don Quixote. These frescoes, let it be said in confidence, seemed to me then rather poor consolation and rather mediocre. I don't know who they were by.

But at any rate I saw the Courrières countryside then, the haystacks, the brown farmland or the almost coffee-coloured marly soil, with whitish spots where the marl appears, which is something rather extraordinary for those of us who are used to blackish soil. And the French sky seemed to me far more clear and limpid than the smoky and misty Borinage sky. Furthermore, there were the farmhouses and sheds that had still preserved their mossy thatched roofs, God be praised and thanked for it; I also saw hosts of crows, famous from the paintings of Daubigny and Millet. Not to mention first of all, as one should, the typical and picturesque figures of the workmen: different diggers, woodcutters, a farm-hand driving his team, and the occasional outline of a woman in a white bonnet. Even there, at Courrières, there was a coal-mine or pit; I saw the day-shift coming up at dusk, but there were no women workers in men's clothing, as in the Borinage, only miners looking weary and miserable, blackened by coal-dust, wearing pit-rags and one of them an old army greatcoat. Although this stage was almost unbearable to me, and I returned from it worn out, with bruised feet and in a rather melancholy state, I don't regret it, because I saw interesting things and you learn to see with a quite different eye, there among the raw ordeals of poverty itself. I earned a few crusts of bread en route here and there in exchange for some drawings that I had in my suitcase. But when my ten francs were gone, I had to bivouac out in the open for the last 3 nights, once in an abandoned carriage, all white with frost in the morning, a rather poor shelter, once in a wood-pile and once, and it was a little better, in a haystack that had been broached, where I managed to make a slightly more comfortable nest, only a fine rain didn't exactly add to my well-being.

Well, and notwithstanding, it was in this extreme poverty that I felt my energy return and that I said to myself, in any event I'll recover from it, I'll pick up my pencil that I put down in my great discouragement and I'll get back to drawing, and from then on, it seems to me, everything has changed for me, and now I'm on my way and my pencil has become somewhat obedient and seems to become more so day by day. It was poverty, too long and too severe, that had discouraged me to the point where I could no longer do anything.

Another thing that I saw during that excursion was the weavers' villages.

The miners and the weavers are something of a race apart from other workmen and tradesmen, and I have a great fellow-feeling for them and would count myself happy if I could draw them one day, so that these types, as yet unpublished or almost unpublished, could be brought to notice. The man from the bottom of the abyss, 'de profundis', that's the miner; the other one, with a dreamy, almost pensive, almost a

sleep-walker's air, is the weaver. And now it's roughly 2 years that I've been living with them, and to some extent I've learned to know their original character, mainly that of the miners at least. And more and more I find something touching and even heart-rending in these poor and obscure workers, the lowest of all, so to speak, and the most looked down upon, which one usually pictures through the effect of a perhaps vivid but very false and unjust imagination as a race of criminals and brigands. There are criminals, drunkards, brigands here as elsewhere, but that's not at all the true type.

In your letter you spoke to me vaguely about coming to Paris or the surrounding area. Sooner or later, when it would be possible and when I felt like it. Of course, it would be my great and ardent desire to come either to Paris or to Barbizon or some-where else. But how could I do it, because I don't earn a sou, and although I work hard it'll take more time yet to reach the level of being able to think of such a thing as coming to Paris. Because in truth, to be able to work as one should, it would take at least about a hundred francs a month; you can live on less, but then you're hard up, far too much so in fact.

Poverty prevents good minds succeeding; that's Palissy's old proverb, in which there's truth, and which is entirely true if one understands its real purpose and import.

For the moment I can't see how the thing would be practicable, and it's better that I stay here, working as I can and will be able to, and after all, it's cheaper to live here.

However, I'd be unable to continue much longer in the little room where I am now. It's tiny as it is, and there are two beds, the children's and mine. And now that I'm doing the Bargues, quite big sheets, I couldn't tell you what a nuisance it is to me. I don't want to bother the people in their household arrangements; and also they've told me that as far as the other room in the house goes, there was no way for me to have it, even if I paid more, because the wife needs it to do her washing, which in a miner's house has to be done almost every day.

So I would like simply to take a little workman's house; that costs 9 francs a month on average.

I couldn't tell you how much (despite the fact that every day new difficulties present themselves and will continue to present themselves), I couldn't tell you how happy I feel to have taken up drawing again. It had already been on my mind for a long time, but I always saw the thing as impossible and beyond my reach. But now, while feeling both my weakness and my painful dependence in respect of many things, I've recov-ered my peace of mind, and my energy is coming back day by day.

Now, about coming to Paris. If we found an opportunity to get in touch with some decent, valiant artist, it would be extremely advantageous for me, but, to go there just like that, it would only be a repetition on a large scale of my trip to Courrières, where I'd hoped perhaps to meet some living being of the Artist species, but where I didn't find one. For me it's a matter of learning to draw well, to be master either of my pencil or my charcoal or my brush; once that's achieved I'll do good things almost no matter where, and the Borinage is every bit as picturesque as old Venice, as Arabia, as Brittany, Normandy, Picardy or Brie.

If I'm doing the wrong thing, the fault is mine. But one can very certainly find more easily at Barbizon than elsewhere, if one perhaps were to have this happy encounter, the opportunity to fall in with some more advanced artist who would be for me truly a Heaven-sent angel, let it be said seriously and without any exaggeration.

Cuesmes, September 1880 | 133

So if, sometime, you were to see means and opportunity, think of me; while waiting I'll stay quietly in some little workman's house, where I'll work as best I can.

You also speak to me of Meryon; what you say about him is very true, I am indeed slightly acquainted with his etchings. Would you like to see something curious — put one of his so precise and so powerful scratches beside any print by Viollet-le-Duc or by anyone at all who does architecture. Then you'll see Meryon in full light because of the other etching, which will serve, if I may be so free, as a foil or contrast. So what do you see, then? This. Meryon, even when he's drawing bricks, granite, the iron bars or the parapet of a bridge, puts something of the human soul, shaken by I know not what heartache, into his etching. I've seen drawings of Gothic architecture by V. Hugo. Well, without having Meryon's powerful and masterly execution, there was something of the same sentiment. What is this sentiment? It has some kinship with that which Albrecht Dürer expressed in his *Melancholy*, which in our times James Tissot and M. Maris also have (however different these two may be one from the other). Some profound critic rightly said of James Tissot 'He's a soul in need'. But in any event, there's something of the human soul there; it's for that reason that that is great, immense, infinite, and put Viollet-le-Duc beside it, it's stone, and the other (namely Meryon), that's *Spirit*. Meryon must have had such a power to love that now, like Dickens's Sydney Carton, he loves the very stones of certain places. But it's also found more and better, in a nobler, worthier and, if I may be allowed to say so, more Evangelical tone — the precious pearl, the human soul revealed — in Millet, in Jules Breton, in Jozef Israëls. But to return to Meryon, he has also, it seems to me, some distant kinship with Jongkind and perhaps Seymour Haden, because at certain moments these two artists were very strong. Wait, perhaps you'll still see that I too am a worker, although I don't know in advance what will be possible for me; nevertheless, I do hope to make some scratch yet in which there might be something human. But first I have to draw the Bargues and do other things that are rather tricky. The way is strait and the gate is strait and there are few that find it.

Thanking you for your kindness, chiefly for The bush, I shake your hand.

Vincent

I've taken all your collection now, but you'll have it back later, and in addition, for your collection of wood engravings, which I hope you're continuing, I have some very good things in the 2 volumes of the Musée Universel, which I intend for you.

160 | Brussels, Monday, 1 November 1880 | *To Theo van Gogh* (D)

Brussels, 1 Nov.
72 blvd du Midi

My dear Theo,

I want to tell you a few things in reply to your letter.

First of all, that I went to see Mr Roelofs the day after I received your letter, and he told me that his opinion was that from now on I should concentrate on drawing from nature, i.e. whether plaster or model, but not without guidance from someone who

understands it well. And he, and others too, seriously advised me definitely to go and work at a drawing academy, at least for a while, here or in Antwerp or anywhere I could, so I think I should in fact do something about getting admitted to that drawing academy, although I don't particularly like the idea. *Tuition is free here in Brussels,* I hear that in Amsterdam, for example, it costs 100 guilders a year, and one can work in an adequately heated and lighted room, which is worth thinking about, especially for the winter.

I'm making headway with the examples of Bargue, and things are progressing. Moreover, I've recently drawn something that was a lot of work but I'm glad to have done it. Made, in fact, a pen drawing of a skeleton, rather large at that, on 5 sheets of Ingres paper.

1 sheet	the head, skeleton and muscles	
1 "	torso, skeleton	
1 "	hand from the front, skeleton and muscles	
1 "	" from the back, " "	
1 "	pelvis and legs, skeleton.	

I was prompted to do it by a manual written by Zahn, *Esquisses anatomiques à l'usage des artistes.* And it includes a number of other illustrations which seem to me very effective and clear. Of the hand, foot &c. &c.

And what I'm now going to do is complete the drawing of the muscles, i.e. that of the torso and legs, which will form the whole of the human body with what's already made. Then there's still the body seen from the back and from the side.

So you see that I'm pushing ahead with a vengeance, those things aren't so very easy, and require time and moreover quite a bit of patience.

To be admitted to the drawing academy one must have permission from the mayor and be registered. I'm waiting for an answer to my request.

I know, of course, that no matter how frugally, how poorly even, one lives, it will turn out to be more expensive in Brussels than in Cuesmes, for instance, but I shan't succeed without any guidance, and I think it possible — if I only work hard, which I certainly do — that either Uncle Cent or Uncle Cor will do something, if not as a concession to me at least as a concession to Pa.

It's my plan to get hold of the anatomical illustrations of a horse, cow and sheep, for example, from the veterinary school, and to draw them in the same way as the anatomy of a person.

There are laws of proportion, of light and shadow, of perspective, that one *must know* in order to be able to draw anything at all. If one lacks that knowledge, it will always remain a fruitless struggle and one will never give birth to anything.

That's why I believe I'm steering a straight course by taking matters in hand in this way, and want to try and acquire a wealth of anatomy here this winter, it won't do to wait longer and would ultimately prove to be more expensive because it would be a waste of time.

I believe that this will also be your point of view.

Drawing is a hard and difficult struggle.

If I should be able to find some steady work here, all the better, but I don't dare count on it yet, because I must first learn a great many things.

Also went to see Mr Van Rappard, who now lives at rue Traversière 64, and have

spoken to him. He has a fine appearance, I've not seen anything of his work other than a couple of small pen drawings of landscapes. But he lives rather sumptuously and, for financial reasons, I don't know whether he's the person with whom, for instance, I could live and work. But in any case I'll go and see him again. But the impression I got of him was that there appears to be seriousness in him.

In Cuesmes, old boy, I couldn't have stood it a month longer without falling ill with misery. You mustn't think that I live in luxury here, for my food consists mainly of dry bread and some potatoes or chestnuts which people sell on the street corners, but I'll manage very well with a slightly better room and by eating a slightly better meal from time to time in a restaurant if that were possible. But for nearly 2 years I endured one thing and another in the Borinage, that's no pleasure trip. But it will easily amount to something more than 60 francs and really can't be otherwise. Drawing materials and examples, for instance, for anatomy, it all costs money, and those are certainly essentials, and only in this way can it pay off later, otherwise I'll never succeed.

I had great pleasure lately in reading an extract from the work by Lavater and Gall. Physiognomie et phrénologie. Namely character as it is expressed in facial characteristics and the shape of the skull.

Drew The diggers by Millet after a photo by Braun that I found at Schmidt's and which he lent me with that of The evening angelus. I sent both those drawings to Pa so that he could see that I'm doing something.

Write to me again soon. Address *72 blvd du Midi*. I'm staying in a small boarding-house for 50 francs a month and have my bread and a cup of coffee here, morning, afternoon and evening. That isn't very cheap but it's expensive everywhere here.

The Holbeins from the Modèles d'apres les maitres are splendid, I notice that now, drawing them, much more than before. But they aren't easy, I assure you.

That Mr Schmidt was entangled in a money matter which would involve the Van Gogh family and for which he, namely Mr S., would be justly prosecuted, I knew not the slightest thing about all that when I went to see him, and I first learned of it from your letter. So that was rather unfortunate, though Mr Schmidt received me quite cordially all the same. Knowing it now, though, and matters being as they are, it would perhaps be wise not to go there often, without it being necessary deliberately to avoid meeting him.

I would have written to you sooner but was too busy with my skeleton.

I believe that the longer you think about it the more you'll see the definite necessity of more artistic surroundings for me, for how is one supposed to learn to draw unless someone shows you? With the best will in the world one cannot succeed without also coming into and remaining in contact with artists who are already further along. Good will is of no avail if there's absolutely no opportunity for development. As regards mediocre artists, to whose ranks you think I should not want to belong, what shall I say? That depends on what one calls mediocre. I'll do what I can, but in no way do I despise the mediocre in its simple sense. And one certainly doesn't rise above that level by despising that which is mediocre, in my opinion one must at least begin by having some respect for the mediocre as well, and by knowing that that, too, already means something and that one doesn't achieve even that without much effort. Adieu for today, I shake your hand in thought. Write again soon if you can.

Vincent

2/4-81
72 blvd du Midi Bruxelles

My dear Theo,

In answer to your two good letters and prompted by a visit from Pa, which I'd been looking forward to for some time, I have a few things to tell you.

And this, first of all. I heard from Pa that you've already been sending me money without my knowing it, and in doing so are effectively helping me to get along. For this accept my heartfelt thanks. I have every confidence that you won't regret it; in this way I'm learning a handicraft, and although I'll certainly not grow rich by it, at least I'll earn the 100 francs a month necessary to support myself once I'm surer of myself as a draughtsman and find steady work.

What you told us about the painter Heyerdahl has greatly aroused the interest of both Rappard and myself.

Because the former will no doubt write to you about it himself, I address this question only because it concerns me personally, to some extent.

Your remarks about the Dutch artists, that it's doubtful whether they'd be able to give clear advice on the difficulties of perspective &c. with which I'm wrestling, I find in a certain sense quite correct and true. At any rate, I whole-heartedly agree with you that someone like Heyerdahl, because he seems to be such a highly cultivated man, would be far preferable to some others who might not have the ability to explain their way of doing things to anyone else, or to give one the guidance and advice that's so necessary.

You speak of Heyerdahl as one who takes great pains to seek 'proportions for the purpose of design', that's precisely what I need. Many good painters have no idea, or almost no idea, what 'proportions for the purpose of design' are, or beautiful lines or distinctive compositions, and ideas and poetry. Yet these are important questions which Feyen-Perrin and Ulysse Butin and Alphonse Legros, not to mention Breton and Millet and Israëls, take very much to heart and never lose sight of.

Many Dutch painters would understand nothing, absolutely nothing, of the beautiful work of Boughton, Marks, Millais, Pinwell, Du Maurier, Herkomer, Walker, to name but a few artists who are true masters as 'draughtsmen', over and above their qualities in other directions.

Many, I say, shrug their shoulders at such work, just as many — even among the painters here in Belgium, who should know better — do at the work of Degroux. I saw 2 things by Degroux this week that I didn't know yet, namely a painting, The conscript's departure, and a drawing in vertical format, The drunkard, two compositions that so much resemble Boughton that I was struck by the resemblance, as of two brothers who had never met each other but were nevertheless kindred spirits.

So you see that I share your view of Heyerdahl, that I'll consider myself fortunate if you can put me in touch with that man later on, that I certainly won't insist on having my way about going to Holland, not, at least, if I have the prospect of going to Paris later on and can more or less count on it.

In the meantime, though, what should I do? What would you think best? I can

carry on working at Rappard's for a week or so, but then he'll probably be leaving. My bedroom is all too small and the light isn't good, and the people would object to my shutting out some of the light coming in through the window, I'm not even allowed to hang my etchings on the wall or my drawings. So when Rappard leaves here in May I'll have to move, and in that case I'd very much like to work in the country for a while, Heist, Kalmthout, Etten, Scheveningen, Katwijk or wherever. Or even, which is closer, Schaarbeek, Haren, Groenendaal. But preferably a place where there's a chance of coming into contact with other painters, and if possible of living and working together, because that's cheaper and better. The cost of accommodation, no matter where, is at least 100 francs a month, anything less means suffering deprivation, either bodily or through a lack of indispensable materials and tools.

This winter I spent around 100 francs a month, I reckon, although in truth it was scarcely that much. And of that I spent a considerable amount on drawing materials and also bought some clothes. Namely bought two workmen's suits of coarse black velvet, of the material I think one calls velveteen. They look smart and one looks presentable in them; moreover, they'll come in handy later on, for I'll need a great many workman's clothes later, and even now already, for my models, whom I naturally need like anyone else. Gradually I'll have to acquire articles of clothing of all kinds, second-hand if necessary, both men's and women's clothing, for that purpose.

Naturally this doesn't have to happen all at once, though I've already made a start and shall continue.

You say, and rightly so, that financial matters have done a lot both to assist and to thwart people in the world. So be it, and the words of Bernard Palissy remain true: 'Poverty prevents good minds succeeding'. But when I think about it, I nonetheless say, Could it be that in a family like ours, in which 2 Messrs van Gogh are very rich, and that in the art business, C.M. and our uncle at Princenhage, and in which you and I in the present generation have also chosen that line of work, albeit in different spheres, I say, notwithstanding these facts, could it be that I can't continue to count in one way or another on those 100 francs a month for the time that must necessarily elapse before I obtain regular employment as a draughtsman? 3 years ago I had words with Uncle Cor on an entirely different matter, but is that any reason for C.M. to bear me ill will for ever and ever? I much prefer to assume that he never bore me any ill will, and view it as a misunderstanding for which I gladly take the entire blame, rather than bickering about whether and to what extent I'm to blame, because I have no time for such arguments.

Now, Uncle Cor so often does things to help other draughtsmen, and would it now be so very unnatural for him to take an active interest in me as well, should the occasion arise? I say these things, however, not so much to obtain financial help from His Hon. but rather because I think it wouldn't be good if he were to show himself completely unwilling for there to be a vigorous renewal of harmony, at least, between us. His Hon. could help me a great deal in a wholly different way than by giving me money, for example by putting me in touch, if possible, now or later, with people from whom I could learn a great deal. And, if possible, by His Hon.'s mediating to bring about one thing or another during the time that must still elapse before I obtain regular employment — in Paris, for example — at some illustrated magazine or other. I also spoke to Pa in this vein, I don't know whether it will be of any use, but I noticed

that they were talking about how strange and inexplicable it was that I had to struggle so hard even though I belonged to such and such a family. In reply to this I said that I thought that this was a passing thing and would be set to rights later. Nonetheless, it seemed to me advisable to speak to Pa and to you about it, and I wrote to Mr Tersteeg and mentioned it briefly, but His Hon. seems not to have understood my meaning, because he took it to mean that I was planning to live out of C.M.'s pocket and, this being his interpretation, he wrote me a rather discouraging letter and said that I had no right to such a thing. I don't claim to have the right, but I wish to prevent the matter being talked about sooner or later in the studios, and so, in my opinion, harmony must be restored between me and the family, at least temporarily and in the eyes of the world, in expectation of their changing their minds about me. If they refuse, so be it, but then I can't prevent it being talked about here and there. If I were to write immediately to C.M., or to go and see His Hon., there would be a chance that he wouldn't read my letter or would receive me all too brusquely, so I'm speaking about it to Pa and to you, because you'll probably be able to say a word or two about it in passing, and then he won't misconstrue my meaning. It isn't my intention to obtain money from His Hon., as Mr Tersteeg thought, unless it be the case that after talking to me he acquires faith and confidence in my future and starts to see me in an entirely different light. And if he were to be convinced of it, then I'd certainly not spurn his help, that goes without saying, and then he would be able to smooth my way a little in an entirely different way than by giving me money, for instance, in the interval of time between now and going to Paris. I wrote to Mr Tersteeg that it didn't surprise me in the least that he had interpreted my letter in that way, since you had also spoken at one time of 'idling'. And just as I now understand from the tone of your letter that you no longer see my difficult position in that dismal light, and experience it as well through your effective assistance, so I hope that Mr Tersteeg, too, will gradually change his opinion. The more so because His Hon. was the first to help me with those Bargues, for which I'll always be grateful.

Now you write about a manikin. There's no particular hurry, but it would be of great use to me in composing and finding poses, you're sensible of that. However, I'd rather wait a bit longer and have a better one than have a tool sooner that was far too inadequate.

Be sure and keep an eye out, though, for all manner of prints or books about proportion, and find out as much as you can about them, that's of inestimable value, without it one can't make a figure drawing quickly. Moreover, it would be very beneficial for me to have a thing or two about the anatomy of the horse and sheep, cow, not with an eye to veterinary medicine but rather with a view to drawing the aforementioned animals. If I'm asking you for all these things like this, it's because you'll most likely have an opportunity to find such prints very cheaply, relatively speaking, just as I've already found a few myself, and you'd perhaps pay them less heed if I hadn't said that they're of such great use to me. If you ever have an opportunity to ask Bargue or Viollet-le-Duc, for example, about those prints about proportion, that's most probably the best place for such information.

I should, of course, find it wonderful to live with you later on, but we haven't reached that point yet. If C.M. could be persuaded to give me a chance to learn the ropes somewhere on a temporary basis, I'd certainly not scorn it. One can sometimes

learn much indirectly even from relatively bad artists, just as, for example, Mauve learned a great deal from Verschuur about bringing a stable and a wagon into perspective, and the anatomy of a horse, and yet how Mauve towers above Verschuur.

If by any chance you can recommend the painting of Madiol at the Salon, do so, for there's much that's beautiful in it, and the man is in a fix and has lots of small children. He's painting a smithy that will also be good, and he recently made a little old woman that is superb in its drawing and especially colour. But he's very inconsistent. His chalk drawings are often outstanding.

This letter is really rather long, but I can't make it any shorter. If I mention that it would be desirable for at least the general public, but in fact even more so for C.M. and others, to change their minds about me, it's because people like Roelofs, for example, don't know what to think of such an untoward position, whether there is something wrong with me or with the other side, but he sees that there is something wrong somewhere anyhow.

Such a person is therefore too circumspect and will have nothing to do with me at present, just when it's most necessary for me to receive advice and help.

And such experiences are unpleasant, to say the least, it remains to be seen whether, working on with patient energy, I gradually make progress notwithstanding. I mean to. Where there is a will there is a way.

And would I be to blame later on if I were to take revenge?

Nonetheless, a draughtsman doesn't draw for the sake of revenge but for the love of drawing, and that's more compelling than any other reason. And so it's likely that later on some things will be set to rights that aren't quite right yet.

I've collected a lot of woodcuts this winter. Your Millets have been augmented with various others, and you'll see that your wealth of woodcuts &c. haven't had an unproductive stay with me. I now have 24 woodcuts by or after Millet, counting the Labours of the fields. But my own drawing is the main thing, and everything has to work towards that.

The cheapest thing, of course, would be for me to spend this summer in Etten, there's subject matter enough there. If you think this desirable, you can write to Pa about it, I'm willing to conform to what they want as regards clothing or anything else, and I'd most likely run into C.M. there this summer, if he were to go there or to Princenhage. There's no real objection to it, as far as I know. I'll always be judged or talked about in differing ways, whether within or outside the family, and one will always hear the most wide-ranging opinions being put forward.

And I don't blame anyone for it, for relatively very few people know why a draughtsman does this or that.

Peasants and townsfolk, however, generally impute very great wickedness and evil intentions never dreamt of by one who betakes himself to all manner of places, corners and holes that others prefer not to visit, in order to find picturesque places or figures.

A peasant who sees me drawing an old tree-trunk and sees me sitting there in front of it for an hour thinks I'm mad, and naturally laughs at me. A young lady who turns up her nose at a workman in his patched and dusty and sweaty work-clothes can't understand, of course, why anyone visits the Borinage or Heist and goes down a coal-mine all the way to the *maintenages*, and she, too, comes to the conclusion that I'm mad.

All that, though, doesn't matter to me in the slightest, of course, if only you and Mr

Tersteeg and C.M. and Pa and others I'm concerned with know better and, far from criticizing it, say instead, your line of work involves that, and we understand why it is so. So that I repeat, in the circumstances there's actually no particular reason why I shouldn't be able to go to Etten, for example, or to The Hague, if it should work out that way, even if little gentlemen and ladies chop logic on the subject. So, since Pa said to me during his visit, do write to Theo and arrange with him what would be best and least expensive, be so good as to let me know your views on this matter before long. Heist (near Blankenberge, thus on the sea) or Kalmthout are very picturesque, there's subject matter in Etten as well, here too if necessary, although I'd move to Schaarbeek all the same. Scheveningen or Katwijk would of course be possible if C.M. were to change his opinion of me, and then I could profit directly or indirectly from the artists in Holland. As far as expenses go, I reckon them to be at least around 100 francs a month, less isn't possible, 'thou shalt not muzzle the ox that treadeth out the corn'.

And so I'll wait until you write more concerning one thing and another, and will work at Rappard's in the meantime. Rappard has really painted some spirited studies, including a few from the models at the academy which are vigorously conceived. A bit more passion or emotion would do him no harm, a little more self-confidence and a little more daring. Someone once said to me, *We must make an effort like the lost, like the desperate. But he isn't doing it yet.* I find his landscape drawings in pen very witty and pleasing, in those too, though, gradually a bit more passion please! And now I take my leave with a handshake in thought, and remain

Ever yours,
Vincent

I'm sending you three scratches that are still awkward, but from which I hope you'll nonetheless see that there's gradual improvement. You must remember that I haven't been drawing for long, even if I did sometimes make little sketches as a boy. And also that this winter the most important thing for me was to make strict anatomical studies and not my own compositions.

170 | Etten, Friday, 5 August 1881 | *To Theo van Gogh* (D)

My dear Theo,

I found it really nice that you were here again and we could talk about things again. I still think it a pity that we can't yet be together more. Not that I attach much value to talking in itself, but I mean that I do wish we knew each other much better and more intimately than is now the case. I thought this especially during the ride back from Roosendaal, after I had brought you to the station, also because of some things we talked about during our last moments at the station. But possibly, probably, you don't even know what that was any more. I'm glad that your letter of today holds out hope that it won't be so very long before you come back again.

I am, of course, completely better again, though I did stay in bed the day after you left and have spoken to Dr Van Genk, a thoroughly practical man, not because I thought this insignificant malaise to be worth the bother, but rather because in general, well or not well, I like to speak to a doctor from time to time to find out if everything is all right. If one hears wholesome and true words about health now and then, it seems to me that one gradually acquires much clearer notions about such matters, and if one knows more or less what one should take care not to do, and what one should abide by, one isn't tossed about by the shifting winds of opinion, by all manner of nonsense that one hears so often concerning health and ill health.

I'm also busy drawing the Exercices au fusain on the Ingres paper that you brought. It costs me a great deal of effort to stick to that work. It's much more stimulating to draw something outdoors than such a sheet from the Bargues, but still, I set myself the task of drawing them again, thus for the last time. It wouldn't be good if, when drawing from nature, I lapsed into too much detail and overlooked the important things. And I found much too much of that in my last drawings. And that's why I want to study Bargue's method once more (who works with broad lines and large masses and simple, delicate contours). And if I let outdoor drawing rest for the moment, then when I come back to it in a short while I'll have a better eye for things than I used to.

I don't know if you ever read English books. If so, then I can highly recommend *Shirley* by *Currer Bell*, the author of another book, *Jane Eyre*. This is as beautiful as the paintings of Millais or Boughton or Herkomer. I found it at Princenhage and read it in three days, even though it's quite a thick book.

I'd wish that everyone had what I'm gradually beginning to acquire, the ability to read a book easily and quickly and to retain a strong impression of it. Reading books is like looking at paintings: without doubting, without hesitating, with self-assurance, one must find beautiful that which is beautiful.

I'm gradually putting my books back in order. I've read too much not to continue systematically to try to keep abreast of modern literature, to some extent at least.

Sometimes I very much regret not knowing a great deal more about history, for example, especially modern history. Well, one won't get any further by being sorry and having these sad thoughts; what one must try and do is simply struggle on.

It gave me a great deal of pleasure to detect some truly good philosophy occasionally in your recent conversation. Who knows what a thoughtful creature you may become with time?

If *Illusions perdues* by Balzac is too long for you (2 volumes), start with *Le père Goriot*, 1 volume only, once you've tasted Balzac you'll prefer it to a great many other things. Remember Balzac's nickname, 'veterinary surgeon for incurable maladies'.

By the time I've finished the Bargues it will be autumn, that's really a wonderful time to draw, I'd like Rappard to come here again then. I also hope to succeed in finding a good model, such as Piet Kaufmann the labourer, though I think it will be better not to have him pose here at the house, but either in the yard at his place or in the field with a spade or plough or something else. But what a business it is to get people to understand what posing is! Peasants and townsfolk desperately cling to an idea they won't give up, namely that one shouldn't pose other than in one's Sunday suit with impossible folds in which neither knee nor elbow nor shoulder blades nor any other part of the body has made its characteristic dent or hump. Truly, this is one of the petty vexations in the life of a draughtsman.

Well, adieu, write if you can, and accept in thought a handshake, and believe me

Ever yours,
Vincent

172 | Etten, mid-September 1881 | *To Theo van Gogh* (D)

My dear Theo,

Even though I wrote to you only a short while ago, this time I have something more to say to you.

Namely that a change has come about in my drawing, both in my manner of doing it and in the result.

Prompted as well by a thing or two that Mauve said to me, I've started working again from a live model. I've been able to get various people here to do it, fortunately, one being Piet Kaufmann the labourer.

The careful study, the constant and repeated drawing of Bargue's Exercices au fusain has given me more insight into figure drawing. I've learned to measure and to see and to attempt the broad outlines &c. So that what used to seem to me to be desperately impossible is now gradually becoming possible, thank God. I've drawn a peasant with a spade no fewer than 5 times, 'a digger' in fact, in all kinds of poses, twice a sower, twice a girl with a broom. Also a woman with a white cap who's peeling potatoes, and a shepherd leaning on his crook, and finally an old, sick peasant sitting on a chair by the fireplace with his head in his hands and his elbows on his knees.

And it won't stop there, of course, once a couple of sheep have crossed the bridge the whole flock follows.

Diggers, sowers, ploughers, men and women I must now draw constantly. Examine and draw everything that's part of a peasant's life. Just as many others have done and are doing. I'm no longer so powerless in the face of nature as I used to be.

I brought Conté in wood (and pencils as well) from The Hague, and am now working a lot with it.

I'm also starting to work with the brush and the stump. With a little sepia or indian ink, and now and then with a bit of colour.

It's quite certain that the drawings I've been making lately don't much resemble anything I've made up till now.

The size of the figures is more or less that of one of the Exercices au fusain.

As regards landscape, I maintain that that should by no means have to suffer on account of it. On the contrary, it will gain by it. Herewith a couple of little sketches to give you an idea of them.

Of course I have to pay the people who pose. Not very much, but because it's an everyday occurrence it will be one more expense as long as I fail to sell any drawings.

But because it's only rarely that a figure is a total failure, it seems to me that the cost of models will be completely recouped fairly soon already.

For there's also something to be earned in this day and age for someone who has learned to seize a figure and hold on to it until it stands firmly on the paper. I needn't tell you that I'm only sending you these sketches to give you an idea of the pose. I scribbled them today quickly and see that the proportions leave much to be desired, certainly more so than in the actual drawings at any rate. I've had a good letter from Rappard who seems to be hard at work, he sent me some very nice sketches of landscapes. I'd really like him to come here again for a few days.

[*Sketch* 172A]

This is a field or stubble field which is being ploughed and sown, I have a rather large sketch of it with a storm brewing.

[*Sketch* 172B]

The other two sketches are poses of diggers. I hope to make several more of these.

[*Sketches* 172C–D]

The other sower has a basket.

It would give me tremendous pleasure to have a woman pose with a seed basket in order to find that figure that I showed you last spring and which you see in the foreground of the first sketch.

[*Sketch* 172E]

In short, 'the factory is in full swing', as Mauve says.

Remember that Ingres paper, if you will, of the colour of unbleached linen, the stronger kind if possible. In any case, write to me soon if you can, and accept a handshake in thought.

Ever yours,
Vincent

[*Sketches* 172F–L]

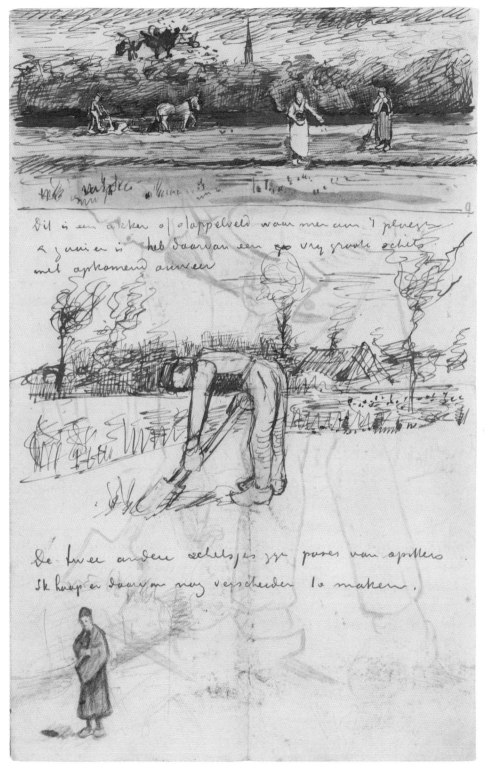

Dit is een akker of aardappelveld waar men aan 't ploegen & zaaien is. heb daarvan een vrij groote schets met opkomend onweer

De twee andere schetsjes zijn poses van spitters. Ik hoop er daarvan nog verscheiden te maken.

172A–C (top to bottom). *Storm clouds over a field; Digger; Figure of a woman*

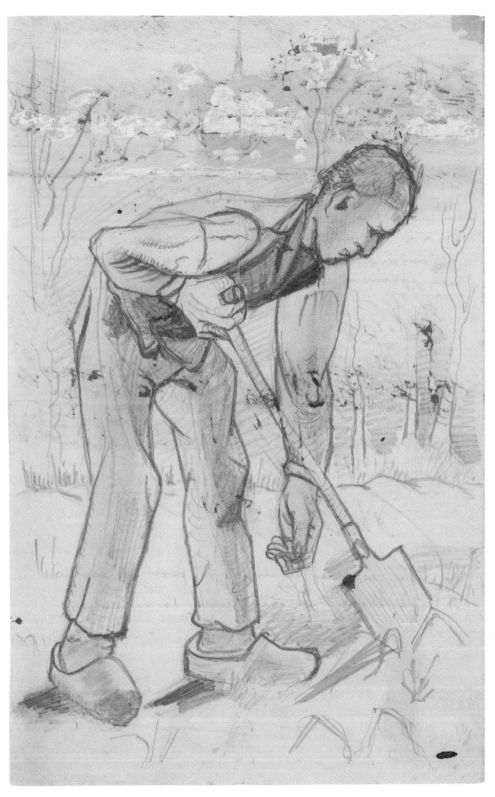

172D. *Digger*

De andere gaaien heeft een korf.
Enorm graag zou ik eens een vrouw laten poseeren
als met een gaaikorf om dat figuurtje te vinden dat ik
in 't voorjaar u het laten zien en dat ge op den
voorgrond van 't eerste schetsje ziet

Enfin zooals Mauve gezt. "de fabriek is in
volle werking".
Als ge wilt en kunt denk dan om het papier Ingres
van de kleur van ongebleekt linnen zoo mogelyk
het sterkere soort. Schryf my eens spoedig als gy kunt
in elk geval. en ontvang een handdruk in gedachten.
t. à t.
Vincent

172E. *Man leaning on his spade*

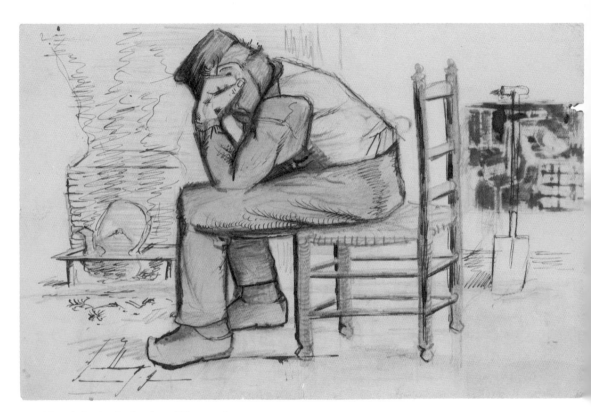

172F. *Man sitting by the fireplace ('Worn out')*

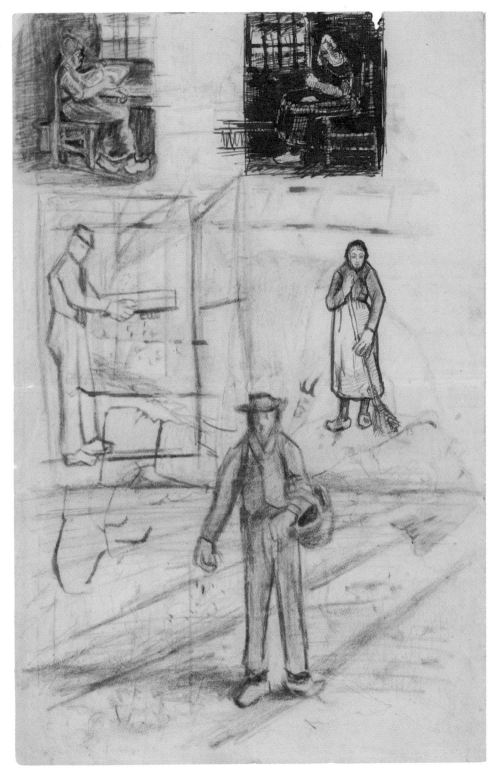

172G–K (left to right, top to bottom). *Woman near a window*; *Woman near a window*;
Man with a winnow; *Woman with a broom*; *Sower*

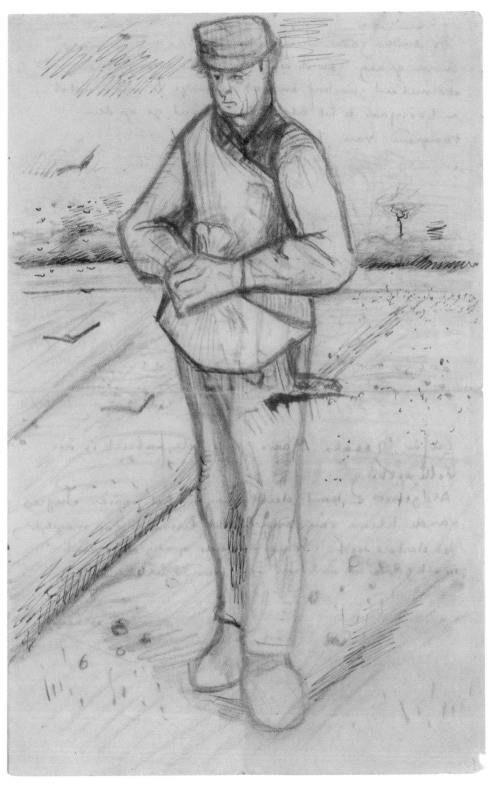

172L. *Sower with a sack*

Etten, 3/9 1881

My dear Theo,

There's something on my mind that I want to tell you. Perhaps you already know something about it, and what I'm telling you isn't news.

I wanted to tell you that this summer I've come to love Kee Vos so much that I could find no other words for it than 'it's just as if Kee Vos were the closest person to me and I the closest person to Kee Vos'. And—I said these words to her. But when I told her this, she replied that her past and her future were all one to her and so she could never return my feelings.

Then I was in an awful dilemma about what to do, to resign myself to that no, nay, never, or—not yet to regard the matter as over and done with, and to take courage and not give up yet.

I chose the latter. And until now I haven't regretted that decision, even though I'm still confronted with that no, nay, never.

Since then, of course, I've suffered a great many 'petty miseries of human life', which, if they were written down in a book, could perhaps serve to amuse some people, though they can hardly be considered pleasant if one experiences them oneself. Nonetheless, up to now I've been glad that I left the resignation or 'how-*not*-to-do-it' method to those who prefer it and, as for myself, plucked up a little courage. You understand that in cases like this it's surprisingly difficult to know what one can, may and must do. But 'wandering we find our way', and not by sitting still.

One of the reasons I haven't written to you about it before now is that the position in which I found myself was so vague and undecided that I couldn't explain it to you.

Now, though, we've progressed to the point where I've spoken about it—in addition to her—to Pa and Ma, to Uncle and Aunt Stricker and to Uncle and Aunt at Princenhage. The only one who said to me, though very informally and in private, that I did indeed have a chance if I worked hard and prospered, is one from whom I didn't expect it at all, Uncle Cent. He was amused at the way I took Kee's no, nay, never, i.e. by making light of it and sort of joking about it, bring no grist to Kee Vos's mill of no, nay, never, for example, I wish her all good things, apart from hoping that the aforementioned flour-mill will go bankrupt. Likewise I didn't much mind when Uncle Stricker said there was a danger I 'would sever friendly relations and break old ties', to which I replied that in my opinion the case in question, far from breaking old ties, could renew the old ties where they were in need of repair. At any rate, I hope to go on like this and to keep well away from melancholy and pessimism. Meanwhile working hard, and since meeting her my work is going much better.

I said that now the situation is becoming somewhat clearer. First, Kee says no, nay, never, and furthermore I believe that I'll have tremendous difficulty with the elders who already regard the matter as over and done with and will try and force me to give up. For the time being, though, I believe they'll proceed with caution, keeping me dangling and fobbing me off until Uncle and Aunt Stricker's big celebration (in December) is over. Because they want to avoid scandal. After that, though, I fear that steps will be taken to get rid of me.

Forgive the rather harsh terms I'm using to make my position clear to you. I admit that the colours are a little harsh and the lines drawn a bit too hard, but it will nevertheless give you a clearer picture of the situation than if I were to beat about the bush. So don't suspect me of lack of respect for those Elder persons.

Only I believe that they're decidedly *against* it, and I want to make you see this. They'll try and see to it that Kee and I can neither see nor speak nor write to one another, just because they understand very well that if we were to see, speak or write to one another there would be a chance of a change of heart in Kee. Kee herself thinks she'll never change her mind and, though the elder persons are trying to convince me that she can't change, they fear that change nonetheless.

The elder persons will change their minds about this matter not when Kee changes her mind but when I become someone who earns at least 1,000 guilders a year. Again, forgive the hard contours with which I outline things. While I find little sympathy from the elders, I think that some of the younger ones will be able to understand my attitude. Perhaps you, Theo. Perhaps you've heard it said of me that I want to force the issue and suchlike expressions. But who doesn't understand how senseless it is to try and force love! No, that's far, far from my thoughts. But it's not unfair or unreasonable to wish that Kee and I, instead of not being allowed to see one another, will see, speak and write to one another so that, getting to know each other better, we'll be able to see for *ourselves* whether or not we're suited to each other. A year of contact with one another would be beneficial for her and for me, yet the elders won't budge on this point. If I were rich they'd talk altogether differently.

Yet by now you understand that I mean to leave no stone unturned in my endeavours to bring me closer to her, and I declare that

I shall love her so long
That in the end she'll love me too.

The more she disappears, the more she appears.

Theo, aren't you in love too, at times? I wish you were, for believe me, the 'petty miseries' of it are also of some value. Sometimes one is desolate, there are moments when one is in hell, as it were, but — it also brings with it other and better things. There are three stages, first not loving and not being loved, second loving and not being loved (the case in question), third loving and being loved.

I'd say that the second stage is better than the first, but the third! That's *it*.

Now, old boy, go and fall in love and tell me about it sometime. Keep quiet about the case in question and sympathize with me. I'd much rather have a yea and amen, of course, but meanwhile I'm really rather happy with my '*no, nay, never*'. I consider that *something*, but older and wiser people say it's *nothing*. Rappard was here, brought along watercolours that are becoming good. Mauve is coming soon, I hope, otherwise I'll go to him. I'm drawing a great deal and think it's getting better, I'm working much more with the brush than I used to. Now it's so cold that practically all I do is draw figures inside, seamstress, basket-maker &c.

A handshake in thought, and write soon, and believe me

Ever yours,
Vincent

They wanted me to promise not to say or write anything more on this subject, but I wouldn't promise that; no one in the world, in my opinion, can reasonably demand such a thing of me (or of anyone else in the same situation). I've only given assurances to Uncle Cent that I would stop writing to Uncle Stricker for the time being, until unforeseen circumstances should make it necessary. A lark can't help singing in the spring.

If you should ever fall in love and receive a no, nay, never, by no means resign yourself to it! But you're such a lucky dog that something like this will probably never happen to you, I hope.

186 | Etten, Friday, 18 November 1881 | *To Theo van Gogh* (D)

Friday evening.

Dear Brother,

When I sent my letter to you this morning, meaning when I put it in the post-box, I had a feeling of relief. For a moment I'd hesitated, should I tell him or not? But thinking it over later it seemed to me that it really wasn't unwarranted. I'm writing to you here in the little room that's now my studio because the other is so damp. When I look round it's full of all kinds of studies that all relate to one and the same thing, 'Brabant types'.

So that is work started, and if I were wrenched from this environment I'd have to start all over again doing something else and *this* would come to a standstill, half-finished! That mustn't happen! I've now been working here since May, I'm getting to know and understand my models, my work is progressing, though it's taken a lot of hard work to get into my stride. And now that I've got into my stride, should Pa say, because you're writing letters to Kee Vos, thereby causing difficulties between us (*because this is the fundamental cause*, and no matter what they might say: that I don't obey the 'rules of decorum' or whatever, it's all just idle talk), so because difficulties have arisen I curse you and drive you out of the house.

That's really too bad, after all, and it would indeed be ridiculous to stop working for such a reason on a project that's already started and progressing well.

No, no, one can't just let that happen. Anyway, the difficulties between Pa and Ma and myself aren't so terrible, aren't at all of the kind that would keep us from staying together. But Pa and Ma are getting old, and sometimes they get a little angry, and they have their prejudices and old-fashioned ideas that neither you nor I can share any more.

If, for example, Pa sees me with a French book by Michelet or V. Hugo in my hand, he thinks of arsonists and murderers and 'immorality'. But that's just too silly, and of course I don't let idle talk of that kind upset me. I've already said so often to Pa: just read a book like this, even if only a couple of pages, and you'll be moved by it. *But Pa stubbornly refuses to do so*. Just now, when this love was taking root in my heart, I read Michelet's books L'amour and La femme again, and so many things became clear to me that would otherwise remain a mystery. I also told Pa frankly that in the circumstances I valued Michelet's advice more than his, and had to choose which of the two I should

follow. But then they come with a story about a great-uncle who had become obsessed with French ideas and had taken to drink, thus insinuating that such will be my career in life. What misery!

Pa and Ma are extremely good to me inasmuch as they do what they can to feed me well &c. I appreciate that very much, but that doesn't alter the fact that eating and drinking and sleeping isn't enough, that one yearns for something nobler and higher, indeed, one simply can't do without it.

That higher thing I can't do without is my love for Kee Vos. Pa and Ma reason, She says no, nay, never, so *you must remain silent*.

I can't accept that at all, on the contrary. And if I write to her or something like that then there are ugly words like 'coercion' and 'it won't help anyway' and 'you'll spoil things for yourself'. And then they're surprised if someone doesn't just resign himself to finding his love 'indelicate'! No, truly not! In my opinion, Theo, I must stay here and quietly go on working and do everything in my power to win Kee Vos's love and to melt the no, nay, never. I can't share Pa and Ma's view that I shouldn't write or speak either to her or to Uncle Stricker; indeed, I feel the exact opposite. And I'd rather give up the work started and all the comforts of this house than resign myself one iota to leaving off writing to her or her parents or you. If Pa curses me for it, then I can't prevent His Hon. from doing so. If he wants to throw me out of the house, so be it, but I'll continue to do what my heart and mind tell me to do with respect to my love.

Be assured, Pa and Ma are actually *against* it, because otherwise I can't explain why they went *so* far this morning, so it now seems to me that it was a mistake for me ever to think that they didn't care one way or the other. Anyhow, I'm writing to you about it because, where my work is involved, that is definitely your concern, since you're the one who has already spent so much money on helping me to succeed. Now I've got into my stride, now it's progressing, now I'm starting to see something in it, and now I tell you, Theo, this is hanging over me. I'd like nothing better than simply to go on working, but Pa seems to want to curse me and put me out of the house, at least he said so this morning. The reason is that I write letters to Kee Vos. As long as I do that, at any rate, Pa and Ma will always find something to reproach me with, whether that I don't obey the rules of decorum or that I have an indelicate way of expressing myself or that I'm breaking ties or something of the kind.

A forceful word from you could perhaps straighten things out. *You* will understand what I tell you, that to work and be an artist one needs *love*. At least someone who strives for feeling in his work must first feel and live with his heart.

But Pa and Ma are harder than stone on the point of 'a means of subsistence', as they call it.

If it were a question of marrying at once, I'd most certainly agree with them, but NOW *it's a question of melting the no, nay, never*, and a means of subsistence can't do that.

That's an entirely different matter, an affair of the heart, for to make the no, nay, never melt, *she and I must see each other, write to each other, speak to each other*. That's as clear as day and simple and reasonable. And truly (though they take me to be a weak character, 'a man of butter'), I won't let anything in the world deter me from this love. May God help me in this.

No putting it off from today to tomorrow, from tomorrow to the next day, no *silent* waiting. The lark can't be silent as long as it can sing. It's absurd, utterly absurd, to

make someone's life difficult for this reason. If Pa wants to curse me for it, that's his business—my business is to try and see Kee Vos, to speak to her, to write to her, to love her with everything in me.

You'll understand that a father shouldn't curse his son because that son doesn't obey the rules of decorum or expresses himself indelicately or other things, assuming this were all true, though I think it's actually very different.

But unfortunately it's something that happens all too often in many families, that a father curses his son because of a love the parents disapprove of.

THAT's the rub, the other—rules of decorum &c., expressions, the *tone* of my words—those are just pretexts. What should we do now?

Wouldn't it be foolish, Theo, not to go on drawing those Brabant folk types, now that I'm making progress, just because Pa and Ma are vexed by my love?

No, that mustn't happen. Let them accept it, for God's sake, that's what I think. It really would be mad to expect a young man to sacrifice his energy to the prejudice of an old man. And truly, Pa and Ma are prejudiced in this.

Theo, I still haven't heard one word of love towards *her*, and to tell you the truth *that* is what bothers me more than anything else.

I don't think that Pa and Ma love her deep down, at any rate in the mood they're in *now* they can't think of her with love. But I hope this will change in later and better days. No, no, no, there's something wrong with them, and it can't be good that they curse me and want me out of the house at this very time. There are no grounds for it and it would thwart me in my work. So it can't be allowed to happen for no good reason.

What would *she* think if she knew what happened this morning? How would *she* like it, even though she says no, nay, never, if she heard that they called my love for her indelicate and spoke of 'breaking ties' &c. No, Theo, if she'd heard Pa cursing me, *she* wouldn't have approved of his curse. Ma once called her 'such a poor wee thing' in the sense of so weak, so nervous or whatever.

But be assured that lurking in 'that poor wee thing' is strength of mind and pride, energy and resoluteness that could change the minds of many towards *her*, and I maintain that sooner or later one might see things from '*that poor wee thing*' that very few now expect! She's *so* good and friendly that it pains her deeply to say one single unfriendly word, but if such as *her*, *so* gentle, *so* tender, *so* loving, rebel—piqued to the quick—then woe betide those they rebel against.

May she not rebel against me, then, dear brother. I think that *she* is beginning to see that I'm not an intruder or bully, but rather quieter and calmer on the inside than I seem on the surface. She didn't realize that immediately. At first, for a time, she really had an unfavourable opinion of me, but lo and behold, I don't know why, while the sky clouds over and darkens with difficulties and curses, light rises up on her side. Pa and Ma have always passed for such gentle, quiet people, so kindly and good. But how can I reconcile that with this morning's scene or that matter of Geel last year?

They really are good and kindly, but even so, they have prejudices they want to impose. And if they want to act as the 'wall of partition' between me and her, I doubt whether it will do them any good.

Now, old chap, if you send me some 'travelling money' you'll soon receive 3 drawings, 'Mealtime', 'the fire-lighter' and 'an almsman'. So send the travelling money, if

you can, for the journey won't be completely in vain! If I have but 20 or 30 francs, at least I can see her face once again. And write a word or two, if you will, about that certain (terrible?) curse and that *banishment*, because I'd like so much to go on working quietly here, that's what I'd like best. I need *her* and *her influence* to reach a higher artistic level, *without* her I am nothing, but *with* her there's a chance. Living, working and loving are actually one and the same thing. Now, adieu with a handshake,

Ever yours,
Vincent

A word from you 'from Paris'! That would possibly carry some weight, even against prejudices.

That matter of the asylum happened last year 'out of a conscientious conviction', as they call it, now it's another 'conscientious conviction' that's forbidding me to write to Kee Vos. But that's simply a 'conscientious conviction' based on very slight grounds, one that doesn't hold water. No, it can't be allowed to happen for no good reason!

And if one asks Pa, 'Explain to me the basis of your conviction', he answers, 'I don't owe you an explanation', 'it's not fitting to ask your father such a question'. That, however, is no mode of reasoning!

Another mode of reasoning that I don't understand either is Ma's: You know that we've been against it from the beginning, so stop going on about it! No, listen to me, brother, it would really be too bad if I had to leave my field of work here and waste a lot of money elsewhere, where it's much more expensive, instead of gradually earning some 'travelling money'!

That matter of Geel last year, when Pa wanted to have me put in an asylum against my will!!! taught me to be on the *qui vive*. If I didn't watch out now, Pa would 'feel compelled to do' a thing or two.

190 | Etten, Wednesday, 23 November 1881 | *To Anthon van Rappard* (D)

23 November 1881

My dear Rappard,

When I re-read your letters, old chap, I find such good, nice remarks in them, and, you see, that's precisely what spurs me on to keep up this correspondence.

Aha! So I'm actually a headstrong person after all! Well, I'll admit defeat, you've stung me to the quick! So be it. I thank you for that revelation, yes, thank God, at first I didn't dare believe it myself but you've made it clear to me, so I have a *will*, an *inclination*, I'm going *in a definite direction*, and, what's more, not satisfied with that, I want others to go with me! Thank God, so I'm a headstrong person! Well, from now on I want to be nothing else. And now I'd really like to have my friend Rappard as my travelling companion — it's not a matter of indifference to me to lose sight of him — am I wrong about that?

Well, I was saying, in my haste, that I wanted to drive people 'to the open sea' (see

previous letter). If that's all I did I would be a terrible barbarian. But there's something else that makes the matter more reasonable. A man can't stand it on the open sea for long — he has to have a little hut on the beach with a fire on the hearth — with a wife and children around that hearth.

You see, Rappard, where I myself seek to go, whither I seek to push others as well, is to become fishermen in the sea that we call the ocean of reality, but for myself, and for those fellow human beings I sometimes buttonhole, I definitely want 'that little hut' as well. And in that little hut the above-mentioned things. So the sea and that haven, or that haven and the sea.

And as regards that doctrine I'm preaching. That tenet of mine, 'people, let us love what we love', is based on an axiom. I thought it unnecessary to mention that axiom, but now for the sake of clarity I'll spell it out. That axiom is 'People, we love'. From that I derive the first proposition.

People, let us love what we love, let us be *ourselves*, 'let us not want to know better than God'. ('Let us not want to know better than God' is not an expression of mine but of Mauve's.) And I'll prove that proposition with a *reductio ad absurdum*, namely in this way. To begin with, suppose a man didn't love what he loved, how much misery he would cause himself and others, and how much trouble he would stir up in the world of our blessed Lord. In short, if everyone were like that person of whom we assume for the moment — if it's possible for us to do so, that is — that he didn't love what he loved, how the world would gradually (which in my view was ordained uprightly by our blessed Lord, and is maintained in that position by Him, and for the time being, for at least as long as you and I shall live, will stay in that position, it will no doubt last out our time), if, I say, everyone were like that supposed man, intentionally standing upside down and turned inside out (it's fortunate that he can exist only in our imagination as an abstraction in our *reductio ad absurdum* of an *ungeometric* proposition!), how the world rightly created by God would start to look very like a totally wrong world. It seems to me, starting off with that as an abstraction, that the person in question, intentionally standing upside down and turned inside out, existing for the moment only in our imagination (and not even that), who wouldn't choose to love what he loved, we feel to be going *so much* 'against the grain' that we may in fact take as proved the logic or the reasonableness of the proposition 'people, let us love what we love'. (Moreover, if I haven't proved clearly enough that the falseness of the proposition in question is a great absurdity, you, who are much further along in geometry than I am, would — with a bit of good will — easily succeed in finding more conclusive proof of my proposition.)

We now come to remarkable conclusions or 'consequences' of this basic principle, which include,

First, a man who flatly refuses to love what he loves drives himself into the ground.

Second, he'd have to have a very strong dose of O/Abstinence (the O and the A are both applicable, coincidentally. Eh!) to stand it for long.

Third, *if* he were to change, his conversion wouldn't be great.

Yes, and whether I say it or don't say it, I think you'll understand in any case that I'm more or less insinuating: Rappard, that by sticking so close to the academy you're keeping a spare turn of rope around your arm with which many a man has 'hanged' himself — because he couldn't be free of it when he wanted to choose the sea!

Because *you*, though, have rather strong muscles, *you* will be able to break that spare turn of rope in time of need. But others! Believe me, there are those who hang themselves with it!

Are there, in addition to 'academic' ones, yet other 'turns of rope'? There are, by your leave, as many kinds of turns of rope as there are eye beams. (See chapter on '*eye beams*' in previous letter.)

How many? 'LEGION', I say, 'LEGION'.

'Hanging oneself' by the 'spare turn of rope' is a much more protracted and fearful death than hanging oneself straightforwardly with a noose.

Are there also moral turns of rope?

And why shouldn't they be just as good as moral eye beams? But you and I haven't really laboured under them, nor do we labour under them, nor shall we labour under them.

Hmm — I'm not so very sure of that, and if instead of speaking of you and me I were speaking of myself alone, I'd say: as far as I'm concerned, I have laboured under, am labouring under, shall continue to labour under moral eye beams and moral turns of rope, but that did not, does not and will not alter the fact that I have cast out, am casting out and shall continue to cast out moral eye beams from my eye. And moral turns of rope I have rent asunder, am rending asunder and shall continue to rend asunder with flashes of lightning.

Until at the end I'll stand with a single eye and a free arm. When?

Provided I persevere until the end — in the end.

Well, you will indeed see that together we'll win *this* by persevering with our correspondence, that this correspondence will gradually become more serious.

Because although, as I've already said, I'm giving free rein to my imagination, I'm nevertheless writing to you truly, not *without* but very much *with* earnestness. And, while far from writing to you out of any desire to argue, my intention nonetheless is: 'to wake Rappard up', and I doubt whether in that 'waking of Rappard' I'll nod off myself. God forbid that such would be the case, far from it.

I told you on a previous occasion that I generally scrutinize, with artists in particular, the man who produces the work just as much as the work itself. Lacking the man, I must sometimes draw conclusions from the work alone (we can't know all artists personally), lacking the work, I must take the measure of the man alone. Well, of a certain Mr van Rappard I know, first, his work to some extent, second, him to some extent.

His work always says to me, hereafter better.

His person says the same.

From good to better.

Do you think that a very unmerciful judgement? Now (turning to a completely different subject), as regards my special '*bête noire*', I've had little opportunity today to occupy myself with pursuit of the same; even so, I couldn't refrain from attacking it just for a bit.

But we'll discuss this in more detail at some point. It's beginning, however, to be slightly on the *qui vive*, the fact is that resignation is accustomed to resignation and, I thought, it would give up the fight, but you see, I'm not inclined to do it yet. Anyway, perhaps I'll tell you later about the *bête noire* in question. Bloody *bête noire*! It does me good all the same.

Meanwhile, believe me, with a handshake,

Ever yours,
Vincent

I'm now writing to you often because I'll soon have a lot of other correspondence.

192 | The Hague, on or about Sunday, 18 December 1881 | *To Theo van Gogh* (D)

My dear Theo,

It's possible that you've been expecting a word from me to hear what I'm doing these days. And for my part I've been looking forward to a word from you.

I'm still going to Mauve's every day, during the day to paint, in the evenings to draw. Have now painted 5 studies and 2 watercolours, and naturally a few scratches.

I can't tell you how good and kind Mauve and Jet have been to me these days. And Mauve has shown and told me things which I can't do straightaway but will gradually put into practice. But I must go on working hard, and when I'm in Etten again a couple of changes will be necessary, among other things I'll have to see about renting a large room somewhere in which I can stand back a sufficient distance, otherwise figure drawing isn't really possible, except for studying a few fragments.

Anyway, I'm considering the matter with M. and I'll write to you about it again one of these days.

The painted studies are still lifes, the watercolours done from a model, a Scheveningen woman. Perhaps M. will write a letter to you himself soon.

But Theo, I've been gone almost a month now, and you'll understand that I've had more expenses than usual. M. has in fact given me various things, paint &c., but I've had to buy more of this and that, I've also paid the model for several days. And needed a pair of shoes, and besides, I didn't always pay attention to every penny, so that I've rather exceeded the 100-franc limit, for the whole trip has now cost me 90 guilders altogether. And now I think that Pa is rather short of money and I don't know what to do.

For my part, I'd like to stay here a while longer, would even like to rent a room here for a couple of months, in Scheveningen, for example, and possibly for more than a couple of months. But in the circumstances it would perhaps be better to return to Etten. I find Scheveningen so almightily beautiful and the types and figures. But the models there cost 1.50 or 2 guilders a day, some of them even more.

But here one is in touch with painters &c. When I wrote to Pa this week for money, he thought the 90 guilders I'd spent so terribly much.

You, though, will understand, I think, that this wasn't unreasonable, because everything is expensive. But I damned well hate having to give Pa an account of every penny, the more so because everything is blabbed to everyone else, not without embellishments and exaggerations.

What's more, Pa has now spent money on an overcoat for me that hung to the ground when I got it, and was a vulgar, flamboyant style to boot. Perhaps Pa did it out of kindness, but it really wasn't the time to do it, since we have so many expenses already, and it's also no way to buy clothes, without consulting the person and without

fitting or measuring. Pa sent the coat here, but I immediately sent it back. So I only want to say, Theo, I'm beginning to get rather hard up.

And I'm writing to you to tell you this. I haven't any money to stay, I haven't any money to go back. I'll wait a day or so in any case and do whatever you want.

Do you think it's better that I stay here a while? I'd very much like to stay a bit longer, and not go back before I've progressed a great deal more.

If you want me to go back immediately, that's also fine with me. Provided I find a good room somewhere, somewhat larger than the little studio at home. Then I can potter about by myself for a while, and go back to The Hague again later. In any event, Theo, I've been so enlightened by Mauve as regards the mysteries of the palette and painting in watercolour. And that will repay the 90 guilders this trip has cost. M. says that the sun is rising for me but that it's still shrouded in mist. Oh well, I have nothing against that. Sometime I'll tell you more about how kind and good M. was.

So now I'll wait here a couple of days, awaiting your answer. But if your answer doesn't come within 3 or 4 days, I'll ask Pa for the money to go back immediately.

I still have all kinds of things to tell you which you'll perhaps be interested in, about the way of working from a model at Etten, but as I already said, I'll write to you about this later — soon. I'm sending you herewith scratches of the two watercolours. I have every hope of making something saleable within a relatively short time, yes, *believe that if necessary it ought to be possible to sell these two.* Especially the one in which M. has added some touches. But I'd prefer to keep them myself for a while, the better to remember various things regarding their execution.

How marvellous watercolour is for expressing space and airiness, allowing the figure to be part of the atmosphere and life to enter it.

Now would you like me to make a few more watercolours for you here? I'd like nothing better, but accommodation here and the models and the paint and the paper &c. &c. all cost me money, and I haven't got any more.

So write to me in any case by return of post, and if you want me to stay, send me some money if possible.

I really think that I'll be able to make more progress now, now that I've heard some practical things about colour and the handling of the brush. And you can imagine that I set great store by M. not having to regret his kindness.

We'll try and pull through and put some energy into it.

Now adieu, I'm counting in any case on your writing a word by return of post, address A. Mauve. Uilenbomen 198. Believe me, with a handshake in thought,

Ever yours,
Vincent.

I have extremely bad ink here which has something red in it that has come through in the sketches.

[*Sketches* 192A–C]

These are the subjects of 2 painted studies. One is a terracotta head of a child wearing a fur cap, the other a white cabbage and some potatoes &c.

[*Sketches* 192D–E]

192A–C (bottom to top, left to right). *Scheveningen woman standing; Sculpture; Still life with cabbage and clogs*

192D–E (left to right). *Scheveningen woman sewing; Scheveningen woman knitting*

Sometimes, I fear, you throw a book away because it's too realistic. Have compassion and patience with this letter, and read it through, despite its severity.

My dear Theo,

As I already wrote to you from The Hague, I have some things to discuss with you now that I'm back here. It's not without emotion that I look back on my trip to The Hague. When I went to see M. my heart was beating rather hard, because I was thinking to myself, will he too try and fob me off or will I find something else here? And well, what I experienced with him was that he instructed and encouraged me in all manner of kind and practical ways. Though not merely by always approving of everything I did or said, on the contrary. But if he tells me, this or that isn't good, then it's because he's saying at the same time 'but try it this way or that way', and that's entirely different from criticizing for the sake of criticizing. Or if someone says 'you're ill with this or that', that doesn't help much, but if someone says 'do this or that and you'll get better', and his advice isn't deceit, look, that's the real thing, and — and — it naturally helps. Now I've come from him with a few painted studies and a couple of watercolours. Of course they aren't masterpieces and yet I truly believe there's something sound and real in them, more at least than in what I've made up to now. And so I now consider myself to be at the beginning of the beginning of making something serious. And because I now have a few more technical resources at my disposal, namely paint and brush, all things are made new again, as it were.

But — now we have to put it into practice. And the first thing is that I must find a room large enough to be able to take a sufficient distance. Mauve just said to me, when he saw my studies, 'you're too close to your model'.

In many cases this makes it next to impossible to take the necessary measurements for the proportions, so this is certainly one of the first things I have to watch out for. Now I must arrange to rent a large room somewhere, be it a room or a shed. And that won't be so terribly expensive. A labourer's cottage in these parts costs 30 guilders a year to rent, so it seems to me that a room twice as large as that in a labourer's cottage would cost something like 60 guilders.

And that isn't insurmountable. I've already seen a shed, though it has too many inconveniences, especially in the winter. But I'd be able to work there, at least when the weather is milder. And here in Brabant, moreover, there are models to be found, I believe, not only in Etten but also in other villages, if difficulties were to arise here.

Still, though I love Brabant very much, I also have a feeling for other figures than the Brabant peasant types. Scheveningen, for example, I again found unspeakably beautiful. But after all I'm here, and it would very probably be cheaper to stay here. However, I've definitely promised M. that I'll do my utmost to find a good studio, and now I must also use better paint and better paper.

Nevertheless, Ingres paper is excellent for studies and scratches. And it's much cheaper to make sketchbooks in all formats from it oneself than to buy ready-made sketchbooks. I still have a small supply of Ingres paper, but you'd be doing me a big favour if you could send some more of the same kind when you send back those studies. Not pure white, though, but the colour of unbleached linen, no *cold* shades.

Theo, what a great thing tone and colour are! And anyone who doesn't acquire a feeling for it, how far removed from life he will remain! M. has taught me to see so many things I didn't see before, and when I have the opportunity I'll try and tell you about what he's told me, because perhaps there are still one or two things that you don't see properly either. Anyway, we'll talk about artistic matters sometime, I hope.

And you can't imagine the feeling of relief I'm beginning to get when I think of the things M. said to me about earning money. Just think of how I've slogged away for years, always in a kind of false position. And now, now there's a glimmer of real light.

I do wish that you could see the two watercolours I've brought with me, because you would see that they're watercolours just like any other watercolours. There may be many imperfections in them, be that as it may, I'd be the first to say that I'm still very dissatisfied with them, and yet, it's different from what I've done up to now, and it looks fresher and sounder. All the same, it must become much fresher and sounder, but one can't do what one wants all at once. It comes gradually. I need those couple of drawings myself, however, to compare with what I'll be making here, because I have to do them *at least* as well as what I did at M.'s.

But even though Mauve tells me that if I continue to slog away here for a couple of months and then go back to him again in March, for instance, I'll then be able to make saleable drawings on a regular basis, I'm nevertheless going through a rather difficult period. The cost of models, studio, drawing and painting materials are multiplying, and there are no earnings as yet.

Admittedly, Pa said that I needn't be afraid of the inevitable expense, and Pa is pleased with what M. himself said to him, and also with the studies and drawings I brought back. But I do find it utterly, utterly wretched that Pa should suffer by it. Of course we hope that things will turn out well later, but still, it weighs heavily on my heart. Because since I've been here Pa really hasn't profited from me, and more than once he's bought a coat or trousers, for example, which I'd actually rather not have had, even though I really needed it, but Pa shouldn't suffer by it. The more so if the coat and trousers in question don't fit and are only half or not at all what I need. Anyway, still more petty vexations of human life. And, as I've told you before, I find it absolutely terrible not to be free at all. Because even though Pa doesn't ask me to account for literally every penny, still, he always knows exactly how much I spend and what I spend it on. And now, although I don't necessarily have any secrets, I don't really like people being able to look at my cards. Even my secrets aren't necessarily secrets to those for whom I feel sympathy.

But Pa isn't the kind of man for whom I can feel what I feel for you, for example, or for Mauve. I really do love Pa and Ma, but it's a very different feeling from what I feel for you or Mauve. Pa cannot empathize or sympathize with me, and I cannot settle in to Pa and Ma's routine, it's too constricting for me — it would suffocate me.

Whenever I tell Pa anything, it's all just idle talk to him, and certainly no less so to Ma, and I also find Pa and Ma's sermons and ideas about God, people, morality, virtue, almost complete nonsense. I also read the Bible sometimes, just as I sometimes read Michelet or Balzac or Eliot, but I see completely different things in the Bible than Pa sees, and I can't agree at all with what Pa makes of it in his petty, academic way. Since the Rev. Ten Kate translated Goethe's Faust, Pa and Ma have read that book, because now

that a clergyman has translated it, it can't be all that immoral (??? what is that?). Yet they don't see anything in it but the catastrophic consequences of an unchaste love.

And they certainly understand the Bible just as little. Take Mauve, for instance, when he reads something deep he doesn't immediately say, that man means this or that. Because poetry is so deep and intangible that one can't simply define it all systematically, but Mauve has a refined sensibility and, you see, I find that sensibility to be worth so much more than definition and criticism. And oh, when I read, and I actually don't read so much and even then, only one-and-a-half writers, a couple of men whom I accidentally found, then I do so because they look at things more broadly and milder and with more love than I do, and are better acquainted with reality, and because I can learn something from them. But all that drivel about good and evil, morality and immorality, I actually care so little about it. For truly, it's impossible for me always to know what is good, what is evil, what is moral, what is immoral.

Morality or immorality coincidentally brings me to K.V. Ah! I'd written to you that it was beginning to seem less and less like eating strawberries in the spring. Well, that is of course true. If I should lapse into repetition, forgive me, I don't know if I've already written to you about what happened to me in Amsterdam. I went there thinking, who knows whether the no, nay, never isn't thawing, it's such mild weather. And so one evening I was making my way along Keizersgracht, looking for the house, and indeed found it. And naturally I rang the bell and heard that the family were still at table. But then I heard that I could come in all the same. And there they were, including Jan, the very learned professor, all of them except Kee. And they all still had a plate in front of them, and there wasn't a plate too many. This small detail caught my eye. They wanted to make me think that Kee wasn't there, and had taken away her plate, but I knew she was there, I thought it so much like a comedy or game.

After a while I asked (after chatting a bit and greeting everyone), But where's Kee? Then J.P.S. repeated my question, saying to his wife, Mother, where's Kee? And the missus said, Kee's out. And for the time being I didn't pursue the matter but talked a bit with the professor about the exhibition at Arti he'd just seen. Well, the professor disappeared and little Jan Vos disappeared, and J.P.S. and the wife of the same and yours truly remained alone and got ourselves into position. J.P.S., as priest and Father, started to speak and said he'd been on the point of sending a certain letter to yours truly and he would read that letter aloud. However, first I asked again, interrupting His Hon. or the Rev., Where's Kee? (Because I knew she was in town.) Then J.P.S. said, Kee left the house as soon as she heard you were here. Well, I know some things about her, and I must say that I didn't know then and still don't know with certainty whether her coldness and rudeness is a good or bad sign. This much I do know, that I've never seen her so seemingly or actually cool and callous and rude towards anyone but me. So I didn't say much in reply and remained dead calm. Let me hear that letter, I said, or not, I don't really care either way. Then came the epistle. The writing was reverent and very learned and so there wasn't really anything in it, though it did seem to say that I was being requested to stop corresponding and I was given the advice to make vigorous attempts to forget the matter. At last the reading of the letter was over. I felt exactly as though I were hearing the minister in the church, after some raising and lowering of his voice, saying amen — it left me just as cold as an ordinary sermon. And then I began, and I said as calmly and politely as I could, well yes, I've

already heard this line of reasoning quite often, but now go on—and after that? But then J.P.S. looked up . . . he even seemed to be somewhat amazed at my not being completely convinced that we'd reached the extreme limit of the human capacity to think and feel. There was, according to him, no 'after that' possible. We went on like this, and once in a while Aunt M. put in a very Jesuitical word, and I got quite warm and finally lost my temper. And J.P.S. lost his temper too, as much as a clergyman can lose his temper. And even though he didn't exactly say 'God damn you', anyone other than a clergyman in J.P.S.'s mood would have expressed himself that way. But you know that I love both Pa and J.P.S. in my own way, despite the fact that I truly loathe their system, and I changed tack a bit and gave and took a bit, so that at the end of the evening they said to me that if I wanted to stay at their house I could. Then I said, thank you. If Kee walks out of the house when I come, then I don't think it's the right moment to stay here, I'm going to my boarding-house. And then they asked, where are you staying? I said, I don't know yet, and then Uncle and Aunt insisted on bringing me themselves to a good, inexpensive boarding-house. And heavens, those two old dears came with me through the cold, misty, muddy streets, and truly, they showed me a very good boarding-house and very inexpensive. I didn't want them to come at all but they insisted on showing me. And, you see, I thought that rather humane of them and it calmed me down somewhat. I stayed in Amsterdam two more days and talked with J.P.S. again, but I didn't see Kee, she made herself scarce each time. And I said that they ought to know that although they wanted me to consider the matter over and done with, I couldn't bring myself to do it. And they continued to reply firmly: 'Later on I would understand it better'. Now and then I also saw the professor again, and I have to say he wasn't so bad, but—but—but—what else can I say about that gentleman? I said I hoped that he might fall in love one day. Voilà. Can professors fall in love? Do clergymen know what love is?

I recently read Michelet, La femme, la religion et le prêtre. Books like that are full of reality, yet what is more real than reality itself, and what has more life than life itself? And we who do our best to live, why don't we live even more!

I walked around aimlessly those three days in Amsterdam, I felt damned miserable, and that half-kindness on the part of Uncle and Aunt and all those arguments, I found them so tedious. Until I finally began to find myself tedious and said to myself: would you like to become despondent again? And then I said to myself, Don't let yourself be overwhelmed. And so it was on a Sunday morning that I last went to see J.P.S. and said to him, Listen, my dear Uncle, if Kee Vos were an angel she would be too lofty for me, and I don't think that I would stay in love with an angel. Were she a devil, I wouldn't want to have anything to do with her. In the present case, I see in her a real woman, with womanly passions and whims, and I love her dearly, that's just the way it is, and I'm glad of it. So long as she doesn't become an angel or a devil, the case in question isn't over. And J.P.S. couldn't say very much to that, and spoke himself of womanly passions, I'm not really sure what he said about them, and then J.P.S. left for the church. No wonder one becomes hardened and numb there, I know that from my own ex-perience. And so as far as your brother in question is concerned, he didn't want to let himself be overwhelmed. But that didn't alter the fact that he felt overwhelmed, that he felt as though he had been leaning against a cold, hard, whitewashed church wall for too long. Oh well, should I tell you more, old chap? It's rather daring to remain a

realist, but Theo, Theo, you too are a realist, oh bear with my realism! I told you, even my secrets aren't necessarily secrets. Well, I won't take those words back, think of me as you will, and whether you approve or disapprove of what I did is less important.

I'll continue—from Amsterdam I went to Haarlem and sat very agreeably with our dear sister Willemien, and I took a walk with her, and in the evening I went to The Hague, and I landed up at M.'s around seven o'clock.

And I said: listen M., you were supposed to come to Etten to try and initiate me, more or less, into the mysteries of the palette. But I've been thinking that that wouldn't be possible in only a couple of days, so now I've come to you and if you approve I'll stay four weeks or so, or six weeks or so, or as long or as short as you like, and we'll just have to see what we can do. It's extremely impertinent of me to demand so much of you, but in short, I'm under a great deal of pressure. Well, Mauve said, do you have anything with you? Certainly, here are a couple of studies, and he said many good things about them, far too many, at the same time voicing some criticism, far too little. Well, and the next day we set up a still life and he began by saying, This is how you should hold your palette. And since then I've made a few painted studies and after that two watercolours.

This is a summary of my work, but there's more to life than working with the hands and the head.

I remained chilled to the marrow, that's to say to the marrow of my soul by that aforementioned imaginary or not-imaginary church wall. And I didn't want to let myself be overwhelmed by that deadening feeling, I said. Then I thought to myself, I'd like to be with a woman, I can't live without love, without a woman. I wouldn't care a fig for life if there wasn't something infinite, something deep, something real. But, I said to myself in reply: you say 'She and no other' and should you go to a woman? But surely that's unreasonable, surely that goes against logic? And my answer to that was, Who's the master, logic or I? Is logic there for me or am I there for logic, and is there no reason and no understanding in my unreasonableness or my stupidity? And whether I act rightly or wrongly, I can't do otherwise, that damned wall is too cold for me, I'll look for a woman, I cannot, I will not, I may not live without love. I'm only human, and a human with passions at that, I need a woman or I'll freeze or turn to stone, or anyway be overwhelmed. In the circumstances, however, I struggled much within myself, and in that struggle some things concerning physical powers and health gained the upper hand, things which I believe and know more or less through bitter experience. One doesn't live too long without a woman without going unpunished. And I don't think that what some call God and others the supreme being and others nature is unreasonable and merciless, and, in a word, I came to the conclusion, I must see whether I can't find a woman. And heavens, I didn't look so very far. I found a woman, by no means young, by no means pretty, with nothing special about her, if you will. But perhaps you're rather curious. She was fairly big and strongly built, she didn't exactly have lady's hands like K.V. but those of a woman who works hard. But she was not coarse and not common, and had something very feminine about her. She slightly resembled a nice figure by Chardin or Frère or possibly Jan Steen. Anyhow, that which the French call 'a working woman'. She'd had a great many cares, one could see that, and life had given her a drubbing, oh nothing distinguished, nothing exceptional, nothing out of the ordinary.

Every woman, at every age, if she loves and if she is kind, can give a man not the infinite of the moment but the moment of the infinite.

Theo, I find such infinite charm in that *je ne sais quoi* of withering, that drubbed by life quality. Ah! I found her to have a charm, I couldn't help seeing in her something by Feyen-Perrin, by Perugino. Look, I'm not exactly as innocent as a greenhorn, let alone a child in the cradle. It's not the first time I couldn't resist that feeling of affection, particularly love and affection for those women whom the clergymen damn so and superciliously despise and condemn from the pulpit. I don't damn them, I don't condemn them, I don't despise them. Look, I'm almost thirty years old, and do you think I've never felt the need for love?

K.V. is older than I am, she also has love behind her, but she's all the dearer to me for that very reason. She's not ignorant, but neither am I. If she wants to subsist on an old love and if she wants to know nothing of new ones, that's her business, but the more she perseveres in that and avoids me, the more I can't just stifle my energy and strength of mind for her sake. No, I don't want that, I love her, but I don't want to freeze and deaden my mind for her sake. And the stimulus, the spark of fire we need, that is love and I don't exactly mean mystic love.

That woman didn't cheat me — oh, anyone who thinks all those sisters are swindlers is so wrong and understands so little.

That woman was good to me, very good, very decent, very sweet. In what way? That I won't repeat even to my brother Theo, because I strongly suspect my brother Theo of having experienced something of this himself now and then. The better for him.

Did we spend a lot together? No, because I didn't have much and I said to her, listen, you and I don't have to get drunk to feel something for one another, just pocket what I can afford. And I wish I could have afforded more, because she was worth it.

And we talked about all kinds of things, about her life, about her cares, about her destitution, about her health, and I had a livelier conversation with her than with my learned professorial cousin Jan Stricker, for instance.

I've actually told you these things because I hope you'll see that even though I perhaps have some feeling, I don't want to be sentimental in a senseless way. That, no matter what, I want to preserve some warmth of life and keep my mind clear and my body healthy in order to work. And that I understand my love for K.V. to be such that for her sake I don't want to set about my work despondently or let myself get upset.

You'll understand that, you who wrote in your letter something about the matter of health. You talk of having been not quite healthy a while back, it's very good you're trying to get yourself straightened out.

Clergymen call us sinners, conceived and born in sin. Bah! I think that damned nonsense. Is it a *sin* to love, to need love, not to be able to do without love? I consider a life without love a sinful condition and an immoral condition. If there's anything I regret, it's that for a time I let mystical and theological profundities seduce me into withdrawing too much inside myself. I've gradually stopped doing that. If you wake up in the morning and you're not alone and you see in the twilight a fellow human being, it makes the world so much more agreeable. Much more agreeable than the edifying journals and whitewashed church walls the clergymen are in love with. It

was a sober, simple little room she lived in, with a subdued, grey tone because of the plain wallpaper and yet as warm as a painting by Chardin, a wooden floor with a mat and an old piece of dark-red carpet, an ordinary kitchen stove, a chest of drawers, a large, perfectly simple bed, in short, a real working woman's interior. She had to do the washing the next day. Just right, very good, I would have found her just as charming in a purple jacket and a black skirt as now in a brown or red-grey frock. And she was no longer young, perhaps the same age as K.V., and she had a child, yes, life had given her a drubbing and her youth was gone. Gone? — there is no such thing as an old woman. Ah, and she was strong and healthy — and yet not rough, not common. Those who value distinction so very highly, can they always tell what is distinguished? Heavens! People sometimes look for it high and low when it's close by, as I do too now and then.

I'm glad that I did what I did, because I think that nothing in the world should keep me from my work or cause me to lose my good spirits.

When I think of K.V., I still say 'she and no other', and I think exactly the same as I did last summer about 'meanwhile looking for another lass'. But it's not only recently that I've grown fond of those women who are condemned and despised and cursed by clergymen, my love for them is even somewhat older than my love for Kee Vos. Whenever I walked down the street — often all alone and at loose ends, half sick and destitute, with no money in my pocket — I looked at them and envied the people who could go off with her, and I felt as though those poor girls were my sisters, as far as our circumstances and experience of life were concerned. And, you see, that feeling is old and deeply rooted in me. Even as a boy I sometimes looked up with endless sympathy and respect into a half-withered female face on which it was written, as it were: life and reality have given me a drubbing. But my feelings for K.V. are completely new and something entirely different. Without knowing it, she's in a kind of prison. She's also poor and can't do everything she wants, and you see, she has a kind of resignation and I think that the Jesuitisms of clergymen and devout ladies often make more of an impression on her than on me, Jesuitisms that no longer impress me for the very reason that I've learned a few tricks. But she adheres to them and couldn't bear it if the system of resignation and sin and God and whatnot appeared to be a conceit. And I don't think it occurs to her that perhaps *God* only actually begins when we say those words with which Multatuli closes his prayer of an unbeliever: 'O God, there is no God'. Look, I find the clergymen's God as dead as a doornail. But does that make me an atheist? The clergymen think me one — be that as it may — but look, I love, and how could I feel love if I myself weren't alive and others weren't alive? And if we live, there's something wondrous about it. Call it God or human nature or what you will, but there's a certain something that I can't define in a system, even though it's very much alive and real, and you see, for me it's God or just as good as God. Look, if I must die in due course in one way or another, fine, what would there be to keep me alive? Wouldn't it be the thought of love (moral or immoral love, what do I know about it?). And heavens, I love Kee Vos for a thousand reasons, but precisely because I believe in life and in something real I no longer become distracted as I used to when I had thoughts about God and religion that were more or less similar to those Kee Vos now appears to have. I won't give her up, but that inner crisis she's perhaps going through will take time, and I have the patience for it, and nothing she says or does makes me angry. But as long as she goes on being attached to the past and clinging to it, I must work and keep my mind clear for painting and drawing and business. So I did

what I did, from a need for warmth of life and with an eye to health. I'm also telling you these things so that you don't get the idea again that I'm in a melancholy or distracted, pensive mood. On the contrary, I'm usually pottering about with and thinking about paint, making watercolours, looking for a studio &c. &c. Old chap, if only I could find a suitable studio.

Well, my letter has grown long, but anyway.

I sometimes wish that the three months between now and going back to M. were already over, but such as they'll be, they'll bring some good. Write to me, though, now and then. Are you coming again in the winter?

And listen, renting a studio &c., I'll do it or I won't, depending on what Mauve thinks of it. I'm sending him the floor plan as agreed, and perhaps he'll come and have a look himself if necessary. But Pa has to stay out of it. Pa isn't the right man to get mixed up in artistic matters. And the less I have to do with Pa in business matters, the better I'll get along with Pa. But I have to be free and independent in many things, that goes without saying.

I sometimes shudder at the thought of K.V., seeing her dwelling on the past and clinging to old, dead notions. There's something fatal about it, and oh, she'd be none the worse for changing her mind. I think it quite possible that her reaction will come, there's so much in her that's healthy and lively. And so in March I'll go to The Hague again and — and — again to Amsterdam. But when I left Amsterdam this time, I said to myself, under no circumstances should you become melancholy and let yourself be overwhelmed so that your work suffers, especially now that it's beginning to progress. Eating strawberries in the spring, yes, that's part of life, but it's only a short part of the year and it's still a long way off.

And you should envy me because of this or that? Oh no, old chap, because what I'm seeking can be found by all, by you perhaps sooner than by me. And oh, I'm so backward and narrow-minded about so many things, if only I knew exactly why and what I should do to improve. But unfortunately we often don't see the beams in our own eye. Do write to me soon, and you'll just have to separate the wheat from the chaff in my letters, if sometimes there's something good in them, something true, so much the better, but of course there's much in them that's wrong, more or less, or perhaps exaggerated, without my always being aware of it. I'm truly no scholar and am so extremely ignorant, oh, like many others and even more than others, but I can't gauge that myself, and I can gauge others even less than I can gauge myself, and am often wide of the mark. But even as we stray we sometimes find the track anyway, and there's something good in all movement (by the way, I happened to hear Jules Breton say that and have remembered that utterance of his). Tell me, have you ever heard Mauve preach?? I've heard him imitate several clergymen — once he gave a sermon on Peter's barque (the sermon was divided into 3 parts: First, would he have bought it or inherited it? Second, would he have paid for it in instalments or parts? Third, did he perhaps (banish the thought) steal it?). Then he went on to preach on 'the goodness of the Lord' and on 'the Tigris and the Euphrates' and finally he did an imitation of J.P.S., how he had married A. and Lecomte.

But when I told him that I had once said in a conversation with Pa that I believed that one could say something edifying even in church, even from the pulpit, M. said, Yes. And then he did an imitation of Father Bernhard: God — God — is almighty — he

created the sea, he created the earth and the sky and the stars and the sun and the moon, he can do everything — everything — everything — and yet — no, He's not almighty, there's one thing He cannot do. What is the one thing that God Almighty cannot do? God Almighty cannot cast away a sinner. Well, adieu, Theo, do write soon, in thought a handshake, believe me

Ever yours,
Vincent

The Hague, 29 December 1881–10 September 1883

194 | The Hague, Thursday, 29 December 1881 | *To Theo van Gogh* (D)

The Hague, Thursday evening

My dear Theo,

Accept my thanks for your letter and the enclosure. When I received your letter I was back in Etten, following Mauve's advice, as I wrote to you. But now, as you see, I'm back in The Hague again.

At Christmas I had a rather violent argument with Pa, and feelings ran so high that Pa said it would be better if I left home. Well, it was said so decidedly that I actually left the same day.

Things actually came to a head because I didn't go to church, and also said that if going to church was something forced and I *had* to go to church, I'd most certainly never go again, not even out of politeness, as I've been doing fairly regularly the whole time I've been in Etten. But oh, there's actually much more to it, including the whole story of what happened this summer between me and K.V.

I was angrier than I ever remember being in my whole life, and I told Pa plainly that I found the whole system of that religion loathsome, and precisely because I dwelled on those things too much during a miserable time in my life I don't want anything more to do with it, and have to guard against it as against something fatal.

Was I *too* angry, *too* violent? — so be it, but even supposing that to be the case, then at least now it's over and done with.

I went back to M. and said, listen M., I can't stay in Etten and I have to go and live somewhere else, preferably here.

Well, M. said, stay here then. And so I've rented a studio here, namely a room and alcove which can be made suitable. Inexpensive enough, just outside town in Schenkweg, about 10 minutes from M.

Pa told me that if I needed money he would lend it to me if necessary, but now that's impossible, I must remain completely independent of Pa. How? I don't know yet, but M. is willing to help me if necessary, and you too, I hope and trust, and of course I'll work and do my utmost to earn a little.

I'm here now, and the fact is there's no turning back. At an inconvenient time, but what's to be done?

I must have some simple furniture, and my expenses for drawing and painting materials aren't getting any lower.

I also have to try and dress better. It's a daring move, and a question of sink or swim. But some day I'd have set up house on my own, so what else can I do? Now things have gone faster than I expected.

As far as the relations between Pa and Ma and me are concerned, they can't be put to rights so very quickly. The difference in our mentality and outlook on life is simply too great.

And although I spoke in anger, I said things that I also think when I'm in a calmer

mood. So I don't take back what I said, and anyway Pa has now heard it plainly. If I'd been calmer, I'd have said it in other, less extreme colours, but basically I'd have thought the same.

And I hope that in any case it will lead to something good. I must endure bad times and the waters will rise, possibly as high as the lips and possibly even higher, how can I know beforehand? But I'll fight my fight and sell my life dearly and try to win and pull through.

I'll be moving into the studio around 1 January. Regarding furniture, I'll take the very simplest, a wooden table, a couple of chairs.

For a bed, I'd be content with a woollen blanket and the floor. But M. wants me to buy a bed and will lend me the money if necessary. When drawing up an account of the 100 francs, there turned out to be money left over, even though I made two journeys this summer, and once, the last time, for such a long time. It's true that I ate and slept at home, but Pa himself said at the time that he could spare it.

You understand that I'm now extremely worried, and foresee much toil and tribulation. But still it's a relief to me that I've gone so far that I *can no longer* go back, and that even though the path is difficult, my path is now clear enough.

It goes without saying that I'm asking you, Theo, if you can do it, to send me now and then what you can without going short yourself. And — in the circumstances, send it to me rather than giving it to others. Because if possible we shouldn't get Mauve mixed up in this, as far as financial matters are concerned. It's already of inestimable value that he helps me artistically in word and deed. He insists, however, that I buy a bed, for instance, and a couple of pieces of furniture, and says, I'll lend it to you if necessary. Because according to him I must, *no matter what*, appear presentable as regards my clothing, and not try to scrimp and save.

I'll write to you again soon. *I don't want to consider it a misfortune* that it's turned out this way, on the contrary, despite all the emotion I feel a certain calm.

There is safety in the midst of danger. What would life be if we didn't dare to take things in hand?

I ran around everywhere to find that studio, both in the city and in Scheveningen.

Scheveningen is terribly expensive. This studio costs only 7 guilders a month, but the furniture makes it difficult. Still, if one has one's own things, they won't disappear, and one has surer ground beneath one's feet.

The light comes from the south, more or less, but the window is large and high, and I have hopes that it will look nice after a time.

You can imagine how stimulated I feel. What will my work be like in a year? If only I could express what I feel — well, Mauve understands all this and wants to give me as many technical tips as he can — what fills my head and heart must be expressed in drawings or paintings.

Mauve himself is very busy with a large painting of a pink against the dunes being hauled by horses. I think it's wonderful to be in The Hague, and I find no end of beautiful things and I must try and depict some of them.

Adieu, old chap, accept a handshake in thought and write soon, believe me

Ever yours,
Vincent

Many regards from M. and Jet.

I still have a bit of money, but how long will I be able to get by on it? I have to stay at the boarding-house until 1 January.

Just address your letters to the address A. Mauve. Uilebomen 198, since I go there almost every day.

196 | The Hague, on or about Tuesday, 3 January 1882 | *To Theo van Gogh* (D)

Dear brother,

I'm just writing to wish you a happy New Year, may it be a good year for you in every way and, I add egoistically, for myself as well.

Now as to me, it will perhaps not be disagreeable for you to learn that I'm installed in a studio of my own. A room and alcove, the light is bright enough, for the window is large (twice as large as an ordinary window), and it's more or less facing south. I've bought furniture in true 'village constable style', as you call it, but I think that mine resembles it much more than yours, although it was you who coined the phrase. (I have real kitchen chairs, for example, and a really sturdy kitchen table.)

Mauve lent me some money, 100 guilders, to rent it, furnish it and get the window and light fixed up. This is rather a worry, you'll understand, but anyhow it's the only sensible way, and in the long run it's much less expensive having one's own things than always spending money on yet another semi-furnished room.

I've had a great deal of difficulty, what with finding it and then arranging the furniture in such a way that I could manage with what I had. But now, old chap, I have a real studio of my own and am terribly pleased with it.

I hadn't dared hope that things would go this quickly, but now I think it superb and hope that you do too.

Listen, you know it all, my expenses will be slightly higher than they were in Etten, but let's put our shoulders to the wheel. M. gives me much hope that I'll soon be earning something.

And now that I'm in my own studio, it will most probably make a not unfavourable impression on some people who until now have thought that I'm merely dabbling, idling or loafing about.

I hope that you'll be able to send me something one of these days. If I needed something urgently and asked it of Mauve, he wouldn't refuse me, but for the time being he's really done enough. It happens to everyone at some point in life that he has to set himself up in his own house, and although at first I couldn't face being in debt, I do feel that it's better this way.

The plan is that I continue to work regularly from a model. That's expensive, and yet it's the cheapest way.

De Bock ultimately disappoints me, there's something spineless about him, and he gets angry if one says certain things to him that are actually only the ABCs. He has a feeling for landscape, he sometimes manages to imbue them with a kind of charm (including the large painting he's now working on), but in himself there's nothing to get

hold of. He's too vague and too insubstantial — cotton too finely woven. His paintings are a shadow of an impression, and in my opinion that impression is scarcely worth repeating so often.

I won't associate very much with the painters. I find Mauve more capable and more solid every day. And what more do I want? Theo, I'll have to start dressing a bit better now, though. Now I know more or less the direction I must take, and can stand up for it openly, so I won't avoid contact with people — also not follow them too much. M. and Jet send you their regards, adieu, I still have a lot to do, believe me

Ever yours,
Vincent

199 | The Hague, Sunday, 8 or Monday, 9 January 1882 | *To Theo van Gogh* (D)

You mustn't think that I'm sending the letter back to insult you, but I find this the quickest way to answer it clearly. And if you didn't have your letter back, you wouldn't be able to understand what my answer refers to, whereas now the numbers guide you. I have no time, I'm waiting for a model today.

Because I have only a little time, I knew no better means of answering your letter than to answer one thing and another like this, point by point.

(1) I didn't '*contrive*' to do it, on the contrary, when Pa was here, Mauve, Pa and I talked about my renting a studio in Etten — spending the winter there — coming back to The Hague in the spring. Because of the models and because I'd arranged to work there, and it was beginning to go well.

All the same, I'd have liked to prolong my stay in The Hague a bit, since I was here anyway, but nonetheless I seriously intended continuing my studies of the Brabant peasant types. And when I was crossed in realizing that plan, after M. had been consulted and I had already written to him about the studio in question (a shed which needed some repairs), I couldn't suppress my anger.

Please remember one of my letters to you in which I wrote to you in broad terms about my plan to continue those studies. I mean the letter in which I asked you to say a few heartfelt words to impress upon Pa and Ma how important my work in Etten was to me &c. I remember the words I used: it really would be too bad if a whim of Pa were to make me give up work which is now progressing so well and which I've been working on for months. Think about it yourself — despite Mauve's help, I'm in far more trouble here than at home, and I truly don't know how I'll get by.

2) That expression *that I contrive to make Pa and Ma's life miserable* is actually not yours, I've known it for a long time as one of Pa's Jesuitisms, and also told Pa and Ma that I considered it a Jesuitism and didn't take the slightest notice of it.

Pa regularly comes up with some such saying if someone says something to him that he doesn't know how to answer, and says, among other things, 'you'll be the death of me', while calmly reading the newspaper and smoking his pipe. So I take such expressions at their face value.

Or else Pa gets incredibly angry and is used to people being afraid, and it surprises Pa if people don't give way to his anger.

Pa is very easily hurt and irritable and full of obstinacies in domestic life and is used to getting his way. And the category 'the conventions and rules of this house', which I'm supposed to observe, includes literally everything that comes into Pa's head.

3) 'Fighting with an old man isn't difficult &c.' Because Pa is an old man I've spared him a hundred times, and tolerated things that are well-nigh intolerable. Well, this time it wasn't fighting but simply saying 'enough', and because he wasn't listening to reason and common sense I said it outright for once, and it's very good indeed that Pa has finally heard one thing and another spoken plainly that others sometimes think as well.

4) That it won't be put to rights quickly. For appearances' sake I straightened things out by writing again to Pa to say that I'd rented a studio, that I also wished him a happy New Year, that I hoped that in that new year we should no longer fight in that way or in any other manner. I'm not doing any more about it, I don't have to do any more about it. If this last scene were the only one of its kind, it would be different, but it was preceded by other scenes, when I'd said to Pa, in a calmer yet resolute way, many things that His Hon. systematically brushed aside one by one. So as regards those things I said in anger, I think the same things in a calmer mood, only then I refrain from saying them out of diplomacy or I say them in another way. But all diplomacy abandoned me when I got angry, and, well, now I've finally said it. I'm not asking for an apology, and as long as Pa and Ma take this attitude I won't take any of it back. If, later on, they possibly become a bit more humane and sensitive and fair, then I'll be glad to take it all back. But I doubt if that will happen.

5) That Pa and Ma can't stand it if there's bad blood &c. That's true inasmuch as they create a desert around themselves and are making their old age miserable, even though it could be good and satisfying. But as to those expressions, 'I can't stand it', 'this will be the death of me', 'my life is a misery', I no longer take any notice, because it's only a mannerism. And if they don't change, I fear, as I already said, that they're in for many miserable and lonely days.

6) That I'll regret it &c. Before things got as bad as they are now, I felt a great deal of remorse and sorrow, and tormented myself because things were going so badly between Pa and Ma and me. But now that it's come to this, well, so be it, and to tell you the truth I'm no longer sorry but can't help feeling relieved. If I realize later that I did the wrong thing, yes, then of course I'll regret it, but I still don't exactly see how it would have been possible to act otherwise. When someone tells me in no uncertain terms, 'leave my house, the sooner the better, within the half-hour rather than the hour', well, old chap, then I'm out in less than a quarter of an hour, and won't come back again either. It really is too bad. For financial reasons, and so as not to cause you or anyone else any more trouble, I wouldn't have left so easily of my own accord, you surely understand that, but now that they and not I said 'go away', well, the path I must take is clear enough.

7) As far as Mauve is concerned—yes of course I'm very fond of M., and sympathize with him, I like his work very much—and I consider myself fortunate to learn something from him, but I can't shut myself up in a system or school any more than Mauve

himself can, and in addition to Mauve and Mauve's work, I also like others who are very different and work very differently. And as far as me and my own work are concerned, perhaps there's a similarity sometimes, but certainly also a distinct difference. If I love someone or something, then I mean it, and there is definitely passion and fire sometimes, but that doesn't mean that I systematically find only some people perfect and all the others worthless — God forbid.

8) Free-thinking: actually that's a word I loathe, though I'm sometimes forced to use it for want of something better.

9) The thing is that I'm doing my best to think things through and try to take reason and common sense into account in what I do. And it would be totally inconsistent with that if one wanted to reduce someone to nothing. So it's entirely true that I sometimes said to Pa 'do consider this or that fully', or 'this or that doesn't hold water in my opinion', but that isn't trying to reduce someone to nothing. And I'm not Pa's enemy if I tell him the truth for once, not even when I said it angrily in salty language. Only it didn't help me at all, and Pa took it badly. Does Pa mean that I said that the morality and religious system of the clergymen and academic notions aren't worth tuppence to me since I've learned many of their tricks, then I certainly won't take it back, because I really mean it. It's only in a calm mood that I don't talk about it, but it's something else if one tries, for instance, to force me to go to church or to attach value to it, then of course I say it's absolutely out of the question.

10) Does Pa's life count for nothing? I already said that if I hear someone say 'you'll be the death of me', and all the while that man is reading his newspaper and half a minute later starts talking about goodness knows what advertisement, then I find such an expression rather inappropriate and unnecessary and pay no attention to it. As soon as those words or suchlike are repeated to others, who then start to look upon me as something of a murderer or even a parricide, then I say, such calumnies are neither more nor less than Jesuitisms. So there you have it. Besides, now the murderer has left home and so, in a word, I take no notice of it, and I even think it ridiculous.

11) You say 'I don't understand you'. Well, that I certainly believe, because writing is actually an awful way to explain things to each other. And it takes a lot of time, and you and I have rather a lot to do. But we must have a bit of patience with one another until we see and speak to one another again.

12) Write to me again. Yes of course, but first I have to agree with you on how.

Do you want me to write in a sort of business style, dry and formal and picking and choosing my words and actually saying nothing?

Or do you want me to go on writing just as I've been doing recently, telling you everything that pops into my head without being afraid to let fly, without mincing my words or holding back.

I prefer to do the latter, namely write or say plainly what I mean.

And now I'll end my direct answer to your letter because I still have to speak to you about drawing &c., and I prefer to talk about that. Please bear with me if I pretend for the time being that Pa and Ma don't exist, it would have been much better if I'd spent this winter in Etten, and it would have been much easier for me, particularly for financial reasons. If I were to think and fret about it, it would make me despondent, so that's it, it's over. Now I'm here and I have to manage somehow. If I were to write to Pa about it again, it would be adding fuel to the flames, and I don't want to get so angry

again, and I'm throwing myself with all my might into life and things here, what else can I do? Etten is lost and Het Heike, but I'll try to regain something else instead.

Now I thank you very much indeed for what you sent.

I don't need to tell you that I really have a great many worries besides. Naturally my expenses are more than in Etten and I can't set to work with half as much energy as I should like and should be able to if I had more at my disposal.

But my studio is turning out well. I wish you could see it, I've hung up all my studies, and you must send back the ones you have because they might prove useful to me. They may be unsaleable, and I myself acknowledge all their faults, but they contain something of nature because they were made with a certain passion.

And you know that I'm now struggling to make watercolours, and if I become adept at it they'll become saleable.

But Theo, you can be certain that when I first went to Mauve with my pen drawings and M. said, you should try it with charcoal and chalk and brush and stump, it was damned difficult for me to work with that new material. I was patient and it didn't seem to help at all, and sometimes I grew so impatient that I trampled on my charcoal and was wholly and utterly discouraged. And yet, a while later I sent you drawings made with chalk and charcoal and the brush, and I went back to Mauve with a whole batch of such drawings which of course he criticized, and rightly so, and you too, but all the same I had taken a step forward.

Now I'm going through a similar period of struggle and despondency, of patience and impatience, of hope and desolation. But I must plod on and anyway, after a while I'll understand more about making watercolours.

If it were that easy, one wouldn't take any pleasure in it. And it's exactly the same with painting. Moreover, the weather is bad, and this winter I haven't yet gone out for pleasure. Still, I enjoy life and, in particular, having my own studio is too wonderful for words. When will you come and have coffee or tea with me? Soon I hope. You can stay here too, if necessary, that would be nice and companionable. And I even have flowers, and a couple of boxes of bulbs. And I've also acquired another ornament for my studio, I got a great bargain on some splendid woodcuts from The Graphic, some of them prints not of the clichés but of the blocks themselves. Just what I've been wanting for years.

The drawings by Herkomer, Frank Holl, Walker, and others. I bought them from Blok, the Jewish bookseller, and chose the best from an enormous pile of Graphics and London News for five guilders. Some of them are superb, including the Houseless and homeless by Fildes (poor people waiting outside a night shelter) and two large Herkomers and many small ones, and the Irish emigrants by Frank Holl and the 'Old gate' by Walker. And especially a girls' school by Frank Holl and also that large Herkomer, the invalids.

In short, it's exactly the stuff I need.

And I have such beautiful things with a kind of restfulness in my house because, old chap, even though I'm still a long way from making them so beautifully myself, still, I have a couple of studies of old peasants and so on hanging on the wall that prove that my enthusiasm for those draughtsmen is not mere vanity, but that I'm struggling and striving to make something myself that is realistic and yet done with

sentiment. I have around 12 figures of diggers and people working in the potato field, and I'm wondering if I couldn't make something of them, you also have a couple of them, including a man putting potatoes in a sack. Anyway, I don't know what yet, but whether it's now or later, I must do it sometime, because I took a look at it this summer, and here in the dunes I could make a good study of the earth and the sky and then boldly put the figures in. Though I don't value those studies so very much, and hope of course to make them very differently and better, but the Brabant types are distinctive, and who knows how they might be put to use. If there are some among them you'd like to keep, then by all means, but I'd very much like to have back those you don't value. By studying new models I'll automatically become alert to the mistakes in the proportion of my studies of this summer and, taking that into account, they can easily be of use to me. When your letter took so long to arrive (for because it went first to Mauve I got it even later), I had to go to Mr Tersteeg and he gave me 25 guilders to last until I received your letter. Perhaps it would be good if I, with your knowledge, or you, with my knowledge, were to settle a few things with Mr T. Because you understand, Theo, I must know as definitely as possible where I stand, and I have to work it out in advance, and know that I can or cannot do this or that. So you'll be doing me a great favour by entering into a definite agreement, and I hope you'll write to me about it soon.

Mauve has promised to recommend me for an associate membership of Pulchri, because there I'd be able to draw from a model two evenings a week and would have more contact with artists. Later on I'll become a regular member as soon as possible. Well, old chap, thanks for what you sent — and believe me, with a handshake,

Ever yours,
Vincent

203 | The Hague, Thursday, 26 January 1882 | *To Theo van Gogh* (D)

Schenkweg 138 Thursday.

My dear Theo,

I received your letter and the 100 francs enclosed in good order, and thank you very much for both. What I feared would happen when last I wrote to you has now truly come about, namely that I fell ill and spent three days or so lying in bed with fever and anxiety. Accompanied now and then by headache and toothache. It's a wretched condition and comes from nervous exhaustion. Mauve came to see me and we agreed again to bear up bravely through it all.

But then I loathe myself so much for not being able to do what I'd like, and at such moments one feels as though one is bound hand and foot, lying in a deep, dark pit, powerless to do anything. Now it's over, inasmuch as I got up last night and pottered around a bit, putting one thing and another in order, and when this morning the model came of her own accord to have a look, even though I only half expected her, together with Mauve I arranged her in a pose and tried to draw a little, but I can't yet, and this evening I felt completely weak and miserable. But if I do as little as possible for

a couple of days then it will be over for a good long time, and if I'm careful I needn't be afraid that it will recur for the time being. I'm very sorry that you're not well either. When I was in Brussels last winter, I had baths as often as I could, 2 or 3 times a week in the bathhouse, and I felt very well and shall start doing it again here. I don't doubt but that it would also help you a lot if you were to keep it up for a while, because one gets what they call 'radiation' here, namely that the pores of the skin stay open and the skin can breathe, whereas otherwise it shrivels up a bit, especially in the winter.

And I tell you frankly that I definitely think you mustn't be embarrassed about going to a girl now and then, if you know one you can trust and you can feel something for, of which there are many in fact. Because for someone whose life is all hard work and exertion it's necessary, absolutely necessary, to stay normal and to keep one's wits about one.

One doesn't have to overdo that kind of thing and go to excess, but nature has fixed laws and it's fatal to struggle against them. Anyway, you know everything you need to know about it.

It would be good for you, it would be good for me, if we were married, but what can one do?

I'm sending you a little drawing, but you mustn't conclude from it that they're all like that, this is fairly thin and washed quickly, but that doesn't always work, especially with larger ones, in fact it seldom does.

Yet it will perhaps prove to you that it's not a hopeless case, that I'm beginning to get the hang of it, rather.

When Mauve was last here he asked me if I needed any money. I could put on a brave face towards him and that's going better, but you see that in an emergency he would also do something.

And so, although there will still be worries, I do have hope that we'll muddle through. Especially if Mr Tersteeg would be kind enough, if it's inconvenient for you, to give me some credit if it should prove absolutely necessary.

You speak of *fine promises*. It's more or less the same with me. Mauve says it will go well, but that doesn't alter the fact that the watercolours I'm making still aren't exactly saleable. Well, I also have hope and I'll work myself to the bone, but one is sometimes driven to desperation when one wants to work something up a bit more and it turns out thick. It's enough to drive one to distraction, for it's no small difficulty. And experiments and trials with watercolours are rather costly. Paper, paint, brushes and the model and time and all the rest.

Still, I believe that the least expensive way is to persevere without losing any time.

For one *must* get through this miserable period. Now I must learn not to do some things which I more or less taught myself, and to look at things in a completely different way. A great effort must be made before one can look at the proportion of things with a steady eye.

It's not exactly easy for me to get along with Mauve all the time, any more than is the reverse, because I think we're a match for each other as regards nervous energy, and it's a downright effort for him to give me directions, and no less for me to understand them and to attempt to put them into practice.

But I think we're beginning to understand each other quite well, and it's already beginning to be a deeper feeling than mere superficial sympathy. He has his hands full

with his large painting that was once intended for the Salon, it will be splendid. And he's also working on a winter scene. And some lovely drawings.

I believe he puts a little bit of his life into each painting and each drawing. Sometimes he's dog-tired, and he said recently, 'I'm not getting any stronger', and anyone seeing him just then wouldn't easily forget the expression on his face.

This is what Mauve says to console me when my drawings turn out heavy, thick, muddy, black, dead: If you were already working thinly *now*, it would only be being stylish and *later* your work would probably become thick. Now, though, you're struggling and it becomes heavy, but later it will become quick and thin. If indeed it turns out like that, I have nothing against it. And you see it now from this small one, which took a quarter of an hour to make from beginning to end, but — after I'd made a larger one that turned out too heavy. And it was precisely because I'd struggled with that other one that, when the model happened to be standing like this for a moment, I was later able to sketch this one in an instant on a little piece of paper that was left over from a sheet of Whatman.

This model is a pretty girl, I believe she's mainly Artz's model, but she charges a *daalder* a day and that's really too expensive for now. So I simply toil on with my old crone.

The success or failure of a drawing also has a lot to do with one's mood and condition, I believe. And that's why I do what I can to stay clear-headed and cheerful. But sometimes, like now, some malaise or other takes hold of me, and then it doesn't work at all.

But then, too, the message is to keep on working — because Mauve, for instance, and Israëls and so many others who are examples know how to benefit from every mood.

Anyway, I have some hope that as soon as I'm completely better things will go well, a little better than now. If I have to rest for a while I'll do it, but it will probably be over soon.

All things considered, though, I'm not like I was a year or so ago, when I never had to stay in bed for a day, and now there's something thwarting me at every turn, even if it isn't so bad.

In short, my youth is past, not my love of life or my vitality, but I mean the time when one doesn't feel that one lives, and lives without effort. Actually I say all the better, there are now better things, after all, than there were then. Bear up, old chap — it really is rather petty and mean of Messrs G&Cie that they refused you when you wanted to have some money. You certainly didn't deserve that, that they were so cold-hearted towards you, because you do a lot of their dirty work and don't spare yourself. So you have a right to be treated with some respect.

Accept a handshake in thought, I hope that I'll soon have something better to tell you than I did today and recently, but you mustn't hold it against me, I'm very weak. Adieu.

Ever yours,
Vincent

13 Feb. 82

My dear Theo,

Even though I'm rather expecting a letter from you one of these days, I'll write again anyway.

I heard a few things about you from Mr Tersteeg when he returned from Paris. He told me that you were doing well, and he seemed to be rather pleased with his trip. When I went to see him I had a couple of drawings, and he said that they were better than the last ones and told me that I should again make a couple of small ones. I'm working on those now. And I've also been working on a new pen drawing of an old woman knitting. And I believe it's better than last summer's, at least it has more tone. When I have a couple of pen drawings that have turned out quite well, I believe I know an art lover who will take them.

I also wrote to C.M. the other day to say I'd rented a studio here, and hoped that when he came to The Hague he'd let me know, or come and have a look. Uncle Cent also told me last summer that if I have a drawing, a little smaller than those of last summer and with more watercolour, I should simply send it and he would take it. Perhaps the time will soon come when my work will put some money in my pocket, which I'm badly in need of, precisely in order to tackle things more seriously.

If you can find out about it, you must tell me what kind of drawings one might be able to sell to the illustrated magazines. It seems to me they could use pen drawings of types of the people, and I'd like so much to start working on them, in order to make something suitable for reproduction. I don't think that all drawings are drawn directly on the blocks, there must be some means of getting a facsimile onto the block. Though I don't rightly know.

Sometimes I long so very much to see you and talk to you, will it be a long time before you come to Holland? I believe Pa half expected you to come for his birthday.

I was very glad that Mr Tersteeg found the drawings a little better, well, I'm also beginning to feel more at home with my model, and that's precisely the reason why I must continue with her now.

In the last two studies I captured the character much better, everyone who saw them said so. At the moment I quite often go to draw with Breitner, a young painter who's acquainted with Rochussen as I am with Mauve. He draws very skilfully and very differently from me, and we often draw types together in the soup kitchen or the waiting room &c. He sometimes comes to my studio to look at woodcuts, and I go to see the ones he has as well. He has the studio that Apol used to have at Siebenhaar's.

Last week I went to an art viewing at Pulchri which had sketches by Bosboom and Henkes. Very beautiful; there were a number of drawings by Henkes, larger figures than one usually sees from him. He ought to make more of them, I think.

Weissenbruch also came to see me.

I look forward every day to a letter from you, because I hope you'll send me something one of these days.

We must stick it out for a while, old chap, and persevere, you as well as I, and then we'll both get pleasure from it sometime.

I'm really very glad that I've gone on with the figure so far. If I'd been making only landscapes, perhaps I'd already be making something that would fetch a price, but later on I'd end up getting stuck anyway. Although the figure is more difficult and a more complicated matter, I believe it's more solid in the long run.

De *Bock* came here this afternoon just as I was working from the model, and when he saw the model he started saying that he'd quite like to draw figures too; all the same, he doesn't do it. He recently made a beautiful drawing, though.

In your last letter you told me something about the matter of your not being able to have any money before the inventory was finished. But if you don't have it, be so good as to write to Mr Tersteeg about it immediately, because I have only three guilders or so left and it's already nearly the middle of February.

So at all events I'm expecting a letter from you any day now.

I believe that I've got the proportions much better in my last drawings than in the previous ones, and that's exactly what seemed to me to be the worst fault in my drawings up to now, but that's changing, thank God, and then I won't be afraid of anything.

Adieu Theo, write soon, accept in thought a hearty handshake.

Ever yours,
Vincent

207 | The Hague, Friday, 3 March 1882 | *To Theo van Gogh* (D)

Friday, 3 March

My dear Theo,

Since receiving your letter and the money I've taken a model every day and I'm up to my ears in work.

It's a new model I have, although I'd drawn her before superficially. Or rather it's more than one model, because I've already had 3 people from the same family, a woman of about 45 who's just like a figure by E. Frère, and her daughter, 30 or so, and a younger child of 10 or 12.

They're poor people and, I must say, invaluably willing. I got them to pose for me, though not without difficulty and on the condition that I'd promise them steady work. Well, that was exactly what I wanted so very much, and I consider it a good arrangement. The younger woman doesn't have a pretty face because she had smallpox, but her figure is very graceful and I find it charming. They also have good clothes. Black woollens and nicely shaped caps, and a pretty shawl &c.

You needn't worry too much about the money, because we've agreed to compromise in the beginning. I've promised them a guilder a day as soon as I sell one. And that I'll make it up to them later for giving them too little now.

But I must manage to sell something.

If I could do so, I'd keep everything I'm now making of them for myself, because if I only kept them for a year I'm sure I could get more for them then than now.

But anyway, in the circumstances, it would be very nice if Mr Tersteeg bought a thing or two now and then, if necessary on the condition that he can exchange them if they don't sell. Mr Tersteeg promised to come and see me as soon as he can find the time.

The reason I'd like to keep them is simply this: when I draw individual figures it's always with an eye to making a composition with a number of figures, for instance, a 3rd-class waiting room or a pawnshop or an interior. But those larger compositions must ripen gradually, and *for a drawing with 3 seamstresses, for example, one must draw at least 90 seamstresses.* That's how it works.

I had a friendly letter from C.M. promising to come to The Hague soon and to visit me too. Well, that's just a promise, yet again, but perhaps something after all. Oh well.

For the rest I'll run after people less and less as time goes on, whoever they may be, neither art dealers nor painters, the only ones I'll run after are models, because I find working without a model totally wrong, at least as far as I'm concerned.

I say, Theo, it really is nice to see a tiny bit of light, and I do see a bit of light. It's nice to draw a person, something that lives, it's damned difficult but wonderful anyhow.

Tomorrow two children are coming to visit whom I must amuse and draw at the same time. I want some life in my studio, and already have all kinds of acquaintances in the neighbourhood. On Sunday an orphan boy is coming, a perfect type, but unfortunately I can have him only for a short time.

Perhaps it's true that I don't have the ability to mix with people who are keen on etiquette, but on the other hand I perhaps have more feeling for poor or simple folk, and if I lose on the one hand I win on the other hand, and sometimes I simply give up and think, after all it's right and reasonable that I, as an artist, live in what I feel and try to express. Evil be to him who evil thinks.

Now it's the beginning of the month again. Even though it hasn't been a full month since you sent me something, all the same, I'd like to ask you kindly to send me something if you can one of these days. It needn't be the 100 francs all at once, just as long as it's something to be getting along with between now and the time when you can send something. I say this because in a previous letter you mentioned that you couldn't get any money until the inventory had been finished.

Sometimes it grieves me to think that I might have to let the model wait, because they need it so much. I've paid them up to today, but next week I wouldn't be able to do it. But I can in fact have the model, be it the older woman or the younger or the child.

By the way, Breitner spoke to me about you recently, that there was something he very much regretted, for which he thought you might still be angry at him. For he still has a drawing that belongs to you, I believe, though I didn't rightly understand the matter. He's working on a large thing, a market scene which must accommodate a lot of figures. Yesterday evening I went out with him to look for figure types in the street in order to study them later in the studio with a model. In that way I drew an old woman I'd seen in the Geest district where the madhouse is — like this:

207A. *Old woman with a shawl and a walking-stick*

[*Sketch* 207A]

Well, good evening, I hope to hear something from you soon.

Ever yours,
Vincent

I also had to pay the rent this week. Good-night. It's already two o'clock and I'm not finished yet.

My dear Theo,

You will have received my letters, I'm answering yours, received this afternoon. In accordance with your request, I immediately sent Tersteeg 10 guilders, lent to me this week by His Hon. I wrote to you about C.M.'s order, this is what happened. C.M. appeared to have spoken to Tersteeg before he came to see me, at any rate began talking about things like 'earning your bread'. My answer suddenly came to me, quickly and, I believe, correctly. Here's what I said: earn my bread, what do you mean by that? — to earn one's bread or to deserve one's bread — not to deserve one's bread, that is to say, to be unworthy of one's bread, that's what's a crime, every honest man being worthy of his crust — but as for not earning it at all, while at the same time deserving it, oh, that! is a misfortune and A great misfortune. So, if you're saying to me here and now: you're unworthy of your bread, I understand that you're insulting me, but if you're making the moderately fair comment to me that I don't always earn it because sometimes I'm short of it, so be it, but what's the use of making that comment to me? It's scarcely useful to me if it ends there. I recently tried, I continued, to explain this to Tersteeg, but either he's hard of hearing in that ear or my explanation was a little confused because of the pain his words caused me.

C.M. then kept quiet about earning one's bread.

The storm threatened again because I happened to mention the name Degroux in connection with expression. C.M. suddenly asked, But surely you know there was something untoward about Degroux's private life?

You understand that there C.M. touched a tender spot and ventured on to thin ice. I really can't let that be said about good *père* Degroux. So I replied, it has always seemed to me that when an artist shows his work to people he has the right to keep to himself the inner struggle of his own private life (which is directly and inextricably connected with the singular difficulties involved in producing a work of art) — unless he unburdens himself to a very intimate friend. It is, I say, indelicate for a critic to dig up something blameworthy from the private life of someone whose work is above criticism. Degroux is a master like Millet, like Gavarni.

C.M. had certainly not viewed Gavarni, at least, as a master.

(To anyone but C.M. I could have expressed myself more succinctly by saying: an artist's work and his private life are like a woman in childbed and her child. You may look at her child, but you may not lift up her chemise to see if there are any bloodstains on it, that would be indelicate on the occasion of a maternity visit.)

I was already beginning to fear that C.M. would hold it against me — but fortunately things took a turn for the better. As a diversion I got out my portfolio with smaller studies and sketches. At first he said nothing — until we came to a little drawing that I'd sketched once with Breitner, parading around at midnight — namely Paddemoes (that Jewish quarter near the Nieuwe Kerk), seen from Turfmarkt. I'd set to work on it again the next morning with the pen.

Jules Bakhuyzen had also looked at the thing and recognized the spot immediately.

Could you make more of those townscapes for me? said C.M. Certainly, because I amuse myself with them sometimes when I've worked myself to the bone with the

model—here's Vleersteeg—the Geest district—Vischmarkt. Make 12 of those for me. Certainly, I said, but that means we're doing a bit of business, so let's talk straightaway about the price. My price for a drawing of that size, whether with pencil or pen, I've fixed for myself at a *rijksdaalder*—does that seem unreasonable to you?

No—he simply says—if they turn out well I'll ask for another 12 of Amsterdam, provided you let me fix the price, then you'll earn a bit more.

Well, it seems to me that that's not a bad way to end a visit I had rather dreaded. Because I actually made an agreement with you, Theo, simply to tell you things like this in my own way, as it flows from my pen, I'm describing these little scenes to you just as they happen. Especially because in this way, even though you're absent, you get a glimpse of my studio anyway.

I'm longing for you to come, because then I can talk to you more seriously about things concerning home, for instance.

C.M.'s order is a bright spot! I'll try to do those drawings carefully and put some spirit into them. And in any case you'll see them, and I believe, old chap, that there's more of such business. Buyers for 5-franc drawings can be found. With a bit of prac- tice, I'll make one every day and voilà, if they sell well, a crust of bread and a guilder a day for the model. The lovely season with long days is approaching, I'll make the 'soup ticket', i.e. the bread and model drawing, either in the morning or the evening, and during the day I'll study seriously from the model. C.M. is one buyer I found myself. Who knows whether you won't succeed in turning up a second, and perhaps Tersteeg, when he's recovered from his reproachful fury, a third, and then things can move along.

Tomorrow morning I'll go and look for a subject for one of those for C.M.

I was at Pulchri this evening—Tableaux vivants and a kind of farce by Tony Offer- mans. I skipped the farce, because I can't stand caricatures or the fug of an assembly hall, but I wanted to see the tableaux vivants, especially because one of them was done after an etching I gave Mauve as a present, Nicolaas Maes, the stable at Bethlehem. (The other was Rembrandt, Isaac blessing Jacob, with a superb Rebecca who watches to see if her ruse will succeed.) The Nicolaas Maes was very good in chiaroscuro and even colour—but in my opinion not worth tuppence as far as expression goes. The expres- sion was definitely wrong. I saw it once in real life, not the birth of the baby Jesus, mind you, but the birth of a calf. And I still know exactly what its expression was like. There was a girl there, at night in that stable—in the Borinage—a brown peasant face with a white night-cap among other things, she had tears in her eyes of compassion for the poor cow when the animal went into labour and was having great difficulty. It was pure, holy, wonderfully beautiful like a Correggio, like a Millet, like an Israëls. Oh Theo—why don't you let it all go hang and become a painter? Old chap—you could do it if you wanted to. I sometimes suspect you of keeping a great landscapist hidden in- side you. It seems to me you'd be extremely good at drawing birch trunks and sketch- ing the furrows of a field or stubble field, and painting snow and sky &c. Just between you and me. I shake your hand.

Ever yours,
Vincent

Here's a list of Dutch paintings intended for the Salon.

Israëls, an old man (if he weren't a fisherman he'd be Tom Carlyle—the author of the French Revolution and Oliver Cromwell—for he definitely has that distinctive head of Carlyle), an old man sits in a hut by the fireplace in which a small piece of peat barely glows in the twilight. For it's a dark hut the old man sits in, an old hut with a small window with a little white curtain. His dog, who's grown old with him, sits beside him—those two old creatures look at each other, they look each other in the eye, the dog and the old man. And meanwhile the man takes his tobacco box out of his trousers pocket and he fills his pipe like that in the twilight. Nothing else—the twilight, the quiet, the loneliness of those two old creatures, man and dog, the familiarity of those two, that old man thinking—what's he thinking about?—I don't know—I can't say— but it must be a deep, a long thought, something, though I don't know what, surfacing from long ago, perhaps that's what gives that expression to his face—a melancholy, satisfied, submissive expression, something that recalls that famous verse by Longfellow that always ends, But the thoughts of youth are long long thoughts. I'd like to see that painting by Israëls as a pendant to Millet's Death and the woodcutter. I definitely know of no other painting than this Israëls that can stand up to Millet's Death and the woodcutter, that one can see at the same time, on the other hand I know of no other painting that could stand up to this Israëls than Millet's Death and the woodcutter, no other painting that one can see at the same time as this Israëls. Moreover, I feel in my mind an irresistible desire to bring together that painting by Israëls and that other by Millet and make them complement each other. It seems to me that what this Israëls lacks is having Millet's Death and the woodcutter hanging close by, one at one end and the other at the other end of a long, narrow room, with no other painting in that gallery but those two and them alone.

It's a fabulous Israëls, I couldn't really see anything else, it made such a deep impression on me. And yet, there was another Israëls, a small one with 5 or 6 figures, I think, a labourer's family at table.

There's a Mauve, the large painting of the pink being dragged onto the dunes, it's a masterpiece.

I've never heard a good sermon about resignation nor been able to imagine one, except for this painting by Mauve and the work of Millet. It is indeed *resignation*, but the true kind, not that of the clergymen. Those nags, those poor, sorry-looking nags, black, white, brown, they stand there, patiently submissive, willing, resigned, still. They'll soon have to drag the heavy boat the last bit of the way, the job's almost done. They stand still for a moment, they pant, they're covered in sweat, but they don't murmur, they don't protest—they don't complain—about anything. They're long past that, years ago already. They're resigned to living and working a while longer, but if they have to go to the knacker's yard tomorrow, so be it, they're ready for it. I find such a wonderfully elevated, practical, wordless philosophy in this painting, it seems to be saying,

to know how to suffer without complaining, that's the only practical thing, that's the great skill, the lesson to learn, the solution to life's problem.

It seems to me that this painting by Mauve would be one of those rare paintings which Millet would stand in front of for a long time, mumbling to himself, he has a good heart, that painter.

There were other paintings—I must say I scarcely looked at them, I had enough with the above-mentioned.

Listen Theo, wouldn't you like to ponder whether there's not a great landscapist in you? We should both of us quite simply become painters, we'd be able to make a living at it. For the figure one must be more of a draught ox or work-horse, more a man of hard labour. There's a long long thought for you—old boy.

Theo, remain something better than HGT. When I first got to know him, HGT was better than now, he'd been a bigwig only a short time and was newly married. Now he's been caught, he's trapped. He'll grow more and more to have secret regrets about many, many things and will be forced to conceal them. The thing is, Theo, my brother, not to let your hands be tied by anyone, especially not with a gilt chain. I have to say that the chain tying Tersteeg is very beautiful to look at, but anyone who thinks about it doesn't envy his position. Be that as it may, artist is healthier—pecuniary difficulties are the greatest worry, I repeat, you, and you as a landscape painter, would surmount them sooner than I, though I, too, shall pull through some day. But, if you push off immediately, you'll overtake me, because the figure is complicated, takes longer. You'll understand that I speak in all seriousness.

214 | The Hague, on or about Sunday, 2 April 1882 | *To Theo van Gogh* (D)

My dear Theo,

I've set about writing to you several times, but I couldn't bring myself to finish the letter, because I wanted to write to you about various reasons why I thought it such a natural thing for you to become a painter. But I didn't like what I'd written, and I couldn't find any words that were strong enough.

Your objections are indeed serious, but on the other hand there are a great many things that weigh against them. By your 30th year you could have progressed to the extent that people must respect you as a painter and take your work seriously. And in your 30th year you'll still be young. What you've learned at Goupil, your knowledge of many things, means that you have exactly what it takes to catch up with many who 'started early'. Because those early starters often have a period of staying at the same level fruitlessly for years, and that period isn't necessary for someone who starts energetically at a later age. Painting is just as good a profession by which to earn a living as, for example, smith or doctor. An artist, in any case, is the exact opposite of someone living a life of leisure, and as I said, if one wants to draw a parallel, then either a smith or a doctor corresponds more closely. Now that you write about it, I remember very well that when you spoke to me back then about my becoming a painter, I thought it very inappropriate and wouldn't hear of it.

What made me stop doubting is that I read a clearly written book on perspective, Cassagne, Guide de l'Abc du dessin, and a week later drew an interior of a little kitchen, with stove, chair and table and window in their place and on their legs, whereas it used to seem to me downright witchcraft or coincidence that one had *depth* and proper perspective in a drawing. If you drew just one thing as it should be drawn, the desire to attack 1,000 other things would be irresistible. But the most difficult part

is taking that first step. If a painter took you by the arm and said: Look, Theo, *this* is how you should draw that field, *this* is how the lines of the furrows run, for this reason or that they run like *this* and not otherwise, and must be brought into perspective like this. And that pollard willow being this big, the other one further on is by contrast *that* small, and that difference in size can be measured this way or that and—look! if you fling that down on paper then the broad outlines are immediately correct, and you have firm ground beneath your feet on which to continue.

Such a talk, provided it's accompanied by practice, would be more appropriate in the circumstances than a lot of discussion about either abstract or financial matters. And so I won't venture further into that territory, but you're on the verge of getting an idea of the practice one day soon—and if you should happen to draw something correctly or, in short, if you learn to see things in perspective, then your art dealership has had it, and you'll feel, just like Correggio: I, too, am a painter, and then you'll see immediately that you're in your element and then—then—you'll be younger and more full of life than ever before, then your second youth will begin, which is better than the first, because the second never ends, thank God—doesn't end like the other one. But the first youth—has left me and—and—is beginning to leave you.

As regards Cor's education and Ma's bread—those two things won't be lacking, not even if you become a painter. And as far as you're concerned, your food, drink, sleep, your studio, your model—. they aren't far off—and if the idea to paint should awaken in you, you'd see that it could be done.

Nevertheless, so that you won't suspect me of overlooking the financial side, I'd just like to say—yet with all due respect for your present position as an art dealer: unless one has a certain handicraft and can make something with his own hands, I doubt the soundness of the means of subsistence.

Meaning that I consider the social position of Jaap Maris, for example, more solid and independent than that of H.G.T.—I have a lot of respect for intellect and intelligence, if those are lacking then one comes to nought in spite of one's handicraft, because one can't stand up and defend one's own work—you see this in Thijs Maris. But it's precisely those people who have the intellect and intelligence, and it goes without saying that I count you among them and I'd like to count myself among them too, it's fitting that they're eminently suited to handiwork.

I repeat: if you take up painting you'll succeed and, by your 30th year, you as a painter will have worked your way up, no less so in any respect than at present. A mediocrity in the bad sense of the word will certainly not be the case with you if you take up painting.

As regards painting, there are two lines of reasoning, how *not* to do it and HOW TO DO IT. *How to do it*: with much drawing and little colour. How not to do it: with much colour and little drawing.

Now I see the opportunity to manage very well if you can arrange it this month as you said, namely that around the 15th you give me another 100 francs to last until the beginning of May. From the 100 francs just sent I haven't yet been able to pay Tersteeg— I have a lot of expenses—and I could wait no longer to buy a pair of trousers and pay the rent, for example. If you send some again around the middle of April, then I *could* pay him back, and will do so if you really wish it. Though I'd rather pay it back later with a drawing. That's what I ought to be doing, I mustn't give any cash back to *dealers*.

My debt to you is something else. We don't know how things will turn out. If you carry on as an art dealer, then in time you'll be getting drawings and paintings for it — if you become a painter, then money, and gladly with interest.

Regarding the money owed to Tersteeg, when I first came here, he and Mauve were so friendly and said I didn't have to worry at all — but in less than a month they'd turned around and were talking completely differently. Perhaps thinking that I'd collapse.

At first that grieved me — and then later it left me rather cold and I thought, I won't let it upset me any more.

Breitner's in hospital, I visit him quite often to bring him books or drawing materials. C.M. paid me, and a new order, but difficult enough, *6 detailed, specific, townscapes*. I'll see that I make them in any case, because if I understand correctly I'll get for these 6 as much as for the first 12. And then perhaps sketches of Amsterdam.

Blommers was here to talk about a viewing of the woodcuts. Sat here looking at them for 3 hours, and was angry because Pulchri's board had complained about 'those things one sees now and then in the Zuid-Hollandsch Koffiehuis'. If that's all they know about wood engraving they're indeed competent to condemn! Still, Pulchri's board had complained. Blommers wanted to go ahead with it anyway, and told me to have them ready for next Saturday. It's very strange to hear some painters here discussing what they call 'illustrators', Gavarni, for instance, or Herkomer!! This NOT keeping abreast of things is part of what some of them call their *general education*. Good luck to them!

Now, with a handshake

Ever yours,
Vincent

Accept my thanks for a wonderful box of Ingres paper and for the studies.

One fine day when people start to say that I can in fact draw but not paint, perhaps I'll appear with a painting just when they least expect it, but as long as it looks as though I *must* do it and *may not* do anything else, then I certainly won't do it.

220 | The Hague, on or about Sunday, 23 April 1882 | *To Theo van Gogh* (D)

Theo,

Since I wrote to Mauve 'do you realize that those two months are long past, let's shake hands and go our separate ways rather than quarrel', I say, since I wrote such a thing and received no sign of life in return, it's as though something has been choking me.

Because — and you know this — I do love Mauve, and it's so awful that nothing much will come of all that happiness he held out to me. For I fear that the better I draw the more trouble and opposition I'll encounter. Because I'll have to suffer greatly for various idiosyncrasies that I *cannot* change. First of all, my appearance and manner of speaking and clothing, and also because later, when I'm earning more, I'll continue

to live in a different sphere from most other painters, because my view of things, the subjects I want to depict, inevitably demand it.

Enclosed is a little sketch of Diggers, I'll tell you why I'm enclosing it:

Tersteeg says to me: 'Things didn't go well for you earlier either, and it was a failure, and now it's the same all over again'. Stop right there — no, it's wholly different from before, and that line of reasoning is in fact fallacious. That I wasn't suited to commerce or professional studies in no way proves that I'd also be unfit to be a painter. On the contrary, if I were fit to be a clergyman or a dealer selling the work of others, perhaps I wouldn't have been fit for painting and drawing, and wouldn't have both handed in and been given my notice as such.

It's precisely because I have a draughtsman's fist that I can't keep myself from drawing and, I ask you, have I ever doubted or hesitated or wavered since the day I began to draw? I think you know very well that I've hacked my way through and am obviously ever more keen to do battle.

Coming back to that little sketch — it was made in the Geest district in the drizzle, standing in a street in the mud, in all that bustle and noise, and I'm sending it to show you that my sketchbook proves that I try to capture things first-hand. Put Iterson or H.G.T. himself, for example, in front of a sandpit in the Geest district where the dredgers are at work laying a water or gas pipe — I'd like to see the kind of face someone like that would pull and what kind of sketch he'd make. Struggling on wharves and in alleys and streets and inside houses, waiting rooms, even public houses, that's not a nice job, *unless one is an artist*. As such one would rather be in the filthiest neighbourhood, provided there's something to draw, than at a tea party with nice ladies. Unless one draws ladies, in which case a tea party is nice even for an artist.

I only mean to say that looking for subjects, frequenting the labourers, the struggle and worry with models, drawing from nature and on the spot, is all rough work — sometimes even filthy work, and truly, the manners and clothing of a shop assistant aren't exactly the most appropriate for me or anyone else who doesn't have to speak to beautiful ladies and wealthy gentlemen and sell them expensive things and earn money, but instead draws diggers in a pit in the Geest district, for instance.

If I could do what H.G.T. or Iterson can, if I were suited to it, I wouldn't be fit for my profession, and for my profession it's better that I am as I am than that I force myself to adopt manners that wouldn't fit me. I — who wasn't at ease in a reasonably good coat in a respectable shop and no longer could be, especially now, and would most likely be bored and be a bore — am a completely different person when I'm working in the Geest district, say, or on the heath or in the dunes. Then my ugly face and my weather-stained jacket are perfectly in keeping with my surroundings, and I'm myself and work with pleasure.

Whatever the '*How to do it*' entails, I hope to battle on. If I wear a nice coat, the workers I need as models are distrustful and fear me like the devil, or else they want a lot of money from me.

Now I'm struggling along as I see fit, and it seems to me I'm not one of those who complain that 'there are no models in The Hague'. So if remarks are made about my manners in the sense of clothing, face, manner of speaking, what shall I say in reply — — — that such talk bores me.

Am I then *someone without manners* in another sense, namely rude or tactless? Look, in

my opinion all civility is based on kindness towards everyone, especially towards those we know — based on the need felt by anyone with a heart in his breast to mean something to others and to be of some use — on the need one ultimately has to live with others and not alone. It's for that that I do my best, I draw not to annoy people but to amuse them, or to draw their attention to things that are worth looking at and which not everyone knows. I refuse to believe, Theo, that I'm such a monster of rudeness or incivility as to deserve to be cut off from society or, in the words of Tersteeg at any rate, 'be unable to remain in The Hague'.

Do I lower myself by living with the people I draw, do I lower myself by frequenting the houses of workers and poor people or by receiving them in my studio? It seems to me that my profession involves that, and only those who understand nothing of painting or drawing are entitled to find fault with it.

I ask this: where do the draughtsmen for The Graphic, Punch &c. get their models? Do they or don't they go themselves to round them up in the poorest alleyways of London? And the knowledge they have of the people, is it innate — or did they acquire it later in life by living among the people and by paying attention to things that most people walk right past, by remembering what many forget?

When I go to see Mauve or Tersteeg, I can't express myself as I'd like, and perhaps I do more harm than good. When they get used to my manner of speaking, it won't bother them.

But, if you will, tell them from me how matters stand, that if I said or did anything to hurt them, I hope they'll forgive me. Tell them, in better words than I can find and with the necessary civility, how *they*, for their part, caused *me* much pain, much sorrow, much trouble in the few short months which these unpleasantnesses have made so long. *Make them understand this, because they don't know it, they take me to be insensitive and indifferent.* And by doing so you'll be doing me a big favour, and I believe that everything can be settled in this way. I wish they'd simply accept me as I am. Mauve has been good to me and has given me considerable and unstinting help, but — it lasted a fortnight. *That's too short.*

Adieu Theo — do your best in this affair — if I have a bit of good fortune here instead of misfortune, I won't have to make life difficult for you, and now enough, believe me

Ever yours,
Vincent

You've no doubt heard of Pa's calling and that Ma's better again, but Uncle Cent is ill. I'm working on the drawings for C.M., but I've been so depressed these days by what I wrote to you that it's torn me away from my work, and then I thought, some light must be shed on the matter, perhaps Theo can enlighten me.

It's no wonder that it depressed me, because Tersteeg already told me '*that I wouldn't be able to remain in The Hague*', and I thought, he's just the kind of person who, if he puts his mind to it, will thwart me and try to cripple me every step of the way. But how on earth is it possible, and what has come over them? If he thinks my drawings aren't good, is that any reason for such resolute *opposition*, with whichever weapons?

[*Sketches* 220A–B]

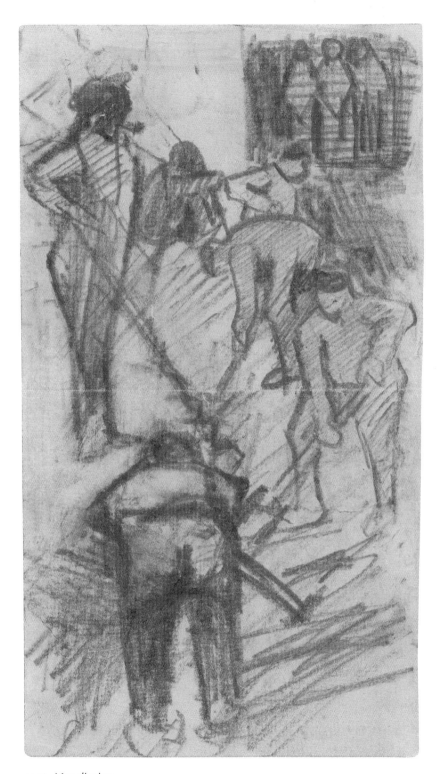

220A. *Men digging*

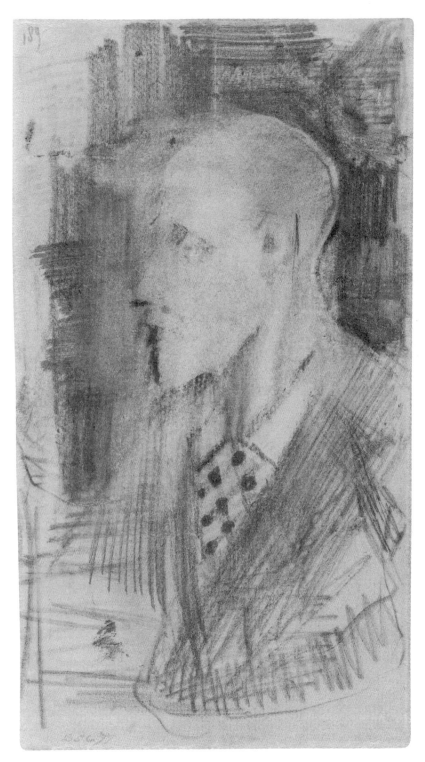

220B. *Head of a man*

My dear Theo,

I received your letter with the enclosed 100 francs and thank you most sincerely for it. Your letter enlightened me more than all my worrying and fretting about the question of Mauve and HGT. I compliment you on it, because now I believe I understand it better. And, if I understand correctly, what I have to do is go on working calmly without dwelling on it or taking it to heart as much as I did. If I dwell on it, I have the same feeling of dizziness which, you say, someone who hasn't studied perspective feels when he tries to follow the receding lines in nature and give an account of them. And I believe that just as the whole perspective changes with a change in eye level, which depends not on the objects but on the man viewing them (whether he stoops or stands on top of something), so too the change in Mauve and H.G.T. is in part only an outward seeming and can be explained by my own mood. I don't see these affairs clearly, but I think I see plainly from your letter that there's no reason for me to be overly concerned about it if only I go on working. And now enough about it, because there are other things to write.

Heyerdahl's sympathy moved me deeply, will you give him my regards and say that I hope very much to make his acquaintance some day, and that I set great store by it.

I've now finished two larger drawings. First of all, Sorrow, but in a larger format, the figure alone without surroundings. But the pose has been altered somewhat, the hair doesn't hang down the back but to the front, part of it in a plait. This brings the shoulder, the neck and back into view. And the figure has been drawn with more care.

The other one, 'Roots', is some tree roots in sandy ground. I've tried to imbue the landscape with the same sentiment as the figure.

Frantically and fervently rooting itself, as it were, in the earth, and yet being half torn up by the storm. I wanted to express something of life's struggle, both in that white, slender female figure and in those gnarled black roots with their knots. Or rather, because I tried without any philosophizing to be true to nature, which I had before me, something of that great struggle has come into both of them almost inadvertently. At least it seemed to me that there was some sentiment in it, though I may be mistaken, anyway, you'll have to see for yourself.

If you see something in them, perhaps they'll be suitable for your new home, and then I'll have made them for your birthday, on which I congratulate you. But because they're rather large (1 whole sheet of Ingres), I don't know if I should send them straightaway. Let me know. Perhaps H.G.T. would find it impertinent or priggish if I asked him to pack them in a crate as a return shipment.

Although *Roots* is only a 'pencil' drawing, it has been brushed in and scraped off, the same as one paints.

As regards the carpenter's pencil, my reasoning is as follows. The old masters, what would they have drawn with? Certainly not with Faber B, BB, BBB, &c. &c., but with a rough piece of graphite. The implement Michelangelo and Dürer used was perhaps very similar to a carpenter's pencil. But I wasn't there and don't know. This I do know, that with a carpenter's pencil one can achieve intensities differently than with those fine Fabers &c.

I like graphite better in its natural form than cut too fine in those expensive Fabers. And the shininess disappears by fixing it with milk. If one sits outdoors and works with Conté, one can't really tell what one's doing because of the bright light and notices that it's become too black, but graphite is more grey than black, and one can always obtain a couple of extra octaves by working it over with the pen, so that the strongest intensities of graphite actually lighten up through the repoussoir of the pen.

Charcoal is best, but if one works with it too long it loses its freshness, and to keep the subtlety one has to fix those spots. For landscapes as well, I see that such draughtsmen as Ruisdael, Van Goyen and Calame, Roelofs too, among the moderns, used it to great advantage. But if someone invented a good pen to work with outdoors, with accompanying inkwell, perhaps more pen drawings would be made.

One can do wonderful things with charcoal that has been soaked in oil, I've seen this from Weissenbruch. The oil is then the fixative, and the black becomes warmer and deeper. But I imagine it would be better for me to do that in a year and not now, because I want the fine appearance to come from me and not from my material. When I'm a bit further along I'll put on a nice suit now and then, meaning I'll work with rewarding drawing materials. And provided I myself am capable of doing something, I'll make twice as much progress, and perhaps it will prove easier than expected. But first, before any success, hand-to-hand combat with the things in nature.

Last year I wrote you a great many letters telling you what I thought about love. I'm not doing so now, because I'm busy putting those same things into practice. The person for whom I felt what I wrote to you is not on my path, is beyond my reach, despite all my longing for her. Would I have done better to go on thinking of her and to overlook what came my way? I cannot decide whether I'm acting consistently or inconsistently. Suppose I were to start today on a drawing of a digger, for example — but the man says, I have to leave and won't or can't pose again — I don't have the right to blame him for leaving me there with a barely sketched drawing, the more so because I started to draw him without asking permission. Must I then give up drawing a digger? I think not, especially not if tomorrow I encounter one who says, I want to come not only today but also tomorrow and the day after, and I understand what you need, go ahead, I'm patient and have the good will to do it. To be sure, I didn't stick exactly to my first impression, but would I have done better to reason: no, I definitely need that first digger, even if he says, I can't and won't? And once I've started on No. 2, then I may certainly not work without reference to the nature standing before me, thinking the while of No. 1. That's how things stand. And concerning that, I add this to my previous letter. In order for me to succeed, you'll have to help me a bit, but I believe the expense would be not more but less than what you've been sending me these last few months.

I'd be willing and daring enough to embark on this undertaking if I could count on 150 francs a month for another year. I do hope in that case to earn something as well, but if that were to fail I'd be able to scrape by anyway, though admittedly in straitened circumstances. And then later — when that year has passed? It seems to me that there's nothing in my work to indicate that I won't succeed, provided I plough on and continue to make an effort. And I'm not one to work slowly or fretfully. Drawing is becoming a passion with me, and I'm becoming increasingly absorbed in it, and where there is a will is a way.

Where is a will is a way, but that has to come from both sides. For me *the will* must

be the making of things, and for those who have or may acquire sympathy for me, *the will* is selling or buying those things.

The will being there, I think *the way* can be found. But if everyone reasoned like H.G.T. — 'unsaleable', 'disagreeable' — then I'd be confronted with a mountain of trouble. Oh well — be that as it may — I'll put more effort into my work to defeat the disagreeable and unsaleable.

There's been a terrible storm here for 3 nights running. In the night from Saturday to Sunday the window of my studio gave out. (The house where I live is very dilapidated.) 4 large panes broken and the window wrenched loose. You can imagine this wasn't all. The wind came sailing over the flat pastures directly at my window. The fence below was also knocked down, the drawings ripped from the wall, the easel on the floor. I nevertheless tied the window down with my neighbour's help, and nailed up a woollen blanket against the opening, certainly a □ metre in size. Didn't sleep a wink the whole night, as you can imagine. And lots of trouble to fix it because it was Sunday. The landlord is a poor pedlar, he gave me the glass, I paid for the work. All the more reason why I'm thinking of moving next door. There's an upstairs flat like this:

[*Sketch* 222A]

The studio is larger than mine, the light very good. There's an attic, completely panelled over, so that one doesn't see the roof tiles. Extremely large, where one can partition off as many rooms as one likes (and I have the planks to do it). Rent 12.50 guilders a month, a strong, well-built house, but it won't bring in any more, because it's 'only in Schenkweg' and the rich people the owner had hoped for won't come here.

I'd like it very much, and the owner would like to have me rent it; he spoke to me about it first and then I went to see it.

And now I'll finish by saying that I assure you I think about home a great deal, and am of the opinion that half a year from now, if the matter about which I wrote to you has been undertaken and Pa and Ma come to visit me, it would result in a change of feeling on both sides. Unfortunately, though, now is not the time, we have to get things started first. Because Pa and Ma, whom I consider to be lay people in the circumstances, will think it very nice if it's more finished (Belgian merchants say more *finessed*, according to Mauve), but the rough sketch, which you'd understand if you'd been here, would make them dizzy at the very least. Adieu — I wish you the best.

Ever yours,
Vincent

If you're coming soon, I won't send the drawings. But it's time you started to get things from me, I'll do my best, and if you like these two, for example, you'll get many more and of all kinds.

If you show the ones you find suitable to the people who come to your room, perhaps that would be the beginning of selling them, and particularly when a number of them are shown together, and various ones by the same hand, they draw attention to one another, and the one complements and explains the other.

What I value most is your sympathy. If I positively win that, the selling will follow. But neither I nor you must force that sympathy.

I believe I can produce a great deal, I mean, work rapidly and not waste time. And

Where is a will is a way doch dat moet
van twee kanten gaan. The will by my moet zyn
het maken der dingen the will by wee.
sympathie voor my hebben of krygen moyten en het
verkoopen of koopen van die dingen.
The will daarzynde meen ik the way te vinden zy.
Maar als alleen redeneeren zou als H.G.T. "onverkoopbaar"
"onbehagelyk" dan kwam er een berg displeizier my voor den
neus. Enfin — wat hier ook van zy — om het onbehagelyk &
onverkoopbaar te overwinnen zal ik my nog meer op het werk
inspannen.
Gedurende 3 nachten heeft het hier erg gestormd. Den nacht van
Zaturdag op Zondag is het raam van myn atelier bezweken.
(het huis waar ik woon is zeer wrak.) 4 groote ruiten kapot en
het venster losgerukt. Gy kunt denken dat niet
alles was. De wind kwam over de vlakke weilanden aanzetten
en myn raam kreeg hem uit de eerste hand. De schutting
beneden ook omver. De teekeningen van den muur gescheurd
7 ezel tegen den grond. Met behulp van myn buurman
heb ik evenwel het raam nog vastgebonden & tegen het
gat zeker een □ meter groot een wollendeken gespykerd.
Den heelen nacht geen oog dicht gedaan zoo als ge denken kunt
En nog veel gescharrel om 't gemaakt te krygen om reden van den
Zondag. De huisheer is een arme schanrelaar hy heeft het glas
gegeven ik het werkloon. Maar reden te meer waarom ik er over
denk om hier naast te gaan wonen. En is daar een bovenhuis aldus.

Keuken Kamer
opgang alkoof
Atelier 3 ramen op
't noordwesten

't atelier is grooter dan 't myne 't licht zeer
goed. Er is een zolder geheel met planken
beschoten enorm groot waar men nog
zooveel kamers kan afscheiden (en ik de
schotten er voor) als men maar wil. Huurprys
f12.50 per maand een steil goedgebouwd huis
Doch het doet niet meer omdat het "maar op den
Schenkweg" staat en daar de ryke huurders niet
komen die de eigenaar wel wachtte
Ik zou er zeer veel zin in hebben. en de
eigenaar zou my er wel in willen hebben en heeft er my 't eerst over gesproken
en morgen ik gaan zien.
En nu eindig ik met te zeggen. Dat ik U verzeker ik veel aan 't huis
denk en van meening ben dat als het een half jaar verder is en de zaak
waarover ik schreef op ondernomen en Tu en giue eens by me komen
dit wel een verandering van stemming van weerskanten ten gevolge
zou hebben. Doch dat 't nu helaas nog niet 't moment is en we eerst
bi omg op syn pooten moeten zien te krygen. Want Tu en Moe die ik
in de gegevenen wel als leeken mag beschouwen zullen het heel mooi vinden
als 't verder af is (meer gefinisteerd zeggen de belgische koopler volgens Mauve)
doch van de ruwe schets die gy begrypen zoudt als ge hier waart zouden
zy minstens duizelig worden. adieu — het beste U toegewenscht. t. à t.
Vincent

222A. Ground plan of Van Gogh's future house

if I've sent you another couple, since you sent back the old studies as I asked you to do (the Laan van Meerdervoort and Sorrow), it's to give you a sign that I can make more of the same if you'd like. If you say they aren't ready, I'll go on working before sending more, because what I sent isn't something accidental: what I can do, I can do. I must go on working for a time to make even more progress. But I want to say this: if the last batch I sent proves to have anything you could begin showing to people, I could start to send you things as soon as I have something. What you considered good would then have to be put into grey mounts, and a portfolio would gradually take shape in this way. Think about it.

I have another drawing of an old man by the fireplace, 'the boarder', an old woman from the Geest district, a couple of female figures which I think would go well with the others. Also small sketches.

I'm not saying this to make you hurry, but it can't do any harm to think it over.

You started helping me without knowing what would come of it, and when others wouldn't. I do hope that one day you'll be able to say calmly to those who think it's foolish of you to help me that you haven't lost anything by it. And that stimulates me all the more, and I think you should start by taking a few drawings, and every month there will be more. There are days when I make 5, but with drawings you must count on 1 in 20 succeeding. That 1 in 20 is no longer an accident, though, I can count on that. There will probably be 1 every week about which I feel 'that will remain'. For the time being it's better for you to keep the ones that 'will remain' than for me to give them to someone here for 10 guilders or so, and then only by the grace of God and as a great favour. Here *everyone* criticizes the technique, but I also hear the same platitudes from everyone about English drawings, for example. Weissenbruch alone said, when I told him that I *see* the things as pen drawings — then you must draw with the pen.

He, namely Weiss., saw the large rather than the small Sorrow, and he said things about it that pleased me. That's why I dare to say what I say about the large one. I've had no 'guidance', no 'instruction' from others, but have taught myself, as it were, so it's no wonder that on the face of it my way of doing things differs from that of others. But that's no reason for my work to remain unsaleable. I'll wager that the large Sorrow, the woman from the Geest district, the boarder and others too, if you will, will indeed find a buyer one day. But it could well be that I'll work on them again later. I've even worked again on the Laan van Meerdervoort. I have a female figure in a black merino frock in front of me, and I'm certain that if you had it for a few days you would become reconciled to its manner and wouldn't wish it had been done differently.

I didn't understand English drawings either at first, as little as any other foreigner, but 'I took the trouble to become acquainted with them' and haven't regretted it.

Adieu, enough for today.

I give you leave to say what you like to Mauve about the contents of this letter, but it doesn't have to go any further.

My dear Theo,

Today I met Mauve and had a very regrettable conversation with him which made it clear to me that Mauve and I have parted ways for ever. Mauve has gone so far that he can't retract it, or at least certainly wouldn't want to. I asked him to come and see my work and talk things over afterwards. Mauve refused outright, 'I certainly won't come to see you, it's over and done with'.

In the end he said, 'you have a vicious character'. At that point I turned around—it was in the dunes—and walked home alone.

Mauve blames me for saying, I'm an artist—which I won't take back, because those words naturally imply always seeking without ever fully finding. It's the exact opposite of saying, 'I know it already, I've already found it'. To the best of my knowledge, those words mean 'I seek, I pursue, my heart is in it'. I do have ears, Theo—if someone says 'you have a vicious character', what should I do? I turned around and went back alone, but with great sorrow in my heart because Mauve dared to say that to me. *I* won't ask him to explain such a thing to me, nor will I apologize.

And yet—and yet—and yet. I wish that Mauve regretted it. People suspect me of something . . . it's in the air . . . I must be hiding something . . . Vincent is keeping something back that may not be divulged . . Well, gentlemen, I'll tell you—you who set great store by manners and culture, and rightly so, provided it's the real thing— what is more cultured, more sensitive, more manly: to forsake a woman or to take on a forsaken one?

This winter I met a pregnant woman, abandoned by the man whose child she was carrying.

A pregnant woman who roamed the streets in winter—who had to earn her bread, you can imagine how.

I took that woman as a model and worked with her the whole winter. I couldn't give her a model's full daily wage, but all the same, I paid her rent and have until now been able, thank God, to preserve her and her child from hunger and cold by sharing my own bread with her. When I met this woman, she caught my eye because she looked ill.

I made her take baths and as much fortifying remedies as I could afford, she's become much healthier. I went with her to Leiden, where there's a maternity hospital she'll go to for her confinement. No wonder she was ill, the child was the wrong way round and she had to have an operation, which entailed turning the child with forceps. Still, there's a good chance that she'll come through it all right. *She'll have the baby in June.*

It seems to me that any man worth the leather his shoes are made of would have done the same in such circumstances. I find what I did so simple and natural that I thought I could keep it to myself. She found posing difficult, but she learned it anyway. I've progressed with my drawing by having a good model. This woman is now attached

to me like a tame dove—for my part, I can marry only once, and when would be a better time to do it than with her, because only by doing so can I continue to help her, and otherwise hardship will make her take the same road that ends in the abyss. She has no money, but she helps me to earn money in my work. I'm full of enthusiasm and ambition for my profession and work, if I left off painting and making watercolours for a while, it's because I was so shaken by Mauve's forsaking me, and if he really were to reconsider, I'd begin again with courage. As it is, I can't even look at a brush, it makes me nervous.

I wrote: Theo, can you enlighten me as to Mauve's attitude—perhaps this letter will enlighten you. You're my brother, it's natural that I speak to you about private matters, but someone who says to me, you have a vicious character, I stop speaking to him from that very moment.

I couldn't do otherwise, I did what the hand found to do, I worked. I thought I would be understood without words. I was in fact thinking of another woman for whom my heart beats—but she was far away and didn't want to see me, and this one—there she was, ill, pregnant, hungry—in the winter. I couldn't do otherwise. Mauve, Theo, Tersteeg, you all have my livelihood in your hands, will you leave me penniless or turn your backs on me—now I've spoken and shall wait to hear what's said to me.

Vincent

I'm sending you a couple of studies, because perhaps you'll see from them that she helps me greatly by posing.

My drawings are 'by my model and me'.

The one with the white cap is her mother.

Considering, however, that in a year, when I'll probably be working very differently, I'll have to base myself on the studies I'm making *now* as conscientiously as I possibly can, I'd like to have these three back in any case. You see that they've been made with care. If I later have an interior or a waiting room or some such thing, these will be of use to me because I'll have to consult them for the details.

But I thought it might be good for you to know how I spend my time. These studies demand a rather dry technique, if I'd concentrated here on the effect they'd be less useful to me later on.

But I think you'll understand this yourself. The paper I'd actually like to have most is the kind on which the female figure is drawn bending forwards, but if possible of the colour of unbleached linen. I have no more of it *in that thickness*, I believe one calls it *double* Ingres. I can't get any more of it here. When you see how that drawing is done, you'll understand that the thin kind can barely take it. I wanted to include a small figure in black merino, but I can't roll it. The chair by the large figure isn't finished because I'd like to put an old oak chair there.

My dear Theo,

If I'm to give you a better understanding of what I've already written to you about, you'll have to know where its origin lies. And I mustn't tone down anything about my visit to Amsterdam. But I begin by asking you not to regard it as impertinent if I have to disagree with you. *And first of all thank you sincerely for the 50 francs you enclosed.* If I don't put it forcefully it will be no use to you, but I would keep silent if you made it a precondition that I give in. I don't believe that you're making such a precondition, and you yourself will perhaps not find it unnatural that there are aspects of life that are less developed in you than your understanding of business, about which I freely grant that you're far better informed than I, and shan't lightly dare to say to you this or that isn't so. On the contrary, especially when you explain a little to me, I often feel that your grasp of things is better than mine. But on the other hand, when it comes to love — I'm sometimes astonished by your views. And I even want — please forgive me — to add something new. Your last letter about M. and H.G.T. proved to me that you appear to have a firm foothold in the circle and class of M. and H.G.T. and a way of behaving that isn't mine, so that you get on well with them whereas I do not. But outside that class your view is superficial and prejudiced. For your last letter gave me more food for thought than you may realize. My mistake lies here, it seems to me, and this is the true reason for my being fobbed off. If one has no money, one is by definition ineligible from the start, and so it was a mistake and short-sighted of me to take what M. said literally, and to think even for a moment: H.G.T. will remember that I've already been through so much trouble.

These days, money is what might is right was in the past. Contradicting someone is fatal, and if you do it their reaction is not to reflect but to give you a punch in the throat. That's to say, in the shape of 'I shan't buy anything by him any more' or 'I won't help him again'.

This being the case, I risk my head if I argue with you but, Theo, I don't know what else I can do — if it must go, here's my neck. You know my circumstances and that my living or not living, as it were, depends on your help. But I'm caught in a dilemma. If I reply to your letter: Yes, Theo, you're right, I'll give up Christien, then in the first place I'll be telling an untruth by saying you're right, and in the second I'll be committing myself to do something terrible. If I contradict you, and you do the same as H.G.T. and M., I get it in the neck, in a manner of speaking.

Well, in God's name off with my head if you must. The alternative is even worse.

So here begins a short text in which I'll state some things frankly which I think you may take in such a way that you withdraw your help, but to be silent in order to keep your help seems to me a poor way to act, and I would rather risk the worst. If I can make clear to you what I believe you do not yet understand, things will go better for Christien and her child and myself. And to achieve that, I must venture to say what I shall say.

To express what I felt for Kee Vos, I said plainly: she and no other. Her 'no, nay, never' wasn't enough to make me give her up. I still had hope, and despite that — which I believed was a block of ice that would melt — my love remained strong.

Yet I had no rest. The tension became unbearable because she stayed silent all the time, because I never received so much as a syllable in reply.

Then I went to Amsterdam. There I was told . . . When you are in the house Kee will leave it. Your 'she and no other' is opposed by her 'certainly not him'—your persistence is *sickening*. I put my fingers in the flame of the lamp and said, let me see her for as long as I hold my hand in the flame, and it's no wonder that later H.G.T. might have looked at my hand.

But they blew the lamp out, I believe, and said, *you shall not see her*. And then afterwards I had a talk with her brother, who said, officially or unofficially, that nothing but *rijksdaalders* would have any effect. Official or unofficial, I find both equally vile, and when I left Amsterdam I felt as if I had been on the slave market. You see, to me that was just crass, especially when they spoke of my coercion, and I felt that the things they told me were meant to beat me to death, and that my 'she and no other' was beaten to death. It wasn't straightaway but still quickly enough that I *felt* that love *die*, to be replaced by a void, an infinite void. Now, as you know, I believe in God, I did not doubt the power of love. But then I felt something like, My God, my God, why hast thou forsaken me? And nothing made sense any more. I thought, have I deluded myself? O God, there is no God! I couldn't bear that horrible, cold reception in Amsterdam—people reveal their true colours when it comes to settling accounts.

Would the Rev. J.P.S. and the Rev. T. v. G., looking so respectable in their robes and with their grey hair, dare to preach about love from the pulpit the way they talk about it behind closed doors? They would not.

I thought of the words of the prophet: 'Ancients of Israel, what do ye in the dark?', words directed at deceitful priests who were influenced by bribes.

Enough. I was distracted and cheered up by Mauve. I threw myself into my work with all my strength. Then, after M. let me down and I was ill for a few days, at the end of January I met Christien.

Theo, you say that if I had truly loved K.V. I wouldn't have done that. But now do you understand better that I couldn't go on after what had been said in Amsterdam?—should I have despaired then?—why should an honest man despair?—I'm no blackguard, I do not deserve to be treated so dreadfully. Well, what can they do? True, they had the whip hand, they thwarted me in Amsterdam. But now I no longer ask their advice and, being of age, I ask: am I at liberty to marry, yes or no? Am I at liberty to put on a working man's clothes and to live as a working man, yes or no? To whom am I accountable? Who will try to coerce me?

If anyone wants to stop me, let him come forward! You see, Theo, I am faint and weary. Think it over and you will understand. Pa, Uncle Stricker, H.G.T. and I don't know who else call themselves well-mannered, civilized people and they behave with a coarseness, a Jesuitism, an injustice that my soul abhors. Never ever is there a hint or shadow of remorse or an honest turning back to say, I did this or that, it was wrong.

They have too much support, they know all too well that most people want to have things that way, and they keep in with everybody.

If they take pleasure in that, if they think that it will work out well for them and that they'll also be at peace with it at the end—well, let them go ahead—I can't stop them. But for myself I may and must act according to my own conscience. And is my way less right because someone says, 'You are straying from the right way'? C.M.

always talks about the right way too, just like H.G.T. and the clergymen. But C.M. also calls Degroux a common fellow, so what is C.M.? In future I'll let him talk; my ears are tired. To put it out of my mind, I'm going to lie in the sand in front of the roots of an old tree and draw them. Wearing a linen smock and smoking my pipe and looking at the deep blue sky . . . or at the moss or the grass.

That calms me down. And I feel equally calm when, for example, Christien or her mother poses and I work out the proportions and try to make the body with its long, undulating lines palpable under the folds of a black dress.

Then I'm a thousand miles away from C.M., J.P.S. and H.G.T., and much happier.

But . . . alas, then the cares come and I have either to speak or write about money and it starts all over again. Then I think: H.G.T. and C.M. would do so much better if they didn't interfere with my 'way' and just encouraged me to draw. You will say: C.M. does that, but let me explain why the order hasn't been completed yet. Mauve said to me: that uncle of yours only did that because he'd paid you a visit, but you should realize that it doesn't mean anything and that immediately afterwards it will all be over, and then you won't have anyone left.

You must understand, Theo, *that I can't bear that*; if something like that is said to me, my hand goes limp as if paralyzed. Especially since C.M. has also made remarks about manners, I believe.

For C.M. I've done 12 drawings for 30 guilders, that's 2.50 apiece. It's a tricky job involving more than 30 guilders' worth of effort, and it isn't fair to ask me to see it as a favour or something like that. I had already gone to a great deal of trouble for the other 6, I had done studies for them. That's as far as I got. *I've already put the effort in for the new ones*, so it's not laziness — I am paralyzed.

Then I reason with myself: I shan't take it to heart, but I'm nervous and a thing like that stays with me and comes back when I start work again. So that I have to change tack and work on other things.

I don't understand Mauve — it would have been kinder of him never to have bothered with me. *What do you advise: should I carry on with the order for C.M. or not?* I didn't know what to do.

Years ago there was a different tone among painters — now they devour each other and are fine gentlemen living in villas and intriguing. I prefer to be in Geest or another back street — drab, down at heel, muddy, sombre — but I'm never bored there, whereas I'm bored stiff in those mansions, and I think it's a bad thing to be bored and so I say: I don't belong there and I'm not going there any more. Thank God I have my work, but in order to work I still need money instead of earning it, and that's the difficulty. If in a year's time, or I don't know how much longer or shorter, I can draw that Geest district or another street as I see it with the figures of old women, workers, girls, then H.G.T. &c. will be very pleasant, but then they'll get my 'go to hell' and I'll say, you left me in the lurch when I was in trouble, friend, I don't know you, go away, you're standing in my light.

Oh Lord, why should I be afraid? What do I care about H.G.T.'s 'disagreeable' and 'unsaleable'? If occasionally I lose heart, I look at The diggers by Millet and The paupers' pew by Degroux and then H.G.T. seems so small, so negligible, and all those remarks so pathetic that my good humour comes back and I light my pipe and get on with

drawing. But if at such a moment, sooner or later, someone from civilization were to cross my path, he might just hear some things that were pretty sobering.

Now you will ask, Theo, whether this applies to you too. In reply I say: Theo, who has given me bread and helped me? You, I believe, so it certainly doesn't apply to you. Only sometimes the thought occurs to me: why isn't Theo a painter, won't he eventually become bored in that civilization in the end? Won't he later be sorry that he abandoned civilization to learn a craft, marry a woman, put on a smock? But there may be reasons that I can't appreciate, so enough. As for love, I don't know whether you already know what its ABC really is. Do you think me arrogant? By that I mean that you feel what love is best when you sit beside a sickbed, sometimes without a penny in your pocket. This isn't picking strawberries in the spring — that only lasts a few days and most months are drab and more sombre, but in that sombreness one learns something new, and sometimes it seems to me that you know that, and sometimes I think, he doesn't know it.

I want to go through the domestic joys and sorrows myself so that I can draw them from experience. After I had left Amsterdam I felt that my love, which was truly honest, truly unfeigned and strong, had been literally *beaten to death* — yet after death one rises from the dead. Resurgam. Then I found Christien. It was no time to hesitate or delay. Action was required. If I don't marry her, it would have been kinder of me not to have taken any interest in her. Yet through this step a gulf opens; I then 'marry beneath my station', as they say, as decisively as I possibly can, but that is not forbidden and not bad, even if the world calls it wrong. My domestic arrangements will be like those in a worker's household. I'm more at home with that, I wanted to do it before but couldn't put it into practice then. I hope that you'll still extend your hand to me across the gulf. I mentioned 150 francs a month. You say I need more. Wait a moment. My expenses have never been more than 100 francs a month on average since I left Goupil, except for occasional travelling. And at Goupil I first had thirty guilders and later 100 francs.

Now, these last months I've had more expenses, but I've had to settle in, and I ask you: are these expenses unreasonable or excessive? Especially since you know what else was involved. And how often in those long years I had much less than 100 francs. And if I sometimes had expenses because of travelling, have I not improved my knowledge of languages and developed my mind? Was that money down the drain?

Now I need to make a straight path for my feet. If I postpone marriage, there will be something false in my position that will be repugnant to me. She and I are willing to scrimp and scrape as long as we marry.

I am 30, she 32, so we're not starting out as children. As for her mother and her child, the latter removes her stain; I have respect for a woman who is a mother and I don't enquire into her past. I'm glad that she has a child; because of that she knows what she should know. Her mother is very hard-working and deserves a medal for the way she has raised a family of 8 children for years and kept their heads above water. She wouldn't want there to be any dependence, she earns her living by going out to work.

I'm writing to you late at night. Christien is unwell and the time of her departure for Leiden is at hand. You must forgive me if my writing is sloppy, for I'm tired.

And yet, after your letter I wanted to write to you. In Amsterdam I was so flatly refused, so fobbed off that it would have been lunacy to persist.

But should I have despaired at that point? Jumped into the water or something like that? God forbid. I would have done that if I had been a bad person. I renewed myself, not on purpose but because I found an opportunity for renewal and didn't refuse to begin again.

This time, though, things are different and Christien and I understand each other better. We needn't take account of anyone, but of course are far from pretending to keep up a position.

Knowing the prejudices of the world, I'm aware that what I must do is withdraw from my social circle, which cast me out long ago anyway. But then there's nothing more to be said and one may go no further. My personal liberty may not be infringed. I told my Father that plainly enough at the time of the Geel affair, when he wanted to pack me off to a madhouse. She and I are of age, so if Pa is opposed he'll have to register his refusal formally according to the law and the judge will have to decide. However, I hope that this won't be necessary and that we can reach a resolution by rather more peaceful means.

It may be that I wait a while before we start living together if our circumstances are particularly difficult, but even then I want to get married—without telling anyone, completely quietly. If anybody makes a fuss, I won't take any notice. Since she's a Catholic, the wedding will be all the simpler, for the church is naturally out of the question; neither she nor I want to have anything to do with it. You will say, that's short and to the point. So be it. I want to be concerned with one thing only, drawing, and she too has one regular occupation, posing. I sincerely wish that it were possible for me to take the house next door. It's exactly big enough, because the attic can be turned into a bedroom and the studio is a good size and light, much better than here. But would it be possible? But even if I had to live in a hovel, I would rather have a crust of bread beside my own hearth, however poor, than live without marrying her.

She knows what poverty is, so do I. Tersteeg doesn't know a damned thing about it, and neither do you, Theo. Poverty has its advantages and disadvantages. Despite poverty, we'll take the chance. The fishermen know that the sea is dangerous and the storm fearsome, *but could never see that the dangers were a reason to continue strolling on the beach.* They leave that wisdom to those to whom it appeals. When the storm comes—when night falls—what's worse: the danger or the fear of danger? Give me reality, the danger itself. Adieu Theo, it's late. Pardon me for this letter, I'm tired but wanted to write anyway. I wish you could understand and that I could put it in a clearer and friendlier way, but don't take offence, and believe me

Ever yours,
Vincent

I believe (or rather there's a glimmer of beginning to believe) that there's a possibility that the notion 'Theo will withdraw his help if I argue with him' &c. &c. may be utterly needless. But, Theo, I've seen things like that done so often that I wouldn't respect you less and not be angry with you if you did likewise. Because I would think, he knows no better; they all behave like that, unthinkingly but not from malice. If I continue to receive your help, that will be something utterly new, a rare chance I haven't

counted on. Because for a considerable time I've gone around, so to speak, always with the prospect of the very worst before me, as has Christien, because I continually said to her 'Lass, I fear a time will come when I'm completely penniless'. But I haven't said that to you before it was necessary. If you continue your help it is a solution, a deliverance, so unexpected, so undreamt-of, that I would be utterly overwhelmed by joy. And now, I daren't think about it and resolutely push the thought away, even while I write to you about it with a steady hand, so as not to weaken.

What I experienced this winter with Mauve has been a lesson to me, making me prepare myself since then for the worst . . . a death sentence from you, that is, the ending of your help.

You'll say, but that help hasn't stopped . . . but I received it with a certain reserve, thinking he doesn't yet know everything he will know one day, and until the crisis comes I'll have no rest and remain on guard, prepared for the worst.

Now the crisis is here and I still can't decide, I don't dare hope yet. I've told Christien: I'll support you until Leiden. When you come back from Leiden, I don't know how you'll find me — with or without a penny — but what I have is as much yours and the child's as mine. Christien doesn't know the details — and doesn't ask, knowing that I deal honestly with her and wanting to be with me come what may. The postscript in your last letter made me think . . . I thought, how does he mean that? . . . But up to now I've always thought of you as likely to turn away from me as soon as you knew everything.

So I lived by the day but with a sombre fear of the worst from which I dare not yet account myself freed. I also worked by the day, not daring to order more drawing or painting materials than I could pay for by the day, not daring to undertake anything in the way of painting, for example, not daring to tackle it as I would have done had I counted on relations with Mauve and H.G.T. being restored. Thinking that if their friendliness was superficial, their unfriendliness went deeper, and anyway, I took seriously what Mauve said, 'it's all over', not when he said it to me (for then I took it coolly enough in a spirit of bravado like the Indians who say 'it doesn't hurt at all' when they're tortured), but since he wrote to me 'I don't want to have anything to do with you for two months'. Since I broke the plaster casts.

In short, I've always argued *to myself*: I can expect nothing more from Mauve and Tersteeg, and I'll thank God if Theo carries on sending me the needful long enough for me to support Christien safely until Leiden, and then I'll explain to him and say, stop, this is what I've done.

Do you understand any of this? . . .

So I'm writing to you now as I spoke to Mauve when he said, 'it's all over' — almost as a challenge — prepared for the worst — cold-bloodedly — sarcastically — and yet deadly serious, not sparing you, criticizing you for your conventions, yet not frivolously but . . . IN DAMNED EARNEST.

Do you understand now? Having just gone through the dreadful suspense with Christien, but she having pulled through, I am now pleading, declaring, Gentlemen, here is my neck. I plead guilty in that I hid from all of you something that has cost money, but there was a human life to be saved and I wanted to save it come what may, not talk about it. But now . . . if you condemn me I'll be guilty and shan't protest. I supply work for your money, but if it isn't enough then I'm in your debt and can't repay

you. I'm prepared for your displeasure but not for your mercy . . . I've never counted on that and I don't know how I stand what is it to be??? I've prepared myself for the worst and not hoped for anything less bad. What's the position? But speak clearly.

In short, I knew very well that I was compromising myself in the eyes of the world by helping Christien, and I did not, or rather still do not, count on your wanting to have anything to do with me after knowing that I compromised myself. But I couldn't leave her to her fate. I wanted to save her, even though my head might be at stake. And now I still don't know whether it's to be 'POLLICE VERSO', *yes* or *no*??? If it's yes: '*Morituri te salutant*'. I've seen the thumbs move, but don't know whether they're pointing up or down.

235 | The Hague, Saturday, 3 June 1882 | *To Theo van Gogh* (D)

My dear Theo,

Today, Saturday, I'm sending you the two drawings

Fish-drying barn in the dunes, Scheveningen
Carpenter's yard and laundry (from the window of my studio).

I've thought of you so often these past few days, and also occasionally about the time long ago when, as you will remember, you visited me in The Hague and we walked along Trekweg to Rijswijk and drank milk at the mill there. It may be that this influenced me somewhat when I did these drawings, in which I have tried as naïvely as possible to draw things exactly as I saw them. At the time of the mill, however dear those days still are to me, it would have been impossible for me to put what I saw and felt on paper. So what I'm saying is that the changes brought about by time have not fundamentally altered my feelings; it's just that I believe they have taken a different form. My life, and yours too perhaps, after all, is no longer as sunny as it was then, but I still wouldn't want to go back, because it's precisely through some trouble and adversity that I see something good emerging, namely the expression of those feelings.

Rappard was pleased with a similar drawing which C.M. has, and moreover with all the others C.M. has. Especially with the largest of the almshouse. And he is someone who understands what I want and appreciates how difficult it is. I believe you would find Rappard much changed since his first time in Paris when you knew him.

I have in front of me a volume of the Household edition of Dickens, with illustrations. They are excellent and are drawn by Barnard and Fildes. They show parts of Old London, which take on a very different appearance from the carpenter's yard, for example, also because of the peculiarities of the wood engraving. Yet I still believe that the way to get that boldness and daring later is to quietly carry on observing as faithfully as possible now. As you see, there are several planes in this drawing, and one can look around in it and peer into all sorts of nooks and crannies. It lacks that ruggedness as yet, at least doesn't by any means have that quality to the same extent as the above illustrations, but that will come with practice.

I have heard from C.M. in the form of a postal order for 20 guilders but without a single word to go with it. So for the time being I haven't the slightest idea whether

he wants to order something new from me or whether the drawings are to his taste. But comparing it with the price paid for the previous ones, 30 guilders, and bearing in mind that this last batch (the first contained 12 small ones; this had 1 small one, 4 like the enclosed and 2 large ones — i.e. 7 items in all) was more substantial than the first, it seems to me that His Hon. had got out of the wrong side of the bed the day he received them, or that they failed to please for some reason or another. I readily admit that, to an eye used only to watercolours, drawings which have been scratched by pen or had lights scraped off or put back on in body-colour may seem a little harsh. But there are also people who, just as it is sometimes pleasant and invigorating for a healthy constitution to go for a walk when a strong wind is blowing, so there are also art lovers, I say, who aren't afraid of the harsh.

Weissenbruch, for example, wouldn't find these two drawings disagreeable or dull.

In the circumstances, should I learn that C.M. would rather not have any more, of course I cannot and will not force them on His Hon., but I hope that, for example when you come, you will be able to find out how things really stand.

Naturally, although I hadn't expected him to give me 10 guilders less for this batch than for the previous one, I agree with the 20 guilders, all the more so because I left it to His Hon. to fix the price. And if he wants me to start on another 6 or 12, I'm ready to do that because I don't want to miss any opportunity to sell something. I really want to do my best to accommodate His Hon., because I think that it's worth the effort as long as I get my rent out of it and can make ends meet more easily. It's just that His Hon. himself talked about giving more, not less, for more detailed drawings. I only raise the matter, after all, mainly to know what to do as regards a new order that is or is not to follow. It may also be that His Hon. will write to me himself later.

In a few days, or today if I have time, I'll send you a brief list of what is in my collection of wood engravings. I'm so sure you will take pleasure in them. While I spent less on *paint* this winter than others did, I had *more* expenses in connection with the study of perspective and proportion for an instrument described in a work by Albrecht Dürer and used by the Dutchmen of old. It makes it possible to compare the proportions of objects close at hand with those on a plane further away, in cases where construction according to the rules of perspective isn't feasible. Which, if you do it *by eye*, will always come out wrong, unless you're very experienced and skilled.

I didn't manage to make the thing the first time around, but I succeeded in the end after trying for a long time with the aid of the carpenter and the smith. And I think that with more work I can get much better results still.

It would please me greatly if perhaps in your wardrobe there was a jacket and trousers suitable for me which you no longer wear.

Because if I buy something I like it to be as practical as possible for working in the dunes or indoors, but my clothes for going out are getting rather threadbare. And while I am not ashamed to be seen in the streets in a cheap suit when I go out to work, I am decidedly ashamed by gentleman's clothes that give the impression of a gentleman down on his luck. My everyday clothes, however, aren't at all shoddy, because now I have Sien to keep check of them and make minor repairs.

I end this letter by saying to you again that I so dearly wish that the family should not view my relationship with Sien as something of which there isn't the slightest question, namely an intrigue. Which I would find unspeakably offensive and would

only widen the gulf. What I hope is that they don't interfere, with some ill-timed wisdom, to prevent me from being with her. I mean of the same sort as when Pa wanted to pack me off to Geel. The speculating about inheritances that you mention is quite out of the question, if only because there are no inheritances for me as far as I know, and indeed there cannot be for there is nothing. I believe there is literally *no* money at home. The only person from whom, in very different circumstances, I might perhaps have inherited something because I share his name, Uncle Cent, is someone with whom I have been on bad terms for many years on account of numerous things, and in such a manner that by the nature of the matter it cannot be resolved as if I were his protégé, because I myself certainly wouldn't want that, and of course he hasn't the slightest thought of any such thing any more, although I hope that, just like last year, if I meet His Hon. we shall not make a public scene. And now with a handshake

Ever yours,
Vincent

		Woodcuts
1 portfolio		Irish characters, miners, factories, fishermen &c. for the most part small pen sketches.
1	"	Landscapes and animals, Bodmer, Giacomelli, Lançon, also some landscapes
1	"	Labours of the fields by Millet, also Breton, Feyen-Perrin and English prints by Herkomer, Boughton, Clausen &c.
1	"	Lançon
1	"	Gavarni, supplemented with lithographs, but no rare ones
1	"	Ed. Morin
1	"	G. Doré
1	"	Du Maurier, very numerous.
1	"	Chs Keene and Sambourne
1	"	J. Tenniel, supplemented with the Beaconsfield cartoons.

} illustrators for Punch.

Missing here is John Leech, but this gap can easily be filled because there's a reprint of his woodcuts that isn't expensive.

1	"	Barnard
1	"	Fildes and Charles Green &c.
1	"	small French wood engravings, Album Boetzel &c.
1	"	Scenes on board English ships and military sketches.
1	"	*Heads of the people* by Herkomer, supplemented with drawings by others and by portraits
1	"	Scenes from everyday London life, from the opium smokers and Whitechapel and The Seven Dials to the most elegant ladies and Rotten Row or Westminster Park. Together with corresponding scenes from Paris and New York, the whole forms a curious 'Tale of those cities'.
1 portfolio.		The large prints from The Graphic, London News, Harper's Weekly, L'Illustration &c. including Frank Holl, Herkomer, Fred Walker, P. Renouard, Menzel, Howard Pyle.

1 portfolio. The Graphic portfolio, being a separate publication of impressions of
 several woodcuts, not from the printing plates but the blocks themselves,
 among them the Homeless and hungry by Fildes.
Several illustrated books, including Dickens and the Frederick the Great by Menzel,
small edition.

237 | The Hague, on or about Thursday, 8 June 1882 | *To Theo van Gogh* (D)

Municipal hospital (4th class, Ward 6, no. 9)
Brouwersgracht.

My dear Theo,

Should you come here towards the end of June, I hope you'll find me back at work,
but at present I'm in hospital, although I'll only be here for about a fortnight. For some
3 weeks I'd been suffering a good deal from sleeplessness and chronic fever, and felt pain
on passing water. And now it turns out that I've got a very mild case of what's known
as 'a dose of the clap'. So I have to stay quietly in bed, swallow a lot of quinine tablets
and from time to time have instillations of pure water or alum water, thus as harmless
as could be. There's no reason for you to be in the least concerned about this, but as you
know one has to take this sort of thing seriously and act immediately, because neglect
can make it incurable or exacerbate matters. Take the case of Breitner, who's still here,
though in another ward, and will probably leave soon — he doesn't know I'm here.
 I'd be grateful if you didn't mention this, because people sometimes think it's terri-
bly serious or make it sound serious by telling exaggerated tales. Of course I'm telling
you exactly what it is, and you needn't keep silent if someone asks you directly, and in
any event you needn't worry. Naturally I had to pay for a fortnight in advance, 10.50
guilders for nursing costs. There's no difference in food or treatment between those
whose nursing is paid for by poor relief and those who pay the 10.50 guilders them-
selves. There are 10 beds in a ward, and I must say that the treatment is very good in
every respect. I'm not bored, and the rest and proper, practical medical treatment are
doing me good.
 If it's convenient, be so good as to send around 20 June to the above address, but NOT
by registered letter, 50 francs without registering the letter. As you know, I received
100 francs on 1 June, so I'm taken care of in any event. If I have to stay longer, I'll pay
the extra and stay on, and otherwise I'll have enough to carry on with.
 I'd prefer to get back to work in a fortnight, of course, and I'll be dying to go back
to the dunes in a fortnight.
 Sien comes to see me on visiting days and is keeping an eye on the studio. Now I
must tell you that the day before I came here I received a letter from C.M. in which
he writes a good deal about the 'interest' that he takes in me and which, he says, Mr
Tersteeg has shown, but, he continues, he didn't approve of how ungrateful I was for
H.G.T.'s interest. So be it. I'm lying here completely calmly and quietly now, but I
assure you, Theo, that I would be put in a very bad mood if someone again dished me
up with the same sort of interest as H.G.T. on certain occasions. And when I think how

His Hon. took that interest to the point of daring to compare me to an opium smoker, I'm still amazed that for my part I didn't show my interest by telling him to go to hell.

Talking of smoking opium, the comfort and luxury, the sort of glory in which H.G.T. moves and the fairly strong doses of flattery that his visitors bring for him — those are things that perhaps befuddle His Hon. now and again more than he realizes.

In short, with all his superficially refined politeness, with his superficially civilized manners, his smart clothes and so on and so on, on consideration and also looking back on it, I find something *malicious* in His Hon.'s character. I wish it weren't so, but I can't say otherwise. I don't doubt for a moment that His Hon. is a clever man, but another question comes first before I can respect him: is he a good man? Namely someone who doesn't deliberately and on principle cultivate hatred, rancour, bickering and sarcasm inside himself. That is the question.

I haven't replied to C.M.'s last letter, nor shall I. I appreciate His Hon.'s telling me that he'll also take something else later, no doubt out of interest too, but especially if he means it, which time will tell.

Another reason for not regretting lying here quietly for a few days is that, should I need it, I can get an official statement from the doctor here that I'm absolutely not the sort of person who should be sent to Geel or made a ward of court.

And if that isn't enough, I can also get another, if I make an effort, from the professor in charge of the lying-in clinic in Leiden.

But perhaps those people who might possibly get it into their heads to declare that *the family* or *society* would be so much better off if someone like me were to be declared mad or made a ward of court are so extraordinarily brilliant that in such cases they know far better than, for example, the doctor here.

Anyway, a letter from you would of course give me great pleasure at the moment.

Sien is getting ready to leave. I think of her a great deal — I expect her again later. May she come through it safely.

I resisted as long as I could and carried on working, but in the end I realized I needed to see a doctor urgently. But he told me just this morning that I would soon be rid of it. Did you get the two little drawings?

Adieu with a handshake, and wishing you as much good fortune as anyone could deal with.

Ever yours,
Vincent

I must tell you again that the precedent of *Geel*, at which time they were minded to make me a ward of court on *physical* grounds, makes it difficult for the family suddenly to change their story now and look for *financial* rather than *physical* reasons. Such arguments won't hold water. Again, I hope they won't go that far.

But write soon, for I'm longing for a letter.

You do understand, Theo, that I don't discuss family matters with the doctor here or the professor in Leiden — but because I'm being treated by the former and Sien by the latter, it will only take a word from me in the last resort to secure the testimony of these two gentlemen to set against any possible statements by a few people of which you spoke.

Sunday afternoon

My dear Theo,

As I wrote to you yesterday, I went to Leiden. Sien gave birth last night, had a very difficult delivery but thank God she survived, together with a jolly nice little boy. Her mother and child and I went there together — you can imagine how tense we were, not knowing what we'd hear when we enquired after her from the nurse at the hospital, and how delighted we were to be told: gave birth last night but you mustn't talk to her too much . . . I shan't soon forget that 'you mustn't talk to her too much', because that meant 'you can still talk to her' and might equally well have been 'you will never speak to her again'. Theo, I was so happy when I saw her again, and she was lying right by the window with a view of the garden full of sun and greenery in a sort of exhausted drowse in between sleeping and being awake, and then she looked up and saw us all. Ah, old chap, she had such a look on her face and she was so glad to see us, and because by chance we were there exactly 12 hours after it happened, while visitors are allowed only 1 hour a week. And she was so cheered up and came to her senses in every respect in a second, and asked about everything.

But what I can't get over is the child, in particular because although it was delivered with forceps it wasn't the least bit harmed, and lay in its cradle with a sort of air of worldly wisdom. They're so clever, those doctors. By all accounts it was a critical situation. There were 5 professors present when it happened, and she was given chloroform. Before that she had endured an enormous amount because the baby was stuck from 9 in the evening until half past one. And she's still in considerable pain. But she forgot it all when she saw us, and even said to me that we'd soon be drawing again, and I have absolutely no objection if her prediction proves entirely accurate. There's no tearing or anything, which can easily happen in such a case.

By Jove, I'm so thankful. But the sombre shadow still threatens, and the master Albrecht Dürer knew that when he placed Death behind the young couple in the wonderful etching you know. But we must hope that the sombre shadow remains only a shadow that will pass. Well, Theo, as you well know, if I hadn't had your help Sien probably wouldn't be here. Another thing — I asked Sien to ask the professor to give her a proper examination, because she often has what they call a white discharge. He did so, and advised her on what she must do to be completely cured.

And he says that she had been at death's door more than once, especially during her previous throat illness, in an earlier miscarriage, and then last winter, that she has been profoundly weakened by a life of turmoil and agitation, year after year, that now that she no longer needed to lead that life she'd recover of her own accord, provided there are no complications, with rest, tonics, plenty of fresh air and no heavy labour.

When she's past her old misery, there will be a completely new period in her life: she won't get back her spring — that is over, and was cruel anyway — but her *second growth* can be all the fresher. You know how, in the middle of summer when the greatest heat

has passed, the trees throw out fresh young shoots, a new layer of young green over the old, faded one.

I'm sitting writing to you next to Sien's mother at a window looking out on a sort of courtyard. I've drawn it twice, once large and once smaller. C.M. has both and they were the ones, especially the large one, that Rappard liked. I'd like you to see them if you visit C.M. because I would particularly like to know what you think of the large one. When are you coming?

I long to see you. Well brother, you have it on your conscience that I'm so happy today that it made me cry. Thanks for everything, old chap, and believe me, with a handshake in thought,

Ever yours,
Vincent

244 | The Hague, Thursday, 6 July 1882 | *To Theo van Gogh* (D)

Dear brother,

Having received your letter and the 100 francs enclosed, I thank you most sincerely and feel the need to write to you again straightaway. Because I think it would be a good idea if I explained, honestly and to the best of my knowledge and with all the earnestness in me, some matters which it's important you should be fully aware of and understand. So I hope that you'll read this letter at your ease and with patience, because for me so much depends on it. Tomorrow morning I'm going back to the hospital and I'll lay my head down there calmly if I know that you've been informed about everything as fully and clearly as the distance permits.

I would much, much rather that you'd been present, so that I could have shown you everything here this afternoon and discussed it with you. But let's hope that will happen in August. Before going on to various other matters, I must tell you that I was very taken by one passage in your letter describing Paris by night. Because it evoked a memory of myself when I too saw 'Paris all grey' and was struck by that so very curious effect, with the little black figure and the distinctive white horse that brings out the delicacy of those curious greys exactly like that. That touch of dark and that tonal white are the key to the harmony. But in the hospital just recently, as it happens, an artist who described that Paris all grey with the hand of a master made a great impression on me. In 'Une page d'amour' by Emile Zola I found several townscapes painted or drawn in a masterly, masterly fashion — entirely in the sentiment of the simple passage in your letter. And that small book by him is why I'm very definitely going to read *everything* by Zola, of whom I had only known a few fragments up to now: 1 for which I attempted to make an illustration, 'Ce que je veux', and another piece describing an old peasant that was exactly like a drawing by Millet. You have something mightily artistic in you, brother — cultivate it — let it first put down roots one way or another and then flower — don't give it to just anyone — but seriously, for yourself, think about it, and don't consider it a misfortune if it concentrates itself through that thinking and comes to occupy quite an important place in your activity. But I may be venturing into

forbidden territory, so no more about that for today. Only, again, there is 'drawing' in your short description—for me palpable and comprehensible, even though you haven't yet pursued your impression to the point where it would acquire a more robust body and stand on its feet visibly or palpably for everyone. The true pain and tension of creating begins at the point where you let go of the description—but you have the intelligence of creating in damned good measure. Now you can't go any further because you don't yet believe in yourself in this respect, otherwise you would take the plunge, that's to say venture further. But enough. There's a certain *je ne sais quoi* in your description, a scent—a memory—of a watercolour by Bonington, for example, only it's still faint as if in a mist. Do you know that drawing in *words* is also an art, and sometimes betrays a hidden force latent inside, just as the blue or grey cloud of smoke betrays the hearth?

I most certainly do appreciate what Pa and Ma did during my illness—you remember I wrote to you about it right away—as much as I value the visit by H.G.T. However, that's not why I didn't immediately write to Pa and Ma about Sien or anything else, and only sent a brief word to tell them of my recovery. And here's why. Because something is left of what happened last summer and this winter that marks the line between past and present like an iron barrier.

It isn't in the least my intention to go *in the same manner* as last year to Pa and Ma to ask their advice or opinion, because it became clear to me then that there was a sharp difference in way of thinking and attitude to life. Nonetheless, it is my ardent desire to keep the peace and to convince Pa and Ma that it wouldn't be right if they were to turn against me, in the belief that I was someone who only dreamed and didn't know how to act—that, I say, they are mistaken in their view that my approach to situations is so impractical as to make it necessary for them to 'guide' me.

You see, Theo, believe me, I don't say this out of bitterness, contempt or disdain for Pa and Ma—or to glorify myself—but only to help you grasp one fact, namely this. Pa and Ma aren't the sort of people to understand me—neither my faults nor my better side—they can't put themselves in my position. Reasoning with them only leads to quarrels. What's to be done??? Here's my plan, which I hope you will approve. I hope to arrange things so that, next month for example, I can put aside 10 guilders, or preferably 15. Then—but not before—I want to write to Pa and Ma that I have something to say to them, that I invite Pa to repeat his journey at my expense and to stay with me for a few days.

I want to show him Sien and her baby, which he won't be expecting, as well as the house bright and the studio with all manner of work in progress, and myself, by then fully recovered, I hope.

In my view all this will have a better and deeper and more desirable effect than words or writing. I'll tell him briefly how Sien and I struggled through her anxious pregnancy last winter—how you helped and still help us loyally, even though you only heard about Sien later. That for me she is priceless, first through the love and attachment between us that circumstances have strengthened, and second because from the start she has devoted herself utterly, with great good will, intelligence and practical skill, to helping me in my work. And that she and I dearly hope that Pa will approve of my having taken her as my wife. I can't put it any other way than '*having* taken', because the formality of marriage is not what makes her my wife, since this is a bond

that already exists — a feeling from both sides that we love, understand and help each other. As for what Pa will say about marrying itself, I believe he'll say, 'Marry her'.

I would like Pa to have a fresh and clear impression of a new future for me, to see me here in surroundings very different from what he may imagine, for him to be completely reassured about my feelings towards him, for him to have confidence in my future and put wardship or Geel a thousand miles from his thoughts. You see, Theo, I know of no more direct or honest way or means than what I've described to restore relations soon and in a practical fashion. Write and let me know your feelings about this.

Now, furthermore, I don't think it superfluous to tell you again, although it's difficult to express, what I feel for Sien. I have a sense of being *at home* when I'm with her, a sense that she brings my '*hearth and home*' with her, a sense that we have grown together. This is an intensely deep feeling, serious and not without the dark shadow of her and my fairly sombre pasts, a shadow I've written to you about before, as if, indeed, something sombre continues to threaten us against which our life must be a constant struggle. At the same time, though, I feel a great calm and clarity and cheerfulness at the thought of her and of the straight path lying before me.

You know that last year I wrote to you a great deal about Kee Vos — so that, it seems to me, you have a clear picture of what took place within me. Don't think that I exaggerated my feelings to you — it was a strong, passionate love I felt for her, unlike that for Sien. When I discovered in Amsterdam that she had a sort of dislike for me, which I didn't think was the case, to such an extent that she regarded my behaviour as coercion and wasn't even prepared to see me, but 'that she went out of the door of her own house as long as I was inside it', then — but not before — my love for her received a mortal blow. Which I first became aware of when, recovering from my intoxication as it were, I was in The Hague this winter. At that time there was a sense of inexpressible melancholy in me which I find impossible to describe. I know that I then thought very, very often of a manly remark by *père* Millet: 'It has always seemed to me that suicide is the act of a dishonest man'.

The emptiness, the inexpressible wretchedness inside, made me think — yes, I can understand why there are people who jump into the water — it's just that I was far from approving of what those people did, and I found solidity in the words I've quoted, and thought it much the better approach to get hold of oneself and seek a medicine in work. The way, as you know, I tackled it then.

It's difficult, terribly difficult, indeed impossible, to think of something like my passion of last year as an illusion. That's what Pa and Ma do, but I say, '*Even if it will never be, it could have been*'. It wasn't an illusion, but the attitudes differed and the turn taken by circumstances was such that the ways diverged further and further instead of coming together.

This is how I see it — these are my clear and honest thoughts — *it could have been but now it never can be*. Was Kee Vos right to have a dislike for me, was I wrong to persist? I declare I do not know. And it isn't without pain and sorrow that I think back on it and write about it. I would like so much to understand better why Kee Vos was like that then and how it was that my parents and hers were so adamantly ominous and opposed, not so much through their words — although very certainly through them too, above all indirectly in the meaning more than the form — as through their complete

lack of genuine, warm, living sympathy. I can't soften these words, but I think of it as a mood of theirs that I would rather forget. Now, in the circumstances, it's like a large, deep wound in me that has healed but is still palpable.

At that time — in that winter — could I feel 'love' again straight afterwards? Certainly not. But was it wrong that the human feeling in me wasn't extinguished or numbed, and that my sorrow indeed aroused a need for compassion with others??? I think not. So *at first* Sien was a fellow human being to me, as alone and unhappy as I was. Yet, not being in despair, I was in the right state of mind to be able to give her some practical support, which at the same time was a stimulus to me to carry on. But gradually, slowly, something else developed between her and me. *A certain need for each other.* So that she and I stayed close together, entering each other's lives more and more, and then it was *love*.

Theo, I must perhaps touch on a point that may be painful for you that may make you understand what I mean. In the past you had what Pa and Ma also call an 'illusion' for a woman of the people, and the fact that nothing came of it wasn't because you *couldn't* take that path in life but because things took a different course, and you have since adapted to life in another class where you are now firmly established, so that for *you* it wouldn't again be an illusion if you wanted to marry a girl from your class. In your case that wouldn't arouse any comment, and although nothing came of that first love, something might come of a new love, and you would succeed. In my opinion, *your* way is definitely not to take a woman of the people: with *you* the so-called *illusion* was the woman of the people; the reality for you has now become the woman from the same kind of class as Kee Vos.

For me, though, it's the other way round: the *illusion* (ALTHOUGH I DON'T BE-LIEVE THAT WORD OR DEFINITION WAS APPROPRIATE OR ACCURATE, EITHER IN YOUR CASE OR MINE) was Kee Vos; the reality has become the woman of the people.

There's a difference between your case and mine in several respects. Your failure was when you were twenty, mine last year. But although both you and I may have had an illusion, failure or whatever — I really don't know what to call it — that doesn't rule out something more real, either for you or for me. For I'm quite sure that neither of us is cut out to be celibate.

What I want to make clear is this: what there is between Sien and me is *real*; it's not a dream, *it is reality*. I count it a great blessing that my thoughts and capacity for work have found a focus, a particular direction. While it may be that I felt more *passion* for Kee Vos, and that in some respects she was more charming than Sien, it is certainly not so that the love for Sien is therefore less sincere, for the circumstances are too grave, and it all comes down to taking action and being practical, and that has always been so since I first met her.

You can see what the result is . . . now if you come you won't find me dejected or melancholy, but you'll enter a setting with which I believe you'll be satisfied, or at least like. A young studio, a still young, fully functioning household.

Not a mystical or mysterious studio, but one that has rooted itself in real life. *A studio with a cradle and a close-stool.* Where there's no stagnation and everything prompts and urges and generates activity.

Now if someone or other comes to tell me that I'm a poor financier, I'll show him

my place here. I've done my best, brother, to ensure that you can see (and not just you, but everyone with eyes in his head) that I strive and sometimes manage to tackle things practically. HOW TO DO IT.

This winter we had the woman's pregnancy and my expenses in getting settled. Now the woman has given birth, I've been ill for four weeks — and still not better — despite all that the place is clean and cheerful and bright and tidy, and I have a large part of my furniture, bedding and painting materials.

It has cost what it cost, to be sure I won't underestimate it, but your money hasn't gone down the drain. A young studio has come from it which can't yet do without your help, but from which more and more drawings will gradually emerge and which requires only essential furniture and tools, which retain their value.

You see, old chap, if you come here now to a house full of life and activity, knowing that you are its founder — won't that give you a proper sense of satisfaction, more so than if I were a celibate spending my life in bars? Would you have it otherwise??? You know that I wasn't always happy, and sometimes truly wretched, and now through your help my youth is emerging, and my true development.

Now I just hope that you won't lose sight of this great change, even when people think you're mad to have helped or to help me. And that you'll continue to see in the present drawings the seed of later ones. A little longer in the hospital and then I'll go back to work, and the woman and child will pose.

It's as clear as daylight to me that one must feel what one makes, that one must live in the reality of family life if one wants to portray family life intimately — a mother and child, a washerwoman, a seamstress, whatever. As a result of stubborn labour, the hand is gradually becoming obedient to that feeling. But if I were to snuff out this feeling, and the *strength* to have my own household, that would be suicide. *That's why* I say — onward — despite dark shadows, cares and difficulties, also, alas, through people interfering and gossiping. Theo — make no mistake — although I, as you rightly say, *stay out of it*, it often pierces me to the soul. But do you know why I no longer argue with them and why I stay out of it? — because I *must* work and *may* not let myself be diverted from my path by the gossip and difficulties.

But I don't stay out of it because I'm afraid of them or am at a loss for words. Also, I've often noticed that they say nothing in my presence, and even claim never to have said anything. As for you, knowing that I don't get involved in order not to make myself nervous and because of my work, you'll be able to understand my attitude and not think it cowardly of me, won't you?

Don't imagine that I think myself perfect — or that I believe it isn't my fault that many people find me a disagreeable character. I'm often terribly and cantankerously melancholic, irritable — yearning for sympathy as if with a kind of hunger and thirst — I become indifferent, sharp, and sometimes even pour oil on the flames if I don't get sympathy. I don't enjoy company, and dealing with people, talking to them, is often painful and difficult for me. But do you know where a great deal if not all of this comes from? Simply from nervousness — I who am terribly sensitive, both physically and morally, only really acquired it in the years when I was deeply miserable. Ask a doctor and he'll immediately understand entirely how it couldn't be otherwise than that nights spent on the cold street or out of doors, the anxiety about coming by bread, constant tension because I didn't really have a job, sorrow with friends and family were

at least ¾ of the cause of some of my peculiarities of temperament—and whether the fact that I sometimes have disagreeable moods or periods of depression couldn't be attributable to this?

But neither you nor anyone else who takes the trouble to think about it will, I hope, condemn me or find me unbearable because of that. I fight against it, but that doesn't alter my temperament. And even if I consequently have a bad side, well damn it, I have my good side as well, and can't they take that into consideration too?

Write to me to say whether you approve of my little plan for telling Pa and Ma and establishing better relations. I don't feel in the least like just writing about it or going to discuss it, and would probably then make my usual mistake of putting it in such a way that they take offence at some expression or other. There you are. I think when the woman is back with her child, I fully recovered and back from the hospital, the studio working, then I would like to say to Pa: come and resume your visit and stay with me for a few days to talk things over. And then send the travel expenses as a courtesy. I can't think of a better plan. Adieu, thank you for everything, and a hand-shake, and believe me

Ever yours,
Vincent

249 | The Hague, on or about Friday, 21 July 1882 | *To Theo van Gogh* (D)

Dear Brother,

It's already late, but I wanted to write to you again. You aren't here, yet I'm in need of you, and it seems to me as if we aren't far apart sometimes.

Today I made an agreement with myself, which was to regard my illness, or rather what's left of it, as non-existent. Enough time has been lost, the work must be carried on.

So, well or not well, I'm going to draw again regularly from morning till evening. I don't want anyone else to be able to say, 'Oh, those are only old drawings.'

I've drawn a study of the cradle today with touches of colour in it.

I'm also working on a ditto like the meadows I recently sent you.

My hands have become rather whiter than I care for, but what can I do about it? I'll also go outdoors again. It matters less to me that it may strike me down than that I'm kept longer from my work. Art is jealous; she won't allow illness to be placed above her. So I'll let her have her way. I hope, therefore, that you'll soon have a few reason-able ones.

People like me aren't really *allowed* to be ill. You must really understand how I regard art. One must work long and hard to arrive at the truthful. What I want and set as my goal is damned difficult, and yet I don't believe I'm aiming too high. I want to make drawings that *move* some people. Sorrow is a small beginning—perhaps small land-scapes like the Laan van Meerdervoort, the Rijswijk meadows and the Fish-drying barn are also small beginnings. At least they contain something straight from my own feelings.

Whether in figures or in landscapes, I would like to express not something sentimentally melancholic but deep sorrow.

In short, I want to reach the point where people say of my work, that man feels deeply and that man feels subtly. Despite my so-called coarseness — you understand — perhaps precisely because of it. It seems pretentious to talk like this now, but that's why I want to push on.

What am I in the eyes of most people? A nonentity or an oddity or a disagreeable person — someone who has and will have no position in society, in short a little lower than the lowest.

Very well — assuming that everything is indeed like that, then through my work I'd like to show what there is in the heart of such an oddity, such a nobody.

This is my ambition, which is based less on resentment than on love in spite of everything, based more on a feeling of serenity than on passion.

Even though I'm often in a mess, inside me there's still a calm, pure harmony and music. In the poorest little house, in the filthiest corner, I see paintings or drawings. And my mind turns in that direction as if with an irresistible urge. As time passes, other things are increasingly excluded, and the more they are the faster my eyes see the picturesque. Art demands persistent work, work in spite of everything, and unceasing observation.

By persistent I mean in the first place continued labour, but also not abandoning your approach because of what someone else says. I have hopes, brother, that in a few years, and even now already, you'll gradually see things by me that will give you some recompense for your sacrifices.

I've had very little conversation with painters lately. I felt none the worse for that. It isn't the language of painters one ought to listen to but the language of nature. I can now understand, better than six months ago or more, why Mauve said: don't talk to me about Dupré, talk to me instead about the side of that ditch, or something like that. It sounds crude and yet it's perfectly correct. Feeling things themselves, reality, is more important than feeling paintings, at least more productive and life-giving.

Because I now have such a broad, such a large sense of art and of life itself, of which art is the essence, it sounds to me so shrill and false when there are people like Tersteeg who are always on the hunt.

For my part I find a peculiar charm in many modern paintings that the old ones don't have. For me one of the highest and noblest expressions of art is always that of the English, for instance Millais and Herkomer and Frank Holl. What I mean to say as regards the difference between old and contemporary art is: perhaps the new artists are deeper thinkers.

There's another great difference: in sentiment, between Chill October by Millais and the Overveen bleaching grounds by Ruisdael, for example. And equally between the Irish emigrants by Holl and the women reading the Bible by Rembrandt.

Rembrandt and Ruisdael are sublime, for us as much as for their contemporaries, but there's something in the moderns that strikes us as more personally intimate.

That's how it is with the woodcuts by Swain, and those by the old German masters too.

So it was a mistake a few years ago when there was a vogue among the moderns for imitating the old masters.

This is why I think what *père* Millet says is so right: I think it absurd that people want to appear to be something other than they are. That seems to be an unremarkable observation and yet it's as unfathomably deep as the ocean, and I for one think it advisable to take it to heart in all things.

I just wanted to tell you that regular work will and must be resumed, come what may — and I want to add that I'm longing so much for a letter from you, and also to wish you good-night.

Adieu, with a handshake.

Ever yours,
Vincent

Please remember the *thick* Ingres if you can, a sample is enclosed. I still have enough of the thin. I can wash in watercolour on the *thick Ingres*; on the *sans fin*, for example, it always gets muddy without it being entirely my fault.

I'll draw the cradle, I hope, a hundred times apart from the one today. With *persistence.*

250 | The Hague, Sunday, 23 July 1882 | *To Theo van Gogh* (D)

Sunday morning

My dear Theo,

I received your letter and the 50-franc note enclosed. I thank you right heartily for both, and I'm delighted that you gave me some details about your visit.

Do you think we could agree that while you're here we'll spend the time together that's left after your business and visits and then do our best, on both sides, to be in the same sort of mood as in the past at the Rijswijk mill?

As for me, old chap — although the mill has gone and with it the years and my past youth, just as irrevocably — what has reawakened deep inside me is the belief that there's something good and that it's worthwhile making an effort and doing one's best to take life seriously. This is now perhaps, or rather certainly, more firmly rooted in me than in the past, when I had experienced less. For me the point now is to express the poetry of those days in drawings.

Your letter to me crossed mine, in which I told you I'd decided to carry on working regularly, well or not well.

Well, that's what I've done and I feel fine, though I have to take more to keep it up. But the work itself makes me much more clear-headed, of course — towards the end I couldn't bear not being able to draw. I'll have a couple of watercolours for you when you come, brother. By Jove, the studio works so nicely. You remember, last winter I said: in a year you'll have watercolours.

These ones are simply intended to show you that if I work at drawing, the correctness of perspective and proportion, it also benefits the watercolouring.

And for myself I did them to test whether now, after doing nothing but drawing for a time (around six months), I found watercolours easier, and secondly to see where

I still need to do more work on the foundation or basic drawing on which everything depends.

They're landscapes, very difficult in their delineation, with complicated perspective —but precisely because of that there's a true Dutch character and sentiment to them. They look like the last ones I sent, and are no less conscientiously delineated, only now there's also: colour—the gentle green of the meadow contrasting with the red tiled roof, the light in the sky set off by the matt tones of the foreground, a yard with earth and damp wood.

In judging me and my behaviour, Tersteeg always starts from the premise that I'm incapable of anything and am good for nothing. He told me that himself. . . 'Oh, it will be the same with that painting of yours as with all the other things you've started—it won't come to anything.'

That's how he talked last winter, that's how he talks now—whereupon I told him that it would please me not to visit him or see him here for the next six months. Since that sort of talk only impedes and upsets me.

You must understand this, as a result I couldn't care less about him and I'm quite content for him finally to understand now, clearly and plainly, that I've taken a thorough dislike to him in recent months, and would rather not have anything to do with him.

I carry on working quietly, and he can say, to his heart's content, all the absurd things about me that pop into his head.

As long as he doesn't impede me in my work, I'll forget all about him.

It was different when he said last winter that he would intervene to see that I didn't get any more money from you. Then I immediately wrote to you about it.

But I won't write to you about him any more until something similar happens again. I would think myself foolish if I were to chase after him and say: Mr T, Mr T, I'm a true painter like other painters, despite all your arguments.

No, it seems to me more self-restrained, precisely because it (the artistic) is in fact in my very marrow, to go on bivouacking with my things in meadows or dunes very calmly, or to work in the studio with a model without taking the slightest notice of him.

But what I find rather pleasing is that you too have read Le ventre de Paris recently. I've also read Nana. Listen, Zola is actually Balzac II.

Balzac I portrays the society of 1815–1848, Zola begins where Balzac leaves off and goes on to Sedan or rather to the present day.

I think it's absolutely superb. Now I must ask you what you think of Mme François, who picks up poor Florent as he lies unconscious in the middle of the road where the vegetable carts are passing, and lets him ride with her. Although the other vegetable sellers shout: 'Leave him lying there, the drunk! We've no time to pick up men lying in the gutter,' &c. The figure of Mme François stands against the background of the Halles throughout the book, contrasting with the brutal egoism of the other women, so calm and so dignified and so sympathetic.

You see, Theo, I believe Mme François' act showed true humanity, and in relation to Sien I have done and will continue to do what I believe someone like Mme François would have done for Florent if he hadn't cared more about politics than about her. So there you have it, and that humanity is the salt of life, without that I wouldn't care about life. Enough.

I care as little about what Tersteeg says as Mme François cared about what the

other vegetable sellers and women shouted: leave him alone — we've no time. In short, the whole commotion and racket. Besides, it won't be long before Sien is supporting herself entirely through posing. She posed for my very best drawing, Sorrow, at least I think it's the best thing I've done, and in less than a year there'll be regular drawings of figures as well, *that I promise you*. For make no mistake — much as I love landscape, I love figures even more. Still, it's the hardest part, and of course takes me a great deal of study and work, and time too. But don't let them fool you into thinking that she's keeping me from the work; you'll see for yourself in the studio. If it were so that I was working less because of her, I would agree with you, but now the absolute opposite is true, really. Well, we'll gradually reach agreement on that, I hope, not so much through words as through drawings. I'm coming to hate words — but anyway.

But I'm so delighted you're coming, old chap. Shall we actually go into the meadows again together? — with nothing before us except that still, gentle, delicate green and such a light sky. Excellent! And the *sea*! And the beach! And the OLD out-of-the-way Scheveningen. Marvellous.

By the way, recently I've been seeing some very beautiful small charcoal drawings by T. de Bock, mostly touched up with white and delicate blue in the sky — very good and more to my liking than his paintings.

I can't tell you how much I enjoy the space in the studio — I immediately notice the effect on me now that I'm working again. We'll teach them to say of my drawings: '*they're only old ones*'. I wasn't ill for the fun of it.

So you must imagine me sitting at my attic window as early as 4 o'clock, studying the meadows and the carpenter's yard with my perspective frame — as the fires are lit in the court to make coffee, and the first worker ambles into the yard.

Over the red tiled roofs comes a flock of white pigeons flying between the black smoking chimneys. But behind this an infinity of delicate, gentle green, miles and miles of flat meadow, and a grey sky as still, as peaceful as Corot or Van Goyen.

That view over the ridges of the roofs and the gutters in which the grass grows, very early in the morning and the first signs of life and awakening — the bird on the wing, the chimney smoking, the figure far below ambling along — this is the subject of my watercolour. I hope you'll like it.

Whether I succeed in the future depends, I believe, more on my work than on anything else. Provided I can stay on my feet, well I'll fight my fight quietly in this way and no other, that is by calmly looking through my little window at the things in nature, and drawing them faithfully and lovingly.

For the rest only adopting a defensive posture if attacked, but otherwise drawing is too dear to me for me to allow anything to distract from it.

The singular effects of perspective are more intriguing to me than human intrigues. If Tersteeg had better understood that my painting is an entirely different matter from other things, he wouldn't make such a fuss. But now, in his eyes, I've deceived and disappointed Mauve. Moreover, he thinks I only do it on account of the money from you. I find it all absurd — too absurd to attach any importance to it. Mauve himself will realize later that he wasn't deceived in me and that I was absolutely not unwilling. It's just that he HIMSELF persuaded me to draw more conscientiously long before I did anything else. But back then we didn't understand each other correctly, again because of H.G.T., who was behind it.

As to your letter, I would like to say again that I can't help it that you didn't know about Sien's child, because when I told you about her I certainly mentioned it, but you probably thought I meant the child that hadn't yet come into the world. But I had already spoken a few words about the humanity sometimes found in a person, as in Mme François in the book by Zola. But I have no humanitarian plans or ideas, as if I thought I could do the same for everyone. Yet I'm not ashamed to say (though I know very well that the word humanity is out of favour) that for my part I've always felt the need to love one creature or another, and will continue to do so. Preferably an unfortunate or spurned or abandoned creature, I don't know why. Once I nursed a poor burnt miner for six weeks or 2 months — I shared my food with an old man a whole winter long — and I don't know what else, and now Sien. But to this day I don't believe that this was foolish or bad, I see it as so natural and self-evident that I can't understand how people can be so indifferent to each other normally. Let me add that if I did wrong, you also did wrong in helping me so loyally — that would be wrong too, but that would surely be absurd. I've always believed that 'love thy neighbour as thyself' isn't an exaggeration but the normal state of affairs. But anyway. And you know that I'll make the greatest possible effort to ensure that I start selling soon, precisely to avoid abusing your goodness.

I also firmly believe, brother, that if, in response to suggestions that you should stop sending me the money — which I think may possibly be made, you calmly reply that you're confident I'll turn out to be a good painter and that you'll therefore continue to support me. That you've left me free as regards my private life and affairs, and won't coerce or help to coerce me, and then there will very soon be a stop to the gossip, and then only in certain circles will I be seen as a social pariah and be cast out. Which leaves me pretty indifferent, and to which I'm already accustomed. Which will make me concentrate on art more and more. And though some may damn me irrevocably and for all time, in the nature of things my profession and my work will open up new connections, all the fresher for not being made cold, stiff and sterile by old prejudices about my past. Connections with people like Tersteeg, who persist in their prejudices, are absolutely sterile and useless. Well, old chap, thank you for your letter and the fifty francs — my drawing has dried somewhat in the meantime and I'm going to touch it up. The lines of the roofs and gutters now shoot away nicely like arrows from a bow — drawn without hesitation. Adieu, with a handshake.

Ever yours,
Vincent

P.S. Read lots of Zola, it's healthy stuff and clears the mind.

My dear Theo,

Just a word to say welcome before you come here. And to report the safe arrival of your letter and the enclosure, and to thank you very much.

It was most welcome for I'm working hard and again need one or two things.

As regards black in nature, we are of course in complete agreement, as I understand it. Absolute black doesn't in fact occur. Like white, however, it's present in almost every colour and forms the endless variety of *greys* — distinct in tone and strength. So that in nature one in fact sees nothing but these tones or strengths.

The 3 fundamental colours are red, yellow, blue,

 " composite " orange, green, purple.

From these are obtained the endless variations of grey by adding black and some white — *red*-grey, *yellow*-grey, *blue*-grey, *green*-grey, *orange*-grey, *violet*-grey.

It's impossible to say how many different green-greys there are for example — the variation is infinite.

But the whole chemistry of colours is no more complicated than those simple few fundamentals. And a good understanding of them is worth more than 70 different shades of paint — given that more than 70 tones and strengths can be made with the 3 primary colours and white and black. The colourist is he who on seeing a colour in nature is able to analyze it coolly and say, for example, that green-grey is yellow with black and almost no blue, &c. In short, knowing how to make up the greys of nature on the palette.

To make notes out of doors, however, or make a small scratch, a highly developed feeling for the outline is absolutely essential, as it is for working it up later.

This doesn't come of its own accord, but firstly through observation, and then above all through persistent hard work and seeking. Some study of anatomy and perspective is also required.

Hanging beside me is a landscape study by *Roelofs*, a pen sketch, but I can't tell you how expressive that simple outline is. Everything is in there.

Another, even more telling example is the large Shepherdess woodcut by Millet which you showed me last year, and which has remained in my memory. Also, for example, the pen sketches by Ostade and Peasant Bruegel.

When I see such results, I feel the cardinal importance of the outline most clearly. And you know from Sorrow, for example, that I take great trouble to make myself better in that respect.

But you'll see when you come to the studio that besides seeking the outline I certainly also have a feeling, like anyone else, for the *strengths*.

And that I also have nothing against making watercolours — but they're founded on drawing first, and then from the drawing springs not only the watercolour but all kinds of other shoots that will develop in due course in me as in anyone else working with love.

I've attacked that old giant of a pollard willow, and I believe it has turned out the best of the watercolours. A sombre landscape — that dead tree beside a stagnant pond

covered in duckweed, in the distance a Rijnspoor depot where railway lines cross, smoke-blackened buildings — also green meadows, a cinder road and a sky in which the clouds are racing, grey with an occasional gleaming white edge, and a depth of blue where the clouds tear apart for a moment.

In short, I wanted to make it like how I imagine the signalman with his smock and red flag must see and feel it when he thinks: how gloomy it is today.

I get a lot of pleasure out of work these days, though now and again I still clearly feel the after-effects of my illness.

As to the drawings I'm going to show you now, I think only this: that they will, I hope, serve as evidence that I'm not stuck on one level but am moving in a direction that is reasonable. As for the commercial value of my work, I have no pretensions other than that I would be very surprised if in time my work doesn't sell as well as that of others. Whether that happens *now* or *later*, well, I'm not bothered about that too much. Just working faithfully from nature and with persistence seems to me a sure way, and one that *can't* end up with nothing. The feeling for and love of nature always strike a chord sooner or later with people who take an interest in art. The duty of the painter is to study nature in depth and to use all his intelligence, to put his feelings into his work so that it becomes comprehensible to others. But working with an eye to saleability isn't exactly the right way in my view, but rather is cheating art lovers. The true artists didn't do that; the sympathy they received sooner or later came because of their sincerity. I know no more than that, and don't believe I need to know any more. Making an effort to find art lovers and arouse their love is something else, and of course permissible. But it mustn't become a speculation that might well go wrong and would certainly waste time that ought to be spent on work.

Of course you'll find things in my present watercolours that should be taken out, but that must improve with time.

But you should know that I'm a long way from having a system or anything like that to keep up and lock myself into. That sort of thing exists in H.G.T.'s imagination, for example, rather than in reality. As for H.G.T., you understand that I have a personal reason for my opinion of him, and that I don't in the least intend to press *you*, for example, to take the same view of him as I am forced to do. As long as he thinks and says of me the kind of things you know of, I can't regard him either as a friend or as someone of use to me in any way, but quite the opposite. And I fear that his opinion of me is too firmly rooted ever to change, all the more so because, as you say yourself, he won't take the trouble to reconsider some things and to change.

When I see how several painters I know here struggle with their watercolours and paintings, unable to find the answer, I sometimes think, friend, your drawing is where the trouble lies. I don't for a moment regret not moving straight on to watercolour and painting. I know for sure that I'll catch up if I keep hacking away at it, so that my hand doesn't hesitate in drawing and perspective. But when I see young painters composing and drawing *off the top of their head* — then daubing on all sorts at random, *also off the top of their head* — then holding it at a distance and putting on a very profound, sombre expression to find out to what in God's name it might bear some resemblance, and finally, still off the top of their head, making what they can of it, it makes me feel feeble and faint, and I find it truly tedious and heavy going.

The whole thing makes me sick!

Yet these gentlemen regularly ask me — not without a certain patronizing air — 'whether I've started painting yet'.

Now I also sometimes find myself playing, so to speak, at random on a piece of paper, but I attach no more value to this than to a rag or cabbage leaf.

And I hope you'll understand that if I go on just drawing, I do that for two reasons. Because at all costs I want to acquire a sure hand when drawing above all else and, second, because painting materials and watercolours entail considerable expense for which there's no return in the early stage — and these costs are multiplied twice and ten times if you work on the basis of a drawing that isn't yet sufficiently correct.

And if I got into debt or surrounded myself with canvases and papers daubed all over with paint without being sure of my drawing, my studio would quickly become a kind of hell, like a studio I once saw that seemed like that to me.

As it is, I always enjoy going there, and work there with pleasure.

So I don't believe that you suspect me of *unwillingness*.

It seems to me that the painters here have a way of reasoning as follows. They say, you must do this or that — if you don't do it, or not immediately or exactly, or if you object, the reply is: 'So you know better than I do, do you?' Thus immediately, sometimes within 5 minutes, there's a conflict between you. And the situation is such that neither side can move forwards or backwards. The least odious outcome of this is if one of the two parties has the presence of mind to keep silent and in one way or another quickly slip away through some opening. And would almost say, Sapristi, the painters are a family too. That's to say, an ill-fated association of people with conflicting interests, each one at odds with the rest, two or more of whom share the same feelings only when they join forces to obstruct another member. I hope, my dear brother, that this definition of the word 'family' doesn't always apply, especially not in the case of the painters or our own family. I hope with all my heart that peace will reign in our family, and I remain with a handshake,

Ever yours,
Vincent

[*The top part of the next sheet is missing; the following text is crossed out*]

not to be afraid [xxxxxxxxxxxxxxxxxxxxxxxx] to make it difficult for them if they'd rather not see me.

I refused, even when they asked me lately whether I wouldn't come sometime, so that they'd clearly see that I didn't want to make it difficult for them in any way. But I also expect that they, for their part, won't meddle in my affairs. While I care about the good will of those at home, Princenhage matters much less to me. Would you and can you be so good as not to talk about one thing and another, so much the better, if, though, it is talked about and that can't be avoided — too bad, but what do I care?

Well, as I said, I want nothing so much as to keep the peace, nothing is as necessary for my work as that very peace. So I'm grateful to you for everything you can do to reassure those at home and to keep them calm. I hope that you'll have pleasant days there and breathe in plenty of Brabant air. I still think of Het Heike so often, and have again been busy these last few days with a study from there, cottages with mossy roofs under the beech trees.

252A. *Pollard willow*

must take. This is just about the *effect* of the pollard willow, but in the watercolour itself there's no black except in a mixed state.

[*Sketch 252A*]

Where the black is darkest in this little sketch is where the greatest strengths are in the watercolour — dark green, brown, dark grey. Well, adieu, and believe me that I sometimes laugh heartily at how people suspect me (who am really just a friend of nature, of study, of work — and of people chiefly) of various acts of malice and absurdities which I never dream of. Anyway — goodbye for now, with a handshake.

Ever yours,
Vincent

258 | The Hague, Sunday, 20 August 1882 | *To Theo van Gogh* (D)

Sunday afternoon.

My dear Theo,

I've just received a good letter from home which truly gives me great pleasure, and from which it's clear that your visit and the things you said about me and my work have left an impression that reassures them.

I believe this can only have desirable consequences, and I thank you in particular for the way in which you talked about me, though it seems to me you've praised me more about one thing and another than I yet deserve. At home they seem to be very pleased with their new surroundings, and are still full of your visit.

As I am myself, by the way, for various things you said to me cause me to think of you even more than I used to, certainly not with less affection. What you told me about your health, in particular, makes me think of you often.

I am well — I feel fine not avoiding anything because of it, and just carrying on. But, as you'll understand, it isn't entirely over. At times, mainly in the evening when I'm tired, it troubles me, but fortunately it's no longer such that it stops me working.

This week I painted a few fairly large studies in the woods which I've tried to work up more highly and elaborate more than the first ones. The one I believe I've been most successful with is no more than a piece of ground dug over — white, black and brown sand after a downpour. So that the clods of earth catch the light here and there and are more expressive. After I'd been sitting in front of that piece of ground for a while drawing, there came a thunderstorm with torrential rain that lasted a good hour. I had become so gripped, however, that I stayed at my post and sheltered as best I could behind a thick tree. When it had finally passed and the crows took to the air again, I wasn't sorry I had waited, because of the wonderfully deep tone the ground of the wood had taken on after the rain.

Because I had started before the storm on my knees with a low horizon, I now had to kneel down in the mud, and it's because of similar adventures, which happen very

often in different ways, that it seems sensible to me to wear ordinary working clothes that aren't easily ruined.

The outcome this time was that I was able to take that piece of ground with me to the studio — although Mauve rightly said to me when we were discussing one of his studies that it's a job to draw clods of earth and to get depth into them.

The other study from the woods is of big green beech trunks on a ground with dead leaves, and the small figure of a girl in white.

The great difficulty there was to keep it clear and bring in space between the tree-trunks, which stand at different distances — and the place and relative thickness of the trunks altered by the perspective. To ensure, in short, that one can breathe and wander about in it — and smell the woods.

I particularly enjoyed doing these two. Just as much as something I saw at Scheveningen.

A large expanse in the dunes in the morning after rain — the grass is very green, relatively speaking, and the black nets are spread out on it in huge circles, creating tones on the ground of a deep, reddish black, green, grey. Sitting, standing or walking on this sombre ground like strange dark ghosts were women in white caps, and men who spread out or repaired the nets.

In nature it was as compelling, distinctive, sombre and severe as the finest one could imagine by Millet, Israëls or Degroux. Above the landscape a plain grey sky with a light band above the horizon. Despite showers of rain, I made a study of it on a sheet of oiled torchon.

A lot needs to be done before I'll be capable of working that up highly — but it's things like this that I find most compelling in nature.

How beautiful it is outdoors when everything is wet with rain — before — during — after the rain. I really ought not to miss a single shower. This morning I hung all the painted studies in the studio. I wish I could talk to you about them.

As I indeed expected and counted on while I was at work, I had to buy rather a lot extra, and the money is almost used up. I've now painted for a fortnight from early morning to late in the evening, so to speak, and if I continued like this it would work out too expensive as long as I'm not selling.

I think it possible that if you saw the work you would say that I shouldn't paint only on occasion, when I took particular pleasure in it, but carry on with it regularly, as absolutely the main thing, even if it entailed higher costs.

But although I enjoy it tremendously, and probably won't paint as much as my ambition and pleasure demand for the time being, because of the heavy costs, I reckon I'll lose nothing by devoting much of my time to drawing, and do that just as eagerly. I am, however, in doubt — painting has proved less difficult than I expected — perhaps the course to adopt would be to concentrate every effort on toiling with the brush above all — but I declare I don't know.

At any rate, I know for sure that drawing with charcoal is something I must now study more closely than in the past — at any rate I have enough to do and can carry on; even if I restrain myself somewhat as regards painting, I can work just as hard. If I've now painted quite a number of studies in a short time it's also because I keep on working on them, and literally work all day, barely taking the time even to eat or drink.

In several studies there are small figures. I've also worked on a larger one and

already scraped everything off twice, which you might perhaps have thought rash if you had seen the effect, but it wasn't rash — the reason is that I feel I can do even better with more effort and study, and I'm absolutely determined to achieve that better result, whether it takes more time or less, more effort or less. Landscape the way I've now tackled it also definitely requires figures. These are studies for backgrounds that must be very thoroughly examined, because the tone of the figure depends on it, and the effect of the whole.

One of the things I like about painting is that for the same effort as for a drawing one takes home something that conveys the impression much better and is much more pleasing to look at. And at the same time more accurate.

In a word, it's more rewarding than drawing. But it's absolutely essential that one draw the objects in the correct proportion and position with some certainty before one begins.

If an error is made there, it will all come to nothing.

I'm looking forward to the autumn. By then I must make sure I stock up on paint and various things again. I'm particularly fond of the effects of yellow leaves against which the green beech trunks stand out so beautifully, and the figures no less.

The past few days I've been reading part of a rather melancholy book, 'Brieven en dagboek' of Gerard Bilders. He died at the age when I was more or less beginning. When I read it, I don't regret making a late start. He was certainly unhappy and was often misunderstood, but at the same time I find a great weakness in him, something unhealthy in his character. It's like the story of a plant that shoots up too early and can't withstand the frost, and as a result one fine night it's struck to the root and withers away. At first he does well — he's a master as in the hothouse — making rapid growth there — but in Amsterdam he stands almost alone, and despite his brilliance he can't cope there, and in the end he comes back to his father's house, completely discouraged, dissatisfied, apathetic — and there he does some more painting and finally dies of consumption or another disease in his 28th year.

What I dislike in him is that *while painting* he complains about terrible boredom and idleness as things he can do nothing about, and he carries on going round in the same stifling circle made up of his friends and the entertainments and way of life he's so heartily sick of. In short, I find him a sympathetic figure, but I would rather read the life of *père* Millet or T. Rousseau or Daubigny. When you read Sensier's book about Millet you take courage from it, but Bilders's book makes you feel wretched.

In a letter by Millet I always find a list of difficulties, but then: 'nonetheless I've made this or that', and in addition to that constantly thinking about other things that he's determined to do and does indeed carry out. And too often with G. Bilders it's 'I was in a bad mood this week and made a mess of things — and went to this or that concert or play which left me feeling even worse.'

What strikes me in Millet is that simple '*Nonetheless* I must make this or that.' Bilders is very witty and can heave grotesque sighs about manilas *pointus* that he fancies but cannot buy, and about tailors' bills he sees no way of paying. He describes his anxiety about money matters so wittily that he himself and the reader can't help laughing.

Yet however wittily these things are put, I still don't like them, and have more respect for the private difficulties of Millet, who says 'Nonetheless there must be soup for the children,' and doesn't talk about manilas *pointus* or entertainments.

What I want to say is this. G. Bilders was a romantic in his outlook on life, and he never got over his lost illusions. For my part I regard it as in a sense a privilege that I began when romantic illusions were a thing of the past. Now I have some way to catch up, work hard, but particularly when you have lost illusions behind you, work is something you need and one of the few pleasures left. And from this comes a great peace and calm.

I'm sorry that now it may be a year before you see what I'm painting all together — even if I send something now and again — and before we can discuss what to do and how. I believe I can assure you that my painting these things now will prove to be worthwhile. Perhaps what failed in January will now succeed.

Do not, above all, suspect me of indifference as regards earning; I fully intend to take the shortest route to that end.

Provided they are genuine and lasting earnings, of which I only see a prospect in my case if something truly good comes into my work, and not through working solely on saleability — which one pays for later — but through honest study of nature.

If you could see from the paintings that they'd have the best chance of success, I wouldn't, of course, refuse to paint more. But should it take a long time before it becomes saleable, I would be the first to say, in that case we must live as thriftily as possible in the meantime, and with *drawing* one avoids a lot of costs and very certainly makes sure and steady, if slow, progress. I see a change in these painted things, and I write to you about it because you're better placed than I am to say how this might affect possible sales. It seems to me that *at any rate* the painted studies *are more agreeable to look at* than what I've drawn. For my part, I attach less importance to the more agreeable, less gaunt effect, and make the expression of more austere and manly things the aim I want to achieve, for which I must first labour hard. But if you were to say: work on those views of woods or landscapes or seascapes, then that needn't get in the way of larger and more serious things, and I would have nothing against that.

It's just that I would have to know that they were worth the brushes, the paint, the canvas, and that making a lot of them wasn't a waste of money, but that the costs could be recouped. If that was or could become the case, it might be a way of enabling me to undertake more difficult things.

In that case I would even work on them with great ambition. I want to begin by letting them ripen somewhat, by working them up a bit more highly. Then in a few months, say, I'll send you something and we can see. I believe that most painters have worked their way up to higher things in this way. I wouldn't want to make things that were bad in principle, tending towards the untrue and the false, because nature is too dear to me. But we're faced with this question: I must make many more studies in order to achieve something higher and better. What will work out cheapest: drawing or painting those studies? If the paintings are *un*saleable, it will certainly be cheaper to draw in charcoal or something else.

The reason why I myself am delighted with painting is not the agreeable appearance, but the fact that it throws light on other questions of tone and form and material before which I used to be helpless, but now I can attack them with this means. I do now see, for example, more opportunity to have another try with charcoal and get a result.

But supposing it was possible to recover the costs of painted studies, I want to say to you that in principle I would have nothing against that, now I see that I'm making some headway and that it could perhaps be an exceptional opportunity.

My only objection in principle is to expending paint on things that can also be learnt with something else, while there's still no question of selling. I don't want to put either you or me to great expense for no good purpose, but I see clearly that the painted things have a more agreeable appearance. This makes me unsure as to what to do.

My money isn't yet exhausted, but there isn't much left. Today is the twentieth, if I'm not mistaken. This month I've spent less, not more, than usual on household needs. I've had to spend a lot all at once on painting materials, but much of that will last for some time. But everything is expensive. I hope you can send something soon. Accept a warm handshake in thought, and believe me

Ever yours,
Vincent

I sincerely hope that you won't take this letter to mean that I already presume that something can be done with these first studies. C.M. once interpreted certain remarks by me in that way, though I had definitely not meant them like that. I used to be able to say, better than now at any rate, what something was worth and whether it was likely to sell or not. Now it's clear to me each day that I no longer know, and what matters more to me now is to study nature rather than the prices of paintings.

But I believe I see that the painted studies have a much more agreeable look than either the black-and-white drawings or the watercolours that you saw recently. And this is why I'm in doubt as to whether it's possible that, despite the higher costs, painting as absolutely the main pursuit might not work out cheaper.

I would rather that you make this decision, because I believe you're more competent than I am as regards judging the financial success, and I have complete confidence that your judgement will be correct.

And if I send you something sooner or later, it will be to find out whether you have any tips to give me, not to say: I reckon this or that is saleable — for I no longer feel able to say that. And I'll also send it in any case to keep you abreast of what I'm working on.

You told me to do my best sometime to try to work up a drawing in watercolour — I believe that, precisely as a result of painting, I'll be more capable than in the past if I go back to watercolour.

But if that doesn't work out so well occasionally, you mustn't lose heart, nor must I, and you mustn't be afraid to make comments to me. I don't systematically ignore comments made to me, but in many cases it takes longer to change something than to point out the change. I've just been putting things into practice that Mauve said to me in January and, for instance, painted that piece of ground as the result of a conversation about a study by him.

Sunday morning

My dear Theo,

I've just received your very welcome letter and want to reply immediately, since today I'm having a bit of a rest anyway. I thank you for it, and for the enclosure and for one or two things you say in it.

And for your description of the scene with the workmen in Montmartre, which I found most interesting, because you give the colours as well so that I can see it — many thanks.

I'm glad you're reading the book about Gavarni. I thought it very interesting, and have become doubly attached to G. because of it.

Paris and its surroundings may be beautiful, but we can't complain here either. This week I painted something which I believe may give some idea of the impression of Scheveningen as we saw it when we walked there together. A large study of sand, sea, sky — a big sky of delicate grey and warm white through which an occasional spot of soft blue shines — the sand and the sea light — so that the whole becomes blond, though enlivened by the bold and distinctively coloured figures and pinks, which take on tone. The subject of the sketch I made of it is a pink weighing anchor. The horses stand ready to be hitched to the pink before pulling it into the sea. I enclose a scratch of it. I really laboured over it — I wish I'd painted it on panel or canvas. I tried to get more colour into it, namely depth, firmness of colour.

It certainly is curious how you and I often seem to have the same thoughts. Yesterday evening, for example, I came back with a study of the woods, and this week in particular, especially then, I was very absorbed in the question of depth of colour. And would have liked to discuss it with you, particularly in connection with the study I had made — and lo and behold, in your letter of this morning you happen to remark on how you were struck in Montmartre by the very pronounced colours, which nonetheless remained harmonious. I don't know if it was exactly the same thing that struck us, but I'm absolutely sure you would also have felt what particularly struck me and probably seen it in the same way. I'll begin by sending you a scratch of the subject and telling you what the problem was.

The woods are already getting really autumnal — there are colour effects which I only rarely see depicted in Dutch paintings.

Yesterday evening I was occupied with an area of woodland with a slight upward slope covered in rotting and dead beech leaves. The ground was lighter and darker red-brown, all the more so because of the cast shadows of trees that threw bands across, weaker or stronger, half blotted out. The problem, and I found it to be most difficult, was to get the depth of colour — the enormous strength and fixity of that area — and yet it was only while painting that I noticed how much light there still was in that darkness. To keep it light and yet keep the glow, the depth of that rich colour, for there's no carpet imaginable as splendid as that deep brown-red in the glow of an autumnal evening sun, although tempered by the wood.

Out of the ground shoot young beech trees that catch the light on one side — are

brilliantly green there — and the shaded side of those trunks a warm, strong black-green. Beyond these trunks, beyond the brown-red ground, is a sky, a very delicate blue-grey, warm — almost not blue — sparkling. And set against this is another hazy edge of greenness and a network of slender trunks and yellowish leaves. A few figures gathering wood move about like dark masses of mysterious shadows. The white cap of a woman who bends over to pick up a dry branch suddenly stands out against the deep red-brown of the ground. A skirt catches the light — a cast shadow falls — a dark silhouette of a fellow appears on top of the undergrowth against the brushwood fence. A white cap, bonnet, shoulder, bust of a woman set off against the sky. These figures — they're large and full of poetry — appear in the half-light of the deep shadow tone like huge terracottas being made in a studio. I'm describing nature to you — to what extent I conveyed it in my sketch I'm not sure myself — but I do know that I was struck by the harmony of green, red, black, yellow, blue, brown, grey. It was very Degroux-like, an effect similar, for example, to that sketch of the conscript's departure formerly in the Palais Ducal.

Painting it was hard graft. There are one and a half large tubes of white in the ground — yet that ground is very dark — in addition red, yellow, brown ochre, black, terra sienna, bistre, and the result is a red-brown that varies from bistre to deep wine-red and to pale, blond reddish. Then there are also mosses and an edge of fresh grass that catches the light and sparkles brightly and is very difficult to get. There at last you have a sketch which — whatever may be said about it — I maintain has some meaning, says something.

While making it I said to myself: let me not leave before there's something of an autumn evening in it, something mysterious, something with seriousness in it.

However, because this effect doesn't last, I had to paint quickly. The figures were done with a few vigorous strokes with a firm brush — in one go. I was struck by how firmly the slender trunks stood in the ground — I began them using a brush, but because of the ground, which was already impasted, one brushstroke simply disappeared. Then I squeezed roots and trunks into it from the tube, and modelled them a little with the brush. Yes, now they stand in it — shoot up out of it — stand firmly rooted in it. In a sense I'm glad that I've never *learned* how to paint. Probably then I would have LEARNED to ignore effects like this. Now I say, no, that's exactly what I want — if it's not possible then it's not possible — I want to try it even though I don't know how it's supposed to be done. *I don't know myself* how I paint. I sit with a white board before the spot that strikes me — I look at what's before my eyes — I say to myself, this white board must become something — I come back, dissatisfied — I put it aside, and after I've rested a little, feeling a kind of fear, I take a look at it — then I'm still dissatisfied — because I have that marvellous nature too much in mind for me to be satisfied — but still, I see in my work an echo of what struck me, I see that nature has told me something, has spoken to me and that I've written it down in shorthand. In my shorthand there may be words that are indecipherable — errors or gaps — yet something remains of what the wood or the beach or the figure said — and it isn't a tame or conventional language which doesn't stem from nature itself but from a studied manner or a system.

Herewith also a scratch from the dunes. Standing there were small bushes whose leaves are white on one side and dark green on the other, and which constantly move and sparkle. Behind them dark wood.

As you see, I'm immersing myself in painting with all my strength—I'm immersing myself in colour—I've held back from that until now, and don't regret it. If I hadn't drawn I would never have felt or tackled a figure that looks like an unfinished terracotta. But now, I feel I'm on the high seas—painting must proceed with all the strength that we can muster.

If I work on panel or canvas, the costs go up again—everything is so expensive—paint is expensive too, and is used up so quickly. Well, these are drawbacks that all painters face—we must see what's possible. I know for sure that I have a feeling for colour that will develop more and more, that painting is in my very marrow. I appreciate it enormously that you support me so loyally and strongly. I think of you so often—I would so much like my work to be substantial, serious, manly, and for it to give you pleasure as soon as possible.

I want to bring one thing to your attention as important. Wouldn't it be possible to get paint, panels, brushes, &c. for the *net* price? At present I have to pay the *retail* price. Are you in touch with Paillard or someone like that? If so, it seems to me it would work out considerably cheaper to buy paint, for example, in larger quantities, such as white, ochre, terra sienna, and we could come to an arrangement as to the money. It would of course be cheaper. Think about it, if you will. Good painting doesn't consist in using a great deal of paint, but to give a ground true strength, to make a sky bright, sometimes one mustn't worry about a tube more or less.

Sometimes the subject requires that one paints thinly, sometimes the material, the nature of the things, makes it self-evident that they must be impasted. At Mauve's—who paints very soberly in comparison with J. Maris, and even more so in comparison with Millet or Jules Dupré—in the corners of the studio there are nevertheless cigar

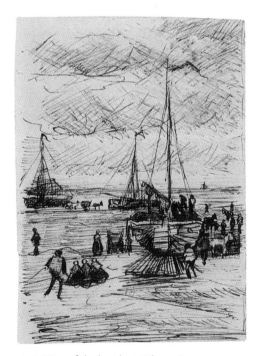

260A. *View of the beach at Scheveningen*

236 | The Hague, September 1882

boxes with the remains of tubes as numerous as the empty bottles in the corners of rooms at a soirée or meal such as Zola describes, for example. Now, if this month a little extra is possible, that would be wonderful. If not, then not. I'll work as far as I can. You enquire after my health, but how's yours? I believe that my remedy could also be yours. Being outdoors, painting. I'm well. I'm still troubled when I'm tired, but it's getting better rather than worse. I believe that it's also beneficial that I live as frugally as possible, but painting is my chief remedy. I hope with all my heart that you have some happiness and will find much more.

Accept a handshake in thought, and believe me

Ever yours,
Vincent

As you see, in the scratch of the seascape there's a blond, soft effect, and in the woods a more sombre, serious mood. I'm glad that both of these exist in life.

[*Sketch 260A*]

267 | The Hague, on or about Tuesday, 19 September 1882 | *To Anthon van Rappard* (D)

My dear friend Rappard,

Your letter, very welcome, has just arrived, and I'm answering at once because I'm longing to talk to you again.

You ask: do you have many German things? As it happens, on the subject of Vautier and other Germans in a letter to my brother about some figure studies I had drawn, I wrote almost exactly the same as what you say. I told him that I'd been to an exhibition of watercolours where there was a great deal by the Italians. Clever, very clever, and yet they left me with an empty feeling, and I said to my brother, old chap, what a pleasant time it was in art when that group of artists from Alsace began, Vautier, Knaus, Jundt, Georg Saal, Van Muyden, *Brion* above all, *Anker*, T. Schuler, who mainly made drawings, who were, so to speak, explained and supported by other artists, namely writers like Erckmann-Chatrian and Auerbach. Yes, the Italians are most definitely clever, but where is their sentiment, their human feeling? I'd rather see a grey scratch by Lançon — a few rag-pickers eating their soup while it's snowing and raining outside — than the dazzling peacock's feathers of the Italians, who seem to multiply daily, while the more sober artists are no less rare than they always were.

I mean it, Rappard. I would rather be a waiter in a hotel, for example, than the sort of watercolour manufacturer some Italians are.

I don't say that this applies to all of them, but you get my drift as regards the direction and tenor of that school. What I say doesn't detract from the fact that I also know many whom I find beautiful, namely the artists who have something *Goya*-like, such as Fortuny sometimes, and Morelli, and sometimes even Tapiró &c., Heilbuth, Duez. When I first saw some of this work 10 or 12 years ago, I was with Goupil at the time, I thought it was splendid, and even found it much more beautiful than the well-wrought things by either the Germans or, for example, the English draughtsmen or,

for example, Rochussen or Mauve. I've long since changed my mind, because I believe those artists are rather like birds with only one note in their song, whereas I feel more sympathy for larks or nightingales that have more to say with less noise and more passion. However, I don't have a great deal by the Germans—the beautiful ones from the time of Brion are hard to find now. I once put together a collection of woodcuts, mainly after the above artists, which I gave away to a friend in England when I left Goupil. I regret that so much now. If you want to have something really beautiful by them, put in an order at the offices of L'Illustration for *L'Album des Vosges*, drawings by T. Schuler, Brion, Valentin, Jundt, &c. I believe it costs 5 francs. But I fear that it's sold out. It's worth asking, though. Perhaps, indeed probably, the price has gone up—they won't send it on approval, that's why I didn't dare ask for it myself.

I can give few details about English artists, in the sense that I couldn't provide biographies of them. Having spent 3 full years in England, however, and having seen the work of many of them, I've learned quite a lot in broad outline about them and their work. It's hardly possible to appreciate them fully without having spent a long time in England.

It's a different way of feeling, conceiving, expressing, which one has to get used to first. Studying them more than repays the effort, for they are great artists, the English. *Israëls, Mauve and Rochussen* come closest, but in appearance a painting by Thomas Faed, for example, is very different from an Israëls, and a drawing by Pinwell, Morris or Small looks different from one by Mauve, and a Gilbert or Du Maurier different from Rochussen.

Speaking of Rochussen, I saw a splendid drawing by him: French generals demanding information and papers from the mayor and councillors in a room in an old Dutch town hall. I thought it was just as beautiful as, say, the scene at Dr Wagner's in Madame Thérèse by Erckmann-Chatrian. I know that you didn't greatly appreciate Rochussen at the time, but I'm sure that when you see his important drawings you'll like him very much indeed.

For me the English draughtsmen are what Dickens is in the sphere of literature. It's one and the same sentiment, noble and healthy, and something one always comes back to. I would very much like it if sooner or later you had an opportunity to quietly look through my whole collection. It's through seeing a lot together that one gets an overall view and it begins to speak for itself, and one sees clearly what a splendid entity this school of draughtsmen forms. Just as one must read Dickens or Balzac or Zola in their entirety to know them separately.

Thus, for example, I now have as many as 50 prints about Ireland—one might well overlook them seen individually, but they are striking when seen all together.

The portrait of Shakespeare by Menzel is unknown to me; I'd very much like to see how the one lion interpreted the other. For Menzel's work has some resemblance to Shakespeare's in that it LIVES, so. I have the small edition of Menzel's Frederick the Great. Bring it with you if you would, if you come to The Hague again. *I don't have the prints you write about (except for the Régamey), I do* NOT *have Heilbuth, Marchetti, Jacquet.*

I have nothing by *Whistler*, but in the past I've seen beautiful etchings by him, figures and landscape.

I was also struck by the seascapes by Wyllie from The Graphic which you write about.

I know The widow's field by Boughton; it's very beautiful. Yes, I'm so taken by all

of it that my whole life is aimed at making the things from everyday life that Dickens describes and these artists draw. Millet says — *in art one must give one's heart and soul.* I'm already wrestling, I know what I want, and nonsense about the illustrative won't divert me from my path. Contact with artists has, so to speak, completely ceased for me, without my being able to explain exactly how or why. I'm made out to be everything peculiar and bad. This means that I sometimes have a certain sense of being abandoned, but on the other hand it concentrates my attention on the things that aren't changeable, namely the eternal beauty of nature. I often think of the old story of Robinson Crusoe, who didn't lose heart because of his solitariness but organized things so that he created work for himself and had a very active and very stimulating life through his own searching and toiling.

Anyway, lately I've also been painting and watercolouring, and in addition I'm drawing many figures from the model as well as scratches on the street. Lately I've quite often had a man from the Old Men's Home to pose.

Now it's high time that I sent Karl Robert, Le fusain, back to you. I've read it through more than once and tried, and yet I make no progress with charcoal, and I prefer to work with a carpenter's pencil. I would like to see someone make a charcoal drawing — with me it so quickly becomes flat, and the cause is something that I believe would go if I saw it being done. If you come sometime, I have a few things to ask you about it.

In any case I'm glad that I've read it, and I entirely agree with the writer that it's a delightful medium to work in, and I wish that I could handle it better. Perhaps I'll discover the secret, along with other things that are still unclear to me.

So I'm returning it with thanks. I'm adding a few woodcuts, two German ones by Marchal, as it happens. The Lançons seem beautiful to me, and especially the Green, and The miners.

If you have any duplicates, I would always welcome having one of them.

I would also welcome letters — and if you read something that strikes you let me know, for I'm out of touch with what comes out these days — I know a little more about the literature of a few years ago. When I was ill and afterwards I read Zola's books with great admiration. I thought that Balzac stood alone, but I see that he had successors. Yet, Rappard, the age of Balzac and Dickens, the age of Gavarni and Millet, is now far behind us. For while it isn't long since those men passed on, it's a very long time *since they began*, and in the meantime there have been many changes that aren't exactly improvements in my view. I once read in Eliot 'though it be dead, yet let me think it lives', so it is with the period I'm writing to you about, in my opinion. And that's why I'm so especially fond of Rochussen, for example. You mention illustrations of fairy tales — did you know that Rochussen did splendid watercolours of German legends? I know a series called Lenore, splendid in sentiment. But Rochussen's important drawings aren't in circulation much, but in the portfolios of wealthy art lovers. If you go about collecting woodcuts energetically, you too will hear rhetoric about 'the illustrative'. But what happens with woodcuts? The fine ones become rarer as time passes, harder and harder to find — and later people will search for them and not be able to find them any more. The other day I saw the whole of Doré's work on London — I say, that's splendidly beautiful and noble in sentiment — for example in the room in the night refuge for beggars, which you have, I believe, and otherwise can still get.

Adieu, with a handshake.

Ever yours,
Vincent

I'm working on a watercolour of orphans — various things started — I have my hands full.

When I had finished my letter, I went out and came back with another pile of illustrations, namely old Hollandsche Illustraties, so I can add some duplicates to this batch.
 First 3 very beautiful *Daumiers*.
 1 *Jacque.*
If you have them already, please return them when you get the chance.
 The four ages of the drinker by Daumier has always seemed to me one of his most beautiful things.
 There is soul in it as in a *Degroux*. I'm very glad to be able to send you this print. The Daumiers are becoming rare.
 Even if you had nothing else by Daumier, the master would still be well represented in your collection. I saw splendid *drawings* by Frans Hals once. In this sheet I find something — in fact, everything — of Frans Hals or Rembrandt.
 I'm also adding some very beautiful *Morins* and old Dorés — prints that are becoming rarer and rarer.
 Like me, you've no doubt heard talk — on the subject of 'the illustrative' — against Doré above all, and of course against Morin.
 I believe that notwithstanding this you've continued admiring the work of these artists all the same. But if one isn't on one's guard, things like that can still influence one more or less. That's why I don't think it superfluous, now that I'm sending you these prints, to say that for me there's still the smell of the days of Gavarni and of Balzac and V. Hugo in these grubby woodcuts — something of the Bohème, now almost forgotten — which I respect, and that each time I see them again they encourage me to do my best and tackle things energetically.
 Of course, I too see the difference between a drawing by Doré and one by Millet, but the one doesn't rule out the other.
 There may be a difference, but there's also correspondence. Doré can model a torso and construct the joints better, infinitely better, than many a person who scoffs at him like a conceited know-all — witness, for example, that print of sea bathing, which for him is no more than a scratch.
 I'm only saying that if someone like Millet made comments about Doré's drawing — I doubt if he would, but suppose he did — well, he would have the right to do so. But when those who with their two hands can't do a tenth of what Doré can do with one finger rail against his work, that's nothing but arrogance, and they'd be well advised to be silent and to learn to draw better themselves.
 It's so silly that this lack of appreciation of drawing is so widespread these days.
 You saw the drawings by Lynen in Brussels — how witty and amusing and clever they were. If you talked to anyone about them, they answered loftily with a certain contempt that yes, they were 'quite nice'. Lynen himself, for example, will always remain fairly poor even though he's probably very active and very productive and likely to become

more so. Well, for my part, provided I stay active and become more and more productive, I have nothing against being fairly poor all my life, provided I have my daily bread.

Well, regards again, I hope you like the woodcuts, and that I'll soon hear from you again. Adieu.

274 | The Hague, Sunday, 22 October 1882 | *To Theo van Gogh* (D)

Sunday afternoon

My dear Theo,

Your letter and the enclosure gave me very great pleasure, I don't need to tell you that. It's just what was needed and is a mighty help to me.

It's still autumnal weather here — rainy and chilly, but full of atmosphere — especially good for figures, which show a range of tones on the wet streets and roads in which the sky is reflected. It's what Mauve, above all, does so beautifully time and again.

As a result I've been able to do some more to the large watercolour of the crowd of people in front of the lottery office, and I've also just started another of the beach, of which this is the composition.

[*Sketch* 274A]

I can agree entirely with what you say about times one occasionally has when one seems to be deadened to the things of nature, or when nature no longer seems to speak to us.

I, too, often have that, and sometimes it helps if I turn to something very different. If I'm dead to landscape or effects of light, I tackle figures, and vice versa. Sometimes there's nothing to be done except wait for it to pass, but on many occasions I manage to get rid of the unresponsiveness by changing the subjects I'm concentrating on. I'm becoming more and more fascinated by figures though. I remember having had a time in the past when the feeling for landscape was very strong within me, and I was much more struck by a painting or drawing in which a light effect or the mood of a landscape was well expressed than by figures. In general, the figure painters even inspired in me a kind of fairly cool respect rather than warm sympathy. However, I well remember being particularly struck at the time by a drawing by Daumier, an old man under the chestnut trees in the Champs Elysées (an illustration for Balzac), although the drawing wasn't that important. But I remember that it struck me so forcefully that there was something so firm and manly in Daumier's approach that I thought: it must be good to feel and think like that and overlook or ignore a mass of things so as to concentrate on something that's thought-provoking and appeals to a human being as a human being more directly than meadows or clouds.

And similarly the figures of either the English draughtsmen or the English writers, on account of their Monday morning-like sobriety and deliberate austerity and prose and analysis, continue to attract me as something solid and firm which gives one something to hold onto on days when one is feeling weak. And those of Balzac and Zola

Waarde Theo,

Uw brief & het ingeslotene deden my zeer veel plezier, dat behoef ik U niet te zeggen, het komt erg van pas en is my een krachtige hulp.

We houden hier herfstweer — regenachtig & kil, maar vol stemming — prachtig voor figuren vooral, die op de natte straten en weyen waar de lucht in weerkaatst koonig uitkomen.

Het is 't geen Mauve vooral telkens zoo mooi doet.

Ik heb nog wat daardoor kunnen doen aan de groote aquarel van den troep volk voor het loterykantoor en zoo pas heb ik er ook weer een van het strand begonnen waarvan dit

de compositie is.

Ik kan volkomen overeenstemmen met wat gy zegt omtrent ty dan die men soms heeft waarin men slomp schynt voor de dingen van de natuur of waarin de natuur niet meer tot ons schynt te spreken.

Ik heb dat ook dikwyls en het helpt my wel eens als ik dan heel andere dingen aanpak. ben ik stomp op landschap of lichteffecten dan gryp ik de figuren aan en omgekeerd. Soms is er niets aan te doen dan of te wachten tot het over gaat, maar menigen keer lukt het my de ongevoeligheid weg te krygen door verwisseling van motieven waarop ik myn attentie het. Hoe langer hoe meer echter boeien my de figuren. Ik herinner my vroeger een tyd gehad te hebben dat het gevoel voor 't landschap erg sterk by me was en ik veel meer getroffen werd door een schildery of teekening waar een lichteffect of stemming van landschap goed was uitgedrukt dan door figuren. Zelfs boezemden in 't algemeen de figuurschilders my meer een soort jamelyk koelen eerbied in dan wel dat ik er warme sympathie voor had. Ik herinner my echter nog zeer wel in dien tyd toch byzonder getroffen geweest te zyn door een teekening van Daumier & een oud man onder de kastanje-boomen in de Champs Elysées (een illustratie voor Balzac) ofschoon die teekening zoo ong'volant niet was maar ik weet wel dat het my toen zoo byzonder trof dat er iets zoo flinks en mannelyks in de opvatting van Daumier was dat ik dacht het moet toch goed zyn zoo te voelen en te denken en een massa dingen over 't hoofd te zien of voorby te gaan om zich te concentreeren op zoo iets wat te denken geeft en een mensch als mensch meer direkt persoonlyk aangaat dan weilanden of wolken.

274A. Beach with people strolling and boats

among the French writers just as much. As yet I don't know the books by *Murger* you write about, but I hope to become acquainted with them.

Did I write to you before that I read Daudet's Les rois en exil? I thought it rather beautiful.

The titles of those books sound very attractive, La bohème among others. How far we have strayed in our age from la bohème of Gavarni's day! It seems to me that things were a little warmer then, and more good-humoured and livelier than now. But I don't know, and there's also much that's good in the present, or would be more than is actually the case if there were rather more joining together.

At the moment a wonderful effect can be seen from the window of my studio. The city with its towers and roofs and smoking chimneys stands out as a dark, sombre silhouette against a horizon of light. The light, though, is only a broad strip; above it hangs a heavy shower, more concentrated below, above torn by the autumn wind into great tufts and clumps that float off. But that strip of light makes the wet roofs glisten here and there in the sombre mass of the city (in a drawing you would lift it with a stroke of body-colour), and ensures that, although the mass all has the same tone, you can still distinguish between red tiles and slates.

Schenkweg runs through the foreground as a glistening line through the wet, the poplars have yellow leaves, the banks of the ditch and the meadow are deep green, figures are black.

I would draw it, or rather try to draw it, if I hadn't spent the whole afternoon toiling at figures of peat carriers which are still too much in my mind for there to be room for something new, and must remain there.

I do so often long for you and think of you so much. What you write about some characters in Paris, about artists who live with women, are less petty-minded than others perhaps, try desperately to stay young, seems well observed to me. Such people exist there and here. It's perhaps even more difficult there than here for a person to keep some freshness in domestic life, because that's almost more of an uphill struggle there. How many have become desperate in Paris — calmly, rationally, logically and rightly desperate? I read something along these lines about Tassaert, among others, whom I like very much, and was pained by what happened to him.

All the more, all the more, I think every attempt in this direction is worthy of respect. I also believe that it may happen that one succeeds and one mustn't begin by despairing; even if one loses here and there, and even if one sometimes feels a sort of decline, the point is nevertheless to revive and have courage, even though things don't turn out as one first thought. Moreover, don't think that I look with contempt on people such as you describe because their life isn't founded on serious and well-considered principles. My view on this is as follows: the result must be an *action*, not an abstract idea. I think principles are good and worth the effort only when they develop into deeds, and I think it's good to reflect and to try to be conscientious, because that makes a person's will to work more resolute and turns the various actions into a whole. I think that people such as you describe would get more steadiness if they went about what they do more rationally, but otherwise I much prefer them to people who make a great show of their principles without making the slightest effort to put them into practice or even giving that a thought. For the latter have no use for the finest of principles, and the former are precisely the people who, if they ever get round to

living with willpower and reflection, will do something great. For the great doesn't happen through impulse alone, and is a succession of little things that are brought together.

What is drawing? How does one get there? It's working one's way through an invisible iron wall that seems to stand between what one *feels* and what one *can do*. How can one get through that wall?—since hammering on it doesn't help at all. In my view, one must undermine the wall and grind through it slowly and patiently. And behold, how can one remain dedicated to such a task without allowing oneself to be lured from it or distracted, unless one reflects and organizes one's life according to principles? And it's the same with other things as it is with artistic matters. And the great isn't something accidental; it must be *willed*. Whether originally deeds lead to principles in a person or principles lead to deeds is something that seems to me as unanswerable and as little worth answering as the question of which came first, the chicken or the egg.

But I believe it's a positive thing and of great importance that one should try to develop one's powers of thought and will.

I'm very curious about what you'll think of the figures I'm doing at present, when you see them sooner or later. It's the same with them as with the question of the chicken and the egg: should one make figures for a composition one has done first, or combine the figures made separately so that the composition flows from them? I believe it comes down to the same thing. *Just as long as one works.* I end with that with which you close your letter—that we have in common a liking for seeing behind the scenes or, in other words, are inclined to analyze things. Now this, I believe, is exactly the quality one must have in order to paint—one must exercise this power when painting or drawing. It may be that there has to be something innate in us, to some extent (but that too you have, and so do I—for that we may have to thank our childhood in Brabant and a background that helped, much more than is usually the case, to teach us to think), but above all, above all, it's only later that the artistic sense develops and ripens through working. *How* you might become a very good painter I don't know, but I certainly believe that it is in you and will come out.

Adieu, old chap, thanks for what you sent, and a hearty handshake.

Ever yours,
Vincent

I have the stove in place already—old chap, how I wish we could look at drawings and sketches for an evening sometime—and *woodcuts*. I have some more splendid ones.

This week I hope to have orphan boys to pose, then I may be able to rescue the drawing of orphan children after all.

1 Nov.

My dear Theo,

For several days I've been completely taken up by something that may also be of interest to you and I think it well worth writing to you about it especially. In a letter from Rappard I received an extract from a lecture by *Herkomer* on the subject of the wood engravings of recent times.

I can't tell you about the whole thing in detail, you may have read the article yourself (which was in an English art magazine, perhaps the Art Journal). It was mainly about the drawings in The Graphic. *Herkomer* relates how he himself worked on them with great ambition and enthusiasm, and he particularly recalls the splendid prints in the first volumes. Feels that no words can express sufficiently forcefully how important he finds the work of those first artists. He reviews the progress made in process and technique, the difference between the old and the modern wood engraving, &c. &c. Then talks about the present day, and that brings him to the real subject of his lecture. He says: the wood engravers are cleverer than ever, but nonetheless I see a decadence if I think back to when The Graphic began. And—he goes on—in my view the reason lies in two things against which I protest. One has to do with the publishers, the other with the artists.

Both have their faults, which will ruin things if one doesn't combat them.

The publishers, he says, demand things done for effect: 'correct and honest drawing is no longer wanted, complete designs are no longer in request, a "bit" just covering an awkward corner of a page, is all that is required'.

'The managers declare that the public require the representation of a public event or so and are satisfied if it is correct and entertaining, caring nothing for the artistic qualities of the work. I do not believe what they say. The only excuse you may accept is "dearth of good draughtsmen"'.

Then he comes to the artists, and says that he regrets that these days all too often it's the wood engraver, not the draughtsman, who makes the prints beautiful. Urges the artists not to accept this—to draw soberly and forcefully so that the engraver remains what he should be, the translator of the draughtsman's work, and doesn't get the upper hand. Then comes his conclusion, a forceful plea to all to continue supporting the cause warmly, and not to allow any weakening.

There's something of a reproach in his plea, and it isn't without some melancholy that he speaks, and as one fighting against the indifference he finds intolerable.

'To you—the public—the art offers infinite pleasure and edification. For you it is really done. Therefore clamour loudly for good work and be sure it will be forthcoming'—are his closing words.

The whole thing is thoroughly sound, firm, honest. His manner of speaking makes the same impression on me as some letters by Millet.

It gives me encouragement, and it truly does me good to hear someone talk like that for once.

I say that it's a terrible pity that here there's no enthusiasm, so to speak, for the art that's most suitable for the common people.

If the painters were to close ranks to ensure that their work (which, after all, is made for the people, in my view—at least I believe that is the highest, noblest vocation for any artist) could also come into the hands of the people and was put within everyone's reach, that would be something that would produce the same results as were produced in the first years of The Graphic.

Neuhuys, Van der Velden and a few others made drawings this year for 'De Zwaluw', a magazine that appears monthly and costs 7½ cents. There are some good ones, but one can see that most were done with a weak hand (not the original drawings but the way of popularizing them), and from what I hear the magazine is no more likely to keep going than its predecessors. Why doesn't it work?—the booksellers say they earn nothing from it, and instead of circulating it they block it.

And as for the painters, I believe they haven't yet made every effort to take the matter to heart. The definition that many a painter here in Holland gives in reply to the question 'What is a wood engraving?' is: 'it's *those things* lying in the Zuid-Hollandsch Koffiehuis'. So they rank them among the drinks. And the makers of them among the drunks, perhaps.

And what do the dealers say? Suppose I went to anyone here with around 100 sketches that I've gathered together. At best I fear I would be told 'did you imagine *those things* had commercial value?'

My love and respect for the great draughtsmen of both the age of Gavarni and of the present day increases the better acquainted with their work I become, and above all as I do my best myself to make something from what one sees every day on the streets.

What I value in *Herkomer*, in *Fildes*, in *Holl* and the other founders of The Graphic, why I find and will continue to find them even more sympathetic than Gavarni and Daumier, is that, while the latter seem to view society more with mockery, the former, like such men as Millet, Breton, Degroux and Israëls, choose subjects which—while as *true* as those of Gav. or Daum.—have something noble and in which there's a more serious sentiment. That, above all, must remain, it seems to me.

An artist need not be a minister or a collector in church, but he must have a warm heart for people, and I find it a noble thing that, for example, no winter passed without The Graphic doing something to keep alive sympathy for the poor. For instance, I have a print by Woodville showing the distribution of turf tickets in Ireland, another by Staniland entitled *Help the helpers* depicting various scenes in a hospital—where money was short, Christmas in the workhouse by Herkomer, Homeless and hungry by Fildes &c. I find them even more beautiful than the drawings by Bertall or somebody for the Vie Elégante or other élégances. Perhaps you'll find this a tedious letter—but everything was once more fresh in my mind. I had gathered together and mounted my 100 or so studies and when I had finished the job a slightly melancholy sense of 'what's the good?' came over me—but then Herkomer's forceful words calling on people not to weaken and saying that it's more necessary than ever to keep the hand to the plough did me so much good, and I thought I'd briefly tell you the substance of what he said. With a handshake in thought, believe me

Ever yours,
Vincent

I hope to hear from you in the coming days, I received a good letter from home.

Sunday

My dear Theo,

Yesterday I at last got around to reading a book by Murger, namely Les buveurs d'eau. I find something of the same charm in it as in, say, the drawings of Nanteuil, Baron, Roqueplan, Tony Johannot, something witty, something lively. Yet it's highly conventional, or at least so this book seems to me (I haven't yet read any others by him), and in my view there's the same difference between him and Alph. Karr and Souvestre, for example, as between an Henry Monnier and Compte-Calix and the above artists. I'm trying to take all the people I compare from the same era.

It breathes that age of la bohème (though the reality of that period is papered over in the book) and that's why it interests me, but in my view it lacks originality and honesty of sentiment. It may be, though, that his books in which there are no painter characters are better than this one — it appears that writers are always unfortunate with painter characters, Balzac among them (his painters are fairly *un*interesting). Even Zola might be right in his Claude Lantier — Claude Lantiers certainly exist — but still one would like to see Zola doing a kind of painter different from Lantier for once, who it seems to me is drawn from life by Zola after someone or other, and certainly not the worst, from the movement that was known as Impressionists, I believe. And *they* aren't the ones who make up the core of the body of artists.

Conversely, I know of few good drawn or painted portraits of writers. On this point most painters also lapse into the conventional and make of a writer a man who simply sits at a table full of papers, or don't even go that far and make him a gentleman with a collar and tie, and moreover a face without any particular expression.

There's a painter by *Meissonier* that I find beautiful; it's that figure seen from behind, bending forwards, with the feet on the cross-bar of the easel, I believe. All one sees is a pair of knees drawn up, a back, a neck and the back of a head, and just a glimpse of a fist with a pencil or something like that. But the fellow does it well, and the action of concentrated attention is caught, just like in a certain figure by Rembrandt where a little fellow sits reading, also huddled up, with his head resting on his fist, and one immediately feels that sense of being absolutely gripped by the book.

Take the Victor Hugo by Bonnat — beautiful, really beautiful — but even more beautiful in my view is the Victor Hugo described in words by Victor Hugo himself, nothing else than just this:

And I, I was silent —
As one sees a blackcock keep silent on the heath.

Don't you think that little figure on the heath is splendid? Isn't it as vivid as a little general of 93 by Meissonier — about 1 centimetre or so in size?

There's a portrait of Millet by Millet that I find beautiful, no more than a head with a kind of shepherd's cap on top.

But the looking — with half-closed eyes — the intense looking of a painter — how beautifully that's caught, and that cockerel-like quality, if I may put it like that.

It's Sunday again. This morning I was on Rijswijkseweg. The meadows are partly flooded so that there was an effect of tonal green and silver with the rough, black and grey and green trunks and branches of old trees twisted by the wind in the foreground, a silhouette of the village with its spire against the light sky in the background, here and there a fence, or a dung-heap with a flock of crows picking at it.

How you would feel something like that — how well you would paint it if you wanted to.

It was extraordinarily beautiful this morning, and it did me good to go for a long walk, for with all the drawing and the lithographs I'd hardly been out of doors this week.

As to the lithography, I hope to get a proof tomorrow of an old man. I hope it turns out well. I did it with a kind of crayon that's specially intended for this process, but I fear that the ordinary lithographic crayon will turn out to be the best after all, and I'll be sorry I didn't use that. Well, we'll see how it turns out.

Tomorrow I hope to learn various things about printing that the printer's going to show me. I would love to learn how to print myself. I think it quite possible that this new method will revive lithography. I believe that a way could be found of uniting the advantages of the new with the old method. One can never predict anything for certain, but who knows whether it might not lead to new magazines being founded again.

Monday

That was as far as I got yesterday evening — this morning I had to go to the printer's with my old man. Now I've followed everything: the transfer to the stone, the preparation of the stone, the actual printing. And I have a better understanding of what I can change by retouching. Herewith the first impression, not counting one that went wrong.

I hope to do it better in time. I myself am very far from satisfied with this but, well, getting better must come through *doing* it and through trying. It seems to me that a painter has a duty to try to put an idea into his work. I was trying to say this in this print — but I can't say it as beautifully, as strikingly as reality, of which this is only a dim reflection seen in a dark mirror — that it seems to me that one of the strongest pieces of evidence for the existence of 'something on high' in which Millet believed, namely in the existence of a God and an eternity, is the unutterably moving quality that there can be in the expression of an old man like that, without his being aware of it perhaps, as he sits so quietly in the corner of his hearth. At the same time something precious, something noble, that can't be meant for the worms.

Israëls has done it so very beautifully. Perhaps the most wonderful passage in Uncle Tom's cabin is the one where the poor slave, sitting by his fire for the last time and knowing that he must die, remembers the words

Let cares like a wild deluge come,
And storms of sorrow fall,
May I but safely reach my home,
My god, my Heaven, my All.

This is far from all theology — simply the fact that the poorest woodcutter, heath farmer or miner can have moments of emotion and mood that give him a sense of an eternal home that he is close to.

Just as I get back from the printer's I receive your letter. I think your Montmartre is splendid, and I would certainly have shared the emotion that it evoked in you. I believe, by the way, that Jules Dupré or Daubigny also often tried to arouse those thoughts in their work. Sometimes there's something indescribable in those effects—it's as if the whole of nature is speaking—and when one goes home one has the same feeling as when one has just finished a book by Victor Hugo, for example. For my part I can't understand that not everyone sees and feels it—after all, nature or God does it for everyone who has eyes and ears and a heart to perceive. I think that a painter is happy because he's in harmony with nature as soon as he can depict, to some extent, what he sees.

And that's a great deal. One knows what one has to do; there's an abundance of subjects and Carlyle rightly says, Blessed is he who has found his work. If that work—as in the case of Millet, Dupré, Israëls &c.—is something intended to bring peace, to say *sursum corde* or '*lift up your hearts*', then it's doubly encouraging. One is also less alone then, because one thinks: I may be here on my own, but while I'm here holding my tongue my work may be speaking to my friend, and whoever sees it won't suspect me of being cold-hearted. Understand, however, that the dissatisfaction about poor work, the failure of things, the technical difficulties can make one terribly melancholy.

I assure you that when I, for my part, think of Millet, of Israëls, Breton, Degroux— so many others, Herkomer among them—I can be terribly despondent. One only knows what those fellows are when one is at work. Now, to stomach that despondency and melancholy as one is, to be patient with oneself, not to take a rest but to toil despite a thousand shortcomings and faults and the precariousness of the victory—that's why a painter is also not happy: the battle with himself, improving himself, renewing his energy. All this complicated by the material difficulties.

That painting by Daumier must have been beautiful. It's puzzling that something that speaks as clearly as that, for example, isn't understood, or at least that the position is that, as you say, it isn't certain a buyer will be found, even at a low price.

For many a painter this is something intolerable, or almost intolerable, at least. One wants to be an honest man, and one is, one works just as hard as a porter, and yet one falls short, one has to give the work up, one sees no chance of carrying it out without spending more on it than one will get back for it. One has a feeling of guilt, of falling short, of not keeping promises, one isn't honest as one would be if the work was paid for at its natural, fair price. One is afraid to make friends, one is afraid to stir, one would like to call out to people from a distance like one of the old lepers: Don't come too close, for contact with me will bring you sorrow and harm. With this whole avalanche of cares in one's heart, one must set to work with a calm, everyday face, without moving a muscle, carry on with daily life, try things out with the models, with the man who comes to collect the rent, in short, with all and sundry. One must cool-headedly keep one hand on the tiller to continue the work, and with the other hand try to ensure that one does no harm to others. And then come storms, things one hadn't foreseen; one doesn't know what to do, and one has a feeling that one may hit a rock at any moment.

One can't present oneself as somebody who can be of benefit to others or who has an idea for a business that's bound to be profitable—no, on the contrary, it's to be expected

that it will end with a deficit and yet, yet, one feels a power seething inside one, one has a task to do and it must be done.

One would like to speak like the men of 93, we must do this and that, first those, then those, then the last will die, it's a duty so it goes without saying, and nothing more need be added.

Yet this is the time to combine and to speak.

Or is it rather that, given that many have fallen asleep and don't wish to be woken up, one must try to confine oneself to things that one can finish alone, which one faces alone and has sole responsibility for? So that those who sleep can go on sleeping and rest. Now you see that this time I too am expressing more intimate thoughts than normally; you're to blame for this, because you did the same.

Concerning you, this is what I think: you are after all one of those on watch, not one of the sleepers. Would you not rather keep watch while painting than while selling paintings? I say this coolly, not even adding: this or that would be preferable in my view, and trusting to your own insight into things. That one runs a high risk of going under oneself, that being a painter is like being a *forward sentry*, this and other things — that goes without saying. You mustn't think I'm so very afraid; painting the Borinage would be something, for instance. That would be so difficult, so dangerous even, as is needed for a life in which rest and pleasure are quite a long way off. All the same, I would undertake something like that if I could undertake it, that is if I couldn't foresee for certain, as I do now, that the costs would exceed my means. If I found others interested in this or a similar enterprise, I would risk it. Precisely because at the moment it's really only you who cares what I do, for the time being it's in the dark and must remain there. So I'll find things to do in the meantime. But I'm not leaving it in order to spare myself or anything like that. I hope it'll be possible for you to send something again not later than 1 Dec. Well, old chap, I thank you right heartily for your letter, and a warm handshake in thought, believe me

Ever yours,
Vincent

291 | The Hague, between Monday, 4 and Saturday, 9 December 1882 |
 To Theo van Gogh (n)

My dear Theo,

You've received my letter in which I wrote about how, while I was working, an idea came to me for making figures *from the people for the people*. How it seemed to me that it would be a good thing if several individuals joined together for this purpose, not for the bookshops but out of charity and duty. Since I wrote that to you, I've naturally thought not so much 'Who will do this or that?' as 'What shall I do for it?' on the grounds that I'm not responsible for the one, but I am for the latter.

But I can tell you this, just when I was drawing for this purpose the idea took shape more firmly in my mind that setting up such a thing would be useful, and that there would be absolutely no need to resort to aping other popular publications, that on

the contrary, the existence of similar magazines like *British Workman*, for instance, is a guide as to How to do it and How not to do it. I don't know whether you know Little Dorrit by Dickens and the character *Doyce* in it, the man who could be taken as typical of those who have as their principle: How to do it.

Even if you don't know this wonderful figure of a working man from the book, you will understand the chap's character from this one quotation. When what he wanted didn't come about, encountering indifference and even worse, and he couldn't carry on, he simply said: This misfortune alters nothing — the thing is just as true *now* (after the failure) as it was *then* (before the failure).

And began again on the continent with what hadn't succeeded in England, and launched it there.

What I wanted to say is this. The idea of drawing types of working man from the people for the people, and circulating them as a popular publication, seeing the whole thing as necessarily being an affair of duty and charity — that and nothing else than that — see, that idea is such that I believe one is entitled to assume, even if it isn't successful immediately or at once: The thing is as true today as it was yesterday, and will be as true tomorrow. And that it's thus something that one can begin and pursue with serenity, something whose good outcome one also needn't doubt or despair of — provided one doesn't weaken or lose heart.

I said to myself that what I should do was obvious — do my very best with the drawings. So since my letter on this subject I now have some new ones.

First of all a Sower. A big old chap, a tall dark silhouette against a dark ground.

Far off a heath cottage with a mossy roof and a bit of sky with a lark. This is a sort of cockerel type: a shaven face, fairly sharp nose and chin, the eye small, mouth sunken. Long legs with boots.

Then a second sower with a light brown bombazine jacket and trousers, so this figure comes out light against the black field bounded at the end by a row of pollard willows. This is a very different type, with a fringe of beard, broad shoulders, a little stocky, a little like an ox in the sense that his whole appearance has been shaped by working on the land. If you like, more the type of an Eskimo, thick lips, broad nose.

Then a reaper with a big scythe in a pasture. The head with a brown woollen cap stands out against the light sky.

Then one of the old boys with short jackets and big, old top hats one meets sometimes in the dunes.

He's carrying home a basket of peat.

Now in these drawings I've tried to express my intention even more clearly than in the old man with his head in his hands. All these chaps are doing something, and I think that in general that, above all, should be adhered to in the choice of subjects. You yourself know how fine the numerous resting figures are, which are made so very, very often. They're done more often than working figures.

It's always very tempting to draw a figure at rest — expressing action is very difficult, and in the eyes of many the effect is 'more pleasing' than anything else.

But this pleasing aspect mustn't lose sight of truth, and the truth is that there's more toil than rest in life.

So you see that my attitude to it all is chiefly this, that for my part I'm trying to work on it. It seems to me that the drawings themselves have greater urgency than even the reproduction.

I'll also be careful about talking about the matter, because I believe that people generally act more practically in a small group than when many are involved.

Too many cooks spoil the broth.

How I wish we were together a little more.

Do you know why I, for my part, don't doubt that I could do it? You know from physics that an object immersed in a fluid loses as much weight as the specific gravity of the amount of fluid that the body displaces. This is why some things float, and why even those that sink are lighter under water than in the air. Something similar — a kind of fixed law of nature — seems to exist as regards working, in the sense that when one is engaged in it, one feels more capacity for work than one knew one had, or rather actually did have. You would experience that too if you set yourself to painting sometime. At first it seems something unattainable, a hopeless thing, later it becomes clear, and I believe that you would see this in my work too.

But something I've already written to you has been confirmed, namely that Rappard is seriously ill. I've again had news from his father, who doesn't say what it is exactly. By the time he's better I want to have as many drawings as possible finished, because I'd like R. to do the same as soon as he's up and about. R. has what not everyone has, namely he ponders, and his feeling is something he cultivates. He can make a plan, take stock of something, keep hold of an idea.

Many others regard the pondering and the willing as unartistic, are at least not equipped for *long-term labours*. The matter in question now involves *both* skill and action *and* perseverance, and furthermore being calmly patient. Then Rappard has another thing that in my view means he can be of great value for something like this. He really studies the figure, not just as a note of colour in a watercolour, but more strictly as to its form and structure.

I often think I'd like to be able to spend more time on landscape proper. I often see things that I find remarkably beautiful, which moreover make me say instinctively, I've never seen this or that painted like that.

In order to paint it — how to do it — I would have to give up other things. I would like to know whether you agree with me that in landscape there are things that have still not been done, that, for example, *Emile Breton* has imparted effects (himself continues to work in that direction) that are a beginning of something new which it seems to me hasn't yet reached its full force, understood by few, practised by even fewer. Many landscape painters don't have that intimate knowledge of nature possessed by those who have looked at the fields with feeling from childhood. Many landscape painters give something that satisfies neither you nor me, for example, as people (even if we appreciate them as artists). People call Emile Breton's work superficial, which it isn't, he ranks much higher in sentiment than many others, and knows much more and his work holds up.

Truly, huge voids are also beginning to come in the sphere of landscape, and I'd like to apply a remark by Herkomer: the interpreters allow their cleverness to mar the dignity of their calling. And I believe that the public will begin to say, deliver us from artistic combinations, give us back the simple field. How good it feels to see a fine

Rousseau that has been laboured over in order to be faithful and honest. How good it feels to think of people like Van Goyen, Old Crome and Michel. How beautiful an Isaac Ostade or a Ruisdael is. Do I want them back, or do I want them to be imitated? No, but I do want the honesty, the naivety, the faithfulness to remain. I know old lithographs by Jules Dupré, either by himself or facsimiles of his croquis.

But what spirit and what love is in them, and yet how freely and gaily they are done.

Copying nature absolutely isn't the ideal either, but knowing nature in such a way that what one does is fresh and true — that's what many now lack. Do you think, for instance, that De Bock knows what you know? No, most definitely not. You will say, but everyone has surely seen landscapes and figures from childhood. Question: was everyone also thoughtful as a child? Question: did everyone who saw them — heath, grassland, fields, woods — also love them, and the snow and the rain and the storm? Not everyone has that the way you and I do; it takes a special kind of setting and circumstances to contribute to it, and a special kind of temperament and character as well to make it take root.

I remember letters from you from when you were still in Brussels with descriptions of landscapes like those in your last letters.

Do you realize that it's so very, very necessary that honest people should remain in art? I'm not saying that there are none, but you yourself feel what I mean, and know as well as I how a host of people who paint are enormous liars. *Honesty is the best policy* applies here too, as does the fable of the hare and the tortoise, and the ugly duckling by Andersen. Edwin Edwards the etcher, for example — why is his work so absolutely beautiful, why did he rightly gain a position among the best in England? Because what he wanted was honesty and faithfulness. I would rather be Jules Dupré than Edwin Edwards, but, you see, one must have great respect for sincerity, and it holds up when other things turn out to be chaff.

To me the *Bernier, The fields in winter* in the Luxembourg is an ideal.

Then you have *Lavieille*, the wood engraver and painter — I saw a winter night with a Christmas sentiment by him that now comes to mind.

Then you have *Mme Collart* — for instance that painting of an apple orchard with an old white horse.

Then you have *Chintreuil* and *Goethals*. (I've often sought someone in order to explain to you with whom the beautiful things by Goethals could be compared — I believe Chintreuil.) But then I don't know much of Chintreuil's work, or of Goethals's either, for that matter.

Misconceptions as to the intentions of the great landscape painters are to a large extent the cause of the trouble. Almost no one knows that the secret of beautiful work is to a large extent good faith and sincere feeling.

Many can't help it that they aren't deep enough, and act in good faith, in so far as they have good faith.

Yet I believe you'll admit (the more so since it's a question here of something that isn't your own sphere, although it does concern you somewhat) that it's a fact that if many a landscape painter who is now highly rated knew half what you know of sound ideas about the outdoors, with which you're naturally familiar, he would produce much better and sounder work. Think this over, and put this and many more things besides in the balance when, weighing yourself, you say things like, 'I would

only be something mediocre'. Unless you mean mediocre in its good, noble sense. STALWARTNESS, as people say here, they make great play of this word—for my part I don't know the true meaning of it, and have heard it applied to very insignificant things—stalwartness, is that what must save art? I would be more hopeful that things were going well if there were more people like E. Frère or Emile Breton, for example, rather than *stalwarts* like Boldini or Fortuny coming. Frère, Breton, will be missed and mourned; Boldini, Fortuny, one may respect them *in themselves*, but the influence they exercised is fatal.

A chap like Gustave Brion has left something good, Degroux, for instance, too. If there were many more like them the world would be a better place; art would be a blessing. But Boldini, but Fortuny, but Regnault even, what good does it do us, what progress have we made? What you say is absolutely true, 'Seriousness is better than raillery, however sharp and witty it is'. In other words, I would say, loving-kindness is better than mockery, that goes without saying, but many say, no, there's good in that mocking. Well, they must reap as they sow. Adieu, old chap, I wanted to write to you about the drawings, namely that I hope this idea of prints for the people will induce me to make some progress. As I write to you, news of Rappard that there's some change for the better, but he seems to be very ill. I know for sure that both he and his father are interested in the types from the people. I hope to go over there as soon as Rappard is back on his feet, or at least when his eyes are normal again.

Write again soon, and believe me

Ever yours,
Vincent

301 | The Hague, on or about Saturday, 13 January 1883 | *To Theo van Gogh* (D)

My dear Theo,

What you write about has literally not been out of my thoughts since I received your letter. And I'm writing again precisely because the matter preoccupies me so much. In cases like this one is faced by a patient who is ill in *both* body *and* soul. So it's doubly serious. And financial help with the necessities of life etc. isn't enough to bring about complete recovery, for the very best and most effective medicine is still love and a home. At least that's what I felt last winter, and since then—now, for instance—far more so, precisely because the experience made clear to me what my feelings were also telling me. Maintaining a life above water is a great and fine thing, but it's also very difficult and requires a lot of care. Making a home for the homeless, well, that's something that *must* be good, whatever the world may say, it *cannot* be wrong. And yet it's often seen as some sort of crime.

I couldn't help thinking and thinking again about it. How will people take it? Will it bring you into conflict with the world? That, too, is a question in my mind that I can't answer, because I don't yet know the circumstances well enough. And there's something else, which is actually the reason for this letter and which I wanted to suggest you consider and which you've probably thought of yourself.

Something like this is a long-term business. But I do think it possible that you'll soon see the reward for your care, although the complete recovery in body and soul of a constitution that has had such a shock really is something that will take years.

The woman and the children are with me at the moment. There's a big difference when I think back to last year. The woman is stronger and sturdier, has lost a great, a very great deal of that harried look. The little child is as charming, healthy and cheerful a little fellow as you can imagine. He crows like a cockerel—has nothing but the breast yet is fat and plump.

And the poor little girl—you can see from the drawing that the deep misery of the past hasn't been wiped away yet, and I often worry about that, but still, she's already very different from last year—then it was very, very bad, and now there's already something truly childlike in her.

Anyway, though not yet completely normal, the situation is better than I would have dared hope for last year. And when I now reflect, would it have been better if the mother had had a miscarriage, or if the child had withered and wasted away for lack of mother's milk, and if that girl had been left more and more unclean and neglected, and the woman herself in who knows what wretched, near indescribable state?—see, then I may not hesitate and I say, onward in good heart. Something simple—truly motherly—is coming in the woman, and as that strengthens she will be saved.

And how is progress made??? Not through doctors or through unusual remedies. Through the sense of one's own home, through a regular, motivated life. Not by sparing oneself a great deal, for that *cannot* be done, but because the harried heart has more rest, even during hard and tedious work. With this case that I know intimately before me as a reality, I come back to what I wanted to say. It seems to me that you should pay special attention to the surroundings of the woman you write about if you want to see some benefit. It would be desirable for her to be somewhere other than in an empty room in a hotel or something like that, and for her to be in more domestic surroundings. Think about this, for I believe it's an important thing. She needs to be distracted by very ordinary everyday things that keep her occupied.

Solitude or idleness is absolutely fatal. She should be able to talk to good people. In short, a domestic circle with nothing out of the ordinary would be wonderful. Occupy herself with children, say. I think it rather a pity that she has no child, in my view that makes the case even more critical.

Yes, I believe that the most practical thing you can do is to put her in a domestic circle. I believe that the main consideration for you at the moment is—this life must be saved—and that unselfishly you think more of *her* than of *yourself*. For my part, last year I knew of only one home for her, namely with me, and if I could have done something else I wouldn't have taken her into my house immediately, precisely in order to avoid unpleasantnesses that couldn't then be avoided. Unable to do otherwise, I didn't hesitate though. And all in all everything has gone well so far. But with you the position is different, and perhaps you can take her, the person you write about, somewhere for the time being where she'll be calm and safe until she's fully recovered. I fear that it may be a long-term business, her recovery, and moreover, *if it can be avoided* one needn't sin against society's prejudices, which simply do exist. *If it can't be avoided*, then what carries most weight must outweigh the rest, and this summer I would rather have sinned against all possible prejudices, even if there were more, than leave the woman

without a roof and a hearth. But in your case everything *can* and *should* take place more calmly, it seems to me, and if I were you I'd provide her with a solid home. Not alone in a room, with no company. For her own good, and not because you want to spirit her away or keep her concealed, but for her it's essential that emotions and shocking things are avoided as far as possible, and the sooner she's in normal, everyday occupations and surroundings, the better.

Well, if you could take her in immediately, I wouldn't speak of it. Yet I fear that's not possible and you yourself wouldn't immediately agree.

I'm very agitated and I think of you all the time. Just now I did another drawing for which the woman posed. Listen, old chap, to put it briefly, it has been my experience this year that while there are hard, very hard, moments of care and trouble, it's infinitely better to live with a woman and children than without.

So if you continue to think that this person is the woman for whom you want to live, I regard it as a happy thing for you. And then it's precisely through love persevered with that she will bloom again. But it's always desirable to get to know each other first, that's more orderly and more prudent. And I too would have done that if it could have been arranged, even though I thought, I'll stay with this person for ever. But there was no home immediately open to her except mine. Anyway, it's the circumstances that one must take into account, and sometimes one can't avoid giving offence. I don't in the least want to advise you to give it up, since you write that you love her, but I believe we agree that it's good to be careful vis-à-vis the world, which otherwise sometimes ruins everything.

And so, be careful. For the present the recovery is the main concern, and the other is secondary. Well then, I believe nothing will be better for her than to spend each day in a quiet circle. Don't you know someone among your friends who would be willing to help and take her in for the time being?

For, I repeat, if she's alone in a room, with no distraction or occupation, then I believe that could be quite fatal for her. And a kind of hospital (ordinary or private) where she had company would perhaps be preferable, provided you visited her often. It may be that all this has already been arranged; I write about it just because I don't know anything definite in this regard.

I wish I knew when you were coming. If you come and are able, bring the old studies with you. As for my writing to ask whether you could send me a little more, well, I'm a little worried and wish it was possible, but don't let *her* go short for my sake. And be assured that because of what you write I'll gladly redouble my efforts to make progress, so that the burden on you is lightened. But that's just the thing: working hard sometimes actually costs money, because one has more outgoings. Write soon, for I'm truly longing for news of you. My blessing in everything. Rappard is getting better, I have a letter from him. I'm busy with work, still doing various Heads. Adieu, with a handshake in thought.

Ever yours,
Vincent

You'll say that I'm spending a lot of time writing, I can't help it, for you've confided in me, so I want to tell you that this didn't fail to touch me.

It's an odd thing about cases of this kind that it's so extremely difficult to know how far one should go. You will experience this too. One asks oneself, should I help this woman and otherwise see only a friend in her, or should I definitely choose this woman as my wife with whom I want to live always? Is she the one? Or is she not?

You see, I believe that you haven't avoided this conflict, or perhaps you're still in it. For were it to be otherwise, it would seem to me rather unnatural.

At any rate I felt that conflict, and it was so difficult that for my part I *couldn't* entirely answer those questions when circumstances forced me to make a decision. Because I thought, I don't have the means to maintain two separate households, but perhaps I have enough for one, and so I must tell her how things stand: what I might be able to do and what I *certainly couldn't* do. Perhaps we'll be able to get by together, but if we don't live together I won't have enough. With you it may take a different form while still being the same conflict, and I remember a remark of yours last year that I thought very right and true: 'marrying is such a funny thing'. Yes, by Jove, it certainly is. You said to me then, don't marry her, and I conceded to you that the circumstances were such that there was good reason not to speak of that for the time being. And now you know that I haven't spoken further of that, but also that she and I have remained true to each other. And precisely because I can't say that you were wrong when you said 'don't marry her', I ask you to consider these words of yours, and indeed believe that you've thought about them, for it isn't *I* who says this but you yourself. And I remind you of this only because I believe that it was indeed good that it didn't happen immediately.

So don't let go of this thought, for it's good for love to ripen so that marrying becomes very much a secondary matter. That is safer, and no one suffers harm as a result.

I wanted to say one thing to you in the beginning, which you'll understand anyway. Whether or not this puts you in difficulties, I respect the noble feelings that prompted you to help, and because I respect that I hope that if you do run up against difficulties, large or small, you'll think me worthy of your confidence.

Yet I do NOT view the matter with melancholy, but with every hope of a good outcome, namely happiness for you and for her.

But once again—I consider it likely that a crisis will come sooner or later, consisting of a kind of mutual disappointment—if there was a child, it would be like a lightning conductor for the two of you. Now there isn't one in your case and so, above all when the crisis comes—not *now* but *later*—trust me then and talk to me. See, for that's where there are rocks where many a love has foundered alas and could have been saved. Once one has surmounted those rocks there's plain sailing ahead. Although I'm busy writing to you, I'm busy working too. I can't say how much I long to discuss many things with you. Tomorrow I'll be getting a *sou'wester* for the heads. Heads of fishermen, old and young, that's what I've been thinking about for a long time and I had already done one, but then later I couldn't get hold of a sou'wester again. Now I'm going to have one of my own, an old one that many gales and seas have swept over.

My dear friend Rappard.

Sincerest thanks for your letter and for the information about the woodcuts you've found. I'd very much like to see some of them, particularly *Degroux* and *Lançon*.

The fact that you're recovering so well gives me no little pleasure. You know that before your illness we were corresponding fairly regularly about the lithographs, and then we had to break off that correspondence.

Since then I've been toiling away, not directly on stone but using lithographic crayon.

That's an excellent material.

If I write quite frequently now, please bear with me, and for your part write often too, for you have some way to catch up — although not you yourself but the circumstances of your illness are to blame for that.

I do assure you that The Graphics I now have are amazingly interesting. More than 10 years ago I used to go every week to the display case of the printer of The Graphic and London News in London to see the weekly publications. The impressions I gained there on the spot were so strong that the drawings have remained clear and bright in my mind, despite everything that has since gone through my head. And now it sometimes seems to me as if nothing lies between those old days and now — at any rate my old enthusiasm for them is now greater rather than less than it was originally. I don't doubt for a moment that you'll have no complaints if you come to see them one day.

I know that you *don't* look on the Black and White in the way that most of the Dutch do, and while I don't know for sure whether you have plans to make use of this means yourself to express what you feel, I do believe that at any rate you have no prejudice about it. The one needn't rule out the other, and in many cases Black and White especially is a means that makes it possible to put effects on paper in a relatively short time which would lose something of what people call their 'spontaneity' if done in another way. I wonder whether the *London sketches* — such as Low lodging house St Giles's by Herkomer, Casual ward by Fildes — wouldn't be a little less compelling and full of character if painted than they are in the rough Black and White.

There's something manly about it, something rough that I find highly attractive. Something else — the boss of Black and White may be someone neither you nor I know. In reviews of exhibitions I see mention made of the work of *Lhermitte*, a Frenchman who does scenes from the life of fishermen in Brittany. It's said of him that 'he is the Millet and Jules Breton in Black and White', and his name crops up again and again. I'd like to be able to see something by him, and have recently written about him to my brother, who has given me very good information several times in the past (about Daumier's painted work, for example).

As to the lithographs, the one of the chap sitting on a basket slicing his bread is a failure. When it was being transferred to the stone, the upper half came out all blotted and I could only partly correct it with the scraper. All the same you'll see that there are things in them that prove that with this technique one can work vigorously and render materials, for example the basket, the trousers and muddy boots. And while I myself found this sheet very ugly in the first days, I've since become more reconciled to it,

and if I began again I'd continue in the same, more vigorous way — with a background behind.

I read in Herkomer's biography how in his early days (when the incident with the rough sketch of Sunday at Chelsea Hospital took place) he did his best to find some among the artists of that time who also wanted to do figures from the people. He then found Gregory, who was the first to come up with sketches from the Franco-Prussian War (Paris under the red flag ((I didn't know at first that this print was by him)) and an emergency hospital in a theatre), and later confined himself to scenes on board ships. And Gregory and Herkomer have remained friends ever since.

Now your writing to me about getting better brings back the days last summer when I too was getting better.

There's something that dates from that time that I must tell you about. Perhaps I wrote to you about it at the time but I don't remember for sure. Do you recall that when you visited me last summer we met a woman and I told you that she was a model I'd found, and also told you how I discovered that she was pregnant and tried all the harder to help her because of that?

Soon after that I fell ill myself. She was then in the hospital in Leiden, and in hospital I got a letter from her saying how anxious she was. Before then — during the winter when she suffered terribly — I did what I could, and now I was deeply divided within myself as to what to do. Could, should I help? I was ill myself and the future was so dark. Nonetheless, I got up, against the doctor's advice in fact, and went to see her. I saw her in the hospital in Leiden on 1 July. That night she had given birth to a boy who lay sleeping in his cradle beside her with his pert little nose above the blanket — knowing nothing, of course, about the ways of the world. At any rate, a sick painter like me struggling to get by knows things about it a child like that doesn't know.

And what should I do? I had much to think about at that moment. She'd had a very difficult birth, the poor creature of a mother. Aren't there moments in life when remaining inactive or saying, 'What's it to do with me?' is criminal? At any rate, I said to the woman, when you're better, move in with me. I'll do what I can. Now, my dear friend, this woman had another child as well, a sickly, neglected lamb. It was an undertaking that was in fact considerably further beyond my strength than, say, buying The Graphic, but what else could I do? A person has a heart in his body after all, and if we didn't dare take on things we wouldn't be worthy of life. Well, she moved in with me — I went to live in a house that wasn't even entirely finished and that I could get for a relatively low rent. That's where I still live, two doors along from my old studio, it's No. 138. And we're still there. But now the baby from the cradle in the hospital doesn't sleep as much as in those first few days. He's turned out to be a delightful, lively fellow, now 7 or 8 months old. I fetched his cradle from a junk shop on my shoulders, and that child — for me he was a light in the house through the whole dark winter. And the woman, although she isn't strong and must nevertheless work hard to keep everything in order, has still become stronger because of it. So you see that while I try to penetrate deeper into Art, I also try to do that in life itself — the two go together.

That I've had no lack of unpleasantness with former friends who no longer looked me in the eye is something that didn't particularly surprise me.

This was happily not the case with my best friend, namely my brother — for he and I are more friends than brothers — and he's someone who understands such matters, and

not only that — he himself has helped and still helps many an unfortunate. Nonetheless, I've lost some friends because of it, but I've gained more light and shade in my own house and more of a *Home*, even though sometimes when cares weigh heavily on me it's as if I were on a ship in a storm. Anyway, though I know very well that the sea holds dangers and one can drown in it, I still love the sea deeply and despite all the perils of the future I have a certain serenity.

Now I have a great desire to speak to you again, and I'd very much like you to come to see The Graphics before long, if you can, but I write to you in advance about the changes in my household because I don't know exactly what you think of such matters in life. If we were in the days of the 'Bohème', a painter's family and studio like mine would be nothing unusual. Nowadays, though, we're a very long way from the original Bohème, and among the painters there are considerations of decency that I don't exactly understand, but I don't wish to offend those who have them.

Again, were we still in the days of Bohème, I'd let everything take its course, but now I say to you, my dear friend Rappard, I live with a poor woman and two children, and there are so many who will have no dealings with me, for that and other reasons, that I'm bound to tell you this when I write, Would you like to come and go through The Graphics one of these days?

What I must also tell you is that when my father first heard about this, you will understand that he wasn't best pleased, or rather didn't know what to think, not having expected such a thing from me. Then we saw each other again nonetheless, which hadn't happened since I came here after leaving home because of the problems there. And when he heard more of the details, he looked at it differently from at first. The disagreement I had with him when I left home didn't last long, and we'd already settled our differences before I was with this woman. Since then even my father has paid me a visit while I was living with her.

But how many misunderstandings there are in life, and how much better everything would be if people cooperated a little more instead of arguing.

Oh, old chap, I wish more of the Bohème was left in society, and especially among the painters.

Above all, you mustn't think that it's because of the woman that they don't visit me; that's one thing, but in general it's because of the painting itself, although this summer I certainly painted studies too. In short, contact with painters here has been a severe disappointment to me. Will it get any better???

One painter here recently ended up in the madhouse — Boks, a landscape painter. It was very difficult to get help for him before he was in there, although during one illness he did get some help after all, chiefly through Mauve. *Now that he's inside*, everyone speaks sympathetically of him and calls him very clever. Among others, a person who refused him help on several occasions and rejected studies by him said lately, 'finer than Diaz', which I find rather an exaggeration. The chap himself told me a year ago that he got a medal in England — which he'd sold for the silver. Another painter, Breitner, with whom at first I occasionally went out drawing in the street, and who was in the hospital at just about the same time as I was, has become a teacher at the secondary school, although I know he wasn't looking forward to it.

Is it a good time for the painters??? When I first came here to the city I went to all the studios I could get into for the sake of seeking contact and making friends. Now

I'm much cooler on that point, and believe that there *is* a very dark side to it, precisely because the painters seem warm-hearted but all too often try to trip you up. That's the fatal thing. We should help and trust each other, for there are hostilities enough in society anyway, and in general we'd do better if we did no harm to each other. Envy drives many to malign others, systematically. And what is the result? —instead of one large entity, a body of painters where unity is strength, everyone withdraws into his shell and works by himself. Those who are now cock of the walk create a kind of desert around them just because of their envy, and that's very unfortunate for themselves, it seems to me. A battle with paintings or drawings is good in a sense, and at any rate fair, but we shouldn't become personal enemies of each other or use other means for fighting.

Anyway, if this kind of thing is no obstacle for you, think about coming to see those Graphics, for they're splendid, and I'd like to have a word with you about what to do with the duplicates. For there are many, and among them some of the *very finest*, Last muster by Herkomer, old women's home, Low lodging house St Giles's by him. Emigrants and BOARD SCHOOL by Frank Holl. *Caxton printing by Small, Barque at sea by Nash, Old Gate by Fred Walker* and suchlike that are the *core* of a woodcut collection. In short, it's a lot. From earlier correspondence I understand that you don't want to have them for nothing, though for my part I would gladly give you what I have in duplicate without further conditions, as long as you take pleasure in them and love them.

But I know for sure that we can arrange it so that you needn't feel any qualms about accepting them and, since this can certainly be settled one way or another, it seems to me that perhaps we may soon meet each other again, especially if your recovery continues to progress.

And I would find it all the more desirable if you came because I've now put together a large number of studies from this winter which I'd like to speak to you about.

I would have written to you before about one or two things that I'm telling you now, but it was still so strange for me myself, and I was rather put out by some unpleasantness with others. And I'm writing about it now, not because I regard you as someone with narrow views on life, and not because I believe you'll find anything incomprehensible in what I did, but because I wouldn't think it honest of myself if, while asking you: couldn't you come and see these woodcuts?, I didn't say that things in my household had changed considerably since your visit, and that because of that change many avoid me and would certainly never set foot inside.

The studio is much larger than my old one, but I'm always afraid that the landlord will raise the rent or find tenants who can pay more than I.

Still, as long as I can keep it, it's a very good studio.

If you reckon that almost every one I already had from The Graphic has now become a duplicate, you'll understand that it's rather a lot.

And I have hopes of getting some more, especially from the very first volumes.

I've had both illusions and disappointments with other women once or twice, and in the past I didn't imagine that I would end up like this. But there was something that struck me in this woman, that as a mother she was so alone and abandoned, and I didn't hesitate, and neither then nor now do I believe I did wrong. For in my view one shouldn't pass by where a woman is a mother and is abandoned and in need. This is a figure like those done by Holl or Fildes.

If you do come before long, don't make your visit too short. The Graphics are *so* beautiful that I believe that, even while you're still weak, provided the journey itself isn't too tiring (as it happens, I live close by Rijnspoor station), looking at them could revive and strengthen you. Anyway, do as you think fit.

With a handshake.

Ever yours,
Vincent

310 | The Hague, Thursday, 8 February 1883 | *To Theo van Gogh* (D)

8 Feb.

My dear Theo,

My sincere congratulations to you too on Pa's birthday, and thank you for your letter, which I received just now and am delighted by. I congratulate you especially on the operation being behind you. Things such as you describe make one shudder. May it now be overcome — and at least the crisis over. Poor woman!

If women sometimes don't have the same energy and resilience in their thinking as men who have striven to think things through and analyze them — are they to be blamed for that? I believe not, because in general they must devote so much more strength than we to suffering pain. They suffer more and are more sensitive. And even if they sometimes don't understand what one is thinking, they're sometimes quite capable of understanding whether one is good for them. Not in every respect perhaps, but 'the spirit is willing' and there's a sort of goodness in women at times that is entirely peculiar to them.

It must be a weight off your mind that the operation has been done.

What a riddle life is, and love is a riddle within a riddle. Staying the same is the only thing that it certainly doesn't do in a literal sense, but on the other hand the changes are a kind of ebb and flow and make no difference to the sea itself.

I've rested my eyes a little since I last wrote to you and felt better for it, although they still sting.

Do you know what I couldn't help thinking? — that in the first part of life as a painter one sometimes unintentionally makes things difficult for oneself — through a feeling of not yet having mastered the business — through the uncertainty one feels about whether one will master it — through the fierce desire to make progress — through not yet trusting oneself — one *cannot* put aside a certain feeling of being harried, and one harries oneself despite not wanting to be harried when one works. There's nothing to be done about it, and this is a time that one also can't do without, and that should not and cannot be otherwise, in my view.

In the studies, too, one sees for oneself the agitation and a certain precision that's diametrically opposed to the calm breadth one seeks — and yet one feels bad if one works specifically for that breadth and devotes oneself to that.

As a result there's sometimes a bottling up of nervous restlessness and stress, and one feels an oppressiveness as on some summer days before a storm. I've just had that again,

and when I feel like that I change to different work, precisely in order to start from scratch.

The difficulties one faces in the first phase give the studies a painful quality at times.

I don't regard this as something that discourages me, though, because I've noticed it in others as much as in myself, and in them it has increasingly gone away of its own accord.

And work remains *difficult at times* throughout one's life, I believe, but not always with so few results as in the beginning.

What you write about Lhermitte is entirely in accord with what it said in a review of an exhibition of Black and White.

That also talks about a rude assault that is almost impossible to compare with anything else except Rembrandt.

I'd like to know how someone like that sees Judas — you write about a drawing of Judas before the scribes by him. I believe Victor Hugo could describe that in detail *so that one saw it*. But it would be even more difficult to paint the expressions.

I've found a *Daumier* print, Those who have seen a tragedy and those who have seen a vaudeville. I begin to long for Daumier more and more as time passes. There's something pithy and 'considered' in him. He's amusing and yet full of emotion and passion. Sometimes, it seems to me I find a passion that might be likened to white-hot iron, in the drunkards, for instance, and probably in the Barricade too (which I don't know). That's also in some heads by Frans Hals, for example. It's so subdued that it seems cold, and when one takes a look at it — — — one is amazed that someone evidently working with *so* much emotion and becoming completely absorbed and lost in nature at the same time has that presence of mind to set it down with *such* a steady hand. I found something similar in studies and drawings by Degroux. Perhaps *Lhermitte* is another white-hot one. And *Menzel* too. There are sometimes passages in Balzac and Zola — in *Père Goriot*, for example — in which one finds a degree of passion in *words* that's white-hot.

I sometimes think about experimenting with a completely different way of working, namely daring and risking more. But I don't know whether I ought not to study the figure more directly, definitely with a model.

I'm also looking for a way of shutting out the light in the studio or letting it in as desired. At present not enough comes from above, I believe, and there's too much. I've sometimes closed it off with cardboard temporarily, but I'll see if I can get shutters from the landlord.

What was in the letter I told you I had torn up was in the spirit of what you say. But as one realizes more and more that one isn't perfect and has shortcomings, and that others do too, and thus there are continual difficulties that are the opposite of illusions, so I believe that those who don't lose heart and don't become apathetic as a result mature through it, and one must endure in order to mature.

Sometimes I can't understand all the same that I'm only 30 and feel so much older.

I feel older *especially* when I think that most of the people who know me regard me as a failure, and I believe that if a few things don't change for the better this really could be the case, and when I think, *it could turn out like that*, then I feel that with such reality that I'm totally oppressed by it and I lose all enjoyment, as if it were really so. When I'm in a more normal and calm mood, I'm sometimes glad that 30 years are past and haven't gone by without my learning something in them for the future, and I feel

strength and zest for the next 30 — if I last that long. And in my imagination I see years of serious work, and happier ones than the first 30.

How it will turn out in reality doesn't depend on me *alone* — the world and circumstances must also cooperate.

What concerns me, and what I'm responsible for, is that I make the most of the circumstances I'm in, and do my best to make progress.

As a working man, at the age of 30 one is at the beginning of a period in which one feels steadiness in oneself. As such, one feels young and full of zest.

Yet at the same time a period of life is over, which makes one sad that this or that will never come back. And it isn't weak sentimentality to feel a certain sorrow now and then. Anyway, much only begins when one is 30, and it's certain that not everything is over by then. But one doesn't expect from life *what* one already knows from experience that it cannot give. Rather, one begins to see much more clearly that life is only a time of fertilization and that the harvest is not here.

This is why one sometimes thinks, what do I care about the world's judgement?, and if that judgement is too much of a burden, one can shrug it off.

Perhaps now I ought to tear up this letter as well.

I can understand that you're very much preoccupied with the woman's condition, and that's one of the things needed to save her and to ensure that she makes a good recovery.

For one must throw oneself into it, and the saying applies, If you want it well done you must do it yourself, you mustn't leave it to others.

That is to say, one must keep hold of the general care and overseeing of the whole.

We've had a couple of true spring days, including last Monday, which I enjoyed. The change of the seasons is something the people feel very much. For example, in a neighbourhood like the Geest district and in the almshouses or so-called 'gift houses' winter is always an anxious and difficult and frightening time, and spring a deliverance. If one looks closely, one sees that there's a kind of gospel on the first day of spring.

And on such a day it's heart-rending to see so many grey, withered faces expressly coming out of doors, not to do anything in particular but as if to convince themselves that spring has come. So, for example, sometimes all kinds of people in whom one wouldn't expect it crowd round a spot on the market where a trader is selling crocuses, snowdrops, goatsbeard and other bulbs. Sometimes a parchment ministry official, a sort of Josserand evidently, in a threadbare black coat with a felt collar — I find *him* beside the snowdrops beautiful.

I believe that the poor and the painters have the sentiment of the weather and the changing seasons in common. Of course everyone feels that, but for the better-off they're hardly events at all, and don't generally make much difference to their state of mind.

I like this remark by a polder worker: 'In the winter I suffer as much cold as the winter corn'.

Now, your patient will certainly welcome the spring too. May she do well. What a difficult operation that is, at least I was shocked when I read the description.

Rappard is getting better — did I write to you that he'd had a nervous fever of the brain? It will be some time before he can work as before, but he has started going for walks now and then.

I'll follow your advice to bathe my eyes with tea if it doesn't go away. It's lessening, so for the present I'll let things take their natural course. Because I was never troubled by it in the past, except this winter along with toothache, and so I believe it to be something accidental caused by my unusual exertions. And now I can bear the tired eyes when drawing better than in the beginning. Write again soon if you can, and believe me, with a handshake,

Ever yours,
Vincent

I don't know if you know the 'gift houses' on Brouwersgracht opposite the hospital. I'd like to draw there when the weather permits. I've already made a few scratches there this week. They're some rows of houses with small gardens which belong to the poor board, I believe.

312 | The Hague, Sunday, 11 February 1883 | *To Theo van Gogh* (D)

Dear brother,

It's Sunday again and I'm writing again. Sometimes it seems to me that I haven't told you warmly and sincerely enough how deeply touched I've been by what you've told me of late.

As to whether a sincerely felt love could turn into a lost illusion, I don't doubt that it sometimes happens — it would surprise me very much if it happened in your case, and I don't believe it will happen to me. *Michelet* says, singularly, that love is a spider's web at first and grows to be as strong as a cable.

Provided there is faithfulness, that is.

Lately I've walked a good deal in the Geest district and in the streets and alleys where I often walked with the woman last year in the beginning. It was wet weather — I find everything there beautiful then — and when I got home I said to the woman, it's just like last year. I write this in relation to disenchantment — no, no, there's a wilting and a budding again in love as in the whole of nature, but not a dying for ever. There's ebb and flow, but the sea remains the sea. And in love, whether for a woman or for art, for instance, there are times of exhaustion and powerlessness, but not a lasting disenchantment.

I regard love — as I do friendship — not only as a feeling but chiefly as an *action* — and particularly when it involves working and is an effort, it has another side of fatigue and powerlessness.

Where people love sincerely and in good faith, they are blessed I believe, although that doesn't dispel difficult times.

I'm glad that my eyes are no worse, in fact already much better, but it isn't completely over yet, and I must be careful. I must tell you, I wasn't pleased.

How I'd like to talk to you — for I'm not despondent about the work, not apathetic or powerless, but I am rather stuck and that may be because I need to have some friction with people one can discuss it with; and with whom could I discuss it here in the present circumstances? At the moment there isn't a single person in whom I can

confide—NOT *that I think none is to be trusted*, far from it, but unfortunately I have too little contact with such people.

I sometimes think that when I first came to The Hague to G&Cie, years ago now, two of the 3 years I spent there were fairly unpleasant, but the last was much happier and so, who knows, something similar may happen here.

I like the saying, When things are at the worst they are sure to mend, but I sometimes ask, Are we by now at '*the worst*'?, for the 'mending' wouldn't be unwelcome. Anyway.

Lately I read '*Le peuple*' by Michelet, or rather I read it some time ago, this winter in fact, but I was strongly reminded of it for the first time just lately.

The book was written quickly and evidently in haste, and if it was all one read by M. I believe one wouldn't find it very beautiful, or one would be less struck by it. Knowing the more carefully worked books like La femme, L'amour, La mer and L'histoire de la revolution, I found it to be like a rough sketch by a painter I like very much, and as such it had a special charm.

I, for one, find M.'s way of working enviable. I don't doubt for a moment that there will be many writers who disapprove of M.'s technique, just as some painters believe they have the right to find fault with Israëls's technique. M. feels strongly, and what he feels he slaps on without troubling himself in the least about *how* he does it, and without thinking in the least about '*technique*' or generally accepted forms, except in so far as he casts it into one form or another such that it's comprehensible to those who wish to comprehend. In my view, though, Le peuple is less a first thought or impression than an unfinished but yet deliberate conception well thought-out in advance. Some fragments were evidently done in haste from nature and added to other parts that are more worked and studied.

Judging by his fur coat, De Bock appears to be in especially flourishing circumstances. I hadn't seen him in months but ran into him a few days ago, in a magnificent fur coat &c., as mentioned. But he *didn't* look flourishing, I thought. Have you yourself sometimes felt a sympathy towards a person who *you* saw was unhappy but who nonetheless appeared to be and was regarded as thriving?, and then felt in yourself, *if* I tried to make friends with him, he would think I was making a fool of him and it would be almost impossible to win his trust, let alone his attachment—and even if I got that far, he would say 'The fact is that I'm in this situation' &c. and we'd have no effect on each other. This is how I think of De Bock, and although I do feel sympathetic towards him and find much of what he does beautiful, I don't believe that he and I would be much help to each other; we see opposite things, mainly in life but in art too.

I sometimes find it difficult to give up a friendship, but if I were to go to a studio and had to think to myself: talk about trivia, don't bring up anything more important, and don't say what your real feeling is about this or that in art, then I would be more melancholy than if I had stayed away. It's hard for me to be content with conventional friendship, precisely because I seek and persevere in sincere friendship.

If there's a desire to be friends *on both sides*, even if there are disagreements from time to time, one doesn't get irritated with each other lightly, or if one does one makes it up. Where there is convention it's almost inevitable that bitterness arises, precisely because one doesn't feel free, and even if one doesn't express one's true feelings they're still enough to leave a lasting, unpleasant impression on both sides and to remove any hope that one might be able to be of help to each other. Where there is convention

there is suspicion, and from suspicion comes all kinds of intrigues. With rather more sincerity we'd make life easier for each other.

In the meantime one gets used to the existing situation, but it isn't normal, and if it were possible to suddenly go back 30, 40 or 50 years I believe one would feel more at home in that period than in this — that's to say, you or I, for example, would feel at home there, I believe. In 50 years from now people won't, I think, wish they were back in *this* period. For if it's followed by a 'periwig age', people will be too drowsy to think about it at all, and if things improve — so much the better.

I don't think it absurd to consider it possible that there may again be a kind of periwig age in the future, for after all what's known as the periwig age in Dutch history had its origins in the abandonment of principles and the replacement of the original by the conventional.

If the Hollanders feel like it, they can be the syndics, but if the salt loses its savour it's a periwig age. Not all of a sudden, but history proves that it can happen. I sometimes find it difficult to believe that a period of only 50 years, say, is enough to bring about a total change that turns *everything* around. Yet precisely through reflecting on history sometimes, one sees these relatively rapid and continuous changes. And for my part I'm led by this to the conclusion that every person still always puts some weight in the scale, though it may not be much, and that how one thinks and acts isn't a matter of indifference. The battle is short and it's worthwhile being sincere. If many are sincere and want what they want, then the whole period will be good, or at least energetic.

Yes, I think a great deal about what you've written to me recently. Don't you agree that if one meets someone in such a state, that's to say so weak and dependent, that very dependence is something through which one surrenders, as it were, and can't imagine how one could abandon such a person? I believe there's certainly a great difference between the woman you've met and the one I've been with for a whole year now, but they have misfortune in common, and the fact of being women, at any rate. Once people are so tied to each other, the bond is sacred and one thinks of the words 'if I did not have you for ever, I would rather not have you'.

Taking a broad view, such an encounter is like an apparition. Have you read Madame Thérèse by Erckmann-Chatrian? There's a description of a woman recovering that's very striking and beautifully felt. It's a modest book, but deep at the same time.

If you don't know Mme Thérèse, read it sometime — I believe she'll find it beautiful too, and be moved by it.

I sometimes regret that the woman I'm with can understand as little of books as of art. But (although she definitely can't) isn't the fact that I'm so attached to her nonetheless proof that there's something sincere between us? Later, who knows, she may learn to grasp it, and it may become another bond between us, but now with the children, you understand, she's got enough on her mind.

And through the children, especially, she's in touch with reality and learning by herself. Books and reality and art are the same kind of thing for me. I'd find someone who was outside real life tiresome company, but someone who is fully inside it knows and feels by herself. If I didn't seek art in the real, I'd probably find her stupid or something. Now I wish it were otherwise, but I'm still content with the way it is.

I hope to be able to work more regularly this week. I have the feeling that I have to

work twice as hard to make up for starting late, and it's the very sense that I'm behind others in my age that gives me no rest.

These days Montmartre no doubt has those curious effects painted by Michel, for example, i.e. that withered grass and sand against the grey sky. At any rate the colour in the meadows at present is often such that one thinks of Michel. The ground yellow, brown withered grass with a wet road with puddles, the tree-trunks black, the sky grey and the houses white, tonal from a distance and yet still having colour, in the red of the roofs, for example. These effects are telling enough, and Michel's secret is such that it depends (as with Weissenbruch) on taking accurate measurements, seeing correct proportions of foreground to background, and correctly feeling the direction the lines take through perspective.

These are not things one finds by chance (Michel's work is abundant enough, and from it I see clearly how he was on a height, so to speak, doing it with ease) but things one *knows*, and I believe that before the period when everything started going well Michel was sometimes amazed and disappointed that things *weren't working*.

However simple everything may look — behind it there's very extensive general science, as there is behind other simple-looking work, for example that of Daumier.

Well, I'll end this. Write again soon if you haven't already written. I'm longing to know whether any unusual effects of the operation have appeared in your patient.

I'm pleased that in the first letter I received from Rappard after his illness he again wrote with great enthusiasm, especially about woodcuts he had found, by Lançon among others. He's now so keen that I no longer need to encourage him, and in the beginning he was as little interested as others. His collection is becoming very good, and I believe that I see the influence of the English in what he does and wants, although of course it's far from his nature to imitate something. But the fact that, for example, he went to make studies at the institution for the blind before his illness is a very practical outcome of his love for draughtsmen like Herkomer and Frank Holl.

Adieu, old chap, write soon, with a handshake.

Ever yours,
Vincent

318 | The Hague, Tuesday, 20 or Wednesday, 21 February 1883 | *To Theo van Gogh* (D)

My dear Theo,

I wanted to write to you on Sunday but I waited because I was busy with something that hadn't yet been decided. A week or so ago I was reading Fritz Reuter's 'Uit mijn gevangenistijd', in which he describes very amusingly how Fritz R. and others serving fortress sentences made life as agreeable as possible and secured various privileges from their 'field officer'. That book gave me the idea of tackling my landlord with a view to certain improvements that would make my work easier.

And I've been back and forth to Voorburg, where he lives, several times to get him to do one thing and another. There were some old wooden blinds and planks lying there that I wanted to use, but it wasn't easy to get them. Still, I have them now. As

you know, there are 3 windows in the studio. They give much too much light, even if I cover them, and I've long been thinking about how to remedy this.

But he didn't want to do anything unless I paid him.

But now, as the result of tackling him again, I have 6 blinds and about 6 long planks.

[*Sketch* 318A]

Those blinds are now being sawn to make shutters that can be manoeuvred so that more or less light is shut out or let in as required, from above or below. From this scratch I think you'll see that it works very nicely.

And the planks are for a big cupboard in the alcove, for storing drawings, prints, books, and as a hatstand for various smocks, jackets, old coats, shawls and hats, not forgetting the sou'wester, which I need for the models.

I've paid the landlord regularly and have now told him straight out that I wouldn't contradict him if he thought the rent for the house was low, but I asked him to consider that for me the rent was still a heavy burden. And that I *could* not work readily or make progress until I had better light.

That if he couldn't change it I, for my part, really would be *forced* to find another studio. That if I could afford it I would put up with paying for it, but now I wasn't in a position to pay more than I was already. So my paying more was out of the question, and whether I stayed depended on whether or not he would have this done. If my leaving was a matter of indifference to him, we'd part as good friends and say no more. Well, then he said, no, he did want to do *something*, and so we finally agreed that I need only pay a few guilders' worth of labour.

He's been to the studio himself repeatedly and is certainly not a swindler, though he has a pretty sharp tongue (a bit like a Yankee). And it seems that the studio was better than he'd expected (he hadn't seen it since July last year); at any rate I got it approved while in the studio, and more easily even than I expected.

If only one could always deal with people in the studio! But outside it I, for one, can't get them to do much and can't get on well with them.

Have been working on some figures, rather large, busts or to the knees, which will be a sort of decoration for the corridor and stairs, together with a few others, though they're really no more than ordinary studies. Anyway, you see from one thing and another that I've once again thrown myself headlong into it, so that I'll get new ideas in my head through being busy.

At Voorburg, for example, when I went with him to sort out that wood, I saw beautiful scenes of labourers in a shed and the excavation of a cellar and the laying of the foundations of a house. I thought of what you once wrote to me about the labourers in Montmartre when you were there, when one of them injured himself in a stone quarry.

As you know, I already had something in front of the windows, namely canvas stretched on laths. They're no longer needed now, but will be highly desirable as backgrounds, with darker or lighter material stretched over them, when one wants to draw heads, for example.

You see now that I'll be able to cover over one or two windows completely and thus obtain one general light that will make the effects much stronger. Otherwise they'd be neutralized by reflections or different lights.

318A. Studio window with shutters

The job would have been entirely out of the question if I'd had to pay for it myself, since it was expensive, and I'm very pleased with it.

I felt that better light was desirable, especially when doing drawings like those I was working on of late, such as those heads I sent you in which I used a stronger black. I hope everything will work properly but you can see for yourself from this scratch that it's so simple that it's *bound* to work, it seems to me.

Yet how miserable today's houses often are compared with what they could be if people made an effort to furnish them pleasantly.

Compare a modern window with one from Rembrandt's time. In those days everyone seems to have had a sort of need for a curious, dimmed light that no longer seems to exist, at least there's a tendency to make it cold, harsh and loveless. A good start was made with workers' dwellings, but I see no sign of advances being made since those of 20 or 30 years ago. On the contrary, the pleasing aspect is increasingly lost, and it turns into something cold and systematic and methodical that becomes ever more empty with time. If I could have, I would have had the windows altered like this:

[*Sketch* 318B]

which wouldn't have been that much more if we hadn't been dealing with blinds that already existed. The difference is only that there's a frame around each square of light, and the blinds are thus slightly smaller.

But the latter is an agreeable and easily achieved, pleasing window. But one can't have everything. And it ought really to have a broad window-sill — where one could sit — which is entirely lacking in this house.

I'm longing for your letter and news of your patient. May she have remained calm and may the recovery be normal and successful. But it doesn't always go smoothly and rapidly, and something or other almost always comes up, and at all events one must be very much on the alert. Just last week I read Notre-Dame by Hugo, which I had read before over 10 years ago. Do you know who I recognized in it, or at least was so convinced I recognized that I don't doubt that Victor Hugo intended some such thing? I recognized Thijs Maris in Quasimodo.

Most people who read N. Dame probably have an impression of Quasimodo as a sort of clown. But you wouldn't think Quasimodo ridiculous any more than I would, and like me you would feel that what Hugo says is true. *For those who know that Quasimodo existed*, now Notre-Dame is empty. For not only was he its inhabitant, but *he was its soul.* If one takes Notre-Dame as a symbol of the movement in art that found expression in, for instance, Leys and Degroux (sometimes) and Lagye and De Vriendt, Henri Pille, the following can be applied to Thijs Maris: now there's an emptiness for those who know that he existed, for he was its soul, and the soul of that art, it was he. Anyway, Thijs Maris still exists but not in his full prime and vigour — not unhurt and disenchanted *to the extent that there can be disenchantment with him.* One of the enormities committed by the painters here is, I believe, that *even now* they still laugh at Thijs Maris. I think there's something as dismal as suicide in that. Why suicide? Because Thijs Maris is such an embodiment of something high and noble that in my view a painter can't mock that without lowering himself.

Those who don't understand Maris, so much the worse for them, those who do understand him grieve for him, and grieve that such a person has snapped.

Ik hoop maar alles goed uitkomt
doch uit dat krabbeltje ziet ge zelf wel
dat het zóó eenvoudig is dat mij dunkt
het goed moet uitkomen.
Toch wat zijn de huizen van tegenwoordig dikwijls
miserabel in vergelijking van wat ze zouden kunnen
zijn indien men er op werkte ze wat gezelliger in
te rigten.
Vergelijk een raam van nu bij een uit den tijd
van Rembrandt. Toen ten dage scheen iedereen
een soort behoefte aan eigenaardig getemperd
licht te hebben die nu niet meer schijnt te
bestaan. althans er is een streven om het
koud cru en zonder liefde in te rigten.
De arbeiderswoningen begon men goed doch
ik zie niet in men vorderingen gemaakt heeft
sedert die van een jaar of 20 of 30 terug.
Integendeel het aardige gaat er meer en meer
uit en wordt het als koud en systematisch en
methodieker dat hoe langer hoe leeger wordt.
Als ik 't had kunnen doen zou ik de ramen aldus

gelaten hebben ...

... geen zwaar maar
niet geweest zou zijn
indien wij niet met reeds
eenmaal bestaande blinden
te doen hadden gehad.
't verschil alleen zijnde,
er om elk licht vak een
lijst is en de blindjes
iets ets kleiner
maar dit laatste is
een aardig en gemakkelijk
te verkrijgen gezellig
karakter. Maar men
kan niet alles hebben.
En er behoort een breed
kozijn bij eigenlijk - waar
men in alles kan - wat hier in dit huis toch geheel ontbreekt.

318B. *Studio window with shutters*

Noble blade, ignoble scabbard—
In my soul I am fair.

This is applicable to Thijs M. and to Quasimodo.

Well—write soon if you haven't written already, and believe me, with a handshake,

Ever yours,
Vincent

323 | The Hague, on or about Saturday, 3 March 1883 | *To Theo van Gogh* (D)

[*Sketch* 323A]

My dear Theo.

Herewith a scratch of the selling of soup that I did in the public soup kitchen. It takes place in a large hall where the light enters from above through a door on the right.

I re-created this scene in the studio. I put a white screen in the background and on it I drew the hatch in the proportions and dimensions it has in reality, with the furthest window covered and the lower part of the middle window covered. So that the light falls from *P*. Just as in the place itself.

As you see, when I have the figures pose there, I get them exactly as they were in the actual soup kitchen.

Above you see the positioning in the studio. I've framed the area to be drawn.

[*Sketch* 323B]

Of course now I can search for the poses of the figures for as long and as much and as minutely as I like, while still remaining broadly true to what I saw.

I'd like to try this again, as a watercolour, for example. And really work to get somewhere with it. I feel that there's now more opportunity for figure painting in the studio. When I sometimes tried this summer, before the changes, the figures took on such a neutral, cold colour that one didn't feel a strong desire to paint. The picturesque quality went, so to speak, as soon as they came into that strong light.

Do you know what I'll need very badly for that?—some different pieces of fabric, brown, grey &c., to get the right background colour. In the case overleaf the wall is white with panelling painted grey, the floor darker. One can re-create the locality much more accurately by paying attention to things like that. I already have several things for it, and also have various REAL clothes. Yesterday, for example, bought a re-markably picturesque patched smock of coarse linen. I always keep an eye open for that kind of thing; if one gives it some thought one gets much more satisfaction from one's models than if one leaves it entirely to chance.

I have a love for the studio such as a bargee would have for his boat. I believe I'll get it right. But my purse doesn't always permit what I would like. Yet they are lasting things that one buys in this way, and *now* I have an opportunity that I may not have later, perhaps.

323A–B (top to bottom). *Soup distribution in a public soup kitchen; Soup distribution in a public soup kitchen (detail)*; to the left, a failed, crossed-out version

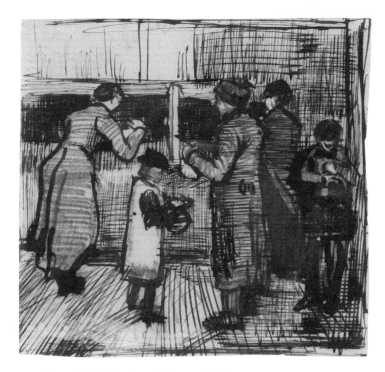

323C. *Soup distribution in a public soup kitchen*

The changes to the studio present me with more indirect costs than direct ones. For I won't consider it finished before I have various things that I need to make it practical.

You will have many expenses because of your patient—for my part I needn't sit still if you can't send anything extra at the moment. For that matter, you sent something extra not long ago. So I'd like to emphasize that I can manage if need be.

But I have a fire inside me to press on and make good progress. There's also another stimulus, namely that Rappard is making an effort too, more than in the past, and I want to keep up with him so that we can get on better and probably be of more help to each other. He has painted far more than I and drawn for longer, but there's still a similarity in the level we're at. I concede to him as to painting, but I don't want to lag behind him in drawing. What I would like to see happen is that he and I go on in the same direction, namely the figures from the people, scenes in a soup kitchen, Hospital &c. He's coming to visit me soon, he's promised, and I'd like to reach some sort of agreement with him as regards making a series of drawings from the people that we could lithograph, for example, *if it was good enough*—not otherwise. That and in fact a pile of other things make me long to press on vigorously.

In any case, I dare to promise you better drawings soon, whether you can send something or whether it's inconvenient. The changes to the studio in themselves, to the extent that they're now finished, already enable me to tackle certain things.

But the road would have fewer obstacles if you could send me something extra soon. Otherwise I foresee that I'll come up against various things, whether drawing materials or taking a model or making some more changes.

I say 'better drawings'; that is relatively. There are some among the studies of

heads — orphan men &c. that I still have here — that I won't immediately do better, since nature is definitely in them, and something I'm not yet satisfied with, of course, but of which equally I don't yet dare say that I'll do it so much better tomorrow or the day after.

But by better drawings I mean something else, namely that I'll approach them differently and try to put more chiaroscuro in them, which is something rarely if at all found in my studies of this winter.

And I now dare promise you that in any event.

Tomorrow I'll have a house full of people, namely the woman's mother and the woman's youngest sister and a lad from the neighbourhood, and these people will pose with the rest of my household for the drawing for which this is the first scratch.

Rappard is also working hard with models, and in my view there's no better way. Especially if one stays loyal to one model, one comes to see more and more in the person. So this letter supplements my letter of yesterday in the sense that you can see from it that today I've made a plan for a new watercolour in the same genre as the one I sent you, and tomorrow I'll get the models for it. I hope to reach a higher standard with this one than in the one I sent. Shall I succeed??? I can't tell in advance.

I'm starting on it even though there are still things I lack. But I have one thing I didn't have in the past, and that's the better light. And that's worth more to me than any amount of paint. If you can run to paint as well, please do so, but I've already had so much from you and am so dissatisfied with the result up to now in many respects that I hardly dare ask. Anyway, I still have hope that, just as in algebra the product of two *negatives* will be *positive*, so the result of *failures* may be *successes*.

Adieu, and best wishes for your patient, or rather your convalescent.

Ever yours,
Vincent

[*Sketch* 323C]

325 | The Hague, on or about Monday, 5 March 1883 | *To Anthon van Rappard* (D)

My dear friend Rappard

Thanks for your letter of 27 February, which I'm answering today. First of all your questions about lithography. You'll have seen that it's the same paper for ink or crayon. I get this paper from *Jos. Smulders & Co.*, paper dealers, Spuistraat of this city; their warehouse is in Laan, and there they have a large stock of stones in various sizes. They called it 'Korn paper', and had ordered it for one of the ministries, where various maps were drawn on it for lithographing.

There were a few sheets over and I took all of it. He then said that he would order a few more sheets. I don't know whether he did so, but in any case Smulders knows all about it and can order it within a few days by post. It's rather expensive, 1.75 guilders a sheet. Lithographic crayon — as well as a type made specially for the paper, more expensive than the ordinary type and in my view greatly inferior to the sort *not*

specially made for it — as well as autographic ink, liquid and in pieces, can also be obtained from Smulders and other places, for these ingredients can surely be found at all lithographers.

The scraper I used is this shape

[*Sketch* 325A]

and I bought it at Smulders. There's also what's known as a point, for scratching in hairs, say, at all events for quick, delicate scratches like those made by an etching needle, only *white* in black.

[*Sketch* 325B]

Needless to say, you can in fact use various things as a scraper. The shape doesn't matter much — I did it with my pocket-knife as well.

How much do I pay for my experiments?? He's promised to quote a fixed price, together with prices for printing and stones. The prices I paid provisionally don't count since we had come to an arrangement, because the printer himself didn't know at that point — and there were failures &c. However, I'm to get a quotation from Smulders which will be rather interesting but which he had to take time to work out. He was to quote me prices, that is, for stones of different sizes bought 12 at a time, and for printing one series of 1 and one series of 2 dozen drawings. And the price for paper. When I last spoke to him he was terribly busy and said, remind me at the end of March, then we'll check on everything together in the warehouse. So for the present I know next to nothing about the actual prices.

The running of the ink when printing doesn't depend directly on the thickness of the lines, at least I've seen enormously thick lines transferred perfectly. As to your friend who draws with a *fine* pen, that's up to him, but I think it's absolutely wrong, because I fear that in this way he's trying to get something out of the process that isn't in its nature. If one wants to work with a fine point and still be forceful, I know of only one way, namely etching. If one wants to work with a pen in autographic ink, my feeling is that one should certainly not use a pen finer than an ordinary writing pen.

Very fine pens, like very elegant people, are sometimes amazingly impractical, and in my view often lack the suppleness or elasticity that most ordinary pens have to some degree.

Last year I bought at least 6 expensive, special penholders and various pens — it was all rubbish. But at first sight they looked very practical. Anyway, I don't know either, some may be good, and a good result may come from working with autographic ink and fine pens — so be it — I'll be pleased if it works out well, but I should think one would get more satisfaction from the fuller, bolder stroke of an ordinary quill pen, for example.

Now another thing — do you know *natural chalk*? Last year I was given a few large pieces by my brother, this size, no less.

[*Sketch* 325C]

I worked with it but didn't pay it much attention and forgot about it. Now lately I found a piece again and I was struck by how beautiful its colour was, its blackness.

325A–B (top to bottom). *Scraper; Point*

Yesterday I did a drawing with it, women and children at a hatch at the public kitchen where soup is sold. And I must tell you that this experiment pleased me very much indeed.

[*Sketch* 325D]

I scrawl some lines here at random to show you the range of black.

Don't you think it's beautifully warm?

I immediately wrote to my brother for more of the same. Shall I send you a piece when I get it? But if you already know of it and can get it at your place, then you send me some. For I intend to use it continually in combination with lithographic crayon.

It's just as if there were soul and life in the stuff, and as if it understands what one intends and itself cooperates. I'd like to call it *Gypsy chalk*.

Because the pieces are very big, there's no need to use a holder. It has the colour of a ploughed field on a summer evening! I'll get half a barrel if that's the measure it's sold by, which I doubt, however.

Album des Vosges is already a fairly old publication, but it certainly does exist. And it's beautiful. Your list of woodcuts has some fine things, especially the Lançons. I have Smugglers, but I lack Aid Committee, for example. But I have *Soup distribution* in duplicate—perhaps the same one but perhaps not, and have an inn with *Rag-pickers* in duplicate. So you can have them. I know sketches by Renouard of cats, pigs, rabbits but I haven't got them. I have Speech by Gambetta and moreover Beggars on New Year's Day too.

Have found 2 beautiful Régameys, a Foundling hospital in Japan by F. Régamey, and soldiers in white cloaks keeping black horses in check by Guillaume Régamey, after a painted sketch, very fine. Read a short biography of both brothers. Guillaume is dead, was only 38 years old. Began by exhibiting some military paintings that resembled Bellangé. Afterwards he became rather reclusive, seems to have had an illness that made life difficult for him. Yet worked throughout it all—for years—when he was dead—a host of superb studies were found—which were then exhibited—while during his lifetime almost no one knew about them. Isn't that beautiful?

F. Régamey travels a great deal and, as you know, is very strong in the Japanese. What you say about the French woodcuts in general is what I also feel: the English have found more of the *soul* of woodcuts, the original character that's as singular as the character of etchings, such as Buckman, A London dustyard, and Harbour of refuge by Walker. Still, Boetzel and Lavieille know that too, though, but *Swain* is the master. I think, though, that the Lançons engraved by Moller are highly original in character. There is soul in the Feyen-Perrins by Boetzel, for example, and the Millets by Lavieille. But otherwise, well, often they lapse into the industrial, the unfeeling.

You ask after De Bock. I haven't visited him for a long time, not since before I became ill. I noticed that whenever I looked him up or saw him he said 'Oh, I'll come round and see you' in such a manner that I concluded I should take it as meaning: but don't come to see me until I've been to see you, which isn't going to happen. At any rate I haven't gone back there, precisely because I don't want to intrude. I know that De Bock is working on a very large painting at present. This winter I saw a few smaller ones that I thought very beautiful. I didn't meet De Bock himself at his studio but on the street, twice recently, in fur coat, kid gloves &c. In short, like someone in

325C–D (top to bottom). *Natural chalk; Head of a woman in profile, and two drafts*

extremely flourishing circumstances. And I hear on all sides that he is indeed what one might call flourishing.

I often find his work very beautiful, but it doesn't remind me all that much of Ruisdael, for example, and on reflection that may not be your lasting impression either. Actually, I'd very much like to see his studio again, just because I'd so like to be convinced that it's as beautiful as I'd like it to be, and now I can't help having my doubts about him all the time. Last year my impression of him was really not very favourable — he was always talking about Millet — fine, and about the greatness, broadness, of Millet — for example, out of doors too; I once spoke to him about this in the Scheveningse Bosjes. I said then — But De Bock, if Millet were here now, would he look at those clouds and that grass and those twenty-seven tree-trunks and forget only that little chap in his bombazine suit who's sitting eating, his spade at his side?

Or would that small part of the panorama where the little man sits be the point on which he fixed his attention? I don't think I love Millet less than you, I said. The fact that you admire Millet gives me great pleasure, but forgive me if I don't believe that Millet looked in the way you're forever suggesting to me. Millet is above all, and more than anyone else, the painter of *mankind*. To be sure he painted landscapes, and it's no doubt true that they're beautiful, but it's hard for me to understand how you can really mean what you say when you see in Millet *above all* the kind of thing you suggest to me.

In short, Rappard, in friend De Bock I find more of BILDERS, *for example, than of Millet or Ruisdael.* Still, I may be mistaken or see more in him later, nothing would please me more.

I certainly like Bilders too, and there isn't a painting by De Bock that I don't see with some pleasure. They always have something fresh and friendly about them.

But there's a certain kind of art, perhaps less flowery, more *thorny*, in which I find more for my heart.

I know Ruisdael himself had his metamorphoses, and his finest works may not be the waterfalls and grand views of woods but '*The breakwater with russet waters*' and *The bush* in the Louvre. The mills at Van der Hoop. The bleaching grounds at Overveen in the Mauritshuis here. And more of the more ordinary things he went in for later on, probably because of the influence of Rembrandt and Vermeer of Delft. I'd like something like that to happen to De Bock. But will that be the case? I'd pity him if he didn't land more in the thorns than in the flowers, that's all.

And although there has been an unintended coolness for some time now, nothing more serious than a few discussions about Millet and similar subjects has passed between us. And I've nothing against him — only so far I don't exactly see the likes of Millet or Ruisdael in him. For the time being I find it like Bilders, not Gerard Bilders but the elder. And I certainly don't dismiss that, and wouldn't write so much about him if I didn't care for him.

I'm still very happy with the changes to the studio, especially because the experiments I did with various models showed me that a great deal has been gained.

In the past a figure in the studio had no cast shadow, since the strong reflection threw light back on it. In this way all effects were neutralized. Now that drawback has been overcome.

Don't think for a moment that I'm abandoning lithographs, but I've had so many

expenses and have so many things I need to buy that I can't tackle any new stones. Nothing will be lost by waiting a little.

But I'm longing to work more with natural chalk.

Do you know what I sometimes long for so much? — it's to see your studio. And not just that, but also the area where you normally stroll and potter about in search of subjects. I'm sure there are beautiful courtyards and alleys in Utrecht too.

The Hague is beautiful — and there's enormous diversity. I hope to work hard this year. There are often financial difficulties, too, that hold me back — you will understand that — but I'll concentrate more and more on Black and White, precisely because I want to and must work a lot.

With watercolour and painting, too, I have to keep stopping because of the costs, and with a piece of chalk or a pencil one has only the costs of the model and some paper.

I would rather spend what I have on models than on painting materials, I do assure you.

I've never complained about money spent on models.

Do you have the portrait of Carlyle — that beautiful one in The Graphic? At the moment I'm reading his 'Sartor resartus' — the philosophy of old clothes — under 'old clothes' he includes all manner of forms, and in the case of religion all dogmas. It's beautiful — and honest — and humane. There's been a lot of grumbling about this book, as with his other books. Many regard Carlyle as a monster. One nice comment on 'the philosophy of old clothes' is the following. Carlyle not only strips mankind naked but skins it too. Something like that. Well, that isn't true, but it's true that he's honest enough not to call the shirt the skin — and far from finding a desire to belittle man in his work, I for one see that he puts man in a high position in the universe. At the same time, more than bitter criticism, I see love of mankind in him, a great deal of love. He — Carlyle — learned much from Goethe, but even more I believe from a certain man who wrote no books but whose words have survived nonetheless, although he didn't write them down himself, i.e. Jesus. Before Carlyle he included many forms of all kinds under 'old clothes'.

This week I bought a new 6-penny edition of *Christmas carol* and *Haunted man* by Dickens (London Chapman and Hall) with about 7 illustrations by Barnard, for example, a junk shop among others. I find *all* of Dickens beautiful, but those two tales — I've re-read them almost every year since I was a boy, and they always seem new to me. Barnard has understood Dickens well. Lately I again saw photographs after Black and White drawings by B., a series of characters from Dickens. I saw *Mrs Gamp, Little Dorrit,* SIKES, SYDNEY CARTON, and several others.

They're a few figures worked up to a very high standard, very important, treated like cartoons. In my view there's no other writer who's as much a painter and draughtsman as Dickens. He's one of those whose characters are *resurrections*. On a children's print I found a small woodcut by Barnard engraved by Swain. A policeman in black drags along a woman in white who struggles against him. A band of street urchins follow behind. It's almost impossible to express *so* much of the true character of a poor neighbourhood with fewer means. I'll get another copy of that print for you — it's only a small scratch.

Unfortunately, I *can't* get you the print Empty chair by Fildes, which I was promised along with some others. The man now remembers 'clearing them up' a few years ago.

Write again soon — may the work prosper in every respect.

Oh — I have a near complete French edition of Dickens translated under the supervision of Dickens himself.

I believe you once told me that you couldn't enjoy all of Dickens's English works because sometimes the English was complicated, for instance the miners' dialect in Hard times. If ever you would like to read some of it, it's at your disposal, and I'm willing to exchange the whole collection of Dickens in French for something else, if you like. I'm gradually coming round to the idea of taking the English Household Edition. Adieu, with a handshake.

Ever yours,
Vincent

In The Graphic, 10 Feb. 1883 there's a little figure by Frank Holl, a child in an attic room, very real. I bought the issue for it.

The illustrations by John Leech and Cruikshank have character too, but the Barnards are more worked up. Leech, though, is strong with street urchins.

[*Sketch* 325E]

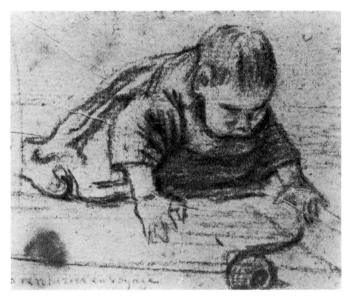

325E. *Baby crawling ('Adventurer sallying forth')*

My dear friend Rappard —

Thanks for your letter, I was interested to learn that you're again working on your painting The tile painters. In your letter I also found something about your coming here, and that was all the more reason to send you the duplicate woodcuts I still have left quickly, since I believe you would rather not wait any longer than necessary. At any rate *after* seeing them, you'll regard various prints as not unwelcome possessions, I imagine.

I've also taken The Graphic Portfolio apart and inserted it between my loose prints. This is why you already have Low lodging house by Herkomer, and several of the best of this consignment too. I'm sending you the ordinary impressions of some prints that I obtained in duplicate in this way, and in the case of some the prints from the book itself, which are printed not from the clichés but from the blocks themselves.

In this consignment you'll at last find something by *Boyd Houghton*, namely Shaker Evans, Liverpool harbour, Mail in the wilderness and Niagara falls. Once you've seen my Boyd Houghtons from the first year of The Graphic you will better understand what I wrote to you about the importance of this master's work. Van der Weele saw them this week and was also struck by them.

This week I worked on drawings of figures with wheelbarrows — perhaps for lithography as well — yet what do I know of how it will turn out? — I just carry on drawing. As I wrote, Van der Weele came by this week — I was just working with a model — and we held a viewing from The Graphic on a wheelbarrow that I had drawn with the model. One sheet that we paid particular attention to was by Boyd Houghton — I wrote to you about it at the time — it shows a corridor at the offices of The Graphic at Christmas. The draughtsmen's models come to wish them a merry Xmas and no doubt receive a tip. Most of the models are disabled — a man on crutches leads the way — holding on to his coat-tail is a blind person with someone else on his back who can't walk at all — his coat-tail is held by a second blind person who is followed by an injured person with a bandage round his head, behind whom yet more come trudging along. I asked Van der Weele — Tell me, do we take *models* often ENOUGH??? Van der W. replied: When Israëls was at my studio lately and saw my big painting of the sand-carts, he said: 'Now above all take plenty of models'.

Now I believe that many people would use more models if they had more money to spend — but still, as long as we always spend on them every 10 stuivers we can spare.

It would be wonderful if people joined forces and there was a place where models would rendezvous each day, as at The Graphic in the past. Anyway, be that as it may, *let's keep up each other's enthusiasm*, and let's encourage each other, as far as we can, to carry on working. Not in the direction of pleasing dealers or the ordinary art lovers but in the direction of manly strength, truth, loyalty, honesty.

Which are all directly connected, in my view, with working with models. It seems that everything one makes in this way is doomed to be called 'disagreeable', but I believe this far from imaginary but definitely existing prejudice ought to give way all the same before the attempts of the painters *against it*, provided the painters are agreed on this between themselves and support and help each other, and don't allow the dealers

to be the only ones who speak to the public, but put a word in for themselves now and again. For while I'm prepared to accept that what a painter says about his own work won't always be understood, I still believe that in this way better seed would be scattered in the field of public opinion than the seeds the dealers and their associates are in the habit of sowing according to a conventional formula that's always the same.

These thoughts naturally bring me to the field of exhibitions. You work for exhibitions — fine — I myself am decidedly not at all fond of exhibitions.

I used to be fonder of them in the past than I am now — I don't know why this is — in the past I viewed exhibitions from a different angle — perhaps in the past I had ample occasion to see behind the scenes of certain affairs connected to exhibitions &c. — and perhaps it isn't just nonchalance on my part that I believe that many are mistaken regarding the results of an exhibition. I don't want to discuss it further now, other than to say that I myself would have more faith in a coming together of painters through mutual sympathy and similarity of purpose and warm friendship and loyalty than in a coming together of their works by means of exhibitions.

This is why, when I see paintings hung together in the same room, I don't yet venture to conclude that a spirit of unity and a respect for each other and a certain healthy collaboration exists among those who made the aforementioned paintings &c. I regard this last point — the existence or non-existence of these things — as being of such great weight that little else qualifies as possibly being important, other than in connection with this spiritual unity, and whatever other matters, important in themselves, there may be apart from that, no surrogate can make up for the lack of that unity, and the lack of that is a lack of firm ground under one's feet. I don't have the least desire for exhibitions &c. to stop, but I do desire a reform or rather renewal and strengthening of the associations and the collaboration between painters, which would certainly have the kind of influence that would make even exhibitions beneficial. As for your Tile painters — I was interested to hear that you're working on it again — I'm especially interested in what it's like and what it will become. I take an interest in everything to do with this painting or with your other paintings, and see something of them and hear about them with sympathy — but whether or not they go to an exhibition matters as little to me as what kind of frame you have them in. Well, adieu — write again soon.

Ever yours,
Vincent

I dislike writing or talking about *technique* in general, Rappard — although all the same I sometimes long to talk about how to realize some idea or other that I might have, be it with you or with someone else, and I don't take the practical value of such discussions lightly.

However, this latter doesn't alter the first thought — which perhaps I'm not expressing properly. That first thought — I can't exactly put it into words — is based not on something negative but on something positive.

In the positive awareness that art is something larger and loftier than our own skill or learning or knowledge. That art is something which, although produced by human hands, is not wrought by the hands alone but wells up from a deeper source in our soul, and that I find something in dexterity and technical knowledge about art that reminds me of what, in religion, they'd call self-righteousness.

My sympathies in the literary as well as the artistic sphere are drawn most strongly to those artists in whom I see the soul most at work. Israëls, for instance, is a clever technician, but Vollon is equally so — I like Israëls even more than Vollon, though, because in Israëls I see something more and something very different from the masterly rendering of fabrics, something very different from the light and shade, something very different from the colour — yet that something very different being achieved by that accurate rendering of the effect of light, fabric, colour. Eliot really has that 'something different', which I see, as I said, in Israëls much more than in Vollon, and Dickens has it too.

Does it lie in the choice of subjects? *No*, that too is another *consequence*.

And what I'm getting at, among other things, is that Eliot is masterly in execution, but above and beyond that is that extra something of singular genius of which I would say: perhaps one improves by reading these books — or, these books have the power to invigorate.

Without meaning to I wrote a lot about exhibitions there, actually I barely think about them. Now I do happen to be thinking about them, and I view my thoughts with a degree of surprise. I wouldn't be expressing them fully enough if I didn't add that there's something so thoroughly honest and good in some paintings that, whatever is done with them — whether they fall into good or into bad — into honest or dishonest hands — something good comes from them. 'Let your light shine before men' is something that I believe is every painter's duty, but — it doesn't, in my view, immediately follow that letting the light shine before men *has to be* done in exhibitions — I have to tell you that, rather than wanting to hide the candle under the bed instead of putting it in a candlestick, I wish there were *more* and *better* opportunities than exhibitions to bring art to the people. Anyway, enough of that.

I recently re-read Eliot's Felix Holt, The radical. This book has been very well translated into Dutch. I hope you know it — if you don't know it, see if you can't get hold of it somewhere.

There are certain ideas about life in it that I find outstanding — profound things said in a plain way — it's a book written with great spirit, and various scenes are described exactly as Frank Holl or someone like him would draw them. It's a similar conception and outlook. There aren't many writers who are as thoroughly sincere and good as Eliot. This book, The radical, isn't as well known in Holland as, say, her Adam Bede, and her scenes from clerical life aren't very well known either — more's the pity, in the same way that it's a great pity that not everyone knows Israëls's work.

342 | The Hague, on or about Thursday, 10 May 1883 | *To Theo van Gogh* (D)

My dear Theo,

I received your letter in good order with the 50 francs enclosed. Which were a deliverance for me, at any rate a respite. I've also heard from friend Rappard — but nothing definite as yet.

A letter that's a reply to my letter, and that he will help me and come as well, but, he writes, my health is letting me down again. Ends with: I enclose the money herewith.

Postscriptum: oh, I'll come immediately and bring it myself—I'll come tomorrow. This is followed by a telegram the next day. Not coming, letter follows later.

So, despite having heard something, it's still the same as with a game of goose, if you remember how one can land on a goose, thus go forward, but unfortunately just then land on a new goose with its beak pointing in a direction one doesn't want to take, and so one must count back to one's original position. Yet it isn't his fault, for he's been really very ill and is still feeling the remnants or after-effects of that. Moreover, his sister had a fairly similar illness, and they were most concerned about her, but she recovered too.

Nonetheless, I do believe this of friend Rappard, that he does things that cost him a great deal of energy and nervous tension and aren't worth the powder he expends on them. Thus before his illness I heard about decorations for the centenary of the Utrecht painters' society, and now this time it was church ornaments. By chance I wrote to him that I thought they were both unwise, and he fell ill last time and now this time. I would approve if he overworked himself on normal things, but, as I said, this isn't worth the powder expended on it, and I wrote again to him: you're a soldier and one of the few who have cartridges in their box at the present time. Use them only in cases where a shot is unavoidable.

I fear—dear brother—that the money you loaned to our dear cousin H. has currently taken the form of a vicious gun dog, for instance, or some similar curiosity, since I believe he's quite often mistaken about such purchases—and then later it's sometimes impossible for him to bring it back from that form to the state of banknotes or to cash it in because, like other lovers of horses and hounds, he's caught in the snares of some crooked dealer. I'm one of those who wish him as much good fortune as possible in these negotiations, and would like to see nothing better than that their outcome is that he may speedily return what he owes you. At one time there were big plans to populate the plantation with countless dogs. This livestock farming is highly commendable, but at present I want to say no more about it than that I hope it may prove exceedingly profitable.

Is your patient already discharged from hospital? But there may still be worrying days, no less grave than when she was in there. Michelet says rightly: a woman is an illness. They are changeable, Theo—they are changeable like the weather. Now those with an eye for it see something beautiful and good in *all* weathers, find snow beautiful and burning sun beautiful and storm beautiful and calm beautiful, cold good and heat, are fond of all seasons and don't want to miss a single day of the year, and are fundamentally content and resigned to things being as they are—yet even if one looks at the weather and the changing year like this—and the changing female nature in the same way—believing that in the essence of that nature, in its mysteriousness, there is a *Reason*—accepting where one doesn't understand—even, I say, if one should view it in that way, our own nature and vision isn't always and at every moment in harmony and accord with that of the woman with whom we're united, and individually one feels either concern or dissatisfaction or vacillation, despite the belief and the good spirits or serenity one may have.

I was told by the professor who delivered her that the complete cure of my woman would take years. That is, the nervous system remains tremendously sensitive, for example, and she has that changeableness of women very strongly. The great danger is—as you will understand—tumbling back into old mistakes.

This danger, although of a moral nature, has links with the physical constitution. And I have constant and sometimes serious concerns about what I would call these lurches between getting better and lapsing back into old bad habits. Her mood can be such that it's almost unbearable, even for me, quick-tempered, wilfully wrong, in short, sometimes I despair. It passes — and more than once she has said to me later — I DON'T MYSELF KNOW WHAT I'M DOING THEN.

Do you remember writing to me last year that you feared that I would be burdened with the mother? Sometimes I wish things had taken that turn. The mother is very sturdy when she wants to be, and could have done so much better than she has. Now she sometimes obstructs more than she helps. Anyway, when the woman does something wrong it's sometimes the mother's fault, and when the mother does wrong it's sometimes the family who are behind the mother. Things which aren't so bad in themselves but which prevent progress and overwhelm or neutralize better influences.

My woman has certain faults and defects in the way she acts — that's bound to be the case. THAT DOES NOT MAKE HER BAD in my view. Still, those defects must be eliminated — habits of laxity, indifference, lack of activity and deftness, oh, a mass of things. But all with the same root — wrong upbringing, years of an utterly wrong view of life, fatal influences of bad company. I tell you this in confidence, mind — and not out of desperation but so that you will understand that for me this love isn't a bed of roses, but something as prosaic as Monday morning.

A small painting by *Tissot* showed a figure of a woman in the snow amid withered stalks. *Way of flowers, way of tears.* Well, my woman no longer walks on a way of flowers as she did when she was younger and pleased herself and followed her inclination, but life has become thornier for her and become a Way of tears, especially last year — yet this year has thorns too, and the following years as well — still, by persevering she will overcome them.

But sometimes there's a crisis — particularly when I venture to raise the matter of some fault of hers that I've been quietly observing for a long time. For example, just to mention one thing, mending the clothes and making the children's clothes herself. But that ends with her getting down to it one day, and she's already much improved in this respect and in other respects.

I must change so much in myself too, but I must ensure that in me she has an example of working and of patience, and that's damned difficult, brother, to be so that one can indirectly show someone how to do something, and I too fall short sometimes, I must raise myself to something better in order to awaken her interest.

The boy, above all, is doing extremely well, though — the girl was very ill in the past and neglected.

But the little lad is a miracle of high spirits, already appears inclined to oppose social institutions and conventions. For instance, as far as I know *all* children are brought up on a kind of bread porridge. But he has refused that with the greatest determination. Although as yet without teeth, he bites firmly into a piece of bread and gets down all kinds of eatables while all the time smiling and crowing and making noises, but his mouth stays firmly shut for porridge &c. &c. He often sits with me in the studio on the floor in a corner on a couple of sacks or something, he crows at the drawings and is always quiet in the studio because he looks at the things on the wall. Oh, he's such an agreeable little lad.

The number of studies keeps growing—when you come I think you'll find some to put in a portfolio in your room perhaps, anyway that's up to you, as long as you clearly understand that you may of course regard anything you take a liking to as your own. Other things must come forth from the studies, though, and better studies come from the old ones. I myself don't know exactly how.

But I do long for you to see them again.

I saw with great interest a publication, Le Salon 1883, a first issue of a series of illustrations, some deuced good. Done with that new way of reproduction. I've subscribed to it, although I have enough expenses, with a view to what I'm doing myself at present with the printer's ink and lithographic crayon. Listen, I definitely believe that some of my things would do well if reproduced in that way—particularly those that have the more intense blacks obtained by lithographic crayon and printer's ink; I can also get the brownish wash that I often come across in the above prints.

Well, when you come perhaps we can arrange one thing and another.

And perhaps I'll write down a detailed statement of several matters about which I need information, and you could take some of my studies together with that to show to *Buhot*, for instance, who would then probably shed light on a few things for me.

Recently read Un mâle by Camille Lemonnier—very strongly done in the manner of Zola. Everything observed from nature and everything analyzed.

Saw a big Fromentin, a battle of fellahs, in the window at G&C.

Also saw the *nouveautés*, perhaps not all of them. I again came across Julien Dupré, whom I wrote to you about, in two things that I found less beautiful and more conventional than what I saw by him in an illustrated magazine in the winter.

Did you already know that Rappard's painting has been accepted this time in Amsterdam?

Well, it's late already—thanks for your timely dispatch—I just hope that R's 'letter follows' doesn't take too long, or that H. v. G.'s livestock farming may prosper.

Adieu—good fortune in all things, especially the woman.

Ever yours,
Vincent

Still, Fromentin is clever—and a *seeker*, and someone who carries through, and conscientious too.

348 | The Hague, Sunday, 3 June 1883 | *To Theo van Gogh* (D)

My dear Theo,

Thanks for your letter and thanks for the enclosure. Today is Sunday, and this week I've worked furiously and am taking today off to be able to write quietly to you, at somewhat greater length than has been possible recently, because many things distracted me. And my need to write is all the greater because I see from your letter that not everything is going well for you, and I wanted to write rather more warmly than normal.

If in my own case—with my limited income—Pa and Ma objected to marriage because of the lack of money, I could more or less accept that, and at least understand

their speaking like that and make allowances. But now that they're raising this same objection in *your* case, Theo, you who have a permanent position and a good income (more substantial than their own, mark you), I find that unspeakably pretentious and utterly wicked. Ministers are in fact among the wickedest people in society, and barren materialists. Not in the pulpit so much, but in private matters. From a moral standpoint one might perhaps be entitled to object to marriage in certain cases where *destitution* in the absolute sense is to be expected, but in my view this objection is at once completely invalid morally as soon as there's no question of *destitution* in the *literal* sense. And in your case it would be ridiculous to expect immediate *destitution*.

Suppose someone like old Mr Goupil had an objection concerning money — one expects no less from his standpoint, that of a rich dealer.

But with Pa and Ma, who are supposed to be humble and content with simplicity, I think it very nasty of them to speak like that, and I'm ashamed, as it were, that they're like that. I wish everybody in our house would seek peace and stint themselves rather than chase after a high position. And put our energy into improving ourselves in cultivation of the mind and humanity while being content with the simplest of things on principle.

So it grieves and offends me, it again disappoints me terribly, that Pa and Ma said that.

I would do I don't know what if I could get this undone somehow. I'd like to be proud of Pa because he was a truly poor village pastor in the pure sense of the gospel, but I find it so wretched when Pa stoops to things that aren't in keeping with 'the dignity of his calling'.

I think Pa might rightly be expected to cooperate where it's a matter of saving a poor woman on her own — to take *her* side precisely because she was poor and alone.

Not to do this is a great fault in Pa, and it's inhuman of whoever does this, and doubly inhuman if a minister does it.

And to stand in the way of such a woman, to *obstruct* her rescue and salvation, is monstrous.

Now I know full well that almost every minister would say the same as Pa — and that's why I for one count that entire corps among the wickedest people there are in society. You and I likewise, we occasionally do something that's perhaps a sin, but after all we're not merciless and we do feel compassion, and precisely because we don't consider ourselves to be without fault and know how these things work, we don't scold fallen or weak women as the ministers do, as if it were all their own fault.

And, moreover, your woman is a decent woman from a respectable family, and really Pa is *greatly* at fault, I think.

Suppose there were difficulties, it seems to me that Pa, especially as a pastor, ought to urge you to help her and to bear the difficulties for the sake of saving her. With someone like Pa one ought to be able to find comfort where society offers no comfort — but oh yes — they make it worse than ordinary people.

It's atrocious that Pa adopts this attitude.

When Pa was here he spoke disapprovingly about my being with the woman. I said then that I didn't refuse to marry her.

Then Pa AVOIDED that and talked around the subject.

He didn't want to come out with it and say that I should abandon her, but regretted that I had relations with her.

I've hardly talked this over with Pa at all, as a matter of fact, precisely because I fail to see that he's exactly the person who has anything to do with this. You've fulfilled your duty to inform Pa and Ma, but now that they talk like this they give you the right, it seems to me, to exclude them from further confidences and to consult them less than you would if they were more reasonable. They're mistaken in the sense that they're not humble and humane enough in this case.

Well, you say that business isn't flourishing. That's bad enough. But the situation has always been precarious and always will be in life. Let's keep our spirits up and seek energy and serenity.

I can inform you that my first composition, of which I sent you a croquis, has progressed to a level where it's nearly finished. I did the drawing in charcoal first, then I worked it over with the brush and printer's ink. So there's quite some force in it, and I believe that the second time one looks at it one will be able to find more than one saw the first time.

And a second drawing of a similar scene was made since I sent you a croquis. Do you remember describing to me some time ago (last year) an accident in a quarry on the Butte Montmartre where you saw a band of workmen and one had injured himself in the quarry?

Well, it's a similar scene, but just the team of workmen labouring.

I was in Dekkersduin with Van der Weele and there we came across the sand quarry, and I've been there since and had plenty of models day in, day out, and so the second is now done too.

They are fellows with wheelbarrows and diggers. I'll see that I do a croquis of them as well, but it's a complicated composition and perhaps it may be hard to see both the one and the other in a croquis.

The figures are drawn from extensive studies. I would very much like them to be reproduced. The first is on grey paper, the other on yellow.

I long greatly, Theo, for you to be in the studio once more, for there are so many studies too and you can now see what my aim is when I do the studies, and many more things could be taken from them.

I've had a frame, or rather passe-partout, made of ordinary wood and given it the colour of walnut with a black inside edge, and that encloses the drawing well and one can work comfortably in the frame.

I've arranged everything in readiness for larger compositions and again have strainers for two new ones. I want to do the tree-felling in the woods sometime, and the rubbish dump with the rag-pickers and the potato-digging in the dunes.

It's good that I went to Rappard, for his sympathy raised my spirits when I hadn't enough self-confidence.

But when you see these drawings, Theo, and see the studies, you'll understand that this year I've had as much care and trouble as I can bear. It's maddeningly difficult to forge the figure.

And really, it's the same as with iron — one works on a model and carries on working on it, it's difficult in the beginning but eventually it becomes more pliant, and one finds the figure just as iron becomes malleable when it's red-hot and *then* one must keep going at it. So I've had models continually for these two drawings, and toiled away early and late.

It's disappointing that you write that business isn't going very well — if the position gets more precarious, let's redouble our efforts.

I'll be doubly attentive to my drawings, but for the time being you be doubly attentive to sending the money. For me it represents model, studio, bread; reducing it would lead to something like suffocating or drowning, I mean I can no more do without it now than I can do without air. I've had these two drawings in my heart for a long time already, but I didn't have the money to do them and now, through that from Rappard, progress has been made. The creative power can't be held back, what one feels must come out.

Do you know what I often consider? It's to establish relations in England with The Graphic or London News. Now that I'm making progress, I want so very much to carry on working on some larger compositions suitable for an illustrated magazine. *Boughton* and *Abbey* are together doing drawings of '*picturesque Holland*' for Harper of New York (also the agent for The Graphic). I saw these illustrations (very finished although they're small, definitely done after larger drawings) at Rappard's. Now I think to myself that if The Graphic and Harper send their draughtsmen to Holland, they wouldn't be unwilling to take on a Dutch draughtsman if he could supply them with something good for not too much money. I'd like to work towards being PERMANENTLY employed for a monthly wage rather than selling a drawing now and again for a relatively higher sum. And commit myself to a series of compositions following on, for example, from these two that are on the easel or from others that I'll add. I would think it advisable to go to London myself with studies and drawings and to look up the managers of the various organizations, or preferably the draughtsmen Herkomer, Green, Boughton (some, however, are in America at present) or others, if they're in London. And would be able to get information about processes better there than elsewhere. Who knows, perhaps Rappard would also like to come along and bring drawings as well? Something like that needs to be done, I believe, with or without changes to the plan. I would dare, I believe, to undertake to supply about 1 large drawing each month for a double-page engraving, and shall apply myself to the other formats too, the whole page and the half page. I know that they can reproduce large and small, but the double page lends itself better to what is done broadly; the smaller can be drawn in other ways, say, with pen and pencil.

Now I believe that it isn't every day that the managers of illustrated magazines find someone who regards those magazines as his special goal.

From the small sketch that I've made just this minute (in a quarter of an hour and enclosed herewith) of the large drawing, you can see that, if it's a matter of making the format smaller or bigger, I'm not daunted by that. If I know definitely that this or that is required in a certain size, I can do that.

But for my own study I prefer to work in a somewhat larger size, so that I can study the hands, feet, head in more detail.

Don't you agree that a host of scenes of tree-felling &c. could be done in the same style in which I've handled *Peat diggers and Sand workers* which it seems to me would have enough vitality done like that to serve as illustrations?

But once again, as long as I don't find employment the money from you is absolutely indispensable. What I received from you today — I immediately have to pay out exactly as much as I receive, I still have to pay three models whom I had several times,

I have to pay the carpenter, pay rent, still pay the baker and grocer and the cobbler as well, and stock up again. Well, in front of me I have two blank sheets for new compositions and must set to work on them. I ought to take a model again, day in, day out, and struggle until I've got it down. I'm starting work on it nonetheless, but in a few days, you understand, I'll be absolutely broke, and then those terrible 8 long days of not being able to carry on and waiting, waiting until it's the tenth again.

Yes, old chap, if only we could find someone who would take the drawings.

For me work is an absolute necessity, indeed I can't really drag it out, I take no more pleasure in anything than in work, that's to say, pleasure in other things stops immediately and I become melancholy if I can't get on with the work. Then I feel like a weaver when he sees his threads getting tangled and the pattern that he had on the loom going to the devil and his thought and effort coming to nothing. So try to handle it so that we can persevere energetically. I'm going to ask for permission to work in the old people's home. I already have many studies of orphan men, but I need to have the women too, and also the setting at the place itself. Well, you have your woman to look after, so you know well enough that I don't have it easy from that angle either, with two more little ones on top.

Tell me, Pa and Ma's answer won't affect whether you come this summer, will it?

It's so essential, I believe, that you see the studies and the large drawings, especially with a view to the financial side as well. You could take the same steps in Paris as I would take in London as regards the people at the illustrated magazines, I believe, if you could show them a couple of large drawings.

But in this case I think it would be wise not to begin before we're as good as certain that they'll readily accept it.

These larger compositions entail many outgoings if one treats them conscientiously. For, old chap, it all has to be done with models; even if one uses studies, one still has to retouch with the model there again. If I could take a model more often, I could do them far, far better. So, old chap, as for my not needing you one time, I need it more than ever, but I would point out the opportunity we have if we persevere. Because of the money from Rappard, I already have several things such as sketchbooks &c., and everything you send is converted into drawings, and I believe you'll find what I'm working on now more suitable than the previous ones. So let's be of good heart and energetic.

One obstacle to several things that I have in my head from the beach is that I don't have a Scheveningen woman's costume. You understand that I could do that kind of composition with Scheveningen figures in the spirit of the enclosed croquis. But if I draw a figure outdoors it is of course too superficial. It has to be taken up again and worked over with a model, and one needs the costumes. Well, that would be an expense which, if I could afford it, would make three, four drawings I have in my head smooth going. Yet how can I afford it? As I say, in three days everything I have now will be gone, because almost all of it has to be paid out immediately. For these two drawings I also needed various smocks, trousers, sou'wester &c. A model doesn't always have on a fine smock that's picturesque — one changes that and it becomes more real and more expressive. When you come you must see how those studies for the figures in the foreground of the croquis are solidly worked. I did them outdoors on a pile of sand near a florist.

In the beginning of your letter you write that you're pleased that there's no reason

to be concerned about the woman. Well, there isn't immediately, inasmuch as I try to preserve my serenity and good spirits in that respect too. But I do have cares, heavy cares even, and there's no lack of difficulties. I began trying to save the woman despite the difficulties, and have persevered up till now despite the difficulties, but it won't all be rosy in the future either. Still, we must work as hard as we can. Theo, the difficulties I was having with the woman when I last wrote to you — do you know what that was? *Her* family were trying to get her away from me. I've never involved myself with *anyone* except the mother, because I considered them untrustworthy. The more I try to analyze the history of that family, the more I'm strengthened in that view. Well, they were intriguing precisely because I ignored them, and this led to a treacherous attack. I've told the woman how I view their intentions and also that she must choose between her family and me, but that I didn't wish to have any dealings with any of them, in the first place because I believed relations with her family would lead her back to her previous wrong life. The family's proposal was that she and her mother should keep house for a brother of hers who is separated from his wife and is a notoriously bad lot. The reason why the family advised her to leave me was that I earned too little and I wasn't good for her, and only did it for the posing but would leave her in the lurch. Mark you, because of the small child she hasn't done much posing for me this whole year, has she? Anyway, I leave it to you to decide to what extent these suspicions about me were well founded. Well then, but it was secretly discussed behind my back, and in the end the woman told me. I said to her, do what you like but I shan't abandon you unless you go back to your previous life. The wretched thing is, Theo, that if we're poor at some point, they try to upset the woman in this way, and that bad lot of a brother, for instance, tries to get her back to the old life. Now — I say only this of her — I would think it brave and generous of her if she broke off all relations with her family, I myself advise her not to go there, but if she wants to go I let her. And the temptation to show off her child, say, often brings her back to her family. And that influence is fatal and has a grip on her precisely because it comes from her family and those who unsettle her by saying 'he'll leave you in the lurch'. In this way they seek to persuade her to leave *me* in the lurch. Adieu, old chap, let's work and keep a clear head and try to act rightly. You know how things are with my money, help me if you can.

Vincent

[*Sketch* 348A]

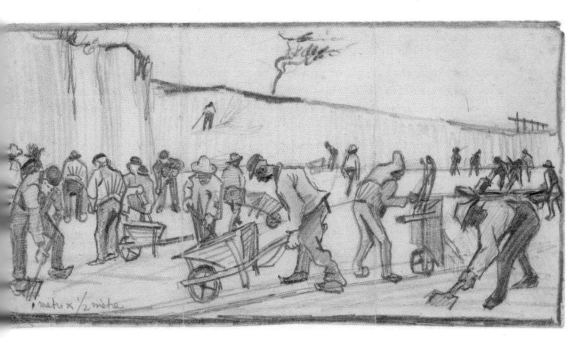

A. *The sandpit at Dekkersduin near The Hague*

My dear Theo,

Today I received a letter from home and I wanted to talk to you about it, although Pa doesn't mention you in the letter, because in the circumstances you might perhaps like to know something about their state of mind, above and beyond what they may write to you directly. And my impression is that for the present you may be entirely at ease on that score.

The letter in question is Pa's first since his visit and is very amiable and cordial and was accompanied by a package containing a coat, a hat, a packet of cigars, a cake, a money order.

In the letter was the outline of a sermon, by far the best part of which I thought was the biblical text, and which made less of an impression on me than a few words about the funeral of a farm labourer later on.

And otherwise that Ma was at Princenhage and domestic details.

Well, the reason I'm telling you this at such length is so that you'll see from it that there's no particular tension or anything abnormal; rather, I got the impression that Pa's mood was more passive or resigned, tending towards good-natured melancholy, more so than one would expect if one were to go only by the expressions of objections you wrote to me about.

So I think those words were intended more as advice or warning (advice that in the end has no solid grounds in my view, and doesn't hold water) and less as a sign of definite resistance or opposition to your firm decision.

They may think that you haven't yet made up your mind, or they may believe that you haven't given it enough thought.

Because in my last letter I disapproved so strongly of what Pa had said — and still disapprove of it now, being decidedly of the opposite opinion inasmuch as I don't consider it appropriate in this case to raise objections to do with money and religion — I wanted to soften my words, in the sense that I believe that it's a question here of a fault (at any rate a fault in my view) that lies more in Pa's words than in his heart and mood.

And I have in mind to talk to you about how Pa is an old man and so deeply fond of you, and you'll find, I believe, that he'll accept your view if there's no alternative, even if it conflicts with his own, yet couldn't possibly accept estrangement from you or having less contact, etc.

And adopting a humane point of view, I take back my opinion: 'by saying that, they have shown they are unworthy of your trust and in my eyes you needn't confide in them any further', or something similar that I wrote then, I don't remember exactly. But don't misunderstand me, not because I disapprove less of what they said, but because I believe that in this case one shouldn't take it too seriously, and there's no pressing need to take up arms against it as long as it remains only words.

Cutting it short by saying something like, for example, 'You take a rather gloomy view of the future' and 'can hardly demand from me that I act as if the end of the world were imminent' is wiser in this case, I believe, than taking their words very seriously.

It seems to me that Pa's a little melancholy, though, and is perhaps fretting a little

about you and imagining gloomy things—but again Pa writes not a syllable about it directly, and said not a word about it at the time of his visit. But *not* talking about it is in fact also rather abnormal. Anyway—I, too, know Pa quite well, and believe I can see signs of some melancholy.

If you want to help him, write quite lightly and cheerfully, and write about your visit this summer as though it's certain you'll see them again soon (even though you may not know yourself yet how you'll fit your visit in as regards the time).

For perhaps, perhaps Pa himself is conscious of having gone a little too far, or worried about how you'll take it, or afraid that you won't come.

Of course I don't know how matters stand and am only guessing, but I do think this, Pa is an old man and deserves to have people cheer him up if they can.

You know well enough that in my view you ought to be loyal to the woman; there's no question of my saying anything less about that than I did, but do what's right and don't blame Pa if he's mistaken. That's what I wanted to say. Don't even refer to the fact that he's mistaken unless he keeps going on, perhaps he'll retract of his own accord.

Now a word about the work.

Today I asked for permission to draw sketches in the old men's and old women's home, namely the men's ward, the women's ward and the garden. I was there today. From the window I sketched an old gardener by a crooked apple tree, and the workshop of the home's carpenter, where I drank tea with two orphan men.

I can go into the men's ward as a visitor. It was very real, inexpressibly real.

A small chap with a long, thin neck in a chair on rollers, among others, was priceless.

In the carpenter's workshop, with a view of the cool, green garden with those two old boys, it was just like the scene in, for example, that photo by Bingham after that small painting by Meissonier, the two priests sitting drinking. Perhaps you know the one I mean. Whether I'll get permission isn't, however, entirely certain, and has to be applied for from the assistant deacon, which I've done and have to go back for the answer.

Apart from that, I'm working out how to draw the dung-heap. I wrote to you that I had hopes of getting a Scheveningen cape, well, I've got it, and an old hat thrown in which isn't particularly beautiful, but the cape is superb and I immediately started working with it. Am just as pleased with it as I was with the sou'wester before.

And I've got as far with the sketch of the dung-heap as more or less getting into it that sheep-shed effect of inside against outside—the light under the dark sheds—and the group of women emptying their dustbins is beginning to develop and take shape.

Now the wheelbarrows going up and down and the rag-pickers with dung forks, that grubbing about under the sheds, has still to be expressed without losing the effect of light and shade of the whole. On the contrary, it must be strengthened as a result.

I believe you'll have your own, similar view of Pa's words, and so I'm not telling you anything new, but because I spoke so sharply about it I wanted you to know at the same time that I don't do such a thing with pleasure but with regret, and would be glad if peace could be kept with a little geniality.

This winter Pa was pretty much against my being with the woman just as much as now, yet he sent a warm coat 'in case I could make use of it', not specifying what for

but obviously with the idea 'she may be cold'. Well, you see, that is right after all, and for one such deed I would gladly put up with a deluge of words.

Because I myself am not one of those who don't fail in words either — such people would be perfect — and don't make the slightest claim to perfection.

And wanted to point out to you that in any case Pa objects to my being with the woman, MUCH MORE SO indeed than with you, and despite that last winter he still no doubt thought something like: 'that wretched woman — but she shouldn't suffer from the cold'. Now, probably the same in your case: 'that poor papist woman shouldn't be alone even so', or something like that. So don't be concerned, be of good heart, and put their minds at ease.

Adieu, old chap, with a handshake.

Ever yours,
Vincent

354 | The Hague, on or about Friday, 15 June 1883 | *To Anthon van Rappard* (D)

My dear friend Rappard,

Was writing a letter to you when the post brought your most welcome letter just a moment ago. I'm pleased you've made progress with your drawing, I didn't doubt that you would, by the way, for you'd made a manly start.

Well, let me begin by saying that I think what you say about the English draughtsmen is entirely correct and entirely right. I saw it in your work, exactly what you say. Well, I take the same view.

On the bold outlines in particular.

Take the etching by *Millet, The diggers*, take an engraving by Albrecht Dürer, take above all the large woodcut by *Millet* himself, The shepherdess, and then one sees fully what can be expressed by such an outline.

And as you say, one then has the feeling 'that's how I'd always have wanted to do it if I'd always gone my own way' &c. That's well said, old chap, and spoken like a man.

Now, what I also find an example of singularly robust, forceful drawing is Leys's paintings, particularly the series of decorations for his dining room. The walk in the snow, the skaters, the reception, the table, the servant. And Degroux has it as well and Daumier has it as well.

Israëls himself and sometimes, sometimes Mauve and Maris too, cannot resist forceful outline, but don't do it like Leys or like Herkomer.

And when one hears them, they really don't want to know, and talk most about tone and colour. Yet in some charcoal drawings Israëls used lines reminiscent of Millet. I for one declare to you frankly that, with all the love and respect I have for these masters, I find it a pity that they, especially Mauve and Maris, don't point out what can be done with the outline more often when talking to others, and recommend drawing carefully and softly.

And so it is that these days watercolour is the order of the day and considered to be the most expressive medium, and in my view too little effort goes into Black and

White, to the point even that there's a certain antipathy to it. In watercolour there's no black, so to speak, and that's the basis for people talking about 'those black things'. All the same, there's no need to spend the whole of this letter writing about that.

Wanted to inform you that at present I have 4 drawings on the easel. *Peat diggers — Sand quarry — Dung-heap — Loading coal.*

I even did the dung-heap twice; the first became too worn to continue working on.

I didn't dare work on them much with turpentine and printer's ink, have used charcoal, lithographic crayon and autographic ink so far. Except in the sketch for the dung-heap that got too worn — I tackled that with them, with not unfavourable results. It became black, but still some of the freshness came back into it, and now I see possibilities for working in it again, whereas before the printer's ink came on it I saw no possibility of that.

I've worked hard since I visited you, I hadn't composed for so long and had done a great many studies, so once I began I went at it furiously. Several mornings I was already at work at 4 o'clock. I would like it immensely if you saw them sometime, for I can make no sense of what Van der Weele said about them, the only one to have seen them.

Van der Weele's judgement was rather sympathetic, but he said of the Sand quarry that there were too many figures in it. The composition wasn't simple. He said, look, draw that one little fellow with his wheelbarrow on a dyke in the evening set against the light sky, how beautiful that would be, for instance, and now it lacked cohesion.

Well, then I showed him the drawing by *Caldecott, Brighton Highroad*, and said, do you mean that it's absolutely not permitted to put many figures in a composition and to make it highly complicated? Leaving aside my drawing, tell me what you think of this composition. Well, he said, I don't find that beautiful either but, he added, I'm speaking personally and can only speak personally. And that's not what I like or what I look at. Well, I thought that was rather well said, but you understand that I didn't find in him that awareness of the question that I sought. But for the rest he's a solid fellow, and I had some very pleasant excursions with him and he showed me some devilishly beautiful things.

It was also during a walk with him that I saw the sand quarry, but that time he hardly looked at it and I went back alone the next day. I drew the sand quarry with a lot of figures, because sometimes there really are a great many fellows toiling away in those sandpits, for example in the winter and the autumn they provide work there in the name of the city for those who have no work. And then it's wonderfully pleasing there.

I've had several fine models of late. A superb grass-mower, a splendid country lad, exactly like one of Millet's figures.

A fellow with a wheelbarrow — you may remember me drawing his head in Sunday clothes with a Sunday patch over his blind eye.

Now I have him in his everyday suit, and it's perhaps hard to believe that it's the same man who posed for the two figures.

These four big drawings are 1 metre by ½ metre.

I feel happy using a brown passe-partout with a very deep black inside edge. Then many blacks that would appear too black in a white passe-partout look grey and the whole remains clear.

By Jove, I wish you could see them, not because I myself think they are good, but

I would like to hear your thoughts about them, even though I'm not yet satisfied with them. To my taste they aren't yet figure drawings in the true sense of the term, although they are still figure drawings, but I wanted to express the outlines of actions and structure even more squarely and boldly.

What you write about feeling that you're now on a *road* and not on byways or side roads seems to me absolutely right. Have a similar feeling myself, because this last year I've concentrated more on the figure than in the past.

Be assured, if you believe I have eyes to see, that there is certainly sentiment in your figures; what you make is healthy and manly, do not doubt yourself in that respect and, precisely because you do not doubt, dash it on without hesitating.

The studies of heads for the blind fellows seem superb to me.

Wanted to tell you about a type of pencil by Faber that I've found. Here you see the thickness of the cross-section.

[*Sketch* 354A]

They're soft and better quality than the carpenter's pencils, produce a marvellous black and are very agreeable to work with for large studies.

I used it to draw a woman sewing on grey *papier sans fin* and got an effect like lithographic crayon. These pencils are made of soft wood, dyed green on the outside, cost 20 cents apiece.

Before I forget — I wanted to borrow the issues of Harper's Magazine you have to read the articles about Holland that Boughton and Abbey illustrated. I'll send you a package with the old loose issues that I have with illustrations by Howard Pyle &c. so that you can look through them at your leisure. And shall add Erckmann-Chatrian, Histoire d'un paysan illustrated by Schuler, and enclose several illustrations by Green that you will remember I promised. If you still have duplicates, add them to the Harpers (at least if you can do without the latter for about a fortnight so that I can read them), and Zola's book about Manet if you've finished it.

I'm sorry that your health isn't yet in order, but I think that what will cheer you up more than the baths or whatever it is they do there in Soden is to make solid progress with your drawings. I reckon you'll be longing for your studio as soon as you're out of it. I know that Mauve became terribly melancholy during a journey to a similar kind of factory, speaking with all due respect.

As you know, I'm very unbelieving in matters of this kind, and can sympathize with *Bräsig* in Reuter's Gedroogde kruiden as regards what I think that authority calls 'the water art'.

How beautiful Fritz Reuter's work is.

I do think you'll find the Erckmann-Chatrian beautiful.

Must also tell you that I recently got hold of a splendid old Scheveningen woman's cape and a hat, but the hat isn't beautiful. And I'm also to get a skipper's jacket with a stand-up collar and short sleeves. I'd dearly like to see your charcoal drawing, perhaps when my brother comes — I don't know exactly when yet — I could go with him to Brabant and then come for a look while passing Utrecht. Perhaps if I can manage it I'll come anyway sometime, for I would like to see it.

For your part, make sure you come to The Hague again, for the wedding you spoke

of then. If I carry on having such success as just recently in finding models, I'll certainly do one or two things in large drawings this summer.

Now I want to continue with those I'm working on to get them to the same level, if possible, by the time my brother comes.

In Harper's Weekly I see a very true thing after Smedley—a black figure of a man on a white sandy road. He calls it 'a generation ago'. It's the figure of a kind of minister perhaps; the impression it made on me was: yes, my grandfather was like that. I wish I had done it. In the same number after Abbey two girls fishing on the bank of a ditch with pollard willows. In Harper's they're both just croquis in a review of an exhibition.

I would send you croquis of the drawings but I haven't got much time.

I asked permission to draw in the old men's and women's home here but that has been refused me. Still, there are more homes in the villages around here. But here I knew a few people whom I could use as models. I was there, though, to have a look, and saw among others a gardener next to an old, crooked apple tree that was very real.

Well, there's my model. Adieu, send the Harpers if you can do without them, with a handshake.

Ever yours,
Vincent

358 | The Hague, Monday, 2 July 1883 | *To Theo van Gogh* (D)

My dear Theo,

Your letter and the enclosure were not a little welcome, and the message that you'll write again at greater length no less welcome. I hope you'll write to me in detail about the hundred masterpieces; it must be good to have seen something like that. And when one remembers—at the time there were some people who were rather suspect as regards their character, intentions and genius, according to public opinion, people of whom the most absurd things were said, Millet, Corot, Daubigny, etc., who were regarded more or less the way the village constable regards a stray shaggy dog or a tramp without a passport, and time passes and lo and behold 'the hundred masterpieces', and if a hundred isn't enough, then *innumerable*. Let alone what becomes of the village constables. Little remains of *them* except some notes of the testimony as a curiosity. Yet it remains a drama, I believe, the history of the great men—given too that they not only had to deal with village constables during their lifetimes, since usually they're no longer with us when their work is publicly recognized, and during their lifetimes they were under some pressure for a long time because of the opposition and the difficulty of struggling through life. And so whenever I hear of the public recognition of the merits of some people, I think all the more of the quiet, slightly sombre figures of those who had few personal friends, and in their simpliity I find them *even* greater and more poignant like that.

There's an etching by *Legros—Carlyle in his study*—which often comes to mind when I want to imagine Millet or anyone else as he was.

What V. Hugo says about Aeschylus: 'They killed the man and then they say: "let us put up a bronze statue of Aeschylus"'; something of that is always in my mind when I hear of an exhibition of someone's work. So I don't look much at 'the bronze statue'. Not because I disapprove of something being publicly honoured, but because of the association, they killed the man. Aeschylus was simply banished, but here too banishment was a death sentence, as it often is.

Theo, when you come to the studio I'll be able to show you some things that you'll most certainly not be able to see all together anywhere else.

I could show you some things that one might call the hundred masterpieces of modern wood engraving. Work by people whose names, even, are totally unknown to most art lovers.

Who knows of Buckman, who knows of the two Greens, who knows of Régamey's drawings? Only a few. Seeing them all together, one is astonished by that steadiness of the drawing, that personal character, that seriousness of approach, and that fathoming and presentation of the most everyday figures and subjects found on the street, on the market, in a hospital or orphanage.

I already had some last year, but what I've found since goes far beyond my expectations.

It's agreed, isn't it, that your visit to the studio when you come won't be too brief?

I've worked on the potato grubbers since writing to you. And begun a second one of the same subject with a single figure of an old man.

I'm also working on a sower on a large field with clods of earth, which I believe is better than the other sowers I tried before. I have at least 6 studies of the figure himself, but now I've placed him in the space more specifically as the drawing proper, and carefully studied the land and sky as well.

And then I have studies for the burning of weeds and stalks, and of a chap with a sack of potatoes on his back. And one with a wheelbarrow.

If I now reflect with all possible good will (in order to see things differently, supposing I was wrong) on Tersteeg's opinion that I should do watercolours, then I can't understand how these figures of the chap with a sack, of the sower, of the old potato grubber, of the wheelbarrows, of the weed burner could keep their personal character if I attacked them with watercolour. The result would be something very mediocre, of the sort of mediocre which I don't care to go into in depth. Now at least they have character, something that's in harmony — though distantly — with what Lhermitte, for instance, is seeking. Watercolour isn't the most sympathetic means for anyone who particularly wants to express the boldness, the robustness and the force of the figures.

If one is looking more exclusively for tone or colour, then it's rather different, then watercolour lends itself excellently to that. Now I *do* admit that one could do different studies of those same figures in reality from a different point of view (namely tone and colour), done with a different intention — yet I ask, if my frame of mind and personal feeling makes me notice first of all the character, the structure, the action of the figures, will I be blamed if, following this emotion, I arrive not at a watercolour but at a drawing in black and brown only?

Yet there are watercolours in which the outlines are very forcefully expressed, such as those by Régamey, those by Pinwell and Walker and Herkomer, which I certainly think about sometimes (those of the Belgian *Meunier*), but even if I sought that,

Tersteeg would still not be content with it. Keep on saying, it isn't saleable and the saleable must be your no. 1.

For my part I see in that in plainer terms 'you're a mediocrity and you're pretentious in not submitting yourself and not making small mediocre things; you make yourself ridiculous with your so-called seeking, and don't work.' This is implied in what Tersteeg said to me the year before last and last year, and I'm still faced with it. To me Tersteeg will I think remain '*the everlasting* NO'.

Not only I but almost all who seek their own way have something like this behind or beside them as a perpetual discourager. Sometimes one is burdened by it and feels wretched and, so to speak, overwhelmed.

But, as said, it's the everlasting no. Against that, one finds an everlasting *yes* in the example of men of character, and sees *collier's faith* in them.

It is so, however, that life sometimes becomes sombre and the future dark when working costs money and one feels oneself going ever deeper into the ground the harder one works, instead of work helping one to stay above water and one being able to overcome the difficulties and costs by making a greater effort.

I'm making progress with my figures, but financially I'm losing ground and can't keep up.

And of late I've sometimes thought of moving to the country, either on the seashore or somewhere where work on the land is real. Because I believe it would save some money. I could do what I want here as well if I could earn some more — go here and there now and again to get studies. And the advantage here is that my studio is good, and one isn't completely outside the art world, after all. In any event, one can hardly do entirely without some measure of contact, seeing and hearing something now and again.

I sometimes think of going to England — in London a new magazine of importance has been established, The Pictorial News, of the same standing as L. News and The Graphic, perhaps there may be work and a salary there. But what can one say about it for sure? I hope you'll come soon, a year is a long time not to have seen each other while thinking of each other all the time.

I haven't asked you for details about the woman recently because I'm confident that you two love each other, and that's the main thing, and if one knows that there's no need to ask about details.

Our little man is now just one year old, since 1 July, and is the most cheerful, most agreeable child you can imagine, and I believe it's an important point gained as regards the recovery and complete cure of the woman herself that this child is doing well and keeps her busy and draws her thoughts towards him. I sometimes think that otherwise it might be good for her to spend some time in the country and not see the city and be away from her family; this could help to bring about a radical improvement. For she is improved now, but still, the influence of her family obstructs a great deal at times, I wanting to have simplicity and she being urged to intrigue and be two-faced. Well, she's what one might call a child of her time, and her character has been influenced by her circumstances, so that the remnants will always persist in the form of a certain dejection and indifference and lack of a firm belief in one thing and another. I've already thought of country life for her many, many times. But moving also means spending a

large amount in one go. And I'd also like to be married before I moved, if it came to going to the country or to London.

Here I miss the necessary friction with others, and I don't see how that will get any better. In the end, one place or another will do for me, and I prefer to move as little as possible.

Write to me above all as soon as you can decide anything about when you're coming. Lately I've been in two minds about various things, and consequently under strain, and that will continue until we've seen each other again and talked about the future.

I recently read articles about Holland by Boughton. They were written to accompany illustrations by him and by Abbey in which there are splendid things.

I made a note of something from it — a description of the island of Marken — it makes me want to go there. When one had once got round to settling somewhere where it was very beautiful, who knows how happy one would feel about it? But in that sort of situation one needs at least one point of contact with the art world, because of course the fishing folk know nothing about it, and one has to live.

Above all write the promised letter about the one hundred masterpieces &c., and should you do well in business and if a little extra is possible, it wouldn't be untimely. As for living in the country — I find nature beautiful, and yet there are many things tying me to the city, the magazines especially, the opportunities for reproduction. I wouldn't mind not seeing locomotives, but never seeing a printing press again would be harder to take. Adieu, old chap, with a handshake and thanks again for what you sent.

Ever yours,
Vincent.

I read 'Mes haines' by Zola — there are strong things in it, although in my view he is greatly mistaken, not even mentioning Millet in his general reflections. I do think this is true: note that what pleases *the* PUBLIC is always what's most banal, what we're accustomed to seeing every year; we're used to insipidities of that kind, to such pretty lies, that we reject powerful truths with all our might.

359 | The Hague, on or about Tuesday, 3 July 1883 | *To Anthon van Rappard* (D)

My dear friend Rappard,

I still wanted to write again while you're travelling. Thanks for the consignment of books. I would like to apply to Zola's Mes haines Zola's own words about Hugo, 'I should like to demonstrate that, given such a man on such a subject, the result could not be another book than the one it is', also Zola's own words on the same occasion: 'I shall not cease to repeat, the criticism of this book, as it has been made, seems to me a monstrous injustice'.

I would truly like to begin by saying that I'm *not* one of those who blame Zola for this book. Through it I'm getting to know Zola, I'm getting to know Zola's weak side — insufficient understanding of painting — prejudices instead of correct judgement

in this special case. But, my dear friend, should I get irritated with a friend on account of a fault in him? —far from it. On the contrary, he is all the dearer to me because of his fault. So I read the articles about the Salon with a most curious feeling. I think it utterly wrong, entirely mistaken, except in part the appreciation of Manet —I too think Manet is clever —but very interesting, Zola on art, interesting in the same way as, for instance, a landscape by a figure painter: it isn't his genre, it's superficial, incorrect, but what an approach —not carried through —so be it —not quite clear —so be it —but at any rate it makes one think and is original and tingling with life. But it's mistaken and most incorrect, and rests on shifting sands.

Most interesting to hear him on Erckmann-Chatrian. Here he doesn't lash out so wildly as when he talks about paintings, and his criticism is sometimes deuced telling. I permit him with pleasure to accuse Erckm.-C. of mixing a measure of egotism into his morality. Furthermore, he's right to say that Erckm. becomes a simpleton when he starts describing Parisian life and that he isn't familiar with it. A question, however, inevitably raised by this criticism: is Zola familiar with the Alsace, and if he were, wouldn't he take more interest in Erckmann's characters, who are as fine as Knaus and Vautier?

As for the grain of egotism in most of the characters whose side Erckm. appears to choose, in the old Rabbi David and in Wagner and in *Thérèse*, I believe the somewhat egotistical Erckmann-Chatrian becomes sublime, and so for me he is extraordinary.

What Zola has in common with Balzac is that he knows little about painting. I think two artist types in Zola's works, Claude Lantier in Le ventre de Paris and one in Thérèse Raquin, are just like pale ghosts of Manet, Impressionists of a sort. Anyway. Well, Balzac's painters are awfully heavy going, very tiresome.

Now I'd like to carry on talking about this but I'm no critic. But I'm glad, I just wanted to add, that he scores a hit on Taine, who deserves it because he's sometimes irritating with his *mathematical* analysis. Still, through that he (Taine) arrives at curiously deep pronouncements. For example, I read a remark of his —about Dickens and Carlyle: 'the essence of the English character is the absence of happiness.' Now I don't want to insist on the greater or lesser accuracy, but just say that such words are evidence of very deep reflection, looking into the darkness with one's eyes until one sees something more in it where others no longer see anything. I find that remark beautiful, extraordinarily beautiful, and it says more to me than a thousand other remarks on the subject, and in this case Taine deserves our respect.

Well, am glad to be able to look at the Boughtons —*Abbeys* at my leisure for once. I think In the potato field is the finest of all, and the Bellringers by Abbey.

Text a little dry, a little too full of stories about hotels and antique dealers —read it with pleasure. Why? For the same reason as the book by Zola. Because of the personality of the man who wrote it.

Have you noticed that Zola doesn't even mention Millet? Yet I read a description by Zola of a country graveyard and a deathbed and funeral of an old peasant, which was as beautiful as if they were Millets. So this omission is probably a question of not being familiar with M.'s work.

I can tell you that I've found an uncommonly beautiful print by T. Green, the brother or something of C.G. It's a party at the Foundling Hospital in London, a sort of orphan girls at the table. Oh, you'll be in raptures over it.

Also by him a smaller 'A city congregation', so delicately drawn, as exquisitely done as *Braemar* by our friend J. McL.R.

I found two more prints, The ascent of Mount Vesuvius and A game of football by this sphinx J. McL.R., whose name we've so far been unable to decipher but whom I assume to be a brother or at least a relative of *W. M.* RIDLEY. Both good, but not as beautiful as the Braemar coach. I also know a salmon fishers, by him and I have a 'volunteers in the camp' — the latter print enlightened me about the name.

Furthermore, a procession of monks in the snow by A. Hunt, as fine as a Legros. London Bridge and emigrants by W.M. Ridley, two markets by Buckman, drawn particularly broadly and boldly effective.

By Barnard, Hampstead Heath — First to come — Last to go. How the poor live.

By Hopkins, Children at the beach, very fine in tone; a beautiful sheet by Millais himself, Xmas stories.

By Birket Foster, Winter landscapes, Christmas time, very cosy, two important Gavarnis of the highest quality, Porters of the market, Women of the market and The New Year's presents.

Then Régameys — beautiful Japanese subjects and a very large print by him, a masterpiece, *The diamond field*, and another large composition too, The fatted ox.

And by M.F. a sheet of about medium size showing the treadmill in a prison, as beautiful as a Régamey.

By I don't know whom, a splendid thing about the steel mills in Sheffield called 'The Fork-grinders'. It's in the manner of Edmond Morin, namely his most compact and concise manner.

As you see, this isn't all that many, but they're all beautiful things which I consider valuable additions.

By Howard Pyle, a very beautiful female figure. By S. Read, fine landscapes too.

Yet more perhaps, but these are about the most important.

How are you getting on with drawing on your travels, if you've already left?

I'm working on the potato grubbers, also have a single figure of an old man and several rough studies of figures from the time of the potato harvest. A weed burner and a chap with a sack and one with a wheelbarrow &c. When you return from your travels I hope you go ahead with your visit quickly.

Then I also have another sower, perhaps the seventh or eighth figure I've done for it.

This time I've placed him in the space for once, in a large field with clods of earth and a sky.

I'd like to put to Zola the question that I'd like to put to some other people. Tell me, is it true that there's no distinction between, say, a red ochre dish with a cod on it and, say, the figure of a digger or a sower? Is there or is there not a distinction between Rembrandt and Van Beijeren (just as gifted technically), between *Vollon* and *Millet*?

Have you already noticed that new magazine Pictorial News? Sometimes there are good things in it, but most aren't very special.

My dear friend, I wish we could spend a little more time together. But what can one do? Write again when you have the time and the inclination. The summer issues of The Graphic and London News aren't particularly special in my view. The Graphic does, though, have a fine Caldecott, that's the best thing. And several Reinharts, not the best. London News, Caton Woodvilles again.

You'll find the sheets I'm writing to you about more interesting. Diamond field by Régamey isn't at all gripping at first sight, but one finds it more and more beautiful with time. The T. Greens are masterpieces.

My brother writes to me about a particularly beautiful exhibition in Paris, called 'The hundred masterpieces'. Adieu, my dear friend, have a good journey, remember to write if there's time.

With a handshake.

Ever yours,
Vincent

361 | The Hague, on or about Wednesday, 11 July 1883 | *To Theo van Gogh* (D)

My dear Theo,

I had already been looking out for your letter, more or less, and was again glad of it. Thank you. I find what you write about the exhibition most interesting. What was that old painting by Dupré that you thought especially beautiful? You must write again to tell me. Your description of Troyon and Rousseau, for instance, is lively enough to give me some idea of which of their manners they are done in.

There were other paintings from the time of Troyon's municipal pasture that had a certain *mood* that one would have to call *dramatic*, even though they aren't figure paintings.

Israëls put it perfectly in the case of a Jules Dupré (the large one in Mesdag): 'It's just like a figure painting'. It's that dramatic quality that causes one to find a *je ne sais quoi* in it that makes one feel what you say, 'It expresses that moment and that place in nature where one can go alone, without company.'

Ruisdael's Bush has it strongly too.

Haven't you ever seen old Jacques that were perhaps a little overdone, a little strain-ing for effect — but not really — and for that reason were thought particularly beautiful, even though not everyone considered them to be among the finest Jacques?

Speaking of Rousseau, do you know Richard Wallace's Rousseau? An edge of a wood in the autumn after rain, with a vista of meadows stretching away endlessly, marshy, with cows in them, the foreground rich in tone. To me that's one of the finest — is very like the one with the red sun in the Luxembourg.

The dramatic effect of these paintings is something that helps us to understand 'a corner of nature seen through a temperament' and that helps us understand that the principle of 'man added to nature' is needed more than anything else in art, and one finds the same thing in Rembrandt's portraits, for example — it's more than nature, more like a revelation. And it seems good to me to respect that, and to keep quiet when it's often said that it's overdone or a manner.

Oh, I must tell you that De Bock came round — very pleasant. Breitner, whom I didn't in the least expect because he had apparently broken off contact completely some time ago, turned up yesterday. That pleased me because in the past — when I was first

here—he was very pleasant to go walking with. I mean to go out together not in the country but in the city itself, to look for figures and nice scenes.

Here in The Hague there isn't a single person I've ever done that with in the city itself; most think the city ugly and pass by all of it. And yet it's really beautiful in the city sometimes, don't you agree?

Yesterday, for example, I saw workmen in Noordeinde pulling down that part opposite the palace, chaps covered in white from the clouds of plaster dust with carts and horses. It was cool, windy weather, the sky grey, and there was great character in the scene. I saw Van der Velden once last year—at De Bock's one evening when we looked at etchings. I've already written to you that he made a very favourable impression on me at the time, although he said little and wasn't much company that evening. But the impression he immediately made on me was that he was a solid, genuine painter.

It's a square, Gothic head—something bold or daring, and yet gentle in his look. Very broad build, in fact the exact opposite of Breitner and De Bock. There's something manly and strong in him, even if he says nothing and does nothing special. I do hope I'll get in closer touch with him at some point, perhaps through Van der Weele.

Was at Van der Weele's last Sunday; he was working on a painting of cows in the milking yard, for which he has several substantial studies. He's moving to the country for some time.

Of late I've done a few watercolours outdoors again for a change, a cornfield and a bit of a potato field. And also drawn a few small landscapes, to have something to go by for the settings of a few figure drawings that I'm looking for.

[*Sketches* 361A–B]

These are the designs of the figure drawings, very superficially. Above, weed burners, below, coming back from the potato field.

I'm seriously considering painting a number of figure studies, mainly with a view to raising the standard of the drawings.

It's good news for me that you're planning to come to Holland at the beginning of August, for I've said often enough that I dearly long to see you.

I'm looking forward to hearing from you sometime as to how informed your woman is about art. In any event, much will have to be done and cultivated in that respect, I imagine. So much the better. In any case I hope she'll get a sort of album, for which I hope you'll find a few sheets among the smaller studies. Sometimes there are sheets in a sketchbook which still say something, even though they're only scratches. I'll gather one or two things together before you come.

Well, I've spoken to De Bock again and I can leave my stuff with him when I go to do studies in Scheveningen.

I also hope to go and see Blommers again soon. I talked to De Bock about his painting at the Salon, *November*, which I thought so beautiful, and the reproduction in the catalogue. He should still have a sketch of it, and I'd like to see it.

As for going to London sooner or later for a while, long or short, I too believe that there would be more chance of doing something with my work over there; I also think that I could learn a great deal if I could make the acquaintance of some people there. And there I wouldn't be short of subjects to do, I assure you. There would be beautiful

361A–B (top to bottom). *Weed burners; Three people returning from the potato field*

things to do on the wharves beside the Thames. Anyway, we must talk about various things again when you come. I hope you won't be in too much of a hurry; we'll have rather a lot to deal with. I'd like to be able to get some studies in Brabant again in the autumn.

Above all I'd like to have studies of a Brabant plough, of a weaver and of that village cemetery at Nuenen. Again, everything costs money.

Well, regards, and thanks again for your letter and the enclosure. I wish you well. Do you think about bringing the woman to Holland, or is that not advisable as yet? I hope it happens. Adieu, old chap, with a handshake.

Ever yours,
Vincent

I'm adding a word here to tell you something more about Breitner as well — since I've just come back from his temporary studio here (you know that he really lives in Rotterdam these days). You know *Vierge* or *Urrabieta*, the draughtsman for L'Illustration. Well, at times B. reminds me of Vierge, but very rarely.

When he's good it looks like something done in haste by Vierge; but when he, that is B., is too hasty or doesn't work things through, which is usually the case, it's difficult to say what it resembles, for it looks like nothing — except like strips of an old, faded wallpaper from I don't know which era, but in any event a very singular one, probably from long ago. Imagine, I go to the garret that he has at Siebenhaar's. It was furnished mainly with various matchboxes (empty), and then with a razor or something, and a cupboard with a bed in it. I see something leaning against the chimney, 3 endlessly long strips that I at first think are sun blinds. But on closer inspection they turn out to be canvases in this format.

[Sketch 361C]

As you see from the above illustration, painted with a not unmystical scene, probably taken from Revelation, one would imagine at first sight.

Yet I'm informed that they are artillery manoeuvres in the dunes. Off the cuff I would put it at over 4 metres long by ¾ of a metre.

The second was a story of a man who was leaning against the wall on the extreme left of the painting, while on the far right various types of ghostly women stood gawking at him, while care had been taken to leave a substantial space between these two groups. I was then informed that what was depicted in the left-hand corner was a drunkard, and I wouldn't venture to doubt that this may just as well have been the maker's intention as something else.

The third is almost better, and is a sketch of the market that he did last year, but since then it seems it's meant to depict a Spanish instead of a Dutch market, in so far as one can make anything of it.

Whatever merchandise is sold at the market (wherever it's located, I for one doubt whether it's meant to be on this earth; it's much more likely to strike the naive beholder as portraying a scene on one of those planets visited by Jules Verne's miraculous travellers (by projectile)) — whatever merchandise really is being traded is impossible to make out, but it's faintly reminiscent of a huge mass of preserves or sweets. You see, try

361C. Sketch of a painting by George Hendrik Breitner

to picture such a thing, but it couldn't be more absurd, and heavy-handed as well, and you have the work of Friend Breitner.

From a distance they're areas of faded colour as on bleached and rotting and mouldering wallpaper, and in that sense there are qualities in it that are absolutely unpalatable to me.

I utterly fail to understand how anyone could possibly come up with something like that. It's the sort of thing one sees when one has a fever — or impossible and meaningless as in a dream that makes no sense at all. I take the view, quite simply, that Breitner isn't yet cured, and actually did it while he had a fever. Which, given his illness last year, may be considered entirely possible. Last year when I was cured but still couldn't sleep and was feverish, I too had moments when I wanted to force myself to work all the same and did some things, though thank God not so absurdly big, and later on I couldn't understand why I'd done them.

This is why I think that B. will be all right in the end, but I find this absurd.

In a corner lay a crumpled watercolour study of some birches in the dunes that was much better and had nothing abnormal about it. But those big things are nothing.

I saw another one at Van der Weele's, very ugly, and a head, very good, but a portrait of Van der W. — that he'd started — again bad.

So he's making a terrible mess on a very big scale. I like the work of Hoffmann and Edgar Poe on occasion. (Contes fantastiques, Raven &c.) But I find this unpalatable because the fantasy is heavy-handed and without meaning, and there are almost no correspondences to what exists. I find it very ugly.

But I regard it as a period of illness. Van der Weele has two rather curious drawings by him, elegantly done in watercolour, which have a certain *je ne sais quoi* of what the English call 'weird'.

I learned a lesson today from that visit, namely that one can count oneself lucky if one is in relatively normal surroundings in today's society, and doesn't have to seek refuge in a coffee-house life which will make one begin to see things ever more cloudily and confusedly. For the latter is his situation, about that I have no doubt. Imperceptibly he has strayed terribly far from a calm, rational contemplation of things, and now he can't put down a single calm, reasonable line or brushstroke as long as this stress continues.

I wish I could offer him some company and diversion, I wish I could often take a turn with him and perhaps make him a little calmer. You remember the painting The madness of Hugo van der Goes by Wauters? In some things B. faintly reminds me of a state of mind like Van der Goes's. I'd not like to be the first to say this, but I believe his work has already been discussed in these terms for some considerable time.

The remedy would be to look at length at the potato leaves that are so deep and elegant in colour and tone at present, instead of driving himself mad looking at lengths of yellow satin and pieces of gilt leather.

Anyway, we'll see how it goes. He's intelligent enough, but it's a kind of bias towards eccentricity that he persists in regardless. If he deviated from the normal for a reasonable motive, well and good, but here it's a question of not taking any trouble with his work either. I find it truly wretched and I hope he recovers, but he has lost his way badly.

This week I'm going to start in Scheveningen. I would have liked there to be room for a little extra, then I would have bought some painting materials.

I'm going to have photographs taken of a few drawings in cabinet format or slightly larger (to see how they'd look on a small scale) by a photographer who has photographed those drawings by Ter Meulen, Du Chattel, Zilcken. He does it for 75 cents, that's not expensive, is it? I'll have the sower and the Peat diggers done for now, the one with many smaller figures, the other with 1 large figure. And if they work, later on when I have drawings I'll be able to send you photos to show to Buhot, say, to see if he thinks he can place them. They could have the drawings themselves of the ones they want for reproduction or I can redraw them on their paper.

Regards again, Theo. Best wishes.

Do write again soon. I'll have the photos taken, for we must stick to our guns with Buhot & Cie. I must try to earn a little so that I can make a start on something new and do some painting too, for I'm just in the mood for that.

Mauve not only had some unpleasantness with me but also, to give an example, had unpleasantness with Zilcken. It's only now that I've seen Z.'s etchings, and just now photos of drawings by Zilcken at the photographer's. Leaving myself out of it, I hereby declare that I don't understand what M. has against Z. His drawings were good and not in the least bad; it's capriciousness on Mauve's part.

After all, I don't think it very nice of C.M. that I haven't received one syllable in reply to my letter, in which I took the trouble to do two croquis of the drawings in question.

Nor do I think it nice of H.G.T. that he didn't pay a call after I'd made an attempt to break the ice. It's rubbish to say that he's busy, because that's not the reason in this case, he could find the time to come once a year.

I'm adding half a page to talk about Brabant. Among the figures of types from the people that I did there are several with a certain, what many would call old-fashioned, character, also in the approach. For example, a digger who's more like those one sometimes finds in the bas-reliefs carved in wood on Gothic pews than a contemporary drawing. I very often think of the Brabant figures, which I find especially sympathetic.

Something I'd like to have terribly much, and which I feel I can do, given certain conditions of patient posing, is the figure of Pa on a path on the heath, the figure severely drawn with character and, as I say, a stretch of brown heath with a narrow, white, sandy path running across it, and a sky applied with some passion and evenly expressed.

Then, for instance, Pa and Ma arm in arm — in an autumn setting — or with a beech hedge with dry leaves.

I'd also like to have the figure of Pa when I do a country funeral, which I'm definitely planning, although it would be a great deal of trouble.

Leaving aside irrelevant differences in religious views, to me the figure of a poor village pastor is one of the most sympathetic in type and character that there is, and I wouldn't be myself if I didn't attack it sometime.

When you come I'd truly like to consult you on what to do about travelling over there. When you see my drawings of orphan men, for instance, you'll understand what I want and how I mean it.

My aim is to do a drawing that not exactly everyone will understand, the *figure* expressed in its essence in simplified form, with deliberate disregard of those details that aren't part of the true character and are merely accidental. Thus it shouldn't, for example, be the portrait of Pa but rather the *type* of a poor village pastor going to visit a sick person. The same with the couple arm in arm by the beech hedge — the type of a man and woman who have grown old together and in whom love and loyalty have remained, rather than portraits of Pa and Ma, although I hope they'll pose for it. But they must know that it's serious, which they might not see for themselves if the likeness isn't exact.

And should be a bit prepared, in the event that this happens, for having to pose as I say and not change anything. Well, that will be all right, and I don't work so slowly as to make it a great effort for them. And for my part I would greatly value doing it. Simplifying the figures is something that very much preoccupies me. Anyway, you'll see some for yourself among the figures I'll show you. If I went to Brabant, it should certainly not be an excursion or pleasure trip, it seems to me, but a short period of very hard work at lightning speed. Speaking of expression in a figure, I'm becoming more and more persuaded that it lies not so much in the features as in the whole manner. I find few things as horrible as most academic facial expressions. I would rather look at 'Night' by *Michelangelo*, or a drunk by Daumier, or The diggers by Millet, and that large woodcut by him, The shepherdess. Or at an old horse by Mauve &c.

363 | The Hague, Sunday, 22 July 1883 | *To Theo van Gogh* (D)

My dear Theo,

I thank you for your letter, and for the enclosure, although I can't suppress a feeling of sadness over what you say, 'as for the future, I can give you little hope'. If you mean that only in relation to financial matters, I wouldn't be downcast, but if I'm to take it as applying to my work, I really don't see how I deserve that. It just so happens that I can now send you the prints of photos after a few of my recent drawings, which I promised you earlier but couldn't manage because I was flat broke.

I don't know how you intended those words, nor can I know. Your letter is too brief, but it gave me an unexpected blow right in the chest.

But I would like to know what the position is, whether you noticed something in me, that I wasn't making progress or something.

As for financial matters, you'll remember writing to me months ago about bad times. My answer was: very well, a reason for us to do our very best on both sides; see that you send me the absolutely essential, I'll get on with making more progress so that perhaps we can place something with the illustrated magazines. I've since made a start on various large compositions in which there was more of a subject than in studies of single figures.

So now my first consignment of photos to be shown to someone or other if needed coincides with your 'as for the future, I can give you little hope'. Is there something in particular???

I'm rather nervous about this. You must write again soon. Well, as you see, the

photos are SOWER — POTATO GRUBBERS — PEAT DIGGERS. I've now done some more, SAND QUARRY, WEED BURNERS, DUNG-HEAP, POTATO GRUBBER 1 figure, COAL LOADERS, and at Scheveningen this week I worked on MENDING NETS (Scheveningen fishermen's wives).

And two larger compositions of Dune workers (one of which I showed to Tersteeg again) which, although they'll require a lot more labour, are still what I'd most like to complete.

Long rows of diggers — poor fellows set to work by the city — in front of a piece of dune land that's to be dug over. But to do that is terribly difficult.

Peat diggers gives you a first idea of it. I wouldn't be so melancholy about it, brother, if you hadn't added something that worries me. You say 'let's hope for better times'.

You see, that's one of the things one must be careful about, in my view. *Hoping for better times mustn't be a feeling but a doing something in the present.*

My doing depends on your doing, in the sense that if you were to reduce what you send I couldn't go on and would be desperate.

Precisely because I felt the hope of better times alive within me, I continued to throw myself into it with all my strength — into the work of THE 'PRESENT' — without thinking about that future other than to trust that work would bring its reward, although the spending on food, drink, clothes had to be reduced again and again, week after week, more and more. I was faced by the question of going to Scheveningen, the question of painting. I thought: come, press ahead. But now I wish I hadn't begun, old chap, for it means extra expenses and I don't have it. The weeks passed, many, many weeks and months of late, when each time the expenses were slightly more than I could keep up with, even with all the fretting and worrying and economizing. So when the money arrives from you, not only do I have to manage on it for 10 days but I immediately have to pay out so much that in those 10 days that lie ahead one couldn't be in a more meagre situation from the outset. And the woman must breastfeed the child, and the child is strong and growing, and she's often worried because there's no milk.

I, too, have an enormous feeling of faintness at times in the dunes or elsewhere, because there's nothing coming in.

Everyone's shoes patched and worn out and other petty vexations that give one wrinkles. Anyway — it would be nothing, Theo, if only I could hold on to the thought: it will work all the same, just press on. But now to me your words 'as for the future, I can give you little hope' are like '*the hair that breaks the camel's back at last*'. The burden is sometimes so heavy that one hair more makes the animal fall to the ground.

Well, what to do? I've seen and spoken to Blommers twice already in Scheveningen, and he saw a few things of mine and asked me to call on him sometime.

I did some painted studies there, a bit of sea, a potato field, a field with women mending nets, and here at home a chap in the potato field planting cabbage in the empty spaces between the potato leaves, and then I'm working on the large drawing of beeting the nets, as they call it. But I feel my enjoyment fading, one needs a fixed point somewhere. You see, the fact that you say to me, just have hope for the future, is as if you yourself no longer have any hope for me. Is that so? I can't help it, I feel unwell because of the worry, and I just wish you were here.

You say that the effect of the autographs is rather meagre. That doesn't surprise me in the least when I consider that someone's physical state influences his work, and my life is too dry and too meagre. Honestly, Theo, for the sake of the work we ought

to have eaten a little better, but we couldn't afford it and things will stay like that if I don't get a little more leeway by one means or another. So do show the photos to Buhot or someone if you can't arrange it yourself, and try to find a market through him, if you can.

I almost regret starting to paint again, for if I can't make any progress I would rather I had given it up. It can't be done without paint, and paint is dear, and because I still owe Leurs and Stam some money I can't run up a bill. And I like painting so much. Now that I was doing it again I took more pleasure in things from last year, and have hung painted things in the studio again. The sea, which I love very dearly, needs to be attacked with painting, otherwise one has no grip on it.

Look, Theo, I just hope that you aren't losing heart, but truly, if you're going to talk about 'giving no hope for the future' then I feel sad, for you must have the courage and the energy to send, otherwise I'll be stuck and powerless to move forward, for those who could be friends have become hostile, and appear to want to stay like that.

Consider the fact that, after all, I've done nothing that could justify this, at any rate not explain why Mauve, say, or Tersteeg or C.M. are so cool as not to want to see anything or say a word. I find it human that a coolness may arise over one thing or another, but to maintain the coolness now that more than a year has passed, and after repeated attempts at reconciliation, is not kind.

Thus I end for today with the question, Theo, when in the beginning you spoke to me about painting, and if we could have foreseen then the work now, would we have hesitated to think it was right that I should become a painter (or draughtsman then, what difference does it make?)? I don't believe that we'd have hesitated to press ahead if we could have foreseen these photos, for instance, would we?, for a painter's hand and eye are needed after all if one wants to create such a scene in the dunes in one form or another. But now I often feel so wretched when I see people remaining so apathetic and cold that I lose heart. Well, then I recover again and go back to work and smile about it, and because I work in the present and don't let a day go by without working, I believe that I do indeed have hope for the future, although it doesn't feel like that because, as I say, there's no room left in my brain for philosophizing about the future, either to upset me or to console me. Holding on to the present and not letting it pass by without managing to get something out of it—now that's what I believe duty is.

So you should also try to hold on to the present with respect to me, and let's persevere with what we can persevere with, preferably today rather than tomorrow.

But you needn't spare me, Theo, if it's just a question of money, and if you, as friend and brother, retain some sympathy for the work, saleable or unsaleable. As long as that's the case, that I still retain your sympathy in this respect, then it matters precious little to me, and we must confer calmly and coolly. Then, if there's no hope for the future financially, I would propose a move to the country, saving half the rent in a village *deep in the country*, and for the same amount of money that one pays here for bad food getting good, healthy food, which is needed for the woman and the little ones, and for me too in fact. *Also* having advantages perhaps for models.

As you know, last summer I painted—now I've hung up several studies again, because when I was doing new ones I saw that there was something in them after all. Painting helped me indirectly with my drawing during the winter months and the spring, and I worked that up right until these recent drawings. Now, though, I feel it

would be good to paint again for a while, and I need that to become richer in tone, in the drawings too. I had planned to paint the women sitting in the grass mending the nets in a fairly large format, but after what you said I'll wait until I've spoken to you.

I've received small prints of the autographs, but weak ones, yet the man tells me he ought really to have put on more ink and that he'll give me better ones. No matter, I've experimented with doing a croquis in a small format as if for an illustrated magazine. Oh, Theo, I could make much more progress if I was a little better off.

But I can't think of a way out, I come up against expenses on all sides. When I read the life story of one painter or another, I see that in fact they all needed money, and were miserable when they couldn't carry on.

Write soon, for I'm not well and in two minds as to whether I dare go ahead with Scheveningen, which will involve the costs of painting materials.

I had hoped that you would have been able to send something — well, in any event, especially if you have no money, you must write to me soon, for it's quite a feat to keep one's spirits up in the circumstances.

I think the drawings from which the photos have been taken aren't yet deep enough in tone, not yet depicting the emotion nature evokes sufficiently, but if you compare this with what I began with, the earlier figures, I believe I'm not mistaken in seeing signs of progress and we mustn't let go of that advance, so let us toil on.

I wish you could come. Write soon in any case. Adieu, with a handshake.

Ever yours,
Vincent

I don't think it right, Theo, to spend more than one receives — but if it's a question of stopping or carrying on working, I'm for carrying on to the end. Millet and other predecessors carried on right up to the bailiff, and some went to prison or had to move hither and thither, yet I don't see in them that they stopped. And with me it's still only the beginning, but I see it in the distance like a dark shadow, and it sometimes makes working sombre.

I've spoken to Breitner again, about those three compositions in progress. It was indeed so that he had done them in a moment when he was out of sorts. He told me that he regretted doing them like that, and showed me an altered composition of the drunkard and studies of low street women that were infinitely better. And I also saw some water-colours in the making and a painting of a farrier's that were done with a calmer and more correct hand and head. I read a book he lent me, *Soeur Philomène* by De *Goncourt*, who wrote Gavarni. The story is set in a hospital, very good.

367 | The Hague, on or about Wednesday, 25 July 1883 | *To Theo van Gogh* (D)

My dear Theo,

A man comes to me this morning who had repaired the lamp for me 3 weeks ago, and from whom at the same time I bought some earthenware that he himself pressed me to take.

He came to tell me off because I had just paid his neighbour but not him. Accompanied by a lot of noise, swearing, ranting &c. I tell him I'll pay him as soon as I receive money but that I don't have it at the moment, and that adds fuel to the flames. I ask him to leave, and in the end I push him out of the door but, perhaps deliberately letting things get to this point, he grabs me by the neck and throws me against the wall and then flat on the floor. You see, this is the sort of thing from which you can see the petty vexations one is faced with. A chap like that is stronger than I am, right?—they aren't at all ashamed. Well, all the small shopkeepers &c. one deals with for daily necessities belong to the same type. They come themselves to ask you to take this or that from them or, if one goes to someone else, they ask for your custom, but if one must unfortunately put off payment for longer than a week it's cursing and scolding. Anyway, that's the way they are, and what can one say? They themselves are sometimes hard pressed. I'm telling you about this to show you that it's rather urgent that I make some money if possible. When I went to Scheveningen I had to leave one or two others waiting. I'm a little worried, brother, and have considerable sorrow and difficulty. I long for you to come because I want to decide whether or not I should move. To carry on here I would need to earn a bit more in general; the little that I lack makes life here unbearable.

Otherwise, I have so few setbacks in the work that all the petty vexations don't affect my pleasure in it and don't prevent me doing one thing and another. There are a couple of small seascapes at De Bock's, one with a choppy, one with a calm sea, a genre I'd very much enjoy pursuing. Yesterday a peasant cottage with a red roof under tall trees. Well, I believe that painting figure studies would help me with many things, I made a start with one boy in the potato field and one in the garden by a cane fence. I ought to be able to put some effort into them.

The incident this morning is a sign to me that it's a duty to confer and to take a smaller place in a village if there's no hope of being a little better off here. Otherwise, the studio here is practical enough, and there's no lack of beautiful subjects to do here. And it isn't everywhere that one has the sea.

What I said to you about not feeling strong is true, it has now come down to pain between the shoulders and in the lumbar vertebra, which I've had before from time to time, but I know from experience that one must then be careful, otherwise one gets too weak and can't easily recover.

I'm relatively resigned to things. Circumstances have been a little too much for me recently, and my plan to win back old friends by working constantly and sensibly has been shattered. Theo, there's one thing that it would be good for us to discuss at some point—I'm not saying that there's any question of this right now, but the days could become darker still and I would like us to agree on this for that eventuality. My studies and everything in the way of work in the studio is definitely your property. The question doesn't arise *now*—I repeat—but in due course, for instance because of unpaid tax, the things may be sold, and in that case I would like to put the work in a safe place and out of the house. It's my studies that I can hardly do without for later work, things that have taken me a great deal of trouble to do.

So far there hasn't been a soul here in the street who pays tax, yet all have been assessed for various sums, including me, and I have twice had appraisers here; I drew their attention, however, to my 4 kitchen chairs and unpainted table and said I wasn't

eligible to be assessed for so much. That if they found carpets, pianos, antiques &c. at a painter's, they might not be wrong to assess such a man as being able to pay, but that I couldn't even pay my paint bill, and that there were no luxury items but only children in my house, and that consequently there was nothing to be had from me. They then sent me demands and final notices but I ignored all that and said, when they came back again, that it was pointless because I simply lit my pipe with them. That I didn't have it, and my 4 chairs, table &c. wouldn't raise anything anyway. That they weren't worth as much new as they wanted to assess me for.

They have indeed left me in peace since, for months now. And other people here in the street aren't paying either.

Still, now that we're talking about this, I wish I knew where to store my studies in such an event. Well, I could take them to Van der Weele, say, or someone. Together with my tools. I always have a certain hope that when you come to the studio sometime you will yet find things in which someone might possibly be interested, even though they have no particular commercial value.

There's no lack of work.

Despite everything, at heart I don't have a feeling of dejection, and on the contrary I can agree with what I read recently in Zola, 'If at present I'm worth something, it's because I am alone and because I hate the ninnies, the incapable, the cynics, the idiotic and foolish mockers'. But none of that can perhaps do away with the fact that I can't withstand the siege if I stay here. I write about this very matter because it's at the beginning, and the manoeuvre of moving to a cheaper place may perhaps be the solution, although it's very urgent in itself purely for the sake of spending less on accommodation.

Van der Weele has the silver medal for his painting that he more than deserves, I'm glad he has got it.

I've thought a good deal about that painting by Van der W. because I saw it being done in part, and talked quite a lot about it with him and was immediately attracted by it.

I believe, Theo, that I too could do something like that through carrying on working regularly and calmly in the future.

But in any event, there would have to be a period of constant painting in between, and for that there would have to be means, and at present the prospect of getting them seems to me slight. Van der Weele has managed it by sacrificing half of his time on things he doesn't do for pleasure but through which he raises the means to keep his painting box filled and to eat &c. Perhaps, perhaps, if there were to be some article in my work that people wanted to have, I might be able to pull it off too. Otherwise I don't care much about selling in itself, other than as a means of being able to keep going. I tell you plainly that few of the ideas about art with which I became familiar during my time with Goupil—in so far as they had to do with practice—have been borne out, although I've kept the same taste. Creating things doesn't take place as one imagines if one is a dealer, and the life of a painter is different, the study is different. I would find it hard to say in what sense, but Daubigny's words, 'my paintings that I value more highly aren't the ones that bring in the most' are something I now believe, and if I'd heard them when I was with G&Cie, I would have thought he was just saying that as a manner of speaking. Adieu, old chap—I'm a little worried, you can see from what I've written about my skirmish this morning that people don't treat me with

much consideration. They'd probably keep their distance more if one wore a top hat and I don't know what else besides. One has one's sense of things after all, and it isn't pleasant. Anyway, I wish there was something to be found in the work so that a little more leeway would be possible. Adieu, write soon, I long for that so much.

Ever yours,
Vincent

371 | The Hague, on or about Tuesday, 7 August 1883 | _To Theo van Gogh_ (D)

My dear Theo,

Pending your arrival there's hardly a moment that I'm not with you in my thoughts.

These days I'm doing my best to paint some different studies so that you can see something of them at the same time.

And I feel fine when I seek distraction through this change of work, for while I don't literally do as Weissenbruch does and spend a fortnight with the polder workers, I nonetheless act in the same spirit, and looking at nature has a calming effect.

And, moreover, I have definite hopes of making considerable progress with colour in this way. It seems to me that the latest painted studies are more assured and sounder in colour.

Thus, for example, a few I did recently in the rain of a man on a wet, muddy road better express the mood, I believe. Anyway, we'll see when you come. Most are landscape impressions. I wouldn't claim that they're as good as the ones sometimes found in your letters, since I often run into technical difficulties, but still I believe they have something similar.

For example, a silhouette of the city in the evening as the sun is setting, and a towpath with mills.

Otherwise things are so wretched that I still feel faint if I'm not actually at work, but I believe that is passing. I'm definitely going to do my best to build up a reserve of strength, because I'll need it if I want to do a lot of painting, including figures. A certain feeling for colour has been aroused in me of late when painting, stronger than and different from what I've felt before.

It may be that this recent malaise is connected to a kind of revolution in the working method which I've sought for more than once already, and have thought about a great deal. I've often tried to work less drily, but each time it came out roughly the same. But these days, now that some weakening prevents me from working as normal, it's just as if this helps rather than hinders, and letting myself go a little and looking more through my eyelashes instead of looking sharply at the joints and analyzing how things fit together leads me more directly to see things as patches of colour next to each other.

I'm curious as to how this will continue and where it will lead. It has sometimes surprised me that I'm not more of a colourist, because my temperament would certainly lead one to expect that, and yet up to now that has hardly developed at all.

I repeat, I'm curious as to how it will continue — I see clearly that my recent painted

studies are different. If I remember rightly, you have another one from last year, of a few tree-trunks in the woods. I don't think it's particularly bad, but it's still not what one sees in studies by colourists. There are even correct colours in it, but although they're correct they don't do what they should do, and while the paint is highly impasted here and there, the effect remains too meagre. I take this one as an example, and believe that the recent ones that are less impasted are nonetheless becoming more assured in colour, because the colours are more worked into each other and the brush-strokes are painted over each other, so that it fuses together more, and one captures something of the softness of the clouds or of the grass, for instance.

At times I've been very concerned that I wasn't making progress with colour, and now I have hope again. We'll see what happens. Now you can imagine how eager I am for you to come, for if you also see that it's changing I'll no longer doubt that we're on course. I don't dare trust my own eyes when it comes to my work.

For example, the two studies that I did while it was raining, a muddy road with a small figure. It seems to me that it's the opposite of some other studies — when I look at it I recognize the mood of that sad, rainy day, and in the figure, though no more than a few patches, there's a kind of life that isn't due to accuracy of drawing, for it isn't drawn, so to speak. What I want to say is that I therefore believe that in those studies, for instance, there's something of that mysteriousness that one gets by looking at nature as if through the eyelashes, so that the forms simplify themselves into patches of colour.

Time will tell, but for the present I see something different in the colour and the tone in several studies.

Lately I've thought sometimes of a story that I read in an English magazine, a tale of a painter in which a person featured who had also been weakened during a difficult time, and went to a remote area in the peat fields and found himself in the melancholy nature there, so to speak, and was able to paint nature as he felt and saw it. It was very accurately described in the story, evidently by someone who knew about art, and it struck me when I read it, and I've now been thinking of it from time to time these past few days.

Anyway, I hope we'll soon be able to talk about it and confer together. If you can, write again soon and, of course, the earlier you can send, the more I would welcome it.

With a handshake in thought.

Ever yours,
Vincent

For no particular reason I can't help adding something here that's just a recurring thought of mine.

Not only did I start drawing relatively late, but on top of that I can't count on living for a great many years, relatively speaking. When I think about that cool-headedly and calculatedly — as if estimating or measuring something — then it's in the nature of things that I can't possibly know anything definite about it.

Yet through comparisons with various people with whose life one is familiar, or in comparison with whom one believes one sees certain correspondences, one can nonetheless put forward certain propositions that aren't absolutely without foundation.

So as to the length of time in which to work that lies ahead of me, I believe I may

assume the following without being too hasty: that my body will endure for a certain number of years *come what may* — a certain number, say between 6 and 10. I dare all the more to assume this because at present there's no immediate come what may.

That's the period that I count on FOR SURE, for the rest I would find it far too airily speculative to dare to determine anything in myself, given that whether or not anything is left after that period will depend precisely on these first 10 years, say. If one goes into a serious decline in those years, one won't get past 40; if one remains sufficiently well preserved to withstand certain shocks to which a person is likely to be subject, solving more or less complicated physical problems, then from 40–50 one is once more in new, relatively plain sailing.

Calculations about that are *not* on the agenda *now*, but plans for a period, as I began by saying, of between 5 and 10 years are.

My plan is *not* to spare myself, not to avoid a lot of emotions or difficulties. It's a matter of relative indifference to me whether I live a long or a short time. Moreover, I'm not competent to manage myself in physical matters the way a doctor can in this respect. So I carry on as *one unknowing* but who knows this one thing — '*I must finish a particular work within a few years*' — I needn't *rush* myself, for that does no good — but I must CARRY ON *working* in calm and serenity, as regularly and concentratedly as possible, as succinctly as possible. I'm concerned with the world only in that I have a certain *obligation* and *duty*, as it were — because I've walked the earth for 30 years — to leave a certain souvenir in the form of drawings or paintings in gratitude. Not done to please some movement or other, but in which an honest human feeling is expressed. Thus this work is the goal — and concentrating on that thought, what one does and *does not* do simplifies itself in that it's not a chaos, but everything one does is one and the same aspiration. Now the work is going slowly — all the more reason not to lose any time.

Guillaume Régamey was, I believe, someone who doesn't have much of a reputation (as you know, there are two Régameys, F. Régamey paints Japanese and is his brother), but was a character for whom I have great respect all the same. He died at the age of 38, and a period of 6 or 7 years was devoted almost exclusively to drawings that are in a very singular style and were done while working was made difficult by physical problems. He is one of many — a very good person among many good people. I mention him not to liken myself to him — I'm not as good as he was — but to give an example of a certain self-control and willpower that held on to an inspiring idea that showed him the way to produce a good work in serenity despite difficult circumstances.

I see myself in a similar way — as having to do something with heart and love in it within a few years, and do it with willpower. If I live longer, so much the better, but I'm not thinking about that. In those few years SOMETHING MUST BE DONE — that thought is my guiding principle in making plans for the work. A certain desire to make every effort will thus seem to you all the more understandable. At the same time a certain resolve to use simple means. And perhaps you'll also be able to understand that, for my part, I don't view my studies in isolation, but always have in mind the work as a whole.

Dear brother,

Coming home just now, the first thing I feel I have to do is to make a request of you — a request which I have no doubt is necessary simply because you'll see from it that my intentions are the same as yours. It is: not to rush me in the various matters we were unable to deal with all at once this time. For I need some time in order to decide. As for my relative coolness towards Pa, here's something I want to tell you, because you brought it up.

About a year ago now, Pa came to The Hague for the first time since I'd left home in search of peace, which I didn't find there. Of course I was already with the woman then and said, 'Pa, since I don't blame anyone for finding something shocking in my behaviour, given the present conventions, I stay away of my own accord from those who I believe would be ashamed of me.

And you understand that I won't make it difficult for you, and as long as I haven't yet got my affairs in order and am not back on my feet, wouldn't you think it better if I didn't visit you?' If to that Pa had said something like 'No, that's going too far', I would have been friendlier since, but Pa's reply was in between yes and no; it was, Oh, do what you think best.

Well, thinking thus that they were more or less ashamed of me, which tallied with what you told me, I wasn't a busy correspondent and nor was Pa, and neither his letters nor mine were particularly confiding. This, between you and me, is only to explain, not to draw further conclusions. The opposite of seizing the hand and insinuating one's way in when someone offers only a finger is to let go of the hand that isn't offered to us fully and freely. Or voluntarily going away from where one is merely tolerated.

Whether or not I was mistaken, what do I know? There's a bond between you and me which time can only strengthen if we press on with the work, and that is art, and I have hope we'll continue to understand each other after all.

I fear I've said something to you about the work that I ought to have put differently, and have a vague feeling that I must have bothered you with something, because there seemed to be something the matter when you left.

I hope this will resolve itself.

As to the work, what is becoming increasingly clear to me in everything since it caught my attention is the meagreness of the execution. That would worry me if I didn't think it a natural consequence (which I believe I've also seen in the early work of very many people I find sympathetic), a natural consequence of the effort one must make to overcome the very first obstacles. And, looking back on recent years, seeing them full of trouble behind me. That trouble having subsided, there will be another period of working, I hope.

This error is so pervasive and its correction so badly needed that we must see to it that we take steps to give us a period of calm. And so work at it; otherwise it will stay like that. I am as my work is, and you must take this into consideration a little. I don't know whether or not you think it would be better to see someone like Herkomer, Green or Small, for instance, *now* or *to wait* until both the work and I myself have calmed down. I'd be in favour of the latter. Things inside me may clear up soon, but

at the moment I'd rather not have to navigate through complicated London affairs. As regards one or two things that you said to me when you left, I hope you won't forget that one or two things about my clothes &c. are somewhat exaggerated. If it were really so, well I'd be the first to admit my fault, but it seems to me that it's an old piece of gossip dragged up from the past rather than based on recent observation — unless I'm out in the fields or in the studio.

You mustn't rush me if you truly want to make this clear to me. This year I've been completely outside any kind of social circle, so to speak.

And in truth haven't bothered about clothes.

If that's all, it won't be so difficult to change, will it?, especially now that I have the new suit from you.

But I sincerely wish that people would forgive me such failings rather than talk about them.

If I get irritated about this, it's because I've already heard so much about it; dressed up one time and less so another, and it's a story like that of the farmer, his son and the donkey, the moral of which, as you know, is that people are hard to please.

It wasn't so much that I got angry with you as that you astonished me, because you know how much pain I've already suffered over it, and that it has become a piece of gossip that won't disappear whatever I do. Anyway. At all events I have the new suit from you and the old one, which is certainly still good, and so it's over for the time being, isn't it?, and let's say no more about it.

If only I had got a bit further so that it would be easier to sell, I would definitely say, you be the man who takes care of business, I don't want to have anything to do with selling, and live entirely outside those circles.

Unfortunately, though, I can't yet say that now, and you aren't to blame for that, but I ask you for patience in both our interests and for the sake of peace. I'm terribly sorry that I make life difficult for you — perhaps it will clear up by itself — but if you're faltering, tell me plainly. In that case I would rather give up everything than make you carry a heavier burden than you can bear. Then I would certainly go to London right away to look for no matter what, even carrying bales, and leave art for better times, at least having a studio and painting.

When I look back on the past, I always come up against the same fatal points that are still not entirely clear to me and that coincide with the months August 1881 to February 1882. That's why I can't help mentioning the same names all the time. Which appeared to astonish you.

Dear brother, don't think of me as being anything other than an ordinary painter facing ordinary problems, and don't imagine there's anything unusual when there are hard times. I mean, don't picture the future either black or brightly lit; you'll do better to go on believing in grey.

Which I also try to do, and I consider it a fault if I deviate from that.

Regards, and

Ever yours,
Vincent

As for the woman, I don't doubt that in any event you'll understand that for my part I shan't rush matters.

And as for how I think about selling, I wanted to say this again. I believe that the best would be if we carry on working until, instead of having to praise or explain it to art lovers or say something to go with it, they feel drawn to it of their own accord. At any rate, if it's refused or doesn't please, one must remain dignified and calm as far as possible. I fear that my efforts when I present myself do more harm than good, and I wish I could be spared that.

It's so painful for me to talk to most people, I'm not afraid to, but I know I make a disagreeable impression. Attempts to change that may well come up against the difficulty that the work would suffer if one lived differently. And provided one perseveres with the work, it will turn out all right later. Take Mesdag, a veritable mastodon or hippopotamus, all the same he sells his paintings. I haven't got as far as that yet, but the person I mention also began late and worked his way up by an honest, manly route, whatever else he may be. It's not in the least because of laziness that I don't do this or that; rather it's to be able to work more and to leave aside anything not directly part of the work.

Just to return briefly to what you said on leaving: 'I'm beginning to think more and more like Pa'. Well, so be it, you speak the truth, and I for my part, while as I said not thinking or doing exactly the same, respect this character and know of a weak side to it perhaps, but also a good side. And when I consider that if Pa knew anything about art I would doubtless be able to talk to him more easily and agree with him more; suppose you become like Pa plus your knowledge of art — fine — I believe we'll continue to understand each other.

I've had repeated disagreements with Pa, but the bond has never been completely broken.

So let's simply allow nature to develop: you will become what you become, I too shan't stay exactly as I am now. Let us not suspect each other of absurd things and we'll continue to get by. And let us reflect that we've known each other from childhood, and that thousands of other things can bring us ever closer.

I'm a little concerned about what seems to be bothering you, and doubt whether I know exactly what the trouble is. Or rather, I believe the cause lies not so much in a particular, specific matter as in the realization that there are points on which our characters diverge, and that one of us understands one thing better and the other something else. I believe that this is desirable, if you and I try to remain in agreement.

One thing — if I become too much of a burden on you — let the friendship remain, even if you can give less help financially. I'll complain now and again — I'm in a fix over this or that — but without any ulterior motive, and more just to say it for once than because I demand or expect from you that you can do everything, which indeed I wouldn't do, old chap!

It grieves me that I said things that I, for my part, would like to take back entirely if need be, or wish I had left unsaid — or, supposing you conceded they had a grain of truth in them, would like to have them regarded as highly exaggerated. For be assured that the continuing main thought — compared with which all the rest becomes as little as nothing — is and will remain, whatever the future brings, a sense of gratitude towards you. Furthermore, *if* I'm ever less fortunate in the future, in no circumstances — I say in NO CIRCUMSTANCES — you understand — not even if you have to withdraw your help entirely — shall I regard it as your fault. Which wouldn't need to be said, had I not said things more because of the strong effect of my nerves than because I think

you should have said something more adequate at the time when I was calm. Forget about that, you'd be doing me a favour if you took that as unsaid. I think that if that turns out all right, it will turn out all right by itself through time when I'm calm, but in nervousness I blame it now on this, now on that.

It's the same with other things, which I don't want to drag up now, although I later remember what I say, even in nervousness, and a grain of it may be right, yet not all beginnings have a continuation, and in nervous tension they often seem more than they are.

For my part, although there seemed to be something wrong when you left, shall also not go on about it. I do indeed think about what you say, and have already written to you about clothes that I don't refuse them and agree with you completely—but would have known even if you hadn't said it—that attention would be paid to appearance if ever I were to go to Herkomer or someone. Also, what you said about Pa—there was now a reason for writing more to Pa than otherwise, and you will read the letter. And the same with everything else.

In short, if I pass judgement on people, circumstances, circles in which I do not move, it's understandable that I don't hit the mark but fantasize beyond nature and see things very fantastically, just as everything becomes strange when seen against the light. You, who are closer, don't understand how it's possible that they can appear a little like that when seen at a distance, in retrospect. And even if I saw everything totally wrong, anyone who thought it over would perhaps understand that, given certain events, I can hardly speak otherwise. Where things became confused was a brief period, and that brief period CANNOT but occupy a place in my thoughts *constantly*, and I regard it as natural that that moment must have a reaction in the future, because people, even if they deliberately avoid each other, still inevitably end up facing each other in the course of time.

377 | The Hague, Monday, 20 August 1883 | *To Theo van Gogh* (D)

My dear Theo,

You'll understand that I'm rather eager to hear from you whether you've read my letter. As for myself, the course that's the cheapest by our calculations—I believe a village would be the answer—would seem to me the most sensible in the given circumstances.

If the 150 francs a month can continue, I believe we can cover the cost completely, or nearly so. Dear brother, you see that it doesn't look as if there'll be any leeway for me, in any event.

I'll try not to complain, and swallow what I can swallow.

I remain convinced that actually more is required for the work, and that I ought to be able to spend a little more on food and other needs, but if I must manage with less—after all, my life may not be worth the food—why should I make a fuss about it? And it isn't anyone's direct fault, not mine either.

I hope, though, that you understand one thing—that one cannot do *more* than scrimp, even on food, clothes, every kind of comfort, everything that's really needed.

When one has stinted oneself even in those things, there can be no question of unwillingness, can there?

You understand that if someone said to me, do this, do that, do a drawing of this or that, I wouldn't refuse, indeed I would try repeatedly with pleasure if it didn't work the first time. But no one says that, or so vaguely, so in general, that it confuses me rather than helps me on my way.

Dear brother, regarding clothes, I've put on what I got without wishing for more, without asking for more. I've worn clothes from Pa and from you that sometimes fit my body differently and I can't help that, also because the waists may differ.

If you won't mention that my dress occasionally leaves something to be desired, I'll be content with what I have and even grateful for it, in no small measure, although of course at a later stage I'll return to it if I can, and hope to say to you: Theo, do you remember the days when I went round in a long minister's coat of Pa's &c.?; and it seems to me that quietly registering things *now* and laughing about them together later when we're more on top of them is infinitely preferable to arguing about them now. For the present, if I have to go out I have your suit that you brought, and more that is presentable. Forgive me if I don't wear it in the studio or out of doors, that would be to ruin it wilfully, because one always gets some stain or other when painting, and particularly when trying to capture an effect in rain and wind.

My view as regards earning money is as simple as can be; it is that it must come through the work, and that in the circumstances I gain nothing by speaking to people about it personally.

Yet if I see a chance, I pursue it, for instance, what I told you about Belinfante, and Smulders. But so far I've had little luck. Well, I shan't grieve about that as long as you don't upset me by suspecting me of being unwilling.

For I believe that if you think about it carefully you won't doubt that I'm industrious, and if, moreover, you were to *demand* that I asked people to buy from me, *I would do it*, but I might *then* become melancholic. If possible, allow me to go on as before. If not, and if you want me to call on people with my work, I shan't refuse if you advise that.

Yet, dear brother, human brains can't withstand everything. Take Rappard, who got brain fever and has now gone all the way to Germany to get rid of it. I become more agitated than is good for me when I take steps like going to people to talk about the work. And what do I come away with? A refusal or a fobbing-off.

It wouldn't agitate me if it was you, say, who know me and to whom I'm used to speaking.

I tell you, I feel less energetic outdoors when I've been among people.

If we don't waste time with steps of that kind, we'll make progress slowly but surely, and I know of no better way.

In no case shall I refuse a serious commission, whatever is asked for, to my liking or not, I'll try to do it as required, or do it again if required.

In short, I resolve not to get impatient in *any* event, even if people were deliberately to make it difficult for me.

I can't say more than that, and if you care to commission something from me, you can carry out a test, or several tests. I'm at your disposal.

I believe there's a difference between now and the past. In the past more passion went into both the making and the judging of work. One made a definite choice for this or that movement, one enthusiastically backed one side or another. There was more verve. Now I believe there's a spirit of caprice and satiety. People are generally more lukewarm. For my part, I wrote to you before that it seemed to me that since Millet a sharp falling off was evident, as if the peak had already been reached and decline had set in.

This affects everyone and everything.

I'm always glad that I saw the collection of drawings by Millet at the Hôtel Drouot.

At the moment you're in Nuenen.

I wish, brother, that there were no reasons for me to be absent. I wish we were walking together through the old country churchyard or at a weaver's. Now that isn't so. Why not? Oh, because I realize that I would seem like a spoilsport in the given atmosphere.

Theo, again—I don't entirely understand it, and think it has gone rather too far when both you and Pa feel ashamed to walk a little with me. For my part I'll keep away, though my heart yearns to be together. At least, given that I at any rate can't do without that brief moment of seeing either you or Pa with no reservations for once—solely because of unbreakable bonds—henceforth I would like us never again to discuss the question of conventions or clothes when we see each other. You see from everything how instead of insinuating my way in I withdraw as far as possible. But conventions mustn't cause a general cooling. That one point of light that we see each other briefly once a year mustn't be clouded over. Adieu,

Ever yours,
Vincent

As to the work, I don't hesitate. You've read Fromont Jeune and Risler aîné, haven't you? I do NOT see *you* in *Fromont Jeune of course*, but I do see a resemblance between myself and Risler aîné—in his absorption in his work, his decisiveness *in that*, while otherwise he was an 'ordinary chap' and fairly nonchalant and short-sighted, his few wants for himself, so that he changed nothing for himself when he became rich.

As regards my work all my ideas are so ordered, so definite, that I believe you'd do well to accept what I say: let me get on with it as I am; my drawings will become good if we stay on the normal footing with each other, but because the improvement depends a little on the money for my outgoings and expenses—and not only on my efforts—be as generous as you can with the money, and if you see a chance to add any help from another quarter, don't let it slip. But in fact these few lines contain everything I have to say.

You mustn't let yourself be misguided as to my true character by my actions when I left Goupil. If the firm had been for me then what art is for me now, I would have acted more decisively then. But in fact I was unsure then about whether it was my career or not, and I was more passive. When I was asked, wouldn't you like to leave?, I said, you think I should leave?, then I'll leave. No more than that. There was more silence then than talk.

If it had been dealt with differently, if they'd said: we don't understand how you acted in this or that case, explain it, it would have turned out differently.

I already told you, brother, discretion isn't always understood. Too bad, perhaps. It's better I have the career I have now, I believe, but when I left Goupil there were motives other than clothes, on my side at any rate.

There was a half or whole plan then for me to get a position in paintings at the new branch in London, which in the first place I didn't consider myself suitable for, and in the second had no interest in. I would have liked to stay with the firm if I'd been given a position that consisted less exclusively of talking to the customers.

In short, if I'd been asked then, do you enjoy the business?, my answer would have been, yes, certainly. Would you like to stay? Yes, if you consider me worth what I earn and don't consider me a hindrance or harmful. Then I would have asked for a position at the printer's perhaps, or for the one in London—but slightly *altered*—and would have got it, I believe.

They didn't ask me anything, though, just told me, 'You are an honest and hard-working employee but you set a bad example to the others', and I said nothing to refute that because I didn't want to influence whether or not I would stay.

I could have said a great deal to refute that, though, if I had wanted, and indeed things that I believe would have ensured that I could stay. I say this because I don't understand how you couldn't know that it was a question not of dress but of very different matters.

Well—to you—I say what I don't doubt is right to say now, given that my profession is my profession and I don't doubt that I should stay in it.

So I say this to you: not only do I wish to keep things between us as they are, but I'm really so grateful for our relationship that I only enquire about poorer or richer, more or less difficult, taking nothing for granted, that I'm content with all conditions and will fit in, adapt, make do if need be.

But I desire only that you shouldn't doubt me with respect to good will, application —and grant me a little common sense so that you don't suspect me of doing silly things, and so quietly let me carry on working in my normal way.

Of course I must seek in order to find, and not everything will come off by a long way, but in the end the work will be good.

Patience until it's good, not letting go until it's good, not doubting, is what I would like you and I to have together and to hold on to. If we hold onto that, I don't know *to what extent* we'll benefit financially, but I do believe that—*on condition of collaboration and solidarity, however*—we'll be able to persevere for our whole lives, sometimes selling nothing and finding life hard, then at times selling and having it easier.

That's sufficiently brief and to the point. Persevering depends on our will to stay together. As long as that will exists, it is possible.

Now I mention Risler aîné again (I believe you know the book, if not read it sometime, and what I mean will be clear to you) and point out to you how that man's appearance was more or less like mine, how his life was working in the attic of the factory on his designs and machines, how he had no time for or interest in anything else for that matter, and his greatest luxury for himself was to drink a glass of beer with an old acquaintance.

The story in the book is one that's of no importance here, other things in the book aren't relevant. I draw your attention to the character, the way of life of Risler âiné in itself, *without any thought of anything else in the story*. Really only to explain to you that I

think very little about my clothes because of my way of working — of doing business, if you like — is working personally, NOT approaching people.

A few friends I'll have later will, believe me, take me as I am. I think you'll understand this letter, and understand that it isn't a case of me getting angry when something is said to me about clothes. No, inside I'm becoming ever more calm and concentrated, and something very different would be needed to make me angry. Wherever I went, I would be roughly the same — perhaps really making a bad impression everywhere in the beginning. But I doubt whether that would remain for ever with the people I talked to about it face to face.

Well, from this moment on I'm again completely absorbed in the work. Do for me what can be done, think yourself about what could be useful or help us to get somewhere more quickly. I don't doubt your good will or friendship. Regards, enjoy your days, and write soon.

Adieu.

Vincent

381 | The Hague, on or about Wednesday, 5 September 1883 | *To Theo van Gogh* (D)

My dear Theo,

I received your letter just now when I came home from the dunes behind Loosduinen, soaking wet because I had spent 3 hours in the rain at a spot where everything was *Ruisdael, Daubigny* or *Jules Dupré*. I came back with a study of crooked, windswept trees, and a second of a farm after the rain. Everything is already bronze, everything is what one can see in nature only at this time of year, or if one stands before one of those paintings like a Dupré, for instance, and so beautiful that one's imagination always falls short of it.

You write about your walk to Ville-d'Avray that Sunday, at the same time on that same day I was also walking alone, and I want to tell you something about that walk, since then our thoughts probably crossed again in some degree.

I spoke to the woman as I wrote to you — we felt that staying together in the future was ruled out, indeed that we'd make each other unhappy, but we felt on both sides how strongly we were attached to each other. And then I went out of doors, a long way away, to talk to nature for a while.

Well, I came to Voorburg, and went from there to Leidschendam.

You know the landscape there, superb trees full of majesty and serenity beside green, dreadful, toy-box summer-houses, and every absurdity the lumbering imagination of Hollanders with private incomes can come up with in the way of flower-beds, arbours, verandas. Most of the houses very ugly, but some old and elegant. Well, at that moment, high above the meadows as endless as the desert, came one driven mass of cloud after the other, and the wind first struck the row of country houses with their trees on the opposite side of the waterway, where the black cinder road runs. Those trees, they were superb, there was a drama in each *figure* I'm tempted to say, but I mean in each tree.

Then, the whole was almost finer than those windblown trees seen on their own, because the moment was such that even those absurd summer houses took on a singular character, rain-soaked and dishevelled. In it I saw an image of how even a person of absurd forms and conventions, or another full of eccentricity and caprice, can become a dramatic figure of special character if he's gripped by true sorrow, moved by a calamity. It made me think for a moment of society today, how as it founders it now often appears like a large, sombre silhouette viewed against the light of reform. Yes, for me the drama of a storm in nature, the drama of sorrow in life, is the best. A 'paradou' is beautiful, but Gethsemane is more beautiful still.

Oh, there must be a little bit of air, a little bit of happiness, but chiefly to let the form be felt, to make the lines of the silhouette speak. But let the whole be sombre.

I must say that the woman is bearing up well. She feels sorrow and I do too, but she isn't despondent and is making an effort.

I bought a piece of cloth recently to make some study linen for myself, and now I've given it to her for vests for those scrawny children. And I'm having clothes of mine altered for them so that they'll get one or two things, and she's busy with that.

When I say we are separating as *friends*, that is true — but we are definitely separated, and I've since been more at peace with that than I expected, because what was wrong with her was of such a nature that it would have been fatal both for me and for her if we'd been bound to each other, given that one is responsible, so to speak, for each other's failings. But I'm still left with the worry — how will she be in a year's time? I'll certainly *not* take her into my house again, but I didn't want to lose touch with her, because I love her and the children too much.

That is also possible, precisely because it was and still is something different from a passion.

I hope the Drenthe plan goes ahead.

You ask what I might need.

I don't need to tell you that I intend to do a lot of work, I must do that to revitalize myself. And over there they have *nothing* in the way of painting equipment, so as regards taking a supply, taking things that are really useful, definitely the more the better.

Good tools are never a waste, and they pay for themselves even if they are expensive. And to get ahead one must do a great deal of painting. I hope to lose very little of the time that I'll spend there, and to have a lot of models too, which will probably be cheap enough there. But life is cheap there, and I'll be able to do more with the 150 francs than here.

But in fact I can arrange all that as it suits me. I would think it desirable to be able to make one big purchase, because I lack many things that others have and that are actually indispensable.

My plan is to get a long way with painting in Drenthe so that I'll be eligible for the Drawing Society when I come back. That, in turn, is linked to a second plan, to go to England.

I believe that it's permissible to speculate provided one doesn't do it in the air or on foundations that are all too shaky. As far as England is concerned, I certainly expect to sell something more easily there than here — that's true — so I think of England from time to time. But I don't know how the point that I've reached stands in relation to

the English art lovers, and because I don't know that I would first like to have a small, positive beginning of sales here before I think it advisable to take steps over there. *If* I begin to sell a few things here, *then* I shan't hesitate for a moment but start sending things over there or go there. Yet as long as I sell absolutely nothing here, I would very likely be mistaken as to the timing if I didn't have the wisdom to wait until I see just a beginning here.

I hope you find this idea reasonable, that would reassure me. For in England people are very serious once they begin; whoever finds favour in England finds *loyal* friends there. I need only mention E. Frère and Henriette Browne, for example, who are now just as well liked as on the first day their work was seen there. But if one wants to succeed over there, one must take a little care and be certain that one can be productive in what one sends over there.

Your letter pleased me greatly, for I see that you think that there's something in the Drenthe plan, and that's enough for me; later on it will become clear of itself what benefit there is to be gained. But for me it's already linked directly to becoming a member of the Drawing Society and also to England — because I know for sure that the subjects from over there will be sympathetically received in England if I'm able to put some sentiment into them.

In short, press on with Drenthe, whether we can spend a great deal or a little for the time being.

I'll go there when I have the money to travel, even though I have few painting materials left, because the time of autumnal effects has already begun, and I hope to capture some of them. Yet I hope I'll be able to give the woman a little more for the early days. But if I *can* leave *I shall.*

I say to *you* that for the time being I plan to help the woman a little, I *may* not and indeed *cannot* make it very much. I'm telling *no one* else but you about this. And what I say to you — that whatever happens to her I cannot and shall not have her in my house again — you can rely on that, for it's not in her to do what she should do. I also sent a few words to Pa to say that I was separated from her, but that my letter to Pa about staying with her and getting married remained a fact all the same, and that Pa had talked around that and given no answer to the real question, a second fact. I don't know how it will appear in years to come, or whether that wouldn't have been better than separating; now we're too close to everything to see things in their true context and the consequences. I *hope* that it will all turn out for the best, but her future and my own look sombre to me. I do believe that something will still awaken in her, but that's precisely the point — it *ought to have been* awakened already, and now it will be difficult for her to follow her better thoughts when she has no one to support her in that. Now she wouldn't listen, then she will yearn to speak to me and it won't be possible. As long as she was with me, she had no contrasting example, and now in other surroundings she'll remember things that she didn't care about and paid no attention to at the time. *Now,* because of the contrast, she'll think about that sometimes. For me it's sometimes thoroughly distressing that we both feel the impossibility of struggling through the future together, and yet that we're so attached. She has been more confiding than normal of late, and the mother had incited her to play some tricks which she didn't want to inflict on me. Things of the kind we talked about when you were here, such as starting a row and the like.

You see, there's something in her like the beginning of something more solid, and may that remain so. I wish she could marry, and when I tell you that I'll keep an eye on her it's because I advised her to do *that*. If only she can find a man who is half good, that's enough, then the beginnings of what has come into her here will develop further, that is, a more domestic, simple disposition, and if she sticks to that I won't have to leave her entirely to her fate in the future either, for then at least I'll remain her friend, and sincerely so.

Write to me again soon, and regards.

Ever yours,
Vincent

I'm adding a few words here. You ask what I need. I thought about that and it's impossible for me to say what I really regard as *necessary*, for that would be no small amount, so let's see what's within our reach and make do with that. What's within our reach will probably remain *below* what's fundamentally needed, but in life it's already something if one can carry out one's plans in part. And I for one say to you that I'll make do with what you can spare.

Life is cheaper over there, and I'll be able to make savings automatically compared to here. And when a year has passed I'll have made substantial progress through those savings alone. I can have paint &c. sent by *parcel post* when I'm over there. So I'll take a supply *if I can*, that goes without saying, but if *I can't* I shan't postpone the journey because of that.

I have hopes that the past year will turn out to have been solid, for I haven't neglected my work and, on the contrary, I've strengthened a number of weak points. There are more that need strengthening, of course, but it's their turn now.

As for what I wrote to you in a previous letter, that the woman had immediately broken certain promises, that was bad enough, namely an attempt to be a maid in a whorehouse, an opportunity the mother had fished out and urged on her. The woman herself immediately regretted it and has rejected it, but all the same it's very, very weak of her, and especially to do it *at that particular time*, but that's what she's like—up to now at least—so far she hasn't had the strength to refuse such a thing with an absolute *no*. Anyway, she forces me to take measures that I've often previously postponed and postponed.

On this occasion, though, I saw something in her as if it had been a crisis—I hope a 'thus far and no further'. And so it is that she herself views this separation as possibly turning out for the best in the end.

And because there's an all too fatal rapport between her and her mother, those two must go together down the wrong or the right road.

And it will come down to living with the mother and going out to work together by turns, and trying to get by in an honest way. That's their plan, and they already have some workdays, and I've placed advertisements, and they look every day and are beginning to enjoy it.

I'll keep on doing that and carry on with advertisements as long as necessary, and in short all the things whereby I can be of use or assistance.

And if I can I'll pay several weeks' rent for them when I go, as well as a loaf a day or some such to give them yet more time to set their plan up properly and add to it. But

the fact that I intend to give them that is something I haven't yet *promised them*, because I don't know myself if I'll be able to do it. I'll act according to circumstances.

And I firmly recommend to her a marriage of convenience with a widower or someone, to which I add that she'll have to be *better* for such a person *than she was for me*.

And that she herself knows well enough in what ways she fell short with me, that now she must be *wise* and *learn from that* that *I don't blame her in the least, because I know that an improvement or reform doesn't succeed all at once but has steps, so to speak*, and so, provided she stays at the point where she is now and works her way up, starting from there, without allowing herself any relapse, she needn't take her mistakes with me to heart or become despondent, just try to make amends by being better for someone else.

And she herself well understands these things for the present, and I hope to keep them alive. Becoming despondent and then letting oneself go is, however, a weakness they share, yet at the same time they're also patient when it comes to starting afresh, the woman in particular is showing that more, and I, although her faults are many and troublesome enough, yet I know that fundamentally there's something good that extenuates *everything*, and for that reason, too, I don't despair of her future. That MISERICORDE MUST *lie in nature itself* for such a person is something I wish I could fully believe, and I find it wicked of myself that I'm not fully persuaded of it, in so far as I'm not yet able to resign myself to everything, however, and can't, for the time being at least, give up *everything* that I've struggled so hard to put right.

Write to me again soon, won't you?

383 | The Hague, Friday, 7 or Saturday, 8 September 1883 | *To Theo van Gogh* (D)

My dear Theo,

I've got so far with packing &c. that I'll leave as soon as I have the travel money. It's best in the circumstances that I set to work straightaway. For during the removals &c. one can't do anything good in the way of work, and I shan't get back into my stride until I'm somewhere in the country. So I hope to be able to get away if you send something towards the 10th, if I can't go straight through I'll stay in a village close by for a day or two if need be.

I hope things will turn out as you think possible, indeed as I do too, more or less, that it will make the woman change direction for the better. Yet I fear that won't happen and she'll go down the old road.

If I judge by my intimate knowledge of her, she's too weak in spirit and willpower in particular to continue on a proper course.

When I talked about it during your visit I was *determined to decide*, but in my view there were two roads, and the decision as to *how* depended more on her than on me. If she had definitely wanted to carry on with me, so that it was something more than words and a turning away from those faults that had made the situation impossible, I believe that it would have been a better lot for her than that awaiting her now, however difficult and poor things might have been for us. But I saw in her something like a *sphinx* that cannot say either yes or no. And if you were to ask me if I knew what she's going to do, all I know is this, 'certainly not as straight as she could have done'.

In recent days I again saw clearly how looking at the advertisements was done merely for the sake of appearances, and that they're probably waiting for my departure before embarking on something they don't discuss with me.

All the more reason for me to leave immediately, for otherwise they'd resort to delaying things deliberately. And the mother again has a hand in this.

This plan, which is again a twisting of what they began a few days ago, will almost certainly lead to nothing but wretchedness.

But I would have to be mad to help when they're not being open with me, wouldn't I? So I intend simply to leave and to let fourteen days or so go by. Then I'll write to them and see how things are.

I'm also beginning to think that I *must* leave in order to make them be serious. But such a test is dangerous, for even in a short time they can spoil a great deal.

Why, why is the woman so unwise? She's what Musset has called 'A child of the age' through and through — and I sometimes think of the ruin of Musset himself when I consider her future.

There was something elevated in Musset; well, in her there's also a *je ne sais quoi*, although she's certainly not an artist. *If only she were*, a little. She has her children, and there'll be something solid in her if they become her *idée fixe* even more than they are now, but that too isn't what it should be, even though her mother love, although imperfect, is still the best thing in her character, in my view.

It's a difficult thing for me that I assume that, once I am gone, she'll regret a few things and want to be better and will need me. I'm ready to help in that case, but I'll get into her head *what* you told me about the woman you met, you found me when I had sunk very low, *I must climb up again*. Instead of *I must climb up again*, she will say *the abyss draws me*.

I once heard that there was a relationship between Musset and George Sand. George was composed, positive, highly industrious. Musset was nonchalant, indifferent, and even neglected his work.

Things came to a head and a separation between these two characters. Later a desperate attempt by Musset and remorse, but not before he had sunk still deeper into the mire, and in the meantime George Sand had got her affairs in order and was completely absorbed in a new work, and said 'it's too late, it's *impossible now*'.

But these are so much questions of inner conflict, and hearts shrink more in pain because of them than appears.

Theo, when I leave I shan't leave feeling easy about her — on the contrary, uneasy — because I fear so much that she won't wake up until it's too late, not have a keen desire for something simpler and purer until the moment for attaining it has passed.

When I see that sphinx-like quality in her, I recognize it of old both in her and in others, and it's a very bad sign. Then staring melancholically into the abyss is fatal too, and the way to make that go away is hard work. And now — Theo — she's again too passively resigned to things — well, melancholy, if it can be overcome, must be overcome by toil, and whoever doesn't feel that is lost for ever and will go straight to the dogs. I've told her this, even got a little of it into her at times.

You see, she's on the edge, isn't she?

It shan't be my hand that pushes her in, but nor *can* I stand beside her forever,

holding her back. A person must have enough common sense to cooperate when he is warned and helped.

I know, there are cases where the melancholic appears to be unwilling, but later quietly does what he must and recovers. If she's like that, then that's fine and she'll be all right.

The melancholic is helped by nothing more — in the period of recovery — than by a friend. That's a great deal then, even if the friend is poor. Well, she'll continue to find that in me — even if *now* it's true that she has been and is at times extremely nasty — of course *nonetheless*.

She'll need a support, and I'll still be that support even though I am gone, provided I see a little energy and good will. The people who tried to turn *her* away from *me* (in her family) did something that would be as bad as murdering her and her children if it weren't that they did it in their obduracy and stupidity. For without that she'd be much further along.

Do your best towards the tenth to send me enough for me to be able to leave if need be, because this would be wise.

All the same, don't put yourself in difficulties for I'll act according to the circumstances and write to you straightaway to say what I've done.

If it's too little for Drenthe I'll go to Loosduinen for a day or so and wait there. I've found splendid things in Loosduinen, old farmhouses, and the effects in the evening are superb there. In that case I would probably send my things ahead or put them in storage.

But it's also just the moment at which I can conveniently end the tenancy, and when your letter comes I'll leave here.

That will be a sign for the woman that she must persevere. I'll place more advertisements, but these last two days it was idling about again, and I fear they've changed the plan fundamentally.

Adieu, Theo, I wish things were already sorted out, for days like these are difficult and little good to anyone. I wish you well and good fortune, believe me

Ever yours,
Vincent

I hope you haven't fallen ill, I also had diarrhoea a while ago but it stopped. Eggs may be the best thing for strengthening the stomach, at least if weakness is the cause.

384 | The Hague, Monday, 10 September 1883 | *To Theo van Gogh* (D)

My dear Theo,

I've just received your letter and the 100 francs enclosed. And I leave tomorrow for Hoogeveen in Drenthe. Then on from there, and from there I'll give you an address.

So don't write any more to *here* in any event. And I would suggest you write a word to C.M. right away to inform him of my departure because, as you say yourself, there's the possibility that he might write to me at this address. If he has already done

so, it would be best if he asked at the post office for the letter to be returned for, not knowing exactly what my next address will be, I can only inform the post here or the landlord later on.

Friend Rappard is also travelling, and already has Drenthe behind him and is nearly on Terschelling. He wrote to me from Drenthe 'the country here is very earnest in mood, the figures often made me think of studies by you. As for life here, one could certainly not live more cheaply anywhere else. And I think that the south-east corner (the area I have in mind) is the most original.'

Theo, I certainly have a feeling of melancholy on leaving, much more so than would have been the case had I been convinced that the woman would be energetic and that her good will wasn't in doubt. Anyway, you know the gist from one thing and another. For my part I must press on or I myself will sink without getting her any further by that. Until she becomes more active of her own accord, namely more steadily instead of in short bursts, she'll remain on the same inadequate spot, and even if she had 3 helpers in my place they wouldn't be able to do anything about it unless she herself cooperated. But the children to whom one's heart goes out? I couldn't do everything for them, but if only the woman had been willing!

I shan't go on moaning, though, for I must press on nonetheless.

Well, to be on the safe side I didn't dare to take paint along, for over there I'll soon have to pay for my things when they arrive, then lodgings and more travel expenses. But if we're lucky enough to get something from C.M., I'll have one or two things I've picked out sent there by parcel post. The sooner that can be done the better. So if you hear anything, write to me as soon as you know my address over there, and of course I agree with the proposed arrangement (regarding the partial reimbursement of the 100 francs); indeed, if you're hard up, wait for a favourable moment before sending everything that might come from him.

I, for one, think that C.M. might just do nothing at all.

In any event, brother, it was firm and well advised of you to send this immediately. For now I'll be over there and able to get my bearings, and we can certainly economize ourselves even if no help comes. So thanks for this, and I believe it'll prove to be a good step. My plan is to stay there until you come to Holland next year, for instance. I wouldn't want to miss you then. But in that way I would just see all the seasons go by and have a general view of the character of things in that region.

I've equipped myself with an internal passport, valid for 12 months. With which I have the right to go where I will and to stay in one place for as long or as short as I please.

So I'm very glad that I can make progress, for in this way we help ourselves; over there I reckon 50 francs for board and lodging and the rest on the work, and that's a big difference from what I was able to do here in the circumstances. So even if others won't help, we won't be idle.

Regards, for I still have a lot to arrange today—write a short letter to C.M.—and in the next few days you'll receive a message with my address, by tomorrow evening if all goes well. Adieu, with a handshake.

Ever yours,
Vincent

You wrote to me recently 'perhaps your *duty* will induce you to behave differently or something'. That's something I immediately thought about a great deal, and because my work so undoubtedly demands the step of going there, it's my understanding that work is more directly duty than even the woman, and that the former mustn't suffer for the sake of the latter. Which was different last year, since in my view I'm *now exactly* at the point of Drenthe. But one has divided feelings and would like to do both, which *cannot be* in the circumstances, both because of the money and, more than that, because she can't be counted on.

386 | Hoogeveen, on or about Friday, 14 September 1883 | *To Theo van Gogh* (D)

My dear Theo,

Now that I've been here for a few days and have walked around a good deal in different directions, I can tell you more about the region I've fetched up in.

I enclose a scratch after my first painted study from this part of the world, a hut on the heath. A hut made of nothing but sods of turf and sticks. I've also seen inside about 6 of this type, and more studies of them will follow.

I can't more accurately describe the way the exterior looks in the twilight or just after sunset than by reminding you of a particular painting by Jules Dupré which I think belongs to Mesdag, with two huts in it on which the mossy roofs stand out surprisingly deep in tone against a hazy, dusty evening sky.

That is *here*.

Well, it's very beautiful inside these huts, dark as a cave. Drawings by certain English artists who have worked on the moors in Ireland most realistically convey what I observe. A. Neuhuys does the same with somewhat more poetry than strikes one at first, but he makes nothing that isn't also fundamentally true.

I saw superb figures out in the country — striking in their expression of soberness. A woman's breast, for example, has that heaving motion that is the exact opposite of voluptuousness, and sometimes, if the creature is old or sickly, arouses compassion or else respect. And the melancholy which things in general have is of a healthy kind, as in Millet's drawings.

Happily, the men here wear breeches; it shows off the shape of the leg, makes the movements more expressive.

To mention one of the many things that gave me something new to see and to feel during my explorations, I'll tell you how here one sees, for example, barges pulled by men, women, children, white or black horses, loaded with peat, *in the middle of the heath*, just like the ones in Holland, on the Trekweg at Rijswijk, for instance.

The heathland is rich. I saw sheepfolds and shepherds that were more attractive than those in Brabant.

The ovens are more or less like the ones in T. Rousseau's Communal oven; stand in the gardens under old apple trees or among the celery and cabbages.

Beehives, too, in many places.

One can see that many of the people have something wrong with them — it isn't exactly healthy here, I think — perhaps because of unclean drinking water. I've seen some girls of, I would say, 17 or younger who still had something very beautiful and youthful, in their features too, but generally it *fades* very early. Yet this doesn't detract from the fine, noble bearing of the figure that some of them have, who prove to be very withered when seen close to.

There are 4 or 5 canals in the village, to Meppel, to Dedemsvaart, to Coevorden, to Hollandscheveld.

If you follow them, you see here and there a curious old mill, farmhouse, shipyard or lock. And always the peat barges coming and going.

To give you an example of the authentic character of this region: while I was sitting painting that hut, two sheep and a goat came up and started grazing *on the roof* of the house. The goat climbed onto the ridge and looked down the chimney.

The woman, who heard something on the roof, shot outside and threw her broom at the said goat, which leapt down like a chamois.

The two hamlets on the heath where I've been and where this incident took place are called *Stuifzand* and *Zwartschaap*. I've also been in various other places, and now you can imagine how unchanged it still is here, since Hoogeveen is a town after all, and yet nearby there are shepherds, those ovens, those turf huts &c.

I sometimes think with great melancholy about the woman and the children, if only they were looked after — oh, it's the woman's own fault, one could say, and it would be true, but I fear that her misfortune will be greater than her guilt. I knew from the outset that her character is a ruined character, but I had hopes of her finding her feet and now, precisely when I don't see her any more and think about the things I saw in her, I increasingly come to realize that she was already too far gone to find her feet.

And that just makes my feelings of pity even greater, and it's a melancholy feeling because it isn't in my power to do anything about it. Theo, when I see some poor woman on the heath with a child in her arms or at her breast my eyes become moist. I see her in them; her weakness and slovenliness, too, only serve to intensify the likeness. *I know that she isn't good*, that I have every right to do what I'm doing, that to stay with her there WASN'T POSSIBLE, that bringing her with me really *wasn't possible* either, that what I did was even sensible, wise, what you will, but that doesn't alter the fact that it goes right through me when I see some poor little creature, feverish and miserable, and that then my heart melts. How much sadness there is in life. Well, one may not become melancholy, one must look elsewhere, and to work is the right thing, only there are moments when one only finds peace in the realization: misfortune won't spare me either. Adieu, write soon, and believe me

Ever yours,
Vincent

390 | Hoogeveen, on or about Wednesday, 26 September 1883 | *To Theo van Gogh* (D)

Dear brother,

Because I have a need to speak frankly, I can't hide from you that I'm overcome by a feeling of great anxiety, dejection, a *je ne sais quoi* of discouragement and even despair, too much to express. And that if I can find no consolation for it, it might all too easily overwhelm me unbearably.

It really bothers me that I have so little success with people in general, I'm very concerned about this, and all the more so because rising above it and getting on with the work is at stake here. The fate of the woman, moreover, the fate of my sweet, poor little lad and the other child, cut me to the quick. I'd still like to help and I can't.

I'm at a point where I need credit, trust and some warmth, and you see there's no trust in me. You're an exception to this, but precisely because everything falls on you it makes it even more apparent how dismal everything is in my case.

And if I look at my things, they're too poor, too inadequate, too much exhausted. We're having gloomy, rainy days here, and when I come into the corner of the attic where I've installed myself it's all remarkably melancholy there — with the light from one single glass roof tile that falls on an empty painting box, on a bundle of brushes with few decent bristles remaining, well it's *so* curiously melancholy that luckily it also has a funny enough side not to weep over it but to regard it more cheerfully. But even so, it's in a very strange relationship to my plans — in a very strange relationship to the seriousness of the work, and — this is where the laughing stops.

What else can I do? — last year ended with an even bigger deficit than I told you, for I've already paid off more than I mentioned to you, *including Rappard*, and still however owe Rappard above all, and that worries me the most because he's a friend, and although at this moment I've paid off everything that was in the slightest bit urgent I'm faced with the problem that I still have to pay for other things before the paint that I would otherwise buy, or rather I don't dare take it on credit, which would again cause me a considerable bill in time. You know yourself how we weren't exactly in the mood to be able to say more during your visit, but I tell you now that The Hague has been too much for me, and I had already put off and put off the separation for one particular specific reason, even though the deficit was inevitable if I persisted.

This was that, rather than separating, I would have risked one more attempt by marrying her and going to live with her in the country, although not without telling you how things stood. But I believed one thing, that this was the right course, even despite the temporary financial drawbacks, and that not only could it have been her salvation but would also have put an end to great inner struggle for me, which has now, unhappily, doubled for me. And I would rather have seen it through to the bitter end.

If either Pa or you had been able to feel it thus, perhaps — I don't say that I would have been happier or unhappier as a result, and if the roles had been reversed, you in my place, I in yours, I don't know whether I would have been able to act other than as you did — but perhaps, I say, *she* would have been saved because of it. I therefore regard it as something where the decision depended not on you two, but on myself (except that I can't give myself my father's consent to marry, this single point is beyond me, and in response to a determined question Pa answered me in generalities in which, however, there was no hint of consent), and so I decided, because I already had debts and the future was dark. But this decision is not yet a renewal, and doesn't take away the exhaustion that a year of too many cares brings in its train, while I'm also left with a wounded heart and a feeling of emptiness and disappointment and melancholy — not so easy to cure. I may be here now, and may almost have covered the financial deficit, and in a while it could be entirely covered, and nature is wonderful here and exceeds my expectations. Yet I'm far from being comfortably settled again and getting on, because the little glimpse of my attic I'm giving you is drawn from life.

If I'd known all these things in advance, I would have moved here with the woman last year when she came out of hospital, then there would have been no deficit and then we wouldn't be separated now, for she's less guilty of her wrongdoing than her

family, who have intrigued very meanly, ostensibly *for* her but fundamentally against her. Meanwhile, I've sometimes wondered, for instance, whether the mother wasn't also being backed in turn by a priest, because too much has been done on their part to influence the woman for me to explain. All the more so because I've still heard nothing from her, although before I left I told her that I would give the carpenter next door my address as soon as I knew it myself; I sent it to him and asked him to tell her, and I've still heard nothing, except just from this carpenter that she's collected all her things (more than she brought with her, after all).

Now you understand that I'm concerned about her fate, although I believe that if she were *simply* in need she'd have written, but now there must be something wrong behind it. You will understand my *feeling* about it, I rather fear that the family is saying to her: he'll surely write and then . . . we'll have him under our thumb—in short they're presuming on my weakness and I am *not* going to walk into that trap. And to-day I'm writing not to her but to the carpenter to tell him that he must make sure she knows my address, but I will *not* write to her first, and *if* she writes will see how things actually stand. When I would definitely try to help is if her family were to cast her off entirely, and if it's the case that her family is helping her, I understand well enough that she's too much in agreement with them, and has been for a long time, so that I may not or cannot have anything more to do with it. *Or*, I've thought, *if* there's a priest behind it, she's being helped but only on condition that she has nothing more to do with me, and that's the reason for her silence.

But I'll say that I haven't yet got *so* far that I can resign myself to the idea of separation, at present I'm still very, very concerned about her fate, precisely because she's leaving me in the dark about it.

And over and above all this, I've been overwhelmed these past few days by sombre feelings about the future, and also about the miserable state of my equipment as far as painting materials are concerned, the impossibility of doing the most essential, most useful things as they really should be done.

Since I can already see straightaway that there's so much beauty here, if I could afford it I would send for my things that are still there in The Hague, and I would either fit up this same attic here as a studio (by letting a bit more light in) or look for another place. And then I'd like to renew and replenish all my equipment. I wish that for once I could do this really thoroughly, and if I could find someone who would trust me that far, my greatest concerns would be allayed. But either everything falls on you or I find no one who trusts me, this is the circle in which my thoughts revolve, and I see no way out.

A painter who has no means of his own can't get by without sometimes rather large credit with people, credit that not only the profession of painter requires, but that the professions of cobbler, carpenter, smith would equally require, I believe no more nor less, if they had to set themselves up or re-establish themselves somewhere.

It's above all in this rainy weather, of which we have months ahead of us, that my hands are really tied. And then, what else can I do?—sometimes my thoughts take on a form—I've worked and economized and still not been able to avoid debt, I've been faithful to the woman and yet lapsed into disloyalty, I've abhorred intrigues and yet I have virtually no credit or possessions. I don't regard your trust in me lightly, on the contrary, but I rather wonder whether I shouldn't say to you, forget about me for we

won't get there — it's too much for one, and there's no chance of getting any relief from another quarter — is this not proof enough that we should give up?

Oh, old chap, I've become so melancholy — I'm in magnificent countryside, I have a desire, indeed an absolute need to work — at the same time I'm absolutely at a loss as to how we're going to get on top of it, when I think that my things are in the most miserable state and I'm here without a studio or anything, and will be embarrassed everywhere until I can improve matters. The models — they refuse to pose if there are bystanders around, and this is the greatest difficulty that makes a studio desirable. I have the same feeling now as I did when I set up the studio in The Hague — 'if I don't do it, I'll certainly not be able to manage'. And even now, given The Hague, I don't regret that I did as I did in those circumstances, only I wish I had come here 1½ years earlier and set up a studio here instead of there.

Pa wrote to me saying that he wanted to help me, but I didn't let him know any-thing about my worries, and I hope that you won't say anything to Pa on this subject either. Pa has his own worries, and would only have even more worries were he to find out that things aren't going well. So I merely wrote to Pa that everything turned out much better than I expected, which is also perfectly true as far as nature is concerned. As long as the weather was good I wasn't aware of things because I saw so much that was beautiful, but now that it's been pouring with rain incessantly for several days I increasingly see how I'm actually stuck here, and I'm embarrassed. What's to be done? Will things worsen or improve with time? I don't know, but I feel really miserable and can't shake it off.

In every life some rain *must* fall
And days be dark and dreary

that is true, it cannot be otherwise, yet I wonder if the number of dark and dreary days can't sometimes get too great? Nevertheless, I've had a model again in the barn, but in very trying light. After all, I don't refuse to do what can be done, but *can I do what* MUST *be done in the circumstances?* And this letter is a sigh for space, and if the winter has to be like these days, I would be in a bad way. It's beautiful, though, indeed extremely beautiful in the rain, but how does one work, how when one lacks too much? Adieu, old chap, I wish everything would turn out all right, but we need more trust from other people, otherwise I fear it won't work. I hope to hear from you soon. *Did you receive studies?*

With a handshake.

Ever yours,
Vincent

My dear Theo,

This time I'm writing to you from the very back of beyond in Drenthe, where I arrived after an endless trip through the heath on the barge.

I see no way of describing the countryside to you as it should be done, because words fail me. But imagine the banks of the canal as miles and miles of Michels or T. Rousseaus, say, Van Goyens or P. de Koninck.

Flat planes or strips differing in colour, which grow narrower and narrower as they approach the horizon. Accentuated here and there by a sod hut or small farm or a few scrawny birches, poplars, oaks. Stacks of peat everywhere, and always barges sailing past with peat or bulrushes from the marshes. Here and there thin cows of a delicate colour, often sheep — pigs. The figures that now and then appear on the plain usually have great character, sometimes they're really charming. I drew, among others, a woman in the barge with crepe around her cap brooches because she was in mourning, and later a mother with a small child — this one had a purple scarf around her head.

There are a lot of Ostade types among them, physiognomies that remind one of pigs or crows, but every so often there's a little figure that's like a lily among the thorns. In short, I'm very pleased about this trip, for I'm full of what I've seen. The heath was extraordinarily beautiful this evening. There's a Daubigny in one of the Albums Boetzel that expresses that effect precisely. The sky was an inexpressibly delicate lilac white — not fleecy clouds, because they were more joined together and covered the whole sky, but tufts in tints more or less of lilac — grey — white — a single small rent through which the blue gleamed. Then on the horizon a sparkling red streak — beneath it the surprisingly dark expanse of brown heath, and a multitude of low roofs of small huts standing out against the glowing red streak.

In the evening this heath often has effects that the English would describe as *weird* and *quaint*. The spiky silhouettes of Don Quixote-like mills or strange hulks of drawbridges are profiled against the teeming evening sky. In the evening a village like that is sometimes really snug, with the light from the little windows reflected in the water or in mud and puddles.

Before I left Hoogeveen I painted a few more studies there, among them a large farmhouse with a mossy roof. For I'd had paint sent from Furnée's, because I thought the same about it as you say in your letter, that by making sure I become absorbed in the work and lose myself in it so to speak, my mood would change, and indeed it's already a good deal better.

But at times — like those moments when you think about going to America — I think about going to the East as a volunteer. But they're those wretched, sombre moments when things overwhelm one, and I would wish that you might see the silent heath that I see through the window here, because such a thing soothes one and inspires more faith, resignation, calm work.

I drew several studies in the barge, but I'm staying here to paint. I'm close to *Zweeloo* here, where *Liebermann*, among others, has been, and besides there's an area here where

there are large, very old sod huts where there isn't even a partition between the barn and the living room. My plan for these first days is to visit that region.

But what tranquillity, what breadth, what calm there is in nature here, one doesn't feel it until one has miles and miles of *Michels* between oneself and the everyday.

I can't give you a definite address at the moment because I don't know exactly where I'll be for the next few days, but *I'll be in* HOOGEVEEN *on 12 October,* and if you send your letter at the usual time *to the same address* I'll find it there in Hoogeveen on the twelfth. The place where I am now is Nieuw-Amsterdam.

I received a postal order for 10 guilders from Pa, which with what I got from you means that I can now do some painting. I'm thinking of returning to this inn where I am now for a long stay if I can reach the area with the large old sod huts easily from here, since I would have better light and space here. For as to that painting by that Englishman with the thin cat and the little coffin, although the idea first came to him in that dark room, he would have found it very difficult to paint in that same place, at least one usually works too light if one sits in a room that's too dark, so that when one brings it into the light one sees that all the shadows are too weak. I experienced this only recently, when I painted an open door and the view through into the little garden from inside the barn.

Well, I just wanted to tell you that I'll also be able to overcome this drawback, because I could get a room here with good light and where a stove can stand in the winter. Now, old chap, if you think no more about America, and I no more about Harderwijk, then I hope things will work themselves out. I admit that your explanation of C.M.'s silence might be the case, but sometimes nonchalance can also be deliberate.

You'll find a few croquis on the back. I write in haste, or rather it's already late.

How I wish that we could walk together here and — paint together. I believe that the countryside would win you over and convince you. Adieu, I hope that you're well and will have a bit of good fortune. I thought about you again and again on this trip. With a handshake.

Ever yours,
Vincent

[*Sketches* 392A–F]

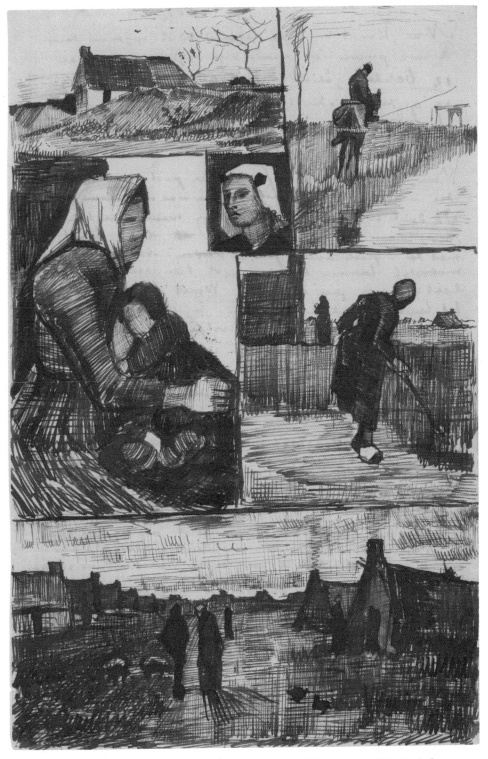

392A–F (left to right, top to bottom). *Farm; Rider by a waterway; Woman and child; Head of a woman; Woman working; Country road with cottages*

Dear brother,

I just received your letter. I read and re-read it with interest, and something that I've already thought about sometimes, without knowing what to do about it, is becoming clear to me. It's that you and I have in common a time of quietly drawing impossible windmills &c., where the drawings are in a singular rapport with the storm of thoughts and aspirations — in vain, because no one who can shed light is concerned about them (only a painter would then be able to help one along the right path, and their thoughts are elsewhere). This is a great inner struggle, and it ends in discouragement or in throwing those thoughts overboard as impractical, and precisely when one is 20 or so, one is passionate to do that. Whatever the truth of the matter that I said something then that unwittingly contributed to throwing those things overboard; at that moment my thoughts were perhaps the same as yours, that's to say that I saw it as something impossible, but as regards that desperate struggle without seeing any light, I know it too, how awful it is. With all one's energy one can do nothing and thinks oneself mad, and I don't know what else. When I was in London, how often I would stand on the Thames Embankment and draw as I made my way home from Southampton Street in the evening, and it looked terrible. If only there had been someone then who had told me what perspective was, how much misery I would have been spared, how much further along I would be now. Well, *fait accompli* is *fait accompli*. It didn't happen then — I did talk to Thijs Maris occasionally (I didn't dare speak to Boughton, because I felt such great respect in his presence) but I didn't find it there either, that helping me with the *first* things, with the ABC.

Let me now repeat that I believe in you as an artist, and that you can still become one, indeed that you should very soon think calmly about whether you are one or not, whether you would be able to produce something or not if you learned to spell the aforementioned ABC, and then also spent some time walking through the wheatfield and the heath, in order to renew once more what you yourself say, 'I used to be part of that nature, now I don't feel that any more'. Let me tell you, brother, that I myself have felt so deeply, deeply *that* which you say there. That I've had a time of nervous, barren stress when I had days when I couldn't find the most beautiful countryside beautiful, precisely because I didn't feel myself part of it. That's what pavements and the office — and care — and nerves — do.

Don't take it amiss if I say now that your soul is sick at this moment — it really is — it isn't good that you aren't part of nature — and I think that No. 1 now is for you to make that normal again. I think it's very good that you yourself feel the difference between your state of mind now and in other years. And don't doubt that you will agree with me that you must work on it to put it right.

I now have to look back into my own past to see what the matter was, spending years in that stony, barren state of mind and trying to emerge from it, and yet it got worse and worse instead of better.

Not only did I feel indifferent instead of responsive to nature but also, which was much worse, I felt exactly the same about people.

People said that I was going mad; I myself felt that I wasn't, if only because I felt

my own malady very deep inside myself and tried to get over it again. I made all sorts of forlorn attempts that led to nothing, so be it, but because of that *idée fixe* of getting back to a normal position I never confused my own desperate doings, scrambling and squirmings with I myself. At least I always felt 'let me just do something, be somewhere, it *must* get better, I'll get over it, let me have the patience to recover'.

I don't believe that someone like Boks, for instance, who really turned out to be mad, thought like that—so I say again, I've thought about it a lot since, about my years of all sorts of scrambling, and I don't see that, given my circumstances, I *could* be other than I have been.

Here is the ground that sank beneath my feet—here is the ground which, if it sinks, must make a person miserable, whoever he may be. I was with G&Cie for 6 years—I had put down roots in G&Cie and I thought that, although I left, I could look back on 6 years of good work, and that if I presented myself somewhere I could refer to my past with equanimity.

But by no means; things are done so hurriedly that little consideration is given, little is questioned or reasoned. People act on the most random, most superficial impressions. And once one is out of G&Cie no one knows who G&Cie is. It's a name like X&Co., without meaning—and so one is simply 'a person without a situation'. All at once—suddenly—fatally—everywhere—there you have it. Of course, precisely because one has a certain respectability one doesn't say I'm so-and-so, I'm this or that. One presents oneself for a new situation serious in all respects, without saying much, with a view to putting one's hand to the plough. Very well, but then, that 'person without a situation', the man from anywhere, gradually becomes suspect.

Suppose that your new employer is a man whose affairs are very mysterious, and suppose that he has just one goal, 'money'. With all your energy, can you really immediately, at once, help him a very great deal in that? Perhaps not, eh? And yet he wants money, money come what may; you want to know something more about the business, and what you see or hear is pretty disgusting.

And soon it's: 'someone without a situation', I don't need you any more. See, now that's what you increasingly become: someone without a situation. Go to England, go to America, it doesn't help at all, you're an uprooted tree everywhere. G&Cie, where your roots are from an early age—G&Cie, although indirectly they cause you this misery because in your youth you regarded them as the finest, the best, the biggest in the world—G&Cie, *were* you to return to them—I didn't do that then—I *couldn't*—my heart was too full, much too full—G&Cie, they'd give you the cold shoulder, say it was no longer their concern or something. With all this one has been uprooted, and the world turns it around and says that you've uprooted yourself. Fact—your place no longer acknowledges you. *I* felt too melancholy to do anything about it—and I don't remember ever having been in the mood to talk to someone about it as I'm talking to you now. Because, and actually to my surprise, for I thought that even if they did it to me they would, however, certainly not have dared to do it to you, I read in your letter the words 'when I spoke to them this week the gentlemen made it almost impossible for me'. Old chap, you know how it is with me, but if you're miserable about one thing and another, *do not feel you are* ALONE. It's *too much* to bear *alone*, and to some extent I can sympathize with you the *way* it is. Now, stand your ground and don't let your pain throw you off balance—if the gentlemen behave like this, stand on your dignity and

don't accept your dismissal except on terms that guarantee you'll get a new situation. They aren't worth your losing your temper, don't do that, even if *they provoke you*. I lost my temper and walked straight out. Now in my position it was different again from yours; I was one of the least, you are one of the first, but what I say about being uprooted, I'm afraid that you would feel the same if you were out of it, so look at *that*, too, cold-bloodedly, stand up to them and don't let them push you out without being a little prepared for that difficult situation of beginning again. And know this — given an uprooting, given not making headway again, don't despair.

Then, in the worst case, do NOT go to America, because it's exactly the same there as in Paris. No, beware of reaching that point where one says: I'll make myself scarce; I had that myself, I hope that you won't have it. *If* you had it, I say again, beware of it, resist it with great coolness, say to yourself, this point proves to me that I'm running into a brick wall. This is a wall for bulls to run into; I am a bull too, but an intelligent one, I am a bull about becoming an artist. Anyway, get out before you smash your head to pieces, that's all. I'm not saying that that's what *will* happen; I hope that there will be no question whatever of running into a wall. But suppose after all that there was a whirlpool with accompanying sharp-edged rocky promontories, well, I would just think that you might avoid it, wouldn't you? Perhaps you'll admit that those rocks might be there, since you yourself pulled me out of that whirlpool when I had no more hope of getting out of it and was powerless to fight against it any more.

I mean, give those waters a very wide berth. They're beginning to drag you down in that one thing — I say no more nor less than I'm sure of — that you aren't part of nature. Do you think it strange of me that I dare to say as much as this: now, at the very beginning, change course *now* and no later than now in so far as you work at restoring the bond between yourself and nature? The more you remain in the frame of mind of not being part of nature, the more you play into the hands of your eternal enemy (and mine too), Nerves. I have more experience than you of the sort of tricks they *could* play on you. You're now beginning to enter waters that are throwing you off balance, inasmuch as the rapport with nature seems to be broken. Take that very coolly as a sign of aberration; say, oh no, not that way if you please. Seek a new passion, an interest in something; think, for example, after all perspective must fundamentally be the simplest of all things and chiaroscuro a simple, not a complicated matter. It must be something that speaks for itself, otherwise I don't much care for it. Try to get back to nature in this way.

Will you now, old chap, simply take it from me when I say that as I write to you I've got something back of what I had years ago. That I'm again taking pleasure in windmills, for example, that particularly here in Drenthe I feel much as I did then, at the time when I first began to see the beauty in art. You'd be prepared to call that a normal mood, wouldn't you? — finding the outdoor things beautiful, being calm enough to draw them, to paint them. And suppose *you* were to come up against a brick wall somewhere, wouldn't you find someone in my present mood composed enough to want to take a little walk with him, precisely in order to have a distraction from thoughts if, through nervousness, these thoughts start to acquire a certain despairing element? You are yourself and not fundamentally changed, but your nerves are beginning to be unstrung by strain. Now, look after your nerves, and don't take them

lightly, because they cause quick-tempered manoeuvres — well, you know a thing or two about that yourself.

Make no mistake, Theo, at this moment Pa, Ma, Wil, Marie, and I above all, are supported by you; it seems to you that you have to go on for our sakes, and believe me I fully understand that, or at least can understand it to a very great extent. Just think about this for a moment. What is your goal and Pa's, Ma's, Wil's, Marie's and mine? What do we all want? We want, acting decently, to keep our heads above water, we all want to arrive at a clear position, not a false position, don't we? This is what we all want, unanimously and sincerely, however much we differ or don't differ among ourselves. What are we all prepared to do against fate? All, all of us without exception to work quietly, calmness. Am I wrong in regarding the general situation in this way? Very well, what are we facing now? We're confronting a calamity which, touching you, touches us all. Fine. A storm is brewing. We see it brewing. That lightning might well strike us. Fine. What do we do now? Do we reach our wit's end? I don't think that we're inclined that way — even if certain nerves that we all have in our bodies, even if certain fibres of the heart, finer than nerves, are shocked or experience pain.

We are today what we were yesterday, even if the lightning strikes or even, perhaps, should it thunder. Are we or are we not the sort who can look at things calmly? That, simply, is the question, and I see no reason why we should *not* be so. What I also see is the following — that our position towards one another is also straight at this moment. That for the purposes of keeping straight it's desirable to have a closer connection, and in my view there are a few things in ourselves that we'll have to work out between us.

In the first place, I would be very pleased if your relationship with Marie were to be put on a firmer footing; in other words a formal engagement if possible.

Secondly, I would consider it desirable that we all understood that circumstances urgently require that Brabant no longer be closed to me. I myself think it better that I do *not* go there unless there's no other choice, but in the event of an emergency the rent that I'm obliged to pay could be saved, because Pa has a house there rent-free.

I'm at a point where there will probably be *some* income from my work soon. And if we could now reduce expenditure to a minimum, even below what it is at present, perhaps I could earn instead of consume, become positive instead of negative.

If it's a question of our *having* to earn, I can see a chance in this way — if there's patience at home, a realization of the necessities, if above all, when it comes to models for me, even the family cooperates. As to the question of models, they'd definitely have to do what I wanted, have to trust that I had my reasons for it. If I were to say to Ma or to Wil or Lies, pose for me, it would have to happen.

I wouldn't make any unreasonable demands, of course. You know how it came about that I left; the fundamental cause was misunderstanding one another, actually in *all* things. So *can* we live together? Yes, for a *time*, if we *have* to and people on both sides understand that everything has to be subordinated to what *the force majeure* of circumstances dictates. I had hoped that that was understood *at the time*, and I didn't take the initiative to leave — when I was told to go away, though, I went.

Anyway, I broach this because I see that perhaps things will come to pass such that you *must* have your hands free, and if it might help for me to live at home for a while, I think that Pa and I would both have to reconcile ourselves to that immediately.

Although if it isn't necessary — so much the better. But I'm not saying that I absolutely *must* be in Drenthe; *where* isn't the most important thing.

So be aware of this, that in that respect I would of course do whatever you thought advisable.

Well, I'll write to Pa today, without more ado, simply this: if Theo were to think it advisable that my expenses should be reduced to a minimum and I should live at home for a while, I hope that both you and I will have the sense *not* to put a spoke in the wheel through mutual discord, but keeping silent about everything that has passed will reconcile ourselves to what circumstances bring. Nothing more about you or about business nor, should I have to live at home, would I talk about you other than in general terms. And for the time being I would certainly *not* mention Marie.

Theo, if you had said perhaps a year ago that you would certainly not become a painter, would certainly stay in your present profession, I would have had to accede; *now* I don't accede so readily, I still see that repeated occurrence in the history of art of the phenomenon of two brothers who are painters. I know that the future is unpredictable, at least I tell you that I don't know how things will turn out. However, it's definitely the case that I believe in you as an artist, and this is actually reinforced by some of the things in your last letter.

Mind now, I advise you of one thing that's urgently necessary — beware of your nerves — use all means to keep your constitution calm. Consult a doctor daily if you possibly can, not so much because a doctor can do anything about it, as much as would be needed, but because the very fact of going to a doctor to talk about it &c. will show you, *this* is nerves, *that* is me.

It's a question here of self-knowledge, of serenity, despite all the tricks that the nerves *must* play. I consider the whole idea that it *could* come to your making yourself scarce to be the effect of nerves. You would do wisely and well to regard it in this way yourself. I hope that you will *not* bring off a coup, I hope that you will *not* make a financial invention — I hope that you will become a painter. If, through cool aplomb, you can let the crisis now deliberately being created by the gentlemen run off you like water off a duck's back, can say to them 'I am *certainly not* leaving in this way, certainly not *now*, *never* like this' — if you say to them, I have plans but they aren't even of a commercial nature, and as soon as they can be put into effect I'll retire in all tranquillity; until that time, as long as you can't find fault with what I do, leave things as they are, but know that you're very much mistaken in me if you think that I would leave because you make things impossible for me, or would part from you in any unreasonable way. If you want to be rid of me, very well, I also want to be rid of you, but amicably and in good order, and it goes without saying that I must keep going. Anyhow, try to make them understand that you're dead cool and calm and will remain so, however that you have absolutely no desire whatsoever to stay — but that you won't leave until you see a favourable moment. This seems to me to be the way to counter what they're now trying to do, to make it impossible for you to stay. Perhaps they suspect that you've already established relations elsewhere, and in such a case making it impossible for someone to stay can sometimes be very nasty. If they turn nasty now, there's nothing for it, cut it short — perhaps the best thing might be to explain calmly that you would retire on certain conditions.

In the meantime, let me know if I should go home for a while so that you have your

hands free. And again, Pa, Ma, Wil, Marie, I, in a word all of us, think much more of *you yourself* than of your money. Making yourself scarce is nothing but sheer nerves.

But — restore — *try* to restore, even if it doesn't happen all at once — the rapport between you and nature and people. And if the only way to do this is to become a painter, well then become one, even if you see ever so many objections and impossibilities.

Now listen — write to me very soon — be sure to do that. With a handshake.

Ever yours,
Vincent.

400 | Nieuw-Amsterdam, Sunday, 28 October 1883 | *To Theo van Gogh* (D)

My dear brother,

It's Sunday today and you're never out of my thoughts. As to these things, I'd find 'the longer you stay there, the more bored you'll be' very applicable to business; 'the more you'll enjoy yourself' to painting — *enjoy* here in a serious sense of a zest for life, good spirits, energy. Oh — I said we should by all means take Tom, Dick and Harry as they are — by all means — let's do that, but apart from taking one thing and another as it is, isn't there something absurd about these forms and conventions, aren't they truly *bad*? Maintaining a certain status fosters certain base acts, insincerities — to be done willingly and knowingly with premeditation. That's what I call the fatal side, even of the black ray, let alone where there's no question of any ray at all.

Now take the Barbizon painters, not only do I understand them as people, but in my view *everything*, the tiniest, most intimate particulars, sparkles with spirit and life. The 'painters' household' with its great and petty vexations, with its calamities, with its *Sorrows* and griefs — it has a certain good will in its favour, a certain sincerity, a certain genuinely human quality.

Precisely by *not* maintaining a certain status, not even thinking about it — if you take *enjoying* in the most serious sense of 'finding it interesting' — for my part I call that 'enjoying'. And then about that certain status 'boring, stupefying'. Do I say this because I despise refinement or something? — just the very opposite, because I regard and respect the genuinely human, living with nature — not going against nature — as refinement. I ask, what most makes me a human being. Zola says — I, an artist, I want to live life to the full — *want to live* without ulterior motive — naive as a child, no not as a child, as an artist — with good will, just as life unfolds, so I'll find something in it, so I'll do my best in it.

Now take all the prearranged airs, the conventional, how hugely priggish it actually is, how absurd it is, a person who thinks that he knows it all and that things go as he thinks — as if there wasn't always a *je ne sais quoi* of almighty good and also an element of evil in all things in life, which one feels as something infinite above us, infinitely bigger, more powerful than us. A person who doesn't feel small — who doesn't realize that he's a speck — what a fundamental mistake he makes. Does one lose something by abandoning some notions, drummed into us as children, of preserving status — of

regarding certain manners as No. 1? For myself, I don't even think about whether I lose or don't lose by it, I only know that my experience is that these forms and notions don't hold water and are often even fatal, yes are decidedly bad. I come to the conclusion that I don't know anything, but at the same time that the life we are in is such a mystery that the system of 'Respectability' is certainly too narrow—so, for me, that has lost its credit.

What shall I do now?—the customary term is 'What is your aim, what is your aspiration?'—oh, I shall do what I shall do—how? I don't know beforehand—do you, who ask me this priggish question: what is your aim, what is your aspiration? Now people say 'you lack character if you have no aim, no aspiration'. My answer: I didn't tell you that I had *no* aim, *no* aspiration; I said that I found it unspeakably priggish to want to force someone to define what is indefinable.

So these are my thoughts on certain questions about life. The whole discussion about them is one of the things that I describe as 'boring'. Live—do something—and that's more enjoyable, that's more positive.

In short. A kind of taking society as it is but feeling oneself completely free, not believing in one's own intellect but in '*reason*'; believing my own intellect, although I don't confuse that with 'reason'—(my intellect is human, reason is divine, but there's a link between the one and the other), my own conscience is the compass that shows me the way, although I know that it doesn't work exactly accurately.

What I wanted to say is that when I look back at the past generation of painters, I remember an expression you used, 'they were SURPRISINGLY cheerful'. I now want to say that IF you were to become a painter, you would have to do it with something of that same *surprising* cheerfulness. You need it as a counterweight against the melancholy aspect of the situation. You do more with that than with anything else. You must have a certain genius, I don't know another word for it, which is the exact opposite of what people call 'ponderous'. Do not, of course, tell me that neither you nor I could have that ourselves. I say it because I believe that we must do our best to become thus, I don't claim that either you or I are already sufficiently thus—I say, let's do our best in that regard—because I want to show you in these letters that in my opinion you aren't mistaken, although I believe that you understand what I think about one thing and another anyway. In my view, the whole plan would gain immeasurably if it could be linked to your remaining with the woman you're with.

And that if you feel that it's in your nature and hers even to have a degree of pleasure—a surprising cheerfulness—in the face of the situation—a *je ne sais quelle* surprising *youthfulness*—and I don't reckon that among the impossibilities—you said she was intelligent—well then, you can do more together than alone. And in this case, if people of the same sentiment, people in the same rather serious misfortune, should join forces to see it through together, I say the more the merrier.

And I say—if this was so or came to pass, this joining together to work one's way through, this is something that's infinitely more than all the forms, and rises above 'what will they say'.

And wanted to tell you the people *here* don't seem to me to be unpleasant or scheming. There's something benevolent here, and I believe that you could do exactly what suits you best here. There is here—a surprisingly youthful atmosphere.

I know that all these things have an inevitable financial aspect, but I say, let's

weaken this inevitable money side as much as possible, in the first place by not be-
ing *too* afraid of it, and by feeling that if one sets to work with love, with a singular
understanding of one another and working together and supporting one another, this
would alleviate many things that would otherwise be unbearable, indeed sometimes
change them utterly. For myself, if there were a few people with whom one could talk
about art, who would, and would want to, feel—I would gain immensely for my own
work—I would feel myself more, be myself more. If there's enough money for us to
hold out for an initial period, I'll be earning by the time it runs out. The more I think
about it, the more it seems to me to be as I originally felt it.

Your heart is partly in the house of G&Cie, but G&Cie don't ask for that, demand
unreasonable things in their overconfidence. In the first place this is a great blow for
you, something that causes you much inner pain. This isn't just a question of money,
you have your heart in it, it's a heartache. You'll embark on a similar career with that
heartache, perhaps with a similar result again. Look, can this be done? I tell you that I
doubt it—that it seems to me that you, who are very young, would *not be reckless* if you
were to argue: I've had enough of the art trade but not of art, I'll abandon the trade
and I'll look to the heart of the profession itself. *I* should have done *that* at the time.
The fact that I made a mistake was an error in point of view, understandable, perhaps,
because I didn't know then how things were regarding teaching or evangelism—knew
nothing about them—and had ideals about them. You'll say, can't one also develop ide-
als about art that don't hold water in existing situations? Well, answer that for yourself;
I also answer it for myself by asking, is Barbizon, is the Dutch school of painters, a fact
or not a fact?

Whatever else the art world may be, it isn't rotten. On the contrary, it has got better
and better—and perhaps it has already reached the highest peak, but we're still very
close to it in any event, and as long as you and I live, even if we were to live to 100,
there will be a certain gusto of a real kind. So if people want to paint—buckle down
to it. If the woman came, of course she'd have to paint too.

Everyone should paint here. The wife of one of the Van Eycks had to do it too.

With the greatest possible good heart, cheerfulness, enthusiasm, one would have
to begin by saying, none of us can do anything and yet we are painters. *Action* follows
from our *intent*. That's what the idea has to be, it seems to me. We live from day to
day—if we don't work 'like a bunch of negroes' then we'll have to die of hunger and
cut the most ridiculous figures. We simply have a tremendous aversion to that, and so
we have to and we shall. It couldn't be done by people who didn't have something of
what I'll simply call surprising youthfulness—and at the same time a seriousness that
was damned serious.

The—*putting your heart and soul into it.*

Now—if it were a speculation I wouldn't be able to think about it like *this*—but
here it's a battle to escape from the world of convention and speculation. It's some-
thing good, something peaceful, a just enterprise. We'll certainly endeavour to earn
our bread, but then definitely in the literal sense. Money leaves us cold except as far
as it's needed for the absolute essentials of life. We do nothing of which we have to be
ashamed. We can openly stroll about the countryside and work, with what Carlyle calls
quite a royal feeling. We can work because we're honest. We say, we made a mistake
when we were children, or rather we had to do what we were told then, and do what

we did to earn our living. Later, this and that happened, and then we deemed it advisable to become artisans. Because certain situations were too pretentious for us.

If you were to talk to people about it, I think they'd all advise against it &c. Perhaps only the woman you're with wouldn't. If you've made a decision for yourself, avoid people so that they can't sap your willpower. At the very moment when one hasn't yet shed one's superficial awkwardness, isn't yet polished, a 'good for nothing' is enough to cause despondency for six months, until one eventually sees after all that one shouldn't have let oneself be disoriented.

There are two people whose intense struggle between 'I'm a painter' and 'I'm not a painter' I know.

Rappard's and my own — sometimes a frightening struggle, a struggle that's precisely the distinction between us and some others who take it less seriously. For ourselves, we sometimes feel wretched, at the end of a spell of melancholy there's a little light, a little progress; some others have less of a struggle, perhaps work more easily, yet their personal character also develops less. You would also have this struggle, and I say you must be aware that you run the risk of being put off by people who doubtless have the very best of intentions.

If something in you yourself says 'you aren't a painter' — IT'S THEN THAT YOU SHOULD PAINT, old chap, and that voice will be silenced too, but precisely because of that. Anyone who goes to his friends and complains about his troubles when he feels like that loses something of his manliness, something of the best that's in him. Your friends can only be those who fight against it themselves, rouse the active in you through their own example of action.

[*Sketch* 400A]

One must take it up with assurance, with a conviction that one is doing something reasonable, like the peasant guiding his plough or like our friend in the scratch, who is doing his own harrowing. If one has no horse, one is one's own horse — a lot of people do that here. *You must regard it not as a change — as a deeper penetration.*

You've learned to see art over the years — now you go on, already knowing *what* you want to make. Don't think that this is a little thing.

You can be decisive, you know *what* you want.

There's a saying of Gustave Doré's that I've always found exceedingly beautiful — I have the patience of an ox — right away I see something good in it, a certain resolute honesty; in short there's a lot in that saying, it's a real artist's saying. When one thinks about people from whose mind something like this springs, it seems to me that the sort of arguments one all too often hears in the art trade about 'gift' is such a hideous croaking of ravens. 'I have the patience', how calm that is, how dignified that is. They wouldn't even say that if it weren't precisely because of all that croaking of ravens. I'm not an artist — how coarse that is — even to think it of oneself — should one not have patience, not learn patience from nature, learn patience from seeing the wheat slowly come up, the growing of things — should one think oneself such a hugely dead thing that one believed one wouldn't grow? Should one deliberately discourage one's development? I say this to show *why* I find it so silly to talk about gifts and no gifts.

But if one wants to grow, one must fall into the earth. So I say to you, plant yourself

om een half jaar moedeloosheid te veroorzaken
waarna men toch eindelijk ziet dat men niet zich
had moeten laten desorienteeren –
Van twee personen ken ik den zielsstrijd tusschen
het ik ben schilder en ik ben geen schilder.
van Rappard en van myzelf – een strijd soms bang
een strijd die juist is dat wat het onderscheid is tusschen
ons en zekere anderen die minder serieus het opnemen
voor ons zelf hebben wy het soms benenerd aan 't eind
eener melankolie een beetje licht een beetje vooruitgang
zekere anderen hebben minder strijd ~~doch het~~ werken
misschien makkelyker doch het ~~niet~~ persoonlyk
karakter ontwikkelt zich ook minder. Gy ~~zoudt~~ ook
dien strijd hebben en ik zeg weet van uw zelf dat gy
het gevaar om door lui die zonder twyfel magry beste
intenties hebben van streek te worden gebragt –
Als wie en u zelf zegt u gy ik geen schilder – schilder
dan juist Kerel en die dien bedoort ook maar
slechts daardoor – wie als hy dat voelt gaat naar
vrienden en zyn nood klaagt verliest iets van
zyn mannelykheid iets van het beste wat in hem is –
Uw vrienden kunnen slechts zyn dezulken die
zich daartegen vechten door eigen voorbeeld van
actie ~~hy~~ active in u opwekken –

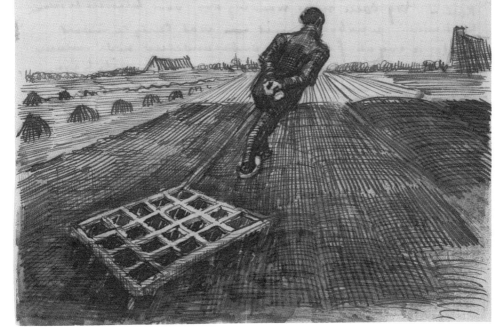

400A. Man pulling a harrow

in the soil of Drenthe — you will sprout there. Don't shrivel up on the pavement. You'll say that there are city plants — well yes, but you are wheat and belong in the wheatfield.

Well, I too foresee that, perhaps for financial reasons, now *cannot* be the moment, but at the same time that perhaps the circumstances would just make it possible. And if there were only half a possibility, it's my opinion that you would do well to risk it. I don't believe that you would ever regret it. You would develop the best that is in you, have a more peaceful life. Neither of us would be alone, our work would flow together. We might have frightening moments at the outset, we'd prepare ourselves for them and arrange things in such a way that we had to withstand them, couldn't turn back. Not look behind us nor be able to look behind us, actually force ourselves to look forward. But it's precisely then that we're far away from all friends and acquaintances, we fight the fight without anyone seeing us, and that's best, other people can only hinder us. We see victory ahead — we feel it in us. We'll be so busy working that we won't be able to do anything but think positively about the work.

I don't suppose in the least that I'm telling you anything new, I just ask, don't go against your own best thoughts. Think about that idea of looking at things with a certain cool, good heart rather than with gloominess. I see that even in Millet; he couldn't help being of good heart, precisely because he was so serious. This is some-thing specific, not to all schools of painting, but to the school of Millet, Israëls, Breton, Boughton, Herkomer, several others. In short, those who seek the really simple are themselves so simple, and their view of life is so full of good will and good heart, even in misfortune.

Think about these things, write about these things. It must be a revolution that is, because it's necessary that it should be — the most self-evident thing in the world for you and for me, so I write about it calmly and I have no doubt you'll also think about it calmly. With a handshake.

Ever yours,
Vincent

402 | Nieuw-Amsterdam, Friday, 2 November 1883 | *To Theo van Gogh* (D)

Dear brother,

Just wanted to tell you about a trip to Zweeloo, the village where Liebermann stayed for a long time and made studies for his painting of the washerwomen at the last Salon.

Where Ter Meulen and Jules Bakhuyzen also spent some time.

Imagine a trip across the heath at 3 o'clock in the morning in an open cart (I went with the man where I lodge, who had to go to the market in Assen). Along a road, or 'diek' as they say here, which they'd put mud on to raise it instead of sand. It was much nicer even than the barge. When it was only just starting to get a little lighter and the cocks were crowing everywhere by the huts scattered over the heath, the few cottages we passed — surrounded by slender poplars whose yellow leaves one could hear falling — an old squat tower in a little churchyard with earth bank and beech hedge,

the flat landscapes of heath or wheatfields, everything, everything became just exactly like the most beautiful Corots. A silence, a mystery, a peace as only he has painted.

It was still very dark, though, when we got to Zweeloo at 6 o'clock in the morning—I saw the real Corots even earlier in the morning. The ride into the village was really so beautiful. Huge mossy roofs on houses, barns, sheepfolds, sheds. The dwellings here are very wide, among oak trees of a superb bronze. Tones of golden green in the moss, of reddish or bluish or yellowish dark lilac greys in the soil, tones of inexpressible purity in the green of the little wheatfields. Tones of black in the wet trunks, standing out against golden showers of whirling, swirling autumn leaves, which still hang in loose tufts, as if they were blown there, loosely and with the sky shining through them, on poplars, birches, limes, apple trees. The sky unbroken, clear, illuminating, not white but a lilac that cannot be deciphered, white in which one sees swirling red, blue, yellow, which reflects everything and one feels above one everywhere, which is vaporous and unites with the thin mist below. Brings everything together in a spectrum of delicate greys.

I didn't find a single painter in Zweeloo, though, and the people said they *never* come there *in the winter*. It's *precisely* in the winter that I hope to be there. Since there were no painters, I decided to walk back and do some drawing on the way instead of waiting for my landlord's return.

So I started to make a sketch of the very apple orchard where Liebermann made his large painting. And then back along the road we had driven down early on. At the moment that area around Zweeloo is entirely given over to young wheat—vast, sometimes, that most tender of tender greens that I know. With above it a sky of a delicate lilac white that gives an effect—I don't think it can be painted, but for me it's the basic tone that one must know in order to know what the basis of other effects is.

A black earth, flat—infinite—a clear sky of delicate lilac white. That earth brings forth that young wheat—it's as if that wheat is a growth of mould. That's what the good, fertile fields of Drenthe are, *au fond*—everything in a vaporous atmosphere. Think of the *Last day of creation* by BRION—well, yesterday I felt that I understood the meaning of that painting.

The poor soil of Drenthe is the same, only the black earth is even blacker—like soot—not a lilac black like the furrows, and melancholically overgrown with eternally rotting heather and peat. I see that everywhere—the chance effects on that infinite background: in the peat bogs the sod huts, in the fertile areas, really primitive hulks of farmhouses and sheepfolds with low, very low walls, and huge mossy roofs. Oaks around them. When one travels for hours and hours through the region, one feels as if there's actually nothing but that infinite earth, that mould of wheat or heather, that infinite sky. Horses, people seem as small as fleas then. One feels nothing any more, however big it may be in itself, one only knows that there is land and sky.

However, in one's capacity as a tiny speck watching other tiny specks—leaving aside the infinite—one discovers that every tiny speck is a Millet. I passed a little old church, just exactly, just exactly the church at Gréville in Millet's little painting in the Luxembourg; but here, instead of the little peasant with the spade in that painting, a shepherd with a flock of sheep came along the hedge. One didn't see through to the sea in the background but only to the sea of young wheat, the sea of furrows instead of that of the waves. The effect produced: the same. I saw ploughmen, very busy now,

a sand-cart, shepherds, road workers, dung-carts. In a little inn along the way drew a little old woman at the spinning wheel, little dark silhouette —like something out of a fairy tale —little dark silhouette against a bright window through which one saw the bright sky and a path through the delicate green and a few geese cropping the grass.

And then, when dusk fell —imagine the silence, the peace of that moment! Imagine, right then, an avenue of tall poplars with the autumn leaves, imagine a broad muddy road, all black mud with the endless heath on the right, the endless heath on the left, a few black, triangular silhouettes of sod huts, with the red glow of the fire shining through the tiny windows, with a few pools of dirty, yellowish water that reflect the sky, where bogwood trunks lie rotting. Imagine this muddy mess in the evening twilight with a whitish sky above, so everything black on white. And in this muddy mess a rough figure —the shepherd —a throng of oval masses, half wool, half mud, that bump into one another, jostle one another —the flock. You see it coming —you stand in the midst of it —you turn round and follow them.

With difficulty and reluctantly they progress along the muddy road. Still, there's the farm in the distance —a few mossy roofs and piles of straw and peat between the poplars. Again the sheepfold is like a triangle in silhouette. Dark.

The door stands wide open like the entrance to a dark cave. The light from the sky behind shines through the cracks in the boards at the back. The whole caravan of masses of wool and mud disappears into this cave —the shepherd and a woman with a lantern shut the doors behind them.

That return of the flock in the dusk was the finale of the symphony that I heard yesterday. That day passed like a dream, I had been so immersed in that heart-rending music all day that I had literally forgotten even to eat and drink —I took a slice of coarse peasant bread and a cup of coffee at the little inn where I drew the spinning wheel. The day was over, and from dawn to dusk, or rather from one night to the other night, I had forgotten myself in that symphony. I came home and, sitting by the fire, it occurred to me that I was hungry, and I found I was terribly hungry. But that's how it is here. One feels exactly as if one had been at an exhibition of one hundred master-pieces, for example. What does one get out of a day like that? Just a few scratches. And yet one gets something else out of it, too —a calm passion for work.

Above all, do write to me soon. It's Friday today but your letter isn't here yet; I'm looking forward to it eagerly. It takes time to get it changed, since it has to go back to Hoogeveen again and then back here again. We don't know how it will work out, but apart from that I would *now* say —the simplest thing perhaps would be to send money once a month. In any event write again soon. With a handshake.

Ever yours,
Vincent.

My dear Theo,

Thanks for your letter and the enclosure. Your letter explains your silence to me.

You thought that '*feeling that I was flush*', I was giving you an '*ultimatum*' — in the way — similar — that the nihilists, say, might send them to the Tsar. Well, fortunately *both* for you *and* for me, there's *no* question here of anything of the kind or similar.

However, I do understand your interpretation *now that I know what it is*, but I had to know. For a start I meant something different — it was simply: 'I wouldn't want to flourish if you had to wither in consequence; I wouldn't want to develop the artistic in me if you had to suppress the artistic in you for my sake. I wouldn't approve if you were to suppress the artistic in you for anyone's sake, even for the sake of father, mother, sister, brother or wife'. There you have my meaning — perhaps expressed nervously and in the wrong words — most decidedly there was no more nor anything else behind it than that. You understand it well enough now, don't you?

As to what I wrote in my last letter, it arose out of your silence, an absolute mystery to me, absolutely inexplicable to me until I knew what the matter was. I already had an answer as far as Marie is concerned before I ever received your letter, simply because I remembered what you wrote to me in the past about your meeting with her and thought, that *has* to be all right, that *can't* be what's wrong. So even my letter on the subject was meant like this: brother, you seem to abandon me without warning; *if* you did this *on purpose* it would be treachery in my view, but I CAN *not* think THAT, so '*explain it to me*' — no more nor less than this was behind *that*, and as to what I said about Lady Macbeth, you've interpreted it *correctly*, as a hint in general that was *not even a question* but only to make you feel: EITHER it has to be like this OR it *is a misunderstanding*.

Be aware of this, though, brother, that I'm absolutely cut off from the outside world — except for you — so that for me *it was enough to make me crazy when your letter didn't come* at a moment when, far from being 'flush', I was in dire straits — *although I didn't mention that* — because I reckon that I'm somewhat above the cares that peck at my vitals, regarding this torture as understandable, so be it, although *not as deserved*. As to '*I wouldn't want to flourish if someone else had to wither in consequence*', I hope that I would say *this — which lay* in what you conceived to be an ultimatum — WHETHER I was 'flush' OR in '*agony*'.

It seems to me that the conclusion that I spoke as if I was 'flush' was rather shallow or hasty on your part — although it must have been in the *way I expressed it*, for it was certainly *not* what I *felt*.

I just want to tell you that since I've been here I've had to see to it that my equipment was organized, that I had paint, that I went to see this and that, that I paid for my lodgings, that I sent the woman something, that I paid off some debts. All this keeping me *very hard up* all the time — to put it *mildly*. Add to this that singular torture . . . loneliness, and you really will no longer be *able* to think that there's any possibility of my feeling 'flush' for the time being — or that I felt it then.

I say loneliness and not even in peace — but *that* loneliness which a painter in an isolated region encounters when every Tom, Dick and Harry takes him to be a madman — a murderer — a vagabond &c. &c. Granted it may be a *petty* vexation, but a

vexation it is. Being a stranger, doubly strange and unpleasant —however stimulating and beautiful the countryside may be.

But I see in this only a bad time that one has to get through. Something, though, which one can do very little about oneself —that is, about the attitude of the people whom one would so much like to have as models and can't get.

With hindsight, I see clearly enough how you and I came to misunderstand each other. There was a moment when you were very melancholy, and you wrote me the following: the gentlemen are making it almost impossible for me, and I actually believe that they *would rather dismiss me than that I should resign* (the underlined precisely my case at the time). And you said, 'sometimes I think I should just disappear' —and you said — there were things about the idea of painting to which you were at least not averse.

Very well —then I candidly told you all my thoughts about the possibility of your becoming a painter, I said *you can do it* provided you want to, and *I* believe in *you as an artist, from the moment you pick up a brush*, even if no one else does.

What I said about that, I'll say to you in the future should a misfortune —a calamity —strike you —what is NOW stopping you from 'a complete renewal' is indeed a misfortune. If a calamity were to strike you, I believe that you as a person would become a greater person as a result, with —with —with —an eternally painful wound at the same time.

I would expect of you that it would raise you *up*, not 'drag you *down*', that wound which can only be caused by a calamity.

But your later letters differ *so* much in tone and *so* much in content that I now say: if your rigged ship is sound, very well, then stay on it.

However I'll always maintain what I said should a calamity put you in a different position in relation to society. Were that ever to happen, I say in that regard: let it be a sign for you to make a *complete* change of profession, rather than starting all over again doing the same thing.

But as long as you have your rigged ship, I don't say that I advise you to put to sea in a fishing-boat. Although *I* wouldn't wish for G&Cie's rigged ship back, as far as I personally am concerned. At the time I thought, for God's sake, calamity —do your worst!

At first I didn't know what to think about the change in the tone of your letters. Now, looking back, I think as regards your somewhat melancholy but for me so touching letter, written at a time when G&Cie *were being terribly nasty to you* (a moment COMPARABLE *to what I experienced myself*) —now in hindsight I think, I say, that you took a *different* view of that moment when *I* said to the G&Cie gentlemen 'if *you force me to go, I won't refuse to go*', and that things really have CALMED DOWN, perhaps for good —and with your consent —so be it —I won't object. Well, I do *not* take it amiss of you —because I believe that in such a case certain conditions that really are *acceptable* CAN be laid down —and I think that you would *not* have accepted them were there to have been anything dishonest in accepting them. But why I said something like, 'if you stay then I'll refuse your financial support,' was because you had said 'let me stay where I am because I have to take care of Pa, Ma, Wil and Marie', and (although you didn't mention me) *me* as well. Tact on your part not to mention *me*, to which I had to respond with tact on my part —I don't want *that* —you sacrificing yourself in so far as you would stay there against your will for the sake of others. There you have what you interpreted as giving you an ultimatum.

If you stay there because 'you have a renewed pleasure in it' — it's all to the good as far as I'm concerned, and I congratulate you on your newly rigged ship, although for myself I have no desire to go back.

What you write about Serret interests me greatly. A man like that who eventually produces something heart-rending as blossom from a hard and difficult life is a phenomenon like the blackthorn, or better yet a gnarled old apple tree which suddenly bears blossoms that are among the tenderest and most 'pure' things under the sun.

When a rough man blossoms — it's indeed a beautiful sight — but HE has had to endure an awful lot of cold winters before then — more than even the later sympathizers know.

The artist's life and WHAT an artist is, that's very curious — how deep is it — infinitely deep.

Because of your silence, inexplicable to me, and because I also associated it with the possible resumption of difficulties with the gentlemen, because for my part I was intolerably hard-pressed as a result of the mistrust of the people in the lodgings, I dropped Pa a line that, not having heard from you, I didn't know what to think and asked Pa for a loan. I added that I was uneasy both about you and about myself, particularly when I thought about the future, and I wished that both you and I had become painters when we were boys, and actually saw no reason why we two brothers shouldn't be painters even now IF G&CIE WERE NOT TO REMAIN WHAT IT ONCE WAS TO YOU. Should Pa ever write to you about it, you know the reason for it, but I'll write to Pa myself (I haven't had a reply from Pa yet) that your last letter has made it plain to me that for the time being G&Cie remains G&Cie. I add this to you, not to Pa: since G&Cie exercises an influence on our family, strangely compounded of good and evil; good, certainly, in any event because it prevents much stagnation (evil not being in question for the moment).

That my heart perhaps has and feels bitterness of its own is something that in my view you both understand and consequently forgive me out of yourself.

Ultimatum — YOU speak of it — NOT I (at least my intention was something very different) — if you want to interpret it that way — then it's all right with me, but I shall not be the first — nor have I been — for the moment your interpretation runs very far ahead of my intention. I would perhaps not contradict you any more than I did G&Cie in the past, if you wanted to carry it through. Then I would say again, you said ultimatum first, NOT I. If you want to interpret it thus, then I don't oppose this interpretation. With a handshake.

Ever yours,
Vincent

Brother — after your last letter all my worst vague anxieties have been quieted — I mean that I have complete confidence in you as a man and in Marie.

But I simply think that you'll run into certain financial difficulties because of the course of events.

I advise you, if you can economize on something, then economize, that's to say if you can put something by, then put something by.

I myself have nothing at the moment — but I'll see if I can arouse some interest in certain plans of mine — or if no one wants to come back to Drenthe with me later on, then at least see if I can't find some credit for myself so that I can settle there. I'm not flush, I have nothing.

I've seen how shaky your finances have been for a long time — you had too much on your shoulders — you think now that the future will put it right — I think you'll find the future hostile in Paris. Again, if I'm wrong you can all laugh at me and I'll laugh about it myself. *If* it's just my nerves deluding me, well then, it's my nerves — but I fear you all too effectively have a *fatality* against you.

I'll be able to write to you more calmly from home. There's certainly a working environment for me in Drenthe, but preferably I'll have to be able to look at things rather differently from the outset and have a little more *certainty* in my finances. I have to watch the cents — on a small scale; at present, for instance, obviously I concede that this is the first time you have definitely skipped — the difference of some 25 guilders is something that may stump me again for 6 weeks perhaps. I can readily believe that you can't imagine this — you *cannot* know what sort of difficulties over and over again, each very small in itself, make something possible or impossible. Don't take it amiss of me, but believe me that I have to try to take some steps in order to accomplish what I want. Last week, for instance, I got a note from my former landlord, who gave me the impression that he could seize my things that I left behind (including all my studies, prints, books — that I could hardly do without) if I didn't send him 10 guilders that I've promised him as payment for the use of an attic room for my belongings, and some rent that it was doubtful he was entitled to claim, but I agreed on condition of an arrangement to store my things. I have to pay for other things by the New Year, I still have to pay Rappard, and I economized on everything I could. In short, it's not the same as feeling flush. Things *can't* remain as they are at present. I have to find a way out. I don't say that you're to blame, of course, but even last year I *couldn't* have economized more than I did. And the harder I work, the more hard-pressed I become. We're now at a point where I say: at present I *cannot* go on.

410 | Nuenen, on or about Friday, 7 December 1883 | *To Theo van Gogh* (D)

My dear Theo,

I lay awake half the night, Theo, after I'd written to you yesterday evening.

I'm heartbroken about the fact that when I come back now, after an absence of two years, the reception at home was as friendly and kind as could be, yet at bottom nothing, nothing, nothing has changed in what I have to call blindness and stupidity to the point of desperation when it comes to understanding the situation. Which was that we were going along in the very best of ways until the moment when Pa banned me from the house — not just in a passion but also 'because he was tired of it'. It should have been understood then that this was something *so* important to my succeeding or not succeeding that it was made ten times more difficult for me because of it — almost intolerable.

If I hadn't felt the same then as I feel again now, that despite all the good intentions, despite all the friendliness of the reception, despite whatever you will, there's a certain steely hardness and icy coldness, something in Pa that grates like dry sand, glass or tin — despite all his outward mildness — if I hadn't already, I say, felt it then as I do now, I wouldn't have taken it so badly then. Now I'm once again in almost unbearable indecision and inner conflict.

You understand that I wouldn't write as I write — having undertaken the journey here of my own volition, having been the first to swallow my pride — if there wasn't really something I'm running up against.

If I had now seen that there was any WILLINGNESS to do as the Rappards did with the best results and as we began here, also with good results, if I had now seen that Pa had also realized that he should *not* have barred the house to me, I would have been reassured about the future.

Nothing, nothing of all that. There wasn't then, nor is there now any trace, any hint of a shadow of a doubt in Pa as to whether he did the right thing then.

Pa doesn't know remorse as you and I and everyone who is human does. Pa believes in his own righteousness while you, I and other human beings are permeated with the feeling that we *consist* of mistakes and forlorn attempts.

I pity people like Pa, *I can't find it in my heart to be angry with them* because I believe that they're unhappier than I am myself. Why do I think they're unhappier? Because they use even the good in them wrongly so that it works as evil — because the *light* that's in them is black — spreads darkness, gloom around them. Their friendly reception desolates me — to me, the way they *make the best of it*, without recognizing the mistake, is even worse, if possible, than the mistake itself.

Instead of readily understanding and consequently promoting both my and indirectly their own well-being with a degree of fervour, I sense a procrastination and hesitancy in everything, which paralyzes my own passion and energy like a leaden atmosphere.

My intellect as a man tells me that I have to regard it as an unalterable fact of fate that Pa and I are irreconcilable down to the deepest depths. My compassion both for Pa and for myself tells me 'irreconcilable? *never*'—until eternity there's a chance, one has to believe in the chance of an ultimate reconciliation. But the latter, oh why is it sadly probably 'an illusion'?

Will you think that I'm making too much of things? Our life is an awful reality and we ourselves go on into eternity, what is—is—and our view, weighty or less weighty, takes nothing from and adds nothing to the essence of things.

That's how I think about it when I'm lying awake at night, for instance, or that's how I think about it in the storm in the sad twilight in the evening on the heath.

Perhaps I sometimes appear as insensitive as a wild pig during the day in everyday life, and I can readily understand that people find *me* coarse. When I was younger I used to think much more than now that the problem lay in coincidences or little things or misunderstandings that were groundless. But as I get older I draw back from that more and more, and I see deeper grounds. Life's 'an odd thing', brother.

You can see how up and down my letters are, first I think *it's possible*, then again *it's impossible*. One thing is clear to me, that it doesn't happen *readily*, as I said, that there's no 'willingness'. I've decided to go to Rappard and tell him that I would like it too if I could be at home, but that against all the advantages that this would have there's a *je ne sais quoi* with Pa that I'm afraid I'm beginning to think is incurable, and that makes me apathetic and powerless.

Yesterday evening it's decided that I'll be here for a while, the next morning, despite everything, we're back to—let's think about it again. Go ahead, sleep on it, think about it!!! *As if they* HADN'T HAD 2 YEARS to think about it, OUGHT to have thought about it as a matter of course, as the natural thing.

Two years, every day a day of worry for me, for them—normal life—as if nothing had happened or nothing would happen. The burden didn't weigh on them. You say, they don't express it but they feel it. I DON'T BELIEVE THAT. I've sometimes thought it myself, but it's *not right*.

People *act* AS they FEEL. Our ACTIONS, our swift readiness or our hesitation, *that's how we can be recognized*—not by what we say with our lips—friendly or unfriendly. Good intentions, opinions, in fact that's *less* than *nothing*.

You may think of me what you will, Theo, but I tell you it's not my imagination, I tell you, *Pa is not willing.*

I see now what I saw *then*, I spoke out four-square AGAINST Pa then, I speak now *in any event*, whatever may come of it, AGAINST PA again, as being UN*willing*, as making it IMPOSSIBLE. It's damned sad, brother, the Rappards acted intelligently, but here!!!!!! And everything you did and do about it, ¾ of it is rendered fruitless by *them*. It's wretched, brother. With a handshake.

Ever yours,
Vincent.

I don't care so much about a friendly or unfriendly reception, what grieves me is that they aren't sorry for what they did then. They think *that* THEY DIDN'T DO ANY-THING *then*, and for me that's going too far.

Dear brother,

I feel what Pa and Ma *instinctively* think about me (I don't say *reasonably*).

There's a similar reluctance about taking me into the house as there would be about having a large, shaggy dog in the house. He'll come into the room with wet paws — and then, he's so shaggy. He'll get in everyone's way. *And he barks so loudly.*

In short — it's a dirty animal.

Very well — but the animal has a human history and, although it's a dog, a human soul, and one with finer feelings at that, able to feel what people think about him, which an ordinary dog can't do.

And I, admitting that I am a sort of dog, accept them as they are.

This home is also too good for me, and Pa and Ma and the family are so unduly fine (no feelings, though) and — and — they are ministers — many ministers. So the dog recognizes that if they were to keep him it would be too much a question of putting up with him, of tolerating him 'IN THIS HOUSE', so he'll see about finding himself a kennel somewhere else.

The dog may actually have been Pa's son at one time, and Pa himself really left him out in the street rather too much, where he inevitably became rougher, but since Pa himself forgot that years ago and actually never thought *profoundly* about what a bond between father and son meant, there's nothing to be said.

Then — the dog might perhaps bite — if he were to go mad — and the village constable would have to come round and shoot him dead. Very well — yes, all that, most certainly, it *is* true.

On the other hand, dogs are guards. But there's no need for that, it's peace, and there's no danger, there are no problems, they say. So then I keep silent.

The dog is just sorry that he didn't stay away, because it wasn't as lonely on the heath as it is in this house — despite all the friendliness. The animal's visit was a weakness that I hope people will forget, and one that he'll avoid lapsing into again.

Since I've had no expenses in the time I've been here, and because I received money from you twice here, I paid for the journey myself and also paid myself for the clothes that Pa bought because mine weren't good enough, yet at the same time I've repaid the 25 guilders from friend Rappard.

I think you'll be pleased that this has been done, it looked so careless.

Dear Theo,

Enclosed is the letter I was engaged in writing when I received your letter. To which, having read what you say attentively, I want to reply. I'll start by saying that I think it noble of you, believing that I'm *making it difficult* for Pa, to take his part and give me a brisk telling-off.

I regard this as something that I value in you, even though you're taking up arms against someone who is neither Pa's enemy nor yours, but who definitely does, however, give Pa and you some serious questions to consider. Telling you what I tell you, that being what I feel, and asking: why is this so?

In many respects, moreover, your answers to various passages in my letter make me

see sides to the questions that aren't unfamiliar to me either. Your objections are in part my own objections, but not sufficiently. So I see once more your good will, your desire at the same time to achieve reconciliation and peace — which indeed I don't doubt. But brother, I could also raise very many objections to your tips, only I think that would be a long-drawn-out way and that there's a shorter way.

There's a desire for peace and for reconciliation in Pa and in you and in me. And yet we don't seem to be able to bring peace about. I now believe that I'm the stumbling block, and so I must try to work something out so that I don't 'make it difficult' for you or for Pa any more.

I'm now prepared to make it as easy as possible, as tranquil as possible, for both Pa and you.

So you also think that it's I who make it difficult for Pa and that I'm cowardly. So — well then, I'll try to keep everything shut up inside me, away from Pa and from you. What's more, I won't visit Pa again, and I'll stick to my proposal (for the sake of mutual freedom of thought, for the sake of not making it DIFFICULT for you either, which I fear is already inadvertently starting to be your opinion) to put an end to our agreement about the money by March, if you approve.

I'm deliberately leaving an interval for the sake of order and so that I'll have time to take some steps that really have very little chance of success, but which my conscience won't allow me to postpone in the circumstances.

You must accept this calmly and accept it with good grace, brother — it isn't giving you an ultimatum. But if our feelings diverge too far, well then, we mustn't force ourselves to act as if nothing is happening. Isn't this your opinion too, to some extent?

You know very well, don't you, that I consider that you've saved my life, that I shall NEVER forget, I'm not only your brother, your friend, even after we put an end to relations that I fear would create a false position, but at the same time I have an infinite obligation of loyalty for what you did in the past by stretching out your hand to me and by continuing to help me.

Money can be repaid, not kindness such as yours.

So let me get on with it — only I'm disappointed that a thoroughgoing reconciliation hasn't come about now — and I'd wish that it still could, only you people don't understand me and I fear that perhaps you never will. Send me the usual by return, if you can, then I won't have to ask Pa for anything when I leave, which I ought to do as soon as possible.

I gave the whole of the 23.80 guilders of 1 Dec. to Pa
 (having borrowed 14 guilders, and shoes and trousers came to 9 guilders)
" " " " " " 25 " " 10 " " Rappard.
I only have a quarter and a few cents in my pocket. So that is the account, which you will now understand when, in addition, you know that from the 20 Nov. money, which came 1 Dec., I paid for the lodgings in Drenthe for a long period, because there had been some hitch then that was later put right, and from the 14 guilders (which I borrowed from Pa and have since given back) I paid for my journey etc.

I'm going from here to Rappard's.

And from Rappard's perhaps to Mauve's. My plan, then, is to try to do everything in calmness, in order.

There's too much in my frankly expressed opinion about Pa that I cannot take back in the circumstances. I appreciate your objections, but many of them I cannot regard as sufficient, others I already thought of myself, even though I wrote what I wrote.

I set out my feelings in strong words, and of course they're modified by appreciation of very much that's good in Pa — of course that modification is considerable.

Let me tell you that I didn't know that someone aged 30 was 'a boy', particularly not when he may have experienced more than just anyone in those 30 years. Regard my words as the words of a boy if you wish, though.

I am not liable for your interpretation of what I say, am I? *That* is your business.

As to Pa, I'll also take the liberty of putting what he thinks out of my mind as soon as we part company.

It may be politic to keep what one thinks to oneself, however it has always seemed to me that a painter, above all, had a duty to be sincere — you yourself once pointed out to me that whether people understand what I say, whether people judge me rightly or wrongly, didn't alter the truth about me.

Well brother, know that, even if there's any sort of a separation, I am, perhaps *much more even than you know or feel*, your friend and even Pa's friend. With a handshake.

Ever yours,
Vincent.

In any event I'm not an enemy of Pa's or yours, nor shall ever be *that*.

I've thought again about your remarks since I wrote the enclosed letter, and I've also spoken to Pa again. I had as good as definitely made up my mind not to stay here — regardless of how it would be taken or what might come of it — when, though, the conversation took a turn because I said: I've been here for a fortnight now and I don't feel any further forward than in the first half hour. If only we'd understood each other better we'd have got all sorts of things sorted out and settled by now — I can't waste time and I have to decide.

A door has to be open or shut. I don't understand anything in between, and in fact it can't exist. It has now ended up that the little room at home where the mangle is now will be at my disposal as a storeroom for my bits and pieces, as a studio too, should circumstances make this desirable. And that they've now started emptying the room, which wasn't the case at first, when the case was still pending then.

I do want to tell you something that I've since understood better than when I wrote to you about what I thought of Pa. I've softened my opinion, partly because I believe I detect in Pa (and one of your tips would support this to some extent) signs that, indeed, he can't follow me when I try to explain something. Gets stuck in *part* of what I say, which becomes wrong when it's taken out of context. There may well be more than one reason for this, but old age is certainly to blame for a large part of it. Now, I respect old age and its weaknesses too, *as you do, even* though it may not seem so to you or you may not believe it of me. I mean that I probably humour Pa in some things that I would take amiss in a man with his full faculties — for the aforementioned reason.

I also thought of Michelet's saying (which he had from a zoologist), 'the male is very wild'. And because now, at this stage in my life, I know that I have strong passions, and so I should have, in my opinion — looking at myself I see that perhaps I am

'very wild'. And yet, my passion abates when I'm faced with one who is weaker; then I don't fight.

Although, for that matter, taking issue in *words* or about principles with a man who, mark you, occupies a position in society concerned with guiding people's spiritual lives is, to be sure, not only permitted but cannot in any way be cowardly. For after all, our weapons are equal. Give this some thought, if you will, particularly since I tell you that, for many reasons, I want to give up even the battle of words because I sometimes think that Pa is no longer able to concentrate the full force of his thoughts on a single point.

In some cases, after all, a man's age may be an added strength.

Going to the heart of the matter, I take this opportunity to tell you that I believe that it's precisely because of Pa's influence that you've concentrated more on business than was in your nature.

And that I believe that, even though you're now so sure of your case that you must remain a dealer, a certain something in your original nature will still *keep on working* and perhaps react more than you expect.

Since I know that our thoughts crossed each other in our first years with G&Cie, that is that both you and I thought then about becoming painters, but so deeply that we didn't dare to say it straight out then, even to each other, it could well be that in these later years we draw closer together. All the more so because of the effect of circum-stances and conditions in the trade itself, which in the meantime has already changed compared with our early days and, in my view, will go on changing more and more.

I forced myself *so much* at the time, and I was so burdened by a conviction that I was certainly not a painter that, *even when I left G&Cie*, I didn't turn my thoughts to it but to something else (which was in turn a second mistake, over and above the first). Being discouraged then about the possibility, because diffident, very diffident approaches to a few painters weren't even noticed. What I'm telling you is not because I want to *force* you to think like me — I force no one — I'm just telling you it in brotherly, in friendly confidence.

My views may sometimes be out of proportion; that may be so. Yet I believe that there *must* be some truth in the nature of them, and in the action and direction. That I myself have now worked on getting the house here open again, even to the ex-tent of having a studio here — I'm not doing it in the first place or primarily out of self-interest.

In this I see that even though we don't understand each other in many things, there's always a will to cooperate between you, Pa and myself, albeit in fits and starts. Since the estrangement has already lasted so long, it can't do any harm to try to place some weight on the other side, so that we shouldn't appear to the world, too, as being more divided than is the case, so as not to lapse into extremes in the eyes of the world.

Rappard says to me, 'a human being isn't a lump of peat, in so far as a human being can't bear to be thrown up in the loft like a lump of peat and be forgotten there' — and he points out that he thought it a great misfortune for me that I couldn't be at home. Give this some thought, if you will. I believe that it has been regarded a little too much as if I acted capriciously or recklessly or, well, you know it better than I do, whereas I was more or less forced into things, and could do nothing other than what they wanted to see in it.

And it was precisely the biased view of seeing base objectives &c. in me that made me very cold and fairly indifferent towards many people.

Brother, once again—think a great deal at this stage in your life; I believe that you're in danger of taking a distorted view of many things, and I believe that you should examine your life's aim once more, and that then *your life* WILL BE BETTER. I don't say it as if I knew it and as if you didn't know it, I say it because I'm increasingly coming to see that it's so terribly difficult to know where one is right and where one is wrong.

417 | Nuenen, on or about Wednesday, 26 December 1883 | *To Theo van Gogh* (D)

My dear Theo,

I came back to Nuenen yesterday evening, and now I must get what I have to tell you off my chest straightaway.

I packed up my tools, studies, &c. there and sent them here and, Pa and Ma having cleared out the little room, I'm already installed for the time being in this new workplace, where I hope I may be able to make some progress.

Know also that I spoke to the woman and that it's our decision, even more definitely, that she will stay by herself and I by myself in any event, so that the world can't reasonably find fault.

Now that we've parted we'll remain parted, only looking back we regret that we didn't choose a middle way instead, and even now there remains a mutual attachment that has roots or grounds that go too deep to be transitory.

Now I have to tell you a few things that I won't return to again after this—which you may take as you will—which you're at liberty to reflect about or to dismiss—that's not my business—you must decide that for yourself.

Know, then, that I look back with deep regret on your visit this summer, on our conversations then, and on what arose out of them. Time has now passed over it, but I can't deny, looking back, that it seems to me that we weren't right. And now I regard your words and you yourself rather differently, and I can no longer think of you with exactly the same feeling as before.

For I now see more clearly how you and others appeared to wish that I should part from her.

I don't doubt the good intentions.

It was up to me to decide and so, if I did wrong, I may not, in my view, blame you in the *first* place (in the *first* place I blame myself), but you in the SECOND place.

The levers that worked on me so that I was unsettled, and with which you were at least to some extent concerned—were, first, touching on an infinitely tender question from the past that troubled me, secondly your saying that 'my duty' would perhaps lead me to part. Well—if what you said had been entirely isolated—I wouldn't even mention it—but it's too much like the feelings of other people with whom I also differ for me to be able to regard your opinions as being entirely isolated. I accepted your point of view—although probably with intentions very different from what you imagine, and concerning which time will clear up one thing and another for you that now isn't the time to discuss.

You drew my attention to a case where it 'had worked well' that a certain man had left a certain woman.

That *may* be true in itself—very true—but was it applicable *here* concerning her and me? You see, that's something else.

And I've taken the liberty of looking back over it to see '*whether it had worked well*'. And—my friend—that's only too doubtful now.

Know that the woman has managed well, *working* (namely as a washerwoman) to keep herself and her children, consequently has done her duty, and that in great physical weakness.

You know that I took her into the house with me because things happened during her confinement that made the doctors in Leiden say that she had to be somewhere quiet if she and her child were to pull through.

There was anaemia and perhaps already the first signs of consumption, too. Well, as long as I was with her she didn't get any worse, but stronger in many respects, so that various nasty symptoms didn't recur.

But now all that is worse again, and I fear very much for her well-being; and the poor baby, which I cared for as if it were my own, is no longer what it was either.

Brother, I found her in great wretchedness and I'm very sad about it.

I know that it's more my own fault, of course, but you could have spoken differently too. Now, too late, I understand better that some of her fits of temper, and some things that I thought she did wrong deliberately, were also symptoms of nerves, and that she did them more unwittingly, as it were. As she said to me on more than one occasion later, '*Sometimes I don't know what I'm doing*'.

Both you and I have an excuse, in that it's understandable that one sometimes doesn't know how to deal with a woman like that, and then there were the financial difficulties—but still we should have chosen more of a middle way, and if we could still find it even now—although it will be difficult to find now—it would still be humane and less cruel.

I didn't want to get her hopes up though, and I encouraged her and tried to comfort her and strengthen her *on the path she is on now*, alone, working for herself and her children. Yet my heart is strongly drawn to her with the same profound pity as in the past, pity that has always lived on in me during these last months, even with a separation.

Well, our friendship, brother, has taken a heavy blow from this, and if you should say, we were certainly not mistaken, and if you should reveal yourself to me to be of exactly the same mind now as you were then—I would no longer be able to esteem you precisely as I did in the past.

I respected you then precisely because, at a time when other people didn't want to know me because I was with her, you helped me to keep her alive.

I don't say that no change or alteration was necessary, but—I think we (or rather I) went too far. Now that I have a studio here, perhaps more than one financial difficulty is less fatal.

I end by saying, think about it if you will—but if, after what I've told you, your sentiments remain precisely the same as this summer, I can no longer have the same respect for you as I did before.

Incidentally, I've also resolved not to say another word to you about a possible change in your circumstances or career. For I see as it were two natures in you,

struggling with each other within you—a phenomenon that I also see in myself, but there are still, perhaps, a few questions fermenting in you that in your eyes have already been resolved for me because I'm 4 years older. Think about what I've said, that would be very good, although you can also dismiss it. But for my part I wanted to talk to you frankly about it, and can't conceal my feelings from you. With a handshake.

Yours truly,
Vincent

As to my view about how far one *may* go in a case where one concerns oneself with a poor, forsaken, sick creature, I've already told you on a previous occasion, and repeat,

 to INfinity.

And on the other hand, our cruelty can be infinite too.

428 | Nuenen, on or about Sunday, 3 February 1884 | *To Theo van Gogh* (D)

My dear Theo,

I was glad to get your letter today and the enclosure, and thank you very much for both. It seems to me that Ma's recovery is proceeding very well so far, generally speaking. And that the longer it goes on, the less *immediate* danger there is, and the more it's reduced to a question of time above all. Yet—Ma will certainly not be entirely the same once the fracture has healed. The effect on her, and perhaps as a result on Pa too, will in my view be to push them instantly a whole lot further into old age.

I was glad to be at home in the circumstances, and the fact of the accident naturally having pushed some questions (on which I have a considerable difference of opinion with Pa and Ma) entirely into the background—it's all going pretty well between us, and it may mean that I'll stay more and longer in Nuenen than I originally imagined could be the case.

To some extent it's in the nature of things, after all, that it's precisely at a later stage, when Ma will have to be moved more &c., that I'll be able to lend a hand. Now that the consternation of the first few days has subsided a little, I can do my work quite regularly, in the circumstances.

Every day I *paint* studies of the weavers here, which I think are better in technique than the painted studies from Drenthe that I sent you.

I think those things of the looms with that quite complicated machinery, in the middle of which sits the little figure, will also lend themselves to pen drawings, and I'll make some as a result of the tip you give me in your letter.

Before the accident happened, my arrangement with Pa was that I would live here free of charge for a while, so as to get breathing space to settle some bills at the beginning of the year.

And the money that you sent at New Year and about the middle of January was ready for that. Because I gave that to Pa when the accident happened, this time it's those paint bills that are waiting their turn.

The more so since Pa has just had a windfall of 100 guilders from Uncle Stricker,

which I think very kind of Uncle S. So I have NOT profited financially from being here. And my plan is to press ahead vigorously with the work.

In a year or so the financial difficulties that Ma's accident can't fail to bring in its train will be more noticeable to Pa than now, I think. So in the meantime, let's also try to do something with my work.

After all, *Pa and Ma personally* are *secure* for their lives, Pa's pension being equivalent to his current income. But brother, THE POOR SISTERS — without capital, at a time when there's no great inclination in society to marry girls without money — for them life could well remain drab and sad, and their normal development thwarted. We don't want to anticipate things, though.

How lying still all the time will affect Ma's constitution is difficult to tell in advance.

All the precautions we can take to prevent bedsores are important, of course. We've made a sort of stretcher in order to be able to change Ma's bedclothes when needed — although the less this happens the better for the time being. Lying quietly is number 1.

Fortunately Ma's mood is very equable and content, considering her difficult situation. And she amuses herself with trifles. I recently painted the little church with the hedge and the trees for her, something like this,

[Sketch 428A]

You will certainly find the fact that I love the countryside here very understandable.

If you ever come I'll take you into the weavers' cottages sometime. The figures of the weavers and the women who wind the yarn will certainly strike you. The last study that I made is the figure of a man sitting in the loom on his own, the bust and the hands.

I'm also painting a loom — of old oak gone greenish brown — with the date *1730* carved into it. Next to that loom, by a little window through which one can see a small green field, there's a high chair, and the little child sits in it, watching the weaver's shuttle fly back and forth for hours. I've tackled that affair just as it is in reality, the loom with the little weaver, the small window and that high chair in the wretched little room with the clay floor.

If you would, write to me in rather greater detail about the Manet exhibition, tell me which of his paintings are to be seen. I've always found Manet's work very original. Do you know Zola's piece on Manet? I regret that I've only seen very few paintings by him. I would particularly like to see his female nudes. I don't find it excessive that some people, Zola, for instance, *idolize* him, although for myself I really don't think that he can be counted among the very best of this century. Still, it's a talent that *very certainly has its raison d'être*, and that's a great deal in itself. The piece that Zola wrote about him is in the volume 'Mes haines'. For myself I can't share the *conclusions* that Zola draws, as if Manet were a man who's opening up a new future for modern ideas in art, as it were; to me *Millet*, not Manet, is that essential modern painter who opened the horizon to many. Regards, with a handshake in thought.

Yours truly,
Vincent

Regards from all — *do write to Ma a bit more often*, the letters are such a diversion.

428A. *The Reformed Church in Nuenen*

My dear friend Rappard,

It's hard to call it very cordial that you haven't even dropped me a line in all this time. Assuming that you'll also think more or less the same yourself, however, this subject isn't under discussion right now.

Something else is that my mother is doing much better than could have been expected at first. And the doctor now dares to give us an assurance that she'll be better in about 3 months.

I've occasionally thought about what we agreed, roughly that I was to have sent you a few watercolours this winter. But because I heard nothing whatsoever from you I didn't feel at all enthusiastic about it, to put it frankly. So nothing came of it — although I made some.

I've mostly been painting these last few weeks — the weavers — toiled away at it quite a bit.

And in these recent mild days painted outside in the fields, a little peasant cemetery. Then 5 pen drawings of weavers.

I haven't got much more in the way of woodcuts this winter — even so, one very fine print by O'Kelly, Irish emigrants — and a cotton spinning mill by Emslie, and then the print from the Xmas issue of The Graphic, For those in peril upon the sea.

Do you know the poems of *Jules Breton*? I re-read them recently at the same time as another little volume of French verse by *François Coppée*, Les humbles and Promenades et intérieurs.

Coppée's really very beautiful too. Character sketches of workers — the demi-monde, too, in which there's a great deal of sentiment. A very great deal.

Have you been working so hard on your Dominican monk, or what was the reason that you haven't written?

Regards.

Ever yours,
Vincent

P.S.: I've also got hold of a *spinning wheel* here.

My dear Theo,

Thanks for your letter — Ma's doing well — at the outset the doctor said it would be six months before the leg had healed — *now* he's talking about a good 3 months — and he said to Ma — 'but that's your daughter's fault, for I seldom, very seldom, see such good care as she gives'. What Wil does *is* exemplary, exemplary, I shan't easily forget that.

Almost everything has fallen on her shoulders from the outset, and she's spared Ma a great deal of misery.

To mention just one thing, it's definitely her fault that Ma has so few bedsores

(which started very badly at the beginning and had deteriorated). And I assure you that the chores she has to do aren't always pleasant.

Now listen—when I'd read your letter about the drawings, I immediately sent you a new watercolour of a weaver and five pen drawings. For my part, too, I'll tell you frankly that I think that what you say is true, that my work will have to get much better, but at the same time also that your efforts to do something with it might also be a little more decisive. You have *never yet* sold *a single thing* of mine—not for a lot or a little—and IN FACT HAVEN'T TRIED TO YET. As you can see, I'm not getting *angry* about it—but—there's no need to beat about the bush.

I certainly wouldn't put up with it in the long run.

For your part, you can also continue to speak frankly.

As far as saleability and unsaleability are concerned, that's an old file I don't intend to blunt my teeth on.

Well, you see that my answer is that I send some new ones—and I'll very willingly go on doing so—Id like nothing better than that. Only you must be totally frank for once—which is what I'd prefer—as to whether you think you'll bother yourself with them in the future, or whether your dignity won't permit it. Leaving aside the past—I'm facing the future, and not counting what you think of them, I fully intend to try to do something with them.

You recently told me yourself that you're a *dealer*—very well—one doesn't lapse into sentimentality with a dealer; one says, sir, if I give you drawings on commission, may I count on your showing them? The dealer has to decide for himself whether he wants to say yes—no—or something in between.

But the painter would be foolish to send them on commission if he could tell that the dealer considered his work to be something that shouldn't see the light of day.

Now, old chap—we both live in the real world—and precisely because we don't want to put a spoke in each other's wheels, we must speak candidly. If you say—I can't be bothered with them—very well, I won't get angry about it—but then I'm not obliged to believe that you're an absolute oracle either, am I?

You say: the public will be annoyed by this little spot and that, &c. &c. Now listen, that may be so, but this or that bothers *you, the dealer, much more* than the public in question, I've already remarked on that so often—and you *start* with that. I have to fight my way through, too, Theo, and with you I'm still at precisely, precisely the same level as a few years ago. What you say of my current work—'it is *almost* saleable *but'*—is *word for word the same as what you wrote to me when I sent you my first Brabant sketches from Etten.* So I say—it's an old file.

And my reasoning is that I foresee that you'll always say the same thing—and that I, who until today have been consistently rather chary of making approaches to dealers, will now change tactics and become very assiduous in trying to sell my work.

I do understand that you couldn't care less about my doings. But if *you* couldn't care less, for my part I always find it fairly wretched and rather dread things that will probably crop up—namely that people will ask me: what, don't you do business with your brother or with Goupil? Well, then I'll say—it's beneath the dignity of those Messrs G&Cie, Van Gogh & Co. This will probably create a bad impression of me—which I'm quite prepared for—but which I foresee will consequently make me cooler and cooler towards you too.

I've now painted the little old church and another new weaver. Are the studies from Drenthe really so very bad? I don't feel inclined to send you the painted studies from here, no, let's not start on that — you can see them if you come here sometime in the spring, perhaps.

What you write about Marie is quite understandable — if a woman isn't very milk and water I can very well imagine that she has little inclination to mope around with cantankerous fathers and pious sisters, at least a woman as much as a man would feel a fairly pressing temptation to end that stagnation, come what may.

Stagnation that begins with a resignation that is perhaps fine in itself, but which alas one must come to regret, usually, when one feels one would eventually freeze. Read something by Daudet about pious women, 'Those two faces looked at each other — they exchanged a spiteful, cold, closed look — what's the matter with him/her? Always the same thing'. There you have it, that singular look of Pharisees and devout ladies. Yes, therefore *we* always lack — the same thing.

Yes — what am I supposed to think about what you say about my work? For example, I'll now turn specifically to the studies from Drenthe — there are some among them that are very superficial, I said that myself — but what do I get served up for the ones that were simply painted quietly and calmly outdoors, trying *to say nothing in them but what I saw*? I get in return: aren't you too preoccupied with Michel? (I'm talking here about the study of the little hut in the dark and about the largest of the sod huts, namely the one with the little green field in the foreground.) You would certainly say exactly the same thing about the little old churchyard.

And yet, neither looking at the little churchyard nor at the sod huts did I think about Michel, I thought about the subject I was looking at. A subject indeed such that I believe, if Michel had passed by, it would have brought him to a halt and struck him.

For my part, I certainly don't put myself on a par with master Michel — but I definitely don't therefore *imitate* Michel either.

Well, I may perhaps try to sell something in Antwerp, and I'd like to put a couple of those selfsame Drenthe studies in black wooden frames — which I'm looking for at a carpenter's here — I prefer to see my work in a deep black frame, and he makes them cheaply enough.

You mustn't take it amiss that I mention it, brother.

I'm seeking something calm and something cool in my work. *No more than* I approve of its just lying about, *do I want* my work to be displayed in fluted frames in the leading galleries, you see.

And now it's time to begin on that middle way, in my view, and I have to know fairly definitely how I stand with you, or rather I tell you that, although you're still evading the issue in what you say, I believe that you will NOT in fact show it. And I don't even believe that you'll change your mind for the time being.

Whether you're right or wrong about this — I'm not going into that. You'll tell me that I'll be treated by other dealers exactly the same as by you, except that, although you can't be bothered with my work, you furnish me with money anyway, and other dealers certainly won't do that, and without money I'll become completely stuck.

I say in reply that things aren't as clear-cut as that in real life, and that I'll see how far I get living from day to day.

I told you beforehand that I wanted to settle these matters this month, and so it must be done. Well, because you probably plan to come as early as the spring I don't insist that you make a final decision *immediately*, but realize that I can't accept it as it is now—for myself, wherever I go and especially at home, too, I'm always being watched—what I do with my work, whether I get anything for it &c., in short in society almost everyone looks out for it all the time and wants to know all about it.

And this is very understandable. Well, it's very wretched for me always being in a false position.

Come on—things can't stay the same as they are now. Why not? Because they can't.

If I'm as cool as can be to Pa—to C.M.—why should I behave any differently towards you were I to observe in you precisely the same tactics of never speaking out. Do I consider myself better than Pa or you? Perhaps not, perhaps I divide things less and less into good and bad—but I do know that these tactics don't befit a painter and that, as a painter, one must speak out and resolve certain things. In short—I believe that a door should either be open or shut.

Well, I think you do understand that a dealer *cannot* be neutral towards painters—that it makes *exactly* the same impression whether you say *no* with or without mincing your words, and that it may be even more infuriating when it's said wrapped up in compliments.

Now here's something that you'll perhaps understand later on better than you do now—I pity dealers when they get old—even if they've already made their piles—that doesn't solve everything—at least not then. Everything has its price, and an ice-cold wilderness is what it often becomes for them *then*.

Well—but you'll perhaps think differently about it. And you'll say that it's also pretty sad when a painter dies miserably in a hospital and is buried with the whores in the common grave—where a lot of them lie, after all—particularly when one considers that dying may not be as difficult as living.

Well, one can't take it amiss that a dealer doesn't always have the money to help, but one can, in my view, take it amiss if one notices that this respectable dealer or that speaks very cordially, but he's ashamed of me in his heart and he completely ignores my work. So frankly, I won't take it amiss if you say straight out that you don't think my work is good enough or that there are, moreover, yet other reasons why you can't be bothered with it, but if you leave it in a corner somewhere and you *don't* show it, this isn't kind if it's accompanied by the assurance—WHICH IS NOT LIKELY—that you yourself see something in it. I don't believe that—you mean practically none of it. And precisely because you say yourself that you know my work better than anyone else, I may assume that you must think very badly of it indeed if you don't want to soil your hands with it. Why should I force myself on you? Well, regards.

Yours truly,
Vincent

Apart from a few years which I find hard to understand myself, when I was confused by religious ideas—by a sort of mysticism—leaving aside that period, I've always lived with a certain warmth. Now it's all becoming bleaker and colder and duller around me. And when I tell you that in the first place I WILL not stand it like this, never mind whether or not I *can*, I refer to what I said right at the very beginning of our

relationship. What I've had against you in the last year is a sort of relapse into cold decency, which I find sterile and of no use to one—diametrically opposed to everything that is action, especially to everything that is artistic.

I say it as I see it, not to make you wretched but to get you to see and feel if possible the reason that I no longer think of you as a brother and friend with the same pleasure as before. There has to be more zest in my life if I want to get more brio into my brush—I won't get a hair's breadth further by exercising patience. If, for your part, you relapse into the above-mentioned, don't then take it amiss if I'm not the same towards you as I was in the first year, say.

About my drawings—at this moment it seems to me that the watercolours, the pen drawings of the weavers, the latest pen drawings I'm working on now, aren't so dull on the whole that they're nothing at all. But *if* I come to the conclusion: they're no good, and Theo is right not to show them to anyone—then—then—it will be *all the more proof* that I have good reason to dislike our present false position, and will try all the more to change, come what may—better or worse, but not the same.

Now if I saw that, if you didn't think I'd improved enough, you did something about it to get me further along by introducing me to another capable painter, for instance, because Mauve has dropped out, or anyway SOMETHING, some sign or other that proved to me that you really believed in my progress or promoted it. But no, there's—yes, the money—but otherwise nothing except that 'just keep on working', 'be patient'—as cold, as dead, as arid and as insufferable, just as if, for instance, Pa said it. I can't live on that—it's too lonely, too cold, too empty and too lacklustre for me.

I'm no better than anyone else, in so far as I have my needs and desires like everyone, and it's very understandable that one reacts KNOWING FOR SURE that one is really being kept dangling, in the dark.

If one goes from bad to worse—this wouldn't be impossible in my case—what would it matter? If one is badly off, one has to take a chance of making things better.

Brother—I really must remind you of how I was at the very beginning of what we began. *Right from the outset* I've talked to you about the question of women. I still recall that I took you to the station in Roosendaal in the first year, and that I said to you then that I was so against being alone that I would rather be with a common whore than alone. Perhaps you remember that.

I found the idea that our relationship might not last almost unbearable at first. And I so very much wished that it had been simple to change things. However I can't always keep on fooling myself that this can be done against the grain.

The depression about it has thus been one of the reasons I wrote to you so assertively from Drenthe, become a painter yet. Which cooled off immediately when I saw that your dissatisfaction about business matters vanished when you were on better terms with Goupil again.

At first I thought it was only half sincere—then later, and now, still, I think it very understandable and think it more a mistake on my part that I wrote to you, become a painter, than on yours that you resumed your affairs with enthusiasm when they became more possible to resume and the machinations making it impossible for you ceased.

What remains, though, is that I still feel depressed by the falseness of the position between us. At this moment it's more important for me to sell for 5 guilders than to

receive 10 guilders by way of patronage. Well, you repeatedly write, actually most definitely, that you haven't made, aren't making, nor believe for the present you're able to make the least or slightest effort for my work; first, not as a dealer (I let that pass, and at least don't take it amiss of you) but, secondly, not in private either (and that I do take somewhat amiss of you).

In this case I mustn't sit doing nothing or be a funker, so straight out, *if you do nothing with my work, I don't want your patronage*. I state the reason plainly and I'll state it precisely the same way, when giving a reason for it is hard to avoid.

So it isn't that I want to ignore or belittle your help from the start until now. It's a matter of my seeing more benefit in even the poorest, most wretched muddling along than in *patronage* (which it's degenerating into).

One can't do without it at the very, very beginning, but now I must for God's sake, God knows how, just start muddling along rather than acquiesce in something that would take us NO FURTHER anyway. Brotherly or not brotherly, if you can do nothing other than absolutely the financial alone, you might as well keep that too. As it has been in the last *year*, I almost dare to say, it was confined solely to money.

And although you say you give me a completely free hand, it seemed to me, at bottom, that if I do this or that with a woman, for instance, that you and others don't approve of (perhaps rightly disapprove of, but *sometimes* I don't give a damn about that), there comes one of those little tugs on the purse-strings just to make me feel that it's 'in my interest' to go along with your opinion.

So you got your way regarding the woman, and it was finished, but — — — — — — what damn good is it to me to get a bit of money if it means I have to practise morality? Yet in itself I don't think it something absurd in you when you disapproved this summer of my still wanting to go through with it. But I can foresee the following in the future: I'll have another relationship in what you people call the lower orders — and again, if I still have a relationship with you, meet the same opposition. *Opposition* that you people could only carry through with any semblance of fairness if I received so much from you that I could do something different. Which you don't give and can't or won't give, after all — neither you, nor Pa, nor C.M. or the rest, who are always first off the mark to disapprove of this or that — and which I don't after all want from you either, since I don't give much thought to the lower or upper orders.

Do you see why it wasn't an irresponsible action on my part, and wouldn't be if I were to try it again?

Because first I don't have any pretension, don't feel any desire at all, and secondly don't receive the means from anyone whatsoever, or earn them, to keep up some sort of position or whatever you call it — I consider myself completely at liberty to consort with the so-called lower orders if the opportunity arises.

We'd perpetually return to the same questions.

Just ask yourself now if I'm alone among those in the same profession who would most definitely turn down patronage if it entails obligations to maintain some sort of position while the money wasn't enough to be able to do it, so that one gets into debt rather than make progress. If it could be done on the money, I might perhaps not refuse to bend, any more than others do. But we're certainly not that far at present — I have a stretch of years in front of me, as you say yourself, when my work will have very little commercial value. Very well — THEN I WOULD RATHER FALL INTO

THE HANDS OF MUDDLING ALONG and of living through hard times — which I've done more than once — than into the hands of Messrs Van Gogh.

My only regret about arguing with Pa when I did is that I didn't do it 10 years earlier. If you carry on in the footsteps of Pa &c. — you'll just see how you'll gradually get annoyed — and — how you would also become annoying to certain people. But those are awkward customers and, you'll say — they're of no consequence.

434 | Nuenen, between about Wednesday, 5 and about Sunday, 9 March 1884 |
 To Theo van Gogh (D)

My dear Theo,

One of these days I'll send you another new pen drawing of a weaver — larger than the 5 others. The loom viewed from the front — that will make this little series of drawings more complete. I think that they'll look best if you mount them on grey Ingres.

It would disappoint me a bit to get these little weavers back. And if nobody else you know wants to take them on, I'd think this is an article that perhaps you could take for yourself, in order to bring together a number of pen drawings of Brabant artisans, with this as the start. Which I'd be happy to undertake and — on the assumption that I'll be in Brabant quite a lot now — would be very keen to do.

On condition that we make them into a set that stays together, I'll be happy to set the price low so that it can stay as a whole, even if many drawings of that kind were to come.

However, for my part I'll go along with what you think best in this regard.

And you see that it isn't my endeavour to break off business with you — only, I've pointed out to you that it occurred to me that it might be useful to show the drawings as I send them.

As regards what you wrote to me about Marie — I believe that in such a case, where one sees no possibility of carrying it through, there's something one shouldn't forget.

Namely that if the woman has loved you and felt something for you, and you for her, this period of love is a stroke of luck in life. Whether the woman is beautiful or ugly, young or old, should she prove better or worse, only indirectly has anything to do with it. The plain fact remains that you have loved each other. On parting now — don't extinguish that or try not to forget it — and the rock to avoid then is that of self-righteousness — one shouldn't then let it appear as if the woman had a great obligation to the man — one should part as if one had an obligation oneself — is in my view more chivalrous — and — more humane. This may be the way you see it too. Love always causes trouble, that's true, but in its favour, it energizes. But anyway.

As to myself, I believe — and consider it possible that to some extent it might also be the same with you — that I haven't yet had enough experience with women. What we were taught about them in our youth is quite wrong, that's certain — had nothing to do with real life at all. And if one has to see to it that one learns something by experience, it would be mightily pleasant if one was good and the world was good &c. — yes indeed — but it seems to me that one increasingly comes to realize that we ourselves are as bad as the world in general — of which we are a speck of dust — and the world as

bad as we are—whether one does one's very best or acts more indifferently, it always becomes something else—works out differently—from what one actually wanted. But whether it turns out better or worse, happier or unhappier, doing *something* is better than doing *nothing*.

Well, provided one takes care, as Uncle Vincent says—that one doesn't grow up into a stiff, self-righteous stick—one may *even* be as good as one wishes. His Hon. taught this wise lesson to C.M.'s daughter.

Well, regards.

Yours truly,
Vincent

Your letter about Millet has good passages—better observed than what you say about Lhermitte, for whom you can safely keep your sympathy, it seems to me. Don't immerse yourself in that absolutely sterile carping about who's the first, who the second &c., that's nothing but nonsense and stupidity. There are enough who do that, and you, be one of those who think Millet very good and Lhermitte too, so that you leave no room to fret about who's *the best, the first*—they're both *above the mark*.

What would be the point of making comparisons between Rembrandt and Nicolaas Maes or Vermeer—nonsense, eh?—so stop it.

There was also something I wanted to ask you about Millet. Do you think that Millet would have become Millet if he'd lived childless and without a wife?

He found his inspiration the more easily and sympathized with the simple folk better and deeper because he himself lived like a labourer's family—but with infinitely more feeling than an ordinary labourer. Millet's motto was: God blesses large families—and his life proves that he meant it. Would Millet have been able to do this without Sensier? Perhaps not. But why did Millet break with those men who were originally his friends and from whom he had an annuity? Sensier says enough about this to make out that the trouble was that they rated both Millet's person and Millet's work as mediocre, and plagued both themselves and Millet with it until that pitcher finally broke, having been too many times to the well. And yet Sensier doesn't go into details about those days—just as if he understood that Millet himself found that time a dreadful bore and preferred not to think of it. Sensier says somewhere that when Millet thought about his first wife and the struggle of those days, he would clasp his head between his two hands with a gesture as if the great darkness and inexpressible melancholy of that period overwhelmed him again. His domestic life was more successful the second time—but he wasn't with those original people any more.

439 | Nuenen, on or about Tuesday, 18 March 1884 | *To Anthon van Rappard* (D)

My dear friend Rappard,

Thank you for your letter—which made me happy. I was pleased that you saw something in my drawings.

I won't go into generalities about technique, but I do foresee that, precisely when I become stronger in what I'll call *power of expression* than I am at this moment, people

will say, not *less* but in fact *even more* than now, that I have *no* technique. Conse-
quently—I'm in complete agreement with you that I must say even *more forcibly* what
I'm saying in my present work—and I'm toiling away to strengthen myself in this
respect—but—that the general public will understand it better *then*—no.

All the same, in my view that doesn't alter the fact that the reasoning of the good
man who asked about your work, 'does he paint for money?', is the reasoning of a
moaner—since this intelligent creature counts it among the axioms that originality
prevents one from earning money with one's work.

Passing this off as an AXIOM, *because* it can decidedly *not* be proved as a *proposition* is,
as I said—the usual trick of moaners—and *lazy* little Jesuits.

Do you think that I don't care about technique or am not searching for it? I do—
but only to the extent that—I want to say what I have to say—and where I can't do
it yet, or not well enough, I work on it to improve myself. But I don't give a damn
whether my language squares with that of these orators—(you know you made the
comparison—if someone had something useful, true—necessary to say, and said it in
terms that were difficult to understand, what good would it be to either speaker or
audience?).

I want to stay with this point for a moment—precisely because I've often come
across a rather curious historical phenomenon.

Let it be clearly understood: that one must speak in the audience's mother tongue
if that audience only speaks one language—that goes without saying, and it would be
absurd not to take it as read.

But now the second part of the question. Given a man who has something to say and
speaks in the language that his audience is also naturally familiar with.

Then—the phenomenon that the *speaker of truth* has little *oratorical chic* will manifest
itself time and time again—and does *not* appeal to the *majority* of his audience—indeed
is branded a man 'slow of speech' and *despised* as such.

He may consider himself lucky if there is one, or a very few at most, who are edified
by him, because these listeners weren't concerned with oratorical tirades but precisely,
effectively with—the truth, usefulness, necessity of the words, which enlightened,
broadened them, made them freer or more intelligent.

And now the painters—is the purpose and *non plus ultra* of art those singular *spots* of
colour—that waywardness in the drawing, that which is called distinction of tech-
nique? Certainly not. If one takes a Corot, a Daubigny, a Dupré, a Millet or an Israëls—
fellows who are certainly the great forerunners—their work is BEYOND THE PAINT, it
stands apart from the chic fellows, just as an oratorical tirade (by, say, a Numa Roumes-
tan) is something very different from a prayer or—a good poem.

One MUST therefore *work* on technique in so far as one must say what one feels bet-
ter, more accurately, more profoundly, but—with the less verbiage the better. But the
rest—one needn't occupy oneself with it.

Why I say this is because I believe I've observed that you sometimes think things in
your own work aren't good, which to my mind are good. In my view, *your* technique
is better than, say, Haverman's—because already your brushstroke often has something
singular, distinctive, reasoned and deliberate about it, which in Haverman is endless
convention, always redolent of the *studio*, not of nature.

Those sketches of yours that I saw, for instance, the little weaver and the old women

of Terschelling, appeal to me — they get to the heart of things. I get little but malaise and boredom from Haverman.

I'm afraid that in the future, too — and I *congratulate* you on it — you will ALSO hear the same comments about technique, as well as about subject and everything, in fact, even when that brushstroke of yours, which already has so much character, gets even more.

There are however art lovers who do, after all, appreciate precisely those things that have been painted with emotion.

Although we're no longer in the days of *Thoré* and of Théophile Gautier — alas. Just think about whether it's wise, particularly nowadays, to talk a lot about technique — you'll say I'm doing that here myself — actually I do regret it.

But for my part, I intend to tell people consistently *that I can't paint*, even when I've mastered my brush much better than now. You understand? — *especially then*, when I really will have an individual manner, more finished and even more concise than now.

I liked what Herkomer said when he opened his own art school — for a number of people *who could already paint* — he kindly asked his students if they would be so good as to *not* want to paint like him — but according to their own nature — I am concerned, he says, with setting originality free — not with winning disciples for Herkomer's *doctrine*.

Lions do not ape one another.

Well, I've painted quite a lot these last few days, a seated girl winding shuttles for the weavers, and the figure of the weaver separately.

I'm longing for you to see my painted studies sometime — not because I'm satisfied with them myself, but because I believe that you'll be convinced by them that I really am exercising my hand and, when I say I care relatively little for technique, it's not because I'm saving myself trouble or trying to avoid difficulties. Because that's not my system.

I'm also longing for you to get to know this corner of Brabant sometime — much more beautiful than the Breda side in my view. It's delightful here at the moment.

There's a village here — *Son en Breugel*, which is amazingly like Courrières, where the Bretons live — yet the figures over there are at least as beautiful. As one starts to appreciate the *form* more, one sometimes takes a dislike to —'the Dutch traditional costumes', as they're called on the photograph albums that they sell to foreigners.

I'm sending you herewith a little booklet about Corot — which I think you'll enjoy reading if you don't know it — there are several accurate biographical details in it. I saw the exhibition at the time, for which this is the catalogue.

What's remarkable in it is that that man ripened and matured for so long. Just look at what he did at different times in his life. I've seen examples of his first ACTUAL WORK — itself the result of years of study — honest as the day is long, thoroughly sound — but how people must have despised it! Corot's *studies* were a lesson to me when I saw them, and was already struck at the time by the difference from studies by many other landscape painters.

If I didn't see *more technique* in *your* little peasant cemetery than in Corot's studies — I'd liken it to them. In sentiment it's identical — an endeavour to express only the intimate and the essential.

What I'm saying in this letter amounts to this — let's try to get the hang of the

secrets of technique so well that people are taken in and swear by all that's holy that we have no technique.

Let the work be so skilful that it *seems* naive and doesn't stink of our cleverness.

I don't believe that *I* have reached this desirable point *yet*, for I don't even believe that *you*, who are further on than I am, are already there.

I believe you'll see more in this letter than nitpicking about words.

I believe that the more one has to do with nature itself — the deeper one penetrates into it — the less attraction one sees in all these studio tricks, and yet, I do want to take them as they are and *see* them painting. I would really like to spend a lot of time in studios.

> Not in the books have I found it
> And from the 'learned' — oh, little learned

is in De Génestet, as you know. One might say as a variant on this,

> Not in the studio have I found it
> And from the painters ⎫
> ⎬ oh, little learned.
> the connoisseurs ⎭

Perhaps my inserting painters or connoisseurs as equals shocks you.

But changing the subject — it's devilishly difficult to feel nothing, not to be affected by what such moaners as 'does he paint for money' say. One hears that rot day in and day out, and later one gets angry with oneself for having taken any notice of it. That's how it is with me — and I think that it must occasionally be the same with you. One doesn't give a damn about it, but all the same it gets on one's nerves — like when one hears someone singing off-key or *is pursued by a barrel-organ with a grudge against you*. Don't you think that's true about the barrel-organ, and also that it seems to pick on you specifically?

For wherever one goes, it's the same old tune everywhere.

Oh, as to me — I'm going to do what I tell you — when people say this and that to me — I'm going to finish their sentences before they do — in the same way as, when I know someone is in the habit of offering me a finger instead of a hand (I pulled it off yesterday with a venerable colleague of my father's), I for my part also have one finger ready and, keeping a straight face, carefully touch his with it when shaking hands — in a way that the man *can't* say anything about it but realizes I'm bloody well getting my own back on him.

Well, I've recently made somebody very angry with something of the sort — does one lose anything by it? No, for in truth these people are a hindrance, and the fact that I write to you about some expressions you use is to ask you: are you sure that those who are praising technique to the skies are in good faith? I just ask it precisely because *I know that your aim is to avoid studio chic.*

My dear Theo,

I just received your letter and the 250 francs enclosed. If I may regard your letter as a reply to my proposal, I would certainly be able to accept what you say. For my part I simply wish—in order to avoid correspondence, dispute—in order to be able to say something when one is railed at in daily life by one person or another as being 'without means of support'—that *if* I continue to receive the usual from you, I may regard it as money that I've earned. Naturally I'll send you work every month. That work, as you say, is then your property—and I completely agree with you that in that case you have every right to do nothing with it—indeed, I wouldn't even be in a position to object if you thought fit to tear it up.

I for my part, needing money, am obliged to accept it even if someone says to me 'I don't want to do anything with this drawing of yours or burn it, you can have this much for it'—in the circumstances I'd say—very well—give me the money—here you have my work—I want to get on—in order to get on I must have money—I'm seeing to it that I get it—and so—if need be, even if I really didn't give a damn about you, as long as I receive money from you each month that is useful and necessary to me (without conditions that I may not do this, that or the other), I won't break the ties, and if need be I'll put up with anything.

This way of mine of regarding you and your money balances your way of regarding me and my work—and as long as it remains in balance—I'll accept it.

If I receive money from you, you drawings or paintings from me—and I have something to justify myself in the view of society and we otherwise have nothing in common with each other, if need be—don't write or talk about anything—even then it's enough for me for the moment and I accept it completely. Even if it pleases you to tear my work up or if you want to do nothing with it, or if you want to do something with it, I no longer have the right to criticize *as soon as, for my part, I may regard it as a purchase.*

Be so good as to tell me which term of abuse I used about your friend Braat in my letter.

In my letter, as far as I know, there was nothing about Braat except that I thought he was already ill in the months that I knew him at G&Cie in Paris. At that time, as far as I can recall, I got on very well with him, and I really don't understand how you get the idea that I 'can't stand' him. So many years have passed, so much has changed for me in those years, that the people I knew then are fairly vague and indistinct in my memory and—that I seldom if ever think about them—which nobody can blame me for, I believe. But as to Braat, far from my not wanting to take any special notice of him, now that you've written about it that way, will you please assure him that my sympathies are with him, as they would be with any sufferer, and that, if he happens to remember me, I send my regards and wish him as much peace and serenity as one may have in such a situation. Yet what good does such a wish do him—not much—so, unless one is called upon to say something, one keeps such things to oneself. I would ask you though, if you've said something to him about my having written about him in the way you reproach me with, to tell him that you had only seen that term of abuse in your imagination. For you definitely won't find it in my letter.

You write that you had tried to answer my letters, but had left off. For my part, too, I had wanted to write to you since then, but also left off.

Know that if you don't want to do anything with the work you buy from me, or tear it up if need be, this will be no reason for me not to do my best in it.

For this month I have some pen drawings for you; in the first place the ones that are with Rappard at the moment — about which I have a letter from him that he thought they were ALL beautiful, and the sentiment in Behind the hedgerows and the Kingfisher PARTICULARLY beautiful. Then those first 3 Winter gardens too, which he was also taken with. Aside from those, I have some painted studies that are *your property* — to do with just as you will — which I can send you *if you wish* — which, if you yourself don't care to have them, I would ask you if I might keep for a while so as to work from them.

One is a large weaver who is weaving a piece of red cloth — the little church amidst the wheat — a view of a little old village near here.

I'd just like to come back to your letter about my drawings — the one you say I've interpreted utterly impossibly.

I see in it first that, among the things you say, there are a few whose tenor is that there were things that pleased you in the tone, in the sentiment — so much the better — if you will, that gives me a good deal of pleasure.

Second, in that letter there's a comparison of the schools of Millet and Lhermitte. I found what you said about Millet better and more sensitive expressions than I am used to from you — this was overshadowed, however, by the way you were again tired of Lhermitte, and I'd also like to say about your whole argument once again, you're splitting your hairs too thin — why didn't you take a broader view, why didn't you feel the same enthusiasm for both (who to my mind are to each other as Rembrandt is to Maes, say) without immersing yourself in barren hairsplitting about who is the greater?

Third, there was something that was *not* in that letter, namely an answer to the question as to whether we'd go on or not.

That was the question that it was all about, and since my work depends on my paint and tools (to an extent that I can't ignore), and they in turn on whether or not I receive money, I can't possibly ascribe much usefulness to that letter.

It would be less impossible for me to preserve my composure in our correspondence if, when you don't have the money on the date, you were to write, I haven't got it, you'll get it at such and such a time. Now you wrote not a word in response to my saying: it surprises me that I hear nothing, my having said I'd rather have it at once than later, because you said that if I need it I can get the money by return. If you'd written again then, I'm sorry but I haven't got it, I shouldn't have had to get ideas into my head that you're *deliberately* being lax in order to make my life a bit more difficult. And — when you *haven't got* it, I can't take it amiss — when you *ignore* — deliberately or not deliberately — that's something that I really wish you could cure yourself of, and something about which one really has to get angry. What I said about doing something with my work, in Antwerp, for instance, definitely is my plan.

The frame of mind in which you now are about me, the frame of mind in which I now am about you, is cool enough simply to ask and to reply coolly. After all — leaving aside — giving a damn about each other or not — can I count on its being fixed for

1 year that I'll continue to receive the usual monthly in return for supplying my work? Why I have to know this is because, if I can count on it, I would take a slightly roomier studio somewhere, which I need in order to be able to work with a model.

The one I have at present has the following geographical location,

[Sketch 440A]

and my powers of imagination aren't strong enough to think this an *improvement* on the situation last year. This doesn't alter the fact that, if I complain about something, there appear in your letters such passages as: I (Theo) think that your position is better now than last summer. Really? And I also draw the little map in response to your expression 'I'm not aware' &c., and I would also not be content with this letter of yours if that wasn't in it.

To which I say — I don't care whether or not you're aware that this or that isn't quite in order, as long as you just don't ask me to walk round befuddled about it, and as long as you give me the means to improve things I have no objection to your being 'aware' of all sorts of things.

I hope this letter is as cool as yours — and I thank you very much for what you sent — which makes up for the rest — at least makes it such that, if I could count on its continuing thus for a year, I ask nothing more of you and will right gladly send you my work.

And would just suggest one other small thing to you: that *if* I can sell something in Antwerp or somewhere, I notify you of it, and it's *deducted* from the 150 francs.

I don't write to Rappard about business matters — at least I haven't told him that latterly I haven't been on terms with you as in the past. Just think about whether it's quite in order that you, who know Rappard, have never seen anything of his work, have absolutely no idea what he's doing — no longer take any notice whatsoever of him, except perhaps by hearsay from me. Yet he's one of the people who will amount to something — with whom people will have to reckon — of whose work people will have to take notice. At the time Rappard came to you and felt small in your presence, you who knew so much about art. Since that year he was in Paris — how immensely he has progressed — but you — haven't you rested on your laurels a bit???

De stemming waarin gy nu zyt jegens
my De stemming waarin ik nu ben
jegens u is koel genoeg om eens
koel weg te vragen en te antwoorden
Après tout — malarij aan elkaar of
niet — Daargelaten — kan ik
er op rekenen gedurende 1 jaar dit
vast staat dat tegen levering van myn
werk maandelyks ik het gewone blyf ontvangen
Waarom ik dit weten moet is omdat ?
als ik er op rekenen kan ik ergens weer
een ruimer ateliertje zou nemen dat ik
noodig heb om met model te kunnen
werken —

Dat wat ik tegenwoordig heb heeft de volgende
geographische ligging.

en myn verbeeldingskracht is niet sterk genoeg
om dit vooruitgang te vinden op den toestand
van verleden jaar — Dat neemt niet weg er als
ik over uitsteaag en passages in uw brieven voorkomen als:
ik (Theo) vind dat uw positie nu beter is dan verl. zomer
zoo — ik leeken het kaartje ook als repliek van uw
expositie „ ik ben me niet bewust" &c.

440A. Plan of the studio

My dear Theo,

Because it's *possible* that you didn't properly understand what I asked you before, and so that there can't be any question later of having misunderstood something or anything like that, I say it again.

At the end of January or beginning of February I wrote to you that, on coming home, it became all too evident to me that the money which I usually received from you was regarded firstly as something PRECARIOUS, secondly as, yes, what I'll call a gift of charity to a poor nincompoop. While I could observe that this opinion was even imparted to people who have absolutely *nothing* to do with it — for instance the respectable natives of these parts — and, for example, 3 times in one week I heard people who were then complete strangers to me ask, 'why is it that you don't sell?' Just how pleasant everyday life is when one sees this all the time, I leave to you.

In addition to this, I had already made up my mind this summer — on account of your letting me feel the reins then, that it was in my interests to go along with this and that — just to let you feel that, for my part, if you made it difficult for me by fiddling with those reins a lot, *I would leave the reins in your hands but not be on the end of them myself* — in other words — if I'm not at liberty in my private life, I decline this allowance from you. In short that my *work* (*not my private life*) should be what determined whether or not I stayed on my feet financially, at least as far as the 150 francs are concerned. Summing these things up, I said in a letter at the end of January that I didn't want to keep it exactly as it was until today, namely *without* any specific agreement.

That I would like, though — would even like very much — nothing better than that — to go on in the same way, provided there's a specific agreement about supplying work.

And that to try this out I would send one thing and another by March.

Your answer was evasive, it certainly wasn't something forthright like: Vincent, I appreciate all these complaints and I approve of us coming to an agreement that you will send me drawings monthly which you can consider as the equivalent of the 150 francs that I usually send you, so that you can consider this money as money earned. I most certainly noticed that you simply did *not* write anything like the above.

Well, I thought, I'll send one thing and another by March anyway and see how it goes. I then sent 9 watercolours and 5 pen drawings, wrote to tell you that I had a 6th pen drawing as well, and the painted study of the old tower that you had especially wished for at one time. But now that I see that your expressions remain *just as* vague, I can do nothing other than say to you most decidedly that this is no way to behave.

As far as my work is concerned, up to now it was indeed apparently the case that you would rather I didn't send something than that I did.

If that's still the case — well, then in my view either I'm not worthy of your patronage or you think only too flippantly about my drawings.

I have still not withdrawn my proposal for a regular supply of work. When I speak of the fact that I want to be able to consider the 150 francs or whatever it may be, more or less as the equivalent of what I send you, *in this respect* it's still a very private affair,

and we leave aside altogether the question of whether or not my work has *commercial value*.

But then I'm more justified in the view of Tom, Dick and Harry, whom I don't have to anticipate accusing me of living off private means or — *absolutely* regarding me as '*having* NO *means of support*'.

At the same time, it's a sign of confidence in my future on your part, which I most certainly won't try to *force* on you, though — and I tell you again that whatever you decide in this matter won't change the past, and that I *most certainly won't* ignore your help in the past and really will appreciate it.

But you have to decide entirely of your own accord whether or not our relationship will endure in the future — for the current year, say.

I end with the assurance, though, that if you refuse to enter into my proposal to supply you with work regularly (you can do whatever you like with that work as regards whether or not you deal in it, although I do in any event insist that you show it from time to time as you already did at the very outset, and rightly to my mind) then I would go ahead with a separation. It seems to me that honour is at stake — so EITHER *this change* OR — *finished*. Regards.

Yours truly,
Vincent

What I prefer not to hear later would be that this or that agreement is more a notion of mine than the intention of the other side, namely yours. You know that you told me C.M. said something of the sort to you about me this summer. As a result I learned that it was important to dot the i's and cross the t's where agreements are concerned.

I believe, because I already wrote to you repeatedly about this change, that by now summing it up once again, everything has been explained plainly and clearly enough, and that for my part I may also ask for a plain yes or a plain no.

The reason I haven't sent you the 6th pen drawing yet is because, just as I insist that you show my work now and then, I'll also occasionally let Rappard see some of my things from now on, since he knows quite a few people — and that drawing was with R. at the time and I should have got it back, but he still has it along with two other '*winter garden*' pen drawings.

Well then, I've already dropped you a line about the painted study in a previous letter, that I was discouraged from sending it because if you don't see anything in the ones from Drenthe I don't think you'll like this one either. It seems to me — as I recall — that among the ones from Drenthe there are some that I would do precisely the same way if I had to do them again.

For the current month I already had the following drawings, *Winter garden* —
Pollard birches — *Avenue of poplars* — the *Kingfisher*, which I would otherwise have sent you in April.

My dear Theo,

I've already left it too long before answering your last letter—and you'll see how it came about. Let me start by saying that I thank you for your letter and for the enclosed 200 francs. And then I'll tell you that today I've just about finished arranging a spacious new studio I've rented. Two rooms—one large and one small—en suite. I've been rather busy because of it this last fortnight. I believe I'll be able to work a good deal more pleasantly there than in the little room at home. And hope that you'll approve the step I've taken when you've seen it.

By the way, of late I've continued working hard on the large Weaver—which I mentioned to you recently—and also started a canvas of the little tower you know.

I think what you write about the Salon is very important. What you say about *Puvis de Chavannes* gives me *very great* pleasure that you see his work thus, and I'm in complete agreement with you in appreciating his talent.

And as regards the colourists—it's after all the same with me as with you—I can immerse myself in a Puvis de Chavannes, and yet that doesn't alter the fact that I should feel the same for Mauve's landscape with cows and Israëls's paintings as you feel for them.

As regards my own colour, in the work I'm doing here you'll find *not* silvery but rather brown tones (Bitumen, for instance, and Bistre)—which I don't doubt some people would take amiss of me. But you'll see for yourself what it's like when you come. I've been so busy painting that recently I haven't made a single drawing between times.

I've heard from Rappard that he's coming at the end of this week, which pleases me greatly. What's more, I have the idea that this year he'll come back again for a little longer.

He's bringing a number of drawings of mine, which I'll then send you right away.

Perhaps—*in a while*—I'll agree with you that my position has improved because of the change last year, and that that change was good.

It will always be a sadness to me, though, that I had to give something up then that I'd have liked to pursue further at the time.

Ma is doing very well, in my view—yesterday she came to my new studio in her bath chair. Walking is getting better, although old age considerably frustrates her progress, which continues regularly now, although not as fast as one might think could be the case.

I've recently been getting on better with the people here than at the outset, which is worth a great deal to me, for one has a definite need to be able to give oneself a little distraction, and when one feels too lonely the work always suffers in consequence. One must, however, perhaps prepare oneself that these things won't last for ever.

But I'm in good heart—it seems to me that the people in Nuenen are generally better than those in Etten or Helvoirt—there's more sincerity here—at least that's my impression now that I've been here a while. People do take a sanctimonious position in what they do—that's true—but in such a way that for my part I have no scruples about

going along with it a bit. And reality sometimes comes very close to the Brabant that one has *dreamt*.

My original plan of settling in Brabant—which fell to pieces—I must confess is attracting me strongly again. Yet knowing how something like that can collapse, we have to see whether or not it would be an illusion. Anyway, I have enough to do for the time being. I now have the space again to be able to work with a model.

And as to how long it will last, there's no telling.

Well, regards—the Salon will certainly give you plenty to do, but at the same time also be an interesting time.

Thanks again for what you sent, which I really needed because of this change, by the way. I hope you'll be able to agree with it when you see how I've fitted it out.

Adieu, with a handshake.

Yours truly,
Vincent

Regards from everyone at home, and they ask whether you won't write to them sometime. Pa has been to Breda; Aunt Bertha was doing well and the dressing had been taken off.

450 | Nuenen, mid-June 1884 | *To Theo van Gogh* (D)

My dear Theo,

I think I already told you in my last letter that I also wanted to start a large male figure as well as that woman spinning. I now send you a little scratch of it herewith. Perhaps you remember two studies of the same corner, which I already had in the studio when you were here.

I read Les maîtres d'autrefois by Fromentin with great pleasure. And in different places in that book I again found the same questions dealt with that have preoccupied me very much recently, and about which I actually think continually, specifically since, at the end of my time in The Hague, I indirectly heard things that Israëls had said about starting in a low register and making colours that are still relatively dark appear light. In short, expressing light through opposition with dark. I already know what you say about 'too black', but at the same time I'm still not completely persuaded that, to mention just one thing, a grey sky always HAS to be painted in the local tone. Which Mauve does; but Ruisdael doesn't do it, Dupré doesn't do it. Corot and Daubigny???

Well, as it is with the landscape, so it is with the figure too—I mean, Israëls paints a white wall quite differently from Regnault or Fortuny. And consequently the figure looks quite different against it.

When I hear you talk about a lot of new names, it's not always possible for me to understand when I've seen absolutely *nothing* by them. And from what you said about 'Impressionism', I've grasped that it's something different from what I thought it was, but it's still not entirely clear to me what one should understand by it.

But for my part, I find so tremendously much in Israëls, for instance, that I'm not particularly curious about or eager for something different or newer.

Fromentin says of Ruisdael that people nowadays are *much more advanced* in technique than he was. They're also more advanced than *Cabat* — who's sometimes very like R. because of his dignified simplicity, for instance in the painting in the Luxembourg. But does this mean that what R., what Cabat said has become untrue or superfluous? No. The same with Israëls, too — with Degroux, too (Degroux was very simple).

If one says what one says clearly, though, this isn't enough, strictly speaking.

And saying it with more charm might make it more pleasant to hear (which I don't disparage, however), but it doesn't make what is true *very much* more beautiful, since the truth is beautiful in itself.

[*Sketch 450A*]

[*Paint sample 1, framed*]

This is the *very highest* note in the study of the little old man, which expresses the snowy white of his skein of yarn *in the light*. That same white is much darker still in the shadow.

[*Paint sample 2, preceded by an arrow*]

The measurement of the subject overleaf is about 105 x 95 cm, and that of the woman spinning 100 x 75. They're painted in a tone of bistre and bitumen which, it seems to *me*, lends itself to expressing the WARM chiaroscuro of an airless, dusty interior. Artz would certainly think it too dirty.

It has bothered me FOR A LONG TIME, Theo, that some of the painters now-adays are taking from us the bistre and the bitumen with which, after all, so many

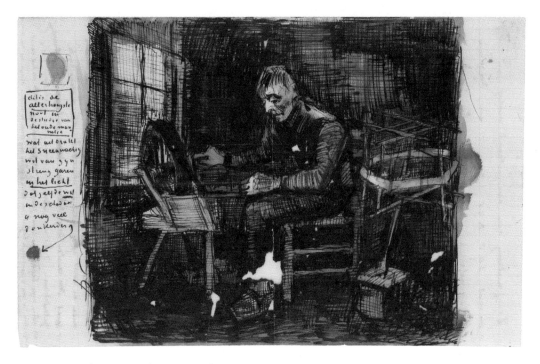

450A. *Man winding yarn* and paint samples

magnificent things were painted, which—properly used, make the coloration lush and tender and generous, and at the same time so dignified. And have such highly remarkable and individual qualities.

At the same time, though, they require that one take the trouble to learn to use them, for one has to deal with them differently from the ordinary types of paint, and I consider it perfectly possible that many people are frightened off by the experiments that one has to do first, and that naturally don't succeed on the first day that one starts to use them. It's now something like *a year* ago since I started using them, specifically for interiors, but at first they really disappointed me, and yet I always remembered the beautiful things I'd seen in them.

You have a better opportunity than I do to hear about books on art. If you come across good works by people like, say, the book by Fromentin on the Dutch painters, or if you remember any from the past, be aware that I'd *very much like* you to buy a few sometime, provided they deal with *technique*—and deduct it from what you usually send. I do intend to learn the theory—I don't regard it as useless at all, and believe that often what one feels or suspects instinctively leads to certainty and clarity if, in one's search, one has some guide in truly practical words. Even if there's just *one* or *a very few* things of that nature in a book, it's sometimes worthwhile not just to read it but actually to buy it, particularly nowadays.

And in the days of Thoré and Blanc there were people who wrote things that are now, unfortunately, already beginning to pass into oblivion.

To mention just one thing. Do you know what *an unbroken tone* and what *a broken tone* is? You can certainly *see* it in a painting, but do you also know how to explain what you see? What they mean by *broken*?

One should know this sort of thing, theoretically too, be it as a practitioner when painting or as an expert talking about colour.

Most people understand *what they want to* by it, and yet these words, for instance, have a VERY SPECIFIC meaning.

The *laws* of colour are inexpressibly splendid precisely because they are not *coincidences*. Just as people nowadays no longer believe in random *miracles*, in a God who jumps capriciously and despotically from one thing to another, but are beginning to gain more respect and admiration for and belief in nature, just so and for the same reasons I believe that people should—I don't say ignore—but thoroughly scrutinize, verify and — very substantially alter the old-fashioned ideas of innate genius, inspiration &c. in art.

I don't deny the existence of genius, though, nor even its innate nature. But I do deny the inferences of it, that theory and training are always useless by the very nature of the thing.

I hope, or rather, I'll try to do *the same thing* that I've now done in the little woman spinning and the old man winding yarn much *better* later on. Yet in these two studies from life I've *been a bit more myself* than I've succeeded in being in most other studies till now (barring a few of my drawings).

As to black—*as it happened* I didn't use it in these studies, since I needed a few stronger effects than black, among other things——and indigo with terra sienna, Prussian blue with burnt sienna actually produce much deeper tones even than pure black.

What I sometimes think when I hear people saying 'there is no black in nature' is — there doesn't have to be any black in paint either.

Don't, whatever you do, get the mistaken idea that the colourists don't use black, because it goes without saying that as soon as an element of blue, red or yellow is added to black, it becomes a grey, that is a *dark* red, yellow or blue grey.

Among other things I thought what C. Blanc says in Les artistes de mon temps about Velázquez's technique was very interesting—that his shadows and half-tones usually consist of *colourless cool greys* of which black and a bit of white are the chief components—in which neutral, colourless parts the least little dash or hint of red, say, is immediately apparent.

Well—regards, do write soon when you have something to write. It does surprise me rather that you don't feel *as much* for Jules Dupré as I wish you did.

I believe so firmly that if I were again to see what I've seen by him before, far from finding it less beautiful I would find it *even more* beautiful than I already did instinctively. Dupré is *perhaps* even more of a colourist than Corot and Daubigny, although they both are too, and Daubigny really is very *daring* in colours. But with Dupré there's something of a magnificent symphony in the colour, *carried through, intended, manly.* I imagine Beethoven must be something like that. This symphony is *surprisingly* CALCULATED and yet simple and infinitely deep, like nature itself. That's what I think about it — about Dupré.

Well—adieu, with a handshake.

Yours truly,
Vincent

456 | Nuenen, on or about Tuesday, 16 September 1884 | *To Theo van Gogh* (D)

My dear Theo,

You're quite right to ask why I haven't replied to you yet. I did indeed receive your letter with 150 francs enclosed. I began a letter to you, chiefly to thank you because you seemed to have understood my letter, and also to tell you that I only *count* on 100 francs, but actually find it hard to manage on it as long as things don't progress. But nevertheless, if it's 150 francs, there's a 50 francs windfall extra in so far as our *very first* agreement BEFORE *The Hague* was only 100 francs, and if we're only half good friends I wouldn't want to accept more.

However, I couldn't finish that letter, and since then I've wanted to write to you but I haven't been able to find the right words. Something has happened, Theo, which most of the people here know or suspect *nothing* about—nor may ever know, so keep as silent as the grave about it—but which is terrible. To tell you everything I'd have to write a book—I can't do that. Miss Begemann has taken poison—in a moment of despair, when she'd spoken to her family and people spoke ill of her and me, and she became *so* upset that she did it, in my view, in a moment of definite *mania.* Theo, I had already consulted a doctor once about certain symptoms she had. 3 days before I'd warned her brother in confidence that I was afraid she would have a nervous breakdown, and

that to my regret I had to state that I believed that the B. family had acted extremely imprudently by speaking to her as they did.

Well, this didn't help, to the extent that the people put me off for two years, and I most definitely wouldn't accept this since I said, *if* there's a question of marriage here it would have to be very soon or not at all.

Well Theo, you've read Mme Bovary; do you remember the FIRST Mme Bovary, who died of a nervous fit? It was something like that here, but complicated here by taking poison. She had often said to me when we were taking a quiet walk or something, 'I wish I could die now' — I'd never paid attention to it.

One morning, though, she fell to the ground. I still only thought it was a little weakness. But it got worse and worse. Cramps, she lost the power of speech and mumbled all sorts of only half-comprehensible things, collapsed with all sorts of convulsions, cramps etc. It was different from a nervous fit although it was very like one, and I was suddenly suspicious and said — have you taken something by any chance? She screamed 'Yes!' Well, I acted boldly. She wanted me to swear I'd never tell anyone about it — I said, fine, I'll swear anything you want, but on condition that you vomit that stuff up straightaway — stick your finger down your throat until you vomit, otherwise I'll call the others. Anyway, you understand the rest. The vomiting only half worked and I went with her to her brother Louis, and told Louis, and got him to give her an emetic, and I went straight to Eindhoven, to Dr van de Loo. It was *strychnine* that she took, but the dose must have been too small, or she may have taken chloroform or laudanum with it to numb herself, which would actually be an antidote to strychnine. But, in short, she then quickly took the antidote that Van de Loo prescribed. No one knows except her herself, Louis B., you, Dr van de Loo and me — and she was rushed straight to a doctor in Utrecht, and it's been put about that she's on a trip for the firm, which she was about to embark on anyway. I believe it's *probable* that she'll make a full recovery, but in my view there will certainly be a long period of nervous trouble, and in what form this will manifest itself — more serious or less serious — is very much the question. But she's in good hands now. Still, you'll understand how depressed I am because of this event.

It was such a dreadful fright, old chap; we were alone in the field when I heard that. But fortunately at least the *poison* has worn off now.

But what sort of a position is it, then, and what sort of a religion is it that these respectable people subscribe to? Oh, they're simply *absurd* things and they make society into a sort of madhouse, into an upside-down, wrong world. Oh, that mysticism.

You understand that in these last few days everything, everything passed through my mind, and I was absorbed in this sad story. Now she's tried this and it has *not* succeeded, I think she's had such a shock that she won't lightly try for the second time — a failed suicide is the best remedy for suicide in the future. But if she has a nervous breakdown or brain fever or something, then — — — Still, everything's gone *fairly* well with her these first few days — only I fear there'll be repercussions. Theo — old chap — I'm so upset by it. Regards, do drop me a line, because I'm speaking to NO ONE here.

Adieu,
Vincent

Do you remember that first Mme Bovary?

398 | Nuenen, September 1884

My dear Theo,

Thanks for your letter, thanks for the enclosure. Now listen here.

What you write is all very well and good, and as far as fuss is concerned I'm beginning to be a bit better prepared to forestall it than before. No fear that Pa and Ma will leave, for instance. *Although a call came just now.* On the contrary, if they set about it the right way, Pa and Ma will be able to consolidate their position here.

Now there are people who say to me, 'what were you doing getting involved with *her*?' — that's *one* fact. Now there are people who say to her, 'what were you doing getting involved with *him*?' — that's a second fact. Apart from that, *both* she *and* I have sorrow enough and trouble enough — but regret — neither of us. Look here —

I certainly believe or know for sure that she loves me,

I " believe " " " " " I " her

that has been sincere — has it also been crazy — etc.? Perhaps it has, *if you like*, but *the wise people* who never do anything that's crazy, aren't they even crazier in my eyes than I in theirs?

That can be said against your argument and other arguments.

I say all this simply *by way of explanation*, not hostilely or nastily.

You say you like *Octave Mouret*, you said you're like him. Since last year I've also read the second volume, in which he pleases me much more than in the first.

I recently heard it said that 'Au bonheur des dames' wouldn't add particularly to Zola's reputation. I find some of the *greatest* and *best* things in it. I've just looked it up, and I'm copying out a few of Octave Mouret's words for you.

You — haven't you gone to the *Bourdoncle* side *over the last* 1½ years or so? Would have done better to stick with Mouret; that was and still is my opinion. Aside from an enormous difference in circumstances, indeed diametrically opposed circumstances, I tend more towards the Mouret direction than you might think — as regards my belief in women and that one needs them, must love them. (Mouret says, '*in our establishment, we* LOVE *the customers*'.)

Think about this — and remember my sorrow about your saying that you had 'cooled'.

I repeat more forcefully than ever everything I said by way of bitter warning against the influence of Guizot-ness, as I called it. Why? It leads to mediocrity. And I don't want to see you among the mediocrities because I have loved you, indeed still love you, too much to be able to bear seeing you numbed.

I know it's difficult, I know that I don't know enough about you, I know that I may perhaps be mistaken. But anyway — just read your Mouret again.

I mentioned a difference between Mouret and what I should want, and YET the parallels. Look here. Mouret worships the modern Parisian woman — very well.

But MILLET, *Breton*, worship the *peasant woman* WITH THE SAME PASSION.

These two passions are ONE AND THE SAME.

Read Zola's description of women in a room at dusk — women often already past 30, up to 50 — such a sombre, mysterious little corner.

I find it *magnificent*, indeed *sublime*.

But equally sublime to my mind is — Millet's Angelus, that same dusk, that same infinite emotion — or that solitary figure by Breton in the Luxembourg, or his Spring.

You'll say that I'm not successful. I don't care, *vanquish* or *be vanquished*, in all events one has emotion and motion, and they're more similar than they appear and are said to be.

As regards *this* woman in question, how it must end remains a mystery to me, but neither she nor I will do anything *crazy*.

I fear for her that the old religion will numb and freeze her *again* with that damned icy coldness that has *already* shattered her once in the distant past *to the point of death*, long years ago. Oh — I'm no friend of present-day Christianity, even though the *founder* was sublime — I've seen through present-day Christianity only too well. It mesmerized me, that icy coldness in my youth — but I've had my revenge since then. How? By worshipping the love that *they* — the theologians — call *sin*, by respecting a whore etc., and *not* many *would-be* respectable, religious ladies.

To the one party, *woman* is always *heresy* and diabolical. To me, the opposite. Regards.

Yours truly,
Vincent

Look at this from Octave Mouret —

Mouret says: 'If you believe yourself strong, because you refuse to be foolish and to suffer! Ah, well — then you are nothing but a dupe, no more!'

'Are you enjoying yourself?'
Mouret seemed not to understand immediately. But, when he recalled their old conversations about empty foolishness and the pointless torment of life, he replied: *'No doubt — never have I lived so much . . . Ah! old chap — don't mock! Those are the shortest hours in which one dies of suffering!*

I want her, I'll have her! and — *if* she escapes me you'll see the things that I'll do to cure myself of it. You don't understand this language, old chap; otherwise, you'd know that action contains its reward within itself — to act — to create — to struggle against facts, *vanquish them or be vanquished by them*, all human joy and health are THERE!'

Just a way of deadening oneself — the other muttered.

'Ah, well! I prefer to deaden myself. To die for the sake of dying — I PREFER TO DIE OF PASSION THAN TO DIE OF BOREDOM!'

— it isn't only I who say this last, after all,
 but *she* too, *instinctively,* " "
that's why I saw something grand in her from the outset, and it's just a damned shame for her that *when she was young* she allowed herself to be *overwhelmed* by disappointments.

Overwhelmed in the sense that the Begemann family of the *old* religion *believed it had to suppress* the *active*, indeed *brilliant* principle in her, and made her *passive* for ever and ever.

If only they hadn't broken her when *she was young*! Or if they'd left it at that and not driven her to distraction *again!*, this time with 5 or 6 or *even more women* fighting *against her alone*.

DO READ L'EVANGELISTE BY DAUDET ABOUT THESE FEMALE INTRIGUES, which were different here but *still of the same kind.*

Oh Theo, why should I change? *In the past* I was very passive and very gentle and quiet — not any more, but I'm not a child any more either — sometimes I feel myself.

Take Mauve — why is he irascible and *by no means always mild?* I'm not yet as far as he is, but still I'll get further than I am. I tell you, if one wants to be active, one mustn't be afraid to do something wrong sometimes, not afraid to lapse into some mistakes. To be good — many people think that they'll achieve it by *doing no harm* — and that's a lie, and you said yourself in the past that it was a lie. That leads to stagnation, to mediocrity. *Just slap something on it* when you see a blank canvas staring at you with a sort of imbecility.

You don't know how *paralyzing* it is, that *stare* from a blank canvas that says to the painter *you can't do anything.* The canvas has an *idiotic* stare, and mesmerizes some painters so that they turn into idiots themselves.

Many painters *are afraid* of the blank *canvas,* but the blank canvas IS AFRAID of the truly passionate painter who dares — and who has once broken the spell of 'you can't'.

Life itself likewise always turns towards one an infinitely *meaningless,* discouraging, dispiriting blank side on which there is *nothing,* any more than on a blank canvas.

But *however* meaningless and vain, however *dead* life appears, the man of faith, of energy, of warmth, and who knows something, doesn't let himself be fobbed off like that. He steps in and *does something,* and hangs on to that, in short, *breaks,* 'violates' — they say.

Let them talk, those cold theologians.

Theo, I feel such damned pity for this woman, precisely because her age and just *possibly* a liver and gall bladder disorder are hanging so fatally over her head. And this is made worse by the emotions. Still, we'll see what can be done or what's made impossible by fate. I'll do nothing, though, without a *very good* doctor, so *I* shan't do her any *harm.*

Yet it was *at precisely this time* that it happened that I was asked to make a drawing or painted sketch for 20 guilders. Which I duly acceded to, but because I suspected, and on investigation found my suspicion was correct, that Margot Begemann was behind it and would have given me the money indirectly, I most decidedly refused the *payment* but not the *drawing,* which I sent. It's not easy to refuse it, though, when one is sorely in need of money. But it would have been a bridge of asses — so —

Instead of bridges of asses — is there something better to do? I very definitely believe so. For your sake and mine and for many others, I wish that we could get MOURETS in the *art trade* who knew how to create a *broader, new* buying public.

You'll say, isn't Tersteeg, for instance, a Mouret. Perhaps he is, after all.

But be that as it may, there are still new careers to be made, simply because the public that buys paintings could be multiplied tenfold, and this is becoming more necessary by the day.

Were a few Mourets to emerge, who bought and sold other than according to the old routine, good, then there would be more and more work to be done.

But if no Mourets come — then — perhaps the trade should change utterly because the painters themselves revived it and started their own permanent exhibitions without

the old intermediary. I wish you knew and felt how young you still are *if you would only act young and be daring.*

If you aren't an artist in *painting*, be an artist as a *dealer*, just like Mouret.

For my part — at times like these, when I get completely stuck — I still feel that in a few years' time I'll happily dare take on a great many larger bills for paint and other things. I want to have a lot of work — believe me — I have no intention of being bored — *do a great deal* or *die*.

469 | Nuenen, on or about Friday, 14 November 1884 | *To Theo van Gogh* (D)

My dear Theo,

You'll certainly be interested in how things stand with the call to Helvoirt that Pa received. Pa told the people in Helvoirt that he *certainly couldn't* even consider it unless the H. stipend was brought up to the level of the Nuenen stipend. And Pa writes today that they don't seem to be raising any objections to making up the difference in stipend — they have to add 150 guilders to it, I believe. So although nothing has been decided — given the willingness of the good natives of Helvoirt — there's a real chance that as a result of his own words Pa will have to consider it very seriously. This is important to me, because I would *certainly not* want to go to Helvoirt with them. I just wanted to tell you exactly how things stand.

These last few days, although it's freezing quite hard here, I've been working outdoors on a rather large study (more than 1 metre) of an old water mill in Gennep, on the other side of Eindhoven. I want to finish the whole thing outdoors — but it will definitely be the last that I paint outdoors this year. Since I wrote to you I've also been working on other studies — among them two heads of polder workers.

I now have *3* people in Eindhoven who want to learn to paint and whom I'm teaching to paint still lifes.

I can safely say that I've progressed in painting technique and in colour since your visit. And that this will continue to improve, too.

In painting, it's the first steps that count — it gets easier later, and I have *some* trumps in my hand. And I think there are tricks to be taken with them. Now you know that I made an approach to Mauve and Tersteeg again, to put right what happened in the past.

I don't regret that approach.

But they've refused to have anything to do with it — 'very definitely' refused. This doesn't discourage me.

I regard it as something like sending a painting to an exhibition and having it rejected.

One has to encounter opposition at first, or even several times.

So again, I don't regret my approach, and shall most likely repeat it — not straightaway, exactly — but before too long.

I wanted to tell you now that I'd be very pleased if you didn't just stay neutral in this matter — but on the contrary helped me to get what I want. I've admitted I was wrong, not just to Mauve but to T. as well.

All the more because I believe that later on they themselves will realize that for their part they totally *misunderstood* things.

Which they don't see yet.

So for my part, by going so far this time as to very generously and decidedly admit I was wrong in the past, *moreover* to simply show them *work* as it gets *better*, in any event I won't have to make any more apologies in future. ONCE *is* ENOUGH, and I didn't necessarily even *have to* go as far as I did, namely — *unconditionally*. Getting them to be *generous* for *their* part — is another thing — you could assist in this *if you want to*. If not — don't bother about it, but then after a while I'll return to it again on my own.

I don't know how you'll have taken my last letter — which wasn't meant angrily. *My affairs can prosper*, and in both our interests I wish that we could concentrate the strength we have at our disposal. I've replied briefly to *both* Tersteeg *and* M. about their refusal, to tell them that '*I rather agree with Tersteeg that it would be* BETTER *for me to seek out new people than to try to renew old relationships, that this really is my own idea, too, but above and beyond that, that I nonetheless have enough faith in the future that I will* NOT LIGHTLY *give up regaining* EVEN *old relationships, even better than before*'. This has been my answer to T. And is also what I tell you — I believe that it's possible — to get on *better* terms than the present ones — with you, too.

But — speaking bluntly — I think that you've been too neutral towards me the last 1 ½ or two years, and I wish above all for more *warmth*, and the friendship was too cool and not animated enough for me.

Find this pedantic of me *if you will* — yet it isn't *pedantic* but it's for sound practical reasons that I pointed this out to you before and point it out again.

Margot Begemann is coming back to Nuenen one of these days — I've always remained good friends with her, and it's on my advice that she did *not* give in to her sisters, who let it be seen that they'd rather she stayed away and who keep telling her that in their view she has made a hash of things. On the contrary, her family has obligations towards her, and in the past she put her own money into the business when her brother went bankrupt.

The issue here is that if she and I choose to love each other, be attached to each other — indeed have been for a long time — this is no *wrongdoing* on our part nor something for which people may blame us. Either her or me. And in my view it's absurd that people felt they should get worked up about it — and then — in *their* opinion — in my interest or in hers. That was a bad turn.

Anyone may do this with the best intentions — yet — — — Louis Begemann — he had his objections, too, but *was* such and *remained* such that both she and I could talk to him, and it was precisely because he was humane and calm that it didn't turn out *much worse*, and when that happened with her, which only I knew about, he could *help* and all the others *only hindered*. And we were in complete agreement about the steps to be taken then.

Three days *before*, after all, I had already warned him and said, I'm concerned about your sister.

Most certainly, at some time *she* has done greater or lesser good turns for pretty well *all* the people here in the neighbourhood, either in sickness or when they were in some trouble or other.

And she and I actually became attached during Ma's illness.

She has just written to me: should there be any people sick in Nuenen, do go and visit them and see if anything can be done to help. Well, there are a thousand things of that nature in her.

And to put it very *mildly*, one can say that there has been a most deplorable misunderstanding here.

I think that, with hindsight, you *would now no longer speak as you did on that evening.*

That concerned *me* alone — and *I* could take it, so there's no question of my reproaching you in this matter.

Only as an *explanation* for you, I say, *just as you spoke to me, who can take it,* so her sisters spoke *to her,* who was made distraught by it. You have *nothing to do with it,* because you spoke to *me,* who can take it, and you did *not* speak to *her.*

But the *real fault* lies with her sisters, or rather *one of the sisters* in particular, who proves to be very hard, since she's actually still *sulking* and bearing a grudge.

You — would *have to tell me again yourself* that you bear a grudge — before I would suspect you of it.

So much on my part to you.

482 | Nuenen, on or about Monday, 2 February 1885 | *To Theo van Gogh* (D)

My dear Theo,

I have a great deal to say about your calling my last letter 'particularly unpleasant'.

First of all this — some time ago *you* wrote various unpleasant things to me which I've been hearing from you and others for the past 15 years and more — that's a long time — about relations at home.

With this specially added, 'that you are suspicious'. Well, if it had only been the former, I probably wouldn't have given it any more attention.

That addition of your suspicion, though, that was a bit too much for me, and I repeatedly asked you to take it back or to explain it, because I don't allow something like that to be said without asking for enlightenment.

And in my last letter I compared suspicion in general with a dark glass one looks through.

And said that the nastiest misunderstandings arise because of it.

And that's true.

When you now *turn this round* and write to me, 'you remind me of the old people who say that things were better in their young days than now, forgetting meanwhile that they themselves have changed', this doesn't upset me.

What we were talking about is suspicion, *which not I but you yourself mention,* by you of me. First apply the thing about the old people to that, and *after that* see whether it also applies to me.

If it also applies to me *after that* — then I'll have to change.

What I wrote about a certain atmosphere at home, which I had more opportunity to observe than I cared to, is, I fear, all too true.

When you ask me in your letter how it is that you never hear me say, 'I'd like to be thus or so' — is — because I believe that those who make the greatest parade of 'I'd like to be thus or so' do the least to improve themselves. Those who say it, usually don't do it.

Were I to express myself about such wishes, it would *not be easy* to do so in an atmosphere like the one that now exists between us.

So that's the reason — and since I take pains to improve my work, I don't have to keep lapsing into lamentations.

I'm sorry you didn't send me that No. of L'Illustration; I've been following Renouard a good while, and have what he's done for L'Illustration going back for years. And this is one of the very finest, which I think you would also have been delighted with yourself.

One can't get the old Nos. if one orders them in the bookshop, at least not here. I do wish you could get it. If it's too much trouble for you, leave it, although it's really not that much trouble after all.

And — after all — take note that as far as that suspicion is concerned and what I replied to it, it isn't so much because I won't allow you or others, if need be, to think of me exactly as you will, but I've warned you that it would give you little satisfaction if your character were to set in that mould.

Since you repeatedly say that you know me better than anyone else and yet it still all ends in suspicion, though, this is serious enough for me to decidedly object to it, *and* to that 'know so well', *and* to the other thing, that suspicion. I've a history like that behind me with Pa — I'm not starting on a Pa II.

If I'd kept on top of things with Pa from the start and not simply stayed silent, a great deal wouldn't have happened.

So don't take it amiss that I now say foursquare what I think about it. That's better for both of us. For the rest, old chap, I think I'm working rather too hard for it to be too long before I can reduce the financial burden on you somewhat. It may take me longer than I'd like for you or for me, but keeping on working is a path that can hardly fail altogether. And when I insist on pressing on with it, it's in order to put an end to the possibility of quarrelling. Because even the *possibility* of quarrelling ceases to exist as soon as I find a means of covering myself financially. Then my work will no longer be at issue, and at present it still is.

And therefore don't despair. But now it's wretched for both of us. And for me the work is expensive; I have to paint a lot and I constantly need a model for it; just all the more reason why, at a time when the work is difficult and exacting, and at the same time thankless, it's quite wretched to get suspicion for it. Never mind, it's a period I have to go through, and one doesn't paint for one's comfort.

Thanks for what you sent. Regards.

Yours truly,
Vincent

My dear Theo,

Many thanks for your parcel of L'Illustrations, with which you've given me great pleasure. I like all of the various drawings by Renouard, and didn't know any of them. However — but this isn't to put you to more trouble, but because I wrote things about it that are perhaps not altogether applicable to the other drawings by him — however, the actual composition by R. that I meant isn't among them, that No. may be sold out. The breadth in the figure was superb in it — it was an old man and some women and a child, I think, who sat doing nothing in a weaver's interior where the looms were still.

I hadn't yet seen *anything* from Salon 84 in reproduction, and now at least got some idea of a few interesting paintings from the Salon No. Among other things, of that composition by Puvis de Chavannes.

I imagine that the *Harpignies* with the setting sun must have been magnificent. And the paintings by Feyen-Perrin, of which there are croquis.

What also struck me was a figure of a girl by Emile Lévy, Japonaise, and the painting by Beyle, *Women burning seaweed*, and the one by Collin, Summer, 3 female nudes.

I'm hard at work on painting those heads. I paint during the day and draw in the evening. I've already painted at least 30 or so this way, and drawn as many.

With the result that I see a chance, before long I hope, of doing it very differently. I think that it will help me with the figure in general. Today I had a white and black one, against the flesh colour.

And I'm also always looking for blue. As a rule, the peasant figures here are blue. That, in the ripe wheat or against the withered leaves of a beech hedge, so that the hidden nuances of darker and lighter blue are brought alive again and made to speak by contrast with gold tones or reddish brown, is very beautiful, and has struck me here from the first.

The people here instinctively wear the most beautiful blue that I've ever seen. It's coarse linen that they weave themselves, warp black, weft blue, which creates a black and blue striped pattern. When it's faded and slightly discoloured by wind and weather, it's an infinitely calm, subtle shade that specifically brings out the flesh colours. In short, blue enough to react with all the colours in which there are hidden orange elements, and faded enough not to clash.

But this is a question of colour, and the question of the form is what matters more to me at the point where I now find myself. Expressing the form — I think — works best with an almost monochrome colour scheme, the tones of which vary chiefly in intensity and in value. For instance, The well by Jules Breton was painted in a single colour, almost. But one does have to study each colour individually in association with its opposite before one can be really sure of being harmonious.

I painted a few more studies of our garden when there was snow on it.

The landscape has changed greatly since then — we now have magnificent evening skies of lilac and gold, above the tonal silhouettes of the houses between the masses of the coppices, which are a ruddy colour, above which rise slender black poplars — while the foregrounds are blanched and bleached green, varied by strips of black earth and

dry, pale reeds along the sides of the ditches. I see all that, too—I find it as superb as anyone else—but what interests me even more is the proportion of a figure, the division of the oval of a head, and I have no grasp on the rest until I have more mastery of the figure. In short—the figure first—for my part, I can't understand the rest without it, and it's the figure that creates the mood. I can understand, though, that there are people like Daubigny and Harpignies and Ruisdael and so many others, who are absolutely and irresistibly carried away by the landscape itself; their work is totally satisfying because they themselves were satisfied by sky and soil and a pool of water and a bush. However, I think what Israëls said about a Dupré is a mighty clever saying—it's just like a painting of a figure.

Regards, and thanks again for the illustrations.

Yours truly,
Vincent

484 | Nuenen, on or about Monday, 2 March 1885 | *To Theo van Gogh* (D)

My dear Theo,

Thanks for the prompt dispatch of the money for this month, arriving promptly like that actually helps me more. Thanks, too, for the splendid woodcut after Lhermitte—one of the *few* things by him that I know, for I saw only these—a troop of girls in the wheat—an old woman in church—and a miner or some such in a little bar, and Harvest by him, and otherwise never anything, and nothing ever as much reflecting his actual manner as these woodcutters.

If Le Monde Illustré prints a composition by him every month—this is part of a series of 'Rural months'—it would give me mighty great pleasure to collect this whole series, and I'd really like you to send them every time.

Because obviously I never see anything here, and after all I do need to see something really beautiful now and then, and so another time feel free to keep back 20 francs, say, but send me things like this when they appear in the illustrated magazines.

Now as to when you write that if I had something ready that I thought was good, you would try to enter it for the Salon—I appreciate your wanting to do this.

This in the first place—and then further that if I'd known it 6 weeks earlier, I would have tried to send you something for this purpose.

Now, though, I don't have anything that I would care to send in. Recently, as you know, I've painted heads almost exclusively. And they are *studies* in the true meaning of the word—that is, they're meant for the studio.

Nonetheless, this very day I've started to make some that I'll send you.

Because I think it possible that it might be of use, when you meet a good many people on the occasion of the Salon, if you had something you could show—albeit only *studies*.

So you'll receive heads of an old and a young woman, and probably more than one of these two models. Given what you write of your feelings about various conceptions of heads, I think that these, which come straight out of a cottage with a moss-grown thatched roof, won't appear to you to be absolutely inappropriate, although they're

studies and nothing else. If I'd known 6 weeks earlier, I would have made a woman spinning or spooling yarn—full length—of them.

To return for a moment to that question of the female heads in the Jacquet genre, not the earlier ones but of the present day. The reaction against them—certainly with a motive—by people who paint heads of girls like our sisters, for instance—I can well understand that there are painters who do such things—Whistler did it well several times—Millais, Boughton—to mention only people by whom I saw something of the sort in the past. I know little by *Fantin-Latour*, but what I saw I thought *very good*. *Chardinesque*. And that's a lot. For my part, though, I'm not the sort of character who has much chance of getting on a sufficiently intimate footing with girls of that sort that they're willing to pose. Particularly not with my own sisters. And am possibly also prejudiced against women who wear dresses. And my province is more those who wear jackets and skirts.

Though I think what you say about it is true—namely that it's perfectly *possible* to paint them—and it has a *raison d'être* as a reaction against the present-day Jacquets and Van Beers &c.

Just this, though—Chardin (let's sum up the aim of the reaction in his name, Fantin-Latour, at least, would approve), Chardin was a Frenchman and painted *French women*. And in my view, *respectable Dutch* women like our sisters really do extraordinarily often lack the charm that the French frequently have.

Consequently, the so-called respectable element among *Dutch* women isn't really so very attractive—to paint or to think about. But certain common servant girls, on the other hand, are very Chardinesque.

At present I'm painting not just as long as there's light, but even in the evening by lamplight in the cottages, if I can somehow make things out on my palette, in order to capture if possible something of the singular effects of lighting at night, for instance with a large shadow cast on the wall.

I've certainly not seen anything in the last few years as fine as those woodcutters by *Lhermitte*.

How his little figures in that composition are felt and wanted.

Thanks again for it.

Yours truly,
Vincent

The Chardinesque is, it seems to me, a singular expression of *simplicity* and of *goodness*—both *through and through*, and I find it a little hard to believe that one would find it in our sisters, say, either one of them. But if Wil were a Frenchwoman rather than a minister's daughter, she *could* have it. But *as good as always* sails to the opposite point of the compass.

487 | Telegram, sent from Eindhoven, Friday, 27 March 1885 | *To Theo van Gogh,*
c/o 19 boulevard Montmartre, Paris (F)

Our father fatal stroke, come, but it is over.

Van Gogh

490 | Nuenen, Monday, 6 April 1885 | *To Theo van Gogh* (D)

My dear Theo,

I'm still very much under the impression of what has just happened—I just kept paint-
ing these two Sundays.

Herewith another scratch of a man's head and one of a still life with honesty in the
same style as the one you took with you. It's rather larger, though—and the objects
in the foreground are a tobacco pouch and a pipe of Pa's. If you think you'd like it, of
course you're right welcome to have it.

Ma looks well, and writing many letters provides some distraction for the time be-
ing. But, of course, still very sad. Cor has just gone back to Helmond.

I don't know whether you still remember that in January, when the snow was lying
on the fields and the sun rose red in the mist, I wrote to you that I'd almost never
started a year in a gloomier mood. It's certain that there'll be a whole lot more trouble
for all of us.

Of course you'll understand that it's not for my convenience that I'll go and live in
the studio.

It will make things even more difficult for me.

But I'm convinced that it's to their advantage for me to leave, particularly in view
of Ma's intention to take in a lodger this summer, if possible, who wanted to be in the
country for his health—or should this not come about, then they're still freer with
regard to guests &c.

However, I still very much regret the incident with Anna that decided me in this
respect. What she said to you changed nothing of what she reproached me for, and
however absurd those reproaches were and her unfounded presumptions about things
that are still in the future—she hasn't told me she takes them back. Well—you under-
stand how I simply shrug my shoulders at such things—and anyway, I increasingly let
people think of me just exactly what they will, and say and do too, if need be.

But consequently I have no choice—with a beginning like that, one has to take
steps to prevent all that sort of thing in the future.

So I'm absolutely decided.

It's likely that Ma, Wil and Cor will go to Leiden next year. Then I'll be the only
one of us who's still in Brabant.

And I think it by no means unlikely that I'll stay here for the rest of my life, too. Af-
ter all, I desire nothing other than to live deep in the country and to paint peasant life.

I feel that I can create a place for myself here, and so I'll quietly keep my hand to my

plough and cut my furrow. I believe that you thought differently about it, and that you would perhaps rather see me take another course as regards where I live.

But I sometimes think that you have more idea of what people can do in the city, yet on the other hand I feel more *at home* in the country.

All the same, it will still take me a great deal of effort before I imprint my paintings in people's heads.

Meanwhile, I have no intention whatsoever of allowing myself to be discouraged.

I was thinking again of what I read about Delacroix—17 of his paintings were rejected; '*dix-sept de refusés*', he himself told his friends straight out.

I was thinking today that they really were almighty brave fellows, those pioneers.

But the battle has to be continued even now, and for my part I also want to fight for as much and as little as I'm worth. And so—Theo, I hope that we can continue on both sides what we've now started again. Awaiting or, rather, while I toil away on more important compositions, I'm sending you the studies as they come straight from the cottages. Of course people will say they're not finished or they're ugly &c. &c., but—in my view—*show them anyway.* For my part, I have a firm belief that there are a few people who, ending up in and tied to the city, retain indelible impressions of the country, and continue to feel homesick for the fields and the peasants all their lives.

Art lovers like this are sometimes struck by sincerity, and not put off by what deters others.

I know how I used to walk round the city for hours, looking in the shop windows, to see some little view of the country somewhere, no matter what.

We're now at the beginning of letting people see; I believe absolutely and utterly that little by little we'll find a few people for it. Circumstances compel us, and gradually we'll also be able to show better things.

Now, at this moment, I'm very much preoccupied with paying off my paint bill, and moreover I need canvas, paint, brushes.

Since you've had to do exceptional things for the people at home because of Pa's death, I've come up with the following idea.

Suppose that you don't feel you're in a position to give me the extra I received in spring and summer in other years, and which, by the way, I can't do without.

Wouldn't you think it fair in that case if, when settling affairs, I were to reserve for myself a sum of, say, 200 francs of my share, which I'll otherwise right willingly let the youngsters have? And would be able to let them have altogether if you can help me.

By the way, I don't see it as *my* letting them have my share—but rather that it's because of you that they can keep my portion.

If I go to live in the studio, I'll inevitably have to have a cupboard built, for instance, because at present I have nowhere at all to store things, and I'll also improve the light.

To me, moving would be as bad as a fire—and anyway I think that we'll stay on top of things with perseverance and effort.

I think I'll start painting in watercolour regularly in the evenings—as soon as I'm living in the studio—it can't really be done in the living room here at home. Until then, I'll go on working from the model in the evenings too.

As to Anna—you mustn't think that I'll continue to take something like that amiss or hold a grudge about it—but only, it's a shame that they think to do Ma a service with something like that—that's a shame—and that's stupid and unwise. As long as Ma

and Wil are here, nothing unpleasant will happen between them and me; I don't think so. Only it's certain that Ma simply cannot comprehend that painting is *a faith* and that it brings with it *the duty* to pay no heed to public opinion — and that in it one conquers by *perseverance* and not by *giving in*. And — 'I can't give you faith' is also the case between Her Hon. and me — just as it was and remained with Pa too.

Anyway — I plan to make a start this week on that thing with the peasants around a dish of potatoes in the evening, or — perhaps I'll make daylight of it, or both, or — 'neither one' — you'll say. But should it succeed or should it fail, I'm going to start on the studies for the different figures. Regards, with a handshake.

Yours truly,
Vincent

[*Sketch* 490A]

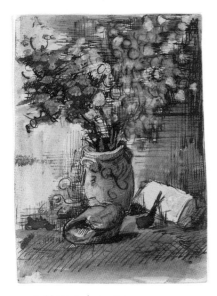

490A. *Honesty in a vase*

My dear Theo,

It has surprised me a little not to have received even a single word from you. You'll say you've been too busy to think about it — and I can very well understand that.

It's already late — but I wanted to tell you once more that I whole-heartedly hope that from now on the correspondence will again become livelier than it has been recently.

Herewith two scratches after a couple of studies that I made, while at the same time I'm working on those peasants around a dish of potatoes again.

I've just come home from there — and have worked on it further by lamplight — although this time I started it in daylight.

[*Sketch 492A*]

See, this is what the composition has now become. I've painted it on a fairly large canvas, and as the sketch is now, I believe there's life in it.

But I know for certain that C.M., for instance, would speak of — badly drawn &c.

Do you know what can definitely be said to counter that? That the beautiful effects of the light in nature require one to work very fast. Now I know very well that the great masters were able both to finish *and* to maintain the vitality, particularly in the period of their mature experience.

But that's something I certainly won't be able to do like that for the time being.

At the point where I now am, though, I see a chance of giving a felt impression of what I see.

Not always literally exactly — rather never exactly — for one sees nature through one's own temperament.

What I'd like to advise now is the following: don't let the time slip by — let me work as much as is in any way possible — and keep all the studies from now on yourself. I'd rather not sign any of them yet, though, because I wouldn't like to have them circulating like paintings, so that one would have to buy them back later should one make something of a name.

But it's good that you're showing them, because you'll see that some day we'll find someone who wants to do what I'm suggesting to you, that is, make a collection of studies.

I mean to go out regularly in the mornings and just tackle whatever I see the people doing in the fields or at home. As I do now anyway.

You're looking for new ideas for the art trade; the idea of being *fair* to the art lovers isn't new, but it's one that *never grows old*. So, too, giving security — on a purchase. And I ask you, isn't an art lover better off when he has, say, 20 very diverse sketches by a painter for the same price that he would reasonably have to pay for one painting that was finished so that it could be put into circulation as a saleable commodity? If I were in your position, because after all you know a lot of young painters who haven't yet made a name, I'd just try once to put *painted studies* on the market proper — not as paintings, but mounted somehow or other, on gilt Bristol, say, or black or dark red.

But I spoke there about giving *security*.

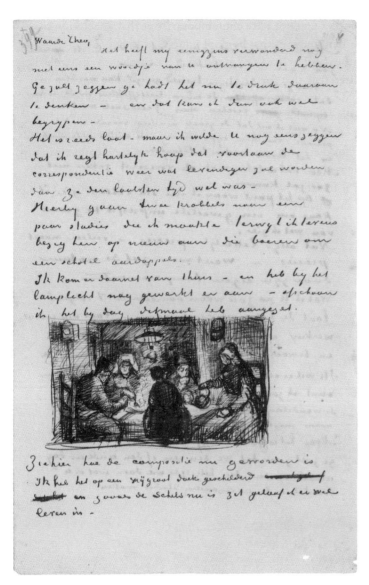

492A. *The potato eaters*

Not *all* painters make a lot of studies — but many do, and the young ones in particular have to do it as much as possible, don't they? Anyone who owns a painter's studies can be as good as certain (at least so it seems to me) that there's a bond between the painter and him that can't easily be broken just on a whim.

There are people, aren't there, who support painters during the time when they aren't yet earning — very well.

But how often does it happen that such a thing ends badly — unpleasantly for both parties? On the one hand because the patron is dissatisfied about money that's wholly wasted, or at least seems to be. On the other hand because the painter feels entitled to ask for more trust, more patience and interest than people are prepared to give. But in most cases it's carelessness on both sides that gives rise to the misunderstandings. I hope that this won't be the case between us. And I hope that gradually my studies will give

you some new courage. Neither you nor I are contemporaries of that generation that Gigoux rightly calls 'the valiant ones' in that book of yours that I read.

But maintaining the enthusiasm of *those days* at *this* time is nonetheless advisable, it seems to me, because it's often true that fortune favours the bold, and be this as it may — about fortune or 'la joie (?) de vivre', that is — one must work and be bold if one really wants to live. And I say, let's paint a lot and be productive, and BE OURSELVES WITH FAULTS AND QUALITIES — I say us — because the money from you that I know causes you trouble enough to provide for me, gives you the right, if anything good happens in my work, to consider half of it as your own creation.

Try to talk to someone at Le Chat Noir and ask them whether they want a scratch of those potato eaters and, if so, what size, because it makes no difference to me.

Regards, with a handshake.

Yours truly,
Vincent

[*Sketches* 492B–C]

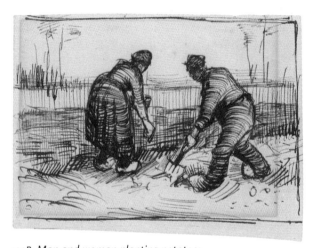

492B. *Man and woman planting potatoes*

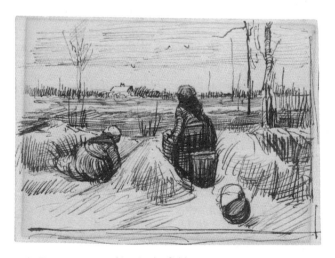

492C. *Two women working in the fields*

My dear Theo,

Many thanks for your registered letter of yesterday and the enclosure. Pursuant to that, I'm writing again right away and enclose herewith a scratch, more precise than the one before, after my latest study.

I haven't been able to work it up as far as had been my intention. I painted 3 days continuously from early till late, and by Saturday evening the paint started to get into a state that didn't allow further work. Unless it's completely dry first.

I've been to Eindhoven today to order a small stone, since this is to be the first in a series of lithographs, which I'm planning to start again. When you were here, I asked you about the cost of reproduction by the G&Cie process. You said then, I believe, 100 francs.

Well — the old — ordinary lithographic process, thought so poorly of nowadays, is nevertheless a good deal cheaper — *particularly in Eindhoven perhaps.*

I'm now getting use of the stone — graining, paper and printing of *50 copies* for *3 guilders.* I'm thinking of making a series of subjects from peasant life, in short — *the peasants at home.*

Today I went for a splendid walk for hours with an acquaintance of mine, whose first watercolour of a figure I showed you.

I don't say that there isn't *even* more stirring and more dramatic nature in Brittany, say, in Katwijk, say, in the Borinage, say — yes — but even so — the heaths and the villages here are still *very* beautiful, and just being here I see in it an inexhaustible resource for subjects from peasant life — and the question is just — to seize it — to work. I have a great desire to start making watercolours and drawings again, too — and when I'm living in my studio I'll make time for it in the evenings.

I was really *immensely* pleased that you sent that 100 francs. As I said, it was absolutely essential that I paid a few things — and that was preoccupying me. It's not that people were pestering me, though, but because I knew that they were in need of it. And that's why I wrote that I could be obliged to reserve a small part when the affairs were to be settled.

But that's not necessary, now — although I can tell you I know for sure the year will be very grim.

But I just think about what Millet said: '*I would never do away with suffering,* for it is often that which makes artists express themselves most vigorously'.

I'm thinking of moving about 1 May — although, of course, things are all right with Ma and the sisters — nevertheless I see and feel it's *so* much for the better — for living together would become insupportable in the long run. Which I don't so much ascribe to them personally nor to me personally either, but rather to the irreconcilability of the ideas of people who keep up a position and — a peasant painter — who doesn't think about it.

When I say that I'm a peasant painter, that is really so, and will become clearer to you in future; I feel at home there. And it's not for nothing that I've spent so many evenings sitting pondering by the fire with the miners and the peat-cutters and the weavers and peasants here — unless I had no time to think — because of the work. I've

become so absorbed in peasant life by continually seeing it at all hours of the day that I really hardly ever think of anything else.

You write that the public mood — that is, indifference — to Millet's work — as you just had the opportunity to see at that exhibition — isn't encouraging, either for the artists or for those who have to sell paintings. I agree — but Millet himself felt and knew that — and, on reading Sensier, what he said about the start of his career struck me so much that although I don't remember it *literally*, I remember the sense of it, that is, 'that (i.e. that indifference) would be bad enough for me if I needed fine shoes and the life of a gentleman — but — *because I go around in clogs, I shall manage*'. And that's how it turned out.

So what I hope not to forget is that — 'it's a question of going around in clogs', that is of being content as regards food, drink, clothes, sleep, with what the peasants are content with.

That's what Millet did — and — *didn't want anything else* anyway — and in my view this means that *as a human being* he has shown painters a way that Israëls and Mauve, say, who live quite luxuriously, do *not* show, and I say again — Millet is — PÈRE *Millet*, that is, counsellor and guide in *everything*, for the younger painters. Most of them *I know*, though (but I don't know all that many) would decline this. As to me — I think the same, and entirely believe what he says. I'm speaking about what Millet says at some length, precisely because you write about the question that when *city-dwellers* paint peasants, their figures, *splendidly* painted though they may be, nonetheless can't help reminding one of the Parisian suburbs.

I've also had that impression sometimes (although, to my mind, the woman digging potatoes by B. Lepage is certainly an exception), but isn't it precisely because the painters are so often not deeply enough involved *personally* in peasant life? Millet said on another occasion — in art one must give heart and soul.

Degroux — this is *one* of his qualities — painted real *peasants*. (And they — the State — demanded history pieces of him! — which he also did well, but how much better he was when he could be *himself*.)

It's an abiding shame and loss for the Belgians that Degroux still isn't appreciated as fully as he deserves — Degroux is one of the *good Milletesque masters*. But even if the general public didn't and don't acknowledge him — and although he remains in obscurity, like Daumier, like Tassaert — there are still people, *Mellery*, for example, to mention just one, who are again making work today that has his sentiment.

I recently saw something by Mellery in an illustrated magazine; a *bargee's* family in the little deckhouse on their barge — husband, wife, children — round a table. As far as *general* sympathy is concerned — years ago I read something about it in Renan that has always stayed with me and that I'll always go on believing — that anyone who really wants to accomplish something good or useful should neither count on nor wish for general approbation or appreciation, but on the contrary should expect nothing other than that only a very few hearts — and even then only *maybe* — will sympathize and join in.

If you run into someone from Le Chat Noir, you can show them *this* little scratch *for now, but I can make a better one if they like, because this is very much in haste* and serves only to give you a clearer idea of effect and composition than the first. Regards and thanks, with a handshake.

Yours truly,
Vincent

You needn't tell Le Chat Noir that I'm also planning to make a lithograph of this thing myself. That lithograph won't be published anyway, but is entirely private. By the way, I don't really mind if they *don't* want it — because I'll certainly lithograph myself what I want to lithograph.

[*Sketch* 493A]

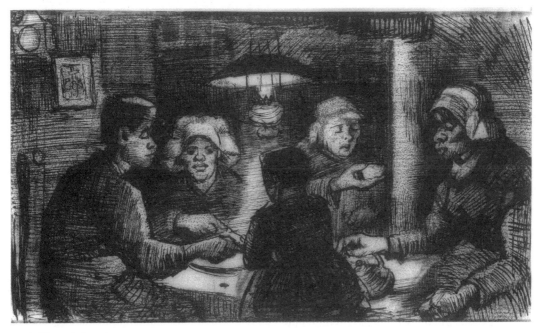

493A. *The potato eaters*

My dear Theo,

Sincere wishes for your good health and serenity on your birthday. I would like to have sent you the painting of the potato eaters for this day, but although it's coming along well, it's not quite finished yet.

Although I'll have painted the actual painting in a relatively short time, and largely from memory, it's taken a whole winter of painting studies of heads and hands. And as for the few days in which I've painted it now — it's consequently been a formidable fight, but one for which I have great enthusiasm. Although at times I feared that it wouldn't come off. But painting is also 'act and create'.

When the weavers weave those fabrics that I believe they call cheviots, and also the singular Scottish multicoloured tartan fabrics — then they try, as you know, to get singular broken colours and greys in the cheviots — or to get the very brightest colours in balance against one another in the multicoloured tartans so that, rather than the fabric clashing, the *overall effect* of the pattern is harmonious from a distance. A grey that's woven from red, blue, yellow, off-white and black threads, a blue that — is *broken* by a green and an orange, red or yellow thread — are very different from *plain* colours — that is, they *vibrate* more and make whole colours look *harsh, whole*, and LIFELESS.

However, it's not always exactly easy for the weaver, or rather the designer of the pattern or the colour combination, to work out his calculation of the number of threads and their direction — nor is it easy to weave brushstrokes together into a harmonious whole. If you saw the first painted studies that I made when I came here to Nuenen — and the present canvas — side by side — I think you'd see that as far as colour is concerned — things have livened up.

I think that the question of the breaking of colours in the relationships of the colours will occupy you too one day. For as an art expert and critic, one must also, it seems to me — *be sure* of one's ground and have certain *convictions*. At least for one's own pleasure and to *be able to give reasons*, and at the same time one must be able to explain it in a few words to others, who sometimes turn to someone like you for enlightenment when they want to know something more about art.

Now, though, I have something to say about Portier — of course his private opinion isn't at all a matter of indifference to me, and I also appreciate to the utmost that he said that he took back nothing of what he'd said.

Nor does it concern me that it appeared that he hadn't hung these first *studies*.

But — if he also wants me to send a painting destined for him, *then he can only have it on condition that he exhibits it.*

As regards the potato eaters — it's a painting *that looks well in gold*, I'm sure of that. Still — it would do equally well on a wall hung with a paper that had a deep tone of ripe wheat. It *simply mustn't be seen, though*, without this *enclosure* to it.

It does *not* appear to advantage against a *dark* background, and particularly not against a *dull* background. And this is because it's a glimpse into a very grey interior.

In *reality*, it's also in a gilt frame as it were — since the hearth and the light from the fire on the white walls — which now lie *outside* the painting but in real life throw the whole thing backwards — would be closer to the viewer.

Once more, one must *enclose* it by placing something in a deep gold or copper colour around it.

Please bear that in mind if you want to see it as it should be seen. This association with a gold tone at the same time brings brightness to *areas where you wouldn't expect it* and takes away the *marbled* look that it gets if one unfortunately places it against a dull or black background. The shadows are painted with blue, and the gold colour works with that.

Yesterday I took it to an acquaintance of mine in Eindhoven, who is painting. In 3 days or so, I'll go over there and lift it with a little white of egg and finish off a few details. This man, who is himself doing his very best to learn to paint and is himself also trying to find a good colour palette, was extremely taken with it. He'd already seen the study from which I made the lithograph, and said that he hadn't thought that I could have raised the level of both the colour and the drawing so much higher. Since he also paints from models, he also knows very well what a peasant's head or fist entails, and as to the hands, he said that he now had a very different concept of how to do them himself.

You see, I really have wanted to make it so that people get the idea that these folk, who are eating their potatoes by the light of their little lamp, have tilled the earth themselves with these hands they are putting in the dish, and so it speaks of MANUAL LABOUR and—that they have thus honestly *earned* their food. I wanted it to give the idea of a wholly different way of life from ours—civilized people. So I certainly don't want everyone just to admire it or approve of it without knowing why.

I've had the threads of this fabric in my hands the whole winter long, and searched for the definitive pattern—and if it's now a fabric that has a rough and coarse look, nevertheless the threads were chosen with care and in accordance with certain rules. And it might well prove to be a REAL PEASANT PAINTING. *I know that it is.* But anyone who would rather see insipidly pretty peasants can go ahead. For my part, I'm convinced that in the long run it produces better results to paint them in their coarseness than to introduce conventional sweetness.

A peasant girl is more beautiful than a lady—to my mind—in her dusty and patched blue skirt and jacket, which have acquired the most delicate nuances from weather, wind and sun. But—if she puts—a lady's costume on, then the genuineness is lost. A peasant in his suit of fustian in the fields is finer than when he goes to church on Sundays in a sort of gentleman's coat.

And likewise, one would be wrong, to my mind, to give a peasant painting a certain conventional smoothness. If a peasant painting smells of bacon, smoke, potato steam—fine—that's not unhealthy—if a stable smells of manure—very well, that's what a stable's for—if the field has an odour of ripe wheat or potatoes or—of guano and manure—that's really healthy—particularly for city folk. *They get something useful out of paintings like this.* But a peasant painting mustn't become perfumed. I'm curious as to whether you'll find anything in it that you like—I hope so. I'm glad that now, just as Mr Portier has said he wants to handle my work, I for my part have something more important than the studies alone. As to Durand-Ruel—although he didn't think the drawings worthwhile, show him this painting. He may think it ugly—very well—but let him see it anyway—so that they may see that we're putting energy into our endeavours. However, you'll hear—'WHAT A DAUB!'; be

prepared for that as I'm prepared myself. But nonetheless go on giving something *genuine* and *honest*.

Painting peasant life is a serious thing, and I for one would blame myself if I didn't try to make paintings such that they give people who think seriously about art and about life serious things to think about. Millet, Degroux, so many others, have set examples of *character*, of taking no notice of the reproaches of — nasty, crude, muddy, stinking &c. &c., that it would be a disgrace if one were even to have misgivings.

No — one must paint the peasants as if one were one of them, as feeling, thinking as they do themselves.

As not being able to be other than one is.

I so often think that the peasants are a world in themselves, so much better in many respects than the civilized world.

Not in all respects, because what do they know of art and many other things?

I do still have a few smaller studies — you can imagine, though, that I've been kept so busy with the larger one that I've been able to do little else besides that.

As soon as the whole thing is finished and dry, I'll just send the canvas to you in a small crate, and then put a few smaller ones in with it. I think it's best not to delay sending it for too long, which is why I'll send it. Then the second lithograph of it will probably have to be abandoned. But still — I understand that Mr Portier, for instance, must be confirmed in what he said, so that we can count on him as a friend for ever. I sincerely hope this will succeed.

I've been so absorbed in the painting that I've literally almost forgotten my move, which nonetheless also has to be done. It won't reduce my concerns, but the lives of all painters in that genre are so full of them that I wouldn't want to have things any easier than they had them. And since, despite everything, they still got their paintings done, the material difficulties will also *hinder* but not *destroy* or *weaken* me. Anyway.

I believe that the potato eaters will come off — the last days are always hazardous for a painting, as you know, because one can't touch it with a large brush when it isn't completely dry without a great risk of spoiling it. And the changes have to be made very coolly and calmly with a small brush. This is why I simply took it away and said to my friend that he just had to make sure that I didn't spoil it in that way, and that I'd come do those small things at his place. You'll see that it has originality. Regards — I'm sorry it wasn't ready for today — again wishing you health and serenity, believe me, with a handshake

Yours truly,
Vincent

Today I'll work on a few smaller studies, which will then go at the same time. Did you ever send that Salon issue?

My dear Theo,

Many thanks for your letter and for the 50 francs enclosed, which was very welcome to me this month in particular, what with the move. I think that I'll save a very great deal of time in the long run by living in the studio, since I'll be able to get started first thing in the morning, for instance, whereas the way it was at home I couldn't do anything.

I've been slogging away at drawings these last few days. The old tower in the fields is being demolished. There was a sale of woodwork and slates and old iron, including the cross.

I've finished a watercolour of it in the manner of that timber sale, but better, I think. I also had a second large watercolour of the churchyard, which has so far been a failure.

But still, I have a very good idea of what I want in it — and perhaps I'll now get what I mean on the third sheet of paper. And if not, then not. I've just now sponged out the two failures, but I'm going to try it once more.

If you want, though, you can have the one of the sale.

Then I'm working on a large study of a cottage in the evening.

And about 6 heads.

One thing and another was the reason I didn't send you confirmation of the receipt of your letter before.

I'm working as hard as I can because I'm thinking of going to see the Antwerp exhibition sometime with that friend of mine in Eindhoven, if I can manage it. And then I'd want to take some work with me so as to do something more with it there if possible. I'm longing to hear whether Mr Portier has seen the potato eaters.

What you say about the figures is true, that as figures they aren't like the heads are. I've therefore thought about starting it very differently, that is tackling it from the *torsos* instead of from the *heads*.

But then it would have become something *altogether* different.

As to sitting, though, don't forget that these people certainly don't sit on chairs like in one of Duval's cafés, say.

The finest thing I saw was that the woman was simply kneeling — that's in the *first* sketch that I sent you.

But anyway, it's simply painted the way it's painted, and we'll do it again sometime — and then certainly not the same. The last few days I've also been busy *drawing* little figures.

Thanks, too, for the No. of Le Temps you sent with Paul Mantz's article about the Salon. I haven't seen such a good article in a long time. I think it uncommonly good — the opening sentences — the painting of those Laplanders in their dark hut, who see the sun rise after the long winter night — how in art one also sits waiting for light.

Then immediately afterwards his reference to Millet, who has certainly given new light — 'and who remains'.

Then pointing to Lhermitte as Millet's successor — I think all of it manly language, and outstanding in accuracy and broad view.

Except I think it a shame that he calls Roll 'a beginner'—for that's to denigrate him, and Roll has already made so many fine things and is—matchless.

Already matchless since his Miners' strike at least. When Paul Mantz says that Roll's labourers don't work very hard, and that it is 'a dream'. Well now—it's a nice conceit and there's something to it. The only thing is that it's precisely because it's Paris, and not the down-to-earth work in the fields. After all, a workman in the city is just exactly the way Roll paints him.

Rappard has a painting in Antwerp that I think will be very fine, at least the sketch, which *practically no one* liked, was to my mind very good. I think he's very clever.

Have you finished Zola's book, *Germinal*, yet? I'd very much like to read it and will send it back within a fortnight or so. Is Lhermitte's month of May in yet?

In Mantz's article I also think what he manages to say about colour in 4 words very good and logical, when he talks about 'the ash blues that we love', and 'the grass of the meadow is very green, the bull is russet brown, the young girl is pink, here is the harmony of 3 tones', when he talks about the same question in regard to Lhermitte.

Regards, with a handshake.

Yours truly,
Vincent

I can understand that Besnard must be interesting.

I'll add another word or two here—I cannot advise you enough to work out E. Delacroix's different propositions about colour for yourself.

Although—out of touch—although out of the art world for a long time—turned out—because of my clogs &c.—yet I see from that article by Mantz that there are still connoisseurs and art lovers, even now, who—*know something*—and that is what Thoré, what Théophile Gautier knew. And that, leaving aside the self-styled more civilized world of progress for what it is, *namely a deception*, it continues to come down to what the reformers already announced about taste in '48, for instance, in a manly and forceful way.

Just as Israëls won't be surpassed here in Holland but, it seems to me, will remain the master. And in Belgium, Leys and Degroux.

Don't, whatever you do, make the mistake of thinking that I'm insisting on *imitation*, because I don't mean that at all.

You've seen much more than I have—and I wish that I'd seen what you've seen and are still looking at every day.

But perhaps seeing a great deal is precisely what makes it difficult to reflect. Anyway.

My assertion is just that it's the same with you as with a mass of others, that when you're older you have to repeat the ground rules once more and study them again. I mean that in your capacity as an art expert you have to know certain rules of colour mixing and perspective just as well as the painters themselves—*in terms of theory even better than them actually*—since you have to advise and speak about paintings in the making. Don't take it amiss, for what I say is true; that this would be of more practical use to you than you might think, and would raise you *above* the usual standard of dealers. Which is necessary, because the *usual* standard is *below* standard. I do know a little from my own experience what the dealers know and what they don't know.

I believe that they're often taken in and make deals that they later regret, precisely because they know too little about how a painting is made. Anyway—I know you're already taking pains—for example by reading good things like the one by Gigoux. Really study the subject of colour etc. for yourself. I'm trying to do it myself too, and I'd also like to read everything you find of that nature. These days I'm working on putting what Delacroix said about drawing into practice on drawing a hand and arm: don't start from the line but from the middle. One has opportunity enough to start from ovals there. And what I'm trying to get with it is *to be able to draw not a hand but* THE GESTURE, not a mathematically correct head but the overall *expression*. The sniffing of the wind when a digger looks up, say, or speaking. Life, in short.

507 | Nuenen, on or about Tuesday, 9 June 1885 | *To Theo van Gogh* (D)

My dear Theo,

Today I sent off that little crate, containing 1 other painting, *Peasant cemetery*, besides what I already told you.

I've left out some details—I wanted to say how this ruin shows that *for centuries* the peasants have been laid to rest there in the very fields that they grubbed up in life—I wanted to say how perfectly simply death and burial happen, coolly as the falling of an autumn leaf—no more than a bit of earth turned over—a little wooden cross. The fields around—where the grass of the churchyard ends, beyond the little wall, they make a last fine line against the horizon—like the horizon of a sea. And now this ruin says to me how a faith and religion mouldered away, although it was solidly founded—how, though, the life and death of the peasants is and will always be the same, springing up and withering regularly like the grass and the flowers that grow there in that churchyard. Victor Hugo, whom they've also just buried, said Religions pass, God remains.

I don't know whether you'll see anything in these two things—the cottage with the mossy roof reminded me of a wren's nest. Anyway, you must just look at them.

Now I must take this opportunity of explaining to you again—which I found new, clear words for—why I wrote and write to you that I'm still far from sure whether your present view is your definite conviction. The firm of G&Cie isn't a good school for getting to know paintings, let alone painters. I tell you this as my opinion—that one doesn't even learn how to look independently there.

Who did they greatly honour? Paul Delaroche.

I don't have to tell you how Delaroche was one of the people who really didn't stand up to scrutiny—there's simply no one left who takes his part.

Someone else who *won't stand up to scrutiny*—even though he's *better*—although he did make something very fine once or twice—who will also *fail*—that is—Gérôme.

His Prisoner, though, his Syrian shepherd are *felt*, and I think them as fine as anybody, and readily and willingly.

But by far the most often he's a Delaroche II. Each of them, *taking into account the context of their age*, is of equal worth. What I'm now asserting is—that I consider it highly likely that the whole situation will BORE you *more by the year*.

What I further assert is that one does both others and especially oneself too a disservice by being bored. In spite of many wise lessons, I've never seriously granted that being bored 'for one's own good' can have its good, practical side. Now a MASS of people have reformed themselves at the age of about 30 and changed very considerably.

Just think calmly about this—I tell you that NOTHING of what I learnt and heard about art at G&Cie stood up to scrutiny. How if one reverses the generalities that count there as the conversation killers in judging art—namely praising the old or present-day Delaroche to the skies and discrediting the unorthodox—if, I say, one *reverses* certain maxims, then—one takes a breath of fresh air. In short—old chap—such curious turns in situations and affairs are possible—not only that—but even the rule. It's funny, isn't it—that, after all, I still doubt whether you'll stay in the trade.

You don't have to take any notice of this or reply to it—I say it to you just to express my idea frankly, not to start futile exchanges of words.

But it's—an enchanted land—where one isn't free.

Anyway—I'll hear sometime whether you've received the little crate and whether you find anything in it.

Tomorrow I'm going to paint a thing in another village—also a cottage—in a smaller size. I found it last Sunday on a long trip I made in the company of a peasant boy—in order to get hold of a wren's nest. We found 6; without doubt it was a place that Bodmer would have adored. And they were all nests from which the young had already flown, so that one could take them without too many pangs of conscience. It was so real; I also have some other splendid nests. Regards, write soon, with a handshake.

Yours truly,
Vincent

I'd like you to give both the paintings a varnish before you show them to Portier or Serret.

The peasant cemetery has sunk in particularly badly, because it was very different on the canvas at first and I scraped the first thing off *completely*. It was a total failure at first—then I gave it short shrift and started from the beginning, went and sat on another side and painted early in the morning instead of in the evening. Well, and the other—the one of the cottage—was originally a shepherd. The sheep were shorn last week; I saw it—on a table in a barn.

I'm glad that this time I can show Portier something very different again. I'm busy drawing, by the way, so as to send a few full-length figures in a little while. But working on the cottages—perhaps you'll say imitations of Michel, although they aren't—and searching for subjects, I've found such splendid cottages that I now really must go bird's nesting with a number of variations of these 'people's nests', which remind me so much of the nests of wrens—that's to say, paint them.

Oh—one mustn't doubt—anyone who paints the peasants nowadays and has his heart in his work, he wins—at least a part, and not the worst although it's not the largest—of the public.

This doesn't alter the fact that my end or second half of the month—can still work out remarkably meagre. But the same happens to the peasant lads too, and—they still have fun.

I wish you'd been here on Sunday when we went on that trip. I came back covered in mud because we had to spend a good half hour wading through a stream. But for me painting is now becoming as stimulating *and enticing* as hunting—it is a hunt, after all, for models, and beautiful places too. Regards again, and best wishes to you. It's already late and I have to be at the place at 5 o'clock, so—adieu.

509 | Nuenen, on or about Monday, 22 June 1885 | *To Theo van Gogh* (D)

My dear Theo,

Thanks for your letter and the enclosure, which is exactly what I meant and enables me to work at the end of the month just as at the beginning of the month.

I was very pleased to hear that Serret is the painter about whom you had previously written things that I had really remembered, but the name had escaped me. I'd like to write much more to you than I will in this letter, but when I get home nowadays I'm really not in the mood for writing when I've been sitting in the sun all day. As to what Serret says, I think so too—I'll drop him a line, because I'd like to become friends with him. As I already told you, these days I'm hard at work on figure drawings—I'll send them specifically with an eye to Serret, to show him that I'm far from indifferent to the unity of a figure and the form.

Do you ever see Wallis? Might the watercolour of the auction be something for him? If it were something for Wisselingh, then better he should take it. I once gave Wisselingh a couple of heads and also just sent him the lithograph. But because he didn't send so much as a word in reply, I think that all I'd get would be an insult if I sent something.

It just happened to me that, having not heard anything from him in 3 months or so, I suddenly got a letter from Rappard, with whom I've been on good terms for years, so supercilious and so full of insults and, it seemed to me, so obviously written after he'd been in The Hague that I'm as good as certain that I've lost him as a friend for good.

It's precisely because I tried it first in The Hague, that's to say my own country, that I have every right and reason to forget all that unpleasantness and to think of something else outside my own country.

You know Wallis well, so perhaps you could bring it up sometime apropos of that watercolour, but act as the opportunity arises. If I could earn something with my work, if we had some firm ground, even a little—under our feet, to be able to go on living—and if ever the desire to become an artisan took shape in you—let me say to make it clear—in the manner of, say, discounting all the differences in age &c.—Hennebeau in Germinal—what you would be able to paint then! Still, the future's always other than one thinks, so one can never know for sure. The drawback to painting is that if one doesn't sell one's paintings one still has to have money for paints and models to make progress. And that drawback *is* ugly. But otherwise— painting and, to my mind, particularly painting peasant life, gives peace of mind, even though one has a lot of scraping along and wretchedness on the *outside* of life. I mean painting is a *home*, and one doesn't have that *homesickness*, that peculiar thing that Hennebeau had.

The passage I copied out then struck me very much because, almost literally at that time, I had just such a longing to be something like a grass-mower or polder worker.

And I was sick of the *boredom* of civilization. It *is* better, one *is* happier if one puts it into effect—but pretty much literally—at least one feels really alive. And it is *something* to be deep in the snow in winter, to be deep in the yellow leaves in the autumn, to be deep in the ripe wheat in the summer, to be deep in the grass in the spring. It is *something* to always be with the mowers and the peasant girls, in summer with the big sky above, in the winter by the black fireplace. And to feel—this has always been so and always will be. One may sleep on straw, eat rye bread—well then, in the long run one is the healthier for it.

I'd like to write more but—as I said—I'm not really in the mood for writing, and I wanted to enclose a note for Serret, which you must just read, since I write in it about what I wanted to send before long, especially because I want to let Serret see my particular figure studies. Regards,

Yours truly,
Vincent

Serret may agree with you that making good things and selling are quite separate. But there's no truth in that. When the public saw Millet at last, his work collected together—then the public in both Paris and London was *enthusiastic*. And who was it who had stood in the way and rejected Millet?—the dealers—the so-called *experts* &c. I ask you, would a Mouret have said something like that, to keep talking about business?

514 | Nuenen, on or about Monday, 13 July 1885 | *To Anthon van Rappard* (D)

My dear friend Rappard,

All that has passed means that when I come to write to you it's more in order to be clear than because I do it for my pleasure. As to my having returned your last letter to you forthwith, there were two reasons for it, each in its own right, to my mind, providing a motive. Firstly—suppose that your comments on the lithograph I sent you were correct, suppose I had nothing to say against them—even then, you wouldn't have been justified in condemning my work in such an insulting manner, or rather in ignoring it as you did.

And secondly—whereas you have had more friendship than you have given, not just from me but from my family too, you certainly cannot *claim* that on an occasion such as my father's death we were *obliged* to send something other than a printed notice.

Particularly not *me*, since before that time you hadn't replied to a letter from me. Particularly not *me*, since on the occasion of my father's death you did send an expression of sympathy in a letter addressed to my mother—but such a one that when it arrived there was comment at home about what reason there might be for not writing to me then—which I didn't want, however, nor do I.

You know—I haven't been on the best of terms with them at home for years. In the first few days after my father died, I *had* to correspond with the immediate family. But otherwise, as soon as family arrived, I withdrew from it all completely. And regarding

any omissions, not me but the family. And I have to tell you that in so far as it goes, you're an exception, that I asked them at home if they'd sent you word and it appeared that it had been forgotten. Much more than enough about that.

The reason I'm writing to you again is in no way to respond to your comment in that regard. Nor to repeat what I said about your remarks about painting. You've been able to re-read your own letter. If you still believe that was justified, if you still really think that 'if you put your mind to it, you can deuced well express yourself correctly' — well — then it's best simply to leave you to your delusions.

To get to the point — the reason why I'm writing to you is simply that — although it was you who insulted me in the first place, not I you — I've known you too long for me to consider this a reason to break off all acquaintance. What I have to say to you is as a painter to a painter and — so long as you and I paint — it will remain so — whether we know each other, whether we don't. There was mention of *Millet*.

Very well — I'll answer you, my dear friend.

You wrote, 'you dare to invoke Millet and Breton'.

My reply to that is that I seriously invite you to consider — simply *not* to fight with me. For my part — I go my own way — you see — but I don't seek a quarrel with anyone — *not* with you now either. I'd also let you say anything that you wanted — if you had any more such expressions — and it would just be like water off a duck's back. So much for the present, though. That I don't care about the form of the figure, which you've said before — it's beneath me to take any notice of it and — old chap — it's beneath you to say something *so* unfounded. You've known me for years now — have you ever seen me do anything other than work from the model and resign myself to the sometimes great expense of it, even though I'm poor enough as it is?

What you didn't write in your last, but did repeatedly and ad nauseam in previous letters, and was the reason for the letter to which you didn't reply, is about '*technique*'. What I replied to you then and reply once more is — the conventional meaning that people increasingly give to the word technique, and the actual meaning, *knowledge*. Well then. Meissonier himself says,

'*the knowledge — nobody has it*'.

Well, 'the knowledge' isn't the same as 'knowledge', that first of all, and that you won't deny. But even that still isn't it.

Take Haverman, for instance; people — you too — say of him that he has so much *technique*. But not only Haverman, how many others — have something that's equivalent to the sort of knowledge that H. has of art — among the French painters — Jacquet, say, and he's *better*.

My assertion is simply this — that drawing a figure academically correctly — that an even, reasoned brushstroke have little — at least less than is generally thought — to do with the needs — the urgent needs — of the present day in the field of painting.

If, instead of saying H. has a lot of 'technique', you were to say H. has a lot of 'craftsmanship', I would have agreed with you for once. You will perhaps understand what I mean when I say that when Haverman sits in front of the head of a beautiful girl/woman, he'll make it more beautiful than almost anyone, but put him in front of a peasant — and — he won't even make a start on it. His art — as far as I know — proves chiefly applicable to subjects which aren't the ones that are needed — is above all

applicable to subjects that are pretty much completely and utterly opposite to Millet or Lhermitte — and sooner run parallel to Cabanel — who for all his what I call — craftsmanship — has said little that lasted — or contributed to progress. And — this I beg of you — don't *confuse* this with the way a Millet or Lhermitte paints.

What I said and still say — the word — technique — is all too often used in a conventional sense — and — it's all too often not used in good faith. People praise the *technique* of all those Italians and Spaniards, and they're fellows who are more conventional, have more sheer routine — than anyone else. And with such as Haverman, I fear, 'craftsmanship' so soon becomes — 'routine'. And then — what's it worth then?

What I want to ask now — what's the real reason that you've broken with me —?

The reason I'm writing to you again is just out of love for Millet, for Breton and for *everyone* who paints the *peasants* and the *people*, among whom I count you. I don't say it because I got a lot from you as a friend — my dear friend — because — I got precious little from you — and don't take it amiss of me for saying this to you straight out for the first and last time — I know of no drier friendship than yours. But — firstly *that's* not why I'm doing it — secondly, that might have improved too — but having created my own opportunities to find models &c., I'm not so petty as to keep it quiet. On the contrary — were any painter, no matter who, to come to this district, I would be glad both to invite him home and to show him the way. Precisely because it's not always easy to find models who are willing to pose — and having a pied-à-terre somewhere isn't a matter of indifference to everyone.

And this is why I say to you that, if you want to paint here, you mustn't be embarrassed because we had a disagreement. And — although I'm living on my own in my studio now — you can even stay too.

It may be, though, that — superciliously — you'll say that this is of no consequence to you. Well, that's all right. I'm *so* accustomed to insults that they really are *so* like water off a duck's back — that — someone like you — probably finds it hard to understand just how cold a letter like yours, say, leaves me. And being indifferent to it — I have no more resentment than a post. But I do have — enough clarity and serenity to reply as I do now.

If you want to break with me — very well.

If you want to go on painting here — you don't have to take any notice of this little bit of bickering in our correspondence.

What you did the last time you were here — had and has my full sympathy — and — my dear friend Rappard — it's because you worked so damned well that last time, and I think to myself that you might perhaps want things here to remain as they were, that I'm writing to you.

Make up your own mind — I say frankly — from one point of view — in spite of all my appreciation of your painting — I have some concerns about whether you'll be able to keep it up like this *later* — I sometimes fear that, because of the influences to which you cannot but be exposed given your social position and standing, you may not remain as good in the long run as you are at the moment — just as a painter in your painting — I don't concern myself with the rest.

So I say to you, as a painter to a painter, that if you want to look for paintings here, *it will stay just the same as before.* You can come here and, although I live on my own, stay just the same as before. You see — I thought that perhaps you had got and could

get something out of it, and I just wanted to tell you this. If you can get on as well elsewhere — well then — I'll have no reason to grieve about it, and then, adieu.

You've told me nothing about *your* work, so I likewise say nothing about *mine*.

Believe me — don't argue with me about Millet — Millet is someone I won't argue about, although I don't refuse to talk about him.

Regards.

Vincent

515 | Nuenen, on or about Tuesday, 14 July 1885 | *To Theo van Gogh* (D)

My dear Theo,

I wish that the 4 canvases I wrote to you about were gone. I may work on them again if I keep them here too long, and I think it's better for you to get them as they come from the heath.

The reason why I don't send them off is that I don't want to send them to you with the carriage unpaid at a moment when you say that you might be short yourself, and I can't pay the carriage myself either.

I've never seen the little house where Millet lived — but I imagine that these 4 little human nests are of the same kind.

One of them is the residence of a gentleman who's popularly known here as 'the peasant of Rauwveld' — the other is occupied by a worthy soul who, when I went there, was engaged in nothing more mysterious than turning over her potato patch, but must also be able to work magic, though — at any rate she goes by the name of 'the witch's head'.

You remember that it says in the book by Gigoux how it came about that Delacroix had *17* paintings rejected at the same time. This shows — at least so it seems to me — that he and others from that period — were faced with connoisseurs and non-connoisseurs, none of whom either understood it or wanted to buy — this shows that those who are rightly described in the book as 'the valiant ones' didn't talk about fighting a losing battle, but *carried on painting*.

Something else I wanted to say to you is that we'll have to paint a lot more if we take that about Delacroix as our starting-point. I must necessarily be the most disagreeable of all people, that's to say having to ask for money. And since I don't think that things will take a turn for the better as regards sales in the next few days, this is bad enough. But I ask you, isn't it better, after all, for both of us to work hard even though there are difficulties attached to it, than to sit about philosophizing at a time like this?

I don't know the future, Theo — but — I do know the eternal law that everything changes — think back 10 years and things were different, the conditions, the mood of the people, everything in short. And 10 years on, a great deal is bound to have changed again. But *doing something* endures — and one doesn't easily regret having done something. The more active the better, and I'd rather fail than sit idle.

Whether Portier is or isn't the man to do something with my work — we need him

now all the same. And here's what I think — after working for a year, say, we'll have got more together than now, and I know for sure that my work will do better as I complete one thing with another. The people who have some feeling for it now, who, like him, talk about showing it sometime — they're consequently useful, because after another year's work, say, they'll have a few more things together that will speak for themselves, even if they say nothing at all. Should you happen to see Portier, feel free to tell him that, far from giving up, I'm planning to send him much more. You must also go on showing when you meet people. It won't be so very long before what we can show will be more important. You can see for yourself — and it's a phenomenon that gives me surprisingly great pleasure — that people are increasingly starting to stage exhibitions of 1 person or a very few who belong together. This is a phenomenon in the art trade which I dare think has more future than other enterprises. It's good that people are beginning to understand that a Bouguereau can't do well beside a Jacque — nor a figure by Beyle or Lhermitte beside a Schelfhout or Koekkoek.

Scatter Raffaëlli's drawings about — and judge for yourself whether it would be possible to form a good idea of this singular artist. He — Raffaëlli — isn't like Régamey — but I find him just as much of a personality. If my work stayed with me — I think I'd be constantly working over it. By sending it to you and to Portier as it comes from the countryside or from the cottages, the odd thing that isn't right will sometimes get through — but things that wouldn't be improved by frequently working over them will be preserved.

If you had these 4 canvases and a few more, smaller studies of cottages, and someone saw nothing by me other than those, they'd be bound to think that I did nothing other than paint cottages. And likewise with that series of heads. But peasant life involves such diverse things that when Millet speaks of 'working like a *bunch* of negroes', this really does have to happen if one wants to achieve a whole. One may laugh at Courbet's saying, 'painting angels! who has ever seen angels!' But I'd just like to add, for instance, 'justices in the harem, who has ever seen justices in the Harem?' (the painting by Benjamin-Constant). 'Bull fights, who has ever seen those?' and so many other Moorish, Spanish things, Cardinals, and then all those history paintings, which are still always there, metres high by metres wide! What's the point of it all, and what do people want with it? After a few years most of it becomes stale and dull, and more and more boring.

But still. Perhaps they're well painted — maybe. Nowadays, when connoisseurs stand in front of a painting like the one by Benjamin-Constant, or like a reception at a cardinal's by some Spaniard or other — it's the custom to say, with a knowing air, something about 'clever technique'. But — as soon as those same connoisseurs found themselves in front of a scene from peasant life or a drawing by Raffaëlli, say, they would criticize the technique with the same air — à la C.M.

Perhaps you think that I'm wrong to comment on this — but — I'm so gripped by the thought that all these exotic paintings are painted *in* THE STUDIO. But just go and sit outdoors, painting on the spot itself! Then all sorts of things like the following happen — I must have picked a good hundred flies and more off the 4 canvases that you'll be getting, not to mention dust and sand &c. — not to mention that, when one carries them across the heath and through hedgerows for a few hours, the odd branch or two scrapes across them &c. Not to mention that when one arrives on the heath after a couple of hours' walk in this weather, one is tired and hot. Not to mention that

the figures don't stand still like professional models, and the effects that one wants to capture change as the day wears on.

I don't know how it is with you—but for my part, the more I work on it the more peasant life absorbs me. And the less and less I care about either the Cabanelesque things, among which I would also count Jacquet, also Benjamin-Constant's present work—or the highly praised but so unspeakably, hopelessly dry technique of the Italians and Spaniards. *Image makers!*—what Jacque said, I often think about it. But I'm *not biased*; I like Raffaëlli who, after all, paints something very different from peasants—I like Alfred Stevens, Tissot, to mention something that's entirely unlike peasants—I like a fine portrait. Zola who otherwise, to my mind, often makes colossal mistakes in his judgement of paintings—says something beautiful about art in general in 'Mes haines'. 'In the painting (the work of art) I look for, I love the man—the artist.'

There you are, I think that's perfectly true—I ask you, what sort of a *man*, what sort of a visionary/observer or *thinker*, what sort of a human character is there behind some of these canvases praised for their technique—often, after all, *nothing*. But a Raffaëlli—is *someone*, a Lhermitte is *someone*, and in many paintings by virtually unknown people one feels that they were made with a *will*, with *emotion*, with *passion*, with *love*. The TECHNIQUE of a painting from peasant life or—like Raffaëlli—from the heart of urban workers—entails difficulties quite different from those of the slick painting and the rendering of action of a Jacquet or Benjamin-Constant.

That's to say, living in those cottages day in and day out, being out in the fields just like the peasants—enduring the heat of the sun in the summer, the snow and frost in the winter, not indoors but outside, and not for a walk, but day in and day out like the peasants themselves.

And I ask you, when you think about it, am I so wrong to criticize the criticism of the connoisseurs, who are presently fencing more busily than ever with the *often* so meaningless word technique (they're increasingly giving it a conventional meaning)?

When one counts all the trudging and lugging one has to do to paint 'the peasant of Rauwveld' and his cottage, I dare swear that this is a longer and more tiring expedition than many painters of exotic subjects, be it the justice in the harem or the reception at the cardinal's, make for their choicest eccentric subjects. For in Paris one can get Arab or Spanish or Moorish models simply by ordering and paying for them. But it's harder for someone like Raffaëlli, who paints the rag-pickers of Paris *in their own small quarter*, and his work is more serious.

Seemingly there's nothing simpler than painting peasants or rag-pickers and other labourers but— *no subjects in painting are as difficult as those everyday figures!*

There isn't—as far as I know—a single academy where one learns to draw and paint a digger, a sower, a woman hanging a pot over the fire, or a seamstress. But in every town of any consequence at all there's an academy with a choice of models for historical, Arab, Louis XV and, in a word, ALL FIGURES, PROVIDED THEY DON'T EXIST IN REALITY.

If I send you and Serret a few studies of diggers or peasant women who are weeding, gleaning corn &c. *as* THE START of a whole series about all kinds of work in the fields—then it may be that either Serret or you will discover faults in them which will be useful for me to know about, and which I'll naturally concede myself.

But I want to point out something that's perhaps worth noting. All academic figures

are constructed in the same way and, let's admit, one couldn't do better. Impeccable — *without faults* — you'll already have seen what I'm driving at — *also without giving us anything new* to discover.

Not so the figures of a Millet, a Lhermitte, a Régamey, a *Lhermitte*, a Daumier. They're also well constructed — but *not the way the academy teaches, after all*. I think that no matter how academically correct a figure may be, it's REDUNDANT in this day and age, even if it were by Ingres himself (apart from his Source of course, because that indeed *was* and *is* and *will* remain something new) if it lacks that essential modernism — the intimate character, the actual DOING SOMETHING.

When will the figure *not* be redundant then, even though there were necessarily faults and grave faults in it to my mind, you'll probably ask.

When the digger digs, when the peasant is a peasant, and the peasant woman a peasant woman. Is this something new? Yes. Even the little figures by Ostade, Ter Borch don't work the way they do nowadays.

I'd like to say a lot more about this and I'd like to say how much I myself want to do what I've begun even better — and how much higher than my own I value the work of some others. I ask you — do you know of a single digger, a single sower in the old Dutch school??? Did they ever try to make 'a labourer'? Did Velázquez try it in his water-carrier? Or his folk types? No.

Work, that's what the figures in the old paintings don't do. These days I'm slogging away at a woman whom I saw last winter, lifting carrots in the snow. There it is — Millet did it, Lhermitte, and in general the peasant painters of *this* century — an Israëls — they find that more beautiful than anything else. But *even* in this century, how relatively few there are among the legion of painters who want the *figure* — yes — above all — *for the sake of the figure* (i.e. for the sake of form and modelling) but *can't conceive of it* other than working, and also have the need — which the old masters avoided, as did the old Dutch masters who depicted so many conventional actions — and — I say — have the need TO PAINT THE ACTION FOR THE ACTION'S SAKE.

So that the painting or the drawing is a FIGURE drawing for the sake of the figure and the inexpressibly harmonic form of the human body — yet at the same time — is *lifting carrots in the snow*. Am I expressing myself clearly? I hope so, and just say this to Serret — I can say it in fewer words — a nude figure by Cabanel, a lady by Jacquet and a peasant woman *not by Bastien-Lepage himself*, but a peasant woman by a *Parisian* who learnt to draw at the academy, will always show the limbs and the structure of the body in the same way — sometimes charmingly — correct — in proportion and anatomy. But when Israëls or when Daumier or Lhermitte, say, draw a figure, one will *feel* the *form* of the body *much more* and yet — this is why I particularly want to include Daumier — the proportions will sometimes be almost *random*, the anatomy and structure often completely wrong 'in the eyes of the academicians'.

But it will *live*. And above all Delacroix, too.

It still isn't expressed properly. Tell Serret *that I would be desperate if my figures were* GOOD, tell him that I don't *want* them academically correct. Tell him that I mean that if one *photographs* a digger, then he would *certainly not be digging*. Tell him that I think Michelangelo's figures magnificent, even though the legs are definitely too long — the hips and buttocks too broad. Tell him that in my view Millet and Lhermitte are consequently the true painters, because they don't paint things as they *are*, examined drily

and analytically, but as *they*, Millet, Lhermitte, Michelangelo, feel them. Tell him that my great desire is to learn to make such inaccuracies, such variations, reworkings, alterations of the reality, that it might become, very well—lies if you will—but—truer than the literal truth.

And now I must close soon—I did need, though, just to talk about the fact that those who paint the life of the peasants or the common people, although they aren't counted among the men of the world—will still, however, perhaps endure better in the long run than the makers of the exotic but painted in Paris harems and cardinals' receptions.

I know that it's being a disagreeable person when one's in need of money at inconvenient times—but my excuse is just that painting the seemingly most everyday things is sometimes the most difficult and most expensive.

The expenses that I MUST *incur if I want to work* are sometimes very heavy in relation to my means. I assure you that if my constitution weren't becoming virtually like that of a peasant as a result of wind and weather, I wouldn't stick it out, for there's simply nothing left over for my own comfort. But I don't desire that for myself either, any more than many peasants desire to live other than as they live. But what I do ask is both for paint and, above all, for models. You'll perhaps realize from what I say about the figure drawings that I'm positively passionate about going on with them.

You recently wrote to me that Serret had spoken to you '*with conviction*' about certain faults in the structure of the figures of the potato eaters. But you'll have been able to see from my answer that my own criticism also condemns them, considered from that point of view, only I've pointed out how this was an impression I had after I'd seen the cottage in the dim lamplight on many evenings, after having painted 40 heads, from which it follows that I was starting from a different point of view. Now we've started talking about the figure, though, I have a great deal to say. I find in Raffaëlli's words, his perception about '*Character*', what he says about that is good—and in its place—and clarified by the drawings themselves.

People who move in artistic and literary circles, though, as Raffaëlli does in Paris, think differently after all from, say, the way I do out in the country among the peasants. I mean they search for one word that sums up all their ideas—he suggests the word '*Character*' for the figures of the future. I agree with it, with the intention—I believe—but I believe as little in the accuracy of the word as in the accuracy of other words—as little as in the accuracy or appositeness of my own expressions.

Rather than saying there has to be character in a digger—I describe it by saying this peasant has to be a peasant, this digger has to dig, and then there's something in it that is essentially modern. But I feel that people can draw conclusions I don't mean even from these words—even were I to add a whole list.

Instead of reducing the expenses for models—which are already quite a burden on me—I think it would be desirable—very desirable—if I could increase them a little. Because I'm concerned with something very different from being able to do 'a little figure' drawing.

Showing the FIGURE OF THE PEASANT IN ACTION, you see that's what a figure is—I repeat—essentially modern—the heart of modern art itself—that which neither the Greeks, nor the Renaissance, nor the old Dutch school have done.

To me, this is a matter I think about every day. However, this difference between

both the great and the lesser masters of the present (the great, for instance Millet, Lhermitte, Breton, Herkomer; the lesser, for instance Raffaëlli and Régamey) and the old schools isn't something I've often found expressed truly forthrightly in articles on art.

Just think about whether you don't find it's true, though. The figure of the peasant and the workman started more as a 'genre' — but nowadays, with Millet in the van as the eternal master, it's the very heart of modern art and will remain so.

People like Daumier — one has to respect them because they're among the pioneers. The simple *nude but modern* figure ranks high — as revived by Henner and Lefebvre, Baudry and, above all, the sculptors like a Mercier, Dalou, they're also among the very soundest. But peasants and labourers simply aren't nude, and so one doesn't have to think nude. The more people who start making figures of workmen and peasants the better I'll like it. And I myself, I know of nothing else in which I take so much delight. This is a long letter and I still don't know whether I've said what I mean clearly enough. I may perhaps drop Serret a line. If I do, I'll send the letter to you to read, because I want to make it clear how much I attach to this question of the figure.

519 | Nuenen, on or about Thursday, 16 July 1885 | *To Theo van Gogh* (D)

My dear Theo,

I had a visit today from Wenckebach, a painter from Utrecht who sees Rappard every day. He makes landscapes and I've often heard his name mentioned, and he got a medal in London at the same time as Rappard. He has seen my work — those cottages I have for you, and the figure drawings too.

I talked to him about the fact that to my regret I'd had trouble with Rappard, which I could hardly explain otherwise than that he'd been prattling about my work with other people from The Hague, and that since, moreover, he hadn't seen anything in a long time, he couldn't help got his head stuffed full there.

I showed Wenckebach figures that Rappard thought good in the past, and at the same time those that I'm doing now, and pointed out to him how I'd changed in a few things and would change even more, but that what I was looking for now was certainly not inferior.

Then he said that he didn't doubt that Rappard would take back what he had written to me.

I also showed him how, as regards the colour, I'm not predisposed to *always* paint darkly. A couple of the cottages are actually very light.

But that I'm concerned with taking the primary colours red, blue, yellow, as starting-points, as points of departure, and not grey.

Then we talked quite a bit about colour, and he said among other things that he'd noticed that in old watercolours Jaap Maris had also used *ruddy*, brown-grey, red tones, and rather a lot in fact — so that if one were to hold it next to one of his present drawings it would look completely red. And the same about Israëls, too.

I may be doing more harm than good by telling you this, because it's part of a conversation, and I actually ought to tell all of it. But we've spoken of it before, and so you may well understand it anyway, in its context. To get an *honest, sound* coloration, to

sustain it, it's advisable — and particularly in this day and age, now imitators of the *great*, grey fellows (not the masters themselves) want more and more, always and everywhere, to paint everything *light* — to practise in the more powerful spectrums and to persevere in using them, since the actual colourists always on the colours

Thus Wenckebach said, for instance, that he liked the thing of the old tower, which I painted last year with a lot of bitumen in it, and thought it was beyond the paint. He said he found the whole thing original. Other old things, too, that water mill, ox-plough, avenue of autumn trees.

But what pleased me most was that he thought the figures good — he called them Millet-like. I know for sure, though, that I'll get them even better if I just have some luck with the expenses and can carry on working hard on them. I'm rather worried about that, though, and as for this month — I'm *absolutely* broke — I haven't a guilder left.

We'll have a hard time — but don't blame me too much, for with perseverance there's still a good chance later of reaping what we sow.

I'm worried enough about your money troubles, though, I wish I could lighten them a little for you.

When you come to Holland — shouldn't you try to approach Tersteeg again? Tersteeg is someone who *dares, provided* he's convinced — he's all right. And Mauve likewise.

If the fellows who *persevered* in *studying* the figure were very numerous, I'd say there would be little chance of finding some help.

But they're not so very numerous — and they're no less necessary than in the past.

It's hard for you to keep going on your own, and I *can't* do anything to reduce the expenses — on the contrary, I wish I could take more models. What's to be done? One mustn't say it's fighting a losing battle, because others have won it, and we'll win it too.

As for Rappard, I've just written to tell him that I want him to retract his letter *once and for all.* You see, though, Theo, how it comes down to sticking to one's guns in one's work.

I wrote to Rappard that we really do have something else to fight besides each other, and that at this moment the fellows who paint peasants and the common people must join hands, because unity is strength. One can't do it alone, at any rate; a whole troop who agree can do more. Keep your spirits up, too, for perhaps we'll get more friends, and then it will liven up, and the squabbling among us might perhaps become a peasant battle against the sort of painters one can still point out in all juries nowa-days, who even now would try to stifle the ideas for which Millet was the pioneer if they could. Regards — but send me something if you can, even if it's only ten francs, to see me through.

Ever yours,
Vincent

Eindhoven, 27 July

My dear friend Rappard,

That there must necessarily be an end to this nagging is, in the first place, because it really would come to resemble the dispute between a certain two pious ministers who debated a difference of opinion concerning the geographical location of the road to salvation with *so* much fervour that at a certain moment, with one and the same gesture, they cast their respective wigs in each other's faces. Those wigs should be part of it — and — how, with the best will in the world, shall we proceed now, for we're just at the critical point and neither you nor I is in the possession of the indispensable projectile in question? I'm at my wits' end for this reason, and I'm very sorry that we've started something that we now don't appear capable of crowning with the above-mentioned end — so utterly worthy of the cause.

I think that the dispute has a decidedly ridiculous side, and would become more and more so, and really, that's the reason why I don't want to go into it any further. It's just too absurd.

Be sensible, and put a stop to it on your part, too.

Everything that occurs to a person doesn't necessarily come straight from his conscience — as if your *conscience* dictated those letters to you? — as if it was your *duty* to write them? — what — nonsense — laugh at it.

However, since you *thought* it was your duty and *thought* your conscience impelled you to do it, for my part I'm willing to let the whole matter with all its ramifications drop, and so be

DONE.

It remains — to ask you whether and, if so, approximately when you're thinking of coming here to make a number of studies.

I would then see to it that you can stay with my mother as usual.

Sincerely,

Vincent

My dear Theo,

I've heard from that colourman — who tells me I can send the paintings. But that he wants me to send them as soon as possible because there are many strangers in The Hague at present.

He's quite right there. What I want to ask you is that you try to send me enough for me to get the crate made and pay the carriage. DEDUCT *it next month*, IF YOU LIKE — but I have nothing, and it's important to me to get my consignment off immediately.

Your visit really left me with a less than favourable impression — I believe more than ever that more difficulties await you in the next few years than you imagine.

I continue to insist that it's somewhat fatal that your energy has evidently taken a different direction, rather than working on our getting our heads above water with the painting. And yet it's such a short while ago that you wrote that you now had more confidence that my work was good.

You take it as though I was doing you wrong or was hostile to you, now I most decidedly have rather a lot of remarks to make. And considerable concerns for the future. I can't speak other than I did, can I?

To my mind you don't in the least belong among the rising men now. Take this amiss of me — if you will — and treat me as you will accordingly.

I'm willing to take back my remarks should I see very different things in you, but that I made them during your visit — *Yes*. But even though you say *today*, 'I'm selling 500,000 francs' worth a year' — this doesn't make any impression on me at all, since I'm only too convinced of the precariousness of it all — you keeping up even a half or a fifth of that and delivering in the years ahead.

It's too up in the air for me, too little at ground level.

And art itself is solid enough, that's not the trouble.

But, 'to be a counting-house *will pass*' was said, not by me, but by someone whose words came *dreadfully* true. And I wish you were, or would become, a painter. I put it bluntly, more strongly than before, because I believe so firmly that the *large-scale* art trade is, in many respects, too much like *tulip mania*.

And the positions in it dependent on chance and whim. Make a miscalculation — make what may be an insignificant mistake — and — what's left of that huge figure you're turning over now? That figure depends on G&Cie's whim.

And KNOWLEDGE OF ART, *stripped bare*, is related, more closely than you think, to the practice of art. TRADE in paintings is something *very different* when one is on one's own from when one works for large distributors. And it's the same with other things, too. Anyway — work hard — but — try to work sensibly too.

The trouble you've taken together with me — for *providing money is also taking trouble and there's absolutely no getting away from it* — this trouble has at least been an act of personal initiative, and of personal will and energy — but what am I to think or say of it if, little by little, with the decided weakening of the financial aid, something else weren't to be put in its place? And now, above all, to my mind at any rate, it's the time to try to push ahead with my work.

I've also been looking for addresses in Antwerp, and will hear more precisely about them before long. Then I can probably send things there, too. But if you want these things, help me to bring them about.

You said to me yourself, *Where there is a will there is a way*; well then, I'll take you at your word a little as to whether you're really seeking for us to make *progress*. If I were to ask for extravagant things and you refused, then so be it — but where they're the most essential, the very simplest necessities, and the lack just becomes more and more, and worse and worse, then I think you're taking economy *too far*, and in this respect it's very far from being useful.

Regards.

Yours truly,
Vincent

Just a word about Serret and about Portier. Tell them as it *is*, that is that I did have studies ready, but that I had to pay a colourman who was making it difficult for me just now. That in order to put a stop to it, I wrote to tell him that I put his paint in my studies, and that I asked him to take the trouble to sell something for me instead of nagging. That I'll go through with it, and have to send him things.

That as to the drawings which I said I'd show Serret, since I'm in a hurry to do things, I need them myself. But I do still think it's of some importance that at any rate he knows that I really did have them when you came, and that you tell him that you saw them at my place, and then also tell him exactly what you think. I won't influence your own opinion. That I'm sad about your thinking that this is all right, though, yes — that is so.

But I don't refuse to take such measures — and even if one of these colourmen wanted to sell off my bits and pieces, he would be welcome to go to those lengths. It's certain that the paint-dealing gentlemen wouldn't blush to do it.

However, I'm fed up with talking about it; I've said what I had to say — and you — you can deal with my suggestion as you see fit.

And if these fellows want to attack me and sell me up, since they expressly threatened me with collection, and that over matters of less than 30 guilders, then I won't be able to resist them and will let them do as they please, but it will be as if it happens before your very eyes, since you've just been here. That I *can't* stop the work at the level I now am, that's true. I need paint &c. every day. I must make progress, and if I want to pay for what I need today, then an outstanding bill from yesterday will have to wait.

For your information, this is how it is with me for the rest of the year, precisely and in detail — I have to pay:

three suppliers who are all pestering me, one 45 guilders, the other 25 guilders, the other 30 guilders. These are the exact sums outstanding on accounts which have of course been much higher over the course of the year, but which I pay off in cash, as much as I possibly can with the utmost effort.

deficit therefore	100 guilders
Add to this rent in November	25 "
	125 guilders = 250 francs

Suppose I get 4 x 150 francs from you for Sept. Oct. Nov. Dec. = 600 francs. That then leaves 350 francs to last from now until New Year. *And then bear in mind that I have literally nothing left this month*, and that I also have to live this month.

So that from Aug.–1 January, in other words *almost 5 months*, I have to live and *paint on 350 francs*. Which I *can* do on 150 francs a month, but *not easily*, but anyway it's *possible* as a minimum.

However, if in the course of 4 months 250 francs has to be deducted to pay for paint and rent, well then, the work is hampered and obstructed so much that one doesn't know what to do, and would rather say to the fellows *sell my things then! But let me work!* Without hesitation I've just thrown *this* month in to calm the fellows down. But the hardship that's caused is bad enough.

And my last word on the subject is that if my work were weak and awful, I would agree with you if you said — '*I can't do anything about it*'.

Well — since larger and smaller painted studies as well as new drawings were able to make you understand that we're making progress with it, I'm not so sure whether 'I can't do anything about it' should be your final word. Talk to Serret, talk to Portier about it — and say how much I want to keep working and how little opportunity I have myself to find art lovers, since painting the peasants means that once and for all the *countryside, not the city* is my place of work.

Vincent

529 | Nuenen, on or about Wednesday, 19 August 1885 | *To Theo van Gogh* (D)

My dear Theo,

I wanted to add to my letter of the day before yesterday that I had a letter from Rappard yesterday, and our quarrel is *wholly* made up, that he sent me a croquis of a large painting of a brickworks that he's working on. This looks very original — if one wanted to find other paintings in the same spirit, it would be Meunier, say, whose mine-workers you saw in Antwerp. He's rented a small house outside Utrecht, just as a studio (and arranged for light from above) near the brickworks, and since he's also going back to Terschelling he's deep *in* nature again, and to my mind that's better than working in town.

I wanted to tell you, though, that I hope that the quarrel that we have will end like this, too, and that it will be settled. No more than I can accept his criticism, can I fully resign myself to the present situation in which my work is held up so badly by my financial difficulties. I don't ask *you* to put this right alone, but I simply want us to do our best *together* (and not just *I* alone either) to make headway. It's an *effort* for you, too, and not *easy*; I know that, and as such I appreciate it very much, but making an *effort* for a *goal* is no misfortune, and having to fight is the precondition for every honest victory.

The expenses of painting can't always be avoided, and *not* incurring them is sometimes *not* the best policy, because nothing decent could come of it if one hesitated to pay for models or essential painting materials. And since it's getting harder for me rather than better, it has eventually got to such a pitch that I definitely have to complain.

And I say once more, let's keep my little painting business in order, because sooner or later we might be in sore need of it.

When there's a storm in the air, one has to keep the boats in good shape. The man I now have in The Hague is Leurs, who doesn't live in Praktizijnshoek any more but in Molenstraat.

He's asking me to send him more than one painting in order to have more than one chance, and is offering me his *two* windows.

And since he's very hard pressed for money himself, he won't shrink from making an effort. I'm sending him a couple of cottages, the old tower and smaller ones of figures. And while he shows those, I'll make a few new ones to keep him going.

I've also got a chance of persuading a second in The Hague.

But for me it comes down to *being able to go on working.*

I've made another small painting of the wheat harvest since you left, the same size as the women pulling turnips in the snow: a reaper, a woman binding sheaves, sheaves, and the windmill, like the drawings you saw. An effect in the evening after sunset.

Also more studies of interiors.

Once again I suggest that you just talk it over with Portier and Serret, say that I'm in quite a fix, encourage them to do what they can, that for my part I'll see about sending them new things.

And let's see about getting that crate off. I've also painted 3 more studies of the women among the potatoes, the first of which you've already seen.

Rappard had spoken to Wenckebach, and in his letter there was no longer any trace of the tone he'd started to take. And although he's going to Terschelling first, he writes that he wants to come and make more studies here. Regards, and wishing you good fortune.

Yours truly,
Vincent

531 | Nuenen, on or about Wednesday, 2 September 1885 | *To Theo van Gogh* (D)

My dear Theo,

Thanks for your letter and 150 francs enclosed. I also received the two new Lhermittes today. He's a master of the figure. He's able to do what he likes with it — conceiving the whole neither from the colour nor from the local tone, but rather proceeding from the light — as Rembrandt did — there's something astonishingly masterly in everything he does — in modelling, above all things, he utterly satisfies the demands of honesty.

A great deal is said about — Poussin. Bracquemond talks about him, too. The French call Poussin their greatest ever painter among the old masters. Well it's certain that what's said about Poussin, whom I know so very little about, I find in Lhermitte and in Millet. But with this distinction, that it seems to me Poussin is the original grain, the others are the full ear. For my part, then, I rate today's *superior*.

This last fortnight I've had a great deal of trouble with the reverend gentlemen of the priesthood, who gave me to understand — of course with the best of intentions and, no less than others, believing that it was their duty to interfere — who gave me to understand that I shouldn't be too familiar with people beneath my station — who, having spoken to me in those terms, spoke in a very different tone to the 'people of lower station', that's to say with threats that they mustn't allow themselves to be painted. This time I simply went straight to the burgomaster and told him exactly what had happened, and pointed out that this was none of the priests' business and that they should stick to their own province of more abstract things. In any event, I'm not encountering any more opposition for the time being, and I think it quite possible that that's how it will remain. A girl I'd often painted was having a child and they thought it was mine, although it wasn't me. However, knowing the facts of the matter from the girl herself and it being a case in which a member of the priest's congregation in Nuenen had behaved extremely badly, they can't get their teeth into me, at least not this time. But

you see that it isn't easy to paint people at home and draw them as they go about their business. Anyway — they won't easily win in this case, and this winter I do hope to keep the very same models, who are of the old Brabant stock through and through.

Even so, I have a few more new drawings.

But now, in the last few days, I could not get anyone in the fields. Fortunately for me, the priest isn't yet, but is nonetheless beginning to become, quite unpopular. It's a bad business, though, and if it were to continue I'd probably move. You'll ask what's the point of being a disagreeable person — sometimes you have to be. If I'd discussed it meekly they'd have ground me down without mercy. And when they hinder me in my work, sometimes the only way I know is an eye for an eye, a tooth for a tooth. The priest went so far as to *promise* the people money if they didn't allow themselves to be painted — however, the people replied very pertly that they'd rather earn it from me than go cap in hand to him. But you see, they only do it for the sake of earning money and I don't get *anything* done for *nothing* around here.

You ask me whether Rappard has ever sold anything. I know he's flusher at present than before, that for a long time, for instance, he had a nude model day after day, that for the purposes of a painting of a brickworks he's now rented a small house actually on the spot and altered it so that he had light from above — I know that he's been on another trip through Drenthe and that he's also going to Terschelling. That all of this is pretty expensive, and the money for it has to come from *somewhere*. That although he may have money of his own, he must be earning as well, because otherwise he couldn't do what he's doing. It may be that his family is buying or friends, that's possible, but at any rate somebody must be.

But this evening I'm much too occupied with Lhermitte's drawings to go on writing any more about other things.

When I think about Millet or about Lhermitte — then — I find modern art as great — as Michelangelo and Rembrandt — the old infinite, the new infinite too — the old *genius*, the new *genius*. Perhaps someone like Chenavard doesn't see it like this — but for my part I'm convinced — that in this regard one can believe in the present.

The fact that I have a definite belief as regards art also means that I know what I want to get in my own work, and that I'll try to get it even if I go under in the attempt. Regards.

Yours truly,
Vincent

534 | Nuenen, on or about Saturday, 10 October 1885 | *To Theo van Gogh* (D)

My dear Theo,

I've been to Amsterdam this week — I hardly had time to see anything but the museum.

I was there 3 days; went Tuesday, back Thursday. Result is that I'm *very glad* I went, whatever the cost, and that I don't propose going for so long again without seeing paintings.

I'd already put it off and put it off, that and so much else, because of the cost. But it's much better that I can no longer imagine that this is the thing to do. I get too much out of it—for my work, and when I look at the old paintings, which I can decipher as regards technique very differently from before—then perhaps I have precious little need for conversation anyway.

I don't know whether you remember that to the left of the Night watch, in other words as a pendant to the Syndics, there's a painting—it was unknown to me until now—by *Frans Hals* and *P. Codde*, 20 or so officers full length. Have you noticed it??? In itself, that painting alone makes the trip to Amsterdam well worth while, especially for a colourist. There's a figure in it, the figure of the standard-bearer in the extreme left corner, right up against the frame. That figure is in grey from top to toe, let's call it pearl grey,—of a singular neutral tone—probably obtained with orange and blue mixed so that they neutralize each other—by varying this basic colour in itself—by making it a little lighter here, a little darker there, the whole figure is as it were painted with one and the same grey. But the leather shoes are a different material from the leggings, which are different from the folds of the breeches, which are different from the doublet—expressing different materials, very different in colour one from another, still all one family of grey—but wait!

Into that grey he now introduces blue and orange—and some white.

The doublet has satin ribbons of a divine soft blue. Sash and flag orange—a white collar.

Orange, white, blue, as the national colours were then. Orange and blue next to each other, that most glorious spectrum—on a ground of grey judiciously mixed, precisely by uniting just those two, let me call them poles of electricity (in terms of colour, though) so that they obliterate each other, a white against that grey. Further carried through in that painting—other orange spectrums against a different blue, further the most glorious blacks against the most glorious whites—the heads—some twenty—sparkling with spirit and life, and how they're done! and what colour! the superb appearance of all those fellows, full length. But that orange, white, blue chap in the left corner——...... I've seldom seen a more divinely beautiful figure——it's something marvellous.

Delacroix would have adored it—just adored it to the utmost.

I stood there literally rooted to the spot. Now you know the singer, that laughing chap—bust in a greenish black with carmine.

Carmine in the flesh colour, too.

You know the bust of the man in yellow—*dull lemon*—whose face, because of the opposition of tones, is a daring and masterly bronze, like wine-red (violet?).

Bürger wrote about Rembrandt's Jewish bride just as he wrote about Vermeer of Delft, just as he wrote about Millet's sower, just as he wrote about Frans Hals—dedicating himself and surpassing himself. The Syndics is perfect—the finest Rembrandt—but that Jewish bride—not reckoned so much—what an intimate, what an infinitely sympathetic painting, painted—with a glowing hand. You see, in The syndics Rembrandt is true to life, although *even there* he still goes into the higher—into the very highest—infinite. But yet—Rembrandt could do something else—when he didn't have to be true in the *literal* sense, as he did in a portrait—when he could—*make poetry*—be a *poet*, that's to say *Creator*. That's what he is in the Jewish bride. Oh how

Delacroix would have understood that very painting! What a noble sentiment, fathomlessly deep. One must have died many times to paint like this — is certainly applicable here. Still — one can speak about the paintings by Frans Hals, he always remains — on *earth*. Rembrandt goes so deep into the mysterious that he says things for which there are no words in any language. It is with justice that they call Rembrandt — *magician* — that's no easy occupation.

I've packed up various still lifes which you'll receive next week, with two souvenirs of Amsterdam that I snatched in haste and also a couple of drawings. Will also send you before long a book by De Goncourt — Chérie. De Goncourt is always good, and the way he works so conscientious, and so much toil goes into it.

I saw two paintings by Israëls in Amsterdam, that is the Zandvoort fisherman and — one of his very latest, an old woman, hunched up like a bundle of rags, by a bedstead in which her husband's corpse is lying. I thought them both masterly. Let people prattle on about technique as they will, with hollow, hypocritical, Pharisee words — the true painters — allow themselves to be guided by that conscience that's called sentiment; their soul, their brains aren't led by the brush, but the brush is led by their brains. Moreover it's the canvas that's afraid of a true painter, and not the painter who's afraid of the canvas.

In Amsterdam I saw other present-day paintings, Witkamp and others. Witkamp's certainly the best, reminds me of Jules Breton; others I have in mind but won't name, who — fence — with what *they* call technique, for my part I found WEAK *precisely in the technical sense*. You know — all those cold, grey tones that they think are distinguished and that are flat and bloody boringly, childishly mixed. Nowadays, for the convenience of painters who work in what they think is a distinguished, light spectrum, they deliberately manufacture colours consisting of — the ordinary ones mixed with pure white. Bah!

Listen — the *technique*, the mixing of colour, the modelling of the Zandvoort fisherman, for instance, is to my mind Delacroix-like and superb, and the present-day cold, flat greys — don't mean much in terms of technique, become *paint*, and Israëls is beyond the paint. To be sure — I'm not talking about Jaap Maris, Willem Maris, Mauve, Neuhuys, who each worked in his singular spectrum in the right manner — Blommers &c. But the school of the masters, their followers, Theo — I think they're getting threadbare.

Went to the Fodor too.

Decamps's shepherd really is a masterpiece — do you remember the Meissonier — a sketch — of a deathbed? The Diaz? Well, I always like to see Bosboom, Waldorp, Nuijen, Rochussen, the *original* fellows of that period 40 years back. Rochussen has a vitality like Gavarni's.

The still lifes I'm sending you are studies for colour. I'm going to do some more — don't think this is pointless. They'll sink in after a while, but in a year, say, they'll be better than now once they're dry right through and are given a thorough varnishing. If you use drawing pins to hang a large number of my studies on a wall in your room, both the earlier ones and these — just jumbled together — you'll see, I believe, that there's a link between these studies, that the colours work well alongside one another.

Speaking — of — too black — I'm very glad, all the more so as I see more of the paintings in cold, childish spectrums — that they think my studies are too black.

Look at the Zandvoort fisherman, and what is it painted with? Is it painted with red, with blue, with yellow, with black and some off-white, with brown (all well mixed and broken) or not? When Israëls says that one mustn't be black, he certainly never means what they're making of it now; he means that one gives colour to the shadows, but of course that really doesn't rule out a single spectrum, however low, not that of the blacks and browns and deep blues.

But what's the point of thinking about it — it's better to think about Rembrandt, about Frans Hals, about Israëls, than about that respectable impotence.

I'm writing at some length — even if you perhaps don't believe what I say about the colours, and even if you think me pessimistic when I say that much of what they call subtle grey is very ugly grey, even if you think me pessimistic or worse still when I also condemn the smooth finishing of faces, hands, eyes, since all the great masters worked differently — perhaps, little by little, your own *study* of art, which you have happily begun again properly, will change you too. Now I have a favour to ask you. That friend of mine in Eindhoven, who went with me to Amsterdam, bought Bürger, Musées de la Hollande, Van der Hoop et Rotterdam at C.M.'s, but C.M. didn't have *the first volume, Musées de la Haye et d'Amsterdam*. We must have that one though. It's out of print, but you'll be able to dig one up somewhere, and he's even prepared to give 10 francs for it if need be, although preferably cheaper, of course. I'll send you what it costs you straight-away, since it's for him, and he charged me with this on that condition. So will you do your best to get it? If you do find it, read it through again yourself first — because it's so good.

I didn't go into C.M.'s with him.

The two little panels I painted in Amsterdam were done in a tearing hurry, one of them, mark you, in the station waiting room when I was a bit early for the train, the other one in the morning, before I went to the museum at about 10 o'clock. Even so, I'm sending them to you, in the manner of tiles on which one has dashed something off with a few strokes.

As regards the end of this month — old chap, I'm literally cleaned out — what's to be done? Couldn't you send an extra twenty francs or something? I have to pay for paint again next month, 1 Nov. 25 guilders rent.

As regards connections for my work — I did speak to someone, and if I ever go again I'll take work with me. There's a general laxness that MAKES it EASY ENOUGH as regards finding a chance to exhibit.

LET'S PAINT A VERY GREAT DEAL. That's the message if we want to succeed, work *a lot* precisely because it's slack — then one day, rather than finding all ports closed to us — we may be able to lash a broom to the mast. Regards.

Yours truly,
Vincent

My dear Theo,

I read your letter about black with great pleasure. And it convinces me accordingly that you aren't prejudiced against black.

Your description of the Manet study, The dead toreador, was well analyzed. And the whole letter proves to me the same as your croquis of Paris made me think at the time, that if you put your mind to it you can paint something in words.

It's certain that by studying the laws of colours one can move from an instinctive *belief* in the great masters to being able to account for why one likes what one likes, and that's very necessary nowadays when one considers how terribly arbitrarily and superficially people judge.

You must just let me maintain my pessimism about today's trade, because it definitely does *not* imply despondency. This is how I reason to myself. Suppose that I'm right when I increasingly see something like tulip mania in the curious haggling about the price of paintings. Suppose, I say, that like tulip mania at the end of the previous century, the art trade, with other branches of speculation, were to disappear at the end of this as it came, that's to say relatively quickly.

Tulip mania may have perished, BULB-GROWING REMAINS. And for my part I'm content, for better or worse, to be a little gardener who loves his nursery.

Presently my palette is thawing, and the bleakness of the earliest beginnings has gone.

I still often run up against a blank wall when undertaking something, but all the same, the colours follow one another as if of their own accord, and taking a colour as the starting-point I see clearly in my mind's eye what derives from it, and how one can get life into it.

Jules Dupré is like Delacroix in landscape, for what enormous diversity of mood he expressed in symphonies of colour.

Now a seascape, with the most delicate blue-greens and broken blue, and all sorts of pearly tones.

Then an autumn landscape with foliage from deep wine red to vivid green, from bright orange to dark havana, with yet more colours in the sky in greys, lilacs, blue, white, forming another contrast to the yellow leaves.

Then again a sunset in black, in violet, in fiery red.

Then again more capricious, like the corner of a garden by him that I saw and have never forgotten; black in the shadow, white in the sun, bright green, a fiery red, and then again a dark blue, a bituminous greenish brown and a light brownish yellow. Truly colours that can have quite a lot to say to one another.

I've always idolized Jules Dupré, and he'll become *even* more recognized than he is now. For he's a real colourist—always interesting, and with something so powerful and dramatic. Yes, he is indeed a brother to Delacroix.

As I said, I think your letter about black very good, and what you say about *not* doing it in the local colour is also correct.

Still, it doesn't satisfy me. To my mind there's far more behind not doing it in the local colour. *True painters are the ones who don't do it in the local colour*—that was what Blanc and Delacroix discussed once.

May I not simply understand by it that a painter does well if he starts from the colours on his palette instead of starting from the colours in nature?

I mean, when one wants to paint a head, say, and one looks closely at the nature one has before one, then one might think, this head is a harmony of reddish brown, violet, yellow, all broken — I'll put a violet and a yellow and a reddish brown on my palette, and break them into each other.

I retain from nature a certain sequence and a certain correctness of placement of the tones, I study nature so as not to do anything silly, to remain reasonable — but — I don't really care whether my colours are precisely the same, so long as they look good on my canvas, just as they look good in life. Truer by far is a portrait by Courbet, manly, free — painted in all sorts of beautiful, deep tones of reddish brown, of goldish, of colder violet in the shadow, with black as a foil, with a little piece of tinted white linen as a rest for the eye — finer than a portrait by anyone you will — who has imitated the colour of the face with hideous *precision*.

A man's head or a woman's head, looked at very composedly, is divinely beautiful, isn't it? Well then — with painfully literal imitation one loses *that general* effect of *looking beautiful* against one another that tones have in nature; one preserves it by re-creating it in a colour spectrum PARALLEL to, but not necessarily exactly, or far from the same as the subject.

Always and intelligently making use of the beautiful tones that the paints form of their own accord when one breaks them on the palette, again — starting from one's palette — from one's knowledge of the beautiful effect of colours, isn't the same as copying nature mechanically and slavishly.

Now here's another example. Suppose I have to paint an autumn landscape, trees with yellow leaves. Very well — if I conceive it as — a *symphony in yellow*, what does it matter whether or not my basic yellow colour is the same as that of the leaves — it makes *little* difference. *Much, everything* comes down to my sense of the *infinite variety* of tones in the *same family*.

If you think this a dangerous tendency towards romanticism, a betrayal of 'realism' — painting from the imagination — having a greater love for the colourist's palette than for nature, well then, so be it.

Delacroix, Millet, Corot, Dupré, Daubigny, Breton, 30 more names, do they not form the heart of this century where art is concerned, and all of them, do they not have *their roots* in romanticism, *even if they surpassed romanticism*? Romance and romanticism are our era, and one must have imagination, sentiment in painting. HAPPILY, realism and naturalism ARE NOT FREE *of* THEM. Zola *creates*, but doesn't hold a *mirror* up to things, creates them *amazingly*, but *creates, poetizes*. That's why it's so good. So much for naturalism and realism, which are NONETHELESS related to romanticism. And I still say that I'm touched when I see a painting from the days of 30–48, a Paul Huet, an old Israëls like the Zandvoort fisherman, a Cabat, an Isabey. But I find that saying, don't paint the local tone, so very true — that I would far rather see a painting with lower values than nature than one that's exactly the same as nature.

Rather a watercolour that's somewhat vague and unfinished, on the other hand, than one that has been worked up to capture reality.

That saying has a broad meaning — don't paint the local tone — and leaves the painter

free to seek colours that form a *whole* and are related to one another, which comes out all the more through contrast to another series.

What do I care that the portrait of a worthy citizen tells me precisely what the milk and water, pinkish, purplish, nondescript colour of the pious man's face — which I'd never seen — is? But the fellow citizens of the little town where the individual in question made himself so estimable that he felt it incumbent upon him to keep posterity familiar with his physiognomy — are very edified by the speaking likeness.

COLOUR EXPRESSES SOMETHING IN ITSELF. One can't do without it; one must make use of it. What looks beautiful, really beautiful — is also right. When Veronese had painted the portraits of his beau monde in the The marriage feast at Cana, when he had devoted to it all the richness of his palette in sombre violets, in magnificent golden tones — then — there was still a faint azure and a pearly white he thought of — which doesn't appear in the foreground. He flung it on at the back — and it was right, changed of its own accord into the surroundings of marble palaces and sky that singularly complete the array of figures.

That background is so magnificent in that it came about of its own accord, spontaneously, from a colour calculation.

Am I wrong about this?

Isn't it painted *differently* from how someone would do it who had thought about the palace *and* about the figures at the same time? As a single whole?

All that architecture and sky is conventional and subordinate to the figures, calculated to make the figures show up well.

That is truly painting — and the result is more beautiful than precise imitation of the things themselves. Thinking about one thing and letting the surroundings belong to it, derive from it.

Making studies from nature, wrestling with reality — I don't want to argue it away. I've tackled it that way myself for years and years, almost fruitlessly and with all sorts of sad results. I wouldn't want to have missed that — *error*.

Always carrying on in the same way would be folly and stupid, that's what I mean — but *not* that all my effort has been utterly in vain.

One begins by killing, one ends by healing is a doctors' saying.

One begins by fruitlessly working oneself to death to follow nature, and everything is contrary.

One ends by quietly creating from one's palette, and nature is in accord with it, follows from it. But these two opposites don't exist without each other. Swotting, even if it's apparently in vain, gives a familiarity with nature, a sounder knowledge of things. And a fine saying of Doré's, who's sometimes so clever! is *I remember*.

Although I believe that the finest paintings are made relatively freely from the imagination, I *can't* break with the idea that one can't study nature, swot even, too much.

The greatest, most powerful imaginations have also made things directly from reality that leave one dumbfounded.

In reply to your description of the study by Manet, I'm sending you a still life of an open, hence an off-white Bible, bound in leather, against a black background with a yellow-brown foreground, with an additional note of lemon yellow.

I painted this *in one go*, in a single day. This to show you that when I say that perhaps

I haven't swotted entirely for nothing I mean it, because these days it really comes quite readily to me to paint a given object, whatever the shape or colour may be, without hesitation.

Lately I made several studies outdoors, of the autumn landscape. I'll send you the still life and one of these autumn studies soon. I'll write again in the next few days anyway, and send this letter in haste to say that I was very pleased with what you say about black. Regards.

Yours truly,
Vincent

541 | Nuenen, on or about Saturday, 14 November 1885 | *To Theo van Gogh* (D)

My dear Theo,

I came across the following sentence that you'd underlined in the article on Chardin in De Goncourt's book. After speaking about painters being badly paid, he says: 'What to do, what to become. He must abandon himself to the inferior occupations or die of hunger. The first course is adopted'. *So*, he goes on to say, aside from a few *martyrs*, the rest 'become fencing masters, soldiers or comedians'.

That really has remained fundamentally true. Seeing as you'd marked the above, I considered it possible you might want to know what I intend to do next, especially since I've just informed you that I've given notice on my current studio.

The present day isn't entirely the same as Chardin's, and nowadays there are a few things that are hard to argue away. The number of painters is much greater.

Now it immediately makes a fatal impression on the public if a painter 'does something on the side'. I'm not at all above that in this respect, I should say keep on painting, make a hundred studies, and if that's not enough, two hundred, and just see if that doesn't get you over 'doing something on the side'. Then accustoming yourself to poverty, seeing how a soldier or a labourer lives and stays healthy in wind and weather with the ordinary people's food and dwelling, is as practical as earning a guilder or a bit more a week. After all, one's not in the world for one's comfort and doesn't have to be any better off than the next man. Being better off helps hardly *at all* — after all, we can't hold on to our youth.

If THAT were possible — but the thing that really makes one happy, being young and staying so for a long time — well, that isn't here — that isn't even in Arabia or Italy, although *that* is better there than here.

And for my part, I'm of the opinion that one has the greatest chance of staying strong and renewing oneself — in today's third estate. Anyway. So I'm saying that I seek to find it in painting, without ulterior motives. But — I'd do well, I think, to bear portrait painting in mind if I want to earn. I know it's difficult to please people with a 'likeness', and I dare not say beforehand that I feel sure of my case. I certainly don't consider it altogether impossible, though, because the people here will be much the same as people elsewhere. Well then, the peasants and the folk from the village aren't mistaken and promptly say, even *contradicting me if I say they're wrong*, that is Renier de

Greef, that's Toon de Groot and that's Dien van der Beek &c. And sometimes even recognize a figure seen from behind. In town, the bourgeois folk, and certainly no less the tarts, no matter who they are, *always* value portraits. And Millet — discovered that ship's captains actually 'respect someone for it' if he can do that (those portraits are probably intended for their mistresses ashore). This hasn't been exploited yet. Do you remember this in Sensier? I've always remembered how Millet kept himself going in Le Havre this way.

Well roughly, my plan is to go to Antwerp — I can't possibly calculate the ins and outs beforehand.

I've come by the addresses of 6 art dealers, so I'd want to take something with me and further, as to the work, I plan to paint a few views of the city as soon as I get there — reasonably large — — and show them straightaway too.

In other words concentrate everything on doing something there. And going there poor, at any rate I can't lose much.

Now as regards here — I know the area and the folk too well and love them too much to believe I'm going for good. I'll see about renting a place to store my things, and then I'm also covered should I want to leave Antwerp for a while — or should become homesick for the country.

As for 'doing something on the side' — right from the outset Tersteeg, for instance, *nagged* me about it. And that was *nagging*, whatever else one may think of Tersteeg. Those who talk about it the most aren't at the same time able to explain precisely what. And as to that, in order to clear the whole thing up in my case — if I did 'something on the side', then the only thing would be that, if I knew either dealers or painters, I would possibly do something with paintings, for instance by going to England for them &c.

Things like this, which are obviously directly related to painting, are an exception, but otherwise, *as a rule*, a painter must be wholly a painter.

Don't forget, either, that I'm not cut out to be a melancholic. The nickname I have around here is generally 'the little painter fellow', and it's not entirely without a measure of malice that I'm going there. I've also thought of Drenthe, though, but as more difficult to bring about.

That would be good, though, should my work from the countryside be liked in Antwerp. If the things from here were liked, either now or later, then I would continue with them, and vary them with similar things from Drenthe.

But the issue is that I can only do one thing at a time, that if I'm engaged in painting peasants, I can't occupy myself with business in town. The present moment is ideal for breaking away, since I've had trouble getting models and am going to move in any case. As to that, it's to be expected that there would never be an end to it in this studio right next door to the priest and the sacristan. So I'm changing that.

But anyway, it doesn't make an *absolute* impression on people, and by renting another room and letting things lie for a few months, the intrigue will lose a great deal of its force. Wouldn't it be best if I could spend the next couple of months, December and January, there? In Amsterdam I lodged in a soup kitchen for 50 cents; I'd do the same there, or better yet reach agreement with some painter or other to be allowed to work in his studio. There's another reason, too — that it's not absolutely impossible I might find an opportunity somewhere to paint from the nude.

They wouldn't want me at the academy, nor probably would I — but — with a sculptor, say, there must surely be a few living there, one might readily find some sympathy. It goes without saying that people with money can get as many models as they want, but it's a difficult matter without it. All the same, there must be people there who use nude models and with whom one could split the cost. I need it for many things.

I received your letter while I was writing to you. I'm willing to go to Van de Loo if need be, only you know that doctors sometimes don't tell you everything, particularly in doubtful cases. You should also understand that what I said about her being rather in a fog will probably recur, is a thing that most people who are getting old have. In any event I think it a very practical idea not to let her stay in the midst of the upheaval of the removal, unless she *absolutely* insists. For the rest, old chap, for my part I believe that Van de Loo has given Ma all, absolutely all the advice there was to give, and would say nothing new. I mean, he would already have given a warning if a danger that could be averted were threatening. But if he doesn't say anything it's a sign that, if there were something, he can't do anything about it and nothing should be done about it; if he's letting nature take its course, he's doing it because that's the best thing — Van de Loo is enormously scrupulous and — Zola-like cool and calm. Anyhow — I'll speak to Wil about it, and either I may go there or Ma may come across Van de Loo sometime when he's in the village; we'll do something. But I think it will just have to take its course. Now in such cases, you'll agree with me, *worrying* and being overanxious is intolerable for the patient *if she notices it*. And with old people there's often no way of predicting it, precisely because in so many cases their hearts aren't normal, because of fatty degeneration, say, and they can just as easily go off suddenly as carry on for another 5, another 10 years. Emotion can have an effect, of course, but precisely because of this there's much more chance of staying alive if the mind is no longer all too clear, than in periods of lucidity. Something else — I'm quite sure that, from time to time at least, there's definitely a substratum of deep thoughts in Ma (for her inner life, her life of the mind is fairly complicated and has levels or layers) that she neither wants to nor could express. In many cases she was rather silent, so — I for one would rather say that I don't always know everything about her. *Particularly now that she's lucid, letting her do as she wants* is certainly the easiest, firstly for her and secondly the most sensible for us.

Silently understanding how it would by no means be a misfortune for her were it to be that she didn't live very much longer and departed without much suffering, serenity is justifiable in this regard. Serenity too, though, were it to be that years of relatively mechanical life remained.

You see that I wanted to arrange my going to Antwerp at around the same time as their trip, which will be over around February. Between then and their final move, I'll either be back in Nuenen or — if something exceptional detained me longer, nonetheless always ready to be present right away if something happened.

This must go off, but I'll write in a few days and tell you what I've arranged with Wil. I'll suggest she goes to Van de Loo with Ma before the trip; that would go without saying for Ma. Once Van de Loo has seen her, that will be the moment for either Wil or me to ask Van de Loo outright whether he can say anything about her life expectancy. For my part, depending on what you and Wil think about it, I'm willing to

prepare Van de Loo before Ma's visit, and tell him what we'd like to know, so that he gives her a really thorough examination. Regards.

Yours truly,
Vincent

Write soon and tell me what you think about my going to Antwerp — I don't believe there's anything against it.

545 | Antwerp, Saturday, 28 November 1885 | *To Theo van Gogh* (D)

Saturday evening

My dear Theo,

Wanted to write to you with a few more impressions of Antwerp. This morning I went for a really good walk in the pouring rain, an expedition with the object of fetching my things from the customs office. The different entrepôts and hangars on the wharves are very fine.

I've already walked in all directions around these docks and wharves several times. It's a strange contrast, particularly when one comes from the sand and the heath and the tranquillity of a country village and hasn't been in anything but quiet surroundings for a long time. It's an incomprehensible confusion.

One of De Goncourt's sayings was '*Japonaiserie for ever*'. Well, these docks are one huge *Japonaiserie*, fantastic, singular, strange — at least, one can see them like that.

I'd like to walk with you there to find out whether we look at things the same way.

One could do anything there, townscapes — figures of the most diverse character — the ships as the central subject with water and sky in delicate grey — but above all — *Japonaiseries*.

I mean, the figures there are always in motion, one sees them in the most peculiar settings, everything fantastic, and interesting contrasts keep appearing of their own accord.

A white horse in the mud, in a corner where heaps of merchandise lie covered with a tarpaulin — against the old, black, smoke-stained walls of the warehouse. Quite simple — but a Black and White effect.

Through the window of a very elegant English inn one will look out on the filthiest mud and on a ship where such delightful wares as hides and buffalo horns are being unloaded by monstrous docker types or foreign sailors; by the window, looking at this or at something else, stands a very fair, very delicate English girl. The interior with figure wholly in tone, and for light — the silvery sky above that mud and the buffalo horns, again a series of contrasts that's quite strong. There'll be Flemish sailors with exaggeratedly ruddy faces, with broad shoulders, powerful and robust, and Antwerp through and through, standing eating mussels and drinking beer, and making a great deal of noise and commotion about it. Contrast — there goes a tiny little figure in black, with her small hands pressed against her body, slipping soundlessly along the grey walls. In a frame of jet-black hair, a little oval face, brown? Orange yellow? I don't know.

She raises her eyelids momentarily and looks with a slanting glance out of a pair of jet-black eyes. It's a Chinese girl, mysterious, quiet as a mouse, small, like a bedbug by nature. What a contrast to the group of Flemish mussel eaters.

Another contrast — people passing along a very narrow street between formidably tall houses. Warehouses and stores. But down at street level, alehouses for all nations

with the corresponding male and female individuals. Shops selling food, sailors' clothes, colourful and bustling.

This street is long, one keeps seeing authentic scenes, and once in a while there's a commotion, louder than usual, when a quarrel breaks out. For instance, you're walking along, looking around, and suddenly a great cheer goes up and all sorts of shouting. In broad daylight a sailor is being thrown out of a brothel by the girls and pursued by a furious fellow and a string of girls. Of whom he is apparently terrified — at any rate, I saw him scramble over a pile of sacks and disappear through a window into a warehouse. Once one's had enough of this racket — at the end of the berths where the Harwich and Le Havre boats lie — having the city behind one — one sees — in front of one, nothing, absolutely nothing but an infinity of flat, half-flooded pasture, incredibly sad and wet, undulating dry reeds, mud — the river with a single small black boat, water in the foreground grey, sky misty and cold, grey — silent as a desert.

The overall effect of the port or of a dock — sometimes it's more tangled and fantastic than a thorn-hedge, so tangled that one can find no rest for the eye, so that one gets dizzy, is forced by the flickering of colours and lines to look now here and now there, unable to tell one thing from another even after staring at a single spot for a long while.

But if one goes to a place where one has an indistinct piece of land as a foreground — then one gets the most beautiful, quiet lines and those effects that Mols, for instance, often gets. Now one sees a girl who is magnificently healthy and, at least seemingly, very sincere and innocently cheerful, then a countenance *so* slyly malicious that one is frightened by it as if by a hyena. Not forgetting the faces ravaged by the pox, the colour of boiled shrimp, with little dull grey eyes and no eyebrows, and sparse, greasy, thin hair, colour of pure pig's bristle or slightly yellower — Swedish or Danish types. It would be good to work there — but how and where? Because one could run into trouble there exceedingly quickly. All the same, I did roam around a whole lot of streets and alleys without mishap, even sat and talked very genially with various girls, who evidently took me for a bargee.

I don't consider it impossible that I might be able to come by some good models by painting portraits.

Today I got my things and tools — which I was eagerly awaiting. And so I have my studio in order. If I could come by good models at virtually no expense I wouldn't be afraid of anything. I don't reckon it a bad thing, either, that I haven't any money, as much as it would take to force things by paying.

Perhaps the idea of painting portraits and getting the sitters to pay for them by posing is a safer way. Because in the city it's not like it is with the peasants. Anyway. One thing's certain, Antwerp's a very singular and beautiful place for a painter.

My studio's quite tolerable, mainly because I've pinned a set of Japanese prints on the walls that I find very diverting. You know, those little female figures in gardens or on the shore, horsemen, flowers, gnarled thorn branches.

I've reconciled myself to having left — and hope not to be idle this winter.

Well, it's a relief to me to have a little cubby-hole where I can work in bad weather.

It's pretty obvious that I shan't exactly be living in the lap of luxury these days.

See that you send your letter off on the first, because I've got enough bread in until then, but after that I'd be in a real stew.

My little room isn't bad at all, and it definitely doesn't look dreary.

Now that I have the 3 studies I brought with me here, I'll set about going to the picture dealers, who mostly seem to live in private houses, though, no shop windows on the street.

The park is beautiful, too. I sat there drawing one morning.

Well—I've had no setbacks so far. I'm safe and sound as far as accommodation is concerned, for by forking out a few more francs I've acquired a stove and a lamp. I shan't easily get bored, I assure you. I've also found OCTOBER by Lhermitte, women in a potato field in the evening, magnificent. Not yet November, though. Have you kept up to date with that, by any chance? I've also seen that there's a Figaro Illustré with a fine drawing *by Raffaëlli*.

You know my address is *194 rue des Images*, so please address your letter there, and the second volume of De Goncourt when you've finished it.

Regards.

Yours truly,
Vincent

It's curious that my painted studies look darker here in the city than in the country—is this because the light isn't as bright anywhere in the city? I don't know—but it might differ more than one would say on the face of it. It struck me, and I could understand that things that are with you also appear darker than I thought they were in the country. Still, the ones I've brought with me now don't look bad all the same—the mill—avenue of autumn trees and still life, and a few small ones.

550 | Antwerp, Monday, 28 December 1885 | *To Theo van Gogh* (D)

My dear Theo,

It's high time that I thanked you for the 50 francs you sent, which enable me to get through the month, even if starting from today it's pretty much the same again.

But—there are a few more studies done, and I believe that as much as I paint, I also progress by as much. As soon as I received the money I got an attractive model and painted a life-size head. It's all light except for the black hair. Even so, the head itself stands out in tone against a background in which I've tried to get a golden gleam of light.

Here, by the way, is the colour spectrum—a tonal flesh colour, more bronzy in the neck. Jet-black hair—black that I had to make with carmine and Prussian blue, dingy white for the jacket, light yellow, much lighter than the white, for the background.

A touch of flame red in the jet-black hair and a second flame-red bow in the dingy white. She's a girl from a café chantant and yet the expression I was looking for is a little Ecce Homo-like. But precisely as to expression, although I add my own thoughts, I nonetheless endeavour to remain *true*, see what I wanted to get into it. When the model came to me, she'd evidently had a few busy nights—she said something that was entirely typical—for my part, champagne doesn't cheer me up, it makes me very sad.

Then I knew what to do, and I tried to get something voluptuous and sad at the same time.

I've now started a second study of the same one, in profile.

Furthermore, I've done that particular portrait that I told you I was in discussions about, and a study of that head for myself.

And now I hope to paint a man's head too, during these last days of the month. I'm in really good spirits, particularly as regards the work, and it's useful for me to be here.

I imagine that, no matter what these girls may be, one can make one's money out of them like this sooner than in any other way. There's no gainsaying that they can be damned beautiful, and it's in keeping with the spirit of the age that this is the very kind of painting that wins the day.

From the most elevated artistic viewpoint possible, there's likewise nothing to be said against — painting *people*, that was the old Italian art, that was Millet and that is Breton.

The question is simply whether one takes the soul or the clothes as one's starting-point, and whether one allows the form to serve as a clothes-horse for bows and ribbons, or whether one should regard the form as a means of expressing an impression, a sentiment, or whether one models for modelling's sake because it's so infinitely beautiful in itself. Only the first is transitory, and the two latter are both high art.

Something that pleased me greatly is — that the girl who posed for me wants a portrait from me for herself, preferably just like the one I did.

And that she's promised to let me paint a study of her in a dancer's costume in her room, as soon as she can. Which isn't possible right now because the man at the café where she works is opposed to her posing, but since she and another girl are going to share rooms, both she and this other girl will want their portraits. And I sincerely hope that it turns out that I do get her back, because she has a remarkable head and is lively. I have to practise, though, because it certainly comes down to dexterity — they don't have much time or patience — for that matter, the work doesn't have to be any the worse if it's put down virtually in one go, and one has to be able to work even when the model doesn't sit stock still. Anyway. You see that I'm working with a will. If I sold something so that I earned a little more, I'd be able to put even more strength behind it.

As to Portier — I'm not abandoning hope yet — but poverty is snapping at my heels and at the moment the dealers are all suffering somewhat from the same ill, that of being more or less a breed withdrawn from the world. They're all too sunk in gloom, and how can one be very inspired to go scratching around in that indifference and that apathy — particularly since this disease is contagious.

For it's just nonsense to say that there's nothing to be done, but one has to work all the same with aplomb and with enthusiasm, in short with a certain fire.

And as to Portier — you told me yourself that he began the first of the exhibitions of the Impressionists and was overwhelmed by Durand-Ruel. Well, one would have to infer from this that he has the initiative not just to *say* something but to *do* something. But it could be to do with his being 60 — and — anyhow perhaps his case is one of the many cases when, at the time when there was a craze for paintings and trade was good, a mass of intelligent people were pushed aside in the jubilation, as if they signified nothing and could do nothing — because they couldn't bring themselves to wholly

trust the sustainability of the sudden painting craze and the huge rise in many prices. NOW — when business is slow, one sees the same dealers who, a few years ago — let's say 10 years ago — were very enterprising — to some extent becoming a breed withdrawn from the world. And we aren't at the end yet.

Personal initiative with little or no capital is perhaps the seed for the future. Anyway.

Yesterday I saw a large photo of a Rembrandt I didn't know — which struck me amazingly — it was the head of a woman. The light fell on breast, neck, chin and the tip of the nose — the lower jaw.

Forehead and eyes in shadow from a large hat with feathers, probably red. Probably also red or a yellow in the little décolleté jacket. Dark background. The expression a mysterious smile like that of Rembrandt himself in his own portrait where Saskia sits on his knee and he has a glass of wine in his hand.

My thoughts are full of Rembrandt and Hals at the moment, not because I see many paintings by them but because I see so many types among the people here who remind me of that age. I still often go to the dance halls to see these women's heads and sailors' or soldiers' heads. One pays 20 or 30 centimes to go in and drinks a glass of beer — for there's little drinking — and can amuse oneself exceedingly for a whole evening — at least I can — watching the folk's high spirits.

What I have to do, and the only thing that can be sure to help me progress, is work a great deal with models.

I notice that my appetite has been kept in check for rather too long and that when I received the money from you I couldn't stomach any food — but I'll see about remedying it. That doesn't alter the fact that I have all my energy and clarity when I'm working. But when I'm outdoors, working in the open air is too much for me and I get too weak. Painting is something that wears one down anyway. Van de Loo told me, though, when I went to see him shortly before I came here, that I'm reasonably strong after all.

That I needn't despair of reaching the age that's necessary for producing a body of work. I told him that I knew several painters who, despite all their nerves etc., had reached 60, even 70, fortunately for them, and that I would like to reach that too.

Then I believe that if one seeks serenity and retains a zest for life, the frame of mind one's in helps a lot. And in this respect I've gained by coming here, because I have new ideas and I have new means of expressing what I want, because better brushes will help me, and I'm really carried away by those two colours, carmine and cobalt.

Cobalt — is a divine colour, and there's nothing so fine as that for putting space around things. Carmine is the red of wine, and it's warm, spirited as wine.

So too is emerald green. It's false economy to do without them, those colours. Cadmium likewise.

Something regarding my constitution that has pleased me very much is that a doctor in Amsterdam, whom I also once spoke to about a few things that sometimes made me think that I wouldn't last long and whose opinion I didn't ask directly, but just to find out the first impression of one who didn't know me at all — taking advantage of a minor illness that I had to turn things to my constitution in general during the course of the conversation — it pleased me very much indeed that this doctor took me for an ordinary workman, said 'you must be an ironworker by trade'. You see precisely

what I've been trying to change in myself—when I was younger it could be seen that I over-exerted myself intellectually, and now I look like a bargee or someone who works in the iron trade. And changing one's constitution such that one becomes 'as tough as nails' is no easy matter. I must take care, though, and see that I keep what I have, and gain still more.

You really must still write and tell me whether it seems such an absurd idea to you that one might create a bit more courage if one were to plant a seed for a business.

As regards the work I'm doing now—I feel that I can do something better—I need more air and space, though. I mean I must be able to expand it a bit. Above all, above all, I still haven't got enough models. I can produce work of a higher quality, but my expenses would be heavier. But isn't it so—shouldn't one search for something high—for the real, for something distinguished?

The women's figures I see among the people here make an enormous impression on me—far more to paint them than to have them, although I'd actually really like both. I'm re-reading the book by De Goncourt again, it's excellent. In the preface to Chérie, which you'll read—there's an account of everything that the De Goncourts experienced—and of how, at the end of their lives, they, yes—were pessimistic—but certainly felt sure of their ground—felt that they'd *done something*, that their work would last. What fellows they were! If we could get on more than now, could be more in agreement—why not then—us too?

Apropos—on account of I will, after all, have some 4 or 5 fast days of pretty well everything at the end of this year—send your letter off 1 January and no later. You might not be able to understand it, but it's true—when I receive money, my greatest hunger, even if I've fasted, isn't for food, but is even stronger for painting—and I set out hunting models right away, and I carry on until it's gone. Meanwhile, the lifeline I cling to is my breakfast with the people where I live, and a cup of coffee and bread in the *crémerie* in the evening. Supplemented, when I have it, by a second cup of coffee and bread in the *crémerie* for my dinner, and otherwise some rye bread that I have in my case.

As long as I'm painting it's more than enough for me, but when my models have gone, a feeling of weakness comes over me.

I really like the models here because they're so very different from the models in the country. And above all because the character is something so very different. And the contrast gives me new ideas, particularly for the flesh tones.

And what I've now got in my last head is—not yet what I myself am content with but something different from the earlier heads. I believe that you sufficiently realize the importance of being *true* so that I can speak freely to you. For the same motives that when I paint peasant women, I want them to be peasant women—for the same reason, when they're whores, I want a whore's expression.

That's precisely why I was so enormously struck by a whore's head by Rembrandt, because he had caught that mysterious smile so infinitely well with a gravity that he alone—the magician of magicians—can achieve. Now this is something new to me, and I want to get it at any price. Manet did it and Courbet—well, confound it, I have the same ambition because, moreover, I've felt to the core the infinite beauty of the studies of women by the very great people in literature, Zola, Daudet, De Goncourt, Balzac.

Even Stevens doesn't satisfy me because his women aren't those whom I personally know anything about. And I think that he doesn't pick the most interesting there are.

Anyway, be that as it may — I want to make progress at all costs, and — I want to be myself.

I'm feeling obstinate, too, and I've got over caring what people say about me or my work. It seems to be difficult to get a nude model here — at least the girl I've had wouldn't do it.

Obviously that — wouldn't — is probably relative, but at any rate it can't be taken as a matter of course. The thing is, though, she would be splendid. From the point of view of business, I can't say anything other than that — we're in what people are already beginning to call 'the end of an era' — the women have a charm as in a time of revolution — and just as much to say, for that matter — and that one would be with-drawn from the world if one worked without them.

It's the same everywhere, in the country and in the city — one must take women into account if one wants to keep up with the times. Adieu, best wishes for the New Year. With a handshake.

Yours truly,
Vincent

552 | Antwerp, between Tuesday, 12 and Saturday, 16 January 1886 |
 To Theo van Gogh (D)

My dear Theo,

Last Sunday I saw the two large paintings by Rubens for the first time, and because I'd looked at the ones in the museum repeatedly and at my leisure, these — The descent from the Cross and The elevation of the Cross — were all the more interesting for it. There's an oddity in The elevation of the Cross that struck me right away, and that is — there are no female figures in it. Unless on the side panels of the triptych. It's no better for it in consequence. Let me tell you that I adore The descent from the Cross. NOT, though, because of the depth of emotion that one would find in a Rembrandt or in a painting by Delacroix or in a drawing by Millet.

Nothing moves me *less* than Rubens when it comes to the expression of human sor-row. Let me start by saying, to make it clearer what I mean — that even his most beau-tiful heads of a weeping Magdalen or Mater Dolorosas always just remind me of the tears of a pretty tart who's caught the clap, say, or some such petty vexation of human life — as such they're masterly, but one needn't look for anything more in them. Rubens excels in the painting of ordinary beautiful women. But he is *not* dramatic in the ex-pression. Compare him with, say, the head by Rembrandt in the La Caze Collection — with the male figure in the Jewish bride — you'll understand what I mean — that, for instance, his 8 or so bombastic fellows performing a feat of strength with a heavy wooden cross in The elevation of the Cross seem *absurd* to me as soon as I look at them from the standpoint of modern analysis of human passions and emotions. That in his expressions, particularly in the men (always excepting actual portraits) Rubens is

superficial, hollow, bombastic, yes, altogether conventional and nothing, like — Giulio Romano and even worse fellows of the decadence.

But all the same, I adore it because it is precisely he, Rubens, who seeks to express a mood of gaiety, of serenity, of sorrow, and actually achieves it, through the combination of colours — even if his figures are sometimes hollow etc.

Thus in The elevation of the Cross, even — the pale spot — the body a high, light accent — is dramatic in the context of its contrast with the rest, which has been pitched so low.

The same thing, but to my mind far more beautiful, is the charm of The descent from the Cross, where the pale spot is repeated by the blonde hair, pale faces and necks of the female figures, while the sombre setting is immensely rich because of those various low masses, brought together by the tone, of red, dark green, black, grey, violet.

And Delacroix tried again to get people to believe in the symphonies of the colours. And in vain, one would say, judging by how much almost everyone understands good colour to mean the *correctness* of local colour, the small-minded preciseness — that neither Rembrandt, nor Millet, nor Delacroix, nor whomever you like, not even Manet or Courbet, set as their aim, any more than Rubens or Veronese did.

I've also seen various other Rubens paintings &c. in several churches. And it's very interesting to study Rubens, precisely because he is, or rather seems, so supremely simple in his technique. Does it with so little, and paints — and above all draws, too — with such a swift hand and without any hesitation. But portraits and — heads or figures of women, that's his forte. There he's deep and intimate, too. And how fresh his paintings have remained precisely because of the simplicity of the technique.

Now what else shall I tell you? That I feel increasingly inclined, without rushing, that's to say without rushing nervously — to do all my figure studies over again from the beginning very calmly and coolly. I'd like to get to the point in knowledge of the nude and the structure of the figure where I can work from memory. I'd like to work either with Verlat or at another studio for a while, and for the rest also paint from models for myself as much as possible. At the moment I've left 5 paintings — 2 portraits, 2 landscapes, 1 still life — with Verlat's painting class at the academy. I've just been there again, but each time I haven't found him there. But I'll soon be able to let you know how that turns out. And I hope to arrange it so that I can paint from the model at the academy all day, which would make it easier for me, since the models are so awfully expensive that I can't keep it up.

And I must find some way of getting help in that regard.

In any event, I think that I'll stay in Antwerp itself for a while, instead of going back to the country. It would be so much better than postponing it, and there's so much more opportunity here of finding people who might take an interest in it. I feel that I dare do something and can do something, and things have already been dragging on for far too long.

You get cross if I make a comment, or rather you take no notice of it, and all the rest that we know, and yet I believe that there will come a time when you yourself will have to acknowledge that you've been too weak in seeing to it that I get back some of my credit with people. But anyway, we're facing the future, not the past. And again — I believe that time will bring you to the realization that, if there had been more cordiality and warmth between us, we could have set up our own business together.

Even if you'd stayed with G&C. You said to me, indeed, that you know very well that you'll get no thanks for your pains — but are you so very sure that this isn't a misunderstanding like the one Pa himself laboured under? At any rate I won't put up with it, you can be sure of that. For there's still too much to do, even nowadays.

The other day I saw an excerpt from Zola's new book for the first time, 'L'oeuvre', which as you know is appearing as a serial in Gil Blas. I think that this novel will do some good if it sinks in a little in the art world. I thought the excerpt that I read was very realistic.

For my part I'll admit that something else is needed when working absolutely from nature — facility of composition — knowledge of the figure — but after all — I don't think I've been putting myself to all this trouble for years for absolutely nothing. I feel a certain power in me because, wherever I may go, I'll always have a goal — painting people as I see and know them.

As to whether we've already heard the last of *Impressionism* — to stick to the term Impressionism — I always imagine that many newcomers may still emerge in figure painting, in particular, and I'm beginning to think it increasingly desirable in a difficult time like the present that one should seek one's salvation precisely by going deeper into *high* art. For there is relatively higher and lower — *people* are more than the rest, and for that matter a whole lot harder to paint, too.

I'll do my best to make acquaintances here, and I thought that if I worked for a while with Verlat, say, I'd be in a better position to know what's going on here, and what there is to do, and how one can get into it.

So just let me scratch around, and for heaven's sake don't lose heart or weaken. I don't think that you can reasonably ask me to go back to the country for the sake of perhaps 50 francs a month less, when the whole stretch of years ahead is so closely related to the associations I have to establish in town, either here in Antwerp or later in Paris.

And I wish I could make you understand how easy it is to foresee that a great deal will change in the trade. And consequently there are many new opportunities too, if one could come up with something original. But that *that* is therefore necessary, if one wants to do something useful. It's no fault of mine and no crime when I tell you we must put more force into this or that, and if we don't have it ourselves we'll have to find friends and new contacts. I have to earn a bit more or have a few more friends — preferably both. That's the way to get there, but it's been too tough for me recently.

As regards this month, I really do definitely have to insist that you manage to send me at least another 50 francs.

At the moment I'm losing weight, and moreover my clothes are getting too bad &c. You know very well yourself that this won't do. All the same, I have a degree of confidence that we can pull through.

But you said that if I became ill we'd be in even more of a state — I hope it won't come to that, but I would like to be a little bit more comfortable, precisely so as to prevent that.

Anyway — when one thinks how many people just go on living without ever in their lives having even a notion of care — and who always just think that everything will turn out for the best. As if people didn't starve — and no one ever perished.

I'm beginning to object more and more to your imagining yourself to be a financier and, for instance, thinking the exact opposite of me.

People aren't all alike, and if one isn't able to see that in calculating, above all, TIME must have passed over the calculation before one can consider for certain that one has calculated correctly; if one can't see this, *one is no calculator*. And a broader view of finance is precisely what characterizes many modern financiers. That's to say not exploiting, but allowing freedom of action. I know, Theo, how you yourself could perhaps be rather hard pressed. But you've never in your life had it as hard as I have for the last 10 or 12 years in a row. Can't you understand that I'm right when I say that now, perhaps, it's been long enough; in that time I've learned something I couldn't do before, so all the opportunities have been renewed and I come up against it, against always being neglected? And if it were now to be my wish to stay here again in city life for a while, then perhaps also go to a studio in Paris, will you try to prevent it? Be fair enough to let me go on, because I tell you, I'm not looking for a row and I don't want a row, but I won't allow my career to be blocked. And what can I do in the country, unless I go there with money for models and paint? There's no opportunity in the country, absolutely none, to make money from my work, and that opportunity does exist in town. So I won't be secure until I've made friends in the city, and that's the order of the day. Now for the moment it might make things a bit more diffi-cult but it's the way, all the same, and going back to the country now would end in stagnation.

Anyway — regards — De Goncourt's book is good.

Yours truly,
Vincent

555 | Antwerp, on or about Thursday, 28 January 1886 | *To Theo van Gogh* (D)

My dear Theo,

I've already left it too long to confirm the safe receipt of your letter and the enclosure. As regards your letter, it's still the same and, to my mind, when you judge me you rely too much on generalities and on prejudices that are too superficial and too wrong for me to be able to believe that you'll always stick to them.

And for this very reason, I believe that *in any event* it can do no harm if we see each other again in Paris after a while.

I've been dreadfully busy this week because, as well as the painting class, I also go drawing in the evenings, and then after that go on and work from a model at a club from half past 9 to half past 11. For I've become a member of no fewer than two of these clubs. And I now know two fellows who to my mind draw well, both Dutch. This week I painted a large thing with two nude torsos — two wrestlers, a pose set by Verlat. And I really like doing that.

And the same is true of drawing from the antique — I've now finished two large figures. At any rate it has two things in its favour — firstly that it interests me greatly, after having drawn clothed models for years, to see the nude and the antique again and to verify things.

Further, just to be admitted anywhere in Paris one has to have been somewhere else

and have lost one's rough edges, and one always has to contend with fellows who've already worked at an academy for some length of time.

What Verlat tells me is very severe and so too is what Vinck, who takes the drawing class, tells me — and they strongly advise me *above all* to draw, *if necessary do nothing else* but draw from the antique and nudes for at least a year, and that this would be the *shortest* way, that then I'll return very differently to my other work outdoors or my portraits.

And I think it's true — so I have to see to it that I'm somewhere where I have access to both the antique and nude models at first.

The best one in the class has done it like this too, and he says that he felt himself progressing a little with each study, and I've been able to see that for myself in things he did before and his recent things.

I think you'll remember:

The Greeks don't start from the outline, they start from the centres, from the cores.

Géricault took that from Gros, who took it from the Greeks, but Géricault himself wished to take it from the Greeks, too, and he studied them for that very thing — afterwards Delacroix did the same as Géricault.

This question — Millet draws like that too — more than anyone else — is perhaps the root of all figure painting — is extremely closely related to modelling by drawing directly with a brush — conceived totally differently from Bouguereau and others, who lack interior modelling, are *flat* compared with Géricault and Delacroix, and who don't go beyond the paint.

In which latter, Géricault &c., the figures have backs, even when one sees them from the front, air around the figures — *beyond the paint.*

It's to search for this — which I wouldn't want even to talk about with Verlat or with Vinck — that I'm working; there's no risk that *they* could show it to me, because the fault with both of them is in the colour which, as you know, isn't true with either of them.

It's strange that when I compare my study with those of other people, it has almost nothing in common with them. Theirs have more or less *the same colour as the flesh* — and so look very accurate from close to — but if one steps back a bit, it becomes painful and flat to look at — all that pink and delicate yellow etc., etc., soft in itself, produces a hard effect.

The way I do it, from close to it's greenish red, yellow-grey, white, black and a lot of neutral, and mostly colours one can't put a name to. But if one steps back a little it's indeed beyond the paint — and then there's air around it and a restrained undulating light falls on it. At the same time, the least little lick of colour with which one might glaze it is telling.

But what's lacking in it is — practice — I must paint 50 or so like that — I believe that I'll have *something* then. I make the business of *putting on the paint* too difficult because I haven't yet sufficiently got into the way of it, have to search too long, work it to death. But this is a question of keeping on painting for a while, so that the touch is effective *straightaway* as one gets it more fixed in one's mind.

There are some fellows who've seen my drawings — after seeing my peasant figures

one of them immediately started drawing the model in the life class with more vigorous modelling, putting the shadows in strongly.

He showed me the drawing and we talked about it. It was full of life and it was the finest drawing that I've seen by any of the fellows here. Now do you know what they think about it? The teacher, Siberdt, purposely sent for him and said that if he dared to do it again in that manner it would be considered that he was making a fool of the teacher. And I tell you, it was the only drawing that was *generously done*, like Tassaert or Gavarni.

So you see how it is. But it's not bad, though, and one mustn't get angry about it, and must keep quiet just as if one would really like to break oneself of it, that bad manner, but unfortunately keeps slipping back into it.

The figures that they draw—are virtually always top-heavy and topple forwards, headlong—there's not one that *stands* on its feet.

And this *standing*, this really must *already be there in the initial design.*

Anyway—I'm still really pleased that I came here—however it goes and however it turns out—whether or not I get along with Verlat. I find the friction of ideas that I'm looking for here—I'm getting a fresh eye for my own work, can judge better where the weak points are and thus make progress in order to correct them.

What I ask you very earnestly for the sake of things working out well, is not to lose your patience, nor above all your optimism, for we'd be cutting our own throats if our courage were to fail us precisely as the moment presents itself when we could acquire a degree of influence if we show that we know what we want, and dare to do something and manage to see it through.

And as to the money—if I worked in a studio and so saved a good part of the cost of models, even then 150 francs still wouldn't be much, because painting is very expensive—but it CAN BE DONE, provided one economizes even on food &c.

If models have to come out of it, *then it definitely* CAN'T BE DONE on 150 francs, and one wastes time &c.

So at the same time it's cheapest to stay in a studio—because for more finished nude studies, above all, it's not possible to pay the cost of the model oneself.

I don't consider it impossible that in due course, especially if some of the other fellows couldn't help starting to put in more powerful shadows, that Verlat or someone else will *seek* a row with me, even if I systematically avoid it. Which I'll do systematically because it's to my advantage to stay here for a bit.

Anyway—I'm curious as to what will happen with your apartment. As to me, though, if I come I'll be perfectly content to take a cheap little room or a garret in a hotel somewhere in an out-of-the-way quarter (Montmartre). But that's pretty much by the way and we're not there yet. Let's stay here for a while first—and then, all in good time. The winter course ends on 31 March. Regards.

Yours truly,
Vincent

My dear Theo,

I already wrote to you the day before yesterday that on the one hand I was far from well, but that on the other hand I nevertheless thought I could see some light.

However, I regret that I have to tell you even more categorically that I'm most definitely literally exhausted and overworked. When you think that I went to live in my own studio on 1 May — since then it's perhaps been a matter of 6 or 7 times, so far, that I've had my midday meal. For good reasons, I don't want you to tell Ma that I'm not well — because she might possibly consider that it wasn't nice that what happened, happened, that's to say that I didn't stay there — precisely because of these consequences. I shan't say anything about it; don't you say anything either. But I lived then, and since then, here, having nothing for my food because the work cost me too much and I relied too much on the idea that I could stick it out like this.

What the doctor tells me is *that I absolutely must live better*, and that I have to take more care of myself with my work until I'm stronger. It's *total* debilitation.

Well I've made it worse by smoking a lot, which I did all the more because then one isn't troubled by one's empty stomach.

Anyway, they say — one has to experience lean times, and I've had my share of them.

Because it's not just the food, it's also all the worry and sorrow that one has.

You know that for one reason or another the time in Nuenen was far from carefree for me. What's more — here — I'm very pleased to have come here — but it's been a difficult time all the same.

What we have to do and what is largely lacking — is this. Paying the models ourselves is too much; as long as one doesn't have enough money, one must take advantage of the opportunities at the studios, like Verlat, like Cormon. And one must be in the artists' world and work at clubs where one shares the cost of the models.

Now it's true that I didn't think of this before, or at least didn't do it — but I wish now that I'd started on it a year earlier. If we could now find some way of living in the same city it would be far and away the best thing, at least for the time being.

Only, the more I think about it, the more and more I fancy that it might be better not to spend much on a studio in the *first year*, because I'll mostly have to draw in that first year.

Because speaking of Cormon — I imagine he would tell me much the same as Verlat says — that I have to draw nudes or plaster casts for up to a year, precisely because I've always drawn from life.

This isn't really a harsh requirement, because I tell you that there are people here who've been in the class for *3 years* and are still not allowed to stop, who also paint.

In that year I have to practise the male and the female figure, both in detail and as a whole, and — then I'll know it by heart, as it were. Drawing in itself, technically, is easy enough for me — I'm beginning to do it the way one writes, with the same ease. But precisely at this level it becomes more interesting, as one is *not* satisfied with the facility that one gradually acquires but really looks for originality and breadth of conception. Drawing the masses rather than the outlines. Solid modelling. And I can assure you it's

not a bad sign if people like Verlat or Cormon, let's say, demand that of someone. For there are enough of them that Verlat simply leaves to get on with it because — they just aren't the fellows for the loftier figure. You talk about the clever fellows at Cormon's studio. Precisely because I damned well want to be one of them, I'm setting myself in advance, out of my own conviction, the requirement of spending at least a year in Paris mainly drawing from the nude and plaster casts. For the rest, let's do whatsoever our hand finds to do in the way of painting, if an effect out of doors strikes us or we happen to have a good model &c.

And don't think that this is the *long* way, because it's the *short* one. Someone who can draw his figures from *memory* is much more productive than someone who can't. And by my taking the trouble to spend that year drawing — you'll just see how productive we become.

And don't think either that the years I worked out of doors were wasted. For it's the very thing that people who've never been anywhere else but at academies and studios lack, that view of reality in which they live, and finding subjects. Anyway.

Might it not be wise if we put off renting a studio *at least for the first six months*, precisely because it all comes down to the money? But otherwise I like the idea of setting up a studio a great deal, a very great deal. Even, if need be, such that one could combine with other painters to take models together. The more energy the better. And in hard times — one must especially seek a way out in friendship and collaboration.

But Theo, it's so rotten about this indisposition — I'm dreadfully sorry — *but I'm still in good spirits*. It will get better. You understand that it would have got worse and worse if I'd delayed doing something about it.

What I think, though, is this — one mustn't think that people whose constitution is damaged, wholly or half, aren't fit for painting. It's desirable for one to make it to 60 at least, and necessary for one to make it to 50, if one begins when one is around 30.

But one absolutely doesn't have to be perfectly healthy; one may have all sorts of things wrong. The work doesn't always suffer as a result — on the contrary, nervous fellows are more sensitive and more refined. But Theo, precisely because it has proved in my case that my health leaves something to be desired — I've decided to concentrate specifically on the loftier figure and to try to refine myself.

It really struck me so unexpectedly — I did feel weak and feverish, but I still kept going. Only it began to worry me that teeth were breaking off one after another. And that I was starting to look worse and worse. Anyway, we'll see about putting it right.

I think that getting the teeth attended to will help in itself because, as my mouth was usually painful, I just swallowed my food as quickly as possible.

And perhaps it will also help my appearance, at least a little.

As regards this month, I've paid 25 francs in advance for my room, 30 francs in advance for my food, and 50 francs to the dentist; also a visit to the doctor and some drawing materials — which leaves *6 francs*.

Now the important issue this month is *not* to be ill, which isn't easy to resolve — and which could very well happen. But we'll see — I still think I've got a certain toughness in common with the peasants, who also don't eat anything very special and still go on living and working. So don't worry too much about it. If you could send a little bit extra, very well — but if you can't, I'll wait calmly to see how it goes. What I don't

like is that I'm feverish, and I reason about it thus: although I may be weakened, I've still taken some care not to eat any unwholesome food. Over-exertion isn't excessive either—because, despite everything, I keep my spirits up all the time—so that it's because I'm weak that I over-exert myself. *It seems to me that it must sort itself out.* You understand, though, that *if* it were to get worse—and took a *virulent* turn—one might have to contend with typhus or at least typhoid fever.

And actually the *only* reasons why I certainly don't expect that are these—*1* that I've had a great deal of fresh air, and *2* that, as I said, even though I've evidently not fed myself well enough, as a precaution I've nonetheless made do with very simple food rather than the muck in the cheap restaurants—and *3*—that I have a degree of calm and serenity in the face of things.

So we must wait and see. Don't you worry about it, because not even I do—I maintain that, supposing I do get a fever, I've lived and eaten too simply for it to become very virulent all that easily. After all, things don't happen of their own accord, and there's a reason for everything.

Write to me soon, though, because I really do need it.

As regards going to Nuenen too—I want to know what you'd think best.

But I'm not needed there—because someone like Rijken, the gardener, for instance, can see to what needs to be packed or sent at least as well as I can.

If there's any point in it, though, I can be ready by March if need be.

Regards, with a handshake.

Yours truly,
Vincent.

559 | Antwerp, on or about Saturday, 6 February 1886 | *To Theo van Gogh* (D)

My dear Theo,

I've received your letter and 25 francs enclosed and I thank you very much for both. I'm really glad that you like my plan to come to Paris. I believe it will help me make progress and at the same time that, if I didn't go, I might easily get into a mess, keep moving around in the same circle too much, persist in the same mistakes. Furthermore, as for you, I don't think that coming home to a studio would do you any harm. For the rest, I have to tell you the same about me as you write about yourself—*I'll disappoint you.*

And even so, this is the way to combine forces. And even so, much greater understanding of each other can follow from it.

Now what shall I tell you about my health? I still believe that I have a chance of avoiding being really ill; all the same, I'll need time to get better. I also still have two more teeth to be filled, then my upper jaw, which was most affected, will be all right again. I still have to pay 10 francs for that, and then another 40 francs to get the bottom half right too.

Some years of those 10 years that I appear to have spent in prison will disappear as a result. Because bad teeth, which one so seldom sees any more as it's so easy to get them put right, since bad teeth give a physiognomy a sort of sunken look.

And then — even eating the same things, one can naturally digest better when one can chew properly, and so my stomach will have a chance to recover.

I really do notice that I've been at a very low ebb, though — and as you wrote yourself, all sorts of things that are even worse could arise out of neglecting it. However, we'll see that we get it put right.

I haven't worked for a few days, gone to bed early a couple of nights (otherwise it was usually 1 or 2 o'clock because of drawing at the club). And I feel that it's calming me.

I've had a note from Ma, who writes that they're going to start packing in March.

Further, since you say you'll have to pay rent until the end of June — well then, perhaps it would be best after all if I were to return to Nuenen, starting in March, only — if I encountered opposition and scenes like I got before I left, I would be wasting my time there and so, even if it were only just for those few months, I'd make a change anyhow, since I want to have some new things from the country ready to bring to Paris with me.

That Siberdt, the teacher of the antique, who spoke to me at first as I told you, definitely *tried* to pick a quarrel with me today, perhaps with a view to getting rid of me. Which didn't work inasmuch as I said — Why are you trying to pick a quarrel with me? I have no wish to quarrel, and in any case I have absolutely no desire to contradict you, but you deliberately try to pick a quarrel with me.

He evidently hadn't expected that and couldn't say much to refute it this time, but — next time, of course, he'll be able to start something.

The issue behind it is that the fellows in the class are talking about things in my work among themselves, and I've said, not to Siberdt but outside the class to some of the fellows, that their drawings were completely wrong.

Bear in mind that if I go to Cormon and run into trouble sooner or later either with the master or the pupils, *I wouldn't let it worry me.* If need be, even if I didn't have a master, I could also go through the antique course by going to draw in the Louvre or somewhere. And so I'd do that if I had to — although I'd far rather have correction — as long as it doesn't become DELIBERATE *provocation*; that correction without one giving any cause other than a certain singularity in one's manner of working which is different from the others. If he starts on me again, I'll say out loud in the class, I'm happy to do mechanically everything that you tell me to do, because I'm determined to pay you back what is your due, if need be, if you insist on it, but — as far as mechanizing me as you mechanize the others is concerned, that has not, I assure you, the slightest hold over me.

Besides, you started by telling me something quite different, that's to say, you told me: tackle it as you wish.

The reason why I'm drawing plaster casts — *not to start from the outline, but to start from the centres* — I haven't got it yet, but I feel it more and more and — I'll certainly carry on with it, it's too interesting.

I wish that we could spend a few days together in the Louvre and could just talk about it. I believe it would interest you.

This morning I sent you *Chérie*, mainly *for the preface*, which will certainly strike you.

And — I wish that at the end of our lives we could also walk somewhere together and — looking back, say — we've done *this* — and that's *one*; and *that* — and that's *two*; and

that—and that's *three*. And if we want to and dare to—will there be anything to talk about then?

We can try two things—making something good ourselves—collecting things by other people that we think are good, and dealing in them. But we must *both live* rather more *robustly*, and perhaps combining forces is a step towards becoming more robust.

But now allow me to touch on a delicate matter—if I've said unpleasant things to you, specifically about our upbringing and our home, this has been because we're in an area where being critical is *essential* in order for us to get along with and understand each other and cooperate in business.

Now I can well understand that one can passionately love something or someone that one *can't* do anything about.

Very well—I won't go into that except in so far as it might make a fatal separation between us where reconciliation is needed.

And our upbringing &c.—won't prove to be so good that we'll retain many illusions about it—there you are—and we might perhaps have been happier with a different upbringing. But if we stick to the positive idea of wanting to produce and *to be something*, then we'll be able, without getting angry, to discuss *faits accomplis* as such when it's unavoidable and might perhaps touch on or directly concern the Goupils or the family. And for the rest, these issues between us are for the understanding of the situation and not out of rancour.

But if we undertake something it won't be a matter of indifference to either of us to improve our health, because we need time alive—some 25 or 30 years of working constantly. There's so much of interest in the present age when one thinks how very possible it is that we may well yet see the beginning of the end of a society. And just as there is infinite poetry in the autumn or in a sunset, and then there's so much soul and mysterious endeavour in nature, so it is now. And as for art—decline, if you will, after the Delacroix, Corots, Millets, Duprés, Troyons, Bretons, Rousseaux, Daubignys—very well—but a decline so full of charm—that there truly is still an immense, immense amount of good things to come, and they're being made every day.

I'm longing dreadfully for the Louvre, Luxembourg etc., where everything will be so new to me.

For the rest of my life I'll regret that I didn't see the Cent chefs d'oeuvre, the Delacroix exhibition and the Meissonier exhibition. But there will still be plenty of opportunities to catch up.

It's true, for instance, that wanting to progress too quickly here, I may actually have progressed less, but what would you? My health is also behind it, and if I regain that as I hope to do, then my taking pains will have been less in vain.

After all, I believe that if one asks permission, one may draw plaster casts in the Louvre, even if one isn't at L'Ecole des Beaux-Arts.

It wouldn't surprise me if, once the idea of living together takes hold, you'll find it odder and odder that we've been together so surprisingly little, if you will—for fully 10 years.

Anyway, I most certainly hope that this will be the end of it, and that it won't begin again.

What you say about the apartment is perhaps really rather expensive. I mean, I'd be just as happy if it weren't quite as good.

I'm curious as to how those few months in Nuenen will be for me. Since I have some furniture there, since it's beautiful there, too, and I know the district a little, it might be a good thing for me to keep a pied-à-terre there, if need be in an inn where I could leave that furniture, since otherwise it will be lost — and it could still come in very useful.

There's sometimes the most to do by returning to old places.

I must finish this now, since I'm going to the club.

Keep thinking about what we can best do. Regards.

Yours truly,
Vincent.

561 | Antwerp, on or about Thursday, 11 February 1886 | *To Theo van Gogh* (D)

My dear Theo,

I definitely need to tell you that it would reassure me greatly if you were to approve my coming to Paris much earlier than June or July if need be. The more I think about it, the more desirable this appears to me.

Consider that if everything goes well and if I had good food &c. throughout that time, which will certainly not be plain sailing, consider that even in that case it will take 6 months or so before I'm entirely well.

But it would certainly take even longer if things were to be the same for me in Brabant from March to July as they've been for the past few months, and it's likely they'd be no different.

Now at the moment it's just because of reaction to over-exertion that I feel terribly weak, in fact even worse. Still, that's the natural course of things and nothing unusual.

But where the issue is — to take better care of oneself — well in Brabant I'd wear myself out again taking models, the same old story would start all over again, and it doesn't seem to me that any good could come of it. That way — we'd be straying from the path. So please give me permission to come sooner if need be. In fact I'd say right away, if need be.

If I take a garret in Paris, bring my painting box and drawing materials with me — then as far as the work's concerned I can finish the most pressing things at once — those studies of plaster casts that will certainly help me when I go to Cormon's. I can go and draw either in the Louvre or in L'Ecole des Beaux-Arts.

For the rest, we could then also think about it and discuss it so much better before we go about setting ourselves up somewhere else.

Know that I don't mind going to Nuenen in the month of March if need be and seeing how things are there, and how the people are, and whether or not I can get models.

But if that doesn't work out, which is likely, then after March I could come straight to Paris and start drawing, in the Louvre, for instance.

I've given a lot of thought to what you wrote about taking a studio — but it seems to

me that it would be a good thing if we were to look for it together and that before we start living together permanently — did it for a while — provisionally — and I started by renting a garret at the beginning of April, say, until June. Then I'll be more accustomed to Paris again by the time I go to Cormon's.

And — I think this way I'll remain more cheerful. I also have to tell you that although I still go there — it's often insupportable for me, the carping of the fellows at the academy, for it has proved that they're still spiteful. However, I make a point of avoiding any quarrel, and go my own way.

And I think I'm getting on the track of what I'm looking for, and perhaps I might find it even sooner if I were to sit in front of the plaster casts entirely on my own. All the same, I'm glad I went to the academy, if only because I have ample opportunity to observe the results of *starting from the outline*, because they do that systematically and they pick petty quarrels with me about it. Make an outline first — your outline isn't right — I won't correct that if you model before having conscientiously finished your outline. You see, it all comes down to that. And you really should see!!! how flat, how dead and how bloody boring the results of that system are. Oh, I tell you, I'm very glad to have seen it properly at close quarters — David or even worse — Pieneman in full bloom. I must have wanted to say at least twenty-five times — your outline's just a trick &c. — but I haven't thought it worthwhile arguing. All the same, even though I don't say anything, I irritate them — and they me.

This doesn't matter so much, though — the issue is to really go on trying to find a better system of working. So, patience and perseverance.

They go so far as to say — colour and modelling, that's nothing, one learns that very quickly — it's the outline that's the essential thing and the most difficult. You see, one can learn something new at the academy — I never knew before that colour and modelling came of their own accord. Just yesterday I finished a drawing that I've made for the competition in the evening class. It's the Germanicus figure that you know. Very well — I know for sure that I'll certainly come last, because all the drawings by the others are the same, and mine is completely different. But I saw the drawing that will be considered to be the best being done — I was sitting just behind — and it's correct, it's anything you like, but it's DEAD and so are all those drawings that I saw.

Enough about this — just let it bore us so much that we become enthusiastic about something nobler. And that we make haste to achieve it.

You also need to take better care of yourself, and should we succeed in uniting, the two of us would know more than each one individually, and could do more.

Tell me, did you notice that subtle remark of Paul Mantz's — *women are perhaps the supreme difficulty in life* — it was in the article on Baudry? We'll certainly experience our share of that, aside from what we may already have experienced. It struck me in a chapter from Zola's L'oeuvre in Gil Blas — that the painter — Manet, of course — had a scene with a woman who had posed for him and had then cooled to the idea; oh curiously well described. What one can learn at the academy in this regard is — just don't paint women then. They hardly ever use nude female models, not at all in class at any rate — very occasionally individually.

Even in the plaster cast class, 10 male figures as against 1 female figure. That's nice and easy.

That must surely be better in Paris — and it occurs to me that one actually learns so

much by constantly *comparing* male and female, which are always so very different in everything. It may be the supreme difficulty, but what would art and what would life be without that? Regards, write back about this soon, with a handshake.

Yours truly,
Vincent

My being in Nuenen, at least for the month of March, would be because of the move, and I ought to go there for myself because of changing my abode. But if need be, as far as I'm concerned, I'd be prepared not to go back at all.

567 | Paris, on or about Sunday, 28 February 1886 | *To Theo van Gogh* (F)

My dear Theo,

Don't be cross with me that I've come all of a sudden. I've thought about it so much and I think we'll save time this way. Will be at the Louvre from midday, or earlier if you like. A reply, please, to let me know when you could come to the Salle Carrée. As for expenses, I repeat, it comes to the same thing. I have some money left, that goes without saying, and I want to talk to you before spending anything. We'll sort things out, you'll see. So get there as soon as possible. I shake your hand.

Yours truly,
Vincent

569 | Paris, September or October 1886 | *To Horace Mann Livens* (E)

My dear Mr Livens,

Since I am here in Paris I have very often thought of your self and work. You will remember that I liked your colour, your ideas on art and litterature and I add, most of all, your personality.

I have already before now thought that I ought to let you know what I was doing, where I was.

But what refrained me was that I find living in Paris is much dearer than in Antwerp and not knowing what your circumstances are I dare not say Come over to Paris, without warning you that it costs one dearer than Antwerp and that if poor, one has to suffer many things. As you may imagine. But on the other hand there is more chance of selling.

There is also a good chance of exchanging pictures with other artists.

In one word, with much energy, with a sincere personal feeling of colour in nature I would say an artist can get on here notwithstanding the many obstructions. And I intend remaining here still longer.

There is much to be seen here—for instance *Delacroix* to name only one master.

In Antwerp I did not even know what the Impressionists were, now I have seen them and though *not* being one of the club yet I have much admired certain Impressionist pictures—DEGAS, nude figure—Claude Monet, landscape.

And now for what regards what I myself have been doing, I have lacked money for paying models, else I had entirely given myself to figurepainting but I have made a series of colour studies in painting simply flowers, red poppies, blue corn flowers and myosotys. White and rose roses, yellow chrysantemums—seeking oppositions of blue with orange, red and green, yellow and violet, seeking THE BROKEN AND NEUTRAL TONES to harmonise brutal extremes.

Trying to render intense COLOUR and not a GREY harmony.

Now after these gymnastics I lately did two heads which I dare say are better in light and colour than those I did before.

So as we said at the time in COLOUR seeking LIFE, the true drawing is modelling with colour.

I did a dozen landscapes too, frankly *green*, frankly *blue*.

And so I am struggling for life and progress in art.

Now I would very much like to know what you are doing and whether you ever think of going to Paris.

If ever you did come here, write to me before and I will, if you like, share my lodgings and studio with you so long as I have any. In spring — say February or even sooner — I may be going to the south of France, the land of the *blue* tones and gay colours.

And look here, if I knew you had longings for the same we might combine. I felt sure at the time that you are a thorough colourist and since I saw the Impressionists I assure you that neither your colour nor mine as it is developing itself, is *exactly* the same as their theories but so much dare I say, we have a chance and a good one of find- ing friends.

I hope your health is all right. I was rather low down in health when in Antwerp but got better here.

Write to me, in any case remember me to Allan, Briët, Rink, Durand, but I have not so often thought on any of them as I did think of you — almost daily.

Shaking hands cordially.

Yours truly,
Vincent

My present adress is

Mr Vincent van Gogh
54 Rue Lepic
Paris

What regards my chances of sale, look here, they are certainly not much but still *I do have* a beginning.

At this present moment I have found four dealers who have exhibited studies of mine. And I have exchanged studies with several artists.

Now the prices are 50 francs. Certainly not much but — as far as I can see one must sell cheap to rise, and even at costing price. And mind my dear fellow, Paris is Paris, there is but one Paris and however hard living may be here and if it became worse and harder even — the french air clears up the brain and does one good — a world of good.

I have been in Cormon's studio for three or four months but did not find that as useful as I had expected it to be. It may be my fault however, any how I left there too as I left Antwerp and since I worked alone, and fancy that since I feel my own self more.

Trade is slow here, the great dealers sell Millet, Delacroix, Corot, Daubigny, Dupré, a few other masters at exorbitant prices. They do little or nothing for young artists.

The second class dealers contrariwise sell those but at very low prices. If I asked more I would do nothing, I fancy. However I have faith in colour, even what regards the price the public will pay for it in the longer run.

But for the present things are awfully hard, therefore let anyone who risks to go over here consider there is no laying on roses at all.

What is to be gained is PROGRESS and, what the deuce, that it is to be found here I dare ascertain. Anyone who has a solid position elsewhere, let him stay where he is but for adventurers as myself I think they lose nothing in risking more. Especially as in my case I am not an adventurer by choice but by fate and feeling nowhere so much myself a stranger as in my family and country.

Kindly remember me to your landlady Mrs *Roosmaelen* and say her that if she will exhibit something of my work I will send her a small picture of mine.

572 | Paris, between about Saturday, 23 and about Monday, 25 July 1887 |
 To Theo van Gogh (F)

My dear friend,

I thank you for your letter and for what it contained.

I feel sad that even if successful, painting won't bring in what it costs.

I was touched by what you wrote about home — 'they're doing quite well, but it's sad to see them nevertheless'. But a dozen years ago or so one would have sworn that the family would continue to prosper after all, and that things would work out well. It would please our mother greatly if your marriage came off, and for your health and business affairs you shouldn't remain single anyway.

Myself — I feel I'm losing the desire for marriage and children, and at times I'm quite melancholy to be like that at 35 when I ought to feel quite differently. And sometimes I blame this damned painting.

It was Richepin who said somewhere

the love of art makes us lose real love.

I find that terribly true, but on the other hand real love puts you right off art.

And sometimes I already feel old and broken, but still sufficiently in love to stop me being enthusiastic about painting.

To succeed you have to have ambition, and ambition seems absurd to me. I don't know what will come of it. Most of all, I'd like to be less of a burden to you — and that's not impossible from now on. Because I hope to make progress in such a way that you'll be able to show what I'm doing, with confidence, without compromising yourself.

And then I'm going to retreat to somewhere in the south so as not to see so many painters who repel me as men.

You can be sure of one thing, and that's that I won't try to do any more work for the Tambourin. I think it's going to change hands, too, and of course I'm not against that.

As far as Miss Segatori is concerned, that's another matter altogether, I still feel affection for her and I hope she still feels some for me.

But now she's in an awkward position, she's neither free nor mistress in her own house, and most of all, she's sick and ill. Although I wouldn't say so in public — I'm personally convinced she's had an abortion (unless of course she had a miscarriage) — whatever the case, in her situation I wouldn't blame her.

In two months she'll be better, I hope, and then perhaps she'll be grateful that I didn't bother her.

Mind you, if she were to refuse in good health and in cold blood to give me back what's mine, or did me any kind of harm, I wouldn't be easy on her — but that won't be necessary.

But I know her well enough still to trust her.

And there again, if she manages to keep her place going, from the commercial point of view I wouldn't blame her for preferring to be the one who eats and not the one who gets eaten. If she stepped on my toes a bit in order to succeed — if need be — she has carte blanche.

When I saw her again she didn't hurt my feelings, which she would have done if she was as nasty as people say she is.

I saw Tanguy yesterday and he put a canvas I had just done in his window, I've done four since you left, and I have a big one on the go. I'm well aware that these big, long canvases are hard to sell, but in time people will see that there's open air and good cheer in them. Now the whole lot will make a decoration for a dining room or a house in the country.

And if you really fell in love and then got married, I wouldn't think it impossible that you too might manage to get hold of a house in the country, like so many other picture dealers. If you live well you spend more, but you also gain more ground, and perhaps these days we do better if we look rich than if we look hard up. It's better to have fun than to kill yourself. Warm regards to all at home.

Yours truly,
Vincent

574 | Paris, late October 1887 | *To Willemien van Gogh* (D)

My dear little sister,

I thank you for your letter, although for my part I so detest writing these days, however there are questions in your letter that I do want to answer.

I must begin by contradicting you where you say that you thought Theo looked 'so wretched' this summer.

For my part, I think on the contrary that Theo's appearance has become much more distinguished in the last year.

You have to be strong to endure life in Paris the way he has for so many years.

But might it not be that Theo's family and friends in Amsterdam and The Hague haven't treated him and even not received him with the cordiality that he deserved from them and to which he was entitled?

I can tell you in that regard that he was perhaps a little hurt by this, but he's

otherwise not letting it bother him, and now, when times are so bad in paintings, he's still doing business, so it could be there's some professional jealousy on the part of his Dutch friends.

Now what shall I say about your little piece about the plants and the rain? You see for yourself in nature that many a flower is trampled, freezes or is parched, further that not every grain of wheat, once it has ripened, ends up in the earth again to germinate there and become a stalk — but far and away the most grains do *not* develop but go to the mill — don't they?

Now comparing people with grains of wheat — in every person who's healthy and natural there's *the power to germinate* as in a grain of wheat. And so natural life is *germinating*.

What the power to germinate is in wheat, so love is in us. Now we, I think, stand there pulling a long face or at a loss for words when, being thwarted in our natural development, we see that germination frustrated and ourselves placed in circumstances as hopeless as they must be for the wheat between the millstones.

If this happens to us and we're utterly bewildered by the loss of our natural life, there are some among us who, willing to submit themselves to the course of things as they are, nonetheless don't abandon their self-awareness and want to know how things are with them and what's actually happening. And searching with good intentions in the books of which it is said they are a light in the darkness, with the best will in the world we find precious little certain at all and not always satisfaction to comfort us personally. And the diseases from which we civilized people suffer the most are melancholia and pessimism.

Like me, for instance, who can count so many years in my life when I completely lost all inclination to laugh, leaving aside whether or not this was my own fault, I for one need above all just to have a good laugh. I found that in *Guy de Maupassant* and there are others here, Rabelais among the old writers, Henri Rochefort among today's, where one can find that — *Voltaire in* CANDIDE.

On the contrary, if one wants truth, life as it is, De Goncourt, for example, in Germinie Lacerteux, La fille Elisa, Zola in La joie de vivre and L'assommoir and so many other masterpieces paint life as we feel it ourselves and thus satisfy that need which we have, that people tell us the truth.

The work of the French naturalists Zola, Flaubert, Guy de Maupassant, De Goncourt, Richepin, Daudet, Huysmans is magnificent and one can scarcely be said to belong to one's time if one isn't familiar with them. Maupassant's masterpiece is Bel-ami; I hope to be able to get it for you.

Is the Bible enough for us? Nowadays I believe Jesus himself would again say to those who just sit melancholy, *it is not here, it is risen. Why seek ye the living among the dead?*

If the spoken or written word is to remain the light of the world, it's our right and our duty to acknowledge that we live in an age in which it's written in such a way, spoken in such a way that in order to find something as great and as good and as original, and just as capable of overturning the whole old society as in the past, we can safely compare it with the old upheaval by the Christians.

For my part, I'm always glad that I've read the Bible better than many people nowadays, just because it gives me a certain peace that there have been such lofty ideas in the past. But precisely because I think the old is good, I find the new all the more so.

All the more so because we can take action ourselves in our own age, and both the past and the future affect us only indirectly.

My own fortunes dictate above all that I'm making rapid progress in growing up into a little old man, you know, with wrinkles, with a bristly beard, with a number of false teeth &c.

But what does that matter? I have a dirty and difficult occupation, painting, and if I weren't as I am I wouldn't paint, but being as I am I often work with pleasure, and I see the possibility glimmering through of making paintings in which there's some youth and freshness, although my own youth is one of those things I've lost. If I didn't have Theo it wouldn't be possible for me to do justice to my work, but because I have him as a friend I believe that I'll make more progress and that things will run their course. It's my plan to go to the south for a while, as soon as I can, where there's even more colour and even more sun.

But what I hope to achieve is to paint a good portrait. Anyway.

Now to get back to your little piece, I feel uneasy about assuming for my own use or recommending to others for theirs the belief that powers above us intervene personally to help us or to comfort us. Providence is such a strange thing, and I tell you that I definitely don't know what to make of it.

Well, in your piece there's always a certain sentimentality and in its form, above all, it's reminiscent of the stories about providence already referred to above, let's say the providence in question, stories that so repeatedly failed to hold water and against which so very much could be said.

And above all I find it a very worrying matter that you believe you have to study in order to write. No, my dear little sister, learn to dance or fall in love with one or more notary's clerks, officers, in short whoever's within your reach; rather, much rather commit any number of follies than study in Holland, it serves absolutely no purpose other than to make someone dull, and so I won't hear of it.

For my part, I still continually have the most impossible and highly unsuitable love affairs from which, as a rule, I emerge only with shame and disgrace.

And in this I'm absolutely right, in my own view, because I tell myself that in earlier years, when I should have been in love, I immersed myself in religious and socialist affairs and considered art more sacred, more than now. Why are religion or law or art so sacred? People who do nothing other than be in love are perhaps more serious and holier than those who sacrifice their love and their heart to an idea. Be this as it may, to write a book, to perform a deed, to make a painting with life in it, one must be a living person oneself. And so for you, unless you never want to progress, studying is very much a side issue. Enjoy yourself as much as you can and have as many distractions as you can, and be aware that what people want in art nowadays has to be very lively, with strong colour, very intense. So intensify your own health and strength and life a little, that's the best study.

It would please me if you would write and tell me how Margot Begemann is doing and how they're doing at De Groot's. How did that business turn out? Did Sien de Groot marry her cousin? And did her child live? What I think about my own work is that the painting of the peasants eating potatoes that I did in Nuenen is after all the best thing I did. Only since then I haven't had the opportunity to find models, but on the contrary have had the opportunity to study the question of colour.

And if I do find models for my figures again later, then I hope to show that I'm looking for something other than little green landscapes or flowers. Last year I painted almost nothing but flowers to accustom myself to a colour other than grey, that's to say pink, soft or bright green, light blue, violet, yellow, orange, fine red. And when I painted landscape in Asnières this summer I saw more colour in it than before. I'm studying this now in portraits. And I have to tell you that I'm painting none the worse for it, perhaps because I could tell you very many bad things about both painters and paintings if I wanted to, just as easily as I could tell you good things about them.

I don't want to be one of the melancholics or those who become sour and bitter and morbid. To understand all is to forgive all, and I believe that *if* we knew everything we'd arrive at a certain serenity. Now having this serenity as much as possible, even when one knows — little — nothing — for certain, is perhaps a better remedy against all ills than what's sold in the chemist's. *A lot comes of its own accord*, one grows and develops of one's own accord.

So don't study and swot too much, because that makes for sterility. Enjoy yourself too much rather than too little, and don't take art or love too seriously either — one can do little about it oneself, it's mostly a matter of temperament. If I were living near you, I'd try to make you understand that it might be more practical for you to paint with me than to write, and that you might be more able to express your feelings that way. At any rate I can do something about painting personally, but as far as writing's concerned I'm not in the business. Anyway, it's not a bad idea for you to want to become an artist, because if one has fire in one, and soul, one can't keep stifling them and — one would rather burn than suffocate. What's inside must get out. Me, for instance, it gives me air when I make a painting, and without that I'd be unhappier than I am. Give Ma my very warmest regards.

Vincent

A la recherche du bonheur affected me very greatly. Now I've just read *Mont-Oriol by Guy de Maupassant*. Art often seems to be something very lofty and, as you say, something sacred. But that's true of love too. And the problem is simply that not everyone thinks about it like that, and those who feel something of it and allow themselves to be swept away by it suffer greatly, firstly because of being misunderstood, but as much because our inspiration is so often inadequate or the work is made impossible by circumstances. One should be able to do two or preferably several things at the same time.

And there are times when it's by no means clear to us that art should be something sacred or good.

Anyway, think carefully about whether it isn't better, if one has a feeling for art and wants to work in it, to say that one is doing it because one was created with that feeling and can't do anything else and is following one's nature, than to say one is doing it for a good cause.

Does it not say in A la recherche du bonheur that evil lies in our own natures — which we didn't create ourselves?

What I think is so good about the moderns is that they don't moralize like the old ones.

It seems coarse to many people, for instance, and they're angered by it: vice and virtue are chemical products like sugar and vitriol.

577 | Arles, Tuesday, 21 February 1888 | *To Theo van Gogh* (F)

My dear Theo,

During the journey I thought at least as much about you as about the new country I was seeing.

But I tell myself that you'll perhaps come here often yourself later on. It seems to me almost impossible to be able to work in Paris, unless you have a refuge in which to recover and regain your peace of mind and self-composure. Without that, you'd be bound to get utterly numbed.

Now I'll tell you that for a start, there's been a snowfall of at least 60 centimetres all over, and it's still snowing.

Arles doesn't seem any bigger than Breda or Mons to me.

Before reaching Tarascon I noticed some magnificent scenery — huge yellow rocks, oddly jumbled together, with the most imposing shapes.

In the small valleys between these rocks there were rows of little round trees with olive-green or grey-green foliage, which could well be lemon trees.

But here in Arles the land seems flat.

I noticed some magnificent plots of red earth planted with vines, with mountains in the background of the most delicate lilac. And the landscape under the snow with the white peaks against a sky as bright as the snow was just like the winter landscapes the Japanese did.

Here's my address

Restaurant Carrel
30 rue Cavalerie
Arles

So far I've taken no more than a little walk round the town, as I was more or less completely done in last night.

I'll write to you soon — an antique dealer whose shop I went into yesterday in this very street was telling me he knew of a Monticelli.

With a good handshake to you and the pals.

Yours truly,
Vincent

My dear Theo,

Thanks for your kind letter and the 50-franc note.

So far I'm not finding living here as profitable as I might have hoped, but I've finished three studies, which I would probably not have been able to do in Paris these days.

I was glad the news from Holland was fairly satisfactory. As far as Reid goes, I wouldn't be very surprised if — (wrongly, however) — he took it badly that I went to the south before him. For us to say we'd never have benefited from knowing him would be relatively unfair since, 1, he made us a gift of a very fine painting (which painting, let it be said by the way, we intended to acquire), 2, Reid made Monticellis go up in value, and since we own 5 of them the result for us is that these paintings have increased in value — 3, he was good and pleasant company in the first months.

Now for our part we wanted him to take part in a bigger deal than the Monticelli one, and he pretended not to understand very much about it.

It seems to me that in order to be even more clearly entitled to stay masters on our own terrain regarding the Impressionists — so that there can be no doubt about our good faith towards Reid — we could leave him alone and let him do as he thinks fit regarding the Marseille Monticellis. Making the point that dead painters are only of indirect interest to us from the monetary point of view.

And if you agree with this, if need be you can tell him on my behalf too that if he intends to come to Marseille to buy Monticellis he has nothing to fear from us, but that we're entitled to ask him his intentions in this regard, given that we came to this territory before he did.

About the Impressionists — it would seem fair to me that they should be introduced into England through you, if not by you in person. And if Reid made a move first, we'd be justified in thinking he had acted in bad faith towards us, all the more so since we'd have left him free regarding the Marseille Monticellis.

You would definitely be doing our friend Koning a favour if you let him stay with you — his visit to Rivet must have proved to him that it wasn't we who advised him badly.

If you did feel like taking him in — and it seems to me that it would get him out of a mess, you'd just have to get things straight with his father, so that you wouldn't have any responsibilities, even indirect ones.

If you see Bernard tell him that so far I'm having to pay more than at Pont-Aven, but that I think if you live here in furnished rooms with middle-class people it must be possible to save money, which I'm trying to do, and as soon as I've found out I'll write and tell him what seem to me the average expenses.

At times it seems to me that my blood is more or less ready to start circulating again, which wasn't the case lately in Paris, I really couldn't stand it any more.

I have to buy my colours and canvases from either a grocer or a bookseller, who don't have everything one might wish for. I'll definitely have to go to Marseille to see what the state of these things is like there. I had hoped to find some beautiful blue &c., and in fact I haven't given up, seeing that in Marseille you should be able to buy raw

materials first hand. And I'd like to be able to do blues like Ziem — which don't change as much as the others, well, we'll see.

Don't worry, and give the pals a handshake for me.

Yours truly,
Vincent

The studies I have are an old woman of Arles, a landscape with snow, a view of a stretch of pavement with a butcher's shop. The women really are beautiful here, it's no joke — on the other hand, the Arles museum is dreadful and a joke, and fit to be in Tarascon — there's also a museum of antiquities, they're genuine.

582 | Arles, on or about Friday, 2 March 1888 | *To Theo van Gogh* (F)

My dear Theo

I was very pleased to receive your letter and the rough draft of the letter to Tersteeg and the 50-franc note.

Your letter to Tersteeg is perfectly good in the draft, I hope you didn't spoil it too much when making a fair copy.

It seems to me that your letter to Tersteeg adds to mine — myself, I regretted the state in which I had posted it. Because you'll have noticed that the idea of getting Tersteeg to take the initiative in introducing the Impressionists to England only came to me when writing the actual letter, and was only partially expressed in a P.S. added afterwards. While in your letter you explain that idea to him more fully. Will he understand? Indeed — it concerns him.

I've had a letter here from Gauguin, who says he's been ill in bed for a fortnight. That he's broke, since he's had to pay off some pressing debts. That he'd like to know if you've sold anything for him but that he can't write to you for fear of bothering you. That he's under so much pressure to earn a little money he'd be determined to reduce the price of his paintings still further.

I can do nothing about this business from my end except write to Russell, which I'll do this very day.

And after all, we've already tried to get Tersteeg to buy one. But what can we do, he must really be hard up. I'm sending you a few lines for him in case you have something to tell him, but open letters if any come for me, because you'll know sooner what's in them if you do that and that will save me the trouble of telling you what's in them. This goes once and for all.

Would you risk buying the seascape from him for the firm? If that were possible he would be out of difficulties for the time being.

Now it's very good that you've taken in young Koning, I'm so glad you won't be living alone in your apartment. In Paris one is always suffering, like a cab-horse, and if on top of that you have to live alone in your stable it would be too much.

About the Independents' exhibition, do whatever you see fit.

What would you say to showing the two large landscapes of the Butte Montmartre

there? It's all much the same to me, I'm inclined to place slightly more hopes in this year's work.

There's a hard frost here, and out in the country there's still snow — I have a study of a whitened landscape with the town in the background. And then 2 little studies of a branch of an almond tree that's already in flower despite everything.

Enough for today, I'm writing a note to Koning.

I'm really very pleased that you've written to Tersteeg, and I have hopes that this will be the renewal of your relations in Holland.

With a handshake to you and to any pals you may meet.

Yours truly,
Vincent

584 | Arles, Saturday, 10 March 1888 | *To Theo van Gogh* (F)

My dear Theo,

Thanks for your letter and the 100-franc note enclosed with it. I very much hope that Tersteeg will come to Paris soon, as you're inclined to believe. That would be very desirable in the circumstances you describe, in which they are all at bay and hard up. I find what you write about the Lançon sale and the painter's mistress very interesting. He's done things of really great character, his drawing has often made me think of Mauve's. I'm sorry not to have seen the exhibition of his studies, just as I'm really sorry not to have seen the Willette exhibition either.

What do you say to the news that Kaiser Wilhelm is dead? Will that speed up events in France, and will Paris stay calm? It seems doubtful. And what effect will all this have on the trade in paintings? I've read that it seems there's a possibility of abolishing import duty on paintings in America, is that true?

Perhaps it would be easier to get a few dealers and art lovers to agree to buy Impressionist paintings than to get the artists to agree to share equally the price of paintings sold.

Nevertheless, artists won't find a better way than — to join together, give their pictures to the association, and share the sale price in such a way that at least the society will be able to guarantee the possibility of existence and work for its members. If Degas, Claude Monet, Renoir, Sisley and C. Pissarro were to take the initiative and say: here we are, each of the 5 of us gives 10 paintings (or rather, we each give to the value of 10,000 francs, the value estimated by expert members, for example, Tersteeg and yourself, appointed by the society, and these experts also invest capital in the form of paintings), and, furthermore, we commit ourselves to give to the value of . . . each year.

And we also invite you, Guillaumin, Seurat, Gauguin &c. &c. to join us (your pictures being put to the same assessment from the point of view of value).

Then the great Impressionists of the Grand Boulevard, giving paintings that become common property, would retain their prestige, and the others wouldn't be able to criticize them for keeping to themselves the benefits of a reputation gained without any doubt by their own efforts and by their individual genius in the first

place — but — nevertheless, in the second place, a reputation that is growing and is now also being consolidated and supported by the paintings of a whole battalion of artists who have so far been working while constantly broke. Whatever happens — it's really to be hoped that the thing comes off, and that you and Tersteeg become the society's expert members (with Portier perhaps?).

I have two more studies of landscapes, I hope the work will continue steadily and that in a month I'll get a first consignment to you — I say in a month because I want to send you nothing but the best, and because I want it to be dry, and because I want to send at least a dozen or so all at once because of the cost of transport.

Congratulations on buying the Seurat — with what I send you you'll have to try to make an exchange with Seurat as well.

You're well aware that if Tersteeg joins you in this venture, the two of you will easily be able to persuade Boussod Valadon to extend substantial credit for the purchases needed. But it's urgent, because without that other dealers will cut the ground from under your feet.

I've made the acquaintance of a Danish artist who talks about Heyerdahl and other people from the north, Krøyer, &c. What he does is dry but very conscientious, and he's still young. Saw the exhibition of the Impressionists in rue Laffitte at the time. He'll probably come to Paris for the Salon, and wants to tour Holland to see the museums.

I think it's a very good idea that you put the books in the Independents' too. This study should be given the title: 'Parisian novels'.

I'd be so happy to know you'd succeeded in persuading Tersteeg — well, patience.

I was obliged to buy supplies for 50 francs when your letter arrived. This week I'll start work on 4 or 5 things.

I think about this association of artists every day, and the plan has developed further in my mind, but Tersteeg would have to be involved, and a lot depends on that.

Nowadays, the artists would probably allow themselves to be persuaded by us, but we can't go ahead before we have Tersteeg's help. Without that we'd be on our own, listening to everybody moaning from morning till night, and each of them individually would be constantly coming to ask for explanations — axioms — &c. Shouldn't be surprised if Tersteeg took the view that we can't do without the Grand Boulevard artists — and if he advised you to persuade them to take the initiative in an association by giving paintings that would become common property and cease to belong to them individually. It seems to me that the Petit Boulevard would be morally obliged to join in response to a proposal from that side. And those Grand Boulevard gentlemen will only retain their current prestige by forestalling the partly justified criticism of the minor Impressionists, who'll say: 'you're putting everything in your pocket'. They can easily reply to that: not at all, on the contrary, we're the first to say: our paintings belong TO THE ARTISTS.

If Degas, Monet, Renoir and Pissarro say that — even leaving plenty of room for their individual ideas about putting it into practice — they could — say worse, unless — they say nothing and let things ride.

Ever yours,
Vincent

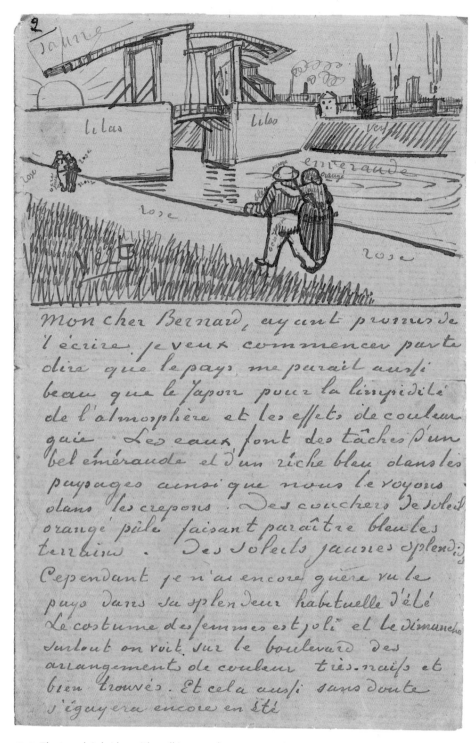

Mon cher Bernard, ayant promis de
l'écrire, je veux commencer par te
dire que le pays me paraît aussi
beau que le Japon pour la limpidité
de l'atmosphère et les effets de couleur
gaie. Les eaux font des tâches d'un
bel émeraude et d'un riche bleu dans les
paysages ainsi que nous le voyons
dans les crépons. Des couchers de soleil
orangé pâle faisant paraître bleus les
terrains. Des soleils jaunes splendides
Cependant je n'ai encore guère vu le
pays dans sa splendeur habituelle d'été
Le costume des femmes est joli et le dimanche
surtout on voit sur le boulevard des
arrangements de couleur très naïfs et
bien trouvés. Et cela aussi sans doute
s'égayera encore en été

587A. The Langlois bridge with walking couple

[*Sketch 587A*]

My dear Bernard,

Having promised to write to you, I want to begin by telling you that this part of the world seems to me as beautiful as Japan for the clearness of the atmosphere and the gay colour effects. The stretches of water make patches of a beautiful emerald and a rich blue in the landscapes, as we see it in the Japanese prints. Pale orange sunsets making the fields look blue — glorious yellow suns. However, so far I've hardly seen this part of the world in its usual summer splendour. The women's costume is pretty, and especially on the boulevard on Sunday you see some very naive and well-chosen arrangements of colour. And that, too, will doubtless get even livelier in summer.

I regret that living here isn't as cheap as I'd hoped, and until now I haven't found a way of getting by as easily as one could do in Pont-Aven. I started out paying 5 francs and now I'm on 4 francs a day. One would need to know the local patois, and know how to eat bouillabaisse and aïoli, then one would surely find an inexpensive family boarding-house. Then if there were several of us, I'm inclined to believe we'd get more favourable terms. Perhaps there'd be a real advantage in emigrating to the south for many artists in love with sunshine and colour. The Japanese may not be making progress in their country, but there's no doubt that their art is being carried on in France. At the top of this letter I'm sending you a little croquis of a study that's preoccupying me as to how to make something of it — sailors coming back with their sweethearts towards the town, which projects the strange silhouette of its drawbridge against a huge yellow sun.

I have another study of the same drawbridge with a group of washerwomen. Shall be happy to have a line from you to know what you're doing and where you're going to go. A very warm handshake to you and the friends.

Yours truly,
Vincent

My dear Theo,

Your letter gave me great pleasure, I thank you for it as well as for the 50-franc note.

I congratulate you heartily on Tersteeg's letter — I think it's absolutely satisfactory.

I'm convinced there's nothing hurtful in his silence towards me, in any case he'd have expected you to give me his reply to read. And it's much more practical for him having only to write to you, and as far as I'm concerned, if he doesn't think what I'm doing is utterly bad, you'll see, he'll write me a line as soon as he's seen my work. So once again, I'm happier with his simple and friendly reply than I could tell you.

You'll have noticed that he states his willingness to make a purchase of a good quality Monticelli for his own collection. If you told him that we have a bouquet of

flowers in our collection that is more artistic and more beautiful than a bouquet by Diaz.

That Monticelli would sometimes take a bouquet of flowers in order to put on a single panel the whole range of his richest and most perfectly balanced tones. And that you have to go straight to Delacroix to find such an orchestration of colours.

That — I'm referring to the painting at the Delarebeyrettes' — we currently know of another bouquet of very good quality and at a reasonable price, and that in any case we think it's much finer than the Monticellis with figures, which are all over the place these days and belong to a period of decline in Monticelli's talent.

I hope you'll send him Gauguin's fine seascape. But how pleased I am that Tersteeg has replied in this way.

When you write to him, say a word about Russell. When I write to Russell myself, I'll talk about his paintings and I'll ask him to do an exchange with me, because we'd want to mention him and show his paintings when it comes to the question of the modern-day Renaissance school.

I've just done a clump of apricot trees in a little fresh green orchard.

Had some trouble with the sunset with figures and a bridge that I was talking to Bernard about. As the bad weather prevented me from working on the spot, I completely worked this study to death trying to finish it at home.

However, I started the same subject again immediately afterwards on another canvas, but as the weather was quite different, in a grey palette and without figures.

I wouldn't think it a bad idea if you sent Tersteeg one of my studies — do you mean the Clichy bridge with the yellow sky and two houses reflected in the water?

[*Sketch 589A*]

That one, or the butterflies or the field of poppies might do. However, I hope to do better things here. If you happen to feel that way, you could tell Tersteeg that I myself think I have a better chance of sales in Holland with the studies of nature in the south, and that when Tersteeg comes to Paris in May he'll find a consignment with some subjects from down here.

And again, many thanks for all the initiatives you've taken for the Independents' exhibition, all in all I'm really pleased that they've put them with the other Impressionists. But — although this time it makes no difference at all — in future my name must be put in the catalogue the way I sign it on the canvases, i.e. Vincent and not Vangogh, for the excellent reason that people here wouldn't be able to pronounce that name.

I'm returning herewith the letter from Tersteeg and the one from Russell — it will perhaps be interesting to keep the artists' correspondence.

If you included the little head of a Breton woman by our friend Bernard in your consignment, that wouldn't be a bad idea. We must show him that all the Impressionists are good and that what they do is very varied.

I think our friend Reid regrets falling out, unfortunately there can be no question of offering him the same advantages again — that is, trying to let him have paintings on commission. It's not enough to love paintings, and it seemed to me that he lacked warm feelings for painters. If he changes in that respect it won't be overnight. Tersteeg was a personal friend of Mauve and many others, and he has that *je ne sais quoi* that wins art lovers over. You'll see that what gives self-confidence is knowing people.

Seulement j'ai aussitôt après
recommencé le même motif
sur une autre toile mais le
temps étant tout autre Dans
une gamme grise et sans figures
Je ne trouverais pas mauvais que
tu envoyes à Tersteeg une étude de
moi - veux tu dire le pont de Clichy
avec le ciel jaune et deux maisons
qui se reflètent dans l'eau celle-
là où les papillons ou le champ de coquelicots
pourraient aller à la rigueur Cependant
J'espère arriver à mieux ici --
Dans le cas où tu serais de cet avis tu
pourrais dire à Tersteeg que moi-même
crois avoir plus de chance de vente en
Hollande avec ~~mes~~ les études de la
nature du midi et que lorsque
Tersteeg viendra à Paris au mois
de Mai il trouvera un envoi de
~~_____~~ quelques motifs d'ici
Merci bien encore aussi de toutes
les démarches que tu a faites pour
l'exposition des indépendants je suis en
somme bien content qu'il les ont
placé avec les autres impressionistes
Mais - quoique pour cette fois ci
cela ne fasse absolument rien - Dans
la suite il faudra insérer mon nom
Dans le catalogue tel que je le
signe sur les toiles c.a.d. Vincent
et non pas Vangogh pour l'excellente
raison que ce dernier nom ne
saurait se prononcer ici

589A. *The Seine with the Clichy bridge*

I'll write more in the next few days, but wanted to congratulate you right away on the renewal of your relations with Holland.

Handshake.

Yours truly,
Vincent

The city of Paris pays practically nothing, would be sorry to see the Seurats in a provincial museum or a cellar—these paintings must stay in living hands. If Tersteeg was willing ———. If we do the 3 permanent exhibitions, we'd need a large Seurat for Paris, one for London and one for Marseille.

590 | Arles, on or about Friday, 30 March 1888 | *To Willemien van Gogh* (D)

My dear sister,

So as not to let your letter go unanswered I'm writing immediately upon receipt of your letter and Ma's and the good wishes from you both.

You should know that I'd be very happy to write to you more often were it not that quite a lot of things contribute to my not being master of my time, and you mustn't imagine that I do exactly what I want or leave what I'd rather not do. The work has me in its grip now, I think for all time, and although this isn't unhappy, I nonetheless imagine happiness as something very different.

To begin with, it gave me an enormous amount of pleasure here that relations have begun between Theo and Mr Tersteeg in order to make the work of the painters from here whom they call Impressionists known in Holland too.

For myself I have no regrets about having come here, since I find nature here almighty beautiful.

By next year—when the World Exhibition will be held—I have to make a mass of things, because my friends will certainly also not fail to have a great many interesting things on hand.

Not that I or any of the painters with whom I'm more especially friendly will exhibit with the others, but an open exhibition will probably be staged alongside the official one at that time. Now here, for instance, at this moment, I have 6 paintings of blossoming fruit trees. And the one I brought home today would possibly appeal to you—it's a dug-over patch of ground in an orchard, a wicker fence and two peach trees in full bloom, pink against a sparkling blue sky with white clouds and in sunshine. You may well see it, since I've decided to send this one to Jet Mauve. I've written on it

Souvenir de Mauve
Vincent & Theo

Now I know very well that I could also have found such a subject elsewhere, but when I think that many painters will do the same I reckon it by no means immaterial to work in nature which, although it's the same as at home in subject and fact, is undoubtedly much richer and more colourful.

Furthermore, the people here are picturesque too, and whereas at home a beggar

looks much like a spectre, here he becomes a caricature. Since, as you'll see when you read Zola and Guy de Maupassant, people definitely want—in art—something very rich and something very cheerful—even though that same Zola and Maupassant have said the most heart-rending things that have perhaps ever been said—the same movement is also beginning to become the rule in painting. For example I can imagine that a painter of today might make something like one finds described in the book by Pierre Loti, Le mariage de Loti, where nature in Otaheite is described. A book that I can really recommend to you.

You understand that the countryside of the south can't exactly be painted with the palette of Mauve, say, who belongs in the north and is and always will be the master of grey. But today's palette is definitely colourful—sky blue, pink, orange, vermilion, brilliant yellow, bright green, bright wine red, violet.

But by intensifying *all the* colours one again achieves calm and harmony. And something happens like with the Wagner music which, performed by a large orchestra, is no less intimate for that. Only people prefer sunny and colourful effects, and nothing stops me from thinking sometimes that later on many painters will go and work in tropical countries. You can get an idea of the change in painting if you think, say, of the colourful Japanese pictures that one sees everywhere, landscapes and figures. Theo and I have hundreds of these Japanese prints.

You see I'm writing to you only about the work today, and I must close, and don't know whether I'll be able to write any more to add to it. Best wishes to you and Ma, and thanks for your letters.

Vincent

For my part I must also wish you a happy birthday—since I'd like to give you something of my work that you'll like I'll set aside a little study of a book and a flower for you—in a large format with a whole mass of books with pink, yellow, green covers and fiery red—my painting *Parisian novels* was the same subject. Theo will bring this for you—I also have a study for Jet Mauve.

592 | Arles, on or about Tuesday, 3 April 1888 | *To Theo van Gogh* (F)

My dear Theo,

I'm in a fury of work as the trees are in blossom and I wanted to do a Provence orchard of tremendous gaiety—writing to you in a calm frame of mind presents serious difficulties, yesterday I wrote some letters that I later destroyed. I continue every day to feel that we're obliged to do something in Holland—that we need to launch it with all the fervour of the sansculottes, with a French gaiety worthy of the cause we're pleading.

So here's a plan of attack that will cost us some of the best paintings we've made together, definitely worth let's say a pundle off tousand-vrenc pills, well anyway they'll have cost us money and a good slice out of our lives.

But it would be a *loud and clear* reply to certain muffled insinuations treating us more or less as if we were already dead, and a revenge for your trip last year when the welcome they gave you was lacking in warmth &c. Enough.

Let's suppose, then, that first of all we gave Jet Mauve the *Souvenir de Mauve*.

Let's suppose I dedicate a study to Breitner (I have one exactly like the study I exchanged with L. Pissarro and Reid's one, oranges, foreground white, background blue).

Let's suppose we also gave our sister some study or other.

Let's suppose we gave the modern museum in The Hague, since we have so many memories in The Hague, the 2 Montmartre landscapes exhibited at the Independents'.

There's one more thing that's not at all easy. With Tersteeg having written to you 'send me some Impressionists, but only paintings you yourself think are among the best', and you having for your part included one of my paintings in this consignment, I'm in the uncomfortable position of *convincing* Tersteeg I really am an Impressionist of the Petit Boulevard and that I expect to retain that position. Ah well, he'll have one of my paintings in his own collection — I've been thinking about it these past few days and I've found a funny thing of a kind I'm not going to do every day. It's the drawbridge with a little yellow carriage and group of washerwomen, a study in which the fields are a bright orange, the grass very green, the sky and the water blue.

It just needs a frame designed specially for it, in royal blue and gold like this, the flat part blue, the outer

[*Sketch* 592A]

strip gold. If necessary, the frame can be of blue plush, but it would be better to paint it.

I think I can assure you that what I'm making here is better than my campaign in Asnières last spring.

Nothing is absolutely decided in the whole plan except for the dedication in memory of Mauve and the dedication to Tersteeg. I haven't yet managed to get a line written to tell him, but I'll manage it, as the painting's done it'll come to me all by itself, but you're well aware that we have the power in us to oblige them to talk about us if it so pleases us, and we can carry on the work of introducing the Impressionists there with the greatest calmness and self-assurance.

If you see Reid again it would be a good idea to tell him we don't have much confidence in the success of ambitious people and that we prefer to do good work, that we were surprised at his ways of behaving, which in the end were inexplicable, and that since then we no longer know what to think of him. I think Russell is trying to make peace between Reid and me, and that he wrote the letter precisely with that in mind. I'll certainly write to Russell saying I told Reid bluntly that I was sure it was a mistake on his part and crazy to like paintings that are dead and to have no regard for living artists. That in any case I hoped to see him change in that respect.

As soon as I received the letter I had to spend almost everything on colours and canvases, and I'd be very pleased if it were possible for you to send me something extra in the next few days. The painting of the garden with lovers is at the Théâtre Libre. Boyer, the framer, still has a lithograph, the old man with a bald head.

I'd like you to get the consignment that I'm going to make for you before Tersteeg arrives in Paris, and you can put the apple trees in blossom in the room. I'm really glad it's going well with Koning and that you aren't living alone. What a bad business with Vignon, no doubt Mr Gendre was involved, I wish Mr Gendre nothing but ill, he does too much of it to other people. It's a sad end for *père* Martin. I still can't manage a letter to you of the kind I'd like, work is absorbing me completely. Well, first and foremost

C'est le pont Levis avec petite voiture jaune
et groupe de laveuses une étude où
les terrains sont orangé vif l'herbe très
verte le ciel et l'eau bleu
il lui faut seulement un cadre calculé
exprès en bleu de roi et or. de ce
modèle le plat bleu la baguette
extérieure or. au besoin le
cadre pourrait être en pluche bleu
mais mieux vaut le peindre

Je crois pouvoir t'assurer que
ce que je fabrique ici est supérieur
à la campagne d'Asnières ~~l'an~~ au
printemps dernier.
Dans tout le plan il n'y a rien d'absolu~~ment~~
décidé que la dédicace souvenir de Mauve
et la dédicace à Tersteeg. Je n'ai pas
encore réussi un petit mot écrit pour
le lui dire mais je le trouverai le
tableau étant fait cela me viendra tout seul
mais tu sens bien que nous avons
la force en nous pour les obliger de
parler de nous si cela nous plaît et
nous pouvons ~~travailler~~ continuer
le travail d'y introduire les impressions
avec le plus grand calme et aplomb.
Si tu vois Reid il serait bon de lui dire
que nous n'avons pas grande confiance
dans ces gens ambitieux et que nous
aimons mieux ~~~~ faire du bon
travail que nous avons été surpris de
ses façons de faire qui pourraient par être
inexplicables et que depuis on ne sait
plus que penser de lui. Je crois que Russell

De mon côté je n'écrirai pas à Tersteeg seulement si je lui dis des quelque chose je
le dirai avec la lettre à toi avec la tienne.

it's to tell you I'd like to do some studies intended for Holland, and after that leave Holland alone for ever. Thinking of Mauve, J.H. Weissenbruch, Tersteeg, our mother and Wil, in the past few days, I've felt more emotion than perhaps reasonable, and it calms me down to say to myself that we'll do some paintings for there. And after that I'll forget them and I'll probably think only about the Petit Boulevard.

Rest assured that Tersteeg won't refuse the painting, and that it's a firm decision that that one and the one for Jet Mauve will go to Holland.

For my part I won't write to Tersteeg direct, if I say something to him I'll send the letter to you with the painting.

595 | Arles, on or about Wednesday, 11 April 1888 | *To Theo van Gogh* (F)

My dear Theo,

It's awfully good of you to have sent me the complete order of colours, I've just received them but haven't yet had the time to check them. I'm so pleased about it. Today has been a good day too. This morning I worked on an orchard of plum trees in blossom — suddenly a tremendous wind began to blow, an effect I'd only ever seen here — and came back again at intervals. In the intervals, sunshine that made all the little white flowers sparkle. It was so beautiful! My friend the Dane came to join me, and at risk and peril every moment of seeing the whole lot of it on the ground I carried on painting — in this white effect there's a lot of yellow with blue and lilac, the sky is white and blue. But as for the execution of what we do out of doors like this, what will they say? Well, let's wait and see.

So, after supper I started on the same painting I intend for Tersteeg, 'The Langlois bridge', for you. And I'd really like to make a repetition of that one for Jet Mauve too, because since I'm spending so much we mustn't lose sight of the fact that we've got to try to get some back, of this money that's quickly slipping away.

Afterwards I was sorry I hadn't asked for the colours from *père* Tanguy anyway, although there isn't the least advantage in that — on the contrary — but he's such a funny fellow and I still think of him often. Don't forget to say hello to him for me if you see him, and tell him that if he'd like any paintings for his shop window he can have some from here, and the best. Ah, it seems to me more and more that *people* are the root of everything, and although it remains for ever a melancholy feeling not to find oneself in real life, in the sense that it would be better to work in flesh itself than colour or plaster, in the sense that it would be better to make children than to make paintings or to do business, at the same time you feel you're living when you consider that you have friends among those who themselves aren't in real life either.

But precisely because what's in people's hearts is also the heart of business, we have to conquer friendships in Holland, or rather, revive them. All the more so since, as far as the cause of Impressionism goes, we have little to fear at the moment of not winning through. And it's because of this victory that's almost guaranteed in advance that for our part we have to have good manners and do everything calmly.

I would really like to have seen the embodiment of *Marat* you spoke about the other day. That would certainly interest me very much. Unwittingly, I imagine Marat as the — moral — equivalent (but more powerful) of Xanthippe — the woman whose love turned sour. Who nevertheless is still touching — but in the end it's not as jolly as Guy de Maupassant's La Maison Tellier.

Has De Lautrec finished his painting of a woman leaning on a little café table?

If I manage to learn how to work up the studies I've done from life on another canvas, we'd gain in terms of possible sales. I hope to succeed in doing it here — and that's why I'm making a trial effort with the two paintings that will go to Holland, and on the other hand, you'll have them too, and in this way there's nothing reckless.

You were right to tell Tasset that the geranium lake should be included after all, he sent it, I've just checked — *all the colours that Impressionism has made fashionable are unstable,* all the more reason boldly to use them too raw, time will only soften them too much. So the whole order I made up, in other words the 3 chromes (the orange, the yellow, the lemon), the Prussian blue, the emerald, the madder lakes, the Veronese green, the orange lead, all of that is hardly found in the Dutch palette, Maris, Mauve and Israëls. But it's found in that of Delacroix, who had a passion for the two colours most disapproved of, and for the best of reasons, lemon and Prussian blue. All the same, I think he did superb things with them, blues and lemon yellows. Handshake to you, to Koning and once again many thanks for the colours.

Ever yours,
Vincent

597 | Arles, on or about Friday, 13 April 1888 | *To Theo van Gogh* (F)

My dear Theo,

Thanks for your letter containing the samples of absorbent canvas. Will be very glad to receive — but it's not at all urgent — 3 metres of the sort at 6 francs.

As for his consignment of colours, there were only 4 large tubes of white in it, while all the other tubes were half-size (of white). If he has charged for them in the same proportions, that's very good, but pay attention to that.

4 tubes of white at 1 franc, but the rest should only be half the price. I find his Prussian blue poor, and his cinnabar. The rest is good.

Now I'll tell you that I'm working on the 2 paintings of which I wanted to make repetitions. The pink peach tree is giving me the most trouble.

[*Sketch 597A*]

You can see from the four squares on the other side that the three orchards go together, more or less. I now also have a *small pear tree*, vertical, also flanked by two other horizontal canvases. That will make 6 canvases of orchards in blossom.

At the moment I'm trying to finish them a little every day, and to make them go together.

I dare hope for 3 more, also going together, but those are still only in the state of embryos or foetuses.

Mon cher Theo, merci de ta lettre
contenant les échantillons de toile
absorbante. Serai bien aise de
recevoir - mais cela ne presse aucunement
3 mètres de celle à 6 fr. -
Pour ce qui est de son envoi de couleurs
il n'y avait que 4 gros tubes de blanc tandis
que tous les autres tubes étaient
des demi gros (de blanc) - S'il les a comptés
dans les mêmes proportions c'est fort bien
mais fais attention à cela -
4 tubes de blanc à 1 fr. mais le
reste ne doit être qu'à moitié prix
Je trouve son bleu de Prusse mauvais
et son cinabre. Le reste est bien
Maintenant je te dirai que je travaille
aux 2 tableaux desquels je voulais faire
des répétitions Le pêcher rose me donne
le plus de mal

Verger rose pâle pêcher Verger blanc
abricotiers rose pruniers
 terrain violet à vert

597A. Three orchards

I'd really like to do this group of 9 canvases.

You understand that we're free to consider the 9 canvases as the initial idea for a much larger, definitive decoration (this one consists of no. 25 and no. 12 canvases), which would be done after exactly the same subjects, at the same time next year.

[*Sketch 597B*]

Here's the other middle piece of the no. 12 canvases.

The ground purple — in the background a wall, with straight poplars — and a very blue sky.

The small pear tree has a purple trunk and white flowers, a large yellow butterfly on one of the clumps.

On the left, in the corner, a little garden with a border of yellow reeds and green bushes and a flowerbed. A small pink house.

So there are the details of the decoration of orchards in blossom, which I was intending for you.

But the last 3 canvases exist only in a provisional state, and are supposed to represent a very large orchard with a border of cypresses and large pear trees and apple trees.

The 'Pont de Langlois' for you is going well, and will be better than the study, I think.

Am in a real hurry to get back to work. As for the Guillaumin, if it's possible, it's certainly a good deal to buy it. But since they're talking about a new method for fixing pastel, would perhaps be wise to ask him to fix it in this way, in case of purchase. Handshake to you and to Koning.

Ever yours,
Vincent

I've had a letter from Bernard with some sonnets that he's made, some of which are successful; he'll succeed in making a good sonnet, for which I almost envy him.

As soon as the Langlois bridge and the repetition of the other painting (the pink peach tree) are dry, will make a consignment.

Voici l'autre pièce de milieu
des toiles de 22
— terrain violet — dans le
fond un mur avec des peupliers
droits. et un ciel très-bleu
Le petit poirier a un tronc
violet et des fleurs blanches
un grand papillon jaune
sur une des touffes
à gauche dans le coin un
petit jardin avec bordure de
roseaux jaunes et des arbustes
verts un parterre de fleurs. — Une maisonnette
rose.

Voilà dans les détails de la décoration
de vergers en fleur que je te destinais.
seulement les 3 dernieres toiles n'existent
qu'à un état provisoire et devraient représenter un
 très grand verger avec bordure
 de cyprès et grands poiriers &
 pommiers
Le pont de l'anglais pour toi marche bien
et sera mieux que l'étude je pense

Suis bien pressé de retourner
travailler. — Pour le Guillaumin
si cela est possible c'est surement
bonne affaire d'acheter. seulement
puisqu'on parle d'un nouveau procédé
pour fixer le pastel serait peutetre sage
de lui demander de fixer de cette façon en
cas d'achat. Poignée de main à toi et à Koning
 Vincent

597B. *Small pear tree in blossom*

My dear old Bernard,

Many thanks for sending your sonnets. For form and sonority I very much like the first one, 'Under the sleeping canopies of the gigantic trees'. Now for idea and sentiment it's perhaps the last one that I prefer: 'For hope has poured its neurosis into my breast', but it seems to me that what you want to evoke isn't stated clearly enough: the certainty that we seem to have and which anyway we can prove, of nothingness, of emptiness, of the treachery of desirable, good or beautiful things, and despite this knowledge we forever allow ourselves to be deceived by the spell that external life, things outside ourselves, cast over our 6 senses, as though we knew nothing, and especially not the difference between objective and subjective. And fortunately for us, in that way we remain ignorant and hopeful. Now I also like 'In winter, have neither a sou nor a flower', and Contempt. Corner of a chapel and Drawing by Albrecht Dürer I find less clear; for example, precisely which drawing by Albrecht Dürer is it? But excellent passages in it nevertheless. 'Having come from the blue plains, Made pale by the long miles' is a jolly good rendering of the landscapes bristling with blue rocks between which the roads wind in the backgrounds of Cranach and Van Eyck.

Twisted on his cross *in a spiral* is a very, very good rendering of the exaggerated thinness of the mystical Christs; why not add to it that the anguished expression of the martyr is like the eye of a broken-hearted cab horse? That way it would be more utterly Parisian, where you see looks like that, either in the pensioners of the little carriages, or in poets and artists. But all in all it's not as good as your painting yet. Never mind. It'll come, and you must certainly continue doing sonnets.

There are so many people, especially among our pals, who imagine that words are nothing. On the contrary, don't you think, it's as interesting and as difficult to say a thing well as to paint a thing. There's the art of lines and colours, but there's the art of words that will last just the same.

[*Sketch* 599A]

Here's a new orchard, quite simple in composition; a white tree, a small green tree, a square corner of greenery — a lilac field, an orange roof, a big blue sky. Have nine orchards on the go; one white, one pink, one almost red pink, one white and blue, one pink and grey, one green and pink.

I worked one to death yesterday, of a cherry tree against blue sky, the young shoots of the leaves were orange and gold, the clusters of flowers white. That, against the blue green of the sky, was darned glorious. Unfortunately there's rain today, which prevents me from going back on the attack.

Saw a brothel here on Sunday (not to mention the other days), a large room tinged with a bluish limewash — like a village school — a good fifty or so red soldiers and black civilians, with faces of a magnificent yellow or orange (what tones in the faces down here), the women in sky-blue, in vermilion, everything that's of the purest and gaudiest. All of it in yellow light. Far less gloomy than the establishments of the same kind in Paris. Spleen isn't in the air down here. At present I'm still keeping very quiet and very calm, because first I have to get over a stomach ailment of which I'm the happy

599A. Orchard with pear trees in blossom

owner, but afterwards I'll have to make a lot of noise, because I aspire to share the renown of the immortal Tartarin de Tarascon.

It interested me enormously that you intend spending your time in Algeria. That's perfect, and a hell of a long way from being a misfortune. Truly, I congratulate you on it. We'll see each other in Marseille in any case.

You'll find that you'll enjoy seeing the blue down here, and feeling the sun.

I now have a terrace for a studio.

I really intend to go and do seascapes too, in Marseille, and I don't pine here for the grey sea of the north. If you see Gauguin, greet him warmly for me; I must write to him in a moment.

My dear old Bernard, don't despair and above all, don't be downhearted, my good fellow, because with your talent and your stay in Algeria, you'll be a hell of a good artist. True — you'll be a southerner too. If I have a piece of advice to give you, it's to build yourself up by eating healthy and simple things for a year beforehand, *yes*. Starting now. Because it's better not to come here with a ruined stomach or spoiled blood. That was the case with me, and although I'm recovering, I'm recovering slowly, and I regret not having been a little more prudent beforehand. But who can do anything in a bloody winter like this one, because it was a preternatural winter. So see that your blood's good beforehand; with the bad food here it's difficult to regain that, but once you're healthy it's less difficult to stay that way than in Paris.

Write to me soon, still same address, Restaurant Carrel, Arles. Handshake.

Ever yours,
Vincent

602 | Arles, Tuesday, 1 May 1888 | *To Theo van Gogh* (F)

My dear Theo,

Thank you very much for your letter and the 50-franc note it contained. It's not in black that I see the future, but I see it bristling with many difficulties, and at times I wonder if these won't be stronger than I am. This is especially so at times of physical weakness, and last week I suffered from a toothache that was so agonizing that it made me waste time quite in spite of myself. Nevertheless, I've just sent you a roll of small pen drawings, a dozen I think. That way you'll see that even though I'd stopped painting I haven't stopped working. Among them you'll find a hasty croquis on yellow paper, a lawn in the public garden at the entrance to the town. And in the background a house more or less like this one.

[*Sketch 602A*]

Ah, well — today I rented the right-hand wing of this building, which contains 4 rooms, or more precisely, two, with two little rooms.

It's painted yellow outside, whitewashed inside — in the full sunshine. I've rented it for 15 francs a month. Now what I'd like to do would be to furnish a room, the one

Mon cher Theo merci beaucoup de ta lettre
et du billet de 50 fr. qu'elle contenait. Ce
n'est pas en noir que je vois l'avenir mais je
le vois très hérissé de difficultés et par moments
je me demande si ces dernières ne seront pas
plus fortes que moi Cela c'est surtout dans
les moments de faiblesse physique et la
semaine dernière je souffrais d'un mal de dents
assez cruel pour qu'il m'aie bien malgré moi
fallu perdre du temps Pourtant je viens de
t'envoyer un rouleau de petits dessins à la
plume une douzaine je crois Par où tu verras
que si j'avais cessé de peindre j'ai pas cessé de
travailler Tu y trouveras un croquis
hatif sur papier jaune

une pelouse dans lesquel
qui se trouve à l'entrée
de la ville. et au fond
d'une bâtisse à peu
près comme ceci –
Eh bien . j'ai aujourdhui
loué l'aile droite
de cette construction qui contient 4 pieces
ou plutôt deux avec deux cabinets
C'est peint en jaune dehors blanchi à la
chaux à l'intérieur en plein soleil
je l'ai loué à raison de 15 francs par mois

602A. *The Yellow House*

on the first floor, to be able to sleep there. The studio, the store, will remain here for the whole of the campaign here in the south, and that way I have my independence from petty squabbles over guest-houses, which are ruinous and depress me. In fact, Bernard writes me that he too has *a whole house*, but he has it for nothing. What luck. I'll certainly make another drawing of it for you, better than the first croquis. And at this point I dare tell you that I intend to invite Bernard and some other people to send me canvases to show them here if the opportunity arises, and it will certainly arise in Marseille. I hope I've been lucky this time — you understand, yellow outside, white inside, right out in the sun, at last I'll see my canvases in a really bright interior. The floor's made of red bricks. And outside, the public garden, of which you'll find two more drawings.

The drawings, I dare assure you, will become even better.

I've had a letter from Russell, who has bought a *Guillaumin* and 2 or 3 *Bernards*. I'm extremely pleased about that, he also writes that he'll exchange studies with me. I wouldn't be afraid of anything unless it was this bloody health. And yet I'm better than in Paris, and if my stomach has become terribly weak that's a problem I picked up there, probably due mainly to the bad wine, of which I drank too much. Here the wine is just as bad, but I only drink very little of it. And so the fact is that as I hardly eat and hardly drink I'm very weak, but my blood is improving instead of being ruined. So once again, it's patience I need in the circumstances, and perseverance.

Having received the absorbent canvas, I'm starting these days a new no. 30 canvas that I hope will be better than the others. Do you remember in La recherche du bonheur the chap who bought as much land as he could run round in a single day? Well, with my orchard decoration I've been that man, more or less, half a dozen out of a dozen I have anyway, but the other 6 aren't as good, and I'm sorry I didn't rather do 2 of them instead of the last 6. Anyway, I'll send you ten or so in the next few days anyway.

I bought 2 pairs of shoes, which cost me 26 francs, and 3 shirts that cost me 27 francs, which meant that despite the 100 note I wasn't enormously rich. But in view of the fact that I plan to do business in Marseille, I definitely want to be well turned out, and I don't intend to buy anything but good quality. And the same for work, it will be better to do one painting fewer than to do it less well.

Should it come about that you had to leave those gentlemen, don't think that I have doubts about the possibility of doing business all the same, but we mustn't be caught unawares, that's all, and if it drags on a bit longer that's actually for the better.

As for me, if a few months from now I'm ready for an expedition to Marseille, I'll be able to do things with more self-assurance than if I arrived there having run out of breath. I've seen MacKnight again, but still nothing of his work. I still have colours, I have brushes, I still have plenty of things in stock. But we mustn't waste our powder.

I think if you were to leave those gentlemen, for my part I'd have to manage to live without spending more than, for example, 150 francs a month. I couldn't do it now, but you'll see that in 2 months I'll be set up like that. If then we earn more, so much the better, but I want to ensure that.

So, if I had some very strong broth, that would get me going right away, it's dreadful, I've *never* been able to get even any of the very simple things I've asked those people

for. And it's the same everywhere in these little restaurants. Yet it's not hard to boil potatoes. Impossible.

And no rice or macaroni either, or else it's ruined with fat or they don't do it, and make the excuse: it's for tomorrow, there's no room on the stove, &c.

It's silly but true all the same that that's why my health is poor.

All the same, it cost me a lot of agonizing to bring myself to make a decision, because I said to myself that in The Hague and in Nuenen I'd tried to take a studio and I said to myself that it had turned out badly. But many things have changed since then, and as I feel I'm on firmer ground—let's go ahead. Only we've already spent so much money on this bloody painting we mustn't forget that it has to come back in paintings. If we dare believe, and I'm sure of it, that Impressionist paintings will go up in value, we've got to do lots of them and keep the prices up.

All the more reason why we should calmly take care of the quality of the thing and not waste time. And after a few years, I can see the possibility that the capital laid out will come back into our hands, if not in cash, then in value.

And now if you agree, I'll rent or buy furniture for the bedroom. I'll go and have a look today or tomorrow morning.

I'm still convinced that nature here is just what's needed to do colour. And so it's more than likely that I won't move far from here.

Raffaëlli has done a portrait of Edmond de Goncourt, hasn't he? That must be beautiful. I've seen Le Salon published by L'Illustration. Is the Jules Breton beautiful?

You'll soon receive a painting I did for you for the first of May.

If necessary, I could live at the new studio with someone else, and I'd very much like to. Perhaps Gauguin will come to the south. Perhaps I'll come to an arrangement with MacKnight. Then we could cook at home.

In any case, the studio is too open to view for me to think it could tempt any woman, and it would be hard for a petticoat episode to lead to a cohabitation. Anyway, moral standards seem to me less inhuman and contrary to nature than in Paris. But with my temperament, to lead a wild life and to work are no longer compatible at all, and in the given circumstances I'll have to content myself with making paintings. That's not happiness and not real life, but what can you say, even this artistic life, which we know isn't *the* real one, seems so alive to me, and it would be ungrateful not to be content with it.

I have one big worry fewer now that I've found the little white studio. I looked at a whole lot of apartments without success. It will seem funny to you that the water closet is at the neighbour's, in quite a large house that belongs to the same owner. In a southern town I think you'd be wrong to complain about it, because these facilities are few and far between, and dirty, and you can't help thinking of them as nests of germs.

On the other hand, I have water here.

I'll put some Japanese prints on the wall.

If there happened to be some canvases in your apartment that were in the way, this could always be used as a storeroom, that might become necessary, because you ought not to have mediocre things at your place.

Bernard has written to me and sent croquis.

I'm very pleased that you found our mother and sister well.

Is Reid going to Marseille? At the bottom of it, perhaps, is that he loves this woman

who didn't trust us, feeling that we might perhaps not want to encourage the cohabitation. I'm inclined to believe she's the psychological reason for his coming back. You'll say that in that case we'll have to consider everything he's going to do in the future, and maintain great composure for the moment. Will you go back to Holland for the holidays? If you could do both, going to see Tersteeg and Marseille on business regarding the Impressionists, and resting at Breda between those two chores.

Have you seen Seurat again?

I shake your hand firmly, wishing you a year as full of sunshine as the weather here today. Warm regards to Koning.

Ever yours,
Vincent

If you could send me 100 francs next time, I could sleep at the studio as early as this week. I'll also write you what arrangement the furniture dealer wants to make.

603 | Arles, Friday, 4 May 1888 | *To Theo van Gogh* (F)

My dear Theo,

Yesterday I went to visit some furniture dealers to see if I could rent a bed, &c. Unfortunately they do *not* rent, and even refused to sell on terms of paying so much per month. This is rather awkward. Now I've thought that perhaps—if Koning were to leave after seeing the Salon, as I believe was his original intention, after he left you could send me the bed he's occupying now.

We have to consider that if I sleep at the studio, that makes a difference after all of around 300 francs at the end of a year, which is otherwise spent at the hotel. I'm quite aware that it's not possible to say in advance: I'll stay here for such or such a length of time; however, I have many reasons to believe that a long stay here is likely.

Yesterday I was at Fontvieille, at MacKnight's—he had a good pastel—a pink tree—two watercolours under way, and I found him working on a head of an old woman in charcoal. He's at the stage when the new colour theories are tormenting him, and while they prevent him from doing things according to the old system, he hasn't sufficiently mastered his new palette to be able to succeed this way. He seemed very embarrassed to show them to me, so I had to go there specially and tell him I *very much* wanted to see his work, and now it's not impossible that he may come to stay with me here for a while. Then we would benefit, I think, on both sides.

I very often think of *Renoir* here and his pure, clean drawing. That's just the way objects or figures are here, in the clear light.

We have a tremendous amount of wind and mistral here, 3 days out of four at the moment, always with sunshine, though, but then it's difficult to work out of doors.

I think something could be done here in the way of portraits. People may be crassly ignorant as far as painting goes, but in general they're *much more artistic* than in the north in their own appearance and their own lives. I've seen figures here as lovely as those of Goya and Velázquez. They know how to stick a touch of pink on a black suit, or make a white, yellow, pink or green and pink, or *blue and yellow* outfit, in which

nothing needs to be changed from the artistic point of view. Seurat would find some very picturesque figures of men here, despite their modern suits.

Now I dare say these people here would jump at portraits. But, before daring to take the risk of throwing myself into that, I want my nervous system to calm down first, and then I want to be settled in such a way that we can receive people at the studio. And if I have to mention the big subject, by my calculations to be in good health and be acclimatized here once and for all I'll need a year, and to establish myself I'll need a good thousand francs. If in the first year—the current one—I spent 100 francs to live and 100 francs for this establishment per month, you can see there wouldn't be a sou left in this budget for painting. But by the end of this year I'm inclined to believe I'd have gained both my quite decent establishment and my health. And my occupation while waiting would above all be to spend every day drawing, with two or three paintings a month in addition.

In—the establishment—I thus also count a complete renewal of all my linen and clothes and shoes.

And I would be a different man by the end of the year.

I'd have a home and I'd have my peace of mind about my health. And so I can hope not to collapse out of breath before my time, here.

Monticelli was physically more vigorous than I am, I think, and if I had the strength I would live like him, one day at a time.

But if he became paralyzed, and without being that much of a drinker—all the more reason why I couldn't withstand it.

I was certainly well on the way to catching a paralysis when I left Paris. It caught up with me afterwards, right enough! When I stopped drinking, when I stopped smoking so much, when I started reflecting on things again instead of trying not to think—my God, what melancholias and what dejection. Working in this magnificent nature kept up my morale, but there too, after a certain amount of effort I didn't have the strength.

Ah well, that's why when I was writing to you the other day I said that if you left the Goupils you would probably feel better in terms of morale but the recovery would be very painful. While the sickness itself, you don't feel it.

My poor friend, our neurosis &c. surely also comes from our rather too artistic way of life—but it's also a fatal inheritance, since in civilization we go on becoming weaker from generation to generation.

Take our sister Wil, she has neither drunk nor led a wild life, and yet we know a photograph of her in which she has the look of a madwoman. Isn't that proof enough that if we want to look the true state of our temperament in the face we have to range ourselves among those who suffer from a neurosis that goes back a good long way.

I think Gruby's in the right in these cases: eat well, live well, see few women, in a word live in anticipation just as though one already had a brain disease and a disease of the marrow, not to mention neurosis, which really does exist.

Certainly that's taking the bull by the horns, which isn't a bad policy.

And Degas—does that and is successful. All the same, don't you feel, as I do, it's awfully hard?

And in short doesn't it do us a tremendous amount of good to listen to the wise advice of Rivet and Pangloss, those splendid optimists of the true and jovial Gallic

race who leave you your self-esteem? Yet, if we want to live and work, we must be very careful and look after ourselves. Cold water, air, good simple food, wear the right clothes, sleep in a good bed and don't have worries. And not letting yourself go with the women and real life to the extent you might like to.

I'm not set on sleeping at the studio but IF I went to sleep there, it would be if I could see the possibility of establishing myself more or less for good and for a long period of time. Having no need at all now of space at the hotel, since I have the studio elsewhere, I'll tell the people it's 3 francs a day, take it or leave it. And consequently there's nothing pressing. But if it's all the same to you, send me 100 francs anyway next time, as I'd also like to have some drawers made, the way I had shirts and shoes made, and as I have to have almost all my clothes cleaned and mended. Then they'll still be perfectly good. This is urgent, in case I'd have to go to Marseille or see people here. With all these pre-cautions we're taking now we can be more certain of being able to hold out in the long term and of putting our work in order.

There are about ten canvases, for which I'm looking for a crate and which I'll send you in the next few days.

I shake your hand firmly, and Koning's too. I had a postcard from Koning to say he'd received a letter to collect the paintings from the Independents. But of course he just had to collect them, what can I do about it?

Ever yours,
Vincent

(It goes without saying that if at your home there were canvases that were taking up too much space you could send them here by goods train and I'd keep them in the stu-dio here. If that isn't yet the case it will be later, so I keep quite a few studies here that don't seem good enough to me to be sent to you.)

609 | Arles, Saturday, 12 May 1888 | *To Theo van Gogh* (F)

My dear Theo,

I'm writing you another few lines to tell you that I've been to see the gentleman whom the Arab Jew in Tartarin calls 'the shustish of the beace'. I still got 12 francs back and my host was reprimanded for keeping my trunk; as I wasn't refusing to pay, he had no right to hold it. If they'd found in favour of the other party, that would have done me harm, because he wouldn't have failed to go around saying that I had not been able or not been willing to pay him, and that he'd been forced to take my trunk. Whereas now — because I left at the same time as him — he said as we went that he'd been angry but hadn't really wished to insult me. But that's just what he was trying to do, probably seeing that I had seen enough of his shack — and that he couldn't make me stay — he'd have gone to tell tales where I am at the moment. All right. If I'd wanted to get the ac-tual reduction, I'd probably have claimed more in damages, for example. If I let myself be annoyed by just anybody I'd soon not know where to turn, you understand.

I've found a better restaurant where I eat for 1 franc.

My health's been better these days.

J'ai trouvé un restaurant mieux
où je mange pour 1 franc.
La santé va mieux ces jours ci
Maintenant j'ai deux nouvelles
études comme ceci

bleu

Tu en as un
dessin déjà d'une
ferme au bord de la
grande route dans
les blés

Bleu

Une prairie pleine de boutons d'or
très jaune un fossé avec des ~~...~~
plantes d'Iris au feuilles vertes à fleurs
violettes dans le ~~...~~ fond la ville
quelques saules gris — une bande de
ciel bleu.

609A–B (top to bottom). *Farmhouse in a wheatfield; View of Arles with irises in the foreground*

Now I have two new studies like this:

[*Sketch 609A*]

You already have a drawing of it, a farmhouse beside the wide road in the wheatfields.

[*Sketch 609B*]

A meadow full of very yellow buttercups, a ditch with iris plants with green leaves, with purple flowers, the town in the background, some grey willow trees — a strip of blue sky.

If they don't mow the meadow I'd like to do this study again, because the subject matter was really beautiful and I had trouble finding the composition. A little town surrounded by countryside entirely covered in yellow and purple flowers. That would really be a Japanese dream, you know.

Having asked the price for sending the consignment that went off by goods train, it will be 7 francs at the station in Paris. As I don't have very much left I didn't put postage on it here — but if they asked more you'd have to complain. The crate is marked uv and w1042.

We've had the mistral again yesterday and today. I hope my consignment arrives before Tersteeg comes to Paris.

Handshake, write to me soon.

Ever yours,
Vincent

611 | Arles, on or about Sunday, 20 May 1888 | *To Theo van Gogh* (F)

My dear Theo,

What you write about your visit to Gruby has upset me, but at the same time it re-assures me that you went there.

Have you considered that your lethargy — a feeling of extreme lassitude — could have been caused by this heart condition, and that in that case potassium iodide couldn't be blamed for these periods of stupefied exhaustion? If you remember how stupefied I was myself this winter, to the point of being quite incapable! of doing anything whatsoever, apart from a little painting, although I wasn't taking potassium iodide at all. So if I were you, I'd have it out with Rivet if Gruby tells you not to take it.

And it will in any case — I have no doubt about it — be your intention to be friends with both the one and the other.

I often think of Gruby *here* and *now*, and in short I feel well, but it's because here I have the pure air and the heat, which make things more possible for me. Among all the trials and the bad air of Paris, Rivet takes things as they are without trying to create a paradise and without in the slightest way trying to make us perfect. But he forges a suit of armour, or rather, he inures us to illness and keeps morale up, I find, by making fun of the trouble we have.

So if you could now have just one year of living in the country and close to nature, that would make Gruby's treatment much easier. So I think he'll urge you not to see women except in case of necessity, but as little as possible. Now for myself, I feel fine here in that respect, but *here*, since I have work and nature, and if I didn't have that I'd become melancholy. As long as work has some appeal for you over there, and the Impressionists are going well, that would be a great gain. Because loneliness, worries, vexations, the need for friendship and fellow-feeling not sufficiently met, that's what's very bad, the mental emotions of sadness or disappointments undermine us more than riotous living: us, that is, who find ourselves the happy owners of troubled hearts.

I think potassium iodide purifies the blood and the whole system, doesn't it — will you be able to do without it? Anyway, you'll have to have a straight talk about it with Rivet, who shouldn't be jealous.

I could wish you had near you something more rudely alive, warmer than the Dutch — but all the same, Koning with his whims is an exception for the better. Anyway, it's always good to have somebody. But I could still wish you had one or two good friends among the French. Would you do me a great favour: my friend the Dane, who leaves for Paris on Tuesday, will give you 2 small paintings — nothing much — that I'd like to give to Mme the Countess De la Boissière at Asnières. She stays in boulevard Voltaire, on the first floor of the first house at the end of the Clichy bridge. *Père* Perruchot's restaurant is on the ground floor. Would you take them to her personally on my behalf, saying I had hopes of seeing her again this spring and that even here I haven't forgotten her; I gave them 2 small ones last year as well, her and her daughter. I'd have hope that you wouldn't regret making these ladies' acquaintance. After all, they're *a family*. The countess is far from young but she's first of all a countess, then *a lady*, the daughter ditto.

And it makes sense for you to go, since I can't be sure that the family's staying in the same place this year (however, they've been coming there for several years, and Perruchot must know their address in town). Perhaps I'm deluding myself — but I can't help thinking of them, and perhaps it will be a pleasure for them and for you too, if you meet them.

Listen — I'll do all I can to send you some new drawings for Dordrecht.

This week I've done two still lifes.

[*Sketch* 611A]

A blue enamelled tin coffee-pot, a royal blue and gold cup (on the left), a pale blue and white chequered milk jug, a cup — on the right — white, with blue and orange designs, on a yellow grey earthenware plate, a blue barbotine or majolica jug with red, green, brown designs, and lastly 2 oranges and 3 lemons; the table is covered with a blue cloth, the background is yellow green, making 6 different blues and 4 or 5 yellows and oranges.

The other still life is the majolica jug with wild flowers.

I thank you very much for your letter and for the 50-franc note. I hope the crate will reach you in the next few days. The next time I think I'll take the canvases off the stretching frames and send them rolled, by fast service. I think you'll soon make friends with this Dane — he doesn't do much but — he has intelligence and a good

Et c'est logique que tu y ailles puisque moi
je ne puis être sûr que la famille reste
au même endroit cette année (cependant
elles y viennent depuis plusieurs années et
Perruchot doit connaître l'adresse en ville)
C'est peut être une illusion que je me
fais mais – je ne puis m'empêcher
d'y penser et peutêtre cela leur fera plaisir
et à toi aussi si tu les connais.
Écoutes – je ferai tout mon possible
de t'envoyer de nouveaux dessins
pour Dordrecht
J'ai fait cette semaine deux natures
mortes.

une cafetière en fer émaillé bleu une tasse (à gauche) bleu
de roi et or un pot à lait carrelé bleu pale à blanc
une tasse – à droite blanc à dessins bleu et orangé sur
une assiette de terre jaune gris un pot en barbotine
ou majolique bleu avec dessins rouges verts bruns
enfin 2 oranges et 3 citrons la table est couverte
d'une draperie bleue le fond est jaune vert
Donc 6 bleu différents et 4 ou 5 jaunes et oranges
L'autre nature morte est le pot de majolique avec des
fleurs sauvages

611A. *Still life with coffee pot*

heart, and he probably started painting not long ago. Take him out a bit one Sunday to get to know him.

For myself, I feel infinitely better, my blood is circulating well, and my stomach's digesting. I've found very, very good food now, which had an immediate effect on me.

Have you seen Gruby's face when he pinches his lips tight and says 'No women'? It would make a really good Degas, that face, like that. But there's nothing to be said against it, because when you have to work all day long with your brain, calculating, thinking, planning business, that's quite enough in itself for your nerves. So go off now and visit women in the world of artists and suchlike, you'll see you'll succeed — really. You'll see it'll work out like that and you won't lose much, will you?

I still haven't been able to make a deal with the furniture dealer, I've seen a bed but it's dearer than I thought. I feel the need to get more work done before spending more on furniture.

My lodgings cost me 1 franc a night. I've bought more linen and colours as well.

I've bought some very strong linen.

Just as my blood is returning to normal, so the idea of succeeding is returning to me too. I shouldn't be too surprised if your illness was also a reaction to this dreadful winter, which lasted an age. And then it will go the same way as with me; take as much spring air as possible, go to bed *very early* because you'll need to sleep; and then food, lots of fresh vegetables and no *bad* wine or *bad* liquor. And very few women and A GREAT DEAL OF PATIENCE. If it doesn't clear up at once that doesn't matter. And now Gruby will give you a heavy meat diet over there. Here, for myself, I couldn't take very much, and it's not necessary here. It's just my stupefaction that's going away, I don't feel as much need to amuse myself, I'm less at the mercy of my passions and I can work more calmly, I could be alone without being bored. I came out of it feeling a little older, but no sadder.

I wouldn't believe you if in your next letter you told me there was nothing wrong with you any more; it's perhaps a more serious change and I shouldn't be surprised if, during the time it will take you to recover, you had some dejection. There is and there remains and it always comes back at times, in the midst of the artistic life, a yearning for — real life — ideal and not attainable.

And we sometimes lack the desire to throw ourselves head first into art again and to build ourselves up for that. We know we're cab-horses and that it'll be the same cab we're going to be harnessed to again. And so we don't feel like doing it and we'd prefer to live in a meadow with a sun, a river, the company of other horses who are also free, and the act of generation. And perhaps in the final account your heart condition comes partly from there; it wouldn't greatly surprise me. We no longer rebel against things, we're not resigned either — we're ill and it's not going to get any better — and we can't do anything specific about it. I don't know who called this condition being struck by death and immortality. The cab we drag along must be of use to people we don't know. But you see, if we believe in the new art, in the artists of the future, our presentiment doesn't deceive us. When good *père* Corot said a few days before he died: last night I saw in my dreams landscapes with entirely pink skies, well, didn't they come, those pink skies, and yellow and green into the bargain, in Impressionist landscapes? All this is to say there are things one senses in the future and that really come about.

510 | Arles, May 1888

And we, who, I'm inclined to believe, are by no means so close to dying, neverthe-less feel the thing is bigger than us and longer-lasting than our lives.

We don't feel we're dying, but we feel the reality of the fact that we're not much, and that to be a link in the chain of artists we pay a steep price in health, youth, free-dom, which we don't enjoy at all, any more than the cab-horse that pulls a carriage full of people who, unlike him, are going out to enjoy the springtime. Well then — what I wish you as well as myself is to succeed in recovering our health, because we'll need it. That Hope of Puvis de Chavannes is such a reality. There's an art in the future and it will surely be so beautiful and so young that, really, if at present we leave it our own youth, we can only gain in tranquillity. Perhaps it's too silly to write all this, but it's what I felt; it seemed that like me, you suffered to see your youth going up in — smoke — but if it comes back and appears in what we do, there's nothing lost, and the power to work is a second youth. So be serious about getting better, because we'll need our health. I shake your hand firmly, and Koning's too.

Ever yours,
Vincent

615 | Arles, Monday, 28 May 1888 | *To Theo van Gogh* (F)

My dear Theo,

I was very pleased to receive this morning's letter from you; I thank you very much for the 100-franc note that was included in it.

And am glad in the end that the crate has arrived.

If you think the Souvenir de Mauve is among those that are passable — then you should add it to the next Hague consignment, with a simple all-white frame. If you found another study among them that seemed to you more suitable for Tersteeg, you should put it in without a dedication, and you should keep the one with the dedi-cation to him, which you could then scratch out. Because it's better to give him one without any sort of dedication. He can then claim not to have understood that it was a gift for him, and send it back without saying anything if he would rather not have something of mine.

I'll certainly have to give him one myself, to prove that I have some enthusiasm for the cause and that I appreciate his having taken it in hand — but in short, do as it turns out, don't send any, send that one with or without a dedication, send another one, it makes no difference to me whatsoever. Only as Mauve and he were so close, in the emotion of the moment it seemed to me a very simple thing to do something for Ter-steeg at the same time as I was doing a souvenir of Mauve. And I had scarcely another thought but that. So that's enough.

The orchard study you mention — where there's a lot of stippling — is half of the main subject of the decoration. The other half is the study in the same format, without a stretching frame.

And those two together would give an idea of how orchards are laid out here. But I myself thought one study too feeble, the other too harsh, both of them failures. The

changeable weather certainly had something to do with it too, and I was like the Russian who tried to swallow up too much ground in a day's march.

I'm very curious to see the results of the Gruby system — *in the long run*, after, let's say, a year's application. It will be wise to show up sometimes — to chat with him — and — to extract his *real attention*, a real, big effort on his part, as Bonger in the end gained his friendship and deeper interest. Then I'd feel easier on your account. I couldn't feel that way now. The proposal by those gentlemen to have you make short trips overseas is wearing you out.

And I blame myself for wearing you out like this — me — with my constant needs for money.

It seems to me that what those gentlemen are demanding of you could, however, be reasonable if they first agreed to give you a year's leave (on full salary) to regain your health. You'd devote that year to going to see all the Impressionists and connoisseurs of the Impressionists at their homes again. That would still be working in the interests of Boussod & Co. After that you'd go off with your blood and your nerves more settled, and fit to do new business over there.

But to go and pull the chestnuts out of the fire for those gentlemen in the state you're in now is to spend a year that will wear you out.

And that does nobody any good.

My dear brother — the Muslim idea that death only comes when it must come — let's just see about that.

To me, it seems that we haven't any proof of such a direct guidance from above.

On the contrary, it seems to me that it's been proved that good hygiene may not only prolong life but above all, can make it more serene — its waters more limpid — while poor hygiene not only muddies life's current, but even more than that, lack of hygiene may put an end to life before time.

Have I not myself seen a fine figure of a man die before my very eyes for want of an intelligent doctor — he was so calm and tranquil through all of that, only he kept saying — 'if I had another doctor', and he died shrugging his shoulders in a way I'll never forget.

Would you like me to go to America with you? It would be only right that those gentlemen paid my fare.

There are many things that wouldn't matter to me one way or the other, but not that — that you didn't first build up your health properly.

Now I think you need to immerse yourself again even more, both in nature and among artists.

And would prefer to see you independent of the Goupils and working on your own account with the Impressionists, to this alternative of a life of travelling with the expensive paintings that belong to those gentlemen. When our uncle was an associate of theirs, in some years he managed to be very well paid — but just count what it cost him.

Now you, your lungs are good — but but but — — — a year of Gruby first, and then you'll see the danger you're in now.

At present you've had over 10 years of Paris, which is more than is good. You'll tell me that Detaille, for example, has had perhaps thirty years of Paris and that he holds himself as straight as a *ramrod*.

Good, do the same if you have comparable capacities. I'm not against it, and our family has a tenacious grip on life.

Everything I could wish to say is summed up in this: if those gentlemen make you pull the chestnuts out of the fire over such distances, see that you're well paid, or refuse, and throw yourself into the Impressionists, doing less business from the point of view of the sums handled, but living closer to nature.

For myself, I'm definitely recovering, and since the past month my stomach has improved enormously. I still suffer from unaccountable, involuntary feelings, or a stupor on some days, but it's getting calmer.

I plan to make an excursion to Saintes-Maries, to see the Mediterranean at last.

Our two sisters will doubtless be quite happy to come to Paris and it won't do them any harm, that's quite certain.

I'd like everybody to come here to the south too.

I'm always blaming myself for the fact that my painting isn't worth what it costs.

We must work nevertheless—but you should know that if circumstances ever made it desirable for me to involve myself more in business, as long as it took a burden off you, I'd do it with no regrets.

Mourier will give you two more pen drawings.

Do you know what we should do with these drawings? Albums of 6 or 10 or 12, like the albums of original Japanese drawings.

I'm very keen to make such an album for Gauguin and one for Bernard. Because the drawings will become better than that.

[*Sketch* 615A]

I bought some colours here today, and canvases, because depending on the weather I'll have to go onto the attack. Another reason why there's nothing urgent in the order for colours, except the ten large tubes of white.

It's funny that one evening recently at Montmajour I saw a red sunset that sent its rays into the trunks and foliage of pines rooted in a mass of rocks, colouring the trunks and foliage a fiery orange while other pines in the further distance stood out in Prussian blue against a soft blue-green sky—cerulean. So it's the effect of that Claude Monet. It was superb. The white sand and the seams of white rocks under the trees took on blue tints. What I'd like to do is the panorama of which you have the first drawings—it's so wide—and it doesn't fade into grey, it stays green to the last line— and that's blue, the range of hills. Thunderstorm and rain today, which will do good anyway. If Koning prefers a painted study, do whatever turns out.

Think carefully before you agree to everything the Goupils demand, and if that brought a change for me, really, now my health's improving I could work anywhere, and don't have an *idée fixe* about work, if it comes to that. Handshake to you and to Koning.

Ever yours,
Vincent

I think that for the *white* orchard we need a cold and raw white frame.

Je voudrais que tout le monde vienne
ici dans le midi également
Je me fais toujours des reproches
que ma peinture ne vaut pas ce
qu'elle coûte
Il faut pourtant travailler – seulement
sache que si jamais les circonstances
rendraient désirable que je m'occupe
plutôt dans le commerce pourvu
que cela te décharge je le ferais
sans regrets
Mourier te donnera encore deux dessins
à la plume.
Sais tu ce qu'il faudrait en faire
de ces dessins – des albums de
6 ou 10 ou 12 comme les albums
de dessins originaux japonais
J'ai grand envie de faire un tel
album pour Gauguin et un
pour Bernard. Car cela deviendra
mieux que ça les dessins

Couverture
orangé
ou jaune
citron

615A. *Album of drawings*

You should know that I'd rather give up my painting than see you wear yourself out to earn money. We need it of course, but have we reached the point where we have to go and look for it so far away?

You see so clearly that 'preparing oneself for death', a Christian idea — (fortunately for him Christ himself didn't share it at all, it seems to me — he who loved the people and things of this earth, more than is wise according to those who see him as nothing more than a crackpot), if — you see so clearly that preparing oneself for death is a thing — to leave there for what it is — don't you also see that — devotion — living for others — is a mistake if it's complicated by suicide — since in that case one truly makes murderers of one's friends.

So if you've reached the point where you have to make trips like that without ever having any peace and quiet, truly that takes away my appetite to recover my own tranquillity.

And if you agree to these proposals, well and good — but then ask those Goupils to take me on again at my previous salary and take me with you on these trips. People are worth more than things and for me, the more trouble I go to over paintings the more paintings as such leave me cold. The reason I try to make them is to be among artists. You'll understand — it would grieve me to drive you to earn money, let's rather stay together in any case — where there's a will there's a way, and I feel you'll cure yourself for a good many years if you cure yourself now. But don't wear yourself out now, either for me or for others. You know the portrait of Six as an old man, a man *who is leaving*, his glove in his hand, well, *live* until you leave like that, that's how I see you, married, with a solid position in Paris. You'll play a good role that way. Think it over and consult Gruby before accepting such a proposal.

Ever yours,
Vincent

616 | Arles, Monday, 28 or Tuesday, 29 May 1888 | *To Theo van Gogh* (F)

My dear Theo,

I thought of Gauguin and here we are — if Gauguin wants to come here there's Gauguin's fare, and then there are the two beds or the two mattresses we absolutely have to buy.

But later on, as Gauguin's a sailor, there's a likelihood we'll manage to make our grub at home.

And the two of us will live on the same money as I spend on myself alone.

You know I've always thought it ridiculous for painters to live alone &c. You always lose when you're isolated.

Well, it's in response to your wish to help him out.

You can't send him what he needs to live on in Brittany, and me what I need to live on in Provence. But you may agree that we should share, and set a sum of, let's say, 250 a month if every month, in addition to and apart from my work, you were to have a Gauguin.

As long as we didn't exceed that amount, wouldn't there even be a benefit? Besides, I'm speculating about joining forces with others.

So herewith rough draft of a letter to Gauguin, which I'll write if you approve, with the changes that will doubtless have to be made to turns of phrase. But I wrote that way first. Think of it as a simple business arrangement, that's best for everyone, and let's treat it straightforwardly that way. Only, given that you're not in business on your own account, you may, for example, think it right that I take it upon myself, and Gauguin would join forces with me as a pal.

I thought that you had a wish to come to his aid, as I suffer myself at the thought that he's in a tight corner — something that won't change overnight.

We can't offer better than that, and others wouldn't do as much.

For my part, it worries me to spend so much on myself alone, but to find a remedy for that there's none other than that of finding a wife with money or pals who associate with one another for paintings. Now I don't see the wife, but I do see the pals.

If that suited him, wouldn't do to keep him waiting.

This would be the beginnings of an association, then. Bernard, who's coming to the south too, will join us, and be sure of this, I still see you *in France*, at the head of an association of Impressionists. And if I could be useful in putting them together, I'd willingly see them abler than myself. You must feel how much it vexes me to spend more than they do; I have to find a partnership that's more advantageous, both to you and to them. And that's how it would be. However, think it over carefully, but isn't it true that in good company you could live on little as long as you spent your money at home?

Later on there may be days when we'll be less hard up, but I'm not counting on it. It would please me so much if you had the Gauguins first. I'm not good at cooking &c., but they've had different training in that, having done their service &c.

Handshake and best wishes to Koning, after all, it's a source of satisfaction for you to deliver him in good condition, which might not have been the case if you hadn't taken him with you. It's also satisfactory that the Goupils have been interested in taking that room you suggested.

Ever yours,
Vincent

Has Tersteeg come to Paris yet?

In order to prepare things, and to expand on this letter, I'm writing to Gauguin, but *without saying anything* about all this, just to talk about work.

You have to think it over very, very, very carefully before starting to travel. It seems so likely to me that your job is to stay in France.

[*Appendix: draft letter to Paul Gauguin*]

My dear old Gauguin,

I've thought of you very often and if I'm only writing now it's because I didn't want to write empty phrases.

The deal with Russell hasn't come off yet, but Russell has bought some Impressionists all the same, Guillaumin and Bernard and — wait for your moment — he'll come

of his own accord, but I couldn't press the point further, having had two refusals, but always with a promise for the future.

Wanted to write now to tell you I've just rented a four-room house here in Arles.

And that it seems to me that if I find another painter who feels like getting the most out of the south, and who like me was sufficiently absorbed in his work to be able to resign himself to living like a monk who'd go to the brothel once a fortnight — apart from that, bound up in his work and not inclined to waste his time — then the thing would be good. On my own, I suffer a bit from this isolation.

So I've very often thought about talking to you about it straight out.

You know that my brother and I have a high regard for your painting and that we'd very much wish to know you were a little at your ease. But all the same, my brother can't send money to you in Brittany and at the same time money to me in Provence. But would you like to share with me here? Then by joining forces, there would perhaps be enough for two; I'm sure of it, even.

Having once attacked the south, I see no reason to give it up.

I was ill when I came, I'm better now and in fact, I feel rather attracted to the south, where outdoor work is possible almost all the year round.

Living here seems more expensive, though, but isn't it also the case that the opportunities for gaining paintings are greater? In any event, if my brother were to send us 250 francs a month for both of us, would you like to come, and we would share. But in that case we'd have to make up our minds to eat at home as much as possible; we'd take on some kind of charwoman for a few hours a day, avoiding all the costs of a hotel that way.

And you would give my brother one painting a month, while you'd be free to do whatever you liked with the rest.

Now the two of us would start exhibiting in Marseille straightaway, thus opening the way for other Impressionists as well as for ourselves.

We mustn't forget that there would now be the cost of travel and of buying a bed, which would also have to be paid for with paintings.

You are, of course, free to correspond with my brother about this matter, but I warn you that he'll most probably refuse to take responsibility for it.

He'll just assure you that the only means we've found up to now of helping you in a more practical way would be this arrangement, if it suits you. We've thought about it a good deal. It seems to me that what you need for your health's sake is peace and quiet above all. If I'm wrong, and if the heat in the south turned out to be too much — well — we'd have to see. For myself, so far I feel very well in this climate. There's plenty more I could tell you — but here we are, business first. Reply to both of us soon.

619 | Les Saintes-Maries-de-la-Mer, on or about Sunday, 3 or Monday, 4 June 1888 |
 To Theo van Gogh (F)

My dear Theo,

I'm writing to you from Saintes-Maries on the Mediterranean at last — the Mediterranean — has a colour like mackerel, in other words, changing — you don't always know

if it's green or purple — you don't always know if it's blue — because a second later, its changing reflection has taken on a pink or grey hue.

It's a funny thing, the family — quite unintentionally, and despite myself, I've often thought here from time to time of our uncle the seaman, who has certainly seen the shores of this sea many times.

I've brought three canvases and I've covered them — two seascapes — a view of the village — and some drawings which I'll send you by post when I get back to Arles tomorrow.

I board and eat for 4 francs a day — they started by asking 6.

As soon as I can I'll probably come back to do some more studies here.

The beach here is sandy, no cliffs or rocks — like Holland — without the dunes and with more blue.

You eat better fried fish here than beside the Seine — only there isn't fish to eat every day, as the fishermen go off to sell in Marseille. But when there is some it's darned good. If there isn't any — the butcher's is no more appetizing than Monsieur Gérôme's fellah butcher's — if there's no fish it's rather hard to find something to eat here, it seems to me.

I don't believe there are 100 houses in this village or town.

The main building after the old church, an ancient fortress, is the barracks. And what houses at that likc those on our Dreuthe heaths and peat bogs, you'll see some specimens in the drawings.

I have to leave my three painted studies here, because of course they aren't dry enough to subject them to 5 hours' jolting in a carriage with impunity.

But I expect to come back here.

Next week I'd like to go to Tarascon to do two or three studies.

If you haven't already written I'll expect your letter in Arles, of course.

A very handsome gendarme came to interview me here. And the priest too — people can't be too bad here, because even the priest seemed almost like a decent fellow.

Next month will be the public bathing season.

Number of bathers varies from 20 to 50.

I'm staying till tomorrow afternoon, have still got some drawings to do.

I took a walk along the seashore one night, on the deserted beach. It wasn't cheerful, but not sad either, it was — beautiful.

The sky, a deep blue, was flecked with clouds of a deeper blue than primary blue, an intense cobalt, and with others that were a lighter blue — like the blue whiteness of milky ways. Against the blue background stars twinkled, bright, greenish, white, light pink — brighter, more glittering, more like precious stones than at home — even in Paris. So it seems fair to talk about opals, emeralds, lapis, rubies, sapphires. The sea a very deep ultramarine — the beach a mauvish and pale reddish shade, it seemed to me — with bushes. In addition to half-sheet drawings I have a large drawing, the pendant of the last one.

More soon, I hope. Handshake.

Ever yours,
Vincent

My dear Theo,

Many thanks for your kind letter and the 50-franc note that was enclosed with it.

We'll still have to write to Gauguin. The problem is this bloody journey, since we urge him to make it, and afterwards we'd be in an awkward position if it doesn't suit him. *I think I'll write to him today and will send you the letter.*

Now that I've seen the sea here I really feel the importance there is in staying in the south and feeling — if the colour has to be even more exaggerated — Africa not far away from one.

I'm sending you by same post some drawings of Saintes-Maries. I did the drawing of the boats as I was leaving, very early in the morning, and I'm working on the painting, a no. 30 canvas with more sea and sky on the right.

It was before the boats cleared off; I'd watched it all the other mornings, but as they leave very early, hadn't had time to do it.

I have another 3 drawings of huts that I still need and which will follow; these ones of the huts are a bit harsh, but I have some more carefully drawn ones. I'll make you a consignment of rolled-up paintings as soon as the seascapes are dry.

Do you see the cheek of these idiots in Dordrecht, do you see that self-importance, they're very happy to condescend to Degas and Pissarro — of whose work they've seen nothing, by the way, any more than of the others.

But it's a very good sign that the young ones are furious, perhaps it proves that there are some old ones who've spoken well of it.

About staying in the south, even if it's more expensive — Look, we love Japanese painting, we've experienced its influence — all the Impressionists have that in common — and we wouldn't go to Japan, in other words, to what is the equivalent of Japan, the south? So I believe that the future of the new art still lies in the south after all.

But it's bad policy to live there alone when two or three could help each other to live on little.

I'd like you to spend some time here, you'd feel it — after some time your vision changes, you see with a more Japanese eye, you feel colour differently. I'm also convinced that it's precisely through a long stay here that I'll bring out my personality. The Japanese draws quickly, very quickly, like a flash of lightning, because his nerves are finer, his feeling simpler. I've been here only a few months but — tell me, in Paris would I have drawn *in an hour* the drawing of the boats?

Not even with the frame. Now this was done without measuring, letting the pen go. So I tell myself that gradually the expenses will be balanced by work. I'd like us to earn a lot of money to bring good artists here who too often get despondent in the mud on the Petit Boulevard. Fortunately it's extremely easy to sell the right sort of paintings in the right sort of place to the right sort of gentleman. Since the distinguished Albert gave us the formula, all our difficulties have disappeared by magic. You only have to go down rue de la Paix — there strolls, just for that purpose — the good art lover.

If Gauguin came here, he and I could perhaps accompany Bernard to Africa when he goes there to do his service.

What have you decided about our two sisters?

Anquetin and Lautrec — I think — won't like what I'm doing. Apparently an article on Anquetin has appeared in the Revue Indépendante in which he seems to have been called the leader of a new movement in which Japonism was even more marked, &c. I haven't read it, but after all — the leader of the Petit Boulevard is without any doubt Seurat, and young Bernard has perhaps gone further than Anquetin in the Japanese style. Tell them I have a painting of boats, that and the Langlois bridge could suit Anquetin. What Pissarro says is true — the effects colours produce through their harmonies or discords should be boldly exaggerated. It's the same as in drawing — the precise drawing, the right colour — is not perhaps the essential element we should look for — because the reflection of reality in the mirror, if it was possible to fix it with colour and everything — would in no way be a painting, any more than a photograph.

More soon, handshake.

Ever yours,
Vincent

622 | Arles, on or about Thursday, 7 June 1888 | *To Emile Bernard* (F)

My dear old Bernard,

More and more it seems to me that the paintings that *ought to be made*, the paintings that are necessary, indispensable for painting today to be fully itself and to rise to a level equivalent to the serene peaks achieved by the Greek sculptors, the German musicians, the French writers of novels, exceed the power of an isolated individual, and will therefore probably be created by groups of men combining to carry out a shared idea.

One has a superb orchestration of colours and lacks ideas.

The other overflows with new, harrowing or charming conceptions, but is unable to express them in a way that's sufficiently sonorous, given the timidity of a limited palette.

Very good reason to regret the lack of an esprit de corps among artists, who criticize each other, persecute each other, while fortunately not succeeding in cancelling each other out.

You'll say that this whole argument is a banality. So be it — but the thing itself — the existence of a Renaissance — that fact is certainly not a banality.

A technical question. Do give me your opinion in next letter.

I'm going to put the *black* and the *white* boldly on my palette just the way the colour-man sells them to us, and use them as they are.

When — and note that I'm talking about the simplification of colour in the Japanese manner — when I see in a green park with pink paths a gentleman who's dressed in black, and a justice of the peace by profession (the Arab Jew in Daudet's Tartarin calls this honourable official shustish of the beace), who's reading L'Intransigeant.

Above him and the park a sky of a simple cobalt.

Then why not paint the said shustish of the beace with simple bone black and L'Intransigeant with simple, very harsh white?

Because the Japanese disregards reflection, placing his solid tints one beside the other — characteristic lines naively marking off movements or shapes.

In another category of ideas, when you compose a colour motif expressing, for example, a yellow evening sky —

The harsh, hard white of a white wall against the sky can be expressed, at a pinch and in a strange way, by harsh white and by that same white softened by a neutral tone. Because the sky itself colours it with a delicate lilac hue.

[*Sketch* 622A]

Again, in this very naive landscape, which is meant to show us a hut, whitewashed overall (the roof, too), situated in an orange field, of course, because the sky in the south and the blue Mediterranean produce an orange that is all the more intense the higher in tint the range of blues —

The black note of the door, of the window panes, of the little cross on the rooftop, creates a simultaneous contrast of white and black

[*Sketch* 622B]

just as pleasing to the eye as that of the blue with the orange.

To take a more entertaining subject, let's imagine a woman dressed in a black and white checked dress, in the same primitive landscape of a blue sky and an orange earth — that would be quite amusing to see, I imagine. In fact, in Arles they often do wear white and black checks.

In short, black and white are colours too, or rather, in many cases may be considered colours, since their simultaneous contrast is as sharp as that of green and red, for example.

The Japanese use it too, by the way — they express a young girl's matt and pale complexion, and its sharp contrast with her black hair wonderfully well with white paper and 4 strokes of the pen. Not to mention their black thorn-bushes, studded with a thousand white flowers.

I've finally seen the Mediterranean, which you'll probably cross before me. Spent a week in Saintes-Maries, and to get there crossed the Camargue in a diligence, with vineyards, heaths, fields as flat as Holland. There, at Saintes-Maries, there were girls who made one think of Cimabue and Giotto: slim, straight, a little sad and mystical. On the completely flat, sandy beach, little green, red, blue boats, so pretty in shape and colour that one thought of flowers; one man boards them, these boats hardly go on the high sea — they dash off when there's no wind and come back to land if there's a bit too much. It appears that Gauguin is still ill. I'm quite curious to know what you've done lately; I'm still doing landscapes, croquis enclosed. I'd very much like to see Africa too, but I hardly make any firm plans for the future, it will depend on circumstances. What I'd like to know is the effect of a more intense blue in the sky. Fromentin and Gérôme see the earth in the south as colourless, and a whole lot of people saw it that way. My God, yes, if you take dry sand in your hand and if you look at it closely. Water, too, air, too, considered this way, are colourless. NO BLUE WITHOUT YELLOW and WITHOUT ORANGE, and if you do blue, then do yellow and orange as well, surely. Ah well, you'll tell me that I write you nothing but banalities. Handshake in thought.

Ever yours,
Vincent

[*Sketches* 622C–H]

le blanc cru et dur d'un mur blanc
contre le ciel à la rigueur s'exprime
et d'une façon étrange par le blanc cru
et ce même blanc rabattu par un ton
neutre Car le ciel même le colore
d'un ton lilas fin ...

Encore dans ce
paysage si naif
lequel est sensé nous
représenter une cabane
bleue ... provoquent un orangé d'autant plus intense
que la gamme des bleus est plus montée de ton

blanchie entièrement
à la chaux (le lait aussi)
pavée sur un terrain
orangé celles ci
le ciel du midi
et la méditerranée

la note noire de la porte Des vitres de la petite croix
... la fait tout qu'il y ait un contraste simultané
de blanc & noir

agréable
à l'oeil
... tout
autant que
celui du
bleu avec
l'orangé.
Pour prendre
un motif plus
amusant
supposons

une femme habillée
d'une robe carrelée
noir & blanc dans
le même paysage
primitif d'un ciel
bleu & d'une terre
orangée. ce serait
assez drôle à voir
je m'imagine
justement à Arles on
porte souvent du carrelé
blanc & noir.

Suffit que le noir et le blanc sont des couleurs
aussi. ... plutôt dans bien des cas peuvent
être considérés comme couleurs car leur contraste
simultané est aussi piquant que celui du
vert & du rouge par exemple.

la partie encadrée seulement

622A–B (top to bottom). *Cottage in Saintes-Maries; Woman with a parasol*

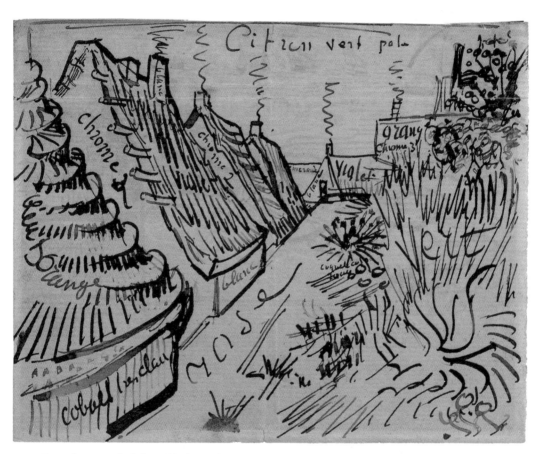

622C. *Row of cottages in Saintes-Maries*

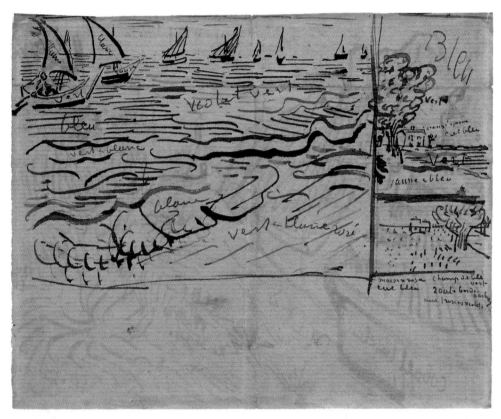

622D–F (left to right, top to bottom). *Fishing boats at sea; Landscape with the edge of a road; Farmhouse in a wheatfield*

622G. *Fishing boats on the beach at Saintes-Maries*

622H. *Still life with coffee pot*

My dear Theo,

When in doubt, it's better to abstain—that, I believe, is what I said in the letter to Gauguin, and that's what I believe now, having read his reply. If he, for his part, returns to the proposal—he's perfectly free to return to it—but we'd look I'm not quite sure what, if for the moment we pressed the point, to make him say yes.

You see that I've received your letter; I thank you very much for it and there were many things in it, I thank you very much for the 100-franc note—as for the delay with the telegram, it was dated Sunday, so it's the postman's fault, but it hardly mattered, since the coach for Saintes-Maries leaves every day.

But what stopped me was the need to buy canvases and pay the rent. I have already mentioned to you that I didn't like Tasset's canvas very much for outdoor work. In future I think we'll take the ordinary kind. I bought 50 francs' worth of canvas with stretching frames—also because I need stretching frames of different sizes to stretch canvases on, even though I'll send them to you rolled up. They're the rather large sizes, 30, 25, 20, 15, all square. It seems to me that the large sizes (after all, it's not very large) suit me better.

But I speak about what you write in your letter. I congratulate you on having the Monet exhibition at your premises, and I much regret not seeing it. It will certainly do Tersteeg no harm to have seen this exhibition; he'll still come round to it, but as your idea was too, very late. It's indeed curious that he's changed his mind on the subject of Zola. I know from experience that he couldn't bear to hear him spoken about. What an odd character Tersteeg is; we shouldn't give up hope with him—the splendid thing about him is that however rigid and fixed his opinions may be, once he has acknowledged that something is in fact different from what he had imagined—as with Zola— then he changes and becomes bold for the cause. Unfortunately, we don't get to be old in modern times, and Mr Tersteeg has lived longer now than he still has to live. And where is his successor? My God, what a sad thing it is that you and he are not entirely as one in business matters these days. But what can you say—it's what I believe they call a fatality.

You were fortunate to meet Guy de Maupassant I've just read his first book, *Des vers*, poems dedicated to his master, Flaubert. There's one, 'Au bord de l'eau', that's already *him*. So you see, what Vermeer of Delft is beside Rembrandt among painters, he is among French novelists beside Zola.

In short, Tersteeg's visit isn't at all what I'd dared hope, and I make no secret of it to myself that I miscalculated the odds on his cooperating.

And perhaps on the business with Gauguin, too. Let's take a look at that: I thought he was at bay and I blame myself for having money and the pal who works better than I, not—I say, he's entitled to half if he wishes.

But—if Gauguin isn't at bay, then I'm not in too much of a hurry.

And I categorically withdraw from it, and the only question for me remains quite simply this: If I looked for a pal to work with, would I be doing the right thing, would this be more beneficial to my brother and me, would the pal lose or would he gain by it?

So these, then, are questions that certainly preoccupy me, but which need to come face to face with reality in order to become actual facts.

I don't wish to discuss Gauguin's plan, having considered the situation once—last winter—you know the results. You know that I believe that an association of the Impressionists would be something along the lines of the associations of the 12 English Pre-Raphaelites, and that I believe that it could come into being. That I'm therefore inclined to believe that the artists would guarantee their livelihood amongst themselves, mutually, and independently of the dealers, each agreeing to give a substantial number of paintings to the society, and that earnings as well as losses would be shared. I don't believe that this society would last indefinitely, but I believe that during its lifetime we would live courageously and would produce. But if tomorrow Gauguin and his banker Jews come and ask me for nothing but 10 paintings for a society of dealers and not a society of artists, well, I don't know if I'd trust them—I who would be glad, on the other hand, to give 50 to a society of artists.

Isn't it a bit the way it was with Reid—why say that Gabriel de la Roquette's a scoundrel if you do the same yourself? Why say artistic Society if it's made up of bankers? Enough, for Heaven's sake, let our pal do as his heart tells him, but his plan is far from making me enthusiastic.

I prefer things as they are—to take them the way it is, without changing anything about them, to half-baked reforms.

The great revolution, art for the artists, my God, perhaps it's a utopia, and too bad, then. I think life's so short and goes by so fast. Now, being a painter you have to paint, all the same.

And you're also well aware that because at that time—last winter with Pissarro and the others, we happened to talk about it a lot, I'm now making a big effort to add nothing more except this, that speaking for myself, before next year I want to make my contribution of 50 paintings. If I manage to do that then I'll stick to my opinion.

I've sent you 3 drawings by post today.

The one with the haystacks in a farmyard will seem too bizarre to you, but it was done in great haste as a project for a painting, and it's to show you what it's like.

Now, the harvest is a bit more serious. And that's the subject I've been working on this week, on a no. 30 canvas—it's hardly done at all—but it kills the rest of what I have, apart from a still life, worked on with patience. MacKnight and one of his friends who's been in Africa too saw this study today and said it was the best I'd done. Like Anquetin and our friend Thomas—you're really not sure what to think of yourself when you hear people say that, but I say to myself: the rest must look bloody awful, to be sure.

Well then—on days when I bring back a study I say to myself, if it was like this every day things could work—but on days when you come home empty-handed and you eat and spend money all the same, you don't feel content with yourself, and you feel like a madman, a scoundrel or an old fool.

And dear old Doctor Ox, I mean our Swede, Mourier, I liked him well enough because, with his spectacles, he went naïvely and benignly about this wicked world, and because I presumed he had a heart that was purer than many a heart, and even with more of a leaning towards rectitude than many of the cleverest people have. And as I knew he hadn't been painting for very long it made not a bit of difference to me

that his work was the very height of inanity. And I saw him every day for months. All right. So what can be the reason for his losing his qualities? This is how I imagine the case to be. Bear in mind that he came to the south to get over a nervous disorder caused by a whole lot of problems he's had, and as a result of which he changed career.

He was *perfectly well* here, he was very calm, &c. But the shock of Paris was too great, the change too sudden, he didn't find the Paris of his dreams, and there he is, worried and perhaps disagreeable, and in any case doing silly things.

He'll soon have sown his wild oats, I hope. While waiting, let him do whatever he likes without attaching any importance to it. He's placing huge hopes in Russell (*I believe*), he's looking for an adviser and a teacher — now — no need to tell you that Russell will perhaps not be *everything* he needs, but I believe that Russell will see that he's someone who doesn't know the circles of people with whom he's dealing, and I think that Russell will take him seriously and will try to be good for him. I believe that Russell is making a name for himself among those who have an instinctive fear of Paris. It's hard to explain what I mean by that.

Russell is such a good man — but you know, you can't recommend that people love Paris, or force them to, any more than you can recommend a pipe or black coffee with cognac. And Russell's rich and has lost money in Paris, so he can and does say to people: 'see what I've had to deal with'. But in any event, I'll write a word to Russell.

It seems that MacKnight wasn't very pleased with me but that Russell indicated to him in reply that he should shut up. All this to tell you I understand very, very well — seeing he has turned out like that — that you're not in complete agreement with the Swede, who probably, according to what you write, has had a recurrence of his nervous trouble and is irritated by Paris. If he has money to waste in taking a studio like Gérôme's, it would be serious. As I'm slightly doubtful that he has a huge amount to waste, he's in for a bit of a drubbing that's not undeserved, I'd say. There's nothing to be done if he won't listen, but you can't live with him. I won't write to Gauguin direct — I'll send you the letter — because when in doubt, it's better to abstain. IF WE SAY NO MORE, if the reply shows we've said something like that but that there has to be an initiative in the matter from his side too, then we'll see if he's keen on it. If he isn't keen on it, if it's all one to him, if he has something quite different in mind, let him remain independent, and me too.

Handshake to you and to Mourier.

Ever yours,
Vincent

I find this in particular rather strange in this plan of Gauguin's: the society *offers its protection in exchange* for 10 paintings that the artists will have to *give*, if ten artists do that, the Jewish company clearly pockets 100 paintings 'for a start'. The protection of this society that doesn't even exist costs a lot of money.

Here's the letter for Gauguin — I'm well aware that in his there is this passage 'I *ask* (underlined) if, the capital having been raised for the most part, your brother would use his efforts to make a success of the business and to be its director'. I'm well aware that he also writes, 'I accept your proposal in principle'. But I believe that it could lead us too far if we weren't a little firm in showing him that our proposal was without all

these afterthoughts, and that we ourselves are too hard up to be able to risk anything other than setting up house together and sharing the month's money.

And it's true I didn't know he had so large a family; he'll more likely wish to stay in the north for that reason.

The most radical thing we could do would be for me to give up the south, and if that would get him out of trouble, go and join him in Brittany myself. And the desire I have to work in the south is naturally subordinate to the interests of people like him.

All the same, we shouldn't change lightly.

And I'm a little afraid of getting a dressing-down for having separated him from his family, or a hornet's nest like that.

Dear God, if he has such a large family his obligations are probably not to be absent from them any more. And perhaps he'd be much happier if you simply bought a painting from him from time to time.

If now I haven't mentioned these two passages and other passages in his letter it's because it seems far too difficult to me to say yes to that in all honesty. However, if it was the case that his whole plan is nothing but a fata Morgana, and as such will vanish, he'll speak of it again of his own accord.

But there's the fare, the debt at the inn, the doctor's bill; now he's talking about another debt of 300 francs which he'll settle with that painting if his collector agrees. But if he doesn't agree? Well now, it wouldn't be very prudent to give him hopes beyond our resources and commit ourselves to doing more than we could stick to. It's all very well for Gauguin to say, he's very very upset and it's a pity, and it can't be good for his work. No, we shouldn't change what we've said and consider that the thing isn't going ahead because of doubts and changes whose presence isn't a good sign. The more I calm myself here and the more I regain my strength, the more I feel that work is the most secure thing.

I admit that if living in Brittany is much less expensive, if necessary I must sacrifice my plan to work here, and I'll do it willingly if it's to his benefit. But all the more reason to work hard on the 50 paintings I wished to have before talking again about projects of the kind we discussed last winter. A letter from home arrives just now.

You know I feel so well now that it isn't indispensable that I stay here for my health alone. We have to act so that you aren't completely overwhelmed by expenses, that's what's necessary and that's serious enough in itself.

626 | Arles, between Saturday, 16 and Wednesday, 20 June 1888 |
 To Willemien van Gogh (D)

My dear sister,

Many thanks for your letter, which I'd been looking forward to; I daren't give way to my desire to write to you often or to encourage this on your part. All this correspondence doesn't always help to keep us, who are of a nervous disposition, strong in cases of possible immersions in melancholy of the kind you refer to in your letter and which I myself have too every now and then. A friend of mine asserted that the best treatment for all ills is to treat them with the most profound contempt.

The remedy for the immersions you refer to doesn't, as far as I know, grow among the usual medicinal herbs. Nonetheless I drink large quantities of bad coffee in such cases, not because this is very good for already bad teeth but because my strong powers of imagination in this respect enable me to have a religious faith — worthy of an idolater, Christian or anthropophagus — in the cheering effect of the aforementioned fluid. Fortunately for my fellow creatures I have so far carefully refrained from recommending this or similar remedies to them as being efficacious. The sun here, *that* is something else, and if for a while one just drinks wine that at least in part has been pressed from grapes. I assure you that the people in our country are as blind as moles and criminally stupid because they don't make more effort to go to the Indies or somewhere else where the sun shines. It's not good to know only one thing; it stultifies one. One shouldn't rest until one also knows the opposite.

What you say about extenuating circumstances, that sadly they don't take away the fact of having done something wrong or spoiled something, is very true.

Well, just think of our national history, rise and fall of the Dutch republic, and you'll understand what I mean, we mustn't give way too much to the extenuating circumstance of not being able &c., it's less Christian (in the sense in which people water it down these days), but it's better for us and perhaps even for others. And energy generates energy, and conversely paralysis paralyzes others.

We're now living here in a world of painting where it's unspeakably paralyzed and wretched. The exhibitions, the shops for paintings, everything, everything is occupied by people who all intercept money. And you mustn't think that I'm imagining this. People pay a lot for the work when the painter himself is dead. And people always disparage living painters by pointing unanswerably to the work of those who are no longer with us.

I know that we can't do anything to change this. For the sake of peace one must therefore resign oneself to it, or have some sort of patronage or captivate a rich woman or something, otherwise one can't work. Everything one hopes for in terms of independence through one's work, of influence on others, absolutely nothing comes of it.

And yet it's something of a pleasure to make a painting, and yet there are 20 or so painters here right now, all of them having more debts than money &c., all of them with a way of life something like that of curs, who will perhaps mean more than the whole official exhibition in so far as the future manner of working is concerned.

The principal characteristic of a painter, I imagine, is *to paint really well*; those who can paint, those who can do it best, are the germs of something that will continue to exist for a long time, just as long as there are eyes that enjoy something that is singularly beautiful.

Well I constantly regret that one can't make oneself richer by working harder — on the contrary.

If one actually could do that, one would be able to accomplish much more, be able to associate with others, and what not. For now everyone is bound by his opportunity to earn his living, and one is far from free, exactly.

You talk about 'whether I had submitted something to Arti' — certainly not — only Theo sent Mr Tersteeg a consignment of paintings by Impressionists and there was one of mine in it. However, all that transpired was that neither Tersteeg nor the artists, so Theo heard, had found anything in it.

Well that's very understandable because it's always the same, people have heard of the Impressionists, they have great expectations of them . . . and when they see them for the first time they're bitterly, bitterly disappointed and find them careless, ugly, badly painted, badly drawn, bad in colour, everything that's miserable. That was my first impression, too, when I came to Paris with the ideas of Mauve and Israëls and other clever painters. And when there's an exhibition in Paris of Impressionists alone, I believe a host of visitors come back from it bitterly disappointed and even indignant, in just the same mood as the good Hollanders were at the time when, coming out of church, they attended a lecture by Domela Nieuwenhuis or other socialists a moment later.

And yet — you know — in the space of 10 or 15 years that whole edifice of a national religion fell and — the socialists are still there and will be there for a long time, although neither you nor I belong very much to either persuasion.

Well art — official art — and its education, management, organization, is as stultified and mouldering as the religion we see falling — and it won't last, however many exhibitions, studios, schools &c. there may be, won't last any more than tulip mania.

But this doesn't concern us, we're neither founders of something new nor called upon to be preservers of something old.

But this remains — a painter is someone who paints, just as a genuine flower lover is someone who loves plants and grows them himself, and *not* the tulip dealer.

And so those 20 or so painters whom people call Impressionists, although a few of them have become fairly rich and fairly big men in the world — all the same, the majority of them are poor souls who live in coffee houses, lodge in cheap inns, live from one day to the next.

But — in one day all those 20 whom I mentioned to you paint everything they set eyes on, and better than many a great man who has a big reputation in the art world.

I say this to get you to understand what sort of tie binds me to the French painters whom people call the Impressionists — that I know many of them personally and like them.

And furthermore that in my own technique I have the same ideas concerning colour, which even I was thinking about when I was still in Holland.

Cornflowers with white chrysanthemums and a few marigolds. There you have a motif in blue and orange.

Heliotrope and yellow roses, motif in lilac and yellow.

Poppies or red geraniums in bold green leaves, motif in red and green.

There you have *basics* that one can subdivide further, can elaborate, but enough to show you without a painting that there are colours that make each other shine, that make a *couple*, complete each other like man and wife.

Explaining the whole theory to you would take quite a lot of writing, but still, it could be done.

Clothes, wallpaper, what couldn't one make a good deal nicer by taking account of the laws of colour.

You understand that Israëls and Mauve, who didn't use whole colours, who always worked in grey, do not, with the greatest respect and love, satisfy the present-day longing for colour.

Something else: someone who can really play the violin or piano is, it seems to me,

a mightily entertaining person. He picks up his violin and starts to play, and a whole gathering enjoys it all evening long. A painter has to be able to do that too.

And this sometimes gives me pleasure, to work outside when someone's looking on. One is in the wheat, say. Well then, in the space of a few hours one has to be able to paint that wheatfield and the sky above it and the prospect in the distance. Anyone who watches that will certainly keep his mouth shut afterwards about the clumsiness of the Impressionists and their bad painting, you see. But nowadays we seldom have acquaintances who are interested enough to come along now and again. But when they do, then they're sometimes won over for good.

Now contrast that with the fellows who need a studio, months and months, and I don't know what else to make something — only too often rather dull, after all that.

Can't you understand then that there's something in the new manner? And I also want this — I want to be able to paint a portrait in a morning or an afternoon, and I've done that now and again, as a matter of fact.

This work definitely doesn't alter the fact that one can work longer on other paintings. Yesterday I sent you by post a drawing that's the first scratch for quite a large painting.

But isn't it curious that, as I said to you just then, there are at least a score of fellows who in an hour or so can paint a portrait with character in it — people hardly ever ask for one — 20 or so fellows who can do whatever landscape you please, at whatever hour of the day, with whatever colour effect you please, on the spot, without hesitation — nobody looks on, they always work alone. If only everyone knew this, though — but you see the circumstances are so little known. Only I imagine that a generation later or in one of the later generations — this working decisively without hesitation, measuring correctly in an instant, skilful mixing of the colour, drawing at lightning speed — a generation will come that will do this not as we do now, alone, unloved, but with a public that will like it both for portraits of people and for portraits of landscapes or interiors.

However, I'm writing to you much too much about painting, only by doing so I wanted to get you to understand that it's rather important that Theo has got things to the point that in the firm he manages there's always an exhibition of Impressionists nowadays. Next year will be rather important. Just as the French are undeniably the masters in literature, so it is in painting too, in modern art history there are names like Delacroix, Millet, Corot, Courbet, Daumier, who dominate everything that was produced in other countries. Yet the clique of painters who currently stand at the head of the official art world is resting on the laurels won by those earlier men, and is in itself of much lesser calibre. So *they* can't do much at the forthcoming World Exhibition to help French art retain that importance it's had until now. Next year the attention, not of the public — who naturally look at everything without wondering about the history — but the attention of those who are well informed, will be attracted by the retrospective exhibition of the paintings of the great men who are already dead, and by the Impressionists. Even that won't immediately change the circumstances in which the latter find themselves, but it will at least help to disseminate the ideas and generate a bit more enthusiasm. The dull schoolmasters who are now on the selection committee for the Salon won't even admit the Impressionists though. The latter won't want that anyway, though, and will exhibit on their own. When you realize that I

want to have at least 50 or so paintings by then, you'll perhaps see that I, who don't exhibit, will nevertheless slowly and steadily play my part in a battle of which one can at least say this, that if one takes part in it, one doesn't have to fear a *prize* or medal like a good boy. They're ambitious here too, but still there's a difference, and many here are beginning to understand how ridiculous it is to make oneself dependent on the opinion of others about what one does. I detest writing about myself and I don't know why I do it. Perhaps to give you answers to your questions. You see what I've found, my work, and you also see what I haven't found, everything else that's part of life. And the future? Either become wholly abstracted from whatever isn't the work or . . . I dare not elaborate on that 'or' because becoming nothing but a work machine, unfit for and indifferent to all the rest, could be either better or worse than that average. I could quite easily resign myself to that average, and for the time being the fact is I'm still in exactly the same junk heap as ever.

By the way, talking of junk. It might still be worth while salvaging anything any good from the junk of mine which, so Theo says, is still somewhere in an attic in Breda, but I daren't ask it of you and perhaps it's been lost, so don't worry about it.

But this is the question. You know Theo brought a whole batch of woodcuts with him last year? Even so, a few of the best portfolios are missing and the rest isn't as good precisely because it's no longer complete. Obviously woodcuts from illustrated magazines get rarer and rarer as the volumes get older. Enough, this junk doesn't leave me completely indifferent; for instance, there's a copy of Gavarni's Mascarade humaine, a book *Anatomy for artists*, in short, a few things that are actually much too good to lose. I consider them as lost in advance, though; anything that still turns up is pure gain. I didn't know when I left that it would be for good like this. Because the work wasn't going badly in Nuenen and it was only a matter of going on with it. *I still miss* my models who were made for me and whom I still adore; if only I had them here now—I'm sure my 50 paintings would hit the mark. Do you understand that I'm not angry with the human race because they think I'm this or that—I freely admit in advance that they're absolutely right, but it saddens me that I don't have enough power to get what I want to pose for me, where I want and for as long or as short as I want. The problem I have to bring to an end, to overcome, lies *there* and not in the technical difficulty. And today I'm a landscape painter whereas I'm actually more suited to portraits. So it wouldn't surprise me much if I were to change style again sometime. A painter—Chaplin—who paints the portraits of the most beautiful women in Paris mightily well, ladies in boudoirs dressed or undressed, has painted powerful landscapes and herds of pigs on the moors. What I'm saying is one has to do what lies to hand and hold fast to one's technique.

If you were within my reach you would, I fear, have to get down to painting. There are Parisian ladies among the Impressionists, at least one really good—even 2 good ones.

And when I think how the new manner could help to put the women who are *incapable* of precision, who feel musically, on the right track, then I sometimes regret getting older and uglier than is in my interest.

It's very good of Theo to have invited you to come to Paris—I don't know what sort of impression it would make on you. The first time I saw it I felt above all the miseries that one cannot wave away, any more than the smell of sickness in the hospital,

however clean it may be kept. And that stayed with me later, but later I gained an understanding of how it's a hotbed of ideas, and how the people try to get everything out of life that could possibly be in it. Other cities shrink by comparison, and it seems as big as the sea. But one always leaves a whole piece of life behind there. And this is certain, *nothing is fresh there*. That's why, when one comes from there, one finds a mass of things elsewhere excellent.

I'm very glad that you've recovered your health; one does everything unwittingly and wrongly, without understanding it oneself, when one's ill.

You would *not, I think*, find the sun here unpleasant at all; I feel fine working outside in the hottest part of the day. It's a dry, clean heat.

The colour here is actually very fine; when the vegetation is fresh it's a rich green the like of which we seldom see in the north, calm. When it gets scorched and dusty it doesn't become ugly, but then a landscape takes on tones of gold of every shade, green-gold, yellow-gold, red-gold, ditto bronze, copper, in short from lemon yellow to the dull yellow colour of, say, a pile of threshed grain. That with the blue — from the deepest royal blue in the water to that of forget-me-nots. Cobalt above all, bright clear blue — green-blue and violet-blue.

Naturally this induces orange — a face tanned by the sun *looks* orange; further, because of all the yellow, the violet really speaks — a wicker fence or grey thatched roof or a ploughed field look much more violet than at home. Further, as you already suspect, the people here are often handsome. In a word, I believe that life here is rather more rewarding than in many other places. Only it seems to me that the people are getting a little slack here, slipping a little too much onto the downward slope of carelessness, indifference, whereas if they were more energetic the land would probably yield more. I haven't read much lately, except Madame Chrysanthème by Pierre Loti.

Also L'abbé Constantin by Ohnet, terribly sweet and heavenly, so that even his Maître de forges, already tending that way, becomes even more suspect. Sometimes, out of ravenous hunger, I even read the newspaper here with fury, but don't take this to mean that I have a need to read. On the contrary, in fact, because I prefer to look at things myself. But it's simply become a habit to read for a few hours in the evening, so one can't help feeling that one's missing something, but you can tell that this isn't irksome from the fact that what one sees is interesting.

I spent a week by the Mediterranean, you would think it beautiful. What strikes me here and what makes painting here attractive to me is the clarity of the air, you *can't* know what that is because it's precisely what we don't have at home — but at an hour's distance one can make out the colour of things, the grey-green of olive trees and the grass green of the meadow, for instance, and the pink-lilac of ploughed land; at home we see a vague grey line on the horizon; here the line is sharp and the shape recognizable from far, far away. This gives an idea of space and air.

Since I'm now so occupied with myself, I'd also like to see if I can't make my own portrait in writing. First I start by saying that to my mind the same person supplies material for very diverse portraits.

Here's an impression of mine, which is the result of a portrait that I painted in the mirror, and which Theo has: a pink-grey face with green eyes, ash-coloured hair, wrinkles in forehead and around the mouth, stiffly wooden, a very red beard, quite unkempt and sad, but the lips are full, a blue smock of coarse linen, and a palette with

lemon yellow, vermilion, Veronese green, cobalt blue, in short all the colours, except of the orange beard, on the palette, the only whole colours, though. The figure against a grey-white wall. You'll say that this is something like, say, the face of—death—in Van Eeden's book or some such thing—very well, but anyway isn't a figure like this—and it isn't easy to paint oneself—in any event *something different* from a photograph? And you see—this is what Impressionism has—to my mind—over the rest, it isn't banal, and one seeks a deeper likeness than that of the photographer.

I look different nowadays, in so far as I no longer have either hair or beard, both being always shaved off close; further, my complexion has changed from green-grey pink to grey-orange, and I have a white suit instead of a blue one, and am always dusty, always more laden like a porcupine with sticks, easel, canvas, and other merchandise. Only the green eyes have remained the same, but another colour in the portrait, naturally, is a yellow straw hat like a grass-mower—and a very black pipe. I live in a little yellow house with green door and shutters, whitewashed inside—on the white walls—very brightly coloured Japanese drawings—red tiles on the floor—the house in the full sun—and a bright blue sky above it and—the shadow in the middle of the day much shorter than at home. Anyway—but can't you understand that one can paint something like that with a few strokes, but at the same time can't you understand that some people say 'it looks too strange', not to mention the ones who find it nothing or abominable? If it just looks like it, but looks different from the work of the pious photographer with his black shadows—it should be done for that reason alone. I really don't like Mr Vosmaer at all, and am callous enough not to care much about the man's exchange of the temporary for the eternal. It's a very good thing that you and Ma have acquired a garden, with cats, tomcats, sparrows and flies, rather than have an extra flight of stairs. I could never get used to climbing the stairs in Paris, and was always dizzy in a dreadful nightmare that has left me here, but recurred regularly there.

Were I not to put this letter in the post I would certainly tear it up if I read it over first—so I won't read it over and I doubt the legibility, I don't always have time to write.

I don't think there's anything in this letter and can't understand how I managed to make it so long. Thank Ma for her letter.

A long time ago I meant you to have a painted study, and you shall get it. I'm afraid that by post, even if I pay the postage, they'll make you pay excess postage, like the flowers from Menton, and this is even bigger—but Theo will certainly send you one, if I don't think about it, ask him for it.

Embracing you and Ma in thought.

Your loving
Vincent

Theo works for all the Impressionists, he's done something for and sold for all of them, and will certainly go on doing so. But just these few things that I write to you about the matter will show you how he's something very different from the run of dealers, who care nothing for the painters.

Was there enough postage on the drawing? Write and tell me that, because I ought to know.

My dear Bernard,

Forgive me if I write in great haste; I fear that my letter won't be at all legible, but I want to reply to you right away.

Do you know that we've been very foolish, Gauguin, you and I, in not all going to the same place? But when Gauguin left, I wasn't yet sure of being able to leave. And when you left, there was that dreadful money for the fare, and the bad news I had to give about the expenses here, which prevented it. If we'd all left for here together it wouldn't have been so foolish, because the three of us would have done our own housekeeping. And now that I've found my bearings a little more, I'm beginning to see the advantages here. For myself, I'm in better health here than in the north — I even work in the wheatfields at midday, in the full heat of the sun, without any shade whatever, and there you are, I revel in it like a cicada. My God, if only I'd known this country at 25, instead of coming here at 35 — in those days I was enthusiastic about grey, or rather, absence of colour. I was always dreaming about Millet, and then I had acquaintances in Holland in the category of painters like Mauve, Israëls.

[*Sketch* 628A]

Here's croquis of a sower.
 Large field with clods of ploughed earth, mostly downright violet.
 Field of ripe wheat in a yellow ochre tone with a little crimson.
 The chrome yellow 1 sky almost as bright as the sun itself, which is chrome yellow 1 with a little white, while the rest of the sky is chrome yellow 1 and 2 mixed, very yellow, then.
 The sower's smock is blue, and his trousers white. Square no. 25 canvas. There are many repetitions of yellow in the earth, neutral tones, resulting from the mixing of violet with yellow, but I could hardly give a damn about the *veracity* of the colour. Better to make naive almanac pictures — old country almanacs, where hail, snow, rain, fine weather are represented in an utterly primitive way. The way *Anquetin* got his Harvest so well.
 I don't hide from you that I don't detest the countryside — having been brought up there, snatches of memories from past times, yearnings for that infinite of which the Sower, the sheaf, are the symbols, still enchant me as before.
 But when will I do the starry sky, then, that painting that's always on my mind? Alas, alas, it's just as our excellent pal Cyprien says, in 'En ménage' by *J. K. Huysmans*: the most beautiful paintings are those one dreams of while smoking a pipe in one's bed, but which one doesn't make. But it's a matter of attacking them nevertheless, however incompetent one may feel vis-à-vis the ineffable perfections of nature's glorious splendours.
 But how I'd like to see the study you did at the brothel. I reproach myself endlessly for not having done figures here yet.

[*Sketch* 628B]

628A. *Sower with setting sun*

mais quand donc ferai je le ciel étoilé ce tableau
qui toujours me préoccupe. – hélas hélas c'est bien
comme dit l'excellent copain Cyprien dans j'en ménage de
JKHuysmans : les plus beaux tableaux sont ceux que l'on rêve
en fumant des pipes dans son lit mais qu'on ne fait pas. S'agit
pourtant de les attaquer quelqu' incompétent qu'on se sente vis a vis
des ineffables perfections de splendeurs glorieuses de la nature.
mais comme je voudrais voir l'étude que tu as fait au bordel
je me fais des reproches à n'en pas finir de ne pas encore avoir fait
des figures ici

Voici encore
un paysage
Soleil couchant?
lever de lune?
Soir d'été en
tout cas.
Ville violette
astre jaune
ciel bleu vert
les blés ont
tous les tons
vieil or cuivre
or vert or rouge
or jaune
bronze jaune
vert rouge. toile de 30 carrée
je l'ai peint en plein mistral . mon chevalet était fixé en terre avec
des piquets de fer procédé que je te recommande
on enfonce les pieds du chevalet et puis on enfonce
à côté un piquet de fer long de 50 centimètres
vous pouvez aussi travailler dans le vent

Voici ce que j'ai voulu dire pour le blanc et le noir
prenons le Semeur le tableau est coupé en deux
une moitié est jaune, le haut, le bas est violet.
eh bien le pantalon blanc repose l'oeil
et le distrait au moment où le contraste simultané
excessif de jaune et de violet l'agacerait. Voilà
ce que j'ai voulu dire

628B–C (top to bottom). *Wheatfield with setting sun; Leg of an easel with a ground spike*

Here's another landscape. Setting sun? Moonrise? Summer evening, at any rate.

Town violet, star yellow, sky blue-green; the wheatfields have all the tones: old gold, copper, green gold, red gold, yellow gold, green, red and yellow bronze. Square no. 30 canvas.

I painted it out in the mistral. My easel was fixed in the ground with iron pegs, a method that I recommend to you.

[*Sketch 628C*]

You shove the feet of the easel in and then you push a 50-centimetre-long iron peg in beside them. You tie everything together with ropes; that way you can work in the wind.

Here's what I wanted to say about the white and the black. Let's take the Sower. The painting is divided into two; one half is yellow, the top; the bottom is violet. Well, the white trousers rest the eye and distract it just when the excessive simultaneous contrast of yellow and violet would annoy it. That's what I wanted to say.

I know a second lieutenant of Zouaves here called Milliet. I give him drawing lessons — with my perspective frame — and he's beginning to make drawings — my word, I've seen a lot worse than that, and he's eager to learn; has been to Tonkin, &c. He's leaving for Africa in October. If you were in the Zouaves he'd take you with him and would guarantee you a wide margin of relative freedom to paint, provided you helped him a little with his own artistic schemes. Could this be of some use to you? If SO, LET ME KNOW AS SOON AS POSSIBLE.

One reason for working is that canvases are worth money. You'll tell me that first of all this reason is very prosaic, then that you doubt that it's true. But it's true. A reason for not working is that in the meantime canvases and paints only cost us money. Drawings, though, don't cost us much.

Gauguin's bored too in Pont-Aven; complains about isolation, like you. If you went to see him — but I have no idea if he'll stay there, and am inclined to think that he intends to go to Paris. He said that he thought you would have come to Pont-Aven.

My God, if all three of us were here! You'll tell me it's too far away. Fine, *but in winter* — because here one can work outside all year round. That's my reason for loving this part of the world, not having to dread the cold so much, which by preventing my blood from circulating prevents me from thinking, from doing anything at all. You can judge that for yourself when you're a soldier. Your melancholy will go away, which may darned well come from the fact that you have too little blood — or tainted blood, which I don't think, however. It's that bloody filthy Paris wine and the filthy fat of the steaks that do that to you — dear God, I had come to a state in which my own blood was no longer working at all, but literally not at all, as they say. But after 4 weeks down here it got moving again, but, my dear pal, at that same time I had an attack of melancholy like yours, from which I would have suffered as much as you were it not that I welcomed it with great pleasure as a sign that I was going to recover — which happened too.

Instead of going back to Paris, then, stay out in the country, because you need strength to get through this ordeal of going to Africa properly. Now the more blood, and good blood, that you make yourself beforehand, the better, because over there in the heat it's perhaps harder to produce it. Painting and fucking a lot aren't compatible; it weakens the brain, and that's what's really damned annoying.

The symbol of Saint Luke, the patron of painters, is, as you know, an *ox*; we must therefore be as patient as an ox if we wish to labour in the artistic field. But bulls are pretty glad not having to work in the filthy business of painting. But what I wanted to say is this. After the period of melancholy you'll be stronger than before, your health will pick up—and you'll find the surrounding nature so beautiful that you'll have no other desire than to do painting. I believe that your poetry will also change, in the same way as in your painting. After some eccentric things you have succeeded in making some that have an *Egyptian* calm and a great simplicity.

'How short is the hour	That's not Baudelaire, I don't even
We spend loving—	know who it's by, they're the words
— It's less than an instant —	of a song in Daudet's Le Nabab,
— A little more than a dream —:	that's where I took it from—but
— Time takes away	doesn't it say the thing *like a real*
— Our spell.'	*Lady's shrug of her shoulder?*

These last few days I read Pierre *Loti's* Madame Chrysanthème; it provides interesting remarks about Japan. At the moment my brother has an exhibition of Claude Monet, I'd very much like to see them. Guy de Maupassant, among others, had been there, and said that from now on he would often revisit boulevard Montmartre.

I have to go and paint, so I'll finish I'll probably write to you again before long. I beg a thousand pardons for not having put enough stamps on the letter; and yet I did stamp it AT THE POST OFFICE *and this isn't the first time that it's happened here*, that when in doubt, and asking *at the post office itself*, I've been misled about the postage.

You can't imagine the carelessness, the nonchalance of the people here. Anyway, you'll see that shortly with your own eyes in Africa. Thanks for your letter, I hope to write to you soon at a moment when I'm in less of a hurry. Handshake.

Ever yours,
Vincent

631 | Arles, on or about Monday, 25 June 1888 | *To Theo van Gogh* (F)

My dear Theo,

If we take a whole piece of ordinary canvas, this is the net price, which I've just found out by chance:

Ordinary rough yellow canvas, No. 0
Width two metres
Whole piece 10 metres long
Price 40 francs
The discount is definitely 25%;
probably the price from the factory —
at first hand — 33⅓ %.

So here's an opportunity to check Tasset's prices. Leaving aside, or not, the 5 metres that I'd requested, the best thing would be to take a whole piece.

Having recently bought some canvases from which I'll keep the stretching frames, it's a big saving.

To do a no. 30 canvas — not counting the stretching frame, which I have — the canvas doesn't cost me 1.50 (at the price quoted above) and at present, with the stretching frame, 4 francs. Count 1 franc for the stretching frame — which costs less; on every no. 30 canvas that makes a difference of 1.50, and more. This extra goes for carriage, which will be 5 francs.

See — if you can — what Tasset says when you ask him the price by the piece, but what I'm telling you about the price by the piece is just so, and you'll be able to compare.

Do you remember among the small drawings a wooden bridge with a washing-place — a view of a town in the background? I've just painted that subject in large format.

I must warn you that everyone will find that I work too quickly.

Don't you believe a word of it.

Isn't it the emotion, the sincerity of our feeling for nature, that leads us and — if these emotions are sometimes so strong that we work — without feeling that we're working — when sometimes the brushstrokes come in a sequence and in relation one to another like the words in a speech or a letter — then we have to remember that it hasn't always been like that, and that in the future there will also be quite a few heavy days without inspiration. So we have to strike while the iron's hot and lay aside the bars we forge.

I don't yet have half of the 50 canvases fit to be presented in public, and I need all of them by the end of this year.

I know in advance that they'll be criticized as *hasty*.

I also know that I very much hope to stick to my argument of the past winter, when we talked about an association of artists.

Not that I still have a great desire or hope to bring it about, but as it was a serious argument, we have to retain our seriousness and retain the right to come back to it, to this question.

If Gauguin weren't to come to work with me, then I have no other resources to balance my expenses but my work.

This prospect only mildly frightens me. If my health doesn't let me down I'll do a whole heap of my canvases and out of that lot there'll be some that will do.

I'm almost reconciled with the orchard, which wasn't on a stretching frame, and its pendant with the stippling. Out of the whole lot, they'll do. But I'm working with *less trouble* in the full heat than back in the spring.

Soon I'll send you some rolled canvases, and the rest as and when it's possible to roll them up.

I'd very much like to double the order for the *zinc whites*. This zinc white is part of the reason why everything dries so slowly, but it has other advantages in the mixtures.

Wasn't it pleasant at Guillaumin's last winter — finding the landing and even the stairs, not to mention the studio — chock-full of canvases? You understand since then that I have a certain ambition, not about the *number* of canvases, but that these canvases as a whole should, after all, represent a real labour on your part as well as mine.

The wheatfields—that has been an opportunity to work, like the orchards in blossom.

And I only just have time to prepare myself for the new campaign, the one on the vineyards.

And between the two I'd like to do some more seascapes.

The orchards represented pink and white,
the wheatfields yellow,
the seascapes blue.

Perhaps now I'll have a try at doing greens. Now autumn—that gives you the whole range of tones.

I'm quite curious to know what Gauguin will do—the main thing is not to discourage him—I still think his whole plan was just a whim.

Do you know what I'd like to tell you once again—this—that my personal desires are subordinate to the interests of a number of people, and that it always seems to me that another person could benefit from the money I spend by myself. Either Vignon, or Gauguin, or Bernard, or someone else.

And that for these arrangements, even if they'd involve my moving, I'm prepared. Two people who get along don't spend—and even three—much more than one.

No more on colours, either.

So—without counting the surplus of finished works—there would be the satisfaction for you of providing for two or three people instead of one.

This for sooner or later. And as long as I'm as strong as the others. You can be sure of this, that it would be hard for us to be deceived, seeing that if they make difficulties about working, I know those difficulties too. And I'd perhaps know what it was all about.

Now, we'd have a perfect right—and perhaps even a duty—to urge them to work.

And that's what we have to do.

If I'm alone, my word, I can't do anything about that—then I have less need for company than for frantic work, and that's why I'm boldly ordering canvas and paints. And so I only feel life when I'm working at full stretch.

And in company I'd feel a bit less need to do that, or rather, I'd work on more complicated things.

But in isolation I can count only on my excitement at certain moments, and then I let myself run to extravagances.

And so the canvases I bought here really not so long ago are almost all covered. When I send you the rolled up canvases you could perhaps take quite a few unimportant things off their stretching frames.

So as to be able, at the end of the year, let's say, to show 50 of them to Pissarro and the others. And the rest, it's studies, which will be a source of information, and being thoroughly dried, we can keep them in a portfolio or in a cupboard without their taking up a lot of space.

Handshake to you, and to the pals if you see any of them.

Ever yours,
Vincent

My dear Bernard,

You do very well to read the Bible — I start there because I've always refrained from recommending it to you.

When reading your many quotations from Moses, from St Luke, &c., I can't help saying to myself — well, well — that's all he needed. There it is now, full-blown — — — . . . the artist's neurosis.

Because the study of Christ inevitably brings it on, especially in my case, where it's complicated by the seasoning of innumerable pipes.

The Bible — that's Christ, because the Old Testament leads towards that summit; St Paul and the evangelists occupy the other slope of the holy mountain.

How petty that story is! My God, are there only these Jews in the world, then? Who start out by declaring that everything that isn't themselves is impure?

The other peoples under the great sun over there — the Egyptians, the Indians, the Ethiopians, Babylon, Nineveh. Why didn't they write their annals with the same care? Still, the study of it is beautiful, and anyway, to be able to read everything would be almost the equivalent of not being able to read at all.

But the consolation of this so saddening Bible, which stirs up our despair and our indignation — thoroughly upsets us, completely outraged by its pettiness and its contagious folly — the consolation it contains, like a kernel inside a hard husk, a bitter pulp — is Christ. The figure of Christ has been painted — as I feel it — only by Delacroix and by Rembrandt And then Millet has painted Christ's doctrine.

The rest makes me smile a little — the rest of religious painting — from the religious point of view — not from the painting point of view. And the Italian primitives (Botticelli, say), the Flemish, German primitives (V. Eyck, and Cranach) They're pagans, and only interest me for the same reason that the Greeks do, and Velázquez, and so many other naturalists. Christ — alone — among all the philosophers, magicians, &c. declared eternal life — the endlessness of time, the non-existence of death — to be the principal certainty. The necessity and the *raison d'être* of serenity and devotion.

Lived serenely as *an artist greater than all artists* — *disdaining marble and clay and paint* — *working in* LIVING FLESH. I.e. — this extraordinary artist, hardly conceivable with the obtuse instrument of our nervous and stupefied modern brains, made neither statues nor paintings nor even books he states it loud and clear . . he made . . LIVING men, immortals.

That's serious, you know, especially because it's the truth.

That great artist didn't make books, either — Christian literature as a whole would certainly infuriate him, and its literary products that could find favour beside Luke's Gospel, Paul's epistles — so simple in their hard or warlike form — are few and far between. This great artist — Christ — although he disdained writing books on ideas and feelings — was certainly much less disdainful of the spoken word — THE PARABLE above all. (What a sower, what a harvest, what a fig tree, &c.)

And who would dare tell us that he lied, the day when, scornfully predicting the fall of the buildings of the Romans, he stated, 'heaven and earth shall pass away, but my words shall not pass away.'

Those spoken words, which as a prodigal, great lord he didn't even deign to write down, are one of the highest, the highest summit attained by art, which in them becomes a creative force, a pure creative power.

These reflections, my dear old Bernard — take us a very long way — a very long way — *raising us above art itself*. They enable us to glimpse — the art of making life, the art of being immortal — alive.

Do they have connections with painting? The patron of painters — St Luke — physician, painter, evangelist — having for his symbol — alas — nothing but the ox — is there to give us hope.

Nevertheless — our own real life — is humble indeed — our life as painters.

Stagnating under the stupefying yoke of the difficulties of a craft almost impossible to practise on this so hostile planet, on the surface of which 'love of art makes one lose real love'.

Since, however, nothing stands in the way — of the supposition that on the other innumerable planets and suns there may also be lines and shapes and colours — we're still at liberty — to retain a relative serenity as to the possibilities of doing painting in better and changed conditions of existence — an existence changed by a phenomenon perhaps no cleverer and no more surprising than the transformation of the caterpillar into a butterfly, of the white grub into a cockchafer.

That existence of painter as butterfly would have for its field of action one of the innumerable stars, which, after death, would perhaps be no more unapproachable, inaccessible to us than the black dots that symbolize towns and villages on the map in our earthly life. Science — scientific reasoning — seems to me to be an instrument that will go a very long way in the future.

Because look — it was thought that the earth was *flat* — that was true — it still is today — from Paris to Asnières, for example.

But that didn't prevent science proving that the earth is above all round. Which nobody disputes nowadays.

Now at present, despite that, we're still in the position of believing that *life is flat* and goes from birth to death.

But life too is probably round, and far superior in extent and potentialities to the single hemisphere that's known to us at present.

Future generations — probably — will enlighten us on this subject that's so interesting — and then science itself — could — with all due respect — reach conclusions more or less parallel to Christ's words concerning the other half of existence.

Whatever the case — the fact is that we are painters in real life, and it's a matter of breathing one's breath as long as one has breath.

Ah — E. DELACROIX's beautiful painting — Christ's boat on the sea of Gennesaret, he — with his pale lemon halo — sleeping, luminous — within the dramatic violet, dark blue, blood-red patch of the group of stunned disciples. On the terrifying emerald sea, rising, rising all the way up to the top of the frame. Ah — the brilliant sketch.

I would make you some croquis were it not that having drawn and painted for three or four days with a model — a Zouave — I'm exhausted — on the contrary, writing is restful and diverting.

What I've done is very ugly: a drawing of the Zouave, seated, a painted sketch of the Zouave against an all-white wall and lastly his portrait against a green door and

some orange bricks of a wall. It's harsh and, well, *ugly* and badly done. However, since that's the real difficulty attacked, it may smooth the way in the future. The figures that I do are almost always detestable in my own eyes, and all the more so in others' eyes — nevertheless, it's the study of the figure that strengthens us the most, if we do it in a different way than we're taught at Monsieur Benjamin-Constant's, for example.

Your letter gave me great pleasure — the CROQUIS IS VERY VERY INTER-ESTING and I do thank you for it — for my part I'll send you a drawing one of these days — this evening I'm too worn out in that respect; my eyes are tired, even if my brain isn't.

Listen — do you remember *John the Baptist by Puvis*? I find it marvellous and as much the MAGICIAN as Eugène Delacroix.

The passage about John the Baptist that you dug out of the Gospel is absolutely what you saw in it . . . People pressing around somebody — art thou Christ, art thou Elias? As it would be in our day to ask Impressionism or one of its searcher-representatives, 'have you found it?' That's just it.

At the moment my brother has an exhibition of Claude Monet — 10 paintings done in Antibes from February to May. It seems it's very beautiful.

Have you ever read the life of Luther? Because Cranach, Dürer, Holbein belong to *him* — it's he — *his personality* — that's the lofty light of the Middle Ages.

I like the Sun King no more than you do — extinguisher of light it rather seems to me — that Louis XIV — my God, what a pain, *in every way*, that Methodist Solomon. I don't like Solomon either, and the Methodists not at all, as well. Solomon seems a hypocritical pagan to me; I really have no respect for his architecture, an imitation of other styles, nor for his writings, which the pagans have done much better.

Tell me a bit about where you stand as far as your military service is concerned; should I talk to that second lieutenant of Zouaves or not? Are you going to Africa or not? In your case, do the years count double in Africa or not? Most of all, see that your blood's in order — you don't get very far with anaemia — painting goes slowly — better try to make your constitution as tough as old boots, a constitution to make old bones — better live like a monk who goes to the brothel once a fortnight — I do that, it's not very poetical — but anyway — I feel that my duty is to subordinate my life to painting.

If I was in the Louvre with you, I'd really like to see the primitives with you.

In the Louvre, I still return with great love to the Dutch, Rembrandt first and fore-most — Rembrandt whom I once studied so thoroughly — then Potter, for example — who makes — on a no. 4 or no. 6 panel, a white stallion alone in a meadow, a stallion neighing, and with a hard-on — forlorn under a sky brewing up a thunderstorm — heartbroken in the tender green immensity of a wet meadow — ah well, there are wonderful things in the old Dutchmen having no connection with anything at all. Handshake, and thank you again for your letter and for your croquis.

Ever yours,
Vincent

The sonnets are going well — i.e. — the colour in them is good — the design isn't as strong, less sure of itself, rather; the conception's still hesitant, I don't know how to put it — its moral purpose isn't clear.

My dear Theo,

Many thanks for your letter, the 50-franc note and the Tasset consignment, colours and canvases, that has just arrived. He'd enclosed his invoice, which comes to 50.85 francs, which enabled me to check his prices and compare them with Edouard's. He's considerably cheaper than Edouard, which, combined with the 20% discount, means we can have no complaints about him. Now, for his canvas at 4.50, I'll probably be able to find out the price by the piece at first hand.

Now your letter brings me a big piece of news — that Gauguin accepts the proposal. Indeed, the best thing would be for him to dash straight over here instead of sorting out the mess he's in there; perhaps he'll get into another one if he comes to Paris first. Perhaps, too, with the paintings he'll bring he'll make a deal, which would be very fortunate. My reply enclosed. I really want to say just this, that I feel enthusiastic not only about painting in the south — but just the same in the north too, feeling healthier than 6 months ago. So if it's safer to go to Brittany where one can board for so little — from the point of view of outgoings I'm definitely prepared to go back to the north. But it must be good for him too, to come to the south.

Especially since in 4 months it'll already be winter in the north. And this seems so certain to me, that two people having exactly the same work must, if circumstances prevent their spending more, be able to live at home on bread, wine and, well, everything else one might wish to add to that. The difficulty is to eat at home *alone*. Restaurants here are expensive because everyone eats at home.

Certainly neither Ricards nor Leonardo da Vincis are less beautiful because there are few of them — on the other hand, Monticellis, Daumiers, Corots, Daubignys and Millets aren't ugly because in many cases they were done at great speed and there are relatively many of them. As for landscapes, I'm beginning to find that some, done more quickly than ever, are among the best things I do.

It's like that with the one of which I sent you the drawing, the harvest and the haystacks too — it's true I have to retouch EVERYTHING to adjust the workmanship a little, to harmonize the brushstrokes, but *all* the essential work was done in a single long session, and I'll spare it as much as possible when I go back to it.

But when I come back from a session like that I can assure you my brain is so tired that if that sort of work is repeated often — the way it's been during this harvest — I become totally distracted and incapable of a whole lot of ordinary things. At these moments the prospect of not being alone isn't unpleasant. And I think very, very often of that excellent painter Monticelli, who people said was such a drinker and *insane*, when I see myself coming back from the mental labour of balancing the six essential colours, red — blue — yellow — orange — lilac — green.

Work and dry calculation, in which one's mind is extremely stretched, like an actor on the stage in a difficult role — where you have to think of a thousand things at the same time in a single half hour.

Afterwards — the only thing that comforts and distracts — in my case — as in others, is to stun oneself by taking a stiff drink or smoking very heavily.

Which is no doubt not very virtuous, but it's in order to go back to Monticelli.

I'd really like to see a drinker in front of a canvas or on the boards. Of course, it's all too crude a lie, this whole malicious, Jesuitical tale of the Roquette woman about Monticelli.

Monticelli the logical colourist, able to carry out the most ramified and subdivided calculations on the ranges of tones that he balanced, certainly overtaxed his brain doing that work, as did Delacroix and Richard Wagner.

But if he did perhaps drink, it was only because — Jongkind too — being physically stronger than Delacroix and suffering more physically (Delacroix was richer), it was, then — I, for one, would be well inclined to believe — because if they hadn't done it — their rebellious nerves would have played other tricks on them. And Jules and Edmond de Goncourt say this, word for word — 'we took very strong tobacco to stupefy ourselves' in the furnace of creation.

Don't believe, then, that I would artificially maintain a feverish state — but you should know that I'm in the middle of a complicated calculation that results in canvases done quickly one after another but calculated long *beforehand*. And look, when people say they're done too quickly you'll be able to reply that they looked at them too quickly. And besides, I'm now going over all the canvases a little more before sending them to you.

But during the harvest my work has been no easier than that of the farmers themselves who do this harvesting. Far from my complaining about it, it's precisely at these moments in artistic life, even if it's not the real one, that I feel almost as happy as I could be in the ideal, the real life.

If all goes well and Gauguin thinks it's a good idea to join us, we could make the thing more serious by suggesting to him that he puts ALL his paintings in common, with mine, to share profits or losses. But that won't happen or will happen of its own accord, depending on whether he found my painting good or bad, and also on whether or not we did things in collaboration. Have to write to Russell now, and I'll hasten my exchange with him. We'll have to work hard to try to sell something from my side to help with the expenses, but let's take heart, despite our difficulties in working to safeguard the artists' life, we'll have fire in our bellies. Handshake, I'll write to you again soon. I'm going to the Camargue for 2 or 3 days, to do some drawings there.

Ever yours,
Vincent

Good that you're bringing our sisters over.

Be patient a little longer with Mourier, perhaps he's going through a crisis.

I'll write to Mourier one of these days; *you'll read the letter*, you'll see the way I used to talk to him. I can see the drawing from here!!! The head in the style of Delaroche.

My dear Theo,

I've just come back from a day at Montmajour, and my friend the second lieutenant kept me company. So the two of us explored the old garden and we stole some excellent figs there. If it had been bigger it would have made you think of Zola's Paradou, tall reeds, grape vines, ivy, fig trees, olive trees, pomegranate trees with fat flowers of the brightest orange, hundred-year-old cypresses, ash trees and willows, rock oaks. Half-demolished staircases, ruined Gothic windows, clumps of white rock covered in lichen, and pieces of collapsed wall scattered here and there in the undergrowth; I brought back another large drawing of it. Not of the garden, though. That makes 3 drawings; when I have half dozen, will send them.

Yesterday I went to Fontvieille to pay a visit to Boch and MacKnight, but those gentlemen had left for a week for a short trip to Switzerland.

I think the heat is still doing me good, in spite of the mosquitoes and flies.

The cicadas — not those at home but like this,

[*Sketch 638A*]

you see them in Japanese albums. And golden and green *Cantharides* swarming on the olive trees. These cicadas (I think their name is *cicada*) sing at least as loudly as a frog.

I had the further thought that if you care to recall that I painted portraits of *père* Tanguy (which he still has), of *mère* Tanguy (which they sold), of their friend (it's true that I was paid 20 francs by him for the latter portrait), that I bought 250 francs worth of colours from Tanguy without a discount, on which he of course made a profit, that after all, I was no less his friend than he was mine, I have the most serious of reasons to doubt his right to demand money from me, which is actually settled with the study of mine that he still has, all the more so since there's the clearly expressed condition that he would be paid with the sale of a painting. Xanthippe, *mère* Tanguy and some other ladies have, by some strange freak of nature, brains of flintstone or gunflint. Certainly these ladies are much more harmful in the civilized society in which they move than the citizens bitten by rabid dogs who live at the Institut Pasteur. So *père* Tanguy would be right a thousand times over if he killed his lady but he doesn't do it, any more than Socrates

And for that reason *père* Tanguy is more closely connected — in terms of resignation and long patience — with the early Christian martyrs and slaves than with present-day Paris pimps.

Which doesn't mean there's any reason to pay him 80 francs, but there are reasons for never losing your temper with him, even if he might lose his temper when, rightly so in this case, you kick him out, or at least send him packing in no uncertain terms.

I'm writing to Russell at the same time — we probably know, don't we, that the English, the Yankees &c. have this in common with the Dutch, that their charity — — is very Christian. Now, the rest of us not being very good Christians That's what I can't stop myself thinking as I write once again.

That Boch looks a bit like a Flemish gentleman from the time of the compromise of

Mon cher Théo, je rentre d'une journée à Montmajour et mon ami le sous lieutenant m'a tenu compagnie. Nous avons alors à nous deux exploré le vieux jardin et y avons volé d'excellentes figues. Si c'eût été plus grand cela eût fait penser au Paradou de Zola de grands roseaux de la vigne du lierre des figuiers des oliviers des grenadiers aux fleurs grasses du plus vif orangé des ~~cui~~ cyprès centenaires des frènes et des saules des chênes de roche. des escaliers démolis à demi des fenêtres ogivales en ruines des blocs de blanc rochers couverts de lichen et des pans de murs écroulés épars çà et là dans la verdure. j'en ai encore rapporté un grand dessin. non pas du jardin cependant. Cela m'a fait 3 dess. lorsque j'en aurai demi douzaine les enverrai.

Hier j'ai été à Fontvieille pour faire une visite à Boch et à Mac knight seulement ces messieurs étaient partis pour 8 jours pour un petit voyage en Suisse.

Je crois que la chaleur me fait toujours du bien malgré les moustiques et les mouches.

Des cigales — non pas celles de chez nous mais des comme ceci ces cigales (je crois que on les voit sur les albums japonais leur nom est cicada) pas des Canthandes dorées et vertes en chantent au moins aussi essaim sur les oliviers fort qu'une grenouille

638A. Cicada

the nobles in the time of the Silent one and of Marnix. I wouldn't be at all surprised if he was good.

I've written to Russell that for our exchange I'd send him my consignment rolled up, straight to his home, if I knew he was in Paris.

This way he should in any case reply to me in the next few days.

And now I'll need more canvas and paint *soon*. Only I don't yet have the address for that canvas at 40 francs for 20 metres.

I believe that at this moment I'm doing the right thing by working chiefly on drawings, and seeing to it that I have colours and canvas in reserve for the time when Gauguin comes. I very much wish we could rein ourselves in as little with paint as with pen and paper.

Because I'm afraid of wasting paint, I often spoil a painted study.

With paper — if it's not a letter I'm writing but a drawing I'm doing — it hardly ever goes wrong: so many sheets of Whatman, so many drawings. I think if I were rich I'd spend less than now.

Ah well — *père* Martin would say — then we'll have to make sure we get rich — and he's quite right, just as he is about the masterpiece.

Do you remember in Guy de Maupassant the gentleman who hunted rabbits and other game and who had hunted so hard for 10 years and was so worn out with running after game that at the point when he wanted to get married he couldn't get a hard-on, which caused him the greatest anxieties and consternation.

Without being in this gentleman's position as far as having or wishing to get married, in the physical sense I'm beginning to resemble him. According to the excellent master Ziem, a man becomes ambitious the moment he can't get a hard-on. *Now*, while it's more or less the same to me whether or not I can get a hard-on, I protest when it must inevitably lead me to ambition.

There is no one but the greatest philosopher of his time and of his country, and therefore of all countries and all times — the excellent master Pangloss — who could — if here were there — give me advice and calm my soul.

There we are — the letter for Russell is in its envelope — and I've written as I thought.

I asked him if he had news of Reid, and I put the same question to you.

I told Russell that he was perfectly at liberty to take what he might want, and from the first consignment too. And that I was only waiting for a categorical answer to know whether he wanted to choose at his home or yours. That in the first case, if he wanted to see them at his home — you'd send him some orchards too. And that you'd have all of them brought back, once he'd made his choice. So he can't say anything to that. If he doesn't buy a Gauguin it's because he can't. If he can do it, I'd be inclined to hope he will do it.

I told him that if I was bold enough to insist on a purchase, it *wasn't* that without him the thing wouldn't come about, but that Gauguin having been ill, and given the complication that he'd been in bed and had to pay his doctor, the business was rather hard for us and we were all the more eager to find a collector for a painting.

I think about Gauguin a lot, and would have plenty of ideas for paintings and for work in general. At the moment I have a charwoman, who sweeps and scrubs the house twice a week for 1 franc; I place great hopes in her, to be able to count on her

making the beds if we decide to sleep at home. On the other hand, there's a possible arrangement with the chap where I'm lodging at the moment. Anyway, we'll try to ensure that in the end it'll be a saving instead of an expense.

How's your health now? Are you still seeing Gruby?

What you were saying about that conversation at the Nouvelle Athènes is interesting. You're familiar with Desboutin's little portrait that Portier has. It's certainly a strange phenomenon that all artists, poets, musicians, painters are unfortunate in the material sense — even the happy ones — what you were saying recently about Guy de Maupassant proves it once again. That rakes up the eternal question: is *life* visible to us in its entirety, or before we die do we know of only one hemisphere?

Painters — to speak only of them — being dead and buried, speak to a following generation or to several following generations through their works. Is that all, or is there more, even? In the life of the painter, death may perhaps not be the most difficult thing.

For myself, I declare I don't know anything about it. But the sight of the stars always makes me dream *in as simple a way as* the black spots on the map, representing towns and villages, make me dream.

Why, I say to myself, should the spots of light in the firmament be less accessible to us than the black spots on the map of France.

Just as we take the train to go to Tarascon or Rouen, we take death to go to a star. What's certainly true in this argument is that while *alive*, we *cannot* go to a star, any more than once dead we'd be able to take the train. So it seems to me not impossible that cholera, the stone, consumption, cancer are celestial means of locomotion, just as steamboats, omnibuses and the railway are terrestrial ones.

To die peacefully of old age would be to go there on foot.

For the moment I'm going to go to bed because it's late, and I wish you good-night and good luck.

Handshake.

Ever yours,
Vincent

642 | Arles, Sunday, 15 July 1888 | *To Theo van Gogh* (F)

My dear Theo,

You'll already have received my letter of this morning, in which I'd included 50-franc note for Bing, and it's about this Bing business again that I wanted to write to you. The fact is, we don't know enough about Japanese art.

Fortunately, we know more about the French Japanese, the Impressionists. That's definitely the essence and the main thing.

So Japanese art, properly speaking, already with its place in collections, already impossible to find in Japan itself, is becoming of secondary interest.

But this doesn't mean that if I had a single day in which I could see Paris again I wouldn't call at Bing's precisely to go and see the Hokusais and other drawings from the true period. What Bing himself, by the way, also said to me when I so much

admired the run-of-the-mill Japanese prints, that later I'd see that there's also something else. Loti's book, Mme Chrysanthème, taught me this: the apartments are bare, without decorations or ornaments. And it was that that awakened my curiosity about the excessively synthetic drawings of another period. Which are probably to our Japanese prints what a sober Millet is to a Monticelli. You know well enough that I'm not averse to Monticellis, myself.

Nor coloured Japanese prints, either, even when people tell me 'you should get out of that habit'. But it seems to me, at the point we've reached, fairly indispensable to know the sober quality that is the equivalent of the colourless Millets.

That has little or nothing to do with the stock, properly speaking, which may as well stay as it is.

Because I don't tire of those figures and landscapes. And he has so many of them!

If I wasn't so caught up and absorbed in work, how I'd like to sell all that lot! There's not much to be earned from it, and that's why nobody takes it up. Nevertheless, after a few years it will all become quite rare, will be sold more dearly. It's for that reason that we shouldn't scorn the small advantage that we have at present, of going through thousands to make our choice.

Now, if you give a whole Sunday to this yourself, if you choose new stock for about a hundred francs, you can tell yourself beforehand that you won't sell those, having chosen them yourself (unless you don't like them) — you can pay for them as and when, replacing them all the time. In the end, when the whole batch has been paid for at your leisure, you still have as many more in stock. And the result is that *what we like best* in the lot *stays with us*. And it's by doing it this way that, in what's currently at your place, there are already many old sheets that are worth a good 1 franc each.

So I urge you, keep the advantages of the stock and don't get rid of the fine sheets; on the contrary, we profit by adding to them.

There are already some sheets that we have that are definitely worth 5 francs. My God, I wasn't able to do as I wished, because I was just as excited about this lot of ten thousand Japanese prints to go through as Thoré about a sale of Dutch paintings, among which there were some interesting ones.

Really, at present my work has kept me busy; I can't do any more about it but I recommend Bing's attic to you.

I learned there myself, and I got Anquetin and Bernard to learn with me.

Now, there's still more *to learn* at Bing's, and that's why I urge you to keep our stock there, and access to the attics and cellars, and you see how far I am from seeing it as a speculation.

Supposing that it costs (myself, I don't believe that we'd lose by it), it doesn't cost an enormous amount.

What's *Reid* doing??? He'll already have been there on his own account, perhaps, as will Russell. I didn't conceal that there were some at Bing's, only I said they were 5 sous, which Bing himself had told me — or rather, the manager. If you keep the stock, then tell him once again that we often send people directly to him but that he must therefore keep his Japanese prints at the stated price — of 5 sous — not less. I'm telling you only this — I've gone through the lot four or 5 times; the sheets at our place are the result of replenishing the stock several times already.

Let's continue in the same way. It has already been a great regret to me, who knows

something about the lot, not to have paid at New Year myself, and chosen the new stock myself. Because you're dazzled, there's so much of it.

And in the other shops—it's not the same thing at all, because people are afraid to go to Bing, thinking him expensive. Now, what I didn't go through was the *library*, where there are hundreds, thousands of bound books.

Look, you'll do well out of paying a visit to their manager—his name continues to escape me—make my profound excuses to him, please, but tell him that I was there three times at New Year to pay up, that afterwards came my journey to the south. And that will procure you a Claude Monet and other paintings, because if you take the trouble to dig out the Japanese prints, you certainly have the right to do exchanges with them, with the painters, for paintings.

But to break off our relations with Bing—oh no, never that.

Japanese art is something like the primitives, like the Greeks, like our old Dutchmen, Rembrandt, Potter, Hals, Vermeer, Ostade, Ruisdael. *It doesn't end.*

If, though, I saw Bing's manager, I'd say to him that when you put yourself out to find collectors for his Japanese prints—you waste your whole day there without thinking about it, and at the end of it all, whether you sell or you don't sell, you lose money on it.

And you, if you don't want to lose on it, I would urge you to make some exchanges with painters whom you know—as Besnard still owes you a study, to tell the truth.

Anyway, that's perfectly natural, and the difficulty of working in Paris.

Today I sent Bernard 6 drawings after painted studies; I promised him 6 more and asked for an exchange of croquis after his painted studies.

And there you have it, General Boulanger's gone and done it again. It seems to me that both of them were right to fight, being unable to get along. That way at least there's no stagnation, and both of them can only gain by it. Don't you find he speaks very badly, Boulanger? He makes no impression in words at all. I don't think him any the less serious for that, since he'll be in the habit of using his voice for practical purposes, to explain things to his officers or to the managers of arsenals. But he makes no impression at all in public.

All the same, it's a funny city, Paris, where you have to live by wearing yourself out, and as long as you're not half dead you can't do a damned thing, and still. I've just read Victor Hugo's L'année terrible. There's hope there, but—. . . . that hope's in the stars. I find that true, and well said, and beautiful; and what's more, I readily believe it myself, too.

But let's not forget that the earth's a planet too, therefore a star or celestial globe. And what if all these other stars were the same!!!!!! It wouldn't be very jolly, in fact you'd have to start all over again.

For art, now—for which you need *time*, it wouldn't be bad to live more than one life. And it's not without appeal to believe in the Greeks, the old Dutch and Japanese masters, continuing their glorious school on other globes. Anyway, that's enough for today.

And look, there's another Sunday got through, writing to you and writing to Bernard; however, I must say it didn't seem long to me. Handshake.

Ever yours,
Vincent

If our sisters could bring us some more wood engravings and things like Gavarni's La masquerade humaine, 100 lithographs, the Charles Keenes, of which there were a good 200, it wouldn't be bad. There's also a very fine book, Anatomy for artists.

645 | Arles, on or about Sunday, 22 July 1888 | *To Theo van Gogh* (F)

My dear Theo,

If I was younger I'd certainly feel like suggesting to *père* Boussod to send us, you and me, to London, without any salary other than 200 francs *credit* a month, but half of the profit on Impressionist paintings, for which they could deduct this salary of 200. Now — our carcasses are no longer young, and an enterprise to go to London to unearth money for the Impressionists would be a sort of thing in the style of Boulanger, in the style of Garibaldi, in the style of Don Quixote.

And besides, *père* Boussod would really send us packing if we suggested such a thing to him. Only I'd really rather see you go to London than to New York.

My painter's fingers are loosening up, though, just at the very time my carcass is breaking down. And your head as a dealer, a salesman, another trade that takes long to learn, is gaining in experience.

In our position—which is, as you rightly say, so precarious—let's not forget our advantages, and let's try to keep our patience for doing well, and our acumen. Is it not, for example, true that in every case it's still better if they were to say to you one day, go off to London, than to kick you out and not to want your services?

I'm ageing faster than you, and what I'm striving for is to be less of a burden to you. Now as far as that goes, if not too monumental a catastrophe occurs, and if it doesn't rain toads, I hope to achieve that.

I've just taken thirty or so painted studies off their stretching frames.

If in *business affairs* we looked only for our livelihood—would it be such a great misfortune to go to London—where it seems to me that there's more chance of selling than elsewhere? In any case, I tell myself that, for example, in the case of the thirty studies that I'll send you, you won't be able to sell a single one in Paris. But then again, as our uncle from Princenhage used to say, 'everything sells'. And in our case—what I do isn't *saleable* like the Brocharts, say, but it's saleable to those who buy things because there's *nature* in them. Look, a canvas that I cover is worth more than a blank canvas. There—my pretensions go no further—don't doubt that—my right to paint, my reason for painting, I do have it!

It's only cost me my broken-down carcass—my mind pretty well cracked as far as living as I could and should goes—living like a philanthropist. It's only cost you, let's say, around fifteen thousand francs that you've advanced me.

Now — — . . there's no reason to make monkeys of us.

And that's the end of my reasoning on the subject of Mister Boussod. Keep your calm and your nerve.

And if they talk to you about London—do *not* say the thing to them bluntly, the way I put it at the beginning of this letter.

But you're right not to contradict the powers that be (what powers!).

My dear brother, if I wasn't all washed up, and driven crazy by this bloody painting, what a dealer I'd still make, with the Impressionists, I mean. But there we are, I'm all washed up. London's good, London's just what we need—but alas, I feel I can no longer do what I could have done. But broken as I am, I myself see *no misfortune* if you were to go to London; if there's fog, well, it seems to be increasing in Paris, too.

What it is—*in fact*—is that we've grown older, and that we've got to behave accordingly—*none of the rest exists*. Now, there's the pro of this con, and——we'll have to turn it to account.

It seems really strange to me that at present you should have had no news from Gauguin either—and I presume he's both ill and discouraged.

If I was reminding you just now what painting costs us, it was only to emphasize what it is that we have to say to ourselves, that we've gone too far to turn back—and for the rest, I don't put the emphasis on anything. Because other than material existence, what could be indispensable to me from now on?

If G. can't pay his debt nor pay for his journey—

If he guarantees me a cheaper life in Brittany—

Why should I not, for my part, go and live with him, if we want to help him?

If he says 'I'm alive and well and my talent's in full flow'—why should I not say the same thing myself? But there you are, our funds aren't in full flow. And so what works out least expensive is what we must do.

A lot of painting, few expenses is the course we must take.

This to repeat once again that I put aside any preference for either the north or the south.

All the plans we make have deep-rooted difficulties behind them.

How simple it would be with Gauguin—but the move—afterwards—will he still be happy? But as making plans can't be done, I'm not worrying that the situation is precarious. Knowing it to be such, and feeling it, is what makes us open our eyes and work. If we do things that way and make a balls of it—I dare think it unlikely myself—we'll be left with something. But look, I declare I'm not expecting anything, when you see people like Gauguin as if up against a wall. Let's hope there'll be a way out, for him and for us.

If I thought about, if I dwelled on the disastrous possibilities, I could do nothing—I throw myself into work with abandon, I re-emerge from it with my studies; if the storm within roars too loudly, I drink a glass too many to stun myself.

It's being crazy, compared with what one *ought to be*.

But earlier on, I felt less of a *painter*, painting is becoming a distraction for me, like hunting rabbits for the crazy people who do it to distract themselves.

My attention is becoming more intense, my hand steadier.

And that's why I dare almost give you an assurance that my painting will become better. Because that's all I have left.

Have you read in De Goncourt that Jules Dupré also gave them the impression that he was *crazy*?

Jules Dupré had found some art lover who was paying him.

If only I could find that, and not be such a burden on you.

After the crisis I went through when I came here, I can no longer make plans or anything else; I'm definitely better now, but *hope, the desire to achieve*, is broken and I work *from necessity*, so as not to suffer so much mentally, to distract myself.

Yesterday MacKnight broke his silence a little by saying he very much liked my last two studies (the flower-garden), and chatting about it for a very long time.

Well then—but do you know that *if you were in business on your own account*, you would perhaps be obliged to look for English connections? This to repeat once again, would it be so great a misfortune to go to London—if, however, it was inevitable, should we be sorry about that? Anyway, there's no comparison. Except the climate—it's infinitely better than the Congo. Good handshake, and many thanks for your letter and for the 50-franc note.

Ever yours,
Vincent.

650 | Arles, Sunday, 29 July 1888 | *To Theo van Gogh* (F)

My dear Theo,

Many thanks for your kind letter. If you recall, mine ended with: we're getting old, that's what *is* and the rest is *imagination* and doesn't exist. Now, I said that even more for myself, than for you. And I said it feeling the absolute necessity for me to act accordingly, to work, not more, perhaps, but with a more serious conception.

Now you talk about the emptiness you sometimes feel; that's just the same thing that I have, too. Considering, if you will, the times in which we live as a true and great revival of art, the moth-eaten and official tradition, which is still on its feet, but which is at bottom powerless and bone-idle, the new painters, alone, poor, treated like madmen and as a result of this treatment becoming so in fact, at least as far as their social life is concerned.

Then remember that you do exactly the same work as these primitive painters, since you provide them with money and you sell their canvases for them, which enables them to produce others.

If a painter ruins his character by working hard at painting, which makes him sterile for many things, for family life, &c. &c.

If as a consequence he paints not only with paint but with self-denial and self-abnegation and a broken heart.

Not only are you not paid for your own work either, but it costs you exactly the same as this effacement of personality, half deliberate, half accidental, costs a painter.

This is to say that if you do painting *indirectly*, you're more productive than me, for example. The more completely you become a dealer, the more you become an artist. Just as I very much hope to be in the same case . . . The more I become dissipated, ill, a broken pitcher, the more I too become a creative artist in that great revival of art of which we're speaking.

These things are indeed so, but this eternally existing art and this revival—this green shoot growing from the roots of the old felled trunk—these are things so

spiritual that a kind of melancholy remains with us when we reflect that at less expense we could have made life instead of making art. You really ought, if you can, to make me feel that art is alive, you who perhaps love art more than I do.

I say to myself that that doesn't have to do with art, but with me, that the only way for me to regain self-confidence and tranquillity is by *doing better.*

And here we are again at the end of my last letter—I'm getting old, but it's only imagination if I were to believe that art is an old, stale thing. Now, if you know what a '*mousmé*' is (you'll know when you've read Loti's Madame Chrysanthème), I've just painted one. It took me my whole week, I wasn't able to do anything else, having been not too well again. That's what annoys me, if I'd been well I'd have knocked off some more landscapes in between times. But in order to finish off my mousmé I had to save my mental powers. A mousmé is a Japanese girl—Provençale in this case—aged between 12 and 14. That makes 2 figures, the Zouave, and her, that I have.

Look after your health, take baths, especially *if Gruby recommends that you do.* Because you'll see in 4 years, the years by which I'm older than you, how far relative health is necessary in order to be able to work. Now we who work with our heads, our only and unique means of avoiding being finished too soon is the artificial prolongation of modern hygiene, rigorously followed, as far as we can endure it. Because I for one don't do everything that I should do. And a little good cheer is better than any other remedy.

I have a letter from Russell. He says that he would have written to me before had it not been that his move to Belle-Île had absorbed him. He's there now, and says that he'd be pleased if sooner or later I came to spend some time there. He still wants to do my portrait again. He even says, 'I would have gone to Boussod's to see the Gauguin, negresses talking, had it not been that I was prevented from doing so for the same reason'.

In short, he's not refusing to buy one, but is making it understood that he wouldn't want poorer quality than ours. You see that this is in any case better than nothing at all.

I'll write this to Gauguin and will ask him for croquis of paintings. We shouldn't push this business and give up on R. for the time being, but consider the thing as an ongoing piece of business that will come off.

And the same for Guillaumin, I'd like him to buy a figure by G.

He says he's received a very fine bust of his wife from *Rodin*, and that on that occasion he lunched with Claude Monet and that he saw the 10 paintings of Antibes then. I'm sending him Geffroy's article. He makes a very good critique of the Monets, first of all liking them very much: the difficulty attacked, the envelope of coloured air, the colour. Now after that he says, what must be repeated is that it all lacks construction everywhere, for example, with him a tree will have far too much foliage for the size of the trunk, and so always and everywhere, from the point of view of the reality of things, from the point of view of a whole number of *laws* of nature, he's pretty well hopeless. He ends by saying that this quality of attacking difficulties is what everyone should have.

I've received from Bernard 10 croquis like his brothel; there are 3 of them that are in the style of Redon; the enthusiasm that he has for that I don't much share myself.

But there's a woman washing herself, very Rembrandtesque, or in the style of Goya, and a very strange landscape with figures.

He expressly forbids me to send them to you, but you'll receive them by the same

post. I think Russell will buy something else from Bernard. Now I've seen work by this *Boch*; it's rigorously Impressionist but not powerful, at this moment when this new technique is still preoccupying him too much to allow him to be himself. He'll become stronger and will bring out his individuality, I think. But MacKnight does watercolours of the power of those by *Destrée*, you know, that vile Dutchman we knew back in the old days. However, he'd washed some small still lifes, yellow jug on purple foreground, red jug on green, orange jug on blue: better, but it's pretty poor.

The village where they're staying is *pure Millet*, small peasants, nothing but that, totally *rustic* and intimate. That character completely escapes them. I believe that MacKnight has civilized and converted to civilized Christianity his lout of a landlord. At least, when you go there that scoundrel and his worthy spouse shake your hand—it's in a café, of course—when you ask for a drink they have ways of refusing the money, 'Oh, I couldn't take money from an arti*ss*' (with two s's). Anyhow, it's their own fault that it's appalling, and this Boch must be getting pretty dull-witted with MacKnight. I think MacKnight has money, but not much. So they contaminate the village; if it weren't for that, I'd go there often to work there. What one ought to do there is not talk to civilized people; but they know the stationmaster and a score of bloody nuisances, and that's largely why they don't do a damned thing. I've already said that to Mourier, who once used to believe that MacKnight got on highly intelligently with the 'man of the fields'.

Naturally, these simple and naive people of the fields make fun of them, and despise them. On the contrary, if you do your work there without worrying about the village idlers with their stiff collars, then you can go into the homes of the peasants, enabling them to earn a few sous. And then that bloody Fontvieille would be a treasure to them, but the natives are—Zola's small peasants, innocent and gentle beings, as we know. It's likely that MacKnight will shortly do little landscapes with sheep, for boxes of sweets.

Not just my paintings, but I myself most of all, I had recently become wild-eyed, a bit like Hugo van der Goes in the painting by Emile Wauters.

But having had all my beard carefully shaved off, I believe that I have as much of the very placid abbot in the same painting as of the mad painter so intelligently depicted in it. And I'm not unhappy to be somewhere between the two, because *you have to live.*

Especially as there's no getting away from the fact that one day or another there could be a crisis if you changed as far as your position with the Boussods was concerned. One more reason for maintaining relations with artists on my part as well as on yours.

Besides, I believe I've told the truth, all the same. If I succeeded in bringing back in prices the money spent, I would be doing no more than my duty. And the *practical* thing I can do is the portrait. As far as drinking too much goes . . . I don't know if it's bad. But just look at Bismarck, who in any case is very practical and very intelligent. His little doctor told him he was drinking too much and *that he'd overtaxed himself all his life, from his stomach to his brain.* B. stopped drinking there and then. Since then he's lost ground and is dragging along. He must really be laughing inside at his doctor, whom fortunately for him he didn't consult too soon. Anyway, good handshake.

Ever yours,
Vincent

Remember that with Gauguin we should in no way change the idea of coming to his aid if the proposal is acceptable as it stands, but *we don't need* him. So, as far as working alone goes, don't believe that it bothers me, and don't press the matter for me, be FULLY ASSURED of that.

The portrait of a young girl is on a white background strongly tinted with Veronese green, the bodice is striped blood-red and purple. The skirt is royal blue with large orange-yellow stippling. The matt areas of flesh are yellow grey, the hair purplish, the eyebrows black, and the eyelashes, the eyes orange and Prussian blue; a sprig of oleander between the fingers, because the 2 hands are included.

651 | Arles, Monday, 30 July 1888 | *To Emile Bernard* (F)

My dear old Bernard.

You'll agree, I've no doubt at all, that neither you nor I can have a full idea of what Velázquez and Goya were like as men and as painters, because neither you nor I have seen Spain, their country, and so many fine things that have remained in the south. Even so, what we know of them does count for something in itself.

It goes without saying that for the northerners, Rembrandt first and foremost, it's extremely desirable, when judging these painters, to know both their work in its full extent and their country, and the rather intimate and hidden history of those days, and of the customs of the ancient country.

I want to repeat to you that neither Baudelaire nor you has a sufficiently clear idea when it comes to Rembrandt.

And when it comes to you, I couldn't encourage you enough to take a long look at major and minor Dutchmen before arriving at an opinion. Here it's not just a matter of strange precious stones, but it's a matter of sorting out marvels from among marvels.

And a fair amount of paste from among the diamonds. Thus for myself, having been studying my country's school for 20 years now, in most cases I wouldn't even reply if the subject came up, so much do I generally hear people talk beside the point when the painters of the north are being discussed.

So to you I can only reply, come on, just look a little more closely than that; really, it's worth the effort a thousand times over.

Now if, for example, I claim that the Van Ostade in the Louvre, which shows the painter's family, the man, the wife, the ten or so kids, is a painting infinitely deserving of study and thought, just like Ter Borch's Peace of Münster. If the paintings in the gallery in the Louvre that I personally *prefer* and find the most astonishing are very often forgotten by the very artists who go to see the Dutchmen, then I'm not in the least surprised, knowing that my own choice in that gallery is based on a knowledge of this subject that most of the French couldn't have.

But if, for example, my opinion differed from yours on those subjects, I'm confident that you would agree with me later. What grieves me at the Louvre is to see their Rembrandts getting spoiled and the cretins in the administration damaging

many beautiful paintings. Thus the annoying yellow tonality of certain canvases by Rembrandt is an effect of deterioration through humidity or other causes, instances of which I could point out to you.

As difficult to say what Rembrandt's colour is as to give a name to the Velázquez greys; we could say, for want of something better, 'Rembrandt gold', and that's what we do, but that's quite vague.

Having come to France I have, perhaps better than many Frenchmen themselves, felt Delacroix and Zola, for whom my sincere and frank admiration is boundless.

Since I had a fairly complete idea of Rembrandt. One, Delacroix, proceeds by way of colours, the other, Rembrandt, by values, but they're on a par.

Zola and Balzac, as painters of a society, of reality as a whole, arouse rare artistic emotions in those who love them, for the very reason that they embrace the whole epoch that they paint. When Delacroix paints humanity, life in general instead of an epoch, he belongs to the same family of universal geniuses all the same.

I love the closing words of Silvestre, I think it was, who ends a masterly article like this:

Thus died — almost smiling — Eugène Delacroix, a painter of high breeding — who had a sun in his head and a thunderstorm in his heart — who went from warriors to saints — from saints to lovers — from lovers to tigers — and from the tiger to flowers.

Daumier is also a really great genius.

Millet, another painter of an entire race and the settings in which it lives.

Possible that these great geniuses are no more than crazies, and that to have faith and boundless admiration for them you'd have to be a crazy too. That may well be — I would prefer my madness to other people's wisdom.

To go to Rembrandt indirectly is perhaps the most direct route. Let's talk about Frans Hals. Never did he paint Christs, annunciations to shepherds, angels or crucifixions and resurrections; never did he paint voluptuous and bestial naked women.

He painted portraits; nothing nothing nothing but that.

Portraits of soldiers, gatherings of officers, portraits of magistrates assembled for the business of the republic, portraits of matrons with pink or yellow skin, wearing white bonnets, dressed in wool and black satin, discussing the budget of an orphanage or an almshouse; he did portraits of good citizens with their families, the man, his wife, his child; he painted the tipsy drinker, the old fishwife full of a witch's mirth, the beautiful gypsy whore, babies in swaddling-clothes, the gallant, bon vivant gentleman, moustachioed, booted and spurred; he painted himself and his wife as young lovers on a turf bench in a garden, after their first wedding night. He painted guttersnipes and laughing urchins, he painted musicians and he painted a fat cook.

He doesn't know much more than that, but it's ——————————————' well worth Dante's Paradise and the Michelangelos and Raphaels and even the Greeks. It's beautiful like Zola, and healthier and more cheerful, but just as alive, because his epoch was healthier and less sad. Now what is Rembrandt? The same thing entirely — a painter of portraits. That's the healthy, broad, clear idea that one must have first of all of the two eminent Dutchmen, who are on a par, before going into the subject more deeply.

This fully understood, ALL this glorious republic, represented by these two prolific portraitists, re-created in broad strokes, we retain very wide margins for landscapes, interior scenes, animals, philosophical subjects.

But I beg you, follow this straightforward argument carefully, which I'm doing my utmost to present to you in a very very simple way.

Get him into your head, this Master Frans Hals, painter of various portraits of a whole self-assured and lively and immortal republic. Get into your head the no less great and universal master portrait painter of the Dutch Republic, Rembrandt Harmensz van Rijn, a broad and naturalistic and healthy man, as much as Hals himself. And after that we'll see flowing from that source, Rembrandt, the direct and true pupils, Vermeer of Delft, Fabritius, Nicolas Maes, Pieter de Hooch, Bol; and those influenced by him, Potter, Ruisdael, Ostade, Ter Borch. I mention Fabritius to you there, by whom we know only — two canvases — I *don't* mention a heap of good painters, and especially not the paste among these diamonds, paste firmly embedded in ordinary French skulls.

Am I, my dear old Bernard, terribly incomprehensible this time? I'm trying to make you see the great simple thing, the painting of humanity, let's rather say of a whole republic, through the simple medium of the portrait. This first and foremost; later — — — if, on the subject of Rembrandt, we're dealing to some extent with magic, with Christs and nude women, it's very interesting — but it's not the main thing. Let Baudelaire hold his tongue in this department, they're resounding words, and how hollow!!! Let's take Baudelaire for what he is, a modern poet just as Musset is another, but let them leave us alone when we're talking painting.

Handshake.

Ever yours,
Vincent

I *don't* like your drawing Lubricity as much as the others; I like *the tree*, though, it has a great look.

655 | Arles, on or about Sunday, 5 August 1888 | *To Emile Bernard* (F)

My dear old Bernard,

I realize that I've forgotten to answer your question as to whether Gauguin is still in Pont-Aven. Yes, he's still there, and if you feel like writing to him am inclined to believe that it will please him. It's still likely that he'll join me here shortly, as soon as either one of us is able to find the travel expenses.

I don't believe that this question of the Dutchmen, which we're discussing these days, is without interest. It's quite interesting to consult them when it's a matter of any kind of virility, originality, naturalism.

In the first place, I must speak to you again about yourself, about two still lifes that you've done, and about the two portraits of your grandmother. Have you ever done better, have you ever been more *yourself*, and someone? Not in my opinion. Profound study of the first thing to come to hand, of the first person to come along, was enough to really *create* something. Do you know what made me like these 3 or 4 studies so much? That *je ne sais quoi* of something deliberate, very wise, that *je ne sais quoi* of something steady and firm and sure of oneself, which they show. You've never been closer to

Rembrandt, my dear chap, than then. In Rembrandt's studio, the incomparable sphinx, Vermeer of Delft, found this extremely sound technique that hasn't been surpassed. Which today we're burning . . . to find. Oh, I know that we're working and arguing COLOUR as they did *chiaroscuro, value.*

What do these differences matter when in the end it's a question of expressing oneself powerfully?

At present you're examining primitive Italian and German techniques, the symbolic meaning that the Italians' abstract and mystical drawing may contain. DO SO.

I myself rather like this anecdote about Giotto — there was a competition for the execution of some painting or other of a Virgin. Lots of proposals were sent to the fine arts authorities of those days. One of these proposals, signed Giotto, was simply — *an oval —*

[*Sketch* 655A]

an egg shape — the authorities, intrigued and trusting — entrust the Virgin in question — to Giotto. Whether it's true or not I don't know, but I rather like the anecdote.

However, let's return to Daumier and to your grandmother. When are you going to show us more of them, studies of that soundness? I urge you to do so, while at the same time in no way belittling your investigations concerning the properties of lines in contrary motion — being not at all indifferent, I hope, to the simultaneous contrasts of lines, of forms. The trouble is, do you see, my dear old Bernard, that Giotto, Cimabue, as well as Holbein and Van Eyck, lived in an obeliscal — if you'll pardon the expression — society, layered, architecturally constructed, in which each individual was a stone, all of them holding together and forming a monumental society. I have no doubt that we'll again see an incarnation of this society when the socialists logically build their social edifice — from which they're a fair distance away yet. But you know we're in a state of total laxity and anarchy.

We, artists in love with order and symmetry, isolate ourselves and work to define *one single thing.*

Puvis knows that very well, and when he, so wise and so just, decided to descend good-naturedly into the intimacy of our very own epoch, forgetting his Elysian Fields, he made a very fine portrait, the serene old man in his bright, blue interior, reading the novel with a yellow cover — a glass of water beside him, in which a watercolour brush and a rose. And also a society lady, like those the De Goncourts portrayed.

The Dutchmen, now, we see them painting things just as they are, apparently without thought, the way Courbet painted his beautiful naked women.

They make portraits, landscapes, still lifes. One could be stupider than that and commit greater follies.

If we don't know what to do, my dear old Bernard, then let's do the same as them, if only so as not to allow our scarce mental powers to evaporate in sterile metaphysical meditations that aren't up to bottling chaos, which is chaotic for the very reason that it won't fit into any glass of our calibre.

We can — and that's what those Dutchmen did, desperately clever in the eyes of people wedded to system — we can paint an *atom* of chaos. A horse, a portrait, your grandmother, apples, a landscape.

J'aime assez mal cette anecdote relative à Giotto – il y avait un
concours – pour exécuter je ne sais quel tableau représentant une
vierge. Un tas de projets sont envoyés à l'administration des
beaux arts de ce temps là – Un de ces projets, signé Giotto
est tout simplement – un ovale – une forme d'œuf
– l'administration intriguée – et confiante – confie
la vierge en question – à Giotto – Est ce vrai ou non
je l'ignore mais j'aime assez l'anecdote.
Pourtant retournons à Daumier et à ta
grand mère. Quand est ce que tu nous en remontreras
d'études de cette solidité là – Je t'y engage tout en ne
méprisant aucunement les recherches relatives aux propriétés
des lignes à mouvement opposé – n'étant point si différent
je l'espère aux contrastes simultanés des
lignes des formes. Le mal est vois tu mon cher copain
Bernard que Giotto Cimabue ainsi que Holbein et v Eyck
vivaient dans une société obéliscale passe moi donc le mot
– echafaudé construite architecturalement ou chaque
individu était une pierre tout se tenant et formant société monumentale.
Cette société lorsque les socialistes construiront – ce dont
ils sont passablement éloigné – logiquement leur édifice
social on en reverra je n'en doute point une incarnation
Mais tu sais nous sommes en plein laisser aller
et anarchie
nous artistes amoureux de l'ordre et de la symétrie
nous nous isolons et travaillons à définir une seule
chose
Puis sait bien cela et lorsque lui si sage et si juste
a voulu oubliant ses champs élysées descendre
aimablement jusqu'à l'intimité de notre époque
même – il a fait un bien beau portrait
le vieillard serein dans son clair intérieur bleu lisant le roman
a couverture jaune – un verre d'eau dans lequel un pinceau
pour l'aquarelle et une rose – a coté de lui. Aussi une dame
du monde telle qu'en ont portraicturé les de Goncourt

655A. *Oval*

Why do you say that Degas has trouble getting a hard-on? Degas lives like a little
lawyer, and he doesn't like women, knowing that if he liked them and fucked them a
lot he would become cerebrally ill and hopeless at painting. Degas's painting is virile
and impersonal precisely because he has resigned himself to being personally no more
than a little lawyer, with a horror of riotous living. He watches human animals stron-
ger than himself getting a hard-on and fucking, and he paints them well, precisely
because he doesn't make such great claims about getting a hard-on.

Rubens, ah, there you have it, he was a handsome man and a good fucker, Courbet too; their health allowed them to drink, eat, fuck.

In your case, my poor dear old Bernard, I already told you last spring. Eat well, do your military drill well, don't fuck too hard; if you don't fuck too hard, your painting will be all the spunkier for it.

Ah, Balzac, that great and powerful artist, already told us very well that for modern artists a certain chastity made them stronger.

The Dutchmen were *married people making children*, a beautiful, very beautiful occupation, very natural.

One swallow doesn't make a summer. I'm not saying that among your new Breton studies there aren't some virile and strong ones, but I haven't seen them yet and so wouldn't be able to talk about them. But — I've seen those virile things, the portrait of your grandmother and the still lifes — judging from your drawings I have vague doubts whether these new studies would have the same vigour, just from the virile point of view.

These studies that I'm talking about first, you see it's the first swallow of your summertime as an artist. If we want, ourselves, to get a hard-on for our work, we must sometimes resign ourselves to fucking only a *little*, and for the rest to be, according as our temperament demands, soldiers or monks. The Dutchmen, once again, had morals, and a quiet, calm, well-ordered life.

Delacroix, ah, him — 'I,' he said, 'found painting when I had no teeth nor breath left'. And those who saw this famous artist paint said: when *Delacroix paints it's like the lion devouring his piece of flesh.* He fucked only a little, and had only casual love affairs so as not to filch from the time devoted to his work. If in this letter, on the face of it more incoherent, and taken on its own without its connections to the previous correspondence and above all, friendship, than I should wish — if in this letter you find that I have some anxieties — concerns in any case — for your health, foreseeing the hard ordeal that you'll have to go through in doing your service, obligatory, alas, — then you will read it correctly. I know that the study of the Dutchmen could only do you good, their works being so virile and so spunky and so healthy.

Personally, I find continence is quite good for me. It's enough for our weak, impressionable artists' brains to give their essence to the creation of our paintings. Because in thinking, calculating, wearing ourselves out, we expend cerebral activity.

Why exert ourselves in spending all our creative juices when those who pimp for a living and even their simple, well-fed clients work more to the satisfaction of the genital organs of the registered whore in this case than we do? The whore in question has my sympathy more than my compassion.

Being exiled, a social outcast, as artists like you and I surely are, 'outcasts' too, she is surely therefore our friend and sister. And finding — in this position — of outcast — the same as us — an independence that isn't without its advantages — all things considered — let's not adopt a false position by believing we're serving her through social rehabilitation, which is in any case impractical and would be fatal for her.

I've just made a portrait of a postman — or rather, two portraits even — Socratic type, no less Socratic for being something of an alcoholic, and with a high colour as a result. His wife had just given birth, the good fellow was glowing with satisfaction. He's a

fierce republican, *like père Tanguy*. Goddamn, what a subject to paint à la Daumier, eh?
He was getting too stiff while posing, and that's why I painted him twice, the second
time at a single sitting, on white canvas, background blue, almost white, in the face
all the broken tones: yellow, green, purples, pinks, reds, the uniform Prussian blue
trimmed with yellow.

Write to me soon if you feel like it; am very encumbered and haven't yet found time
for figure sketches. Handshake.

Yours truly,
Vincent

Cézanne is as much a respectably married man as the old Dutchmen were. If he has a
good hard-on in his work it's because he's not overly dissipated through riotous living.

657 | Arles, Wednesday, 8 August 1888 | *To Theo van Gogh* (F)

My dear Theo,

I've just sent off 3 large drawings, as well as some other, smaller ones and the two litho-
graphs by De Lemud.

The vertical small farmhouse garden is, it seems to me, the best of the three large
ones. The one with the sunflowers is the little garden of a bathhouse.

The third, horizontal, garden is the one of which I've also done some painted studies.

Under the blue sky, the orange, yellow, red patches of flowers take on an amazing
brilliance, and in the limpid air there's something happier and more suggestive of
love than in the north. It vibrates—like the bouquet by Monticelli that you have. I'm
annoyed with myself for not painting flowers here. Anyway, even having already pro-
duced about fifty drawings or painted studies here, I feel as though I've done absolutely
nothing at all. I'd gladly content myself with being nothing but a pioneer for other, fu-
ture painters who'll come to work in the south. Now the harvest, the garden, the sower
and the two seascapes are croquis after painted studies. I believe that all these ideas
are good, but the painted studies lack clarity of touch. One more reason why I felt the
need to draw them.

I wanted to paint a little old peasant who had an enormous resemblance to our
father in his features. Only he was more common, and verged on caricature. Neverthe-
less, I would have been enormously keen to do him just as he was as a little peasant. He
promised to come, and then he said that he ought to have the painting for himself, and
so I had to do two the same, one for him and one for me. I told him no. Perhaps he'll
come back some day. I'm curious to know if you knew the De Lemuds.

At the moment there are still plenty of fine lithographs to be had, Daumiers, re-
productions of Delacroix, Decamps, Diaz, Rousseau, Dupré, &c. Soon, though, it'll be
over, and what a great pity that this art tends to disappear.

Why is it that we don't hold on to what we have, the way doctors and mechanics
do? Once something has been discovered and found, they keep the knowledge of it; in
these wretched fine arts we forget everything, we hold on to nothing.

Millet gave us the essence of the peasant, and now, yes, there's Lhermitte, it's true there are one or two more, *Meunier* and have we now more generally learned how to see peasants — *no*, hardly anyone knows how to polish one off.

Isn't it partly the fault of Paris and the Parisians, fickle and disloyal like the sea? Well then, you're damned right to say, let's go quietly on our way, working for ourselves. You know, whatever becomes of sacrosanct Impressionism, I'd still myself have the wish to do the things that the *previous* generation, Delacroix, Millet, Rousseau, Diaz, Monticelli, Isabey, Decamps, Dupré, Jongkind, Ziem, Israëls, Meunier, a heap of others, Corot, Jacque . . . could understand.

Ah, Manet was really really close to it, and Courbet, to marrying form and colour. Me, I'd be quite happy to stay silent for 10 years doing nothing but studies, then do one or two figure paintings.

The old plan, so often recommended and so rarely carried out.

If the drawings that I send you are too stiff, it's because I did them in such a way as to be able later, if they're still there, to use them as information for painting.

This vertical small farmhouse garden is superbly coloured in reality. The dahlias are a rich and dark purple, the double row of flowers is *pink and green* on one side *and orange* almost without greenery on the other. In the middle a low, white dahlia and a little pomegranate tree, with flowers of the most brilliant orange red, yellow-green fruit, the ground grey, the tall reeds — 'canes' — of a blue green, the fig trees emerald, the sky blue, the houses white with green windows, red roofs. In full sun in the morning, in the evening entirely bathed in shadow cast by the fig trees and reeds. If Quost was there, or Jeannin What can you say, to encompass everything you'd need an entire school of people working together in the same area, complementing each other like the old Dutch: portrait painters, genre painters, landscape painters, painters of animals, still-life painters.

Must also tell you that I made a very interesting tour round the farms with someone who knows the area. But you know that in the real Provence it's more often small peasant farming à la Millet than anything else.

MacKnight and Boch don't understand much of it, or rather, nothing. Now if I myself am beginning to see it a bit more clearly, I'd need a good long stay to do it.

At times it nevertheless seems likely to me that I'll have to make the journey myself if Gauguin doesn't manage to sort out the mess he's in, if we want to put the plan into practice. And then so be it, I'm still among peasants anyway, it's the same. It's even my opinion that we should try to keep ourselves ready to go to him, because I believe that he could soon be in terrible straits again if, for example, his landlord won't give him any more credit.

That's so predictable, and his distress could be so great that it might be urgent to put the partnership into practice. For me there's only the one-way journey, and the prices over there that he has mentioned are in any case considerably lower than what one inevitably spends here.

I'm counting on having your letter on Saturday morning. I've bought two more canvases, so I now have just 5 francs left, and it's already Wednesday evening.

Here, in days with no money, there's just one more advantage over the north, the fine weather (because even the mistral is fine weather to *look at*).

Really glorious sunshine, in which Voltaire dried himself off while drinking his coffee.

You can't help feeling Zola and Voltaire everywhere. It's so full of life! In the style of Jan Steen, in the style of Ostade.

There would certainly be the possibility of a school of painting here. But you'll say that nature is beautiful everywhere if one goes into it deeply enough.

Have you read Madame Chrysanthème yet, have you made the acquaintance of that pimp 'of a surprising courtesy', Monsieur Kangourou? And of the sugared peppers, the fried ices and the salted sweets?

I've been very, very well these last few days; in the long run I believe that I'll belong to these parts in all respects.

In the peasant's garden I saw the figure of a woman carved in wood, originally from the prow of a Spanish ship.

It was in a grove of cypresses, and it was pure Monticelli.

Ah, these farmhouse gardens with the lovely big red Provence roses, the vines, the fig trees; it's quite poetic, and the eternal strong sun, in spite of which the foliage stays very green.

The tank, out of which clear water flows that irrigates the farm through channels forming a little canal system. An old, pure white Camargue horse drives the machinery. No cows on these little farms.

My neighbour and his wife (grocers) strongly resemble the Buteaux, for example.

But here, farmhouse and cheap grog-shops are less gloomy, less tragic than in the north, because the heat &c. makes poverty less hard and melancholy. I'd so much like you to have seen this part of the country. Well, first we'll have to see how the Gauguin business turns out.

I haven't told you yet that I've had a letter from Koning; I wrote to him a week ago. I can easily see him coming back sometime. Is Mourier still there?

I'd be quite surprised if that book by Cassagne was no longer in existence. They'd certainly know it at Latouche's or at the artists' colourman in Chaussée d'Antin. Or know where it is.

If I should ever happen to give drawing lessons, or have to talk with painters about the *principles* of technique, I'll have to have it to hand.

It's THE ONLY genuinely practical book that I know, and I know a little from experience how useful it is.

Mourier, MacKnight, even Boch, *all* of them would need it, and how many others. MacKnight keeps coming.

I've worked on another figure of a Zouave, sitting on a bench against a white wall, which makes the fifth figure.

This morning I was at a washing-place with figures of women as broad as Gauguin's negresses.

One in particular, in white-black-pink.

Another all yellow; there were a good thirty of them, young and old. I hope to send you still more croquis of painted studies.

Hoping to have news from you soon. Handshake.

Ever yours,
Vincent

My dear Theo,

Yesterday I spent the evening with that second lieutenant, and he plans to leave here on Friday, then he'll stay one night in Clermont, and from Clermont he'll send you a telegram to tell you by which train he'll be arriving. Sunday morning, in all probability.

The roll that he'll bring you contains 36 studies; among them there are many with which I'm desperately dissatisfied, and which I'm sending you anyway because it will still give you a vague idea of some really fine subjects in the countryside.

For example, there's a quick sketch I made of myself laden with boxes, sticks, a canvas, on the sunny Tarascon road; there's a view of the Rhône, in which the sky and the water are the colour of absinthe, with a blue bridge and black figures of ruffians; there's the sower, a washing-place and still others, not at all successful and unfinished, especially a large landscape with brushwood.

What's happened to the Souvenir de Mauve? Having heard no more about it, I was inclined to believe that Tersteeg may have said something disagreeable to you, to let you know that it would be refused, or some other unpleasantness. Naturally, I wouldn't get worked up about it in that case.

At the moment I'm working on a study like this:

[*Sketch* 660A]

boats seen from a quay, from above; the two boats are a purplish pink, the water is very green, no sky, a tricolour flag on the mast. A workman with a wheelbarrow is unloading sand. I have a drawing of it too. Did you receive the three drawings of the garden? They'll end up by not taking them at the post office any more, because the format's too big.

I fear that I *won't* have a very fine female model. She had promised, then as it appears, she earned a few sous with some riotous living and has better things to do. She was extraordinary; her expression was like that of Delacroix. And a strange, primitive bearing. I take things with patience, for want of seeing other ways of enduring them, but it's annoying, this constant aggravation with models. I hope to do a study of oleanders in the next few days. If we painted smoothly like Bouguereau people wouldn't be ashamed to let themselves be painted, but I believe it's made me lose models, that people found that it was 'badly done', *it was only pictures* FULL OF PAINTING that I was doing. So the good whores are afraid of being compromised, and that people will laugh at their portraits. But it's enough to make you almost lose heart when you feel that you could do things if people had more good will. I can't resign myself to saying, 'grapes are sour'; I can't get over the fact that I don't have more models. Well, we must be patient and look for others.

Now our sister will come soon to spend some time with you; I have no doubt that she'll enjoy herself.

It's a rather sad prospect to have to say to myself that the painting I do will perhaps never have any value. If it was worth what it costs I could say to myself, I've never concerned myself about money.

Qu'est devenu le souvenir de mauve
n'en ayant plus entendu parler j'ai été
porté à croire que Tersteeg aurait dit
quelquechose _{de desagréable} pour faire savoir qu'on le
refuserait ou autre misère. Naturellement
je ne m'en ferais pas de mauvais sang dans
ce cas

Je travaille dans ce moment à une étude
comme ceci
des bateaux
vu d'en haut
d'un quai
les deux
bateaux
sont d'un

rose violacé l'eau est très verte pas de
ciel un drapeau incolore au mat
Un ouvrier avec une brouette décharge du sable.
J'en ai aussi un dessin . As tu reçu les trois
autres dessins du jardin On finira par ne plus les
prendre à la poste parceque le format est trop grand.
Je crois que je n'aurai pas un bien beau
modèle de femme. elle avait promis puis
elle a à ce qui paraît gagné des sous en

660A. *Quay with sand barges*

But in the present circumstances, on the contrary, one will soak it up. Ah well, and all the same, *we must* still continue and try to do better.

It very often seems wiser to me to go to Gauguin instead of recommending to him the life down here; I so much fear that in the end he'll complain of having been inconvenienced. Will it be possible to live at home here, will we manage to make ends meet? Because that's a new venture. In Brittany, now, we can calculate what it will cost, and here I have no idea. I continue to find life quite expensive, and you don't get very far with the people. Here there would be beds and some pieces of furniture to buy, and the expenses of his journey and everything he owes. That seems to me to risk more than is proper, when he and Bernard spend so little in Brittany. Well, we'll have to make up our minds soon, and for my part I have no preferences. It's a simple question of deciding where we have the most chance of living cheaply.

I must write to Gauguin today to ask him what he pays models, and to find out if there are any. There you are, if you're getting old, it's important to rule out what is an illusion and to calculate before jumping into things. And if when you're younger you're able to believe that you can meet your needs through diligent work, it becomes more and more doubtful now. I also told Gauguin that in my last letter. That if we painted like Bouguereau, that we could then hope to earn — but that the public will never change and only likes soft and smooth things. With a more austere talent, you can't depend on the product of your labours; most of the people intelligent enough to understand and love Impressionist paintings are and will remain too poor to buy. Will Gauguin or I work less for that — no — but we'll be obliged to accept poverty and social isolation as a prior condition. And to start with, let's set ourselves up where living costs the least. So much the better if success comes, so much the better if one day we found ourselves better off.

What touches me most deeply in Zola's *L'oeuvre* is that character Bongrand-Jundt.

It's so true what he says: You believe, unfortunate souls, that when the artist has mastered his talent and gained his reputation, that then he's home and dry?

On the contrary, from that moment on he isn't allowed to produce a thing that isn't good in every way. His very reputation obliges him to take all the more care over his work as chances of sales diminish. At the least sign of weakness the whole jealous pack falls on him and destroys precisely that reputation and that faith that a fickle and treacherous public briefly had in him.

Stronger than that is what Carlyle says. You know the fireflies in Brazil that are so luminous that in the evening ladies stick them into their hair with pins. It's very fine, fame, but see, it is to the artist what the hairpin is to those insects.

You wish to succeed and shine; do you really know what you want?

Now I have a horror of success; I'm afraid of the morning after following a success by the Impressionists; even the present difficult days will later seem like 'the good times' to us.

Well, Gauguin and I must look ahead, we must work at getting a roof over our heads, beds; the essentials, in short, to endure the siege by failure that will last *the whole of our life.*

And we must settle down in the least expensive place. Then we'll have the peace of mind needed to produce a large amount, even if we sell little or nothing.

But if expenses exceeded income, we'd be wrong to hope too much that everything

would work out through the sale of our paintings. On the contrary, we'd be obliged to part with them at any price at the wrong time.

I conclude. Living more or less like monks or hermits, with work as our ruling passion, giving up well-being. *Nature, the fine weather down here*, that's the advantage of the south. But I believe that Gauguin will never give up the battle of Paris; he has that too much at heart, and believes in a lasting success more than I do. That won't do me any harm; on the contrary, perhaps I despair too much. So let's leave him this illusion, but let's be aware that what he'll always need is lodgings, and his daily bread, and paint. That's where the chink in his armour is, and it's because he's getting into debt now that he'll be done for beforehand. By coming to his aid, the two of us make his victory in Paris possible, in fact.

If I had the same ambitions as he has, we probably wouldn't get on well together. But I don't care about my success nor about my happiness, I care about the continuation of the energetic undertakings of the Impressionists, I care about this question of a refuge and of daily bread for them. And I feel it a crime that I have that, while two can live on the same amount.

If you're a painter, you're taken either for a madman or for a rich man. A cup of milk costs you one franc, a slice of bread and butter two, and paintings don't sell. That's why we have to join together as the old monks did, the Brethren of the Common Life of our Dutch heathlands. I realize already that Gauguin hopes for success — he couldn't do without Paris, he doesn't foresee the *infinity* of poverty. You understand how far in these circumstances it's absolutely one and the same to me to stay here or to leave. We have to allow him to fight his battle. He'll win it, what's more. Too far from Paris, he would think himself idle. But for ourselves let's keep a total indifference regarding success or failure. I'd begun to sign my canvases, but I soon stopped; it seemed too silly to me. On a seascape there's a very outrageous red signature, because I wanted a red note in the green. You'll see them soon, anyway. Weekend will be a bit tough, so I hope to have your letter a day early rather than a day late.

Handshake.

Ever yours,
Vincent

663 | Arles, Saturday, 18 August 1888 | *To Theo van Gogh* (F)

My dear Theo,

You'll shortly make the acquaintance of Mr Patience Escalier — a sort of man with a hoe, an old Camargue oxherd, who's now a gardener at a farmstead in the Crau.

Today without fail I'll send you the drawing I made after this painting, as well as the drawing of the portrait of Roulin the postman.

The colour of this portrait of a peasant isn't as dark as the Nuenen potato eaters — but the very civilized Parisian, *Portier*, probably so-called because he kicks paintings out of the *door* — will find himself up against the same question again. You've now changed since then, but you'll see that he hasn't changed, and really it's a pity that there aren't

more paintings *in clogs* in Paris. I don't believe that my peasant will do any harm, for example, to the Lautrec that you have, and I dare even believe that the Lautrec will, by simultaneous contrast, become even more distinguished, and mine will gain from the strange juxtaposition, because the sunlit and burnt, weather-beaten quality of the strong sun and strong air will show up more clearly beside the face powder and stylish outfit. What a mistake that Parisians haven't acquired sufficient taste for rough things, for Monticellis, for barbotine. Well, I know that one shouldn't be discouraged because utopia isn't coming about. It's just that I find that what I learned in Paris *is fading*, and that I'm returning to my ideas that came to me in the country before I knew the Impressionists. And I wouldn't be very surprised if the Impressionists were soon to find fault with my way of doing things, which was fertilized more by the ideas of Delacroix than by theirs.

Because instead of trying to render exactly what I have before my eyes, I use colour more arbitrarily in order to express myself forcefully. Well, let's let that lie as far as theory goes, but I'm going to give you an example of what I mean.

I'd like to do the portrait of an artist friend who dreams great dreams, who works as the nightingale sings, because that's his nature.

This man will be blond. I'd like to put in the painting my appreciation, my love that I have for him.

I'll paint him, then, just as he is, as faithfully as I can—to begin with.

But the painting isn't finished like that. To finish it, I'm now going to be an arbitrary colourist.

I exaggerate the blond of the hair, I come to orange tones, chromes, pale lemon. Behind the head—instead of painting the dull wall of the mean room, I paint the infinite.

I make a simple background of the richest, most intense blue that I can prepare, and with this simple combination, the brightly lit blond head, against this rich blue background achieves a mysterious effect, like a star in the deep azure.

Similarly, I've proceeded in this way in the peasant's portrait.

However, without wishing to evoke the mysterious brilliance of a pale star in the infinite blue in this case.

But imagining the terrific man I had to do, in the very furnace of harvest time, deep in the south. Hence the oranges, blazing like red-hot iron, hence the old gold tones, glowing in the darkness. Ah, my dear brother——and the good folk will see only caricature in this exaggeration. But what does that do to us, we've read La terre and Germinal, and if we paint a peasant we'd like to show that this reading has in some way become part of us.

I don't know if I'll be able to paint the postman *as I feel him*; as a revolutionary this man is like *père* Tanguy, he's probably considered a good republican because he heartily detests the republic we currently enjoy, and because, in short, he's a little dubious and a little disillusioned with the republican idea itself. But one day I saw him singing the Marseillaise—and I thought I was seeing '89, not next year, but the one 99 years ago. It was something out of Delacroix, out of Daumier, out of the old Dutch painting entirely.

Unfortunately, it's impossible to get that in a pose, and yet you need an intelligent model to be able to do the painting.

I must tell you now that materially speaking, these days are extremely hard.

Whatever I do, living is pretty expensive here, more or less like Paris, where, while spending 5 or 6 francs a day, you don't have much.

If I have models, then I suffer considerably as a result. Doesn't matter. And so I'll go on.

So I assure you that if by chance you sometimes sent me a little more money, that would benefit the paintings, but not me. Myself, I only have the choice between being a good painter or a bad one. I choose the former. But the things needed for painting are like those of a ruinous mistress; you can do nothing without money, and you never have enough of it.

And so painting should be done at society's expense, and the artist shouldn't be over-burdened by it.

But there you are, we should keep quiet once again, because *nobody is forcing us to work*, indifference towards painting being, inevitably, fairly general, fairly eternal.

Fortunately my stomach has recovered to such an extent that I lived for 3 weeks of the month on ship's biscuits with milk, eggs.

It's the good heat that gives me strength, and I definitely wasn't wrong to go to the south *now* instead of waiting until the damage was irreparable. Yes, I'm as well now as other men, which I have only been briefly—in Nuenen, for example—and that's not disagreeable. By 'other men' I mean a bit like the road-menders on strike, *père* Tanguy, *père* Millet, the peasants. If you're well, you should be able to live on a piece of bread, while working the whole day long, and still having the strength to smoke and to drink your glass; you *need* that in these conditions. And still to feel the stars and the infinite, clearly, up there. Then life is almost magical, after all. Ah, those who don't believe in the sun down here are truly blasphemous.

Unfortunately, along with the sun, dear God, for 3 quarters of the time there's the devil of a *mistral*.

Saturday's post has gone by, damn it, and I didn't doubt but that I would receive your letter, but you can see that I'm not getting upset about it. Handshake.

Ever yours,
Vincent

665 | Arles, on or about Tuesday, 21 August 1888 | *To Emile Bernard* (F)

My dear Bernard,

I want to do figures, figures and more figures, it's stronger than me, this series of bipeds from the baby to Socrates and from the black-haired woman with white skin to the woman with yellow hair and a sunburnt face the colour of brick.

Meanwhile, I mostly do other things.

Thanks for your letter; this time I'm writing in great haste and really worn out.

I'm very pleased that you've joined Gauguin.

Ah, I do have a new figure all the same, which is absolutely a continuation of certain studies of heads done in Holland; I showed you them once, with a painting from that time, potato eaters. I wish I could show it to you.

Again it's a study in which colour plays a role that the black and white of a drawing couldn't convey.

I wanted to send you a very large and very carefully finished drawing of it.

Well—it turned into something *entirely different*, while still being correct.

Because once again the colour suggests the scorched air of harvest time at midday in the blistering heat, and without that it's a different painting. I would dare to believe that you and Gauguin would understand it, but how ugly they'll find it!

You fellows know what a peasant is, how much of the wild animal there is when you come across somebody pure-bred.

I also have a man unloading a sand boat. That is, there are two boats, purplish pink, in Veronese green water, with yellow-grey sand, wheelbarrows, planks, a little blue and yellow man.

All of it seen from the top of a quay overhanging everything in a bird's-eye view. No sky. It's just a sketch, or rather, a rough sketch done out in the mistral.

Next, I'm attempting to do dusty thistles with a great swarm of butterflies swirling above them. Oh, the beautiful sun down here in high summer; it beats down on your head and I have no doubt at all that it drives you crazy. Now being that way already, all I do is enjoy it.

I'm thinking of decorating my studio with half a dozen paintings of *Sunflowers*.

A decoration in which harsh or broken yellows will burst against various BLUE backgrounds, from the palest Veronese to royal blue, framed with thin laths painted in orange lead.

Sorts of effects of *stained-glass windows* of a Gothic church.

Ah, my dear pals, we crazy ones, let's anyway enjoy with our eyes, shall we?

Alas, nature gets paid in kind, and our bodies are despicable and sometimes a heavy burden. But since Giotto, a sickly character, that's the way things are.

Oh, and nevertheless, what delight of the eye and what laughter, the toothless laughter of Rembrandt the old lion, his head covered in a cloth, his palette in his hand. How I'd like to spend these present days in Pont-Aven, but anyway, I console myself by reconsidering the sunflowers.

I shake your hand firmly; more soon.

Ever yours,
Vincent

669 | Arles, on or about Sunday, 26 August 1888 | *To Theo van Gogh* (F)

My dear Theo,

Many thanks for your letter and for the 50-franc note it contained. Certainly, it isn't impossible that our sister will come later and live with us. It's a good sign as far as her taste goes that she likes sculpture; that really did please me.

Painting as it is now promises to become more subtle—more music and less sculpture—in fact, it promises *colour*. As long as it keeps this promise.

The sunflowers are progressing; there's a new bouquet of 14 flowers on a green-

yellow background, so it's exactly the same effect—but in larger format, no. 30 canvas—as a still life of quinces and lemons that you already have, but in the sunflowers the painting is much simpler.

Do you remember that one day at the Hôtel Drouot we saw a bouquet of peonies by Manet? Pink flowers, very green leaves, painted in thick impasto and not glazed, like Jeannin's. Standing out against a simple white background, I believe.

Now there's something that was really healthy.

As for stippling, making halos or other things, I find that a real discovery, but it can already be foreseen that this technique won't become a universal dogma any more than another. Another reason why Seurat's La Grande Jatte, Signac's landscapes with coarse stippling, Anquetin's boat, will in time become even more personal, even more original.

As far as my clothes are concerned, they were certainly starting to suffer—but only last week I bought a black velvet jacket of quite good quality for 20 francs, and a new hat, so that's not at all urgent.

But I consulted this postman whom I painted, who has very often set up his little household and dismantled it again, moving house for roughly the price of the indispensable pieces of furniture, and he says that here you can't get a good bed that will last, for less than 150 francs, *if you want to have something solid*, of course.

However, that hardly upsets the calculation that by saving the money for lodgings, at the end of a year you find you own furniture without having spent any more during the year. And as soon as I'm able, I won't hesitate to do that.

If we were to refrain from setting ourselves up like that, Gauguin and I could drag on from year to year in small lodgings where one can't fail to become dull-witted. I'm more or less that way already, because it goes back a long, long way. And at present that has even ceased to be a source of pain, and perhaps at first I won't feel at home in my own home. Never mind. However, let's not forget Bouvard et Pécuchet, let's not forget À vau l'eau, because all of that is very, very profoundly true. Au bonheur des dames and Bel-ami, that's no less true, however. It's ways of seeing things—now, with the first one, we're less in danger of behaving like Don Quixote; it's possible, and with the last idea we go the whole hog.

Now I have the old peasant again this week.

Ah—MacKnight has cleared off at last—I don't regret it in the least. His pal the Belgian didn't seem greatly saddened by it either when he came yesterday to tell me about it, and we spent the evening together. He's very reasonable in his ideas, and knows what he wants, at least. At the moment he's doing timid Impressionism, but very much by the rules, very exact. And I told him that it was the best thing he could do, although he would lose 2 years on it perhaps, delaying his originality, but after all, I told him, it's as necessary now to pass through Impressionism properly as it *once* was to go through a Paris studio. He accepted that absolutely in its entirety, precisely because that way you shock nobody, and you can't later be accused of not being abreast of things. He's thinking seriously of going to paint the coal-miners in the Borinage, and if he's still here when Gauguin comes, not impossible then that we'll ask him to do for us in the north what we'd do for him in the south—do our utmost to enable him to live more cheaply than on his own. More soon.

Ever yours,
Vincent

My dear sister,

If you'll let me write to you in French, that will really make my letter easier for me.

You please me much more by being moved by sculpture than by painting — all the more so since Theo assures me that you also have a good eye for paintings. Naturally, that couldn't yet be a settled taste, which will never waver, but intuition, instinct, is already a great deal, and precisely what everyone doesn't always have.

But all the same, I'm very curious to know what effect the Luxembourg will have on you.

Is it true, as I think in moments when I'm in a good mood, that what is alive in art, and eternally alive, is first the painter and then the painting?

Well, what difference does that make — but if one *sees* people *working* it's still something one doesn't find under glass in museums.

Poor Miss Harriet in Guy de Maupassant, she was right, perhaps.

But was the painter wrong to go with the farm-girl? Perhaps not.

In life there's always a fate that's very annoying. And many painters die or go mad from despair, or become paralyzed in their production because nobody loves them personally.

Have you read Whitman's American poems yet? Theo should have them, and I really urge you to read them, first because they're really beautiful, and also, English people are talking about them a lot at the moment. He sees in the future, and even in the present, a world of health, of generous, frank carnal love — of friendship — of work, with the great starry firmament, something, in short, that one could only call God and eternity, put back in place above this world. They make you smile at first, they're so *candid*, and then they make you think, for the same reason. The prayer of Christopher Columbus is very beautiful.

What do you say about Monticelli's bouquet of flowers that's at Theo's, and about Prévost's Spanish woman? There are two real paintings of the south.

I myself think about Monticelli a great deal down here. He was a strong man — a little, even very, cracked — dreaming of sunshine and love and gaiety, but always frustrated by poverty, a colourist's extremely refined taste, a man of rare breeding, carrying on the best ancient traditions. He died in Marseille, rather sadly and probably after going through a real Gethsemane. Ah well, I myself am sure that I'll carry him on here as if I were his son or his brother.

We were talking just now about a fate that seemed sad to us. But isn't there another, delightful fate? And what is it to us if there is or isn't a resurrection, when we see a living man rise up immediately in a dead man's place? Taking up the same cause, carrying on the same work, living the same life, dying the same death.

When friend Gauguin's here, and we go to Marseille, I firmly intend to walk there on the Canebière, dressed exactly like him, as I've seen his portrait, with an enormous yellow hat, a black velvet jacket, white trousers, yellow gloves and a reed cane and with a great southern air.

And I'll find Marseillais who knew him when he was alive, and if you've read in Tartarin what *fèn de brût* is We'll make quite a noise on that occasion.

Monticelli is a painter who did the south all in yellow, all in orange, all in sulphur. Most painters, because they're not *colourists*, properly speaking, don't see these colours there, and declare that a painter who sees with other eyes than theirs is mad. (In the Luxembourg you'll see Montenards that aren't yellow, and I like them very much all the same. But it's likely that Montenard would find what I do totally contemptible.) All that is to be expected, of course. So I've already prepared especially a painting all in yellow of sunflowers (14 flowers) in a yellow vase and against a yellow background (it's yet another one, in addition to the previous one with 12 flowers against a blue-green background). And I expect one day to exhibit that one in Marseille. And you'll see that there'll be some Marseillais or other who will remember what Monticelli once said and did. Has Theo shown you the barbotine yet? It's really fine. Enjoy yourself, I kiss you in thought.

Ever yours,
Vincent

672 | Arles, Saturday, 1 September 1888 | *To Theo van Gogh* (F)

My dear Theo,

A line in haste to thank you very, very much indeed for the prompt dispatch of your letter. In fact, my chap had already come first thing this morning for his rent. Of course, I had to make my decision known today whether or not I'd keep the house on (because I rented it until Michaelmas, and you have to renew or withdraw beforehand). I told my chap that I'd take it on again for 3 months only, or preferably by the month. That way, supposing that our friend Gauguin arrived, we wouldn't have a very long lease ahead of us should he not like it.

Far too often I become thoroughly discouraged, thinking about what Gauguin will say about this part of the country in the long run. Isolation here is quite considerable, and while paying, you have to hack each step out of the ice in order just to get from one day's work to the same the next day. The difficulty about models is there, but patience, and especially always having a few sous, can help there, of course. But this difficulty is real.

I feel that even at the present time I could be an entirely different painter if I was able to settle the question of models. But I also feel the possibility of getting dull-witted and of seeing the time of potency in artistic production disappearing, just as in the course of life our balls start to let us down. That's inevitable, and of course, here as there it's self-confidence and striking while the iron's hot that's pressing.

And so I very often feel despondent. But Gauguin and so many others are in exactly the same position, and we must above all look for the remedy within ourselves, in good will and patience. By being content to be no more than mediocrities. Acting like that, perhaps we'll open up a new path.

I'm very curious to receive your next letter, reporting more fully on your visit to Bing. It doesn't surprise me that you say that after our sister's departure you'll feel an empty gap. You must above all try to fill it. And what could there be against Gauguin's

coming to live with you? That way he could satisfy himself on the subject of Paris while working at the same time.

But in that case it would only be fair that he should also reimburse you in paintings for what you would do for him. For me, it's a constant sorrow to do so comparatively little with the money I spend.

My life is restless and anxious, but then, moving house and moving around a lot, perhaps I would only make things worse. It makes enormous trouble for me that I don't speak the Provençal patois.

I'm still thinking very seriously about using coarser colours, which would be no less solid for being less finely ground.

At present I often stop myself when planning a painting, because of the paint it costs us. Now, that's rather a pity, all the same, for this good reason, that perhaps we have the power to work today, but we don't know if it'll still be there tomorrow.

All the same, rather than losing physical strength, I'm regaining it, and my stomach, especially, is stronger. I'm sending you 3 volumes of Balzac today; it's really a bit old, etc., but the work of Daumier and De Lemud is no uglier for belonging to a period that doesn't exist any more. At the moment, I'm at last reading Daudet's L'immortel, which I find *very beautiful* but hardly consoling.

I believe that I'll have to read a book about elephant hunting, or a totally mendacious book of categorically impossible adventures, by Gustave Aimard for example, in order to get over the heartbreak that L'immortel will leave in me. Particularly because it's so beautiful and so true, in making one feel the emptiness of the civilized world. I must say that for real power I prefer his Tartarin though. Warm regards to our sister, and once again, thank you for your letter.

Ever yours,
Vincent

673 | Arles, Monday, 3 September 1888 | *To Theo van Gogh* (F)

My dear Theo,

Yesterday I spent another day with that Belgian—who also has a sister among the Vingtistes — —the weather wasn't good but it was a jolly good day for chatting; we went for a walk, and all the same we did see some very fine things at the bullfights and outside the town. We talked more seriously about the plan that if I keep on lodgings in the south, he should definitely set up a kind of post in the coal-fields. That then Gauguin and he and I, in cases where the importance of a painting would be a reason for travelling, could exchange places — sometimes being in the north, but in a familiar part of the country where we have a friend, sometimes in the south. You'll see him soon, this young man with the Dante-like face, because he's coming to Paris, and if the room's available you'll be doing him a favour by putting him up. He's quite distinguished in appearance, and he'll become so in his paintings, I believe. He likes Delacroix, and we talked a lot about Delacroix yesterday; actually he knew the violent sketch of Christ's boat.

Ah well, thanks to him — at last I have a first sketch of that painting I've been dreaming about for a long time — *the poet*. He posed for it for me. His fine head, with its green gaze, stands out in my portrait against a starry, deep ultramarine sky; his clothing is a little yellow jacket, a collar of unbleached linen, a multicoloured tie. He gave me two sittings in one day.

Yesterday I received a letter from our sister, who has seen many things. Ah, if she could marry an artist, that wouldn't be bad.

Well, we'll have to go on urging her to untangle her personality, rather than her artistic abilities.

I've finished Daudet's *L'immortel* — I rather like the remark by the sculptor Védrine, who says that achieving FAME is something like when smoking, sticking your cigar in your mouth by the lighted end.

Now I definitely like *L'immortel* less, much less, than *Tartarin*.

You know, it seems to me that *L'immortel* isn't as fine as *Tartarin* for colour, because, with its quantity of subtle and accurate observations, it makes me think of Jean Béraud's disheartening paintings, so dry, so cold. *Tartarin*, now, is so *genuinely* great — with the greatness of a masterpiece, just like *Candide*.

I would very much like to ask you to expose my studies from down here, which aren't completely dry yet, to the air as far as possible. If they stayed shut away or in the dark, the colours would deteriorate. So, the portrait of *the young girl, the harvest* (wide landscape with the ruin in the background and the chain of the Alpilles), the *small seascape*, the *garden* with the weeping tree and the conifer bushes, if you could put them on stretching frames that would be good. I'm a little attached to those.

You can see clearly from the *drawing* of the small seascape that that one's the most worked up.

I'm having 2 oak frames made, for my new head of a peasant and for my study of a poet. Ah, my dear brother, sometimes I know so clearly what I want. In life and in painting too, I can easily do without the dear Lord, but I can't, suffering as I do, do without something greater than myself, which is my life, the power to create.

And if frustrated in this power physically, we try to create thoughts instead of children; in that way, we're part of humanity all the same. And in a painting I'd like to say something consoling, like a piece of music. I'd like to paint men or women with that *je ne sais quoi* of the eternal, of which the halo used to be the symbol, and which we try to achieve through the radiance itself, through the vibrancy of our colorations.

The portrait conceived in this way doesn't become an Ary Scheffer, because there's a blue sky behind it, as in the Saint Augustine. Because Ary Scheffer is so little of a colourist.

But this would be more in tune with what Eugène Delacroix was looking for and found in his Tasso in prison and so many other paintings depicting a *true* man. Ah, the portrait — the portrait with the model's thoughts, his soul — it so much seems to me that it must come.

We talked a lot yesterday, the Belgian and I, about the advantages and disadvantages of this place. We quite agree on both. And on the immense interest that would hold for us, to be able to *move about*, sometimes the north, sometimes the south. He's going to stay with MacKnight again for reasons of living more cheaply.

That, though, has a disadvantage for him, I believe, because living with an idler makes you idle. I believe you'll enjoy meeting him, he's still young. I believe that he'll ask your advice on buying Japanese prints and Daumier lithographs. For those, the Daumiers, it would be good to buy more, because later on we won't be able to find them.

The Belgian was saying that with MacKnight he paid 80 francs for board and lodging. What a difference, then, living together—myself I have to pay 45 a month for my lodging alone. And so I always come back to the same calculation, that with Gauguin I'll spend no more than on my own, and that without suffering thereby.

Now for them, it's to be taken into account that they were very badly housed, not in terms of their beds, but of the possibility of working at home.

So I'm still between two currents of ideas, the first, material difficulties, turning this way and that to build up an existence, and then the study of colour. I still have hopes of finding something there. To express the love of two lovers through a marriage of two complementary colours, their mixture and their contrasts, the mysterious vibrations of adjacent tones. To express the thought of a forehead through the radiance of a light tone on a dark background. To express hope through some star. The ardour of a living being through the rays of a setting sun. That's certainly not *trompe-l'oeil* realism, but isn't it something that really exists? More soon; I'll tell you when the Belgian might pass through, because I'll see him again tomorrow.

Handshake.

Ever yours,
Vincent

The Belgian said that at home they have a Degroux, the sketch for Saying grace in the Brussels museum.

The portrait of the Belgian has something of the portrait of Reid that you have, in terms of execution.

677 | Arles, Sunday, 9 September 1888 | *To Theo van Gogh* (F)

My dear Theo,

I've just put the croquis of the new painting, THE 'NIGHT CAFÉ', in the post—as well as another one that I did some time ago. I'll perhaps end up making some Japanese prints.

Now yesterday I worked at furnishing the house. Just as the postman and his wife told me, the two beds, if you want something sturdy, will come to 150 francs each. I found that everything they'd told me about prices was true. As a result I had to change tack, and this is what I did: I bought one bed in walnut and another in deal, which will be mine, and which I'll paint later.

Then I bought linen for one of the beds, and I bought *two* palliasses. If Gauguin or somebody else were to come, there you are, his bed will be made in a minute. From the start, I wanted to arrange the house not just for myself but in such a way as to be able to put somebody up.

Naturally, that ate up most of my money.

With what was left, I bought 12 chairs, a mirror, and some small indispensable things. Which in short means that next week I'll be able to go and live there.

For putting somebody up, there'll be the prettiest room upstairs, which I'll try to make as nice as possible, like a woman's boudoir, really artistic. Then there'll be my own bedroom, which I'd like to be exceedingly simple, but the furniture square and broad.

The bed, the chairs, table, all in deal. Downstairs, the studio and another room, also a studio, but a kitchen at the same time.

One of these days you'll see a painting of the little house itself, in full sunshine or else with the window lit and the starry sky.

Then you'll be able to believe you own your country house here in Arles. Because I myself am enthusiastic about the idea of arranging it in such a way that you'll like it, and that it'll be a studio in a style absolutely meant to be that way.

Let's say that in a year you come to spend a holiday here and in Marseille, it will be ready then — and the way I envisage it, the house will be just full of paintings from top to bottom.

The room where you'll stay then, or which will be Gauguin's if Gauguin comes, will have a decoration of large yellow sunflowers on its white walls.

Opening the window in the morning, you see the greenery in the gardens and the rising sun and the entrance of the town.

But you'll see these big paintings of bouquets of 12, 14 sunflowers stuffed into this tiny little boudoir with a pretty bed and everything else elegant. It won't be commonplace.

And the studio — the red floor-tiles, the white walls and ceiling, the rustic chairs, the deal table, with, I hope, decoration of portraits. That will have character à la *Daumier* — and it won't, I dare predict, be commonplace.

Now I'm going to ask you to look for some Daumier lithographs for the studio, and some Japanese prints, but it's not at all urgent, and only when you find duplicates of them.

And some Delacroixs too, ordinary lithographs by modern artists.

It's not the least little bit urgent, but I have my idea. I really want to make of it — AN ARTISTS' HOUSE but not precious, on the contrary, *nothing precious*, but everything from the chair to the painting having character.

So for the beds I bought local beds, two wide double beds, instead of iron beds. It gives a look of solidity, durability, calm, and if it takes a bit more bed-linen, that's too bad, but it must have character.

Most fortunately I have a charwoman who's very loyal; without that I wouldn't dare begin the business of living in my own place. She's quite old and has a mixed bunch of kids, and she keeps my tiles nice and red and clean.

I wouldn't be able to explain to you how pleased I am to find a big, serious job this way. Because I hope it'll be a true decoration that I'm going to undertake there.

So, as I've already told you, I'm going to paint my own bed, there'll be 3 subjects. Perhaps a naked woman, I haven't decided, perhaps a cradle with a child; I don't know, but I'll take my time.

I now no longer feel any hesitation about staying here, because ideas for work are coming to me in abundance. I now plan to buy some article for the house every month. And with patience, the house will be worth something for the furniture and the decorations.

I must warn you that very shortly I'll need a big order for colours for the autumn, which I believe is going to be absolutely marvellous. And on reflection, I'll send you the order enclosed herewith.

In my painting of the night café I've tried to express the idea that the café is a place where you can ruin yourself, go mad, commit crimes. Anyway, I tried with contrasts of delicate pink and blood-red and wine-red. Soft Louis XV and Veronese green contrasting with yellow greens and hard blue greens.

All of that in an ambience of a hellish furnace, in pale sulphur.

To express something of the power of the dark corners of a grog-shop.

And yet with the appearance of Japanese gaiety and Tartarin's good nature.

But what would Mr Tersteeg say about this painting? He who, looking at a Sisley — Sisley, the most tactful and sensitive of the Impressionists — had already said: 'I can't stop myself thinking that the artist who painted that was a little tipsy'. Looking at my painting, then, he'd say that it's a full-blown case of delirium tremens.

I find absolutely nothing to object to what you speak of, to exhibit sometime at the Revue Indépendante, as long as I'm not a cause of obstruction for the others who usually exhibit there.

Only we'd then have to tell them that I'd like to reserve a second exhibition for myself, after this first one of what are in fact studies.

Then next year I'd give them the decoration of the house to exhibit, when there would be an ensemble. Not that I insist, but it's so that the studies shouldn't be confused with compositions, and to say beforehand that the first exhibition would be one of *studies*.

Because there's still hardly more than the sower and the night café that are attempts at composed paintings.

As I write, the little peasant who looks like a caricature of our father is just coming into the café.

The resemblance is amazing, all the same. The receding profile and the weariness and the ill-defined mouth, especially. It continues to seem a pity to me that I haven't been able to do him.

I'm adding to this letter the order for colours, which isn't exactly urgent. Only I'm so full of plans, and then the autumn promises so many superb subjects that I simply don't know if I'm going to start 5 or 10 canvases.

It'll be the same thing as in the spring, with the orchards in blossom, the subjects will be innumerable. If you gave *père* Tanguy the coarser paint, he'd probably do that well.

His other fine colours are really inferior, especially for the blues.

I hope, when preparing the next consignment, to gain a little in *quality*.

I'm doing comparatively less, and coming back to it longer. I've kept back 50 francs for the week; thus there has already been 250 for the furniture. And I'll recoup them anyway, doing it this way. And from today you can say to yourself that you have a sort of country house, unfortunately a bit far away. But it would cease to be very, very far if we had a permanent exhibition in Marseille. We'll see that in a year, perhaps. Handshake and

Ever yours,
Vincent

My dear sister,

Your letter gave me great pleasure, and today I have the leisure to reply to you in peace and quiet. So your visit to Paris was a great success. I would really like it if you were to come here too next year. At the moment I'm furnishing the studio in such a way as always to be able to put someone up. Because there are 2 small rooms upstairs, which look out on a very pretty public garden, and where you can see the sunrise in the morning. I'll arrange one of these rooms for putting up a friend, and the other one will be for me.

I want nothing there but straw-bottomed chairs and a table and a deal bed. The walls whitewashed, the tiles red. But in it I want a great wealth of portraits and painted studies of figures, which I plan to do as I go along. I have one to start with, the portrait of a young Belgian Impressionist; I've painted him as something of a poet, his refined and nervous head standing out against a deep ultramarine background of the night sky, with the twinkling of the stars.

Now the other room, I would like it almost elegant, with a walnut bed with a blue blanket.

And all the rest, the dressing-table and the chest of drawers too, in matt walnut. I want to stuff at least 6 very large canvases into this tiny little room, the way the Japanese do, especially the huge bouquets of sunflowers. You know that the Japanese instinctively look for contrasts, and eat sweetened peppers, salty sweets, and fried ices and frozen fried dishes. So, too, following the same system you should probably only put very small paintings in a large room, but in a very small room you'll put a lot of big ones.

I hope the day will come when I'll be able to show you this beautiful part of the world.

I've just finished a canvas of a café interior at night, lit by lamps. Some poor night-prowlers are sleeping in a corner. The room is painted red, and inside, in the gaslight, the green billiard table, which casts an immense shadow over the floor. In this canvas there are 6 or 7 different reds, from blood-red to delicate pink, contrasting with the same number of pale or dark greens.

Today I sent Theo a drawing of it, which is like a Japanese print.

Theo wrote telling me that he has given you some Japanese prints. It's certainly the most practical way of getting to understand the direction that painting has taken at present. Colourful and bright.

For myself, I don't need Japanese prints here, because I'm always saying to myself *that I'm in Japan here.* That as a result I only have to open my eyes and paint right in front of me what makes an impression on me.

Have you seen a tiny little mask of a fat, smiling Japanese woman at our place? The expression on that little mask is really surprising.

Did you think of taking one of my paintings with you for yourself? I hope so, and I'm quite intrigued to know which you would have chosen. I myself thought you would have taken the white huts under the blue sky among the greenery, which I did at Saintes-Maries, on the Mediterranean.

I should have gone back to Saintes-Maries already, now that there are people on the beach. But anyway, I have so much to do right here.

I definitely want to paint a starry sky now. It often seems to me that the night is even more richly coloured than the day, coloured in the most intense violets, blues and greens.

If you look carefully you'll see that some stars are lemony, others have a pink, green, forget-me-not blue glow. And without labouring the point, it's clear that to paint a starry sky it's not nearly enough to put white spots on blue-black.

My house here is painted outside in the yellow of fresh butter, with garish green shutters, and it's in the full sun on the square, where there's a green garden of plane trees, oleanders, acacias. And inside, it's all whitewashed, and the floor's of red bricks. And the intense blue sky above. Inside, I can live and breathe, and think and paint. And it seems to me that I should go further into the south rather than going back up north, because I have too great a need of the strong heat so that my blood circulates normally. I'm in really much better health here than in Paris.

Now I have scarcely a doubt that for you, too, you would like the south enormously.

It's the sun, that has never sufficiently penetrated us northerners.

I started this letter several days ago, up to here, and I'm picking it up again now.

I was interrupted precisely by the work that a new painting of the outside of a café in the evening has been giving me these past few days. On the terrace, there are little figures of people drinking. A huge yellow lantern lights the terrace, the façade, the pavement, and even projects light over the cobblestones of the street, which takes on a violet-pink tinge. The gables of the houses on a street that leads away under the blue sky studded with stars are dark blue or violet, with a green tree. Now there's a painting of night without black. With nothing but beautiful blue, violet and green, and in these surroundings the lighted square is coloured pale sulphur, lemon green. I enormously enjoy painting on the spot at night. In the past they used to draw, and paint the picture from the drawing in the daytime. But I find that it suits me to paint the thing straight-away. It's quite true that I may take a blue for a green in the dark, a blue lilac for a pink lilac, since you can't make out the nature of the tone clearly. But it's the only way of getting away from the conventional black night with a poor, pallid and whitish light, while in fact a mere candle by itself gives us the richest yellows and oranges. I've also done a new portrait of myself, as a study, in which I look like a Japanese. You never told me if you had read Guy de Maupassant's Bel-ami, and what you now think of his talent in general. I say this because the beginning of Bel-ami is precisely the description of a starry night in Paris, with the lighted cafés of the boulevard, and it's something like the same subject that I've painted just now.

Speaking of Guy de Maupassant, I find what he does really beautiful, and I really recommend that you read everything that he's done. Zola—Maupassant, De Goncourt, one has to have read them as thoroughly as possible in order to get a reasonably clear idea of the modern novel. Have you read Balzac? I'm reading him again here.

My dear sister, I believe that at present we must paint nature's rich and magnificent aspects; we need good cheer and happiness, hope and love.

The uglier, older, meaner, iller, poorer I get, the more I wish to take my revenge by doing brilliant colour, well arranged, resplendent.

Jewellers are old and ugly too, before they know how to arrange precious stones well. And arranging colours in a painting to make them shimmer and stand out through their contrasts, that's something like arranging jewels or — designing costumes.

You'll see now that by regularly looking at Japanese prints you'll enjoy making bouquets even more, working among flowers. I must finish this letter if I want it to go off today. I'll be very happy to have the photograph of our mother that you mention, so don't forget to send it to me. Give my warm regards to our mother; I often think of you both, and I'm really pleased that now you know our life a little better. I really fear that Theo will find himself too lonely. But one of these days there'll be a Belgian Impressionist painter, the one I mentioned above, who'll come to spend some time in Paris. And there'll be many other painters who'll soon come back to Paris with their studies done during the summer.

I kiss you affectionately, and Mother too.

Ever yours,
Vincent

683 | Arles, Tuesday, 18 September 1888 | *To Theo van Gogh* (F)

My dear Theo,

I already wrote to you early this morning, then I went to continue working on a painting of a sunny garden. Then I brought it back — and went out again with a blank canvas and that's done, too. And now I feel like writing to you again.

Because I've never had such good fortune; nature here is *extraordinarily* beautiful. Everything and everywhere. The dome of the sky is a wonderful blue, the sun has a pale sulphur radiance, and it's soft and charming, like the combination of celestial blues and yellows in paintings by Vermeer of Delft. I can't paint as beautifully as that, but it absorbs me so much that I let myself go without thinking about any rule.

That gives me 3 paintings of the gardens facing the house. Then the two cafés. Then the sunflowers. Then Boch's portrait, and mine. Then the red sun over the factory and the men unloading sand. The old mill. Leaving the other studies aside, you can see that some hard work has been done.

But my colours, my canvas, my wallet are completely exhausted today. The last painting, done with the last tubes on the last canvas, is a naturally green garden, is painted without green as such, with nothing but Prussian blue and chrome yellow. I'm beginning to feel quite different from what I was when I came here, I have no more doubts, I no longer hesitate to tackle something, and that could increase still further.

But what scenery! It's a public garden where I am, just near the street of the good little ladies, and Mourier, for example, never went there, whereas we used to walk in these gardens almost every day, but on the other side (there are 3 of them). But you'll understand that it's precisely that which gives a *je ne sais quoi* of Boccaccio to the place. That side of the garden is also, for the same reason of chastity or morality, empty of

flowering shrubs such as the oleander. It's ordinary plane trees, pines in tall clumps, a weeping tree and green grass. But it has such intimacy! There are gardens like that by Monet.

As long as you can bear the burden of all the colours, canvas, money that I'm forced to spend, keep on sending me them. Because what I'm preparing will be better than the last consignment, and believe that we'll gain rather than lose by it. If, that is, I manage to do an ensemble that will hold together. Which I'm trying to do.

But is it absolutely impossible for Thomas to lend me two or three hundred francs on my studies? That would mean that I would earn over a thousand from them, because I couldn't tell you enough, I'm thrilled, thrilled, thrilled with what I see.

And that gives you *yearnings for autumn*, a zest that means that time passes without your feeling it. Beware the morning after, beware the winter mistrals.

Today, while actually working, I thought a lot about Bernard. His letter is full of veneration for Gauguin's talent — he says that he finds him so great an artist that it almost frightens him, and he finds everything that he, Bernard, does, bad in comparison with Gauguin. And you know that last winter Bernard was still trying to pick a quarrel with Gauguin. Ah well, whatever the case, and whatever happens, it's very consoling that those artists are our friends, and I dare to believe will remain so, no matter how things turn out.

I have such luck with the house with work — that I even dare believe that blessings won't come singly, but that you'll share them for your part, and have good luck too. Some time ago I read an article on Dante, Petrarch, Boccaccio, Giotto, Botticelli; my God, what an impression that made on me, reading those people's letters! Now Petrarch was just near here, in Avignon, and I see the same cypresses and oleanders.

I've tried to put something of that into one of the gardens, painted with thick impasto, lemon yellow and lemon green. Giotto touched me the most — *always suffering* and always full of kindness and ardour as if he were already living in a world other than this.

Giotto is extraordinary, anyway, and I feel him more than the poets: Dante, Petrarch, Boccaccio.

It always seems to me that poetry is more *terrible* than painting, although painting is dirtier and more damned annoying, in fact. And after all, the painter says nothing; he keeps quiet, and I like that even better.

My dear Theo, when you've seen the cypresses, the oleanders, the sun down here — and that day will come, don't worry — you'll think even more often of beautiful works by Puvis de Chavannes: *Pleasant land* and so many others.

Throughout the Tartarin side and the Daumier side of this funny part of the world, where the good folk have the accent that you know, there's already so much that's Greek, and there's the Venus of Arles, like the one of Lesbos, and you can still feel that youthfulness, despite everything.

I don't doubt in the very least that one day you too will know the south.

You'll perhaps go to see Claude Monet when he's in Antibes, or you'll find some opportunity, anyway.

When the mistral's blowing, though, it's the very opposite of a *pleasant* land here, because the mistral's really aggravating. But what a compensation, what a compensation, when there's a day with no wind. What intensity of colours, what pure air, what serene

vibrancy. Tomorrow I'm going to draw until the colours arrive. But now I've reached the point where I've made up my mind not to draw a painting in charcoal any more. There's no point; you have to tackle the drawing with the colour itself in order to draw well.

Ah — the exhibition at the Revue Indépendante — fine — but once and for all — we're far too much smokers to put the cigar in our mouth the wrong way round.

We'll be obliged to try to sell, in order to be able to do again, better, the same things sold; that's because we're in a lousy trade — but let's look for something other than the joy of the town, which means grief at home.

This afternoon I had a select audience of 4 or 5 pimps and a dozen kids who found it particularly interesting to watch the colours come out of the tubes. Ah, well, that sort of audience — that's fame, or rather, I have the firm intention of thumbing my nose at ambition and fame, like these kids and these ruffians from the banks of the Rhône and rue du Bout d'Arles.

I was at Milliet's today; he's going to come tomorrow, having extended his stay by 4 days. I'd like Bernard to go to do his military service in Africa, because he'd do fine things there, and I still don't know what to say to him. He said he'd exchange his portrait for one of my studies.

But he said that he *daren't* do Gauguin, as I'd asked him, because he feels too shy with Gauguin. Bernard is actually so temperamental!! He's sometimes crazy and mean, but I'm certainly not the one who has the right to blame him for that, because I know the same neurosis too much myself, and I know that he wouldn't blame me either. If he went to see Milliet in Africa, Milliet would certainly make friends with him. Because Milliet's very loyal as a friend, and makes love so easily that he almost has contempt for love.

What's Seurat doing? I wouldn't dare show him the studies I've already sent, but the ones of the sunflowers and the bars and the gardens, those I'd like him to see — I often think about his system, and yet I won't follow it at all, but he's an original colourist, and it's the same thing for Signac, but to a different degree; the pointillists have found something new, and I like them very much all the same. But I — I say so frankly — I'm returning more to what I was looking for before coming to Paris, and I don't know if anyone before me has talked about suggestive colour. But Delacroix and Monticelli, while not talking about it, did it.

But I'm again the way I was in Nuenen, when I made a vain attempt to learn music — even then — so strongly did I feel the connections there are between our colour and Wagner's music. Now it's true, I see in Impressionism the resurrection of *Eugène Delacroix*, but the interpretations being both divergent and somewhat irreconcilable, it won't be Impressionism that will formulate the doctrine. It's for that reason that I remain among the Impressionists, because that says nothing and commits you to nothing. And being there as a pal, I don't have to state my position.

My God, you have to play the fool in life; I ask for the time to study, and you, do you ask for anything other than that? But I feel that you must, like me, long to have the peace and quiet needed in order to study with an open mind.

And I'm so afraid of taking it away from you with my requests for money.

However, I do so many calculations, and actually today I found that for the ten metres of canvas I had calculated the colours correctly, except for one, the fundamental one of yellow. If all my colours run out at the same time, isn't that proof that I can

sense the relative proportions like a sleep-walker? It's the way it is with drawing, I hardly measure, and in that I'm quite categorically opposed to Cormon, who says that if he didn't measure he would draw like a pig.

I think you did quite well, all the same, to buy so many stretching frames, because you have to have a certain number to be able to dry the canvases thoroughly, which preserves them, and I also have a whole lot of them here myself. But you mustn't hesitate to take them off the stretching frames, so that everything doesn't take up too much space.

Here I pay 1.50 francs for no. 30, 25, 20 stretching frames, and 1 franc for no. 15, 12, 10. If I have them made by the carpenter.

As carpentry is very expensive here, Tanguy could also supply them if he reckoned them at that price. I'm looking for a frame in light walnut, at 5 francs, for the square no. 30 canvas, and I think I'll get it. A frame in heavy oak for the no. 10 canvas, portrait, also costs me 5 francs.

I've also had to order 5 no. 30 stretching frames for the new canvas, which are already made and which I have to collect. That will prove to you that I can't be without some money at this period of work.

There's a consolation in that we're always among raw materials, and aren't speculating but only trying to produce. And then we can't go wrong.

I hope it'll be like that, and if I'm in the inevitable necessity of using up my colours and my canvas and my wallet, you can be sure that that's not yet the way that we're to perish.

Even if for your part you use up your purse and what's in it, true, it's bad, but say to me calmly: there's nothing left, then there'll be more, because of what I'll have done with it.

But — you'll say to me, rightly — in the meantime? In the meantime — I'll draw, because it's more convenient to do nothing but draw than to paint.

I shake your hand firmly. What days these are, not because of events, but I feel so strongly that we're not decadents, you and I, and not finished yet, and won't be, in time to come.

But you know that I don't contradict the critics who will say that my paintings aren't — finished. I shake your hand, and more soon.

Ever yours,
Vincent

I've read Richepin's Césarine too — I love what the so-called crazy woman says, all of life is well-constructed equations.

686 | Arles, Sunday, 23 or Monday, 24 September 1888 | *To Theo van Gogh* (F)

My dear Theo,

The fine weather of these past few days has disappeared and has been replaced by mud and rain. But it will surely return before the winter.

Only it'll be a matter of taking advantage of it because —

the fine days — are short —

Especially for painting. I plan to do a lot of drawing this winter. If only I could draw figures from memory, I'd always have something to do, but — take a figure by the most skilful of all the artists who sketch from life — Hokusai, Daumier, for me this figure is never what the figure painted from the model by these same masters would be, or other master portraitists.

Ah well — if inevitably we're too often faced with a shortage of models, and especially of intelligent models, we mustn't despair or grow weary of the struggle for that reason.

I've arranged all the Japanese prints in the studio, and the Daumiers and the Delacroixs and the Géricault. If you come across the Delacroix Pietà, or the Géricault, I urge you to buy as many of them as you can.

Another thing that I'd very much like to have in the studio is Millet's Labours of the fields — and Lerat's etching of his Sower that Durand-Ruel is selling for 1.25 francs. And lastly the little etching by Jacquemart after Meissonier, The reader. A Meissonier that I've always found admirable. I can't help liking Meissoniers.

I'm reading an article on Tolstoy in the Revue des Deux Mondes — it appears that Tolstoy takes an enormous interest in his people's religion. Like George Eliot in England.

There's said to be a religious book by Tolstoy, I believe it's called 'Ma religion'; it must be very beautiful. From what I gather from that article, in it he's searching for what will remain eternally true in the religion of Christ, and what all religions have in common; it appears that he admits of neither the resurrection of the body nor even that of the soul, but says like the nihilists that after death there's nothing more, but when a man's dead, and well and truly dead, living humanity remains for ever.

Anyway, not having read the book itself, I couldn't say exactly how he conceives of the matter, but I believe that his religion cannot be cruel and increase our sufferings, but on the contrary, it must be very consoling and must inspire serenity, and energy, and the courage to live, and a whole lot of things.

Among Bing's reproductions I find the drawing of the *blade of grass*, and the carnations, and the Hokusai *admirable*.

But whatever one may say, for me the more ordinary Japanese prints, coloured in flat tones, are admirable for the same reason as Rubens and Veronese. I know perfectly well that this isn't primitive art. But the fact that the primitives are admirable isn't in the very least a reason for me to say, as is becoming a *habit*, 'when I go to the Louvre I can't go beyond the primitives'.

Supposing one were to say to a SERIOUS collector of Japanese art — to Lévy himself — sir, I cannot help finding these 5-sous Japanese prints admirable —

It's more than likely that that person would be a bit shocked and would pity my ignorance and my bad taste.

Exactly as in the past it was in bad taste to like Rubens, Jordaens, Veronese.

I believe that eventually I'll stop feeling lonely in the house, and that on days of bad winter weather, for example, and in the long evenings, I'll find an occupation that will absorb me completely.

A weaver, a basket-maker, often spends entire seasons alone, or almost alone, with his work as his only pastime.

But what makes those people stay where they are is precisely the feeling of the house, *the reassuring, familiar look of things.* Of course I'd like company, but if I don't have it I won't be unhappy on that account, and then, above all, the time will come when I'll have someone. I have little doubt about that. Now in your home too, I believe that if one is willing to put people up one can find plenty among artists, for whom the matter of somewhere to stay is a very serious problem.

And for me, I believe that it's my absolute duty to try to earn money with my work, and so I see my work quite clearly ahead of me.

Ah, if only all artists had enough to live on — enough to work on — but that not being so, I wish to produce, and to produce a great deal, and with intense effort and determination. And perhaps the day will come when we can expand our business and be more influential for others.

But that's a long way off, and there's a great deal of work to be got through first.

If we were living in wartime we'd possibly have to fight, we'd regret it, we'd bemoan not living in peacetime, but at all events, the necessity being there — we'd fight.

And in the same way, we surely have the right to wish for a state of affairs in which money wouldn't be needed in order to live. However, since everything's done with money now, we must think hard about making some while we spend it. But I have a better chance of earning from painting than from drawing.

In short, there are many more people who can skilfully make a croquis than people who can paint freely and who grasp nature from the point of view of colour. That will always be rarer, and whether or not the paintings are slow to be appreciated, they'll find their collector one day.

But I believe that as for the paintings with rather thick impasto, they'll have to dry longer *here.*

I've read that Rubenses in Spain have remained infinitely richer in colour than those in the north. *Ruins,* even exposed to the open air, remain white here, whereas in the north they turn grey, dirty, black, &c. You can be sure that if the Monticellis had dried in Paris they'd now be very much duller.

I'm beginning now to see better the beauty of the women here, and so always, always I think again of Monticelli.

Colour plays an immense part in the beauty of the women here — I'm not saying that their forms aren't beautiful, but that's not where the local charm lies. It's the broad lines of the colourful costume, worn well, and it's the *tone* of the flesh more than the form. But I'll have trouble before I'll be able to do them in the way I'm beginning to feel it. But what I'm certain of is making progress while staying here. And a certain skilfulness isn't enough to make a painting that would be truly of the south. It's looking at things for a long time that matures you and makes you understand more deeply.

I hadn't thought when leaving Paris that I would have found Monticelli and Delacroix so *true.* It's only now, after months and more months, that I'm beginning to realize that they didn't imagine anything. And I think that next year you'll see the same subjects again: orchards, the harvest, but — with a different colour and above all, altered execution. And that will still continue, these changes and these variations. Even while working, I feel that I needn't rush. After all, what would it do to put into practice the

old saying that one should study for ten years or so, and then produce a few figure paintings? That's what Monticelli did, though. Think of several hundred of his paintings as no more than studies.

Then, however, figures the way the yellow woman was, the way the woman with the parasol is, the small one that you have, the lovers that Reid had, those are complete figures, in which as far as the drawing goes there's absolutely nothing to do but to admire it. Because there Monticelli achieves a way of drawing that's as rich and superb as Daumier and Delacroix. Certainly, at the prices Monticellis are at, it would be an excellent speculation to buy some. The day will come when his fine *drawn* figures will be valued as very great art.

I believe that the town of Arles was once infinitely more glorious for the beauty of its women, for the beauty of its traditional dress. Now it all looks sickly and faded as far as character goes.

But if you look at it for a long time, the old charm reveals itself.

And that's why I understand that I'm losing absolutely nothing by staying where I am, and contenting myself with watching things go by, the way a spider in its web waits for flies.

I can't force anything, and as I'm settled now I can take advantage of all the fine days, all the opportunities to catch a real painting from time to time.

Milliet's lucky, he has all the Arlésiennes he wants, but there you are, he can't paint them, and if he was a painter he wouldn't have any. I must bide my time now, without rushing anything.

I've read an article on Wagner — L'amour dans la musique, by the same author who wrote the book on Wagner, I believe. What a need we have of the same thing in painting!

It seems that in the book Ma religion, Tolstoy suggests that whatever may occur in the way of a violent revolution, there will also be a private, secret revolution in people, from which a new religion, or rather, something altogether new, will be reborn, which will have no name but which will have the same effect of consoling, of making life possible, that the Christian religion once had. It seems to me that that book must be very interesting. We'll eventually have enough of cynicism, scepticism, mockery, and we'll want to live — more musically. How will that come about, and what will we find? It would be curious to be able to predict it, but it's even better to have a feeling of what it will be, instead of seeing in the future absolutely nothing but disasters, which will nevertheless be sure to fall into the modern world and civilization like so many terrible thunderbolts, through a revolution or a war or the bankruptcy of moth-eaten governments.

If we study Japanese art, then we see a man, undoubtedly wise and a philosopher and intelligent, who spends his time — on what? — studying the distance from the earth to the moon? — no; studying Bismarck's politics? — no, he studies a single blade of grass.

But this blade of grass leads him to draw all the plants — then the seasons, the broad features of landscapes, finally animals, and then the human figure. He spends his life like that, and life is too short to do everything.

Just think of that; isn't it almost a new religion that these Japanese teach us, who are so simple and live in nature as if they themselves were flowers?

And we wouldn't be able to study Japanese art, it seems to me, without becoming

much happier and more cheerful, and it makes us return to nature, despite our education and our work in a world of convention.

Isn't it saddening that up to now Monticellis have never been reproduced in fine lithographs or vibrant etchings? I'd like to see what artists would say if an engraver like the one who engraved the work of Velázquez were to do a fine etching of them. Be that as it may, I believe it's still more our duty to try to admire and to know things for ourselves than to teach them to others. But the two things can go together. I envy the Japanese the extreme clarity that everything in their work has. It's never dull, and never appears to be done too hastily. Their work is as simple as breathing, and they do a figure with a few confident strokes with the same ease as if it was as simple as buttoning your waistcoat. Ah, I must manage to do a figure with a few strokes. That will keep me busy all winter. Once I have that, I'll be able to do people strolling along the boulevards, the streets, a host of new subjects. While I've been writing you this letter, I've drawn a good dozen of them. I'm on the track of finding it. But it's very complicated, because what I'm after is that in a few strokes the figure of a man, a woman, a kid, a horse, a dog, will have a head, a body, legs, arms that will fit together. More soon, and good handshake.

Ever yours,
Vincent

689 | Arles, Wednesday, 26 September 1888 | *To Theo van Gogh* (F)

My dear Theo,

I'm well aware that I wrote to you only yesterday, but the day has been so beautiful again. My great sorrow is that you can't see what I see here. From 7 o'clock in the morning I sat in front of what was, after all, nothing special — a round cedar or cypress bush — planted in grass. You know this round bush already, since you already have a study of the garden. By the way, included herewith a croquis of my canvas — a square no. 30 again.

The bush is a variegated green, slightly tinged with bronze, the grass is very, very green, Veronese tinged with lemon, the sky is very, very blue.

The line of bushes in the background are all raving mad oleanders. These bloody plants flower in such a way that they could surely catch locomotor ataxia! They're covered in fresh blooms, and then in masses of faded blooms; their foliage also keeps on putting out strong new shoots, apparently inexhaustibly.

A funereal cypress, completely black, stands above them and a number of small coloured figures are strolling along a pink path.

It makes a pendant for another no. 30 canvas of the same place, only from a quite different viewpoint, in which the whole garden is coloured in very different greens under a pale lemon yellow sky. But isn't it true that this garden has a funny sort of style that means that you can very well imagine the Renaissance poets, Dante, Petrarch, Boccaccio, strolling among these bushes on the flowery grass? Now it's true that I've left out some trees, but what I've kept in the composition is really like that.

Only they've overcrowded it with a number of bushes that aren't in character; *and so to find this truer and more fundamental character*, this is the third time I'm painting the same spot.

Now that's the garden that's right in front of my house, after all.

But this corner of a garden is a good example of what I was telling you, that to find the real character of things here, you have to look at them and paint them for a very long time.

Because perhaps you'll see from the sketch alone that the line is now simple.

Again, this painting is heavily impasted, like its pendant with yellow sky.

Tomorrow I hope to work with Milliet again. Today I worked again from 7 o'clock in the morning until 6 o'clock in the evening without moving except to eat a bite a stone's throw away. And that's why the work's going fast.

But what will you say about it — how will it seem to me, too, some time from now?

At the moment I have a clear head, or a lover's blindness toward my work.

Because being surrounded by colour like this is quite new to me, and excites me extraordinarily. Fatigue doesn't come into it; I could do another painting tonight, even, and I could bring it home.

If I tell you that it's very urgent that I receive

6 large tubes lemon chrome yellow I			large tubes
6 " " Veronese green			like the zinc and
3 " " Prussian blue.			silver white
10 " " zinc white			

then it's to be deducted from yesterday's order.

Also 5 metres of canvas.

I can't help it, I feel in a clear frame of mind and I want as far as possible to make sure that I have enough paintings to maintain my position when the others will also be making a great effort for the year '89. Seurat has enough, with 2 or 3 of his enormous canvases, to exhibit all by himself; Signac, who's a good worker, also has enough, Gauguin too, and Guillaumin. So I'd like, myself, to have by that time — whether we were to exhibit it or not — the series of studies:

DECORATION.

That way we'll be entirely original, because the others won't be able to find us pretentious when that's all we have. But be assured that I'll try to give it a *style*.

Milliet was pleased today that I'd done *the ploughed field*; usually he doesn't like what I do, but because the clods of earth were soft in colour, like a pair of clogs, it didn't offend him — with the forget-me-not sky with its flecks of white cloud. If he posed better he would please me greatly, and he would have a smarter portrait than I'll be able do now, although the subject itself is beautiful: his face with its pale, matt complexion, the red képi against an emerald background.

Ah, how I'd like you to see everything that I see these days! With so many beautiful things before me, I can't help letting myself go. Especially because I feel that it'll turn out a little better than the last consignment. But the last consignment was of studies that made me ready to be able to work with confidence these days that are windless.

Why is it that our good *père* Thomas isn't willing to lend me something on my

studies? He'd be wrong not to do it — and I hope that he will do it. I'm fearful of overburdening you, and yet I'd like to order a good two hundred francs worth of colours and canvases and brushes. It's not for something else, it's for that. The whole autumn may be good, and if I knock out a no. 30 canvas every two or three days, I'll earn blenty of thousand-frenk pills. I have a concentrated strength still, which asks for nothing but to be used up in work. But I'll inevitably begin to use up a quantity of colours, and that's why we'd need Thomas.

If I continue working as I am these days, I'll have my study full of really sound studies, the way it is at Guillaumin's. Guillaumin must have some fine new things, of course, I don't doubt it and I'd very much like to see them.

The present studies actually consist of a single *flow of impasto*. The brushstroke isn't greatly divided, and the tones are often broken. And in the end, without intending to, I'm forced to lay the paint on thickly, à la Monticelli. Sometimes I really believe I'm continuing that man's work, only I haven't yet done figures of lovers, like him.

And it's probable that I won't do it, either, before some serious studies from life. But that's not urgent; now I'm determined to work hard until I've surmounted it.

If I want this letter to go off, I must hurry.

Have you any news of Gauguin? I expect a letter from Bernard at any moment, which will follow the croquis, probably.

Gauguin must have another partnership in mind; I've felt that for weeks and yet more weeks.

He's certainly free to do so.

Being alone won't bother me for the time being, and later on we'll find some company anyway, and perhaps more than we'll want. Only I believe that we mustn't say anything unpleasant to Gauguin if he were to change his mind, and take the thing entirely in good part. Because if he joins up with Laval, that's only fair, since Laval's his pupil and they've already kept house together.

If it came to it, well, they could both come here and we'd find a way of putting them up.

As for the furnishing, if I'd known in advance that Gauguin wasn't coming, I'd still have wanted to have two beds in case I had to put someone up. So he's definitely quite free. There will always be those who have a wish to see the south. What has Vignon been doing?? Ah well, if it all turns out for the best everyone will be sure to make great progress, and me too. If you can't see the beautiful days here, you'll still see the paintings of them. And I'm trying to make them better than the others. Handshake and

Ever yours,
Vincent.

[*Sketch* 689A]

689A. *The public garden ('The poet's garden')*

My dear Theo,

Thank you very much for your letter and for the 50-franc note it contained. It's not a rosy prospect that the pains in your leg have come back — my God — it should have to be possible for you to live in the south as well, because I always think that what we need is sunshine and fine weather and blue air as the most dependable remedy. The weather's still fine here, and if it was always like that it would be better than the painters' paradise, it would be Japan altogether. How I think of you and of Gauguin and of Bernard, everywhere and at all times! It's so beautiful, and I'd so much like to see everyone over here.

Included herewith little croquis of a square no. 30 canvas — the starry sky at last, actually painted at night, under a gas-lamp. The sky is green-blue, the water is royal blue, the fields are mauve. The town is blue and violet. The gaslight is yellow, and its reflections are red gold and go right down to green bronze. Against the green-blue field of the sky the Great Bear has a green and pink sparkle whose discreet paleness contrasts with the harsh gold of the gaslight.

Two small coloured figures of lovers in the foreground.

Likewise croquis of a square no. 30 canvas showing the house and its surroundings under a sulphur sun, under a pure cobalt sky. That's a really difficult subject! But I want to conquer it for that very reason. Because it's tremendous, these yellow houses in the sunlight and then the incomparable freshness of the blue.

All the ground's yellow, too. I'll send you another, better drawing of it than this croquis from memory; the house to the left is pink, with green shutters; the one that's shaded by a tree, that's the restaurant where I go to eat supper every day. My friend the postman lives at the bottom of the street on the left, between the two railway bridges.

The night café that I painted isn't in the painting; it's to the left of the restaurant.

Milliet finds it horrible, but I don't need to tell you that when he says he can't understand that someone can enjoy doing such an ordinary grocer's shop, and such stiff, square houses with no charm at all, I reflect that Zola did a certain boulevard at the beginning of L'assommoir and Flaubert a corner of quai de la Villette in the summer heat, at the beginning of Bouvard et Pécuchet, that aren't half bad. And it does me good to do what's *difficult*. That doesn't stop me having a tremendous need for, shall I say the word — for religion — so I go outside at night to paint the stars, and I always dream a painting like that, with a group of lively figures of the pals.

Now I have a letter from Gauguin, who seems very sad and says he'll definitely come once he's made a sale, but still doesn't commit himself as to whether, if he had his fare paid, he would simply agree to untangle himself over there. He says that the people where he's staying are and have been faultless towards him, and that to leave them like that would be a bad deed. But that I turn a dagger in his heart if I were to believe that he wouldn't come straightaway if he could. And furthermore, that if you could sell his canvases cheaply, he for one would be happy. I'll send you his letter with the reply.

Certainly, his arrival would increase the importance of this venture of painting in the south by 100 per cent. And once here, I don't see him leaving soon, because I believe he would put down roots.

And I always say to myself that with his collaboration, what you do in private

would eventually be a more considerable thing than my work on my own; you would have more satisfaction without an increase in expenses.

Later, if some day you were perhaps established on your own account with Impressionist paintings, we'd only have to continue and to expand what exists at present. Lastly, Gauguin says that Laval has found someone who'll give him 150 francs a month, for a year at least, and that Laval will perhaps also come in February. And I having written to Bernard that I believed that he couldn't live on less than 3.50 or 4 francs a day in the south, for board and lodging alone, he says that he believes that for 200 francs a month there would be board and lodging for all 3, which isn't impossible, by the way, living and eating at the studio.

This Benedictine priest must have been very interesting. What, in his opinion, is the religion of the future likely to be? He'll probably say, still the same as the past. *Victor Hugo says, God is a lighthouse whose beam flashes on and off,* and so now, of course, we're passing through that darkness.

My only wish is that they could manage to prove something that would be calming to us, that would console us so that we'd cease to feel guilty or unhappy, and that just as we are we could proceed without getting lost in loneliness or nothingness, and without having at each step to fear or nervously calculate the harm which, without wishing to, we might cause others.

That odd fellow, Giotto, whose biography said that he was always unwell, and always full of ardour and ideas. Well, I'd like to be able to attain that self-confidence that makes a person happy, cheerful and lively at all times. That can happen much more easily in the country or a small town than in that Parisian furnace.

I wouldn't be surprised if you liked the starry night and the ploughed fields — they're calmer than some other canvases. If the work always went like that I'd have fewer worries about money, because people would come to it more easily if the technique continued to be more harmonious. But this bloody mistral is a real nuisance for doing brushstrokes that hold together and intertwine well, with feeling, like a piece of music played with emotion.

With this quiet weather, I let myself go and I have less need to struggle against impossibilities.

Tanguy's consignment has arrived and I thank you for it very, very much, because this way I hope to be able to do something during the autumn for the next exhibition. What's most urgent now is 5 or even 10 metres of canvas. I'll write to you again and will send you Gauguin's letter with the reply. Very interesting what you say about Maurin; at 40 francs his drawings are certainly not dear. More and more I believe that we must believe that true and fair dealing in paintings is to follow one's taste, one's education looking at the masters, one's faith, in a word. It *is no easier*, I'm convinced, to make a good painting than to find a diamond or a pearl; it requires effort, and you stake your life as a dealer or an artist on it. So once you have good stones, it's important not to lack faith in yourself either, but boldly keep things at a certain price.

While waiting, however. . . . But all the same, that thought gives me courage to work, while, however, I naturally suffer from the fact of having to spend money. But this thought of the pearl came to me right in the midst of my suffering, and I wouldn't be surprised if it did you good, too, in your moments of discouragement. There are no more good paintings than there are diamonds.

And there's absolutely nothing dishonest about dealing in good stones. One can believe in oneself when the thing one's selling is good. Now if, though, people like paste, they're at liberty to do so, and since they ask for it, well, one may keep it in stock.

But that isn't enough to feel one is oneself—with good paintings, though, one can feel one is oneself and be firm, because it's a pure error to think that there are as many as one wishes. Perhaps I express myself badly, but I've thought about it a lot lately, and calm has come to me about the Gauguin business.

All these Gauguins are good stones, and let's boldly be the dealers in Gauguins.

Milliet greets you warmly, I have his portrait now, with the red képi against an emerald background, and in this background the emblem of his regiment, the crescent and a 5-pointed star.

[Sketch 691A]

Good handshake and more soon, and thank you very much, and I hope your pains won't last. Have you seen a doctor again? Look after yourself, because physical pain is so annoying.

Ever yours,
Vincent

[Sketches 691B–C]

Et faire le commerce et ... des bonnes
pierres cela n'a absolument rien de
malhonnête. on peut croire en soi
lorsqu'on voit que la chose qu'on vend est
bonne. maintenant pourtant les gens
aiment le strass cela leur est loisible
... et puisqu'ils le demandent bon
en peut en avoir en magasin
mais cela ne suffit pas pour se sentir
soi. avec les bons tableaux pourtant
on peut se sentir soi et être ferme
car c'est pure erreur qu'il y en ait
tant qu'on veut. Peutêtre je m'exprime
mal mais j'y ai beaucoup pensé
de ces jours ci et le calme m'est venu
pour l'affaire Gauguin
Tous ces Gauguin sont de bonnes
pierres et soyons ... marchand
des Gauguin hardiment.
Millet te dit bien le bonjour j'ai
... son portrait maintenant avec
le kepi rouge sur fond emeraude et
dans le fond les armes de son regiment
le croissant et une étoile à 5 pointes.
bonne poignée de main et à bientôt
et bien merci et j'espère que les douleurs
ne dureront pas as tu ... revu un medecin
Soigne toi car la douleur physique est si
aigue. t a t Vincent

691A. *Crescent moon and star*

691B. *The Yellow House ('The street')*

691C. *Starry night over the Rhône*

My dear Gauguin,

This morning, I received your excellent letter, which I've immediately sent to my brother; your conception of the Impressionist in general, of which your portrait is a symbol, is striking. I couldn't be more intrigued to see it — but it will seem to me, I'm already sure, that this work is too important for me to wish to have it as an exchange.

But if you wish to keep it for us, my brother will buy it from you, as I immediately asked him, at the first opportunity if you wish, and let's hope that will be very soon.

Because we'll try once again to urge the possibility of your coming.

I must tell you that even while working I never cease to think about this enterprise of setting up a studio with yourself and me as permanent residents, but which we'd both wish to make into a shelter and a refuge for our pals at moments when they find themselves at an impasse in their struggle. When you left Paris, my brother and I spent more time there together that will always remain unforgettable to me. Our discussions took on a broader scope — with Guillaumin, with Pissarro, father and son, with Seurat, whom I didn't know (I visited his studio just a few hours before my departure). In these discussions, it was often a matter of the thing that's so dear to our hearts, both my brother's and mine, the steps to be taken in order to preserve the financial existence of painters, and to preserve the means of production (colours, canvases), and to preserve directly to them their share in the price that their paintings at present fetch only when they have long ceased to be the property of the artists.

When you're here we'll go back over all those discussions.

In any event, when I left Paris very, very upset, quite ill and almost an alcoholic through overdoing it, while my strength was abandoning me — then I withdrew into myself, and without daring to hope yet.

At present, dimly on the horizon, here it comes to me nevertheless — hope — that intermittent hope that has sometimes consoled me in my lonely life.

Now I'd like to see you taking a very large share in this belief that we'll be relatively successful in founding something lasting.

When we'll talk about those strange days of discussions in the poor studios and the cafés of the *Petit* Boulevard, and you'll see in full our idea, my brother's and mine, which hasn't in any way been carried out, in terms of forming an association.

Nevertheless, you'll see that it is such that everything that we'll do in future to remedy the terrible state of these past few years will either be just what we said, or something similar to it. So unshakeable a basis will we have given the thing. And you'll admit, when you have the full explanation, that we've gone *well beyond* the plan we've already told you about. It's no more than our duty as picture dealers to have gone further, because you perhaps know that I too spent years in the trade, and I don't look down on a profession in which I've eaten my daily bread.

Suffice it to say that I don't believe that even when apparently cutting yourself off from Paris you will cease to feel that you're in fairly direct contact with Paris.

I have an extraordinary fever for work these days, at present I'm grappling with a landscape with blue sky above an immense green, purple, yellow vine with black and orange shoots.

Little figures of ladies with red sunshades, little figures of grape-pickers with their cart further liven it up.

Foreground of grey sand. Once again square no. 30 canvas for the decoration of the house.

I have a portrait of myself, all ash-coloured. The ashy colour that comes from mixing Veronese with orange lead, on a pale background of uniform Veronese, with a red-brown garment. But exaggerating my personality also, I looked more for the character of a bonze, a simple worshipper of the eternal Buddha. It cost me a good deal of trouble, but I'll have to do it all over again if I want to express the thing. I'll have to cure myself even further of the conventional numbness of our so-called civilized state, in order to have a better model for a better painting.

Something that gave me enormous pleasure; I received a letter from Boch yesterday (his sister is one of the Belgian Vingtistes), who writes that he's settled in the Borinage to paint miners and coal-mines there. He'll return, though, to what he has in mind in the south — to vary his impressions, and in that case will certainly come to Arles.

I find my artistic ideas extremely commonplace in comparison with yours.

I always have an animal's coarse appetites. I forget everything for the external beauty of things, *which I'm unable to render* because I make it ugly in my painting, and coarse, whereas nature seems perfect to me.

Now, however, the energy of my bony carcass is such that it goes straight to the target; from that comes a perhaps sometimes original sincerity in what I make, if, that is, the subject lends itself to my rough and unskilful execution.

I believe that if from now on you began to think of yourself as *the head of this studio*, which we'll attempt to make a refuge for several people, little by little, bit by bit, as our unremitting work provides us with the means to bring the thing to completion — I believe that then you'll feel relatively consoled for your present misfortunes of penury and illness, considering that we're probably giving our lives for a generation of painters that will survive for many years to come.

These parts of the world have already seen both the cult of Venus — essentially artistic in Greece — and the poets and artists of the Renaissance. Where these things have been able to flower, Impressionism can do so too.

About the room where you'll stay, I've made a decoration especially for it, the *garden of a poet* (in the croquis Bernard has there's a first idea for it, later simplified). The unremarkable public garden contains plants and bushes that make one dream of landscapes in which one may readily picture to oneself Botticelli, Giotto, Petrarch, Dante and Boccaccio. In the decoration I've tried to tease out the essence of what constitutes the changeless character of the region.

And I'd have wished to paint this garden in such a way that one would think both of the old poet of this place (or rather, of Avignon), Petrarch, and of its new poet — Paul Gauguin.

However clumsy this effort, you'll still see, perhaps, that while preparing your studio I've thought of you with very deep feeling.

Let's be of good heart for the success of our enterprise, and may you continue to feel very much at home here.

Because I'm so strongly inclined to believe that all this will last for a long time.

Good handshake, and believe me

Ever yours,
Vincent

Only I'm afraid that you'll find Brittany more beautiful — even though you may well see nothing more beautiful than things out of Daumier, figures here are often pure Daumier. Now, as for you, it won't take you long to discover, under all the modernity, the ancient world and the Renaissance, which is sleeping. Now, as far as they're concerned, you're at liberty to reawaken them.

Bernard tells me that he, Moret, Laval and someone else would do an exchange with me. I am really, in principle, a great supporter of the system of exchanges among artists, since I see that it occupied a considerable place in the life of the Japanese painters. So one of these days I'll send you such studies as I have to spare, in the dry state, and you'll have first choice.

But I won't exchange a single one with you if on your part it would mean costing you something as significant as your portrait, which would be too beautiful. *For sure,* I wouldn't dare, because my brother will gladly buy it from you against a whole month's allowance.

698 | Arles, on or about Friday, 5 October 1888 | *To Emile Bernard* (F)

My dear old Bernard.

The consignment Gauguin and you sent arrived at almost the same time as my studies went off. I was delighted, it really warmed my heart to see the two faces again. As for your portrait — you know — I like it very much — actually I like everything that you do, as you know — and perhaps nobody *before* me has liked what you do *as much* as I do.
 I really urge you to study the portrait; make as many as possible and don't give up — later we'll have to attract the public through portraits — in my view that's where the future lies. But let's not get sidetracked into hypotheses now. Because it's up to us next to thank you for the collection of rough sketches entitled *At the brothel*.
 Bravo! The woman washing herself and the one who says 'I'm second to none when it comes to taking it out of a man' are the best, it seems to me. The others are grimacing too much — and most of all, are too vague, too little flesh and bone properly built up.
 It doesn't matter; it's already something altogether new and interesting, and the rest, too — at the brothel — yes, that's what needs to be done, and I assure you that I for one almost envy you this bloody good opportunity you have to go in there in uniform. Which those good little women adore. The poem at the end is really beautiful; stands up better than some of the figures. What you want, and what you say you believe, you say well and resonantly.
 Write to me when you're going to be in Paris — the thing is that I've already written you a thousand times that my night café *isn't a brothel*, it's a café where night prowlers

cease to be night prowlers, since, slumped over tables, they spend the whole night there without prowling at all. Occasionally a whore brings her fellow there. But arriving there one night I came across a little group of a pimp and a whore who were making up after a quarrel. The woman was pretending to be indifferent and haughty, the man was tender. I started to paint it for you from memory — on a little no. 4 or no. 6 canvas — now if you're leaving soon — I'll send it to you in Paris; if you're staying longer, say so, I'll send it to you in Pont-Aven. I couldn't add it to the consignment, it was nowhere near dry enough.

But I don't want to sign this study, because I never work from memory — there will be colour in it, which will suit you, but to repeat, here I'm doing a study for you that I would prefer not to do. I mercilessly destroyed an important canvas — a Christ with the angel in Gethsemane — as well as another one depicting the poet with a starry sky — because the form hadn't been studied from the model beforehand, necessary in such cases — despite the fact that the colour was right.

If the study I'm sending you in exchange doesn't suit you, just look at it a little longer.

I had the devil's own job to do it with an irritating mistral (like the study in red and green, as well). Well, despite the fact that it wasn't painted as fluently as the old mill — it's more delicate and more intimate. You see that all of this is perhaps not at all — Impressionist — well, too bad, I can't do anything about it — but I do what I do with an abandonment to reality, without thinking about this or that. Goes without saying that if you preferred another study from the batch to the Men unloading sand, you could take it and remove my dedication if someone else wants it. But I believe that that one will suit you once you've looked at it a little longer.

If Laval, Moret and the other one agree to make exchanges with me, perfect, but on my side I'd be especially satisfied if they wanted to do their portraits for me.

You know, Bernard, it always seems to me that if I want to do studies of brothels I'd need more money than I have; I'm not young or womanizer enough for them to pose for me for free. And I can't work without a model. I'm not saying that I don't flatly turn my back on reality to turn a study into a painting — by arranging the colour, by enlarging, by simplifying — but I have such a fear of separating myself from what's possible and what's right as far as form is concerned.

Later, after another ten years of studies, all right, but in very truth I have so much curiosity for what's possible and what really exists that I have so little desire or courage to search for the ideal, in so far as it could result from *my* abstract studies.

Others may have more clarity of mind than I for abstract studies — and you might certainly be among them, as well as Gauguin and perhaps myself when I'm old.

But in the meantime I'm still living off the real world. I exaggerate, I sometimes make changes to the subject, but still I don't invent the whole of the painting; on the contrary, I find it ready-made — but to be untangled — in the real world.

But you'll probably find these studies ugly, I don't know. In any case, neither you nor anyone else should do an exchange grudgingly.

My brother writes that Anquetin's back in Paris; I'm curious to know what he's made. When you see him you'll give him my warm regards.

The house will seem more lived-in now that I'll see the portraits in it.

How happy I would be to see you there yourself this winter; it's true that the trip

costs rather a lot. Nevertheless, may one not risk those expenses by taking one's revenge by working? Work's so difficult in the north in winter. Here too, perhaps; I've hardly had the experience yet and it remains to be seen.

But it's damned useful to see the south, where life is lived more in the open air, in order to understand the Japanese better.

And that touch of the haughty and the noble that certain places have down here will suit your book very well. In the Red sunset, the Sun should be imagined higher, outside the painting, let's say just at the level of the FRAME. Because it so happens that an hour, an hour and a half before it sets, the things on the earth still keep their colours like that. Later the blue and the violet colour them darker, as soon as the sun sends out rays that are more horizontal. Thanks once again for what you sent me, it really warmed my heart.

And a good handshake in thought, and write to me the day of your departure so that I know when you'll be in Paris; address in Paris still avenue de Beaulieu 5, isn't it?

Ever yours,
Vincent

702 | Arles, Wednesday, 10 or Thursday, 11 October 1888 | *To Theo van Gogh* (F)

My dear Theo,

When lately I very often think that all the costs of painting weigh on you, you couldn't imagine what anxiety I have about it. When things like what you describe about Bague in your last letter happen to us, then we must be on the point of selling. Or much rather, we must be on the point of being able to find some help, either from Thomas or from someone else, of the half-dealer, half-collector sort. Thus C.M., even without helping us in any other way, could buy another study from us. I don't know if you've ever read Les frères Zemganno by the De Goncourts, who perhaps loosely retrace their own history. If you know it, you'll know, more than I'd know how to express to you, that I fear that the effort of obtaining money for us will be too exhausting for you.

If I wasn't dreadfully, and always, tormented by that anxiety, I would say things were going well, because the work will improve and my health is much better than in Paris. I realize more and more that work goes infinitely better when you feed yourself well, when you have your paint, when you have your studio, and all that. But is my heart set on my work going well? *No*, and a thousand times *no*. I'd like to succeed in making you clearly feel this truth, that in giving money to artists you yourself are doing an artist's work, and that I'd wish only that my canvases might become of such a kind that you aren't too unhappy with *your* work.

And that's not all; I'd also like you to feel that we earn from the money that we transfer, and that by so doing, we'll achieve a more complete independence than that provided by the trade as such.

And what we'll do later to revive the trade could well be precisely that dealers live with artists, the one for what one may call the housekeeping side, to supply studio, food, paint &c., the other to produce. Alas, we're not at that stage with the old trade,

which will always follow the old routine that benefits nobody among the living and does no good for the dead, either. But what of it; that may leave us more or less cold, not having a duty to change what exists or to battle against a wall. Anyway, we'd have to get our share of sunshine without vexing anyone. And I always figure to myself that you don't have your whole share of sunshine, since your work in Paris with the Goupils is too exhausting. So when I think about that, I have a dealer's rage; then I want to earn money so that you can be freer to go and do what you want. I feel that we're on the point of selling or of finding help that will give us breathing space.

There you are, perhaps I believe that what may still be far away is nearer than it in fact is, and then I feel this anxiety coming over me, of spending too much.

However, paintings come off better if one takes care of oneself and keeps well. But for you, for your work, for your whole life as well, you mustn't have too many worries. How are those sciatic pains? Have they stopped?

Whatever happens, you'd help me more by keeping well, by living well; even if the consignments of colours had to suffer as a result, than by being too much in straits on my account. I believe that the day will come when people will want the work — well — but perhaps that's still far away, and meanwhile, don't be too hard up.

Because business, too, will come to you by itself and as if in a dream, better and more quickly if you take care of yourself than if you make yourself hard up. And look, at our age, surely we can finally have a certain calm, a certain wisdom about doing things. I fear now (and I avoid them) poverty, bad health and all that, and I hope you have the same sentiments.

So I almost have a feeling of remorse at having today bought this piece of furniture, although it's good, because I had to ask you to send me money sooner than if it hadn't been for that.

Be sure of this. If you were ill or if you had too much pain and trouble, nothing would work any more. And if you are well, business will eventually come to you by itself, and ideas for doing some business will come to you infinitely more by eating well than by not eating enough.

So shout at me to stop if I'm going too far. If not, it's naturally much better, because for me too, I can of course work much better if I'm comfortable rather than too hard up. But don't go believing that I'm more attached to my work than to our well-being, or at least to our peace of mind, above all. Once Gauguin's here he'll feel the same thing — and he'll recover.

The day may well come for him when he'll wish, and will be able, to become the family man again that he really is. I'm very, very curious to know what he has done in Brittany. Bernard writes many good things about it. But doing rich painting is so difficult to do in the cold and in poverty — and possible that in fact his real home will prove to be, when all's said and done, the warmer and happier south.

If you saw the vineyards! There are bunches *weighing a kilo*, even — the grape is magnificent this year, from the fine autumn days coming at the end of a summer that left much to be desired.

I regret having spent money on this chest of drawers, but it can save us buying a dearer one — the *least* would have been 35. And when Gauguin comes, he would in any case have to have something there to put his linen in, and anyway his bedroom will be

more complete like this. (I notice that this cupboard has panels just like those on which Monticelli painted.)

Once we have a richer moment I'd take this one for myself and he'd take the one at 35 francs. At that price there's *always* something second-hand, but *not* always at the price at which I bought this one.

I've been thinking that if at your place there are now beginning to be certain studies that might be taking up too much room at your place and getting in your way, they could be taken off their stretching frames and sent here, where we have enough room to store them. I'm saying that about certain things from the past year, or, indeed, for everything that might be in your way. Paris will be very beautiful in the autumn, all the same. The town here is *nothing* at night, everything's *dark*.

I believe that an abundance of gaslight, which, after all, is yellow and orange, intensifies blue, because at night the sky here seems to me, and it's very funny, *darker* than in Paris. And if I ever see Paris again, I'll try to paint effects of gaslight on the boulevard.

Ah, it must be the opposite in Marseille; I imagine that it must be more beautiful than Paris, La Canebière.

I so often think of Monticelli, and when I reflect on what they say about his death it seems to me that not only must we put aside the idea that he died *a drinker* in the sense of *stupefied* by drink, but we should also know that, even more than in the north, life is quite naturally spent in the open air and in cafés. My friend the postman, for example, lives a great deal in cafés and is certainly more or less a drinker and has been so all his life. But he's so much the opposite of *stupefied*, and his elation is so natural, so intelligent, and then he argues with such a broad sweep, à la Garibaldi, that I'm quite prepared to reduce the legend of Monticelli the absinthe drinker to exactly the proportions of this case of my postman. My paper's full, write to me as soon as is possible for you. Handshake and good luck.

Ever yours,
Vincent

One day I'll perhaps know the details about those last days of Monticelli's.

One day Mrs de Larebey la Roquette said to me: Monticelli, now, Monticelli, but he was a man who should have been at the head of a big studio in the south.

The other day, you remember, I wrote to our sister and to you that sometimes I believed I had the feeling that I was continuing Monticelli here. Good—but you see now—the studio in question, we're setting it up.

What Gauguin will do, what I'll also do myself, will be in keeping with that fine oeuvre by Monticelli, and we'll try to prove to the good folk that Monticelli didn't quite die, slumped over the tables of the cafés along La Canebière, but that the little old chap is still alive.

And the thing won't end with us either; we're starting it off on quite a solid footing.

My dear Theo,

I had hardly dared hope so soon for your new 50-franc money order, for which I thank you very much.

I have many expenses, and it sometimes distresses me greatly when I increasingly come to realize that painting is a craft that is probably practised by extremely poor people, since it costs a lot of money.

But the autumn still continues to be so fine! What a funny part of the country, this homeland of Tartarin's! Yes, I'm happy with my lot; it isn't a superb and sublime country, it's all something out of Daumier come to life. Have you re-read the Tartarins yet? Ah, don't forget to! Do you remember in Tartarin the lament of the old Tarascon diligence — that wonderful page? Well, I've just painted that red and green carriage in the yard of the inn. You'll see.

[*Sketch* 703A]

This hasty croquis gives you its composition.

Simple foreground of grey sand.

Background very simple too, pink and yellow walls with windows with green louvred shutters, corner of blue sky.

The two carriages very colourful: green, red, wheels yellow, black, blue, orange. A no. 30 canvas once again. The carriages are painted in the style of Monticelli, with impastos. You once had a very beautiful Claude Monet, of 4 colourful boats on a beach. Well, here it's carriages, but the composition is of the same kind.

Now imagine a huge green-blue fir tree spreading its horizontal branches over a very green lawn and sand dappled with light and shade.

[*Sketch* 703B]

This very simple corner of a garden is enlivened by beds of orange lead geraniums in the background areas, under the black branches. Two figures of lovers stand in the shade of the big tree. No. 30 canvas.

And then two more no. 30 canvases, the Trinquetaille bridge and another bridge; the railway goes over the road.

[*Sketch* 703C]

That canvas is a little like a Bosboom in coloration.

[*Sketch* 703D]

Lastly, the Trinquetaille bridge with all its steps is a canvas done on a grey morning, the stones, the asphalt, the cobblestones are grey, the sky a pale blue, the small figures colourful, a puny tree with yellow foliage. Two canvases, then, in grey, broken tones, and two highly coloured canvases.

Forgive these very poor croquis.

I'm knocked out from painting this Tarascon diligence, and I can see that I haven't a head fit for drawing. I'm off to have supper, and I'll write to you again this evening.

Mon cher Theo, je n'avais tout a fait ~~osé~~ espérer
aussitôt ton nouveau mandat de 50 francs
dont je te remercie beaucoup.
J'ai beaucoup de frais et cela me chagrine
bien quelquefois lorsque de plus en plus je m'aperçois
que la peinture est un metier que probablement
est exercé par des gens excessivement pauvres
puisqu'il coûte beaucoup d'argent. ~~et~~
Mais l'automne continue encore à être d'un
beau! quel drôle de pays que cette patrie
de Tartarin. Oui je suis content de mon
sort; c'est pas un pays superbe et sublime
ce n'est que du Daumier bien vivant.
As tu deja relu les Tartarin ah ne
l'oublie pas! Te rappelles tu dans Tartarin
la complainte d'alvieill. ~~omnibus~~
dilligence de Tarascon - cette admirable
page - Eh bien je ~~viens~~ de la peindre
cette voiture rouge et verte dans la
cour de l'auberge - Tu verras.

703A. *The Tarascon diligence*

Le croquis hâtif t'en donne la composition · un
avant plan simple de sable gris
fond aussi très simple murailles roses et
jaunes avec fenêtres vertes coin de ciel bleu
Les deux voitures très colorées, vert rouge
jaune noir bleu orangé Toile de 30
toujours. Les voitures sont peintes à
avec des empâtements
la monticelli . Tu avais dans le temps un
bien beau Claude Monet representant 4
barques colorées sur une plage. Eh bien
c'est ici des voitures mais la composition
est dans le même genre .

Suppose maintenant
un sapin bleu
vert immense étend
des branches horizontales
sur une pelouse très
vert et du sable
tacheté de lumière
et d'ombre .
Ce coin de jardin
fort simple

est egayé par des parterres de géraniums nains
orange dans les fonds sous les branches noires.
Deux figures d'amoureux se trouvent à l'ombre
du grand arbre Toile de 30.

703B. *The public garden with a couple strolling ('The poet's garden')*

703C–D (top to bottom). *The viaduct; The Trinquetaille bridge*

But this decoration is coming along a bit, and I believe that it will broaden my way of seeing and doing things.

It will be open to a thousand criticisms; very well, but never mind, as long as I manage to put some spirit into it.

But yes, good old Tartarin's country, I'm enjoying myself there more and more, and it will become like a new homeland for us. I don't forget Holland, though; it's precisely the contrasts that make me think of it a lot. I'll get back to this letter shortly.

Now I'm getting back to this letter again. How I'd like to be able to show you the work that's in progress!

I'm really so tired that I can see that my writing isn't up to much.

I'll write to you better another time, because it's beginning to take shape now, this idea of the decoration.

I wrote to Gauguin again the day before yesterday, to say once again that he would probably recover much more quickly here.

And he'll do such fine things here.

He'll need time to recover. I assure you that I believe that if ideas for work are coming to me more clearly and more abundantly at present, then eating good food has a lot to do with it. And that's what everybody in painting should have.

How many things that still have to change! Isn't it true that all painters ought to live like manual workers? A carpenter, a blacksmith, normally produces infinitely more than they do. In painting too, there should be large studios where each person would work more steadily.

I'm really falling asleep standing up, and I can't see any longer, my eyes are so tired.

More soon, because I still had lots of things to say, and I should make you some better croquis. Probable that I'll do it tomorrow.

Thank you many times again for your money order. I shake your hand firmly.

Ever yours,
Vincent

It's 5 canvases that I've started on this week; that brings, I believe, to 15 the number of these no. 30 canvases for the decoration.

2 canvases of sunflowers

3	"	poet's garden
2	"	other garden
1	"	Night café
1	"	Trinquetaille bridge
1	"	Railway bridge
1	"	the house
1	"	the Tarascon diligence
1	"	the starry night
1	"	the furrows
1	"	The vineyard.

My dear Gauguin,

Thanks for your letter, and thanks most of all for your promise to come as early as the twentieth. Agreed, this reason that you give won't help to make a pleasure trip of the train journey, and it's only right that you should put off your journey until you can do it without it being a bloody nuisance. But that apart, I almost envy you this trip, which will show you, *en passant*, miles and miles of countryside of different kinds with autumn splendours.

I still have in my memory the feelings that the journey from Paris to Arles gave me this past winter. How I watched out to see 'if it was like Japan yet'! Childish, isn't it?

Look here, I wrote to you the other day that my vision was strangely tired. Well, I rested for two and a half days, and then I got back to work. But not yet daring to go outside, I did, for my decoration once again, a no. 30 canvas of my bedroom with the whitewood furniture that you know. Ah, well, it amused me enormously doing this bare interior.

With a simplicity à la *Seurat*.

[*Sketch 706A*]

In flat tints, but coarsely brushed in full impasto, the walls pale lilac, the floor in a broken and faded red, the chairs and the bed chrome yellow, the pillows and the sheet very pale lemon green, the bedspread blood-red, the dressing-table orange, the washbasin blue, the window green. I had wished to express *utter repose* with all these very different tones, you see, among which the only white is the little note given by the mirror with a black frame (to cram in the fourth pair of complementaries as well).

Anyway, you'll see it with the others, and we'll talk about it. Because I often don't know what I'm doing, working almost like a sleepwalker.

It's beginning to get cold, especially on the days when the mistral blows.

I've had gas put in the studio, so that we'll have good light in winter.

Perhaps you'll be disillusioned with Arles if you come at a time when the mistral's blowing, but wait . . . It's in the long term that the poetry down here soaks in.

You won't find the house as comfortable yet as we'll gradually try to make it. There are so many expenses, and it can't be done in one go. Anyway, I believe that once here, like me, you'll be seized with a fury to paint the autumn effects, in between spells of the mistral. And that you'll understand that I've insisted that you come now that there are some very beautiful days. Au revoir, then.

Ever yours,
Vincent

Eh bien cela m'a énormément amusé
de faire cet intérieur sans rien.
D'une simplicité à la Seurat.

A teintes plates mais grossièrement brossés
en pleine pâte les murs, lilas pâle
le sol d'un rouge rompu e fané les
chaises e le lit jaune de chrome les oreille
et le drap citron vert très pâle la couverture
rouge sang la table à toilette orangée
la cuvette bleue la fenêtre verte
j'avais voulu exprimer un repos
absolu par tous ces tons très divers
vous voyez et où il n'y a de blanc que
la petite note que donne le miroir à
cadre noir (pour fourrer encore la quatrième
paire de complémentaires dedans)
Enfin vous verrez cela avec les autres et nous
en causerons; car je ne sais souvent

706A. *The bedroom*

My dear Theo,

Thank you for your letter and for the 50-franc note it contained. Thank you for having written me more about those Dutch artists' painting.

I've had gas put in, in the studio and the kitchen, which is costing me 25 francs for installation. If Gauguin and I work every evening for a fortnight, won't we earn it all back again? But since, what's more, G. may come any day now, I'll absolutely absolutely need at least another 50 francs.

I'm not ill, but I'd become so without any doubt if I didn't take hearty food and if I didn't stop painting for a few days. In fact, I'm once again nearly reduced to the state of madness of Hugo van der Goes in Emile Wauters's painting. And if it wasn't for the fact that I had something of a dual nature, something of both the monk and the painter, I should be — and that long since — utterly and entirely reduced to the above-mentioned state.

But even for all that, I don't believe that my madness would be of the persecution kind, since my feelings in a state of excitement have more to do with preoccupations about eternity and eternal life.

But even so, I must be wary of my nerves, &c.

I only say that because you'd be wrong to believe that I'd have had the slightest *wariness* about these two Dutch painters. But in truth, it's only after your second letter that I can form an idea of what they're doing, and I'm very curious to see the photographs of their drawings.

I have a great urge to write you a letter just so that you can have them read it, to explain once again why I myself believe in the south for the future and the present.

And at the same time to say how strongly I believe that we're right to see in the Impressionist movement a tendency towards great things, and not *only* a school that would limit itself to making optical experiments. Similarly with those who do history painting, then, or at least have done it in the past; while there are some very bad history painters, like Delaroche and Delort, are there not also good ones, like E. Delacroix and Meissonier?

Well then, since I have the firm intention not to paint for at least 3 days, perhaps I'll rest by writing to you and to them at the same time. Because you know that that interests me a good deal, the influence that Impressionism will have on Dutch painters and on Dutch art lovers.

[*Sketch* 709A]

Here's very rough croquis of my last canvas. A row of green cypresses against a pink sky with a pale lemon crescent moon.

Foreground a piece of waste land, and some sand and a few thistles. Two lovers, the man pale blue with a yellow hat, the woman has a pink bodice and a black skirt. That makes the fourth canvas of the 'poet's garden', which is the decoration for Gauguin's bedroom.

It horrifies me to have to ask you for money again, but I can do nothing about it, and what's more, I'm worn out again. However, I'd believe that the work that I'm

J'ai bien envie de t'écrire une lettre
exprès que tu pourras leur faire lire
pour ~~leur~~ expliquer encore une fois
pourquoi je crois mois au midi pour
l'avenir et le présent.
Et pour dire en même temps combien
je crois qu'on a raison de voir dans
le mouvement impressioniste une
tendance vers les choses grandes
et non pas seulement une école
qui se bornerait a faire des expériences
optiques. Ainsi pour eux qui font
alors de la peinture d'histoire ou au moins
l'ont faite dans le temps s'il y a des bien
mauvais peintres d'histoire comme Delaroche et
Delort n'en a t il pas également des bons
comme Eug Delacroix et Meissonnier.
Enfin puisque decidemment j'ai l'intention
de ne pas peindre au moins durant 3 jours
peut être me reposerai je en l'écrivant et à
eux en même temps. Car tu sais que cela
m'intéresse assez l'influence qu'aura l'impressionnisme
sur les peintres hollandais et sur les amateurs
hollandais.

709A. *Row of cypresses with a couple strolling ('The poet's garden')*

doing while spending a little more will one day seem to us less costly than my previous work.

Besides, I'd already told you that if the thing had been possible, to do a deal with Thomas, I'd have had a strong desire to be able to put even 200 more into the work before Gauguin's arrival.

As that couldn't be done, I nevertheless pressed ahead as far as I could with what I had on the go, in a strong desire to be able to show him something new. And not to fall under his influence (because of course he'll have an influence on me, I hope) before being able to show him beyond any doubt my own originality. He'll see that anyway from the decoration as it is now.

Please, at least if the thing's possible for you, send me another fifty francs right away; I don't quite know how I'll be able to get by otherwise. I'm pleased that you've read Tartarin again. Anyway. I hope you'll be able to write to me no later than by return of post. I shake your hand firmly.

Ever yours,
Vincent

712 | Arles, on or about Thursday, 25 October 1888 | *To Theo van Gogh* (F)

My dear Theo

Thank you for your letter and for the 50-franc note. As you learned from my telegram, Gauguin arrived in good health. He even gave me the impression of being in better shape than me.

He's naturally very pleased with the sale that you made, and I no less, since that way certain other expenses absolutely necessary for moving in needn't wait nor will fall on your shoulders alone. G. will certainly write to you today. He's very, very interesting as a man, and I have every confidence that with him we'll do a great many things. He'll probably produce a great deal here, and perhaps I shall too, I hope.

And then I dare believe that for you the burden will be *a little* less heavy, and I dare believe *much* less heavy.

I myself feel, to the point of being mentally crushed and physically drained, the need to produce, precisely because in short I have no other means, none, none, of ever recouping our outlay.

I can do nothing about it if my paintings don't sell.

The day will come, though, when people will see that they're worth more than the cost of the paint and my subsistence, very meagre in fact, that we put into them.

I have no other wish nor other concern regarding money or finances than in the first place not to have debts.

But my dear brother, my debt is so great that when I've paid it, which I think I'll succeed in doing, the hardship of producing paintings will, however, have taken my entire life, and it will seem to me that I haven't lived. The only thing is that perhaps the production of paintings will become a little more difficult for me, and as far as the number goes, there won't always be as many.

The fact that they don't sell now makes me anxious that you're suffering too, but it would be of little concern to me if you didn't become too hard up by my bringing nothing in.

But in money matters it's enough for me to feel this truth, that a man who lives for 50 years and spends two thousand a year spends a hundred thousand francs, and that he must bring a hundred thousand in, too. To make a thousand paintings at a hundred francs during one's life as an artist is very, very, very hard, but when the painting is at a hundred francs and again our task is very heavy at times. But nothing about that can be altered.

We'll let Tasset down completely, probably, because to a large extent at least, we'll use less expensive colours, both Gauguin and I. As for canvas, we'll also prepare it ourselves.

For a time I had the slight feeling that I was going to be ill, but Gauguin's arrival has so taken my mind off it that I'm sure it will pass. I mustn't neglect my diet for a while, and that's all. And absolutely all.

And after a time you'll have some work.

Gauguin has brought a magnificent canvas that he exchanged with Bernard, Breton women in a green meadow. White, black, green and a red note, and the matt tones of the flesh. Anyway, let's all be of good heart.

I believe that the day will come when I'll sell too, but I'm so far behind with you, and while I spend I bring nothing in.

That feeling sometimes makes me sad.

I'm very, very happy at what you write, that one of the Dutchmen will come and live with you, and that that way you won't be alone any more, either. It's perfectly, perfectly good, especially as we'll soon have winter.

Anyway, I'm in a hurry, and have to go out to get back to work on another no. thirty canvas.

Soon, when Gauguin writes to you, I'll add another letter to his.

Of course, I don't know in advance what Gauguin will say about this part of the world and about our life, but in any case he's very happy with the good sale that you made for him.

More soon, and I shake your hand firmly.

Ever yours,
Vincent

716 | Arles, Thursday, 1 or Friday, 2 November 1888 | *Vincent van Gogh and Paul Gauguin to Emile Bernard* (F)

My dear old Bernard,

We've done a great deal of work these past few days, and in the meantime I've read Zola's Le rêve, so I've hardly had time to write.

Gauguin interests me greatly as a man — greatly. For a long time it has seemed to me that in our filthy job as painters we have the greatest need of people with the

hands and stomach of a labourer. More natural tastes — more amorous and benevolent temperaments — than the decadent and exhausted Parisian man-about-town.

Now here, without the slightest doubt, we're in the presence of an unspoiled creature with the instincts of a wild beast. With Gauguin, blood and sex have the edge over ambition. But enough of that, you've seen him close at hand longer than I have, just wanted to tell you first impressions in a few words.

Next, I don't think it will astonish you greatly if I tell you that our discussions are tending to deal with the terrific subject of an association of certain painters. Ought or may this association have a commercial character, yes or no? We haven't reached any result yet, and haven't so much as set foot on a new continent yet.

Now I, who have a presentiment of a new world, who certainly believe in the possibility of a great renaissance of art. Who believe that this new art will have the tropics for its homeland.

It seems to me that we ourselves are serving only as intermediaries. And that it will only be a subsequent generation that will succeed in living in peace. Anyway, all that, our duties and our possibilities for action could become clearer to us only through actual experience.

I was a little surprised not yet to have received the studies that you promised in exchange for mine.

Now something that will interest you — we've made some excursions in the brothels, and it's likely that we'll eventually go there often to work. At the moment Gauguin has a canvas in progress of the same night café that I also painted, but with figures seen in the brothels. It promises to become a beautiful thing.

I've made two studies of falling leaves in an avenue of poplars, and a third study of the whole of this avenue, entirely yellow.

I declare I don't understand why I don't do figure studies, while theoretically it's sometimes so difficult for me to imagine the painting of the future as anything other than a new series of powerful portraitists, simple and comprehensible to the whole of the general public. Anyway, perhaps I'll soon get down to doing brothels.

I'll leave a page for Gauguin, who will probably also write to you, and I shake your hand firmly in thought.

Ever yours,
Vincent

Milliet the 2nd lieut. Zouaves has left for Africa, and would be very glad if you were to write to him one of these days.

[Continued by Paul Gauguin]

You will indeed do well to write him what your intentions are, so that he could take steps beforehand to prepare the way for you.

Mr Milliet, second lieutenant of Zouaves, Guelma, Africa.

Don't listen to Vincent; as you know, he's prone to admire and ditto to be indulgent. His idea about the future of a new generation in the tropics seems absolutely right to me as a painter, and I still intend going back there when I find the funds. A little bit of luck, who knows?

Vincent has done two studies of falling leaves in an avenue, which are in my room and which you would like very much. On very coarse, but very good sacking.

Send news of yourself and of all the pals.

Yours,
Paul Gauguin

718 | Arles, Saturday, 10 November 1888 | *To Theo van Gogh* (F)

My dear Theo,

I've received a letter from Mr E. Dujardin regarding the exhibition of some canvases of mine in his dark hole. I find it so disgusting to pay for the planned exhibition with a canvas that in reality there aren't two answers to this gentleman's letter. There's one, and you'll find it enclosed. Only I'm sending it to you and not to him so that you know my thoughts and so that you can simply tell him that I've changed my mind and haven't the slightest desire to exhibit at this moment. It's no use at all getting angry with the chap, it's better to be tritely polite.

So no exhibition at the Revue Indépendante, I make so bold as to believe that Gauguin is of the same opinion. In any case he doesn't at all urge me to do it.

We've hardly ever exhibited, have we?

There were a few canvases at Tanguy's place first of all, at Thomas's and then at Martin's.

Now I declare here that I absolutely do not know what useful purpose that even serves, and it would seem to me more just, certainly, that you should simply keep the studies that you liked in your apartment, that you send the others back to me here rolled up, since the apartment is small and if you kept everything they'd clutter it up.

So, without our hurrying I'm preparing the wherewithal here to stage a more serious exhibition.

But as for the Revue Indépendante I'd ask you to put a complete end to it, the opportunity is too good, and you'll feel that they're completely mistaken if they imagine I'm going to pay to have myself put on show in such a small, dark and above all scheming hole.

Now with regard to the few canvases at Tanguy's or Thomas's place . . . that's a matter of such absolute indifference to me that in reality it isn't worth talking about — but you should know above all that I'm really not at all attached to the idea. I know in advance what I'll do the moment I have enough canvases. For the moment I'm simply busying myself with making them.

What will please you is that Gauguin has finished his canvas of the women picking grapes, it's as fine as the negresses and if, say, you paid the same price for it as for the negresses (400 I think) that would certainly be good too. But naturally you have to choose from all of them, and I haven't seen the Breton things. He's explained several of them to me, and they must be fine.

I've done a rough sketch of a brothel, and I'm in fact planning to do a brothel painting.

Gauguin came here on 20 Oct., so we must reckon that he received 50 francs from you last month.

Yes, I think that for the exhibition of my work we must express ourselves clearly. As for you, you're with the Goupils, you aren't authorized to do business outside the firm. So since I'm absent I do *not* exhibit.

I repeat, I'm indifferent as regards Tanguy's place, provided Tanguy is fully aware that he has no right over my canvases, *none*.

So, my position is clear at least, which isn't a matter of absolute indifference to me. With a little more work I'll have sufficient not to need to exhibit at all any more, that's what I'm aiming at.

I myself have also finished a canvas of a vineyard, all purple and yellow with little blue and violet figures and a yellow sun.

I think you'll be able to place this canvas next to Monticelli's landscapes.

I'm going to set myself to work often from memory, and the canvases done from memory are always less awkward and have a more artistic look than the studies from nature, especially when I'm working in mistral conditions.

I don't think I've yet told you that Milliet has left for Africa. He has a study of mine for troubling to take the canvases to Paris and Gauguin gave him a little drawing in exchange for an illustrated edition of Madame Chrysanthème. I've still not received the exchanges from Pont-Aven, but Gauguin assures me that the canvases were done.

The weather's windy and rainy here, and I'm very happy not to be alone, I work from memory on bad days, and that wouldn't work if I were alone.

Gauguin has also almost finished his night café. He makes a really interesting friend — I must tell you that he knows how to cook *perfectly*, I think that I'll learn that from him, it's really convenient.

We're very satisfied with making frames with simple strips of wood nailed on the stretching frame and *painted*, which I've started doing.

[*Sketch* 718A]

Do you know that Gauguin is partly the inventor of the white frame? But the frame made from four strips of wood nailed on the stretching frame costs 5 *sous*, and we're certainly going to perfect it. It serves very well, since this frame doesn't stick out at all and is one with the canvas.

More soon, I shake your hand firmly and send my regards to the Dutchmen.

Ever yours,
Vincent

Gauguin sends his warm regards, and asks you to keep back from the price of the first painting you sell the amount necessary for the stretching frames, which he wants with keys, and also what Bernard will ask from you for a commission he gave him.

J'ai fait moi aussi une toile d'une vigne
toute pourpre et jaune avec des figurines bleues
et violettes et un soleil jaune.

Je crois que tu pourras mettre cette toile à côté
des paysages de monticelli

Je vais me mettre à travailler souvent de tête
et les toiles de tête sont toujours moins gauches
et ont un air plus artistique que les études sur
nature surtout lorsqu'on travaille par un temps
de mistral.

Je crois ne pas encore t'avoir dit que millet est parti
en Afrique. Il a une étude de moi pour le mal
qu'il s'est donné pour porter les toiles à Paris et
gauguin lui a donné un petit dessin en échange
d'une édition illustré de m^m chrysanthème
Je n'ai toujours pas reçu les échanges de Pont
aven. mais gauguin m'assure que les toiles
étaient faites.
Il fait un temps de vent et de pluie ici et
je suis bien content de ne pas être seul
je travaille de tête les jours mauvais et
cela si j'étais seul n'irait pas.
Gauguin a aussi presque fini son café
de nuit. Il est bien intéressant et
comme ami – il faut que je te dise
qu'il sait faire la cuisine parfaitement
je crois que j'apprendrai cela de lui c'est
bien commode.
Nous nous trouvons fort bien de faire
des cadres avec de simples baguettes clouées
autour sur le chassis et peints ce que moi j'ai commencé
Sais tu que c'est un peu gauguin
l'inventeur du cadre blanc.
mais le cadre de 4 baguettes
clouées sur le chassis coûte 5 sous

718A. Example of a simple frame, with *The red vineyard*

My dear Theo,

Gauguin's canvas, Breton Children, has arrived, and he's altered it very, very well.

But although I quite like this canvas, it's all the better that it should be sold, since the two he's going to send you from here are thirty times better.

I'm speaking of the women picking grapes and the woman with the pigs. The reason for this is that G. is beginning to overcome his liver or stomach trouble that has bothered him lately.

Now I'm writing to you in reply to what you were telling me, that you would frame a small canvas of a pink peach tree I think, to place it with those gentlemen.

I don't want to leave any doubt about what I think of that.

First, if you yourself would like to place either a bad or good thing of mine there, my word if that will make you happier, then of course you have and will have carte blanche either now or later.

But if, on the other hand, it's either for my pleasure *or for my own benefit*, I'd be of the opinion that it's completely unnecessary.

If you were to ask me what would give me pleasure, it's quite simply one single thing, that you keep for yourself what you like from what I do, in the apartment, and that you don't sell any of it now.

The rest, the stuff that gets in the way, send it to me here for this good reason, that everything I've done *from nature* is chestnuts pulled out of the fire.

Gauguin, in spite of himself and in spite of me, has proved to me a little that it was time for me to vary things a bit — I'm beginning to compose from memory, and all my studies will still be useful to me for that work, as they remind me of former things I've seen.

So what does selling any of it matter if we're not absolutely pressed for money?

For in addition, I'm sure even now that you'll eventually see things that way.

As for you, you're with the Goupils, but I certainly am not, after however working there for 6 years we were absolutely dissatisfied on both sides with everything, them with me, me with them. It's an old story, but all the same that's how it is.

So continue on your way, but as far as the business is concerned it seems to me incompatible with my previous behaviour to come back there with a canvas of such innocence as this little peach tree or some other thing like it. *No.* If in a year or two I have enough to make an exhibition of my own, let's say thirty or so no. thirty canvases —

And if I said to them, will you do it for me, Boussod would certainly send me packing. Knowing them alas a little too well, I think that I won't approach them. Not that I'd ever try to ruin anything, on the contrary, you must admit that I urge on all the others there zealously.

But as for me, my word I have an old grudge against them.

Be sure and certain that I consider you, as a seller of Impressionist paintings, to be very independent of the Goupils, that it will therefore always be a pleasure for me to urge artists to go there. But I don't want Boussod ever to have a chance to say 'this little canvas isn't too bad for this young beginner', as if never before . . .

On the contrary, I won't come back to them, I'd prefer never to sell than to enter into it other than very straightforwardly. Now they're not people to act straightforwardly, so it isn't worth beginning again.

Be assured that the more clear-cut we are about this the more they'll come to you to see them. You don't sell them, so in showing my work you aren't trading outside the firm of Boussod, V. & Cie. Thus you're acting honestly, and that's worthy of respect.

If one or the other wants to buy however, fine, all they have to do is approach me directly. But be sure of this: if we can withstand the siege my day will come. I cannot and must not at this moment do anything other than work.

One thing however perhaps, I'm going to reply to Jet Mauve, tell her a whole heap of things about Gauguin &c. &c., send her some croquis, and indirectly Tersteeg will prick up his ears again. Gauguin and I often talk about the need to hold exhibitions in London, and perhaps we'll send you a letter for Tersteeg to read. The thing is, should Tersteeg have an energetic successor — that day is approaching — the latter won't be able to work with anything but new paintings.

Handshake — we'll need some more colours.

I must also tell you that the month with the two of us together is going better on 150 each than I did on 250 just for myself. At the end of a year you'll notice that this is working after all.

I can't say anything more yet. I rather regret having the room full of canvases and having nothing to send when Gauguin sends his.

The thing is, regarding the impasto things, Gauguin has told me how to get rid of the grease by washing them from time to time.

What's more, when that's done I must work on them again to retouch them.

If I sent you any of them now, their colour would be duller than it will be later.

They all think that what I've sent was done too hastily. I wouldn't deny it, and I'll make certain changes.

It does me enormous good to have company as intelligent as Gauguin and to see him work. You'll see that certain people are going to reproach G. for no longer doing Impressionism.

His two latest canvases which you're going to see are very firm in the impasto, there's even some work with the knife in them. And that will put his Breton canvases into the shade a little, not all, but some of them.

I hardly have the time to write, otherwise I'd already have written to those Dutchmen. I've had a letter from Boch, you know that Belgian who has a sister in the Vingtistes. He's enjoying working up there.

I really hope that we'll always remain friends with Gauguin, and in business with him, and if he succeeds in setting up a tropical studio that would be magnificent.

But that will take more money by my calculations than by his.

Guillaumin has written to Gauguin, he seems very hard up but must have done some fine work. He has a child now, but he was *terrified* by the confinement and says he'll always have 'the red vision' of it before his eyes. Only Gauguin has replied to him very well, saying that he, G., had seen it 6 times.

Jet Mauve is in much better health, and as you perhaps know has been living in The Hague since last August, near the Jewish cemetery, so almost in the country.

You won't lose anything by waiting a little while for my work, and we'll calmly leave our dear pals to scorn the present ones.

Fortunately for me I know what I want better than they believe and am, basically, extremely indifferent to the criticism of working hurriedly.

In reply I've produced work these last few days *even more* hurriedly.

Gauguin was telling me the other day — that he'd seen a painting by Claude Monet of sunflowers in a large Japanese vase, very fine. But — he likes mine better.

I'm not of that opinion — only don't think that I'm weakening. I regret as always, as you know, the scarcity of models, the thousand obstacles to overcome that difficulty.

If I were a completely different man and if I were wealthier I could *force* it, at present I'm not giving up and am plodding on quietly.

If at the age of forty I do a painting of figures like the flowers Gauguin was talking about I'll have a position as an artist alongside anything.

So, perseverance.

In the meantime I can tell you anyway that the last two studies are rather funny. No. 30 canvases, a wooden and straw *chair* all yellow on red tiles against a wall (*daytime*). Then Gauguin's armchair, red and green, night effect, on the seat two novels and a candle.

On sailcloth in thick impasto.

What I say about sending back studies, there's no hurry at all, and I'm referring to the bad ones which, however, will serve me as documents — or those that are cluttering up your apartment. As to what I say in general about the studies, I'm set on just one thing: that the position is quite clear. Don't trade on my behalf *outside the firm*; as for me, either I'll never return to the Goupils, which is more than likely, or I'll return straightforwardly, which is quite impossible.

One more handshake, and thanks for everything you're doing for me.

Ever yours,
Vincent

723 | Arles, on or about Saturday, 1 December 1888 | *To Theo van Gogh* (F)

My dear Theo,

On my side, too, it's more than time that I wrote to you with a rested mind for once. Thanks first of all for your kind letter and for the 100-franc note it contained. Our days pass in working, working always, in the evening we're worn out and go to the café before retiring to bed early. That's our existence. Naturally it's winter here too, although the weather still continues to be very fine from time to time. But I don't find it disagreeable to try to work from the imagination, since that permits me not to go out. Working in the heat of a stove doesn't bother me, but the cold isn't for me, as you know. Only I've spoiled that thing I did of the garden at Nuenen and I feel that habit is also necessary for works of the imagination. But I've done the portraits of *an entire family*, the family of the postman whose head I did before — the man, his wife, the baby, the young boy and the 16-year-old son, all characters and very French, although they

have a Russian look. No. 15 canvases. You can sense how in my element that makes me feel, and that it consoles me to a certain extent for not being a doctor.

I hope to persevere with this and be able to obtain more serious sittings, which can be paid for with portraits.

And if I manage to do *this entire family* even better, I'll have done at least one thing to my taste and personal.

At the moment I'm really in the shit, studies, studies, studies, and that'll go on for some time yet — such a mess that it breaks my heart — and yet that'll give me neatness when I'm 40. From time to time a canvas that makes a painting, such as that sower, which I too think is better than the first one.

If we can withstand the siege, a day of victory will come for us, even though we wouldn't be among the people who are being talked about. It's rather a case of thinking of that proverb, joy in town, grief at home.

What can you expect? Supposing that we still have a whole battle to fight, then we must try to mature calmly. You've always told me to do more quality than quantity. Now, nothing is preventing us from having a lot of studies classed as such, and consequently not having a whole heap of things for sale. And if sooner or later we're *obliged* to sell, then selling at a slightly higher price the things that can hold their own from the point of view of serious research.

I think that — in spite of myself — I won't be able to prevent myself sending you a few canvases shortly, *say within a month*. I say in spite of myself, for I'm convinced that the canvases gain from drying right through here in the south, to the point where the impasto is thoroughly hardened, which takes a long time — that's to say a year. If I restrain myself from sending them that would certainly be best. For we don't need to show them at the moment, I'm well enough aware of that.

Gauguin works a lot — I very much like a still life with yellow background and foreground. He's working on a portrait of me which I don't count as one of his undertakings that don't come to anything.

At present he's doing landscapes, and finally he has a good canvas of washerwomen, even very good as I see it.

You should receive two of Gauguin's drawings in return for 50 francs which you sent him in Brittany. But old mother Bernard simply appropriated them.

Speaking of indescribable stories, this is indeed one. I think that she'll give them back though in the end. Beware of the Bernard *family*, but you should know that in my opinion Bernard's work is very fine and that he'll have some well-deserved success in Paris.

Very interesting that you met Chatrian. Is he blond or dark? I'd like to know that, since I know the two portraits.

In their work, it's above all Madame Thérèse and L'ami Fritz that I like.

As regards L'histoire d'un sous-maître, it seems to me that there's more to find fault with than seemed possible to me at the time.

I think we'll end up spending our evenings drawing and writing, there's more to work on than we can do.

You know that Gauguin has been invited to exhibit at the Vingtistes. His imagination is already leading him to think of settling in Brussels, which would indeed be a

means of finding himself in a position to see his Danish wife again. Since he has some success with the Arlésiennes in the meantime, I wouldn't consider that as being absolutely without consequences.

He's married and doesn't much appear to be, in short I fear there may be an absolute incompatibility of character between his wife and himself, but naturally he's more attached to his children, who judging from the portraits are very beautiful. We, on the other hand, aren't too gifted in that respect. More soon, a handshake for you and for the Dutchmen.

Vincent

Gauguin will write to you tomorrow, he's waiting for a reply to his letter and sends his warm regards.

726 | Arles, Monday, 17 or Tuesday, 18 December 1888 | *To Theo van Gogh* (F)

My dear Theo,

Yesterday Gauguin and I went to Montpellier to see the museum there, and especially the Bruyas room — there are many portraits of Bruyas, by Delacroix, by Ricard, by Courbet, by Cabanel, by Couture, by Verdier, by Tassaert, by others too. After that there are paintings by Delacroix, Courbet, Giotto, Paul Potter, Botticelli, T. Rousseau, very fine.

Bruyas was a benefactor to artists, and this is all I'll say to you: in the Delacroix portrait, he's a gentleman with a beard, red hair, who looks damnably like you or me, and who made me think of that poem by Musset . . . everywhere I touched the earth, an unfortunate man dressed in black came to sit beside us, a man who looked at us like a brother. It would have the same effect on you, I'm sure.

I'd really ask you to go and see, at that bookshop where they sell lithographs of ancient and modern artists, if you could manage to get the lithograph after Delacroix's 'Tasso in the madhouse' without great expense, since it would seem to me that this figure (by Delacroix) must have some relationship to this fine Bruyas portrait.

They have other Delacroixs there, a study of a mulatto woman (which Gauguin once copied), the Odalisques, Daniel in the lions' den.

By Courbet, first, *The village girls*, magnificent, a nude woman seen from the back, another on the ground, in a landscape. Second, The woman spinning (superb), and a whole load more Courbets. Anyway, you must know that this collection exists, or else know people who have seen it, and consequently be able to talk about it. So I shan't insist on the museum (except for the Barye drawings and bronzes!).

Gauguin and I talk a lot about Delacroix, Rembrandt &c.

The discussion is *excessively electric*. We sometimes emerge from it with tired minds, like an electric battery after it's run down.

We've been right in the midst of magic, for as Fromentin says so well, Rembrandt is above all a magician and Delacroix a man of God, of God's thunder and bugger off in the name of God.

I'm writing this to you with reference to our friends, the Dutchmen De Haan and Isaäcson, who have so sought and loved Rembrandt, in order to encourage you to pursue the researches.

One mustn't get discouraged about that. You know the strange and superb portrait of a man by Rembrandt at the La Caze gallery, I told Gauguin that, for me, I saw in it a certain family or racial resemblance to Delacroix, or to him, Gauguin.

I don't know why, but I always call that portrait *'the traveller'* or *'the man coming from far away'*.

That's an equivalent and parallel idea to what I've already told you, always to look at the portrait of old Six. The fine portrait with the glove for your future, and the Rembrandt etching, Six reading by a window in a ray of sunlight, for your past and your present.

That's the stage we're at.

Gauguin said to me this morning, when I asked him how he felt: 'that he could feel his old self coming back', which gave me great pleasure.

As for me, coming here last winter, tired and almost fainting mentally, I too suffered a little inside before I was able to begin to remake myself.

How I'd like you to see that museum in Montpellier some day, there are some really beautiful things there!

Say so to Degas, that Gauguin and I have been to see the portrait of Bruyas by Delacroix at Montpellier, for we must boldly believe that *what is, is*, and the portrait of Bruyas by Delacroix resembles you and me like a new brother.

As regards setting up a life with painters as pals, you see such odd things and I'll end with what you always say, time will tell.

You can tell all this to our friends Isaäcson and De Haan, and even boldly read them this letter, I would already have written to them if I'd felt the necessary electric force.

On behalf of Gauguin as well as myself, a good, hearty handshake to you all.

Ever yours,
Vincent

If you think that Gauguin or I have a *facility* in our work, the work isn't always accommodating. And for the Dutchmen not to get discouraged in their difficulties any more than we do, that's what I wish for them, and for you too.

728 | Arles, Wednesday, 2 January 1889 | *Vincent van Gogh and Félix Rey to Theo van Gogh* (F)

Arles, 2 January 1889

My dear Theo,

In order to reassure you completely on my account I'm writing you these few words in the office of Mr Rey, the house physician, whom you saw yourself. I'll stay here at the

hospital for another few days — then I dare plan to return home very calmly. Now I ask just one thing of you, not to worry, for that would cause me one worry TOO MANY.

Now let's talk about our friend Gauguin, did I terrify him? In short, why doesn't he give me a sign of life? He must have left with you.

Besides, he needed to see Paris again, and perhaps he'll feel more at home in Paris than here. *Tell Gauguin to write to me*, and that I'm still thinking of him.

Good handshake, I've read and re-read your letter about the meeting with the Bongers. It's perfect. As for me, I'm content to remain as I am. Once again, good hand-shake to you and Gauguin.

Ever yours
Vincent

Write to me, still same address, 2 place Lamartine.

[*Continued by Félix Rey*]

Sir —

I shall add a few words to your brother's letter to reassure you, in my turn, on his account.

I am happy to tell you that my predictions have been borne out, and that this over-excitement was only fleeting. I strongly believe that he will have recovered in a few days' time.

I very much wanted him to write to you himself, to give you a better account of his condition.

I have had him brought down to my office to talk a little. It will entertain me and do him good.

With my sincerest regards.

Rey F.

730 | Arles, Friday, 4 January 1889 | *To Paul Gauguin* (F)

My dear friend Gauguin

I'm taking advantage of my first trip out of the hospital to write you a few most sincere and profound words of friendship.

I have thought of you a great deal in the hospital, and even in the midst of fever and relative weakness.

Tell me. Was my brother Theo's journey really necessary — my friend? Now at least reassure him completely, and yourself, please. Trust that in fact no evil exists in this best of worlds, where everything is always for the best.

So I want you to give my warm regards to good Schuffenecker —

to refrain from saying bad things about our poor little yellow house until more mature reflection on either side —

to give my regards to the painters I saw in Paris.

I wish you prosperity in Paris. With a good handshake

Ever yours,
Vincent

Roulin has been really kind to me, it was he who had the presence of mind to get me out of there before the others were convinced.

Please reply.

732 | Arles, Monday, 7 January 1889 | *To Theo van Gogh* (F)

My dear Theo,

Perhaps I won't write you a really long letter today, but anyhow a line to let you know that I returned home today. How I regret that you were troubled for such a little thing, forgive me, for I am after all probably the primary cause of it. I hadn't foreseen that it would lead to you being told about it. Enough.

Mr Rey came to see the painting with two of his doctor friends, and they at least understand darned quickly what complementaries are. Now I'm planning to do Mr Rey's portrait and possibly other portraits as soon as I've accustomed myself a little to painting once again.

Thank you for your last letter, I do indeed always feel your presence, but on your side you should also know that I'm working on the same thing as yourself.

Ah, how I wish that you'd seen the portrait of Bruyas by Delacroix and the whole museum at Montpellier where Gauguin took me. How people have already worked in the south before us! In truth, it's quite difficult for me to believe that we've gone so far astray as that.

As to it being a hot country — my word, I can't help but think of a certain country Voltaire speaks of — and without even counting the simple castles in the air. Those are the thoughts that come to me as I return home.

I'm very eager to know how the Bongers are, and if relations with them continue to be good, which I hope they do.

If you think it all right — now that Gauguin has left — we'll go back to 150 francs a month. I think I'll see calmer days here again than in the course of the past year. What I'll need very much for my instruction are all the reproductions of Delacroix's paintings that one can still get in that shop where they sell lithographs of ancient and modern artists &c. for 1 franc, I think. I *definitely* don't want the most expensive ones.

How are our Dutch friends De Haan and Isaäcson? Give them my warm regards.

I just think that we must still keep calm regarding my own painting. If you want some I can certainly send them to you now, but when calm returns to me I hope to do something else.

In any case, as regards the Independents, do what seems best to you and what the others will do.

But you've no idea how much I regret that your journey to Holland hasn't already been made. Ah well, we can't change any of the facts, but make up for it as far as possible by correspondence or however you can, and tell the Bongers how much I regret

having, perhaps unwittingly, caused a delay. I'll write to Mother and Wil one of these days, I must also write to Jet Mauve.

Write to me soon, and be completely reassured as to my health, it will cure me completely to know that things are going well for you. What is Gauguin doing? As his family are in the north, and as he's been invited to exhibit in Belgium and has some success in Paris at the moment, I like to think that he's found his way. Good handshake, I'm quite happy all the same that this is a thing of the *past*. Another vigorous handshake.

Ever yours,
Vincent

My dear brother,

I hope that it won't amaze you too much that although I wrote to you this morning I'm adding a few words this same evening. For I've been unable to write for several days, but you can clearly see that that's *over* now.

I've written a line to Mother and to Wil, *which I addressed to our sister* with the sole aim of reassuring them, should you have happened to mention to them that I had been ill. For your part, simply tell them that I've been a bit ill like the time when I had the clap in The Hague, and that I got myself treated at the hospital. But that it's not worth the trouble of mentioning, since I got off with a fright and that I was only in the aforesaid or mentioned hospital for a few days. Thus you'll doubtless find yourself in agreement with the short note that I've made them swallow down there at home in Holland.

And by so doing it will be pretty difficult for them to get worked up about it. In fact, they'll imagine that I ALMOST had the clap. I hope that you'll find this stratagem innocent enough.

Also you'll see from this that I haven't yet forgotten how to jest sometimes.

I'm going to get back to work tomorrow, I'll begin by doing one or two still lifes to get back into the way of painting.

Roulin has been excellent to us, and I dare believe that he'll remain a staunch friend whom I'll still need quite often, for he knows the country well.

We dined together today.

If ever you want to make the house physician Rey *very happy*, this is what would give him great pleasure: he has heard about a painting by Rembrandt, The anatomy lesson. I told him that we'd get an engraving of it for his study. I hope to do his portrait as soon as I feel a little stronger.

Last Sunday I met another doctor who, in theory at least, knows what Delacroix and Puvis de Chavannes are all about, and who's very curious to know about Impressionism.

I dare hope to get to know him better.

I think that this engraving of The anatomy lesson is published by François Buffa and Sons, and that the net price should be between 12 and 15 francs. It would be best to frame it HERE to avoid transportation costs.

I can assure you that a few days in the hospital were very interesting, and that one perhaps learns how to live from the sick.

I hope that I've just had a simple artist's bout of craziness and then a lot of fever following a *very* considerable loss of blood, as an artery was severed.

But my appetite came back immediately, my digestion is good, and the blood is recovering day by day, and likewise serenity is returning to my mind day by day.

So please deliberately forget your sad journey and my illness.

Painting is the profession you know, and my goodness we're perhaps not wrong to try to keep our hearts human.

You can see that I'm doing what you asked me to, that I'm writing what I feel and what I think. For your part, follow up this meeting with the Bongers calmly, I hope that it will continue as a solid friendship, and that perhaps it's even more.

If I remain here it's because I might not be able to transplant myself for the moment. After a little while we can review the pros and cons of the situation and do the calculations again.

I shake your hand firmly.

Ever yours,
Vincent

736 | Arles, Thursday, 17 January 1889 | *To Theo van Gogh* (F)

My dear Theo,

Thanks for your kind letter and for the 50-franc note it contained. As to answering all your questions, can you do it yourself, at the moment I don't feel up to it. On reflection I do indeed want to seek a solution, but I must re-read your letter again &c.

But before discussing what I might or might not spend in a whole year, it would perhaps put us on track to review nothing but the present, current month for a moment.

In any case it has been completely lamentable, and indeed I would count myself fortunate if finally you might pay some serious attention to the way things are and have been for so long.

But what can one do, unfortunately it's complicated in several ways, my paintings are worthless, they cost me an extraordinary amount, it's true, perhaps sometimes even in blood and brain. I won't press the point, and what do you want me to say about it. Let's get back in any case to the present month and speak only of money.

On 23 December there was still a louis and 3 sous in the cash-box. That same day I received the 100-franc note from you.

Here are the expenses

Given to Roulin to pay the charwoman for the month of December	20 Francs.		
same for 1st fortnight of January	10	"	Fr. 30.–
Paid to hospital			21
" to the nurses who dressed the wound			10

On returning here paid for a table, a gas heater &c., which had been lent to me and which I then took on account	20
Paid for having all the bedding, bloodstained linen &c. laundered	12.50
Various purchases like a dozen brushes, a hat &c. &c. let's say	10
	————
	103.50

Thus we've already arrived, on the day I left hospital or the day after, at an involuntary expenditure on my part of 103.50, to which it must be added that then on the first day I cheerfully went to have dinner with Roulin at the restaurant, completely reassured and with no fear of renewed anguish. In short, the result of all that was that I was broke around the 8th. But one or two days after that I borrowed 5 francs. We were barely at the tenth. I was hoping for a letter from you around the tenth, but as that letter only arrived today, 17 January, the interval has been a fast of the most rigorous sort, all the more painfully so because my recovery couldn't take place under those conditions.

Nevertheless, I've started work again and I already have 3 studies done in the studio plus the portrait of Mr Rey, which I gave him as a keepsake.

So this time again there's no more serious harm than a little more suffering and relative anguish. And I retain all good hope. But I feel weak and a little anxious and fearful.

Which will pass, I hope, as I regain my strength.

Rey told me that being very impressionable was enough to have had what I had as regards the crisis, and that currently I was only anaemic, but that really I ought to feed myself up. But myself, I took the liberty of telling Mr Rey that if currently the first thing for me was to recover my strength, if by pure chance or misunderstanding it had just happened again that I'd had to keep to a rigorous one-week fast, if in similar circumstances he had seen many madmen quite calm and capable of working — and if not then would he deign to remember occasionally that for the moment I myself am not yet mad.

Now, in these payments that I made, is there anything unwarranted, extravagant or exaggerated in these expenses, considering that the whole house was turned upside down by this adventure, and all the linen and my clothes soiled? If I paid what was *owing* to people almost as poor as myself as soon as I got back, is there an error on my part or could I have economized more?

Now today, the 17th, I receive 50 francs at last. Out of this I first pay the 5 francs borrowed from the café owner, then for 10 refreshments taken during this last week on credit, which makes Fr. 7.50

Now today, the 17th... which makes	Fr. 7.50
I still have to pay for the linen brought back from the hospital, and then for this past week, for the repair of shoes and of a pair of trousers, certainly all in all something like	5
Wood and coal still to be paid for December, and to be bought again, not less than	4
Charwoman 2nd fortnight of January	10
	————
	26.50

Tomorrow morning when I've cleared this amount I'll have left, net Fr. 23.50

It's the 17th today, there are still 13 days left to get through.

Question: how much can I spend per day? Next there must be added the fact that you sent 30 francs to Roulin, out of which he paid the 21.50 for the rent for December.

There you are, my dear brother, the account for the current month. It isn't finished.

We now come to the expenses occasioned by a telegram from Gauguin which I've already reproached him quite formally for having sent.

Are the expenses thus wrongly incurred less than 200 francs?

Does Gauguin himself claim to have acted brilliantly in this?

Look, I won't press the point any more about the absurdity of that course of action. Let's suppose that I was as distraught as could be, why then wasn't the illustrious pal calmer I shan't labour this point any more.

I can't praise you enough for paying Gauguin in such a way that he couldn't but congratulate himself on the relations he's had with us.

Unfortunately, that's another expense, perhaps more sizeable than it should have been, but anyway, I glimpse hope in it.

Mustn't he, or at least shouldn't he begin to see a little that we weren't his exploiters, but that on the contrary we were anxious to safeguard his existence, his possibility of work and and . . . his integrity.

If that's unworthy of the grandiose prospectuses for artists' associations (which he proposed and to which he still holds) in the way you know, if that's unworthy of his other castles in the air.

Why then not consider him as not responsible for the sorrows and damage which unconsciously he could have caused us in his blindness, you as much as me. If currently that thesis still seems too bold to you — I won't press the point — but let's wait and see.

He's had previous experience with what he calls 'banking in Paris' and believes that he's clever at it . . . Perhaps you and I are decidedly not so very curious in that regard.

All the same, this isn't in complete disagreement with certain passages of our earlier correspondence.

If Gauguin were to examine himself properly in Paris or have himself examined by a specialist doctor, my word I don't really know what the result of it would be.

Several times over I've seen him do things that you or I wouldn't permit ourselves to do, having consciences that feel things differently — I've heard two or three things said of him in the same vein — but I, who saw him at very, very close quarters, I believed him led by his imagination, by pride perhaps but — — quite irresponsible. This conclusion doesn't imply that I firmly recommend that you listen to him in all circumstances. But in the matter of settling his account I see that you acted with a higher conscience, and so I believe that we have nothing to fear from being led into errors of 'banking in Paris' by him. But as for him . . . upon my word, let him do what he wants, let him have his independences????? (in what way does he consider his character independent), his opinions . . . and let him go his own way, as it seems to him that he knows it better than we do.

I find it quite odd that he's claiming a painting of sunflowers from me, offering me in exchange I suppose, or as a gift, a few studies that he left here. I'll send back his studies — which will probably have uses for him that they certainly wouldn't have for me.

But for the moment I'm keeping my canvases here, and I'm categorically keeping those sunflowers of mine.

He already has *two* of them, let that be enough for him. And if he's unhappy with the exchange he made with me he can take back his little canvas of Martinique and his portrait that he sent me from Brittany, giving me back for his part both my portrait and my two canvases of sunflowers which he took in Paris. So if he ever raises this subject again, what I've said is clear enough.

How can Gauguin claim to have feared disturbing me by his presence when he would have difficulty denying that he knew I asked for him continually, and people told him time and again that I was insisting on seeing him that very moment?

Precisely to tell him to keep it between himself and me without disturbing you. He wouldn't listen.

It wearies me to recapitulate all this and calculate and recalculate things of this kind.

I've tried in this letter to show you the difference that exists between my net expenses which come directly from me and those for which I am less responsible. I was sorry that just at that moment you should have those expenses, which were of no benefit to anyone.

What will happen next, I'll see if my position is tenable as I regain my strength. I so dread a change or moving house precisely because of new expenses. For quite a long time I've never been able to catch my breath completely. I'm not giving up work, because at moments it's going well, and I believe that it's precisely with patience that I'll arrive at this result of being able to recover the previous expenses with paintings I've done.

Roulin's going to leave, and as early as the 21st, he's going to be employed in Marseille.

The increase in salary is minimal, and he'll have to leave his wife and his children for a while, who won't be able to follow him until much later because the expenses of a whole family would be heavier in Marseille.

It's a promotion for him, but it's a very, very meagre consolation the government gives in this way to such an employee after so many years of work.

And at heart I think they, he and his wife, are still very, very upset. Roulin has very often kept me company during this past week.

I completely agree with you that we mustn't meddle in doctors' issues that have absolutely nothing to do with us.

Just because you wrote a note to Mr Rey saying you would introduce him in Paris, I thought you meant to Rivet.

I didn't think I was doing anything compromising by saying to Mr Rey myself that if he went to Paris it would give me great pleasure if he wanted to take a painting from me to Mr Rivet as a keepsake.

Naturally I didn't speak of anything else, but what I said is that I would always regret not being a doctor, and that those who believe painting is beautiful would do well to see in it only a study of nature.

All the same, it will continue to be a pity that Gauguin and I were perhaps too quick to drop the question of Rembrandt and light which we embarked upon.

Are De Haan and Isaäcson still there, they mustn't get discouraged.

After my illness I've naturally had a very sensitive eye. I have re-looked at De Haan's undertaker, of which he was kind enough to send me a photograph. Well, it seems to

me that there's some real Rembrandt spirit in that figure, which seems lit by the reflection of a light emanating from the open tomb before which the said undertaker stands like a sleep-walker. It's there in a very subtle way. I don't tackle the question with charcoal and he, De Haan, has taken as a means of expression this very charcoal, which is again a colourless material.

I would really like De Haan to see a study of mine of a lighted candle and two novels (one yellow, the other pink) placed on an empty armchair (Gauguin's armchair, to be precise), no. 30 canvas in red and green. I've just been working on the pendant again today, my own empty chair, a deal chair with a pipe and a tobacco pouch. In these two studies, as in others, I myself sought an effect of light with bright colour—De Haan would probably understand what I'm seeking if you read him what I write to you on this subject.

However long this letter may now be, in which I've tried to analyze the month and in which I complain a little about the strange phenomenon of Gauguin preferring not to speak to me again while at the same time making himself scarce, it remains for me to add a few words of appreciation.

What's good about him is that he knows how to apportion expenditure from day to day marvellously well.

Whereas myself, I'm often absent-minded, preoccupied with reaching a good *end-point*.

He has more of a sense for balancing money for each day than I do.

But his weakness is that by a sudden attack and animal-like impulse he upsets everything he was setting up.

Now, does one remain at one's post once one has taken it, or does one desert it? I don't judge anyone in this, hoping not to be condemned myself should I lack the strength. But if Gauguin has so much real virtue and such capacities for doing good, how is he going to employ himself? As for me, I've ceased to be able to follow his actions, and I halt silently but with a question mark.

From time to time he and I have exchanged ideas on French art, on Impressionism . . .

It now seems to me impossible, at least quite improbable, that Impressionism will organize itself and calm down.

Why will the same not happen as happened in England at the time of the Pre-Raphaelites?

The association is dissolved.

Perhaps I take all these things too much to heart, and I'm perhaps too sad about them. Has Gauguin ever read Tartarin sur les Alpes, and does he remember Tartarin's illustrious pal from Tarascon who had such an imagination that in one fell swoop he imagined an entire imaginary Switzerland?

Does he remember the knot in a rope rediscovered high up in the Alps after the fall?

And you, who wish to know how things happened, have you ever read the whole of Tartarin?

That would teach you to recognize Gauguin pretty well.

I urge you in all seriousness to look at that passage in Daudet's book again.

During your trip here were you able to notice the study that I painted of Tarascon's diligence, which as you know is mentioned in Tartarin the lion-hunter?

And then do you remember Bompard in Numa Roumestan and his happy imagination?

This is what we have here, though of another kind, Gauguin has a fine and frank and absolutely complete *imagination of the south*, with that imagination he's going to work in the north! My word, we may yet see some more funny things!

And now dissecting the situation in all boldness, nothing prevents us from seeing him as the little Bonaparte tiger of Impressionism as regards . . . I don't know quite how to say this, his vanishing let's say from Arles is comparable or parallel to the Return from Egypt of the little corporal mentioned above, who also went to Paris afterwards. And who always left the armies in the lurch.

Happily Gauguin, I and other painters aren't yet armed with machine guns and other very harmful engines of war. I, for one, am quite determined to try to remain armed only with my brush and my pen.

With loud shouts Gauguin nevertheless demanded from me in his last letter 'HIS FENCING MASKS AND GLOVES' hidden in the little room of my little yellow house.

I'll make haste to send him these childish things by parcel post. Hoping that he'll never use more serious things.

He's physically stronger than we are, so his passions must also be much stronger than ours. Then he's the father of children, then he has his wife and his children in Denmark, and at the same time he wants to go right to the other end of the globe to Martinique. It's horrifying, all the vice versa of incompatible desires and needs which that must cause him. I had dared to assure him that if he'd stayed quietly with us, working here in Arles without wasting money, earning it, since you were busying yourself with his paintings, his wife would certainly have written to him and would have approved of his quiet life. There's still more besides, there's the fact that he was sick and seriously ill, and that it was a question of discovering both the illness and the remedy. Now here his pains had already ceased. Enough for today.

Do you have the address of Laval, Gauguin's friend? You can tell Laval that I'm very astonished that his friend Gauguin didn't take a portrait of me which I intended for him, in order to give it to him. I'll now send it to you and you can let him have it. I have another new one for you too. Thanks again for your letter. Please try and think that it would be really impossible to live for 13 days on the 23.50 francs that I'll have left. I'll try to manage with 20 francs which you'd send me next week.

Handshake, I'll read your letter again and will write to you soon about the other matters.

Ever yours,
Vincent

My dear friend Gauguin,

Thanks for your letter. Left behind alone on board my little yellow house — as it was perhaps my duty to be the last to remain here anyway — I'm not a little plagued by the friends' departure.

Roulin has had his transfer to Marseille and has just left. It has been touching to see him these last days with little Marcelle, when he made her laugh and bounce on his knees.

His transfer necessitates his separation from his family, and you won't be surprised that as a result the man you and I simultaneously nicknamed 'the passer-by' one evening had a very heavy heart. Now so did I, witnessing that and other heart-breaking things.

His voice as he sang for his child took on a strange timbre in which there was a hint of a woman rocking a cradle or a distressed wet-nurse, and then another sound of bronze, like a clarion from France.

Now I feel remorse at having perhaps, I who so insisted that you should stay here to await events and gave you so many good reasons for doing so, now I feel remorse at having indeed perhaps prompted your departure — unless, however, that departure was premeditated beforehand? And that then it was perhaps up to me to show that I still had the right to be kept frankly *au courant*.

Whatever the case, I hope we like each other enough to be able to begin again if need be, if penury, alas ever-present for us artists without capital, should necessitate such a measure.

You talk to me in your letter about a canvas of mine, the sunflowers with a yellow background — to say that it would give you some pleasure to receive it. I don't think that you've made a bad choice — if Jeannin has the peony, Quost the hollyhock, I indeed, before others, have taken the sunflower.

I think that I'll begin by returning what belongs to you, making it plain that it's my intention, after what has happened, to contest categorically your right to the canvas in question. But as I commend your intelligence in the choice of that canvas I'll make an effort to paint two of them, exactly the same. In which case it might be done once and for all and thus settled amicably, so that you could have your own all the same.

Today I made a fresh start on the canvas I had painted of Mrs Roulin, the one which had remained in a vague state as regards the hands because of my accident. As an arrangement of colours: the reds moving through to pure oranges, intensifying even more in the flesh tones up to the chromes, passing into the pinks and marrying with the olive and Veronese greens. As an Impressionist arrangement of colours, I've never devised anything better.

And I believe that if one placed this canvas just as it is in a boat, even one of Icelandic fishermen, there would be some who would feel the lullaby in it. Ah! my dear friend, to make of painting what the music of Berlioz and Wagner has been before us . . . a consolatory art for distressed hearts! There are as yet only a few who feel it as you and I do!!!

My brother understands you well, and when he tells me that you're a kind of unfortunate like me, then that indeed proves that he understands us.

I'll send you your things, but at times weakness overcomes me again, and then I can't even make the gesture of sending you back your things. I'll pluck up the courage in a few days. And the '*fencing masks and gloves*' (make the very least possible use of less childish engines of war), those terrible engines of war will wait until then. I now write to you very calmly, but I haven't yet been able to pack up all the rest.

In my mental or nervous fever or madness, I don't know quite what to say or how to name it, my thoughts sailed over many seas. I even dreamed of the Dutch ghost ship and the Horla, and it seems that I sang then, I who can't sing on other occasions, to be precise an old wet-nurse's song while thinking of what the cradle-rocker sang as she rocked the sailors and whom I had sought in an arrangement of colours before falling ill. Not knowing the music of *Berlioz*. A heartfelt handshake.

Ever yours,
Vincent

It will please me greatly if you write to me again before long. Have you read Tartarin in full by now? The imagination of the south creates pals, doesn't it, and between us we always have friendship.

Have you yet read and re-read Uncle Tom's cabin by Beecher Stowe? It's perhaps not very well written in the literary sense. Have you read Germinie Lacerteux yet?

740 | Arles, on or about Tuesday, 22 January 1889 | *To Arnold Koning* (D)

My dear friend Koning,

Thank you for sending me New Year's greetings from the far north of our old native country. I received your postcard in the hospital in Arles, where I was quartered at the time because of an attack of brain or some other fever that had already pretty much passed off. And as regards the causes and effects of the illness in question, we'll do best to leave it to possible discussions by the Dutch catechists as to whether or not I have been or still am — mad, fancy myself mad, or regarded as mad in a flight of fancy consisting only of sculpture.

And if not, whether I already was before that time; am or am not at present, or will be hereafter.

Having thus informed you more than enough about my mental and physical state . . . it will appear less odd to you that I didn't reply to you sooner. But meanwhile we mustn't forget to stick to our guns.

And starting from there, I ask you: what are you doing in painting at the moment, and how are you working with colour?

I've seen absolutely nothing of your studies sent to Theo (*I believe*), despite urging you to make an exchange. Is this to do with Theo, who possibly had other things on his mind, or with the not inconsiderable distance between us?

Did you know that Theo is engaged and will marry an Amsterdam girl quite soon?

After this question about your work, a few words about mine. At present I have a portrait of a woman on the go, or rather on the easel.

Which I've called 'la berceuse', or as we say in Dutch with Van Eeden (you know, who wrote that book I got you to read) — or would simply call in Van Eeden's Dutch 'our lullaby', or the woman by the cradle.

It's a woman dressed in green (bust olive green and the skirt pale Veronese green). Her hair is entirely orange and in plaits. The complexion worked up in chrome yellow, with a few broken tones, of course, in order to model. The hands that hold the cradle cord ditto ditto. The background is vermilion at the bottom (simply representing a tiled floor or brick floor). The wall is covered with wallpaper, obviously calculated by me in connection with the rest of the colours. This wallpaper is blue-green with pink dahlias and dotted with orange and with ultramarine. I believe I've run fairly parallel to Van Eeden in this, and consequently don't regard his style of writing as unparallel to my style of painting in the matter of colour. Whether I've actually sung a lullaby with colour I leave to the critics, particularly to those aforementioned. But we've talked enough about this in the past, haven't we? About the eternal question of colour that guides us, in so far as our composure can go.

In any event, on leaving the hospital I painted my own doctor's portrait. And haven't yet altogether lost my equilibrium as a painter.

But obviously I've painted a lot more other studies or paintings in all this time. Among other things this summer, two flower-pieces with nothing but *Sunflowers* in a yellow earthenware pot. Painted with the three chrome yellows, yellow ochre and Veronese green and nothing else.

For the time being I'm still in Arles and at your disposal for further correspondence by letter or painted study. Theo went to see Breitner recently, and said of his work that he thought Breitner the best painter and thinker among you over there.

Regards, my dear friend, with a handshake in thought.

Your friend
Vincent

Address still
2 Place Lamartine
Arles.

If you see Breitner, you may let him read this epistle or tell him about it just as I write it, without bringing too much of your own imagination into play.

741 | Arles, Tuesday, 22 January 1889 | *To Theo van Gogh* (F)

My dear Theo,

Thanks for your letter and for the 50-franc note it contained. Naturally I'm now covered until the arrival of your letter after the 1st. What happened as regards that money was absolutely sheer chance and a misunderstanding for which neither you nor I are responsible. To telegraph, as you rightly say, I couldn't do by the same sheer chance, for I didn't know if you were still in Amsterdam or back in Paris. It is, with the rest, over now, and one more proof of the proverb that misfortunes never come singly. Yesterday

Roulin left (naturally my dispatch of yesterday was sent before the arrival of your letter this morning). It was touching to see him with his children on the last day, above all with the very little one when he made her laugh and bounce on his knees and sang for her.

His voice had a strangely pure, moved timbre which to my ear contained a sweet, distressed wet-nurse's song and something like a distant echo of the clarion of revolutionary France. He wasn't sad, though, on the contrary, he had put on his brand-new uniform, which he'd received the same day, and everyone was making much of him.

I've just finished a new canvas which has an almost chic little look to it, a willow basket with lemons and oranges — a cypress branch and a pair of blue gloves, you've already seen some of these fruit-baskets of mine.

Listen — what you know I'm trying to do, myself, is to recoup the money that my training as a painter has cost, neither more nor less. That's my right, along with earning my bread each day.

It would appear just to me that it should come back, I don't say into your hands, since we've done what we've done together, and we find it so upsetting to talk of money.

But may it go into the hands of your wife, who anyway will join with us to work with the artists.

If I'm not yet busying myself with selling directly it's because my tally of paintings isn't yet complete, but it's coming along and I've set to work again with this iron resolve.

I have good and bad luck in my production, but not bad luck *alone*. If, for example, our Monticelli bouquet is worth 500 francs to an art lover, and it's worth that, then I dare assure you that my sunflowers are also worth 500 francs to one of those Scots or Americans. Now, to be sufficiently heated up to melt those golds and those flower tones, not just anybody can do that, it takes an individual's whole and entire energy and attention.

When I saw my canvases again after my illness, what seemed to me the best was the bedroom.

It seems to me that your apartment would be cluttered if I were to send all of this to you in Paris, especially after your wife will be staying there too. Then it would get the canvases known that would have lost their bloom and be talked about downstairs as if they were nothing, before the time and the hour.

The sum we're working with is certainly quite respectable, but a lot of it runs away and we must above all be watchful to ensure that not *everything* slips through the net from year to year. It's also the fact that even if the month goes on I'm always trying to strike more or less a balance through production, at least relative. So many annoyances certainly make me a little anxious and fearful, but I'm not yet in despair.

The trouble I foresee is that much *prudence* will be required to prevent the expenses we have when selling from exceeding the sale itself when the day comes. As regards that, how many times have we been in a position to see that sad thing in the lives of artists.

I have the portrait of Roulin's wife on the go that I was working on before being ill.

In it I had ranged the reds from pink to orange, which rose into the yellows as far as

lemon with light and dark greens. If I could finish that, it would give me great pleasure but I fear she won't want to pose any more, with her husband away.

You're right in seeing that Gauguin's departure is terrible, right because it pushes us back down when we had created and furnished the house to take in friends in bad times.

Only we'll keep the furniture &c. all the same. And although today everyone will be afraid of me, that may disappear with time.

We're all mortal and subject to all possible illnesses, what can we do about it when the latter aren't precisely of a pleasant kind. The best thing is to try to recover from them.

I find remorse, too, in thinking of the trouble that I've occasioned on my side, however involuntarily it may be — to Gauguin. But prior to the last days I could see only one thing, that he was working with his heart divided between the desire to go to Paris to carry out his plans, and life in Arles. What will the outcome of all that be for him?

You'll feel that although you have a good salary we still lack capital, except in goods, and that we need to be even more powerful to really change the sad position of the artists we know. But then one often just comes up against distrust on their part, and the fact that they're always plotting among themselves, which always arrives at the result of — *emptiness*. I think that at Pont-Aven 5 or 6 of them had already formed a new group, perhaps broken up already.

They aren't dishonest, but that's a thing without name and one of their defects as 'enfants terribles'.

Now the main thing will be that your marriage isn't delayed. By marrying you're putting Mother's mind at rest and making her happy, and anyway what your position in life and business rather necessitates. Will that be appreciated by the society to which you belong? Perhaps no more than the artists suspect that from time to time I've worked and suffered for the community . . . So from me, your brother, you won't wish for the absolutely banal congratulations and the assurances that you'll be transported straight to paradise.

And with your wife you'll cease to be alone, which I'd so wish for our sister Wil too.

I still hope that perhaps, if we can't make her meet and marry a doctor, we might at least perhaps be able to make her meet a painter.

That, after your own marriage, would be what I would wish for now more than all the rest.

Once your marriage is done, there will perhaps be others in the family, and in any case, you'll see your path clear and the house will no longer be empty.

Whatever I think on a few other points, our father and our mother have been exemplary as married people.

And I'll never forget Mother on the occasion of our father's death, when she said only one small word, which for me made me begin to love our old mother again more than before. Anyway, as married people our parents were exemplary, like Roulin and his wife to quote another specimen.

Well, go straight ahead along that road.

During my illness I again saw each room in the house at Zundert, each path, each

plant in the garden, the views round about, the fields, the neighbours, the cemetery, the church, our kitchen garden behind — right up to the magpies' nest in a tall acacia in the cemetery.

That's because I still have the most primitive memories of all of you, of those days; to remember all this there's now only Mother and me. I shan't go on since it's better that I don't try to restore everything that passed through my mind then.

Know only that I'll be very happy when your marriage has taken place.

Listen now, if as regards your wife it would perhaps be good for a painting of mine to be at the Goupils' from time to time, then I'll drop my old grudge that I have against them in the following way. I said that I didn't want to return there with too innocent a painting. But you can exhibit the two canvases of sunflowers there if you wish.

Gauguin would be pleased to have one of them, and I very much enjoy doing Gauguin quite a big favour. So, he wants one of those two canvases, well I'll do one of them over again, the one he wants.

You'll see that these canvases will catch the eye. But I'd advise you to keep them for yourself, for the privacy of your wife and yourself.

It's a type of painting that changes its aspect a little, which grows in richness the more you look at it. Besides, you know that Gauguin likes them extraordinarily. He said to me about them, among other things:

'that — . . . that's . . . the flower'.

You know that Jeannin has the peony, Quost has the hollyhock, but I have the sunflower, in a way. And all in all it will give me pleasure to continue the exchanges with Gauguin, even if sometimes it costs me dear too.

Did you see, during your fleeting visit, the portrait in black and yellow of Mrs Ginoux?

That's a portrait painted in 3 quarters of an hour.

I must finish for the moment.

The delay in sending the money is sheer chance, and thus neither you nor I could do anything about it.

Handshake.

Ever yours,
Vincent

743 | Arles, Monday, 28 January 1889 | *To Theo van Gogh* (F)

My dear Theo,

Just a few words to tell you that I'm getting along so-so as regards my health and work.

Which I already find astonishing when I compare my state today with that of a month ago. I well knew that one could break one's arms and legs before, and that then afterwards that could get better but I didn't know that one could break one's brain and that afterwards that got better too.

I still have a certain 'what's the good of getting better' feeling in the astonishment that an ongoing recovery causes me, which I wasn't in a state to dare rely upon.

When you visited I think you must have noticed in Gauguin's room the two no. 30 canvases of the sunflowers. I've just put the finishing touches to the absolutely equivalent and identical repetitions. I think I've already told you that in addition I have a canvas of a *Berceuse*, the very same one I was working on when my illness came and interrupted me. Today I also have 2 versions of this one.

On the subject of that canvas, I've just said to Gauguin that as he and I talked about the Icelandic fishermen and their melancholy isolation, exposed to all the dangers, alone on the sad sea, I've just said to Gauguin about it that, following these intimate conversations, the idea came to me to paint such a picture that sailors, at once children and martyrs, seeing it in the cabin of a boat of Icelandic fishermen, would experience a feeling of being rocked, reminding them of their own lullabies. Now it looks, you could say, like a chromolithograph from a penny bazaar. A woman dressed in green with orange hair stands out against a green background with pink flowers. Now these discordant sharps of garish pink, garish orange, garish green, are toned down by flats of reds and greens. I can imagine these canvases precisely between those of the sunflowers — which thus form standard lamps or candelabra at the sides, of the same size; and thus the whole is composed of 7 or 9 canvases.

(I'd like to make another repetition for Holland if I can get the model again.)

As it's still winter, listen. Let me quietly continue my work, if it's that of a madman, well, too bad. Then I can't do anything about it.

However, the unbearable hallucinations have stopped for now, reducing themselves to a simple nightmare on account of taking potassium bromide, I think.

It's still impossible for me to deal with this question of money in detail, but I want to deal with it in detail all the same, and I'm working furiously from morning till night to prove to you (unless my work is yet another hallucination), to prove to you that really, truly, we're following in Monticelli's track here and, what's more, that we have a light on our way and a lamp before our feet in the powerful work of Bruyas of Montpellier, who has done so much to create a school in the south.

Only don't be absolutely too amazed if, in the course of the coming month, I would be obliged to ask you for the month in full, and even the relative extra included.

After all, it's only right if in these productive times when I expend all my vital warmth I should insist on what is necessary to take a few precautions. The difference in expenditure is certainly not excessive on my part, not even in cases like that. And once again, either lock me up in a madhouse straightaway, I won't resist if I'm wrong, or let me work with all my strength, while taking the precautions I mention.

If I'm not mad the time will come when I'll send you what I've promised you from the beginning. Now, these paintings may perhaps be fated for dispersal, but when you, for one, see the whole of what I want, you will, I dare hope, receive a consolatory impression from it.

You saw, as I did, a part of the Faure collection file past in the little window of a framer's shop in rue Lafitte, didn't you? You saw, as I did, that this slow procession of canvases that were previously despised was strangely interesting.

Good. My great desire would be that sooner or later you should have a series of canvases from me that could also file past in that exact same shop window.

Now, in continuing the furious work this February and March I hope I'll have finished the calm repetitions of a number of studies I did last year. And these, together

with certain canvases of mine that you already have, such as the harvest and the white orchard, will form quite a firm base. During this same time, so no later than March, we can settle what has to be settled on the occasion of your marriage.

But although I'll work during February and March, I'll consider myself to be still ill, and I tell you in advance that in these two months I may have to take 250 a month from the year's allowance.

You'll perhaps understand that what would reassure me in some way regarding my illness and the possibility of a relapse would be to see that Gauguin and I didn't exhaust our brains for nothing at least, but that good canvases result from it. And I dare hope that one day you'll see that in remaining upright and calm now, precisely on the question of money — it will be impossible later on to have acted badly towards the Goupils. If indirectly I've eaten some of their bread, certainly through you as an intermediary —

Directly I will then retain my integrity.

So, far from still remaining awkward with each other almost all the time because of that, we can feel like brothers again after that has been sorted out. You'll have been poor all the time to feed me, but I'll return the money or turn up my toes.

Now your wife will come, who has a good heart, to make us old fellows feel a bit younger again.

But this I believe, that you and I will have successors in business, and that precisely at the moment when the family abandoned us to our own resources, financially speaking, it will again be we who haven't flinched.

My word, may the crisis come after that . . . Am I wrong about that, then?

Come on, as long as the present earth lasts there will be artists and picture dealers, especially those who are apostles at the same time, like you. And if ever we're comfortably off, even while perhaps being old Jewish smokers, at least we'll have worked by forging straight ahead and won't have forgotten the things of the heart that much, even though we have calculated a little.

What I tell you is true: if it isn't absolutely necessary to shut me away in a madhouse then I'm still good for paying what I can be considered to owe, at least in goods.

Then, my dear brother, we have 89. The whole of France shivered at it and so did we old Dutchmen, with the same heart.

Beware of 93, you may perhaps tell me.

Alas there's some truth in that, and that being the case let's stay with the paintings.

In conclusion I must also tell you that the chief inspector of police came yesterday to see me, in a very friendly way. He told me as he shook my hand that if ever I had need of him I could consult him as *a friend*. To which I'm a long way from saying no, and I may soon be in precisely that case if difficulties were to arise for the house. I'm waiting for the moment to come to pay my month's rent to interrogate the manager or the owner face to face.

But to chuck me out they'd more likely get a kick in the backside, on this occasion at least. What can you say, we've gone all-out for the Impressionists, now as regards myself I'm trying to finish the canvases which will indubitably guarantee my little place that I've taken among them.

Ah, the future of that . . . but from the moment when *père* Pangloss assures us that everything is always for the best in the best of worlds — can we doubt it?

My letter has become longer than I intended, it matters little — the main thing is

that I ask categorically for two months' work before settling what will need to be settled at the time of your marriage.

Afterwards, you and your wife will set up a commercial firm for several generations in the renewal. You won't have it easy. And once that's sorted out I ask only a place as an employed painter as long as there's enough to pay for one.

As a matter of fact, work distracts me. And I *must* have distractions — yesterday I went to the Folies Arlésiennes, the budding theatre here — it was the first time I've slept without a serious nightmare. They were performing — (it was a Provençal literary society) what they call a Noel or Pastourale, a remnant of Christian theatre of the Middle Ages. It was very studied and it must have cost them some money.

Naturally it depicted the birth of Christ, intermingled with the burlesque story of a family of astounded Provençal peasants. Good — what was amazing, like a Rembrandt etching — was the old peasant woman, just the sort of woman Mrs Tanguy would be, with a head of flint or gun flint, false, treacherous, mad, all that could be seen previously in the play. Now that woman, in the play, brought before the mystic crib — in her quavering voice began to sing and then her voice changed, changed from witch to angel and from the voice of an angel into the voice of a child and then the answer by another voice, this one firm and warmly vibrant, a woman's voice, behind the scenes.

That was amazing, amazing. I tell you, the so-called 'Félibres' had anyway spared themselves neither trouble nor expense.

As for me, with this little country here I have no need at all to go to the tropics.

I believe and will always believe in the art to be created in the tropics, and I believe it will be marvellous, but well, personally I'm too old and (especially if I get myself a papier-mâché ear) too jerry-built to go there.

Will Gauguin do it? It isn't necessary. For if it must be done it will be done all on its own.

We are merely links in the chain.

At the bottom of our hearts good old Gauguin and I understand each other, and if we're a bit mad, so be it, aren't we also a little sufficiently deeply artistic to contradict anxieties in that regard by what we say with the brush?

Perhaps everyone will one day have neurosis, the Horla, St Vitus's Dance or something else.

But doesn't the antidote exist? In Delacroix, in Berlioz and Wagner? And really, our artistic madness which all the rest of us have, I don't say that I especially haven't been struck to the marrow by it. But I say and will maintain that our antidotes and consolations can, with a little good will, be considered as amply prevalent. See Puvis de Chavannes' Hope.

Ever yours,
Vincent

My dear Theo,

As long as my mind was so out of sorts it would have been fruitless to try and write to you to reply to your kind letter. Today I've just returned home for the time being, I hope for good. There are so many moments when I feel completely normal, and actually it would seem to me that, if what I have is only a sickness peculiar to this area, I should wait quietly here until it's over. Even if it were to happen again (which, let's say, won't be the case).

But here is what I'm saying once and for all to you and to Mr Rey. If sooner or later it were desirable that I should go to Aix, as has already been suggested — I consent in advance and will submit to it.

But in my capacity as painter and workman it isn't permissible for anyone, not even you or the doctor, to take such a course of action without warning me and consulting me *myself* about it too, because as up to now I've always kept my relative presence of mind for my work, it's my right to say then (or at least to have an opinion on) what would be best, to keep my studio here or to move completely to Aix. That in order to avoid the expenses and the losses of a move as much as possible, and not to do it except in the event of an absolute emergency.

It appears that the people around here have a legend that makes them afraid of painting and that people talked about that in the town. Good. As for me, I know that it's the same thing in Arabia, and yet we have heaps of painters in Africa, don't we? Which proves that with a little firmness one can alter these prejudices, or at least do one's painting all the same. The unfortunate thing is that I'm rather inclined to be impressed, to feel the beliefs of other people myself and not always to laugh at the foundation of truth that there may be in the absurd.

Besides, Gauguin is like that too, as you were able to observe, and was himself also tired out at the time of his stay by some malaise or other.

As I've already been staying here for more than a year, and have heard people say pretty much all the bad things possible about me, about Gauguin, about painting in general, why shouldn't I take things as they are and wait for the outcome here.

Where can I go that's worse than where I've already been twice — the isolation cell.

The advantages that I have here are, as Rivet would say — first — 'they're all sick' here, and so at least I don't feel alone.

Then, as you well know, *I love Arles so much*, although Gauguin is darned right to call it the filthiest town in all of the south.

And I've found so much friendship already from the neighbours, from Mr Rey, from everyone at the hospital for that matter, that really I'd prefer to be always ill here than to forget the kindness there is in the same people who have the most incredible prejudices towards painters and painting, or in any case have no clear and healthy idea whatsoever about it as we do.

Then at the hospital they know me now, and if this were to come on again it would pass in silence, and at the hospital they'd know what to do. I have absolutely no desire to be treated by other doctors, nor do I feel the need for it.

The only desire I might have is to be able to continue to earn with my own hands what I spend.

Koning has written me a very kind letter, saying that he and a friend would probably come to the south with me for a long time. That in response to a letter I wrote him a few days ago. I no longer dare to urge painters to come here after what has happened to me, they run the risk of losing their heads like me. The same thing for De Haan and Isaäcson.

Let them go to Antibes, Nice, Menton, it's perhaps healthier.

Mother and our sister also wrote to me, the latter was very upset about the sick woman she was caring for. At home they're very pleased about your marriage.

Be well aware that you mustn't preoccupy yourself with me too much, nor fret yourself.

It must probably run its course, and we couldn't change very much about our fate with precautions.

Once again, let's try to seize our fate in whatever form it comes. Our sister wrote to me that your fiancée would come to stay with them for a while. That is well done. Ah well, I shake your hand most heartily, and let us not be discouraged. Believe me

Ever yours,
Vincent

Warm regards to Gauguin, I hope he's going to write to me, I'll write to him too.

Address next letter place Lamartine.

750 | Arles, Tuesday, 19 March 1889 | *To Theo van Gogh* (F)

19 March.

My dear brother,

I seemed to see so much restrained brotherly anguish in your kind letter that it seems to me to be my duty to break my silence. I write to you in full possession of my presence of mind and not like a madman but as the brother you know. Here is the truth: a certain number of people from here have addressed a petition (there were more than 80 signatures on it) to the mayor (I think his name is M. Tardieu) designating me as a man not worthy of living at liberty, or something like that.

The chief of police or the chief inspector then gave the order to have me locked up once again.

Anyway, here I am, shut up for long days under lock and key and with warders in the isolation cell, without my culpability being proven or even provable.

It goes without saying that in my heart of hearts I have a lot to say in reply to all that. It goes without saying that I shouldn't get angry, and that apologizing would seem to me to be accusing myself in such a case.

Only to warn you: to free me — first I don't ask it, being sure that all of this accusation will be reduced to nothing.

Only I say to you, you would find it difficult to free me. If I didn't restrain my

indignation I would immediately be judged to be a dangerous madman. In waiting let us hope, besides, strong emotions could only aggravate my state.

If in a month's time, though, you have no direct news of me, then act, but as long as I'm writing to you, wait.

That's why I now ask you to promise to let them act without getting yourself mixed up in it.

Consider yourself warned that it would perhaps complicate and confuse the matter.

All the more so since you'll understand that while I'm absolutely calm at the given moment, I may easily fall back into a state of over-excitement through new moral emotions.

So you can imagine how much of a hammer-blow full in the chest it was when I found out that there were so many people here who were cowardly enough to band themselves together against one man, and a sick one at that.

Good. That's for your guidance; as regards my moral state, I'm badly shaken, but all the same I'm recovering a certain calm so as not to get angry. Besides, humility suits me after the experience of repeated attacks.

So I'm being patient.

The main thing, I couldn't say it too often, is that you should keep your calm too, and that nothing should disturb you in your affairs. After your marriage we can deal with sorting all this out, and in the meantime, my word, leave me here quietly. I'm convinced that Mr Mayor, as well as the chief of police, are more like friends and that they'll do everything they can to settle all this. Here, except for freedom, except for lots of things that I would wish otherwise, I'm not too bad. Besides, I told them that we weren't in a position to bear expenses. I can't move without expenses, now I haven't been working for 3 months, and mind you, I would have been able to work if they hadn't exasperated and bothered me.

How are Mother and our sister? Having nothing else to distract me—I'm even forbidden to smoke—which, however, the other patients are allowed to do. Having nothing else to do I think about all those I know all day and night long.

What misery—and all of it, so to speak, for nothing.

I won't hide from you that I would have preferred to die than to cause and bear so much trouble. What can you say, to suffer without complaining is the only lesson that has to be learned in this life.

Now, in all that, if I must resume my task of painting I naturally need my studio, the furniture, which we certainly can't afford to renew if it's lost.

To be reduced once again to living in the hotel, you know that my work won't allow it, I must have a fixed pied-à-terre. If these fellows here protest against me, I protest against them, and they just have to provide me with damages and interest in a friendly way, in short they just have to give me back what I would lose by their fault and ignorance.

If—let's say—I were to become definitively insane—certainly I don't say that it's impossible, in any case they should treat me differently, give me back the fresh air, my work &c.

Then—my word—I would resign myself. But we aren't even there yet, and if I'd had my tranquillity I'd have been back on my feet long ago. They scold me about what I've smoked and drunk, fine.

But what can you say, with all their sobriety they're actually only giving me new miseries. My dear brother, the best thing remains perhaps to joke about our little miseries, and also a little about the great ones of human life. Take it like a man and walk dead straight towards your goal. We artists in present-day society are no more than the broken pitcher. How I'd like to be able to send you my canvases, but everything is under lock and key, police and keepers of the insane. Don't free me, it will settle itself on its own — all the same, warn Signac that he shouldn't get involved until I write again, for he'd be putting his hand into a wasps' nest. I shake your hand most cordially in thought, regards to your fiancée, to Mother and our sister.

Ever yours,
Vincent

I'll read this letter as it stands to Mr Rey, who isn't responsible, having been ill himself — no doubt he'll write to you himself too. My house has been shut up by the police.

I have a vague memory of a registered letter from you for which I was made to sign but which I didn't want to accept because they were making such a fuss for the signature, and of which I've since had no more news.

Explain to Bernard that I haven't been able to reply to him, it's quite a performance to write a letter: at least as many formalities are necessary as in prison now. Tell him to ask Gauguin for advice, but shake his hand firmly from me.

Once again warm regards to your fiancée and to Bonger.

I would have preferred not to write to you yet for fear of compromising you and disturbing you in what must work out above all. It will settle itself, it's too idiotic to last.

When you move house, address please.

I had hoped that Mr Rey would come to see me in order to talk with him before sending this letter, but although I had made it known that I was waiting for him, nobody came. I urge you again to be cautious. You know what it is to go to the civil authorities to complain. Wait until your journey to Holland at least.

I myself fear a little that if I go outside at liberty I wouldn't always be master of myself if I was provoked or insulted, and one could take advantage of that. The fact remains that a petition was sent to the mayor. I bluntly replied that I was entirely disposed to chuck myself into the water, for example, if that could make these virtuous fellows happy once and for all, but that in any case if in fact I had wounded myself I had done nothing of the sort to these people &c. So courage, then, although the guts fail me at times. Your coming here — my word — for the moment it would precipitate things. I'll move house when I see the means naturally.

I hope that this reaches you in good condition. Let's not fear, I'm quite calm now. Leave them to their own devices. You will perhaps do well to write one more time, but nothing more for the moment. If I'm patient, that could only make me stronger so that I won't be so much in danger of relapsing into a crisis. Naturally I who really have done my best to be friends with the people and didn't suspect it, it has been a harsh blow to me.

More soon, I hope, my dear brother, don't worry. It's perhaps a sort of quarantine I'm being put through. What do I know?

752 | Arles, Sunday, 24 March 1889 | *To Theo van Gogh* (F)

My dear Theo,

I'm writing to tell you that I've seen Signac, which did me a lot of good. He was very nice and very straight and very simple when the difficulty arose of whether or not to force open the door closed by the police, who had demolished the lock. They began by not wanting to let us do it, and yet in the end we got in. As a keepsake I gave him a still life which had exasperated the good gendarmes of the town of Arles because it depicted two smoked herrings, which are called gendarmes, as you know. You know that I did this same still life two or three times before in Paris, and once exchanged it for a carpet back then. That's enough to say what people meddle in and what idiots they are.

I find Signac very calm, whereas people say he's so violent, he gives me the impression of someone who has his self-confidence and balance, that's all. Rarely or never have I had a conversation with an Impressionist that was so free of disagreements or annoying shocks on either side.

For example, he went to see Jules Dupré and reveres him. No doubt you had a hand in his coming to boost my morale a little, and thank you for that. I took advantage of my trip out to buy a book, *Ceux de la glèbe* by Camille Lemonnier. I've devoured two chapters of it — it's so serious, so profound. Wait for me to send it to you. This is the first time for several months that I've picked up a book. That tells me a lot and heals me a great deal.

In fact there are several canvases to send to you, as Signac was able to see — he wasn't frightened by my painting, or so it seemed to me.

Signac thought I was looking well, and it's perfectly true.

On top of that, I have the desire and the taste for work. Of course, it's still the case that if things were to be messed up for me in my work and in my life every day by gendarmes and venomous layabouts of municipal electors who petition against me to their mayor elected by them (and who is consequently keen on their votes) it would be only human on my part that I should succumb once more. Signac, I'm led to believe, will tell you something similar.

In my opinion we must squarely oppose the loss of the furniture &c.

Then — my word — I must have my freedom to practise my profession.

Mr Rey says that instead of eating enough and regularly I have been particularly sustaining myself with coffee and alcohol. I admit all that, but it will still be true that I had to key myself up a bit to reach the high yellow note I reached this summer. That, after all, the artist is a man *at work*, and that it's not for the first passer-by who comes along to vanquish him once and for all.

Must I suffer imprisonment or the madhouse — why not? Didn't Rochefort with Hugo, Quinet and others give an eternal example by suffering exile, and the first even the penal colony.

But all I want to say is that this is above the question of sickness and health.

Naturally one is beside oneself in parallel cases — I don't say equivalent cases, as I have only a very inferior and secondary place — but I say parallel. And that was the first and last cause of my going out of my mind.

Do you know that expression by a Dutch poet

I am tied to the earth
With more than earthly bonds.

That's what I experienced in many moments of anguish — above all — in my so-called mental illness. Unfortunately I have a profession which I don't know well enough to express myself as I would wish.

I'll stop dead for fear of relapsing, and move on to something else.

Could you send me before you leave

3 tubes blanc zinc white
1 tube same size cobalt
1 " " " ultramarine
4 " " " Veronese green
1 " " " emerald "
1 " " " orange lead

This in case — probable if I find the means to take up my work again — that in a short while I can set to work again in the orchards.

Ah, if only nothing had happened to mess things up for me!

Let's think carefully before going somewhere else. You can see that in the south I have no more luck than in the north. It's about the same everywhere. I'm thinking of squarely accepting my profession as a madman just like Degas took on the form of a notary. But there it is, I don't feel I quite have the strength needed for such a role.

You speak to me of what you call 'the real south'. Above is the reason why I'll never go there. I rightly leave that to people more complete, more entire than myself. As for me, I'm good only for something intermediate and second-rate and insignificant.

However much intensity my feeling may have or my power of expression may acquire, at an age when the material passions are more burned out — never can I build an imposing edifice on such a mouldy, shattered past.

So I don't really mind what happens to me — even staying here — I think that my fate will be balanced in the long term. Beware of sudden impulses — since you're getting married, and I'm getting too old — it's the only policy that can suit us.

More soon, I hope — write to me without much delay and believe me, after asking you to give my warm regards to Mother, Sister and your fiancée, your brother who loves you dearly,

Vincent

I'll send you Camille Lemonnier's book quite soon.

My dear friend Signac,

Thanks very much for your postcard, which gives me news of you. As for my brother not having replied to your letter yet, I'm inclined to believe that it's not his fault. I've also been without news of him for a fortnight. It's because he's in Holland, where he's getting married one of these days. Now, while not denying the advantages of a marriage in the very least, once it has been done and one is quietly set up in one's home, the funereal pomp of the reception &c., the lamentable congratulations of two families (even civilized) at the same time, not to mention the fortuitous appearances in those pharmacist's jars where antediluvian civil or religious magistrates sit — my word — isn't there good reason to pity the poor unfortunate obliged to present himself armed with the requisite papers in the places where, with a ferocity unequalled by the cruellest cannibals, you're married alive on the low heat of the aforementioned funereal receptions.

I remain much obliged to you for your most friendly and beneficial visit, which considerably contributed to cheering me up.

I am well now and I'm working in the hospital or its surroundings. Thus I've just brought back two studies of orchards.

[*Sketch* 756A]

Here's a hasty croquis of them — the largest is a poor green countryside with little cottages, blue line of the Alpilles, white and blue sky. The foreground, enclosures with reed hedges where little peach trees are in blossom — everything there is *small*, the gardens, the fields, the gardens, the trees, even those mountains, as in certain Japanese landscapes, that's why this subject attracted me.

The other landscape is almost all green with a little lilac and grey — on a rainy day.

Very pleased to hear you say that you've settled down, and will very much wish to have more news of you. How is work going, what is the character of those parts?

[*Sketch* 756B]

Since then my mind has returned yet more to the normal state, for the time being I don't ask for better, provided it lasts. That will depend above all on a very sober regime.

For the first few months, at least, I plan to go on staying here. I've rented an apartment consisting of two very small rooms. But at times it isn't completely convenient for me to start living again, for I still have inner despairs of quite a large calibre.

My word, these anxieties . . . who can live in modern life without catching his share of them?

The best consolation, if not the only remedy, is, it still seems to me, profound friendships, even if these have the disadvantage of anchoring us in life more solidly than may appear desirable to us in the days of great suffering.

Thank you again for your visit, which gave me so much pleasure.

Good handshake in thought.

Yours truly,
Vincent

Address until end of April, place Lamartine 2, Arles.

Je vous demeure bien obligé de votre
amicale et bienfaisante visite qui
m'a considerablement contribué à me
remonter le moral
Je vais bien maintenant et je travaille
à l'hospice ou dans les environs.
Ainsi je viens de rapporter deux
études de vergers.

En voici croquis hatif. — le plus grand
est une pauvre campagne verte à petites mas
ligne bleue des alpines ciel blanc à bleu
Le devant des clos aux hores de roseaux ou de petits
pechers sont en fleur — tout y est petit les jardins
les champs les jardins les arbres même ces montagnes
comme dans certains paysages japonais c'est pourquoi
ce motif m'allait
L'autre paysage est presque tout vert avec un peu
de lilas et de gris — par un jour pluvieux
Bien aise de ce que vous dites que vous vous êtes
tiré et serai désireux d'avoir encore de vos nouvelles
comment le travail marche/, comment est le caractère de ces
 parages là.

756A. *Orchard in blossom with a view of Arles*

756B. *La Crau with peach trees in blossom*

My dear Theo

You'll probably be back in Paris when this letter arrives. I wish you and your wife lots of happiness.

Thanks very much for your kind letter and for the 100-franc note it contained.

Out of the 65 francs which I owe him, I've paid my landlord only 25 francs, having had to pay 3 months' rent in advance on a room where I shan't live but where I've stored my furniture, and having in addition had around ten francs in various removal expenses &c.

Then, since my clothes were in not too brilliant a state — so that when I went out into the street it became necessary to have something new — I took a 35-franc suit and 4 francs for 6 pairs of socks. Thus I have only a few francs left out of the note, and at the end of the month I must pay the landlord again, although we could make him wait a few days, more or less. At the hospital, after having settled the bill up to today, there's still almost enough for the rest of the month from the money I still have on deposit there.

At the end of the month I'd still wish to go to the mental hospital at St-Rémy or another institution of that kind, which Mr Salles has told me about.

Forgive me for not going into details to weigh up the pros and the cons of such a course of action.

It would strain my mind a great deal to talk about it.

It will, I hope, suffice to say that I feel decidedly incapable of starting to take a new studio again and living there alone, here in Arles or elsewhere — it comes down to the same thing — for the moment — I've nevertheless tried to make up my mind to begin again — for the moment not possible. I'd be afraid of losing the faculty of working, which is coming back to me now, by forcing myself to have a studio, and also having all the other responsibilities on my back.

And for the time being I wish to remain confined, as much for my own tranquillity as for that of others.

What consoles me a little is that I'm beginning to consider madness as an illness like any other and accept the thing as it is, while during the actual crises it seemed to me that everything I was imagining was reality. Anyway, in fact I don't want to think or talk about it. Excuse the explanations — but I ask you, and Messrs Salles and Rey, to act so that at the end of the month or the beginning of the month of May I may go there as a confined boarder.

Beginning again this painter's life I've led up to now, isolated in the studio sometimes, and without any other source of entertainment than to go to a café or a restaurant with all the criticism of the neighbours &c., I CAN'T DO IT. Going to live with another person, even another artist — difficult — very difficult — one takes too great a responsibility upon oneself. I dare not even think of it.

Anyhow, let's begin with 3 months, afterwards we'll see. Now the cost of board must be around 80 francs and I'll do a little painting and drawing. Without putting as much fury into it as the other year. Don't get upset about all this.

So there you have it, these days have been sad, moving house, transporting all my

furniture, packing up the canvases which I'll send you, but above all it seemed sad to me that all that had been given to me by you with so much brotherly affection, and that for so many years, it was however you alone who supported me, and then to be obliged to come back to tell you all this sad story . . . but it's difficult for me to express that as I felt it.

The kindness you have had for me isn't lost, since you have had it and you still have it, so even if the material results should be nil, you still have that all the more, but I can't say that as I felt it.

Now you well understand that if alcohol was certainly one of the great causes of my madness, then it came very slowly and would go away slowly too, should it go, of course. Or if it comes from smoking, same thing.

But I would hope only that it — this recovery . . . The frightful superstition of certain people on the subject of alcohol, so that they prevail upon themselves never to drink or smoke. We're already advised not to lie or steal and not to commit other great or small crimes, and it becomes too complicated if it was absolutely indispensable not to possess anything but virtues in a society in which we're very indubitably rooted, be it good or bad.

I assure you that these strange days in which many things seem odd to me because my brain is shaken up, I don't hate *père* Pangloss in all of this.

But you'll do me a service by tackling the question forthrightly with Mr Salles and Mr Rey.

It would seem to me that with a boarding cost of around seventy-five francs a month there must be a way of confining me such that I have all I need.

Then I'd very much wish, if the thing is possible, to be able to go out in the daytime to go and draw or paint outside. Seeing as I go out here every day now, and I think that may continue.

I warn you that by paying more I'd be less happy. The company of the other sick people, you understand, isn't at all disagreeable to me, on the contrary it distracts me.

Ordinary food suits me perfectly well, especially if, like here, I could be given a little more wine than usual down there, half a litre instead of a quarter, for example.

But a separate apartment, it remains to be seen what the rules of an institution like that will be. Be aware that Rey is overburdened with work, overburdened. If he or Mr Salles writes to you, it's better to do exactly what they say.

Anyway, my dear fellow, we must accept it, the illnesses of our time, all in all it's only fair that having lived for years in relatively good health, sooner or later we have our share of them. As for me, you'll feel a little that I wouldn't exactly have chosen madness if there had been a choice, but once one has something like that one can't catch it any more. However, in addition there will still perhaps be the consolation of being able to continue to work on some painting a little. What will you do so as not to say to your wife either too many good or too many bad things about Paris and of a heap of things? Do you feel in advance completely able to keep exactly the right measure always, from every point of view?

I shake your hand heartily in thought, I don't know if I'll write to you very, very often, because all my days aren't clear enough to write somewhat logically. All your kindnesses for me, I've found them greater than ever today.

I can't tell you it as I feel it, but I assure you that that kindness has been of great

worth, and if you don't see its results, my dear brother, don't be upset about it, you will still have your kindness. Only transfer this affection onto your wife as much as possible.

And if we correspond a little less you'll see that if she is as I think she is, she will console you. That's what I hope.

Rey is a really good fellow, terribly hard-working, always at the daily grind. What people today's doctors are!

If you see Gauguin or if you write to him, give him my kind regards.

I'll be very happy to have a little news of what you say about Mother and Sister and whether they're well, tell them to take my story, my word, as a thing they mustn't upset themselves about excessively, for I'm relatively unfortunate, but in spite of that, after all, I perhaps still have some almost ordinary years ahead of me: it's an illness like any other, and currently almost all those we know among our friends have something. So is it worth talking about? I regret causing trouble to Mr Salles, to Rey, especially also to you, but what can one do — the mind isn't steady enough to begin again like before — so it's a matter of no longer causing scenes in public, and naturally being a little calmer now, I feel completely that I was in an unhealthy state, mentally and physically. And people were kind to me then, those I remember and the rest, anyhow I've caused anxiety, and if I'd been in a normal state all of this wouldn't have happened in that way. Adieu, write when you can.

Ever yours,
Vincent

764 | Arles, between about Sunday, 28 April and Thursday, 2 May 1889 |
 To Willemien van Gogh (F)

My dear sister,

Your kind letter really touched me, especially since it tells me that you've returned to care for Mrs du Quesne.

Certainly cancer is a terrible illness, as for me, I always shiver when I see a case — and it isn't rare in the south, although often it's not the real incurable, mortal cancer but cancerous abscesses from which one sometimes recovers. Whatever the case, you're very brave, my sister, not to recoil before these Gethsemanes. And I feel less brave than you when I think of these things, feeling awkward, heavy and clumsy in them. We have, if my memory serves, a Dutch proverb to this effect: they aren't the worst fruits that wasps gnaw at . . .

This leads me straight to what I wanted to say, ivy loves the old lopped willows each spring, ivy loves the trunk of the old oak tree — and so cancer, that mysterious plant, attaches itself so often to people whose lives were nothing but ardent love and devotion. So, however terrible the mystery of these pains may be, the horror of them is sacred, and in them there might indeed be a gentle, heartbreaking thing, just as we see the green moss in abundance on the old thatched roof. However, I don't know anything about it — I have no right to assert anything.

Not very far from here there's a very, very, very ancient tomb, more ancient than

Christ, on which this is inscribed, 'Blessed be Thebe, daughter of Telhui, priestess of Osiris, who never complained about anyone.' I couldn't help thinking of that when you told me in your previous letter that the sick lady you're caring for didn't complain.

Mother must be pleased with Theo's marriage, and he writes to me that she looks as if she's getting younger. That pleases me greatly. Now he too is very pleased with his matrimonial experiences, and is considerably reassured.

He has so few illusions about it, having to a rare degree the strength of character to take things as they are without making pronouncements about good and evil. In which he's quite right, for what do we know of what we do?

As for me, I'm going for at least 3 months into an asylum at St-Rémy, not far from here.

In all I've had 4 big crises in which I hadn't the slightest idea of what I said, wanted, did.

Not counting that I fainted 3 times previously without plausible reason, and not retaining the least memory of what I felt then.

Ah well, that's quite serious, although I'm much calmer since then, and physically I'm perfectly well. And I still feel incapable of taking a studio again. I'm working though, and have just done two paintings of the hospital. One is a ward, a very long ward with the rows of beds with white curtains where a few figures of patients are moving.

The walls, the ceiling with the large beams, everything is white in a lilac white or green white. Here and there a window with a pink or bright green curtain.

The floor tiled with red bricks. At the far end a door surmounted by a crucifix.

It's very, very simple. And then, as a pendant, the inner courtyard. It's an arcaded gallery like in Arab buildings, whitewashed. In front of these galleries an ancient garden with a pond in the middle and 8 beds of flowers, forget-me-nots, Christmas roses, anemones, buttercups, wallflowers, daisies &c.

And beneath the gallery, orange trees and oleanders. So it's a painting chock-full of flowers and springtime greenery. However, three black, sad tree-trunks cross it like snakes, and in the foreground four large sad, dark box bushes.

The people here probably don't see much in it, but however it has always been so much my desire to paint for those who don't know the artistic side of a painting.

What shall I say to you, you don't know the reasonings of good *père* Pangloss in Voltaire's Candide, nor Flaubert's Bouvard et Pécuchet. These are books from man to man, and I don't know if women understand that. But the memory of that often sustains me in the uncomfortable and unenviable hours and days or nights.

I've re-read Beecher Stowe's Uncle Tom with EXTREME *attention* precisely because it's a woman's book, written, she says, while making soup for her children, and then also with extreme attention C. Dickens's Christmas Tales.

I read little so as to think about it more. It's very likely that I have a lot more to suffer. And that doesn't suit me at all, to tell you the truth, for I wouldn't wish for a martyr's career in any circumstances.

For I've always sought something *other* than the heroism I don't have, which I certainly admire in others but which, I repeat, I do *not* believe to be my duty or my ideal.

I haven't re-read those excellent books by Renan but how often I think of them here, where we have the olive trees and other characteristic plants and the blue sky. Ah,

how right Renan is and what a fine work his is, to speak to us in a French like no other person speaks. A French in which, *in the sound of the words*, there's the blue sky and the gentle rustling of the olive trees and a thousand *true* and *explanatory* things in short that turn his history into a resurrection. It's one of the saddest things I know, the prejudices of people who through bias oppose so many good and beautiful things that have been created in our time. Ah, the eternal '*ignorance*', the eternal 'misunderstandings', and how much good it then does to happen upon words that are truly Serene . . . Blessed be Thebe — daughter of Telhui — priestess of Osiris — who never complained about anyone.

For myself, I quite often worry that my life hasn't been calm enough, all these disappointments, annoyances, changes mean that I don't develop naturally and in full in my artistic career.

'A rolling stone gathers no moss'

they say, don't they?

But what does that matter if, as rightly the above-mentioned *père* Pangloss alone proves, 'everything is always for the best in the best of worlds'.

Last year I did about ten or a dozen orchards in blossom and this year I have only four, so work isn't going with much gusto.

If you have the Drône book you speak of I'd very much like to read it, but do me the pleasure of *not* buying it especially for me at the moment. I've seen some very interesting nuns here, the majority of the priests seem to me to be in a sad state. Religion has frightened me so much for so many years now. For example, do you happen to know that *love* perhaps doesn't exist exactly as one imagines it — the junior doctor here, the worthiest man one could possibly imagine, the most dedicated, the most valiant, a warm, manly heart, sometimes amuses himself mystifying the little women by telling them that love is also a microbe. Although then the little women, and even a few men, let out loud shouts, he doesn't care at all and is imperturbable on that point.

As for kissing and all the rest that it pleases us to add to it, that's just a natural kind of act like drinking a glass of water or eating a piece of bread. Certainly it's quite indispensable to kiss, otherwise serious disorders arise.

Now must cerebral sympathies always go with or without what precedes. Why regulate all that, eh, what's the use?

For myself I'm not opposed to love being a microbe, and even so that wouldn't prevent me at all from feeling things such as respect before the pains of cancer for example.

And do you see, the doctors of whom you say, sometimes they can't do very much (which I leave you free to say as much as you consider right) — very well — do you know what they can do all the same — they give you a more cordial handshake, gentler than many other hands, and their presence can really be very pleasant and reassuring sometimes.

There you are, I'm letting myself go on and on. Yet often I can't write two lines, and I really fear that my ideas may be futile or incoherent this time too.

Only I wanted to write to you in any case while you were there. I can't precisely describe what the thing I have is like, there are terrible fits of anxiety

sometimes — without any apparent cause — or then again a feeling of emptiness and fatigue in the mind. I consider the whole rather as a simple accident, no doubt a large part of it is my fault, and from time to time I have fits of melancholy, atrocious remorse, but you see, when that's going to discourage me completely and make me gloomy, I'm not exactly embarrassed to say that remorse and fault are possibly microbes too, just like love.

Every day I take the remedy that the incomparable Dickens prescribes against suicide. It consists of a glass of wine, a piece of bread and cheese and a pipe of tobacco. It isn't complicated, you'll tell me, and you don't think that my melancholy comes close to that place, however at moments — ah but . . .

Anyway, it isn't always pleasant, but I try not to forget completely how to jest, I try to avoid everything that might relate to heroism and martyrdom, in short I try not to take lugubrious things lugubriously.

Now I wish you good-night, and my respects to your patient, although I don't know her.

Ever yours,
Vincent

I don't know if Lies is in Soesterberg at the moment, if she's there, kind regards from me.

768 | Arles, Friday, 3 May 1889 | *To Theo van Gogh* (F)

My dear Theo,

Your kind letter did me good today, my word — let's go for St-Rémy then, but I tell you one more time, if after due consideration and consultation with the doctor it would be perhaps either necessary or simply useful and wise to enlist, let's consider that with the same eye as the rest, and without *prior prejudice against it*. That's all. For dismiss the idea of sacrifice in it — I was writing to our sister the other day that throughout my life, or almost at least, I've sought something other than a martyr's career, of which I'm not capable.

If I find annoyance or cause it, my word I remain stunned by it. Certainly I would gladly respect, I would admire martyrs &c., but you must know that in Bouvard et Pécuchet, for example, quite simply there is some other thing that adapts itself more to our little existences.

Anyway, I'm packing my trunk, and probably Mr Salles will go there with me as soon as he can.

Ah, what you said about Puvis and Delacroix is darned right, those fellows have well demonstrated what painting could be, but let's not confuse things when there are immense distances. Now, myself as a painter, I'll never signify anything important, I sense it absolutely. Supposing everything were changed, character, upbringing, circumstances, then this or that could have existed. But we're too positive to confuse. I sometimes regret not having simply kept the Dutch palette of grey tones, and brushed landscapes in Montmartre without pressing the point.

Also, I'm thinking of beginning to draw more with the reed pen again which, like last year's views of Montmajour, is less expensive and distracts me just as much. Today I've made one of those drawings which became very dark and quite melancholic for springtime, but anyway, whatever happens to me and in whatever circumstances I find myself, that's something that I could keep as an occupation for a long time, and in some way could even become a means of earning a livelihood.

Anyway, all in all what does it matter to you or to me to have a little more or a little less annoyance.

Certainly you *joined up* much earlier than I did, if we come to that, at the Goupils', where all in all you spent some pretty bad moments often enough, for which you weren't always thanked. And indeed you did it with zeal and devotion, because then our father rather had his back to the wall with the big family at the time, and it was necessary for you to throw yourself into it completely in order to make everything work. I've thought again with much emotion of all these old things during my illness.

And in the end the main thing is to feel ourselves closely united, and that hasn't yet been disturbed.

I have a certain hope that with what I know of my art in total, a time will come when I'll produce again, although in the asylum. What use would the more artificial life of an artist in Paris be to me — one by which, all in all, I would only be half duped and for which I consequently lack primitive enthusiasm, indispensable for launching myself into it. Physically it's amazing how well I am, but that isn't enough of a basis for going on believing that it's the same mentally.

I would happily, once I was known there a little, try and make myself a male nurse little by little, in short to work at anything and take up an occupation again — the first one that comes along.

I'll have terrible need of *père* Pangloss when it naturally comes about that I become amorous again. Alcohol and tobacco have after all this good or bad point — it's a bit relative, this — that they're anti-aphrodisiacs, one should call it that I think. Not always to be despised in the exercise of the fine arts.

Anyway, that will be the ordeal in which one mustn't forget completely how to jest. For virtue and sobriety, I'm only too afraid, would lead me again into those parts where usually I very quickly lose the compass completely, and where this time I must try to have less passion and more bonhomie.

The possible passionate thing is no great thing for me, although the power remains, I dare believe, to feel oneself attached to the human beings with whom one lives. How is *père* Tanguy — you must give him my warm regards.

I hear in the newspapers that there are good things at the Salon. Listen — don't make yourself a completely exclusive Impressionist after all, if there's good in something let's not lose sight of it. Certainly colour is making progress, *precisely by* the Impressionists, even when they go astray. But Delacroix was already more complete than they are.

And my goodness, Millet, who has hardly any colour, what work his is!

Madness is salutary for this, that one becomes perhaps less exclusive.

I don't regret having wanted to know a little technically about this question of the theories of colours.

As an artist one is merely a link in a chain, and whether you find or you don't find, you can console yourself with that.

I've heard talk of a completely green interior with a green woman at the Salon which people were saying good things about, as well as a portrait by Mathey, and another by Besnard, 'The siren'. People were also saying that there's something extraordinary by a fellow called Zorn, but they didn't say what, and that there was a Carolus-Duran there, Triumph of Bacchus, bad. However, I still find his 'Lady with a glove' in the Luxembourg so good; anyway, there are things that aren't serious that I like a lot, such as a book like Bel-ami. And Carolus's work is a little like that. Our epoch has been like that, though, and all Badinguet's time too. And if a painter does as he sees, he always remains someone.

Ah, to paint figures like Claude Monet paints landscapes. That's what remains to be done despite everything, and before, of necessity, one sees only Monet among the Impressionists.

For after all in figures, Delacroix, Millet, several sculptors have otherwise done better than the Impressionists, and even J. Breton.

Anyway, my dear brother, let's be just, and I say to you *as I retire*, let's think, just when we're getting too old to class ourselves with the young ones, of what we have loved in our time, Millet, Breton, Israëls, Whistler, Delacroix, Leys. And be fully assured that I myself am sufficiently convinced that I shan't see a future beyond that, nor moreover desire one.

Now society is as it is, naturally we can't wish for it to adapt itself just to our personal needs. Anyway, however while finding it really really good to go to St-Rémy, however with people like me it would really be more just to stuff them into the legion. We can't do anything about it, but more than probably they'd refuse me there, at least here where my adventure is too well known, and above all exaggerated. I say this very, very seriously, physically I'm better than I have been for years and years, and I could do military service. So let's think again about that while going to St-Rémy. I shake your hand heartily, and your wife's too.

Ever yours,
Vincent

Ah, when I wrote to you that we mustn't forget to appreciate what's good in those who aren't Impressionists, I didn't exactly mean to say that I was urging you to admire the Salon beyond measure, but rather a heap of people like, for example, Jourdan, who has just died in Avignon, Antigna, Feyen-Perrin, all those whom we knew so well before, when we were younger, why forget them or why attach no importance to their present-day equivalents? Why are Daubigny and Quost and Jeannin not colourists for example? So many distinctions in Impressionism do *not* have the importance one wanted to see in them.

Crinolines also had something pretty and consequently good about them, but anyway the fashion was fortunately short-lived all the same. Not for some people.

And thus we'll always retain a certain passion for Impressionism, but I sense that I'm returning more and more to the ideas I already had before coming to Paris.

Now that you're married we no longer have to live for great ideas but, believe it, for little ones only. And I find that a real relief which I don't complain about at all.

(In my room I have the famous portrait of a man (the wood engraving) that you know, a mandarin woman by Monorou (the large print from the Bing album), the

blade of grass (from the same album), the Pietà and the good Samaritan by Delacroix, and Meissonier's reader, then two large reed pen drawings.)

At the moment I'm reading Balzac's Le médecin de campagne, which is really fine, in it there's a character of a woman, not mad but too sensitive, who is really charming, I'll send it to you when I've finished it. Wil wrote me a kind letter, still very firm and calm.

They have a lot of room here at the hospital, there'd be enough to make studios for thirty or so painters.

I really must make up my mind, it's only too true that an awful lot of painters go mad, it's a life which makes you very distracted, to say the least. If I throw myself fully into work again, that's good, but I still remain cracked. If I could enlist for 5 years I would recover considerably and would be more rational and more the master of myself.

But one or the other, it's all the same to me.

I hope that in the heap of canvases I've sent you there may be some which will end up giving you pleasure. If I remain a painter, then sooner or later I'll probably see Paris again, and I firmly promise myself that I'll thoroughly touch up several old canvases on that occasion. What's Gauguin doing, I'm still avoiding writing to him until I'm completely normal, but I think of him so often, and I'd so much like to know if everything is going relatively well for him.

If I hadn't been in such a hurry, if I'd kept my studio, this summer I would have worked again on all the canvases I've sent you. As long as the impasto isn't dry all the way through, naturally it can't be scraped.

You'll clearly see that the two women's expressions are different from the expressions one sees in Paris.

Is Signac back in Paris yet?

772 | Saint-Rémy-de-Provence, Thursday, 9 May 1889 | *To Theo van Gogh
and Jo van Gogh-Bonger* (F)

My dear Theo,

Thanks for your letter. You're quite right to say that Mr Salles has been perfect in all of this, I'm much obliged to him.

I wanted to tell you that I think I've done well to come here, first, in seeing the *reality* of the life of the diverse mad or cracked people in this menagerie, I'm losing the vague dread, the fear of the thing. And little by little I can come to consider madness as being an illness like any other. Then the change of surroundings is doing me good, I imagine.

As far as I know the doctor here is inclined to consider what I've had as an attack of an epileptic nature. But I haven't made any enquiries.

Have you by chance yet received the crate of paintings, I'm curious to know if they've suffered more, yes or no.

I have two others on the go — violet irises and a lilac bush. Two subjects taken from the garden.

The idea of my duty to work comes back to me a lot, and I believe that all my faculties for work will come back to me quite quickly. It's just that work often absorbs me so much that I think I'll always be absent-minded and awkward in getting by for the rest of life too.

I won't write you a long letter — I'll try to answer the letter from my new sister, which greatly touched me, but I don't know if I'll manage to do it.

Handshake, and ever yours,
Vincent

My dear sister,

Thanks very much for your letter, in which I above all looked for news of my brother. And I find it very good. I can see that you have already observed that he loves Paris and that this surprises you a little, you who don't like it, or rather who above all like the flowers there, such as, I suppose, for example, the wisterias which are probably beginning to flower. Could it not be the case that in liking a thing one sees it better and more accurately than in not liking it.

For him and for me Paris is certainly already a cemetery in a way, where many artists have perished, whom we knew directly or indirectly.

Certainly *Millet*, whom you'll learn to like a lot, and with him many others, have tried to get out of Paris. But Eugène Delacroix, for example, it's difficult to portray him 'as a man' other than as a Parisian.

All this to urge you — with all caution, admittedly — to believe in the *possibility* that there are *homes* in Paris, and not just apartments.

Anyway — fortunately *you* are now his home yourself.

It's quite odd perhaps that the result of this terrible attack is that in my mind there's hardly any really clear desire or hope left, and I'm wondering if it is thus that one thinks when, with the passions somewhat extinguished, one comes down the mountain instead of climbing it. Anyway my sister, if you can believe, or almost, that everything is always for the best in the best of worlds then you'll also be able to believe, perhaps, that Paris is the best of the towns in it.

Have you noticed yet that the old cab-horses there have big, beautiful heartbroken eyes, like Christians sometimes. Whatever the case, we're not savages nor peasants, and we perhaps *even have a duty* to love civilization (so-called). Anyway, it would probably be hypocritical to say or believe that Paris is bad when one lives there. The first time one sees Paris it may be, besides, that everything there seems against nature, dirty and sad. Anyway, if you don't like Paris, above all do not like painting nor those who directly or indirectly are engaged in it, for it's only too doubtful whether that's beautiful or useful.

But what can you do, there are people who love nature while being cracked or ill, those are the painters, then there are some who love what is done by the hand of man, and those even go as far as liking paintings.

Although there are a few people here who are seriously ill, the fear, the horror that I had of madness before has already been greatly softened.

And although one continually hears shouts and terrible howls as though of the animals in a menagerie, despite this the people here know each other very well, and help each other when they suffer crises. They all come to see when I'm working in the garden, and I can assure you are more discreet and more polite to leave me in peace than, for example, the good citizens of Arles.

It's possible that I'll stay here for quite a long time, never have I been so tranquil as here and at the hospital in Arles to be able to paint a little at last. Very near here there are some little grey or blue mountains, with very, very green wheatfields at their foot, and pines.

I shall count myself very happy if I manage to work enough to earn my living, for it makes me very worried when I tell myself that I've done so many paintings and drawings without ever selling any. Don't be in too much of a hurry to consider this an injustice, I don't know anything at all about it.

Thanking you again for writing to me, and being very happy to know that now my brother doesn't return to an empty apartment when he comes home in the evening, I shake your hand in thought, and believe me

your brother
Vincent

My dear Theo,
Your letter which I've just received gives me great pleasure. You tell me that J.H. Weissenbruch has two paintings in the exhibition—but I thought he was dead—am I mistaken? He certainly is one hell of an artist and a good man, with a big heart too.

What you say about the Berceuse gives me pleasure; it's very true that the common people, who buy themselves chromos and listen with sentimentality to barrel organs, are vaguely in the right and perhaps more sincere than certain men-about-town who go to the Salon.

Gauguin, if he'll accept it, you shall give him a version of the Berceuse that wasn't mounted on a stretching frame, and to Bernard too, as a token of friendship.

But if Gauguin wants sunflowers it's only absolutely fair that he gives you something that you like as much in exchange. Gauguin himself above all liked the sunflowers later, when he had seen them for a long time.

You must know, too, that if you put them in this order:

[*Sketch* 776A]

776A. *Triptych with 'La berceuse' and two versions of 'Sunflowers in a vase'*

that is, the Berceuse in the middle and the two canvases of the sunflowers to the right and the left, this forms a sort of triptych. And then the yellow and orange tones of the head take on more brilliance through the proximity of the yellow shutters. And then you will understand that what I was writing to you about it, that my idea had been to make a decoration like one for the far end of a cabin on a ship, for example. Then as the size gets bigger, the summary execution gets its *raison d'être*. The middle frame is then the red one. And the two sunflowers that go with it are those surrounded by strips of wood.

You see that this framing of simple laths does quite well, and a frame like that costs only very little. It would be perhaps good to frame the green and red vineyards, the sower and the furrows and the interior of the bedroom with them too.

[*Sketch* 776B]

Here's a new no. 30 canvas, commonplace again, like one of those chromos from a penny bazaar that depict eternal nests of greenery for lovers.

Thick tree-trunks covered with ivy, the ground also covered with ivy and periwinkle, a stone bench and a bush of roses, blanched in the cold shadow. In the foreground a few plants with white calyxes. It's green, violet and pink.

It's just a question — which is unfortunately lacking in chromos from a penny bazaar and barrel organs — of putting in some style.

Since I've been here, the neglected garden planted with tall pines under which grows tall and badly tended grass intermingled with various weeds, has provided me with enough work, and I haven't yet gone outside.

However, the landscape of St-Rémy is very beautiful, and little by little I'm probably going to make trips into it. But staying here as I am, the doctor has naturally been in a better position to see what was wrong, and will, I dare hope, be more reassured that he can let me paint.

I *assure* you that I'm very well here, and that for the time being I see no reason at all to come and board in Paris or its surroundings. I have a little room with grey-green paper with two water-green curtains with designs of very pale roses enlivened with thin lines of blood-red. These curtains, probably the leftovers of a ruined, deceased rich man, are very pretty in design. Probably from the same source comes a very worn armchair covered with a tapestry flecked in the manner of a Diaz or a Monticelli, red-brown, pink, creamy white, black, forget-me-not blue and bottle green.

Through the iron-barred window I can make out a square of wheat in an enclosure, a perspective in the manner of Van Goyen, above which in the morning I see the sun rise in its glory.

With this — as there are more than 30 empty rooms — I have another room in which to work.

The food is so-so. It smells naturally a little musty, as in a cockroach-ridden restaurant in Paris or a boarding school. As these unfortunates do absolutely nothing (not a book, nothing to distract them but a game of boules and a game of draughts) they have no other daily distraction than to stuff themselves with chickpeas, haricot beans, lentils and other groceries and colonial foodstuffs by the regulated quantities and at fixed times.

Voici une nouvelle toile
de 30 encore banale
comme un chromo de
bazar qui représentent
les éternels nids de verdure
pour les amoureux
Des gros troncs d'arbres
couverts de lierre le
sol également couvert
de lierre & de pervenche
un banc de pierre et
un buisson de roses
pales à l'ombre froide
Sur l'avant plan quelques
plantes à calice blanc
c'est vert violet et
rose

Il ne s'agit – ce qui manque malheureusement aux
chromos de bazar et aux orgues de barbarie d'y mettre
du style.
Depuis que je suis ici le jardin désolé planté de grands pins
sous lesquels croit haute et mal entretenue une herbe
entremelée d'ivraies diverses m'a suffi pour travailler et
je ne suis pas encore sorti dehors.
Cependant le paysage de S.t Remy est très beau et
peu à peu je vais y faire des étapes probablement.
Mais en restant ici naturellement le medecin a
mieux pu voir ce qui en était & sera j'ose
espérer plus rassuré sur ce qu'il peut me laisser
peindre.
Je t'assure que je suis bien ici et que provisoirement
je ne vois pas de raison du tout de venir en pension
à Paris ou environs. J'ai une petite chambre à
papier gris vert avec deux rideaux vert d'eau à dessins
de roses très pales ravivés de minces traits de rouge sang
Ces rideaux probablement des restes d'un riche ruiné et
défunt sont fort jolis de dessin De la même source proviennent
probablement un fauteuil très usé recouvert d'une tapisserie
tachetée à la Diaz ou à la Monticelli brun rouge rose
blanc crème noir bleu myosotys et vert bouteille
à travers la fenêtre barrée de fer j'apercois un carré
de blé dans un enclos une perspective à la v Goyen
au dessus de laquelle le matin je vois le soleil se
lever dans sa gloire

776B. *Trees with ivy in the garden of the asylum*

As the digestion of these commodities presents certain difficulties, they thus fill their days in a manner as inoffensive as it's cheap. But joking apart, the *fear* of madness passes from me considerably upon seeing from close at hand those who are affected with it, as I may very easily be in the future.

Before I had some repulsion for these beings, and it was something distressing for me to have to reflect that so many people of our profession, Troyon, Marchal, Meryon, Jundt, M. Maris, Monticelli, a host of others, had ended up like that. I wasn't even able to picture them in the least in that state.

Well, now I think of all this without fear, i.e. I find it no more atrocious than if these people had snuffed it of something else, of consumption or syphilis, for example.

These artists, I see them take on their serene bearing again, and do you think it's a small thing to rediscover ancient members of the profession.

Joking apart, that's what I'm profoundly grateful for.

For although there are some who howl or usually rave, here there is *much* true friendship that they have for each other. They say, one must suffer others for the others to suffer us, and other very true reasonings that they thus put into practice. And between ourselves we understand each other very well, I can, for example, chat sometimes with one who doesn't reply except in incoherent sounds, because he isn't afraid of me.

If someone has some crisis the others look after him, and intervene so that he doesn't harm himself.

The same for those who have the mania of often getting angry. Old regulars of the menagerie run up and separate the fighters, if there is a fight.

It's true that there are some who are in a more serious condition, whether they be filthy, or dangerous. These are in another courtyard. Now I take a bath twice a week, and stay in it for 2 hours, then my stomach is infinitely better than a year ago, so I only have to continue, as far as I know. I think I'll spend less here than elsewhere, since here I still have work on my plate, for nature is beautiful.

My hope would be that at the end of a year I'll know better than now what I can do and what I want. Then, little by little, an idea will come to me for beginning again. Coming back to Paris or anywhere at the moment doesn't appeal to me at all, I feel that I'm in the right place here. In my opinion, what most of those who have been here for years are suffering from is an extreme sluggishness. Now, my work will preserve me from that to a certain extent.

The room where we stay on rainy days is like a 3rd-class waiting room in some stagnant village, all the more so since there are honourable madmen who always wear a hat, spectacles and travelling clothes and carry a cane, almost like at the seaside, and who represent the passengers there.

I'm obliged to ask you for some more colours, and especially some canvas. When I send you the 4 canvases of the garden I have on the go you'll see that, considering that life happens above all in the garden, it isn't so sad. Yesterday I drew a very large, rather rare night moth there which is called the death's head, its coloration astonishingly distinguished: black, grey, white, shaded, and with glints of carmine or vaguely tending towards olive green; it's very big.

[*Sketch* 776C]

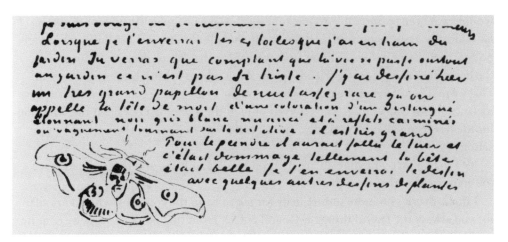

776C. *Giant peacock moth*

To paint it I would have had to kill it, and that would have been a shame since the animal was so beautiful. I'll send you the drawing of it with a few other drawings of plants.

You could take the canvases which are dry enough at Tanguy's or at your place off the stretching frames and then put the new ones you consider worthy of it onto these stretching frames. Gauguin must be able to give you the address of a liner for the Bedroom who won't be expensive. This I *imagine* must be a 5-franc restoration, if it's more then don't have it done, I don't think that Gauguin paid more when he quite often had canvases of his own, Cézanne or Pissarro lined.

Speaking of my condition, I'm still so grateful for yet another thing. I observe in others that, like me, they too have heard sounds and strange voices during their crises, that things also appeared to change before their eyes. And that softens the horror that I retained at first of the crisis I had, and which when it comes to you unexpectedly, cannot but frighten you beyond measure. Once one knows that it's part of the illness one takes it like other things. Had I not seen other mad people at close hand I wouldn't have been able to rid myself of thinking about it all the time. For the sufferings of anguish aren't funny when you're caught in a crisis. Most epileptics bite their tongues and injure them. Rey told me that he had known a case where someone had injured his ear as I did, and I believe I've heard a doctor here who came to see me with the director say that he too had seen it before. I dare to believe that once one knows what it is, once one is aware of one's state and of possibly being subject to crises, that then one can do something about it oneself so as not to be caught so much unawares by the anguish or the terror. Now, this has been diminishing for 5 months, I have good hope of getting over it, or at least of not having crises of such force. There's one person here who has been shouting and *always* talking, like me, for a fortnight, he thinks he hears voices and words in the echo of the corridors, probably because the auditory nerve is sick and too sensitive, and with me it was both the sight and the hearing at the same time which, according to what Rey said one day, is usual at the beginning of epilepsy.

Now the shock had been such that it disgusted me even to move, and nothing

would have been so agreeable to me as never to wake up again. At present this *horror of life* is already less pronounced, and the melancholy less acute. But I still have absolutely no *will*, hardly any desires or none, and everything that has to do with ordinary life, the desire for example to see friends again, about whom I think however, almost nil. That's why I'm not yet at the point where I ought to leave here soon, I would still have melancholy for everything. And it's even only in these very last days that the repulsion for life has changed quite radically. There's still a way to go from there to will and action.

It's a shame that you yourself are still condemned to Paris, and that you never see the countryside other than that around Paris.

I think that it's no more unfortunate for me to be in the company where I am than for you always the fateful things at Goupil & Cie. From that point of view we're quite equal. For only in part can you act in accordance with your ideas. Since, however, we have once got used to these inconveniences, it becomes second nature.

I think that although the paintings cost canvas, paint &c., at the end of the month, however, it's more advantageous to spend a little more thus, and to make them with what I've learned in total, than to abandon them while one would have to pay for board and lodging all the same anyway. And that's why I'm making them. So this month I have 4 no. 30 canvases and two or three drawings.

But no matter what one does, the question of money is always there like the enemy before the troops, and one can't deny it or forget it.

I retain my duties in that respect as much as anyone. And perhaps some day I'll be in a position to repay all that I've spent, because I consider that what I've spent is, if not taken from you at least taken from the family, so consequently I've produced paintings and I'll do more. That is to act as you too act yourself. If I had private means, perhaps my mind would be freer to do art for art's sake, now I content myself with believing that in working assiduously even so, without thinking of it one perhaps makes some progress.

Here are the colours I would need

3 emerald green	
2 cobalt	
1 ultramarine	large tubes.
1 orange lead	
6 zinc white	
5 metres canvas	

Thanking you for your kind letter, I shake your hand warmly, as well as your wife's.

Ever yours,
Vincent.

My dear Theo,

Thanks very much for the consignment of canvases, colours, brushes, tobacco and chocolate, which reached me in good order.

I was very glad of it, for I was pining for work a little. Also, for a few days now I've been going outside to work in the neighbourhood.

Your last letter was dated 21 May, if I remember rightly. I've had no news of you yet since then, except that Mr Peyron told me he'd received a letter from you. I hope that you're in good health, and your wife too.

Mr Peyron intends to go to Paris to see the exhibition and then pay you a visit.

What can I tell you that's new, not much. I have two landscapes on the go (no. 30 canvases) of views taken in the hills.

One is the countryside that I glimpse from the window of my bedroom. In the foreground a field of wheat, ravaged and knocked to the ground after a storm. A boundary wall and beyond, grey foliage of a few olive trees, huts and hills. Finally, at the top of the painting a large white and grey cloud swamped by the azure. It's a landscape of extreme simplicity — in terms of coloration as well. It would be suitable as a pendant to that study of the bedroom that's damaged.

When the thing depicted is stylistically absolutely in agreement and at one with the manner of depiction, isn't that what creates the quality of a piece of art?

That's why, as regards painting, a household loaf is above all good when it's painted by Chardin.

Now Egyptian art, for example, what makes it extraordinary, is it not that those calm, serene kings, wise and gentle, patient, good, seem unable to be other than they are; eternally farmers who worship the sun. How I'd have liked to see an Egyptian house in the exhibition, built by the architect Jules Garnier — painted in red, yellow and blue with a garden divided regularly into beds by rows of bricks — the dwelling of the people we know only in the state of mummies or in granite.

But there you are, to get back to the point, since the Egyptian artists thus have a *faith*, working from feeling and instinct, they express all these intangible things: goodness, infinite patience, wisdom, serenity, with a few masterly curves and marvellous proportions. That's to say once more, when the thing depicted and the manner of depicting it are in accord, the thing has style and quality.

Thus also the servant girl in Leys's great fresco, when she's engraved by Braquemond, becomes a new work of art — or Meissonier's little reader when it's Jacquemart who engraves him — since the *manner of engraving* and the thing depicted are as one.

As I want to keep this study of the bedroom, if you would send it back to me when I'm sent canvas, rolled up, I'll repaint it. Initially I'd wanted to have it lined because I didn't think I'd be able to do it again. However, as my mind has grown calmer since, I can indeed redo it now.

The thing is, among the number of things that one makes there are always some that one has felt or wanted more and which one wants to keep all the same.

When I see a painting that intrigues me, I can never help asking myself, 'in what

house, room, corner of the room, in whose home would it do well, would it be in its rightful place'.

Thus the paintings of Hals, Rembrandt, Vermeer are only at home in the old Dutch house.

Now the Impressionists — once again, if an interior isn't complete without a work of art, neither is a painting if it isn't at one with original surroundings, resulting from the era in which it was produced. And I don't know if the Impressionists are worth more than their time, or rather aren't yet worth as much.

In a word, are there souls and interiors of houses that are more important than what has been expressed by painting, I'm inclined to believe so.

I've seen an advertisement for a forthcoming exhibition of Impressionists called Gauguin, Bernard, Anquetin and other names. Am therefore inclined to believe that another new sect has been formed, no less infallible than the others that already exist. Was this the exhibition you were talking to me about? What storms in teacups.

I'm in good health — so-so, I feel happier with my work here than I could outside. By staying here a fairly long time, I'll have acquired controlled behaviour, and in the long run the result will be more order in my life and less impressionability. And that would be something gained. Besides, I wouldn't have the courage to begin again outside. I once went into the village — accompanied, at that. The mere sight of the people and things had an effect on me as if I was going to faint, and I felt very ill. In the face of nature it's the feeling for work that keeps me going. But anyway, that's to tell you that there must have been some over-strong emotion inside me that brought that about, and I have no idea what could have caused it.

I'm bored to death at times after work, and yet I have no desire to begin again.

The doctor who has just come by says that he won't be going to Paris for a few weeks yet, so don't expect his visit for the time being.

I hope that you'll write to me soon.

This month I'll again really be in need of

8 tubes silver white
6 " Veronese Green
2 " Ultramarine
2 " Cobalt
2 yellow Ochre
1 red "
1 raw sienna
1 ivory black

It's funny that every time I try to reason with myself in order to get a clear picture of things — why I came here, and that after all it's only an accident like any other — a terrible terror and horror seizes me and prevents me from thinking. It's true that it tends vaguely to diminish, but it also seems to me to prove that there is indeed something, I don't know what, disturbed in my brain. But it's astounding to be afraid of nothing like this, and not to be able to remember.

Only you can count on the fact that I'm doing everything I can to become active and perhaps useful again, in this sense at least, that I want to do better paintings than before.

Many things in the landscape here often recall Ruisdael, but the figure of the ploughman is lacking. In our country one sees men, women, children, animals at work everywhere and at all times of the year, and here not a third of that, and in addition they're not the honest workers of the north. They seem to work the land in an awkward, lax way, without energy. Perhaps I've got hold of the wrong idea here, I hope so at least, since I'm not from round here. But it makes things colder than one would dare think from reading Tartarin, who had perhaps been expelled many years ago with his entire family.

Above all write to me soon, for your letter is very slow in coming, I hope that you're well. It's a great consolation for me to know that you're no longer living alone.

If one month or another it should be too difficult for you to send me colours, canvas &c., then don't send them, for believe me it's better to live than to do art in an absent-minded way. And before everything else, your house must be neither sad nor dismal. That first and painting next.

Then I feel tempted to begin again with the simpler colours, the ochres for example.

Is a Van Goyen ugly because it's painted all in oils with very little neutral colour, or a Michel?

My undergrowth with ivy is completely finished, I want very much to send it to you immediately, as soon as it's dry enough to be rolled up.

With a really strong handshake to you and your wife.

Ever yours,
Vincent.

782 | Saint-Rémy-de-Provence, on or about Tuesday, 18 June 1889 |
 To Theo van Gogh (F)

My dear Theo,

Thanks for your letter of yesterday. I too cannot write as I would wish, but anyway we live in such a disturbed age that there can be no question of having opinions that are firm enough to judge things.

I would have very much liked to know if you now still eat together at the restaurant or if you live at home more. I hope so, for in the long run that must be the best.

As for me, it's going well — you'll understand that after almost half a year now of absolute sobriety in eating, drinking, smoking, with two two-hour baths a week recently, this must clearly calm one down a great deal. So it's going very well, and as regards work, it occupies and distracts me — which I need very much — far from wearing me out.

It gives me great pleasure that Isaäcson found things in my consignment that please him. He and De Haan appear very faithful, which is sufficiently rare these days for it to be worthy of appreciation. And that, as you say, there was another who found something in the yellow and black figure of a woman, that doesn't surprise me, although I think that its merit lies in the model and not in my painting.

I despair of ever finding models. Ah, if I had some from time to time like that one, or like the woman who posed for the Berceuse, I'd do something quite different.

I think you did the right thing by not exhibiting paintings of mine at the exhibition by Gauguin and others. There's reason enough for me to abstain from doing so without offending them as long as I'm not cured myself.

For me it's beyond doubt that Gauguin and Bernard have great and real merit.

It's still perfectly understandable, though, that for beings like them, really alive and young, who *must* live and try to carve out their path, it's impossible to turn all their canvases to the wall until it pleases people to admit them somewhere in the official pickle. One causes a stir by exhibiting in the cafés, which I don't say isn't in bad taste. But for myself, I have that crime on my conscience, and to the point of doing it twice, having exhibited at the Tambourin and at avenue de Clichy. Not counting the disturbance caused to 81 virtuous cannibals of the good town of Arles and to their excellent mayor.

So in any case, I am worse and more blameworthy than they are in that regard (causing a stir quite involuntarily, my word).

Young Bernard — according to me — has already made a few absolutely astonishing canvases in which there's a gentleness and something essentially French and candid, of rare quality.

Anyway, neither he nor Gauguin are artists who could look as if they were trying to go to the World Exhibition by the back stairs. You can be sure of that. It's understandable that they *couldn't* keep silent. That the Impressionists' movement has had no unity is what proves that they're less skilled fighters than other artists like Delacroix and Courbet.

At last I have a landscape with olive trees, and also a new study of a starry sky.

Although I haven't seen the latest canvases either by Gauguin or Bernard, I'm fairly sure that these two studies I speak of are comparable in sentiment. When you've seen these two studies for a while, as well as the one of the ivy, I'll perhaps be able to give you, better than in words, an idea of the things Gauguin, Bernard and I sometimes chatted about and that preoccupied us. It's not a return to the romantic or to religious ideas, no. However, by going the way of Delacroix, more than it seems, by colour and a more determined drawing than *trompe-l'oeil* precision, one might express a country nature that is purer than the suburbs, the bars of Paris. One might try to paint human beings who are also more serene and purer than Daumier had before him. But of course following Daumier in the drawing of it. We'll leave aside whether that exists or doesn't exist, but we believe that nature extends beyond St-Ouen.

Perhaps, while reading Zola, we are moved by the sound of the pure French of Renan, for example.

And after all, while Le Chat Noir draws women for us after its own fashion, and above all Forain does so in a masterly way, we do some of our own, less Parisian but no less fond of Paris and its elegances, we try to prove that something else quite different exists.

Gauguin, Bernard or I will all remain there perhaps, and won't overcome but neither will we be overcome. We're perhaps not there for one thing or the other, being there to console or to prepare for more consolatory painting. Isaäcson and De Haan may not succeed either, but in Holland they've felt the need to state that Rembrandt did great painting and not *trompe l'oeil*, they also felt something different.

If you can get the Bedroom lined it's better to have it done *before* sending it to me.

I have no more white at all at all.

You'll give me a lot of pleasure if you write to me again soon. I so often think that after a while you'll find in marriage, I hope, the means to gain new strength, and that a year from now your health will have improved.

What I'd very much like to have here to read from time to time would be a Shakespeare. There's one priced at one shilling, *Dicks' Shilling Shakespeare*, which is complete. There's no shortage of editions, and I think the cheap ones have been changed less than the more expensive ones. In any case I wouldn't want one that cost more than three francs.

Now, whatever is too bad in the consignment, put it completely to one side, pointless to have stuff like that; it may be of use to me later to remind me of things. Whatever is good will show up better by being part of a smaller number of canvases. The rest, if you put them in a corner, flat between two sheets of cardboard with old newspapers between the studies, that's all they're worth.

I'm sending you a roll of drawings.

Handshakes to you, to Jo and to our friends.

Ever yours,
Vincent

The drawings Hospital in Arles, the weeping tree in the grass, the fields and the olive trees, are a continuation of those from Montmajour from back then. The others are hasty studies done in the garden.

There's no hurry for the Shakespeare, if they don't have an edition like that, it won't take an eternity to have one sent.

Don't be afraid that I would ever venture onto dizzy heights of my own free will, unfortunately, whether we like it or not, we're subject to circumstances and to the illnesses of our time. But with all the precautions I'm now taking, it will be difficult for me to relapse, and I hope that the attacks won't start again.

784 | Saint-Rémy-de-Provence, Tuesday, 2 July 1889 | *To Theo van Gogh* (F)

My dear Theo,

Enclosed I'm sending you a letter from Mother, naturally you know all the news it contains. I think it's very logical of Cor to go there. What is different there from staying in Europe is that down there one doesn't have to undergo the influence of our large cities, as one does here, so old that everything in them seems to be in its dotage and tottering. So instead of seeing one's vital forces and natural, native energy evaporate in circumlocution, it's possible that one might be happier far from our society. Even if it were otherwise, the fact remains that it's to act uprightly and in accordance with his upbringing for him not to hesitate to accept this position. So now it isn't to tell you all this news that you know that I'm sending you the letter. But it's for you to observe in it a little how remarkably firm and regular the writing is when one thinks that it's true what she says, that she's 'a mother approaching 70'. And as you've already written to me, and our sister has too, that she seems to have got younger, I see it myself from this very

clear writing and in her tighter logic in what she writes, and the simplicity with which she appreciates facts. I believe now that this rejuvenation has obviously come to her from the fact that she's happy that you've got married, which she'd wanted for so long; and I congratulate you that your marriage can give you and Jo the rather rare pleasure of seeing your mother growing young again. It's really for that that I'm sending you this letter. Because, my dear brother, it's sometimes necessary later to remember—and it's so timely that, at the very moment when she'll have the great pain of being separated from Cor—and it will be hard on her, that—she should be consoled by knowing that you're married. If the thing were possible you shouldn't wait fully a whole year before returning to Holland, for she'll be longing to see you again, you and your wife.

At the same time, having married a Dutchwoman, that could in a few years, sooner or later, warm up business relations with Amsterdam or The Hague again.

Anyway, once again I haven't seen a letter from Mother indicating so much inner serenity and calm contentment as this one—not for many years. And I'm sure that this comes from your marriage. It's said that pleasing one's parents brings a long life.

I now thank you very much for the consignment of colours, deduct them from the order placed since, but if it's at all possible, *not* for the quantity of white. I thank you also very cordially for the Shakespeare. It will help me not to forget the little English I know—but above all it's so beautiful.

I've begun to read the series I know the least well, which before, being distracted by something else or not having the time it was impossible for me to read, the series of the kings. I've already read Richard II, Henry IV and half of Henry V. I read without reflecting on whether the ideas of the people of that time are the same as ours, or what becomes of them when one places them face to face with republican or socialist beliefs &c. But what touches me in it, as in the work of certain novelists of our time, is that the voices of these people, which in Shakespeare's case reach us from a distance of several centuries, don't appear unknown to us. It's so alive that one thinks one knows them and sees it.

So what Rembrandt alone, or almost alone, has among painters, that tenderness in the gazes of human beings we see either in the Pilgrims at Emmaus, or in the Jewish bride, or in some strange figure of an angel as in the painting you had the good fortune to see—that heartbroken tenderness, that glimpse of a superhuman infinite which appears so natural then, one encounters it in many places in Shakespeare. And then serious or gay portraits like the Six, like the traveller, like the Saskia, it's above all full of that. What a good idea Victor Hugo's son had of translating all of it into French so that it's thus within the reach of all. When I think of the Impressionists and of all these present-day questions of art, how many lessons there are precisely for us in there.

So from what I've just read the idea comes to me that the Impressionists are right a thousand times over. Yet even they must think about it for a long time and always. If it follows from that that they have the right or the duty to do themselves justice, and if they dare call themselves primitives, certainly they'd do well to learn to be primitive as *people* a little, too, before pronouncing the word primitive like a title that would give them rights to whatsoever. But those who would be the cause of the Impressionists being unhappy, well naturally the case for them is serious, also when they make light of it.

And then it would appear that waging a battle seven times a week couldn't go on.

It's amazing, though, how L'abbesse de Jouarre, when you think of it, holds its own even beside Shakespeare.

I think that Renan treated himself to that in order to be able to say *beautiful* words for once in full and at his ease, because these are beautiful words.

So that you may have an idea of what I have on the go I'm sending you ten or so drawings today, all after canvases on the go.

The latest one begun is the wheatfield where there's a little reaper and a big sun. The canvas is all yellow with the exception of the wall and the bottom of purplish hills. The canvas with almost the same subject differs in coloration, being a greyish green and a white and blue sky.

How I think of Reid as I read Shakespeare, and how I've thought of him several times when I was iller than at present. Finding that I'd been infinitely too harsh and perhaps discouraging towards him in claiming that it was better to love painters than paintings. It isn't up to me to make distinctions like that, not even when faced with the problem that we see our living friends suffering so much from the lack of enough money to feed themselves and pay for their colours, and on the other hand the high prices that are paid for the canvases of dead painters. In a newspaper I was reading a letter from a collector of Greek objects to one of his friends, which contained this phrase 'you who love nature, I who love all that the hand of man has made, this difference in our tastes deep down creates the unity in it'. And I found that better than my reasoning.

I have a canvas of cypresses with a few ears of wheat, poppies, a blue sky, which is like a multicoloured Scottish plaid. This one, which is impasted like the Monticellis, and the wheatfield with the sun that represents extreme heat, also thickly impasted, I think that this would explain to him more or less, however, that he couldn't lose much by being our friend. But that's true on our side too, and precisely *because we were perhaps right* to disapprove of his method we ought on *our* side to take a step towards reconciliation. Anyway, I daren't yet write now for fear of saying too many foolish things, but when I'm more certain of my pen I'd very much like to write to him one day. It's the same for other friends, but I really have told myself that I should wait as long as possible before *being able*, even in the best of circumstances, to arrive at this 'being a little more certain of myself'.

I still have canvases in Arles that weren't dry when I left, I very much want to go and get them one of these days in order to send them to you. There are half a dozen of them. The drawings appear to me to have little colour this time, and this is very probably due to the over-smooth paper.

Anyway, the Weeping tree and the Courtyard of the hospital at Arles are more coloured, but that though will give you an idea of what I have on the go. The canvas of the reaper will become something like the Sower of the other year.

As later the books of Zola will remain beautiful precisely because they have life.

What also has life is the fact that Mother is happy that you're married, and I think that this cannot be disagreeable to yourselves, you and Jo. But the separation from Cor will be so hard for her that it's difficult to imagine. It is precisely in learning to suffer without complaining, learning to consider pain without repugnance, that one risks vertigo a little; and yet it might be possible, yet one glimpses even a vague probability that on the other side of life we'll glimpse justifications for pain, which seen from here

sometimes takes up the whole horizon so much that it takes on the despairing proportions of a deluge. Of that we know very little, of proportions, and it's better to look at a wheatfield, even in the state of a painting. I shake your hands firmly and will have news of you soon I hope. Good health to you both.

Ever yours,
Vincent

785 | Saint-Rémy-de-Provence, Tuesday, 2 July 1889 | *To Willemien van Gogh* (F)

My dear sister,

In recent days I already began another letter in reply to yours, but I became aware that I didn't have sufficient mastery of my mind to write. I thank you and Lies for the Rod book which I've finished and which I'll return to you soon. The terrible title, Le sens de la vie, terrified me a little, but as it's happily scarcely spoken of in this volume, I was quite content to read something which has a family resemblance to Souvestre's Le philosophe sous les toits or with Monsieur, madame et bébé by Droz. The moral of it is that in some cases a gentleman ends up preferring to live with a nice, devoted wife and his child, to the life of the restaurant, boulevard and café which he had previously led without too much excess. That's undoubtedly very pleasant.

It is indeed remarkable that good Mrs du Quesne's illness came to an unexpected end after all. It must have been a day of great deliverance for her all the same.

If you say in your letter that when you see so many others in life who come and go, seeking their own path, appearing to you perhaps to be making more headway than you, what can I tell you, that I too sometimes have a feeling of stupefaction in the face of my own life, and as regards several other lives of workers in my profession besides. I've just sent Theo a dozen drawings after canvases which I have on the go, while all the rest of my life is absolutely as inept as it was at the time when, at the age of 12, I was at a boarding school where I learned absolutely nothing.

An enormous number of painters who certainly couldn't do my 12 canvases either in 2 months or in 12 are regarded as artists and as intelligent people in town or in the countryside. But believe me, I say this in order to be explanatory and not because I would see any urgency or possibility or desire to change things. We scarcely know life, we're so unaware of its hidden aspects, anyway we're living in an age when everything appears to be in its dotage and tottering, and it isn't unfortunate to find a duty which forces us to stay calmly in our corner, occupied with a little simpler toil, with certain duties that retain some *raison d'être*.

In these days in which we live we risk coming back from a battle ashamed of having done battle.

So my friend who was with me in Arles and a few others have thus organized an exhibition in which, in good health, I would have taken part.

And what have they been able to do—almost nothing—and yet in their canvases there was something brand new, good, something to give me pleasure and make me enthusiastic for example, me, I can assure you of that. Among artists, we no longer

know what to say to each other, we don't know if we ought to laugh or cry about it, and doing, my word, neither one thing or the other, we are happiest when we find ourselves in possession of a little paint and canvas, the thing we also lack sometimes and which at least we can work on. But any idea of a regular life, any idea of awakening in ourselves or in others gentle ideas or sensations, all of this must necessarily appear pure utopia to us.

So although yesterday more than half a million francs were paid for Millet's Angelus, don't go believing that more souls will feel what was in Millet's soul. Or that middle-class people or workers will begin to put in their houses the lithograph of that Millet Angelus, for example. Don't go believing that the painters who are still working in Brittany among the peasants will have more encouragement for that matter, less of the same black famine that always surrounded Millet, above all more courage.

Alas, we often lack breath and faith, wrongly certainly but — and here we come back to the point — if, however, we want to work we must submit both to the stubborn harshness of the time and to our isolation, which is sometimes as hard to bear as exile. Now before us, after our years which have thus been lost, relatively speaking, poverty, illness, old age, madness and always exile. It is indeed the moment to say 'blessed be Thebe, daughter of Telhui, priestess of Osiris, who never complained about anyone'.

Cherishing the memory of good people, wouldn't that be worth more than being among the ambitious ones on the whole?

I'm quite absorbed in reading the Shakespeare that Theo sent me here, where at last I'll have the calm necessary to do a little more difficult reading. I've first taken the kings series, of which I've already read Richard II, Henry IV, Henry V and a part of Henry VI — as these dramas were the most unfamiliar to me. Have you ever read King Lear? But anyway, I think I shan't urge you too much to read such dramatic books when I myself, returning from this reading, am always obliged to go and gaze at a blade of grass, a pine-tree branch, an ear of wheat, to calm myself.

So if you want to do as artists do, gaze upon the white and red poppies with the bluish leaves, with those buds raising themselves up on stems with gracious curves. The hours of trouble and battle will assuredly come and find us without our going to look for them.

The separation from Cor will be hard. And it's going to happen really soon. What else can one do, thinking of all the things whose reason one doesn't understand, but gaze upon the wheatfields. Their story is ours, for we who live on bread, are we not ourselves wheat to a considerable extent, at least ought we not to submit to growing, powerless to move, like a plant, relative to what our imagination sometimes desires, and to be reaped when we are ripe, as it is?

I tell you, as for myself I think it would be wisest not to wish to get better, not to wish to regain more strength than now, and I'll probably grow accustomed to it, to being cracked. A little sooner, a little later, what can that matter to me?

What you write about Theo's health I know completely, nevertheless it is my hope that married life will completely restore him. I believe his wife to be wise and loving enough to take lots of care of him and to see that he doesn't just eat restaurant food, but that he gets back to Dutch cooking. Dutch cooking is good, and so let her turn herself into something of a cook, let her take on a *reassuring* outer appearance, even if

it's a little rough. Theo himself is obliged to be a Parisian, but with that he absolutely needs what reminds him of his youth and his past. I, who have neither wife nor child, I need to see the wheatfields, and it would be difficult for me to exist in a town for long. So, knowing his character, I'm optimistic that his marriage will do him an enormous amount of good. Before we can form an idea of his health we must allow them a little time to take root within each other.

And afterwards, I dare also hope, she'll have found lots of ways to make his life a little more pleasant than was the case before. For he has seen hard times.

Anyway I must close this letter if I want it to go off today, and I don't even have time to re-read it. So, if I've said too many silly things you will kindly excuse me. Look after yourself, don't get too bored, and by cultivating your garden as you do, and the rest that you do, be well assured that you're getting through a lot of work. I kiss you affectionately in thought.

Ever yours,
Vincent.

790 | Saint-Rémy-de-Provence, Sunday, 14 or Monday, 15 July 1889 |
 To Theo van Gogh (F)

My dear Theo,

If I'm writing to you again today it's because I'm enclosing a few words that I've written to our friend Gauguin, feeling sufficient calm return to me these last few days for my letter not to be absolutely absurd, it seemed to me. Besides, there's no proof that by over-refining one's scruples of respect or feeling one thereby gains respectfulness or good sense. That being so, it does me good to talk with the pals again, even if at a distance. And you — my dear fellow — how are things, and so write me a few words one of these days — for I can imagine that the emotions which must move the forthcoming father of a family, emotions of which our good father so loved to speak, must be great and of sterling worth in you, as in him, but for the moment are almost impossible for you to express in the rather incoherent mixture of the petty vexations of Paris. Realities of this sort must anyway be like a good gust of the mistral, not very soothing, but health-giving. As for me, it gives me very great pleasure I can assure you, and will contribute greatly to bringing me out of my moral fatigue and perhaps from my listlessness.

Anyway, there's enough to bring back the taste for life a little when I think that I myself am going to be promoted uncle of this boy planned by your wife. I find it quite funny that she's so convinced that it's a boy, but anyway, we'll see.

Anyway, in the meantime I can do nothing but fiddle with my paintings a little. I have one on the go of a moonrise over the same field as the croquis in the Gauguin letter, but in which stacks replace the wheat. It's dull ochre-yellow and violet. Anyway, you'll see in a while from now.

I also have a new one with ivy on the go. Above all, dear fellow, I beg of you, don't fret or worry or be melancholy on my account, the idea that you would do so,

certainly in this necessary and salutary quarantine, would have little justification when we need a slow and patient recovery. If we manage to grasp that, we spare our forces for this winter. I imagine that winter must be quite dismal here, anyway will however have to try and occupy myself. I often imagine that I could retouch a lot of last year's studies from Arles this winter.

Thus, having kept back these past few days a large study of an orchard which was very difficult (it's the same orchard of which you'll find a variation in the consignment, but quite a vague one), I've set to reworking it from memory, and have found a way better to express the harmony of the tones.

Tell me, have you received any drawings from me? I sent you some once, by parcel post, half a dozen, and then later ten or so. If by chance you haven't received them, they must have been at the railway station for days and weeks.

The doctor was telling me about Monticelli, that he had always considered him eccentric, but as for *mad*, he had only been a little that way towards the end. Considering all the miseries of M's last years, is it any surprise that he bowed beneath a weight that was too heavy, and is one right in trying to deduce from that that he failed in his work, artistically speaking? I dare to believe not. There was some very logical calculation about him, and an originality as a painter, so it remains regrettable that one wasn't able to sustain it so as to make its blossoming more complete.

I enclose a croquis of the cicadas from here.

Their song in times of great heat holds the same charm for me as the cricket in the peasant's hearth at home. My dear fellow — let's not forget that small emotions are the great captains of our lives, and that these we obey without knowing it. If it's still hard for me to regain courage over faults committed and to be committed, which would be my recovery, let's not forget from that moment on that neither our spleens and melancholies nor our feelings of good nature and good sense are our sole guides, and above all not our final custodians, and that if you yourself also find yourself facing hard responsibilities to venture, if not to take, my word let's not be *too* concerned with each other, while it so happens that life's circumstances in situations so far removed from our youthful conceptions of the life of the artist would render us brothers after all, as being companions in fate in many respects. Things are so closely connected that here one sometimes finds cockroaches in the food as if one were really in Paris, on the other hand it can happen in Paris that you sometimes have a real thought of the fields. It's certainly not much, but it's reassuring anyway. So take your fatherhood as a good fellow from our old heaths would take it, those heaths that remain ineffably dear to us through all the noise, tumult, fog, anguish of the towns, however timid our tenderness may be. That's to say, take your fatherhood there, from your nature as an exile and a foreigner and a poor man, henceforth basing himself with the poor man's instinct on the probability of the real existence of a native country, of a real existence at least of the memory, even while we've forgotten every day. Thus sooner or later we find our fate. But certainly for you, as well as for me, it would be a little hypocritical to forget completely our good humour, the confident sloppiness we had as the poor devils we were as we came and went in that Paris, so strange now — and to place too much weight upon our cares.

Truly, I'm so pleased with the fact that if sometimes there are cockroaches in the food here, in your home there is wife and child.

Besides, it's reassuring that Voltaire, for example, left us free to believe not absolutely all of what we imagine. Thus while sharing your wife's concerns about your health I'm not going so far as to believe what momentarily I was imagining, that worries about me were the cause of your relatively rather long silence in respect of me, although this is so well explained when one thinks of how preoccupying a pregnancy must necessarily be. But it's very good and it's the path where everyone walks in life. More soon, and good handshake to you and to Jo.

Ever yours,
Vincent.

In haste, but didn't want to delay sending the letter for our friend Gauguin, you must have the address.

[*Sketch* 790A]

790A. *Three cicadas*

My dear Theo,

I thank Jo very much for writing to me, and knowing that you wish me to write you a line I'm letting you know that it's very difficult for me to write, so disturbed is my mind. So I'm taking advantage of an interval.

Dr Peyron is really kind to me and really patient. You can imagine that I'm very deeply distressed that the attacks have recurred when I was already beginning to hope that it wouldn't recur.

You'll perhaps do well to write a line to Dr Peyron to say that working on my paintings is quite necessary to me for my recovery.

For these days, without anything to do and without being able to go into the room he had allocated me for doing my painting, are almost intolerable to me.

I've received catalogue of the Gauguin, Bernard, Schuffenecker &c. exhibition, which I find interesting. G. also wrote me a kind letter, still a little vague and obscure, but anyway I must say that I think they're quite right to have exhibited among themselves.

For many days I've been *absolutely distraught*, as in Arles, just as much if not worse, and it's to be presumed that these crises will recur in the future, it is ABOMINABLE. I haven't been able to eat for 4 days, as my throat is swollen. It's not in order to complain too much, I hope, if I tell you these details, but to prove to you that I'm not yet in a fit state to go to Paris or to Pont-Aven unless it were to Charenton.

It appears that I pick up filthy things and eat them, although my memories of these bad moments are vague, and it appears to me that there's something shady about it, still for the same reason that they have I don't know what prejudice against painters here.

I no longer see any possibility for courage or good hope, but anyway it wasn't yesterday that we found out that this profession isn't a happy one.

All the same it gives me pleasure that you've received that consignment from here, the landscapes. Thank you above all for that etching after Rembrandt. It's surprising, and yet it makes me think again of the man with the staff in the La Caze gallery. If you want to do me a very, very great pleasure, then send a copy of it to Gauguin. Then the Rodin and Claude Monet brochure is really interesting.

This new crisis, my dear brother, came upon me in the fields, and when I was in the middle of painting on a windy day. I'll send you the canvas, which I nevertheless finished. And it was precisely a more sober attempt, matt in colour without looking impressive, broken greens, reds and rusty ochre yellows, as I told you that from time to time I felt a desire to begin again with a palette like the one in the north.

I'll send you that canvas as soon as I can. Good-day, thank you for all your kindnesses, good handshake to you and to Jo, and naturally to Cor if he's still there.

Vincent

Mother and Wil have also written me a very nice letter.

Whilst not liking Rod's book excessively, I've nevertheless done a canvas of that passage in which he speaks of the darkish mountains and huts.

(Our friend Roulin has written to me too.)

My dear Theo,

Since I wrote to you I'm feeling better, and whilst I don't know if it'll last I don't want to wait any longer to write to you again.

Thanks once again for that beautiful etching after Rembrandt. I'd very much like to get to know the painting and know in which period of his life he painted it. All this goes with the Rotterdam portrait of Fabritius, the traveller in the La Caze gallery, into a special category in which the portrait of a human being is transformed into something luminous and consoling.

And how very different this is from Michelangelo or Giotto, although the latter however comes close to it, and Giotto thus forms a sort of possible hyphen between the school of Rembrandt and the Italians.

[*Sketch* 798A]

Yesterday I started working again a little — a thing I see from my window — a field of yellow stubble which is being ploughed, the opposition of the purplish ploughed earth with the strips of yellow stubble, background of hills.

Work distracts me infinitely better than anything else, and if I could once really throw myself into it with all my energy that might possibly be the best remedy.

The impossibility of having models, a heap of other things, prevent me from managing it however. Anyway, I really must try to take things a little passively and be patient.

I often think of our pals in Brittany, who are certainly doing better work than I am. If, with the experience I'm having at present, it was possible for me to begin again, I wouldn't go and look around the south.

Were I independent and free, I would nevertheless have retained my enthusiasm, for there are some really beautiful things to do.

Such as the vineyards, the fields of olive trees. *If* I had confidence in the management here, nothing would be better and simpler than to put all my furniture here at the hospital and quietly continue. If I were to recover, or in the intervals, I could sooner or later come back to Paris or Brittany for a time. But first they're *very expensive* here, and then I'm afraid of the other patients at the moment. Anyway, a heap of reasons mean that I don't think I've been lucky here either.

I'm perhaps exaggerating in the sadness I feel at being knocked down by illness again — but I feel a kind of fear. You'll tell me what I tell myself too, that the fault must be inside me and not in the circumstances or other people. Anyway, it isn't fun.

Mr Peyron has been kind to me and he has long experience, I shan't scorn what he says or considers good.

But will he have a firm opinion, has he written anything definite to you?? And possible?

You can see that I'm still in a very bad mood, it's because things aren't going well. Then I consider myself imbecilic to go and ask doctors for permission to make paintings. Besides, it's to be hoped that if I recover sooner or later, up to a certain point it'll

798A. Field with a ploughman

be because I've cured myself by working, which fortifies the will and consequently allows these mental weaknesses less hold.

My dear brother, I wanted to write to you better than this, but things aren't going very well. I have a great desire to go into the mountains to paint for whole days, I hope they'll allow me to in the coming days.

You'll soon see a canvas of a hut in the mountains which I did under the influence of that book by Rod. It would be good for me to stay on a farm for a while, at least I might do some good work there.

I must write to Mother and to Wil in the next few days. Wil asked to be sent a painting, and I'd very much like to give one to Lies as well on the same occasion, who doesn't have any yet as far as I know.

What do you say about Mother going to live in Leiden? I think she's right in this sense, that I can understand that she's pining for her grandchildren. And then there'll be none of us left in Brabant.

Speaking of that — not very long ago in Arles I was reading a book, I can't remember which one, by Henri Conscience. It's excessively sentimental if you like, what with his peasants, but speaking of *Impressionism* do you know that it contains descriptions of landscape with colour notes of accuracy, feeling and primitiveness of the *first* order. And it's always like that. Ah my dear brother, those heaths in the Kempen were something though. But anyway, that won't come back, and onward we go.

He — Conscience — described a brand-new little house with a bright red slate roof in the full sunshine, a garden with dock and onions, potatoes with dark foliage, a beech hedge, a vineyard, and further on the pine trees, the broom all yellow. Don't be afraid, it wasn't like a Cazin, it was like a Claude Monet. Then there's originality even in the excess of sentimentality.

And as for me, who feels it and can't damned well do anything, isn't that sickening.

If you get opportunities for lithographs of Delacroix, Rousseau, Diaz &c., ancient and modern artists, Galeries modernes &c., I can't advise you too strongly to hold onto them, for you'll see that they'll become rare. Yet it was really the way to popularize beautiful things, those 1-franc sheets of those days, those etchings &c. back then. Very interesting the Rodin — Claude Monet brochure. How I'd have liked to see that. Pointless to say that nevertheless I don't agree when he says that Meissonier is nothing and that T. Rousseau isn't much. Meissoniers and Rousseaus are something highly interesting for those who like them and try to discover what the artist was feeling. It isn't possible for everyone to be of that opinion, because one has to have seen and looked at them, and you don't find that on every corner. Now a Meissonier, if you look at it for a year there's still enough in it to look at the next year, never fear. Not to mention that he's a man who had his days of happiness, of perfect finds. Certainly I know, Daumier, Millet, Delacroix have *another* way of drawing — but Meissonier's execution, that something essentially French above all, although the old Dutchmen would find nothing to fault in it, and yet it's something other than them and it's modern; one has to be blind to believe that Meissonier isn't an artist and — one of the first rank.

Have many things been done that give the note of the 19th century better than the portrait of Hetzel? When Besnard did those two very beautiful panels, primitive man and modern man, which we saw at Petit's, in making the modern man a reader he had the same idea.

And I'll always regret that in our times people believe in the incompatibility of the generation of, say, 48 and the present one. I myself believe that the two hold their own all the same, though I can't prove it.

Let's take good Bodmer for example. Was he not able to study nature as a hunter, a savage, did he not love it and know it with experience of an entire long manly life — and do you think that the first Parisian to come along who goes to the suburbs knows as much or more about it because he'll do a landscape with harsher tones? Not that it's bad to use pure and clashing tones, not that *from the point of view of colour* I'm *always* an admirer of Bodmer, but I admire and I like the man who knew all the forest of Fontainebleau, from the insect to the wild boar and from the stag to the lark. From the tall oak and the lump of rock to the fern and the blade of grass.

Now a thing like that, not anyone who wants to can feel it or find it.

And Brion — oh a maker of Alsatian genre paintings people will tell me. That's fine, he has indeed done the Engagement meal, the Protestant wedding &c. which are indeed Alsatian. When no one is up to illustrating Les Misérables, he however does it in a manner unsurpassed up to now, and he isn't mistaken in his types. Is it a small thing to know people so well, the humanity of that period, so well that one scarcely makes a mistake in expression and type?

Ah — the rest of us would have to get old working hard, and that's why we then get despondent when things don't go right.

I think that if you see the Bruyas museum in Montpellier one day, I think that then nothing will move you more than Bruyas himself, when one realizes from his purchases what he sought to be for artists. It's a little disheartening when one sees from certain portraits of him how heartbroken and obviously frustrated his face is. If one doesn't succeed in the south there still remains he who suffered all his life for that cause.

The only serene portraits are the Delacroix and the Ricard.

For example, by a great chance the one by Cabanel is accurate and most interesting as an observation, at least it gives an idea of the man.

I'm pleased that Jo's mother has come to Paris. Next year it will perhaps be a little different and you'll have a child, and that brings a fair few petty vexations of human life — but as certain great miseries of spleen etc. will disappear for ever, that's certainly how it should go.

I'll write to you again soon, I'm not writing to you as I would have wished, I hope that all is well at your place and will continue to go well. Am very, very pleased that Rivet has rid you of the cough, which really worried me a bit too.

What I had in my throat is starting to disappear, I'm still eating with some difficulty, but anyway it has got better.

Good handshake to you and to Jo.

Ever yours,
Vincent.

My dear Theo,

I think your letter is really good, what you say about Rousseau and artists like Bodmer, that they are *men* in any case, and of such a kind that one would wish the world populated with people like that — yes indeed, that's what I myself feel too.

And that J.H. Weissenbruch knows and does the muddy towpaths, the stunted willows, the foreshortenings and the learned and strange perspectives of the canals 'as Daumier does his lawyers', I think that's perfect. Tersteeg did well to buy some of his work from him, the fact that people like that don't sell, according to me that's because there are too many sellers who try to sell other things, with which they deceive the public and mislead them.

Do you know that today, still, when I read by chance the story of some energetic industrialist or above all a publisher, that the same feelings of indignation then come to me again, the same feelings of anger from the old days when I was with G.&Cie.

Life goes on like that, time doesn't come back, but I'm working furiously, because of the very fact that I know that the opportunities to work don't come back.

Above all, in my case, where a more violent crisis may destroy my ability to paint forever. In the crises I feel cowardly in the face of anguish and suffering — more cowardly than is justified, and it's perhaps this very moral cowardice which, while before I had no desire whatsoever to get better, now makes me eat enough for two, work hard, take care of myself in my relations with the other patients for fear of relapsing — anyway I'm trying to get better now like someone who, having wanted to commit suicide, finding the water too cold, tries to catch hold of the bank again.

My dear brother, you know that I came to the south and threw myself into work for a thousand reasons.

To want to see another light, to believe that looking at nature under a brighter sky can give us a more accurate idea of the Japanese way of feeling and drawing. Wanting, finally, to see this stronger sun, because one feels that without knowing it one couldn't understand the paintings of Delacroix from the point of view of execution, technique, and because one feels that the colours of the prism are veiled in mist in the north.

All of this remains somewhat true. Then when one also adds to it an inclination of the heart towards this south that Daudet did in Tartarin, and the fact that here and there I've also found friends and things that I love here.

Will you then understand that while finding my illness horrible I feel that all the same I've entered into attachments that are a little too strong here — attachments which could mean that later on the desire to work here will take hold of me again — while all the same it may well be that I'll return to the north relatively soon.

Yes, for I don't hide from you the fact that in the same way that I'm taking my food avidly at present, I have a terrible desire that comes to me to see my friends again and to see the northern countryside again.

Work is going very well, I'm finding things that I've sought in vain for years, and feeling that I always think of those words of Delacroix that you know, that he found painting when he had neither breath nor teeth left. Ah well, I myself with the mental illness I have, I think of so many other artists suffering mentally, and I tell myself

that this doesn't prevent one from practising the role of painter as if nothing had gone wrong.

When I see that crises here tend to take an absurd religious turn, I would almost dare believe that this even *necessitates* a return to the north. Don't speak too much about this to the doctor when you see him — but I don't know if this comes from living for so many months both at the hospital in Arles and here in these old cloisters. Anyway I ought not to live in surroundings like that, the street would be better then. I am not indifferent, and in the very suffering religious thoughts sometimes console me a great deal. Thus this time during my illness a misfortune happened to me — that lithograph of Delacroix, the Pietà, with other sheets had fallen into some oil and paint and got spoiled.

I was sad about it — then in the meantime I occupied myself painting it, and you'll see it one day, on a no. 5 or 6 canvas I've made a copy of it which I think has feeling — besides, having not long ago seen the Daniel and the Odalisques and the Portrait of Bruyas and the Mulatto woman at Montpellier, I'm still under the impression that it had on me. This is what edifies me, as does reading a fine book like one by Beecher Stowe or Dickens. But what disturbs me is constantly seeing those good women who believe in the Virgin of Lourdes and make up things like that, and telling oneself that one is a prisoner in an administration like that, which very willingly cultivates these unhealthy religious aberrations when it ought to be a matter of curing them. So I say, it would be even better to go, if not into penal servitude then at least into the regiment.

I reproach myself for my cowardice, I ought to have defended my studio better, even if I had to fight with those gendarmes and neighbours. Others in my position would have used a revolver, and indeed, had one killed onlookers like that as an artist one would have been acquitted. I would have done better in that case then, and now I was cowardly and drunk.

Ill too, but I wasn't brave. Then in the face of the Suffering of these crises I feel very fearful too, and so I don't know if my zeal is something other than what I say, it's like the man who wants to commit suicide, and finding the water too cold he struggles to catch hold of the bank again.

But listen — to be in a lodging-house like I saw Braat back then — fortunately that time is far off, no and again *no*.

It would be different if *père* Pissarro or Vignon, for example, wanted to take me into their home. Well I'm a painter myself — that can be sorted out, and better that the money goes to feed painters than to the excellent nuns.

Yesterday I asked Mr Peyron point blank: since you're going to Paris, what would you say if I suggested that you be good enough to take me with you? He answered in an evasive way — that it was too quick, that he must write to you beforehand.

But he's very kind and very indulgent towards me, and whilst he isn't the absolute master here, far from it, I owe him many freedoms.

Anyway, one must not only make paintings but one must also see people and — from time to time, by associating with others too, recover one's temperament and furnish oneself with ideas. I leave aside the hope that it wouldn't recur — on the contrary I must tell myself that from time to time I'll have a crisis. But then one might for that time go into an asylum or even to the town prison, where there's usually an isolation

cell. Don't worry yourself in any case—work is going well and look, I can't tell you how much it gives me a warm glow sometimes to say, I'm going to do this and that again, wheatfields &c.

I've done the portrait of the orderly, and I have a repetition of it for you. It makes quite a curious contrast with the portrait I did of myself, in which the gaze is vague and veiled, while he has something military about him, and dark eyes that are small and lively. I made him a present of it, and I'll also do his wife if she wants to pose. She's a faded woman, an unfortunate, quite resigned one, and really not much, and so insignificant that I myself have a great desire to do that dusty blade of grass. I spoke with her from time to time when I was doing olive trees behind their little farmhouse, and then she told me that she didn't think that I was ill—anyway, you would say that too at present if you saw me working, with my thoughts clear and my fingers so sure that I drew that Delacroix Pietà without taking a single measurement, though there are those four outstretched hands and arms—gestures and bodily postures that aren't exactly easy or simple.

Please send me the canvas soon, if that's possible, and then I think I'll need 10 tubes of zinc white as well.

However, I know quite well that recovery comes, if one is brave, from inside, through the great resignation to suffering and death, through the abandonment of one's own will and one's self-love. But it's not coming to me, I love to paint, to see people and things and everything that makes up our life—artificial—if you like. Yes, real life would be in something else, but I don't think I belong to that category of souls who are ready to live and also at any moment ready to suffer.

What a funny thing the *touch* is, the brushstroke. Out of doors, exposed to the wind, the sun, people's curiosity, one works as one can, one fills one's canvas regardless. Yet then one catches the true and the essential—that's the most difficult thing. But when one returns to this study again after a time, and orders one's brushstrokes in the direction of the objects—certainly it's more harmonious and agreeable to see, and one adds to it whatever one has of serenity and smiles.

Ah, I'll never be able to render my impressions of certain figures I've seen here. Certainly the road to the south is the road where there's something brand new, but men of the north have difficulty in getting through. And I can see myself already in advance, on the day when I have some success, longing for my solitude and distress here when I see the reaper in the field below through the iron bars of the isolation cell. Every cloud has a silver lining.

To succeed, to have lasting prosperity, one must have a temperament different from mine, I'll never do what I could have and ought to have wanted and pursued.

But as I have dizzy spells so often, I can only live in a situation of the fourth or fifth rank. While I clearly sense the value and originality and superiority of Delacroix, of Millet, for example, then I make a point of telling myself, yes I am something, I can do something. But I must have a basis in these artists, and then produce the little I'm capable of in the same direction.

So *père* Pissarro has been really cruelly struck by those two misfortunes at the same time.

As soon as I read that I had this idea of asking you if there would be a way of going to stay with him.

If you pay him the same thing as here, he'll find it worth his while, for I don't need much — except for working.

So do it directly, and if he doesn't want to I would willingly go to Vignon's.

I'm a little afraid of Pont-Aven, there are so many people there. But what you say about Gauguin interests me a lot. And I still tell myself that G. and I will perhaps work together again. I myself know that G. can do things even better than what he has done, but how to reassure him! I still hope to do his portrait. Have you seen that portrait he did of me painting sunflowers? My face has lit up after all a lot since, but it was indeed me, extremely tired and charged with electricity as I was then.

And yet to see the country one must live with the common people and in the little houses, the bars &c. And that was what I said to Boch, who complained of seeing nothing that tempted him or made an impression on him. I go walking with him for two days and I show him thirty paintings to do, as different from the north as Morocco would be. I'm curious to know what he's doing at the moment.

And then do you know why the paintings of E. Delacroix — the religious and historical paintings, Christ's barque — the Pietà, the Crusaders, have this allure? Because E. Delacroix, when he does a Gethsemane, went to see on the spot beforehand what an olive grove was like, and the same for the sea whipped up by a hard mistral, and because he must have said to himself, these people whom history talks to us about, doges of Venice, crusaders, apostles, holy women, were of the same type and lived in a manner analogous to those of their present-day descendants.

So I must tell you it, and you can see it in the Berceuse, however failed and weak that attempt may be. Had I had the strength to continue, I'd have done portraits of saints and of holy women from life, and who would have appeared to be from another century and they would be citizens of the present day, and yet would have had something in common with very primitive Christians.

The emotions that that causes are too strong though, I wouldn't survive it — but later, later, I don't say that I won't mount a fresh attack.

What a great man Fromentin was — for those who want to see the orient he will always remain the *guide*. He was first to establish relationships between Rembrandt and the south, between Potter and what he saw himself.

You're right a thousand times over — one mustn't think about all that — one must do — even if it's studies of cabbages and salad to calm oneself down, and after being calmed then — what one is capable of.

When I see them again I'll do repetitions of that study of the Tarascon diligence, the Vineyard, the Harvest and above all the Red bar, that night café which is the most characteristic as regards colour. But the white figure in the middle, correct as regards colour, must be redone, better constructed. But I dare say that this is a bit of the real south, and a calculated combination of the greens with the reds.

My strength has been exhausted too quickly, but I can see from afar the possibility for others to do an infinity of beautiful things. And again and again that idea remains true, that to facilitate the journey of others it would have been good to found a studio somewhere in these parts.

To make the journey from the north to Spain in one go, for example, isn't good, one won't see there what one ought to see — one must first and gradually *accustom one's eyes* to the different light.

I myself have no great need to see works by Titian and Velázquez in museums, I've seen certain living types who have made me know better now what a painting of the south is than before my little journey.

My God, my God, the good people among artists who say that Delacroix is not of the true orient! Look, is the true orient then what Parisians like Gérôme do?

Because you paint a bit of sunny wall, even from life and well and true according to our *northern* way of seeing, does that also prove that you've seen the people of the orient? Now that's what Delacroix was seeking there, which didn't prevent him at all from painting walls in the Jewish wedding and the Odalisques.

Isn't that true — and then Degas says that it's too expensive to drink in the bars while doing paintings, I don't say no, but would he then have me go into the cloisters or the churches, there I'm the one who's afraid.

That's why I make an effort at escape through the present letter, with many handshakes to you and Jo.

Ever yours,
Vincent

I still have to congratulate you on the occasion of Mother's birthday, I wrote to them yesterday but the letter hasn't gone off yet, because I wasn't in the mood to finish it.

It's funny that the idea had already come to me 2 or 3 times before to go to Pissarro's, this time, after you've told me of his recent misfortunes, I don't hesitate to ask it of you.

Yes we must be done here, I can no longer do both things at once, working and doing everything in my power to live with the odd patients here — it's unsettling. I'd like to force myself to go downstairs, but in vain. And yet it's almost 2 months since I've been out in the open air.

In the long run here I would lose the faculty to work, now there I begin to call a halt, and so I'll send them packing, if you agree. And paying for it what's more, no, then one or the other of the artists fallen in misfortune will consent to set up house with me.

Fortunately, you can write that you're well, and Jo too, and that her sister is with you. I'd very much like to be back myself when your child arrives — not with you, certainly *not*, that isn't possible, but in the area around Paris with another painter.

I could, to mention a third, go and stay with the Jouves, who have a lot of children and a whole household.

You'll understand that I've tried to compare the second crisis with the first, and I say only this to you: it appears to me to be some kind of influence from outside rather than a cause that comes from within myself. I may be mistaken, but whatever the case I think you'll consider it right that I'm a little horrified by all religious exaggeration. I can't help thinking of good André Bonger, who himself let out loud shouts when anyone wanted to try out some unguent or other on him. Good Mr Peyron will tell you heaps of things, about probabilities and possibilities of involuntary actions. Good, but if he's specific I'll believe none of it. And we'll see then *what he specifies*, if it's specific. The treatment of the patients in this hospital is certainly easy to follow, even on a journey, for they do absolutely *nothing* about it, they leave them to vegetate in idleness and feed them with stale and slightly spoiled food. And I'll tell you now that from the first

day I refused to take this food, and until my crisis I ate nothing but bread and a little soup, which I'll continue to do as long as I remain here. It's true that after this crisis Mr Peyron gave me some wine and meat, which I willingly accept in these first days but wouldn't want to make an exception to the rule for a long time, and it's right to respect the establishment according to their ordinary regime. I must also say that Mr Peyron doesn't give me much hope for the future, which I find justified, he makes me really feel that *everything* is doubtful, that nothing can be ensured in advance. But I myself am *counting* on it recurring, but only work preoccupies me so thoroughly that I think that with the body I have it will continue like this for a long time. The idleness in which these poor unfortunates vegetate is a plague, and there you are, it's a general evil in the towns and country areas under this stronger sun, and having learned differently it's a duty to resist it, certainly for me. I finish this letter by thanking you again for yours and asking you to write to me again soon, and many handshakes in thought.

804 | Saint-Rémy-de-Provence, Thursday, 19 September 1889 |
 To Willemien van Gogh (F)

My dear sister,

More than once already I've tried — in the interval since my last letter — to write to you and to Mother. So I thank you for having again written me such a kind letter. How right I think both of you were, Mother and you, to have left Breda for a while after Cor's departure. Certainly grief mustn't build up in our hearts like the water of a turbid pool. From time to time I feel like that inside, as if I have a very turbid soul, but that's an illness, and for people who are well and active, certainly they must do as you have done.

 As I write to Mother I'll send her a painting in let's say around a month, and there'll be one for you too.

 I've painted a few for myself, too, these past few weeks — I don't much like seeing my own paintings in my bedroom, so I've copied one by Delacroix and a few by Millet.

 The Delacroix is a Pietà, i.e. a dead Christ with the Mater Dolorosa. The exhausted corpse lies bent forward on its left side at the entrance to a cave, its hands outstretched, and the woman stands behind. It's an evening after the storm, and this desolate, blue-clad figure stands out — its flowing clothes blown about by the wind — against a sky in which violet clouds fringed with gold are floating. In a great gesture of despair she too is stretching out her empty arms, and one can see her hands, a working woman's good, solid hands. With its flowing clothes this figure is almost as wide in extent as it's tall. And as the dead man's face is in shadow, the woman's pale head stands out brightly against a cloud — an opposition which makes these two heads appear to be a dark flower with a pale flower, arranged expressly to bring them out better. I didn't know what had become of this painting, but while I was in the very process of working on it I came across an article by Pierre Loti, the author of Mon frère Yves and Pêcheur d'Islande and Madame Chrysanthème.

 An article by him on Carmen Sylva.

 If I remember rightly, you've read her poems. She's a queen — she's queen of

Hungary or another country (I don't know which), and in describing her boudoir, or rather her studio where she writes and where she makes paintings, Loti says that he saw this Delacroix canvas there, which struck him greatly.

He speaks of Carmen Sylva, making one feel that she's personally even more interesting than her words, although she says things like this: A woman without a child is a bell without a clapper—the sound of the bronze would perhaps be very beautiful—but—...

However, it does one good to think that a canvas like that is in such hands, and it consoles painters a little to be able to imagine that really there are souls who have a feeling for paintings.

But there are relatively few of them.

I thought of sending you yourself a sketch of it to give you an idea of what Delacroix is. This little copy of course has no value from any point of view. However, you'll be able to see in it that Delacroix doesn't draw the features of a Mater Dolorosa in the manner of Roman statues—

And that the pallid aspect, the lost, vague gaze of a person tired of being in anguish and in tears and keeping vigil is present in it rather in the manner of Germinie Lacerteux.

I consider it very good and very fortunate that you're not absolutely enthusiastic about De Goncourt's masterly book. So much the better that you prefer Tolstoy, you who read books above all to derive energies from them in order to act. I think you're right a thousand times over.

But I, who read books to seek in them the artist who made them, could I be wrong to like French novelists so much?

I've just finished the portrait of a woman of forty or more, insignificant. The face faded and tired, pockmarked, an olive-tinged, suntanned complexion, black hair.

A faded black dress adorned with a soft pink geranium, and the background in a neutral tone between pink and green.

Because I sometimes paint things like that—with as little and as much drama as a dusty blade of grass by the side of the road—it's right, as it seems to me, that I should have an unbounded admiration for De Goncourt, Zola, Flaubert, Maupassant, Huysmans. But as regards yourself, don't hurry, and continue boldly with the Russians. Have you read Ma religion by Tolstoy yet—it must be very practical and really useful. So go right to the very depths of that, since you like it.

Lately I've done two portraits of myself, one of which is quite in character, I think, but in Holland they'd probably scoff at the ideas about portraits that are germinating here. Did you see at Theo's the portrait of the painter Guillaumin and the portrait of a young woman by the same? That really gives an idea of what one is searching for. When Guillaumin exhibited his portrait, public and artists laughed at it a great deal, and yet it's one of the rare things that would hold up alongside even the old Dutchmen Rembrandt and Hals.

I myself still find photographs frightful and don't like to have any, especially not of people whom I know and love.

These portraits, first, are faded more quickly than we ourselves, while the painted portrait remains for many generations. Besides, a painted portrait is a thing of feeling

made with love or respect for the being represented. What remains to us of the old Dutchmen? The portraits.

Thus in Mauve's family the children will always continue to see him in the portrait that Mesker did so very well of him.

At this very moment I've just received a letter from Theo in which he answers me on the subject of what I'd said of my desire to return to the north for a while. It's quite likely that this will happen, to say exactly when, that still depends on the opportunities there may be to go and live with some artist or another.

But as we know several of them and it's often advantageous to live in pairs, it won't take long.

Finally, I say 'à bientôt' to you, thanking you again very much for your letters.

I don't know yet which canvases I'll send to you and Mother, probably a wheatfield and an olive grove with that copy after Delacroix.

The weather outside has been splendid for a very long time, but I haven't left my room for two months, I don't know why.

I would need courage, and I often lack it.

And it's also that since my illness the feeling of loneliness takes hold of me in the fields in such a fearsome way that I hesitate to go out. With time, though, that will change again. It's only in front of the easel while painting that I feel a little of life.

Anyway, that will change again, for my health is so good that the physique will win the day again.

I kiss you affectionately in thought, and more soon.

Ever yours,
Vincent

805 | Saint-Rémy-de-Provence, on or about Friday, 20 September 1889 |
 To Theo van Gogh (F)

My dear Theo,

Thanks very much for your letter. First, it gives me very great pleasure that you, for your part, had also already thought of *père* Pissarro.

You'll see that there are other possibilities, if not there then elsewhere. Now business is business, and you ask me to answer categorically — and you're right to do so — if I would consent to go into an asylum in Paris in the event of moving immediately for this winter.

I answer *yes* to that, with the same calmness and for the same reasons as I entered this one — even though this asylum in Paris might not be ideal, which might easily be the case, for the opportunity to work isn't bad here, and work my only distraction.

But that being said, I'll point out to you that in my letter I gave a very serious motive as a reason for wishing to move.

And I insist on repeating it — I'm astonished that with the modern ideas I have, I being such an ardent admirer of Zola, of De Goncourt and of artistic things which

I feel so much, I have crises like a superstitious person would have, and that mixed-up, atrocious religious ideas come to me such as I never had in my head in the north.

On the assumption that, very sensitive to surroundings, the already prolonged stay in these old cloisters which are the Arles hospital and the home here would be sufficient in itself to explain these crises — then — even as a stopgap — it might be necessary to go into a lay asylum at present.

Nevertheless, to avoid doing or appearing to do anything rash, I declare to you, after having thus warned you of what I might desire at a given moment — that is, a move — I declare to you that I feel sufficiently calm and confident to wait a while longer to see if there'll be a new attack this winter.

But if *then* I was to write to you: I want to get out of here, you wouldn't hesitate and it would be arranged in advance, for you would know then that I'd have a serious reason, or even several, to go into a home that wasn't run like this one by the nuns, however excellent they might be.

Now if by some arrangement or another we might move sooner or later, then let's begin as if almost nothing was wrong, at the same time being very prudent and ready to listen to the least thing that Rivet has to say, but let's not set ourselves immediately to taking overly official measures as if it were a lost cause.

As regards eating a lot, I'm doing so — but if I was my doctor I would forbid it.

Not seeing any good for myself in really enormous physical strength, for if I absorb myself in the idea of doing some good work and wanting to be an artist and nothing but that, that would be the most logical thing.

Mother and Wil, each for their part after Cor's departure, have changed surroundings — they were darned right. Grief mustn't build up in our souls like the water of a swamp. But it's sometimes both costly and impossible to move.

Wil wrote very well, it's a great grief for them, Cor's departure.

It's funny, just at the moment when I was making that copy of the Pietà by Delacroix I discovered where that canvas has gone. It belongs to a queen of Hungary or another country around there who has written poems under the name of Carmen Sylva. The article which talked of her and of the painting was by Pierre Loti, who made one feel that this Carmen Sylva was as a person yet more touching than what she writes — and yet she writes things like this: A woman without a child is like a bell without a clapper — the sound of the bronze would perhaps be very beautiful, but no one will hear it.

At present I have 7 copies out of ten of Millet's Travaux des champs.

I can assure you that it interests me enormously to make copies, and that not having any models for the moment it will ensure, however, that I don't lose sight of the figure.

What's more, it will give me a studio decoration for myself or another.

I would like also to copy the Sower and the Diggers.

There's a photo of the Diggers after the drawing.

And Lerat's etching of the Sower at Durand-Ruel's.

In these same etchings is the Field under the snow with a harrow. Then The four times of the day, there are examples of them in the collection of wood engravings.

I would like to have all of this, at least the etchings and the wood engravings. It's a study I need, for I want to *learn*. Although copying may be the *old* system, that absolutely doesn't bother me at all. I'm going to copy Delacroix's Good Samaritan too.

I've done a portrait of a woman — the orderly's wife — which I think you'd like. I've done a repetition of it which wasn't as good as the one from life.

And I fear that they'll take the latter, I would have liked you to have it. It's pink and black.

Today I'm sending you my portrait of myself, you must look at it for some time — you'll see, I hope, that my physiognomy has grown much calmer, although the gaze may be vaguer than before, so it appears to me.

I have another one which is an attempt from when I was ill. But I think this one will please you more, and I've tried to create something simple, show it to *père* Pissarro if you see him.

You'll be surprised what effect the Travaux des champs take on in colour, it's a very intimate series of his.

What I'm seeking in it, and why it seems good to me to copy them, I'm going to try to tell you. We painters are always asked to *compose* ourselves and *to be nothing but composers.*

Very well — but in music it isn't so — and if such a person plays some Beethoven he'll add his personal interpretation to it — in music, and then above all for singing — a composer's *interpretation* is something, and it isn't a hard and fast rule that only the composer plays his own compositions.

Good — since I'm above all ill at present, I'm trying to do something to console myself, for my own pleasure.

I place the black-and-white by Delacroix or Millet or after them in front of me as a subject. And then I improvise colour on it but, being me, not completely of course, but seeking memories of *their* paintings — but the memory, the vague consonance of colours that are in the same sentiment, if not right — that's my own interpretation.

Heaps of people don't copy. Heaps of others do copy — for me, I set myself to it by chance, and I find that it teaches and above all sometimes consoles.

So then my brush goes between my fingers as if it were a bow on the violin and absolutely for my pleasure. Today I attempted the Sheep shearer in a colour scale ranging from lilac to yellow. They are small canvases, around no. 5.

I thank you very much for the consignment of canvases and colours. On the other hand, I'm sending you a few canvases with the portrait, the following

Moonrise (wheatsheaves)
Study of fields
 " of olive trees
Night study
The mountain
Field of green wheat
Olive trees
Orchard in blossom
Entrance to a quarry

The first four canvases are studies that don't have the effect of an ensemble like the others. Myself I quite like the Entrance to a quarry which I did when I felt this attack beginning, because to my taste the dark greens go well with the ochre tones, there's something sad in them that's healthy, and that's why it doesn't annoy me. That's perhaps

also the case with the Mountain. People will tell me that mountains aren't like that, and that there are black contours as wide as a finger. But anyway it seemed to me that it expressed the passage in Rod's book — one of the very rare passages of his in which I find something good — on a lost land of dark mountains in which one noticed the darkish huts of goatherds, where sunflowers bloomed.

The olive trees with white cloud and background of mountains, as well as the Moonrise and the Night effect —

These are exaggerations from the point of view of the arrangement, their lines are contorted like those of the ancient woodcuts. The olive trees are more in character, just as in the other study and I've tried to express the time of day when one sees the green beetles and the cicadas flying in the heat.

The other canvases — the Reaper &c. aren't dry. And now in the bad season I'm going to make a lot of copies, for really I must do more figure work. It's the study of the figure that teaches one to grasp the essential and to simplify.

When you say in your letter that I've never done anything but work, no — that's not right — I myself am very, very discontented with my work, and the only thing that consoles me is that experienced people say that one must paint for 10 years for nothing. But what I've done is only those 10 years of unfortunate studies that didn't come off. Now a better period could come, but I'll have to strengthen the figure work, and I must refresh my memory by very close study of Delacroix, Millet. Then I'll try to sort out my drawing. Yes, every cloud has a silver lining, it gives one more time for study.

I'm also adding a study of flowers to the roll of canvases — not much, but anyway I don't want to tear it up.

All in all the only things I consider a *little* good in it are the Wheatfield, the Mountain, the Orchard, the Olive trees with the blue hills and the Portrait and the Entrance to the quarry, and the rest says *nothing* to me, because it lacks personal will, feeling in the lines. Where these lines are close together and deliberate the painting begins, even if it may be exaggerated. That's what Bernard and Gauguin feel a little bit, they won't ask for the correct shape of a tree at all, but they absolutely insist that one says if the shape is round or square — and my word, they're right —

Exasperated by certain people's photographic and inane perfection. They won't ask for the correct tone of the mountains but they'll say: for Christ's sake, were the mountains blue, then chuck on some blue and don't go telling me that it was a blue a bit like this or like that, it was blue wasn't it? Good — make them blue and that's enough! Gauguin is a genius sometimes when he explains that, but as for the *genius* Gauguin has, he's very timid about showing it, and it's touching how he likes to say something really useful to young folk. What an odd fellow all the same.

It gives me great pleasure that Jo is well, and I think you'll feel much more in your element thinking of her pregnancy, and naturally having concerns about it too, than if you were alone without these family concerns. For you'll feel more in nature.

When one thinks of Millet and Delacroix, what a contrast. Delacroix without a wife, without children, Millet completely in his family, more than anyone.

And yet what similarities there are in their work.

So Jouve has still kept his big studio and he's working on decorations.

That one came very close to being an excellent painter. It's money troubles with

him, in order to eat he's forced to do a thousand things other than painting, which costs him more money than it brings in when he makes something beautiful.

And he quickly loses his touch for drawing with the brush. This probably comes from the old training method, which is the same as the current one — in the studios — they fill in outlines. And Daumier was always painting his face in the mirror to learn how to draw!

Do you know what I think about quite often — what I used to say to you back in the old days, that if I didn't succeed I still thought that what I had worked on would be continued. Not directly, but one isn't alone in believing things that are true. And what does one matter as a person then? I feel so strongly that the story of people is like the story of wheat, if one isn't sown in the earth to germinate there, what does it matter, one is milled in order to become bread.

The difference between happiness and unhappiness, both are necessary and useful, and death or passing away . . . it's so relative — and so is life.

Even in the face of an illness that's unsettling or worrying, this belief is absolutely unshaken.

I'd have liked to see those Meuniers.

Well, let it be understood that if I were to write to you again expressly and briefly that I wanted to come to Paris, I would have a reason for that, which I've explained above, that in the meantime there's no great hurry, and I'm quite confident, after warning you, to wait for the winter and the crisis which may recur then. But if I have another fit of religious exaltation, then no delay, I'd like to leave *immediately* without giving a reason. Only we have no right, at least it would be indiscreet, to meddle in the nuns' management or even to criticize them. They have their own belief and ways of doing good to others, sometimes it works very well. *But I don't warn you lightly.* And it isn't to regain more freedom or something else that I don't have. So let's wait very calmly until an opportunity presents itself to find a place.

It's a great advance that my stomach is working well, and so I don't think that I'll be as sensitive to the cold. Then I know what to do when the weather is bad, as I have this plan to copy several things that I like.

I'd very much like to see Millet reproductions in schools, I think there would be children who became painters if only they saw good things.

Give my warm regards to Jo, and handshake, more soon.

Ever yours,
Vincent

811 | Saint-Rémy-de-Provence, on or about Monday, 21 October 1889 |
 To Anna van Gogh-Carbentus (D)

Dear Mother,
I wanted to write to you one more time while you're still in the old house, to thank you for your last letter and the news of Cor's safe passage.

I believe that he'll work there with enthusiasm and have some enjoyment in his life

now and then. What he writes to you reminds me of what my friend Gauguin told me about Panama and Brazil. I didn't know that Isaäcson is also going to the Transvaal. You know that I never met him personally — but I did write to him recently because he more or less intended to write about my work in a Dutch newspaper, which I asked him not to do, but at the same time to thank him for his loyal sympathy, because from the beginning we often thought about each other's work and have the same ideas about our old Dutch and the present-day French painters.

And I also like De Haan's work a lot.

Now I can inform you that what I promised you is entirely ready — that's to say five of my landscape studies and a small portrait of myself and a study of an interior. I'm afraid it will disappoint you, though, and a few things seem unimportant and ugly to you. Wil and you can do with them as you wish, and give the other sisters a couple of them if you like, that's why I'm sending a couple more.

But this is something that doesn't concern me, only I wanted to make sure that there were things of mine in the family, and am only trying to form a few things into a sort of ensemble that I would prefer to see stay together so that in time it becomes rather more important. Only, I can understand in advance that you won't have room for all 6, and so do with them as you wish. But I advise you to keep them together, at least for a while, since then you'll be better able to judge which you like best in the long run.

I'm sorry that Aunt Mina is suffering so, as you write; it's a good many years since I saw her.

I certainly agree with you that it's a good deal better for Theo like this than before, and just hope everything goes well with Jo's confinement, then they'll be set up for quite a while. It's always good to experience how a human being comes into the world, and that leads many characters to more peace and truth.

The countryside here is very beautiful in the autumn, and the yellow leaves. I'm just sorry there aren't more vineyards here, though I did go and paint one a few hours away. What happens is a large field turns entirely purple and red, like the Virginia creeper at home, and next to it a square of yellow and a little further on a patch that's still green.

All that beneath a sky of magnificent blue, and lilac rocks in the distance. Last year I had a better opportunity to paint that than now.

I would have liked to include something like that with what I'm sending you, but I'll have to owe it to you till another year.

You'll see from the little portrait of myself that I include that although I saw Paris, London and so many other large cities, and that for years at a time, I still look more or less like a peasant from Zundert, Toon or Piet Prins, say, and I sometimes imagine that I feel and think like that too, only the peasants are of more use in the world. It's only when they have all the rest that people get a feeling for, need for paintings, books etc. So in my own estimation I definitely reckon myself below the peasants. Anyway, I plough on my canvases as they do in their fields.

Otherwise things are wretched enough in our profession — that's always been so, in fact — but it's really very bad at present.

And yet there have never been such prices paid for paintings as nowadays.

What keeps us working is friendship for one another and love of nature, and anyway, when one's taken the trouble to become master of the brush, *one can't stop painting.*

Compared with others I'm still among the fortunate ones, but just imagine what

it must be like when someone starts in the profession and has to give it up before he's done anything, and there are many like that.

Reckon on 10 years needed to learn the profession, anyone who gets through 6, say, and pays for them and then has to give up, if you knew how miserable that is and how many there are like that. And the high prices one hears about, paid for work by painters who are dead and weren't paid like that in life, it's a sort of tulip mania from which the living painters get more disadvantage than advantage. And it will also pass like tulip mania.

One can reason, however, that although tulip mania is long gone and forgotten, the flower growers have remained and will remain. And so I regard painting in the same way, that what remains is a sort of flower growing. And as to that I reckon myself fortunate to be in it. But the rest!

These things to prove to you than one mustn't be under any illusions. My letter must go off — at the moment I'm working on a portrait of one of the patients here. It's strange that when one is with them for some time and is used to them, one no longer thinks about their being mad. Embraced in thought by

Your loving
Vincent

816 | Saint-Rémy-de-Provence, on or about Sunday, 3 November 1889 | To Theo van Gogh (F)

My dear Theo,

Enclosed I'm sending you a list of colours I need as soon as possible.

You gave me very great pleasure by sending me those Millets, I'm working on them zealously. I was growing flabby by dint of never seeing anything artistic, and this revives me. I've finished The evening and am working on The diggers and the man who's putting his jacket on, no. 30 canvases, and The sower, smaller. The evening is in a range of violets and soft lilacs, with light from the lamp pale citron, then the orange glow of the fire and the man in red ochre. You will see it. It seems to me that doing painting after these Millet drawings is much rather *to translate them into another language* than to copy them. Apart from that I have a rain effect on the go, and an *evening* effect with tall *pines*.

And also a leaf-fall.

My health is very good — except often a lot of melancholy however — but I feel much much better than when I came here, and even better than in Paris. Also, as for the work the ideas are becoming firmer, it seems to me. But then I don't quite know if you'd like what I'm doing now. For despite what you say in your previous letter, that the search for style often harms other qualities, the fact is that I feel myself greatly driven to seek style, if you like, but I mean by that a more manly and more deliberate drawing. If that will make me more like Bernard or Gauguin, I can't do anything about it. But am inclined to believe that in the long run you'd get used to it.

For yes, one must feel the wholeness of a country — isn't that what distinguishes a

Cézanne from something else. And Guillaumin, whom you mention, he has so much style and a personal way of drawing. Anyway, I'll do as I can.

Now that most of the leaves have fallen the landscape looks more like the north, and then I really feel that if I went back to the north I would see it more clearly than before.

Health is a big thing, and a lot depends on it, as regards work too.

Fortunately those abominable nightmares no longer torment me.

I hope to go to Arles in the next few days.

I'd very much like Jo to see The evening, I think that I'll send you a consignment shortly, but it's drying very badly because of the dampness of the studio. Here the houses have scarcely any cellar or foundations, and one feels the damp more than in the north.

At home they'll have moved by now, I'll add 6 canvases for them to the next consignment. Is it necessary to have them framed, perhaps *not*, for it isn't worth it. Above all, don't frame the studies I send you from time to time, that can be done later, pointless for them to take up too much room.

I've also done a canvas for Mr Peyron, a view of the house with a tall pine tree.

I hope that your health and Jo's continue to be good.

I'm so happy that you're no longer alone, and that everything's more normal than before.

Is Gauguin back, and what's Bernard doing?

More soon, I shake your hand firmly, and Jo's, and our friends', and believe me

Ever yours,
Vincent

I'm trying to simplify the list of colours as much as possible — thus I very often use the ochres as in the old days.

I know very well that the studies drawn with long, sinuous lines from the last consignment weren't what they ought to become, however I dare urge you to believe that in landscapes one will continue to mass things by means of a drawing style that seeks to express the entanglement of the masses. Thus, do you remember Delacroix's landscape, Jacob's struggle with the angel? And there are others of his! For example the cliffs, and the very flowers you speak of sometimes. Bernard really has found perfect things in there. Anyway, don't be too swift to adopt a prejudice against it.

Anyway, you'll see that there's already more character in a large landscape with pines, red ochre trunks defined by a black line than in the previous ones.

820 | Saint-Rémy-de-Provence, on or about Tuesday, 19 November 1889 |
 To Theo van Gogh (F)

My dear Theo,

Thanks for your letter, and am very glad that you write that Jo is staying well. The great event is nearing now, I think of you both very often. For you, when you write about seeing so many paintings that you would wish not to see any for a while, this clearly proves that you've had too many business worries. And then — yes there's

something in life other than paintings, and this something else one neglects and nature seems to avenge itself then, and besides, fate is bent on thwarting us. I think that in these circumstances one must keep to the paintings as much as duty demands but no more. As for the Vingtistes, here's what I'd like to exhibit:

1 and 2 the two pendants of sunflowers
 3 The ivy, upright
 4 Orchard in blossom (the one Tanguy's exhibiting at the moment, with poplars crossing the canvas)
 5 The red vineyard
 6 Wheatfield, rising sun, which I'm working on at the moment.

Gauguin wrote me a very kind letter and speaks animatedly of De Haan and of their rough-and-ready life at the seaside.

Bernard also wrote to me, complaining about a heap of things while resigning himself like the good boy he is, but not happy at all; with all his talent, all his work, all his sobriety, it appears that home is often a hell for him.

Isaäcson's letter gives me great pleasure, I enclose my reply which you will read — the ideas are beginning to link together a little more calmly, but as you'll see from it I don't know if I should continue to paint or leave painting alone.

If I continue, certainly I'm in agreement with you that perhaps it's better to attack things with simplicity than to seek abstractions.

And I'm not an admirer of Gauguin's Christ in the Garden of Olives for example, a croquis of which he sent me. Then as for Bernard's, he promises me a photograph of it, I don't know, but I fear that his biblical compositions will make me wish for something else. Lately I've seen women picking and gathering olives, no way for me to get a model, so I didn't do anything about it. However now isn't the moment to ask me to approve of friend G's composition — and friend Bernard has probably never seen an olive tree. Now he therefore avoids conceiving the least idea of the possible and of the reality of things, and that isn't the way to synthesize. No, never have I got involved in their Biblical interpretations. I said that Rembrandt and Delacroix had done this admirably, that I liked that even better than the primitives, but then stop. I don't want to begin on that chapter again. If I remain here I wouldn't try to paint a Christ in the Garden of Olives, but in fact the olive picking as it's still seen today, and then giving the correct proportions of the human figure in it, that would perhaps make people think of it all the same. Before I've done more serious studies than I have up to now I don't have the right to get involved in this. And then the Pre-Raphaelites went a long way in that category of ideas. When Millais painted his Light of the World it was serious in another way. Really, there's no comparison. Not to mention Holman Hunt and others, Pinwell and Rossetti.

And then here there's Puvis de Chavannes.

Now I'll tell you that I've been to Arles and I saw Mr Salles, who handed me the rest of the money you sent him and the rest of what I'd handed over to him, that is, 72 francs. However, only around twenty francs remain in the cash-box with Mr Peyron at the moment, since down there I stocked myself up with colours and paid for the room where the furniture &c. is. Stayed there for 2 days, not yet knowing what to do next, it's good to show oneself there from time to time so that the same story doesn't

start again with the people. At present no one there is hostile to me as far as I can tell, on the contrary, they were very friendly, and even gave me a warm welcome. And if I stayed in the area, little by little I'd have a chance to acclimatize myself, which isn't easy for strangers and would have its uses for painting there. But first we'll see a little if this journey might provoke another crisis. I almost dare hope not.

It's often cold here too, however we're a little more sheltered from the mistral by the mountains. And between times I keep working. I have several things to send you with the canvas for the Vingtistes. I'm waiting for that one to be dry.

If I'd known in time that there were trains from here to Paris at only 25 francs I would certainly have come. It's only on going to Arles that I found this out, and it's because of the expense that I haven't done it — at the moment it would seem to me that in springtime it would however be good to come in any event to see the people and things of the north again. For this life here is terribly numbing, and in the long run I'd lose my energy. I had hardly dared hope that I would still be as well as is the case.

However, everything depends on whether this suits you or not, and I think it's wise not to rush things. Perhaps by waiting a little we won't even have need of the doctor at Auvers or the Pissarros.

If my health remains stable, then if while I'm working I again start to try to sell, exhibit, make exchanges, perhaps there'll be some progress so as to be less of a burden to you on the one hand and to regain a little more zest on the other. For I don't hide from you the fact that my stay here is very tiring on account of its monotony, and because the society of all these unfortunates, who do absolutely nothing, gets on one's nerves.

But what can one do, one can't have pretensions in my case, I already have too many as it is.

Gauguin says that they get models easily. That's what I lack most here.

Bernard speaks to me of an exchange, you're quite free to deal with this with him if he wishes and speaks to you about it. I'd really like that, besides the portrait of his grandmother, you should have a good thing of his. It appears he fancies the Berceuse.

I think that the 6 paintings for the Vingtistes will make an ensemble like this, the wheatfield will make a very good pendant to the orchard.

I'm dropping a line to Mr Maus to give him titles, as he asks in his letter.

Now, warm regards to Jo, and good handshake.

You must read the letter to Isaäcson, it complements this one. More soon.

Ever yours,
Vincent

20 November 1889
St-Rémy in Provence

Sir,

I accept with pleasure your invitation to exhibit with the Vingtistes. Here is the list of canvases I intend for you

No 1 Sunflowers
2 Sunflowers
3 The ivy
4 Orchard in blossom (Arles)
5 Wheatfield. Rising sun (St-Rémy)
6 The red vineyard (Montmajour)
(All these canvases are no. 30 canvases.)

I am perhaps exceeding the 4 metres of room but as I believe that the 6 together, thus chosen, will make a rather varied colour effect, perhaps you will find a way of placing them.

Please accept the expression of my entire fellow-feeling for the Vingtistes.

Vincent van Gogh

My dear friend Bernard,

Thank you for your letter, and thank you especially for your photos, which give me an idea of your work.

Incidentally, my brother wrote to me about it the other day, saying that he very much liked the harmoniousness of the colour, a certain nobility in several figures.

Look, in the adoration of the shepherds, the landscape charms me too much for me to dare to criticize, and nevertheless, it's too great an impossibility to imagine a birth like that, on the very road, the mother who starts praying instead of giving suck, the fat ecclesiastical bigwigs, kneeling as if in an epileptic fit, God knows how or why they're there, but I myself don't find it healthy.

Because I adore the true, the possible, were I ever capable of spiritual fervour; so I bow before that study, so powerful that it makes you tremble, by *père* Millet — peasants carrying to the farmhouse a calf born in the fields. Now, my friend — people have felt that from France to America. After that, would you go back to renewing medieval tapestries for us? Truly, is this a sincere conviction? NO, you can do better than that, and you know that one has to look for the possible, the logical, the true, even if to some extent you had to forget Parisian things à la Baudelaire. How I prefer Daumier to that gentleman!

An annunciation of what — — —I see figures of angels, elegant, my word, a terrace with two cypresses, which I like very much; there's an enormous amount of air, of clarity in it but in the end, once this first impression is past, I wonder if it's a mystification, and these secondary characters no longer tell me anything.

But this is enough for you to understand that I would long to see things of yours again, like the painting of yours that Gauguin has, those Breton women walking in a meadow, the arrangement of which is so beautiful, the colour so naively distinguished. Ah, you're exchanging that for something — must one say the word — something artificial — something affected.

Last year, from what Gauguin was telling me, you were doing a painting more or less like this, I imagine.

[*Sketch* 822A]

Against a foreground of grass, a figure of a young girl in a blue or white dress, lying full length. Behind that: edge of a beech wood, the ground covered in fallen red leaves, the verdigrised trunks crossing it vertically — I imagine the hair a colourful note in the tone required as complementary to the white dress: black if the clothing was white, orange if the clothing was blue. But anyway, I said to myself, what a simple subject, and how he knows how to create elegance with nothing.

Gauguin spoke to me of another subject, nothing but three trees, thus effect of orange foliage against blue sky, but still really clearly delineated, well divided, categorically, into planes of contrasting and pure colours — that's the spirit!

[*Sketch* 822B]

And when I compare that with that nightmare of a Christ in the Garden of Olives, well, it makes me feel sad, and I herewith ask you again, crying out loud and giving you a piece of my mind with all the power of my lungs, to please become a little more yourself again.

The Christ carrying his Cross is atrocious. Are the splashes of colour in it harmonious? But I won't let you off the hook for a COMMONPLACE — commonplace, you hear — in the composition.

When Gauguin was in Arles, I once or twice allowed myself to be led into abstraction, as you know, in a woman rocking a cradle, a dark woman reading novels in a yellow library, and at that time abstraction seemed an attractive route to me. But that's enchanted ground, — my good fellow — and one soon finds oneself up against a wall. I'm not saying that one may not take the risk after a whole manly life of searching, of fighting hand-to-hand with reality, but as far as I'm concerned I don't want to rack my brains over that sort of thing. And the whole year, have fiddled around from life, hardly thinking of Impressionism or of this or that.

However, once again I'm allowing myself to do stars too big, &c., new setback, and I've enough of that.

So at present am working in the olive trees, seeking the different effects of a grey sky against yellow earth, with dark green note of the foliage; another time the earth and foliage all purplish against yellow sky, then red ochre earth and pink and green sky. See, that interests me more than the so-called abstractions.

And if I haven't written for a long time, it's because, having to struggle against my

l'année passée vous faisez un tableau d'après ce que me disait
Gauguin à peu près je suppose ainsi.
Sur un avant plan d'herbe une figure de jeune
fille en robe bleue ou blanche étendue tout de
son long un second plan — lisière de
bois de hêtre le sol couvert de feuilles rouges
tombées les troncs vert de grisés le barrant verticalement — la chevelure
je la suppose une note colorée du ton necessité comme complémentaire
de la robe blanche noire si le vêtement était blanc orangée si le vêtement
était bleu — Mais enfin je ne sais quel motif simple et
comme me il sait faire de l'élégance avec rien —
Gauguin me parla d'un autre motif rien que trois arbres ainsi
effet de feuillage orangé contre ciel bleu mais encore
bien nettement délinée bien divisé cathégoriquement
en plans de couleurs opposés et franches — à la bonne
heure —
Et lorsque je compare cela à ce cauchemar d'un
christ au jardin des oliviers ma foi je m'en
suis triste et le redemande par la présente
à hauts cris et l'engueulant ferme de toute la
force de mes poumons de vouloir bien un peu
redevenir toi —
Le christ portant sa croix est atroce. Sont elles harmonieuses
les tâches de couleur là dedans? je ne te fais pas grace cependant
d'un poncif — tiens poncif — dans la composition

Lorsque Gauguin était à Arles comme tu le sais une ou deux fois je
me suis laissé aller à une abstraction dans la berceuse
une liseuse de romans noire dans une bibliothèque jaune
et alors l'abstraction me paraissait une voie charmante
mais c'est terrain enchanté ça — mon bon — et
vite on se trouve devant un mur — je ne dis pas qu'après
toute une vie mâle de recherches de lutte avec la nature
corps à corps on peut s'y risquer mais quant à moi
je ne veux pas me creuser la tête avec ces choses là
Et toute l'année ai tripoté d'après nature ne songeant
guère à l'impressionisme ni à ceci ni à cela.
cependant encore une fois je me laisse aller à faire des
étoiles trop grande & nouvel échec et j'en ai assez
Donc actuellement travaille dans les oliviers cherchant
les effets variés d'un ciel gris contre terrain jaune avec note
vert noir du feuillage une autre fois le terrain et feuillage
tout violacé contre ciel jaune puis terrain ocre rouge
et ciel rose vert — Va ça m'intéresse d'avantage que
les abstractions ainsi nommées

822A–B (top to bottom). Sketches after Emile Bernard, *Madeleine in the Bois d'Amour* and *Red poplars*

illness and to calm my head, I hardly felt like having discussions, and found danger in these abstractions. And by working very calmly, beautiful subjects will come of their own accord; it's truly first and foremost a question of immersing oneself in reality again, with no plan made in advance, with no Parisian bias. Besides, am very dissatisfied with this year, but perhaps it will prove a solid foundation for the coming one. I've let myself become thoroughly imbued with the air of the small mountains and the orchards. With that, I'll see. My ambition is truly limited to a few clods of earth, some sprouting wheat. An olive grove. A cypress; the latter not easy to do, for example. You who love the primitives, who study them, I ask you why you appear not to know Giotto. Gauguin and I saw a tiny panel of his in Montpellier, the death of some sainted woman or other. The expressions in it of pain and ecstasy are human to the point that, 19th century though it may be, you feel you're in it — and believe you were there, present, so much do you share the emotion. If I saw your actual canvases, I believe the colour could nevertheless excite me. But then you speak of portraits that you've done, and have captured precisely; that's something that will be good, and where you will have been yourself.

Here's description of a canvas that I have in front of me at the moment. A view of the garden of the asylum where I am, on the right a grey terrace, a section of house, some rosebushes that have lost their flowers; on the left, the earth of the garden — red ochre — earth burnt by the sun, covered in fallen pine twigs. This edge of the garden is planted with large pines with red ochre trunks and branches, with green foliage saddened by a mixture of black. These tall trees stand out against an evening sky streaked with violet against a yellow background. High up, the yellow turns to pink, turns to green. A wall — red ochre again — blocks the view, and there's nothing above it but a violet and yellow ochre hill. Now, the first tree is an enormous trunk, but struck by lightning and sawn off. A side branch thrusts up very high, however, and falls down again in an avalanche of dark green twigs.

This dark giant — like a proud man brought low — contrasts, when seen as the character of a living being, with the pale smile of the last rose on the bush, which is fading in front of him. Under the trees, empty stone benches, dark box. The sky is reflected yellow in a puddle after the rain. A ray of sun — the last glimmer — exalts the dark ochre to orange — small dark figures prowl here and there between the trunks. You'll understand that this combination of red ochre, of green saddened with grey, of black lines that define the outlines, this gives rise a little to the feeling of anxiety from which some of my companions in misfortune often suffer, and which is called 'seeing red'. And what's more, the motif of the great tree struck by lightning, the sickly green and pink smile of the last flower of autumn, confirms this idea. Another canvas depicts a sun rising over a field of new wheat. Receding lines of the furrows run high up on the canvas, towards a wall and a range of lilac hills. The field is violet and green-yellow. The white sun is surrounded by a large yellow aureole. In it, in contrast to the other canvas, I have tried to express calm, a great peace.

I'm speaking to you of these two canvases, and especially the first, to remind you that in order to give an impression of anxiety, you can try to do it without heading straight for the historical garden of Gethsemane; in order to offer a consoling and gentle subject it isn't necessary to depict the figures from the Sermon on the Mount — ah — it is — no doubt — wise, right, to be moved by the Bible, but modern reality has

such a hold over us that even when trying abstractly to reconstruct ancient times in our thoughts—just at that very moment the petty events of our lives tear us away from these meditations and our own adventures throw us forcibly into personal sensations: joy, boredom, suffering, anger or smiling. The Bible—the Bible—Millet was brought up on it from his childhood, used to read only that book and yet never, or almost never, did biblical paintings. Corot did a Garden of Olives with Christ and the star of Bethlehem: sublime. In his work you feel Homer, Aeschylus, Sophocles too, sometimes, as well as the Gospels, but how sober and always giving due weight to modern, possible sensations common to us all. But, you'll say, Delacroix—yes, Delacroix—but then you'd have to *study* in a very different way, yes, *study* history before putting things in their place like that.

So, they're a setback, my dear fellow, your biblical paintings, but . . . there are few who make mistakes like that, and it's an error, but your return from it will be, I dare to say, astonishing, and it's by making mistakes that one sometimes finds the way. Look, avenge yourself by painting your garden as it is, or anything you like. In any case, it's good to look for what's distinguished, what's noble in figures, and your studies represent an effort that's been made, and so something other than wasted time.

To know how to divide a canvas into large, tangled planes like that, to find contrasting lines and forms—that's technique—trickery, if you like, but anyway, it means you're learning your craft more thoroughly, and that's good. No matter how hateful and cumbersome painting may be in the times in which we live, the person who has chosen this craft, if he nevertheless practises it with zeal, is a man of duty, both sound and loyal. Society sometimes makes existence very hard for us, and from that too comes our impotence and the imperfection of our works. I believe that Gauguin himself suffers greatly from it, too, and cannot develop as he yet has it in him to do.

I myself suffer in that I'm utterly without models. On the other hand, there are beautiful sites here. Have just done 5 no. 30 canvases of the olive trees. And if I still stay here it's because my health is recovering greatly. What I'm making is harsh, dry, but it's because I'm trying to reinvigorate myself by means of rather arduous work, and would fear that abstractions would make me soft. Have you seen a study of mine with a little reaper? A field of yellow wheat and a yellow sun. It isn't there yet—but in it I've again attacked this devil of a question of yellow. I'm talking about the one that's impastoed and done on the spot, not about the repetition with hatching, in which the effect is weaker. I wanted to do it in pure sulphur. I'd have plenty more things to tell you—but although I write today that my mind is somewhat stronger, previously I was afraid of overheating it before I was cured. In thought a very warm handshake, to Anquetin too, to other friends if you see them, and believe me

Ever yours,
Vincent

No need to tell you that I regret, for you as well as for your father, that he didn't approve of your spending the season with Gauguin. The latter wrote to me that for reasons of health your service has been postponed for a year. Thank you anyway for the description of the Egyptian house. I would still have liked to know if it was larger or smaller than a cottage back home—the size relative to the human figure, in short. I was looking for information about the colouring in particular.

My dear Theo,

Thanks very much for your last letter, I'm very glad that you and Jo are in good health, and very often think of you both.

It's very interesting what you tell me about a publication of coloured lithographs with a text on Monticelli, honestly, that gives me very great pleasure, and I'd be very curious to see them one day. I hope that he'll reproduce in colour the bouquet you have, for that's a thing of the first order as regards colour. One day I'd very much like to do a print or two myself in this vein after my canvases. Thus I'm working on a painting at the moment, women picking olives, which would lend itself to it, I think. These are the colours: the field is violet and further away yellow ochre, the olive trees with bronze trunks have grey-green foliage, the sky is entirely pink, and 3 small figures pink also. The whole in a very discreet range. It's a canvas I'm working on from memory after the study of the same size done on the spot, because I want a far-off thing like a vague memory softened by time. There are only two notes, pink and green, which harmonize, neutralize each other, oppose each other. I'll probably do 2 or three repetitions of it, for in fact it's the result of a half-dozen studies of olive trees.

I think it likely that I'll do hardly any more things in impasto, it's the result of the calm life of seclusion I'm leading, and I feel I'm better for it. Fundamentally I'm not as violent as that, anyway I feel more *myself* in calmness.

You'll perhaps also see it in the canvas for the Vingtistes that I sent yesterday, the Wheatfield with rising sun. You'll receive the Bedroom at the same time. I've also added two drawings to them. I'm curious to know what you'll say about the Wheatfield, you may have to look at it for a while perhaps. However, I hope that you'll write to me soon whether it's arrived in good order if you find a free half hour next week.

I'd be completely resigned to staying here next year too, because I think the work will get along a little. And through the prolonged stay, I feel the country here differently from the first place encountered — good ideas are now germinating a little and should be allowed to develop. And thus I wouldn't be so very far removed from the idea of going to look for something in the land of Tartarin. I have a great desire to do more of both the cypresses and the Alpilles, and often going on long walks in all directions I've noted many subjects and know good places for when the fine days come. Then, from the point of view of expenditure there would hardly be any advantage in moving I think, and moving makes the success of the work all the more doubtful. I've received another very nice letter from Gauguin, a letter thoroughly impregnated with the proximity of the sea, I think he must be doing fine, rather savage things.

You tell me not to give myself *too many* worries and that better days will come again for me. I'd say that these better days have already begun for myself, when I glimpse the possibility of completing, to some extent, the work in such a way that you'll have a series of Provençal studies done with feeling which will hold up, this is what I hope, with our far-off memories of youth in Holland, and thus I'm treating myself by redoing the olive trees again for our mother and sister. And if I could one day prove that I wouldn't impoverish the family, that would relieve me. For at present I always

have a great deal of remorse in spending money that doesn't come back. But as you say, patience and working is the only chance of getting out of that.

However, I often tell myself that if I'd done like you, if I'd stayed at the Goupils', if I'd restricted myself to selling paintings, I would have done better. For in the trade, if one doesn't produce oneself one makes others produce, now that so many artists need support among the dealers and only rarely find it.

The money that was with Mr Peyron has run out, and a few days ago he even gave me 10 francs in advance. And in the course of the month I'll certainly need another ten, and at New Year I'd consider it right to give something to the servant lads who work here, and to the porter, which will make another ten francs or so.

As regards winter clothing, what I have isn't very much, as you'll understand, but it's warm enough and so we can wait until spring with that. If I go out it's to work, so then I put on the most worn-out things I have, and I have a velvet waistcoat and trousers for here. In the spring, if I'm here, I'm planning to go and make a few paintings in Arles as well, and if I get something new around then, that will suffice.

I'm sending you enclosed an order for canvas and colours, but I still have some and it can wait until next month if this one is too heavily burdened already.

I remember the painting by Manet you speak of. As to figure, the portrait of a man by Puvis de Chavannes has always remained an ideal for me, an old man reading a yellow novel, with beside him a rose and watercolour brushes in a glass of water — and the portrait of a lady that he had in the same exhibition, a woman already old but completely as Michelet felt, that there's no such thing as an old woman. These are consolatory things, to see modern life as bright despite its inevitable sadnesses.

Last year around this time I was certainly not thinking that I would recover as much as this.

Give my kind regards to Isaäcson if you see him, and to Bernard.

I regret not being able to send the olive trees one of these days, but it's drying so badly that I'll have to wait.

I think it'll be a good course of action to have our sister come in January. Ah, if that one could get married, that would be a good thing.

I shake your hand warmly in thought, I'm going to work some more outside, the mistral's blowing. It usually dies down by the time the sun's about to set, then there are superb effects of pale citron skies, and desolate pines cast their silhouettes into relief against it with effects of exquisite black lace.

At other times the sky is red, at other times a tone that's extremely delicate, neutral, still pale lemon but neutralized by delicate lilac.

I have an evening effect of a pine again against pink and green-yellow. Anyway, shortly you'll see these canvases, of which the first, the Wheatfield, has just left. More soon, I hope, warm regards to Jo.

Ever yours,
Vincent

My dear Theo,

Thanks for your letter. Although I just wrote to you yesterday I'm replying immediately.

The fact is that I've never worked more calmly than in my latest canvases — you're going to receive a few at the same time as this letter, I hope. For the moment I've been caught unawares by a great discouragement. But since this attack ended in a week, what's the good of telling oneself that it can in fact recur? First we don't know, nor can we foresee how and in what form.

So let's continue the work as much as possible as if nothing were amiss. I'll soon have the opportunity to go outside when the weather isn't too cold, and then I'd rather like to try to finish the work undertaken here.

To give an idea of Provence it's vital to do a few more canvases of cypresses and mountains.

The ravine and another canvas of mountains with a path in the foreground are types of this. And especially the Ravine that I still have here because it isn't dry. As well as the view of the park too, with the pines. It took me all the time to observe the character of the pines, cypresses &c. in the pure air here, the lines that don't change and which one finds again at every step.

It's perfectly true that last year the crisis recurred at various times — but then, too, it was precisely by working that the normal state returned little by little. It will probably be the same on this occasion too. So act as if nothing were amiss, for we can do absolutely nothing about it. And what would be infinitely worse is to let myself slide into the state of my companions in misfortune who do nothing all day, week, month, year, as I've told you many times and repeated again to Mr Salles, making him promise never to recommend this asylum. The work makes me retain a little presence of mind still, and makes it possible that I can get out one day.

At the moment I have the paintings ripe in my mind, I see in advance the places that I still want to do in the coming months. Why would I change means of expression.

Once I'm back from here, let's suppose, we'll have to see a little if there's really nothing to be done with my canvases, I would have a certain number of mine, a certain number of other people's, and perhaps I'd try to do a little dealing. I don't know in advance, but I see no reason not to do more of the canvases here that I'll need were I to get out of here. Once again, I can foresee absolutely nothing, I see no way out, but I also see that my stay here cannot be prolonged indefinitely. Then, in order not to hurry anything or break it off suddenly, I'd wish to continue as usual as long as I'm here.

Yesterday I sent 2 canvases to Marseille, i.e. I made a present of them to my friend Roulin, a white farmhouse among the olive trees and a wheatfield with a background of lilac mountains and a dark tree, as in the large canvas I sent you. And I've given Mr Salles a little canvas with pink and red geraniums on a completely black background, like I used to do in Paris.

As regards the money you sent, 10 francs of it were owing to Mr Peyron, which he'd advanced me last month, I gave 20 francs in New Year's gifts, and I took 10 for the postage on the canvases and other expenses, so 10 francs still remain in the cash-box.

At the moment I've just done a little portrait of one of the lads from here which he wanted to send to his mother, that's to say I've already started work again, and Mr Peyron would probably not have allowed me to if he saw any obstacles there. What he said to me was 'let's hope that this doesn't happen again'—so absolutely the same thing as always. He talked to me with great kindness and these things scarcely surprise him, but since there's no ready remedy it's time and circumstances alone that can perhaps have influence.

I'd very much like to go to Arles one more time, not immediately, but towards the end of February for example, first to see friends, which always cheers me up, and then to test whether I'm capable of risking the journey to Paris.

Am very pleased that our sister has come. Warm regards to her and to Jo, and as for you and me, let's not worry ourselves. In any event, it didn't last as long as the other year, and so we can still hope that little by little time will make all of this pass. Well, be of good heart, and good handshake

Ever yours,
Vincent

839 | Saint-Rémy-de-Provence, on or about Monday, 13 January 1890 | To Theo van Gogh (F)

My dear Theo,

Thanks for your last letter, I hope that Wil has recovered from her indisposition and that it was no more serious than you say. Thanks very much, too, for the consignment of canvases and colours, which has just arrived. I have enough subjects for paintings in my head for when the weather permits me to work outside.

What you say about the copy after Millet, The evening, pleases me. The more I think about it the more I find that there's justification for trying to reproduce things by Millet that he didn't have the time to paint in oils. So working either on his drawings or the wood engravings, it's not copying pure and simple that one would be doing. It is rather translating into another language, the one of colours, the impressions of chiaroscuro and white and black. In this way I've just finished the three other 'times of the day' after the wood engravings by Lavieille. It took me a lot of time and a lot of trouble. For you know that this summer I've already done The labours of the fields. Now these reproductions—you'll see them one day—I haven't sent, because more than the former ones they were gropings, but they have, however, served me well for The times of the day. Later, who knows, perhaps I could do lithographs of them. I'm curious as to what Mr Lauzet will say about them. They'll take a good month more to dry, the last three, but once you have them you'll clearly see that they were done through a most profound and sincere admiration for Millet. Then, even if they're criticized one day or despised as copies, it will remain no less true that it's justifiable to try to make Millet's work more accessible to the ordinary general public.

Now I'm going to talk to you again about what I think we could do for the future so as to have fewer expenses. At Montevergues there's an asylum where one of the

employees here used to be a warder. He tells me that there they only pay 22 sous a day, and that then the patients are even dressed by the establishment. Then they're put to work on the lands that belong to the house, and there's also a forge, a carpenter's workshop &c. Once they'd got to know me a little I don't think I'd be forbidden to paint, then for one thing there's still the fact that it's less expensive, and second, that one can work at something. So with good will one isn't unfortunate there, nor is one to be pitied too much. Now, even leaving Montevergues aside, returning to Holland, aren't there establishments in our native country where people work too and where it isn't expensive, and which one has the right to benefit from, while I'm not too sure if there might not be a slightly higher rate at Montevergues for foreigners, *and above all admission difficulties which it's better to avoid.* I must tell you that it reassures me a little to tell myself that we can simplify things if we need to. For at present it costs too much, and the idea of going to Paris then to the country, having no other resource to combat the expenses than painting, means manufacturing paintings that come quite expensive.

You must talk about it one day with C.M., should you see him, and tell him frankly that I'll willingly try to do what's for the best, that I have no preference whatsoever.

I saw Mr Peyron again this morning, he says that he's allowing me complete freedom to distract myself, and that I must react against the melancholy as much as I can, which I'm gladly doing. Now, it's a good reaction to ponder resolutely, and it's also a duty. Now, you understand that in an establishment where the patients work in the fields I would find hosts of subjects for paintings and drawings, and that I wouldn't be at all unhappy there. Anyway, it's necessary to ponder while we have the time to ponder.

I think that if I came to Paris I wouldn't do anything but draw Greek casts again at first, because I must always keep on studying.

For the moment I feel very well, and I hope that it'll remain like that.

And I even have hopes that it will be dispelled even more if I return to the north. Just mustn't forget that a broken pitcher is a broken pitcher, and so I have no right at all to entertain pretensions.

I tell myself that at home in Holland people always value painting more or less, that in an establishment they'd hardly make difficulties about letting me do it. Now, it would still be a lot, however, to have the opportunity to occupy oneself over and above painting, and it would cost less. Hasn't the countryside and working there always been to our taste? And aren't we a little indifferent, you as much as I, to the life of a big city?

I must tell you that at moments I still feel too well to be idle, and in Paris I fear I wouldn't do anything good.

So when you see C.M., and it seems very likely to me that he will indeed drop by in February to see the little one you're expecting, let's try a little to act firmly.

I can and I indeed want to earn some money with my painting, and we ought to ensure that my expenses don't exceed its value, and even that the money spent comes back little by little. Well, that can be done with energy, and it's a duty. With good behaviour I think that one can arrive at some relative freedom, even in an establishment for the insane. And it seems to me that the attacks have been too frequent, too decisive, to cease considering myself as ill.

To talk of something else — I can't manage to see the south like the good Italians, Fortuny, Jiménez, Tapiró and others — how on the contrary it makes me see more with my northern eyes!

It isn't, believe me, that I wouldn't wish to be able to live like before, without this preoccupation with health. Anyway, we'll make the attempt *once* but probably *not twice* in the spring if it goes away completely.

Today I took the ten francs that were still with Mr Peyron. When I go to Arles I'll have to pay 3 months' rent on the room where my furniture is. That'll be in February. This furniture, it seems to me, will be of use, if not to me then to another painter wanting to settle in the country.

Wouldn't it be wiser, in the event of leaving here, to send it to Gauguin, who'll probably spend more time in Brittany, than to you, who'll have nowhere to put it. This is another thing we need to consider in time.

I think that in giving up two very old, heavy chests of drawers to someone, I could exempt myself from paying the remainder of the rent and perhaps the packing costs. They cost me around thirty francs. I'll drop a line to Gauguin and De Haan to ask if they're planning to stay in Brittany and if they'd like me to send the furniture, and then if they want me to come too. I won't commit myself to anything, only say that I'm very probably not staying here.

This week I'm going to start on Millet's 'Snow-covered field' and 'First steps' in the same format as the others. Then there'll be 6 canvases forming a series, and I assure you that I've worked on them, these last three of the 'Times of the day', with much thought to calculate the colour.

You see, these days there are so many people who don't feel made for the public but who support and consolidate what others do. Those who translate books, for example. The engravers, the lithographers. Take Vernier, for example, and Lerat. So that's to say that I don't hesitate to make copies. If I had the leisure to travel, how I'd like to copy the works of Giotto, this painter who would be as modern as Delacroix if he weren't primitive, and who's so different from the other primitives. I haven't seen much of his work, though. But there's one who is consolatory.

So what I'm pondering doing in painting is Daumier's Drinkers and Régamey's Penitentiary. You'll find them in among the wood engravings. I'm busy with the Millets for the moment, but this is to say that I'll find no lack of things to work on. Thus even half locked up I'll be able to occupy myself for a long time.

What the Impressionists have found in colour will develop even more, but there's a link that many forget which links this to the past, and I'll make efforts to show that I have little belief in a rigorous separation between the Impressionists and the others. I find it a very happy thing that in this century there have been painters like Millet, Delacroix, Meissonier, who *cannot be surpassed*. For although we don't like Meissonier as much as certain individuals do, there's no getting away from it, when one sees his Readers, his Halt and so many other paintings — that really is something. And then one's leaving aside his strongest point, i.e. military painting, because we like that less than the fields. Nevertheless, to be fair we must say that what he's done cannot be surpassed or changed. Once again I hope that our sister has recovered.

Warm regards to all.

Ever yours,
Vincent.

My dear sister,

The other day I saw some people sick with influenza and I'm so curious to know if you've had it too, as I'm inclined to believe. I saw a female patient who had a rather worrying nervous complication, and a distressing change of life.

Are you enjoying yourself in Paris? I could very well imagine that it would strike you as being an over-large city, too muddled. That's what always vexes us, we who are rather accustomed to simpler surroundings.

Write to me one of these days if you'd like to, for I very much want to hear you say that you're better.

I fear a little the effect that Paris will have on me should I return there, as will probably be the case in the spring. For all through the year I've forced myself to forget Paris as much as I could from the point of view of the disturbance and excitement a prolonged stay causes.

No matter what people say; we painters work better in the country, everything there speaks more clearly, everything holds firm, everything explains itself, now in a city when one is tired one no longer understands anything and feels as if one is lost.

I hope that the painting of the women in the olive trees will be a little to your taste — I sent the drawing of it to Gauguin just recently and he told me that he thought it good, and he knows my work well, and he isn't embarrassed to say so when it isn't right. You would naturally be quite free to take another of them in its place if you wished, but in the long run I almost dare believe that you'd return to this one. It hasn't been at all cold here lately, and next month I'll go and work outdoors with all my strength. Ah, speaking of the difference between the city and the fields, what a master Millet is. That fellow, so wise, so moved, does the countryside in such a way that even in town one continues to feel it. And then he has something unique and so good right down to his depths that it consoles one to look at his works, and one wonders if he did them this way expressly to console us. Now, better than in the beginning, I see the real countryside of Provence — and as regards people it's so very very much the same thing as in our native country, while it manifests itself quite differently, while the farming practices and labours of the fields aren't the same as in our northern heaths and fields. I think a lot about Holland and about our youth back then — precisely because here I feel right in the middle of the countryside. However I'm getting old, you know, and it seems to me that life passes more quickly and the responsibilities are more serious, the question of working to make up for lost time more critical, the day more difficult to do and the future more mysterious, and my word a little more gloomy too.

One of these days I also hope to write a line to Mother, we all owe a great deal to you, to you who care for her so faithfully and will keep her for us for as long as possible.

I imagine that Theo is probably going to be very happy one of these days, only I do have something of an idea that the days of vigil before and during have their great anxieties. Which, moreover, I cannot completely refrain from sharing. And from what he writes to me, Jo is so brave and so lively. Anyway, that is moreover how one should always take things. I like friend Gauguin so much because he has found the means to make both children and paintings at the same time, at the moment he's horribly in

distress and has this worry that one of his children has had a misfortune and he not there and in no condition to come to its aid.

Have you met Emile Bernard now — I'd very much like him to come and see some of my canvases one of these days, I ought to write to him, but just now I'm expecting a letter from him at any moment. He must have a lot of difficulty getting by, he's a complete Parisian by birth, that one, and he's an example of vivacity for me, he looks as if he comes straight out of Daudet, but then much more immature, and naturally much more incomplete.

However my dear sister, how much more practical and solid are the ideas of doctors, mechanics, in fact of heaps of people, than those of artists. I myself often sigh deeply that I should have been better than I am. I'll shut up quickly so as not to discourage myself. Anyway, one can't retrace one's steps, and the steps one has taken have a lot of influence on the future. I hope that you'll see lots of beautiful things, and above all that you're well now.

Have you read anything these last few days or lately: I haven't at all.

If you have a spare half hour I recommend myself heartily to have news from you. I kiss you affectionately in thought.

Ever yours,
Vincent

Above all, tell me what you think of Isaäcson, myself I think very highly of him, and heartily recommend him to you.

849 | Saint-Rémy-de-Provence, Saturday, 1 February 1890 | *To John Peter Russell* (F)

My dear friend Russell

Today I'm sending you a little roll of photographs after Millet which perhaps you may not know.

In any event, it's to recall us, my brother and myself, to your good memory. Do you know that my brother has since married and that any day now he's expecting his first-born? May it go well — he has a very nice Dutch wife.

How it pleases me to write to you after a long silence. Do you remember the time when, almost simultaneously, you I think first and I afterwards, met our friend Gauguin? He's still struggling on — and alone, or almost alone, like the good fellow he is. Am sure, though, that you don't forget him.

He and I are still friends, I can assure you, but perhaps you're not unaware that I myself am ill, and have more than once had serious nervous crises and delirium. This was why, having had to go into an asylum for the insane, he and I separated. But prior to that, how many times we talked about you together! Gauguin is currently still with one of my fellow-countrymen called De Haan, and De Haan praises him a great deal and doesn't find it at all bad to be with him.

You will find article on canvases of mine at the Vingtistes, I assure you that I myself owe a lot to things that Gauguin told me as regards drawing, and hold his way of loving nature in high, very high esteem. For in my opinion he's worth even more as

a man than as an artist. Are things going well with you? And are you still working a lot?

Although being ill isn't a cause for joy, I nevertheless have no right to complain about it, for it seems to me that nature sees to it that illness is a means of getting us back on our feet, of healing us, rather than an absolute evil.

If you ever come to Paris, take one of my canvases from my brother's place if you wish, if you still have the idea of making a collection for your native country one day. You'll remember that I've already spoken to you about it, that it was my great desire to give you one for this purpose. How is our friend MacKnight? If he's still with you, or if there are others with you whom I've had the pleasure of meeting, give them my warm regards. Above all, please remember me to Mrs Russell and believe me, with a hand-shake in thought,

Yours truly,
Vincent van Gogh

c/o Doctor Peyron
St-Rémy en Provence.

850 | Saint-Rémy-de-Provence, Saturday, 1 February 1890 | *To Theo van Gogh* (F)

My dear Theo,

Today I've just received your good news that you're a father at last, that the most criti-cal moment has passed for Jo, finally that the little one is well. It does me, too, more good and gives me more pleasure than I could express in words. Bravo — and how pleased Mother is going to be. I also received a quite long and very serene letter from her the day before yesterday. Finally what I've certainly hoped for so much for a long time has happened. No need to tell you that I've often thought of the two of you the past few days, and it touched me greatly that Jo still had the kindness to write to me the night before. How brave and calm she is in her danger, that touched me greatly. Well this contributes a great deal to making me forget thesc last few days when I was ill, then I no longer know where I am and my mind wanders.

I was extremely surprised by the article on my paintings that you sent me, no need to tell you that I hope to go on thinking that I don't paint like that, but rather I do see from it how I ought to paint. For the article is quite right in the sense that it indicates the gap to be filled, and I think that basically the writer writes it rather to guide not only me but also the other Impressionists, and even rather to make the breach in the right place. So he proposes a collective self, as ideal for the others as it is to me. He tells me simply that there's something good here and there, if you like, in my very imper-fect work as well, and there's the consolatory side which I appreciate and which I hope I'm grateful for. Only it must be understood that I don't have a strong enough back to carry out a job like that, and by concentrating the article on me, no need to tell you how I feel mired in flattery, and in my opinion it's as exaggerated as what a certain arti-cle by Isaäcson said on your account about you, that at present artists declined to argue, and that a serious movement was silently being created in the little shop on boulevard

Montmartre. I admit that it's difficult to say, to express oneself otherwise — just as one can't paint as one sees — and it's therefore not to criticize Isaäcson's boldness or that of the other critic, but as regards us, well, we're *posing* a little for THE *model*, and my word, that's a duty and a job like any other. So if you or I were to gain some reputation or other, it's a matter of trying to retain a certain calm, and if possible presence of mind. Why not say, WITH MORE REASON, what he says about my sunflowers about Quost's magnificent and so-complete Hollyhocks and about his yellow irises, about Jeannin's splendid peonies? And you, like me, foresee that being praised *must* have its other side, its reverse of the coin. But gladly I'm very grateful for the article, or rather 'glad at heart', as the revue song has it, since one can need it as one can truly need a medal. Then an article like that has its own merit as a critical work of art, as such I consider it worthy of respect, and the writer *must* use exalted tones, synthesize his conclusions &c.

But right from the start we must think of not putting your young family *too much* into the artistic environment. Old Goupil ran his household well in the Paris undergrowth, and I think that you'll still think of him very often. Things have changed so much, for today his cold aloofness would be shocking, but his strength to weather so many storms, that though was something.

Gauguin proposed, very vaguely it's true, founding a studio in his name, he, De Haan and I, but said that first he's pursuing his Tonkin project vigorously, and he appears to have cooled about continuing to paint, I don't know exactly why. And he's the sort of man who would scarper to Tonkin, indeed, he has a certain need for expansion and finds the artist's life — and to an extent he's right — a mean one. With his experiences of several journeys, what can one say to him? So I hope that he'll feel that you and I are indeed his friends without counting on us too much, which he doesn't anyway. He writes with a lot of reserve, more serious than the other year. I've just written a line to Russell once again to remind him about Gauguin a little, for I know that Russell is very serious and strong as a man. And if I got back together with G., then we'd have need of Russell. Gauguin and Russell are people with a rustic background; wild no, but with a certain innate gentleness of the far-off fields, probably much more than you or I, that's how I find them.

One must — it is true — believe in it a little from time to time in order to see it. If, for myself, I wanted to continue, let's call it TRANSLATING certain pages of Millet, then in order to prevent people, not criticizing me, I couldn't care about that, but bothering or obstructing me under the pretext that I'm manufacturing copies — then among the artists I need people like Russell or Gauguin to carry this task to a successful conclusion, to make something serious of it. To do the things by Millet that you sent, for example, the choice of which I consider completely right — I have scruples of conscience, and I took the pile of photographs and I sent them unhesitatingly to Russell so that I shouldn't see them again until I'd thought long and hard about it. I don't want to do it before first having heard something of your opinion, then also that of certain others on those that you'll soon receive. Without that I'd have scruples of conscience, a fear that it might be plagiarism. And not now, but in a few months, I'll try to get Russell's honest opinion about the usefulness of the thing. In any case, Russell *has outbursts*, he gets angry, he says something true, and that's what I need sometimes. You know that I found the Virgin so dazzling *that I didn't dare look*. Immediately I felt a — 'not yet'. Now the illness makes me very sensitive, and for the

moment I don't feel capable of continuing these 'translations' when it would involve such masterpieces. I'm stopping with the sower, which is in progress and isn't coming along as would be desirable. However, being ill, I thought a lot about continuing this work, and that *when* I do it I do it calmly, you'll see it soon when I send the five or 6 finished canvases. I hope that Mr Lauzet will come, I very much want to make his acquaintance. I trust in his opinion when he says that it's Provence, there he touches on the difficulty, and like the other fellow he points out a thing to be done rather than one done. The landscapes with the cypresses! Ah, that wouldn't be easy. Aurier feels it too when he says that even black is a colour, and about their flame-like aspect. I'm thinking of it but I don't dare do it either, and say like Isaäcson, who is cautious, that I don't yet feel that we've reached that point. It requires a certain dose of inspiration, a ray from on high which doesn't belong to us, to do beautiful things. When I'd done those sunflowers I was seeking the contrary and yet the equivalent, and I said, it's the cypress. I'm stopping there — I'm a little anxious about a woman friend who is still ill, it seems, and to whom I'd like to go, she's the one whose portrait I did in yellow and black, and she had changed so much. It's nervous crises and the complications of a premature change of life, very difficult in short. She looked like an old grandfather last time. I had promised to come back in a fortnight and was taken ill again myself.

Anyway, for me the good news you've told me and that article and a heap of things mean that I'm personally feeling completely well today.

Now in thought I remain with you all as I finish my letter. May Jo long remain for us all that she is. Now as for the little one, why then don't you call him Theo in memory of our father, that would certainly give me so much pleasure. Handshake.

Ever yours,
Vincent

I'm sorry too that Mr Salles didn't find you. Thanks again to Wil for her kind letter, I'd have liked to reply to it today but I'll put it back until a few days from now, tell her that Mother has written me another long letter from Amsterdam. How happy she's going to be too.

If you see him, for the time being thank Mr Aurier very much for his article, naturally I'll send you a line for him, and a study.

853 | Saint-Rémy-de-Provence, Sunday, 9 or Monday, 10 February 1890 |
 To Albert Aurier (F)

Dear Mr Aurier,
Thank you very much for your article in the Mercure de France, which greatly surprised me. I like it very much as a work of art in itself, I feel that you create colours with your words; anyway I rediscover my canvases in your article, but better than they really are — richer, more significant. However, I feel ill at ease when I reflect that what you say should be applied to others rather than to me. For example, to Monticelli above

all. Speaking of 'he is—as far as I know—the only painter who perceives the color-ation of things with such intensity, with such a metallic, gem-like quality'—if you will please go and see a particular bouquet by Monticelli at my brother's place—bouquet in white, forget-me-not blue and orange—then you will feel what I mean. But for a long time the best, the most astonishing Monticellis, have been in Scotland, in England. In a museum in the north however—the one in Lille I think, there must still be a marvel by him, far richer and certainly no less French than Watteau's Departure for Cythera. At present Mr Lauzet is in the process of reproducing around thirty Monticellis. Here you have it, as far as I know there is no colourist who comes so straight and directly from Delacroix; and yet it is likely, in my opinion, that Monticelli only had Delacroix's colour theories at second hand; in particular he had them from Diaz and Ziem. It seems to me that his, Monticelli's, artistic temperament is exactly that of the author of the Decameron—Boccaccio—a melancholy man, an unhappy, rather resigned man, seeing high society's party pass by, the lovers of his day, painting them, analyzing them, he—the outcast. Oh! He does not *imitate* Boccaccio any more than Henri Leys imitated the primitives. Well, this was to say that things seem to have strayed onto my name that you would do better to say of Monticelli, to whom I owe a great deal. Next I owe a great deal to Paul Gauguin, with whom I worked for a few months in Arles, and whom, besides, I already knew in Paris.

Gauguin, that curious artist, that stranger whose bearing and gaze vaguely recall Rembrandt's Portrait of a man in the La Caze gallery, that friend who likes to make one feel that a good painting should be the equivalent of a good deed, not that he says so, but anyway it is difficult to spend time with him without thinking of a certain moral responsibility. A few days before we parted, when illness forced me to enter an asylum, I tried to paint 'his empty place'.

It is a study of his armchair of dark, red-brown wood, the seat of greenish straw, and in the absent person's place a lighted candlestick and some modern novels. If you have the opportunity, as a memento of him, please go and look a little at this study again, which is entirely in broken tones of green and red. You may perhaps then realize that your article would have been more accurate and—it would seem to me—thus more powerful—if in dealing with the question of the future 'painting of the tropics' and the question of colour, you had done justice to Gauguin and Monticelli before talking about me. For the share that falls or will fall to me will remain, I assure you, very secondary.

And then, I would also have something else to ask of you. Supposing that the two canvases of sunflowers that are presently at the Vingtistes have certain qualities of colour, and then also that they express an idea symbolizing 'gratitude'. Is this any differ-ent from so many paintings of flowers that are more skilfully painted and which people do not yet sufficiently appreciate, *père* Quost's Hollyhocks, Yellow Irises? The magnifi-cent bouquets of peonies which Jeannin produces in abundance? You see, it seems to me so difficult to separate Impressionism from other things, I cannot see the point of so much sectarian thinking as we have seen these last few years, but I fear its absurdity.

And, in closing, I declare that I do not understand that *you* spoke of Meissonier's infamies. It is perhaps from that excellent fellow Mauve that I have inherited a boundless admiration for Meissonier; Mauve was endless in his praise for Troyon and Meissonier—a strange combination.

This is to draw your attention to how much people abroad admire, without attaching the slightest importance to what unfortunately so often divides artists in France. What Mauve often repeated was something like this, 'if you want to do colour you must also know how to draw a fireside or an interior like Meissonier'.

I shall add a study of cypresses for you to the next consignment I send to my brother, if you will do me the pleasure of accepting it as a memento of your article. I am still working on it at the moment, wanting to put in a small figure. The cypress is so characteristic of the landscape of Provence, and you sensed it when saying: 'even the colour black'. Until now I have not been able to do them as I feel it; in my case the emotions that take hold of me in the face of nature go as far as fainting, and then the result is a fortnight during which I am incapable of working. However, before leaving here, I am planning to return to the fray to attack the cypresses. The study I have intended for you depicts a group of them in the corner of a wheatfield on a summer's day when the mistral is blowing. It is therefore the note of a certain blackness enveloped in blue moving in great circulating currents of air, and the vermilion of the poppies contrasts with the black note.

You will see that this constitutes more or less the combination of tones of those pretty Scottish checked cloths: green, blue, red, yellow, black, which once appeared so charming to you as they did to me, and which alas one scarcely sees any more these days.

In the meantime, dear sir, please accept my grateful thanks for your article. If I were to come to Paris in the spring I shall certainly not fail to come and thank you in person.

Vincent van Gogh

When the study I send you is dry right through, also in the impasto, which will not be the case for a year—I should think you would do well to give it a good coat of varnish. And between times it should be washed several times with plenty of water to get out the oil completely. This study is painted in full Prussian blue, that colour about which people say so many bad things and which nevertheless Delacroix used so much. I think that once the Prussian blue tones are really dry, by varnishing you will obtain the dark, the very dark tones needed to bring out the different dark greens.

I do not quite know how this study should be framed, but as I really want it to make one think of those dear Scottish fabrics, I have noticed that a very simple flat frame, *bright orange lead*, creates the desired effect with the blues of the background and the dark greens of the trees. Without this there would perhaps not be enough red in the canvas, and the upper part would appear a little cold.

My dear sister,

Thanks very much for your last two letters, the one dated from Paris and today's.

What you write further about Jo's confinement touches me, yes you were very brave and very kind to stay by her side. In circumstances where fright seizes us, I'd probably be more of a milksop than you.

But anyway, the result is that the child's here — and as I wrote to his grandmother, I've started painting for him these last few days — a large sky-blue canvas against which branches covered in blossoms stand out. Possible that I may see him soon — I hope so at least — towards the end of March. I'm going to try to go to Arles once more tomorrow or the day after tomorrow to see if I can bear the journey and ordinary life without the attacks recurring.

Perhaps in my case I must strengthen my resolve not to want to have a feeble mind.

Naturally, through continual brain-work, the thoughts of an artist sometimes take on something of the exaggerated and eccentric. I found Mr Aurier's article — leaving aside whether I deserve what he says of me — in itself very artistic, very curious — but it's rather like this that I *ought* to be than the sad reality of what I feel myself to be.

I wrote to him that in any event it seemed to me that Monticelli and Gauguin were rather like that, that it therefore seemed to me that the share which was owing to me would be only secondary, very secondary. These ideas of which he speaks aren't mine, for in general the Impressionist artists are all like this, under the same influence, and we're all of us somewhat neurotic. This makes us very sensitive to colour and its particular language, its effects of complementaries, contrasts, harmony. But when I read the article it made me almost sad as I thought: should be like this and I feel so inferior. And pride intoxicates like drink, when one is praised and has drunk one becomes sad, or anyway I don't know how to say how I feel it, but it seems to me that the best work one could do would be that carried out in the family home without self-praise. And then among artists, people's friendly dispositions aren't always *enough*. Either someone's qualities are exaggerated or he's over-neglected. However, I very much want to believe that basically *Justice* is in better health than it appears to be. One really must be able to laugh sometimes, and make merry a little or even a lot. I think you were lucky to see Degas at his home.

I have a portrait of an Arlésienne on the go in which I'm seeking an expression different from that of Parisian women.

Ah Millet! Millet! How that fellow painted humanity and the 'something on high', familiar and yet solemn.

These days, to think that that fellow wept as he started painting, that Giotto, that Angelico painted on their knees, Delacroix so utterly sad and moved . . . *almost* smiling. Who are we Impressionists to act like them already? Soiled in the struggle for life . . . 'who will give back to the soul that which the breath of revolutions has taken away' — that's the cry of a poet of the other generation who seemed to have a premonition of our present weaknesses, our sicknesses, our confusions. And I say it often, are we as brand new as the old Belgian, Henri Conscience? Ah, that's why I was pleased with the

success in Brussels, because of that Kempen of Antwerp that I still try to recall from time to time in the calm furrows of the fields while feeling myself become a most degenerate child. Thinking like this, but very far off, the desire comes over me to remake myself and try to have myself forgiven for the fact that my paintings are, however, almost a cry of anguish while symbolizing gratitude in the rustic sunflower. You can see that I'm not yet reasoning well—it's better to know how to calculate what a pound of bread and a quarter of coffee are worth, the way the peasants know. And here we are again. Millet set the example by living in a cottage, keeping in well with people without our lapses of pride and eccentricity. So rather a little wisdom than a lot of gusto. So, just like then.

I hope to write to you again soon—look after yourself, and Mother too.

In Paris I hope to do a few portraits, I've always had the belief that through portraits one learns to reflect. It isn't what pleases art lovers the most, but a portrait is something almost useful and sometimes pleasant, like pieces of furniture one knows, they recall memories for a long time.

I kiss you affectionately in thought. If our other sisters would also like to have canvases you can ask Theo for others, and you could choose them according to your taste. Once again warm regards, and good handshake.

Yours truly,
Vincent.

I don't hate it at all that a few more canvases should go to Holland, as you know, if the opportunity arises.

857 | Saint-Rémy-de-Provence, on or about Monday, 17 March 1890 |
 To Theo van Gogh (F)

My dear Theo,

Today I wanted to try and read the letters that had come for me, but I wasn't yet clear-headed enough to be able to understand them.

However, I'm trying to answer you straightaway, and am hoping that it will lift within a few days from now. Above all I hope that you're well, and your wife and your child.

Don't worry about me, even if it should last a little longer, and write the same thing to those at home and give them my warm regards.

Warm regards to Gauguin, who wrote me a letter for which I thank him very much, I'm terribly bored but must try to be patient. Once again warm regards to Jo and to her little one, and handshake in thought.

Ever yours,
Vincent

I'm picking up this letter again to try and write, it will come little by little, it's just that my mind has been so affected—without pain, it's true—but totally stupefied. I must tell you that there are—as far as I can judge—others who have this like me;

who having worked during a period of their life are reduced to powerlessness even so. One doesn't easily learn anything good between four walls, that's understandable, but nevertheless it's true that there are also people who can no longer be left at liberty as if they had nothing wrong with them. And so I almost or entirely despair of myself. Perhaps, perhaps I would indeed get better in the country for a time.

Work was going well, the last canvas of the branches in blossom, you'll see that it was perhaps the most patiently worked, best thing I had done, painted with calm and a greater sureness of touch. And the next day done for like a brute. Difficult to understand things like that, but alas, that's how it is. I have a great desire to get back to my work, though, but Gauguin also writes that he, who is nevertheless robust, also despairs of being able to continue. And isn't it true that we often see the story of artists like that. So, my poor brother, take things as they are, don't grieve on my account, it will encourage me and support me more than you think to know that you're running your household well. Then, after a time of trial, perhaps days of serenity will return for me too. But in the meantime I'll send you some canvases soon.

Russell also wrote to me, and I think it's good to have written to him so that he doesn't forget us completely — for your part speak of him from time to time so that people may know that although he works in isolation he's a very good man, and I think he'll do good things as one used to see in England, for example. He's right a thousand times over to barricade himself in a little.

Give my regards to the Pissarros, later I'm going to read your letters more calmly, and hope to write again tomorrow or the day after.

863 | Saint-Rémy-de-Provence, Tuesday, 29 April 1890 | *To Theo van Gogh* (F)

My dear Theo,

I haven't been able to write to you until now, but as I'm feeling a little better these days I didn't want to delay wishing a happy year to you, your wife and your child, since it's your birthday. At the same time, please accept the various paintings I'm sending you with my thanks for all the kindnesses you've shown me, for without you I would be most unhappy.

You'll see that first there are canvases after Millet. As these aren't destined for public viewing, perhaps you'll make a present of them to our sisters sooner or later. But first you must keep the ones you consider good, and as many as you wish, they're absolutely yours. One of these days you must send me some other things by ancient and modern artists to do, if you find any.

The rest of the canvases are meagre, I'm very much behind, not having been able to work for two months. You'll find that the olive trees with the pink sky are the best, with the mountains, I would imagine; the first go well as a pendant to those with the yellow sky. As regards the portrait of the Arlésienne, you know that I've promised our friend Gauguin one, and you must see that he gets it. Then the cypresses are for Mr Aurier. I would have liked to redo them with a little less impasto, but I don't have the time.

Anyway, they must be washed again several times in cold water, then a strong varnish when the impasto is dry right through, then the blacks won't get dirty when

the oil has fully evaporated. Now I would necessarily need colours, part of which you could well get from Tanguy's if he's hard up, or if that would please him. But of course he mustn't be dearer than the other.

Here's the list of colours I would need

Large tubes
{
12 zinc white, 3 cobalt, 5 Veronese green
1 ordinary lake
2 emerald green, 4 chrome 1, 2 chrome 2
1 orange lead, 2 ultramarine
}

Then (but from Tasset's) 2 geranium lake, medium-sized tubes.

You would do me a service by sending me at least half of it at once, at once, for I've lost too much time.

Then I would need 6 brushes

[*Sketch* 863A]

6 fitch brushes

[*Sketch* 863B]

around these sizes, and 7 metres of canvas, or even 10.

What can I tell you of these two last months, things aren't going well at all, I'm more sad and bored than I could tell you, and I no longer know what point I'm at.

As the order for colours is a little large, let me wait for half if that suits you better.

While I was ill I nevertheless still did a few small canvases from memory which you'll see later, reminiscences of the north, and now I've just finished a sunlit corner of a meadow which I think is fairly vigorous. You'll see it soon.

As Mr Peyron is away I haven't yet read your letters, but I know that some have come. He has been quite kind in informing you of the situation, as for me I don't know what to do or think. But I have a great desire to leave this place. That won't surprise you, I don't need to tell you any more about it.

Letters have also come from home, which I haven't yet had the courage to read, so melancholy do I feel.

Please ask Mr Aurier not to write any more articles about my painting, tell him earnestly that first he is wrong about me, then that really I feel too damaged by grief to be able to face up to publicity. Making paintings distracts me — but if I hear talk of them that pains me more than he knows. How is Bernard? Since there are duplicates of some canvases, if you want you could do an exchange with him, because a good-quality canvas of his would look well in your collection. I fell ill at the time I was doing the almond-tree blossoms. If I'd been able to continue working, you can judge from that that I would have done others of the trees in blossom. Now the trees in blossom are almost finished, really I have no luck. Yes, I must try to leave here, but where am I to go? I don't believe one can be more shut up and imprisoned in the places where they don't pretend to leave you free, such as at Charenton or Montevergues.

If you write home, give them my warm regards and tell them I think of them often.

Then good handshake to you and Jo. Believe me

Ever yours,
Vincent.

Voici la liste des couleurs qu'il me faudrait
12 blanc de zinc 3 Cobalt 5 Vert véronèse
1 Laque ordinaire ~~Laque geranium~~
2 Vert émeraude 4 Chrome 1 3 Chrome 2
1 mine orange 2 Outremer
Puis (mais chez Tasset) ~~en tubes~~ 2 laque geranium
tubes moyen format
Tu me rendrais service en m'en faisant parvenir
au moins la moitié de suite de suite car je perds
trop de temps.
Puis il me faudrait 6 brosses
6 pinceaux
à peu près de ces grandeurs. et 7 mètres toile ou même 10
Que le dire de ces deux mois passés cela va pas bien
du tout je suis triste et embêté plus que je ne saurais
d'exprimer et je ne sais plus ou j'en suis
~~Note~~ La commande de couleurs étant un peu lourde
laisse moi attendre la moitié si cela te convient mieux
Étant malade j'ai bien encore fait quelques petites
toiles de l'été que tu verras plus tard des souvenirs
du nord et à présent je viens de terminer un
coin de prairie ensoleillée que je crois plus ou moins
vigoureux Tu verras cela bientôt.
Monsieur Peyron étant absent je n'ai pas encore lu
tas lettres mais je sais qu'il en est venu. Il a été assez
bon pour te mettre au courant de la situation mais
je ne sais que faire et que penser. mais j'ai grande
envie de sortir de cette maison - Cela ne l'étonnera
pas je n'ai pas besoin de l'en dire davantage.

863A–B (top to bottom). *Large brush; Brush*

Please send me what you can find of *figures* among my old drawings, I'm thinking of redoing the painting of the peasants eating supper, lamplight effect. That canvas must be completely dark now, perhaps I could redo it entirely from memory. You must above all send me the women gleaning and diggers, if there are any left.

Then if you like I'll redo the old tower at Nuenen and the cottage. I think that if you still have them I could now make something better of them from memory.

865 | Saint-Rémy-de-Provence, on or about Thursday, 1 May 1890 |
 To Theo van Gogh (F)

My dear brother,

Today, as Mr Peyron had come back, I read your kind letters, then the letters from home as well, and that did me an enormous amount of good in giving me back a little energy, or rather the desire to climb back up again from the dejected state I'm in. I thank you very much for the etchings — you've chosen some of the very ones that I've already liked for a long time, the David, the Lazarus, the Samaritan, and the large etching of the wounded man, and you've added the blind man and the other very small etching, the last one so mysterious that I'm afraid of it and dare not wish to know what it is. I didn't know it, the little goldsmith. But the Lazarus! Early this morning I looked at it and I remembered not only what Charles Blanc says of it, but indeed even that he doesn't say everything about it.

The unfortunate thing is that the people here are too curious, idle and ignorant about *painting* for it to be possible for me to practise my profession. This is what one could always observe, that you and I made an effort here in the same direction as some others who weren't understood either, and were bitterly saddened by circumstances.

If ever you go to Montpellier you would see that what I tell you here is true.

Now, rather, you propose coming back to the north, and I accept.

I've had too hard a life to kick the bucket as a result, or to lose the power to work.

So Gauguin and Guillaumin, the two of them, want to do an exchange for the landscape of the Alpilles. Besides, there are two of them, only I think that the one finished last, which I've just sent, is done with more determination and is more accurate in expression.

I'm perhaps going to try to work from the Rembrandts, above all I have an idea to do the man at prayer in the range of tones running from bright yellow to violet.

Included is Gauguin's letter, do what you think best as regards the exchange, take the ones you like for yourself; I'm sure that our taste is increasingly becoming the same.

Ah, if I'd been able to work without this bloody illness! How many things I could have done, isolated from the others, according to what the land would tell me. But yes — this journey is well and truly finished. Anyway, what consoles me is the great, the very great desire that I have to see you again, you, your wife and your child, and so many friends who have remembered me in my misfortune, as, for that matter, I don't stop thinking of them either.

I'm almost sure that I'll soon get better in the north, at least for quite a long time,

while still apprehensive of a relapse in a few years' time — but not immediately. That's what I imagine after having observed the other patients here, some of whom are considerably older than I am or, among the young ones, were more or less idlers — students. Anyway, what do we know about it?

Fortunately the letters from our sister and mother were very calm. Our sister writes very well, and describes a landscape or an aspect of the town as if it were a page from a modern novel. I always urge her to busy herself with domestic rather than artistic things, for I know that she's already too sensitive, and at her age would have difficulty in finding the way to artistic development. I'm really afraid that she too will suffer from a thwarted artistic will. But she's so energetic that she'll make up for it. I talked with Mr Peyron about the situation, and told him that it was almost impossible for me to bear my fate here, that not knowing anything very clear regarding the line to take, it seemed preferable to me to return to the north.

If you think this is a good idea, and if you suggest a date when you expect me over there in Paris, I would have someone from here accompany me part of the way, as far as Tarascon or Lyon. Then you would wait for me, or have someone wait for me, at the station in Paris. Do what seems best to you. For the time being I would leave my furniture behind in Arles. It's with friends, and I'm sure they'd send it the day I wanted it. But the carriage and packing would be almost what it's worth. I consider this as a shipwreck, this journey, well, one can't do as one wants, and as one ought to either. Once I got out a little into the park I recovered all my clarity for work, I have more ideas in my head than I could ever put into action, but without it dazzling me. The brushstrokes go like a machine. So based on that I dare believe that in the north I would rediscover my confidence once freed from surroundings and circumstances which I neither understand nor wish to understand. It was very kind of Mr Peyron to write to you, he's writing to you again today, I leave him regretting that I have to leave him. Good handshake to you and to Jo, I thank her very much for her letter.

Ever yours,
Vincent

868 | Saint-Rémy-de-Provence, Sunday, 4 May 1890 | *To Theo van Gogh* (F)

My dear brother,

Thanks for your kind letter and for the portrait of Jo, which is very pretty and is very successful as a pose. Well, I'll be very simple and as practical as possible in my reply. First, I categorically reject what you say that I should be accompanied throughout the journey. Once on the train I no longer run any risk, I'm not one of those who are dangerous — even supposing I have a crisis, aren't there other passengers in the carriage, and besides, don't they know what to do in all the stations in such a case? You're giving yourself worries here that weigh on me so heavily that it might directly discourage me.

I've just said the same thing to Mr Peyron, and I pointed out to him that crises like the one I've just had have always been followed by three or four months of complete

calm. I wish to take advantage of this period to move — I want to move in any event, my desire to leave here is now absolute.

I don't feel competent to judge the way they treat patients here, I don't feel any desire to enter into the details — but please remember that I warned you around 6 months ago that if I was seized by a crisis of the same nature I'd wish to change asylums. And I've delayed too long already, having allowed an attack to go by in the meantime, I was then right in the middle of work, and I wanted to finish canvases in progress, otherwise I would no longer be here by now. Right, so I'm going to tell you that it seems to me that a fortnight at the most (a week, though, would please me more) should be enough to take the necessary steps to move. I shall have someone accompany me as far as Tarascon — even one or two stations further if you insist. Once I've arrived in Paris (I'll send a telegram when I leave here) you would come and pick me up at the Gare de Lyon.

Now it would seem preferable to me to go and see this doctor in the country as soon as possible, and we'd leave the luggage at the station.

So I would only stay at your place for let's say 2 or 3 days, then I'd leave for this village. Where I would start off by lodging at the inn.

This, it seems to me, is what you could do in the next few days — without delay — write to our future friend, that doctor: 'my brother would very much like to make your acquaintance, and as he would prefer to consult you before prolonging his stay in Paris, hopes that you will approve of his spending a few weeks in your village, where he will come to make some studies; he has complete confidence that he will reach an understanding with you, believing that with a return to the north his illness will abate, whereas by staying on in the south his condition would be in danger of becoming more acute.'

There, you could write to him like that, we'd send him a telegram the day after my arrival in Paris, or the day after that, and he'd probably wait for me at the station.

The surroundings here are starting to weigh on me more than I could express — my word, I've waited patiently for over a year — I need air, I feel damaged by boredom and grief.

Then work is pressing, I'd be wasting my time here. Why then, I ask you, do you fear accidents so much — it isn't that that ought to frighten you, my word, since I've been here I've seen people fall over or lose their mind every day — what's more serious is to try and take misfortune into account. I assure you that it's already something to resign oneself to living under guard, even in the event of it being sympathetic, and to sacrifice one's freedom, to stand outside society and to have only one's work, without distraction. That has carved out wrinkles that won't be rubbed off in a hurry. Now that it's beginning to weigh *too heavily* upon me here, I think that it's only right to put a stop to it.

So please write to Mr Peyron that he should let me leave, let's say on the 15th at the latest. If I waited I would let the good moment of calm between two crises pass, and leaving now I'll have the free time necessary to make the other doctor's acquaintance. Then, if in a while from now the illness were to recur it would be foreseen, and according to how serious it was we could see if I can continue at liberty or if I must stick myself in an asylum for good. In the latter case — as I told you in my last letter I would go into an institution where the patients work in the fields and in the workshop. I think that even more than here I'd then find subjects for painting.

Consider, then, that the journey costs a lot, that it's pointless and that I do have the right to change asylums if I please, it isn't my absolute freedom that I'm demanding.

I've tried to be patient up to this point, I haven't done any harm to anyone, is it fair to have me accompanied like a dangerous animal? No thank you, I protest. If a crisis occurs, they know what to do in every station, and then I'd let them do it.

But I dare believe that my composure won't desert me. I have so much distress at leaving like this, that the distress will be stronger than the madness, I'll therefore have the necessary nerve, I dare believe. Mr Peyron says vague things, to free himself from responsibility he says, but that way we'd never, never get to the end of it, the thing would drag on and on, and in the end we'd get angry with each other.

As for me, my patience is at an end, at an end, my dear brother, I can't go on, I must move, even if as a stopgap.

However, there really is a chance that the change will do me good — work is going well, I've done 2 canvases of the fresh grass in the park, one of which is extremely simple. Here's a hasty croquis of it.

[*Sketch* 868A]

The trunk of a pine tree violet pink, and then grass with white flowers and dandelions, a little rose bush and other tree-trunks in the background, in the uppermost part of the canvas. I'll be out of doors there. I'm sure that the desire to work will devour me and make me insensible to everything else and in a good mood. And I'll let myself go there, not without consideration but without dwelling on regrets for things that might have been.

They say that in painting one must seek nothing and hope for nothing but a good painting and a good talk and a good dinner as the height of happiness, not counting the less brilliant interludes. Perhaps it's true, and why refuse to take what is possible, especially if by doing so one gives the illness the slip.

Good handshake to you and to Jo, I think I'm going to do a painting for myself after the subject of the portrait, it may not be a resemblance perhaps, but anyway I'll try.

More soon, I hope — and come on, spare me this forced travelling companion.

Ever yours,
Vincent.

Mais j'ose croire que mon aplomb ne me
manquera pas. J'ai tant de chagrin de quitter
comme cela que le chagrin sera plus fort que
la joie j'aurai donc j'ose croire l'aplomb nécessaire
M. Peyron dit des choses vagues pour dégager
dit-il sa responsabilité mais aussi on n'en finirait
jamais jamais la chose trainerait en longueur et
on finirait par se fâcher de part et d'autre
moi ma patience est à bout à bout mon cher frère
je n'en peux plus il faut changer même pour
un pis aller. –

. Cependant il y a une chance réellement que le
changement me fasse du bien – le travail marche bien
j'ai fait 2 toiles de l'herbe fraiche dans le parc dont
il y en a une d'une simplicité extrème. en voici un croquis

hatif. Un tronc de pin
violet rose et puis de l'herbe
avec des fleurs blanches et
des pissenlits un petit rosier
et d'autres troncs d'arbre dans
le fond tout en haut de la
toile. Je serai là bas dehors
je suis sûr que l'envie de
travailler me dévorera
et me rendra insensible
à tout le reste et de bonne humeur. Et je m'y laisserai
aller non pas sans réflexion mais sans m'appesantir sur
des regrets de choses qui auraient pu être.
Ils disent que dans la peinture il ne faut rien chercher ni
espérer qu'un bon tableau et une bonne causerie et un bon
dîner comme maximum de bonheur sans compter
les parenthèses moins brillantes – C'est peut être vrai et
pourquoi refuser de prendre le possible d'autant si ainsi faisant
on donne le change à la maladie.
Bonne poignée de main à toi et à Jo je crois que
je vais faire une peinture pour moi d'après le motif du portrait
cela ne sera pas ressemblant peut être mais enfin je chercherai
j'espère à bientôt – et voyons épargnez moi ce compagnon
de voyage forcé – t. à t. Vincent.

My dear brother

After a last discussion with Mr Peyron I obtained permission to pack my trunk, which I've sent by goods train. The 30 kilos of luggage one is allowed to take will allow me to take a few frames, easel and some stretching frames &c.

I'll leave as soon as you've written to Mr Peyron, I feel calm enough, and I don't think that a mental upset could easily happen to me in the state I'm in.

In any event, I hope to be in Paris before Sunday to spend the day, which you will have off, quietly with all of you. I really hope to see André Bonger too at the first opportunity.

I've also just finished a canvas of pink roses against yellow-green background in a green vase.

I hope that the canvases of the last few days will compensate us for the expenses of travel.

This morning, as I'd been to have my trunk stamped, I saw the countryside again — very fresh after the rain and covered in flowers — how many more things I would have done.

I've also written to Arles for them to send the two beds and the bed linen by goods train. I estimate that this can only cost a good ten francs in transport charges, and it's still something gained from the debacle. For it'll certainly be useful to me in the country.

If you haven't yet replied to Mr Peyron's letter, please send him a telegram, in such a way that I may make the journey on Friday or Saturday at the latest to spend Sunday with you. In doing so I'll also lose the least time for my work, which is finished here for the moment.

In Paris, if I feel up to it, I'd immediately very much like to do a painting of a yellow bookshop (gas effect), which I've had in my mind for so long. You'll see that I'll be at work right from the day after my arrival. I tell you, as regards work, my mind feels absolutely serene and the brushstrokes come to me and follow each other very logically.

Anyway until Sunday AT THE LATEST, I shake your hand firmly in the meantime, warm regards to Jo.

Ever yours,
Vincent.

Probably the answer to Mr Peyron will already have left, which I hope. I was a little vexed that there were a few days' delay, because that seems to me to be of no use for anything. For either I'd plunge into new works here, or it's now that I have the leisure for the journey. Spending days doing nothing, here or elsewhere, that's what would make me miserable in my current state of mind. Besides, Mr P. isn't opposed to it, but naturally when you leave, your position is a little difficult with the rest of the administration. But it's going well, and we'll part amicably.

873 | Auvers-sur-Oise, Tuesday, 20 May 1890 | *To Theo van Gogh and Jo van Gogh-Bonger* (F)

My dear Theo and dear Jo

After making Jo's acquaintance it will be difficult for me from now on to write to Theo alone, but Jo will permit me, I hope, to write in French, because after two years in the south I really think, in doing so, that I tell you better what I have to say. Auvers is really beautiful — among other things many old thatched roofs, which are becoming rare.

I'd hope, then, that in doing a few canvases of that really seriously, there would be a chance of recouping some of the costs of my stay — for really it's gravely beautiful, it's the heart of the countryside, distinctive and picturesque.

I've seen Dr Gachet, who gave me the impression of being rather eccentric, but his doctor's experience must keep him balanced himself while combating the nervous ailment from which it seems to me he's certainly suffering at least as seriously as I am.

He directed me to an inn where they were asking 6 francs a day.

For my part I've found one where I'll pay 3.50 a day.

And until there's a change of circumstances I think I ought to stay there. When I've done a few studies I'll see if there would be any advantage in moving. But it seems unjust to me, when one wants to and can pay and work like any other workman, to have to pay almost double all the same because one works at painting. Anyway I'm starting with the 3.50 inn.

You'll probably see Dr Gachet this week — he has a *very* fine Pissarro, winter with red house in the snow, and two fine bouquets by Cézanne.

Also another Cézanne of the village. Myself, in my turn I'll gladly, very gladly give a stroke of the brush here.

I told Dr Gachet that I would find the inn he suggested preferable at 4 francs a day, but that 6 was 2 francs too dear for the expenses I'm having. It's all right for him to say that I'll be quieter there, enough is enough.

His own house is full of old things, dark, dark, dark, with the exception of a few sketches by Impressionists I mentioned. Despite the fact that he's an odd fellow, the impression he made on me isn't unfavourable. Chatting of Belgium and the days of the old painters, his grief-stiffened face took on a smile again, and I really think that I'll stay friends with him and that I'll do his portrait. Then he tells me that I must work a great deal, boldly, and not think at all about what I've had.

I really felt in Paris that all the noise there wasn't what I need.

How pleased I am to have seen Jo and the little one and your apartment, which is indeed better than the other one.

Wishing you good luck and health, and hoping to see you again very soon, good handshakes

Vincent.

My dear Theo, my dear Jo,

Thank you for your letter which I received this morning, and for the fifty francs that were inside it.

Today I saw Dr Gachet again, and I'm going to paint at his place on Tuesday morning, then I'm going to lunch with him and afterwards he'll come to see my painting. He seems very reasonable to me, but is as discouraged in his profession of country doctor as I with my painting. So I told him that I would, however, gladly swap profession for profession. Anyway, I readily think that I'll end up being friends with him. He told me, besides, that if melancholy or something else were to become too strong for me to bear, he could well do something again to lessen its intensity, and that I mustn't be embarrassed to be open with him. Well, that moment when I have need of him may indeed come, however up to today things are going well. And they may get even better, I still believe that it's above all an illness of the south that I caught, and that the return here will be enough to dispel all that.

Often, very often, I think of your little one, and I then tell myself that I would like him to be big enough to come to the country. For it's the best system of bringing them up here. How I would like you, Jo and the little one to have a rest in the country instead of the traditional journey to Holland. Yes, I'm well aware that Mother will absolutely want to see the little one, and it's certainly a reason to go there. However, she would certainly understand if it were really in the little one's best interests.

Here we're far enough from Paris for it to be the real countryside, but nevertheless, how changed since Daubigny. But not changed in an unpleasant way, there are many villas and various modern and middle-class dwellings, very jolly, sunny and covered with flowers. That in an almost lush countryside, just at this moment of the development of a new society in the old one, has nothing disagreeable about it; there's a lot of well-being in the air. I see or think I see a calm there à la Puvis de Chavannes, no factories, but beautiful greenery in abundance and in good order.

When you have the opportunity, will you tell me which painting Miss Boch bought? I must write to her brother to thank them, and then I would propose the exchange of two of my studies for one by each of them.

Enclosed is a note which you will please send to Isaäcson.

I have a drawing of an old vineyard of which I plan to do a no. 30 canvas, then a study of pink chestnut trees and one of white chestnut trees. But if circumstances permit, I hope to do a little figure work. Paintings vaguely present themselves to my sight which it will take time to shape, but that will come little by little. If I hadn't been ill, I would have written to Boch and to Isaäcson long since. My trunk hasn't arrived yet, which annoys me, I sent a telegram this morning.

Thank you in advance for the canvas and the paper. Yesterday and today it rains and is stormy, but it isn't unpleasant to see these effects again. The beds haven't arrived either. But despite these annoyances, I feel happy no longer to be so far from you all and our friends. I hope that your health will be good. It seemed to me, though, that you had less appetite than before, and from what the doctors say, we should have very solid

food for our temperaments. So be sensible about it, especially Jo too, as she has her child to feed. Truly, the amount should be doubled, it wouldn't be any exaggeration when there are children to make and feed. Without that it's like a train moving slowly where the route is straight. Time enough to reduce steam when the route is more uneven. Handshake in thought.

Ever yours,
Vincent.

877 | Auvers-sur-Oise, Tuesday, 3 June 1890 | *To Theo van Gogh* (F)

My dear Theo,

For several days now I'd have liked to write to you with a rested mind, but have been absorbed in work. This morning your letter arrives, for which I thank you and for the 50-franc note it contained. Yes, I think that it would be good for many reasons that we were all together again here for a week of your holidays, if longer isn't possible. I often think of you, Jo and the little one, and I see that the children here look well in the healthy fresh air. And yet it's difficult enough to raise them, even here, all the more is it rather terrible sometimes to keep them safe and sound in Paris on a fourth floor. But anyway, one must take things as they are. Mr Gachet says that father and mother must feed themselves quite naturally, he talks of taking 2 litres of beer a day &c., in those amounts. But you'll certainly enjoy furthering your acquaintance with him, and he's already counting on it, speaks of it every time I see him, that you'll all come. He certainly appears to me as ill and confused as you or I, and he's older and a few years ago he lost his wife, but he's very much a doctor, and his profession and his faith keep him going however. We're already firm friends, and by chance he also knew Bruyas of Montpellier and has the same ideas on him as I have, that he's someone important in the history of modern art. I'm working on his portrait

[*Sketch 877A*]

the head with a white cap, very fair, very light, the hands also in light carnation, a blue frock coat and a cobalt blue background, leaning on a red table on which are a yellow book and a foxglove plant with purple flowers. It's in the same sentiment as the portrait of myself that I took when I left for here.
 Mr Gachet is absolutely *fanatical* about this portrait, and wants me to do one of him if I can, absolutely like that, which I also wish to do. He has now also come to understand the last portrait of the Arlésienne, one of which you have in pink — he comes back all the time, when he comes to see the studies, to these two portraits and he accepts them fully, but fully as they are. I hope to send you a portrait of him soon. Then I painted two studies at his house which I gave him last week. One aloes with marigolds and cypresses, then last Sunday white roses, vines and a white figure in it.
 I'll very probably also do the portrait of his daughter, who is 19, and with whom I can easily imagine Jo will quickly make friends.

Mon cher Theo, déjà depuis plusieurs jours j'aurais désiré t'écrire
à tête reposée mais ai été absorbé par le travail. Ce matin
arrive ta lettre de laquelle je te remercie et du billet de 50fr.
qu'elle contenait. Oui je crois que pour bien des chôses il serait
bien que nous fussions encore ensemble tous ici pour une
huitaine de tes vacances si plus longtemps n'est pas
possible. Je pense souvent à toi à Jo et au petit, et je
vois que les enfants ici au grand air ont l'air
de bien se porter. Et pourtant c'est déjà ici assez difficile
assez de les élever à plus forte raison est ce plus ou moins
terrible à de certains moments de les garder sains & saufs
à Paris dans un quatrième étage. Mais enfin il faut
prendre les chôses comme elles sont. M. Gachet dit qu'il
faut que père et mère se nourrissent bien naturellement
et parle de prendre 2 litres de bière par jour &c. Dans ces
mesures là. Mais tu feras certes avec plaisir plus ample
connaissance avec lui et il y compte déjà en parle
toutes les fois que je le vois que vous tous viendrez. Il me
paraît certes aussi malade et ahuri que toi ou moi et
il est plus agé et il a perdu il y a quelques années sa femme
mais il est très médecin et son métier et sa foi le tiennent
pourtant. Nous sommes déjà très amis et par hasard
il a connu encore Bruas de Montpellier et a les mêmes
idées sur lui que j'ai que c'est quelqu'un d'important
dans l'histoire de l'art moderne. Je travaille à son portrait

la tête avec une casquette blanche très blonde très claire les mains
aussi à carnation claire un frac bleu et un fond bleu cobalt
appuyé sur une table rouge sur laquelle un livre jaune et
une plante de digitale à fleurs pourpres. Cela ~~faithet avec~~ est dans
le même sentiment que le portrait de moi que j'ai pris lorsque
je suis parti pour ici. ~~Ils offrent~~
M. Gachet est absolument fanatique pour ce portrait et veut
que j'en fasse un de lui si je peux absolument comme cela
ce que je désire faire aussi. Il est maintenant aussi ~~et~~
arrivé à comprendre le dernier portrait d'Arlésienne ~~et~~ dont tu en
as un en rose. Il revient lorsqu'il vient voir les études tout le temps
sur ces deux portraits et il les admet en plein mais en plein tels qu'ils sont.

877A. Doctor Gachet

So I'm looking forward to doing the portraits of all of you in the open air, yours, Jo's and the little one's.

I still haven't found anything interesting in the way of a possible studio, and yet I'll have to take a room to put in the canvases which are surplus at your apartment and which are at Tanguy's. For they still need a great deal of retouching. But anyway, I live from day to day—the weather is so fine. And my health is good, I go to bed at 9 o'clock but I get up at 5 o'clock most of the time.

I have hopes that it won't be disagreeable to be together again after a long absence. And I also hope that I'll continue to feel much surer of my brush than before I went to Arles. And Mr Gachet says that he would consider it highly improbable that it should recur, and that it's going completely well. But he, too, complains bitterly of the state of things everywhere in the villages where the least foreigner has come, that life there becomes so horribly expensive. He says that he's astonished that the people where I am lodge and feed me for that, and that I'm still fortunate, compared to others who have come and whom he's known. That if you come, and Jo and the little one, you can't do better than stay at this same inn. Now nothing, absolutely nothing keeps us here but Gachet—but the latter will remain a friend, I'd assume. I feel that at his place I can do not too bad a painting every time I go there, and he'll certainly continue to invite me to dinner each Sunday or Monday.

But up to now, however agreeable it is to do a painting there, it's a chore for me to dine and lunch there for, the excellent man goes to the trouble of making dinners in which there are 4 or 5 courses, which is as abominable for him as it is for me, for he certainly doesn't have a strong stomach. What has held me back a little from saying something about it is that I see that, for him, it reminds him of the days of yore when people had family dinners, which anyway we too well know.

But the modern idea of eating one, at most two courses is, however, certainly progress, and a healthy return to true antiquity.

Anyway *père* Gachet is a lot, yes a lot like you and I. I was pleased to read in your letter that Mr Peyron asked for news of me when he wrote to you. I'm going to write to him this very evening that things are going well, for he was very kind to me and I'll certainly not forget him. Dumoulin, the one who has Japanese paintings at the Champ de Mars, has come back here, and I very much hope to meet him.

What did Gauguin say about the last portrait of the Arlésienne that's done after his drawing? You'll end up seeing, I would think, that it's one of the least bad things I've done. Gachet has a Guillaumin, naked woman on a bed, which I consider very beautiful, he also has a very old Guillaumin portrait by him, very different from ours, dark but interesting.

But his house, you will see, is full, full like an antique dealer's, of things that aren't always interesting, it's terrible, even. But in all of this there's this good aspect, that there would always be what I need there for arranging flowers or still lifes. I've done studies for him, to show him that should he not be paid in money we'll nevertheless still compensate him for what he does for us.

Do you know an etching by Bracquemond, the portrait of Comte, it's a masterpiece.

I'd also need as soon as possible 12 tubes zinc white from Tasset and 2 medium tubes geranium lake.

Then as soon as you could send them I'd be absolutely set upon copying all of Bargue's

Etudes au fusain again, you know the nude figures. I can draw them quite quickly, let's say the 60 sheets that there are in a month, so you might send a copy on loan, I'd make sure not to stain or dirty it. If I neglected to keep on studying proportions and the nude I'd find myself in a bad position later on. Don't think this absurd or futile.

Gachet also told me that if I wanted to give him great pleasure he would like me to redo for him the copy of Delacroix's Pietà, which he gazed at for a long time. Later he'll probably give me a hand with the models, I feel that he'll understand us completely, and that he'll work with you and me without reservation, with all his intelligence, for the love of art for art's sake. And he'll perhaps have me do some portraits. Now to have clients for portraits one must be able to show different ones that one has done. That's the only possibility I can see of placing something. But however, however, certain canvases will one day find collectors. Only I think that all the fuss created by the large prices paid lately for Millets &c. has further worsened the state of things as regards the chance one has of merely recouping one's painting expenses. It's enough to make one dizzy. So why are we thinking about it, it would stupefy us. Better still, perhaps, to seek a little friendship and live from day to day. I hope that the little one will continue to be well, and you two also until we see each other again, more soon, I shake your hand firmly.

Vincent

879 | Auvers-sur-Oise, Thursday, 5 June 1890 | *To Willemien van Gogh* (F)

My dear sister,

I ought to have replied to your two letters long since, which I received while still in St-Rémy, but the journey, work and a host of new emotions up to today made me put it off from one day to the next. It interested me very much that you've cared for patients at the Walloon hospital, that's certainly how one learns heaps of things, the best and most necessary that one can learn, and I myself regret that I know nothing, in any event not enough, about all that.

It was a great happiness for me to see Theo again, to meet Jo and the little one. Theo was coughing more than when I left him more than 2 years ago, but while talking and when I saw him at close hand, however, I considered him certainly rather changed for the better, all things considered, and Jo is full of both good sense and good will. The little one is not sickly, but not strong either. It's a good system that if one lives in a large town the woman gives birth in the country and spends the first months there with the little one. But there you are, for the first time especially, as the birth is frightening, they certainly couldn't have done better or otherwise than they did. I hope that they'll come here to Auvers for a few days soon.

For me the journey and the rest up to now have gone well, and coming back to the north distracts me a lot. Then I've found in Dr Gachet a ready-made friend and something like a new brother would be — so much do we resemble each other physically, and morally too. He's very nervous and very bizarre himself, and has rendered much friendship and many services to the artists of the new school, as much as was in his

power. I did his portrait the other day and am also going to paint that of his daughter, who is 19. He lost his wife a few years ago, which has greatly contributed to breaking him. We were friends, so to speak, immediately, and I'll go and spend one or two days a week at his house working in his garden, of which I've already painted two studies, one with plants from the south, aloes, cypresses, marigolds, the other with white roses, vines and a figure. Then a bouquet of buttercups. With that I have a larger painting of the village church — an effect in which the building appears purplish against a sky of a deep and simple blue of pure cobalt, the stained-glass windows look like ultramarine blue patches, the roof is violet and in part orange. In the foreground a little flowery greenery and some sunny pink sand. It's again almost the same thing as the studies I did in Nuenen of the old tower and the cemetery. Only now the colour is probably more expressive, more sumptuous. But in the last few days at St-Rémy I worked like a man in a frenzy, especially on bouquets of flowers. Roses and violet Irises.

For Theo and Jo's little one I brought back a rather large painting — which they've hung above the piano — white almond blossoms — big branches on a sky-blue background, and in their apartment they also have a new portrait of an Arlésienne. My friend Dr Gachet is *decidedly enthusiastic* about this latest portrait of the Arlésienne, one of which I also have myself, and about a portrait of myself, and that gave me pleasure, since he'll drive me to do figure work and I hope he'll find me a few interesting models to do. What I'm most passionate about, much much more than all the rest in my profession — is the portrait, the modern portrait. I seek it by way of colour, and am certainly not alone in seeking it in this way. I WOULD LIKE, you see I'm far from saying that I can do all this, but anyway I'm aiming at it, I *would like* to do portraits which would look like apparitions to people a century later. So I don't try to do us by photographic resemblance but by our passionate expressions, using as a means of expression and intensification of the character our science and modern taste for colour. Thus the portrait of Dr Gachet shows you a face the colour of an overheated and sun-scorched brick, with a reddish head of hair, a white cap, in surroundings of landscape, blue background of hills, his suit is ultramarine blue, this brings out the face and makes it paler, despite the fact that it's brick-coloured. The hands, hands of an obstetrician, are paler than the face.

Before him on a red garden table yellow novels and a dark purple foxglove flower. My portrait of myself is almost like this too, but the blue is a fine southern blue and the suit is light lilac. The portrait of the Arlésienne is of a colourless and matt flesh tone, the eyes calm and very simple, the clothing black, the background pink, and she's leaning her elbow on a green table with green books. But in the one Theo has, the clothing is pink, the background yellow-white, and the front of the open bodice is of white muslin, verging on the green. In all these bright colours, only the hair, the eyelashes and the eyes form dark patches.

[*Sketch* 879A]

I can't manage to do a good croquis of it.

At the exhibition there's a superb painting by Puvis de Chavannes.

[*Sketch* 879B]

879A–B (left to right). *Marie Ginoux ('The Arlésienne')*; sketch after Pierre Puvis de Chavannes, *Inter artes et naturam (Between art and nature)*

The figures are dressed in bright colours and one doesn't know if they're costumes from now or clothes from antiquity; two women are talking (also in long, simple dresses). On one side, artistic-looking men on the other, in the centre a woman, her child in her arms, is picking a flower from an apple tree in blossom. One figure will be forget-me-not blue, another bright lemon, another soft pink, another white, another violet, the ground a meadow dotted with little white and yellow flowers. Blue distance with a white town and a river. All humanity, all nature simplified, but how it could be, if it isn't already.

This description doesn't say anything—but by seeing the painting, by looking at it for a long time one would think one was present at an inevitable but benevolent rebirth of all things that one might have believed in, that one might have desired, a strange and happy meeting of the very distant days of antiquity with raw modernity.

I was also pleased to see André Bonger again; he looked strong and calm, and my word reasoned with great accuracy on artistic things, it pleased me very much that he'd come during the days when I was in Paris.

Thank you again for your letters, more soon, I kiss you in thought.

Ever yours,
Vincent

889 | Auvers-sur-Oise, Tuesday, 17 June 1890 | *To Theo van Gogh* (F)

My dear Theo,

Thanks much for your letter of the day before yesterday, and for the 50-franc note it contained. I waited for the consignment of colours and canvas from Tasset, which has just arrived, and for which I also thank you very much, to answer the question regarding the difference between Tanguy and Tasset colours. Well, it's absolutely the same thing, in the Tasset tubes there are some from time to time, especially for the *white*, that aren't filled properly. However, when Tanguy for his part also fills them badly too,—certainly without doing so deliberately—the tubes of cobalt, for example like the one I have in my hands—so I'm talking only based on the same fact that exists on both sides—I just don't see why one would have any very serious things to reproach the other with.

Is there a difference in the invoices? That's what would interest me more. And then in the colours there is adulteration as in wines. How can one judge correctly when, like myself, one knows nothing of chemistry. I'd nevertheless consider it very good that, should *père* Tanguy be going to extraordinary lengths for us by putting his time and his effort into packing up and dispatching the canvases that are in his attic, then you should get paint from him, even if it's a little worse than the other. It would only be fair.

But what he says about a difference in the tubes, I repeat, it's pure imagination on his part. And the reason why we went to Tasset's is that the latter's colours are in general less insipid. Now this difference isn't important, and if Tanguy has the good will to pack up the canvases stored at his place—fair that he has the order for the colours.

It was with pleasure that I made the acquaintance of the Dutchman, who came yesterday. He looks much too nice to be doing painting in the current conditions. If he nevertheless persists in wanting to do it I told him that he would do well to go to Brittany with Gauguin and De Haan, because he'll live there on 3 francs a day instead of 5 francs, and will have good company. That I myself also hope very much to join them, since Gauguin is going there. I was really pleased to learn that they're going to renew their attempt there. Certainly you're right that it's better for Gauguin than staying in Paris. Very pleased, too, that he likes the head of that Arlésienne. I really hope to do a few etchings of subjects from the south, let's say 6, since I can print them free of charge at Mr Gachet's; he's very willing to run them off for nothing if I do them. It's certainly a thing that must be done, and we'll act in such a way that in some way it forms a sequel to the Lauzet-Monticelli publication, if you approve. And Gauguin will probably engrave a few of his canvases in combination with me. His painting which belongs to you, and especially for the rest of the Martinique things.

Which plates Mr Gachet will also print off for us. Of course we'll leave him free to run off copies for himself. Mr Gachet will come one day to see my canvases in Paris, and then we'd choose the ones to be engraved. At the moment I have two studies on the go — one a bouquet of wild plants, thistles, ears of wheat, leaves of different types of greenery. One almost red, the other very green, the other yellowing.

The second study a white house amid greenery with a star in the night sky and an orange light at the window and dark greenery and a sombre pink note.

That's all for the moment. I have an idea for doing a more important canvas of *Daubigny's* house and garden, of which I already have a small study.

I was really pleased that Gauguin is going off with De Haan again. Naturally this Madagascar plan seems to me hardly possible to carry out, I would much prefer to see him leave for Tonkin. If, however, he went to Madagascar I'd be able to follow him there. For one *should* go there in twos or threes. But we aren't there yet. Certainly the future is very much in the tropics for painting, either in Java or in Martinique, Brazil or Australia, and not here, but you feel that it hasn't been proved to me that you, Gauguin or I are those people of that future. But certainly once again, there and not here, one day, probably soon, one will see Impressionists working who will hold their own with Millet, Pissarro. Believing in that is natural, but going there without the means of existence or a relationship with Paris, a mad impulse when for years on end one has rusted away while vegetating here. Well. Thanks again, and good handshake to you and your wife, and good health to the little one, whom I'm really longing to see again.

Yours truly,
Vincent.

My dear Theo and dear Jo.

I've just received the letter in which you say that the child is ill; I'd very much like to come and see you, and what holds me back is the thought that I'd be even more powerless than you are in the given state of distress. But I can feel how very exhausting it must be, and would like to be able to lend a hand. By coming straightaway I fear I would increase the confusion. However, I share your anxieties with all my heart. It's a real pity that at Mr Gachet's the house is so cluttered with all sorts of things. Otherwise I think it would be a good plan to come and lodge here at his house — with the little one, at least for a good month — I think that the country air has an enormous effect. In the street here there are kids born in Paris and really sickly — who however are well. Coming here to the inn would be possible too, it's true. So that you aren't too alone I could come myself to stay at your place for a week or fortnight.

That wouldn't increase the expenses. For the little one, truly I'm beginning to fear that he must be given air, and especially the little bustle of the other children of a village. Surely, Jo too, who shares our anxieties and risks, I think that from time to time she must take this distraction of the country.

A rather melancholy letter from Gauguin, he talks vaguely of having definitely decided on Madagascar, but so vaguely that one can clearly see that he's only thinking of it because he doesn't really know what else to think about. And the execution of the plan seems almost absurd to me.

[*Sketches* 896A–C]

Here are three croquis — one of a figure of a peasant woman, big yellow hat with a knot of sky-blue ribbons, very red face. Coarse blue blouse with orange spots, background of ears of wheat.

It's a no. 30 canvas but it's really a little coarse, I fear. Then the horizontal landscape with the fields, a subject like one of Michel's — but then the coloration is soft green, yellow and green-blue. Then undergrowth, violet trunks of poplars which cross the landscape perpendicularly like columns. The depths of the undergrowth are blue, and under the big trunks the flowery meadow, white, pink, yellow, green, long russet grasses and flowers.

The people here at the inn used to live in Paris; there they were constantly indisposed, parents and children, here they never have anything, and especially not the littlest one which came here when it was 2 months old, and then the mother had difficulty in suckling him, while here all of that went well almost immediately. In another respect you work all day long, and at the moment you're probably hardly sleeping. I'd willingly believe that Jo would have twice as much milk here, and that then when she came here one could do without cows, donkeys and other quadrupeds. And as for Jo, so that during the daytime she has company, my word, she could also go and stay just opposite *père* Gachet, perhaps you remember that there's an inn just opposite at the bottom of the slope.

896A–C (left to right, top to bottom). *Girl against a background of wheat; Couple walking between rows of poplars; Wheatfields*

What do you want me to say as regards the future, perhaps, perhaps, without the Boussods?

What will be, will be, you haven't spared yourself trouble for them, you've served them with an exemplary fidelity all the time.

I, too, am trying to do as well as I can, but I don't hide from you that I scarcely dare count on always having the necessary health.

And if my illness recurred you would excuse me, I still love art and life very much, but as to ever having a wife of my own I don't believe in it very strongly. I fear, rather, that towards let's say the age of forty—but let's not say anything—I declare that I know nothing, absolutely nothing, of what turn it may yet take.

But I'm writing to you at once that as regards the little one I think you mustn't worry yourselves excessively; if it's that he's teething, well to make the task easier for him perhaps we could distract him more here where there are children, animals, flowers and good air.

I shake your hand and Jo's firmly in thought, and kiss the little one.

Ever yours,
Vincent

Thank you for the consignment of colours, for the 50-franc note and for the article on the Independents.

An Englishman, Australian, called Walpole Brooke will probably come to see you; he lives at 16 rue de la Grande Chaumière—I told him that you would let him know a time when he could come and see my canvases that are at your place.

He'll probably show you some of his studies, which are still rather lifeless, but however he does observe nature. He has been here in Auvers for months, and we went out together sometimes, he was brought up in Japan, you would never think so from his painting—but that may come.

898 | Auvers-sur-Oise, on or about Thursday, 10 July 1890 | *To Theo van Gogh and Jo van Gogh-Bonger* (F)

Dear brother and sister,

Jo's letter was really like a gospel for me, a deliverance from anguish which I was caused by the rather difficult and laborious hours for us all that I shared with you. It's no small thing when all together we feel the daily bread in danger, no small thing when for other causes than that we also feel our existence to be fragile.

Once back here I too still felt very saddened, and had continued to feel the storm that threatens you also weighing upon me. What can be done—you see I usually try to be quite good-humoured, but my life, too, is attacked at the very root, my step also is faltering. I feared—not completely—but a little nonetheless—that I was a danger to you, living at your expense—but Jo's letter clearly proves to me that you really feel that for my part I am working and suffering like you.

There—once back here I set to work again—the brush however almost falling from

my hands and—knowing clearly what I wanted I've painted another three large canvases since then. They're immense stretches of wheatfields under turbulent skies, and I made a point of trying to express sadness, extreme loneliness. You'll see this soon, I hope—for I hope to bring them to you in Paris as soon as possible, since I'd almost believe that these canvases will tell you what I can't say in words, what I consider healthy and fortifying about the countryside.

Now the third canvas is Daubigny's garden, a painting I'd been thinking about ever since I've been here.

I hope with all my heart that the planned journey may provide you with a little distraction.

I often think of the little one, I believe that certainly it's better to bring up children than to expend all one's nervous energy in making paintings, but what can you do, I myself am now, at least I feel I am, too old to retrace my steps or to desire something else. This desire has left me, although the moral pain of it remains.

I very much regret not having seen Guillaumin again, but it pleases me that he's seen my canvases.

If I'd waited for him I would probably have stayed to talk with him in such a way as to miss my train.

Wishing you luck and good heart and relative prosperity, please tell Mother and Sister sometime that I think of them very often, besides this morning I have a letter from them and will reply shortly.

Handshakes in thought.

Ever yours,
Vincent

My money won't last me very long this time, as on my return I had to pay the baggage costs from Arles. I retain very good memories of this trip to Paris. A few months ago I little dared hope to see our friends again. I thought that Dutch lady had a great deal of talent.

Lautrec's painting, portrait of a female musician, is quite astonishing, it moved me when I saw it.

899 | Auvers-sur-Oise, between about Thursday, 10 and Monday, 14 July 1890 |
 To Anna van Gogh-Carbentus and Willemien van Gogh (D)

Dear mother and sister,

Sincere thanks for your kind letters, which gave me a great deal of pleasure. For the present I feel calmer than last year, and the turmoil in my head has really abated so much. I've always believed that, incidentally; that seeing the old surroundings again would have this effect.

I often think of you both, and would very much like to see you again.

Very good that Wil's started working in the hospital. And that she says—the operations weren't as bad as she expected, precisely because she appreciates the means of lessening the pain, and the way many doctors endeavour to do what has to be done

simply and sensibly and with kindness—well I call *that* looking at things the right way and—having faith.

But precisely for one's health, as you say—it's very necessary to work in the garden and to see the flowers growing.

For my part, I'm wholly absorbed in the vast expanse of wheatfields against the hills, large as a sea, delicate yellow, delicate pale green, delicate purple of a ploughed and weeded piece of land, regularly speckled with the green of flowering potato plants, all under a sky with delicate blue, white, pink, violet tones.

I'm wholly in a mood of almost too much calm, in a mood to paint that.

I sincerely hope that you'll have really happy days with Theo and Jo and, like me, you'll see how well they look after the baby, who looks well.

How big Anna's children must be by now.

Regards for today, I must get out and work, all embraced in thought.

Your loving
Vincent

902 | Auvers-sur-Oise, Wednesday, 23 July 1890 | *To Theo van Gogh* (F)

My dear brother,

Thanks for your letter of today and for the 50-franc note it contained.

I'd perhaps like to write to you about many things, but first the desire has passed to such a degree, then I sense the pointlessness of it.

I hope that you'll have found those gentlemen favourably disposed towards you.

As regards the state of peace in your household, I'm just as convinced of the possibility of preserving it as of the storms that threaten it.

I prefer not to forget the little French I know, and certainly wouldn't see the point of delving deeper into the rights or wrongs in any discussions on one side or the other. It's just that this wouldn't interest me.

Things go quickly here—aren't Dries, you and I a little more convinced of that, don't we feel it a little more than those ladies? So much the better for them—but anyway, talking with rested minds, we can't even count on that.

As for myself, I'm applying myself to my canvases with all my attention, I'm trying to do as well as certain painters whom I've liked and admired a great deal.

What seems to me on my return—is that the painters themselves are increasingly at bay.

Very well. But has the moment to make them understand the utility of a union not rather passed already? On the other hand a union, if it were formed, would go under if the rest went under. Then you'd perhaps tell me that dealers would unite for the Impressionists; that would be very fleeting. Anyway it seems to me that personal initiative remains ineffective, and having done the experiment, would one begin it again?

I noted with pleasure that the Gauguin from Brittany that I saw was very beautiful, and it seems to me that the others he's done there must be too.

Perhaps you'll see this croquis of Daubigny's garden—it's one of my most deliberate canvases—to it I'm adding a croquis of old thatched roofs and the croquis of 2 no. 30

canvases depicting immense stretches of wheat after the rain. *Hirschig* asked me to ask you please to order the attached list of colours for him from the same colourman you send me. Tasset can send them directly to him, cash on delivery, but then he would have to be given the 20%.

Which would be simplest.

Or you'd put them into the consignment of colours for me, adding the invoice or telling me how much they cost, and then he'd send you the money. Here one can't find anything good in the way of colours.

I've simplified my own order to a very bare minimum.

Hirschig is beginning to understand a little, it has seemed to me, he's done the portrait of the old schoolmaster, which he gave him, good — and then he has landscape studies which are a little like the Konings at your place as regards colour. It will become completely like that, perhaps, or like the things by Voerman that we saw together.

More soon. Look after yourself, and good luck in business &c. Warm regards to Jo, and handshakes in thought.

Yours truly,
Vincent.

[*Sketch* 902A]

902A. *Daubigny's garden*

Daubigny's garden

Foreground of green and pink grass, on the left a green and lilac bush and a stem of plants with whitish foliage. In the middle a bed of roses. To the right a hurdle, a wall, and above the wall a hazel tree with violet foliage.

Then a hedge of lilac, a row of rounded yellow lime trees. The house itself in the background, pink with a roof of bluish tiles. A bench and 3 chairs, a dark figure with a yellow hat, and in the foreground a black cat. Sky pale green.

[*Sketches* 902B–D]

902B. *Wheatfields*

902C. *Thatched cottages and figures*

902D. *Wheatfields*

Sketch Illustrations

This list of Vincent van Gogh's letter sketches illustrated in this volume is organized chronologically by letter number.

83A. *View of Royal Road, Ramsgate*, 1876. Pen and ink (discoloured to brown), 5.6 x 5.7 cm. Van Gogh Museum, Amsterdam

99A. *Small churches at Petersham and Turnham Green*, 1876. Pencil, pen and ink (discoloured to brown), 3.8 x 10 cm (image). Van Gogh Museum, Amsterdam

148A. *Café Au charbonnage*, 1878. Pencil, pen and brown ink, 14 x 14.2 cm. Van Gogh Museum, Amsterdam

151A. *Cells where the miners work*, 1879. Pen and ink (discoloured to brown), 0.6 x 0.9 cm (image). Van Gogh Museum, Amsterdam

172A–C (top to bottom). *Storm clouds over a field*, 1881. Pen and ink (discoloured to brown), watercolour, 5.5 x 13.2 cm (image). *Digger*, 1881. Pen and ink (discoloured to brown), 8.5 x 13.2 cm (image). *Figure of a woman*, 1881. Pencil and watercolour, 5 x 5.5 cm (image). Van Gogh Museum, Amsterdam

172D. *Digger*, 1881. Pencil, pen and ink (discoloured to brown), 20.1 x 13.2 cm. Van Gogh Museum, Amsterdam

172E. *Man leaning on his spade*, 1881. Pen and ink (discoloured to brown), 8 x 13.4 cm (image). Van Gogh Museum, Amsterdam

172F. *Man sitting by the fireplace ('Worn out')*, 1881. Pencil, pen and ink (discoloured to brown), watercolour, 13.5 x 20.9 cm. Van Gogh Museum, Amsterdam

172G–K (left to right, top to bottom). *Woman near a window*, 1881. Pencil, pen and ink (discoloured to brown), watercolour, 4.8 x 4.2 cm (image). *Woman near a window*, 1881. Pen and ink (discoloured to brown), watercolour, 4.6 x 5 cm (image). *Man with a winnow*, 1881. Pencil, 8 x 7 cm (image). *Woman with a broom*, 1881. Pencil, pen and ink (discoloured to brown), 5.8 x 2.5 cm (image). *Sower*, 1881. Pencil, 10.5 x 13.5 cm (image). Van Gogh Museum, Amsterdam

172L. *Sower with a sack*, 1881. Pencil, pen and ink (discoloured to brown), 20.9 x 13.5 cm. Van Gogh Museum, Amsterdam

192A–C (bottom to top, left to right). *Scheveningen woman standing*, 1881. Pen and ink (discoloured to brown), 9.5 x 5.7 cm (image). *Sculpture*, 1881. Pen and ink (discoloured to brown), 8 x 5.8 cm (image). *Still life with cabbage and clogs*, 1881. Pen and ink (discoloured to brown), 5.4 x 8.5 cm (image). Van Gogh Museum, Amsterdam

192D–E (left to right). *Scheveningen woman sewing*, 1881. Pen and ink (discoloured to brown), 11.7 x 10 cm (image). *Scheveningen woman knitting*, 1881. Pen and ink (discoloured to brown), 13.5 x 9 cm (image). Van Gogh Museum, Amsterdam

207A. *Old woman with a shawl and a walking-stick*, 1882. Pencil, 13.4 x 7.3 cm (image). Van Gogh Museum, Amsterdam

220A. *Men digging*, 1882. Pencil, 19.8 x 11.2 cm. Van Gogh Museum, Amsterdam

220B. *Head of a man*, 1882. Pencil, 19.8 x 11.2 cm. Van Gogh Museum, Amsterdam

222A. *Ground plan of Van Gogh's future house*, 1882. Pen and black ink, 3.7 x 4.2 cm (image). Van Gogh Museum, Amsterdam

252A. *Pollard willow*, 1882. Pen and black ink, watercolour, 6.3 x 13.4 cm (image). Van Gogh Museum, Amsterdam

260A. *View of the beach at Scheveningen*, 1882. Pen and black ink, 8.8 x 6.4 cm. Van Gogh Museum, Amsterdam

274A. *Beach with people strolling and boats*, 1882. Pen and ink (discoloured to brown), 4.9 x 9.8 cm (image). Van Gogh Museum, Amsterdam

318A. *Studio window with shutters*, 1883. Pencil, pen and black ink, 9 x 10.5 cm (image). Van Gogh Museum, Amsterdam

318B. *Studio window with shutters*, 1883. Pencil, pen and black ink, 9.7 x 9.5 cm (image). Van Gogh Museum, Amsterdam

323A–B (top to bottom). *Soup distribution in a public soup kitchen*, 1883. Pen and black ink, 6.7 x 10.8 cm (image). *Soup distribution in a public soup kitchen (detail)*, 1883. Pen and black ink, 1.3 x 1.8 cm (image). Van Gogh Museum, Amsterdam

323C. *Soup distribution in a public soup kitchen*, 1883. Pencil, pen and black ink, 9.9 x 10.5 cm. Van Gogh Museum, Amsterdam

325A–B (top to bottom). *Scraper*, 1883. Pen and black ink, 1.7 x 9.4 cm (image). *Point*, 1883. Pen and black ink, 0.6 x 8 cm (image). Private collection, Musée des Lettres et Manuscrits, Brussels

325C–D (top to bottom). *Natural chalk*, 1883. Pen and black ink, 1.2 x 13 cm (image). *Head of a woman in profile, and two drafts*, 1883. Pen and black ink, natural chalk, 5 x 12.5 cm (image). Private collection, Musée des Lettres et Manuscrits, Brussels

325E. *Baby crawling ('Adventurer sallying forth')*, 1883. Natural chalk, 7 x 9 cm. Present whereabouts unknown

348A. *The sandpit at Dekkersduin near The Hague*, 1883. Pencil, 10.9 x 20.9 cm. Van Gogh Museum, Amsterdam

354A. *Section of Faber pencil*, 1883. Pen and black ink, 1.2 x 1.2 cm (image). Van Gogh Museum, Amsterdam

361A–B (top to bottom). *Weed burners*, 1883. Pen and ink (discoloured to brown), 5.5 x 13.2 cm (image). *Three people returning from the potato field*, 1883. Pen and ink (discoloured to brown), 6.2 x 13.2 cm (image). Van Gogh Museum, Amsterdam

361C. *Sketch of a painting by George Hendrik Breitner*, 1883. Pen and ink (discoloured to brown), 1 x 9.4 cm (image). Van Gogh Museum, Amsterdam

392A–F (left to right, top to bottom). *Farm*, 1883. Pencil, pen and ink (discoloured to brown), 4 x 8 cm (image). *Rider by a waterway*, 1883. Pencil, pen and ink (discoloured to brown), 7 x 5.5 cm (image). *Woman and child*, 1883. Pencil, pen and ink (discoloured to brown), 10.3 x 6.5 cm (image). *Head of a woman*, 1883. Pencil, pen and ink (discoloured to brown), 2.8 x 2.5 cm (image). *Woman working*, 1883. Pencil, pen and ink (discoloured to brown), 7.3 x 7 cm (image). *Country road with cottages*, 1883. Pencil, pen and ink (discoloured to brown), 6.5 x 13.5 cm (image). Van Gogh Museum, Amsterdam

400A. *Man pulling a harrow*, 1883. Pencil, pen and ink (discoloured to brown), 9 x 13.4 cm (image). Van Gogh Museum, Amsterdam

428A. *The Reformed Church in Nuenen*, 1884. Pen and ink (discoloured to brown), 5 x 4 cm (image). Van Gogh Museum, Amsterdam

440A. *Plan of the studio*, 1884. Pen and black ink, 2.3 x 5.7 cm (image). Van Gogh Museum, Amsterdam

450A. *Man winding yarn*, 1884. Pen and black ink, 13.2 x 15.5 cm (image). Van Gogh Museum, Amsterdam

490A. *Honesty in a vase*, 1885. Pen and ink (discoloured to brown), watercolour, gouache, 7.8 x 5.8 cm. Van Gogh Museum, Amsterdam

492A. *The potato eaters*, 1885. Pen and black ink, 5 x 8.5 cm (image). Van Gogh Museum, Amsterdam

492B. *Man and woman planting potatoes*, 1885. Pen and ink (discoloured to brown), 6.5 x 9 cm. Van Gogh Museum, Amsterdam

492C. *Two women working in the fields*, 1885. Pen and ink (discoloured to brown), 6 x 8.5 cm. Van Gogh Museum, Amsterdam

493A. *The potato eaters*, 1885. Pen and black ink, lithographic chalk, 11 x 18 cm. Present whereabouts unknown

587A. *The Langlois bridge with walking couple*, 1888. Pen and ink (discoloured to brown), 8.3 x 13.2 cm (image). Thaw Collection, The Morgan Library & Museum, New York

589A. *The Seine with the Clichy bridge*, 1888. Pen and ink (discoloured to brown), 3 x 2.6 cm (image). Van Gogh Museum, Amsterdam

592A. *Corner of a frame*, 1888. Pen and ink (discoloured to brown), 1 x 1.5 cm (image). Van Gogh Museum, Amsterdam

597A. *Three orchards*, 1888. Pen and purple ink, 5.7 x 12.5 cm (image). Van Gogh Museum, Amsterdam

597B. *Small pear tree in blossom*, 1888. Pen and purple ink, 8.5 x 5 cm (image). Van Gogh Museum, Amsterdam

599A. *Orchard with pear trees in blossom*, 1888. Pen and ink (discoloured to brown), 9.2 x 7.5 cm (image). Thaw Collection, The Morgan Library & Museum, New York

602A. *The Yellow House*, 1888. Pen and black ink, 4 x 6 cm (image). Van Gogh Museum, Amsterdam

609A–B (top to bottom). *Farmhouse in a wheatfield*, 1888. Pen and ink (discoloured to brown), 4.5 x 7 cm (image). *View of Arles with irises in the foreground*, 1888. Pen and ink (discoloured to brown), 6 x 10.7 cm (image). Van Gogh Museum, Amsterdam

611A. *Still life with coffee pot*, 1888. Pen and ink (discoloured to brown), 7.3 x 10.5 cm (image). Van Gogh Museum, Amsterdam

615A. *Album of drawings*, 1888. Pen and ink (discoloured to brown), 3 x 8 cm (image). Van Gogh Museum, Amsterdam

622A–B (top to bottom). *Cottage in Saintes-Maries*, 1888 (image). Pen and black ink, 2.5 x 6 cm. *Woman with a parasol*, 1888. Pen and black ink, 7.3 x 8.5 cm (image). Thaw Collection, The Morgan Library & Museum, New York

622C. *Row of cottages in Saintes-Maries*, 1888. Pen and black ink, 14.2 x 17.9 cm. Thaw Collection, The Morgan Library & Museum, New York

622D–F (left to right, top to bottom). *Fishing boats at sea*, 1888. Pen and black ink, 9.5 x 13.2 cm (image). *Landscape with the edge of a road*, 1888. Pen and black ink, 6.5 x 4.3 cm (image). *Farmhouse in a wheatfield*, 1888. Pen and black ink, 2.5 x 4.3 cm (image). Thaw Collection, The Morgan Library & Museum, New York

622G. *Fishing boats on the beach at Saintes-Maries*, 1888. Pen and black ink, 9 x 17.8 cm. Thaw Collection, The Morgan Library & Museum, New York

622H. *Still life with coffee pot*, 1888. Pen and black ink, 9 x 17.8 cm. Thaw Collection, The Morgan Library & Museum, New York

628A. *Sower with setting sun*, 1888. Pen and black ink, 11.4 x 14.5 cm (image). Thaw Collection, The Morgan Library & Museum, New York

628B–C (top to bottom). *Wheatfield with setting sun*, 1888. Pen and black ink, 10.8 x 16.2 cm (image). *Leg of an easel with a ground spike*, 1888. Pen and black ink, 3.2 x 5.5 cm (image). Thaw Collection, The Morgan Library & Museum, New York

638A. *Cicada*, 1888. Pen and black ink, 5.5 x 5 cm (image). Van Gogh Museum, Amsterdam

655A. *Oval*, 1888. Pen and black ink, 1.2 x 0.9 cm (image). Thaw Collection, The Morgan Library & Museum, New York

660A. *Quay with sand barges*, 1888. Pen and black ink, 6.2 x 9.3 cm (image). Van Gogh Museum, Amsterdam

689A. *The public garden ('The poet's garden')*, 1888. Pen and ink (discoloured to brown), 13.5 x 17 cm. Auction, Sotheby's New York, 13 November 1997

691A. *Crescent moon and star*, 1888. Pen and black ink, 1.4 x 1.8 cm (image). Private collection

691B. *The Yellow House ('The street')*, 1888. Pen and black ink, 13.4 x 20.6 cm. Private collection

691C. *Starry night over the Rhône*, 1888. Pen and black ink, dimensions unknown. Private collection

703A. *The Tarascon diligence*, 1888. Pen and black ink, 8 x 13.5 cm (image). Van Gogh Museum, Amsterdam

703B. *The public garden with a couple strolling ('The poet's garden')*, 1888. Pen and black ink, 6 x 9 cm (image). Van Gogh Museum, Amsterdam

703C–D (top to bottom). *The viaduct*, 1888. Pen and black ink, 7 x 13.5 cm (image). *The Trinquetaille bridge*, 1888. Pen and black ink, 12.2 x 13.5 cm (image). Van Gogh Museum, Amsterdam

706A. *The bedroom*, 1888. Pen and black ink, 9 x 14.2 cm (image). Thaw Collection, The Morgan Library & Museum, New York

709A. *Row of cypresses with a couple strolling ('The poet's garden')*, 1888. Pen and ink (discoloured to brown), 9 x 13.4 cm (image). Van Gogh Museum, Amsterdam

718A. Example of a simple frame, with *The red vineyard*, 1888. Pen and ink (discoloured to brown), 2 x 2.5 cm (image). Van Gogh Museum, Amsterdam

756A. *Orchard in blossom with a view of Arles*, 1889. Pen and black ink, 13.5 x 20.9 cm (image). Private collection

756B. *La Crau with peach trees in blossom*, 1889. Pen and black ink, 8.4 x 13.4 cm. Private collection

776A. *Triptych with 'La berceuse' and two versions of 'Sunflowers in a vase'*, 1889. Pen and black ink, dimensions unknown. Present whereabouts unknown

776B. *Trees with ivy in the garden of the asylum*, 1889. Pen and black ink, dimensions unknown. Present whereabouts unknown

776C. *Giant peacock moth*, 1889. Pen and black ink, dimensions unknown. Present whereabouts unknown

790A. *Three cicadas*, 1889. Pen and ink (discoloured to brown), 20.1 x 17.8 cm. Van Gogh Museum, Amsterdam

798A. *Field with a ploughman*, 1889. Pen and ink (discoloured to brown), 8.4 x 11 cm (image). Van Gogh Museum, Amsterdam

822A–B (top to bottom). Sketch after Emile Bernard, *Madeleine in the Bois d'Amour*, 1889. Pen and black ink, 3.5 x 8.5 cm (image). Sketch after Emile Bernard, *Red poplars*, 1889. Pen and black ink, 4.8 x 3.4 cm (image). Thaw Collection, The Morgan Library & Museum, New York

863A–B (top to bottom). *Large brush*, 1890. Pen and black ink, 0.4 x 3.8 cm (image). *Brush*, 1890. Pen and black ink, 0.5 x 3.6 cm (image). Van Gogh Museum, Amsterdam

868A. *The garden of the asylum with dandelions and tree trunks*, 1890. Pen and ink (discoloured to brown), 5.2 x 12.5 cm (image). Van Gogh Museum, Amsterdam

877A. *Doctor Gachet*, 1890. Pen and ink (discoloured to brown), 4 x 3.5 cm (image). Van Gogh Museum, Amsterdam

879A–B (left to right). *Marie Ginoux ('The Arlésienne')*, 1890. Pen and black ink, 6.8 x 6.8 cm (image). Sketch after Pierre Puvis de Chavannes, *Inter artes et naturam (Between art and nature)*, 1890. Pen and black ink, 4.8 x 10.3 cm (image). Van Gogh Museum, Amsterdam

896A–C (left to right, top to bottom). *Girl against a background of wheat*, 1890. Pencil, pen and ink (discoloured to brown), 16 x 10 cm (image). *Couple walking between rows of poplars*, 1890. Pencil, 7.5 x 17 cm (image). *Wheatfields*, 1890. Pencil, 10.2 x 20.9 cm (image). Van Gogh Museum, Amsterdam

902A. *Daubigny's garden*, 1890. Pen and black ink, 7.3 x 21.8 cm (image). Van Gogh Museum, Amsterdam

902B. *Wheatfields*, 1890. Pen and black ink, 17 x 21.8 cm. Van Gogh Museum, Amsterdam

902C. *Thatched cottages and figures*, 1890. Pen and black ink, 17 x 21.8 cm. Van Gogh Museum, Amsterdam

902D. *Wheatfields*, 1890. Pen and black ink, 17 x 21.8 cm. Van Gogh Museum, Amsterdam

Index of Names

This index lists all people mentioned specifically by name in this anthology. Please refer to www.vangoghletters.org for people mentioned otherwise than by name. See also "Note to the Reader" in the present volume. Names are indexed by letter number.

A

Abbey, Edwin Austin (1852–1911), American artist, 348, 354, 358, 359

Adler, August Carl (1835–1907), clergyman in Amsterdam, 143

Aertsen (Aerssen or Aarssen), Adriana (1851–after 1883), daughter of Jan Aertsen, 117

Aertsen (Aerssen or Aarssen), Cornelia (1837–after 1910), daughter of Jan Aertsen, 117

Aertsen (Aerssen or Aarssen), Johannes (Jan) (1805–1877), farmer in Rijsbergen, 117

Aeschylus (525 BC–456 BC), Greek playwright, 155, 358, 822

Aimard, Gustave (1818–1883), French writer, 672

Albertien. See Brugsma, Albertina Ludovica

Allan, Henry (1865–1912), Irish art student at the Antwerp academy, 569

Allebé, August (1838–1927), Dutch artist, 120

Andersen, Hans Christian (1805–1875), Danish writer, 66, 291

Andry, Jean Baptiste Benjamin Luther (1845–1903), clergyman in Wasmes, 154

Angelico, Fra (c. 1395/1400–1455), Italian artist, 856

Anker, Albert (1831–1910), Swiss artist, 17, 267

Anna. See Gogh, Anna Cornelia van

Anne de Bretagne. See Anne of Brittany

Anne of Brittany (1488–1514), daughter of François II, duke of Brittany, 137

Anquetin, Louis Emile (1861–1932), French artist, 620, 625, 628, 642, 669, 698, 779, 822

Antigna, Jean Pierre Alexandre (1817–1878), French artist, 17, 768

Apol, Lodewijk (Louis) Franciscus Hendrik (1850–1936), Dutch artist, 204

Arouet, François Marie. See Voltaire

Artz, David Adolph Constant (1837–1890), Dutch artist, 203, 450

Auerbach, Moses Baruch (Berthold) (1812–1882), German writer, 267

Aunt Bertha. See Gogh, Elisabeth Hubertha van

Aunt Cornelie. See Gogh-Carbentus, Cornelia van

Aunt Fie. See Carbentus-Van Bemmel, Sophie Cornelia Elisabeth

Aunt Leentje. See Haanebeek-Stricker, Leonarda Catharina Adriana

Aunt Mietje. See Gogh-Boon, Maria Johanna van

Aunt Mina. See Stricker-Carbentus, Willemina Catharina Gerardina

Aunt Pompe. See Gogh, Elisabeth Hubertha van

Aurier, Gustave Albert (1865–1892), French writer and art critic, 850, 853, 856, 863

Bague, Athanase (1843–1893), art dealer in Paris, 702

Bakhuyzen. *See* Sande Bakhuyzen, Julius Jacobus van de

Balzac, Honoré de (1799–1850), French writer, 170, 193, 250, 267, 274, 288, 310, 359, 550, 651, 655, 672, 678, 768

Bargue, Charles (c. 1826/27–1883), French artist, 137, 158, 160, 164, 170, 172, 877

Barnard, Frederick (1846–1896), English artist, 235, 325, 359

Baron, Henri Charles Antoine (1816–1885), French artist, 288

Barye, Antoine Louis (1796–1875), French sculptor, 726

Bastien-Lepage, Jules (1848–1884), French artist, 515

Baudelaire, Charles (1821–1867), French writer, 628, 651, 822

Baudry, Paul Jacques Aimé (1828–1886), French artist, 515, 561

Beecher Stowe. *See* Stowe, Harriet Elizabeth Beecher

Beek, Ardina (Dien) van der (1840–1901), inhabitant of Nuenen, 541

Beers, Jan van (1821–1888), Belgian poet, 11

Beers, Jan Maria Constantijn van (1852–1927), Belgian artist, 484

Beethoven, Ludwig van (1770–1827), German composer, 450, 805

Begemann, Amalia Polixena Rosina (1840–1919), sister of Margot Begemann, 469

Begemann, Jacobus Lodewijk (Louis) (1838–1906), brother of Margot Begemann, 469

Begemann, Lutgera Wilhelmina (1834–1906), sister of Margot Begemann, 469

Begemann, Margaretha (Margot) Carolina (1841–1907), girlfriend of Van Gogh in Nuenen, 456, 464, 469, 574

Begemann, Wilhelmina Johanna (1836–1922), sister of Margot Begemann, 469

Begemann-Schröter, Amalia Polixena Rosina (1806–1877), mother of Margot Begemann, 464

Beijeren, Abraham Hendricksz. van (1620/21–1690), Dutch artist, 359

Belinfante, Auguste (1841–1908), bookseller and publisher in The Hague, 377

Bell, Currer. *See* Brontë, Charlotte

Bellangé, Hippolyte (1800–1866), French artist, 325

Benjamin-Constant, Jean-Joseph (1845–1902), French artist, 515

Béraud, Jean (1848–1935), French artist, 673

Bergh, Arie van den (1817–1879), chemist and distiller in The Hague, 88

Bergh-Stricker, Johanna Ewaldine van den (1820–1887), wife of Arie van den Bergh, 88

Berkel, W.A. van (?–1899), Dutch clergyman, 390

Berlioz, Hector (1803–1869), French composer, 739, 743

Bernard, Emile (1868–1941), French artist and writer, 578, 589, 597, 599, 602, 615, 616, 620, 622, 628, 631, 632, 642, 650, 651, 655, 660, 665, 683, 689, 691, 695, 698, 702, 712, 716, 718, 723, 750, 776, 779, 782, 797, 805, 816, 820, 829, 841, 863

Bernard, Ernest (1841/42–1911), father of Emile Bernard, 822

Bernard-Bodin, Héloïse Henriette (1838/39–1909), mother of Emile Bernard, 723

Bernier, Camille (1823–1902), French artist, 17, 55, 291

Bertall, vicomte d'Arnoux, Charles Albert (1820–1882), French artist, 278

Besnard, (Paul) Albert (1849–1934), French artist, 502, 642, 768, 798

Beyle, Pierre Marie (1838–1902), French artist, 483, 515

Bida, Alexandre (1823–1895), French artist, 123, 155

Bilders, Albertus Gerardus (Gerard) (1838–1865), Dutch artist and writer, 258

Bilders, Johannes Warnardus (1811–1890), Dutch artist, 325

Bing, Siegfried (1838–1905), art dealer in Paris, 642, 672, 686, 768

Bingham, Robert Jefferson (1825–1870), English photographer, 351

Bismarck-Schönhausen, Otto von (1815–1898), German statesman, 650, 686

Blanc, Charles (1813–1882), French writer, 450, 537, 865

Blok, Jozef (1832–1905), bookseller in The Hague, 199

Blommers, Bernardus Johannes (1845–1914), Dutch artist, 214, 361, 363, 534

Boccaccio, Giovanni (1313–1375), Italian writer, 683, 689, 695, 853

Boch, Anna (1848–1936), Belgian artist, 673, 721, 875

Boch, Eugène Guillaume (1855–1941), Belgian artist, 638, 650, 657, 669, 673, 678, 683, 695, 721, 801, 875

Bock, Théophile Emile Achille de (1851–1904), Dutch artist, 196, 204, 250, 291, 312, 325, 361, 367

Bodmer, Karl (1809–1893), Swiss artist, 17, 37, 55, 66, 235, 507, 798, 801

Boetzel, Ernest Philippe (1830–c. 1920), French artist, 235, 325, 392

Boissière, Countess Clara Levaillant de la (c. 1857–?), acquaintance of Van Gogh in Asnières, 611

Boissière, Eugénie Jeanne (c. 1874–?), daughter of Countess Clara Levaillant de la Boissière, 611

Bokma, Dirk Rochus (1831–1911), director of the Flemish college in Brussels, 148

Boks, Mari(n)us (Martinus) (1849–1885), Dutch artist, 307, 394

Boldini, Giovanni Giusto (Jean) (1842–1931), Italian artist, 291

Bonger, Andries (André or Dries) (1861–1936), friend of Theo in Paris, brother of Jo van Gogh-Bonger, 615, 728, 732, 750, 801, 872, 879

Bonger, Hendrik Christiaan (1828–1904), father of Jo van Gogh-Bonger, 732

Bonger, Hermina (Mien) (1858–1910), sister of Jo van Gogh-Bonger, 732, 801

Bonger, Johanna Gezina. See Gogh-Bonger, Johanna Gezina van (Jo)

Bonger, Willem (Wim) Adriaan (1876–1940), brother of Jo van Gogh-Bonger, 732, 836

Bonger-Van der Linden, Anne (Annie) Marie Louise (1859–1931), wife of Andries Bonger, 732

Bonger-Weissman, Hermine Louise (1831–1905), mother of Jo van Gogh-Bonger, 798

Bonheur, Marie-Rosalie (Rosa) (1822–1899), French artist, 55

Bonington, Richard Parkes (1802–1828), English artist, 17, 37, 244

Bonnat, Léon (1833–1922), French artist, 288

Borch (the Younger), Gerard ter (1617–1681), Dutch artist, 515, 651

Borchers, Egbert Rubertus (1849–1932), civil servant in The Hague, 46, 66, 83, 88, 133, 148

Bosboom, Johannes (1817–1891), Dutch artist, 123, 148, 204, 534, 703

Botticelli, Sandro (1444/45–1510), Italian artist, 632, 683, 695, 726

Boudin, Eugène Louis (1824–1898), French artist, 17

Boughton, George Henry (1833–1905), English artist, 11, 17, 99, 164, 170, 235, 267, 348, 354, 358, 359, 394, 400, 484

Bouguereau, Adolphe William (1825–1905), French artist, 515, 555, 660

Boulanger, Georges Ernest Jean Marie (1837–1891), French general and politician, 642

Boulanger, Louis (1806–1867), French artist, 645

Boussod, Etienne (1857–1918), art dealer in Paris, son of Léon Boussod, 896

Boussod, Léon (1826–1896), art dealer in Paris, 645, 896

Boussod, Valadon & Cie, art dealers in Paris, successors of Goupil & Cie, 584, 615, 650, 721. See also Goupil & Cie

Boyer, Jean Marie (1850–after 1906), frame maker in Paris, 592

Braat, Frans (1852–1888), employee at Goupil & Cie in Paris, 440, 801

Braat, Pieter Kornelis (1823–1888), manager of the Blussé & Van Braam bookshop in Dordrecht, 102

Bracquemond, Joseph Auguste (Félix) (1833–1914), French artist, 531, 877

Braekeleer (the Elder), Ferdinand de (1792–1883), Belgian artist, 11, 17

Braekeleer, Henri de (1840–1888), Belgian artist, 11, 17

Braun, Adolphe (1812–1877), French publisher of reproductions, 160

Breitner, George Hendrik (1857–1923), Dutch artist, 204, 207, 211, 214, 237, 307, 361, 363, 592, 740

Breton, Emile Adélard (1831–1902), French artist, 17, 55, 61, 235, 278, 288, 291

Breton, Jules Adolphe Aimé Louis (1827–1906), French artist and poet, 17, 55, 61, 133, 143, 158, 164, 193, 235, 278, 288, 307, 400, 431, 439, 464, 483, 514, 515, 534, 537, 550, 559, 602, 768

Breton-De Vigne, Elodie (1836–1909), wife of Jules Breton, 439

Briët, Arthur Henri Christiaan (1867–1939), Dutch art student at the Antwerp academy, 569

Brinkman Jr, Carel Leonhard (1853–1938), bookseller and publisher in Amsterdam, 133

Brion, Gustave (1824–1877), French artist, 17, 55, 143, 267, 291, 402, 798

Brochart, Constant-Joseph (1816–1899), French artist, 645

Brontë, Charlotte (pseudonym: Currer Bell) (1816–1855), English writer, 170

Brooke, Edmund Walpole (?–?), Australian artist, 896

Browne, Henriette (pseudonym of Sophie de Saux-De Bouteillier) (1829–1901), French artist, 381

Bruegel the Elder (Peasant Bruegel), Pieter (c. 1525/30–1569), Flemish artist, 148, 252

Brueghel the Elder (Velvet Brueghel), Jan (1568–1625), Flemish artist, 148

Brugsma, Albertina (Albertine, Albertien) Ludovica (1859–1891), friend of Lies van Gogh, 76

Bruininga, Catharina Helena (1828–1918), inhabitant of Tongerle (near Nuenen), 515

Bruyas, Alfred (1821–1877), French art collector, 726, 732, 743, 798, 801, 877

Buckman (Buckmann), Edwin (1841–1930), English artist, 325, 358, 359

Buffa & fils, François (Frans), publishers and art dealers in Amsterdam, 732

Buhot, Félix Hilaire (1847–1898), French artist, 342, 361, 363

Bunyan, John (1628–1688), English writer, 99, 117, 133, 155

Bürger, W. See Thoré, Etienne Joseph Théophile

Butin, Ulysse Louis Auguste (1838–1883), French artist, 164

C

C.M. See Gogh, Cornelis Marinus van

Cabanel, Alexandre (1823–1889), French artist, 514, 515, 726, 798

Cabat, Louis (1812–1893), French artist, 55, 66, 450, 537

Calame, Alexandre (1810–1864), Swiss artist, 222

Caldecott, Randolph (1846–1886), English artist, 354, 359

Carbentus, Anna Cornelia. See Gogh-Carbentus, Anna Cornelia van (Ma); Lecomte-Carbentus, Anna Cornelia

Carbentus, Ariëtte Sophia Jeanette (Jet). See Mauve-Carbentus, Ariëtte Sophia Jeanette (Jet)

Carbentus, Willemina Catharina Gerardina (Aunt Mina). See Stricker-Carbentus, Willemina Catharina Gerardina (Aunt Mina), 120, 811

Carbentus-Van Bemmel, Sophie (Fie) Cornelia Elisabeth (Aunt Fie) (1828–1897), sister-in-law of Anna van Gogh-Carbentus, 5, 17, 22, 193

Carlyle, Thomas (1795–1881), English writer and philosopher, 133, 211, 288, 325, 358, 359, 400, 660

Carolus-Duran (Charles Emile Auguste Durand) (1837–1917), French artist, 768

Cassagne, Armand Théophile (1823–1907), French artist, 214, 657

Caton Woodville. See Woodville (II), Richard Caton

Cavenaille, Hubertus Amadeus (1841–1914), doctor in Antwerp, 558

Caxton, William (c. 1415/22–1491), English printer, 307

Cazin, Jean-Charles (1841–1901), French artist, 798

Cézanne, Paul (1839–1906), French artist, 655, 776, 816, 873

Chamaillard, Ernest Ponthier de (1862–1930), French artist, 695, 698, 741

Champaigne, Philippe de (1602–1674), Flemish/French artist, 37, 38, 55

Chaplin, Charles (1825–1891), French artist, 626

Chardin, Jean Baptiste Siméon (1699–1779), French artist, 193, 484, 541, 779

Charlet, Nicolas Toussaint (1792–1845), French artist, 37

Chatrian, (Charles) Alexandre (1826–1890), French writer, 55, 267, 312, 354, 359, 723

Chattel, du. See Rossum du Chattel, Fredericus Jacobus van

Chenavard, Paul Marc Joseph (1807–1895), French artist, 531

Chenu, Fleury (1833–1875), French artist, 17

Chevalier, Hippolyte Sulpice Guillaume. See Gavarni, Paul

Chintreuil, Antoine (1814–1873), French artist, 291

Christien or Christine. See Hoornik, Clasina (Sien) Maria

Cimabue, Cenni (Benciviene) di Pepo (1240–1302), Italian artist, 622, 655

Clausen, George (1852–1944), English artist, 235

Codde, Pieter (1599–1678), Dutch artist, 534

Collart, Marie (1842–1911), Belgian artist, 17, 291

Collin, Louis Joseph Raphaël (1850–1916), French artist, 483

Compte-Calix, François-Claudius (1813–1880), French artist, 17, 288

Conscience, Henri (Hendrik) (1812–1883), Belgian writer, 143, 798, 856

Constable, John (1776–1837), English artist, 17

Constant. See Benjamin-Constant, Jean-Joseph

Coosemans, Joseph Théodore (1828–1904), Belgian artist, 148

Coppée, François Edouard Joachim (1842–1908), French poet, 431

Cor. See Gogh, Cornelis Vincent van

Cormon, Fernand Piestre (1845–1924), French artist, 558, 559, 561, 569, 683

Corot, Jean Baptiste Camille (1796–1875), French artist, 3, 17, 37, 73, 148, 250, 358, 402, 439, 450, 537, 559, 569, 611, 626, 635, 657, 822

Correggio (Antonio Allegri) (c. 1489/94–1534), Italian artist, 155, 211, 214

Courbet, Gustave (1819–1877), French artist, 515, 537, 550, 552, 626, 655, 657, 726

Couture, Thomas (1815–1879), French artist, 726

Cranach the Elder, Lucas (1472–1553), German artist, 599, 632

Crevoulin, François Damase (1844–1903), grocer, neighbour of Van Gogh in Arles, 657, 747

Crevoulin-Favier, Marguerite (1856–1927), grocer, neighbour of Van Gogh in Arles, wife of François Damase Crevoulin, 657, 747

Crome, John (Old Crome) (1768–1821), English artist, 291

Cromwell, Oliver (1599–1658), English statesman, 120, 211

Cruikshank, George (1792–1878), English artist, 325

Cuyp, Aelbert (1620–1691), Dutch artist, 102

Cuyp, Jacob Gerritsz. (1594–1652), Dutch artist, 137

D

Dalou, Jules (Aimé-Jules) (1838–1902), French sculptor, 515

Dante Alighieri (1265–1321), Italian poet, 651, 673, 683, 689, 695

Daubigny, Charles-François (1817–1878), French artist, 11, 17, 37, 55, 102, 126, 133, 158, 258, 288, 358, 367, 381, 392, 439, 450, 483, 537, 559, 569, 635, 768, 875, 889, 898, 902

Daudet, Alphonse (1840–1897), French writer, 274, 432, 464, 550, 574, 622, 628, 672, 673, 736, 801, 841

Daumier, Honoré (1808–1879), French artist, 267, 274, 278, 288, 307, 310, 312, 354, 361, 493, 515, 626, 635, 651, 655, 657, 663, 672, 673, 677, 683, 686, 695, 703, 782, 798, 801, 805, 822, 839

David, Jacques Louis (1748–1825), French artist, 561

Decamps, Alexandre-Gabriel (1803–1860), French artist, 17, 534, 657

Decrucq, Charles Louis (1822–1884), Van Gogh's landlord in Cuesmes, 155

Degas, (Hilaire Germain) Edgar (1834–1917), French artist, 569, 584, 603, 611, 620, 655, 726, 752, 801, 856

Degroux, Charles Camille Auguste (1825–1870), Belgian artist, 17, 129, 143, 148, 164, 211, 228, 258, 260, 267, 278, 288, 291, 307, 310, 318, 354, 450, 493, 497, 502, 673

Dekkers, Driek (1875–1952), inhabitant of Nuenen, 348

Delacroix, Ferdinand Victor Eugène (1798–1863), French artist, 155, 490, 502, 515, 534, 537, 552, 559, 569, 589, 626, 632, 635, 651, 657, 660, 663, 673, 677, 686, 709, 726, 732, 768, 772, 782, 798, 801, 804, 805, 816, 820, 822, 839, 853, 856, 877

Delarebeyrette, François Joseph (1825–1886), art dealer in Paris, 589

Delarebeyrette, Gabriel ('Gabriel de la Roquette') (1862–1891), art dealer in Paris, 625

Delarebeyrette-Lassarre, Evelina (?–after 1891), art dealer in Paris, 635, 702

Delaroche, Paul (Hippolyte) (1797–1856), French artist, 17, 507, 635, 709

Delort, Charles Edouard Edmond (1841–1895), French artist, 709

Denis, Jean-Baptiste (1825–1893), Van Gogh's landlord in Petit-Wasmes, 151

Desboutin, Marcellin Gilbert (1823–1902), French artist, 638

Destrée, Johannes Joseph (1827–1888), Belgian artist, 650

Detaille, Edouard Jean Baptiste (1848–1912), French artist, 615

Diaz de la Peña, Narcisse Virgile (1808–1876), French artist, 11, 17, 307, 534, 589, 657, 776, 798, 853

Dickens, Charles John Huffam (1812–1870), English writer, 133, 143, 155, 158, 235, 267, 291, 325, 332, 359, 764, 801

Dolci, Carlo (Carlino) (1616–1686), Italian artist, 148

Domela Nieuwenhuis, Ferdinand (1846–1919), Dutch socialist, 626

Doré, Gustave (1832–1883), French artist, 129, 133, 267, 400, 537

Douwes Dekker, Eduard. *See* Multatuli

Drift, Adrianus Johannes van der (?–1882), Van Gogh's landlord in The Hague, 222

Droz, Antoine Gustave (1832–1895), French writer, 785

Duez, Ernest Ange (1843–1896), French artist, 267

Dujardin, Edouard (1861–1949), French writer, 718

Du Maurier, George Louis Palmella Busson (1834–1896), French artist, 164, 235, 267

Dumoulin, Louis Jules (1860–1924), French artist, 877

Dupré, Jules (1811–1889), French artist, 17, 37, 66, 73, 137, 143, 155, 249, 260, 288, 291, 361, 381, 386, 439, 450, 483, 537, 559, 569, 645, 652, 657

Dupré, Julien (1851–1910), French artist, 342

Du Quesne van Bruchem-Van Willis, Catharina Marianne Louise (1850–1889), a patient nursed by Elisabeth and Willemien van Gogh, 764, 785

Du Quesne-Van Gogh, Elisabeth (Lies) Huberta. *See* Gogh, Elisabeth Huberta van (Lies)

Durand, Charles Emile Auguste. *See* Carolus-Duran

Durand, Ernest (c.1855–?), Belgian art student at the Antwerp academy, 569

Durand-Ruel, Paul (1831–1922), French art dealer, 73, 497, 550, 686, 805

Duval, Pierre Louis (1811–1870), owner of restaurants in Paris, 502

Duverger, Théophile Emmanuel (1821–1886), French artist, 55

E

Edouard, G. (?–?), seller of artists' materials in Paris, 635

Edwards, Edwin (1823–1879), English artist, 291

Eeden, Frederik Willem van (1860–1932), Dutch writer, 626, 740

Eliot, George (pseudonym of Mary Ann [Marian] Evans) (1819–1880), English writer, 88, 96, 193, 267, 332, 686

Emslie, Alfred Edward (1848–1918), English artist, 431

Erckmann, Emile (1822–1899), French writer, 55, 267, 312, 354, 359, 723

Erckmann-Chatrian. See Chatrian, (Charles) Alexandre; Erckmann, Emile

Escalier, Patience (?–?), gardener in Arles, 663

Escombard, Charles Ferdinand (1827–1893), clergyman in Saintes-Maries, 619

Evans, Mary Ann (Marian). See Eliot, George

Eyck, Hubert van (c. 1370–1426), Flemish artist, 599, 632, 655

Eyck, Jan van (c. 1390–1441), Flemish artist, 599, 632, 655

Eyck, Margaretha van (?–?), sister of Jan and Hubert van Eyck, 400

F

Fabritius, Carel (1622–1654), Dutch artist, 155, 651, 798

Faed, Thomas (1826–1900), English artist, 267

Fantin-Latour, Henri (1836–1904), French artist, 484

Father Bernhard. See Zuijlen, Cornelius Johannes van

Faure, Jean Baptiste (1830–1914), French art collector, 743

Feyen, (Jacques) Eugène (1815–1908), French artist, 17

Feyen-Perrin, François Nicolas Auguste (1826–1888), French artist, 17, 164, 193, 235, 325, 483, 768

Fildes, Samuel Luke (1844–1927), English artist, 199, 235, 278, 307, 325

Fisher, Edmund Henry (1835–1879), English clergyman, 84

Fitzgerald, Patrick Michael (fl. 1871–1891), Irish artist, 359

Flaubert, Gustave (1821–1880), French writer, 574, 625, 691, 764, 804

Forain, Jean Louis (1852–1931), French artist, 782

Fortuny y Carbó, Mariano José Maria Bernardo (1838–1874), Spanish artist, 267, 291, 450, 839

Français, Louis-François (1814–1897), French artist, 55, 155

Francq, Edouard Joseph (or Joseph Edouard) (1819–1902), evangelist in Cuesmes, 154

Franken, Johanna. See Gogh-Franken, Johanna van

Frère, Edouard (1819–1886), French artist, 37, 133, 137, 193, 207, 291, 381, 702, 804

Fromentin, Eugène (1820–1876), French artist and writer, 17, 342, 450, 622, 726, 801

G

Gachet, Clémentine Elisa Marguerite (Marguerite-Clémentine) (1869–1949), daughter of Paul-Ferdinand Gachet, 879

Gachet Sr, Paul-Ferdinand (1828–1909), doctor in Auvers, 873, 875, 877, 879, 889, 896

Gachet-Castets, Elisa Angélique (Blanche) (1840–1875), wife of Paul-Ferdinand Gachet, 879

Gagnebin, Ferdinand Henri (1816–1890), clergyman in Amsterdam, 133

Gainsborough, Thomas (1727–1788), English artist, 11

Gall, Franz Joseph (1758–1828), German doctor, 160

Garnier, Jean Louis Charles (1825–1898), French architect, 779

Gauguin, (Eugène Henri) Paul (1848–1903), French artist, 582, 584, 589, 599, 602, 615, 616, 620, 622, 625, 628, 631, 635, 638, 645, 650, 655, 657, 660, 665, 669, 670, 672, 673, 677, 683, 689, 691, 695, 698, 702, 703, 706, 709, 712, 716, 718, 721, 723, 726, 728, 730, 732, 736, 739, 741, 743, 747, 750, 760, 768, 776, 779, 782, 790, 797, 801, 805, 811, 816, 820, 821, 829, 839, 841, 849, 850, 853, 856, 857, 863, 865, 877, 889, 896, 902

Gauguin-Gad, Mette Sophie (1850–1920), wife of Paul Gauguin, 723, 736

Gautier, Théophile (1811–1872), French writer and art critic, 439, 502

Gavarni, Paul (pseudonym of Hippolyte Sulpice Guillaume Chevalier) (1804–1866), French artist, 211, 214, 235, 260, 267, 274, 278, 359, 363, 534, 555, 626, 642

Geffroy, Gustave (1855–1926), French writer, 650

Gendre (?–?), (French?) art collector, 592

Genk, Ludovicus Cornelis van (1832–1888), doctor in Etten, 170

Géricault, (Jean Louis André) Théodore (1791–1824), French artist, 555, 686

Germanicus, Gaius Julius Caesar (15 BC–AD 19), Roman general, 561

Gérôme, Jean Léon (1824–1904), French artist, 17, 507, 619, 622, 625, 801

Gigoux, Jean François (1806–1894), French writer and artist, 492, 502, 515

Gilbert, John (1817–1897), English artist, 267

Ginoux, Joseph Michel (1835–1902), manager of Café de la Gare in Arles, 736, 747, 865

Ginoux-Julien, Marie (1848–1911), manager of Café de la Gare in Arles, wife of Joseph Ginoux, 741, 747, 841, 850, 856, 857, 863, 865, 879, 889

Giotto di Bondone (1267/75–1337), Italian artist, 622, 655, 665, 683, 691, 695, 726, 798, 822, 839, 856

Gladwell, Harry (1857–1927), friend of Van Gogh in Paris, 84, 88, 99, 129, 133, 137

Gladwell, Henry William (1834–1893), father of Harry Gladwell, 84, 88, 99, 137

Gladwell, Susannah Eleanor (1858/59–1876), sister of Harry Gladwell, 99

Gleyre, Charles (1806–1874), Swiss artist, 38, 55

Goes, Hugo van der (c. 1440–1482), Flemish artist, 361, 650, 709

Goethals, Raymond Eugène (1804–1864), French artist, 291

Goethe, Johann Wolfgang von (1749–1832), German writer, 193, 325

Gogh, Anna Cornelia van (Anna) (1855–1930), sister of Vincent, wife of Joan Marius van Houten, 5, 11, 33, 76, 79, 84, 123, 126, 129, 154, 490, 811, 856, 899

Gogh, Cornelis Marinus van (Uncle Cor or C.M.) (1824–1908), brother of Theodorus van Gogh, art dealer and bookseller in Amsterdam, 33, 106, 109, 123, 129, 133, 137, 158, 160, 164, 204, 207, 211, 214, 220, 228, 235, 237, 242, 258, 361, 363, 384, 392, 432, 442, 492, 534, 702, 784, 839

Gogh, Cornelis Vincent van (Cor) (1867–1900), brother of Vincent, 76, 120, 214, 490, 784, 785, 797, 804, 805, 811

Gogh, Elisabeth Huberta van (Lies) (1859–1936), sister of Vincent, 3, 11, 76, 129, 394, 428, 493, 615, 635, 642, 764, 785, 798, 811, 856

Gogh, Elisabeth Hubertha van (Aunt Bertha, Aunt Pompe) (1823–1895), second wife of Abraham Pompe Sr, sister of Theodorus van Gogh, 123, 446

Gogh, Elisabeth Hubertha Vincentia van (Bertha) (1859–1938), daughter of Theodorus van Gogh's brother Willem Daniel, 126

Gogh, Hendrik Jacob Eerligh van (1853–1886), son of Johannes van Gogh Sr, 342

Gogh, Hendrik Vincent van (Uncle Hein) (1814–1877), brother of Theodorus van Gogh, 3, 5, 9, 11

Gogh, Johanna Hendrina van (1863–1945), daughter of Cornelis Marinus van Gogh, 434

Gogh Sr, Johannes van (Uncle Jan) (1817–1885), brother of Theodorus van Gogh, rear admiral, director of the naval dockyard in Amsterdam, 66, 83, 99, 117, 120, 123, 129, 133, 137, 619

Gogh, Mr van. *See* Gogh, Theodorus van

Gogh, Mrs van. *See* Gogh-Carbentus, Anna Cornelia van

Gogh, Theodorus van (Pa or Mr van Gogh) (1822–1885), husband of Anna Cornelia van Gogh-Carbentus, father of Vincent, clergyman, 3, 33, 38, 49, 66, 76, 83, 84, 99, 102, 106, 109, 120, 123, 126, 129, 133, 137, 148, 155, 160, 164, 179, 186, 192, 193, 194, 199, 204, 220, 222, 228, 235, 244, 307, 310, 348, 351, 361, 375, 377, 381, 390, 392, 394, 408, 410, 413, 417, 428, 432, 446, 464, 469, 482, 487, 490, 514, 552, 657, 677, 741, 768, 850

Gogh, Vincent van (1789–1874), grandfather of Vincent, 109

Gogh, Vincent van (Uncle Cent or Uncle Vincent) (1820–1888), brother of Theodorus van Gogh, art dealer, 3, 5, 38, 49, 61, 84, 129, 160, 164, 179, 204, 220, 235, 434, 515, 615, 645

Gogh, Vincent Willem van (1890–1978), son of Theo van Gogh, 850, 856, 857, 863, 865, 873, 875, 879, 889, 896, 898, 899

Gogh, Willemina Jacoba van (Wil or Willemien) (1862–1941), sister of Vincent, 76, 193, 394, 408, 428, 432, 484, 490, 493, 541, 574, 590, 592, 602, 603, 615, 626, 635, 642, 660, 669, 670, 673, 678, 732, 741, 747, 750, 752, 760, 764, 768, 784, 785, 797, 798, 804, 805, 811, 829, 836, 839, 841, 850, 856, 865, 879, 898, 899

Gogh-Bonger, Johanna Gezina van (Jo) (1862–1925), wife of Theo van Gogh, 728, 732, 740, 741, 743, 747, 750, 752, 760, 768, 772, 776, 779, 782, 784, 785, 790, 797, 798, 801, 805, 811, 816, 820, 829, 836, 841, 849, 850, 856, 857, 863, 865, 868, 872, 873, 875, 879, 889, 896, 898, 899, 902

Gogh-Boon, Maria Johanna van (Aunt Mietje) (1819–1885), wife of Hendrik Vincent van Gogh, 3, 5, 9, 11

Gogh-Carbentus, Anna Cornelia van (Ma or Mrs van Gogh) (1819–1907), wife of Theodorus van Gogh, mother of Vincent, 49, 76, 99, 120, 126, 129, 179, 186, 193, 194, 199, 214, 220, 222, 244, 348, 351, 361, 394, 408, 413, 417, 428, 431, 432, 446, 464, 469, 490, 493, 514, 541, 558, 559, 572, 574, 590, 592, 602, 626, 678, 732, 741, 747, 750, 752, 760, 764, 784, 797, 798, 801, 804, 805, 811, 829, 841, 850, 856, 865, 875, 898, 899

Gogh-Carbentus, Cornelia van (Aunt Cornelie) (1829–1913), wife of Vincent van Gogh (Uncle Cent), sister of Anna van Gogh-Carbentus, 179

Gogh-Franken, Johanna van (1836–1919), second wife of Cornelis Marinus van Gogh, 133

Goncourt, Edmond de (1822–1896), French writer, 260, 363, 534, 541, 545, 550, 552, 559, 574, 602, 635, 645, 655, 678, 702, 804, 805

Goncourt, Jules Huot de (1830–1870), French writer, 260, 363, 534, 541, 545, 550, 552, 574, 635, 645, 655, 678, 804, 805

Gorkom, Jacobus van (1827–1880), Dutch artist, 22

Goupil, Adolphe (1806–1893), founder of Goupil & Cie, 348, 850

Goupil, Albert (1840–1884), French art collector, 620

Goupil, Jules Adolphe (1839–1883), French artist, 133

Goupil & Cie, art dealers and publishers with branches in Paris, London, The Hague and Brussels, 3, 5, 9, 84, 137, 214, 228, 267, 367, 377, 432, 559, 603, 615, 616, 702, 718, 721, 741, 743, 768, 776, 829. See also Boussod, Valadon & Cie

Goya (y Lucientes), Francisco José de (1746–1828), Spanish artist, 267, 603, 650, 651

Goyen, Jan van (1596–1656), Dutch artist, 222, 250, 291, 392, 776, 779

Greef, Renier de (1855–1910), farmer in Nuenen, 541

Green, Charles (1840–1898), English artist, 235, 267, 348, 354, 358, 359, 375

Green, Henry Towneley (1836–1899), English artist, 267, 348, 354, 358, 359, 375

Gregory, Edward John (1850–1909), English artist, 307

Groot, Antonie (Toon) de (1829–1909), inhabitant of Nuenen, 541, 574

Groot, Cornelis de (1885–1951), son of Gordina de Groot, 574

Groot, Gordina (Dien, Sien) de (1855–1927), inhabitant of Nuenen, 574

Gros, Antoine Jean (1771–1835), French artist, 555

Gruby, David (1810–1898), doctor in Paris, 603, 611, 615, 638, 650

Guillaumin, (Jean Baptiste) Armand (1841–1927), French artist, 584, 597, 602, 616, 631, 650, 689, 695, 721, 804, 816, 865, 877, 898

Guizot, François Pierre Guillaume (1787–1874), French writer, 464

H

H.G.T. See Tersteeg, Hermanus Gijsbertus

Haan, Meijer Isaac de (1852–1895), Dutch artist, 726, 732, 736, 747, 782, 820, 839, 849, 850, 889

Haanebeek, Carl Adolph (1821–1906), wine merchant in The Hague, father of Caroline van Stockum-Haanebeek, 1, 5, 17, 22, 96, 99, 120, 133

Haanebeek, Jannetje (Annet) Cornelia (1851–1875), daughter of Carl Adolph Haanebeek, sister of Caroline van Stockum-Haanebeek, 1, 5, 17, 22, 96, 99, 120, 133

Haanebeek-Stricker, Leonarda (Leentje) Catharina Adriana (1822–1904), second wife of Carl Adolph Haanebeek, 1, 5, 17, 22, 96, 99, 120, 133

Haden, Francis Seymour (1818–1910), English artist, 158

Hals, Frans (1581/85–1666), Dutch artist, 17, 267, 310, 534, 550, 642, 651, 779, 804

Hamman, Edouard Michel Ferdinand (1854–1952), colleague of Theo at Goupil's in Brussels, 3, 5, 9, 11

Hamon, Jean Louis (1821–1874), French artist, 17

Harpignies, Henri Joseph (1819–1916), French artist, 483

Haverman, Hendrik Johannes (1857–1928), Dutch artist, 439, 514

Hébert, Ernest (1817–1908), French artist, 17, 55

Heilbuth, Ferdinand (1826–1889), French artist, 11, 267

Heldring, Ott(h)o Gerhard (1804–1876), Dutch clergyman, 109

Henkes, Gerke (1844–1927), Dutch artist, 204

Henner, Jean Jacques (1829–1905), French artist, 515

Herkomer, Hubert von (1849–1914), English artist, 164, 170, 199, 214, 235, 249, 278, 288, 291, 307, 312, 332, 348, 354, 358, 375, 400, 439, 515

Hermans, Petrus Antonius (Antoon) (1822–1897), amateur artist in Eindhoven, friend of Van Gogh, 469

Hetzel, Pierre Jules (1814–1886), French publisher and writer, 798

Heyerdahl, Hans Olaf (1857–1913), Norwegian artist, 164, 222, 584

Hirschig, Anthonius (Anton, Tony) Matthias (1867–1939), Dutch artist, 902

Hoffmann, E.T.A. (Ernst Theodor Amadeus) (1776–1822), German writer, 361

Hokusai, Katsushika (1760–1849), Japanese artist, 642, 686

Holbein the Younger, Hans (1497–1543), German artist, 160, 632, 655

Holl, Francis (Frank) Montague (1845–1888), English artist, 199, 235, 249, 278, 307, 312, 325, 332

Hombergh, Johannes van (1814–1895), mayor of Nuenen, 531

Homer (c. 800 BC–c. 750 BC), Greek poet, 822

Hooch, Pieter de (1629–c. 1683), Dutch artist, 651

Hoornik, Carolus Ernestus Jacobus (1856–1904), brother of Clasina Maria Hoornik, 348

Hoornik, Clasina Maria (also Christien, Christine, Sien) (1850–1904), Van Gogh's girlfriend in The Hague, 224, 228, 235, 237, 242, 244, 250, 301, 307, 312, 342, 348, 351, 358, 361, 363, 375, 381, 383, 384, 386, 390, 400, 408, 417, 432

Hoornik, Maria Wilhelmina (1872–1931), sister of Clasina Maria Hoornik, 323

Hoornik, Maria Wilhelmina (1877–1940), daughter of Clasina Maria Hoornik, 207, 224, 228, 242, 250, 301, 307, 312, 342, 381, 383, 384, 386, 390, 417

Hoornik, Willem (1882–c. 1958/60), son of Clasina Maria Hoornik, 242, 244, 301, 307, 312, 342, 358, 363, 381, 383, 384, 386, 390, 417

Hoornik-Pellers, Maria Wilhelmina (1829–1910), mother of Clasina Maria Hoornik, 224, 228, 242, 323, 342, 348, 381, 383, 390

Hoornik-Rombouts, Johanna Elisabeth Angenita (1863–after 1890), wife of Carolus Ernestus Jacobus Hoornik, 348

Hopkins, Arthur (1848–1930), English artist, 359

Houghton, Arthur Boyd (1836–1875), English artist, 332

Houten, Anna (Annie) Theodora van (1883–1969), daughter of Anna van Gogh, 798, 899

Houten, Joan Marius van (1850–1945), husband of Anna van Gogh, 123, 126

Houten, Sara (Saar) Maria van (1880–1977), daughter of Anna van Gogh, 798, 899

Houten-Van Gogh, Anna Cornelia van. See Gogh, Anna Cornelia van (Anna)

Huet, Paul (1803–1869), French artist, 17, 537

Hugo, Victor Marie (1802–1885), French writer, 11, 155, 158, 186, 267, 288, 310, 318, 358, 359, 361, 507, 642, 650, 691, 709, 752, 784

Hunt, Alfred William (1830–1896), English artist, 359

Hunt, William Holman (1827–1910), English artist, 820

Huysmans, Joris-Karl (1848–1907), French writer, 574, 628, 804

I

Idenburg, Petrus Johannes (1825–1899), doctor in Utrecht, 456

Ingres, Jean Auguste Dominique (1780–1867), French artist, 515

Isaäcson, Joseph Jacob (1859–1942), Dutch writer and artist, 726, 732, 736, 747, 782, 811, 820, 829, 841, 850, 875

Isabey, Louis Gabriel Eugène (1803–1886), French artist, 537, 657

Israëls, Jozef (1824–1911), Dutch artist, 17, 129, 133, 151, 158, 164, 203, 211, 258, 267, 278, 288, 312, 332, 354, 361, 400, 439, 446, 450, 483, 493, 502, 515, 519, 534, 537, 595, 626, 628, 657, 768

Iterson, Teunis van (1847–1925), employee at Goupil & Cie in The Hague, 5, 96, 220

Iterson, Willem Frederik van (1856–after 1879), acquaintance of the Van Gogh family in The Hague, 73

J

J.P.S. See Stricker Sr, Johannes Paulus

Jacquand, Claude (1803–1878), French artist, 133

Jacque(s), Charles Emile (1813–1894), French artist, 17, 66, 126, 133, 267, 361, 515, 657

Jacquemart, Jules Ferdinand (1837–1880), French artist, 686, 779

Jacquet, Gustave Jean (1846–1909), French artist, 22, 267, 484, 514, 515

Jalabert, Charles François (1819–1901), French artist, 17

Jeannin, Georges (1841–1925), French artist, 657, 669, 739, 741, 768, 850, 853

Jiménez Aranda, José (1837–1903), Spanish artist, 839

Johannot, Tony (1803–1852), French artist, 288

Jones, Mr. See Slade-Jones, Thomas

Jonge, Nicolaas de (1845–1898), clergyman in Brussels, 148

Jongkind, Johan Barthold (1819–1891), Dutch artist, 158, 635, 657

Jordaens, Jacob (1593–1678), Flemish artist, 686

Jourdan, Adolphe (1825–1889), French artist, 17, 768

Jouve, Auguste (1846–?), (French?) artist, 801, 805

Jundt, Gustave Adolphe (1830–1884), French artist, 11, 17, 267, 776

K

K.V. *See* Vos-Stricker, Cornelia Adriana

Kam, Jan Gerrit (1833–1917), clergyman in Leur, 109

Karr, Alphonse (1808–1890), French writer, 288

Kate, Jan Jacob Lodewijk ten (1819–1889), Dutch poet and clergyman, 126, 193

Kaufmann, Piet (1864–1940), gardener in Etten, 170, 172

Kee Vos. *See* Vos-Stricker, Cornelia Adriana

Keene, Charles Samuel (1823–1891), English artist, 235, 642

Kempis, Thomas a (1379/80–1471), Dutch writer, 129, 137

Kerssemakers, Antonius (Anton) Cornelius Augustinus (1846–1924), tanner in Eindhoven, pupil of Van Gogh, 469, 493, 497, 502, 534

Keyser, Thomas de (1596/97–1667), Dutch artist, 155

Kiesenberg, Willem (1814–1904), acquaintance of Van Gogh in The Hague, 390

Knaus, Ludwig (1829–1910), German artist, 17, 267, 359

Koekkoek, Barend Cornelis (1803–1862), Dutch artist, 17, 515

Koninck, Philips (de) (1619–1688), Dutch artist, 392

Koning, Arnold Hendrik (1831–1895), lawyer, father of Arnold Hendrik Koning, 578

Koning, Arnold Hendrik (1860–1945), Dutch artist, 578, 582, 592, 595, 597, 602, 603, 611, 615, 616, 657, 740, 747, 902

Kroes, Jacobus Cornel(i)us (1829–1899), sexton of the Oosterkerk in Amsterdam, 120

L

La Caze, Louis (1798–1869), French art collector, 552, 726, 797, 798, 853

Lagye, Victor (1825–1896), Belgian artist, 11, 17, 318

Lambinet, Emile Charles (1815–1877), French artist, 17

Lamennais, (Hugues) Félicité Robert de (1782–1854), French writer, 120

Lançon, Auguste André (1836–1885), French artist, 235, 267, 307, 312, 325, 584

Landseer, Edwin Henry (1802–1873), English artist, 133

Latouche, Louis (1829–1884), seller of artists' materials in Paris, 657

Laurillard, Eliza (1830–1908), Dutch poet, clergyman in Amsterdam, 120

Lauzet, Auguste Marie (1865–1898), French artist, 839, 850, 853, 889

Laval, Charles (1862–1894), French artist, 689, 691, 695, 698, 736

Lavater et Gall. *See* Gall, Franz Joseph; Lavater, Johann Caspar

Lavater, Johann Caspar (1741–1801), Swiss physiognomist, 160

Lavieille, Adrien (Jacques Adrien) (1818–1862), French artist, 291, 325, 839

Lavieille, Eugène Antoine Samuel (1820–1889), French artist, 291

Lecomte (Le Comte), Adolf (1850–1921), husband of Anna Cornelia Lecomte-Carbentus, 193

Lecomte-Carbentus, Anna Cornelia (1854–1926), wife of Adolf Lecomte, 193

Leech, John (1817–1864), English artist, 235, 325

Lefebvre, Jules Joseph (1836–1911), French artist, 515

Legros, Alphonse (1837–1911), French artist, 164, 358, 359

Lemonnier, (Antoine Louis) Camille (1844–1913), Belgian writer, 342, 752

Lemud, François Aimé de (1816–1887), French artist, 657, 672

Leonardo da Vinci (1452–1519), Italian artist, 635

Lerat, Paul-Edmé (1849–1892), French artist, 686, 805, 839

Lessore, Henri Emile (1830–1894), French artist, 158

Leurs, Wilhelmus Johannes (1828–1895), seller of artists' materials and frame maker in The Hague, 363, 529

Lévy, Emile (1826–1890), French artist, 483

Lévy, Nephtalie (?–?), manager at Siegfried Bing's gallery in Paris, 686

Leys, (Jean Auguste) Henri (1815–1869), Belgian artist, 17, 148, 381, 354, 502, 768, 779, 853

Lhermitte, Léon Augustin (1844–1925), French artist, 307, 310, 358, 434, 440, 484, 502, 514, 515, 531, 545, 657

Liebermann, Max (1847–1935), German artist, 392, 402

Lies. *See* Gogh, Elisabeth Huberta van

Linder, Philippe Jacques (?–?), French artist, 11

Lith, Johan van (1814–1893), inhabitant of Tongerle (near Nuenen), 515

Livens, Horace Mann (1862–1936), English artist, 569

Longfellow, Henry Wadsworth (1807–1882), American poet, 66, 126, 129, 211

Loo, Arnold Louis Karel Hubert van de (1852–1898), doctor in Eindhoven, 431, 432, 456, 541, 550

Loti, Pierre (pseudonym of Louis Marie Julien Viaud) (1850–1923), French writer, 590, 626, 628, 642, 650, 804, 805

Louis XIV (1638–1715), king of France, 632

Loyer, Sarah Ursula (1815–1895), lodging-house-keeper in London, 99, 394

Luther, Martin (1483–1546), German theologian, 632

Lynen, Amédée Ernest (1852–1938), Belgian artist, 267

M

Ma. *See* Gogh-Carbentus, Anna Cornelia van

Maaten, Jacobus (Jakob) Jan van der (1820–1879), Dutch artist, 37, 120

MacKnight, Dodge (1860–1950), American artist, 602, 603, 625, 638, 645, 650, 657, 669, 673, 849

Madiol, Adriaan Johannes (Jan) (1845–1927), Dutch artist, 164

Madrazo y Garreta, Raimundo de (1841–1920), Spanish artist, 17

Maes, Nicolaes (1632/34–1693), Dutch artist, 211, 434, 440, 651

Mager, Nicolaas (1857–?), clerk in Dordrecht, 120

Manet, Edouard (1832–1883), French artist, 354, 428, 537, 550, 552, 561, 657, 669, 829

Mantz, Paul (1821–1895), French art critic, 502, 561

Marat, Jean Paul (1743–1793), French revolutionary, 595

Marchal, Charles François (1825–1877), French artist, 267, 776

Marchetti, Ludovico (1853–1909), Italian artist, 267

Marie (?–?), girlfriend of Theo in Paris, 301, 310, 312, 318, 323, 342, 348, 351, 361, 394, 400, 408, 432, 434

Maris, Jacob (Jaap) Hendrik (1837–1899), Dutch artist, 11, 17, 151, 214, 260, 354, 519, 534, 595

Maris, Matthijs (Thijs) (1839–1917), Dutch artist, 11, 17, 37, 120, 148, 151, 155, 158, 214, 318, 394, 595, 776

Maris, Willem (1844–1910), Dutch artist, 11, 17, 534, 595

Marks, Henry Stacy (1829–1898), English artist, 164

Marnix, Lord of Sint-Aldegonde, Philips van (1538–1598), Dutch poet and diplomat, 638

Martin (père Martin), Pierre Firmin (1817–1891), art dealer in Paris, 592, 638, 718

Mathey, Paul (1844–1929), French artist, 768

Maupassant, Guy de (1850–1893), French writer, 574, 590, 595, 625, 628, 638, 670, 678, 804

Maurin, (Jean Baptiste Joseph Antonin) Charles (1856–1914), French artist, 691

Maus, Octave (1856–1919), secretary of Les Vingt in Brussels, 820, 821

Mauve, Anton Rudolf (1838–1888), Dutch artist, 11, 17, 18, 22, 66, 88, 99, 120, 123, 133, 137, 148, 151, 164, 172, 179, 190, 192, 193, 194, 196, 199, 203, 204, 211, 214, 220, 222, 224, 228, 249, 250, 258, 260, 267, 274, 307, 354, 361, 363, 413, 432, 446, 450, 464, 469, 493, 519, 534, 584, 589, 590, 592, 595, 615, 626, 628, 660, 691, 804, 853

Mauve-Carbentus, Ariëtte Sophia Jeanette (Jet) (1856–1894), wife of Anton Mauve, 22, 88, 99, 133, 192, 196, 590, 592, 595, 721, 732

Max, Gabriel Cornelius Ritter von (1840–1915), Czech artist, 133

Meijjes. *See* Posthumus Meijjes

Meissonier, Ernest (1815–1891), French artist, 17, 38, 288, 351, 514, 534, 559, 686, 709, 768, 779, 798, 839, 853

Mellery, Xavier (1845–1921), Belgian artist, 493

Memling, Hans (1430/40–1494), German/Flemish artist, 154

Mendes da Costa, Maurits Benjamin (1851–1938), Van Gogh's teacher in Amsterdam, 120, 123, 133, 137

Menzel, Adolf Friedrich Erdmann (1815–1905), German artist, 133, 235, 267, 310

Mercier, Michel Louis Victor (1810–c. 1894), French sculptor, 515

Meryon, Charles (1821–1868), French artist, 158, 776

Mesdag, Hendrik Willem (1831–1915), Dutch artist, 361, 375, 386

Mesker, Theodorus (Theo) Ludovicus (1853–1894), Dutch artist, 804

Meulen, François (Frans) Pieter ter (1843–1927), Dutch artist, 361, 402

Meunier, Constantin Emile (1831–1905), Belgian artist, 358, 529, 657, 805

Meusnier, Mathieu. *See* Robert, Georges Karl

Meyboom (Meijboom), Claas (1851–1911), brother of Margreet Meyboom, 120, 133

Meyboom (Meijboom), Margreet Anna Sophia (1856–1927), girlfriend of Van Gogh's cousin Paul Stricker, 120

Michel, Georges (1763–1843), French artist, 66, 73, 129, 143, 291, 312, 392, 432, 507, 779, 896

Michelangelo Buonarroti (1475–1564), Italian artist, 222, 361, 515, 531, 651, 798

Michelet, Jules (1798–1874), French writer, 46, 55, 102, 133, 143, 155, 186, 193, 312, 342, 413, 829

Middelbeek (?–?), acquaintance of the Stricker family in Amsterdam, 133

Millais, John Everett (1829–1896), English artist, 11, 17, 155, 164, 170, 249, 359, 484, 820

Millet, Jean-François (1814–1875), French artist, 17, 37, 55, 73, 137, 143, 155, 158, 160, 164, 211, 228, 235, 244, 249, 252, 258, 260, 267, 278, 288, 307, 325, 354, 358, 359, 361, 363, 377, 386, 400, 402, 428, 434, 439, 440, 464, 493, 497, 502, 509, 514, 515, 519, 531, 534, 537, 541, 550, 552, 555, 559, 569, 626, 628, 632, 635, 642, 650, 651, 657, 663, 665, 686, 768, 772, 785, 798, 801, 804, 805, 816, 822, 839, 841, 849, 850, 856, 863, 889

Milliet, Paul Eugène (1863–1943), French lieutenant of the Zouaves, 628, 683, 686, 689, 691, 716, 718

Molenaar, Cornelis Anthonie (1856–1887), assistant physician in The Hague, 237

Moller, Frederick William (fl. 1862–1865), English artist, 325

Mols, Robert (1848–1903), Belgian artist, 545

Monet, Claude Oscar (1840–1926), French artist, 569, 584, 615, 625, 628, 632, 642, 650, 683, 703, 721, 768, 797, 798

Monnier, Henry Bonaventure (1799–1877), French writer, 288

Montenard, Frédéric (1849–1926), French artist, 670

Monticelli, Adolphe Joseph Thomas (1824–1886), French artist, 577, 578, 589, 603, 635, 642, 657, 663, 670, 683, 686, 689, 702, 703, 718, 741, 743, 776, 784, 790, 829, 853, 856, 889

Morelli, Domenico (1823–1901), Italian artist, 267

Moret, Henry (1856–1913), French artist, 695, 698

Morin, Edmond (Edward) (1824–1882), French artist, 235, 267, 359

Morris, Philip Richard (1836–1902), English artist, 267

Motley, John Lothrop (1814–1877), American writer, 133

Mourier Petersen, Christian Vilhelm (1858–1945), Danish artist, 615, 625, 635, 650, 657, 683

Multatuli (pseudonym of Eduard Douwes Dekker) (1820–1887), Dutch writer, 193

Murger, Henri (1822–1861), French writer, 274, 288

Musset, Louis Charles Alfred de (1810–1857), French poet, 38, 383, 651, 626

Muyden, (Jacques) Alfred van (1818–1898), Swiss artist, 267

N

Nanteuil-Leboeuf, Célestin François (1813–1873), French artist, 288

Nash Jr, Joseph (?–1922), English artist, 307

Neuhuys, Johannes Albert (1844–1914), Dutch artist, 278, 386, 534

Neuhuys, Jozef Hendrikus (1841–1889), Dutch artist, 534

Nuijen, Wijnand Johannes Joseph (1813–1839), Dutch artist, 534

O

Obach, Charles (Carl) (1840/41–?), manager at Goupil & Cie in London, 9, 11, 99

Obach, Lena (?–?), daughter of Charles Obach, 99

Obach, Malchen (?–?), daughter of Charles Obach, 99

Obach, Pauline (1847–?), wife of Charles Obach, 99

Offermans, Anton (Tony) Lodewijk George (1854–1911), Dutch artist, 211

Ohnet, Georges (1848–1918), French writer, 626

O'Kelly, Aloysius (1853–1892), Irish artist, 431

Old Crome. *See* Crome, John

d'Ornano, Joseph (1843–?), chief of police in Arles, 743, 750

Ostade, Adriaen van (1610–1685), Dutch artist, 252, 392, 515, 642, 651, 657

Ostade, Isaac van (1621–1649), Dutch artist, 291, 515, 642, 657

P

Pa. *See* Gogh, Theodorus van

Paillard, Jacques Michel (1808–between 1878 and 1884), seller of artists' materials and owner of a paint factory in Paris, 260

Palissy, Bernard (1510–1589/90), French artist and writer, 158, 164

Pasini, Alberto (1826–1899), Italian artist, 17

Pasteur, Louis (1822–1895), French chemist and bacteriologist, 638

Pauwels, Andreas (1826–1889), clergyman in Nuenen, 541

Perruchot, Marcellin (1836–?), restaurant owner and wine merchant in Asnières, 611

Petrarch (Francesco Petrarca) (1304–1374), Italian poet, 683, 695

Peyron, Théophile Zacharie Auguste (1827–1895), director of the asylum in Saint-Rémy,

779, 797, 801, 816, 820, 829, 836, 839, 849, 863, 865, 868, 872, 877

Pieneman, Jan Willem (1779–1853), Dutch artist, 561

Pieneman, Nicolaas (1809–1860), Dutch artist, 561

Pieterszen. *See* Waeyen Pieterszen, Abraham van der

Pille, Charles Henri (1844–1897), French artist, 318

Pinwell, George John (1842–1875), English artist, 164, 267, 358, 820

Pissarro, Lucien (1863–1944), French artist, son of Camille Pissarro, 592, 695

Pissarro, Camille Jacob (1830–1903), French artist, 584, 620, 625, 631, 695, 776, 801, 805, 820, 857, 873, 889

Pissarro-Vellay, Julie (1838–1926), wife of Camille Pissarro, 820, 857

Poe, Edgar Allan (1809–1849), American writer, 316

Polack, Emile Ferdinand (1859–after 1904), French artist, 782

Pompe Sr, Abraham (Uncle Pompe) (1831–1909), Dutch commander, later lieutenant-colonel, uncle of Van Gogh, 22, 123

Pompe, Elisabeth Hubertha (Aunt Bertha). *See* Gogh, Elisabeth Hubertha van

Portier, Alphonse (1841–1902), art dealer in Paris, 497, 502, 507, 515, 527, 529, 550, 584, 638, 663

Posthumus Meijjes, Jeremias (Jeremie) (1831–1908), clergyman in Amsterdam, son of Reinier Posthumus Meijjes Sr, 123, 129

Posthumus Meijjes Sr, Reinier (1803–1891), clergyman in Amsterdam, 120

Posthumus Meijjes-Tilanus, Jeanne Louise Agathe (1834–1881), wife of Jeremias Posthumus Meijjes, 129

Posthumus Meijjes-Van Maanen, Willemina Petronella (1807–1880), wife of Reinier Posthumus Meijjes Sr, 120

Potter, Paulus (1625–1654), Dutch artist, 632, 642, 651, 726, 801

Poussin, Nicolas (1594–1665), French artist, 531

Prévost, Charles Eugène (1855–?), French artist, 670

Prins, Antonie (Toon) (1849–1932), farmer in Zundert, classmate of Van Gogh, 811

Prins, Petrus (Piet) (1851–1892), farmer in Zundert, classmate of Van Gogh, 811

Provily, Jan (1800–1875), boarding-school proprietor in Zevenbergen, 76

Puvis de Chavannes, Pierre (1824–1898), French artist, 446, 483, 611, 632, 655, 683, 732, 743, 768, 820, 829, 875, 879

Pyle, Howard (1853–1911), American artist, 235, 354, 359

Q

Quinet, Edgar (1803–1875), French writer, 752

Quost, Ernest (1844–1931), French artist, 657, 739, 741, 768, 850, 853

R

Rabelais, François (c. 1494–1554), French writer, 574

Raffaëlli, Jean-François (1850–1924), French artist, 515, 545, 602

Raphael (Rafaello Sanzio) (1483–1520), Italian artist, 651

Rappard, Anthon Gerard Alexander, ridder van (1858–1892), Dutch artist, 160, 164, 170, 172, 179, 190, 235, 242, 267, 278, 291, 301, 307, 310, 312, 323, 325, 332, 342, 348, 354, 359, 377, 384, 390, 400, 408, 410, 413, 431, 439, 440, 442, 446, 450, 502, 509, 514, 519, 521, 529, 531

Rappard, Frans Alexander Lodewijk, ridder van (1828–1888), father of Anthon van Rappard, 291, 410

Rappard, Wilhelmina Elisabeth van (1861–1934), sister of Anthon van Rappard, 342

Rappard-Lantsheer, Suzanna Adriana Carolina van (1832–1902), mother of Anthon van Rappard, 410

Raumer, Karl Georg von (1783–1865), German writer, 126

Ravoux, Arthur Gustave (1848–1914), manager of Auberge Ravoux in Auvers, 896

Ravoux, Germaine (1888–?), daughter of Arthur Gustave Ravoux, 896

Ravoux-Touillet, Adeline Louise (1855–?), wife of Arthur Gustave Ravoux, 896

Read, Samuel (1815–1883), English artist, 359

Redon, Odilon (1840–1916), French artist, 650

Régamey, Félix Elie (1844–1907), French artist, 267, 325, 358, 359, 371, 515, 839

Régamey, Guillaume Urbain (1837–1875), French artist, 267, 325, 358, 371, 515

Regnault, Alexandre Georges Henri (1843–1871), French artist, 291, 450

Reid, Alexander (1854–1928), Scottish art dealer, 578, 589, 592, 602, 625, 638, 642, 673, 686, 784

Reid, George Robert (1851–after 1916), English artist, 84

Reinhart, Charles Stanley (1844–1896), American artist, 359

Rembrandt van Rijn (1606–1669), Dutch artist, 37, 120, 123, 129, 133, 143, 148, 155, 158, 211, 249, 267, 288, 310, 318, 325, 359, 361, 434, 440, 531, 534, 550, 552, 625, 632, 642, 650, 651, 655, 665, 726, 732, 736, 743, 779, 782, 784, 797, 798, 801, 804, 820, 853, 865

Renan, (Joseph-Ernest) Ernest (1823–1892), French writer, 33, 55, 493, 764, 782, 784

Renoir, Pierre Auguste (1841–1919), French artist, 584, 603

Renouard, Charles Paul (1845–1924), French artist, 235, 325, 482, 483

Rethel, Alfred (1816–1859), German artist, 120

Reuter, Fritz (1810–1874), German writer, 318, 354

Rey, Félix (1865–1932), assistant physician in the hospital in Arles, 728, 732, 736, 740, 747, 750, 752, 760, 776

Reynolds, Joshua (1723–1792), English artist, 11

Ricard, Louis Gustave (1823–1873), French artist, 635, 726, 798

Richard, Jacques Jeremie (1823–1897), clergyman in Vlissingen, 129

Richard-Nieuwenhuis, Anna Jacoba Maria Geertruida (1826–1877), wife of Jacques Jeremie Richard, 129

Richepin, Jean (Auguste-Jules) (1849–1926), French writer, 572, 574, 683

Ridley, Matthew White (1837–1888), English artist, 359

Rijken, Adriaan (1834–1915), gardener in Nuenen, 558

Rijken, Pieter (1841–1922), lodging-house-keeper in Dordrecht, 102, 109

Rijken-Aelmans, Maria (1863–1922), wife of Pieter Rijken, 102, 109

Rink, Paulus (Paul) Philippus (1861–1903), Dutch art student at the Antwerp academy, 569

Rivet, Louis Marie Hippolyte (1851–1931/32?), doctor in Paris, 578, 603, 611, 736, 747, 798, 805

Robert, Georges Karl (pseudonym of Mathieu Meusnier) (fl. 1874–1882), French writer and artist, 267

Rochefort-Luçay, Victor Henri Marquis de (1831–1913), French journalist, 574, 752

Rochussen, Charles (1814–1894), Dutch artist, 17, 204, 267, 534

Rod, Edouard (1857–1910), Swiss writer, 785, 797, 798, 805

Rodin, Auguste (1840–1917), French artist, 650, 797, 798

Roelofs, Willem (1822–1897), Dutch artist, 160, 164, 222, 252

Roll, Alfred Philippe (1846–1919), French artist, 502

Romano, Giulio (1499?–1546), Italian artist, 552

Rooij, Anthonius van (1823–1908), cousin of Gordina de Groot, 574

Rooij, Francis (Frans) van (1839–1917), cousin of Gordina de Groot, 574

Roos, Willem Marinus (1816–1893), lodging-house-keeper in The Hague, 1, 5, 17, 49, 61, 66, 73, 83, 88, 96, 99, 102, 106, 120, 137, 148

Roos-Van Aalst, Dina (Dientje) Margrieta van (1813–1904), wife of Willem Marinus Roos, 1, 5, 22, 49, 61, 66, 73, 83, 88, 96, 99, 102, 106, 120, 137, 148

Roosmaelen-Duerwaerder, Isabella Adriana de (1830–1928), landlady in Antwerp, 569

Roqueplan (Rocoplan), Camille Joseph Etienne (1803–1855), French artist, 288

Roquette, Gabriel de la. See Delarebeyrette, Gabriel, 625, 635, 702

Rossetti, Dante Gabriel (1828–1882), English artist, 820

Rossum du Chattel, Fredericus Jacobus van (1856–1917), Dutch artist, 361

Roulin, Armand Joseph Désiré (1871–1945), son of Joseph Roulin, 723, 736, 741

Roulin, Camille (1877–1922), son of Joseph Roulin, 723, 736, 741

Roulin, Joseph Etienne (1841–1903), postal worker in Arles, 655, 663, 669, 677, 691, 702, 723, 730, 732, 736, 739, 741, 747, 797, 836

Roulin, Marcelle (1888–1980), daughter of Joseph Roulin, 723, 736, 739, 741

Roulin-Pelicot, Augustine Alex (1851–1930), wife of Joseph Roulin, 655, 677, 723, 736, 739, 740, 741, 747, 782

Rousseau, Théodore (1812–1867), French artist, 17, 158, 258, 291, 361, 386, 392, 559, 657, 726, 798, 801

Rubens, Peter Paul (1577–1640), Flemish artist, 552, 655, 686

Ruipérez, Luis (1832–1867), Spanish artist, 129

Ruisdael, Jacob Isaacksz. van (1628/29–1682), Dutch artist, 37, 66, 120, 126, 137, 158, 222, 249, 291, 325, 361, 381, 450, 483, 642, 651, 779

Russell, John Peter (1858–1931), Australian artist, 582, 589, 592, 602, 616, 625, 635, 638, 642, 650, 849, 850, 857

Russell-Mattiocco, Anna-Maria (Marianna) Antoinetta (1865–1908), wife of John Peter Russell, 849

S

Saal, Georg Eduard Otto (1818–1870), German artist, 11, 17, 267

Sainte-Beuve, Charles Augustin (1804–1869), French poet, 38

Salles, Frédéric (1841–1897), clergyman in Arles, 760, 768, 772, 816, 836, 850

Sambourne, Edward Linley (1845–1910), English artist, 235

Sand, George (pseudonym of Amandine Lucile [Lucie] Aurore Dupin) (1804–1876), French writer, 383

Sande Bakhuyzen, Julius Jacobus van de (1835–1925), Dutch artist, 22, 211, 402

Sarto, Andrea del (1486–1530), Italian artist, 155

Saux-De Bouteillier, Sophie de. See Browne, Henriette

Schalekamp, J.M., bookseller in Amsterdam, 133

Scheffer, Ary (1795–1858), Dutch artist, 17, 155, 673

Schelfhout, Andreas (1787–1870), Dutch artist, 17, 515

Schmidt, Tobias Victor (1842–1903), manager at Goupil & Cie in Brussels, 3, 5, 9, 11, 160

Schreyer, Adolphe (1828–1899), German artist, 17

Schuffenecker, Claude Emile (1851–1934), French artist, 730, 797

Schuler, (Jules) Théophile (1821–1878), French artist, 267, 354

Seeley & Co., publishers and booksellers in London, 133

Segatori, Agostina (1841–1910), manager of café-cabaret Le Tambourin in Paris, 572

Sensier, Alfred Jean Philippe Auguste (Alfred) (1815–1877), French poet, 258, 434, 493, 541

Serret, Charles Emmanuel (1824–1900), French artist, 408, 507, 509, 515, 527, 529

Seurat, Georges (1859–1891), French artist, 584, 589, 602, 603, 620, 669, 683, 689, 695, 706

's Graeuwen, Elisabeth (Bet) Hubertha (1862–1898), daughter of Theodorus van Gogh's sister Geertruida, 123, 126

's Graeuwen, Francina (Fanny or Fan) (1859–1935), daughter of Theodorus van Gogh's sister Geertruida, 123, 126

Shakespeare, William (1564–1616), English playwright, 155, 158, 267, 782, 784, 785

Siberdt, Eugène François Joseph (1851–1931), Belgian artist, teacher at the Antwerp academy, 555, 559

Siebenhaar, Christiaan (1824–1885), Dutch fencing teacher, 204, 361

Sien. See Hoornik, Clasina Maria

Signac, Paul (1863–1935), French artist, 669, 683, 689, 750, 752, 756, 768

Silvestre, Théophile (1823–1876), French writer, 651

Sisley, Alfred (1839–1899), French artist, 584, 677

Six, Jan (1618–1700), mayor of Amsterdam, 615, 726, 784

Slade-Jones, Annie (1838–1924), wife of Thomas Slade-Jones, 129

Slade-Jones, Thomas (Mr Jones) (1829–1883), clergyman and headmaster of a school in Isleworth, 96, 99

Small, William (1843–1929), English artist, 267, 307, 375

Smedley, William Thomas (1858–1920), American artist, 354

Smulders & Co., Jos., stationers and lithographers in The Hague, 325, 377

Socrates (469 BC–399 BC), Greek philosopher, 638, 665

Soek, Frans (?–1879), employee at Goupil & Cie in Paris, 88

Sophia Frederika Mathilda (1818–1877), queen of The Netherlands, wife of King Willem III, 120

Sophocles (496 BC–406/405 BC), Greek playwright, 822

Soulé, Bernard (1826–1903), agent of Van Gogh's landlord in Arles, 672, 743, 760

Souvestre, Emile (1806–1854), French writer, 155, 288, 785

Staniland, Charles Joseph (1838–1916), English artist, 278

Steen, Jan (1626–1679), Dutch artist, 193, 657

Steffens, Louise Eugénie (1841–1865), Dutch artist, 133

Stevens, Alfred (1823–1906), Belgian artist, 515, 550

Stieler, Adolf (1775–1836), German map-maker, 137

Stockum, Wilhelmus Petrus van (1810–1898), father of Willem Jacob van Stockum, 46, 88, 96, 99

Stockum, Willem Jacob van (1846–1900), husband of Carolina Adolphina van Stockum-Haanebeek, 18

Stockum-de Langen, Maria van (1814–1882), mother of Willem Jacob van Stockum, 46, 88, 96, 99, 133

Stockum-Haanebeek, Carolina (Caroline) Adolphina van (1852–1926), distant relative of Van Gogh, wife of Willem Jacob van Stockum, 18, 88, 126

Stokes, William Port (c. 1832–1890), teacher and clergyman in Ramsgate, 76, 79, 83, 84

Stokes-Blyth, Lydia (before 1835–1878), wife of William Port Stokes, 76

Stowe, Harriet Elizabeth Beecher (1811–1896), American writer, 155, 739, 764, 801

Stricker, Cornelia Adriana (Kee). See Vos-Stricker, Cornelia Adriana

Stricker, Johannes Andries (1848–1901), son of Johannes Paulus Stricker Sr, 193, 228

Stricker Sr, Johannes Paulus (Uncle Stricker or J.P.S.) (1816–1886), clergyman in Amsterdam, uncle of Van Gogh, 109, 120, 123, 126, 129, 133, 137, 179, 186, 193, 228, 244, 428

Stricker-Carbentus, Willemina Catharina Gerardina (Aunt Mina) (1816–1904), wife of Johannes Paulus Stricker Sr, 120, 129, 133, 137, 193, 244, 811

Swain, Joseph (1820–1909), English artist, 133, 249, 325

Swart, Elisabeth Sara Clasina de (Sara) (1861–1951), Dutch sculptor, 898

Sylva, Carmen (pseudonym of Elizabeth Pauline Ottilie Louise of Wied) (1843–1916), German writer, queen of Romania, 804, 805

T

T. (Mr T.). See Tersteeg, Hermanus Gijsbertus

Taine, Hippolyte Adolphe (1828–1893), French writer, 133, 359

Tanguy (père Tanguy), Julien François (1825–1894), seller of artists' materials in Paris, 572, 595, 638, 655, 663, 677, 683, 691, 718, 768, 776, 820, 863, 877, 889

Tanguy-Briend, Renée Julienne (1821–1897), wife of Julien Tanguy, 638, 743

Tapiró y Baró, José (1830–1913), Spanish artist, 267, 839

Tardieu, Jacques (1834–after 1894), mayor of Arles, 750

Tassaert, Nicolas François Octave (1800–1874), French artist, 274, 493, 555, 726

Tasset, Guillaume Charles (1843–1925), seller of artists' materials in Paris, 595, 625, 631, 635, 863, 889, 902

Tasset & Lhote, sellers of artists' materials in Paris, 631

Teixeira de Mattos, Isaäc (1821–1904), teacher of Van Gogh in Amsterdam, 137

Tenniel, John (1820–1914), English artist, 235

Tersteeg, Elisabeth (Betsy) (1869–1938), daughter of Hermanus Gijsbertus Tersteeg, 88

Tersteeg, Hermanus Gijsbertus (H.G.T., T. or Mr T.) (1845–1927), manager at Goupil & Cie in The Hague, 17, 22, 33, 49, 55, 65, 66, 73, 88, 96, 99, 102, 133, 158, 164, 199, 203, 204, 207, 211, 214, 220, 222, 224, 228, 237, 244, 249, 250, 252, 358, 361, 363, 464, 469, 519, 541, 582, 584, 589, 590, 592, 595, 602, 609, 615, 616, 625, 626, 660, 677, 721, 801

Tersteeg-Pronk, Maria Magdalena Alida (1845–1925), wife of Hermanus Gijsbertus Tersteeg, 22, 66, 73, 88, 96, 99, 102, 120, 133

Thomas (père Thomas), Georges (?–after 1908), art dealer in Paris, 625, 689, 702, 709, 718

Thomas, Jean Joseph (1814–1898), seller of artists' materials in Paris, 683

Thoré, Etienne Joseph Théophile (pseudonym: W. Bürger) (1807–1869), French art critic, 439, 450, 502, 642

Thorvaldsen, Bertel (1770–1844), Danish sculptor, 120

Tissot, James (Jacques-Joseph) (1836–1902), French artist, 11, 17, 158, 342, 515

Titian (Tiziano Vecellio) (1477–1576), Italian artist, 158, 801

Tolstoy, Ljev (Leo) Nikolaevich (1828–1910), Russian writer, 686, 804

Toulouse-Lautrec, Henri Marie Raymond de (1864–1901), French artist, 595, 620, 663, 898

Tournemine, Charles Emile Vacher de (1812–1872), French artist, 17

Trabuc, Charles Elzéard (1830–1896), orderly in the asylum in Saint-Rémy, 801

Trabuc-Lafuye, Jeanne (1834–1903), wife of Charles Elzéard Trabuc, 801, 804, 805

Troyon, Constant (1810–1865), French artist, 17, 37, 361, 559, 776, 853

Turner, Joseph Mallord William (1775–1851), English artist, 11

U

Uncle Cent. See Gogh, Vincent van

Uncle Cor. See Gogh, Cornelis Marinus van

Uncle Hein. See Gogh, Hendrik Vincent van

Uncle Jan. See Gogh Sr, Johannes van

Uncle Pompe. See Pompe Sr, Abraham

Uncle Stricker. See Stricker Sr, Johannes Paulus

Uncle Vincent. *See* Gogh, Vincent van

Urrabieta Vierge, Daniel (1851–1904), Spanish artist, 361

V

Valadon, René (1848–1921), art dealer in Paris, 584

Valentin, Henri (1820–1855), French artist, 267

Valkis, Willem Marinus (1853–1935), boarder with Willem Marinus Roos in The Hague, 79, 83

Vautier (the Elder), Benjamin (1829–1898), Swiss artist, 17, 267, 359

Velázquez, Diego Rodríguez de Silva y (1599–1660), Spanish artist, 450, 515, 603, 632, 651, 686, 801

Velden, Petrus (Piet) van der (1837–1913), Dutch artist, 278, 361

Verdier, Lucien Aimé Antoine (1813–?), owner of the Yellow House in Arles, 743

Verdier, Marcel-Antoine (1817–1856), French artist, 726

Verkissen, François Antoine (1839–1881), mustard manufacturer in Saint-Gilles, 148

Verlat, Charles (Karel) Michel Marie (1824–1890), Belgian artist, director of the Antwerp academy, 552, 555, 558

Vermeer, Johannes (Jan) (1632–1675), Dutch artist, 325, 434, 534, 625, 642, 651, 655, 683, 779

Verne, Jules Gabriel (1828–1905), French writer, 361

Vernier, Emile Louis (1829–1887), French artist, 3, 839

Veronese, Paolo (Paolo Caliari) (c. 1528–1609), Italian artist, 537, 552, 595, 626, 650, 665, 677, 686, 689, 695, 739, 740, 752, 779, 863

Verschuur, Wouterus (Wouter) (1812–1874), Dutch artist, 164

Viaud, Louis Marie Julien. *See* Loti, Pierre

Vierge, Daniel Urrabieta. *See* Urrabieta Vierge, Daniel

Vignon, Victor Alfred Paul (1847–1909), French artist, 592, 631, 689, 801

Vinck, Frans (François) Kasper Huibrecht (1827–1903), Belgian artist, 555

Vintcent-De Lezenne Greve, Cornelia Wilhelmina (1822–1876), acquaintance of the Van Gogh family in The Hague, 88

Viollet-le-Duc, Eugène Emmanuel (1814–1879), French architect, 158, 164

Voerman Sr, Jan (1857–1941), Dutch artist, 902

Vollon, Antoine (1833–1900), French artist, 332, 359

Voltaire (pseudonym of François Marie Arouet) (1694–1778), French writer, 574, 611, 657, 732, 764, 790

Vos, Christoffel Martinus (1841–1878), clergyman in Amsterdam, husband of Kee Vos-Stricker, 126, 137

Vos, Johannes (Jan) Paulus (1873–1928), son of Christoffel and Kee Vos, 193

Vosmaer, Carel (1826–1888), Dutch writer, 626

Vos-Stricker, Cornelia Adriana (Kee, Kee Vos, K.V.) (1846–1918), daughter of Johannes Paulus Stricker Sr, wife of Christoffel Martinus Vos, 126, 137, 186, 193, 194, 228, 244

Vriendt, Albert (Albrecht) Frans Lieven de (1843–1900), Belgian artist, 318

Vriendt, Juliaan (Julien) de (1842–1935), Belgian artist, 318

Vries, Theodorus de (1836–1890), carpenter in Nuenen, 432

W

Waeyen Pieterszen, Abraham van der (1817–1880), clergyman in Mechelen, 148

Wagner, Richard (1813–1883), German composer, 590, 635, 683, 686, 739, 743

Wahlberg, Alfred (Herman Alfred Leonard) (1834–1906), Swiss artist, 17

Wakker, Willem van de (1859–1927), telegraph operator and amateur artist in Nuenen, 469

Waldorp, Antonie (1803–1866), Dutch artist, 534

Walker, Frederick (1840–1875), English artist, 164, 199, 235, 307, 325, 358

Wallace, Richard (1818–1890), art collector in London, 361

Wallis, Thomas (?–?), art dealer in London, 509

Watteau, Jean Antoine (1684–1721), French artist, 853

Wauters, Emile (1846–1933), Belgian artist, 11, 361, 650, 709

Weber, Otto (1832–1888), German artist, 11, 17

Weehuizen, Johannes Wilhelmus (1852–1875), housemate of Theo in The Hague, 46

Weele, Herman Johannes van der (1852–1930), Dutch artist, 332, 348, 354, 361, 367

Weissenbruch, Johan Hendrik (Jan Hendrik) (1824–1903), Dutch artist, 11, 17, 123, 204, 222, 235, 312, 371, 592, 776, 801

Wenckebach, Ludwig Willem Reijmert (1860–1937), Dutch artist, 519, 529

Whistler, James Abbot McNeill (1834–1903), American artist, 267, 484, 768

Whitman, Walt (1819–1892), American poet, 670

Wied, Elizabeth Pauline Ottilie Louise of. *See* Sylva, Carmen

Wil. *See* Gogh, Willemina Jacoba van

Wilhelm I (1797–1888), German emperor and king of Prussia, 584

Willemien. *See* Gogh, Willemina Jacoba van

Willette, Adolphe (1857–1926), French artist, 584

William the Silent (William I, Prince of Orange) (1533–1584), Dutch statesman, 738

Wisselingh, Elbert Jan van (1848–1912), Dutch art dealer, 509

Witkamp, Ernest (1854–1897), Dutch artist, 534

Woodville (II), Richard Caton (1856–1927), English artist, 278, 359

Wyllie, William Lionel (1851–1931), English artist, 267

Z

Zahn, Albert von (1836–1873), German writer, 160

Zamacois y Zabala, Eduardo (1842/43–1871), Spanish artist, 17

Ziem, Félix (1821–1911), French artist, 11, 17, 578, 638, 657, 853

Zilcken, Charles Louis Philippe (1857–1930), Dutch artist, 361

Zola, Emile (1840–1902), French writer, 244, 250, 260, 267, 274, 288, 310, 342, 354, 358, 359, 367, 400, 428, 464, 502, 515, 537, 541, 550, 552, 561, 574, 590, 625, 638, 650, 651, 657, 660, 678, 691, 716, 782, 784, 804, 805

Zorn, Anders Leonard (1860–1920), Swedish artist, 768

Zuijlen (Father Bernhard), Cornelius Johannes van (1836–1901), clergyman in The Hague, 193

Zuyderland, Adrianus Jacobus (1810–1897), inhabitant of the Old Men's and Women's Home in The Hague, 267

Zwart, Michiel Antonie de (1853–1922), Van Gogh's landlord in The Hague, 307, 310, 318, 408

Biographies of the Editors

In 1994 Leo Jansen and Hans Luijten started the Van Gogh Letters Project, a collaboration between the Van Gogh Museum, Amsterdam, and Huygens ING, The Hague, to publish the artist's correspondence. In 2002 Nienke Bakker joined the team. Together, they are the editors of *Vincent van Gogh, Painted with Words: The Letters to Emile Bernard* (2007), the web version of Van Gogh's complete correspondence, www.vangoghletters.org (2009), and the six-volume *Vincent van Gogh—The Letters: The Complete Illustrated and Annotated Edition* (published in Dutch, French and English in 2009), and coauthors of *The Real Van Gogh: The Artist and His Letters* (2010).

Leo Jansen was curator of paintings at the Van Gogh Museum from 2005 until 2014. He is the author of *Van Gogh and His Letters* (2007) and coeditor of *Brief Happiness* (1999), the correspondence between Theo van Gogh and his fiancée and then wife, Jo Bonger. Since May 2014, Leo Jansen is editor of the Mondrian Edition Project (RKD and Huygens ING, The Hague).

Hans Luijten is a senior researcher at the Van Gogh Museum. He is the author of *Van Gogh and Love* (2007), and currently is working on a biography of Jo Bonger.

Nienke Bakker has worked at the Van Gogh Museum since 2000 as a researcher, since 2010 as the curator of exhibitions, and since June 2014 as the curator of paintings. Her publications and exhibitions include *Van Gogh and Montmartre* (2011) and *Van Gogh at Work* (2013).